STUDIES IN
LATE MEDIEVAL
AND RENAISSANCE PAINTING
IN HONOR OF
MILLARD MEISS

STUDIES IN
LATE MEDIEVAL AND
RENAISSANCE PAINTING
IN HONOR OF

MILLARD MEISS

Edited by

IRVING LAVIN and JOHN PLUMMER

VOLUME I

TEXT

NEW YORK UNIVERSITY PRESS * 1977

Copyright © 1977 by New York University
Library of Congress Catalog Card Number: 75-27118
ISBN: 0-8147-4963-1 (Vol. I)
ISBN: 0-8147-4978-x (Vol. II)
Composed by Cahill (1976) Limited, East Wall Road, Dublin 3
Vol. I printed by Cahill (1976) Limited, East Wall Road, Dublin 3
Vol. II printed by Meriden Gravure, Meriden Connecticut
Bound by Tapley-Rutter Co., Moonachie, New Jersey

THE PUBLICATION COMMITTEE

Foreword

Like the *ovum struthionis*, this book has been slow in hatching; neither the penetrating stares nor the combined heat of the editors seems to have hurried its incubation. When these essays were written, it was hoped that they could be presented to Millard Meiss on his seventieth birthday in 1974. This proved quite impossible; but before his death on June 12, 1975, he had received the galley proofs of all the essays. Only now, over two years later, is the book breaking its shell and appearing in print.

The scope of the volume, as its title indicates, has been limited to articles on subjects related to Millard Meiss's own research. The nature of that research, its extraordinary range and variety, may be seen in the bibliography of his writings included here. That he also with rare wisdom, tact, and humor played a substantial role in the scholarship of others is amply attested in the fond references to him by the authors. It has seemed fitting to keep those references as he saw them, as though he were alive—for indeed he still lives in the affection of his friends and in his scholarship.

The editors offer their gratitude to the authors for their contributions, their patience—and occasionally their impatience—and to all others who have assisted in this publication in any way. The efforts of four people have been exceptional and need specific acknowledgment: Mary E. D. Laing undertook the painstaking task of laying out the plates; Johanna M. Cornelissen and Elizabeth H. Beatson compiled the bibliography; and Helen M. Franc helped at all stages in the herculean labors of editing the text and overseeing the book's recalcitrant production. We are also indebted to R.L. Lenhart for the photograph reproduced here as the frontispiece.

This publication would have been impossible without the financial support so generously provided by the individuals, firms, and institutions listed below.

IRVING LAVIN, *The Institute for Advanced Study*
JOHN PLUMMER, *The Pierpont Morgan Library*

February, 1977

GEORGE BRAZILLER, INC.

THE INSTITUTE FOR ADVANCED STUDY

SAMUEL H. KRESS FOUNDATION

THE METROPOLITAN MUSEUM OF ART

PRINCETON UNIVERSITY—DEPARTMENT OF ART AND ARCHAEOLOGY

LESSING J. ROSENWALD

THE NORTON SIMON FOUNDATION

WILDENSTEIN & CO., INC.

AND

A GROUP OF FRIENDS

Table of Contents

VOLUME ONE

Foreword IRVING LAVIN and JOHN PLUMMER — vii

Bibliography of Millard Meiss — xiii

Alberti's Light — 1
JAMES S. ACKERMAN

A Book of Hours Made for King Wenceslaus IV of Bohemia — 28
J. J. G. ALEXANDER

Un Cas d'influence italienne dans l'enluminure du Nord de la France au quatorzième siécle — 32
FRANÇOIS AVRIL

Dalla Sinopia al cartone — 43
UMBERTO BALDINI

"Una Prospettiva . . . di mano di Masaccio" — 48
JAMES H. BECK

A Propos de Deux Dessins inédits du Parmesan — 54
SYLVIE BÉGUIN

Man and Mirror in Painting: Reality and Transience — 61
JAN BIAŁOSTOCKI

Sulla *Madonna del Manto* e su altri affreschi nello Spedale di Santa Maria della Scala a Siena — 73
ENZO CARLI

Sur Deux Rameaux de figuier — 83
ANDRÉ CHASTEL

Pope Innocent VIII and the Villa Belvedere — 88
DAVID R. COFFIN

An Image Not Made by Chance: The Vienna *St. Sebastian* by Mantegna — 98
MIRELLA LEVI D'ANCONA

Mensurare temporalia facit Geometria spiritualis: Some Fifteenth-Century Italian Notions
about When and Where the Annunciation Happened — 115
SAMUEL Y. EDGERTON, JR.

Bemerkungen zu Raffaels *Madonna di Foligno* 131
 HERBERT VON EINEM

A Late Trecento *Custodia* with the Life of St. Eustace 143
 MARVIN EISENBERG

Michelangelo and Domenico Ghirlandaio 152
 EVERETT FAHY

L'Ancien Trône d'émaux de Notre-Dame à Guadalupe et la naissance du Style international 157
 en Castille
 MARIE-MADELEINE GAUTHIER

Giovanni Bellini's Topographical Landscapes 174
 FELTON GIBBONS

The Patron of Starnina's Frescoes 185
 CREIGHTON GILBERT

Il Ciclo cavalleresco del Pisanello alla corte dei Gonzaga: I. Il Pisanello e la grande scoperta 192
 di Mantova
 CESARE GNUDI

Il Ciclo cavalleresco del Pisanello alla corte dei Gonzaga: II. Tecnica e stile nel ciclo murale 205
 GIOVANNI PACCAGNINI

Eine verspätete Apocalypsen-Handschrift und ihre Vorlage 219
 REINER HAUSSHERR

Qui è la veduta: Über einige Landschaftszeichnungen Leonardo da Vincis im Madrider 241
 Skizzenbuch (Cod. 8936)
 LUDWIG H. HEYDENREICH

Meister Bertrams Engelsturz 249
 GEORG KAUFFMANN

Albrecht Dürer um 1500 261
 HANS KAUFFMANN

The Chantilly *Miroir de l'humaine salvation* and Its Models 274
 HERBERT L. KESSLER

New Criteria for Dating the Netherlandish *Biblia Pauperum* Blockbook 283
 ROBERT A. KOCH

Fra Angelico and—perhaps—Alberti 290
 RICHARD KRAUTHEIMER

The Mystic Winepress in the Mérode Altarpiece 297
MARILYN ARONBERG LAVIN

Ariosto's *Roger and Angelica* in Sixteenth-Century Art: Some Facts and Hypotheses 302
RENSSELAER W. LEE

Vicende di una pala 320
GIUSEPPE MARCHINI

Hatred, Hunting, and Love: Three Themes Relative to Some Manuscripts of Jean sans Peur 324
CARL NORDENFALK

"Petri de Burgo opus" 342
ROBERT OERTEL

Disegni per esercitazione degli allievi e disegni preparatori per le opera d'arte nella testimonianza del Cennini 352
UGO PROCACCI

The Architectural Setting of Antonello da Messina's San Cassiano Altarpiece 368
GILES ROBERTSON

Per Paolo Uccello 373
MARIO SALMI

Paralipomena su Leonardo e Dürer 377
ROBERTO SALVINI

A Note on Early Titian: The *Circumcision* Panel at Yale 392
CHARLES SEYMOUR, JR.†

A Manuscript Illustrated by Bacchiacca 399
JOHN SHEARMAN

Taddeo Gaddi, Orcagna, and the Eclipses of 1333 and 1339 403
ALASTAIR SMART

Un Nouveau Tableau bourguignon et les Limbourg 415
CHARLES STERLING

The Back Predella of Duccio's *Maestà* 430
JAMES H. STUBBLEBINE

Il Bianco di piombo nelle pitture murali della Basilica di San Francesco ad Assisi 437
LEONETTO TINTORI

Vecchietta and the Persona of the Renaissance Artist 445
HENDRIK W. VAN OS

The Earliest Known Painting by Niccolò da Foligno 455
 LUISA VERTOVA

Una Tavola boema del Trecento 462
 FEDERICO ZERI

VOLUME TWO

Plates 1–161

Sources of the Illustrations

MILLARD MEISS

BIBLIOGRAPHY AS OF AUGUST 1976

1. "Ugolino Lorenzetti," *Art Bulletin*, XIII, 1931, pp. 376–97.

2. "The Problem of Francesco Traini," *Art Bulletin*, XV, 1933, pp. 97–173.

3. "Un Dessin par le Maître des Grandes Heures de Rohan," *Gazette des Beaux-Arts*, s. 6, vol. XIII, part I, 1935, pp. 65–75.

4. "Bartolommeo Bulgarini altrimenti detto 'Ugolino Lorenzetti'?," *Rivista d'Arte*, XVIII, 1936, pp. 113–36.

5. "The Earliest Work of Giovanni di Paolo: Venus and the Three Graces," *Art in America*, XXIV, 1936, pp. 137–43.

6. "The Madonna of Humility," *Art Bulletin*, XVIII, 1936, pp. 435–64.

7. "A Dugento Altarpiece at Antwerp," *Burlington Magazine*, LXXI, 1937, pp. 14–25.

8. "Fresques italiennes, cavallinesques et autres, à Béziers," *Gazette des Beaux-Arts*, XVIII, 1937, pp. 275–86.

9. Review of Grace Frank and Dorothy Miner, *Proverbes en rimes*, *Art Bulletin*, XX, 1938, pp. 332–33.

10. "An Austrian Panel in the Huntington Library," *Art in America*, XXVIII, 1940, pp. 30–43. Abstract in *Art News*, XXXVII, 1939, p. 8.

11. "A Documented Altarpiece by Piero della Francesca," *Art Bulletin*, XXIII, 1941, pp. 53–68. *See also* 129.

12. "Italian Style in Catalonia and a Fourteenth-Century Catalan Workshop," *Journal of the Walters Art Gallery*, IV, 1941, pp. 45–87.

13. Letter to the Editor of the *Journal of Aesthetics and Art Criticism* (signed as "The Editors of the *Art Bulletin*") on article by Leo Balet, "The History of Art of the Future," *Journal of Aesthetics and Art Criticism*, I, Winter 1941–42, pp. 75–77.

14. "A Statement on the Place of the History of Art in the Liberal Arts Curriculum," *College Art Journal*, III, 1944, pp. 82–87.
 Written as Chairman of a committee of the College Art Association of America.

15. Letter to the Editor of the *Art Bulletin* on Frank Jewett Mather, Jr., "The Problem of the Brancacci Chapel Historically Considered," *Art Bulletin*, XXVI, 1944, pp. 274–75.

16. "Light as Form and Symbol in Some Fifteenth-Century Paintings," *Art Bulletin*, XXVII, 1945, pp. 175–81.
 Reprinted with slight changes in Creighton Gilbert, ed., *Renaissance Art*, New York, 1970, pp. 43–68.
 See also 129.

17. "Italian Primitives at Konopiště," *Art Bulletin*, XXVIII, 1946, pp. 1–16.
 Abstract in *American Journal of Archaeology*, LI, 1947, p. 190.

18. "War's Toll of Italian Art," *Magazine of Art*, XXXIX, 1946, pp. 240–41.

19. "A Note on Piero della Francesca's St. Augustine Altarpiece," *Burlington Magazine*, LXXXIX, 1947, p. 286.

20. "Conditions of Historic Art and Scholarship in Italy," *College Art Journal*, VII, 1948, pp. 199–202.

21. Review of Enzo Carli, *Le Sculture del Duomo di Orvieto*, *Magazine of Art*, XLI, 1948, p. 321.

22. Review of Philip Hendy and Ludwig Goldscheider, *Giovanni Bellini*, *Art Bulletin*, XXX, 1948, pp. 75–76.

23. "Orcagnesque Painter," *One Hundred Master Drawings*, ed. Agnes Mongan, Cambridge, Massachusetts, 1949, pp. 2–3.

24. Review of Frederick Antal, *Florentine Painting and Its Social Background*, *Art Bulletin*, XXXI, 1949, pp. 143–50.

25. *Painting in Florence and Siena after the Black Death: The Arts, Religion and Society in the Mid-Fourteenth Century*, Princeton, New Jersey, 1951.
 Paperback editions: New York (Harper Torchbook), 1964; (Icon edition), 1973.
 Excerpts reprinted in N. F. Cantor and S. Berner, ed., *Early Modern Europe 1500–1815*, New York, 1970, pp. 67–69; E. Cherniavsky and A. J. Slavin, ed., *Social Textures of Western Civilization: The Lower Depths*, I, Waltham, Massachusetts, 1972, pp. 392–411.
 See also 27, 129.

26. "Five Ferrarese Panels," *Burlington Magazine*, XCIII, 1951, pp. 69–72.

27. "Guilt, Penance and Religious Rapture after the Black Death," *Magazine of Art,* XLIV, 1951, pp. 218–27.
 Abstracted from Chapter III of 25, above.

28. "A New Early Duccio," *Art Bulletin,* XXXIII, 1951, pp. 95–103.

29. "London's New Masaccio," *Art News,* L, 1952, pp. 24–25, 50–51.

30. " 'Nicholas Albergati' and the Chronology of Jan van Eyck's Portraits," *Burlington Magazine,* XCIV, 1952, pp. 137–44.
 See also 34.

31. "Scusi, ma sempre Duccio," *Paragone,* no. 27, 1952, pp. 63–64.

32. Review of Grete Ring, *A Century of French Painting: 1400–1500, Magazine of Art,* XLV, 1952, p. 46.

33. "Trecento Scramble," *Art Bulletin,* XXXV, 1953, pp. 52–55.

34. Letter to the Editor of the *Burlington Magazine,* "Jan van Eyck," *Burlington Magazine,* XCV, 1953, p. 27.
 See also 30.

35. *"Addendum Ovologicum," Art Bulletin,* XXXVI, 1954, pp. 221–24.
 See also 37.

36. "An Early Altarpiece from the Cathedral of Florence," *Bulletin of The Metropolitan Museum of Art,* XII, 1954, pp. 302–17.

37. *"Ovum Struthionis,* Symbol and Allusion in Piero della Francesca's Montefeltro Altarpiece," *Studies in Art and Literature for Belle da Costa Greene,* Princeton, New Jersey, 1954, pp. 92–101.
 See also 35, 129.

38. Foreword to catalogue, "Spanish Medieval Art," Loan Exhibition in Honor of Dr. Walter W. S. Cook at The Metropolitan Museum of Art, The Cloisters, 1954–1955.

39. Review of George Kaftal, *Iconography of the Saints in Tuscan Painting, Art Bulletin,* XXXVI, 1954, pp. 148–49.

40. Review of Erwin Panofsky, *Early Netherlandish Painting: Its Origins and Character, New York Times Book Review,* March 7, 1954, p. 5.

41. "The Exhibition of French Manuscripts of the XIII–XVI Centuries at the Bibliothèque Nationale," *Art Bulletin,* XXXVIII, 1956, pp. 187–96.

42. "Jan van Eyck and the Italian Renaissance," *Venezia e l'Europa: Atti del XVIII Congresso Internazionale di Storia dell'Arte, 1955,* Venice, 1956, pp. 58–69.
 See also 129.

43. "Nuovi dipinti e vecchi problemi," *Rivista d'Arte,* XXX, 1956, pp. 107–45.

44. "Primitifs italiens à l'Orangerie," *Revue des Arts,* VI, 1956, pp. 139–48.

45. "St. John the Evangelist by Andrea Vanni," *Annual Report of the Fogg Art Museum,* 1955–56, pp. 46–47.

46. *Andrea Mantegna as Illuminator: An Episode in Renaissance Art, Humanism and Diplomacy,* New
 York and Hamburg, 1957.
 Chapter IV ("The Alphabetical Treatises") adapted in "The First Alphabetical Treatises of the
 Renaissance," *Journal of Typographic Research,* III, 1969, pp. 3–30.
 See also 129.

47. "The Case of the Frick Flagellation," *Journal of the Walters Art Gallery,* XIX–XX, 1956–1957,
 pp. 43–63.

48. Review of Carl Nordenfalk, *Kung Praktiks och drottning teoris jaktbok: Le Livre des deduis du roi
 Modus et de la reine Ratio,"* *Speculum,* XXXII, 1957, pp. 594–95.

49. "Four Panels by Lorenzo Monaco," *Burlington Magazine,* C, 1958, pp. 190–98.
 See also 51.

50. "The Baptist Preaching by Paolo di Giovanni Fei," *Annual Report of the Fogg Art Museum,*
 1957–58, pp. 29–31.

51. Letter to the Editor of the *Burlington Magazine,* "Four Panels by Lorenzo Monaco," *Burlington
 Magazine,* C, 1958, p. 359.
 See also 49.

52. "Mortality among Florentine Immortals," *Art News,* LVIII, 1959, pp. 26–29.

53. *Giotto and Assisi,* New York, 1960.
 Paperback edition: New York (Norton), 1967.

54. "A Madonna by Francesco Traini," *Gazette des Beaux-Arts,* LVI, 1960, pp. 49–56.

55. "A New French Primitive" (with Colin Eisler), *Burlington Magazine,* CII, 1960, pp. 233–40.
 See also 58.

56. "Role of the Art Historian," *Forum Lectures.* Forum Art Series, 1960, pp. 1–6.

57. "Toward a More Comprehensive Renaissance Palaeography," *Art Bulletin,* XLII, 1960,
 pp. 97–112.
 See also 129.

58. Letter to the Editor of the *Burlington Magazine,* "A New French Primitive," *Burlington Magazine,*
 CII, 1960, p. 489.
 See also 55.

59. *De Artibus Opuscula XL: Essays in Honor of Erwin Panofsky,* edited by Millard Meiss, New York,
 1961. 2 vols.

60. "Contributions to Two Elusive Masters," *Burlington Magazine,* CIII, 1961, pp. 57–66; rejoinder
 to reply by S. M. Pearce, p. 189.

61. "An Early Lombard Altarpiece," *Arte Antica e Moderna,* 1961, pp. 125–33.

62. " 'Highlands' in the Lowlands: Jan van Eyck, The Master of Flémalle and the Franco-Italian
 Tradition," *Gazette des Beaux-Arts,* LVII, 1961, pp. 273–314.
 See also 129.

63. "International Congress: Comment from the New President," *Art Journal,* XXI, 1961, pp. 1, 18.

64. Foreword to Colin T. Eisler, *Les Primitifs flamands. I. Corpus de la peinture des anciens Pays-Bas
 méridionaux au 15. siècle, 4. New England Museums,* Brussels, 1961.

65. *The Painting of the Life of St. Francis in Assisi, with Notes on the Arena Chapel* (with Leonetto Tintori), New York, 1962.
 Chapter v ("Observations on the Arena Chapel and Santa Croce") reprinted in J. Stubblebine, ed., *Giotto: The Arena Chapel Frescoes*, New York [1969], pp. 203–14.
 See also 75.

66. "Un Fragment rare d'un art honorable," *Revue du Louvre et des Musées de France*, XII, 1962, pp. 105–14.

67. "Reflections of Assisi: A Tabernacle and the Cesi Master," *Scritti di Storia dell'Arte in Onore di Mario Salmi*, Rome, 1962, II, pp. 75–111.

68. *Studies in Western Art: Acts of the Twentieth International Congress of the History of Art*, edited by Millard Meiss, Princeton, New Jersey, 1963. Vol. I: *Romanesque and Gothic Art*; Vol. II: *The Renaissance and Mannerism*; Vol. III: *Latin American Art, and the Baroque Period in Europe*; Vol. IV: *Problems of the 19th and 20th Centuries*.

69. "French and Italian Variations on an Early Fifteenth-Century Theme: St. Jerome and His Study" (Essai en l'honneur de Jean Porcher), *Gazette des Beaux-Arts*, LXII, 1963, pp. 147–70.

70. "Giovanni Bellini's St. Francis," *Saggi e Memorie di Storia dell'Arte*, III, Venice, 1963, pp. 11–30.

71. "A Lost Portrait of Jean de Berry by the Limbourgs," *Burlington Magazine*, CV, 1963, pp. 51–53.

72. "Masaccio and the Early Renaissance: The Circular Plan," *Studies in Western Art: Acts of the Twentieth International Congress of the History of Art*, Princeton, 1963, II, pp. 123–45.
 See also 129.

73. "Notes on Three Linked Sienese Styles," *Art Bulletin*, XLV, 1963, pp. 47–48.

74. *Giovanni Bellini's St. Francis in the Frick Collection*, Princeton, New Jersey, 1964.
 See also 85.

75. "Additional Observations on Italian Mural Technique" (with Leonetto Tintori), *Art Bulletin*, XLVI, 1964, pp. 377–80.
 See also 65.

76. "The Altered Program of the Santa Maria Maggiore Altarpiece," *Studien zur toskanischen Kunst: Festschrift Heydenreich*, Munich, 1964, pp. 169–90.

77. "The *Art Bulletin* at Fifty," *Art Bulletin*, XLVI, 1964, pp. 1–4; *Art Journal*, XXIII, 1964, pp. 226–27.

78. "The Yates Thompson Dante and Priamo della Quercia," *Burlington Magazine*, CVI, 1964, pp. 403–12.

79. Statement in John Plummer, *The Book of Hours of Catherine of Cleves*, New York, 1964, pp. 8–9.

80. "An Illuminated *Inferno* and Trecento Painting in Pisa," *Art Bulletin*, XLVII, 1965, pp. 21–34.

81. "Once Again Piero della Francesca's Montefeltro Altarpiece" (with Theodore G. Jones), *Art Bulletin*, XLVIII, 1966, pp. 203–06.
 See also 129.

B

82. "Una Pittura murale del Maestro della *Pietà* Fogg," *Bolletino d'Arte,* LI, 1966 (appeared 1969), pp. 149–50.

83. "La Prima interpretazione dell' 'Inferno' nella miniatura veneta," *Atti del Convegno di Studi: Dante e la Cultura Veneta, March 30–April 5, 1966,* Florence, 1966, pp. 299–302.

84. "Sleep in Venice: Ancient Myths and Renaissance Proclivities," *Proceedings of the American Philosophical Society,* CX, 1966, pp. 348–82.
 See also 129.

85. Letter to the Editor of the *Burlington Magazine,* "Giovanni Bellini's St. Francis," *Burlington Magazine,* CVIII, 1966, p. 27.
 See also 74.

86. *French Painting in the Time of Jean de Berry: The Late Fourteenth Century and the Patronage of the Duke,* London and New York, 1967. 2 vols. (*Kress Foundation Studies in the History of European Art,* 2).
 Second edition: 1969.

87. "The First Fully Illustrated Decameron," *Essays in the History of Art Presented to Rudolf Wittkower,* London, 1967, II, pp. 56–61.

88. "Important Discoveries of Renaissance Art in Florence," *Art News,* LXVI, 1967, pp. 26–81.

89. "A Lunette by the Master of the Castello Nativity," *Gazette des Beaux-Arts,* LXX, 1967, pp. 213–18.

90. "Sleep in Venice," *Stil und Überlieferung in der Kunst des Abendlandes: Acts of the XXI International Congress of the History of Art, Bonn, 1964,* Berlin, 1967, III, pp. 271–79.
 See also 129.

91. *French Painting in the Time of Jean de Berry: The Boucicaut Master* (with the assistance of Kathleen Morand and Edith W. Kirsch), London, 1968. (*Kress Foundation Studies in the History of European Art,* 3).
 Excerpts reprinted in "The Boucicaut Master and Boccaccio," *Studi sul Boccaccio,* V, 1968, pp. 251–63.

92. "Florence and Venice a Year Later" (Reports on Scholarship in the Renaissance), *Renaissance Quarterly,* XXI, 1968, pp. 103–18.

93. "La Mort et l'Office des Morts à l'époque du Maître de Boucicaut et les Limbourg," *Revue de l'Art,* no. 1, 1968, pp. 17–25.

94. "Some Remarkable Early Shadows in a Rare Type of Threnos," *Festschrift Ulrich Middeldorf,* Berlin, 1968, pp. 112–18.

95. Preface and comments in exhibition catalogue, "The Great Age of Fresco: Giotto to Pontormo," New York, The Metropolitan Museum of Art, 1968, pp. 15–17, 64–70, 90, 150, 160.

96. *Illuminated Manuscripts of the Divine Comedy* (with Peter Brieger and Charles S. Singleton), New York, 1969. 2 vols. (*Bollingen Foundation,* 81).

97. *The "Très Riches Heures" of Jean, Duke of Berry* (with Jean Longon and Raymond Cazelles), New York and London, 1969. Munich and Utrecht, 1973.

98. "Florence and Venice Two Years Later," *Renaissance Quarterly,* XXII, 1969, pp. 88–90.

99. "A Sienese *St. Dominic* Modernized Twice in the Thirteenth Century" (with Carmen Gómez-Moreno, Elizabeth H. Jones, and Arthur K. Wheelock, Jr.), *Art Bulletin,* LI, 1969, pp. 363–66.

100. *The Great Age of Fresco: Discoveries, Recoveries and Survivals,* New York and London, 1970.
French edition: *Grandes époques de la fresque,* Paris, 1970.
German edition: *Das grosse Zeitalter der Freskenmalerei,* Munich, Vienna, and Zurich, 1971.

101. "The Master of the Breviary of Jean sans Peur and the Limbourgs," *Proceedings of the British Academy,* LVI, 1970, pp. 111–29.
See also 104.

102. "The Original Position of Uccello's *John Hawkwood*," *Art Bulletin,* LII, 1970, p. 231.

103. "Progress in Florence and Venice during 1969," *Renaissance Quarterly,* XXIII, 1970, pp. 107–11.

104. *The Master of the Breviary of Jean sans Peur and the Limbourgs,* London, 1971. (*Henriette Hertz Trust: Annual Lecture on Aspects of Art, British Academy*).
See also 101.

105. *La Sacra Conversazione di Piero della Francesca,* Florence, 1971. (*Quaderni della Pinecoteca di Brera,* 1).
See also 129.

106. "Alesso di Andrea," *Giotto e il suo tempo: Atti del Congresso Internazionale per la Celebrazione del VII Centenario della Nascita di Giotto, 1967,* Rome, 1971, pp. 401–18.

107. "*Atropos-Mors:* Observations on a Rare Early Humanist Image," "*Florilegium Historiale*": *Essays Presented to Wallace K. Ferguson,* Toronto, 1971, pp. 151–59.

108. "The Bookkeeping of Robinet d'Estampes and the Chronology of Jean de Berry's Manuscripts" (with Sharon Off), *Art Bulletin,* LIII, 1971, pp. 225–35.

109. "Notable Disturbances in the Classification of Tuscan Trecento Paintings," *Burlington Magazine,* CXIII, 1971, pp. 178–87.

110. "A Note on the Marciana Dante and Its 'Signature,' " *Art Bulletin,* LIII, 1971, pp. 310–11.

111. "Recovery in Florence and Venice during 1970" (Renaissance Society Seventeenth Annual Meeting), *Renaissance Quarterly,* XXIV, 1971, pp. 121–23.

112. *The "De Lévis Hours" and the Bedford Workshop,* New Haven, 1972. (*Yale Lectures on Medieval Illumination*).

113. *The Visconti Hours, National Library, Florence* (with Edith W. Kirsch), New York, London, Paris, and Utrecht, 1972.

114. "Bulgarini (Bolgarini), Bartolomeo," *Dizionario biografico degli italiani,* XV, 1972, pp. 38–39.

115. "Deux miniatures perdues du *Térence des ducs*" (with Sharon Off), *Revue de l'Art,* no. 15, 1972, pp. 62–63.

116. "Early Italian Paintings" in exhibition catalogue, "European and American Art from Princeton Alumni Collections," The Art Museum, Princeton University, 1972, p. 8.

117. *The Rohan Master: A Book of Hours* (with Marcel Thomas), New York, London, and Paris, 1973.

118. *Sts. Elijah and John the Baptist by Pietro Lorenzetti; The Baptism by Giovanni di Paolo* (Three Loans from the Norton Simon Foundation), The Art Museum, Princeton University, May 1973.

119. "A New Monumental Painting by Filippino Lippi," *Art Bulletin,* LV, 1973, pp. 479–93.
See also 127.

120. "Ugo Procacci: Forty Years in the Florentine Soprintendenza," *Burlington Magazine,* CXV, 1973, pp. 41–42.

121. *The Belles Heures of Jean, Duke of Berry* (with Elizabeth H. Beatson), New York, London, Munich, and Utrecht, 1974.

122. *French Painting in the Time of Jean de Berry: The Limbourgs and Their Contemporaries* (with the assistance of Sharon Off Dunlap Smith and Elizabeth Home Beatson), New York, 1974; London, 1975. 2 vols. (The Franklin Jasper Walls Lectures, The Pierpont Morgan Library).

123. "A New Panel by Giovanni di Paolo from His Altarpiece of the Baptist," *Burlington Magazine,* CXVI, 1974, pp. 72–77.

124. "Once Again Filippino's Panels from San Ponziano, Lucca," *Art Bulletin,* LVI, 1974, pp. 10 ff.

125. "Raphael's Mechanized Seashell: Notes on a Myth, Technology and Iconographic Tradition," *Gatherings in Honor of Dorothy E. Miner,* Baltimore, 1974, pp. 317–32.
 See also 129.

126. "Scholarship and Penitence in the Early Renaissance: The Image of St. Jerome," *Pantheon,* XXXII, 1974, pp. 134–40.
 See also 129.

127. Additional bibliography, "A New Monumental Painting by Filippino Lippi," *Art Bulletin,* LVI, 1974, pp. 10–11.
 See also 119.

128. "Not an Ostrich Egg?," *Art Bulletin,* LVII, 1975, p. 116.

129. *The Painter's Choice: Problems in the Interpretation of Renaissance Art,* New York, 1976.
 See also 11, 16, 37, 42, 46, 57, 62, 72, 81, 84, 104, 124, 125.

130. *La Pittura a Firenze e a Siena dopo la Grande Peste: Arte, Religione e Società intorno all metà del Trecento,* Turin (forthcoming, 1977).
 See also 25.

131. *La Vie de Nostre Benoit Sauveur Ihesuscrist and La Saincte Vie de Nostre Dame, translatee a la requeste de tres hault et puissant prince Iehan, duc de Berry,* edited by Millard Meiss and Elizabeth H. Beatson. (College Art Association of America Monograph XXXII). New York, New York University Press (in press).

132. "Notes on a Dated Diptych by Lippo Memmi," *Scritti in onore di Ugo Procacci* (forthcoming).

STUDIES IN
LATE MEDIEVAL
AND RENAISSANCE PAINTING
IN HONOR OF
MILLARD MEISS

Alberti's Light

JAMES S. ACKERMAN

I

The closest bond between art and science in the fifteenth century developed in the field of optics. Optics was the foundation on which rationalist painters and sculptors in relief could build a technique for conveying the illusion of consistent and rational space and of three-dimensional objects within that space in correct proportion to one another. It suggested to the painters, in particular, ways of imitating the action of natural light to give the effect of relief. Thus in both of the first two theoretical writings of the Renaissance, Leon Battista Alberti's *De pictura* of 1435[1] and Lorenzo Ghiberti's *Commentarii* of 1447–1448, one of the three parts was devoted to a discussion of the application of optics to art.

Since Ghiberti's third commentary has been shown in recent times to consist almost entirely of notes and transcriptions from medieval optical tracts,[2] the key to the assimilation of this science into art is found in Alberti's small but tightly packed treatise; it was the first Renaissance book on art, and possibly the most influential and imaginative one of all time.

"In writing about painting in these short books," Alberti begins, "we will, to make our discourse clearer, first take from mathematicians those things which seem relevant to the subject. When we have learned these, we will go on, to the best of our ability, to explain the art of painting from the basic principles of nature."[3] And so he begins by defining a point, a line, and a surface, and from there proceeds to the effects of light and how it is transmitted to the eye by rays. The exclusively geometrical approach of ancient and medieval science to the study of optics, which postulated rays of light traveling in straight lines between the object seen and the eye, made it possible for Alberti and his contemporaries to rationalize vision through mathematics, and thereby to produce an illusion of the complex three-dimensional world on the two-dimensional surface of a painting. Because the science was dominated by mathematics, physiological optics—the study of the implications of vision with two eyes, the effects of the motion of the head and eyeball, distortions in peripheral

In homage to the major contributions of Millard Meiss to the study of light in quattrocento painting: "Light as Form and Symbol in Some Fifteenth-Century Paintings," *Art Bulletin* (XXVII, 1945), 175–81; "Some Remarkable Early Shadows in a Rare Type of Threnos," *Festschrift Ulrich Middeldorf* (Berlin, 1968), 112–18.

[1] *On Painting and On Sculpture: The Latin Texts of De Pictura and De Statua*, edited and translated by C. Grayson (London–New York, 1972); I have not yet seen the more richly annotated edition of the Italian text published by Grayson as Vol. III of Alberti, *Opere volgari* (Bari, 1973). The new editions will doubtless supersede that of J. Spencer, *On Painting* (New Haven, 1956 and 1966), done from the Italian text, and the earlier German and Italian editions.

Grayson dates the text of *De pictura* from a note of August 26, 1435, in one of the manuscripts and proposes 1436 for the Italian translation executed by the author ("The Text of Alberti's *De Pictura*," *Italian Studies*, XXIII, 1968, 71–92; see also Grayson's "Studi su L.B. Alberti," *Rinascimento*, IV, 1953, 54–62). Before receiving galleys, I was alerted (by Prof. D.C. Lindberg) to the study by M. Simonelli, "On Alberti's Treatises of Art and Their Chronological Relationship," *Yearbook of Italian Studies* (1971), 75–102, which offers persuasive testimony that the Latin version is a later expansion and correction of the Italian.

[2] As accounted by G. Ten Doesschate, "De derde Commentaar van Lorenzo Ghiberti in Verband met de middeleeuwsche Optiek," Dissertation, Utrecht, 1940; summarized in *idem*, "Over de Bronnen van de derde Commentaar van Lorenzo Ghiberti," *Tijdschrift voor Geschiednis* (XLVII, 1932), 432–38. Cf. J. White, *The Birth and Rebirth of Pictorial Space* (London, 1957), 126ff.

[3] The location in the Grayson edition of passages from the optical section of Book One of *De pictura* is given in the "Outline of Alberti's Optical System" on pp. 2–3 and is therefore not indicated separately in the notes.

vision, and the like—-was not a factor in Alberti's system, though some medieval writers were aware of the physiology of vision, and it began to preoccupy Leonardo.

The medieval term for optics, *perspectiva*, survives in the modern "perspective," but what we understand by this term is only half of the discipline as defined by Alberti. He divides Book One of *De pictura* into two parts (see "Outline of Alberti's Optical System," below). The first (I–III, §§2–21) is an exposition of the operation of light in transmitting images of objects to the eye, a review of the tradition of *perspectiva* as it had been transmitted to scholars of the early fifteenth century, with observations on its application to the practice of painting. The second (IV, §§13–22) is a description of the method of constructing on a two-dimensional surface by geometrical means an illusionary three-dimensional spatial framework in which the dimensions of any object could be made proportional to its distance from the observer; this, by contrast to the foregoing, was entirely an invention of Alberti's, aided by the earlier researches of his older contemporary Filippo Brunelleschi, but not anticipated (except insofar as it was based on optical theory) in ancient or medieval art or science.[4] By way of differentiation, the traditional study of optics was referred to in the Renaissance as *perspectiva naturalis* or *communis*, and Alberti's invention—perspective as we understand it today—*perspectiva artificialis*.[5]

Outline of Alberti's Optical System in Book One of *De Pictura*
(paragraph numbers in parentheses refer to the Grayson edition)

I. Geometry: point; line; surface (§§2, 3, 4)

II. Properties of Objects (§5)
 A. *Permanent*
 1. edge
 2. surface or skin

 B. *Accidental*
 1. changes due to place
 2. changes due to light

III. Light: The Ray Theory
 A. *Rays* (explained in two dimensions) (§§5, 6)
 1. extrinsic
 2. median
 3. centric

[4]For the Brunelleschian system, see n. 46, below.

That Alberti may have been aided in his refinement of artificial perspective by an ancient scientific treatise in a quite different field—Ptolemy's *Geografia* (brought to Florence ca. 1400 and translated from the Greek ca. 1406)—is suggested by Samuel Edgerton in his forthcoming book on Renaissance perspective and its origins. Cartographers have problems in common with painters in reducing three-dimensional reality to a flat image. This study owes much to conversations with Professor Edgerton, and to his careful reading of it in manuscript; I discovered after completing it that it duplicates in part his chapter entitled "Alberti's Optics." An essay by him concerning religious symbolism and Albertian perspective appears on pp. 115–30 of this volume.

[5]Called *costruzione legittima* in modern literature (I was unable to answer Professor Edgerton's query as to whether the term originated in the Renaissance). I believe the Latin term would apply to any Renaissance perspective construction and the Italian to Alberti's and its descendants.

B. *The Visual Pyramid* (§§7, 8): functioning of the three types of ray in three dimensions

C. *Color* (§§9, 10): relation to light; the four primaries and black and white

D. *Light* (§11)

E. *Application of the Theory to Painting* (§12)

IV. Artificial Perspective: The surfaces (§13); proportionality, two-dimensional (§14) and three-dimensional (§15); exceptional angles of vision (§§16, 17); scale (§18); the method of constructing perspective image (§§19–21).

V. Conclusion (§§22–24)

Though Alberti meant the two parts to be complementary, modern readers of his book have focused almost exclusively on the second. A very large literature testifies to the fascination that artificial perspective holds for twentieth-century scholars (among whom there is still warm controversy over the interpretation of Alberti's description of his method and even over whether Renaissance perspective is "correct").[6] But the study of light and color in optics and its application to painting, which Alberti necessarily placed first and treated at greater length, has been neglected.[7] I think there are two reasons for this bias: one, that the mathematical clarity of the perspective box appeals to the positivistic attitude of modern art history and is easily taught and discussed, particularly at a time when art is studied primarily from photographs; and two, that perspective could be represented as the paradigmatic invention of the Renaissance, in that it literally brought all of perceived space under rational control, whereas Alberti's optical exposition was dependent on medieval sources and focused on issues of light and color that were not resolved in his time. I intend to demonstrate that though Alberti's theory may not have been new, it is essential for understanding the genesis of perspective, and that his perception of its relevance for the future of painting is incalculably important.

Optics was one of the most highly developed of the ancient and medieval sciences, both because it could be pursued to a sophisticated level with the mathematical tools available, and because the processes of sense perception concerned all philosophers who addressed problems of epistemology. Already in antiquity, however, the optics of ordinary vision had been expanded by the investigation of reflection (using mirrors) and refraction.[8] Though many ancient scientist-philosophers wrote on optical problems, three were particularly influential in the later development of the science: Euclid and Ptolemy, who wrote treatises specifically on the subject, and Galen, whose interest was anatomical. These writers, all of whom were known

[6]A basic bibliography is given in Grayson's edition of *De pictura*, 26ff., and M. Dalai, "La questione della prospettiva, 1960–68," *L'Arte* (II, 1968), 96–105. Some issues of the continuing controversy are mentioned in n. 50, below.

[7]Except for H. Siebenhüner, *Über den Kolorismus in der Frührenaissance*, Dissertation, Leipzig (Schramberg, 1935), which first alerted me to the importance of Alberti's text, and

recently, S.Y. Edgerton, "Alberti's Colour Theory: a Medieval Bottle without Renaissance Wine," *Journal of the Warburg and Cortauld Institutes* (XXXII, 1969), 109–34. See also n. 58, below.

[8]A good survey of ancient writing on the subject is A.E. Haas, "Antike Lichttheorien," *Archiv für Philosophie* (xx, n. F., xii, 1907), 345ff. See also V. Ronchi, *The Nature of Light* (Cambridge, Mass., 1970), 1–39.

throughout the Middle Ages, and most other ancient students of optics, proceeded on the hypothesis that vision is made possible by rays of light emanating from the eye to reach the object of vision (Diagram 1b); the concept of the "light of the eye" is pervasive in Western culture and has survived linguistically the withdrawal of scientific support. Because the rays were assumed to extend in straight lines from a point source within the eye, the study of optics could be closely allied with that of geometry, since the basic visual percept could be represented as a triangle, cone, or pyramid with its apex in the eye, its sides formed by rays, and its base by the object viewed (Diagram 1a, 1b). By this means the study of vision was translated from the experiential to the mathematical realm and, thus abstracted, could be pursued accurately and to a complex level without resolving the question of whether the eye really emits or receives the rays of light. Thus most of Euclid's work, for example, remained valid after the abandonment of the extromission hypothesis, while the opposing theories of Aristotle and the Epicureans, in which the image originates in the object, did not generate an alternative optical literature.

As in other fields of the mathematical and physical sciences, it was the Arab scholars who preserved and added to the work of the ancients.[9] In optics, Ibn-al-Haitham (d. ca. 1039), known in the later Middle Ages as Alhazen, dominated the future course of the discipline. In a number of separate studies passed on to the Renaissance under the title *Perspectiva* or *De aspectibus*, he rejected the metaphysical interpretations of light that had entered optics in late-antique and Neoplatonic texts and had survived even in Avicenna, returning to the empirical tradition of Euclid and Ptolemy. He gave it a more materialist base, however, by postulating that light rays emanate from the object and are received by the eye (Diagram 2a), and that they are in a sense corporeal, each issuing from a point on the perceived object and traveling from there to the eye. He offered two persuasive proofs for the first theory (intromission): first, that light rays "wound" the eye (one feels pain and can suffer burns from looking straight at the sun), and second, that we experience an afterimage when we close our eyes after looking at a well-lit object in a dark environment. Neither of these phenomena would occur if the eye emitted rays of light. In addition, he studied the effects of atmosphere and of the structure of the eye on the refraction of light and raised, without solving, the problem of where and how images are projected within the eye. Alhazen accepted the Galenic theory that images are sensed on the surface of the crystalline or glacial humor, rather than on the retina, as we believe today. This was the result of an effort to suppress the evidence of geometrical laws and of the camera obscura (which Alhazen knew) that a retinal image would have to be inverted (see Fig. 1)—evidence which is so hard to adjust to common-sense experience that even today laymen are confused by it.

Virtually all later writing on optics was indebted to Alhazen; the most widely read works, the *Perspectiva* of the Polish scholar Witelo and the *Perspectiva communis* by John Pecham of

[9]The medieval authors are closely analyzed with extensive quotations in the fundamental study by G.F. Vescovini, *Studi sulla prospettiva medievale*. Pubblicazioni della Facoltà di Lettere e Filosofia, Università di Torino, XVI, 1 (Turin, 1965), 89–124, and more superficially by Ronchi, *The Nature of Light*, 39ff. See also D.C. Lindberg, "Alhazen's Theory of Vision and Its Reception in the West," *Isis* (LVIII, 1967), 321ff. and *idem*, "Lines of Influence in 13th-Century Optics: Bacon, Witelo and Pecham," *Speculum* (XLVI, 1971), 66–83. I have not yet seen Lindberg's Introduction to a new facsimile of the Basel 1572 edition of the optical texts of Alhazen and Witelo.

Oxford, both composed in the 1270s, owe much to their predecessor for empirical data and to a great extent for theoretical positions. Witelo in particular, however, was affected by the earlier thirteenth-century Oxford scholar Robert Grosseteste, and perhaps also by his older contemporary Roger Bacon, in injecting a Neoplatonic strain that represented light in a metaphysical as well as a physical sense, as the manifestation of God (Bacon's optics, for example, focused on the "multiplication of species," associating the infinite number of images projected by objects in light with the principle of generation). Pecham closely followed Bacon; both were Franciscans and pursued their studies at Oxford and Paris.

Around 1390 the Parmesan scholar and professor Biagio Pelacani used problems raised in Pecham's text as the basis for a penetrating commentary, *Quaestiones de perspectiva*, which, for the first time since Alhazen, returned to a strictly empirical method. We do not know for sure whether Alberti read Pelacani, but it is significant that the recently published transcription of the manuscript was taken from a copy executed in Florence in 1428.[10] Alberti, like Pelacani, entirely eliminated the metaphysical element from his exposition of optical principles; he favored the strictly mathematical theories and must have read Euclid, possibly Ptolemy, and have known Alhazen either in the original or through a later intermediary. This was not an exceptional achievement in his circle: Book Three of Ghiberti's *Commentarii* has been shown to be, apart from a short discussion on some antique sculptures, a compilation of quotations from the works of Vitruvius, Alhazen, Avicenna, Averroes, Witelo, Pecham and Bacon.[11]

This interest in ancient and medieval science and technology was widespread in Florence in Alberti's generation. Though it represented a countercurrent to the mainstream of humanist culture, it shared with it an eagerness to discover and interpret the surviving texts. Alberti's interest in the arts was one of the factors that allied him to a group of liberal intellectuals with strong scientific interests that may have gathered around Ambrogio Traversari and Niccolò Niccoli and was supported by the library and other resources of Cosimo de' Medici—a group that must have included Brunelleschi, to whom the Italian translation of *De pictura* was dedicated, the mathematician and cartographer Paolo Toscanelli, and perhaps the other rationalist artists mentioned in the dedication as the author's friends: Donatello, Ghiberti, Luca della Robbia, and Masaccio. Its physical center was the cloister of Santa Maria degli Angeli, where Traversari taught moral philosophy to provide a counterbalance to the conservative education of the Studio (University), which was supported by the old, anti-

[10]On Pelacani, see G.F. Vescovini, "Le questioni di 'perspectiva' di Biagio Pelacani da Parma," *Rinascimento* (ser. 2, I, 1961), 163–243; *idem, Studi sulla prospettiva medievale*, 239–67. Vescovini transcribed portions of the Laurenziana MS Plut. 29, 18, of 1428. The transcription of another manuscript is cited in n. 28, below. The text was composed ca. 1390 while the author was teaching at Pavia and expanded by him in 1403 by the addition of a section on phenomena of refraction, such as the rainbow, and on optical illusions.

Though not cited by Ghiberti, Pelacani may have been one channel by which the Florentine community became aware of the science of *perspectiva*. His text on Question 16, on the relationship of the apparent size of objects to the angle of vision and to their distance from the eye, may have helped Alberti with his interpretation of perspective construction in §§14–18 of Book One, which discuss the problem of proportion in perspective (see n. 19, below).

Though the question discussed by Pelacani had already been raised by Pecham, his work goes beyond earlier authors, particularly in its empirical method and its abandonment of the metaphysical component of the majority of late medieval writings. The form is still scholastic, but the spirit is of the new rationalism of the Renaissance. Passages of the *Quaestiones* coordinate optical studies with astronomy and geometrical with physiological/psychological optics.

[11]Ten Doesschate, "De derde Commentaar," 4ff.

Medicean oligarchy.[12] Alberti must have been attracted to the Medici orbit partly because he was born and raised in exile, owing to his family's political stance in opposition to the late-fourteenth-century oligarchy. His contact with the scientific tradition outlined here was surely not entirely through self-education; the members of this circle must have come together often to announce and discuss their discoveries. The astonishing variety of subjects covered in Alberti's writings must have been encouraged by the group, which was a sort of precursor of the Parisian café communities of the nineteenth century.

II

An outline of the major ideas presented in Book One of *De pictura* (see pp. 2–3) should make it easier to discuss Alberti's approach. The first section presents geometry, in Euclidean terms, as the basis of painting, and gives a definition of a point, a line, and a surface. But the descriptions differ a little from Euclid's because Alberti makes no reference to abstractions or to infinite extensions; "things which are not visible," he says, "do not concern the painter, for he strives to represent only the things that are seen." Thus he defines the surface in terms of "many lines joined closely together like threads in cloth," whereas in Euclid it is "that which has length and breadth only."[13]

Intertwined with this geometrical introduction there appears an essential optical proposition, injected so inconspicuously that one easily misses it on first reading. Surfaces have two properties that are "permanent" (*perpetua*): their outline and their skin; these quantifiable physical properties are to be distinguished from their accidental qualities (which are of no concern to mathematicians but are of great importance to painters).[14] The latter are of two kinds, those that result first from the position in which an object is placed (and presumably from which it is viewed), and second from the light that falls on it: "these matters are related to the power of vision; for with a change of position surfaces will appear larger, or of a completely different outline from before, or diminished in color; all of which we judge by sight."

[12]See M. Adriani, "Note sulla cultura proto-quattrocentista fiorentina," *Un' altra Firenze: l'epoca di Cosimo il Vecchio* (Florence, 1971), 469–528. Adriani represents the conservative-liberal conflict as an early instance of the battle of the ancients and the moderns; his focus on political-moral philosophy tends, however, to deemphasize the technological-scientific interests of the liberal circle and its debt to the Middle Ages. For different interpretations of early quattrocento intellectual life in Florence, see L. Olschki, *Geschichte der neusprachlichen wissenschaftlichen Literatur*, I (Leipzig, 1919), 1–107; R. Krautheimer–T. Krautheimer-Hess, *Lorenzo Ghiberti* (Princeton, N.J., 1956), chaps. XIX–XXI, 294–334; E.H. Gombrich, "From the Revival of Letters to the Reform of the Arts: Niccolò Niccoli and Filippo Brunelleschi," *Essays Presented to Rudolf Wittkower* (London, 1967), 71–82.

[13]*The Thirteen Books of Euclid's Elements*, translated, with introduction by Sir Thomas L. Heath, 2nd ed. (New York, 1956), 153. Alberti may have been influenced in his departures from Euclid by the earliest of the surviving Arabic optical treatises, Alkindi's *De aspectibus* (ninth century), which argues that visual rays must be corporeal in order to be visible, since we cannot see abstractions (cf. Vescovini, *Studi sulla prospettiva medievale*, 50f.). The issue is raised also in an anonymous fourteenth-century commentary on Euclid's *De visu* in Florence (Biblioteca Nazionale, San Marco, Conv. Soppr. J. X. 19; *ibid*, 223ff.), which contains similarities in vocabulary as well as in content to Alberti's text and may have been consulted by him. Both these connections are noted by Grayson in his edition of *On Painting and On Sculpture*, 108.

[14]The Aristotelian-Thomistic term "accident" appears only later in Book One (§18), where Alberti is explaining the basic principle of perspective, that objects appear to change in size proportionally with their distance from the eye: "large, small, long, short, high, low, wide, narrow, light, dark, bright, gloomy, and everything of the kind, which philosophers termed accidents, because they may or may not be present in things—all these are such as to be known only by comparison." Here, at the start, he is referring to the more limited case of "properties which, even when there is no change in the surface itself, do not always present the same aspect."

a. The Triangle of Vision: intromission

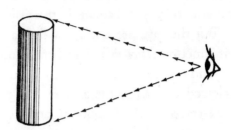

b. The Triangle of Vision: extromission

c. The Pyramid of Vision

DIAGRAM I: RAY THEORIES OF VISION

This leads to the exposition of the optics of normal vision based on "the opinion of philosophers" (that is, scientists). The ray theory is methodically explained first in terms of plane geometry—that is, of a triangle whose base is the line from the top to the bottom of an observed object and whose apex is in the eye (Diagram 1a)—and then in the more complex terms of a pyramid of vision formed by rays joining the eye to all points in an observed continuum (Diagram 1c).[15] It is understood that, for purposes of this theory, one sees with one eye at a fixed position, as through a peephole:

> These rays, stretching between the eye and the surface seen, move rapidly with great power and remarkable subtlety, penetrating the air and rare and transparent bodies until they encounter something dense or opaque where their points strike and they instantly stick. Indeed among the ancients there was considerable dispute as to whether these rays emerge from the surface or from the eye. This truly difficult question, which is quite without value for our purposes, may here be set aside.

[15] Alberti, like most medieval and Renaissance writers, calls this matrix of rays a "pyramid," electing the image invented by Ptolemy rather than the "cone" of Euclid and Galen (see n. 16, below). According to Edgerton, the terms were regarded as synonymous by Alberti and his predecessors, though the pyramid metaphor is suited to a time when nonmural pictures began to be made on rectangular surfaces, and is easier to employ in geometrical operations.

In spite of this profession of neutrality with respect to the alternative theories of extromission and intromission, Alberti proceeds to describe a number of phenomena in a way that makes it clear that he thinks of visual rays as coming to us unaided, and not as being grasped and carried in by ocular exertion. It may be that he evaded an overt statement of this position because it could be interpreted as too materialistic, eliminating as it did the participation of the *anima*, or internal agent, in the visual process.

But the rays are not all of the same sort; there are three kinds, classified according to their function. *Extrinsic rays* communicate the outlines of objects, *median rays* the surface or skin, and the *centric ray* is the single axis of vision that emanates from the center of the object as viewed and enters the center of an eye at a right angle to its vertical axis. This distinction can be traced to the Greek anatomist Galen, who applied it specifically to seeing the circumference, the plane, and the center of a circle.[16] It then appears in Alhazen and other medieval writings on optics in the Euclidean-Galenic tradition, with the primary emphasis being placed on distinguishing the centric ray from the others.[17]

Alberti tells us that the *extrinsic rays*, "which hold on like teeth to the whole of the outline, form an enclosure around the entire surface like a cage." When we form a triangle or a circle, the lines we draw form this outline, which is made up of the points from which such rays emanate. The function of the rays is to permit measurement and the definition of shape: "we use these *extrinsic rays* whenever we apprehend by sight the height from top to bottom, or width from left to right, or depth from near to far, or any other dimensions." In normal vision, of course, these measurements are relative, since a given object looks larger when we see it close up than when it is far away. As Alberti puts it, "the more acute the angle within the eye, the less will appear the quantity."

The *median rays* are defined as:

> . . . the mass of rays which is contained within the pyramid [of vision] and enclosed by the *extrinsic rays*. These rays do what they say the chameleon and other like beasts are wont to do when struck with fear, who assume the colors of nearby objects.[18] These *median rays* behave likewise; for, from their contact with the surface to the vertex of the pyramid, they are so tinged with the varied colors and lights they find there, that at whatever point they were broken, they would show the same light they had absorbed and the same color.

Thus, the *median rays* transmit the qualities of things as we see them—color, light, and texture, and *extrinsic rays* the quantities. Alberti does not confront the problem of whether

[16]The relevant passage from *De usu partium*, X, 12, is quoted by Edgerton, "Alberti's Colour Theory," 125: "Circulique circumferentiam sic per visiones illas videri, ipsiusque centrum per aliam visionem in axe coni locatam, omnemque circuli planitiem per multas quasdam visiones ad ipsam pervenientes" (from ed. G. Kühn, Leipzig, 1822, III, 817).

[17]Though the axial ray is defined as more powerful and effective than the others by all authors in this tradition (cf. the works cited in n. 9, above), Alhazen says that it communicates an even higher level of understanding of the thing seen; the totality of rays produces an *aspectus* of the object, while the axial ray gives an *intuitio* or *obtutus*: "Vision *per aspectu* is had by any ray of the optical pyramid, but vision *per obtutum* is had

only by the axis . . . The comprehension of visible things is therefore had in two ways, one superficial comprehension, which is the first impression, and the other comprehension by intuition. The former is uncertified, while comprehension by intuition is that by which the form of visible things is certified" (from *De aspectibus* in *Opticae Thesaurus*, ed. Risner, Basel, 1572, II, 65 and 64, quoted in Vescovini, *Studi sulla prospettiva medievale*, 120).

[18]The case of the chameleon was cited by Ptolemy (*L'Optique de Claude Ptolémée* . . . , ed. A. Lejeune, Louvain, 1956, II, §15, p. 18) as an exception to his rule that the color of an object remains fixed as long as it is seen in the same light from the same position.

extrinsic rays convey light and color, but they obviously do not because they come from one-dimensional lines.

We should keep in mind that the two types of ray are generated by the two permanent properties of objects described at the start: outline and skin. But the rays do not give conclusive evidence of the permanent properties because they communicate only the accidental appearance of things seen from a certain position and in a certain light. Alberti emphasizes the contingent nature of the evidence when he says: "anyone who has properly understood the theory behind this, will plainly see that some *median rays* sometimes become *extrinsic*, and *extrinsic* ones *median*."

This interchange occurs when we move toward or away from an object like a ball (Diagram 2). If we hold the ball close to one eye, we see less of the whole, and the *extrinsic rays* encompass a smaller area of *median rays*; if we hold it farther off to see more of the whole, the points from which *extrinsic rays* were generated close-up are now the source of *median rays*.[19] The phenomenon is much easier to understand if we imagine ourselves moving *around* an object so that its outline and surface constantly change place (but Alberti does not use this illustration because, perhaps unconsciously, he believed that a single, frontal viewpoint was the correct one for a painting or a sculpture; accordingly his perspective system provided only straight-on views with all planes parallel to the picture plane, and no objects seen at an angle).

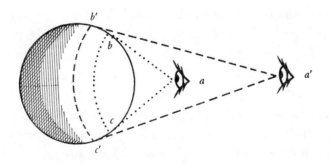

DIAGRAM 2: THE INTERCHANGE OF MEDIAN AND EXTRINSIC RAYS

(from position *a*, the edge of the sphere appears as the circle *bc*, but from position *a'*, the edge appears as *b'c'*, while *bc* is simply part of the visible surface, *i.e.* of the median rays)

The *centric ray* alone is supported in their midst, like a united assembly, by all the others, so that it must rightly be called the leader and prince of rays. In asserting its preeminence, Alberti is simply transmitting a principle of medieval optics. The traditional emphasis was due to the fact that all other rays had to be refracted by the lens of the eye in order to reach

[19]The proposition is a product of the reasoning adduced by Biagio Pelacani in Question 16 of his *Quaestiones,* which examines whether the size of things seen is in direct proportion to the angle of the visual triangle. In proving this not to be the case, he argues that as the eye approaches a sphere, the angle of vision increases, but a smaller portion of the sphere is seen (Vescovini, "Le questioni di 'perspectiva,'" 221ff.). Alberti confronts the issue of the visual angle more overtly in §13–17, at the beginning of his exposition of artificial perspective.

the apex of the visual pyramid (see Fig. 1).[20] This meant that they arrived by a less direct route and therefore, it was said, with correspondingly less effectiveness. Furthermore, because it enters the eye directly rather than at an angle, the *centric ray* was more distinct and less distorted—in Alberti's words "more keen and vigorous." Leonardo made this point vividly by a sort of reversed ballistic metaphor:

> The pupil transmits nothing perfectly to the intellect except when the object presented to it through the light reach it by the line (perpendicular to the pupil); these objects act like the archers who wish to shoot through the bore of a carbine; the one among them who finds himself in a straight line with the bore will be most likely to touch the bottom of the barrel.[21]

An allusion to the field of mechanics lurks just below the surface and is brought out elsewhere in Leonardo's notes,[22] the *centric ray* being visualized as having the virtues of a force applied to a body along the axis in which the body is to be moved. Finally, Alberti points out, "a quantity will never appear larger than when the *centric ray* rests upon it," which is to say that anything seen at an angle is more or less foreshortened and hence diminished in size.[23]

Since the abandonment of the ray theory of light propagation, the hypothesis of a *centric ray* with special powers no longer has validity, but there is a justification in the physiology of the eye for the conception that the image is sharper at the center of the visual field. In the center of the retina, there is a "yellow spot," the *fovea centralis*, a small area alongside the intersection of the retina and the optic nerve where, instead of the more even distribution of cones and rods that occurs elsewhere in the retina, there is a concentration of cones that contributes to sharpening the center of the visual image; the periphery of the retina has much reduced receptivity. Thus the old Italian saying, "se non è vero, è ben trovato," applies to the medieval and Albertian hypothesis. Like many other subsequently superseded principles of earlier science and technology, this one not only fitted the system for which it was conceived but also provided a metaphorical, prescientific explanation of a significant phenomenon, the actual causes of which were not yet accessible to the investigatory method of the time.

It is easy to see how Alberti's description of light propagation based on Euclidean

[20]Thus, in Alhazen: "The form that comes (to the eye) perpendicularly may be distinguished from other forms in two ways: the first is that it reaches from the surface of the thing seen to the center of the glacial humor by a straight line, whereas the others come by refracted lines; the second is that it is not only perpendicular to the surface of the thing seen, but perpendicular to the surface of the glacial humor . . . while the other lines are bent in relation to the surface. And the impact of light coming perpendicularly is stronger than the impact of light coming on inclined lines." (Quoted by Vescovini, *Studi sulla prospettiva medievale*, 118n., from the Basel 1572 ed. of *Opticae Thesaurus*, I, 18, p. 10).

A similar statement is made by John Pecham (1230s–1292), who observes as well that one of the reasons for moving the eye about is that we thus direct the central ray to various parts of the observed object; cf. D.C. Lindberg, *John Pecham and the Science of Optics* (Madison, 1970), 120f.; the passage was called to my attention by Prof. Edgerton.

[21]Codex Atlanticus, 270r, v. In quoting these observations, K.D. Keele, "Leonardo da Vinci's Physiology of the Senses," *Leonardo's Legacy* (Berkeley–Los Angeles, 1969), 44ff., points

out that the metaphor of the gun barrel probably was generated by Leonardo's thesis that the visual image was transmitted to the brain along the optic nerve which, like all nerves in Galenic physiology, was "perforated." It also suited his attempt to apply the principles of percussion to the action of light rays.

[22]Keele, *ibid., passim.*

[23]The point was ultimately challenged by Leonardo, who was the first writer on perspective to perceive the contradictions and limitations of the *costruzione legittima*, though the issue had been raised in a theoretical context by Pelacani (see n. 10, above; Vescovini, *Studi sulla prospettiva medievale,* 262f.). Leonardo cited and drew a row of columns seen at a right angle to their axis; given a fixed eye, the column opposite the eye will appear to be the thinnest, and those on either side will appear to increase in width with distance (MS A., fol 41a; cf. J.P. Richter, *The Notebooks of Leonardo da Vinci*, London, 1883, §544; cf. also Richter, §86, 109, 543, 545). The problem is discussed in a modern context by M.H. Pirenne, *Optics, Painting and Photography* (Cambridge, 1970), chap. 9.

geometry produced this particular triadic system of rays: each of the three is the conduit of one of the basic geometrical elements—the *centric ray* of the point, *extrinsic rays* of the line, and *median rays* of the plane.

In summing up his description of the *centric ray* (§8), Alberti emphasizes that the two geometrical elements that determine the nature of a visual image are the *position* of the *centric ray* (e.g., where the center of the image is) and the *distance* of the observer from the object(s) seen (Diagram 3b, 3c). "There is also a third condition in which surfaces present themselves to the observer as different or of diverse form. This is the reception of *light*." An object seen from a particular position and distance will, for example, look one way when lit from above or from the right, and another when lit from below or from the left (Diagram 3a). Further (§9), "colors vary according to light, as every color appears different when in shade and when placed under rays of light. Shade makes a color look dark, and light makes it bright and clear."

III

What Alberti does not say about his basic variables is that the third, light/color, draws him out of the sphere that can be controlled by the mathematics and science of his time: whereas the effects of light from a particular fixed source, such as cast shadow (merely mentioned by Alberti), were reproduced later with the aid of geometry, many aspects of light and color of interest to painters could be discussed only in terms of experience and could not be quantified. Alberti, in fact, drops his Euclidean mode, apparently unconsciously, the moment he makes an observation about color. In the earlier passage in which he says that the *median rays* carry color, he adds:

> We know for a fact about these *median rays* that over a long distance they weaken and lose their sharpness. The reason why this occurs has been discovered: as they pass through the air, these and all other visual rays are laden and imbued with lights and colors; but the air too is also endowed with a certain density, and in consequence the rays get tired and lose a good part of their burden as they penetrate the atmosphere. So it is rightly said that the greater the distance, the more obscure and dark [*suboscurioram et magis fuscam*] the surface appears.

This remarkable passage attempts to deal with common-sense observation of what, since Leonardo's time, has been called "aerial perspective," a phenomenon that could not be predicted or explained by a purely mathematical model of vision such as that of Euclid. The problem did, however, arise in the studies of Aristotle and Ptolemy, who were more concerned with sensation. Their explanation involved the hypothesis, first, that light is not propagated instantaneously but travels with a finite velocity, and second, that air is not a vacuum but a medium that has a density which affects vision. From the latter assumption they concluded that the denser the air intervening between an object and the eye, the more it would obstruct vision. But Alberti's explanation of this phenomenon—a mixture of vitalism with mechanics (the rays, physically worn down, lose their intensity as they encounter

c

friction)—is unconvincing, and though he states that it "has been discovered," presumably by scientists, it has never been found in another writer. Furthermore, the passage concludes with a statement on the darkening of distant surfaces that appears to be in conflict with normal visual experience.

Alberti was not the only one to have found aerial perspective difficult to explain. To begin with, Aristotle and Ptolemy, though they describe a similar phenomenon, attribute it to quite different causes. In Aristotle, "Dark color is a kind of negation of vision, the appearance of darkness being due to the failure of our sight; hence objects seen at a distance appear darker because sight fails to reach them."[24] And, in Ptolemy, "That which is far off we see less well because the visual rays as they proceed carry with them something of the darkness (*nigretudine*) of the air through which they travel, and thus a thing in the remote air appears as if it were under a veil."[25] What is paradoxical in this comparison is that while Aristotle (in *De anima* and *De sensu*) was the most vigorous opponent in antiquity of the extromission theory (whereby visual rays are cast out from the eye) and attributed a major role in the transmission of images to the action of the medium, this statement from the *Meteorologica* clearly implies extromission, while Ptolemy, who was a supporter of that theory, offers an explanation based on the coloration of the atmosphere that could work equally well whether the rays originated in the eye or the object. The confusion was perpetuated into the Middle Ages, when Witelo, who accepted Alhazen's demolition of the extromission theory, repeated the Aristotelian explanation almost verbatim.[26] Nicholas Oresme, the great physicist and philosopher of the fourteenth century, resolved the problem by attributing the phenomenon simply to the difficulty of seeing through great quantities of air, the cause being, as Ptolemy had said, in the nature of the medium rather than in the power of the eye.[27] While his explanation was oversimplified, it cleared the way for a more effective approach by later investigators; Biagio Pelacani, for example, discussed the effects of varying densities in the atmosphere.[28]

Alberti tried, in a sense, to accommodate the various arguments by suggesting that the rays, rather than the observer, possessed a kind of vital force that was spent by the effort of traveling through a dense medium. This had no foundation elsewhere in his theory and certainly was not sustained by common-sense experience.[29] The only possible explanation is

[24]*Meterologica*, ed. and tr. by H.D.P. Lee, Loeb Classical Library (Cambridge–London, 1952), III, iv, 374b, pp. 258f. The weakening of the sight with distance is mentioned previously in the same passage, in relation to the appearance of rainbows. The passage was cited by Edgerton in his article "Alberti's Colour Theory," 119. I think it is unlikely that Alberti would have gone to this source for information on vision and more probable that he would have seen Witelo's version of the passage cited in n. 26, below. The Early Renaissance is more likely to have used as sources for Aristotle's theory of vision the better-known passages from *De sensu*, II, 437b and *De anima*, II, 7 (ed. Lee, 418f.); the latter states in polemic style the author's refutation of the extromission theory.

[25]*L'Optique* . . . , ed. Lejeune, II, chap. 19, p. 20, ll. 13ff.

[26]". . . ideo accidit quod ea, quae longe videntur, propter visus debilitationem omnia nigriora apparent" (*Perspectiva*, ed. Risner, 1572, IV, 159, as cited in Edgerton, "Alberti's Colour Theory," 133n.).

[27]From *De visione stellarum*, Florence, San Marco, Conv. Soppr., J. X. 19, fol. 33, as quoted in Vescovini, *Studi sulla prospettiva medievale*, 202 n. 19: "Magna aeris quantitas inter-

posita visui valde debilitat visionem . . . unde si tanta spissitudo aeris esset inter lunam et stellas fixas quanta est corpulentia intermedii caeli, stellae non possent a nobis videri." The passage is cited in this connection by Grayson, *On Painting and On Sculpture*, 109.

[28]*Questione perspectivae*, Vienna, Oesterreichische National-bibliothek, cod. lat. 5447, fols. 58vff., ed. F. Alessio, "Questioni inedite di ottica di B.P. da Parma," *Rivista Critica di Storia della Filosofia* (XVI, 1961), 215f., and paraphrased by Vescovini "Le questioni di 'perspectiva,' " 195. These concurrent publications of portions of Pelacani's work are based on different versions, of which Vescovini's, dated 1428, is probably later. Pelacani does not state his opposition directly: he posits a dual nature of the atmosphere (*medium*): "quoddam est susceptivum actionis agentis et quoddam non est susceptivum," but gives an instance of a cloudlike opacity that "fortius evanescat" toward its edges, permitting a partial vision of an object beyond it.

[29]Alberti, nevertheless, may have had also a vitalist principle in the back of his mind when he referred to the centric ray as "vivacissimus" (§8).

that, in spite of his avowed neutrality in the conflict over the extromission theory, he wanted to establish once and for all the concept that the rays originated in the object, and he tried to adjust this position to the Aristotelian-Witelian idea that physical exhaustion was somehow involved.

But why did the early authors and Alberti say that objects seem darker at a distance, when everyday experience confirms the fact that the effect of the atmosphere is to make them seem lighter? While in normal light the atmosphere lowers the intensity of colors, it heightens their value, and Aristotle was too keen an observer of nature to have overlooked the fact that frequently distant mountains seem to fade toward a light blue or purple. The apparent contradiction is due, as Edgerton has shown, to a disjunction between ancient and modern color terminology. In Alberti's vocabulary (which follows Aristotle in this respect, but reduces the number and nature of the primaries), cool colors such as blue and purple are dark no matter how high in value they may be, and this results in descriptions that do not make sense in our terms: the lightest blue would be spoken of as darker than the deepest red. Distinctions were not made between hue and value. Alberti used the term *fuscus*, which roughly means muddy, to refer to the loss of intensity of colors in shadows and at a distance. It implies a dark brownish or neutral tone and, while it does not correspond to later perceptions of the effects of the atmosphere, it is consistent with his other statements.[30]

But §9, which is about color, repeats from earlier sources a number of empirical observations that seem in hindsight to teeter on the brink of the discovery of value and intensity (though the account of "the four true kinds of colors," or primaries associated with earth, air, fire, and water is medieval-symbolic in character). "It is evident," Alberti says, "that colors vary according to light, as every color appears different when in shade and when placed under rays of light. Shade makes a color look dark (*fuscus*), and light makes it bright and clear." This seems a common-sense base on which to proceed with a color theory, but it sets up an unresolved contradiction with the Aristotelian tradition: if those distant bluish mountains are well lit, is their color bright or *fuscus*? In the two passages cited here, Alberti's answers are in apparent conflict.

From theory, Alberti turns to what he presents as practice:

My own view about colors, as a painter, is that from the mixture of colors there arises an almost infinite variety of others, but that for painters there are four true kinds of colors corresponding to the number of elements, and from these many species are produced. There is fire color, which they call red, and the color of air, which is said to be blue or blue-grey, and the green of water, and the earth is ash-colored. So, there are four kinds of colors, of which there are countless species according to the admixture of white and black. For we see verdant leaves gradually lose their greenness until they become white. We also see the same thing with the air, how, when, as is often the case, it is suffused around the horizon with whitish mist, it gradually changes back to its true color.

Though, in telling us that "we see" the described phenomena, Alberti may seem to be

[30]See the slightly different interpretations of Edgerton, "Alberti's Colour Theory," 132f., and Grayson, *On Painting and On Sculpture*, 109. In night scenes, of course, distant objects are enveloped in a darkness nearing black that perfectly illustrates the word *fuscus* and that may be found in Piero della Francesca's *Dream of Constantine* in San Francesco at Arezzo, as pointed out by E. Battisti, "Note sulla prospettiva rinascimentale," *Arte Lombarda* (XVI, 1971), 96.

recording visual experiences, he is in fact still adhering to the written texts—not texts on optics in this case, since they were not concerned with particular colors, but perhaps a short Peripatetic essay, *De coloribus*, believed in the Renaissance to be by Aristotle. Here the phenomenon of the whitening sky at the horizon is discussed and attributed to the "densification" of the air, while the deep blue of the sky is caused by the air's rarity, which permits the passage of more powerful rays of light.[31] Alberti's preceding observation on the whitening of green leaves usually has been taken as a similar instance of atmospheric perspective; but the extended discussion in *De coloribus*—which could be his source—of such phenomena in plants and animals is concerned with their actual color changes from one season to another rather than with the effects of atmosphere on appearances. "The leaves of most trees turn yellow in the end," it says, "because owing to the failure of nutriment, they become dried up before they change to their natural color."[32] Why did Alberti say "white" when both this text and common-sense experience dictate the yellowing of leaves? Apparently because, in his four-color system, yellow is not a primary, but one of the "species" produced, presumably from green, by the "admixture of white." It is hard to reconcile this with Alberti's emphasis that he is speaking here as a painter: a few hours' experience with pigments would persuade a much lesser intelligence than his that the yellows used in the tempera panels of his time could not have been produced by the mixture of any other colors. This passage, then, is one of the many instances in which humanist writers refused to permit empirical evidence to shake the authority of established theory.[33]

More on the palette appears in Book Two (§30) of *De pictura*, in which the art of painting is defined:

> We divide painting into three parts, and this division we learn from Nature herself. As painting aims to represent things seen, let us note how in fact things are seen. In the first place, when we look at a thing, we see it as an object which occupies space. The painter will draw around this space, and he will call this process of sketching the outline, appropriately, *circumscription*. Then, as we look, we discern how the several surfaces of the object seen are fitted together; the artist, when drawing these combinations of surfaces in their correct relationship, will properly call this *composition*. Finally, in looking we observe more clearly the colors of surfaces; the representation in painting of this aspect, since it receives all its variations from light, will aptly here be termed the *reception of light*.

In the studio, then, the study of light focuses on the practice of coloring. When, in the closing paragraphs of Book Two (§§46–49), Alberti expands on this third part of painting, he begins

[31]*De coloribus*, IV, 794a (*The Works of Aristotle*, translated under the editorship of W.D. Ross, VI, Oxford, 1913). This source was proposed by Edgerton ("Alberti's Colour Theory," 121, 128), whose implication that Alberti was referring in the quoted passage to the effects of atmospheric perspective—making the sky whiter near the horizon and a more intense blue overhead—is challenged by Grayson (*On Painting and On Sculpture*, 110): "I see it as a far more bland statement: when there is white mist on the horizon, the sky looks pale; when the mist disperses, the sky appears blue again." Grayson may be correct, but I imagine the artists who read Alberti's text took it in the former sense.

[32]*Ibid.*, IV, 797a.

[33]Cennino Cennini, in his *Libro dell'arte* of ca. 1390 (ed. D.V. Thompson, Jr., New Haven, Conn., 1933, chaps. XLV–L) gives recipes for the manufacture of six different yellows for fresco and panel painting, made from mineral, vegetal, and chemical sources. The one surviving fifteenth-century book of instructions on pigment manufacture (*Il libro dei colori*, ed. O. Guerrini–C. Ricci, Bologna, 1887), however has no recipe for the making of a pure yellow. The only yellow mentioned is made from "spingerbino" and "ramo-verde," and must be a high value yellow-green (p. 96). The recipe is preceded by twenty-three recipes for making greens, none of which involve the mixture of yellow and blue.

by stating that "colors contribute greatly to the beauty and attraction of a painting," but proceeds to discuss only the employment of white and black as the essential factor in the application of pigment. White represents light, and black, shadow; they occur on opposite sides of any body, and skill in their use consists in mixing them with the color of the things painted in order imperceptibly to create transitions from light to shadow, and in employing them sparingly and subtly, never allowing them to be seen in pure state except for the brightest highlights or night shadows. "With such balancing, as one might say, of black and white, a surface rising in relief becomes still more evident." The importance of relief is such that special praise is assigned to pictures in which the faces "seem to stand out . . . as if they had been sculpted." The painter is even advised to begin by drawing the outlines of the light areas as well as of the figures themselves.

Most Italian painters from Masaccio to Leonardo shared Alberti's preoccupation with the illusion of relief; but none accepted his color theory. In spite of its scientific basis, it was quite inapplicable in the workshop, and the prescriptions of Cennino Cennini, the recorder of late-medieval shop practice, continued to be a much closer guide to the color principles of most artists working in tempera before 1500. The reasons for this will be discussed at the close of this article.

IV

Alberti's last word on light and color in Book One, in §11, is a brief recital of a number of kinds of shadows and reflections of special interest to painters—a subject that, like the principles of color, was not treated extensively in most of the ancient and medieval texts on optics. "Some [lights] are of stars, such as the sun and the moon, and the morning-star, others of lamps and fire. There is a great difference between them, for the light of stars makes shadows exactly the same size as bodies, while the shadows from fire are larger than the bodies."

Again, these observations prove to be not the result of Alberti's own investigation: ancient and medieval contributions to the subject are found in the literature on astronomy.[34] Alberti's reference to stars—which were of no more import for painters than for writers on optics—strengthens the likelihood of his dependence on astronomical sources. The science of shadows, based on the study of the gnomon, was essential to the development of sundials and provided the foundation for essential astronomical measurements, such as that of the size of the sun and its distance from the earth; it was basic to Ptolemy's geographical research and perhaps even to his invention of orthographic and stereographic projection.

The only ancient text on shadows is in the introduction to Theon of Alexandria's recension of Euclid's *Optics*.[35] Theon used shadows to prove that light rays are rectilinear,

[34] I am indebted to a current study by Thomas Kaufmann for this review of the history of the study of cast shadows, and particularly for his discovery of the crucial role of Dürer in first associating shadows in painting with perspective. Mr. Kaufmann's study, originally presented as a M. Phil. thesis at the Warburg Institute of the University of London under the direction of Sir Ernst Gombrich, is forthcoming in the *Journal of the Warburg and Courtauld Institutes*.

[35] *Euclidis Optica, Opticorum Recensio Theonis*, ed. J.L. Heiberg (Leipzig, 1895), 144ff., cited by Kaufmann, *ibid.*, and by Grayson, *On Painting and On Sculpture*, 109.

explaining that an object illuminated by light from a small fire (i.e., artificial light) throws a large shadow and vice versa, while a source the same size as the object makes a shadow equal to it in size. It was probably from this text that later writers, including Alberti, got the idea of classifying shadows by relative size and of creating them by "fire." The most penetrating investigations of cast shadows were made by Alhazen, the father of medieval optics, in a study devoted exclusively to the subject in the context of astronomy; he experimented with a candle and made significant observations of shadows cast by the sun, but his work was not translated and does not seem to have been read until recent times.[36]

When Alberti states that celestial light creates shadows of the same size as the intercepting body, he is accepting a tacitly held (and, from a painter's point of view, valid) assumption of ancient astronomers that the rays of the sun, or of other celestial lights, are parallel, as distinct from the divergent rays emitted by a point source such as a candle or lamp.[37] All in all, there is nothing in Alberti's passage to indicate that he had a lively interest in the matter that might have prompted him to study the postclassical literature on it.[38]

Alberti then turns from shadows to reflected rays, informs us that the angle of reflection equals that of incidence, and concludes by observing that reflected rays carry color from the surface on which they originate: "We see this happen when the faces of people walking about in meadows appear to have a greenish tinge." Even this observation appears to have a textual stimulus; the author of *De coloribus*, after stating that firelight, moonlight, and torchlight alter the character of colors, continues, "For if light falls on a given object and is colored by it [say] crimson or herb-green, and then the light reflected from the object falls on another color, it is again modified by this second color, and so gets a new chromatic blend."[39]

The perfunctory nature of Alberti's passage on shadows and the lack of adjustment to the interests of the painter suggest that Alberti did not believe that cast shadows were a significant means for achieving a persuasive illusion of the visual world, or for creating links between parts of a picture. His study of light and shadow concentrated on the modeling of bodies by the addition of white and black—the mode of relief.[40] He was predisposed to thinking about composition as the arrangement of autonomous bodies by the fact that his geometrical-optical theory defined light and vision in terms of rays that delimit and describe the surfaces of people and things, and by the fact that Early Renaissance artists and theorists who turned to ancient art for models found only sculpture and were prompted to think of

[36]I have not been able to find the analysis of this manuscript, cited by Kaufmann; E. Weidemann, "Über einer Schrift von Ibn al Haitam, 'Über die Beschaffenheit des Schattens,'" *Beiträge zur Geschichte der Naturwissenschaften, Berichte der physikalisch-medizinisch Sozietäten Erlangen* (XXXIX, 1907), 226–48.

[37]John Pecham (Lindberg, *John Pecham,* 100f.) wrote that, since the sun is larger than the earth, it must throw light on more than half of the globe at any time; but he did not apply this observation to its effects on local bodies on earth. Alberti's assumption of parallel rays is valid for the processes of normal vision and representation, the actual angle being too small to perceive (see Pirenne, *Optics, Painting and Photography,* 57f.).

[38]The work on optics that was most accessible to Alberti, however, had the most complete and original passages on cast shadows: Pelacani's *Quaestiones de Perspectiva* (see n. 10, above).

His interest in astronomical problems led him to original experiments with shadows cast by a die and a gnomon, and he even explains a method for producing optical illusions through stereographic projection based on Ptolemy's method (Kaufmann, from MS Ashburnham 1042, fols. 54v–59v; Vescovini, "Le questioni di 'perspectiva,'" 242f.).

[39]*De coloribus,* ed. Ross, IV, 793b.

[40]"The mode of relief" is a term applied to the tonal approach of pre-Leonardesque quattrocento painting by A. Pope, *The Painter's Modes of Expression: An Introduction to the Language of Drawing and Painting,* II (Cambridge, Mass., 1939), 71–85. Pope's valuable analysis, made on the basis of surviving works of art without reference to Alberti's theory, indicates an identity of purpose in practice and theory, though, as will appear, the means used by the painters are not those suggested by Alberti.

painting in sculptural terms. But history nonetheless made Alberti an unwitting pioneer in the development of the technique of rendering cast shadows. When Dürer showed for the first time how to calculate geometrically the shadows cast by an object lit from a point source, he simply adopted the technique of perspective projection first proposed in *De pictura* (which he had adjusted and simplified): he represented the pyramid of rays extending from a candle to a depicted object and beyond it to form a shadow as the analogue of the pyramid formed between the object and the eye and intercepted by the plane of the picture.[41]

V

Paragraph 12, which follows, is the conclusion of Alberti's study of light and color and the transition to the exposition of the *costruzione legittima*. It begins with a review of what had gone before and continues with a spirited effort to counter the resistance he anticipates from artists who might have preferred a book of this sort to consist, like Cennino Cennini's, of recipes covering the details of daily workshop practice within the established style. Alberti says, in effect, that it is practical as well as intellectually rewarding to approach painting from a theoretical-scientific foundation. The implication is that painters who fail to do so are missing an opportunity to participate in a challenging new enterprise.[42] With this, the argument is summed up:

> They [the painters] should understand that, when they draw lines around a surface, and fill the parts they have drawn with colors, their sole object is the representation on this one surface of many different forms of surfaces, just as though this surface which they color were so transparent and like glass, that the visual pyramid passes right through it from a certain distance and with a certain position of the centric ray and of the lights established in their proper places in the air. Painters prove this when they move away from what they are painting and stand further back, seeking to find by the light of nature the vertex of the pyramid from which they know everything can be more correctly viewed. . . . Therefore, a painting will be the intersection of a visual pyramid at a given distance, with a fixed center and certain position of lights, represented skillfully with lines and colors on a given surface.[43]

[41]Albrecht Dürer, *Die Underweysung der Messung mit dem Zirckel* . . . (Nuremberg, 1525), unnumbered pages (marked 164–75 in the Fogg Museum copy); cf. E. Panofsky, *Dürers Kunsttheorie* (Berlin, 1915), 26ff. Kaufmann in his dissertation (see n. 34, above) shows that Leonardo, though he made intensive studies of cast shadows from a point source, failed to arrive at a functional method of shadow projection based on perspective, such as Dürer's.

[42]"Even so, someone may ask what practical advantage all this enquiry brings to the painter. It is this: he must understand that he will become an excellent artist only if he knows well the outlines of surfaces and their proportions, which very few do; for if they are asked what they are attempting to do on the surface they are painting, they can answer more correctly about everything else than about what in this sense they are doing. So I beg studious painters to listen to me. It was never shameful to learn from any teacher things that are useful to know." In *De re aedificatoria* Alberti also pauses halfway through his exposition to defend his theoretical approach against anticipated criticism (Book VI, introduction).

He may have had models for this sort of defense in ancient and medieval didactic literature.

[43]The passage contains one difficulty that I have met by eliminating rather than solving it: midway, the phrase "positione cominus in aere suis locis constitutis," which I have translated as "established in their proper places in the air." Grayson's translation reads: "established at appropriate points nearby in space." The problematic word is "cominus" (*comminus*), for which "nearby" is the proper translation, but it is not consistent with Alberti's perspective system to require the distance point and the light source to be near the hypothetical window or to be near one another. Grayson (*in litteris,* and in the notes to his 1973 Bari edition [p. 334], which I have not yet seen), points out that the Basel 1540 edition has "eminus" (at a distance), while the Italian has "altrove" (which would suggest that the light source and distance point each has its own place). Prof. Grayson agrees that either of these alternatives would be preferable as a clarification of the method.

Twice in this quotation, and once at the beginning of the paragraph, Alberti declares that there are three basic processes of orientation to perform in laying out a painted version of a visual image. Two of them refer to the viewer's relationship to the object—his distance away from it, and the position of his eye directly opposite a chosen point on the object (establishing the centric ray means orienting with respect to the up/down and left/right axes)— and the third to the position of the light source(s) illuminating the object. Alberti has been working toward this conclusion from the very start; in §5, he defined accidental qualities as determined by the same three factors (Diagram 3). The reason for the redundant emphasis on these points is that, except in the work of two of Alberti's colleagues, Donatello and Masaccio, who contributed to the formulation of the method, they were not yet a part of artistic practice. No earlier artist had oriented himself precisely in relation to his object: his distance would have been the product of roughly how big or small the parts of his object looked to him, his center of vision would have been higher when he looked up at the ceiling than when he looked down at the floor, and his light, while normally coming from a vaguely defined area to the left or right, would often have shifted from figure to figure.[44] If painters stood back from their paintings to get a better look at relationships of parts to the whole, none of them prior to Masaccio and one or two of his emulators at the time of *De pictura* was being composed would have done it for the reason Alberti states in this passage (i.e., that they were seeking the vertex of the visual pyramid). To understand what he means by this, we must realize that this passage contains his most influential and revolutionary contribution to the history of art.

Up to this point, Alberti has been presenting a rationalized account of the process of seeing, with an emphasis on issues of interest to painters. Here, however, he is concerned for the first time with transferring the image we see onto a flat painted surface with absolute mathematical accuracy, which is the ultimate purpose of all his scientific research. At this point, where the accumulated wisdom of ancient and medieval writers on optics was of no help, Alberti had an inspiration—prompted, it appears, by looking out the window:[45] if the image of the outside world comes to the eye via a pyramid of light rays, the same image could be hypothetically caught at any point between the object and the eye by interposing a vertical screen, or intersection of the pyramid.[46] The look out the window made this highly

[44]Practices in perspective and lighting in the century between Giotto and Alberti are outlined in E. Panofsky, *Renaissance and Renascences in Western Art*, 2nd ed. (New York, 1969), Chap. III.

[45]The metaphor of the window actually appears farther on, in §19, where Alberti explains how he sets about to construct a perspective: "But as it is relevant to know, not simply what the intersection is and what it consists in, but also how it can be constructed, we must now explain the art of expressing the intersection in painting. Let me tell you what I do when I am painting. First of all, on the surface on which I am going to paint, I draw a rectangle of whatever size I want, which I regard as an open window through which the subject to be painted is seen; and I decide how large I wish the human figures in the painting to be . . ."

[46]The conception of the intersection of the visual pyramid and the invention of a method of combining the plan and elevation of a perceived or imagined space in a single geometrical construction are what I believe differentiated Alberti's perspective from Brunelleschi's. What we know of the Brunelleschian system, recorded in the *Life* of the architect

by Manetti (ed. H. Saalman, University Park, Md., 1970, 43–47, ll. 167–227), suggests that it provided the necessary catalyst by postulating an intersection of the visual rays; but as I read it, Brunelleschi got his three-dimensional effect by superimposing two two-dimensional constructions, so that he might be said to have intersected the visual *triangle*. The evidence provided by Manetti is not quite sufficient to confirm hypotheses about the essential differences between the two systems. The Brunelleschian method is explained by R. Krautheimer and T. Krautheimer-Hess in *Lorenzo Ghiberti*, 229–53, and in numerous other commentaries, though with flaws; a discussion that seems to me definitive will appear in Prof. Edgerton's forthcoming book.

The idea of a pane of glass interposed between the object and the eye may have been suggested by medieval optical experiments. Biagio Pelacani, for example, used colored panes of glass to illustrate points in his discussion of the "mixture of the species," or the faculty of light rays to pick up characteristics of the media through which they pass (Vienna, Oesterreichische Nationalbibliothek, cod. lat., 5447, fol. 42v B, in Alessio, "Questioni inedite," 188f.).

abstract notion concrete: there, within a frame, is a view of the outside world that could be thought of as projected onto the glass, though it passes through this "screen" to the eye (windows and paintings looked remarkably alike in Alberti's time, when picture frames were modeled on architectural forms).[47] If one took a brush and pigments and painted onto the window glass all the outside objects visible there, one would have a picture that was a geometrically precise imitation of what was seen through the window. But the experiment works only if one stays in an absolutely fixed position, because the view out the window alters as one moves toward or away from the glass, left or right, up or down. Once the painting is done, and one can no longer see the real world beyond, one could indeed look at the picture from any position within the room, but only one position would correspond precisely to the view out the window, and only in that position would the picture be fully illusionistic.

1) Source on lower right rear 2) Source on upper left front

a. Effect of Change of Light Source

 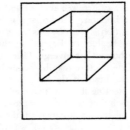

b. Effect of Change of Position

c. Effect of Change of Distance

DIAGRAM 3: VARIABLES IN SEEING OR DEPICTING AN OBJECT

There need be no difference between the painted window glass and a painted panel, except that the former was transparent to start with. In painting a panel, one simply transfers the intersection of the pyramid either from a preparatory sketch done on a transparent sheet— Alberti called it a "veil" (Fig. 2),[48] or one concocts a fictive scene according to the rules of

[47]This cultural phenomenon is not restricted to the Late Gothic period; the rectangular picture and windowframe became popular simultaneously during Alberti's lifetime, ovals in the sixteenth and eighteenth centuries, and in our own time the expanses of plate glass (sometimes symptomatically called "picture windows") made possible by steel and concrete construction, have been paralleled by huge canvases similarly provided with only the vestiges of a frame, frequently made of metal.

[48]Alberti describes the *velo* in Book Two, §31, when he is discussing "circumscription," the first of the three parts of painting: "I believe that nothing more convenient can be found than the veil, which among my friends I call the intersection, and whose usage I was the first to discover. It is like this: a veil loosely woven of fine thread, dyed whatever color you please, divided up by thicker threads into as many parallel square sections as you like, and stretched on a frame. I set this up between the eye and the object to be represented, so that the visual pyramid passes through the loose weave of the veil. This intersection of the veil has many advantages, first of all because it always presents the same surfaces unchanged, for once you have fixed the position of the outlines, you can immediately find the apex of the pyramid you started with, which is extremely difficult to do without the intersection."

the view-out-the-window. Either way, *the illusion works only if the picture is viewed from exactly the same point as the scene was viewed or imagined to begin with*. That is why the painter in Alberti's explanation moves back to locate the vertex of the visual pyramid (that is, the point from which the perspective is constructed), and why we, in looking at Renaissance pictures, should also make an effort to locate it, remembering, of course, to shut one eye.[49] The reader who still finds Alberti's text and my explanation of it baffling is advised to make some sketches in a transparent, and preferably water-soluble, medium on his windowpane.[50]

If all pictures could be made through a window or a veil, there would have been no need for inventing perspective; everything could have been done by eye. But Alberti's was a period in which painting was rarely done from nature, which meant that a system had to be devised that created an imaginary world in which events could be staged. This involved reversing the initial procedure in a sense; with the window or veil the artist began (as in Fig. 2) by delineating people or objects and, if he wished, arrived finally at a convincing representation of a whole environment. But to make an illusionistic imaginary scene it was necessary first to invent a consistent space in which it would take place; otherwise the relationship between the people and objects, and between both of these and the observer, would be arbitrary and unconvincing. So the primary purpose of the invention of artificial perspective was to concoct a measurable void that could subsequently be peopled. It was an abstract geometrical problem, unrelated to the questions of vision (we do not actually see

[49]This involves first placing one's eye opposite the center point, which in Albertian constructions is nearly always midway between the left and right borders of the picture on the horizon. The horizon is by definition at eye level; if its position is not obvious, as it is, say, in a picture of the sea, it can be located by finding the point at which the receding orthogonals converge. Often one cannot make this first step, as the picture may be painted or hung high on a wall above one's head. Early Renaissance painters were not hesitant in presenting illusions that could not be viewed from the point at which they were constructed; but the center point of the most explicit first instance of the *costruzione legittima,* Masaccio's *Trinity* (ca. 1427–1428), was placed exactly at the eye level of an observer standing in the church in which it was frescoed (at the bottom of the picture, to give the illusion that one looks up at the scene).

The second procedure is to find how far away to stand or, in technical terms, to locate the distance point. Although this can be done mathematically by reconstructing the perspective system in reverse, it is more practical to do it by "feel," moving back and forth at a distance somewhere between half the width of the picture and the full width, until the perspective looks right. For an excellent demonstration, see B.A.R. Carter–R. Wittkower, "The Perspective of Piero della Francesca's *Flagellation,*" *Journal of the Warburg and Courtauld Institutes* (XVI, 1953), 292–302 and F. Casalini, "Corrispondenze fra teoria e practica nell'opera di Piero della Francesca," *L'Arte* (II, 1968), 62–95.

[50]Some of the literature on perspective continues to perpetuate the misconception that the Albertian method and its Renaissance variants is invalidated by the fact that we see with two eyes rather than one, that in the process of seeing we move the body, the head, and the eyeball, and that there is distortion at the periphery of vision. But none of these physiological conditions could be used to draw or paint a more accurate perspective construction on a flat surface than Alberti proposes. The painting is indeed like the view out the window, and if it were altered to account for physiological effects—if, say, the

building and the tree at the far edge were distorted as in peripheral vision—then in looking at the picture, our peripheral vision would *distort the distortion,* and the effect would be less illusionistic than Alberti's. The point has been repeatedly and decisively made by Sir E.H. Gombrich (for example, in *Art and Illusion,* New York, 1960, chap. VIII, especially 242–58).

Another canard that occasionally recurs is justified neither on physiological nor on perspectival grounds: that the curvature of the eyeball or of the retina causes us to see curves where there are straight lines. This argument is quite without substance; the eye is constructed, like the camera lens, which is also curved, to give as accurate an image of things as possible; second, in Pirenne's words, "the retinal image is not what we see: we see the external world"; and third, to repeat the foregoing argument, if the shape of our eye did cause us to see straight lines as curved, and if pictures were accordingly made with curvilinear "perspective," our eyes would curve the lines further in looking at them (see Pirenne, *Optics, Painting and Photography,* 145 ff.).

The instances of "synthetic" or curved "perspective" adduced by White, notably in the miniatures of Jean Fouquet (*The Birth and Rebirth of Pictorial Space,* 207–35) do not produce more accurate records of things, but the device can be a forceful means of emphasis in the same way that photographs made with a wide-angle or "fisheye" lens can. They were probably inspired by convex mirrors, which were common household appurtenances in the fifteenth century.

What keeps the controversy over curvature alive is that whereas Albertian perspective is the only accurate way of transferring certain kinds of data about the world onto a picture plane, it is not necessarily the most convincing, because vision is affected by our bodies, our movements, and our psyches. If the artist wants to communicate as precise a record of fact as he can, he should follow Alberti; if he wishes to communicate the way things look to him, he is not obliged to follow anyone, but he might be attracted to the solutions of Fouquet, or of the Impressionists, etc.

space, but only the objects that fill it), that had occupied Alberti in the first twelve paragraphs. But the solution of the problem was wholly dependent on three postulates affirmed in §12: The picture must be regarded as the intersection of the visual pyramid, and the observer must be at a fixed distance, and his eye at a fixed centric point. The centric point became, in fact, the focus of Alberti's perspective construction—the terminus, later called the "vanishing point," toward which all orthogonals converge. Its focal position is conceptually based on the superior powers of the centric ray; indeed, the "vanishing point" is nothing other than the centric ray viewed end-on, or, to put it another way, the point where the centric ray strikes. Because the *costruzione legittima* creates an abstract space, Alberti did not perceive that its procedures could be adapted to his fourth principle, the establishment of a fixed source of light; it was to be ninety years before Dürer announced a method of projecting shadows that was based on an analogy between the pyramid of light rays emanating from the sun and the pyramid entering the eye.[51]

Artificial perspective is relevant here only because of its great debt to Alberti's study of ancient and medieval optics as recorded in the first half of Book One of *De pictura*. The book moves with impressive purpose and logic through the applicable hypotheses of the optical scientists toward a climax in Alberti's unique contribution, the intersection of the visual pyramid, which made it possible to translate the scientific data into the practice of painting, and concludes with the application of the intersection to perspective construction.

VI

The immediate and widespread impact of artificial perspective on Early Renaissance painting is well known, but the effect of the precepts discussed here, which led to its invention, have not been examined.

Alberti's basic hypothesis, that light is propagated by rectilinear rays of three distinct kinds (extrinsic, median, and centric) had direct and indirect implications for the practice of painting. The most obvious was the separation of the outline of objects from their surfaces by the extrinsic rays, which Alberti described (in §2) as constituting a "brim or fringe" serving to measure quantities. Median rays differ by being propagated from the surface of the object and by carrying the color and light from their points of origin. Since the extrinsic rays are by inference not modified by local color or light, a painter reading the passage would conclude that they should be recorded by a thin line of neutral color that retains the same character whether it was on the shaded or the lit side of the object to be portrayed. In Book Two (§30), wherein Alberti defines the nature of painting, he shows circumscription, the application of the concept of the extrinsic ray, to be one of the cornerstones of the art (see above, page 14). The other two parts of painting are then defined as composition and coloring, which is termed "reception of light." The following paragraph expands on the concept of circumscription, the "process of tracing the outlines in the painting":

[51]See n. 41, above.

I believe one should take care that circumscription is done with the finest possible, almost invisible, lines like those they say the painter Apelles used to practice and vie with Protogenes at drawing. Circumscription is simply the recording of the outlines, and if it is done with a very visible line, they will look in the painting, not like the edges of surfaces, but like cracks. I want only the outlines to be sketched in circumscription; and this should be practiced assiduously. No composition and no reception of light will be praised without the presence of circumscription. But circumscription by itself is very often most pleasing.[52]

The outlining of figures in the way described here was indeed the standard practice of Florentine painters throughout the fifteenth century (Fig. 3) and was still used by Michelangelo in the Doni tondo of 1506, and in fresco painting for a much longer time. It was so much the rule that Leonardo launched numerous attacks on it, for example in the *Trattato*: ". . . The outline of one object impinging on another is like a mathematical line, but it is not a line because the limit of one color is the beginning of another color, and must not be called a line because nothing intervenes between the outlines of one color which is placed opposite another color except the outline that is invisible even close up. Therefore, painter, do not accentuate it in distant things."[53]

Alberti had used his scientific hypothesis to support a theoretical position that provided the justification for the Florentine emphasis on *disegno*, and particularly for a style of drawing with a continuous closed outline separating the figure from the ground.[54] Florentine *disegno* does not, however, stem from Alberti, nor is it even substantially indebted to his formulation —it was already well established in the preceding century.[55] But Alberti's formulation affirmed that the primacy of drawing and the concept of composition as an assembly of distinct objects were consistent with the ideal of art in the new era. The historical role of art theory is not only to invent new practices and set new goals but also to indicate which traditional practices remain valid.

The color transmitted by the median rays is what might be called the "real" color of an object as it is affected by light and shadow. Other factors influence color perception, such as atmosphere and reflected light/color, but Alberti presents these as special cases, with somewhat negative overtones, as if they were obstacles to perceiving things rightly, and he provides no encouragement to painters to take pleasure in or to record the kind of special environmental effects that were to be so important in later painting. The practical effect of his advice was to encourage painters to assign a particular hue to the area within the circum-

[52]The advice is contradicted by the proposition cited in §9: "Philosophers say that nothing is visible that is not endowed with light and color." The contradiction is inevitable, since the hypothesis of extrinsic rays is an abstraction borrowed from mathematics and does not correspond to visual experience.

[53]*Treatise on Painting*, ed. A.P. McMahon (Princeton, N.J., 1956), §506. A similar statement is made in MS G., fol. 37 (Richter, *Notebooks*, I, §49): "wherefore, O painter, do not surround your bodies with lines . . ." I cannot explain the apparent illogicality of Leonardo's application of his precept specifically to "distant things" (the passage starts with proposing that objects in the fourth and fifth plane be less sharply distinguished than those in the first and second); it would seem to apply at any distance.

[54]John White has perceptively discussed the evolution of drawing style in the post-Albertian generation in "Aspects of the Relationship between Sculpture and Painting," *Art, Science and History in the Renaissance*, ed. C. Singleton (Baltimore, 1967), 43–108.

[55]Centuries earlier, Vincent of Beauvais (d. 1264) had written: "Painters first draw lines around the images as if around shadows and then fill them up with color" (*Speculum doctrinale* edition Donai, 1624, II, ii, chap. XIX, col 1005, as quoted by I. Galantič, "The Sources of Leon Battista Alberti's Theory of Painting," Dissertation, Harvard, 1969, 152). The parallel with Alberti is probably fortuitous, since Vincent was simply describing a shop convention, whereas Alberti was applying to painting what he held to be a natural law.

scribed outline and then to modulate this by raising its value (with white) on the side toward the light and to lower it (with black) on the opposite, shadowed side. This is discussed in §46 of Book Two, where Alberti expands on the third part of painting, "reception of light." He also suggests that:

> . . . you may change the color with a little white applied as sparingly as possible in the appropriate place within the outlines of the surface, and likewise add some black in the place opposite to it. With such balancing, as one might say, of black and white a surface rising in relief becomes still more evident. Go on making similar sparing additions until you feel you have arrived at what is required.

Modeling of each object individually to achieve relief was the practice followed by quattrocento painters, but neither Alberti nor any other writer or practitioner of the period was able to translate "light" and "shadow" into pigment equivalents in a way that fulfilled his aspirations both to realism and to effective color design.[56]

Alberti failed in this area because he did not differentiate between the behavior of light, as defined scientifically or as experienced optically, and the behavior of pigment. This difference invalidates two of his fundamental principles: first, that white and black are the palette equivalents of light and shadow respectively, and second, that all other colors can be produced by mixing the four primaries with white and black. The second of these principles perpetuated a mistake that originated in Aristotle:[57] we have already seen that Alberti's primaries (blue, red, green, earth color) were excessively limiting, since yellow was excluded. Further, mixing a hue with black and white does not alter it but merely raises or lowers its value. If white is mixed with a pure blue, the resulting pigment is a paler state of the same blue. The term "paler" is more indicative than "lighter" because in the process the blue loses some of its intensity or impact; the majority of colors are neutralized almost as much by the addition of a bit of white as by a comparable amount of black.

The modeling of all objects toward white on the light side and toward black on the dark, which results from the first proposition, is not, on the other hand, unacceptable, but it was rejected by the mass of quattrocento painters because it was not to their taste. They, like the Impressionists, did not mind neutralizing their colors with white, but they found that an equal application of black produced a somber and deadening effect that was particularly uncongenial to the tempera medium.[58] They preferred to make individual experiments based on the old-fashioned formula detailed by Cennino Cennini in his *Libro dell'arte* of about 1390, in which black is not used for modeling at all; the deepest shadows are established by pigment

[56]Modeling practice in the fifteenth century is discussed by Pope, *The Painter's Modes of Expression,* and by Sir E.H. Gombrich, "Light, Form and Texture in Fifteenth-Century Painting," *Journal of the Royal Society of Arts* (CXII, 1964), 826–49, who cites as an example of Albertian modeling a predella of Fra Angelico with scenes from the Life of St. Nicholas in the Vatican (his fig. 13). Gombrich discusses modeling in relation to highlights and sheen, effects which were more cultivated in fifteenth-century Flemish painting than in Italian.

[57]*De sensu,* chap. II.

[58]On the quattrocento palette, see Siebenhüner, "Über den Kolorismus in der Frührenaissance"; T. Hetzer, *Tizian, Geschichte seiner Farbe* (Frankfurt a. M., 1935); J. Shearman, "Leonardo's Colour and Chiaroscuro," *Zeitschrift für Kunstgeschichte* (XXV, 1962), 13–47; S. Cowardin, "Some Aspects of Color in Fifteenth-Century Florentine Painting," Dissertation, Harvard, 1962.

in its purest, and most intense, state, and modeling is done entirely with white.[59] This entirely ignores the neutralizing effect of shadow in nature, on which Alberti insists, and makes areas the most vivid where they ought to be the least: it accounts in large part for the unreal appearance of much quattrocento painting. In Alberti's system, the pure pigment would appear along a band just on the light side of a line that he advises the painter to draw at the start, dividing the light part of the figure from the dark.[60] Of the two practices, Alberti's was actually the more realistic and, for outdoor lighting in the full sunlight, the more capable of producing an acceptable illusion, because in that situation the combined effect of glare, reflection, and the adjustment of the eye to brightness does lower color perception and may make it seem that the most intense color appears roughly midway between the highest and the lowest value.

Neither Alberti nor the painters differentiated between value and intensity; it did not matter, for example, that yellow has a high value at full intensity and ultramarine blue a low one, so that, in either Alberti's or Cennini's system, the blue cloak of a figure could not be modeled in the same way as the yellow shirt without making them appear to be in two different conditions of lighting. The result was that not only was each object or figure kept distinct, but each color area within the figure seems to pull away from its neighbors, which can produce stimulating color patterns but inhibits tonal harmony.

Finally, the Albertian system, in conceiving the value range as creating an equilibrium between light and dark, assumes that the objects in a painting will be illuminated by rays traveling parallel to the picture plane at 90° to the centric rays coming to the eye. Thus, discounting variations in their surface, each will appear half in the light and half in the shadow (because cast shadows are rarely used, objects in quattrocento paintings are almost all lit directly). Each figure is to be modeled in relief, in the nearest possible approximation of the sculptural relief of Ghiberti and Donatello (in §46, Alberti praises "those faces which seem to stand out from pictures as if they were sculpted"); indeed, relief is actually more modified by atmosphere in Donatello's *schiacciato* panels than in any painting done in Alberti's lifetime, with the exception of some frescoes of Masaccio.[61]

[59]Cennino Cennini, *Il libro dell'arte,* ed. Thompson, chap. LXXI: "The Way to Paint a Drapery in Fresco: . . . get three little dishes. Take one of them, and put into it whatever color you choose, we will say red. Take some cinabrese and a little lime white; and let this be one color, well diluted with water. Make one of the other two colors light, putting a great deal of lime white into it. Now take some out of the first dish, and some of this light, and make an intermediate color; and you will have three of them. Now take some of the first one, that is, the dark one; and with a rather large and fairly pointed bristle brush go over the folds of your figure in the darkest areas; and do not go past the middle of the thickness of your figure . . ." When these three levels of relief have been smoothly modeled, the final touches are added first in a still lighter mixture and finally in pure white for the highest lights and pure cinabrese for the deepest shadow. This method results in the use of a great deal more white than Alberti recommends in his discussion of modeling in §47, in which he says "no surface should be made so white that you cannot make it a great deal whiter still," and "those painters who use white immoderately and black carelessly, should be strongly condemned."

Cennino also discusses in chaps. LXXVIII-LXXX the use of the color "shift," which represents shadows not by a low value of the color of the drapery itself, but by a quite different color of lower value. In Alberti's time the latter frequently was ultramarine in practice, as in the first of Cennino's examples.

[60]Book Two, §47: "But if, as I explained, the painter has drawn the outlines of the surface correctly and clearly sketched the border-line between lighter and darker, the method of coloring will then be easy."

[61]The *schiacciato* relief style was first used by Donatello in the relief beneath the statue of St. George in Orsanmichele in Florence, ca. 1417, and reached its culmination in the *Ascension and Delivery of the Keys to St. Peter* in the Victoria and Albert Museum in London, of the late 1420s.

VII

In bringing the hypotheses of medieval optics into the painter's workshop, Alberti necessarily accepted and promoted a particular philosophical position that influenced the goals and the criticism of art. His theory posits the existence of objects out there in the world that light makes it possible for us to see; rectilinear beams that retain the color and the value of the source transmit data from the surface of the objects to the eye. Under exceptional conditions, these data may be altered by the intervening environment, but it is assumed that they enter the eye and pass through it to the mind without being further affected; every eye and mind processes the data in the same way. Philosophically the approach is purely materialist; reality is immanent in the objects of the external world, and our percepts of them are undistorted reflections of that reality.

Alberti's text contains none of the idealist principles that came to the fore with the revival of Neoplatonism and were to dominate later theories of art, according to which the objects of perception are imperfect versions of a pure idea, compromised by their earthliness. In idealist theory, the percept is different for different viewers: the common man sees nothing behind the crass surface of objects, while the more elevated spirit (of the artist, connoisseur, or philosopher) penetrates nearer to the perfection of the idea.[62] Alberti's system did not provide this effective formula for differentiating the artistic imagination or vision from the ordinary. In fact, it appears to call for a purely naturalized art—though one modified by mathematical order.[63] Book Three of *De pictura* faces the problem of reconciling this with a concept of beauty (*pulchritudo*) formulated with the help of the Aristotelian principle of selection:[64] "The early painter Demetrius failed to obtain the highest praise because he was more devoted to representing the likeness of things than to beauty. Therefore, excellent parts should all be selected from the most beautiful bodies, and every effort should be made to perceive, understand and express beauty" (§55). This leads to an account of the legend of the "Maids of Croton," in which the painter Zeuxis devised a perfect female type by taking the best features from the five most beautiful girls of the town in which he was working, a device by which *mimesis* could be reconciled with the idea of beauty. The principle, however, has an obvious and serious flaw, in that the standard by which Zeuxis or Alberti selects the girls to begin with, and then finds their comeliest parts, is kept secret, though it is the key to the whole argument. From what Alberti says, we can conclude only that it emerges as an endowment of upright and well-educated artists (§52).

[62]For idealist theory in the Renaissance and its sources, see E. Panofsky, *Idea, ein Beitrag zur Begriffsgeschichte der älteren Kunsttheorie* (Leipzig–Berlin, 1924; English ed., Columbia, S.C., 1968); Sir Anthony Blunt, *Artistic Theory in Italy, 1450–1600* (Oxford, 1940).

[63]Alberti's concept of the imitation of nature and its roots in Aristotle's theory of *mimesis* as presented in the *Poetics* is ably discussed by Galantič, "The Sources of Leon Battista Alberti's Theory of Painting," chaps. II, III.

[64]A clear statement of Aristotle's position on artistic criteria is found in the *Politica*, 1281b, 10: "... the superiority ... of handsome men, so it is said, over plain men and of the works of the painter's art over the real objects, really consists in this, that a number of scattered good points have been collected together into one example; since if the features be taken separately, the eye of one real person is more beautiful than that of the man in the picture, and some other feature of somebody else."

But quite apart from standards of aesthetic value, Alberti's epistemology poses problems for painters because it fails to account for the experience of anyone trying to work from nature: that things do not always look "the way they are" (in a dim light, for example, the shaded part of a head or body may be indistinguishable from the obscurity of the environment or of a body alongside it). Whatever the causes of differences between the object and the percept, the artist has to choose between portraying things "as they are" (a distinct, definable body in full relief with an outline) and things as they seem. The quattrocento artist almost invariably joined Alberti in preferring the former. Though Alberti was aware that deprivation of light and atmospheric conditions inhibit clarity of vision, he obviously believed that one simply did not make pictures of objects unless their modeling was discernible and their entire outline visible, and every quattrocento painting affirms the same conviction until the moment when it is challenged by Leonardo's *sfumato* technique in the last decade of the century.

Most quattrocento painters avoided the conflict between reality and appearance by not drawing or painting from nature. Because their pictures were totally invented, things could be rendered as if they were solids lit in the way most favorable to bringing out their fullest relief.[65] Figures, objects, and even flora were conceived almost as sculptures; and it is symptomatic that in some of the earliest Florentine life drawings, apprentices are sketched in poses taken from antique statues.[66] This helps to explain why landscape painting was not much cultivated—the appeal of landscape is primarily in textures of indefinite form and effects of atmosphere—and why Mantegna, who was the first particularly to emphasize landscape settings, invented exceptionally stony countrysides with sharp contours edged by curving roads. It also explains how an age committed to realism in art got much farther in creating illusions of space and mass than illusions of color: a completely abstract and intellectual construct such as Uccello's *Mazzocchio* could be made to look like a solid object in three-dimensional space, but the abstract-intellectual treatment of color, even when based on what the artist knew to be the "real" colors of objects, did not produce a convincing illusion and led to decorative, abstract color composition rather than to naturalism.

It would be misleading to suggest either that fifteenth-century painting followed this course because it conformed to the optical theory of Alberti and the scientists or, conversely, that Alberti's optics remained strictly geometrical because the Early Renaissance mode of perception avoided appearances. The art and the science were simply different manifestations of one outlook on the nature of the material world. But without Alberti, they would not have been brought together so that they could be perceived as part of the same conceptual structure, and that, as much as any originality of thought, is the significant contribution. We have seen that the optics are those of the era from Alhazen to Pelacani, and the concepts of color and modeling are not far from the practice of Giotto, but out of these medieval components

[65]But generally this was true only of the figures: for reasons of tonal balance and emphasis, full relief and value contrast was avoided in architectural and landscape backgrounds.

[66]Cf. B. Degenhart–A. Schmitt, *Corpus der italienischen Zeichnungen, 1300–1450*, I–II (Berlin, 1968), xxxi and cat. nos. 336, 338–40, 342–43, 452–53, 461–63, 472, 475–76, attributed to Domenico Veneziano and to the workshop of Benozzo Gozzoli. Also, J. Białostocki, "The Renaissance Concept of Nature and Antiquity," *Acts of the Twentieth International Congress of Art History*, II (Princeton, N.J., 1963), 19–30.

emerged a new alloy that showed artists the relevance of science as a way of making sense out of the experience of nature. No particular precept in the first part of *De pictura* had as pervasive an impact as the following section on perspective construction; the specific recommendations on color and shadow were ineffectual, and until Leonardo artists continued to examine those problems by the old hit-or-miss methods. But the incalculable change that Leonardo wrought was directly dependent on Alberti's vision of art as a branch of natural science and particularly of optics: the debt is acknowledged by the opening lines of Leonardo's *Trattato*, which, in the context of establishing painting as a science, repeat the same Euclidean demonstrations as those at the start of *De pictura*.

HARVARD UNIVERSITY

D

A Book of Hours Made for King Wenceslaus IV of Bohemia

J. J. G. ALEXANDER

It seems appropriate to offer as a tribute to the author of *French Painting in the Time of Jean de Berry* a description of a Book of Hours made for a contemporary of Berry, Wenceslaus IV, King of Bohemia. The Book of Hours is in the possession of Pembroke College, Oxford (MS 20), and, since it was not included in H.O. Coxe's catalogue of the Oxford College Libraries of 1852 and is unknown, as far as I am aware, it will be necessary to begin by describing it.[1]

General Description

In Latin, on parchment; iii+92+1 folios; 163×120 mm.; 93 leaves; 11 long lines. Collation: iii+1¹⁰–3¹⁰, 4⁶, 5⁸–11⁸+1; horizonal catchwords. Binding: blind-stamped leather panel binding rebacked, Netherlandish, late fifteenth or early sixteenth century. The center panel shows St. Margaret with the dragon in the middle flanked by a wyvern and a gryphon. The upper and lower panels are identical, rectangular, and have two scrolls enclosing animals and birds; each of these is framed and surrounded by an inscription: (a) "Adjutorium nostrum in nomine domini qui fecit celum et terram"; (b) "Benedictum sit nomen domini ex hoc nunc et usque in seculum."

Text

Rubrics, in blue, are printed in italics.

fol. 1. Confitebor.

fol. 3v. *Sequitur alia confessio.* Confitebor.

fols. 8–10. Domine Iesu Xpiste qui mundum proprio sanguine redimisti . . .

fols. 11–12. Blank, ruled.

fol. 13. *Cursus de sancto Mathia Apostolo ad matutinas;* fol. 15, Prime; fol. 17, Tierce; fol. 19, Sext; fol. 21, Nones; fol. 23, Vespers; fol. 25, Compline.

fol. 27v. *Sequitur commenda orationum praescriptarum.* Omnipotens sempiterne deus qui septem dierum vicissitudinali cursu.

fol. 28v. *Explicit cursus horarum de sancto Mathia apostolo et cetera.*

fol. 29. *Hore canonice congeste ad Laudem dei et omnium sanctorum ejus et primo pro matutine hore principio de sancta Trinitate quia scriptum est. In matutinis domine meditabor in te quia fuisti adjutor meus.*

fol. 31v. *Pro matutine hore medio. De gloriosa virgine Maria quia ipsa matutina stella veracitatis nuncupatur.*

fol. 33. *Pro matutine hore terminio de novem choris angelorum . . .*

[1]The manuscript was shown by Dr. David Fleeman, Librarian of Pembroke College, to Dr. R.W. Hunt, Keeper of Western Manuscripts, Bodleian Library, Oxford, who in turn showed it to me. I am grateful to them both for facilitating my study of the manuscript and to the Master and Fellows of Pembroke College for permission to publish it. I should also like to thank Professors Otto Pächt and Gerhard Schmidt, Vienna, Dr. Josef Krása, Prague, and Dr. A.C. de la Mare, Bodleian Library, Oxford, for their help.

fol. 35. *Pro prima de sanctis patriarchis et prophetis* . . .

fol. 36v. *Pro hora tertia de sanctis Apostolis* . . .

fol. 38v. *Pro hora sexta de sanctis martiribus* . . .

fol. 40. *Pro hora nona de sanctis confessoribus* . . .

fol. 42. *Pro hora vespertina de sanctis virginibus* . . .

fol. 43v. *Pro hora completorii de sanctis viduis* . . .

fol. 45v. *Pro completorii progressu de sanctis conjugatis* . . .

fol. 47. *Pro completorii complemento de omnibus sanctis et electis dei.*

fol 49. Prayers follow—longer or, if the user reads only the words written in blue (printed here in italics), shorter: *Hec est* nimirum *dies* votiva celebritate colenda *quam* profecto ad laudem et gloriam nominis sui excelsi *fecit* dominantium *dominus.*

fol. 50v. *Hodie* . . . *dominus afflictionem* . . . *populi sui* . . . *respexit et* . . . *redemptionem* . . . *misit.*

fol. 52. *Hodie* . . . *mortem* . . . *quam* . . . *femina* . . . *intulit* . . . *femina* . . . *fugavit.*

fol. 53. *Hodie* . . . *deus factus est homo* . . . *id quod fuit* . . . *permansit et* . . . *quod* . . . *non erat* . . . *assumpsit.*

fol. 54v. *Ergo* . . . *nostre redemptionis exordium devote* . . . *recolamus* . . . *exultemus* . . . *dicentes gloria* . . . *tibi* . . . *domine.*

fol. 56v. *Incipiunt VII psalmi penitentiales.*

fols. 78–86v. Litany, followed by prayers. Martyrs: Stephen, Lawrence, Vincent, Vitus, Wenceslaus, Adalbert, Sigismund, George . . . Virgins and widows: . . . Ludmilla.

fols. 87–92. Blank, ruled.

fol. 93. *Ult.*

Decoration

The divisions of the book are marked with four-line historiated initials, which have hairline spray borders in green, blue, and gold containing flower forms in pink, blue, green, and yellow. The subjects are as follows:

fol. 13. Initial *B*. St. Matthias carrying an axe and three balls (Fig. 1). He is shown half-length, as are all the other figures in the initials except the angel on fol. 33v.

fol. 29v. Initial *D*. Christ blessing (defaced).

fol. 31v. Initial *A*. The Virgin and Child.

fol. 33v. Initial *I*. An angel with a scroll inscribed "sanctus."

fol. 35. Initial *D*. The patriarch Jacob asleep with a ladder behind (Fig. 2).

fol 37. Initial *D*. St. Matthias with an axe.

fol. 39. Initial *P*. St. Wenceslaus of Bohemia (September 28), recognizable by his crown and shield with black eagle on gold (Fig. 3).

fol. 40v. Initial *D*. St. Adalbert, bishop of Prague (April 23), vested as a bishop (Fig. 5).

fol. 42v. Initial *D*. St. Barbara holding a tower.

fol. 44. Initial *C*. St. Ludmilla of Bohemia, grandmother of St. Wenceslaus (September 16), wearing the scarf with which she was strangled (Fig. 4).

fol. 46. Initial *U*. Half-length figures of a man and a woman without haloes or symbols (Fig. 6).

fol. 47v. Initial *Q*. The Virgin with the Dove above and flanked by two saints (Fig. 7).

fol. 49. Initial *H*. Christ as Man of Sorrows.

fol. 57. Initial *D*. Christ holding up His hands, with His chest bare to show His wounds.

Provenance

The initial of the owner, *W*, is given in the prayers on fols. 14v, 16v and 24v. Since they also inform us of his position, they must be quoted: fol. 14. *Oratio*. Venerabilis vir beate Mathia . . . fol. 14v . . . michi W. servo tuo obtinere digneris ut qui me inter electe plebis sue numero (*sic*) recensuit et ejusdem ceptrigerum regimen commendavit dignum vite sue sectatorem efficiat. fol. 16. Altissimi cesaris serve fidelis et prudens sancte Mathia . . . fol. 16v . . . me W. servum tuum domino studiose commenda ut qui me in solio regii honoris constituit morum honestate decoret, amen. fol. 24. *Oratio*. Altis festivande preconiis sancte Mathia . . . fol. 24v . . . michi W. servo tuo clementi misericordie procura.

The only owner's name in the book occurs on fol. 1: Franciscus Muijlwijch, sixteenth century. By this date, the manuscript was probably in the Netherlands, on the evidence of the binding. On fol. i are two nineteenth-century inscriptions in pencil: "Chartagena de passion tertia pars"; and "E Bibl. Coll. Pemb. Oxon." There is no record of how or when the manuscript reached Pembroke College.

The presence of Bohemian saints in the Litany and both the iconography and style of the illumination make it certain that "W," "whom God has placed on the throne of royal honor," is none other than Wenceslaus IV, King of Bohemia, son of the Emperor Charles IV, who was born in 1361 and died in 1419. From the description above it will be seen that this is not a normal Book of Hours but a prayer book likely to have been specially prepared for the King. In view of this it seems probable that the figures in the initial *U* on fol. 46 (Fig. 6), "Compline pro sanctis conjugatis," may represent Wenceslaus himself and his second wife, Sophia of Bavaria, whom he married in 1389 and who survived him.[2]

Though only eight other manuscripts made for Wenceslaus survive, they are all of major importance for their illumination and demonstrate that he was one of the greatest patrons of his time. All the illumination in the Pembroke Hours is of very high quality. Two of the initials, fols. 33v and 47v, seem to differ slightly in style from the rest. Both painted in blue on blue, with gold highlights, they show figures with elongated faces and tapering fingers. The elegant pose of the Virgin (fol. 47v, Fig. 7) can be compared with Bohemian sculpture of the time, such as the Krumauer Madonna. The remaining initials show stockier figures with rounder faces. They are painted in delicate shades of blue, green, pink, and yellow for the most part. The backgrounds to the figures are in gold, the haloes shown by impressed lines. In each initial the color range is limited, with often a small touch of brighter contrasting color; for example, the *P* on fol. 39 (Fig. 3) is in pale green, with the plant scroll lighter in color on a

[2]For Wenceslaus's manuscripts see J. Krása, *Die Handschriften König Wenzels IV* (Prague–Vienna, 1971). None of Wenceslaus's emblems appear in the decoration of the Pembroke Hours. No catalogue of his library survives; the most important of his manuscripts passed into the Hapsburg Library.

blue square. St. Wenceslaus has a gray fur coat over a blue robe. His crown is also blue but with a touch of brighter pink. The small portion of his shield that is visible is painted yellow and also forms a contrasting note. The colors of the flowers in the borders are in the same range, and the whole effect is one of great refinement.

The style of the initials is clearly related to that of the main illuminator in Prague at this date, who has been named the Master of the Gerona Martyrology after one of his most important works.[3] Of the manuscripts attributed to him, the Bible of Konrad von Vechta was written in 1402,[4] the Martyrology is usually dated 1410,[5] and an Antiphonary for the Cistercian monastery of Sedlec is dated ca. 1414.[6] Recent discussion has tended to separate various hands in the workshop. Professor Gerhard Schmidt has distinguished a closely related but slightly older master, whom he has named the Joshua Master after a miniature in the Bible of Konrad von Vechta. The majority of the initials in the Pembroke Hours appear to resemble the work attributed to this artist by Schmidt, whilst the two initials on fols. 33v and 47v seem nearer to the Master of the Gerona Martyrology. As to the date of the Pembroke Hours, Wenceslaus's death in 1419 provides a *terminus ante quem*. Comparisons with the Martyrology and the Sedlec Antiphonary suggest that the Hours were made toward the end of the workshop's activity, in the second rather than the first decade of the fifteenth century.

UNIVERSITY OF MANCHESTER

[3]See especially O. Pächt, "A Bohemian Martyrology," *Burlington Magazine* (LXXIII, 1938), 192–204; M.J. Frinta, "The Master of the Gerona Martyrology and Bohemian Illumination," *Art Bulletin* (XLVI, 1964), 283–306; J. Krása, "Na okraj nové studie o Mistru geronského Martyrologia," *Umění* (XIV, 1966), 394–405; G. Schmidt, "Malerei bis 1450" in *Gotik in Böhmen,* ed. K.M. Swoboda (Munich, 1969).

[4]Antwerp, Musée Plantin-Moretus, MS 15.1.

[5]Gerona, Museo Diocesano.

[6]Brno, State Library, Cod. 25. Other fragments from the same or a related manuscript are scattered elsewhere; see Frinta, "The Master of the Gerona Martyrology," 292–93.

[7]Some of the borders in the Gerona Martyrology are extremely similar, e.g., those on fols. 85–95v.

Un Cas d'influence italienne dans l'enluminure du Nord de la France au quatorzième siècle

FRANÇOIS AVRIL

Un des phénomènes les plus passionnants à observer de l'histoire de l'art européen au quatorzième siècle est sans aucun doute celui de la lente mais irrésistible métamorphose que subit alors la peinture, sous l'influence des découvertes et des redécouvertes faites par les peintres italiens du Trecento dans le domaine de l'expression plastique et de l'évocation de l'espace. Plus ou moins profonde suivant les pays, cette évolution qui ne s'opéra pas sans à-coups ni retours en arrière, n'affecta pas seulement les régions que la géographie, le commerce et les liens politiques mettaient en contact permanent ou sporadique avec l'art de la péninsule, telles la Catalogne, l'Autriche et la Bohême:[1] on en perçoit les effets précoces, mais éphémères il est vrai, jusque dans la lointaine Angleterre.[2] Pas plus que les autres pays, la France ne pouvait se soustraire à l'attraction des innovations italiennes. De celles-ci les peintres transalpins eux-mêmes s'étaient fait les ambassadeurs, que ce soit dans le Midi, où leur présence fut indubitablement favorisée par l'installation de la cour pontificale en Avignon,[3] ou dans la France capétienne. Très tôt en effet les rois de France semblent avoir été conscients de l'importance de la révolution picturale qui s'était produite au-delà des Alpes, et l'on voit Philippe IV le Bel employer, dès 1309, dans son château de Poitiers, plusieurs peintres romains qu'on suit dans les comptes royaux jusqu'en 1317.[4] S'il est impossible aujourd'hui de juger de l'influence de ces artistes sur les peintres français de l'époque, il ne semble pas que le roi ait réussi, si tant est qu'il en ait eu l'intention, à faire de son chantier de Poitiers un Fontainebleau du quatorzième siècle. Au contraire, l'évolution de la peinture française telle qu'on peut la suivre à travers les oeuvres des meilleurs enlumineurs de l'époque, ne témoigne que d'une adhésion discrète aux formules italiennes, résultant, ainsi que l'a fort bien dit Panofsky, d'une "assimilation continue, méthodique et sélective."[5] Cette définition est spécialement adaptée à la situation de l'enluminure parisienne durant la première moitié du quatorzième siècle, et à

[1] La question des influences italiennes sur la peinture et l'enluminure bohémiennes à partir du milieu du quatorzième siècle a été approfondie pour la première fois par M. Dvořak, "Die Illuminatoren des Johann von Neumarkt," *Jahrbuch der Kunsthistorischen Sammlungen des allerhöchsten Kaiserhauses* (XXII, 1901), 35–126. On trouvera des aperçus plus récents sur le problème dans la contribution de G. Schmidt à l'ouvrage collectif publié sous la direction du Prof. K. Swoboda, intitulé *Gotik in Böhmen* (Munich, 1969), 172 et suiv. Sur l'influence de la peinture italienne en Autriche, cf. E. Panofsky, *Early Netherlandish Painting, Its Origin and Character* (Cambridge, Mass., 1953), I, 25. La pénétration du style italien en Catalogne a été dégagée par M. Meiss, "Italian Style in Catalonia and a Fourteenth-Century Catalan Workshop," *Journal of the Walters Art Gallery* (IV, 1941), 45–87. L'expansion de la peinture italienne dans l'Europe du quatorzième siècle a été retracée de façon générale dans l'ouvrage de Panofsky mentionné plus haut, pp. 24–31. Panofsky a résumé ses idées sur le problème dans *Renaissance and Renascences in Western Art* (Stockholm, 1960), 156–61.

[2] Cf. O. Pächt, "A Giottesque Episode in English Mediaeval Art," *Journal of the Warburg and Courtauld Institutes* (VI, 1943), 51–70.

[3] Des peintres italiens ont ainsi travaillé à la cathédrale de Béziers, cf. M. Meiss, "Fresques italiennes, cavallinesques et autres," *Gazette des Beaux-Arts* (XVIII, 1937), 275–86. Sur la présence des peintres italiens en France au quartozième siècle, cf. idem, *French Painting in the Time of Jean de Berry. The Late Fourteenth Century and the Patronage of the Duke* (Londres–New York, 1967), 23–29. Voir également, pour Avignon, E. Castelnuovo, *Un pittore italiano alla corte di Avignone, Matteo Giovanetti e la pittura in Provenza nel secolo XIV* (Turin, 1962).

[4] Les documents concernant ces artistes, parmi lesquels figuraient un certain Risuti, certainement identifiable avec le Filippo Rusuti qui a signé une mosaïque de la façade de Sainte-Marie Majeure, ont été signalés pour la première fois par H. Moranvillé, "Peintres romains pensionnaires de Philippe le Bel," *Bibliothèque de l'Ecole des Chartes* (XLVIII, 1887), 631–32. Voir aussi P. Mantz, *La Peinture française du IXe siècle à la fin du XVIe siècle* (Paris, 1897), 131–32, et Meiss, *French Painting in the Time of Jean de Berry*, 25.

[5] *Renaissance and Renascences*, 157.

son chef de file, Jean Pucelle.[6] Est-ce à dire qu'elle se vérifie dans tous les cas? Les oeuvres encore inédites de l'artiste que je voudrais présenter maintenant, paraissent prouver le contraire. Il m'a semblé que l'étude de cet artiste pourrait constituer un hommage approprié au professeur Millard Meiss, auquel les historiens de l'art sont redevables de tant d'aperçus nouveaux sur la peinture du Trecento et son influence hors d'Italie, sur la peinture française en particulier.

Les manuscrits dans lesquels a travaillé notre artiste sont peu nombreux: quatre au total, dans l'un desquels l'enlumineur n'a exécuté que des éléments de décoration. A eux quatre, cependant, ces manuscrits suffisent pour se faire une idée de la personnalité de l'artiste, et devraient permettre la découverte d'autres oeuvres de sa main. Les textes contenus dans ces quatre volumes appartiennent à des genres fort différents: conservé à la Bibliothèque Royale de Bruxelles, le plus important du groupe doit sa riche décoration (Figs. 1–6) au fait qu'il contient un texte liturgique, le *Pontifical romain* édité au début du quatorzième siècle par l'évêque de Mende, Guillaume Durand.[7] A la Bibliothèque Nationale, se trouvent deux autres manuscrits, dont l'un, de format imposant, comporte un texte de droit canonique, la *Summa* dite *copiosa* d'Henri de Suse, cardinal d'Ostie (Figs. 7–11),[8] le second étant un recueil de traités de théologie et de morale (Figs. 12–15).[9] La seule oeuvre profane rédigée en langue vulgaire enluminée par notre artiste est un *Roman de la Rose* de la Bibliothèque Municipale de Châlons-sur-Marne (Figs. 16–21).[10] De ces quatre manuscrits, seul celui de Bruxelles a jusqu'ici fait l'objet d'une appréciation sur le plan de l'histoire de l'art. Dès 1937, en effet,

[6]Sur Pucelle, cf. Panofsky, *Early Netherlandish Painting*, 27–35; K. Morand, *Jean Pucelle* (Oxford, 1962); Meiss, *French Painting in the Time of Jean de Berry*, 19–20.

[7]Bruxelles, Bibliothèque Royale, MS 9216. 440 fols., 340 × 230 mm. Sur ce manuscrit, cf. J. van den Gheyn, *Catalogue des manuscrits de la Bibliothèque Royale de Belgique*, I (Bruxelles, 1901), 225–26; C. Gaspar–F. Lyna, *Les Principaux manuscrits à peintures de la Bibliothèque Royale de Belgique*, I (Paris, 1937), 323–26 et pl. LXVIIId; M. Andrieu, *Le Pontifical roman au Moyen Age*, III: *Le Pontifical de Guillaume Durand* (Vatican, 1940), 45–56 et 291–92; Catalogue de l'exposition "La Librairie de Philippe le Bon" (Bruxelles, 1967), 19–20, no. 14 et pl. 15. On trouvera la description des initiales historiées dans l'ouvrage de Gaspar–Lyna cité plus haut. L'artiste qui fait l'objet du présent article est l'auteur de la quasi totalité du décor, qui se compose d'initiales historiées et ornées, de bordures ou encadrements, et de petites scènes marginales. Deux autres artistes apparaissent cependant dans le manuscrit: le premier, auteur de la décoration du fol. 6 (*Confirmation des enfants*, Fig. 5), est certainement d'origine parisienne; le second, auteur du décor des fols. 398r et 401, est un enlumineur provincial apparenté au collaborateur de l'artiste italianisant dans le manuscrit latin 3234 (voir n. 9). L'initiale historiée du fol. 400 (*Nativité*) a été exécutée ou refaite vers le second quart du quinzième siècle.

[8]Paris, Bibliothèque Nationale, MS lat. 4000. 264 fols., 440 × 290 mm. Deux artistes ont collaboré à la décoration de ce manuscrit, à ma connaissance inédit: un enlumineur septentrional, qui est l'auteur des initiales historiées des livres I à III (fols. 1, 63, 117) et de la curieuse peinture du fol. 36v, illustrant l'*Arbre de bigamie* et figurant le Christ trônant (Fig. 7); le second étant l'artiste italianisant qui nous occupe ici, et qui a exécuté les initiales historiées des livres IV et V (fols. 169 et 197) et les peintures des fols. 185v et 186v, illustrant l'*Arbor consanguinitatis* et l'*Arbor affinitatis* (Figs. 8–11). Du point de vue

inconographique, les initiales historiées du MS lat. 4000 reproduisent un programme qui apparaît ordinairement dans les copies de ce texte exécutées à Paris et qui a peut-être été élaboré du vivant de l'auteur (livre I: *Christ en Majesté*; II: *Christ du Jugement Dernier*, deux glaives pointés vers la bouche; III: *Christ en Majesté*, trônant au-dessus des apôtres; IV: *Création d'Eve*; V: *Christ du Jugement Dernier*). Sur Henri de Suse, voir *Dictionnaire de droit canonique*, V, col. 1211–27, (s.v. "Hostiensis"). On trouvera une liste des manuscrits de la *Summa copiosa* dans J. Destrez–G. Finck-Errera, "Des manuscrits apparemment datés," *Scriptorium* (XII, 1958), 88 et n. 78.

[9]Bibliothèque Nationale, MS lat. 3234. 104 fols., 280 × 185 mm. Ce manuscrit contient le *De oculo morali* de Pierre de Limoges, les *Distiques* du pseudo-Caton, et la *Moralisatio super ludum scacchorum* de Jacques de Cessoles; cf. *Catalogue général des manuscrits latins de la Bibliothèque nationale*, IV (Paris, 1958), 389–90. Le décor du manuscrit est presque exclusivement ornemental à l'exception des deux initiales historiées des fols. 2 (*Pierre de Limoges lisant*, Fig. 12) et 31 (*Tobie aveuglé par l'hirondelle*), tout le reste se composant d'initiales ornées, contenant parfois des personnages en buste, et se prolongeant dans les marges par des antennes à feuilles de vigne ou de chêne, accompagnées à l'occasion de scènes grotesques. Deux artistes se sont partagés cette décoration: le premier, sur lequel nous reviendrons, a enluminé les fols. 1 à 49, le restant étant dû à l'artiste italianisant étudié ici.

[10]Châlons-sur-Marne, Bibliothèque Municipale, MS 270. 159 fols., 316 × 226 mm. Cf. *Catalogue général des manuscrits des bibliothèques publiques de France*, III (Paris, 1885), 58. Notre artiste a exécuté à lui seul les illustrations du manuscrit, au nombre de vingt-neuf. Leur style italianisant avait déjà frappé G. Vitzthum (*Die Pariser Miniaturmalerei von den Zeit des Hl. Ludwig bis zu Philipp von Valois*, Leipzig, 1907, 61 n.1) qui datait le manuscrit vers 1320.

l'excellent connaisseur qu'était Frédéric Lyna avait perçu l'étrangeté du style du *Pontifical* dans le contexte de l'enluminure française du quatorzième siècle : après avoir loué la sobriété de la composition des initiales historiées et la douceur du coloris, il analyse avec finesse la technique picturale et la palette de l'enlumineur. Remarquant que celui-ci n'emploie la plume que pour faire ressortir les plis des vêtements blancs et parfois rouges et verts, il ajoute: "d'une façon générale, [l'artiste] modèle et d'une façon habile au moyen du pinceau; il éclaire certaines parties du vêtement par l'adjonction de quelques touches blanches." Passant au coloris, il croit deviner chez l'enlumineur "une préférence pour les teintes transparentes et légères," et conclut: "l'effet d'ensemble est agréable mais fort différent de la miniature du Nord de la France et de la Belgique."[11] Partant de ces observations stylistiques judicieuses, Lyna a fait cependant fausse route en abordant le problème de la localisation du *Pontifical*. Le coloris et la technique de l'enlumineur du manuscrit de Bruxelles et un examen insuffisant de ses particularités textuelles et liturgiques l'ont conduit en effet à en rechercher l'origine dans le Midi de la France. Ce faisant, il ignorait la présence dans le *Pontifical* d'un important élément liturgique qui aurait pu le mettre dans la bonne voie. Ajoutés à celui-ci, les divers renseignements fournis par les trois autres manuscrits du groupe permettent en fait de réviser la localisation proposée par Lyna, et de préciser, non seulement le centre d'activité de l'artiste qui nous occupe, mais encore de déterminer pour au moins deux des manuscrits, la personnalité de leur destinataire.

A la vérité une première enquête sur l'origine des quatre manuscrits se révèle plutôt décevante: du destin du *Pontifical* bruxellois, on ne sait rien, sinon qu'il apparaît mentionné pour la première fois dans l'inventaire des livres de Philippe le Bon duc de Bourgogne, dressé en 1467 après la mort du duc.[12] Le manuscrit d'Henri de Suse comporte plusieurs inscriptions finales, dont les plus anciennes, qui remontent au quatorzième siècle, ont été malheureusement grattées et ne sont plus que partiellement visibles, ne nous fournissant aucun indice utilisable pour localiser le volume. Tout au plus un ex-libris daté de 1427 permet-il d'affirmer qu'à cette date le manuscrit se trouvait entre les mains d'un chanoine de la collégiale de Beaune nommé Guillaume Martin.[13] Le manuscrit de Pierre de Limoges contient de son côté une mention tardive indiquant qu'il fut offert à l'abbaye de Livry-en-Aulnois par un chanoine parisien, Jean Allegrain.[14] Le *Roman de la Rose* de Châlons, quant à lui, ne présente aucune marque de provenance. Il semblerait vain, au vu de ces indications disparates de vouloir hasarder une localisation.

Heureusement un examen codicologique des quatre manuscrits permet d'aller plus loin et de circonscrire les recherches. Du point de vue paléographique tout d'abord, le *Pontifical* présente une écriture splendidement calligraphiée, dite "lettre de forme," couramment

[11]Gaspar–Lyna, *Les principaux manuscrits*, 325. Lyna date le *Pontifical* du milieu du quatorzième siècle. Les rédacteurs du catalogue de l'exposition "La Librairie de Philippe le Bon" (v. *supra*, n. 7) assignent le manuscrit à la seconde moitié de ce siècle.

[12]Cf. Andrieu, *Le Pontifical romain*, III, 46–47.

[13]Paris, Bibliothèque Nationale, MS lat. 4000, fol. 264v: "Summa Hostiensis quam ego G. Martini Belne canonicus emi a dominis de capitulo de Belna mensi januarii anno XXVII⁰." Deux autres manuscrits juridiques ayant appartenu au chanoine

Guillaume Martin sont encore conservés à la bibliothèque de Beaune (MSS 7 et 9). Cf. *Catalogue général des manuscrits des bibliothèques publiques de France*, VI (Paris, 1887), 254–55.

[14]Cette mention se trouve au contreplat inférieur: "datus est abbatiae Livryacensis per magistrum Johannem Allegrin." Une seconde inscription au contreplat supérieur précise que le manuscrit fut donné à l'abbaye par Jean du Moulin ("Johannes de Molendino"), "quondam famuli magistri Allegrain, canonici Parisiensis."

employée à l'époque pour les manuscrits les plus soignés et spécialement les manuscrits liturgiques.[15] Cette écriture, aux formes très brisées, n'a rien de commun avec celle des manuscrits méridionaux contemporains, dont les formes, plus arrondies, dérivent de l'écriture bolonaise. Cette remarque vaut également pour l'Henri de Suse, et le Pierre de Limoges dont la graphie très brisée oriente là encore vers le Nord de la France. La décoration fournit des arguments allant dans le même sens: au côté de l'artiste italianisant apparaissent en effet plusieurs enlumineurs dont le style, plus enraciné dans la tradition gothique française, peut être rattaché à la production de centres ou de régions bien déterminés. C'est ainsi qu'un des feuillets du *Pontifical* a été peint par un artiste dont le style, très influencé par Pucelle, permet d'affirmer qu'il était d'origine parisienne (Fig. 5).[16] Ce n'est pourtant pas à Paris même que les quatre manuscrits du groupe que nous étudions ont du être exécutés, mais dans un centre situé plus au Nord, si l'on en juge d'après le style des deux autres collaborateurs du maître italianisant, dont la main apparaît dans le manuscrit de Pierre de Limoges et dans la *Somme* d'Henri de Suse (Figs. 7, 12–13). Bien qu'assez différentes, les oeuvres de ces deux artistes donnent, dans leur conception et leur exécution, une impression de provincialisme accusée, que confirme également leur goût prononcé pour les drôleries marginales (Figs. 12–13), peu conforme à la tradition parisienne, mais très répandu à la même époque dans les milieux artistiques de la France septentrionale, en Artois et en Picardie notamment.[17] D'autres indices codicologiques permettent d'éliminer définitivement Paris comme lieu d'origine de notre groupe: ainsi la décoration filigranée très spéciale de la *Summa* d'Henri de Suse[18] et la réglure à l'encre, très appuyée, utilisée dans le même manuscrit ainsi que dans le *Pontifical* de Bruxelles. Il semble en récapitulant ces divers éléments, qu'il faille chercher l'origine de nos manuscrits dans une ville du Nord de la France, assez voisine de la capitale cependant pour justifier la présence dans le *Pontifical* d'une page de style franchement parisien.

Deux arguments décisifs viennent confirmer et préciser cette impression, l'un d'ordre héraldique, le second d'ordre liturgique. Leur réunion permet, comme on va le voir, de résoudre de façon concordante le problème de la localisation. Le feuillet initial du manuscrit de Pierre de Limoges comporte une riche décoration, assez inhabituelle pour un texte de ce genre. Parmi les multiples motifs qui parsèment les marges de cette page, on remarque à la

[15]L'écriture du *Pontifical* est tout-à-fait semblable à la "lettre de forme" utilisée dans les manuscrits parisiens et du Nord de la France au cours de la première moitié du quatorzième siècle. Parmi les manuscrits parisiens comparables, mentionnons plusieurs manuscrits dus à Jean Pucelle ou à son atelier: la *Bible de Robert de Billyng* (Paris, Bibliothèque National, MS lat. 11915), les *Miracles de Notre Dame* (Paris, Bibliothèque Nationale, MS nouv. acq. franç. 24541), un Missel de Paris (Lyon, MS 5122) et l'Epistolier et l'Evangéliaire qui lui servaient de complément (Londres, British Museum, MS Yates Thompson 34, et Paris, Arsenal, MS 161). Il est intéressant également de rapprocher l'écriture du MS lat. 12649 de la Bibliothèque Nationale (*Constitutions de Benoît XII*), vraisemblablement copié à Corbie en 1337, de celle du Pontifical bruxellois, dont nous verrons qu'il est d'origine amiénoise.

[16]On remarquera également le style très parisien de l'encadrement à "vignettes." Le personnage hybride tenant un orgue portatif figuré dans la marge inférieure du feuillet est également apparenté aux grotesques des manuscrits pucelliens.

[17]Cf. par exemple MS lat. 3234, fol. 1 (parodie de tournoi entre un bélier et un lièvre montés à l'envers sur un loup et un chien de chasse), fol. 5 (âne chantant et lisant un rouleau à notation musicale, Fig. 13), 41v (personnage tenant un lièvre et soufflant dans le bec d'une cigogne). Des thèmes parodiques analogues sont traités fréquemment dans les manuscrits originaires des provinces septentrionales de la France; cf. L.M.C. Randall, *Images in the Margins of Gothic Manuscripts* (Berkeley–Los Angeles, 1966). La présence des mêmes thèmes dans les manuscrits de Pucelle et de son atelier, est inhabituelle à Paris, et s'explique peut-être par l'origine nordique de cet artiste ainsi que l'a suggéré Panofsky, *Early Netherlandish Painting*, 31.

[18]L'artiste chargé de cette partie spéciale de la décoration utilise fréquemment un procédé consistant à dessiner dans les champs des initiales des rinceaux de feuillage épargnées sur fond de tailles croisées. Très couramment employé en Angleterre et dans la région rhénane, ainsi que dans le Nord de la France, ce procédé n'apparaît qu'exceptionnellement à Paris. Cf. mon article, "Un Enlumineur ornemaniste parisien de la première moitié du XIVe siècle: Jacobus Mathey (Jaquet Maci?)," *Bulletin Monumental* (CXXIX, 1971), 252–53.

partie supérieure droite un minuscule écusson supporté par deux étranges volatiles à tête de chien (Fig. 12). Il ne s'agit certainement pas là, malgré leur petite taille, d'armoiries de fantaisie: leur situation en tête du manuscrit indique nettement, au contraire, que l'enlumineur a voulu figurer les armes du destinataire. Celles-ci se lisent de la façon suivante: "d'argent à trois pals de sable, à la bande de cinq losanges de gueules, à la crosse d'or posée en pal brochant sur le tout." Suivant l'avis compétent d'un spécialiste en héraldique médiévale, ces armoiries correspondent, à l'exception de la crosse, à celles de la famille de Cherchemont, qui portait un palé d'argent et de sinople à la bande de losanges de gueules.[19] La différence d'émail (sable au lieu de sinople) qu'on remarque dans le manuscrit peut s'expliquer aisément par la présence de l'argent au contact duquel la couleur verte s'est peut-être oxydée, virant ainsi au noir. Reste à rendre compte de la présence de la crosse, qui semble indiquer que le possesseur des armoiries était un dignitaire ecclésiastique. Deux membres de la famille de Cherchemont, d'origine poitevine, ont connu une certaine notoriété au quatorzième siècle: le premier, Jean de Cherchemont, fut chancelier de France sous le règne de Charles IV le Bel et mourut en 1328;[20] un second Jean de Cherchemont, neveu du premier, occupa le siège épiscopal d'Amiens pendant une période prolongée, de 1325 à 1373.[21] La crosse ajoutée à l'écu du MS lat. 3234 semble bien indiquer que ce fut pour le second de ces personnages que fut exécuté le manuscrit.[22] A l'appui de cette identification vient une autre observation, d'ordre liturgique, faite autrefois à propos du pontifical de Bruxelles par Mgr Michel Andrieu. Dans sa monumentale étude sur le pontifical romain, celui-ci a en effet relevé une particularité qui distingue le manuscrit bruxellois de toutes les autres copies du *Pontifical* de Guillaume Durand: la présence d'une bénédiction spéciale pour la fête de St. Firmin et d'un *ordo* du Jeudi saint dont

[19]Je dois cette identification à l'amabilité de M. J.-B. de Vaivre, que je remercie très vivement ici. Les armoiries des Cherchemont ne sont connues que par les sceaux: celui de Pierre de Cherchemont, chevalier, appendu à un acte daté de 1345 (G. Demay, *Inventaire des sceaux de la collection Clairambault à la Bibliothèque nationale*, I, Paris, 1885, p. 259, no. 2446) et celui de Jean de Cherchemont, évêque d'Amiens scellant un acte de 1370 (idem, *Inventaire des sceaux de Picardie*, Paris, 1885, p. 119, no. 1072). Un sceau du même personnage, daté de 1327, est signalé par G. Durand, *Inventaire sommaire des Archives départementales de la Somme*, v. Archives ecclésiastiques, série G (Amiens, 1902), 136. Il a malheureusement disparu.

[20]Sur le chancelier Jean de Cherchemont (ou plutôt Jean Cherchemont, suivant les diplomatistes), cf. le Père Anselme, *Histoire généalogique et chronologique de la Maison royale de France*, VI (Paris, 1730), 309; G. Tessier, "Les chanceliers de Philippe VI," *Comptes rendus de l'Académie des Inscriptions et Belles Lettres* (novembre, 1957), 358–59; R. Cazelles, *La Société politique et la crise de la royauté pendant le règne de Philippe de Valois* (Paris, 1958), 57–58; R.-H. Bautier, "Recherches sur la chancellerie royale au temps de Philippe VI," *Bibliothèque de l'Ecole des Chartes* (CXXII, 1964), 130–34; R. Cazelles, "Une chancellerie privilégiée: celle de Philippe VI de Valois," *Bibliothèque de l'Ecole des Chartes* (CXXIV, 1966), 359–60. Jean de Cherchemont fut chancelier de France de 1321 à 1328.

[21]*Gallia christiana*, X, *Province de Reims* (Paris, 1751), cols. 1192–93; *Dictionnaire de biographie française*, VIII (Paris, 1959), cols. 1004–05; *Dictionnaire d'histoire et de géographie ecclésiastique*, XII (Paris, 1953), col. 632. La durée exceptionnellement longue de l'épiscopat de Jean de Cherchemont tient à ce qu'il accéda relativement jeune (il avait 23 ans) à cette dignité, grâce à la faveur dont jouissait son oncle. La tombe "en lames

d'airain" de Jean de Cherchemont était conservée autrefois à la cathédrale d'Amiens. Elle n'est plus connue aujourd'hui que par un très médiocre dessin du MS 207 (T. I, 10) de la Société des Antiquaires de Picardie (fol. 13). Cf. R. Rodière, "Epitaphier de Picardie," *Mémoires de la Société des Antiquaires de Picardie*, XXI (Paris, 1925), 4. Cette tombe était accompagnée d'une longue inscription versifiée dont le texte est publié dans le *Gallia christiana* (*loc. cit.*). Sur les sceaux de Jean de Cherchemont, cf. *supra*, n. 19. Le sceau de 1370, le seul conservé, représente l'évêque debout, mitré, tenant une crosse et bénissant. Il est accosté de deux écus à trois pals à la bande de losanges brochant. Les mêmes armes figuraient, semble-t-il, sur son tombeau d'après le dessin cité plus haut.

[22]Il n'est pas rare dans la France du quatorzième siècle de voir les évêques "briser" d'une crosse leurs armoiries familiales. Cf. un exemple cité par L. Carolus-Barré, "Deux conseillers du roi au XIVe siècle: Guy et Alphonse Chevrier," *Bibliothèque de l'Ecole des Chartes* (CI, 1940), 72. Un des successeurs de Jean de Cherchemont, Jean de la Grange, brisait semblablement ses armes d'une crosse en pal brochant (cf. Douët d'Arcq, *Collection de sceaux des Archives de l'Empire*, Ière partie, II (Paris, 1867), 481, no. 6443, sceau daté de 1376). La crosse n'apparaît cependant ni dans le sceau de Jean de Cherchemont de 1370, ni dans les armes qui figuraient sur son tombeau. A ceci on peut donner l'explication suivante: l'évêque a pu fort bien posséder deux types d'armoiries successivement, les premières comportant la crosse en pal, brisure qui lui aurait servi à se distinguer de son illustre parent, le chancelier de France, les secondes correspondant à une période plus tardive de son épiscopat, et ne présentant plus la crosse. Le sceau possédé par l'évêque en 1327 ayant disparu, il n'est pas possible de vérifier cette hypothèse.

les indications topographiques sont propres à Amiens.[23] A cela on peut ajouter un fait qui n'a jamais été mentionné semble-t-il, à propos du *Pontifical* de Bruxelles: lui aussi comporte, mais sur la tranche cette fois, des armoiries peintes. Bien que très difficilement lisibles en raison de leur usure, ces armes semblent bien présenter le palé à la bande de losanges des Cherchemont.[24] On n'y distingue plus toutefois la crosse figurée dans le manuscrit de Pierre de Limoges. Cependant le contenu même du texte et ses particularités amiénoises laissent planer peu de doute quant à l'identité du possesseur du *Pontifical*: ce devait être là encore l'évêque d'Amiens, Jean de Cherchemont.[25]

La localisation à Amiens des quatre manuscrits dans lesquels a travaillé l'artiste qui nous occupe et que nous appellerons dorénavant, par commodité, "Maître de Jean de Cherche-mont," parait donc hautement vraisemblable. Elle est corroborée par d'autres faits: à la fin du *Roman de la Rose* de Châlons-sur-Marne, ont été ajoutée par une main contemporaine, une série de prières en français présentant des particularités picardes. Sur le plan du style d'autre part, l'enlumineur qui a collaboré avec le Maître de Jean de Cherchemont dans le manuscrit de Pierre de Limoges, nous parait s'intégrer parfaitement dans la production amiénoise (Figs. 12–13). Amiens, on le sait, fut un centre particulièrement actif à la fin du treizième siècle et durant le premier quart du siècle suivant, et de ses ateliers sont sorties maintes oeuvres de qualité: le *Psautier-Livre d'heures de la comtesse Yolande de Soissons* étant l'une des plus anciennes, la *Somme le Roi* enluminée en 1311 pour Jeanne d'Eu, comtesse de Guines, se situant à l'autre bout de la production.[26] On conserve en outre des manuscrits signés par des enlumineurs amiénois, qui attestent de la vitalité artistique de la capitale picarde durant le premier quart du quatorzième siècle: un Bréviaire de Froidmont signé et daté de 1316 par l'enlumineur Jean d'Amiens,[27] et un Missel de Saint-Jean d'Amiens enluminé en 1323 par

[23]Andrieu, *Le Pontifical romain*, 46.

[24]La présence de ces armes est signalée dans Gaspar–Lyna, *Les principaux manuscrits*, 323, qui ne les ont pas identifiées.

[25]Il est probable que Jean de Cherchemont, comme la plupart des prélats de son temps s'était constitué une collection de livres. Outre les deux manuscrits à ses armes étudiés ici, il possédait un Missel décrit en termes élogieux dans l'inventaire dressé en 1420 des livres conservés au trésor de la cathédrale d'Amiens: "valde pulchrum missale novum . . . de auro et azuro illuminatum . . . ex dono reverendi patris in Christo domini Johannis de Cercemont episcopi Ambianensis." Cf. l'édition donnée par E. Coyecque de cet inventaire dans le *Catalogue général des manuscrits des bibliothèques publiques de France*, XIX (Paris, 1893), LXXXV–LXXXVI. Ce Missel semble avoir disparu, à une époque indéterminée, avec le reste des manuscrits de la cathédrale. Le manuscrit 525 de Dijon, contenant le *Roman de la Rose* et le *Roman de Fauvel*, comporte des mentions indiquant qu'il fut copié entre 1355 et 1362 dans la résidence parisienne de l'évêque d'Amiens par un clerc d'origine poitevine "Matheus Rivalli." Sur ce manuscrit et les fragments qui en sont conservés à la Bibliothèque Nationale, cf. H. Omont, "Notice sur quelques fragments retrouvés d'un manuscrit français de la Bibliothèque de Dijon," *Romania* (XXXIV, 1905), 364–74. Les illustrations de ce manuscrit sont dues à un enlumineur parisien, fait qui pourrait indiquer que l'artiste italianisant avait disparu, ou du moins qu'il n'était plus employé par Jean de Cherchemont. Celui-ci possédait également une impressionnante série d'ornements pontificaux dont il fit don en 1370 à sa cathédrale. Cf. G.

Durand, *Inventaire sommaire* (cf. n. 19), 552–54.

[26]New York, Pierpont Morgan Library, M. 729, et Paris, Bibliothèque de l'Arsenal, MS 6329. Pour la bibliographie relative à ces deux manuscrits, voir en dernier lieu le catalogue de l'exposition "Art and the Courts. France and England from 1259 to 1328," ed. P. Verdier, P. Brieger, M.F. Montpetit (Ottawa, 1972), 86–87, nos. 15 et 16. Sur l'enluminure amiénoise, voir G. Vitzthum, *Die Pariser Miniaturmalerei von der Zeit des hl. Ludwig bis zu Philipp von Valois* (Leipzig, 1907), 153–59. Aux oeuvres amiénoises mentionnées par Vitzthum, on peut ajouter les exemples suivants: un Psautier probablement exécuté pour l'abbaye de Saint-Fuscien d'Amiens (New York, Pierpont Morgan Library, M. 796), cf. J. Plummer, *Liturgical Manuscripts for the Mass and the Divine Office* (New York, 1964), 38, no. 47, pl. 17; deux peintures du *Canon de la messe* insérées dans un missel parisien de la Bibliothèque Royale de Copenhague (Thott, 146, 2°), cf. le catalogue d'exposition "Gyllene Böcker" (Stockholm, 1952), 55, no. 94; un feuillet enluminé du Musée Mayer van den Bergh d'Anvers, figurant le *Christ en majesté* (catalogue "Art and the Courts," 101–02, no. 31 et pl. 46; bien que rapproché d'oeuvres amiénoises, ce feuillet est placé dans ce catalogue parmi les manuscrits anglais, et attribué avec hésitation à l'East Anglia ou à la France du Nord-Est); et un manuscrit du *Livre de Sydrach* (Bibliothèque Nationale, MS franç. 1159) dont l'origine amiénoise ne semble pas avoir été reconnue jusqu'ici.

[27]Paris, Ecole des Beaux-Arts, Coll. J. Masson. Cf. J. Porcher, "Maître Jean d'Amiens enlumineur (1316)," *Bibliothèque de l'Ecole des Chartes* (CIV, 1943), 258–60.

Pierre de Raimbaucourt.[28] Bien que probablement un peu postérieur, le style du premier artiste du manuscrit de Pierre de Limoges n'est nullement incompatible avec ces oeuvres, dont il partage le goût prononcé pour les drôleries marginales et les figurations d'êtres hybrides.[29]

Tout un faisceau d'arguments concordants parle donc en faveur d'Amiens comme centre d'activité du Maître de Jean de Cherchemont. Reste la question délicate de la datation et de la chronologie de ses oeuvres. Les dates de l'épiscopat de Jean de Cherchemont fournissent un *terminus a quo* solide pour les deux manuscrits portant ses armoiries: après 1325, *terminus a quo* qui peut être étendu à la *Somme* d'Henri de Suse et au *Roman de la Rose*, très certainement postérieurs au manuscrit de Pierre de Limoges qui parait être le plus ancien du groupe. Malheureusement, du point de vue de notre recherche particulière, l'épiscopat de Jean de Cherchemont fut extrêmement long et ne prit fin qu'en 1373. Par chance, une note grattée figurant à la fin de la *Somme* d'Henri de Suse permet de resserrer cette fourchette chronologique: cette inscription, qui n'est plus que partiellement lisible, nous apprend que le volume avait été acquis en 1353 par un personnage nommé Grégoire "de Chanarco."[30] Cette mention autorise par conséquent à placer l'activité du Maître de Jean de Cherchemont entre 1325 et ca. 1353, soit au cours du second quart du quatorzième siècle. Les données stylistiques viennent là encore confirmer ce résultat. Le collaborateur amiénois du Maître de Jean de Cherchemont dans le manuscrit de Pierre de Limoges ne peut guère avoir été actif au delà des années 1330–1340. L'enlumineur pucellien, auteur de la décoration d'un feuillet du *Pontifical*, présente le style usité à Paris autour des années 1340–1350. Le collaborateur du Maître de Jean de Cherchemont dans la *Somme* d'Henri de Suse semble, lui aussi, appartenir à la même période. En résumé, il semble bien, au vu de ces divers éléments, qu'on puisse situer l'activité de notre artiste à Amiens durant le second quart du quatorzième siècle.

Il n'était pas inutile d'insister aussi longuement sur la chronologie et la localisation des oeuvres du Maître de Jean de Cherchemont: les précisions obtenues sur ces deux points ne font que mieux ressortir l'importance et l'intérêt de cet artiste, dont le style révèle une assimilation précoce des leçons de la peinture italienne, qui le rend à la fois proche et distinct de son quasi-contemporain, Jean Pucelle. Avec celui-ci et les Italiens, le Maître de Jean de Cherchemont partage un même intérêt pour l'évocation de la troisième dimension. Comme eux, il parvient à suggérer dans certaines de ses oeuvres une impression de profondeur spatiale, grâce au relief et à la densité plastique qu'il confère aux êtres et aux objets qui entrent dans la composition de ses illustrations. Une de ses meilleures réussites, à ce point de vue, nous est fournie par l'initiale historiée illustrant le chapitre "de barba tondendi" dans le *Pontifical* de Bruxelles (Fig. 1). Au premier plan de la scène figure un barbier en train de raser un person-

[28]La Haye, Museum Meermanno-Westreenianum, MS 78 D. 40. Cf. Vitzthum, *Die Poriser Miniaturmalerei*, 153; A.W. Byvanck, *Les principaux manuscrits à peintures de la Bibliothèque royale et du Musée Meermanno-Westreenianum à la Haye* (Paris, 1924), 19; L.M.C. Randall, *Images in the Margins of Gothic Manuscripts*, 33 et fig.

[29]La main de cet artiste est particulièrement proche de celle de l'enlumineur qui a exécuté l'illustration d'une Bible de la Bibliothèque d'Arras (MS 790) à partir du livre de Ruth. Ce rapprochement m'a été suggéré par Mme Alison Stones.

[30]Bibliothèque Nationale, MS lat. 4000, fol. 264v: "Iste liber constitit mihi R . . . [suivent plusieurs mots grattés] a Gregorio de Chanarco [ou Chempto] anno Domini m° ccc°-liii° ydus junii" (inscription grattée, à la partie inférieure gauche du feuillet). Sous l'ex-libris du chanoine de Beaune Guillaume Martin figurait une autre inscription qui n'est plus que partiellement lisible, et faisant allusion à l'engagement du manuscrit: ". . . pro pignore venerabili viro . . ." Un autre ex-libris gratté, figurant à la partie inférieure droite, se rapportait probablement au personnage à qui la *Somme* avait été engagée, car il est suivi de la mention: "obligatus mihi pro xxxiii fr[ancis]" (écriture du quatorzième siècle).

nage assis sur une chaise. La représentation de ce groupe est déjà, à elle seule, une réussite plastique à mettre au compte de l'habileté et de la vigueur de la technique picturale de l'artiste, qui, au moyen d'ombres et de lumières savamment dosées, a su faire "tourner" ses personnages. L'enlumineur ne s'est pas contenté cependant de cet effet de relief ; il a voulu également évoquer un espace en profondeur en ajoutant à gauche de la scène un curieux édifice polygonal au dôme de forme arrondie, dont la structure et les détails architecturaux (notamment les bandes lombardes) font penser irrésistiblement à quelque baptistère italien.[31] Tirant parti très habilement du tracé de l'initiale, il a su suggérer l'éloignement de l'édifice par rapport au groupe du barbier et de son client. On est d'autant plus surpris de relever dans cette scène des erreurs de détail qui ruinent la cohérence spatiale de l'ensemble : le récipient arrondi, ressemblant à un brasero, placé devant le baptistère, ainsi que le barbier et son client, ne reposent en effet sur aucun support et semblent comme en lévitation. De telles maladresses, dont on retrouve d'autres exemples dans l'oeuvre du Maître de Jean de Cherchemont (Fig. 11), révèlent en celui-ci un artiste dont la perception des problèmes spatiaux est encore empirique, et ne procède pas, au contraire de Pucelle, d'une réflexion méthodique.[32]

Le Maître de Jean de Cherchemont se distingue également de Pucelle sur le plan de la technique utilisée pour obtenir les effets plastiques. Pucelle modèle ses figures en sculpteur et s'attache à rendre avec précision les variations de relief, spécialement dans le plissé des draperies : il évite en général les contrastes violents d'ombre et de lumière, le passage des parties claires aux parties sombres se faisant progressivement au moyen d'un subtil dégradé, d'où l'effet de sculpture peinte en demi-relief que produisent ordinairement ses illustrations. A ce point de vue, le maître parisien s'inscrit dans une tradition propre à la France septentrionale et à l'Angleterre, et dont les premières manifestations apparaissent dès le troisième quart du treizième siècle dans certaines peintures du *Psautier de St. Louis*.[33] Le Maître de Jean de Cherchemont, plus véritablement peintre, s'intéresse davantage aux variations de la lumière sur les corps et emploie une technique picturale beaucoup plus évoluée, distribuant

[31]Une telle "citation," qui semble indiquer une connaissance directe de l'architecture italienne, n'a d'équivalent à l'époque, dans l'enluminure française, que dans la fameuse illustration du manuscrit pucellien des *Miracles de Notre-Dame* souvent invoquée comme argument en faveur d'un possible séjour de Pucelle en Toscane. Cf. Panofsky, *Early Netherlandish Painting*, 32 n.3 ; Meiss, "'Highlands' in the Lowlands," *Gazette des Beaux-Arts* (LVII, 1961) 290-91, fig. 35 ; Morand, *Jean Pucelle*, 8, pl. XIId ; Meiss, *French Painting in the Time of Jean de Berry* (cf. *supra*, n. 3), 19-20, fig. 340. La toiture bombée du baptistère figuré dans le *Pontifical* de Bruxelles ne semble pas très répandue dans la peinture italienne. On en trouve un exemple assez proche cependant dans une fresque de l'église Sant' Agostino de Rimini figurant un tremblement de terre à Ephèse.

[32]Il est symptomatique que l'on ne trouve aucune véritable scène d'intérieur dans les manuscrits enluminés par l'artiste. La seule tentative du Maître de Jean de Cherchemont dans ce domaine n'est pas très convaincante (Fig. 20) : dans cette image, tirée du *Roman de la Rose* de Châlons-sur-Marne, l'artiste a essayé de suggérer la profondeur en représentant l'édifice qui abrite la scène, en projection ; mais les personnages restent plaqués sur un fond or et sont disposés en frise au premier plan.

[33]Paris, Bibliothèque Nationale, MS lat. 10525. Cf. *Scènes de l'Ancien Testament illustrant le psautier de saint Louis*, Introduc-

tion par M. Thomas (Graz, 1970), pl. 72-78. On retrouve le même modelé à effet sculptural dans deux peintures d'un recueil d'illustrations de la vie du Christ et des saints, originaire d'Artois ou du Hainaut, et datable du dernier quart du treizième siècle (Bibliothèque Nationale, MS nouv. acq. franç. 16251, fols. 47v et 54 ; cf. une reproduction de la première de ces peintures dans le volume de planches du catalogue "Art and the Courts," pl. 16), et dans les deux oeuvres les plus achevées d'Honoré, le *Bréviaire de Philippe le Bel* et la *Somme le Roi* léguée par E.G. Millar au British Museum. Sur ces deux manuscrits, cf. E.G. Millar, *The Parisian Miniaturist Honoré* (Londres, 1959), et D.H. Turner, "The Development of Maître Honoré," *Eric George Millar Bequest of Manuscripts and Drawings* (Londres, 1968), 53-65. Certains manuscrits apparentés au style d'Honoré ou dans sa lignée directe, présentent également ce modelé sculptural, ainsi le *Missel-bréviaire de Châlons-sur-Marne* (Paris, Arsenal, MS 595, fol. 244 : *Christ en majesté*; cf. "Art and the Courts," pl. 12) et un Missel de Paris (Bibliothèque Nationale, MS lat. 861, fols. 147v, 148). L'attachement de Pucelle au modelé sculptural permet de douter de la validité de l'hypothèse formulée récemment, soutenant l'éventuelle origine italienne de cet artiste (F. Deuchler, "Jean Pucelle, Facts and Fictions," *Metropolitan Museum of Art Bulletin* (XXIX, 1971), 253-56.

hardiment des accents d'un blanc presque pur, destinés à faire ressortir les parties saillantes (Fig. 11). Ces accents ont un aspect différent suivant le relief à évoquer: ce sont parfois de simples traits soulignant la cassure d'un pli (Figs. 1, 10, 11), ou des pastilles suggérant la forme arrondie de l'épaule par exemple (Figs. 2, 11, 18). Ce procédé, employé également pour la végétation, et de façon plus subtile, pour le modelé des visages (ainsi dans la *Summa Hostiensis*, de loin l'oeuvre la plus soignée de l'artiste), confère un aspect brillant et nacré à ses figures, comme si celles-ci réfléchissaient la source de lumière vive à laquelle elles semblent exposées (Fig. 11). L'emploi très systématique de ces accents de lumière n'est pas sans répercussion d'autre part sur le coloris, qui en reçoit une vibration inconnue dans les oeuvres septentrionales de l'époque.

On pourrait définir en conclusion ce qui sépare Pucelle et le Maître de Cherchemont sur le plan de la peinture de la façon suivante: pour Pucelle le phénomène de la troisième dimension (relief des êtres et des objets) a sa réalité propre et doit être évoqué de façon tactile, d'où l'effet souvent sculptural des ses oeuvres, alors que pour le Maître de Jean de Cherchemont, il s'agit d'un phénomène secondaire découlant de la rencontre des corps avec la lumière, et pouvant être rendu par des procédés purement picturaux.

De ces procédés notre artiste n'est évidemment pas l'inventeur. Ils tirent leur origine de la peinture italienne, où ils s'étaient perfectionnés vers la fin du treizième siècle, en partie sous l'influence de la peinture byzantine, qui lui avait transmis, presqu'intactes, les anciennes recettes illusionnistes de l'époque hellènistique.[34] L'utilisation par le Maître de Cherchemont d'une technique picturale beaucoup plus dépendante de l'Italie que celle de Pucelle, rapprochée du fait qu'il a connu sans doute directement l'architecture italienne (Fig. 1), amène inévitablement à la conclusion que l'artiste de l'évêque d'Amiens avait reçu au moins en partie sa formation dans un centre de la péninsule. Est-il possible à partir des données stylistiques offertes par l'oeuvre de l'artiste, d'identifier ce centre? Il faut reconnaitre que l'enquête se révèle décevante si l'on s'en tient à l'examen des seuls manuscrits à peinture. L'un des rares points de rencontre entre les oeuvres enluminées en Italie et celles du Maître de Jean de Cherchemont, consiste en un simple élément décoratif utilisé dans les fonds: l'artiste amiénois emploie en effet pour certains d'entre eux d'épais rinceaux d'or s'achevant en feuille trifoliée. Ce décor est séparé du bord intérieur du cadre limitant la surface du fond par un double liseré également d'or (Figs. 1, 10). Inconnu en France sous cette forme, ce décor n'est pas sans rappeler, en revanche, les fonds à rinceaux d'or qui apparaissent dans l'enluminure bolonaise dès le second quart du quatorzième siècle.[35] Ce rapprochement avec Bologne n'est peut-être pas purement accidentel. Il faut admettre cependant que les oeuvres bolonaises n'ont qu'un rapport éloigné sur le plan stylistique avec celles de l'enlumineur de l'évêque

[34]Cf. E. Kitzinger, "The Hellenistic Heritage in Byzantine Art," *Dumbarton Oaks Papers* (XVII, 1963), 107–09; cf. également G.M.A. Hanfmann, "Hellenistic Art," *ibid.*, 89–91, et O. Demus, *Byzantine Art and the West* (Londres, 1970), 233–36. Un peintre comme Ambrogio Lorenzetti semble avoir étudié et imité ces procédés illusionnistes directement d'après des peintures romaines; cf. G. Rowley, *Ambrogio Lorenzetti* (Princeton, N.J., 1958), I, 96–97, et II, figs. 145 et 188.

[35]Cf. par exemple deux manuscrits de droit canon, dont l'un est daté de 1343, exécutés pour un même personnage, le juriste hongrois Nicolas Vasari et conservés à la Bibliothèque Capitulaire de Padoue, reproduits dans A. Barzon, *Codici miniati della Biblioteca capitolare di Padova* (Rome, 1954), 25–28, et dans M. Salmi, *L'Enluminure italienne* (Paris, 1954), pl. IX. Cf. également un *Justinien* de la Bibliothèque Nationale de Turin (MS E.I. 1) dû au même artiste, le pseudo-Niccolò suivant l'appellation de Salmi, reproduit dans G. Mandel, *Les manuscrits à peintures* (Paris, 1964), pl. 114. Ce décor à épais rinceaux est particulièrement répandu dans les oeuvres de l'enlumineur bolonais Niccolò di Giacomo.

d'Amiens, dont les figures élégantes et allongées diffèrent profondément des personnages lourds et trapus et au visage carré représentés dans les manuscrits bolonais. En fait c'est en dehors de l'enluminure, dans la peinture monumentale, et à Sienne, que l'on trouve peut-être les points de comparaison les plus satisfaisants avec l'art du Maître de Cherchemont. Curieusement, ce n'est pas tant le style de Simone Martini qui semble l'avoir influencé, et qu'il aurait pu connaître et étudier sans sortir de France, en Avignon, que celui des frères Lorenzetti, Pietro et plus encore, peut-être, Ambrogio.[36] Avec le premier, l'enlumineur partage un dessin à la fois flexible et heurté qui se manifeste notamment dans la représentation du corps humain. Le dormeur du *Roman de la Rose*, et Adam et Eve dans la *Somme* d'Henri de Suse (Figs. 8, 16), avec leur modelé plat et le passage des lignes arrondies de l'épaule à la cassure aigue du coude, rappellent le traitement du Christ de la *Déposition de Croix* peinte par Pietro à la Basilique inférieure d'Assise entre 1326 et 1329.[37] Les points communs du Maître de Cherchemont avec l'art d'Ambrogio Lorenzetti paraissent encore plus nombreux: comme le maître siennois, l'enlumineur excelle à modeler subtilement les vêtements de couleur claire. La robe rose de l'élégant jeune homme figuré dans l'*Arbre d'affinité* de l'Henri de Suse en offre un magnifique exemple (Fig. 11). A travers les longs plis serrés qui strient verticalement le vêtement, l'artiste a su laisser transparaître la forme anatomique du personnage, un peu à la manière d'Ambrogio dans la célèbre figure de la *Paix* du palais public de Sienne.[38] Ce système de plis verticaux et serrés se trouve fréquemment d'autre part dans les oeuvres de Lorenzetti, alors qu'il est ignoré en France où l'on préférait à l'époque les jeux compliqués de plis entrecroisés, imbriqués ou cassés inspirés des oeuvres sculptées. Également inhabituel en France le type des visages du Maître de Jean de Cherchemont, dont le nez allongé et aigu et le menton projeté en avant semblent là encore dériver de quelque précédent siennois, en tout cas italien (Figs. 2, 11), de même que les yeux curieusement fendus des figures vues de face (Fig. 9, 10) et la chevelure taillée en arc de cercle horizontal, à la partie supérieure du front, de certains personnages (Figs. 9, 11, 14, 18, 19).[39]

Tant de détails significatifs, et d'autres encore qu'il serait fastidieux d'énumérer ici, confirment abondamment l'hypothèse de l'apprentissage du Maître de Jean de Cherchemont dans un centre italien, qui était vraisemblablement Sienne. Suffisent-ils cependant pour affirmer que l'artiste était d'origine italienne? Différentes considérations nous invitent à demeurer prudent sur ce point. En premier lieu, nous avons vu plus haut les limites du Maître de Cherchemont dans le domaine de l'évocation de l'espace, dont il n'a pas su apparemment maîtriser les principes élémentaires (mais peut-être le petit nombre d'oeuvres que nous connaissons de l'artiste fausse-t-il notre jugement). Il est surprenant de constater, en effet, qu'alors que les enlumineurs siennois contemporains des Lorenzetti ou influencés par eux

[36]De l'abondante bibliographie consacrée aux Lorenzetti, nous ne retiendrons ici que les ouvrages d'E. Carli, *I Lorenzetti* (Milan, 1960), et de Rowley, *Ambrogio Lorenzetti*.

[37]Carli, *I Lorenzetti*, pl. 11.

[38]Rowley, *Ambrogio Lorenzetti*, pl. 167. On trouvera une bonne reproduction en couleur de cette figure dans A. Gonzalez-Palacios, *Ambrogio Lorenzetti, la Sala della Pace* (Milan, 1969).

[39]Ce détail de coiffure apparait fréquemment dans la peinture italienne du Trecento. Cf. par exemple les deux jeunes gens assistant à la réception de St. Louis de Toulouse comme novice de l'ordre franciscain, fresque peinte par Ambrogio Lorenzetti à la salle capitulaire du monastère Saint-François de Sienne (Rowley, *ibid.*, 11, fig. 108), et les scènes de la vie de St. Martin, peintes par Simone Martini à l'église inférieure d'Assise (cf. F. Bologna, *Gli affreschi di Simone Martini ad Assisi*, Milan, 1966). Voir également Carli, *I Lorenzetti, passim*.

transposent couramment les représentations d'intérieurs inventées par les deux frères,[40] on ne trouve nulle tentative du même genre de la part du Maître de Jean de Cherchemont. Également significatives sont les différences sur le plan technique qui séparent ces enlumineurs, à la touche plus picturale et plus empâtée, de l'enlumineur amiénois, dont l'oeuvre la plus tardive, le *Roman de la Rose* de Châlons-sur-Marne, révèle un certain retour à la tradition graphique française (Figs. 16–21). En ce qui concerne les éléments décoratifs d'autre part (initiales ornées, bordures et encadrements), cet artiste manifeste une adhésion presque sans réserve au système d'initiales et de bordures à vignettes, qui parti de Paris, s'était peu à peu imposé à tout le reste de la France au cours du quatorzième siècle.[41] Une telle adhésion paraît difficilement imaginable de la part d'un enlumineur dont l'origine et la formation auraient été purement italiennes. Un peu plus de cinquante ans plus tard, un artiste certainement italien celui-ci, le Maître des Initiales de Bruxelles pour reprendre l'appellation que lui a donné Meiss, a enluminé à Paris une série de Livres d'heures dont les parties décoratives et les illustrations ne révèlent aucune trace d'une quelconque influence française.[42]

Que le Maître de Jean de Cherchemont ait été un Italien francisé ou un Français italianisé, le question apparaît finalement secondaire: le fait important et indéniable est la tentative qu'il représente d'acclimater le style et la technique des Trécentistes italiens en France septentrionale.

Mais l'importance d'un artiste ne réside pas seulement dans son originalité, elle se mesure également à la résonnance que ses expériences peuvent avoir sur l'art de ses contemporains. Sur ce point, le bilan parait avoir été entièrement négatif. A cela deux explications peuvent être données: en premier lieu le Maître de Jean de Cherchemont exerçait dans un milieu artistique provincial alors sur le déclin, peu préparé par suite au changement radical qu'impliquaient le style et la technique de l'enlumineur de l'évêque d'Amiens. Il n'est pas certain d'ailleurs qu'il en eut été très différemment si celui-ci avait travaillé à Paris, où il existait des tendances tout aussi conservatrices. Une autre raison de l'insuccès de l'artiste est à chercher dans les causes mêmes de l'influence de Pucelle: celui-ci a su élaborer un style qui, tout en faisant leur part aux innovations italiennes, restait attaché aux principes esthétiques essentiels de l'enluminure française. Dans cette heureuse synthèse, due à une personnalité d'exception, l'apport italien, filtré et adapté, devenait plus aisément accessible et assimilable par le commun des enlumineurs français de l'époque. L'échec du Maître de Cherchemont fut peut-être de n'avoir pas trouvé le même dosage équilibré.

<div align="right">BIBLIOTHÈQUE NATIONALE</div>

[40]Cf. par exemple l'enluminure d'un *Commentaire sur les Décrétales* conservé aux Archives du chapitre de Vich (Meiss, "Italian Style in Catalonia," *Journal of the Walters Art Gallery*, IV, 1941, 62–63 et fig. 21), qui reproduit la composition de la fresque de la réception de St. Louis de Toulouse citée à la note précédente (Rowley, *Ambrogio Lorenzetti*, fig. 104); une initiale historiée figurant la *Présentation au Temple* (P. Brieger, M. Meiss, C.S. Singleton, *Illuminated Manuscripts of the Divine Comedy* (Princeton, N.J., 1969), I, fig. 96) inspirée du célèbre panneau d'Ambrogio Lorenzetti figurant la même scène

(Rowley, *ibid.*, fig. 9); et la *Nativité de la Vierge* d'un Gradue siennois (reproduit dans *Cahiers archéologiques*, XX, 1970, 215, fig. 7, où ce manuscrit est daté à tort du treizième siècle), dérivée du triptyque de Pietro Lorenzetti conservé au Musée de l'Oeuvre de la cathédrale de Sienne (Rowley, *ibid.*, fig. 122).

[41]Le Maître de Jean de Cherchemont utilise, en outre, des fonds en damier et diaprés, qui n'apparaissent que rarement dans l'enluminure italienne du quatorzième siècle.

[42]*French Painting in the Time of Jean de Berry*, 229–46, figs. 199–215 et 758–812.

Dalla Sinopia al cartone

UMBERTO BALDINI

Nella sala XL della mostra "Firenze Restaura," con la quale si volle celebrare i quarant'anni di attività e di ricerca del laboratorio di restauri della Soprintendenza alla Gallerie nel marzo-luglio del 1972, si portavano, ad esempio per il visitatore, in fotografia e in opera, alcune sinopie. Tra tutte si distinguevano, per bellezza di conduzione e per una problematica che avevano già avviato, le sinopie provenienti dall'ex-convento delle monache di Fuligno, di Bicci di Lorenzo, e la sinopia proveniente dalla Santissima Annunziata, di Andrea del Castagno.

Crediamo che questi due artisti bene possano essere chiamati a rappresentare nella loro diversità operativa i due aspetti essenziali del problema riguardante la sinopia e l'esistenza o meno di un suo rapporto con un disegno precedentemente elaborato *ad hoc* dall'artista. Analizzando il loro operare ci si avvedrà di giungere a una conferma di quanto scrive in proposito in queste stesse pagine Ugo Procacci, che si basa sul testo, del resto chiarissimo, del Cennini. Potremmo anzi fissare, con lui, i tempi del suo assunto: dicendo cioè che soltanto in pieno Quattrocento—e non prima—gli artisti, avanti di eseguire una "sinopia," eseguono un vero e proprio disegno, dapprima su carta, a conclusione dei loro numerosi studi preparatori e, poi, successivamente, sull'arriccio. Osservando infatti le sinopie che conosciamo dal Dugento a tutto il Trecento vediamo che esse sono sempre veri e autentici "primi" disegni: sono cioè espressioni compiute o appunti di espressione in forma autonoma tradotte con il mezzo monocromo del disegno a pennello e che potrebbero vivere, sul piano emozionale e della ricerca, anche da sé sole, non dipendenti da fatti grafici antecedenti e senza la necessità di fare da base a ulteriori opere da esse in qualche modo poi derivate. E sono disegni ora sottoforma di appunto rapido, ora condotti con analisi accurata, in dipendenza dell'estro e dell'interesse. E c'è anche, lo si vede bene, un rapporto con la misura, vale a dire con la dimensione: più grande è lo spazio da dipingere e nel quale si deve inserire per prima la sinopia, e più il disegno è elaborato e condotto a compiutezza analitica (si pensi alla splendida sinopia del "Madonnone" di Lorenzo di Bicci). Nel Quattrocento invece, prima che si giunga all'uso del cartone, la sinopia acquisisce un valore che, via via, più tecnicamente si lega alla redazione dell'affresco. Esistono, sì, anche in questo tempo, disegni nel vero senso della parola (cioè espressioni capaci di esistere e di sussistere anche in forma autonoma come già nel Dugento e nel Trecento), ma nella maggior parte dei casi essi appaiono come la sintesi di un'idea precedentemente disegnata, ottenuta e così trascritta proprio per meglio servire a permettere la traduzione in affresco.

Disegni su muro nel vero senso della parola, noi chiameremo dunque le sinopie di Bicci di Lorenzo rinvenute nell'ex-convento delle monache di Fuligno (Figg. 1–6). L'artista ha fatto uso del muro, anche se con una disinvoltura che supera certo il rigore delle norme del Cennini, come se fosse un foglio di carta e vi si è mosso secondo sua ispirazione e gusto, alla ricerca e nella genesi dell'emozione. A parte l'esercizio e la consuetudine al disegno nel quale doveva ormai avere raggiunto una maestria d'eccezione, è più che evidente, ad una circo-

43

stanziata lettura, che si debba scartare l'ipotesi per cui l'artista abbia fatto uso per la sua sinopia di precedenti disegni fatti in bottega su carta o altrove; la sinopia altrimenti non avrebbe mostrato così apertamente il suo *ductus* creativo, una sua elaborata se non proprio tormentata gestazione, con segni eseguiti come a cercare la definizione più propria. E quand'anche una gestazione così tormentata non apparisse, non vorrebbe dire che essa sia mancata: andrà ricordato infatti che la sinopia è il risultato, spesso, di una messa a punto di una prima idea o di varie idee elaborate in precedenza a carbone e poi cancellate (secondo il dettato cenniniano) e pertanto oggi non più leggibili. Mentre restano leggibili, sempre, nel rapporto con la redazione finale, quelle modifiche o varianti apportate dall'artista dopo ulteriore ripensamento su quello che già pure egli stesso aveva in un primo tempo ritenuto definitivo o quelle modifiche o varianti cui era stato costretto *ab externo* dal committente e che pertanto non potevano avere una precedente presenza sull'arriccio, ma, caso mai, l'avevano avuta all'ultimo minuto, talvolta solo con abbozzi o segni, tanto per un controllo di spazi e di proporzioni atti a rassicurare il committente sulle possibilità esecutive delle correzioni stesse.[1] E a questo proposito andrà detto che anche il fatto per cui la sinopia è spesso modificata per via dei committenti non è senza valore per conferire ulteriore validità all'assunto ribadito da Procacci circa l'inesistenza di redazione di disegni preliminari su carta prima dell'esecuzione dell'affresco. È infatti logico supporre che se fosse esistito l'uso o la necessità di fare tali disegni su carta, una volta eseguiti gli elaborati e messo a punto il disegno finale il pittore avrebbe sottoposto questo, su carta, al giudizio del committente, il quale, avendo da fare osservazioni e imporre modifiche, avrebbe consentito al pittore di risparmiare tempo senza essere costretto a modificare la situazione sull'arriccio, dove più ordine c'era meglio vi si poteva lavorare.

Le modifiche (che appunto confermano la non esistenza di precedenti disegni al di fuori dell'arriccio) appaiono in tutta la loro compiutezza (e non già solo sotto forma di segni suggeritori come nel caso qui citato, n. 1 *infra*, di Ponte a Greve) nella sinopia con la *Natività*, anch'essa esposta alla mostra "Firenze Restaura," proveniente dall'ex-convento di Fuligno e sempre di mano di Bicci di Lorenzo.

Avendo data collocazione non esatta ai due santi ai lati della *Natività* (vedi questa prima redazione nella Fig. 2) ponendo S. Francesco a sinistra di chi guarda e S. Onofrio a destra; e dovendosi invece, per giusta correzione imposta dal committente, dare la posizione di rilievo a S. Onofrio titolare del convento collocandolo alla destra della Madonna (in posizione cioè di privilegio), l'artista ha coperto con un velo di nuovo arriccio le due figure già errata-

[1] Si veda, ad esempio, proprio in un'opera di Bicci di Lorenzo, l'ormai classica trasformazione subita, per via di committenza, dalla sinopia del Tabernacolo di Ponte a Greve: i due Santi (S. Lorenzo e S. Antonio Abate) presenti nella sinopia sono divenuti nell'affresco quattro (con l'aggiunta di S. Giovanni Battista e S. Pietro); non sono stati invece riportati nell'affresco i due angioli intorno al trono; mutata è la posizione delle mani della Vergine, che nell'affresco tiene con la destra la caratteristica rosa. I quattro santi, imposti all'artista dai committenti, sono stati all'ultimo minuto, proprio prima che l'artista passasse alla definitiva redazione dell'affresco, segnati da lui stesso sull'arriccio con dei cerchi che individuano e stabiliscono il posto delle quattro teste e con qualche segno di panneggio per i corpi. A proposito di queste varianti andrà detto che avendo i committenti imposto la presenza di due santi non preventivati nel contratto d'alloga-zione, il pittore per non cambiare prezzo al lavoro e non perderci economicamente con la nuova richiesta, ha tolto i due angioli. (E qui non sono in accordo con U. Procacci, *Sinopie e affreschi*, Firenze, 1961, 60 che attribuisce la sparizione degli angioli a questioni di chiarezza compositiva; si veda per contro una composizione a sei personaggi tutt'altro che caotica nel Tabernacolo di S. Andrea a Rovezzano per il quale ribadiamo l'attribuzione a Niccolò di Pietro Gerini come ci pare, per ulteriori rapporti, confermino gli affreschi nell'ex-Capitolo di San Felicita a Firenze, da poco restaurati.)

mente eseguite e, sopra, ha fatte le due nuove. Tutto questo si sarebbe evitato se fossero esistiti disegni su carta e su di essi si fosse potuto giudicare. E come se non bastasse le nuove due figure a sinopia così elaborate non sono, anch'esse, patentemente altro che disegni murali che denunciano *ad abundantiam*, nel loro segno alla ricerca della soluzione, la mancanza di precedenti redazioni su carta. Altrimenti non si spiegherebbe quel loro chiaro aspetto di appunto, proprio nel *ductus* creativo, che appare così evidente nel nuovo S. Francesco (vedi Figg. 3–4 e 5–6).[2]

Intorno alla metà del Quattrocento, a data tuttavia imprecisabile, forse nel desiderio continuo di abbreviare i tempi del lavoro (anche in rapporto all'aumentata richiesta) nuove metodologie si affacciano al di là della regola del Cennini e lo spolvero, già solitamente usato solo per parti decorative a schemi geometrici, prende il sopravvento nella redazione della pittura vera e propria sull'intonaco fresco. È qui che secondo noi la sinopia acquisisce un carattere tutto diverso dalla sinopia cenniniana e tradizionale. Va da sé che vi sono, come sempre, eccezioni, ma queste vanno intese nel senso che le pratiche dell'arte (oggi come ieri) sono da porre in rapporto specifico con l'attitudine, l'abilità e la preparazione del pittore, che è, in fondo, padrone di fare come a lui piace : c'è anche qui, insomma, l'avvenirista e il tradizionalista.

L'uso sistematico dello spolvero per riportare il disegno dall'arriccio all'intonaco fresco è il gradino che permette il passaggio dall'impiego della sinopia che potremmo definire cenniniana all'impiego del cartone inciso nelle sue linee essenziali sull'intonaco fresco.

Ma per fare uno spolvero o, meglio, per preparare un disegno da spolverare nel migliore e più vantaggioso dei modi occorre anche tutta una prassi da rivedere: occorre cioè tutta una preparazione che non può più fare a meno, ora, di disegni su carta, di appunti precisi, da cui trarre l'elaborato finale.

L'affresco di Andrea del Castagno raffigurante la *Trinità, S. Girolamo e due Sante* nella Santissima Annunziata di Firenze (Fig. 7)[3] con il suo ritrovato disegno sull'arriccio (Fig. 8) e la possibilità di ricostruire, come in un processo a ritroso, quasi nella sua totalità, il disegno preparatorio estraendo prima e rielaborando poi lo spolvero tuttora leggibile sull'intonaco affrescato, ci pare importante per chiarire meglio il discorso e approfondire quella distinzione che potremmo fare tra la sinopia cenniniana (vero e proprio disegno) e la sinopia-cartone (sintesi di disegni elaborati in precedenza).

Il disegno, nel vero senso della parola, è un'espressione autonoma e compiuta, raggiunta dall'artista con mezzi grafici che sono diversi, nell'uso delle materie come nella resa, da qualsiasi altra forma espressiva. Nel caso nostro dobbiamo dire che una cosa è disegnare e una cosa è dipingere. Ma quando il disegno viene fatto come studio per una realizzazione che deve avvenire con mezzi diversi da quelli puramente grafici, allora esso deve cercare di andare

[2] Potremmo, su questo piano, e in questa direzione analizzare e ricordare un'infinità di altri esempi che si potrebbero sottoporre tutti a similari analisi e che porterebbero alla stessa conclusione. Non lo facciamo ritenendo più che sufficiente quanto ora detto, in appoggio di quanto scritto e ricapitolato ora dall'articolo di Procacci.

[3] È merito di M. Meiss l'individuazione in Sta. Paola e Sta. Eustochia delle due Sante dipinte qui da Andrea (cf. il catalogo della mostra "The Great Age of Fresco," New York, The Metropolitan Museum of Art, 1968, 160). A Millard Meiss offro volentieri e con grande affettuosità questo mio studio, che riassume e puntualizza colloqui con lui avuti già fin dal tempo del rinvenimento del disegno di S. Girolamo e ridiscussi poi anche in occasione della mostra di New York.

incontro e di adeguarsi come meglio può ai dati della futura realizzazione; in questo caso raramente si muove con una totale validità autonoma espressiva poiché "è al servizio," "è fatto per." E se questo è il caso generale e più comune della maggior parte delle sinopie (per cui esse andranno viste più che come compiuto e definitivo atto espressivo a sé stante, come mezzo intermedio e transitorio che codifica in sintesi e nei modi più adatti a servire per una appropriata trascrizione in affresco, tutta una somma di idee variamente compiute dall'artista) a maggior ragione e con più evidenza ciò apparirà quando si farà della sinopia il vero mezzo diretto e puntuale della trascrizione.

Tornando al *S. Girolamo* dell'Annunziata (Figg. 7 e 8) la prima cosa che andrà detta (e che balza subito all'occhio) è quella della notevole differenza tra il disegno murale trovato sull'arriccio al disotto dell'intonaco e l'affresco.[4] Non solo: il disegno murale quale è apparso è del tutto "inedito," anche, come fattura, nel gruppo stesso delle sinopie note di Andrea, di solito "sinopista" impeccabile per via di sintesi lineari e qui invece morbido e sciolto nel segno, con un chiaroscuro che fa vibrare di continuo la visione in una liricità nella quale i tre personaggi trovano la giusta calibratura nello spazio, in virtù anche di un equilibrio occasionale che si viene a stabilire fra la luce e la loro stessa monumentalità. Del tutto diverso, questo disegno, poi, dalla redazione dell'affresco che non solo ha varianti di impostazione ma che diviene nervosa, secca, fatta più di contrasti che di equilibri tra forma e forma. E se la variante di impostazione è sorta a seguito del mutamento totale della composizione che ha fatto di necessità diminuire il "metro" delle tre figure, discese sul limitare dello spazio in basso per dar posto alla Trinità non prima pensata, è certo che l'acutezza disegnativa è totalmente diversa dal primitivo disegno le cui tre fluide forme iniziali si modificano ora in un'aspra assemblea di muscoli che paiono tendersi al ruggito del leone, in piedi e con "l'eretta coda ferrigna." Una redazione, questa, condotta ancora e totalmente con lo spolvero, ma in forma indipendente dal disegno sull'arriccio; estratta invece da un nuovo disegno e non già ricalcato, come era consuetudine, direttamente da quello elaborato sull'arriccio a sinopia.[5] Tale disegno del resto, realizzato in forma del tutto autonoma, per questa sua morbida plasticità chiaroscurata più che segnata, mal si sarebbe assoggettato a una traduzione puntuale a ricalco per lo spolvero. Viene allora logico il sospetto che i tempi di lavoro dell'affresco siano stati non più quelli consueti ma diversi. Pensiamo allora che si potrebbe ipotizzare Andrea a lavorare in quel momento nella cappella dedicata a S. Giuliano e che conducendo lì l'affresco abbia avuto l'allogagione da Girolamo Corboli per il S. Girolamo. Sì che preso dal fervore per il nuovo lavoro abbia addirittura preparato subito l'arriccio e lì, facendo del muro il suo foglio di carta, abbia "disegnato" di getto, la sua prima grande idea e non già il risultato e la sintesi estratta da tutta una serie di

[4] Questa differenza ha persino fatto adombrare la possibilità, per noi assolutamente da escludere, che la sinopia ritrovata appartenga ad altro artista, che potrebb' essere anche Domenico Veneziano; meglio, invece pensare che la sinopia appartenga a Andrea del Castagno in un momento di "deciso accostamento all'arte di Domenico Veneziano" stesso (cfr., per questo, U. Baldini, in *La Nazione* (Firenze), 20 agosto 1967; M. Meiss, nel catalogo della mostra citata, 160–61.

[5] Anche a Sant'Apollonia, le sinopie venute alla luce al disotto delle Storie della Passione testimoniano di una redazione sintetica (negli angioli, come nella *Crocifissione* e *Deposizione*) dalla quale poi, come scrisse Procacci, calcando con carta lucida se ne trassero i disegni per il cartone da spolvero (*Sinopie e affreschi*, 67–68). Uno stesso metodo notammo nel *S. Girolamo penitente* del Duomo di Arezzo di Bartolommeo della Gatta; cfr. U. Baldini nel catalogo della "III Mostra di Affreschi Staccati," Firenze, Forte di Belvedere, 1959, suppl. 202.

lunghi studi elaborati in bottega. Possiamo supporre cioè e considerare che Andrea abbia qui fatto non già una "sinopia" nel vero senso della parola ma tradotto solo con i mezzi grafici un'emozione, come sul primo dei fogli a disposizione capitatogli sotto il carboncino. Abbia cioè compiuto, velocemente, in una specie di *raptus* creativo, uno "studio" elaborandolo al meglio delle possibilità espressive permessegli dal mezzo (e si vedano le correzioni segnalate dalla presenza del carbone). Intervenuta in un secondo tempo, al momento dell'esecuzione vera e propria dell'affresco, anche la modifica certamente imposta dal committente, Andrea non ha rifatto *ex-novo* l'opera, ma ispirandosi in parte a quella che esisteva, e operando ora direttamente sulla carta ha elaborato una vera e propria "sinopia-cartone" quale è quella che possiamo leggere traendola, con procedimento ricostruttivo inverso, dallo spolvero che ancora oggi si può vedere sull'affresco (Fig. 9).[6] Vediamo allora che il modo di operare di Andrea, anche qui, è il medesimo di quello che già era a noi noto in Sant'Apollonia. Con una ricostruzione che si adegua allo stile di quanto si vede in Sant'Apollonia si può arrivare senza alcuna forzatura ad ottenere l'immagine quasi perfetta di quella che sarebbe stata, se l'avesse dovuta eseguire, la "sinopia" di Andrea del Castagno (Fig. 10). Quella cioè che avremmo potuto vedere realizzata sull'arriccio solo se, come Bicci nel convento di Fuligno, ricoprendo la sua prima idea con un nuovo intonaco vi avesse sopra voluto disegnare, per sé o per il committente la nuova e definitiva redazione. Ma qui Andrea non volle fare una inutile fatica e preferì disegnare subito sulla carta la sintesi dei suoi disegni: quella che direttamente divenne—forse—la prima "sinopia-cartone."

Così operando Andrea, può darsi anche senza rendersene conto, stava compiendo o aveva compiuto il più rivoluzionario intervento metodologico nel campo degli affreschi. Apriva, cioè, la strada al cartone vero e proprio, non più da spolverare ma da incidere. Stava dimostrando, cioè, che si poteva fare a meno della "sinopia" sull'arriccio.

<div align="center">OPIFICIO DELLE PIETRE DURE E LABORATORI DI RESTAURO DI FIRENZE</div>

[6] Il processo ricostruttivo è stato di estrema semplicità. Dall' affresco si ricava senza errore tutto lo spolvero, tuttora visibile al 99% sulla superficie dipinta. La sua riproduzione su carta fu presentata alla mostra "Firenze Restaura." Riunendo con segno lineare i puntini dello spolvero si è ottenuta la grafia totale di un disegno, che delinea anche i limiti delle zone che venivano occupate dal chiaroscuro. Eliminando queste linee e sostituendole con un chiaroscuro rielaborato in rapporto e assonanza con la realizzazione dell'affresco, si è ottenuta quella che potremmo chiamare la ricostruzione fedele del supposto disegno di partenza di Andrea del Castagno ovvero una "sinopia mancata" (Fig. 10). Ringrazio qui il restauratore Alfio Del Serra per la trascrizione grafica di queste letture e interpretazioni compiute insieme.

"Una Prospettiva . . . di mano di Masaccio"

JAMES H. BECK

The painting usually called *The Healing of the Lunatic Boy* or *Christ and Apostles in the Temple* in the Johnson Collection of the Philadelphia Museum of Art has received considerable attention from scholars since its reemergence in the last decades of the nineteenth century, largely because of its impressive perspective (Fig. 1). The details surrounding the history of the work in modern times may be summarized as follows. W.B. Spense purchased the picture from the Palazzo Guadagni in Florence in the summer of 1877. The picture was mentioned in 1904 at the Somzée sale in Brussels as on wood, while in a catalogue of 1907 it was described as on canvas. The assumption has been made, with justification, that sometime between 1904 and 1907 the painting had been transferred from wood to a canvas support.[1] My own examination of the picture, however, leads to a contrary conclusion. The painting was always on canvas; in other words, at the time of its execution in the late 1420s it was painted directly on the canvas that now supports the colors. Painting on canvas is by no means unheard of in the first half of the quattrocento, though it certainly is not common. An analogous work from the period is the so-called *Thebaid* in the Accademia at Florence (no. 5381), sometimes attributed to Uccello; its measurements, incidentally, are in harmony with those of the Johnson picture: 81 cm. high, contrasted with the latter's 115 cm.

The canvas of *The Healing of the Lunatic Boy* shows a fine, irregular weave, easily seen from detail photographs and in X-rays, which also reveal a seam that runs vertically through the entire picture—crossing, fortuitously, the figure of Christ (Figs. 3, 4 and 5). Pieces of canvas were sewn together without much care because the seam was to be buried by an applied ground, only to disappear entirely from view. It seems to me out of the question that this canvas is not "old," and consequently it cannot reflect a presumed transfer of ca. 1904–1907; in fact, the canvas should be regarded as contemporary with the picture. Furthermore, the thinness of the original painted surface in some places, and the degree to which the paint is embedded into the canvas weave, speak very strongly against the hypothesis of a transfer, and in favor of the suggestion that the picture was painted directly on the existing canvas.

Once it can be agreed that the picture was actually painted on the canvas, an apparent problem must be faced: how to explain the wood support mentioned in 1904? This question is, in turn, related to the earlier history of the painting. From the time of its first reappearance in the nineteenth century, the picture has been associated with one mentioned by Vasari in the life of Masaccio. Vasari writes:

[Masaccio] Fu studiosissimo nello operare, e nelle difficultà della prospettiva, artifizioso e mirabile:

[1] The pertinent data may be found in B. Sweeny, *John G. Johnson Collection, Catalogue of Italian Paintings* (Philadelphia, 1966), 1–3 (no. 17, listed under Andrea di Giusto). I wish to thank the staff of the Philadelphia Museum of Art for their warm cooperation including Michael Botwinick, then Assis-tant Director for Art, Joseph Rishel, Curator of the Johnson Collection, and in particular Theodor Siegl, Conservator, for his invaluable observations which I have had cause to cite on numerous occasions herein.

come si vede in una sua istoria di figure piccole, che oggi è in casa Ridolfo del Ghirlandaio; nella quale, oltre il Cristo che libera lo indemoniato, sono casamenti bellisimi in prospettiva, tirati in una maniera che e dimostrano in un tempo medesimo il di dentro e il di fuori, per avere egli presa la loro veduta non in faccia, ma in su le cantonate per maggior difficultà.[2]

Leaving aside for the moment the question of the attribution of the painting, Vasari's description fits so well with the painting in Philadelphia that a connection is virtually assured; either this is the picture that Vasari saw and admired, or it is a copy of that same picture. Such was the opinion of the late Curtis Shell, who wrote an important article on the Johnson picture.[3] The painting mentioned by Vasari entered the collection of Duke Cosimo de' Medici in the 1560s, as observed by Alessandro Parronchi, who cited a reference of a donation of a "prospettiva di Masaccio," which he associated with the painting under discussion.[4] Although Parronchi failed to give his source, it can be identified. In the 1560 Inventory of the Guardaroba Medicea (subsequently updated) is the following notice, itself dated between 1562 and 1564 on fol. 164a: "Un' quadro di legname, di braccia tre lungo et largo dua, entrovi una prospettiva con alquante figurine, di mano di Masaccio pittore donò il Carota intagliatore di legname, come al giornale carta 309."[5]

Apparently, then, there is evidence that in 1562–1564 the painting had a wood support, precisely as the painting that appeared for the first time in the nineteenth century is said to have had a similar support. But how does subsequent change in the description affect the identification of the picture? Two eventualities would explain the situation. The picture, painted on thin canvas, required some means of protection, and it was therefore glued onto a wood support, either at the time it was painted or at some time before its presentation to Duke Cosimo. This could easily have been done by il Carota, a woodworker of some renown. His real name was Antonio di Marco di Giano, called il Carota ("red head"), and he had worked on the stalls for Michelangelo's Laurentian Library and had long been employed by Duke Cosimo.[6] Apparently the painting had passed from the possession of Ridolfo Ghirlandaio, in whose house Vasari saw it, to il Carota after Ridolfo's death in 1561. In any case, the painting could have been backed by a wooden support at any time between its execution and the date of the Inventory.

The problematic but highly engaging painting on canvas of *The Decollation of St. John the Baptist* in the Museo dell'Opera del Duomo in Florence (Fig. 6) has a history that is remarkably similar to that of the Johnson picture and offers confirmatory evidence for the vicissitudes of the Johnson picture. The *Decollation*, possibly originally a banner, is virtually the same height (now 112 cm., with a strip of about 4 cm. that replaced the frayed original

[2]G. Vasari, *Le vite de' più eccellenti pittori, scultori ed architettori*, ed. G. Milanesi (Florence, 1868–1872), II, 290.

[3]"Francesco d'Antonio and Masaccio," *Art Bulletin* (XLVII, 1965), 465–69.

[4]"Il più vero ritratto di Dante," *Bollettino del Museo Civico di Padova* (LII, no. 1–2, 1963), 6. In his little monograph, *Masaccio* (Florence, 1966), 20, Parronchi calls the Johnson picture perhaps a copy by Andrea del Giusto of Masaccio, but he goes on to point out that since the picture offers the first evidence of the existence of construction with distance points, it is a work of extraordinary importance. Parronchi's views on this picture

have since changed somewhat (see n. 9, below).

[5]Archivio di Stato, Florence, *Guardaroba Medicea*, filza 65. I have prepared the entire inventory of paintings; the first part has already appeared in *Antichità Viva* (III, 1974), 64–66.

[6]U. Thieme-F. Becker, *Allgemeines Lexikon der bildenden Künstler . . .*, VI (Leipzig, 1912), 32. Carota also supplied Cosimo sometime after 1555 with a head of Dante, said to have been painted by Giotto (see the *Guardaroba Medicea*, filza 34), and one might guess that he was the Duke's purchasing agent for art or that he acted as a dealer of paintings.

at the top; the picture has also been cut a few centimeters at the bottom). The work is carefully described by Giulia Brunetti, who on the one hand calls the picture "Florentine School of the beginning of the fifteenth century (?)," while bringing to the argument interesting connections with the Master di Figline,[7] and I am unable to add any new insights. What is especially suggestive for the history of the Johnson picture is the fact that the *Decollation* in the Opera del Duomo was described as "in tela rapportata sopra tavola" in the museum's catalogues of 1891 and 1904; it is now on canvas with stretchers and is framed, but there is no doubt that the canvas is original.[8]

Thus far, it has been reasonably established that the Johnson picture is the same as the one that belonged to Ridolfo Ghirlandaio and subsequently passed into the collection of Duke Cosimo; furthermore, that the original surface upon which the picture was executed was canvas, and (as apparently was the case with the *Decollation* in the Museo dell'Opera del Duomo), after having been applied to a *tavola* in fairly recent times, the canvas was separated from the wood backing. I would rule out the possibility that the Johnson picture is a copy or replica of a lost original, an eventuality of great rarity in the period, and one for which there is no evidence. Along with other indications, the use of gold and lapis lazuli, expensive materials, speaks against the picture's being a copy. Before returning to the question of authorship, another physical feature of the painting can be extracted from the Inventory item cited above: the dimensions are given as *braccia* 3 long and 2 high. This is a precious bit of information, for, transported into modern measurements—174 by 116 cm.—the original picture was impressive in size. The painting of *The Healing of the Lunatic Boy* is presently 106 cm. wide by 115 cm. high. The height thus corresponds almost exactly to the measurement given in the Inventory, but the width does not. The conclusion is inevitable: between 1562–1564 and 1887 the painting was cut down at the sides, losing a total of 68 cm. Earlier critics have by no means been blind to the possibility that the picture had been cut down a bit; Parronchi even suggested at one point that originally it was square.[9] The *casamenti bellisimi* mentioned by Vasari and his general admiration for the picture may now be more readily explained. A drawing reconstructing the original dimensions offers insight into the appearance of the picture when it was made and underscores the impressive character of its conception. As Vasari mentioned, the oblique view of the principal structure provided both exterior and interior views at one and the same time (Fig. 7).[10]

[7]See L. Becherucci and G. Brunetti, *Il Museo dell'Opera del Duomo*, II (Florence, n.d., 1971?), 282–83, no. 41. I should like to thank Dott. Alessandro Conti for bringing this painting to my attention. He also reminded me of the fact that Vasari mentioned an *Annunciation* on canvas by Fra Angelico for the shutters of the old organ in Santa Maria Novella (Vasari, *Le vite . . .*, ed. Milanesi, II, 507). A paliotto considered by E. Carli (*Guida della Pinacoteca di Siena*, Milan, 1968, no. 8) as pertaining to the School of Guido da Siena and datable to 1280 is a rare example from the late Middle Ages of the use of canvas as a support.

[8]As observed by T. Siegl, the two horizontal seams on the right side of the picture were due to tears that occurred after the picture had been painted. These could have resulted from the canvas's having been glued to a wood panel with a horizontal grain that subsequently shrank, causing the canvas to tear and therefore require repairs.

[9]Prof. Parronchi has informed me that in his forthcoming paper ("Prospettiva e pitture in Leonbattista Alberti," based upon a lecture at the "Convegno di L.B. Alberti" in 1972) he briefly takes up the question of the Johnson picture, which he recognizes as having been severely cut down. He reconstructs the original by adding a section at the right. This is entirely the opposite approach from the one taken here and cannot be supported by the physical evidence.

[10]The excellent drawing was made to scale with enormous care and study by Harriet Chamberlain, to whom I am deeply indebted. That the picture is basically intact in height is established by an examination of the weave, which in the X-ray shows "scalloping" at the top and bottom where the unprimed canvas was tacked to a board or to stretchers. Since on the right and left sides, however, this scalloping is absent, there remains no doubt that the work has been cut down on both sides. I owe this observation to T. Siegl.

The proper attribution of the painting must be considered from two different points of view, the conception and the execution. A few comments beyond those made by Shell concerning the physical condition of the picture have been made necessary by the availability of recently taken X-rays and a cleaning that removed all subsequent restorations (Figs. 2 and 3).[11] While a certain amount of complete loss of the painted surface is revealed, there appears to be no serious violation of the original painting by the subsequent restorations, either in the architecture or the figural sections. There are areas of loss in the heads of the apostles to the left of Christ in the central group and in the section with figures at the extreme left side of the painting. There are losses also in the architecture and the sky, but the restorations did not appreciably alter the overall appearance of the original. The gilding of the halos appears to have been heightened, and the heads have been "pulled out" and enlivened by some repainting. But the appearance of the painting in its cut-down condition is reasonably good and indicative of its original state. The stylistic evidence for an attribution marshaled by Shell led him to the conclusion that the Johnson picture was executed by Francesco d'Antonio around 1429–1430, and this is an opinion that I accept, with the modifications that follow below.[12]

That Francesco d'Antonio was incapable of inventing a picture with such engaging perspective elements is hardly arguable; nor for that matter would it have been possible for Andrea di Giusto, often mentioned as a possible author of the picture, to have ideated the work. For the conception of the Johnson picture Shell tentatively assumed, first, that it was not the picture Vasari saw and mentioned as by Masaccio but a copy of that picture. This he believed would explain some imprecisions in the perspective and problems with regard to the placement of the figures. Second, Shell went beyond this point to suggest that the original (apparently lost) seen by Vasari was not by Masaccio at all, but by Masolino.[13] This argumentation is of course possible, but it is, perhaps, an unnecessarily complicated solution to the authorship of the painting. It is my opinion that the Johnson picture is in fact the one Vasari saw, the work listed in the Medici Inventory of 1560. While Vasari's attribution need by no means be taken as accurate, the picture itself speaks for the progressive current of the early quattrocento represented by Masaccio, Donatello, and Brunelleschi, and it would be consistent for Masaccio to have had a hand in this unique work. But it seems quite apparent, as Shell has so convincingly demonstrated, that the hand of Francesco d'Antonio is revealed in the picture, or rather in some of the figures. Thus we must reconstruct a situation somewhat analogous to certain of Masolino's frescoes in the Brancacci Chapel. Masaccio must have invented the picture, laid out the perspective, and perhaps even begun to paint a few of the figures, after which he left hastily for Rome, never to return and never to finish the painting. The unfinished work found itself in the hands of Francesco, who carried it to completion as best he could around 1430.

[11]In July 1973 the painting was carefully cleaned, and Mr. Siegl reports that where the original paint has not flaked off, it is remarkably well preserved.

[12]Dr. Miklòs Boskovits told me that he is in full agreement with C. Shell concerning the attribution to Francesco, and he further indicates certain connections with Masolino's shop in Empoli.

[13]Such is also the opinion of Professor Samuel Y. Edgerton, Jr., who is preparing an important new study on perspective. Meanwhile, see his article "Alberti's Perspective: A New Discovery and a New Evaluation," *Art Bulletin* (XLVII, 1966), 372, n. 29.

In order to obtain an adequate, if approximate, idea of the original picture, the reconstruction drawing should be consulted once again (Fig. 7). The picture offers a remarkable integration of figures and architecture that is essentially new and consistent with the artistic ambitions of subsequent quattrocento artists, and virtually unknown earlier. Figures take their places within the created architectural space of the building and the cityscape in a natural, harmonious way. Putting the matter differently, the architecture, in this case the temple and the figures, are within the same space—quite unlike the trecento examples of a splayed-open church or temple, as in Taddeo Gaddi's *Presentation of the Virgin* in Santa Croce. In that work, although there are figures within the opened temple at the top of the steps, the scale of the figures in relation to the architecture is so unnatural that the building appears like a stage set in miniature, and the impression of a totally integrated space was not attained (and perhaps not sought?). The spatial advances of the later trecento Paduan masters (Avanzo and Giusto) are impressive, with a greater effort to have the actors populate the architectural spaces, but still the scale of the figures in relation to the structures they inhabit diminishes the conviction of real space. In Antonio di Veneziano's *Death of St. Raniero* for the Camposanto at Pisa (Fig. 8), the figures in the building on the right side (certainly a "portrait" of the Pisa Cathedral) are scarcely integrated with the magnificently drawn building, which is but a backdrop for the action on the front plane; this offers a good example of how far beyond trecento examples the Johnson picture is in this respect.[14] A word about the architecture of the temple: although often related to the Florentine Duomo, it is a highly idealized and completely "de-Gothicized" structure—that is, of an architectural style consistent with the progressive artists of the 1420s.

The greatest innovation of the Johnson picture visually is precisely the intimate relationship between the figures and the environment. They are not in front of the nonhuman world but within and a part of it; and though the picture in its present state exhibits few atmospheric qualities, we may conjecture that originally it had more. The total integration of figures and architecture is accomplished by placing the heads of all the figures, in the distance or nearby (except the kneeling nude and the child in the foreground), on the same horizontal axis. This procedure is not foreign to Masaccio's vocabulary in the Brancacci Chapel frescoes, and the *St. Peter Healing the Sick*, for example, may be singled out in this regard.[15]

The Johnson picture appears, then, to have been begun, or at least conceived, by

[14] I am grateful to Dr. Boskovits for pointing out this painting in relation to the general discussion. Cf. M. Bucci and L. Bertolini, catalogue of the exhibition "Camposanto Monumentale di Pisa," Pisa, 1960, 81f.; our Fig. 8 is reproduced after G. Rossi, *Pitture a fresco del Camposanto di Pisa* (Florence, 1832), pl. XIII.

[15] Edgerton (see n. 13, above) points to the isocephalism of the near and distant figures in Masolino's *Resurrection of Tabitha* and *The Healing of the Cripple* in the Brancacci Chapel. These are not convincing examples, in my view, and in any case the design of these frescoes is probably due at least in part to Masaccio.

L. Berti, *Masaccio* (Milan, 1966), 144, n. 228, observes that the gold insignia visible on the halos of some of the figures around Christ could refer to the presence of St. Bernardino in Florence during 1424–1425, thereby helping to date the picture; but if useful at all, this would serve to establish a *terminus post quem*.

The "errors" in perspective in the Johnson picture that have frequently been singled out are not proof that Masaccio could not have planned the composition. On the contrary, there are plenty of such "errors" in the perspective exercises of both Donatello and Masaccio, and one need not go beyond the building on the right side of the *Tribute Money* for an example. The kind of perfection in the use of perspective and foreshortening that is often expected from Masaccio is actually a phenomenon of the following decades of the quattrocento. It is only in *The Trinity*, where he must have had the collaboration of Brunelleschi, that the system is somewhat more perfect. There are also ambiguities within the perspective system itself; but such a discussion must be left to those better equipped in these questions than I.

Masaccio on canvas, and in the best preserved area—that showing figures in the middle distance almost directly in the center of the painting—there are some very fine passages that could even have been executed by the master himself. The picture must have been painted from the start in a spirit of experimentation, and the figures were somewhat reluctantly composed into the biblical narrative, though they are not easily identifiable in all cases. The painting was not a commission for an altarpiece : its dimensions preclude that possibility ; nor could it have been a predella, since it measures more than a meter high. Neither does the subject, nor for that matter its original shape, allow for the possibility that the picture was planned as a banner or processional cloth, as is often the case with paintings on canvas of the period. The purpose and function of this picture must have been entirely experimental, and the artist chose to paint on canvas, something of an "experimental" ground at the time, because it was cheaper than a panel, which would have required extensive preparation.

The Johnson *Healing of the Lunatic Boy* turns out, in shape and scale, to be the first example in a series of cityscapes and views variously attributed to Piero della Francesca, Giuliano da San Gallo, Francesco di Giorgio, and others (located in Urbino, Baltimore, and Berlin); by the time they were executed, however, an overlay of religious imagery was no longer necessary. This Masacciesque work, reflective of Brunelleschi's second perspective painting showing the Palazzo Vecchio obliquely, emerges as an important and innovative experiment of the Early Renaissance.

COLUMBIA UNIVERSITY

A Propos de Deux Dessins inédits du Parmesan

SYLVIE BÉGUIN

Je dois à l'amitié de Charles Sterling, que je remercie bien vivement, d'avoir pu étudier deux dessins d'un album de sa collection, acquis dans le Sud de la France en 1950. C'est à lui que je dois aussi tous les renseignements et les hypothèses concernant cet album qui se présente sous la forme d'un petit livre,[1] dont la reliure et le papier frappé d'un filigrane M. Brun sont du dix-huitième siècle français.[2] Sur la première page, l'inscription "Dessins en mauvais état No. 7" est tracée à la pierre noire, d'une écriture également du dix-huitième siècle.[3] C'est la plus ancienne écriture de l'album, probablement celle du collectionneur français qui dut acquérir les dessins en Hollande car on peut lire, sur un petit papillon de papier collé en haut et à droite de cette première page: "Samen f. 214," soit, en hollandais, le prix en florins,[4] d'une écriture différente de la première.

Le collectionneur français a collé chaque dessin sur le recto des pages de l'album.[5] Il a laissé le verso vide, y notant, parfois, l'attribution du dessin collé sur le recto de la page suivante. Les attributions des possesseurs successifs de l'album apparaissent quelquefois, d'ailleurs, sur les versos; on peut, également, les trouver sur les rectos mais au dessus, ou au dessous, du dessin qui y a été collé.

Le contenu de l'album nous permet de préciser que celui-ci a été composé par le premier collectionneur dans le troisième quart du dix-huitième siècle au plus tard: en effet, le dessin le plus tardif est un Gabriel de Saint-Aubin signé; son origine pourrait, d'ailleurs, être différente de celle des autres dessins de l'album qui, si l'on excepte deux Parrocel et un dessin plus ancien attribué à Pollaiuolo, sont tous des dessins du seizième et du dix-septième siècle.[6] Cet album contient des feuilles intéressantes, par exemple une belle étude inédite pour le *Portrait d'Alessandro de Medici* (Florence, Offices) de Vasari,[7] un Anselmi,[8] un Pontormo, un Baroccio, un Bol,[9] et, parmi les dessins français les plus anciens, un Fréminet (?) et un Sarrazin.

L'un des dessins de l'album représente *Deux Amours* délicatement esquissés à la pierre noire et à la sanguine (Fig. 1).[10] Des repentirs témoignent des solutions successives proposées par l'artiste pour traiter ce thème gracieux: la position de la jambe de l'amour de profil à droite, a été changée; un de ses bras apparaît à la fois relevé au dessus de la tête (pour prendre une flèche dans le carquois?) et tendu en avant (pour saisir l'arc que son compagnon tient debout

Cette note a été rédigée à l'Institute for Advanced Study in Princeton, que je tiens à remercier.

[1] 295 × 210 mm.

[2] P.J. Mariette, *Les grands peintres. I. Écoles d'Italie, ies beaux-arts* (Paris, 1969). Les identifications des écritures sont tirées de cet ouvrage.

[3] Cette écriture apparaît sur quelques pages de l'album comme nous le verrons plus loin.

[4] "Samen" veut dire "ensemble," en hollandais.

[5] Dimensions des pages de l'album: 291 × 202 mm.

[6] Tous ces dessins portent des attributions à la pierre noire de la même main que l'inscription de la première page de l'album.

[7] Identifiée par J. Cox Rearick.

[8] Attribution de Ch. Sterling et d'A. Ghidiglia-Quintavalle.

[9] L'attribution de ces trois dessins est de Ch. Sterling.

[10] Sanguine sur une préparation à la pierre noire, 271 × 131 mm; avant la restauration le feuillet avait une forme irrégulière: il comporte une lacune, en haut à gauche; taché d'encre en haut à droite et, surtout, au centre. La photographie accentue énormément la noirceur de ces taches, en réalité couleur café au lait, ce sont des taches d'encre pâlie ou de lavis d'encre. En bas, à droite, l'inscription: "Primaticcio," à la plume et à l'encre noire, d'une écriture du dix-huitième siècle.

devant lui?). A coté, un peu plus à gauche, le second amour, vu de face, détourne vers la gauche sa tête[11] qui se détache ainsi sur une de ses ailes déployées.

Le dessin n'est pas suffisamment clair pour permettre d'identifier, à coup sûr, les deux figures ni de comprendre leurs relations réciproques. On peut, naturellement, penser à *Eros et Anteros*. Il semble que les deux amours portent chacun un carquois sur le dos et que l'objet de leur contestation, d'ailleurs courtoise, soit le grand arc, très légèrement esquissé, qui est debout entre eux. Ces figures pourraient très bien faire partie d'une plus grande composition car la feuille est irrégulièrement coupée sur les bords de chaque côté. Cependant, le motif se suffit en lui-même.

Si l'on étudie le style des figures, en dépit de l'indication "*Primaticcio*," à la pierre noire, en bas à droite, c'est le nom du Parmesan qui vient à l'esprit.[12] Les rondeurs encore corrègesques des contours rappellent les premiers dessins de l'artiste mais certaines simplifications hardies des formes, l'étude des figures dans l'espace, dénotent une période plus avancée. Dans l'amour de gauche, la torsion du corps, la pose écartée des jambes, sont très caractéristiques des recherches du Parmesan dans sa période romaine et surtout bolonaise, comme le montrent les rapports avec les dessins[13] et les peintures, le *St. Roch* de San Petronio, surtout (Fig. 3). La technique de la sanguine rose[14] silhouettant légèrement les traits menus des visages et les courbes délicieuses des jeunes corps que modèlent, çà et là, quelques hachures, sont aussi typiques du Parmesan à cette époque.

L'étude des *Deux Amours* ne se rapporte, semble-t-il, à aucune oeuvre jusqu'ici connue. On peut penser à un projet pour la gravure comme Parmesan en fit beaucoup à son arrivée à Bologne;[15] le thème des amours et de l'arc apparaît souvent lié au thème de Vénus, par exemple dans le dessin de l'Albertina.[16]

En tous cas, il est bien dans le goût du Parmesan, rappelant autant les amours des fresques de la Stuffetta de Fontanellato que l'amour du tableau du Kunsthistorisches Museum de Vienne. Ce thème a été traité plusieurs fois par Parmesan, particulièrement dans sa période bolonaise: on peut en noter des échos dans le dessin de Budapest.[17] A.E. Popham trouvait à cette datation une sorte de confirmation grâce à la gravure de Jacopo Francia qui montre une Vénus semblable à celle des dessins de l'Albertina et de Budapest, mais avec des amours différents.[18] Cependant, l'amour de profil de la gravure de Jacopo Francia est tout à fait comparable à l'amour de profil de notre album: cette analogie permet de le rapprocher de

[11]Notons que cette attitude est proche de celle de St. Roch dans le dessin du Parmesan de Besançon (verso: Fig. 6) et du *St. Roch* gravé par Bonasone (Fig. 4; cf. infra).

[12]Cette attribution, a, d'ailleurs, été proposée par l'un des possesseurs de l'album. En effet, au milieu du verso de la page qui fait face à la page recto de l'album où avait été collé le dessin, on trouve l'inscription à la pierre noire "Primaticcio," de la main du collectionneur de l'album au dix-huitième siècle. Mais, au bas de la page, une autre inscription à la plume, d'une calligraphie élégante, probablement de la première moitié du dix-neuvième siècle, donne l'attribution "Parmegianino."

[13]Comparer dans A.E. Popham, *Catalogue of the Drawings of Parmigianino* (New Haven, Conn., 1971), particulièrement les dessins en rapport avec les clair-obscurs (II, pl. 116, no. 370); ou pour la pose de la figure de gauche (III, pl. 297, no. 798).

[14]Cf. *infra*, le rapport évident avec les dessins préparatoires pour le *St. Roch* de San Petronio, particulièrement avec les dessins de Besançon et de Chatsworth (Figs. 6, 7, 10).

[15]Vasari, *Le vite de' più eccellenti pittori, scultori ed archittetori…*, éd. Milanesi, V, 226.

[16]Popham, *Catalogue of the Drawings of Parmigianino*, III, pl. 270, no. 614.

[17]Popham, *ibid.*, III, pl. 176, no. 30, qui cite toutes les versions de ce motif et parle d'une gravure du dix-huitième siècle correspondant probablement à une peinture perdue mais différente de tous ces dessins.

[18]Cf. *supra*, n. 16. Jacopo Francia, *Vénus et Cupidon sur des nuages* (A. Bartsch, *Le Peintre-graveur*, XV, 37, et A.M. Hind, *Early Italian Engraving*, VII, 814, no. 6); le motif a été donné à Primatice ou à Parmesan.

toutes ces recherches du Parmesan sur le thème de la Vénus et des amours et de le situer dans sa période bolonaise.

L'attribution et la date des *Deux Amours* furent heureusement confirmées par le verso révélé au moment où on décolla le dessin de la page de l'album : en effet, une nouvelle esquisse, à la sanguine, apparut alors.[19] L'identification de cette figure, un *St. Roch*, peut cette fois aisément être faite à partir du geste de la main gauche qui désigne le bubon fatal de la peste (Fig. 2).

Le thème de *St. Roch* a été traité plusieurs fois par Parmesan dans sa période bolonaise : nous pouvons le déduire des dessins, de la gravure et du tableau de San Petronio. Il est possible que toutes ces recherches se rapportent à une seule commande, le séjour du Parmesan à Bologne ayant été fort court.[20] Mais il est aussi possible qu'elles concernent des oeuvres différentes. Aucun document, à cet égard, n'a été conservé et le seul St. Roch mentionné au seizième siècle sous le nom de Parmesan, le *St. Roch* de San Petronio de Bologne, l'est, malheureusement, d'une façon peu claire,[21] ce qui ne nous permet pas de connaître vraiment l'origine de la commande de la peinture.

Popham,[22] en étudiant les dessins préparatoires du *St. Roch* de San Petronio, arrive à la conclusion que Parmesan a d'abord conçu la figure debout. Il en trouve la preuve dans l'étude comparative des dessins préparatoires du *St. Roch* de San Petronio et dans une gravure de Giulio Bonasone (Fig. 4) qui, selon lui, s'inspire d'un St. Roch perdu du Parmesan.[23]

Le dessin inédit de notre album entretient avec toutes ces oeuvres des rapports qui, en tous cas, confirment l'hypothèse de Popham sur l'évolution du thème de St. Roch et sur l'originalité de la gravure de Bonasone, justifiant, aussi, l'attribution à Parmesan du recto et du verso du dessin, comme leur datation, dans la période bolonaise de l'artiste.

Il y a beaucoup de ressemblances entre le *St. Roch* de la gravure de Bonasone et le *St. Roch* de l'album. Non seulement ils sont tous deux debouts, sans donateur, mais la pose des jambes est absolument la même, comme le vêtement et le mouvement de la draperie. Certes, on voit, de plus, dans la gravure, un chien et un paysage, mais ils sont si médiocres et si peu dans le goût de Parmesan qu'il s'agit visiblement d'une invention maladroite du graveur, probablement pour préciser l'iconographie de la figure par ailleurs assez banale.

[19]A la différence des *Deux Amours*, le *St. Roch* est esquissé à la sanguine. Un peu en biais, horizontalement, deux lignes parallèles à la mine de plomb, interrompues en deux endroits (peut-être parce qu'on a essayé de les gommer).

[20]Parmesan séjourna à Bologne entre fin mai ou juin 1527 jusqu'au début de 1531 (cf. S.J. Freedberg, *Parmigianino, His Work in Painting* (Cambridge, Mass., 1950), 61).

[21]Le tableau fut placé dans la chapelle Monsignori, due à la magnificence du cardinal Angelico Capronica, où il est mentionné par Vasari : la chapelle appartint ensuite aux comtes Gamba-Ghiselli de Ravenne (G.L. Bianconi, *Pitture ed architetture delle chiese, luoghi pubblici, palazzi e case della città di Bologna e suoi suborghi*, Bologna, 1792, 265). Vasari indique que le donateur du tableau est "Fabrizio da Milano"; P. Lamo (*Graticola ossia Descrizione delle pitture, sculture architetture di detta città, fatto l'anno 1560 dal pittore Pietro Lamo*, Bologna, 1844, 38) l'appelle, "Ms Valdassera da Milano." P. Ireno Affò (*Vita del graziosissimo pittore Francesco Mazzola detto Il Parmigianino*, Parma, 1784), 70, lit ce mot "Baldassare." Malheureusement, le témoignage le plus ancien sur la peinture, celui de Michelangelo Biondo (*Della nobilissima pittura e della dottrina di conseguirla agevolmente et presto*, Venise, 1549, 19 et recto) ne donne aucun renseignement et appelle même, à tort, l'église "San Pietro." Le tableau est toujours resté dans la chapelle où il fut placé à l'origine, la huitième chapelle à gauche de la nef.

[22]Popham, *Catalogue of the Drawings of Parmigianino*, I, Introduction, 17–18; cf. aussi G. Neufeld, *Pantheon* (XXIX, 1971), 326–28.

[23]Popham, *ibid.*, I, 18, n. 2 : "The engraving by Giulio Bonasone (Bartsch, XV, p. 130, 70), obviously after Parmigianino, must be based on a lost drawing, in which the Saint was represented standing." Freedberg (*Parmigianino*, 77, n. 96) cite la gravure comme une "additional sixteenth-century documentation." A. Ghidiglia-Quintavalle, *Il Parmigianino* (Milan, 1948) ne la mentionne pas. Pour G. Copertini, *Il Parmigianino* (Parme, 1932, II, 55) cette gravure, dont le dessin est attribué à Bonasone, est la seule où "un bene intenso spirito Parmigianinesco si faccia notare."

Ces adjonctions sont donc négligeables; par contre, les variantes entre les gestes des bras et de la tête sont, certainement, importantes: or, dans le *St. Roch* de Bonasone tous les gestes sont peu expressifs.[24] C'est une image de dévotion qui n'offre rien de personnel ni de nouveau par rapport à la tradition iconographique. Bien qu'également conforme à cette tradition, un autre St. Roch debout de Parmesan, dans un projet de tableau d'autel que nous connaissons grâce au grand dessin très discuté des Offices, la *Vierge sur des nuages entre St. Roch et St. Sebastien* (Fig. 5)[25] est lui, au moins, une figure d'une piété inspirée, avec son visage penché en avant et ses mains jointes.[26] Cette conception de St. Roch diffère tant de la gravure de Bonasone et du dessin inédit qu'il paraît impossible que ceux-ci offrent avec elle d'autre rapport que thématique. Par contre, comme nous allons le préciser, le *St. Roch* debout de l'album s'inscrit certainement dans les recherches de Parmesan en vue du *St. Roch* de San Petronio.

Selon Popham les dessins préparatoires de Besançon (Figs. 6, 7),[27] de Paris (Louvre; Figs. 8, 9)[28] et de Chatsworth (Fig. 10)[29] montrent que Parmesan a considérablement évolué. Il a d'abord conçu sa figure debout (dessins de Besançon), puis agenouillée, avant de la représenter dans l'attitude instable du tableau de San Petronio. Si, en effet, on étudie dans ces dessins les positions successives de la tête, des bras, de la draperie, on ne peut que donner raison à cette thèse d'autant plus que certains éléments importants comme le chien (dessin du Louvre, verso) et le donateur (dessin de Chatsworth) s'ajoutent aux autres données. Ainsi la version finale du tableau de San Petronio offre une remarquable synthèse de toutes ces recherches, conservant la pose extatique de la tête du saint et inventant l'attitude demi-fléchie du corps alors si nouvelle.[30]

Le dessin de la collection Sterling, qui, avec la gravure de Bonasone, confirme la thèse de Popham à propos d'un St. Roch debout, est une étape intéressante dans la conception de ce thème par Parmesan. Dans une certaine mesure, ce St. Roch debout est plus conforme à la tradition et, à cet égard, en peut le comparer, à Bologne même, avec le *St. Roch* de Francia (New York, Metropolitan Museum of Art).[31] Mais, en réalité, il a une qualité de mysticisme qui le rapproche bien davantage du St. Roch de la version peinte dont il anticipe aussi certaines intentions stylistiques.

[24]Le bras gauche tient le baton du pélerin, l'autre est simplement placé le long du corps. L'analogie avec la série gravée des *Apôtres* est évidente.

[25]Popham, *Catalogue of the Drawings of Parmigianino*, II, pl. 236, Uffizi 1998. Le dessin a été justement rendu à Parmesan par G. Copertini (*Nuovo contributo agli studi e ricerche sul Parmigianino* (Parma, 1949), 1314, après la "Mostra del Correggio" de 1935 à Parme où C. Brandi l'avait catalogué comme Michelangelo Anselmi avec un autre dessin de la Galleria dell'Accademia de Venise (no. 560); selon Popham, une copie (*Catalogue*, sous le no. 99). Copertini ajoute à ces études une esquisse à la Bibliothèque Royale de Turin, avec des variantes importantes dans la disposition des figures, au verso d'une étude pour un *St. Nicodème* (cf. A. Bertini, *I disegni italiani della Bibliotheca Reale di Torino*, Turin, 1958, 44, qui trouve ce dessin trop faible pour être de Parmesan). A. Ghidiglia-Quintavalle (*Michelangelo Anselmi*, Parme, 1960, 20 et fig. 4; catalogue 23, fig.) le considère comme une étude d'Anselmi pour le tableau de Vezzano: cette opinion n'est pas contredite

par Popham qui ne catalogue pas le dessin de Turin.

[26]G. Kaftal (*Iconography of the Saints in Tuscan Painting*, Florence, 1952, 893, no. 271, fig. 1002) montre que ce geste est traditionnel pour St. Roch (cf. un tableau d'Andrea di Niccolò à SS. Martino e Vittorio, Sartaneo Val di Chiana.) La tête penchée en avant du St. Roch est aussi traditionnelle (cf. la gravure de Cristofano Robetta, Hind, *Early Italian Engravings*, III, 1938, 285, II, 24, II).

[27]*Catalogue of the Drawings of Parmigianino*, no. 21, pl. 218 (Besançon 1616).

[28]*Ibid.*, no. 377, pl. 219 (Paris, Louvre, no. 6397).

[29]*Ibid.*, no. 722, pl. 220 (Chatsworth, no. 793).

[30]Ce jugement est celui des historiens du vingtième siècle redécouvrant la peinture après une longue période d'oubli. Cependant Vasari l'a remarquée. En fait, les représentations antérieures de St. Roch n'offrent rien de comparable.

[31]Freedberg, *Parmigianino*, 38 a noté l'influence de Francia sur Parmesan dans sa première période parmesane (à propos du *Baptême du Christ* de Berlin).

Le visage a la pose et l'expression qu'il conservera dans le dessin de Chatsworth et la version peinte; la draperie tourbillonnante est déjà, à droite, à sa place definitive. Les vêtements que portent ce *St. Roch* sont aussi sensiblement comparables comme les hautes sandales, si l'on en juge par celle esquissée sur le pied droit dans l'album. La position fléchie de la jambe gauche ressemble à celle du dessin de Besançon (recto et verso), annonçant le parti définitif du tableau. Par contre, les bras diffèrent; le bras droit est levé, partiellement visible; le bras gauche pend le long du corps et la main, magistralement en place en quelques traits rapides, désigne le bubon fatal de la peste sur la cuisse.[32]

Ces gestes du bras sont importants d'un point de vue iconographique. Stylistiquement, ils animent une figure frontale à laquelle la position écartée des jambes, l'une de face, l'autre de profil,[33] donne également un rythme. On peut, d'ailleurs, noter que le mouvement des jambes est, presque exactement, repris dans la peinture de San Petronio, mais le dessin inédit du *St. Roch* ne présente ni chien,[34] ni donateur, et il n'y a évidemment pas de place prévue pour eux. Parmesan les a-t-il ajoutés après coup? On peut se le demander. Cela semble ressortir de l'étude du tableau à travers les dessins et de la manière assez gauche dont le donateur est joint au *St. Roch* dans la version finale peinte, un bras tendu en avant.[35] Ce bras, dont la main est partiellement visible (à la différence du dessin de Chatsworth à cet égard, plus harmonieux . . . mais moins précis dans la liaison St. Roch–donateur), semble réduit à un moignon. Ce geste crée un parallèlisme avec la cuisse gauche du saint, accentuant, ainsi, fortement la construction du tableau sur une diagonale qui rejette complétement à gauche le motif principal un peu comme dans l'*Antiope* du Corrège.[36] Parmesan a aussi inventé dans le tableau, pour la figure, une stylisation étonnamment hardie. Mais, dans cette version, l'échange des regards des personnages entre eux prouve l'importance que l'artiste a attaché au contenu de l'oeuvre: entre le donateur, le chien, St. Roch, et Dieu qui se manifeste sous forme d'une clarté à l'intérieur de laquelle se dessine une croix,[37] s'établit une sorte de gradation spirituelle des divers degrés de la confiance, idée qui ajoute une note profondément touchante aux recherches formelles du tableau.

Remarquons, d'ailleurs, que Parmesan se montre en cela, fidèle à la légende de St. Roch, mendiant et pélerin. Il illustre soit le moment où le saint, frappé à son tour par la maladie qu'il a attrapée en soignant les pestiférés de Piacenza, se réfugie dans la forêt et défaille en appelant Dieu à son aide, attendant la mort;[38] ou, plutôt, comme nous le pensons, un épisode posté-

[32]On peut comparer le bras avec celui du *Diogène* gravé par Caraglio et avec le clair-obscur d'Ugo da Carpi (d'après Caraglio selon Popham); cf. aussi la gravure du British Museum représentant un bras, attribué par Popham (*Catalogue of the Drawings of Parmigianino*, I, Introduction, fig. 32) à Parmesan lui-même d'après l'étude autographe de Chatsworth (III, 714, pl. 134).

[33]Comme sur la gravure de Bonasone.

[34]Le chien est-il esquissé en bas, à droite ou à gauche?

[35]On a l'impression que la place réservée au donateur sur la peinture n'était pas, à l'origine, assez grande. Le rapport des figures entre elles est plus parfait dans le dessin de Chatsworth.

[36]Naturellement, le satyre dans l'angle supérieur de la peinture de Corrège équilibre toute la construction. La prétendue *Antiope* était alors à Mantoue chez les Gonzague et Parmesan a pu avoir l'occasion de la voir (sur sa date cf.

C. Gould, *The School of Love and Corregio's Mythologies*, Londres, s.d. [1970]). Il est frappant que le type de la composition du *St. Roch* soit également celui du *St. Paul* (Vienne, Kunsthistorisches Museum).

[37]Peut-être une allusion au signe de la croix par lequel St. Roch guérissait les pestiférés, selon la légende.

[38]Le tableau du Parmesan a été catalogué par L. Réau (*Iconographie de l'art chrétien*, Paris, 1959, III, 3, 1158–61, pl. 70) comme se rapportant à cette scène. Sur les incertitudes de la légende de St. Roch, cf. F.L. Cross, *The Oxford Dictionary of the Christian Church* (London, 1957), 171. Parmesan pouvait connaître le texte de Francesco Diedo, *Vita Sancti Rocchi* (Venise, 1478), soit celui de J. Philippot, *Vie, légende et oraison de M. S. Roch* (Brescia, 1494; Paris, 1495). Pour la bibliographie des études consacrées à St. Roch, cf. aussi Kaftal, *Iconography of the Saints*, et Réau, *Iconographie*.

rieur de cette légende. En tous cas, l'attitude singulière du saint est aisément explicable par les circonstances mêmes du récit, très exactement commenté par Vasari.[39] Le chien qui le nourrira en volant des pains au riche Gothard est près de lui et, peut-être, aussi, le riche Gothard lui-même (sous les traits du mystérieux donateur).[40]

Pour expliquer la pose du *St. Roch* de San Petronio, Freedberg suppose que le saint, d'abord assis sur une pierre, se lève après avoir entendu la prière du donateur pour intercéder pour lui et qu'en réponse à sa prière la Divinité apparaît sous forme d'une lumière intense.[41] Mais le cadre de la forêt, le baton de pélerin qui tombe (sa position dans l'espace est, autrement, incomprehensible) ne sont guère explicables en dehors du texte même de la légende. C'est à ce moment d'intense faiblesse et de suprême foi en Dieu conté par la légende que le donateur s'associe à St. Roch, vraisemblablement, en action de grâce. L'attitude du *St. Roch* n'est donc pas purement esthétique ("The intention of this action is primarily aesthetic," Freedberg) mais elle est la traduction d'une intention profondément religieuse, même si l'aspect formel a été délibérément recherché par l'artiste.[42] La liaison étroite entre St. Roch et le donateur renforce l'impression que le tableau est un *ex-voto* peint en action de grâce: on sait quelles terribles épidémies de peste ravagèrent l'Italie dans ces années et le choix du thème de St. Roch s'explique aisément par les circonstances.[43] De toute façon, le véritable sujet de la peinture, l'acception de la souffrance grâce à la révélation de la foi et à la certitude de la miséricorde divine, cette idée apparaît déjà sur le visage levé vers le ciel du *St. Roch*, dans le dessin de l'album.

Freedberg et Popham, avec une grande finesse, ont bien senti les rapports stylistiques de la figure du *St. Roch* de San Petronio avec celle du St. Jean-Baptiste de Parmesan dans le tableau de la National Gallery de Londres,[44] spécialement dans les versions du *St. Roch* agenouillé du dessin du Louvre.[45] Il est évident que le *St. Roch* debout que nous étudions ici entretient des rapports avec le thème du St. Jean-Baptiste au geste annonciateur. Selon F. Antal,[46] le *St. Roch* de San Petronio de Parmesan se rapproche également du *St. Sébastien* de Pérugin, au visage aussi levé vers le ciel. Mais le véritable précédent du regard du *St.*

[39]Vasari, *Le vite*, v, 226–27: "E fecelo in tutte le parti bellissimo imaginandoselo alquanto sollevato dal dolore che gli dava la peste nella coscia; il che dimostra guardando con la testa alta il cielo in atto di ringraziarne Dio come i buoni fanno eziando delle adversità che loro addivengono."

[40]Le chien n'est pas, en effet, représenté, comme il l'est, le plus souvent, avec le pain dans la gueule, mais regardant St. Roch, près du donateur agenouillé; ce dernier est donc représenté dans la pose du riche Gothard quand son chien l'eût ramené près du Saint dans la forêt (cf. Cavedone, Oratorio San Rocco, Bologne).

[41]*Parmigianino*, 74. Cependant, dans son dernier ouvrage, *Painting in Italy*, 1500–1600 (Harmondsworth–Baltimore, 1971) 144–45, Freedberg—qui ne cite pas, d'ailleurs, le *St. Roch*—est beaucoup plus proche d'une interprétation plus totale de la peinture du Parmesan. Par exemple, à propos du tableau d'autel de la National Gallery de Londres: "There is no overt religiosity in Francesco's altar, there is a high and intense spirituality in its very aestheticism, and this is in effect a private substitute for the devotion that the Roman Church of Clement's time could not command from individuals of Francesco's sophisticated and questing stripe. The spirituality of such individuals might choose uninstitutionalized ways to express itself and in this time of scepticism the making of

aesthetic experience in art became an important one among these ways."

[42]Cet aspect a été bien compris par M. Fagiolo dell'Arco, *Il Parmigianino, un saggio sull' ermetismo del Cinquecento* (Bologne, 1970), 95. A propos du *St. Roch*, dont il rappelle qu'on l'a appelé "contre-réformiste": "Il san Rocco guarda al cielo con la mane al petto: la pala diventa una esaltazione della preghiera, come dimostra anche l'atteggiamento del committente."

[43]Le tableau d'autel esquissé dans le dessin des Offices avait été certainement commandé pour des raisons analogues car le St. Roch est accompagné d'un autre saint "anti-pesteux," le St. Sébastien.

[44]Popham (*Catalogue of the Drawings of Parmigianino*, 18) suppose que l'attitude fléchie du *St. Roch* a été changée pour ne pas être trop semblable à celle du St. Jean-Baptiste.

[45]Ce thème du St. Roch interfère avec celui du St. Paul pour le tableau de Vienne dont les recherches ont été sensiblement contemporaines (cf. pour les dessins Popham, *ibid.*, I, no. 377 recto and verso, II, pl. 219; no. 722, verso, II, pl. 220) et, pour les peintures, Freedberg (*Parmigianino*, 74, 179).

[46]F. Antal, "Un capolavoro inedito del Parmigianino," *Pinacoteca* (I, 1928), 48–53.

Roch est plutôt à rechercher dans la *Ste. Cécile* de Raphaël, alors à San Giovanni in Monte, une des oeuvres remarquables de Raphaël conservée à Bologne et certainement admirée par Parmesan (Fig. 11).[47] C'est sans doute ce tableau, chef-d'oeuvre mystique de l'extase, qui lui a inspiré l'attitude pleine d'une foi totale et ravie. Bien des traits de cette conception d'une union spirituelle intense entre Saint Roch et Dieu tout puissant sont présents dans le dessin inédit du *Saint Roch* où la figure garde aussi le frappant verticalisme de la *Ste. Cecile*.[48] Si, finalement, Parmesan préfére dans la peinture une expression stylistique plus hardie et plus fidèle à la légende, il demeure encore proche de Raphaël car les projets pour le *Jonas* de Lorenzetto à la chapelle Chigi de Santa Maria del Popolo (Fig. 12) ont pu lui inspirer la pose déséquilibrée du *St. Roch* de San Petronio.[49]

Quoiqu'il en soit, le dessin inédit se rattache certainement aux premières recherches en vue du tableau comme le prouve sa comparaison avec le dessin de Besançon et, plus encore, avec le *St. Roch* de Chatsworth, le plus proche de la version définitive. Quant au *St. Roch* de Bonasone, où l'on a pu voir la version perdue du St. Roch debout du Parmesan, il est, certaine-ment, en effet, inspiré du Parmesan, probablement d'une esquisse rapide comme celle que nous étudions ici plutôt que d'une peinture qui, de toute façon, ne serait pas entièrement conforme à la gravure. Il pourrait se rattacher aux esquisses de Besançon avec lesquelles le *St. Roch* de Bonasone présente beaucoup d'analogies.[50]

Probablement le *St. Roch* inédit de l'album n'a pas été peint. Les mentions des peintures de Parmesan de ce sujet dans les anciens inventaires sont peu explicites et ne permettent pas de savoir si elles correspondent à des versions peintes différentes du *St. Roch* de San Petronio.[51]

MUSÉE DU LOUVRE

[47]Freedberg, avec raison, a été intéressé par l'influence de Raphaël sur Parmesan. Par exemple, celle de la *Ste. Catherine d'Alexandrie* (Londres, National Gallery) que Parmesan a peut-être vue à Rome dans la collection Borghese (*ibid.*, 138, n. 37). Copertini (*Il Parmigianino*) parle de celle de l'*Apollon du Parnasse* et de la *Ste. Cécile* (Bologne, Pinacothèque). L'expression du St. Roch traduit très exactement le moment douloureux où le saint est lui-même atteint de la peste: c'est un des aspects essentiels des réprésentations de sa légende (cf. *Les Petits Bollandistes, Vie des saints de l'ancien et du nouveau testament*, IX, 16 août, 619). Ce qui semble, d'ailleurs, avoir frappé les contemporains, c'est davantage l'expression du visage du St. Roch. M.A. Biondo (*Della nobilissima pittura*, 19) parle de l' "aria veramente divina della faccia del Santo" et fait allusion au "picciol quadro" dans lequel Parmesan l'avait étudié et au dessin semblable (appartenant, selon Oretti, aux frères Galli à Bologne). Cette mention pourrait-elle être rapprochée du dessin de Christ Church, Oxford (Fig. 11), (Popham, *Catalogue of the Drawings of Parmigianino*, no. 351, pl. 217)?

[48]Il paraît aussi intéressant de comparer le *St. Roch* du dessin inédit avec le *St. Paul* de Lorenzo Costa (Washington, National Gallery of Art, Kress Collection); cf. F.R. Shapley, *Paintings from the Samuel H. Kress Collection: Italian Schools, XV–XVI Centuries* (New York, 1968), 466, pp. 65–66, fig. 161.

[49]La décoration sculptée de la chapelle Chigi à Santa Maria del Popolo documentée en 1519, puis, de nouveau, en 1521, fut exécutée par Lorenzo Lotti dit il Lorenzetto d'après les dessins de Raphaël. Lorenzetto sculpta seul le *Jonas*, tandis que l'*Élias* fut exécuté en collaboration avec Raffaello da Montelupo qui vint à Rome en 1523. On admet que Raphaël s'est probable-

ment contenté de donner des dessins très précis pour les sculptures. Le dessin de Windsor serait, selon Popham (*Catalogue . . .*, no. 811), une copie d'un projet proche, sans doute exécutée par un peintre. Selon Marabottini, *The Complete Work of Raphael* (New York, 1969), 279, n. 53, "The Collaborators of Raphael": "Only the Jonas respects these drawings"; "In the Jonas we are witnessing the ardent interpretation of forms of Raphael." Il est très vraisemblable que Parmesan, pendant son séjour à Rome, ait vu et admiré un dessin ou même cette sculpture, alors très nouvelle, où revivait l'esprit de recherche audacieux de Raphaël. L'influence de cette statue sur Dosso Dossi a été également soulignée par U. Middeldorf, "Die Dossi in Rom," *Festschrift für Herbert von Einem zum 16 Februar 1965* (Berlin, 1965), 171, fig. 343. Sur les sources du Jonas, peut-être aussi connues de Parmesan, cf. G. Kleiner, *Die Begegnung Michelangelos mit der Antike* (Berlin, 1950) 22–24.

[50]L'attitude et l'expression de la figure dans la gravure de Bonasone et dans des études de Parmesan à Besançon montrent une évolution considérable par rapport à l'attitude statique (et plus traditionnelle) du St. Roch dans l'esquisse du tableau d'autel des Offices (Fig. 5).

[51]Antal, à tort ("Un capolavoro inedito," 55), et aussi A. Ghidiglia-Quintavalle, *Il Parmigianino*. Les "copies" sont, au contraire, correctement analysées par Freedberg (*Parmigianino*, 177). A celles ci, il convient d'ajouter la mention dans l'inven-taire du "Cavaliere Bazardo" (cité par Freedberg, *ibid.*, 239–40) l'esquisse d'un St. Roch en petit. A propos des oeuvres du Parmesan dans la collection Baiardo, cf. A.E. Popham in *Studies in Renaissance and Baroque Art Presented to Anthony Blunt* (London–New York, 1967).

Man and Mirror in Painting: Reality and Transience

JAN BIAŁOSTOCKI

". . . For this same craftsman is not only able to make all implements, but he produces all plants and animals, including himself, and thereto earth and heaven and the gods and all things in heaven and in Hades under the earth." "A most marvellous sophist," he said. "Are you incredulous?" said I. "Tell me, do you deny altogether the possibility of such a craftsman, or do you admit that in a sense there could be such a creator of all these things, and in another sense not? Or do you not perceive that you yourself would be able to make all these things in a way?" "And in what way, I ask you," he said. "There is no difficulty," said I, "but it is something that the craftsman can make everywhere and quickly. You could do it most quickly if you should choose to take a mirror and carry it about everywhere. You will speedily produce the sun and all the things in the sky, and speedily the earth and yourself and the other animals and implements and plants and all the objects of which we just now spoke."

(Plato, *The Republic*, Book x)

The phenomenon of the reflection of the image of nature in the glossy, polished surface of the mirror or of a metallic object like a piece of armor must have been especially fascinating for artists and connoisseurs in the first period of post-medieval art, a time when there was an exceptionally strong awareness that the main purpose of a picture was to be a true rendering of the visual world. The first in recent times to discuss these problems was Millard Meiss, in his pioneering article "Light as Form and Symbol in Some Fifteenth-Century Paintings";[1] later came E.H. Gombrich's study, "Light, Form and Texture in XVth-Century Painting."[2] In a paper of my own some years ago, I concentrated on a specific form of reflection, namely that of luminous windows shown by painters as reflected in the eyes of represented personages.[3] It seems that Albrecht Dürer is probably the painter who should be credited with first having introduced this ingenious device, which soon appeared also in the works of other German painters of Dürer's time, such as Cranach, Pencz, and many others. I tried to show that neither a purely symbolic interpretation of this type of reflection nor a simply realistic one is justified. I am convinced that an awareness of the concept of the eye as window of the human soul may have played a role in the wide acceptance of this formula in Northern art. There exists a classical *topos*, which found its way into Leonardo da Vinci's writings and in which the eye is said to be the soul's window: "l'occhio, che si dice finestra dell'anima."[4]

On the other hand, it seems very probable that the round, convex mirror used by fifteenth-century artists in their studios could have been the source of the representation of

The present essay was given its final form during my stay as Member of the School of Historical Studies at The Institute for Advanced Study, Princeton, N.J., in the spring of 1973. It rightly belongs to Millard Meiss, to whom it is dedicated with gratitude. I am indebted also to Dr. Carl Kaysen, Director of The Institute for Advanced Study, and to the National Endowment for the Humanities.

[1] *Art Bulletin* (XXVII, 1945), 175–81.
[2] *Journal of the Royal Society of Arts* (1/2, 1964), 826–49.

[3] "The Eye and the Window. Realism and Symbolism of Light Reflections in the Art of Albrecht Dürer and His Predecessors," *Festschrift für Gert von der Osten* (Cologne, 1970), 159–76. I tried to show that C. Gottlieb in "The Mystical Window in Paintings of the *Salvator Mundi*," *Gazette des Beaux-Arts* (ser. 6, LVI, 1960), 313–32, overstresses the symbolic meaning.
[4] *Treatise on Painting*, ed. A.P. McMahon (Princeton, 1956), I, 18 (no. 30); II, 8.

window reflections in eyes. The image of an interior with luminous windows reflected in such a mirror may have suggested to the artists the idea of representing the curved reflection of windows on the spherical surface of the human eye.

In the present paper, I should like to continue this investigation into mirror images and reflections by taking into consideration the role that they played in Renaissance and Baroque painting, especially in portraits. The material is not unknown, most of the pictures which I shall discuss having been analyzed in an interesting book by Gustav Hartlaub, as well as in more recent articles by Heinrich Schwarz and W.M. Zucker.[5] I hope, however, to consider the problems of reflections and mirror images from a different point of view, taking into account not only their symbolic but also their artistic function.

When we turn our attention from the artistic scene in Northern Europe and look toward Italy, we are amazed to find that the interest in light reflections on glossy surfaces, as well as in mirror images, is limited in the fifteenth century to the Northern schools of painting. On the other hand, we are well aware that it was in Italy that the precise theory of perspective was elaborated and that the work of art itself came to be considered as the mirror image of the artist's soul. The Neoplatonic philosophy current in Florence and Italy in the second half of the fifteenth century conceived of the soul as mirrored in the body; thus, Marsilio Ficino wrote: "In paintings and buildings the skill of the artist shines forth. Moreover, we can see in them the attitude and the image, as it were, of his mind; for in these works the mind expresses and reflects itself not otherwise than a mirror reflects the face of a man who looks into it."[6] Nevertheless, in practice Italian artists rarely employed light reflections and mirror images before the early decades of the sixteenth century, and even then it was almost exclusively in Northern Italy that they might be found. It seems that Jan van Eyck should be credited with the discovery of the artistic value and use of light phenomena and reflections, while in Italy the artist who first understood them and possessed the means to introduce them into his paintings was Giorgione.

It is certainly not necessary to dwell here upon the role of the mirror in the *Arnolfini Portrait*,[7] but its fundamental importance may be gauged by the numerous imitations of it in Netherlandish works of the fifteenth century. In van Eyck's masterpiece, the mirror surrounded by episodes of the Passion of Christ reflects the figures of Giovanni Arnolfini and his wife and shows the episode represented from the side opposite to the one from which the beholder of the picture sees it. The mirror not only shows this opposite view, it also shows more than is depicted in the painting itself: besides the figures of Arnolfini and his wife, seen from the rear, there appear two small figures in the open door, and it is obvious that these figures are

[5] G. Hartlaub, *Die Zauber des Spiegels* (Munich, 1951); H. Schwarz, "The Mirror in Art," *Art Quarterly* (XV, 1952), 97–118; idem, "The Mirror of the Artist and the Mirror of the Devout," *Studies in the History of Art Dedicated to William E. Suida* (London, 1959), 90–105; W.M. Zucker, "Reflections on Reflexions," *Journal of Aesthetics and Art Criticism* (XV, 1962), 239–50; H. Schwarz, "Schiele, Dürer and the Mirror," *Art Quarterly* (XXX, 1967), 210–23. Regarding the widespread practice of using convex mirrors in artists' studios see also D. Gioseffi, "Complementi di prospettiva, 2," *Critica d'Arte* (V, 1958), 102–05.

[6] *Theologia Platonica*, in *Opera omnia* (Basel, 1576), quoted in English translation by E.H. Gombrich, "Botticelli's Mythologies," *Journal of the Warburg and Courtauld Institutes* (VIII, 1945), 59.

[7] E. Panofsky, "Jan van Eyck's *Arnolfini* Portrait," *Burlington Magazine* (LXIV, 1934), 117–27; dealing more specifically with the role of the mirror, W. Hager, "Ein Spiegelmotiv bei Jan van Eyck und das gotische Raumsymbol," *Münstersche Forschungen* (IX, 1955), 41–70. The traditional identification has recently been shown to rest on weak ground; see P.H. Schabacker, "De Matrimonio *Ad Morganaticam Contracto*: Jan van Eyck's 'Arnolfini' Portrait Reconsidered," *Art Quarterly* (XXXV, 1972), 375–98.

placed at the point from which the scene represented in the picture was viewed; one of them is very likely the painter himself. These onlookers also participate in the action—if what is going on in the *Arnolfini Portrait* may be called an action at all. In a work by Jan van Eyck, the mirror is not merely a decoration, a symbol, or a means of demonstrating the artist's technical ability to represent glass and its technical effects. It is a second image, a picture within the picture, and it helps such an unsurpassed master as Jan van Eyck give us as complete a view as possible of the section of space represented, and the action taking place within it.

The *Arnolfini Portrait* is dated 1434. It must have become famous immediately. Four years later, a representative of a slightly earlier generation, Robert Campin, the so-called Master of Flémalle, inserted the round, convex mirror, with an almost identical function, into his last known picture, dated 1438. It must have been like a confession of faith, a symbolic act of adherence to van Eyck's pictorial program. In the left wing of the Werl Triptych in the Prado, of which the central part is missing, the round mirror reflects the room, St. John, and two tiny figures, one smaller than the other, who obviously represent the painter and his young assistant.[8] The donor, screened by the open door, is excluded from the reflection in the mirror, as if not admitted to the intimate world of art.[9] The compositional and illusionistic function of the mirror is here similar to that which it had in van Eyck's picture, but it lacks the evidential, logical necessity that requires its appearance in the *Arnolfini Portrait*. It is more a "respectful quotation"—to use Panofsky's words—than a necessary element in the painting.

For the early Netherlandish masters, reflections and mirror images constituted powerful instruments that they used to make their pictures the most complete, fullest reproductions of the three-dimensional world. These devices allowed them to connect various elements represented within the picture frame, as well as others that are only implied and not directly accessible to view. One observes such solutions time and again in works by Jan van Eyck, Hugo van der Goes, and Hans Memling. In van Eyck's *Van der Paele Madonna*—one of the first *sacra conversazione* pictures—a colorful reflection of the painter's figure has been detected by David Carter on St. George's armor, to the right of the donor.[10] Here, too, as in the *Arnolfini Portrait*, van Eyck has enriched the representation by showing in the reflection something that is lacking within the picture but is implied as existing outside the represented space—his own image.

In the second half of the fifteenth century, this artful way of using the mirror to build up a full and consistent representation of space recurs in works by Hans Memling. In his early masterpiece, the triptych of the *Last Judgment* in Gdańsk (finished before 1473), the reflections and mirror images already play an essential role.[11] In spite of the recent attempt by the late K. McFarlane (endorsed by the late Edgar Wind) to exclude the triptych from the catalogue of Memling's certain works,[12] I do not see enough evidence to support this criticism of the generally accepted attribution. In any case, it may be said that precisely this splendid

[8]M.J. Friedländer, *Early Netherlandish Painting*, II (Leyden–Brussels, 1967), no. 67, pl. 96.

[9]I doubt whether this mirror should be interpreted as a Mariological symbol, as H. Schwarz proposed in "The Mirror in Art," 100; he assumes that the circular mirror in the Werl Altarpiece alludes to the message of "the voice crying in the wilderness" and its fulfillment through the Virgin and Christ.

[10]D.G. Carter, "Reflections in Armor in the 'Canon van der Paele Madonna,'" *Art Bulletin* (XXXVI, 1954), 60–62.

[11]J. Białostocki, *Musées de Pologne. Les Primitifs flamands*, I. *Corpus . . .* (Brussels, 1966), 55–123. I am glad to be supported in my opinions by C. Cuttler in his review of McFarlane's book, *Art Bulletin* (LV, 1973), 296–97.

[12]*Hans Memling*, ed. by E. Wind (Oxford, 1971).

use of Eyckian optical effects by the painter of the Gdańsk *Last Judgment* seems to constitute an additional proof of Memling's authorship—if not in the first conception of the work, at least in the actual realization of its execution. Van der Weyden, to whom alone the general concept of the triptych could be credited if Memling's authorship were doubted, as well as Dirk Bouts (recently proposed as having possibly executed the altarpiece), were both much less inclined than Memling to use the Eyckian language of light reflections.[13] In the lower part of the central panel, the whole foreground of the scene is reflected in the armor of St. Michael, who holds the balance, as seen from his point of view (Fig. 1). In the crystal sphere on which rest the feet of the Supreme Judge, the same view can be observed, seen, however, from the vantage point of Christ in Judgment (Fig. 2).[14] It is a characteristic of these reflections that, in contrast to those in van Eyck's pictures, they do not add anything that is not shown in the triptych, but rather combine everything that is going on in the three panels of the triptych into a synthetic view projected onto the spherical surface.

It is only through a knowledge of reflection effects and mirror images such as those in Memling's *Last Judgment* that we can understand the enigmatic representation in Juan de Flandes's *St. Michael and St. Francis* in The Metropolitan Museum of Art (Fig. 3).[15] In this panel, the figure of St. Michael, like that of St. Francis, is shown standing in a niche, and although he "thrusts his cruciform lance through the muzzle of a capricious dragon at his feet," he does it "almost reluctantly," and "his festive, disarming appearance here stresses the purely ceremonial nature of the combat," to quote Colin Eisler's words.[16] Extracted from the scene of the Last Judgment, St. Michael has nevertheless preserved intact the reflection of the background from which his figure has been removed and transferred to its position against the festive gold wall and its niche. In the convex, burnished steel face of the Archangel's shield a mysterious ruined and burning town or fortress is seen through iron rods (Fig. 4). Eisler supposes that "the reflected fortress may perhaps allude to St. Michael's role as militant protector of the children of the Lord."[17] It seems obvious, however, that what we see here is the reflection of Hell, the *Città di Dite* or city of the damned, as seen through the iron rods of its famous gate from the central place of action of the Last Judgment. Since Paradise was always shown on the left, at the right hand of the Supreme Judge, and Hell at the right, to His left, the shield of St. Michael, which is turned to the right, reflects the view of Hell. Translated from the realism of Netherlandish art into the more symbolic and conventional idiom of Spain, it still betrays its origin by its striking similarity to the curved images shown by early Netherlandish painters in the mirrors they represented. A similar mirror reflection of Hell appears in the shield of St. Michael, also turned to the right, in the retable, now in the Museo Diocesano at Salamanca, originally painted by Juan de Flandes to be placed in a niche

[13]See also my discussion of the problem in "Sąd Ostateczny Hansa Memlinga. Spostrzeżenia i analizy w oparciu o badania technologiczne," *Rocznik Historii Sztuki* (VIII, 1970), 7–46.

[14]See Białostocki, *Musées de Pologne*, pl. LXXXVI and CXXXII.

[15]No. 58.132. See C.R. Post, *A History of Spanish Painting*, IV¹ (Cambridge, Mass., 1933), 41; XII² (1958), 615–30; E. Bermejo, *Juan de Flandes* (Madrid, 1962), 31–32, 44. For the photographs and bibliographical references I am indebted to Dr. Everett Fahy, then Curator of European Paintings at The Metropolitan Museum of Art (now Director of The Frick Collection).

[16]"Juan de Flandes's Saint Michael and Saint Francis," *Metropolitan Museum of Art Bulletin* (XVIII, 1959), 129–37.

[17]*Ibid.*, 131.

above the tomb of Diego Rodriguez in the Old Cathedral of Salamanca.[18] In a picture by an anonymous Spanish master of about 1480 in the Prado (no. 1326), the shield of St. Michael reflects not only demons and angels but also the figure of a man who seems to be the painter, shown working at his easel (Fig. 5).[19]

Later in his career, Memling was still interested in the possibilities inherent in the use of mirror reflections. In the diptych of about 1485, now in The Art Institute of Chicago, which represents the Virgin and Child at the left and a donor at the right, he showed in the background wall a window, divided between the two panels.[20] The round, convex mirror hanging on the left wall, close to the Virgin, shows the window as a single element, thus providing a reconstruction of the entire scene represented.

A much more complicated function was given by Memling to the mirror in the outstanding work of his maturity, the so-called *Nieuwenhove Diptych* of 1487, the left panel of which represents the Virgin and Child and the right one the donor, Martin van Nieuwenhove.[21] The space in which the figures are situated has been organized in a special way: in the left wing, the Virgin is shown frontally against a window frame set in the wall parallel to the picture plane; on the right wing, the donor, turned in three-quarters view, is shown kneeling with hands folded in the gesture of prayer, in front of a foreshortened wall perpendicular to the one behind the Virgin. Obviously, what one sees is the corner of a room. The two panels of the diptych thus show a single image, but one with rather complicated spatial relations. Any doubt as to their exact interpretation, however, can be dispelled by noting the reflection of the scene in the round mirror visible behind the Virgin, which shows a rear view of the Madonna and the donor within a unified space. Once again, the mirror links together what is represented separately on the two wings of the diptych.

It is true that quite often the round mirror performed a purely symbolical function, which has been studied by Schwarz and Hartlaub. It could have a religious meaning, as does the mirror held in the hand of the Christ Child in Nicolas Froment's *Triptych of the Burning Bush* in Aix-en-Provence.[22] The Virgin and Child seated in the treetop are reflected in this mirror, possibly denoting a *Speculum sine macula*, which frequently appears in allegorical pictures of the Immaculate Conception and other Mariological representations.[23] It could have a moralistic meaning, as it has in the *Vanitas* by Hans Memling or his close imitator, part of an altarpiece preserved in the Musée des Beaux-Arts in Strasbourg, in which the head of a nude girl is reflected in a mirror that she holds in her hand.[24] Such an overt moralistic meaning is conveyed by the mirror in the portrait of the painter Hans Burgkmair and his wife by Laux Furtenagel.[25] The faces of the pair appear as death's-heads in the convex mirror held by the

[18]*Ibid.*, 133–34. The suggestion that St. Michael's shield in the New York panel "carries the image of what may be a city or perhaps a reflection of the depths of Hell" was made in the "Eighty-Ninth Annual Report of the Trustees for the Fiscal Year 1958–59" in the same volume of the *Bulletin of The Metropolitan Museum of Art* as that in which Eisler's article appeared (p. 37) but was not mentioned in his text.

[19]I am indebted to Dr. Alfonso L. Perez Sanchez of the Prado for the photograph of this work and permission to reproduce it.

[20]M.J. Friedländer, *Early Netherlandish Painting*, VI, I Leyden–Brussels, 1971), no. 50, pl. 98, p. 52.

[21]*Ibid.*, no. 14, pl. 52–53, p. 47.

[22]C. Sterling, *La Peinture française. Les Peintres du moyen-âge* (Paris, 1942), no. 60. pp. 33–34.

[23]H. Schwarz, "The Mirror in Art," 99, sees it as a symbol of virginity.

[24]M.J. Friedländer, *Early Netherlandish Painting*, no. 21, pl. 63, pp. 48–49.

[25]L. Baldass, "Laux Furtenagels Bildnis des Ehepaares Burgkmair," *Pantheon* (XVII, 1936), 143–47. See also G. von der Osten, "Lukas Furtenagel in Halle," *Wallraf-Richartz Jahrbuch* (XXXIV, 1972), 105–18.

lady; here, the mirror stands for self-knowledge, as declared by the German inscription *Erken dich selbs*. This knowledge is, of course, understood to be the recognition of human transience.

But no less numerous are examples of the use of the mirror for artistic rather than symbolic purposes. In many pictures of the fifteenth and early sixteenth centuries, the image reflected in the mirror completes, explains, and enriches the composition. If in van Eyck and Campin the mirror images give a view of the complete interior, in the *St. Eloy* by Petrus Christus the mirror serves to complement the interior view with a representation of the exterior. The spectator is conceived as situated outside, in front of the parapet of the shop window, and he sees what is inside as well as what goes on behind his back in the street. The mirror is an instrument of knowledge, and—since what is reflected in it has a moral significance—of moral knowledge, too.[26]

The round, convex mirror in its function as a source of knowledge must have been considered a suitable element in the furnishings of the study of a humanist, as we may conclude from the Cracow epitaph of Filippo Buonaccorsi, called Callimachus, made in the Vischer workshop after a design by Veit Stoss. A round mirror is placed there together with books, papers, inkwells, scissors, and pens.[27] The mirror still appears as symbol of knowledge, and by implication of truth, in Ripa's *Iconologia*, where it stands for Truth (*Verità*) as well as for self-knowledge.

Petrus Christus's device was picked up by Quentin Massys in his well-known picture in the Louvre showing a banker and his wife; in this, the townscape appears in the window reflection visible in the mirror. We also see a man, who is shown inside, close to the window, and who Hartlaub believes may be Massys himself. According to Schwarz, both Christus and Massys used the mirror symbolically, but it does not seem necessary to assume this.[28]

There exists another picture attributed to Massys, in the Samuel H. Kress Collection of the North Carolina Museum of Art at Raleigh, which poses an interesting problem of symbolical interpretation. The crystalline orb held by the *Salvator Mundi* reflects not only His blessing hand but also the skyline of a northern fortified town (Fig. 6).[29] Just as in St. Michael's shield, in the paintings by Memling and Juan de Flandes, the devil's city is represented, so in the globe held by Christ we catch the glimpse of the city of eternal bliss, the *Civitas Dei*. That it assumes the shape of a Netherlandish town of Massys's time is not astonishing; earlier, in Dürer's *Apocalypse*, the Heavenly Jerusalem is represented in the form of a contemporary German town.

[26]In a recent study of the iconography of the Christus picture by P.H. Schabacker, "Petrus Christus' Saint Eloy: Problems of Provenance, Sources and Meaning," *Art Quarterly* (xxxv, 1972), 103–20, the author opposes the "positive" interpretation of St. Eloy's mirror, finding in it cracks and water stains; "the two elegant young bachelors" reflected in it, "idling along with their falcon, time-honored symbol of the leisure class," seem to indicate the negative and worldly meaning. According to Schabacker, the picture was painted for the altar of the goldsmiths in the chapel of the smiths, to which the goldsmiths also belonged; the moralistic point was probably directed toward the customers with whom they always dealt.

[27]P. Skubiszewski, *Rzeźba nagrobna Wita Stwosza* (Warsaw, 1957), 77–97.

[28]According to G. Marlier, *Erasme et la peinture flamande de son temps* (Damme, 1954), 240, the figure of a man reading shown in the mirror "symbolizes the contemplative life that alone leads to a proper moral conduct. This is precisely the path that has been abandoned by the money changer and especially by his wife, who turns her attention away from her prayer book in the direction of more immediate rewards." (I repeat the English summary given by Schabacker, "Petrus Christus' Saint Eloy," 111.)

[29]*The Samuel H. Kress Collection, North Carolina Museum of Art* (Raleigh, N.C., 1965), 126f.

The mirror motif reappears in portraits by Jan Gossaert, Maerten van Heemskerck, and the German Master of the Aachen Altarpiece, who very early ingeniously took advantage of the mirror to show a three-quarters as well as a profile view of the merchant Hans von Melem, in a painting in Munich.[30] This tradition seems to have been continued later in some double or triple views included in seventeenth-century portraits, such as Van Dyck's *Charles I* or Rigaud's *Mother*, and it obviously reappears in seventeenth-century Dutch portraits, for example Ter Borch's *Lady* in The Detroit Institute of Arts.[31]

It is striking that the round, convex mirror does not appear in Italian pictures and does not play in Italian art the ingenious role given to it by Netherlandish artists. It does not hang in the studies shown by Antonello da Messina in his *St. Jerome* in London, or by Carpaccio in his *St. Augustine*. Hartlaub suggests that the Italians were dissuaded from representing reflections in convex mirrors because of the distortions, which they must have considered disturbing. This may have been among the possible reasons accounting for their absence; but even when we meet a case in which an Italian artist represented a round mirror, it does not play any role in the creation of an illusionistic effect but is given a purely symbolic meaning. I refer to the *Allegory of Vanitas-Prudentia* by Giovanni Bellini in the Accademia at Venice, a small picture that formed part of the frame of an actual mirror (Fig. 7). The nude figure of *Prudentia* standing on a pedestal holds a round, convex mirror in which the image of a demon appears.[32] The mirror introduces a moral element without adding to the visual experience in pictorial terms.

What is more, we know how much the Italians were fascinated by Netherlandish representations of mirrors and their integrating or complementary functions. No Northern European source has preserved a written record of the interest in this play of reflections and mirror images; but instead there is a known Italian source, namely a paragraph from Bartolommeo Fazio's *De viris illustribus*, in which is described a picture by Jan van Eyck, then in the collection of Ottaviano della Carda, a nephew and counsellor of Federigo da Montefeltro of Urbino. Van Eyck showed "women of uncommon beauty emerging from the bath, the more intimate parts of the body being with excellent modesty veiled in fine linen, and of one of them he has shown only the face and breast but has then represented the hind parts of her body in a mirror painted on the wall opposite, so that you may see her back as well as her breast." After having described some other details of the picture, Fazio returns again to the mirror: "But almost nothing is more wonderful in this work than the mirror painted in the picture, in which you see whatever is represented as in a real mirror."[33]

Nothing was more admired by this Italian critic than the mirror and the reality reflected in it. We nevertheless do not find such effects in Italian painting. Why did the Italians, who admired them in Netherlandish paintings, not apply them in their own pictures? What could

[30]Reproduced by Schwarz, "The Mirror of the Artist," fig. 4, p. 93.

[31]S. J. Gudlaugsson, *Gerard Ter Borch* (The Hague, 1959), I, fig. 165 (in the collection of P.E.C. Harris); II (1960), no. 165, p. 169.

[32]G. Ludwig–F. Rintelen, "Venezianischer Hausrat zur Zeit der Renaissance: Restello, Spiegel und Toilettenutensilien in Venedig zur Zeit der Renaissance," *Italienische Forschungen*, I

(Berlin, 1906), 169–361; G.F. Hartlaub, "Die Spiegelbilder des Giovanni Bellini," *Pantheon* (XXIX, 1942), 23–41; E. Wind, *Bellini's "Feast of the Gods"* (Cambridge, Mass., 1948), 48; R. Pallucchini, *Giovanni Bellini* (Milan, 1959), 146; G. Robertson, *Giovanni Bellini* (Oxford, 1968), 103–06 (on p. 105, he admits the Eyckian influence on this picture by Bellini).

[33]Fazio's text is quoted by M. Baxandall, *Giotto and the Orators* (Oxford, 1971), 107.

have been more suitable for the art concept formed by Florentine artists of the first half of the fifteenth century, as known to us from Alberti's treatises? Why do no mirrors, and almost no reflections of light, appear in works by Uccello and Castagno, even those in which armored knights are represented?

We know from written sources that Brunelleschi introduced mirrors into his famous first pictures (now lost), in which the principles of mathematical perspective were used, and which represented respectively the Florentine Baptistery and the Piazza della Signoria with the Palazzo Vecchio. But in these pictures, the mirrors were real. Brunelleschi connected his compositions of architecture, drawn in perfect perspective, with actual mirror surfaces; the painted buildings were mounted on a mirror background.[34] They had only to be inclined in the right way to obtain a reflection of the sky in the mirror; above the illusion of the precisely rendered architecture shone an authentic blue sky, with actual clouds passing. But the mirror was not *in* the picture; in Brunelleschi's works, it became an element *of* the picture. It created an effect of illusion, but it was an effect foreign to the ambitions of quattrocento painting, which sought the illusion that was created by the painter's means and built up by his imagination and skill.

It seems possible to discover the reason that the Italians did not paint light reflections and mirror images in their lack of experience in the oil-painting technique. It was only at the end of the fifteenth and in the early sixteenth century, when the knowledge of the Northern technique became current, that there appeared in Italian art what Leonardo da Vinci called *il lustro*—light reflections on vessels and pieces of armor, as well as the reflection of reality in mirrors. It is true that, at the same time, flat mirrors came into use. From that moment on, the Italian Renaissance attained full mastery of painterly illusion, which was added to the current repertoire of quattrocento art—its classical motifs.

As representative of this double aspect of the Renaissance, let us consider the elements that appear in the foreground of Titian's early painting in Antwerp. Count Pesaro, kneeling before St. Peter, is being recommended to him by Pope Alexander VI. Below is a classical relief, seemingly the front of a Roman sarcophagus, and on the ground is placed a metallic helmet, in which is reflected a motif typical of the Netherlandish interest in the rendering of light—a luminous window. The ability to use the classical language and to represent gesture, movement, and expression has here been linked with the adaptation of the Netherlandish language of art, which opened up to the painter the world of differentiated matter, mat and glossy. At the same time, the introduction of reflecting mirrors opened up the possibility of adopting new points of view to enrich the vision of painting.

Netherlandish elements had already appeared in Urbino in works by Justus van Ghent and under his influence. The helmet of Federigo da Montefeltro in his portrait in Urbino shines in a Netherlandish way, as does his armor in Piero della Francesca's altarpiece in the Brera,[35] but it was only at the turn of the century, and first of all in Northern Italy, in Venice

[34]For the fifteenth-century description, see A. Manetti, *The Life of Brunelleschi*, ed. H. Saalman (University Park–London, 1970), 43–47; the most recent study of the problem is S. Y. Edgerton, Jr., "Brunelleschi's First Perspective Picture," *Arte Lombarda* (XVIII, 1973), 172–95.

[35]On the latter, see M. A. Lavin, "Piero della Francesca's Montefeltro Altarpiece: A Pledge of Fidelity," *Art Bulletin* (LI, 1969), 367 n. 4, 368 n. 14, in which it is noted that the armor includes the reflection of a mirror.

and Lombardy, that the influence of Netherlandish pictorial ideas was felt strongly. It was there also that, in the early sixteenth century, light reflections and mirror images acquired their greatest importance; in Raphael's portraits of the popes, they are fairly marginal.[36]

We have mentioned Bellini's *Allegory*, in which the round, convex mirror was displayed. The same painter used (probably as the first Italian master to do so) the mirrored view from the rear, in his *Girl at Her Toilet* (sometimes called *Venus*) in Vienna.[37] The graceful nude arranging her hair is shown from the front; we have, however, a glimpse of her hair from behind, reflected in a round but flat mirror situated in back of her, while she gazes at this reflection in another small mirror held in her hand. Here it seems that Bellini discovered the possibilities inherent in the Netherlandish use of mirrors; and it seems that the most outstanding master of the following generation, Giorgione, considered the ability to represent mirror images as an important argument in the dispute about the superiority of the arts, of so great concern at that time. For Giorgione, it was precisely this ability that was decisive proof of the superiority of painting over sculpture. His opinions on this subject have been recorded by Paolo Pino in his *Dialogo di pittura* of 1548[38] and by Vasari in his life of Giorgione. We learn from Pino that Giorgione painted a figure of St. George standing in water in which his figure was reflected, while side views of him might be seen in two mirrors placed on trees. Whereas this report describes a rather artificially invented subject, the story told by Vasari seems to be not only more reliable but also to have initiated some imitations of Giorgione's ideas. Vasari writes:

> It is related that Giorgione, at the time when Andrea Verrocchio was making his bronze horse, fell into an argument with certain sculptors, who maintained, since sculpture showed various attitudes and aspects in one single figure to one walking round it, that for this reason it surpassed painting, which only showed one side of the figure. Giorgione was of the opinion that there could be shown in a painted scene, without any necessity for walking round, at one single glance, all the various aspects that a man can present in many gestures—a thing which sculpture can not do without a change of position and point of view, so that in her case the points of view are many, and not one. Moreover, he proposed to show in one single painted figure the front, the back, and the profile on either side, a challenge which brought them to their senses; and he did it in the following way. He painted a naked man with his back turned, at whose feet was a most limpid pool of water, wherein he painted the reflection of the man's front. At one side was a burnished cuirass that he had taken off, which showed his left profile, since everything could be seen on the polished surface of the piece of armor; and on the other side was a mirror, which reflected the other profile of the naked figure; which was a thing of most beautiful and bizarre fancy, whereby he sought to prove that painting does in fact, with more excellence, labor, and effect, achieve more at a single view of a living figure than does sculpture. And this work was greatly extolled and admired, as something ingenious and beautiful.[39]

No trace of these projects or of the picture described by Vasari has come down to us in surviving works by Giorgione, although the flashes of light captured on the armor of St.

[36]Recently these problems have been discussed by K. Schwager, "Über Jean Fouquet in Italien und sein verlorenes Porträt Papst Eugens IV," *Argo. Festschrift K. Badt* (Cologne, 1970), 206–34, especially p. 213.
[37]Pallucchini, *Giovanni Bellini*, 158 (signed and dated 1515).

[38]Edited by P. Barocchi, *Trattatti d'arte del Cinquecento*, I (Bari, 1960), 131.
[39]*Lives of the Most Eminent Painters* . . ., trans. by G. Du C. de Vere (London, 1912–1914), IV, 112.

Liberale in the *Castelfranco Madonna* prove the extent of his interest in such effects and his ability to represent them. In Mantegna's works, an interest in such motifs is already clearly visible, but it was only in Titian's pictures that they became current and developed into essential elements of his paintings.

In the Washington *Venus*, the goddess's body is reflected in a mirror held by two *amorini*.[40] In the Louvre picture of 1512–1517, called *Young Woman Doing Her Hair*, the role of the mirror is exceptionally important (Fig. 8).[41] The girl is turned toward the spectator, her head inclined to her left, and she is separated from the picture plane by a parapet on which stands a bottle of oil. Her left hand is placed upon this. Close to her, in the darkness, is the figure of a man, who presents to her a small rectangular mirror, toward which the girl directs her gaze. His other hand reposes on a large round, convex mirror, which hangs or stands behind the girl's back. We do not see what she perceives in the small mirror, but it must be a reflection of what is represented in the picture (although Panofsky supposes some vision of transience to be shown her).[42] We see, however—although not quite clearly—the reflection in the large round mirror, and it seems to fulfil at least in part Giorgione's program. In the very dark mirror image, we can see the decolletage of the girl's back and the clear shape of a window, partly covered by her head—precisely the window through which we are looking into the room. Farther to the right, dark shapes difficult to interpret suggest that there exists still something else in the reflection; it seems to be a human figure. Is it the artist himself? In Titian's picture, the Netherlandish effect, realized according to Giorgione's prescription, has become the main motif of the composition. What does it mean? Is it only an illusionistic device to show the power of painting, according to Giorgione's argument? Or is it already, as proposed by Panofsky, the attribute of *Vanitas*, so popular in later times? Can we interpret the *Young Woman Doing Her Hair* as a representation of the sinful Magdalene?[43]

When the Venetians developed the skill to represent reflections and the shine of light, when they learned how to show objects of glass and metal in a really convincing way, they acquired a new means for symbolical expression. Hieronymus Bosch, who took advantage of the experience of several generations of Netherlandish painters, knew how to paint on the reverse of the wings of his *Garden of Delights* in the Prado the Creation of the World, enclosed within a glass sphere on which are seen shining reflections of the transcendent light coming from beyond the newly created cosmos.[44] We do not encounter such representations in Italian art. Titian was the first who knew how to paint in a suggestive way a glass sphere in the hands of a young woman, one of the figures in the picture in the Louvre called *The Allegory of the*

[40]See S. Poglayen Neuwall, "Titian's Pictures of the Toilet of Venus and Their Copies," *Art Bulletin* (XVI, 1934), 358–84; idem, "Eine tizianeske Toilette der Venus aus dem Cranach-Kreis in Zusammenhang mit verwandten Darstellungen Tizians und der Kopien," *Münchner Jahrbuch für bildende Kunst* (N.F. VI, 1929), 167–99; idem, "The Venus of the Ca d'Oro and the Origin of the Chief Types of the *Venus at the Mirror* from the Workshop of Titian," *Art Bulletin* (XXIX, 1947), 195–96.

[41]E. Panofsky, *Problems in Titian, Mostly Iconographic* (New York, 1969), 91ff. Cf. also E. Verheyen, "Tizians 'Eitelkeit des Irdischen'; Prudentia et Vanitas," *Pantheon* (XXIV, 1966), 88–99. For the workshop replica of the Louvre picture in the collection of the Castle in Prague, see J. Neumann, *La Galerie de tableaux du Château de Prague* (Prague, 1967), 295–304.

[42]Panofsky, *Problems in Titian*, 93.

[43]*Ibid.* In the recently discovered picture by Caravaggio now in the Detroit Institute of the Arts, the mirror plays an important artistic, rather than symbolic, role. See F. Cummings, "Detroit 'Conversion of the Magdalen' (The Alzaga Caravaggio), 3. The Meaning of Caravaggio's 'Conversion of the Magdalen,'" *Burlington Magazine* (CXVI, 1974), 572–78, especially 576f.

[44]P. Reuterswärd, *Jheronimus Bosch* (Stockholm, 1970), 278–80. E.H. Gombrich, "H. Bosch's 'Garden of Earthly Delights': A Progress Report," *Journal of the Warburg and Courtauld Institutes* (XXXII, 1969), 162–70, suggests that Bosch represented the Earth after the Deluge, but the inscription clearly refers to the Creation.

Marquess del Vasto.[45] In the Marquess's armor, the face of the other allegorical figure is reflected. The whole magic of reflections and mirror images that interconnect the elements of a composition has been adopted here by the great Venetian master.

The most unusual example of the obsession with mirrors to be found in North Italian painting of the sixteenth century is the *Portrait of a Man* by Savoldo in the Louvre, traditionally called Gaston de Foix (Fig. 9).[46] It has already been proposed by others,[47] and it seems to be obvious, that this picture derives from the one by Giorgione that Vasari described. A man is seated behind a table, resting on it with his right elbow; he is turned in three-quarters view toward the spectator, with one hand stretched backward into the picture space. Two mirrors, placed in front of us to the left and in the background, almost completely fill the shallow space of the composition. They meet at a 90° angle and repeat the image of the represented man. In the mirror to the left, he is shown from the rear, and in profile in the mirror in the center. It would indeed be difficult to make a better reconstruction of Giorgione's pictorial idea; only the water is lacking, but there is plenty of armor. The knight wears only those pieces that protect his breast and hips; the upper part, with a metallic collar, as well as the arm plates, rests in disorder on the table. Precisely as in Giorgione's lost picture, this armor repeats on its glossy surfaces the elements of the representation—for instance, the right hand of the knight, clearly reflected in the breastplate at the lower right of the picture.

It seems that Savoldo's portrait is a paramount expression of the fascination with the effects of reflections and mirror images in painting. But in Venetian art this tradition sometimes served not only for a display of skill, but also for narrative purposes. Tintoretto's *Venus, Vulcan, and Cupid*, with Mars under the bed (Munich; dated by Hans Tietze about 1550),[48] is an example of the way in which a Venetian painter used the Netherlandish idea of a mirror image as a picture-within-a-picture. We are given two views of the same scene, since the action is duplicated by the circular mirror placed on the rear wall of the room. On the other hand, in this picture the mirror is essentially connected with the theme. As Carla Lord has shown, it appears in the story as told in the *Roman de la Rose*, in which the deceptive value of the mirror is stressed.[49]

The great period of the mirror, of course, was to come later. In the Renaissance, it was used in order to absorb the visual content of the world in the best possible way. In the Baroque period, the difference between the object and its reflection became unimportant. The borderline between reality and fiction was not essential in a period so greatly concerned with transience; on the contrary, the mirror, which produced an image that was ephemeral *par excellence*, became the most important symbol of *Vanitas*. Actual mirrors were used to decorate interiors, substituting a mere shine for reality. The Galerie des Glaces in Versailles

[45]A thorough discussion of this picture is found in E. Panofsky, *Studies in Iconology* (New York, 1939), 160–64.

[46]See A. Boschetto, *Gian Gerolamo Savoldo* (Milan, 1963), text facing pl. 30.

[47]C. Gilbert, "Milan and Savoldo," *Art Bulletin* (XXVII, 1945), 129; however, he quotes only the text of Pino and not that of Vasari; both sources are obviously later than Savoldo's picture, which is usually dated in the period of the Treviso altarpiece, i.e., about 1521, as noted by Boschetto. The connection is also pointed out by Hartlaub, *Die Zauber des Spiegels*,

and restated by Gilbert in "Alvise e compagni," *Scritti in onore di Lionello Venturi* (Rome, 1956), I, 307.

[48]*Tintoretto* (London, 1948), 356.

[49]"Tintoretto and the Roman de la Rose," *Journal of the Warburg and Courtauld Institutes* (XXXIII, 1970), 315–17. It is strange that Hartlaub, *Die Zauber des Spiegels*, 106, should have suggested that the mirror does not belong in the painting; the passage from the *Roman de la Rose* (ed. Paris, 1538, CCCXXXVIII) quoted by Lord shows how integral a part the mirror is in that version of the story.

was designed so as to repeat illusionistically the actual view of nature surrounding the palace, making reality appear as dubious as its mirror image.[50]

Georges de la Tour developed variations on the theme of St. Mary Magdalene in several pictures.[51] The current symbols of transience—death's-heads, candles, and books—are reflected in the saint's crystalline mirrors. Perhaps even in Velázquez's otherwise so sensual *Venus with the Mirror* the glass has a similar meaning, placed as it is close to the most transient beauty, that of the human body. But after all, here we are dealing with a classical goddess; a different situation is created when what appears to the spectator in the context of a *Vanitas* is his own image.

An actual framed mirror of the seventeenth century, Dutch or German, is to be found in the Museum of Fine Arts in Boston (Fig. 10).[52] At the bottom of the mirror's surface a *Vanitas* still-life is painted—a composition of books and a death's-head, symbols of transience. Everyone who stood before that mirror could behold his own image, encompassed, as it were, by the symbols of *Vanitas*. But his own effigy was itself transient and disappeared whenever he moved out of the visual range of the mirror. What remained then was the *Vanitas* painted on its surface, as if to point out—the real paradox—that the symbols of transience are lasting, while reality is ephemeral and devoid of any imperishable existence.

UNIWERSYTET WARSZAWSKI

MUZEUM NARODOWE W WARSZAWIE

[50]P. Moisy, "Note sur la Galerie des glaces," *XVIIᵉ Siècle* no. 53, 1961), 42–50.

[51]Catalogue of the exhibition "Georges de la Tour," Paris, Orangerie, 1972, nos. 15, 19, 21.

[52]No. 1971. 396. I am indebted to the Museum of Fine Arts in Boston for the photograph and permission to reproduce it.

Sulla *Madonna del Manto* e su altri affreschi nello Spedale di Santa Maria della Scala a Siena

ENZO CARLI

Da vario tempo lo stato di conservazione degli affreschi di Domenico di Bartolo, del Vecchietta e di Priamo della Quercia nello Spedale di Santa Maria della Scala di Siena era per me divenuto motivo di viva apprensione. Non potendo provvedere a quelli, bisognosissimi di restauro, nel Pellegrinaio perchè questo era, ed è tuttora, adibito a corsia per gli ammalati (e chi sa quanto tempo ancora occorrerà perchè quel bellissimo ambiente venga liberato sì da dar agio ai restauratori di lavorarvi), rivolsi intanto la mia attenzione alla ben nota e venerata *Madonna del Manto* (Fig. 1) che nel 1610 era stata trasferita dalla omonima cappella (poi trasformata in ingresso dello Spedale) alla cappella del Sacro Chiodo adiacente alla chiesa, di cui divenne sagrestia e che quindi fu incorporata allo Spedale col nome di Sala di San Pietro (attualmente è biblioteca ed aula di chirurgia). Da un accurato esame emerse la necessità di procedere allo strappo dell'affresco, che si presentava assai deteriorato e fatiscente, forse anche in conseguenza della subìta vicissitudine. Grazie al generoso finanziamento da parte della Fondazione Senatore Ercole Varzi, già resasi benemerita per numerosi interventi per la conservazione del patrimonio artistico, oltre che di altre città italiane, di Siena e del suo territorio,[1] nel 1969 fu effettuato lo strappo che, a parte la sua efficacia per la conservazione dell'opera, riservò non poche sorprese. Infatti non solo fu rinvenuto il disegno preparatorio, impropriamente definito sinopia, dell'affresco, ma, sia pure allo stato frammentario, tornarono alla luce altre parti di questo e in più un'altra composizione a monocromo col relativo disegno preparatorio.[2] Ma prima di illustrare questi rinvenimenti, converrà riassumere quello che già si sa sulla *Madonna del Manto*, tentando di individuare i personaggi principali che la circondano.

Come risulta da un documento pubblicato da G. Milanesi l'affresco, insieme con un altro, venne pagato a Domenico di Bartolo il 2 aprile 1444.[3] Poichè la chiesa, o cappella nella quale si trovava serviva di accesso allo Spedale, al fine di levare il "passo poco decente per questa casa di Dio," il 17 agosto 1608, sotto il rettorato di Agostino Chigi, fu deliberato di rimuovere l' "immagine di quella devotissima Vergine" e di trasferirla nella cappella del Sacro Chiodo "per conservarsi in quel luogo perpetuamente."[4] L'operazione venne effettuata il 7 giugno 1610 da Maestro Pietro di Domenico della Valle di Lugano, capo muratore dello Spedale: di tale traslazione, avvenuta "con gran concorso non solo della fameglia di Casa [cioè del personale dello Spedale], del clero di questa chiesa, suoi musici e apportatori di molte torce, ma anche coll'intervento dell'ill.mo sig. rettore et altri, che a veder tal opera pia

[1] Mi limiterò a ricordare, tra questi ultimi, il restauro completo della cappella di San Galgano sul Monte Siepi, con gli affreschi di Ambrogio Lorenzetti ed aiuti, lo stacco della *Madonna della Loggia* di Ambrogio Lorenzetti nel Palazzo Pubblico, lo stacco dell' *Assunzione* di Pietro di Domenico e del supposto Matteo Balducci nel chiostro dell'ex-convento di Campansi e il restauro del ciclo di affreschi del Sòdoma nel refettorio del monastero olivetano di Sant'Anna in Camprena

presso Pienza.

[2] Le complesse operazioni di strappo e restauro furono eseguite dai signori Leonetto Tintori, Giuseppe Rosi ed Alfio Del Serra e dai loro aiutanti.

[3] *Documenti per la storia dell'arte senese*, II (Siena, 1854), 173.

[4] Archivio di Stato di Siena, Spedale di Santa Maria della Scala, *Deliberazioni*, XII, c. 78.

eran concorsi con molta devotione,"[5] è ricordo, oltre che nelle carte dello Spedale, nell'iscrizione che il rettore Chigi fece dipingere sotto l'affresco. Questo, quando fu rimosso, per adattarlo sotto il bel baldacchino marmoreo quattrocentesco sopra il quale, "in eminenti loco" cui si accedeva con una scala mobile, si conservavano, in una cassa ferrata, le reliquie,[6] venne ridotto da forma semicircolare a forma rettangolare, mutilandolo delle estremità laterali: tuttavia queste—caso veramente singolarissimo—non vennero distrutte ma, sia pure allo stato frammentario, furono collocate a tamponare l'arcata che, passando sotto il baldacchino, metteva in comunicazione la cappella del Sacro Chiodo con la retrostante, piccola sagrestia, e furono occultate dalla cortina di mattoni sulla quale giaceva l'affresco e che insieme con questo venne segata e trasportata. Poichè una sottile intercapedine era stata lasciata tra questa e il muro della cappella e da alcuni saggi effettuati anche con l'aiuto di un cistoscopio gentilmente messo a disposizione dai medici dello Spedale ci si era accorti che anche il tergo della cortina era dipinto, si ritenne opportuno nel 1969, dopo lo strappo dell'affresco e del relativo disegno preparatorio, non distruggere il muro, ma farlo ruotare e rimuoverlo intero, così che fu possibile riportare alla luce e l'affresco che vi si trovava sul tergo e i frammenti di quello di Domenico di Bartolo, destinati altrimenti a stare occultati: anche questi sono stati staccati.

La figurazione della *Madonna del Manto* era in origine di larghezza pressochè doppia di quella attuale, sì da occupare, con la sua forma a lunetta delimitata da una larga fascia con tondi e cartigli scritti (di cui restano pochissimi frammenti ormai non più ricostruibili), l'intera campata di una chiesa, o cappella. Essa reca al centro la Madonna seduta in trono col Bambino seminudo in piedi sul ginocchio sinistro (Fig. 2) e in atto di benedire un pontefice genuflesso che presenta il modellino di una chiesa (Fig. 3), mentre di fronte a questo s'inginocchia un personaggio, pure riccamente abbigliato che, dal sottile scettro che regge con la sinistra, può ritenersi essere un monarca (Fig. 4). Presso la testa della Madonna si dispiega un cartiglio con questo "madrigaletto . . . scritto alla gotica, e in stile antico":

> Questo popul socto 'l mie mante corse
> O dolce mie Figluol riguarda fiso
> Chi so lor avocata et tu 'l soccorso
> Tucti gli benedi per lo mi amore
> Dappoi gli altri e prima 'l tuo Pastore.[7]

Due angioli volanti tengono sollevato l'amplissimo manto sotto il quale stanno, oltre ai due personaggi ricordati, dietro il papa quattro cardinali e dietro il monarca alcune figure di giovani. Dai frammenti ultimamente recuperati risulta che il manto era sostenuto da un'altra coppia di angeli, di cui uno però è totalmente scomparso, mentre dell'altro, a sinistra, sussiste solo un piccolo resto: inoltre la schiera dei devoti sotto la mistica tenda si è sensibilmente

[5]V.L. Banchi, *Statuti senesi scritti in volgare ne' secoli XIII e XIV*, III (Bologna, 1877), 374.

[6]V. la *Relazione della visita pastorale* compiuta da Mons. Egidio Bossio nel 1575, MS nell'Archivio Arcivescovile di Siena, c. 116.

[7]Il primo verso è ormai illeggibile perchè abraso. Il testo del madrigale è riportato integralmente da F. Chigi; v. P. Bacci,

"L'Elenco delle pitture, sculture e architetture di Siena compilato nel 1625–26 da Mons. Fabio Chigi poi Alessandro VII," *Bullettino Senese di Storia Patria* (N.S. X, 1939, fasc. III e IV), 22 dell'estratto e da G. Macchi, *Notizie di tutte le Chiese che sono nella città di Siena*, MS nell'Archivio di Stato di Siena, III, D. 109, c. 197.

arricchita, a sinistra di ben tredici figure e a destra di sette (Figs. 5–6). Nel frammento di sinistra spicca l'immagine di un uomo dalla fisionomia incisivamente caratterizzata, che il robone, il nero mantello e soprattutto la berretta calzata sopra la cuffia fanno riconoscere come il rettore dello Spedale e committente dell'affresco, messer Giovanni di Francesco Buzzichelli, che stette in carica dal 24 marzo 1434 fino alla morte avvenuta l' 11 settembre 1444:[8] essendo egli nato nel 1382, Domenico di Bartolo lo ritrasse che aveva sessantaquattro anni e l'aspetto che gli diede conferma l'identificazione. Dietro di lui sta un monaco con la testa coperta da un cappuccio, assorto in preghiera con le mani giunte reggenti il rosario (Fig. 7) nel quale piacerebbe riconoscere un'immagine del Beato Sorore, il mitico fondatore dello Spedale, se le rappresentazioni che se ne davano nel Quattrocento non ce lo mostrassero sbarbato e già con l'abbigliamento di rettore dello Spedale: così lo rappresentò infatti il Vecchietta nell'affresco col *Sogno della Pia Donna* nel Pellegrinaio (1441), nell'armadio delle reliquie già nella sagrestia dello Spedale, ora nella Pinacoteca (1445) e nel sottarco della *Madonna de Misericordia* in una sala del Palazzo Pubblico (ca. 1453–1457).[9] Comunque, anche se non si tratta del Beato Sorore, questa figura resta tra le più toccanti ed intense creazioni di Domenico sia per la fervorosa devozione ond'è impressa, sia per l'unità formale della sua massa tutta raccolta sotto l'ampio mantello che nel suo profilo conclude mirabilmente, secondando la curvatura del lunettone, la composizione. Nel frammento di destra (Fig. 6) spicca l'affascinante immagine di una dama elegantemente abbigliata e con una grande berretta che le lascia scoperta l'ampia fronte luminosa (Fig. 8): è senza dubbio un ritratto, e forse non sarà troppo azzardato sospettare che questa sorta di Pisanello garbatamente improvincialito raffiguri una delle due mogli del rettore Buzzichelli, Francesca, la seconda, oppure Petra, la prima, nella cui tomba egli volle esser sepolto.

Per quanto riguarda i due personaggi principali, ritengo che il pontefice, per il fatto che presenta alla Madonna il modellino di una chiesa, sia da identificarsi con Alessandro IV (Rinaldo dei Conti di Segni di Anagni) il quale, con Breve del 27 giugno 1257, sotto il rettorato di messer Ranieri Caccianieve (in carica dal 1243 al 1262) confermava l'autorizzazione, già data dal vescovo di Siena Buonfiglio, a costruire la chiesa dello Spedale: a meno che non si tratti del papa allora in trono, Eugenio IV, del quale, per conto dello Spedale, Domenico di Bartolo aveva dipinto nel 1442 le insegne su quattro drappelloni; ma in questo caso sarebbe inesplicabile l'offerta della chiesa.[10] Assai più ardua ed incerta appare l'identificazione del monarca. È stata avanzata l'ipotesi che si tratti dell'imperatore Sigismondo di Lussemburgo,[11] di cui Domenico di Bartolo aveva nel 1434 dato un disegno che lo raffigurava

[8]V. Banchi, *Statuti senesi*, 238–46.

[9]Avvalorerebbe l'identificazione del Beato Sorore quanto scrive Macchi a c. 333 delle sue *Notizie*: "L'anno 1444 fu dipenta la B.V. Maria del Manto nello Spedale, e in essa ci è dipento il Beato Sorore, e sua madre genuflessi vestiti di nero oranti, come si vede nel modello esistente nell'Archivio dello Spedale in quadretto." Al tempo del Macchi (prima metà del sec. XVIII) i due frammenti laterali dell'affresco non erano più visibili, e lo scrittore dovette fondarsi su una tradizione orale e sul "quadretto" che forse era una tarda copia liberamente integrata.

[10]Eugeno IV entrò in Siena con dieci cardinali il 10 marzo 1442 e vi si trattenne, ospite del Vescovado, fino al 13 feb-

braio 1443; poichè i quattro drappelloni "cho l'arme di papa Ugenio" furono pagati a Domenico il 1 febbraio 1442, è da ritenere che essi venissero preparati per solennizzare l'ingresso del papa. Il documento è stato pubblicato da A. Liberati, "Nuovi documenti sul Pellegrinaio dello Spedale di S. Maria della Scala di Siena," *La Diana* (IV, 1929, fasc. III), 240.

[11]V. autore anonimo (probabilmente G. De Nicola), *R.R. Spedali Riuniti di S. Maria della Scala, Guida Storico-Artistica* (Milano, s.a.), 27; l'ipotesi è ripresa anche da D. Gallavotti, "Gli affreschi quattrocenteschi della Sala del Pellegrinaio nello Spedale di Santa Maria della Scala in Siena," *Storia dell'Arte* (XIII, 1972), 34.

in trono, da tradursi a graffito nel pavimento del Duomo mentre un altro disegno "il quale è simile alla faccia de la Cesarea maestà" gli acquistava l'Opera del Duomo nello stesso anno:[12] ma l'unico elemento che conforterebbe tale ipotesi è che nell'affresco della *Madonna del Manto* il personaggio, oltre alle insegne regali, reca la barba a punta e i capelli sciolti sulle spalle, il che sembra che facesse una certa impressione agli Italiani,[13] chè per il resto l'immagine affrescata ha scarsi punti di coincidenza con l'iconografia, assai copiosa anche se non perfettamente coerente, dell'imperatore. Tra l'altro la testa d'uomo di profilo a matita e penna dal Codice Vallardi (ora nel Gabinetto di disegni del Louvre, inv. n. 2339) nella quale il Fischer riconobbe un ritratto dal vero di Sigismondo[14] e che, attribuita al Pisanello, il Beck ha proposto di identificare col disegno di Domenico di Bartolo acquistato, o desiderato, dall'Opera del Duomo nel 1434[15] non somiglia affatto a quella dell'affresco mentre trova precisa rispondenza fisionomica, come rilevò il Degenhart, col ben noto ritratto dell'imperatore nel Kunsthistorisches Museum di Vienna (anch'esso già attribuito al Pisanello ed ora generalmente ritenuto di scuola boema),[16] il quale a sua volta somiglia assai all'effigie di Sigismondo in atto di ricevere la corona imperiale dipinta da un ignoto senese sulla copertina della Biccherna del 1433.[17] Nemmeno mi par di scorgere una particolare somiglianza tra il monarca dell'affresco e il ritratto di Sigismondo disegnato all'inizio del *Liber Tertius de Ingeneis* di Mariano di Jacopo detto "il Taccola."[18] D'altra parte, quale motivo poteva ormai avere il Rettore dello Spedale per far raffigurare nel 1444 l'imperatore Sigismondo? Questi, incoronato re di Roma a Milano nel 1415, era arrivato a Siena "cho gente magna, gratiosa et bella,"[19] l'11 luglio 1432 e vi si era trattenuto fino al 25 aprile 1433 e non risulta che durante il suo non breve soggiorno a Siena, che risultò particolarmente gravoso per le finanze del Comune, abbia preso alcun provvedimento o concesso alcun privilegio a favore dello Spedale il quale, tra l'altro, in quel periodo, si trovava in condizioni piuttosto difficili. Come potevano quindi i Senesi onorarne la memoria sette anni dopo la sua morte, avvenuta nel 1437? Infine, quando Sigismondo era a Siena aveva passato i settanta anni (era nato nel 1362) e il chiomato monarca dell'affresco ne dimostra una trentina o poco più.

Esclusa dunque l'identificazione con Sigismondo, si possono formulare due ipotesi, egualmente valide: che il personaggio raffigurato sia l'imperatore Federico II di Svevia oppure l'imperatore Arrigo VII di Lussemburgo. Del primo riferisce il Macchi che il 17 marzo 1241 ricevette "in protettione lo Spedale nostro, al tempo di Messer Cacciaconte rettore, come per suo Privilegio dato in Siena il dì suddetto sotto rogito di ser Giovanni Martini notaio."[20] La notizia, ancorchè il nome del rettore, Cacciaconte di Beringario, corrisponda alla data, non è riportata nei diligentissimi spogli del Banchi, e non so quanto sia

[12]R.H.H. Cust, *The Pavement Masters of Siena, 1369–1562* (London, 1901), 77–78.

[13]G. Scaglia, "An Allegorical Portrait of the Emperor Sigismund," *Journal of the Warburg and Courtauld Institutes* (XXXI, 1968), 429.

[14]"Zwei Bildnisse des deutschen Kaisers Sigismund von Pisanello," *Jahrbuch der Preussischen Kunstsammlungen* (LIV, 1935), 7.

[15]J.H. Beck, "The Historical 'Taccola' and Emperor Sigismund in Siena," *Art Bulletin* (L, 1968), 317.

[16]"Das Wiener Bildnis Kaiser Sigismunds, ein Werk Pisanellos," *Jahrbuch der Kunsthistorischen Sammlungen* (XIII,

1944), 359–76. Oltre a Beck, v. G.A. Dell'Acqua e R. Chiarelli, *L'opera completa del Pisanello* (Milano, 1972), 90–91.

[17]E. Carli, Catalogo della Mostra "Le tavolette di Biccherna e di altri uffici dello Stato di Siena" (Firenze, 1950), no. 39, e U. Morandi, *Le Biccherne senesi* (Siena, 1964), 78.

[18]V. oltre a Scaglia, "An Allegorical Portrait," *Mariano di Jacopo detto "il Taccola," Liber Tertius de Ingeneis*, a cura di J.H. Beck (Milano, 1969).

[19]È uno dei versi di una iscrizione che ricorreva in una perduta tavoletta della Gabella del 1432 (v. Carli, *Le tavolette*, 50).

[20]Macchi, *Notizie*, II, 107, c. 141.

attendibile, ma può darsi benissimo che tale la si ritenesse nel Quattrocento. L'"alto Arrigo" invece effettivamente il 1° marzo 1313 dagli accampamenti di Poggio Imperiale (cioè da Poggibonsi) emanava un diploma con il quale prendeva sotto la protezione sua e dell'Impero lo Spedale senese.[21] Sembra comunque che il committente abbia voluto simboleggiare, con le due potestà, quella del papa e quella dell'imperatore, il duplice carattere, religioso e laico, dell'istituto ospedaliero: dietro il gruppo dei cardinali sono, a parte il rettore, raffigurati soltanto dei religiosi mentre i devoti dietro l'imperatore sono tutti laici: e tra questi sarà da segnalare, oltre alla dama che abbiamo ricordato, la donna che le sta accanto e il cui profilo energico e spiritoso sembra quasi precorrere, in una sfera più umile, per non dir popolaresca, ma sostanziata di umana verità, quello del celeberrimo ritratto pollaiuolesco nel Museo Poldi Pezzoli. Un altro rilievo interessante ci consentono i due ricuperati frammenti, che fra l'altro, per essere stati oltre due secoli e mezzo all'oscuro, hanno i colori vivacissimi: la grandiosa composizione che si staglia, secondo un criterio assai raro nella pittura a fresco, contro un fondo d'oro,[22] è in realtà ambientata entro uno spazio prospetticamente definito, come indica l'erta fuga dei lastroni rosati di un pavimento che si scorge all'estremità dei predetti frammenti. Il disegno preparatorio, o sinopia, è eseguito a carboncino e presenta curiosamente la stessa incertezza o ambiguità che si ritrova nell'affresco: non sappiamo se altri abbia rilevato l'incoerenza del braccio destro della Madonna che dovrebbe terminare con la mano dietro il volto del pontefice mentre invece, illogicamente, quest'ultima spunta dietro la tiara; come nell'affresco Domenico non si curò di correggere questo sgradevole errore, così nel disegno è traccia delle due soluzioni (Fig. 9). Tra le varianti più notevoli ci sono, nel disegno, quella dell'imperatore che invece di tenere lo scettro regge un grosso globo, il Bambino dai pettorali fortemente pronunciati, che invece di volgersi verso il pontefice, si volge verso l'imperatore, mentre il suppedaneo del trono, che nell'affresco appar ricoperto dai lembi ondeggianti del manto della Madonna, si profila nella sua nuda geometricità.

Sul muro a tergo della *Madonna del Manto* è stato rinvenuto, come ho accennato, un affresco a monocromo raffigurante il rettore dello Spedale che, insieme con altri personaggi, reca dei vassoi con delle coppette o ciotole agli infermi che attendono seduti nei loro letti tenendo davanti delle tavolette apparecchiate: giovani ed eleganti garzoni, uno dei quali col falcone e un altro con un bicchiere, circondano la compassata schiera e l'aiutano a servire (Fig. 10). È una scena di vita ospedaliera se non artisticamente eccelsa, di notevole interesse documentario—certo più aderente alla realtà dei fiabeschi ed affollati affreschi del Pellegrinaio—perchè riflette con fedeltà il nudo ambiente di una corsia con i suoi letti accostati e separati da tende, nel fondo della quale si apre una porta che sembra dare adito ad una cappella di cui si scorge un trittico. L'officiosità dell'episodio, quasi una cerimonia, trova un toccante spunto di umanità in un ammalato che reclina malinconicamente la guancia su una mano (Fig. 11). Il soggetto dell'affresco è chiarissimo: esso infatti illustra il capitolo xxxv degli Statuti dello Spedale che prescriveva che il rettore, sei volte all'anno, cioè nelle ricorrenze delle maggiori festività, era tenuto "a li poveri et a li infermi e ai gittati [i trovatelli] sì

[21]Banchi, *Statuti senesi*, 170–71, riporta l'intero testo del diploma. Il Macchi (ms cit., c. 141) pure riferisce la notizia, errando tuttavia il nome del rettore che fu Ristoro di Giunta

Menghi e non messer Jacomo (di Cristofano di Mancino) il quale fu eletto solo nel giugno 1313.

[22]Gallavotti, "Gli affreschi... della Sala del Pellegrinaio," 33.

maschi come femine servire e ponere dinanzi a loro maschi e femine minestre et embandigioni da mangiare" e che "di questo sia facta publica et autentica scriptura."[23] Infatti non manca neppure, nel personaggio con una carta e un calamaio, l'incaricato di verbalizzare (Fig. 12).

Il retrostante disegno preparatorio, che pure è stato staccato, è di estremo interesse ed appare eseguito in due tempi (Fig. 13). Infatti, prima di tracciare a carboncino la figura, l'artista realizzò a sinopia sull'arriccio la costruzione prospettica dell'ambiente mediante un fitto fascio di linee convergenti verso un punto situato all'incirca sopra la testa del rettore e mediante le linee orizzontali del pavimento progressivamente accostantisi fino al punto in cui presumibilmente s'innalza la parete di fondo. Mentre numerose sono le sinopie nelle quali rimane traccia di quella operazione preliminare che Cennino Cennini definisce come "pigliare i mezzi degli spazi . . . battendo alcun filo," non conosco altro schema prospettico d'affresco elaborato al pari di questo se non la famosa sinopia di Paolo Uccello per la *Natività* già nel chiostro dello Spedale di San Martino alla Scala di Firenze.[24] La sinopia di Paolo Uccello è stata argomento di dotti dibattiti da parte degli specialisti a causa delle due fughe prospettiche che concorrono alle estremità laterali della composizione:[25] la nostra invece è impostata su un unico punto di fuga e quindi potrebbe costituire un rigoroso esempio di "costruzione legittima" di tipo albertiano, dove è da notare tra l'altro che nella realizzazione dell'affresco la linea orizzontale del ventaglio prospettico riappare sotto l'aspetto di un sottile cornicione che percorre in alto le tre pareti visibili della corsia. Al di sopra di questa intelaiatura il pittore ha tracciato a carboncino i personaggi, il disegno di alcuni dei quali è andato perduto, forse scancellato dallo stesso artista, ma che, dove è ancora visibile, è stato sostanzialmente rispettato nella esecuzione dell'affresco. E che il gusto per una, più ancora che precisa, intensa e puntuale elaborazione prospettica fosse vivamente sentito dal pittore lo dimostra, oltre alla perfetta scalatura spaziale in profondità dei piedi dei personaggi, l'iterarsi del motivo dei vassoi da questi sostenuti e rigorosamente raffigurati in scorcio.

Assai ardua è, a mio avviso, l'identificazione dell'autore di questo affresco che non è certo di Domenico di Bartolo e neppure di Priamo della Quercia, mentre anche il nome di Pellegrino di Mariano che fu pronunciato appena si scoprì la scena e sotto il quale questa fu, ed è tuttora, esposta nella Pinacoteca di Siena, non sembra più del tutto soddisfacente in quanto, a parte la singolare caratterizzazione tipologica dei volti dai grandi occhi fortemente marcati, le molte miniature e i pochi dipinti di questo modesto artista sono di cultura più goticheggiante e ritardata, e comunque alieni da ogni interesse prospettico.[26] Qualche vaga affinità si può rilevare con i monocromi con scene di vita eremitica nel secondo chiostro del monastero di Lecceto, alcuni dei quali furono attribuiti dal Brandi a Pietro di Giovanni d'Ambrogio:[27] ma anche questo grande artista è fuori causa, non foss'altro per la diversa qualità del nostro affresco. D'altra parte dei numerosi pittori (pittori, ripeto, non semplici imbianchini e decoratori di lettiere, soffitti, travature ecc.) che durante il Quattrocento si

[23]Banchi, *Statuti senesi*, 46–47.

[24]V. il corpus delle sinopie pubblicato nell'eccellente volume di U. Procacci, *Sinopie e Affreschi* (Milano, 1960). La sinopia di Paolo Uccello vi è chiaramente riprodotta al no. 40 del Catalogo.

[25]I diversi giudizi sulla sinopia di Uccello sono chiaramente riassunti in E.Flaiano–L. Tongiorgi Tommasi, *L'opera com-*

pleta di Paolo Uccello (Milano, 1971), 94.

[26]Su Pellegrino di Mariano pittore v. C. Brandi, *Giovanni di Paolo* (Firenze, 1943), 95–99; sulle sue miniature v. M.G. Ciardi Dupré, *I Corali del Duomo di Siena* (Siena, 1972), 6–7 e le relative riproduzioni, figg. 22–80.

[27]*Quattrocentisti senesi* (Milano, 1949), 135 e 220.

avvicendarono o lavorarono contemporaneamente ad affresco nei locali e nella chiesa dello Spedale noi conosciamo soltanto, oltre al Vecchietta, a Domenico di Bartolo e a Priamo della Quercia, Pietro di Giovanni, che nel 1440 dipinse due storie "ne la fermaria da piei nela faccia dela finestra a chapo la chapela del pelegrinaio" andate distrutte nel prolungamento del Pellegrinaio effettuato nel 1577, e Gualtieri di Giovanni da Pisa, che lavorava nel 1445. Niente sappiamo ad esempio di quel Luciano di Giovanni da Velletri che nel 1441 eseguiva quattro storie di Tobia nel Pellegrinaio, probabilmente sotto altre tre storie sempre di Tobia dipinte nello stesso anno dal Vecchietta "a chapo l'archo del pelegrinaio," di Agostino di Marsilio da Bologna, attivo nel 1440 e 1458, di Paolo di Pietro, attivo nel 1443, di Domenico di Cristofano di Nuccio, attivo come freschista insieme con Pellegrino da Mariano nel 1449, quindi nel 1458, 1474 e 1475, di Guasparre d'Agostino, che fu pagato per vari lavori nel 1458 e di Carlo di Giovanni, attivo nel 1445, 1446 e 1458.[28] L'autore della *Refezione degli Infermi* (così si può chiamare la nostra scena a monocromo) è probabilmente uno di costoro e in modo particolare la nostra attenzione viene richiamata dall'ultimo, Carlo di Giovanni, che il 27 giugno 1446 riceveva ventotto lire "sono per sua fatiga da pentura de una enstoria depinta in biancho a nostri cholori, fata in piligrinaio sopra alarcho che va nela chapela." Si tratta della nostra storia? L'espressione "depinta in biancho" fa sospettare che si tratti di un monocromo, e certamente l'affresco di Carlo si trovava sul tergo della parete di una cappella, così come la *Refezione degli Infermi* si trova sul rovescio della *Madonna del Manto*, la quale stava in una cappella. Ma anche questa ipotesi, seducente in quanto ci permetterebbe non solo di identificare l'autore del dipinto, ma altresì di ricuperare la fisionomia di un artista, Carlo di Giovanni, finora obliterata, sembra destinata a cadere perchè probabilmente si tratta della cappella che stava in fondo al Pellegrinaio: cappella fornita di una finestra ai lati della quale c'erano le due storie dipinte nel 1440 da Pietro di Giovanni d'Ambrogio ed alla quale si accedeva da un'arcata alla cui sommità Carlo dipinse la sua "enstoria." Ancor meno probabile appare che si tratti della parete opposta del Pellegrinaio, perchè essa recava le storie di Tobia dipinte dal Vecchietta e da Luciano da Velletri.

A questo punto sorge il problema, di non facile soluzione, della originaria ubicazione della *Madonna del Manto*, la quale non potè essere nella parete di fondo dell'attuale ingresso dello Spedale, perchè l'affresco retrostante non raffigura una storia di Tobia. D'altra parte la deliberazione del 17 agosto 1608 e, con maggiore precisione, l'iscrizione fatta dipingere dal rettore Chigi sotto la Madonna indicano inequivocabilmente che questa si trovava nell'ingresso dello Spedale, anzi, era "jam depicta ubi nunc lapidea ianua in hospitalis vestibulo." Ma l'attuale ingresso, o vestibolo, dello Spedale non era una cappella, bensì faceva parte della "chiesa grande" cui accenna un documento del 1445[29] e che aveva una delle pareti corte in corrispondenza della parete destra dell'attuale ingresso dello Spedale, dove in alto si scorgono i resti di un affresco—una Madonna tra angeli musici di cui uno solo ormai visibile—probabilmente di Martino di Bartolommeo e comunque databile non oltre il secondo decennio del Quattrocento. La cappella, poi detta del Manto, era attigua alla chiesa e corrispondeva a quel

[28]I documenti cui si riferiscono queste notizie sono stati pubblicati da A. Liberati, "Nuovi documenti artistici dello Spedale di S. Maria della Scala in Siena," *Bullettino Senese di Storia Patria* (XXXIII–XXXIV, 1926–27, fasc. II), 147–79.

[29]Si tratta di un pagamento al Vecchietta per l'armadio ("arliquiera") "ne la sagrestia grande della nostra chiesa grande," pubblicato dal Liberati, *Nuovi documenti sul Pellegrinaio*, 241.

locale a tre campate oggi adibito a pronto soccorso e a passaggio, le cui volte e pareti furono affrescate, come informa un'iscrizione coeva, nel 1370 da Cristofano di Bindoccio detto "Malabarba" con l'aiuto di Meo di Piero. La cappella aveva una porta d'ingresso, oggi ridotta a finestra, e due finestre sulla piazza di fronte al Duomo e si doveva attraversare per entrare nello Spedale. Essa fu rimodernata tra il 1512 e il 1514, quando Domenico Beccafumi vi dipinse tra l'altro, nei due lunettoni laterali della terza e ultima campata, due storie, di cui suissiste ancora l'*Incontro di Gioacchino e Anna*,[30] e che si trattasse della Cappella del Manto lo conferma, oltre ai documenti relativi alle prestazioni del Beccafumi e di Bartolommeo di David (che nel 1513 vi dipinse un "presepio"), la testimonianza di Fabio Chigi, poi papa Alessandro VII, che forse la vide, undicenne (e certo ne sentì parlare), prima della traslazione della Madonna: "nel vestibolo due archetti, dove era la *Madonna del Manto*, Mecarino."[31] L'affresco della *Madonna del Manto* doveva occupare il lunettone della parete di fondo. Il relativo pagamento a Domenico di Bartolo specifica che era "sopra la gratichola di chiexa," cioè, penso, sopra un arco chiuso da una cancellata dal quale si accedeva nello Spedale. Ma nel 1575, quando Mons. Egidio Bossio effettuò la sua visita pastorale, il cancello non c'era più, l'arcone doveva essere chiuso e l'ingresso allo Spedale sostituito forse da una porta praticata sotto il perduto affresco del Beccafumi, perchè sotto la *Madonna del Manto*, adornata da un drappo di seta celeste e circondata da molte tavolette votive, c'era un altare con una tavola raffigurante la Crocifissione, da identificarsi probabilmente con il trittico della *Trinità* del Beccafumi, ora nella Pinacoteca, no. 384:[32] questa prima trasformazione della Cappella dovette avvenire circa il 1492, o poco dopo, quando sotto l'altare dei Pizzicaioli nella chiesa grande fu rinvenuto un morto "tutto intiero fino al naso e gli orecchi" ritenuto il Beato Sorore e che fu traslato sotto l'altare sottostante la *Madonna del Manto*.[33]

Stabilita l'ubicazione della *Madonna del Manto*, ci si domanda per quale ambiente fu dipinto il monocromo della *Refezione degli Infermi*. A questo riguardo le testimonianze sono piuttosto ambigue, se non contraddittorie. Il Macchi infatti, a carta 193 delle sue *Notizie*, afferma che la *Madonna del Manto* "prima stava nella facciata dove hoggi è il portone per entrare nel cortile delle infermarie" e a carta 194 che era "nella cappella . . . la quale è per andare a Santa Crestina dalle Sepolture, o vero dove al giorno d'oggi dorme il Corticellaro." Sembra perciò che la parete a tergo della *Madonna del Manto* rispondesse in un cortile: un cortile però che doveva essere coperto, a meno che con tale termine si intendesse un ambiente di disimpegno per le infermerie perchè nel 1458 Guasparre d'Agostino veniva pagato "per

[30]V.D. Sanminiatelli, *Domenico Beccafumi* (Milano, 1967), 74-75 e 191.

[31]Bacci, "L'Elenco delle pitture," 22 dell'estratto.

[32]Mons. E. Bossio, *Relazione della Visita pastorale* (1575), MS nell'Archivio Arcivescovile di Siena, a.c. 117v. e 118 così descrive la Cappella: "Die martis XIX Julii. . . . Subinde visitavit cappellam Virginis nuncupatam *del Manto*, quae habet altare ut supra ornatum et opertum cum petra sacra non infixa, quam pariter mandavit infigi. Predella est lapidea et congrua et pallium aderat ex damasco albo florato. Icona adest cum imagine Crucifixi et aliarum Sanctarum virginum in tavola depictis et desuper adest imago Beatae Virginis depicta in muro et tela cerulei coloris ex sericum ante eam ducitur cum magno populi concursu venerata, ed circum adsunt plurimae votivae tabellae ibi a diversis personis oblatae. Sub dicto altari adest corpus, ut dixerunt, beati Sororis, quem asserunt non esse canonizzatum, sed tamen pro beato reputari, et dixerunt etiam fuisse unum ex inservientibus in dicto hospitali. Ante dictam cappellam lampas ardet continuo sumptibus, ut dixerunt, dicti hospitalis." Da notare che nella minuziosa relazione della visita al complesso dello Spedale, la qualifica di "cappella" viene data soltanto a quella del Manto e a quella del Sacro Chiodo: tutti gli altri sono altari. Inoltre il Pellegrinaio, contenente "viginti sex cubilia pro peregrinis parata" vien detto "cubiculum quod primum ex ecclesia intuentibus se se offert," cioè era il primo ambiente cui si accedeva *dalla chiesa*, e non dalla cappella.

[33]Banchi, *Statuti senesi*, XIX.

sua manifattura di undici fighure ci à fatte nela nostra sala nuova sopra la corticella."[34]

In questa "corticella" Domenico di Bartolo nel 1444 aveva dipinto una storia con "la limosina."[35] La Gallavotti, che ritiene la corticella fosse una "corte" o una "grancia," forse "la prima che venne donata al Beato Sorore da qualche ricco signore" mentre invece era un ambiente interno dello Spedale, ha proposto, per altro dubitativamente, di identificare la storia della limosina con un monocromo in terra rossiccia su una parete dell'infermeria di San Pio (Fig. 14).[36] Questo affresco, dai pochissimi che appena lo menzionano, viene infatti costantemente assegnato a Domenico di Bartolo e illustra indubbiamente un episodio della vita del Beato Sorore, di cui però non è riscontro alcuno nemmeno nella fantasiosa biografia che ne imbastì il Padre Lombardelli,[37] notorio inventore di vite di Santi, alcuni dei quali come Sorore, nemmeno esistiti. Esso infatti, forse mutilo sul lato sinistro, raffigura il Beato genuflesso in orazione sotto un portico, o entro una cella, mentre dall'alto Cristo lo benedice: un giovane gli si inginocchia davanti, seguito da tre personaggi che assistono edificati, e a sinistra sostano dei giovani elegantemente vestiti e una donna esce da una porta. Comunque l'affresco non è nella "corticella," non rappresenta una scena di elemosine e, a nostro avviso, non è nemmeno di Domenico di Bartolo, anche se da questi chiaramente influenzato. Propongo invece di attribuirlo a Priamo della Quercia che nella scena raffigurante *Il Beato Agostino Novello che dà l'abito al rettore dello Spedale* nel Pellegrinaio, di Domenico si dimostrò il più pedissequo seguace, se pur lo stesso Domenico non intervenne, come suppongono alcuni, a dar mano a Priamo in questo affresco, di gran lunga superiore alle altre pochissime opere certe dell'artista.[38] Operando da solo, Priamo allenta e dilata l'impostazione prospettica

[34]Liberati, "Nuovi documenti artistici," 163. Il Faluschi, *Breve relazione delle cose notabili della città di Siena ampliata e corretta dal Sacerdote Giovacchino Faluschi* (Siena, 1784), 50-51, scrive che sopra una porta "che è nell'ingresso dello Spedale, e conduce al Sepoltuario da quei Ministri chiamato Campo Santo osservasi una Pittura in muro esprimente S. Cristina, e la Risurrezione di Lazzaro opera molto celebre del sopra-nominato Mecarino." Il Sanminiatelli (*Domenico Beccafumi*, 191) suppone che il Faluschi abbia equivocato e interpretato l'affresco con l'*Incontro di Anna e Gioacchino* come una *Risurrezione di Lazzaro con S. Cristina*, perchè la porta sotto la lunetta con l'altro affresco, perduto, del Beccafumi andava in chiesa: ma in tal caso il Faluschi non avrebbe successivamente scritto che "in faccia poi a questa [cioè alla presunta *Risurrezione di Lazzaro*] si scorgono alcune pitture di Paesi e Figure denotanti il *Presepio*, che furono dipinte da Bartolommeo di David, nel 1513." Quest'ultima indicazione è documentariamente provata (Liberati, "Nuovi documenti artistici," 169) e poichè il lunettone di faccia a quello con l'*Incontro di Anna e di Gioacchino* sembra che recasse un altro affresco del Beccafumi, le soluzioni possono essere due: o che esistesse in un'altra campata della cappella un terzo affresco con la *Risurrezione di Lazzaro* creduto del Beccafumi, di fronte al quale stava il *Presepio* di Bartolommeo di David, oppure che le due scene del Beccafumi (una delle quali in questo caso raffigurante la *Risurrezione di Lazzaro*) anzichè fronteggiarsi, fossero affiancate sulla parete destra della seconda e della terza campata e di fronte ad una di esse, sulla parete sinistra, fosse il *Presepio*. Non mi è stato possibile finora appurare l'esatta ubicazione dell'antico Cimitero dello Spedale, ed anche la relazione della visita pastorale del Bossio su questo punto dà adito a perplessità: infatti riferisce che il Bossio, entrato nella chiesa (da intendersi la chiesa grande) "pervenit ad cemeterium eiusdem hospitalis

positum in inferiori fere parte illius," ma che dopo averlo visitato e aver benedetto le sepolture "descendens in viam reversus est in dictam ecclesiam." Sembrerebbe perciò che allora al cimitero si accedesse dalla chiesa, ma che esso avesse anche un accesso indipendente che dava su una strada a quota più bassa della chiesa, e che comunque la cappella del Manto fosse allora estranea a tale percorso. Della devozione a Santa Cristina è prova il bel busto-reliquiario quattrocentesco, in rame dorato, della presunta testa della Santa che si conserva tuttora nello Spedale. Il Faluschi (*Breve relazione*, 51) informa che "sopra ciascun letto degl'Infermi" si vedevano "ritratti di vari Santi di pennelli diversi, sebbene di poco, o niun valore," che furono levati nel 1784.

[35]Il pagamento di questo affresco fu effettuato il 2 aprile in una con quello della *Madonna del Manto*.

[36]Gallavotti, "Gli affreschi . . . della Sala del Pellegrinaio," 34.

[37]A meno che l'affresco illustri l'apparizione di Gesù al Beato di cui al capitolo XVII ("Come il Signore lo visitò e consolò doppo la ricevuta tentazione") della biografia del Lombardelli, *La vita del Beato Sorore da Siena . . . scritta da M.R.P. Maestro Gregorio Lombardelli Sanese dell'Ordine de' Predicatori* (Siena, 1627), 43. Stupisce tuttavia che il Lombardelli, il quale doveva conoscere bene lo Spedale di cui tra l'altro aspirava a diventare rettore (Banchi, *Statuti senesi*, XXI) non abbia tenuto conto di questo affresco che poteva essere per lui una preziosa fonte iconografica.

[38]Per esse v. G. De Nicola, "Studi sull'arte senese. 1–Priamo della Quercia," *Rassegna d'Arte* (XVIII, 1918), 69–74; idem, "Priamo della Quercia—Appendice," *ibid.*, 153–54; M. Battistini, "Maestro Priamo della Quercia e il quadro di S. Antonio a Volterra," *Rassegna d'Arte* (XIX, 1919), 233 e infine M. Meiss, "The Yates Thompson Dante and Priamo della Quercia," *Burlington Magazine* (CVI, 1964), 403–12.

dell'edificio, accentuando quella "incertezza spaziale" che già la Gallavotti ha notato nella scena nel Pellegrinaio, appesantisce il chiaroscuro e ingrossa le linee che non hanno più l'incisività propria di Domenico. Le opere di Priamo, s'è detto, sono così rare da non consentire molti raffronti: tuttavia mi limiterò a rilevare la forte somiglianza, anche fisionomica, tra il giovane visto di fronte a sinistra nel monocromo e il giovane presso la colonna, pure a sinistra, nell'affresco del Pellegrinaio,[39] e quel modo di scavare i lineamenti nel personaggio anziano davanti al Beato Sorore, che si ritrova anche nel *San Bernardino* nella Galleria di Volterra. Ma anche le miniature delle prime due cantiche della *Divina Commedia* nel codice Yates Thompson no. 36 al British Museum con i loro personaggi dagli abiti ridotti a fasci di pieghe tubolari, possono essere avvicinate al nostro affresco. Poichè tali miniature sono state attribuite a Priamo della Quercia da Millard Meiss, mi sembra che l'attribuzione allo stesso del moncromo nell'Infermeria di S. Pio costituisca una, sia pur lieve, conferma dell'avviso dell'illustre studioso ed amico cui questo scritto è dedicato.

UNIVERSITÀ DEGLI STUDI DI SIENA

[39] Si veda il particolare riprodotto alla fig. 14 del citato articolo del Meiss.

Sur Deux Rameaux de figuier

ANDRÉ CHASTEL

Certains détails d'oeuvres d'art—célèbres ou non—se gravent profondément dans l'esprit. Ce sont les supports incomparables du souvenir. Mais ces trouvailles qui créent la surprise et l'enchantement ne se prêtent pas d'ordinaire à l'interprétation. C'est peut-être même parce qu'elles la défient, ou semblent au-delà de l'explicable, qu'elles retiennent. Parfois pourtant l'analyse historique éclaire dans sa particularité le détail poétique en justifiant sa présence à l'intérieur de l'oeuvre. Et le motif devient sans dommage explicite.

La *Madone apparaissant à St. François et à St. Alvise* que l'on voit au musée d'Ancône est une oeuvre signée et datée avec soin (Fig. 1).[1] L'inscription du *cartellino* : "Aloysius Gotius Ragusinus/fecit fieri/MDXX/Titianus cadorinus pinsit" indique le donateur, le millésime, l'auteur, en précisant—ce qui était indispensable, s'agissant de ressortissants vénitiens— l'origine du commanditaire et celle du peintre. Le panneau est de grandes dimensions, mais sans rien de commun avec la taille exceptionnelle de l'*Assomption* des Frari; il marque à cet égard la grande entrée de Titien dans le genre le plus traditionnel de toute la peinture: la *pala*. Les intentions de l'artiste seront confirmées par le polyptyque Averoldo (Brescia), qui offre peu après la même démonstration de puissance.

La composition et la qualité de l'*invenzione* sont étonnantes; jamais *pala* n'avait encore atteint l'intensité dramatique qui, entre des milliers de tableaux d'autel que l'on peut voir en Italie, rend celui-ci inoubliable. Tous les éléments traditionnels—Vierge et Enfant accompagnés d'anges sur les nuées dans un rayonnement clair, les deux saints tournés vers eux à l'étage terrestre, le donateur docile auprès de son saint patron—sont en place, mais une animation qui court comme un frémissement, une concentration des effets à distance obtenus par les regards, les tons sourds et profonds du crépuscule sur la lagune bordant le bas de la scène, infusent au panneau quelque chose d'indiciblement fort et poignant. Découpée sur le ciel du soir, une pousse vivace de figuier, frissonnant au vent du crépuscule, semble participer à l'effort de la terre vers le ciel; trouvaille "lyrique" sans précédent, elle achève le "momentum" original, l'effet global de la scène, en jetant ses deux rameaux, l'un vers le saint dressé dans sa bure, l'autre vers l'évêque mitré: la composition se ferme sur cette note humble, spontanée et fragile (Figs. 2, 3). C'est là un de ces détails merveilleux qui font le prix de la peinture.

Faut-il à tout prix le livrer à l'analyse? Peut-être, mais à condition, croyons-nous, de poser contre les "lectures" déréglées et désinvoltes qui "décodent" les signes sans considération de temps et de lieu, qu'il y a une "vérité iconographique," et contre les spéculations aberrantes ou, en tout cas, gratuites, sur les implications des structures, qu'il y a un "sens" des compositions et une "orientation" de styles. Car ce motif du figuier a, curieusement, une histoire qui a été assez bien explicitée il y a quelques années, mais en même temps recouverte

[1]La fiche bibliographique de l'oeuvre se trouve dans le catalogue de la "Mostra di Tiziano" (1935), no. 12, dans celui de l'exposition de Schaffhouse (1953), no. 47, et de l'Orangerie (1954), no. 50 (où toutefois la description: "un Enfant Jésus très vif qui se précipiterait des genoux de sa Mère vers Gozzi s'il n'était protégé par un ange" ne nous paraît pas correcte). Voir aussi R. Pallucchini, *Tiziano* (Florence, 1969), I, 53; H. Wethey, *The Paintings of Titian, Complete Edition, I. The Religious Paintings* (Londres, 1969), 109–10, no. 66.

d'une abusive épaisseur d'exégèses.[2] On a en effet observé que dans la région de Venise—et, semble-t-il, dans cette zone seulement—le figuier apparait en rapport avec la Nativité et se lie à l'attente du Salut: l'arbre qui, selon une tradition à peu près constante, est d'une part associé à la faute originelle et à la chute, apparaît d'autre part avec une régularité qui ne peut être fortuite comme un symbole sotériologique et marial. En particulier dans l'oeuvre de Bellini, qui fut après tout le maître de Titien: à Pesaro, un peu au Nord d'Ancone, où, quarante ans avant Titien, Gianbellino avait été invité à envoyer un grand ouvrage, le panneau de la prédelle consacré à la *Nativité* dresse un figuier devant la grotte; la tête de l'*Homme de douleurs* (Stockholm) est placée sous un rameau de figuier; et, ce qui est peut-être plus typique encore, l'arbre apparaît dans la coulisse de droite sur la *Pala de San Zaccaria*, 1505 (Fig. 4). Dans un panneau postérieur de Lotto (1533, Académie Carrara, Bergame), la Madone est comme auréolée de larges feuilles de figuier.[3] La branche de figuier que l'on voit au centre du *Couronnement de la Vierge* (Brescia, Santi Nazaro e Celso) de Moretto adapte de toute évidence le motif de Titien (Fig. 5).

L'association paraît assez constante et assez naturelle pour définir une sorte de *syntagme* pictural, ou plutôt l'équivalent imagé, pour les peintres qui ont besoin d'introduire certaines constantes dans leur répertoire, de précis groupements sémantiques, nom et adjectif par exemple. C'est d'une relation fixe de cet ordre que Titien semble avoir tiré parti. Sa pousse de figuier n'est pas née du caprice mais d'une convention tacite, déjà ancienne et familière. Mais pourquoi à Venise et autour? Il peut paraître séduisant d'invoquer les cultes dionysiaques et les origines orientales de l'art de la lagune.[4] Mais l'enquête iconographique doit procéder de palier en palier et ne peut mêler indistinctement des éléments communs à divers systèmes sans les situer d'abord à l'intérieur de chacun d'eux. Le prestige du figuier, arbre facile à identifier et à peindre, est dû avant tout aux Evangiles: les Synoptiques l'évoquent tous par deux fois dans des circonstances qui lui assuraient un statut privilégié dans les symboles végétaux.[5]

[2]F. Klauner, "Zur Symbolik von Giorgiones *Drei Philosophen*," *Jahrbuch der kunsthistorischen Sammlungen in Wien* (LI, 1955), 145 et s. L'auteur a fort bien vu que la présence des feuilles de figuier (révélées par la restauration) sur la grotte à gauche du tableau de Vienne, constituait un argument solide pour l'identification des "Philosophes" avec les Rois Mages. Mais l'accumulation de références empruntées à la mythologie grecque et aux Pères affaiblit la démonstration au lieu de la soutenir. Il nous est impossible de comprendre pourquoi, la référence à l'Evangile ayant été mentionnée (mais non commentée), l'auteur a cru nécessaire de s'adresser aux *Hieroglyphica*, etc., pour interpréter un trait aussi simple d'iconographie "évangélique." D'autre part, il ne semble pas tout à fait exact de dire que "der Feigenbaum wird ein Attribut Marias" chez Bellini et Titien (p. 155); ceci s'accorde mal avec l'indication qui suit sur "der Feigenbaum als Symbol der Erlösung durch den Tod" (p. 156), à propos des saints martyrs auprès de qui l'arbre se trouve parfois représenté.

M. Meiss, "Giovanni Bellini's St. Francis," dans *Saggi e Memorie di Storia dell'Arte*, 3 (Venise, 1963), 11–30 a signalé l'intérêt de l'étude avec quelques réserves (n. 73) que nous développons.

[3]Sur l'*Annonciation* (ca. 1535) de la Scuola di San Rocco, on peut voir une feuille de figuier auprès de la pomme, dans l'étonnant groupement de la nature-morte qui a appelé un commentaire détaillé d'E. Panofsky, *Problems in Titian, Mostly Iconographic* (New York, 1969), 30. Plus ostensible encore est

le rameau qui borde le mur de la cabane de la *Nativité* de Palma le Vieux (Musée du Louvre).

[4]Klauner, "Zur Symbolik von Giorgiones *Drei Philosophen*," 148. Des compléments ont été cherchés dans les légendes bouddhiques, égyptiennes, etc. par M. Auner dans l'excursus "Feigenbaum und Efeu" paru dans le même *Jahrbuch der kunsthistorischen Sammlungen in Wien* (LIV, 1958), 168–72.

[5]Dans Luc XXI: 28, l'analogie est plus large: "Voyez le figuier et tous les arbres: dès qu'ils se sont mis à pousser, vous savez de vous-même, en les voyant, que l'été est proche." La scène du figuier stérile prend dans Luc XIII: 6–9 la forme d'une parabole: "Un homme avait un figuier planté dans sa vigne; il vint y chercher des fruits et, n'en trouvant point, il dit au vigneron: 'voilà trois ans que je viens chercher du fruit à ce figuier et je n'en trouve point; coupe-le donc: pourquoi rend-il la terre improductive?' Le vigneron lui répondit: 'Seigneur, laisse-le encore cette année . . . Peut-être portera-t-il du fruit, sinon vous le couperez.'" Dans Matthieu XXIV: 32, on a, comme dans Marc, l'évidence du figuier servant d'analogie à l'avènement du Christ: "Écoutez une comparaison prise du figuier. Dès que ses rameaux deviennent tendres et qu'il pousse ses feuilles, vous savez que l'été est proche. Ainsi . . ." La scène de la malédiction du figuier est rapportée après l'entrée triomphale à Jérusalem (XXI: 19 et s.), mais la mort du figuier est ici instantanée. Tous les commentateurs ont reconnu là le destin du peuple juif.

On peut penser qu'à Venise les passages de l'Evangile de Marc—patron de la cité—étaient lus avec une attention particulière. Après l'entrée des Rameaux, c'est la scène impressionnante et singulière où l'arbre couvert de feuilles mais dépourvu de fruits est maudit par le Christ et apparaît le lendemain "desséché jusqu'à la racine" (XI: 12–20). Allusion—commente St. Jérôme—à Jérusalem et aux Juifs qui, malgré une apparence flatteuse, se révèlent incapables de sainteté. Mais le même végétal, qui porte cette valeur négative, est évoqué, après l'ultime prédication sur la ruine de Sion, comme le symbole du renouveau et du salut: "Écoutez la comparaison du figuier: dès que ses rameaux sont tendres et qu'il pousse ses feuilles, vous savez que l'été est proche. Ainsi quand vous verrez ces choses arriver, sachez que le Fils de l'homme est proche" (XIII: 28–29). Cette évocation solennelle contenait une incitation explicite et appelait aisément à la figuration, surtout à un moment où se prononce un grand mouvement d'expansion iconographique, comme c'était le cas en Italie au tout début du seizième siècle. La présence d'une grande pousse de figuier auprès de St. Marc dans la petite *pala* d'Andrea Busati (ca. 1520?, Accademia) est d'autant plus intéressante qu'elle se découpe sur le ciel entre deux saints personnages (Fig. 6), comme font les deux rameaux de Titien.

On ne peut pas raisonnablement s'engager à rendre compte de toutes les petites végétations et de tous les arbres dont les peintres de Venise ont garni leurs ouvrages. Sur la *pala* de Busati, un oranger tient compagnie à St. François. On sait le parti que vers 1495 Cima tirait de l'oranger; il exploitait dans sa fameuse *pala* (Accademia) un autre *syntagme*, une autre association toute faite, de justification facile. Chaque artiste avait devant lui un choix de possibilités, où il puisait selon ses prédilections ou selon les obligations inhérentes à son thème. La *Stimmung* pathétique recherchée par Titien s'accordait avec la connotation grave du figuier, surtout lorsqu'il est traité comme la repousse—inespérée, en somme—d'un tronc coupé, c'est-à-dire (et c'est le cas ici) comme l'annonce, le symptôme visible du miracle du Salut, demandant l'abandon de la vieille Loi. Il ne semble ni possible ni nécessaire de trouver une motivation particulière aux deux touffes qui l'accompagnent et qui semblent être des lys sauvages à gauche, des chardons de la lagune à droite (Fig. 3). Enveloppées d'ombre, elles font ressortir la force de la pousse du figuier; avec ce contraste simple, apparaît la limite de la "lecture" iconographique.[6]

Mais la place des rameaux n'est pas indifférente. Ils jalonnent la percée vers l'horizon qui conduit à Saint Marc; le clocher se dresse sous le jour affaibli près du Palais Ducal, que la lagune sombre ne reflète pas. La pousse de figuier encadre en quelque sorte la *veduta* insérée au centre de la composition (Fig. 2): groupe significatif et, à coup sûr, calculé, si l'on songe qu'il s'agit ici d'un ouvrage vénitien offert à une cité que la Sérénissime a toujours considérée avec un intérêt jaloux, et donc nécessairement chargé de quelque message politique.[7] Les années difficiles pour Venise, consécutives à la Ligue de Cambrai et au conflit avec le pape puis avec l'empereur, s'achèvent et le symbole du renouveau promis à l'humanité, révélé au

[6]On pourrait imaginer que le lys sauvage—si c'en est un—est à dessein rapproché de St. François. Mais cette fleur n'apparaît pas parmi les attributs du saint, comme c'est le cas pour St. Antoine de Padoue: par exemple, chez Alvise Vivarini à la *pala* de Trévise, 1480 (Accademia, no. 174); voir R. Pallucchini, *I Vivarini* (Venise, s. d.), no. 236, fig. 238 et dans le panneau charmant du Musée Correr qui en dérive (*ibid.*, no. 240).

[7]La *veduta* du Palais Ducal et de Saint Marc est à la fois symbole de la protection divine et *trade-mark*. Elle apparaît dans la *Madone* de Giorgione (Oxford) ca. 1504, dans la *Mort d'Adonis* de Sebastiano del Piombo (Offices) en 1512, et, bien entendu, derrière le *Lion de St. Marc* de Carpaccio (Palais Ducal) en 1516.

fidèle, peut aussi s'appliquer à la cité d'où est venu ce panneau remarquable et où elle a bien marqué sa présence. C'était la première commande de Titien pour une ville méridionale et, au surplus, liée de près aux États de l'Église. Il n'est peut-être pas si surprenant que l'artiste ait conçu sa *pala* sur un modèle emprunté au peintre le plus glorieux de Rome, et précisément au moment où celui-ci vient de mourir. Les liens avec la *Madone* dite *de Foligno* peinte en 1511–1512 par Raphaël sont évidents : le groupe céleste, présenté comme une sorte de phénomène lumineux, est suspendu au-dessus du monde terrestre où les intercesseurs—celui de droite présentant le donateur—interviennent de part et d'autre d'une percée centrale vers un lointain de nature, que nul dans la scène ne regarde mais qui a sa raison d'être dans la personnalité du donateur et qui est, si l'on peut dire, soumise à l'attention du spectateur (Fig. 7).[8]

La *Madone de Foligno* n'a pas été choisie par hasard comme modèle proche par Titien. La réputation de Raphaël s'étendait depuis plusieurs années au Nord des Apennins; l'envoi de la *Madone de St. Sixte*, commandée à la fin de 1512 ou au début de 1513, à l'abbaye de San Benedetto Po près de Mantoue, n'était pas resté inaperçu. Tout s'est passé comme si, l'année même de la mort de Raphaël, Titien avait entendu démontrer qu'il était capable d'assumer en le reprenant à son compte l'héritage de l'artiste "pontifical," au moins dans ce domaine. Or la *Madone de Foligno* était précisément importante dans la mesure où elle consacrait une importante innovation dans l'économie générale de la *Sacra Conversazione*. Compte tenu d'innombrables variantes et compromis, le problème peut être brièvement présenté de la manière suivante. Le tableau d'autel avait trouvé une formule durable en présentant la Madone et les Saints dans un cadre d'architecture, où le trône surélevé permettait d'affirmer la hiérarchie des personnages. C'est sous cette forme que le thème s'était imposé durablement à Venise, avec des variations de plus en plus nombreuses autour de 1500. Mais en 1520, ce modèle était depuis longtemps remis en cause.

L'initiative de Lotto à Asolo (1506) avait montré qu'il provoquait certaines impatiences: pourquoi ne pas substituer le paysage aux architectures traditionnelles? Cette opération se heurtait, en fait, à de graves difficultés. La structure architecturale permettait de concentrer l'effet—par le seul jeu de la perspective—sur la Madone et d'unifier la composition sur une base simple. Le paysage, prolongeant l'espace jusqu'à l'horizon, éliminait cette possibilité et obligeait à réserver la plate-forme terrestre aux seuls saints et à expulser, si l'on peut dire, la Madone vers le ciel.[9] C'est ce que réalisa Lotto, mais, du même coup, le lien de la Madone avec les Saints cessait d'être clair et, logiquement, le peintre avait transformé la "conversation" qui entraîne une interrelation des personnages en une *Assomption* où la Madone, ignorant les Saints, s'élève vers l'empyrée.

Raphaël avait résolu la difficulté dans la *Madone de Foligno* en reconstituant la *Sacra Conversazione* sous la forme d'une vision, où la Madone flotte au-dessus de la terre mais où

[8]L'importance de la *Madone* commandée par Sigismondo dei Conti et destinée à l'autel principal de l'Aracoeli—situation particulièrement en évidence—a été soulignée par tous les auteurs. La restauration récente a restitué au paysage toute sa force, sans qu'on soit obligé d'accueillir l'hypothèse selon laquelle il serait dû à un aide, Battista ou Dosso Dossi. Voir notamment D. Redig de Campos, "La Madonna di Foligno di Raffaello," *Miscellanea Bibliothecae Hertzianae zu Ehren von Leo Bruhns* (Munich, 1961), 184–97; L. Dussler, *Raffael* (Munich, 1966), 65; J. Pope-Hennessy, *Raphaël* (Londres, s. d.), 207 et s.

[9]Titien a précisément tenté de reprendre le cadre bellinien dans la *pala* destinée à l'église San Niccolo dei Frari de Venise, vers 1520, avec exécution retardée jusque vers 1535 (selon A.L. Mayer, "A propos d'un nouveau livre sur le Titien," *Gazette des Beaux-Arts* (VI, 1937); voir aussi H. Wethey, *The Paintings of Titian*, no. 65); et ce fut loin d'être un succès.

le jeu des regards fait réapparaître la notion d'un entretien mystique. Seulement, il en résulte une sorte de vide spatial au centre du panneau, où un lointain se creuse entre les deux groupes du premier plan et la Madone qui le surplombe. Ce vide intéressait et préoccupait depuis longtemps les peintres d'Italie Centrale.[10] Raphaël limite sa portée en introduisant l'ange-*putto* porteur du cartouche qui équilibre à lui seul le premier plan. Trouvaille qu'il était difficile à Titien de reprendre sans donner l'impression qu'il suivait de trop près son modèle. Le motif du rameau de figuier—familier dans le milieu vénitien et ignoré, semble-t-il, en Italie Centrale—lui offrait une solution originale à deux points de vue : il encadrait la *veduta* profonde en assurant la continuité du premier plan et en ajoutant son frémissement à l'animation générale de la "Sainte Conversation" : en même temps il valorisait un modeste élément de l'iconographie mariale. On comprend peut-être mieux ainsi les intentions du peintre, si attentif à éliminer les éléments inertes et factices et à faire participer tous les termes de la scène à l'effet global, dominé par le flux et le reflux de la lumière. L'hommage à Raphaël contenait ainsi, grâce au figuier, une critique implicite. Et il fournissait un remarquable exemple de l'interaction de la forme et du sens, dont on doit au Professeur Millard Meiss de si belles démonstrations,[11] et dont la prise en considération ne peut que devenir, en accord avec ses observations, une règle fondamentale de nos études.[12]

COLLÈGE DE FRANCE

[10]L'effet de percée profonde—qui s'observe dans d'innombrables panneaux en Italie Centrale—intervient dans un premier temps sous le trône de la Madone, par exemple chez L. Costa à San Giovanni in Monte, Bologne, 1497 : voir B. Berenson, *Italian Pictures of the Renaissance, Central Italian and North Italian Schools* (London, 1968), no. 1630. Voir aussi F. Zaganelli, *Immaculée Conception*, Forlì, 1513 (*ibid.*, no. 1047), et F. Torbido, *Madone avec la Trinité, Tobie et l'Ange et Ste. Apolline*, Vérone (*ibid.*, no. 1872).

Les problèmes de la *pala*, dont nous donnons ici un aperçu excessivement schématique, seront abordés dans un ouvrage en préparation.

[11]Il s'agit—pour ne citer qu'une de ces heureuses formulations—de ces "subtle, often invisible interconnections of style or formal trends with subject and content" (M. Meiss, "Sleep in Venice," *Proceedings of the American Philosophical Society*, CX, 1966, n. 5).

[12]Cette étude ne tient pas compte de l'ouvrage de O. Goetz, *Der Feigenbaum in der religiösen Kunst des Abendlandes* (Berlin, 1965), où quelques-uns des ouvrages évoqués ici sont pris en considération. J'en ignorais son existence au moment de la rédaction de mon texte. Ce traité méthodique aurait permis d'ajouter quelques précisions ; il ne rend pas inutile la démonstration présentée.

Pope Innocent VIII and the Villa Belvedere

DAVID R. COFFIN

The Roman chronicler Infessura records that Pope Innocent VIII (1484–1492) "built in the vineyard, beside the papal palace, a palace which is called from its view the Belvedere, and it is well known to have cost 60,000 ducats for its construction."[1] Built to the north of St. Peter's and the Vatican Palace on the summit of a hill called Monte Sant'Egidio in medieval documents, the Villa Belvedere faced Monte Mario and the Milvian bridge with Monte Soratte on the horizon (Fig. 1). Below were the Prati or meadows that ran to the edge of the Tiber, beyond which was the northern sector of the city of Rome. Most of the trudging pilgrims or splendid ambassadorial corteges coming to Rome from the north would pass beneath the Belvedere to enter the Vatican by one of the gates in the Leonine wall. For lighter diversion the Prati offered one of the most favorite sites sought by the Romans, where they could escape from the dingy, crowded streets of the city on a summer afternoon.

The few documents concerned with the building of the Villa Belvedere are so ambiguous that its exact history is doubtful. It must have been begun, however, in 1485, since the first certain document, dated April 13, 1486, records a mandate of March 3 to pay for 5,000 paving tiles and 2,000 roofing tiles "for the palace in the vineyard of our Very Holy Lord."[2] The purchase of such material suggests that the construction of the Villa was then well advanced. A payment of September 22, 1487 "for the completion of the building of walls in the vineyard of the palace" may also refer to the new Villa, although the description of the work is vague. Finally, the vault of the loggia of the Villa bears an inscription asserting that Pope Innocent VIII founded (*fundavit*) the Villa in 1487. This inscription is usually interpreted as recording the completion of the structure and the commencement of the decorative program. There are several other documents regarding the work of the decorative painter Piermatteo d'Amelia that are difficult to interpret, although according to a very late document of 1492 he worked in part "in the location which is called Belvedere" as well as elsewhere in the Vatican.[3] Those payments to him in 1486 and 1487 for decorative painting "in the secret garden" (*in orto secreto*) or "in the loggia near the well" (*in logia prope puteum*) must refer to the Pope's private garden to the west of the Vatican Palace in the area of the present Court of San Damaso. A payment of February 20, 1486 "for the painting of a round table with the arms of our Very Holy Lord at the pavilion (*pampilionem*) in the vineyard" presumably refers to the pavilion built in 1461 for Pope Pius II. There is, therefore, no exact information as to when Piermatteo painted in the Belvedere or what he did.

The identification of the designer or architect of the Villa is more confusing than the

[1] *Diario della città di Roma di Stefano Infessura scribasenato,* ed. O. Tommasini (Rome, 1890), 279.

[2] E. Müntz, "L'architettura a Roma durante il pontificato d'Innocenzo VIII," *Archivio storico dell'arte* (IV, 1891), 459. Müntz in *Les Arts à la cour des papes Innocent VIII, Alexandre VI, Pie III* (Paris, 1898), 77–78, claimed that a document of April 6, 1485 for the purchase of a vineyard "located behind

the tribune of the Prince of the Apostles" marks the acquisition of land for building the Villa but, as later scholars have noted, the location of the land behind St. Peter's does not correspond to that of the Villa.

[3] E. Müntz, "Nuovi documenti: le arti in Roma sotto il pontificato d'Innocenzo VIII (1484–1492)," *Archivio Storico dell'Arte* (II, 1889), 480–81.

DIAGRAMMATIC PLAN OF THE VILLA BELVEDERE IN THE FIFTEENTH CENTURY

1. Chapel
2. Sacristy
3. Main loggia
4. Papal apartments : Room of
 the Prophets
5. Papal apartments : Room of the Liberal Arts
6. Papal apartments : Anteroom
7. Papal apartments : Pope's bedroom?
8. Loggetta
9. Loggia

dates of its creation. Vasari in the mid-sixteenth century hesitantly reports that "it is said" that the designer was the Florentine sculptor Antonio Pollaiuolo and then qualifies the attribution by adding that the execution of the building was carried out by others, since Pollaiuolo was inexperienced in architecture. On the other hand, a document of 1495 notes that the late Jacopo da Pietrasanta was owed money "for building the house in the vineyard of the Apostolic Palace called the Belvedere" during the lifetime of Innocent VIII.[4] There is not, however, enough comparable material to decide whether Jacopo was also the designer of the Villa or merely the executor of the design of Pollaiuolo or some other artist.

The Villa Belvedere stood on Monte Sant'Egidio at the head of the vineyard or park, called the *pomerium* in contemporary documents, which Pope Nicholas III in 1278–1279 enclosed on the northern side of the Vatican Palace just outside the Leonine wall. Originally the Villa was roughly U-shaped in plan (see Diagrammatic Plan), facing north with a secondary wing on the eastern end projecting down into the vineyard. When Bramante and Pope Julius II added the Statue Court on the southern side of the Villa, much of that exterior elevation was changed, and with the creation of the Museo Clementino in the late eighteenth century most of the interior of the Villa was drastically revised, including destruction of the chapel frescoed by Mantegna. Early-eighteenth-century drawings now in the Library of the British Museum, however, and the descriptions of the Vatican by Taja (written 1712, pub-

[4]E. Müntz, "L'architettura a Roma," 460. Recently the mysterious architect Baccio Pontelli has been suggested as the possible designer on the basis of a resemblance of the Villa Belvedere to the cloister of Santa Chiara at Urbino designed by Pontelli's master Francesco di Giorgio; see C.L. Frommel, *Die Farnesina und Peruzzis Architektonisches Frühwerk* (Berlin, 1961), 100–01. This resemblance, however, does not seem close enough to clarify the problem of the attribution.

lished 1750) and Chattard (1762–1767) permit a reconstruction of the fifteenth-century Villa.[5]

During the recent restoration of the structure of the original Villa, it was discovered that there were two building campaigns under Pope Innocent VIII.[6] The secondary wing at the east was found to have been added to the main block later during the pontificate of Innocent VIII, and presumably at the same time were added the interior walls that form the small papal apartment and chapel within the main block. The first structure, therefore, was essentially a loggia-pavilion for afternoon or early evening repasts and seclusion during the summer. Soon after its completion the pavilion was converted into a villa by the addition of the service wing at the southeast, the incorporation of a small papal apartment in the eastern end, and a chapel and sacristy in the western end of the original building. There is no sure documentation for the date of this change, but the inscription painted in the gallery recording that Innocent VIII "founded" it in 1487 probably refers to this alteration rather than to the commencement of the decoration.[7]

The Villa is set with its main block running east to west and with two small wings projecting to the north. These wings are not symmetrical in size, for the one at the western end projects more than twice the length of the eastern one. The reason for this lack of symmetry is generally attributed to an effort to make the building conform to the irregularity of the site. As the northern terrace and flanking wings are partially built out over the escarpment, however, this explanation does not consider the fact that symmetry might have been gained by building out the eastern end of the escarpment as was done at the western end. Since the principal value of the Villa, as its name indicates, was its magnificent view, the explanation of its asymmetry may be related to this. The end wings are to help protect the main loggia from winds, but, if the eastern wing had projected as far as its companion, much of the breathtaking view out over the Prati would have been cut off. The view to the west toward Monte Mario was limited in comparison to the panorama to the north and east over the Prati to the distant Sabine hills focused on Monte Soratte.

Innocent VIII soon converted his loggia-pavilion into a suburban villa. In the southwestern corner a small chapel and an adjacent sacristy were created in the bay of conjunction of the main loggia and the northern wing, leaving the northern wing as an independent loggia. A portal led from the main loggia into the sacristy and then into the chapel. The eastern wall of the chapel had a window into the main loggia so that Mass being said in the tiny chapel could be heard in the loggia. The altar stood against the western wall opposite this window with a tondo window in the lunette above it.

The papal apartment of five rooms was fashioned in the eastern end of the pavilion by closing, except for windows, the two eastern arches of the principal loggia and introducing interior walls and fireplaces. A secondary service wing was then added at the southeastern corner, but later alterations to this wing prevent any knowledge of its original disposition.

[5]For the drawings, see C. Pietrangeli, "Il Museo Clementino Vaticano," *Rendiconti della Pontificia Accademia Romana di Archeologia* (ser. III, XXVII, 1951–1952), 93–97. The descriptions are A. Taja, *Descrizione del palazzo apostolico vaticano* (Rome, 1750) and G.P. Chattard, *Nuova descrizione del Vaticano* (Rome, 1762–1767), 3 vols.

[6]D. Redig de Campos, "Il Belvedere d'Innocenzo VIII in

Vaticano," *Triplice omaggio a Sua Santità Pio XII* (Vatican City, 1958), II, 296–304.

[7]The document of payment on Sept. 22, 1487 (see above, p. 88) for the completion of masonry walls in the vineyard might possibly belong to this work, but the lack of mention of "palace" or "house" in the document makes this unlikely.

Soon the decorative program of the Villa was underway. In a letter of April 24, 1488 to the Marquis of Mantua, the painter Andrea Mantegna indicated a desire to be released for duty, undoubtedly in Rome, and on June 10, 1488 the Marquis sent Mantegna to Pope Innocent VIII accompanied by a letter of introduction.[8] It was probably on the recommendation of Cardinal Giuliano della Rovere, the future Pope Julius II, that Mantegna was invited to Rome, since, as early as February 1484, the Cardinal had endeavored to lure Mantegna there, and during the papacy of Innocent VIII the Cardinal was the most influential individual at the papal court.[9] From June 1488 until September 1490 Mantegna was active in Rome in the employ of the Pope. Another artist who worked in the Belvedere, according to Vasari's much later account, was the younger Umbrian painter Pinturicchio, who decorated "some rooms and loggias in the palace of the Belvedere, where, among other things, as the Pope desired, he painted a loggia full of landscapes and portrayed there Rome, Milan, Genoa, Florence, Venice, and Naples in the manner of the Flemings."[10] It has generally been assumed that Pinturicchio began the landscape paintings of the loggia in 1487, with the minor decorative painter Piermatteo d'Amelia and other artists executing the lunettes of the loggia, and that Andrea Mantegna came independently in the middle of 1488 to fresco the small chapel and sacristy at the western end of the Villa. Since the work of Piermatteo d'Amelia cannot be precisely dated, however, and the 1487 inscription probably refers to the architectural renovation of the Villa, it is very possible that Mantegna was selected early in 1488, as one of the most famous Italian painters of the period, to be the master in charge of the decoration, and that Pinturicchio, Piermatteo, and other unknown artists joined him to help carry out the program. In fact, in a letter of June 15, 1489, Mantegna complained that the work was too much for one man alone, and, as has been pointed out, such a complaint seems very unlikely to be caused by a commission involving only the decoration of the very tiny chapel and sacristy.[11] It may also be significant that Raffaele Maffei in 1506 in the earliest reference to the decoration of the Villa mentions only Mantegna and does not limit his contribution to the chapel.[12]

Illusionism is the most striking characteristic of most of the decoration of the Villa Belvedere, thus strengthening the suggestion that Mantegna was the master in charge of the entire decorative program.[13] The chapel and sacristy (Diagrammatic Plan, 1 and 2) decorated by Mantegna himself were destroyed in the eighteenth century, so that our knowledge of them is based only on the literary descriptions of that time. In the sacristy a ceiling coffered with various geometric forms was decorated in the grotesque style, while the walls were

[8]W. Braghirolli, "Alcuni documenti inediti relativi ad Andrea Mantegna," *Giornale di Erudizione Artistica* (I, 1872), 201; the other letters regarding Mantegna are best published in C. D'Arco, *Delle arti e degli artefici di Mantova* (Mantua, 1857), II, 19–24.

[9]G. Vasari, *Le vite de' più eccellenti pittori, scultori ed architettori*, ed. G. Milanesi, III (Florence, 1878), 396 and 398, n. 2. Regarding the position of Cardinal della Rovere, see L. von Pastor, *The History of the Popes*, v. 2nd ed. (St. Louis, 1912), 242.

[10]Vasari, *Le vite*, 498.

[11]S. Sandström, "Mantegna and the Belvedere of Innocent VIII," *Konsthistorisk Tidskrift* (XXXII, 1963), 122; the letter is published in C. D'Arco, *Delle arti . . . di Mantova*, 21, no. 24.

[12]*Commentariorum urbanorum* (Rome, 1506), II, fol. CCCr: "Andreas Mantegna Mantuanus edes quas Beluedere cognominant in Vaticano ab Innocentio VIII adibitus ornauit miro tenuitatis opere."

[13]The most recent discussions of the artists and decorative program of the Belvedere are: S. Sandström, "The Programme for the Decoration of the Belvedere of Innocent VIII," *Konsthistorisk Tidskrift* (XXIX, 1960), 35–75; C. Pietrangeli, "Mantegna in Vaticano," *L'Urbe* (XXIV, 1961), 95–103; J. Schulz, "Pinturicchio and the Revival of Antiquity," *Journal of the Warburg and Courtauld Institutes* (XXV, 1962), 35–55; and S. Sandström, "Mantegna and the Belvedere of Innocent VIII," 121–22.

treated illusionistically, with pilasters feigned in paint dividing the walls into compartments in which were depicted open cupboards with the various liturgical paraphernalia found in a sacristy, such as chalices, censers, pyxes, and miters. The adjacent chapel, entered from the sacristy, was dedicated to St. John the Baptist, as indicated by the paintings and also by a dedicatory inscription dated 1490 on the east wall, which also recorded that the chapel was painted by Andrea Mantegna.

The decorative program of the chapel is not unusual but does understandably contain references to its owner, the Pope. The dedication to the Baptist reflects this, since St. John was his name-saint. The bust depictions of the martyrs St. Stephen and St. Lawrence and the hermit saints Anthony Abbot and Paul on the entrance wall are probably also personal references. Of Stephen and Lawrence, who are often paired as the first notable Christian martyrs, the latter was dear to Innocent VIII, because as Cardinal his titular church had been San Lorenzo in Lucina. In the same way, of the pair of hermit saints, Innocent held St. Anthony Abbot in special reverence. For the papal coronation in 1484, the artist Antoniazzo Romano painted twenty-five images of St. Anthony for the new Pope's room at the Vatican, and in 1486 Piermatteo d'Amelia was paid for painting two figures of St. Anthony in the "secret garden" and one painting of St. Anthony in the "loggia near the well." It has been further suggested that these eremitical saints were chosen in reference to the Belvedere as a contemplative retreat beyond the activity of the Vatican Palace.[14] Even later stories, perhaps legendary only in part, connect several of the figures of the Virtues in the lunettes below the vault to the personality of the Pope.[15]

The main loggia of the Villa (Diagrammatic Plan, 3), originally about 18.75 meters long by 6.5 meters wide, had its closed rear or southern wall and end walls compartmented by pilasters feigned in paint to match the open arcade on the northern side (Fig. 2). Before the eighteenth-century alterations, there were six bays on each of the long walls and two on each of the end walls. The areas between the pilasters on the southern wall were painted with a continuous landscape illusionistically suggesting that the wall was open to match the northern side. The end walls are now lost, and only fragments (drastically repainted and restored) of five compartments on the back wall are preserved. These landscapes presumably are the remains of those attributed to the painter Pinturicchio by Vasari, who states that the cities of Rome, Milan, Genoa, Florence, Venice, and Naples were depicted in them. Vasari, therefore, expanded on the earlier notice of Albertini, written by 1509 and published in 1515, that "the

[14]Sandström, "The Programme for the Decoration of the Belvedere," 54. For the depictions of St. Anthony, see Müntz, "Nuovi Documenti," 478 and 48c.

[15]A dialogue published in 1513 by Mantegna's friend Battista Fiera, entitled *De iusticia pingenda*, reveals Mantegna's concern, presumably during his activity in Rome, regarding how the personification of Justice must be depicted. When his interlocutor questions why Justice should be depicted at all, Mantegna replies that "he who can order anything, commanded it"; see B. Fiera, *De iusticia pingenda*, ed. and trans. by J. Wardrop (London, 1957), 11–12. There is also the story, first

published by Paolo Cortese, *De Cardinalatu* (Rome, 1510), fol. 87, and later in Vasari, of Mantegna's painting in the Belvedere Chapel a personification of *Discrezione* as a hint to the Pope of his expectation of reward, which was countered by the Pope's injunction to paint a complementary personification of *Pazienza*. The latter story especially seems legendary, although Mantegna's letters at the time of his work likewise indicate his concern for reward, but in any case these early stories suggest a tradition of personal involvement by the Pope.

most famous cities of Italy" were represented.[16] The present fragments, however, seem rather to be landscapes of fantasy with no identifiable references to specific sites (Fig. 3), except for a small fragment in the third bay from the east end, which depicts the northern elevation of the Villa Belvedere itself (Fig. 4).[17]

Above each wall compartment of the loggia was a lunette, again decorated illusionistically as if open, with a glimpse from below of thick arches under which sport pairs of winged putti as supporters of various attributes. Only seven of these lunettes are now preserved with some approximation of their fifteenth-century decoration, that is, the two lunettes above the eastern end of the loggia and the five on the rear, southern wall commencing at the eastern end. Three different sets of attributes are presented by the putti in the lunettes: two lunettes have the papal arms, two more have the *impresa* of Innocent VIII of a peacock exposing the multi-colored fan of his tail with the motto "Leauté passe tout," and the other three lunettes have putti joyously making music on lute, pipe, drum, harp, trumpet, and bagpipe (Fig. 5). The other lunettes, which are destroyed or completely repainted, continued the same pattern except for the two lunettes at the western end of the loggia above the wall of the chapel and sacristy, which contained half-length figures of St. John the Baptist and St. John the Evangelist appropriate to the dedication and function of these rooms, but our knowledge of these lunettes is solely literary, as they were destroyed with the chapel in the late eighteenth century. Over the loggia is a very decorative, repainted vault with arabesques painted to imitate stucco (Fig. 6). The four vaults toward the east of the loggia remaining from the original decoration have in their centers large tondi with flaming suns on which are superimposed the arms of Innocent VIII within a laurel wreath. Between these large tondi are smaller ones with mythological depictions in grisaille, four of which seem to represent *Ganymede with the Eagle*, *Leda with the Swan*, *Europa with the Bull*, and *Daedalus and Icarus*.

The first room of the papal apartment (Diagrammatic Plan, 4), adjacent to the eastern side of the loggia, had its walls compartmented by columns feigned in paint, between which were again open cupboards as in the sacristy. These cupboards were painted to contain the objects of a study, including books, vases, and a cage with a parrot. The depiction of a parrot was probably not mere whimsy, as there was a tradition since the Middle Ages that one room of the Papal Apartment was entitled the *Camera del Papagallo*, in which presumably the papal parrot was kept. There was such a room in the Vatican Palace, a similar one was provided by Pope Paul II in his Palazzo Venezia, and there was one in the Apostolic Palace at Bologna.[18] The rooms "of the parrot" in the Vatican Palace and the Palazzo Venezia seem to have served the same function, as semiprivate rooms between the inner, private apartment of the Pope

[16]*Opusculum de mirabilibus noue et veteris Rome* (Rome, 1515), fol. 91v. The suggestion (Sandström, "The Programme for the Decoration of the Belvedere," 39) that the landscapes with views as defined by Vasari were to honor the attempt by Innocent VIII late in 1486 and early 1487 to reconcile the other five city states with the papacy rests on very tenuous grounds. The peace treaty of August 1486 did not involve Venice and, as von Pastor indicates (*The History of the Popes*, v, 264–65), the agreement was broken by Naples before the end of September, although not formally repudiated until May 1487.

[17]For accounts of the restoration of the landscapes, see B.

Biagetti, "II. Relazione: Pitture murali," *Rendiconti della Pontificia Accademia Romana di Archeologia* (ser. III, xv, 1939), 248–52, and B. Nogara–F. Magi, "I. Relazione," in *ibid.* (XXIII–XXIV, 1947–1949), 363–69. For the fragment depicting the Belvedere, see D. Redig de Campos, *I Palazzi Vaticani* (Bologna, 1967), 77.

[18]F. Ehrle–E. Stevenson, *Gli affreschi del Pinturicchio nel l'Appartamento Borgia* (Rome, 1897), 14–16, and H. Diener, "Die 'Camera Papagalli' im Palast des Papstes," *Archiv für Kulturgeschichte* (XLIX, 1967), 43–97.

and the public, ceremonial rooms. Unfortunately the wall decoration of this room in the Belvedere was destroyed in the eighteenth century. Slightly later, Pinturicchio painted the walls of the Sala dei Misteri of the Borgia Apartment in the Vatican Palace with similar open cupboards containing a few objects, including the papal tiara of Alexander VI, but probably a closer approximation to the appearance of the Belvedere decoration is offered by the much later Sala della Gloria in the Villa d'Este at Tivoli, where also the small chapel has a window opening into a large adjacent room like the arrangement in the Belvedere.

Of the lunettes above the walls in the first room of the papal apartment of the Belvedere, those on the longer eastern and western walls have been destroyed or revised, presenting now only the arms of Innocent VIII supported by angels, but the pairs of lunettes on the northern and southern walls, although repainted, preserve an idea of the original decoration. Each of these four lunettes contains a pair of half-length figures, presumably of prophets, as two of them wear foreign headdresses and they all have long banderoles, which now lack any inscription, but they have no haloes (Fig. 7). The remaining four prophets, who are now missing, must have been in the central lunettes of the long walls. The vault is an elegantly coffered one centered around the arms of Innocent VIII against a rayed sun as in the loggia (Fig. 8). Around the coat-of-arms are two coffers with Innocent's *impresa* of the peacock and four coffers with female figures playing or holding musical instruments.

The adjacent room to the east (Diagrammatic Plan, 5), although slightly narrower than the Room of the Prophets, was similarly organized for decoration. The walls, now lost, were compartmented by illusionistically painted, freestanding columns. Of the original ten lunettes above, only eight are now preserved, and several of these have been extensively repainted. Two on the western side have the papal arms; the remaining six have half-length male figures. As the figure on the northern end of the eastern wall points to a tablet with geometric figures that he holds with his left hand (Fig. 9), he must be a noted geometer, such as Euclid, and the figures, therefore, probably represent the Seven Liberal Arts, although their identifying symbols are now so scant or repainted as to prevent sure identification. The figure who examines a globe (Fig. 10), may be an astronomer, however, such as Ptolemy, although he now does not have the crown that the Renaissance generally attributed to him, or Gionitus, son of Noah, as depicted on the Campanile at Florence. Among the figures preserved there is none who would seem to be associated with music but, as we shall see, this omission is explained by the decoration of an adjacent room. The barrel vault above the lunettes bears the papal arms in the center surrounded by six panels in the shape of Greek crosses, all the fields filled with delicate arabesque decoration in gold against blue.

Beyond the Room of the Liberal Arts was a smaller room (Diagrammatic Plan, 6) which communicated on the south to the service wing and on the north opened into an even smaller room. Each of these small rooms had a single window in its eastern wall, but eighteenth-century accounts of their decoration are very modest. It has been suggested that the smaller, inner room (Diagrammatic Plan, 7) might have served as the Pope's bedroom.[19]

On the north a small loggetta (Diagrammatic Plan, 8) also opened from the Room of the

[19]Sandström, "The Programme for the Decoration of the Belvedere," 70.

Liberal Arts by a portal and a window that introduced indirect light into the latter room. Although the walls of the loggetta were broken by doors and windows, there were pilasters feigned in paint, between which were small landscapes with buildings and hunting scenes. The decoration of the four lunettes with papal arms or fruit festoons was not unusual except for the lunette over the portal and window into the Room of the Liberal Arts, which still depicts a choir of half-length, singing male figures (Fig. 11). The group of eight young and old choristers centers around an elderly monk holding a large choirbook, while a youth at the right presents a scroll covered with musical notation. This lunette probably represents the art of music, which is missing in the adjacent Room of the Liberal Arts.

The loggetta at the northeastern corner of the Villa opened upon the terrace that ran along the northern side of the building. At the northwestern end of the terrace was a larger, open loggia (Diagrammatic Plan, 9) compartmented on the interior by Doric pilasters with marble capitals and bases, between which were again depicted landscapes.

The decorative program of the Villa Belvedere had at least two notable features. Vasari noted much later that the landscapes painted in the principal loggia were unusual for the late fifteenth century in Rome and credited them to the Pope's own desire. In fact, not only was the main loggia decorated with landscapes but so were the smaller loggias. This is not surprising, however, since the two books that were most concerned with architecture and its decoration, published shortly before the creation of the Villa Belvedere, advocated such decoration. The ancient treatise on architecture by the Roman Vitruvius, which first appeared in print at Rome probably in 1486, mentions that in antiquity covered promenades like the large loggia of the Belvedere, because of the length of their walls, were decorated with landscapes depicting "harbors, promontories, shores, rivers, springs, straits, temples, groves, mountains, cattle, shepherds" (VII, v, 2), rather like the pathetic fragments of landscape revealed recently in the restoration of the Belvedere. In a similar fashion Alberti, in his *De architectura*, published at Florence in 1485, says—probably echoing Vitruvius—that for villa decoration he finds delight in landscapes of "pleasant regions, harbors, fishing, hunting, swimming, country sports, flowery and shady fields" (IX, iv). The eighteenth-century descriptions of the landscapes in the smallest loggia particularly mention hunting scenes. In another passage on decoration in the same section of Alberti's treatise, he admires the depiction of architectural columns on walls suggestive of the illusionistic decoration found in many rooms of the Villa Belvedere. There are also other remarks by Alberti on the villa that seem fitting to this first Roman Renaissance villa, for he wishes a villa to stand on the summit of an easy ascent that suddenly opens up at the site to a wide prospect (IX, ii) and within the villa he recommends that the first room to be reached after the entrance should be the chapel (V, xvii), which is also true in the Belvedere. In terms of the physical orientation of architecture, Alberti tends to be very pragmatic and to adapt the orientation to the particular geographical situation. Vitruvius, however, is more dogmatic on this point, and it may have been his dicta that guided the siting of the Belvedere. Vitruvius insisted that in southern regions oppressed by heat a building should be opened toward the north and northeast (VI, i, 2). It may be accidental, but it is interesting in this regard that, while in general the Villa Belvedere faces northward, it is also turned slightly off the northern axis to the east. Vitruvius

also suggested that private rooms and libraries should be on the east to receive the morning light (VI, IV, I), and in the Belvedere the papal apartment was added to the eastern end of the loggia-pavilion.

The other unusual feature of the decoration of the Belvedere is the frequent reference to music. In the principal loggia, while two-thirds of the lunettes contain personal references to the Pope either in terms of his papal arms or his *impresa* of the peacock, the remaining lunettes have music-making putti. Similarly, in the neighboring Room of the Prophets, the vault contains four music-making figures complementing the arms and *impresa* of the Pope. Then in the small, private loggia off the Pope's apartment is the large lunette decorated with a singing choir. This emphasis on music in the decoration may be explained, as indeed may the creation of the Villa, by the state of the Pope's health.[20]

During his entire pontificate Innocent VIII experienced precarious health. He was elected Pope on August 29, 1484; the first record of illness was early in October 1484, but the diary of Burchard, the Papal Master of Ceremonies, and the Roman chroniclers constantly note attacks of fever thereafter. At least three times—in March 1485, January 1486, and again in August and September 1490—the severity of the Pope's illness was so grave that rumors of his death spread in Rome.[21] Because of war or ill health Innocent VIII was never able to fulfill his vow to visit the sanctuary of the Santa Casa at Loreto or other cities of the Papal States, and his only visits outside of Rome were to Ostia or La Magliana. The solution for Innocent VIII was offered by Alberti in his treatise on architecture when he wrote: "Doctors advise that we should enjoy the freest and purest air that we can; and, it cannot be denied, a villa situated high in seclusion will offer this" (IX, ii).

Since at least late antiquity music was considered to have therapeutic powers. Avicenna's *Canon of Medicine*, which was the standard medical handbook for the late Middle Ages and Renaissance and which was first printed in 1473, listed "sweet song" as one of the sedatives for pain (Bk. I, Fen. IV, chap. xxx). The Renaissance Neoplatonic renewal of interest in the theory of macrocosm-microcosm strengthened this belief.[22] In fact, when Pico della Mirandola was at Rome from at least November 1486 to August 1487 to present his controversial Theses, the role of sympathetic magic in terms of music and words was involved in the argument. For Pico, "as medicine cures the spirit by means of the body, so music does the body by means of the spirit."[23] Bishop Pedro Garcia, who was a member of the Papal Commission that examined the Theses and condemned thirteen of them, admitted that the musical harmony of sounds might cure bodily infirmities but denied such powers to words as Pico had held.[24] Similarly, Marsilio Ficino wrote in his *De vita triplici*, published in 1489, that music and song affected the human spirit and brought it into conformity with the celestial harmony,

[20]The emphasis on music was noted in [L. Raffaele], *Un pittore ignoto di cantori nel palazzetto privato di Innocenzo VIII in Belvedere: Per le nozze della Signorina Ildina Berghi con Guido Raffaele* (Rome, 1926), but not explained. It was William Rhoads, now of the State University of New York at New Paltz, who in a graduate report in 1967 first suggested a possible relationship between the emphasis on music and the health of the Pope.

[21]von Pastor, *The History of the Popes*, V, 247–48, 259, 280–82, and 317–18.

[22]For some general accounts, see L. Thorndike, *A History of Magic and Experimental Science*, IV (New York, 1934); D.P. Walker, *Spiritual and Demonic Magic from Ficino to Campanella* (London, 1958); and G. Bandmann, *Melancholie und Musik* (Cologne–Opladen, 1960).

[23]G. Semprini, *La filosofia di Pico della Mirandola* (Milan, 1936), 115.

[24]L. Dorez–L. Thuasne, *Pic de la Mirandola en France (1485–1488)* (Paris, 1897) and Thorndike, *A History of Magic* 497–505.

referring to David's curing the insanity of Saul by his music.[25] In his book Ficino also considered astrology and how one might attract the benign influences of the planets. Even Pope Innocent VIII was interested in astrology, according to a letter of the Milanese court astrologer to Ludovico il Moro, which indicates that the Pope had requested the Duke to find out from his astrologer the future health of the Pope. The answer in the letter dated July 20, 1492 forecasts the imminent death of the Pope, which did occur on July 25.[26]

Two contemporary events reveal that the concept of the therapeutic power of music and its ability to relieve pain prevailed at the court of Innocent VIII. In 1489 Gabriele Zerbi of Verona, a professor of medicine at the University of Rome, published a treatise on old age, entitled *Gerontocomia*, and dedicated it to the Pope.[27] In the treatise Zerbi discusses all the living conditions beneficial to old age, including a detailed consideration of the effects of every possible food and drink. Toward the end of the book, in Chapter 42, Zerbi claims that "music is the most powerful of the arts, and harmony has the admirable virtue of lessening the pains of human souls and of making them pleasant" (*Potentissima artiū musica est et mirificam habet virtutem armonia ad mitigandos dolores animarum humanarum et ad letificandas ipsas*). He then develops the theme with references to Plato, Aristotle, Galen, Avicenna, Aesculapius, and the account of David and Saul.

So a year later, in a letter of August 17, 1490, a Florentine living in Rome records that he was called the previous day to the bedchamber of Pope Innocent VIII, who was rumored to be on his deathbed, and requested to play his viol just outside the entrance to the room until he was summoned by the Pope himself to enter, where he remained an hour and a half. As this happened during the summer month of August, it is possible that this event occurred in the Villa Belvedere, although there is no proof. In fact, a few days previously, the same Florentine noted that he had been chatting at a table "in a shady loggia," suggestive of the Belvedere, with the Princess of Bissignano and the Pope's daughter Teodorina, whom he also saw later in the papal bedchamber nursing her father.[28]

It is probable, therefore, that Innocent VIII began the Villa Belvedere as a recuperative retreat after his long and serious illness commencing in March 1485.[29] At first this retreat was merely a pavilion for the enjoyment in the afternoon or early evening of the cool, northern exposure; but, as his health was continually threatened, Innocent transformed the pavilion into a private villa where he might dwell accompanied by only a small, intimate entourage. The decoration of the Villa, undertaken probably under the direction of the painter Mantegna, then included frequent references to music as the art of harmony, bringing relief to the human soul and body—appropriate to a setting for physical recuperation.

PRINCETON UNIVERSITY

[25]*Opera omnia* (Turin, 1959), I, 502, likewise the letters of Ficino to Musano (*ibid.*, 609) and to Canigiani (*ibid.*, 650–51); see also P.O. Kristeller, *Renaissance Thought*, II (New York, 1965), 157–58.

[26]F. Gabotto, "L'Astrologia nel Quattrocento in rapporto colla civiltà," *Rivista di Filosofia Scientifica* (VIII, 1889), 382–83.

[27]Probably as a result of his book, Zerbi's salary at the University was increased by Innocent VIII in March 1490 from 150 florins to 250 florins; see [G.L. Marini], *Degli archiatri pontifici*, II (Rome, 1784), 238–39, doc. LXXVI.

[28]C. Carnesecchi, "Il ritratto leonardesco di Genevra Benci," *Rivista d'Arte* (VI, 1909), 293–96.

[29]Alberti also remarks in his treatise (IX, iv), under his discussion of the decoration of domestic architecture, that anyone ill with fever enjoys the depiction of springs and brooks. Unfortunately the landscapes of the smaller loggias, in which we might have particularly expected expression in line with Alberti's advice, are destroyed. In the same chapter, however, he likewise recommends mythological subjects, giving as an example the *Flight of Icarus* painted by Daedalus at Cumae, and Daedalus and Icarus are depicted on the vault of the main loggia. A minor sidelight may be offered by the record of a lost painting entitled *Melancholy* attributed in the seventeenth century to Mantegna, which depicted sixteen boys playing music and dancing; see G. Campori, *Raccolta di cataloghi ed inventarii inediti* (Modena, 1870), 328.

An Image Not Made by Chance:
The Vienna *St. Sebastian* by Mantegna

MIRELLA LEVI D'ANCONA

In this paper I shall discuss the very complex iconography of Mantegna's *St. Sebastian* in the Kunsthistorisches Museum in Vienna (Fig. 1), a painting frequently admired but never fully explained.[1] In spite of its small size, the Vienna *St. Sebastian* was of extreme importance for the application of Albertian and humanistic ideas in the Italian Renaissance.

The history of this panel previous to its acquisition by the Austrian royal collection in 1659 is unknown,[2] but most critics agree that it is the unspecified small work ("operetta") on which Mantegna was working in 1459.[3] It is my contention that the Vienna *St. Sebastian* was indeed painted in the years between 1457 and 1459 as a votive offering to St. Sebastian for having ended the plague that had raged in Padua during the years 1456–1457.[4] St. Sebastian's patronage as protector against the plague suggests an explanation for some of the more perplexing aspects of this painting, including the elusive image of the horseman in the clouds. Far from being a chance image, this figure was introduced by the same rational and deliberate means as controlled the formal and iconographic language in the rest of this painting. It can be understood against the background of plague iconography and lore, the hagiographic traditions about St. Sebastian, philosophic theories about the creation of the universe, and Paduan humanism.

In Padua, humanism was founded more closely on Aristotle than anywhere else in Italy. Indeed, as will be developed, the Aristotelian theories taught at the University of Padua were responsible not only for the symbolism in this painting but also for the manner of reasoning by which the thoughts were presented. At the moment it will suffice to point to the basic premise of Aristotle's aesthetics as applied to the figurative arts: a work of art can teach on two levels, the higher being by way of its thought content, the lower by mere visual percep-

The M.A. thesis on St. Sebastian by Mrs. Hillary Ganton Spiele, written at Hunter College under the direction of Professor Leo Steinberg, was the starting point for this study, although my discussion of the problem is totally unrelated to Mrs. Spiele's discussion of eroticism. I wish also to thank my friend and former pupil Benjamin Rifkin for helping me with the English of this article, as well as for several valuable suggestions, which are acknowledged in the notes.

[1] Poplar wood panel, 26 3/4 × 11 7/8 inches. For various opinions on the iconography of the painting, see P. Kristeller, *Andrea Mantegna* (London, 1901), 168–70; I. Blum, *Andrea Mantegna und die Antike* (Leipzig, 1936), 32; A.M. Tamassia, "Visioni di antichità nell' opera del Mantegna," *Pontificia Accademia Romana di Archeologia, Rendiconti* (XXVIII, 1957), 213–49; M. Meiss, *Andrea Mantegna as Illuminator* (New York, 1957), 62; H.W. Janson, "The 'Image Made by Chance' in Renaissance Thought," *De Artibus Opuscula XL. Essays in Honor of Erwin Panofsky*, ed. by M. Meiss (New York, 1961), I, 262–64; E. Battisti, "Il Mantegna e la letteratura classica," *Atti del 6° Convegno Internazionale di Studi sul Rinascimento* (Florence, 1961), 23–56.

[2] The provenance of the *St. Sebastian* is discussed in the museum's *Katalog der Gemäldegalerie*, I Teil (Vienna, 1960), 76, no. 588.

[3] Three letters written in 1459 by the Marquis of Mantua, Ludovico Gonzaga, mention an "operetta" on which Mantegna was working at the time in Padua. The letters were published by P. Kristeller, *Andrea Mantegna* (Berlin, 1902), 519, document 17; 519–20, document 18; and 520, document 19 (in the English edition of the previous year Kristeller had published only two of the letters). Those who suggest that the Vienna painting may be the work in question, on account of its small size, include E. Tietze-Conrat, *Mantegna* (Florence, 1955), 22–23, 220; and G. Paccagnini, in the exhibition catalogue "Andrea Mantegna," Mantua, 1961, 20, no. 8; however, other small works by Mantegna, or attributed to him, have also been connected with the letters of 1459: the London *Agony in the Garden*, by G. Fiocco, *L'Arte di Andrea Mantegna* (Venice, 1959), 100, and the manuscript of Strabo's *Geography* now in Albi, by Meiss, *Andrea Mantegna as Illuminator*, 48f.

[4] According to Tietze-Conrat, *ibid.*, 22, Mantegna caught the plague of 1456–1457 and survived it.

tion of its form and color.[5] Even the formal aspects of the Vienna *St. Sebastian*, however, reflect Aristotelian theories of optics, which were the basis for the teaching of perspective at the University of Padua at a surprisingly early date (trecento).

Perspective

According to Aristotle, the perception of reality is at the basis of all knowledge, as it is through the knowledge of the particular that one can arrive at universal laws.[6] This fundamental principle is at the root of realism in Renaissance painting and postulates the use of perspective, by which reality can be clearly measured. Mantegna made use of this principle in the foreground of his painting (Fig. 1), which according to Renaissance rules of composition should be the most important part in a work. St. Sebastian is shown standing on a stone block that is set at an angle toward the viewer and is placed on a marble tiled floor. Another smaller stone block, in a similar position, echoes it on a low stone wall that separates the tiled floor from the background. The square tiles are also placed at an angle, aligned so as to form lines of perspective that lead from the picture plane to the wall. A sculpted head and a foot are placed side by side in the foreground, and another sculpted head is placed near the low wall in the middle ground. These details reflect Renaissance discussions about measurements and perspective. Should the head or the foot be taken as the unit of measurement? In antiquity Vitruvius had upheld the theory that the foot should be taken as a module.[7] Alberti instead declared that, although he favored the head, the head and the foot were equivalent units of measurement, because the length of the foot from toe to ankle equaled the length of the profile head from the chin to the back of the head.[8] He went on to state that the measurement of space was done both by comparison and by proportion, and that the distance of one object from another could be measured geometrically by an angle formed by a horizontal plane, such as a floor, and a vertical plane, such as a wall.[9]

It seems to me that Mantegna's *St. Sebastian* provides a beautiful illustration of the Albertian measurements and rules of perspective, for it takes the head and the foot as units of measurement; this explains the placing of the profile head next to the foot in the foreground of the painting, and the placing of another smaller head near the low wall in the middle ground. The presence of two heads shows that Mantegna shared Alberti's preference

[5]*Poetics*, 4, "Origins and Development of Poetry and Its Kinds," in *The Pocket Aristotle*, ed. with prefatory notes by J. Kaplan (New York, 1958), 345: "To be learning something is the greatest of pleasures not only to the philosopher but also to the rest of mankind, however small their capacity for it. The reason of the delight is that one is at the same time learning—gathering the meaning of things . . . for if one has not seen the thing before, one's pleasure will not be in the picture as an imitation of it, but it will be due to the execution or coloring or some similar cause."

[6]*Ibid.*, *Physics* and *Metaphysics*. In the *Physics*, Aristotle outlines the four main causes of motion and change in an ordered universe: (1) *material cause* (creation of an object); (2) *formal cause* (the pattern of an object); (3) the *efficient cause* (stimulus to movement); (4) *final cause* (ultimate goal of the movement). In the *Metaphysics*, Aristotle stated that through the doctrine of causes, one can reach "the Knowledge of Which is Wisdom," the Prime Mover, which is the object of the world's desire. In

Nature the principles are two, three, or one. In Metaphysics, all is united into the One.

[7]*De architectura: Architettura (dai libri I-VII)*, edited and translated with comments by S. Ferri (Rome, 1960), Bk. IV, chap. I. 7.

[8]*Leon Battista Alberti della pittura e della statua* (Milan, 1804), Bk. II, 56: "per lo più è quasi comune negli uomini, che tanta è la misura del piede, quanto è dal mento a tutta la testa."

[9]*Ibid.*, Bk. I, 23–24, 25, 26–27; see also Alberti, *Della pittura*, ed. L. Mallé (Florence, 1950), Bk. I, 66: "Dico la superficie alcuna essere in terra riversa et giacere, come i pavimenti . . . altre stanno apoggiate in lato come i pareti. . . . Agiungi la sentenza dei matematici, onde si pruova che se una dritta linea taglia due lati d'uno triangolo et sia questa linea, qualora fa triangolo, equedistante alla linea del primo e maggior triangolo, certo sarà questo minore triangolo ad quel maggiore proporzionale; tanto dicono i matematici"; and 69: "ogni loro cognitione si fa per comparatione."

for the head as a unit of measurement. Alberti's idea of comparison by proportion is given by Mantegna not only by these two heads, the one further away being smaller than the one in the foreground, but also by the two stone blocks placed at an angle, one under the figure of St. Sebastian and the other on top of the low wall that divides the foreground from the background. Their placement at an angle and their proportionate size are repeated in the tiles of the marble floor, which are also viewed from the same angle. The tiled floor gives the horizontal plane, the wall gives the vertical plane, and each of the tiles in the floor measures the recession in space geometrically.

The use of perspective and proportion, however, should not be understood as a simple application of aesthetic theories but as an integral part of the iconography of the Vienna painting. A study of the higher meaning assigned by Aristotle to significant art will bring out this point. To understand Mantegna's method of presenting his ideas, we must keep in mind that he used the dialectic method of reasoning, by which the singular was united to the plural, and the specific to the general, by comparison and contrast (*sic, sic et non*). According to this method, each idea must lead logically to the next, but it must also link different and contrasting ideas, each thought being decomposed into separate, subsidiary ideas, linked to the others by a central theme. I can best explain this method of reasoning by the image of stones thrown into a pond. Each stone will form its own set of concentric circles of waves, but the waves of one circle will encroach upon the waves formed by another stone, thus forming links in a chain. Through the outer link one is led to the center stone by the parallel circles; while by the interweaving of one set of circles with another set, one perceives a connection between the various stones. The main ideas can be likened to the stones at the center of the concentric rings, each surrounded by its circle of associated ideas. This method of reasoning is no longer familiar to us, which makes it difficult for us to follow Mantegna's train of thought. Moreover, the ideas in the Vienna painting are so closely packed, and the separate thoughts so inextricably woven together, that it is difficult for us to isolate the various symbols and the main thoughts that each represents.

The central theme of the Vienna painting is the figure of St. Sebastian, the Christian martyr invoked as a patron saint against the plague. The saint is also identified, however, with Janus, Apollo, Diana, and Christ, by a process of reasoning and a set of associated symbols that I shall try to explain. The legend of St. Sebastian provides us with one of the main themes and leads to a set of associated ideas, which I have likened to a stone with its set of concentric rings of waves.

The Legend of St. Sebastian

Two main sources for the legend of St. Sebastian were known in the Renaissance, the *Acta Sancti Sebastiani Martyris* and the *Golden Legend* by Jacobus de Voragine.[10] The story as given in the *Golden Legend* (January 20) begins with a few etymologies for the name Sebastian.[11] Born in France, and a citizen of Milan, St. Sebastian came to Rome, where he became the

[10]*Acta Sancti Sebastiani Martyris*, in Migne, *Patrologia Latina*, XVII, cols. 1111–50, "Appendix ad opera S. Ambrosii"; Jacobus de Voragine, *The Golden Legend*, trans. by G. Ryan and H. Ripperger (New York, 1969), 104–10.

[11]I will discuss later their relevance to the Vienna painting.

leader of the First Cohort under Maximinian and Diocletian. He accepted this post in order to be able to help and comfort a large number of persecuted Christians who had been arrested because they refused to worship pagan idols. His mission began with his fortifying the two brothers Marcellinus and Mark against their martyrdom and eventually led to his own martyrdom with arrows in the middle of the Campus Martius in Rome. He was left for dead, but he miraculously survived and returned to his mission, trying to convert the emperor himself. The emperor condemned him to be beaten with rods and afterward to be thrown into a sewer. After his death, the saint appeared to St. Lucina and asked her to give him a decent burial at the feet of the Apostles Sts. Peter and Paul.

This legend has two points in common with the life of Christ: the beating with rods, which parallels Christ's flagellation; and the apparition of the saint after death, which parallels the apparitions of Christ. The *Golden Legend* ends its account of St. Sebastian with a detail that is missing in the *Acta*, the story of the saint's connection with the plague, derived from the *Annals of the Longobards*.[12]

Here is the story of St. Sebastian and the plague. During the reign of King Humbert, a violent outbreak of the plague raged in Italy, during which barely anyone survived to bury the dead. The scourge was especially severe in Pavia, where many saw with their own eyes an angel of the Lord followed by a demon with a rod strike and bring havoc.[13] Then the Lord made known that the plague would cease only if an altar were to be dedicated in that city to St. Sebastian. This was done in the church of St. Peter in Chains, and on that occasion the relics of the saint were brought from Rome to Pavia. The *Golden Legend* ends with a quotation from the *Preface* of St. Ambrose.[14] The *Acta* give instead another ending, which leads from St. Sebastian's preaching of the Gospels to his union with the Trinity as his eternal reward.[15]

So far, we have introduced two of the Vienna painting's main themes: the Albertian theories on measurements and perspective, and the legend of St. Sebastian. Mantegna linked his image of St. Sebastian with the Albertian theories of measurements and proportions through the image of Saturn—the horseman in the clouds—and the rich symbolism associated with the cult of that pagan god. The image of the horseman both *in* the clouds and *made* of clouds is the key to the symbolism connected with Saturn and that god's invention of all measurements. In turn, that image of a horseman was the result of the fusion of several texts, all linked together by the common central theme of a figure in the clouds.

In Isaiah 14, there is a long diatribe against the fall of Babylon, starting with the lines: "How hath the oppressor ceased! the golden city ceased!" (Isaiah 14:4).[16] The high point of

[12]Pauli Warnefridi Langobardi filii Diaconi Foroiuliensis, *De gestis Langobardorum libri VI* (Leiden, 1595), chap. 5, 220–21. (This author is normally referred to in Italian as Paolo Diacono.)

[13]The image of the horseman in the clouds in Mantegna's *St. Sebastian* in Vienna may be a reference to this legend, although the way it is depicted, *made of clouds*, points to other sources that I shall discuss presently.

[14]"The blood of the holy Martyr Sebastian, which was shed in thy name, makes manifest thy greatness, O Lord, who through his intercession workest thy might in the weak, crownest our efforts, and givest health to the sick" (*Golden*

Legend, 110). This role of intercessor, mentioned for St. Sebastian, brought by association the role of Janus as intercessor at sacrifices, as we shall see, while the saint's involvement with the plague, following his martyrdom, brought for Mantegna another set of associated ideas.

[15]*Acta*, Migne, *Patrologia Latina*, XVII, col. 1058: "Qui cum Deo Patre et Spiritu Sancto aequalis vivit et regnat in unitate virtutis in Saecula Saeculorum. Amen".

[16]The Latin text of the Vulgate is more relevant to Mantegna's painting than the English King James Bible, which differs in several details of translation.

this diatribe is the anger of the Lord, which destroyed the mighty heathen reign of Babylon that had brought cruel persecution as well as an incurable plague ("plaga insanabili"; Isaiah 14:6). The heathen reign was identified with the reign of Lucifer, and this led to a comment on Lucifer's fall because of his overweening pride. Lucifer had claimed: "I will ascend above the heights of the clouds; I will be like the most High" (Isaiah 14:14). But then Lucifer, who had been rising in the morning, fell from heaven down to earth; he who had wounded others was destroyed by the Lord: "Quomodo cecidisti de caelo, Lucifer, qui mane oriebaris? corruisti in terram, qui vulnerabas gentes" (Isaiah 14:12). All the princes of the earth rose from their thrones and commented on this fall, saying of Lucifer that he, who had wounded others, was now wounded and made like other human beings: "Omnes principes terrae surrexerunt de soliis suis, omnes principes nationum. Universi respondebunt, et dicent tibi: 'et tu vulneratus es sicut et nos, nostri similis effectus es' " (Isaiah 14:9–10). Mantegna took from Isaiah three main themes that he used in his Vienna painting: the fall of a heathen kingdom connected with the plague and persecution; the figure of Lucifer ascending in the clouds; and the fall of a wounded person from the sky to earth. The first theme connected Isaiah's passage with the figure of St. Sebastian, as that saint had been persecuted during the Roman Empire (heathen kingdom) and was invoked against the plague. The second theme connected Isaiah's passage with the motif of the plague and plague lore, by way of an image in the clouds; through the motif of the plague it was also connected with the legend of St. Sebastian. The third theme connected Isaiah's passage with the legend of Saturn, who was castrated by his son as he had castrated his father (Lucifer was wounded as he had wounded others) and was expelled from heaven by Jupiter (as Lucifer was expelled from heaven by the Lord). This third theme in turn was connected with the legend of St. Sebastian both through the legend of the plague at Pavia, in which a demon was involved, and through the idea of a wounded person, St. Sebastian having been wounded by arrows. The first theme, which connected St. Sebastian with the Roman Empire, also connected him with the second theme, by way of the plague symbolism: the saint's patronage against the plague replaced in Christian times Saturn's patronage against the plague during the time of the Roman Empire. We shall, therefore, first examine the theme of the plague, which connects St. Sebastian with both the first theme and the second; then we shall examine the second theme of the horseman in the clouds; and finally we shall examine the third theme, the legend of Saturn.

The Plague

Two main beliefs about the plague and its manner of propagation were widely circulated in antiquity, one derived from Homer's *Iliad* and the other from Lucretius's *On the Nature of Things.*

In the first book of the *Iliad*,[17] a terrible plague is described, which killed men and beasts alike in the Greek camp on the shores of Troy. Agamemnon had abducted the daughter of Chryses, a priest of Apollo, and in retaliation the angry god killed the Greeks mercilessly

[17]Bk. I. 8–11, 42–54.

with his bow and arrows.[18] In this episode the mortality of the plague was said to have been caused by Apollo's arrows, for it was believed in antiquity that the plague spread through the air, traveling like arrows. Because St. Sebastian was martyred with arrows but survived this martyrdom, his patronage was invoked against the plague.

Another belief about the cause of the plague was that it consisted of some sort of putrefaction of the air, with the moisture of the soil rising and condensing like clouds. This belief was expressed by Lucretius in the last book of his *De rerum natura*.[19] Because Saturn was believed to be a cloudy star, this mythological and astrological figure was both considered to be the cause of the plague and also invoked as a patron god against the plague. The beliefs that Saturn was a cloudy star and that he caused the plague are summed up by Boccaccio in his introduction to the legend of Saturn in the *Genealogy of the Gods*: "Suddenly from the Eastern Ocean, a slow and cloudy star appeared to me, rising from hell into the sky, veiled in Stygian vapor. While I looked at this image mixed with clouds, I remembered the precepts of Venerable Andalò and I knew it to be the hateful and harmful star of Saturn."[20]

Boccaccio's text provided Mantegna with an image rising in the sky, made of clouds ("cloudy"), veiled with clouds ("veiled in Stygian vapor"), and "mixed with clouds," and this image was Saturn-Time-Chronos. One important detail, however, was missing. Although identified with Saturn, the image was not said to have been a human figure, let alone on horseback. Therefore, we shall first have to examine the ideas that led Mantegna to associate Saturn with a figure of a horseman in the clouds.

The Horseman in the Clouds

We began our chain of associations with plague symbolism by citing a passage from Isaiah. Let us return to it: "I will ascend above the heights of clouds; I will be like the most High" (Isaiah 14:14). This verse was linked by St. Gregory the Great with another passage, in which a horseman was mentioned as flying on high: "Cum tempus fuerit in altum alae

[18]In the translation by R. Lattimore (Chicago, 1971), Homer's lines read:

"What god was it then set them together in bitter collision? Zeus' son and Lato's, Apollo, who in anger at the king drove the foul pestilence along the host, and the people perished, since Atreus' son had dishonoured Chryses, priest of Apollo. . . .

" 'Let your arrows make the Danaans pay for my tears shed.' So he spoke in prayer, and Phoibos Apollo heard him, and strode down along the pinnacles of Olympos, angered in his heart, carrying across his shoulders the bow and the hooded quiver; and the shafts clashed on the shoulders of the god walking angrily. He came as night comes down and knelt then apart and opposite the ships and let go an arrow. Terrible was the clash that rose from the bow of silver. First he went after the mules and the circling hounds, then let go a tearing arrow against the men themselves and struck them. The corpse fires burned everywhere and did not stop burning. Nine days up and down the host ranged the god's arrows . . ."

I thank Prof. Claireve Grandjouan, Chairman of the Classics Department at Hunter College, both for calling my attention to this beautiful translation of Homer's text and for lending me her copy of it.

[19]English translation by H.D. Rouse (London, 1928), Bk. VI, ll. 1100–1286, and especially 1100–02: "And all these diseases in their power and pestilence either come from without down through the sky like clouds and mists, or often they gather together and rise from the earth itself, when through damp it has become putrescent, being smitten out of due time by rains and suns. . . ." Lucretius ended his description with the terrible pestilence in Athens (ll. 1138–1286).

[20]Giovanni Boccaccio, *Genealogie deorum gentilium libri*, ed. V. Romano, I (Bari, 1951), Bk. VIII, 385, ll. 19ff. Here is the Latin text: "Et ecce ex orientali Oceano quasi sese ab Inferis in altum efferens, tardum atque nubilum sydus visum est, Stygia velatum caligine. Quod dum nebulis immixtum intuerer, memor preceptorum venerabilis Andalò; odiosum atque nocuum Saturni astrum fore cognovi."

The Andalò mentioned by Boccaccio was the Genoese Andalò di Negro, traveler, geographer, and famous astronomer (A. Hortis, *Studi sulle opere latine del Boccaccio*, Trieste, 1879, 516–17). According to Hortis, Andalò was Boccaccio's friend and was consulted by him especially on matters pertaining to astrology, as Andalò was the author of an astrological treatise *Introductio ad judicia astrologica* (which, according to Hortis, is still preserved in a manuscript in the Bibliothèque Nationale in Paris).

erigit; deridet equitem et ascensorem ejus" ("When time comes, it directs its wings on high; it derides the horse and his rider"; Job 39:18). St. Gregory explained the combination of the two passages in several ways, among which he gave for the horse the meaning of the world that foams away in the passage of time, and for the rider the explanation that it signifies whoever rises in high station in life and then falls backward. St. Gregory added to his explanation a curious detail: the horse's rump that falls backward and disappears could signify sudden death and ignorance of the tortures that life has in store.[21] This detail of the horse's rump that disappears in the clouds is depicted in Mantegna's painting (Fig. 2). In St. Gregory's discussion of the horseman in the clouds, the horse's rump disappeared at the back, and the motif was connected with two main themes: death and time. The theme of death was also connected with a figure in the clouds in a passage from Revelation 14:10 which adds the specification of a white cloud: "And behold a white cloud, and upon the cloud one sat like unto the Son of Man, having on his head a golden crown, and in his hand a sharp sickle." Still another text linked together the themes of time, death, and Saturn, thereby completing all the elements depicted in Mantegna's image of a horseman in the clouds. According to St. Augustine, the legend of Saturn devouring his children was an allegory of the passing of time, and he quoted Cicero as his source.[22] The last link in the chain of associations of figures in clouds led back to Saturn, the cloudy star described by Boccaccio. We find the final touch in Cartari, who ended his legend of Saturn by the image of that god riding on horseback in the sky to avoid being detected by his wife when he was gallivanting with Philyra.[23] Mantegna even added Saturn's identifying attribute, the sickle, held in the god's left hand and curving toward him, as if about to cut the billowing cloud in front of the god's head.

We have thus established, on the one hand, a link between clouds and the plague, and on the other, a link between a horseman in the clouds and Saturn. The legend of Saturn provided an explanation for linking that god with the plague. The symbolism of the entire left side of Mantegna's painting, in fact, may be explained by reference to the legend of Saturn.

Saturn

Saturn was a mythological figure, an agricultural god, an astrological symbol, a cult image, and a euhemeristic hero. In mythology he was the king of the gods, the son of heaven and earth. A prophecy had predicted that one of his sons would castrate and dethrone him, as he had his own father. To avoid this fate, Saturn devoured his sons as soon as they were born.

[21]*Moralium libri*, in Migne, *Patrologia Latina*, LXXVI, cols. 596–97, Job 39:18: "Cum tempus fuerit in altum alas erigit; deridet equitem et ascensorem ejus"; col. 597: "Quo in loco equus nunc mundum insinuat, qui per elationem suam in cursu labentium temporum spumat. Et quia Antichristus extrema mundi apprehendere nititur, cerastes, iste equi ungulas mordere perhibetur. Ungulas quippe equi mordere est extrema saeculi feriendo contingere. *Ut cadat ascensor ejus retro* (Genesis 49:17). Ascensor equi est quisquis extollitur in dignitatibus mundi. Qui retro cadere dicitur, et non in faciem, sicut Saulus cecidisse memoratur (Act. 9:4). In faciem enim cadere est in hac vita suas unumquemque culpas agnoscere, easque poenitendo flere. Retro vero quo non videtur, cadere, est ex hac vita repente decedere, et ad quae supplicia ducatur

ignorare. . . . Bene Jacob eodem loco repente electorum voce conversus est, dicens *Salutare tuum exspectabo Domine* (Genesis 49:18); id est, non sicut infideles Antichristum, sed eum qui in Redemptionem nostram venturus est, vero credo fideliter Christum."

[22]*De civitate dei*, Bk. IV, chap. x, in Migne, *Patrologia Latina* XLI, col. 120: "Quia Saturnus, inquiunt, tempus longitudo est (Cicero, *De natura deorum*, lib. 2 cap. 25). Tempus igitur colunt, qui Saturnum colunt, et rex deorum Jupiter insinuatur natus ex tempore." For an excellent discussion of Saturn under all aspects, see R. Klibansky–E. Panofsky–F. Saxl, *Saturn and Melancholy* (Cambridge, 1964).

[23]V. Cartari, *Le imagini de i dei degli antichi* (Venice, 1624), 20.

But Jupiter was saved by his mother, who presented to Saturn a stone wrapped in swaddling clothes instead of the baby. Eventually the prophecy came true, and Jupiter made his father spit out his various brothers, castrated him, and then expelled him from the kingdom of heaven. Fallen down to earth, Saturn was said to have reached Italy by boat and to have found refuge in Latium, where a local king, the two-faced Janus (who some say was his own son),[24] made him co-regent. Saturn's enlightened reign brought the Golden Age to Italy. He introduced civilization to a population that had formerly been scattered in the mountains, taught man how to till the land, making the plains fertile with fields and trees, and how to divide the fields and measure them. He also introduced all kinds of measurements. Saturn taught the Romans how to graft trees and plant the vine, making wine out of its grapes. This, however, was their undoing, for the Romans got drunk and killed Saturn's co-ruler, Janus. The wrath of the god for this murder was unbounded, and as a punishment he sent a terrible plague. The Romans consulted an oracle of Apollo on how to end this plague and were told that they must first establish a special cult, dedicating an altar to Saturn. This originated the festival of the Saturnalia.[25] At first the cult entailed human sacrifices, as the oracle had said that "a head for a head" was needed to placate Saturn. Later, two sculpted heads were substituted for human beings, the two heads offered being a reminder of the two-faced Janus.

Let us now examine what elements from that legend Mantegna depicted. We have seen that he represented Saturn himself, riding in the clouds and made of clouds, in order to identify him with the very essence of the plague he had sent. The vintage relief, as well as the two sculpted heads (Fig. 3), remind the viewer of the sacrifices of the Saturnalia, instituted by the Romans to put an end to that plague. The two heads, being linked with perspective, are also a reference to measurements, and we have seen how Saturn was credited with having introduced all kinds of measurements. The green fields to the right (Fig. 5) with two rabbits in them are a reference to the fertility of the fields, which Saturn had introduced.[26] An additional allusion to fertility may be found in the winding road (or river?) at the right, shaped like a sickle—Saturn's distinguishing attribute. On the other hand, the stone enclosure on the left side of the painting (Fig. 1) is a reference to the partitions that the god abolished. It is connected with a barren, rugged, mountainous landscape to the left, which is divided by a curved road—possibly an allusion to the state of mankind before Saturn introduced civilization. Saturn was also linked with enlightenment, and his feast, the Saturnalia, was a feast of light, celebrated in December at the incidence of the winter solstice. This may explain the uncommonly bright light in the Vienna painting; by contrast, the darkened mountain to the left would represent the world before it was enlightened by civilization.

The identification of the horseman in the clouds with Saturn brought with it a whole set of ideas associated with the cult of that god, celebrated in the Saturnalia. The image in the clouds could also be linked with the legend of St. Sebastian in two ways: first, as already

[24]*Ibid.*, 14–20.

[25]Macrobius, *Saturnalia*, translated with an introduction and notes by P.V. Davies (New York–London, 1969), Bk. 1, chap. 8 (12). We may recall that the legend of St. Sebastian records a similar dedication of an altar to end the plague (see p. 101 and n. 12, above).

[26]Among its many symbolic connotations, the rabbit was considered in the Renaissance to be a symbol of fertility. The explanation for this was that rabbits reproduce very quickly (Eustathius, *Exaemeri*, in Migne, *Patrologia Latina*, LIII, col. 961, no. 5.)

mentioned, by means of the theme of the plague, with the heavenly apparition in Pavia recounted in the *Golden Legend*; and second, by way of the second etymology given in the *Golden Legend* for the name of St. Sebastian: "saddle." This was explained by reference to the figure of Christ who rode the horse of the Church, using St. Sebastian as a saddle, thereby leading many martyrs to victory.

Having firmly established the link between Saturn and the plague, Mantegna had to do the same for St. Sebastian, in order to offer a Christian counterpart to the pagan cult of Saturn. Because St. Sebastian's arrows could be interpreted merely as a reference to the instruments of his martyrdom, Mantegna had to endow the saint with some other distinguishing sign that would point to his connection with the plague.

The Tau Cross

In Homer's *Iliad*, the theme of the plague had been associated with Apollo's wrath, which punished man's sins—specifically Agamemnon's lust for Chryseis. A parallel idea is found in the Bible, which relates how David's sins were punished by the terrible anger of the Lord, who sent a three-day plague (II Samuel 11:1–27; II Samuel 24:12–15). According to this biblical passage, people were killed indiscriminately; however, elsewhere it is stated that those wearing the Tau mark upon their foreheads were spared death (Ezekiel 9:4–6). It should be noted that the Latin Vulgate definitely identified the saving mark as the Tau sign: Ezekiel 9:4, "signa Thau" and Ezekiel 9:6 "omnes autem super quem videritis Thau, ne occidatis." The Tau mark mentioned in Ezekiel was identified by Christian commentators as the sign of the cross, which brought man to salvation.[27] The Tau cross is clearly visible in the Vienna painting (Fig. 1). It is made with three arrows: one planted in the saint's forehead, a second planted in his neck and aligned with the first, though coming from the opposite direction; and a third arrow planted in his side. Together, these three arrows form a Tau, its crossing clearly outlined against the sky. Mantegna thereby expressed two ideas: on the one hand, St. Sebastian, by wearing the sign of the Tau cross on his forehead, was spared death by arrows, and on the other hand, by the magic of the Tau cross, he could save Christians from death by the plague. It will be noted that in this painting, the arrow that pierces the saint's forehead is shown as coming from above,[28] as an indication of its divine origin. It is the sign of the elect mentioned in Isaiah 49:2: "et posuit me sicut sagittam electam ("he placed me like an elected arrow"; the King James Bible differs here). Thus, the mark of the Tau mentioned in Ezekiel as being worn on the foreheads of those chosen by the Lord, combined with the arrow of the elect mentioned in Isaiah, provided the source for Mantegna's image of a Tau cross made with arrows impaling the saint's body.

[27]This interpretation was given, for instance, by Tertullian, *Adversus Marcionem*, III. 22, in Migne, *Patrologia Latina*, II, col. 353: "Ipsa enim littera graeca Thau nostra autem T, species crucis, quam portendebat futuram in frontibus nostris apud veram et Catholicam Hierusalem in qua fratres Christi, filios scilicet Dei, gloriam Patri Deo relaturos." The same idea of a contrast between Christians led to salvation by their wearing a mark on their foreheads, and heathens led to destruction by their wearing the sign of the Antichrist, is expressed in Revelation 7:3 and 14:9.

[28]I wish to thank Leo Steinberg for directing my attention to this detail and asking if I had an explanation for it.

Janus and the Reform of the Calendar

The symbols we have discussed so far explain one aspect of the cult of St. Sebastian: his patronage against the plague. The saint's connection with the plague links Mantegna's painting with Padua and the year 1457 for the commission of the work, because of the plague that raged in that city in the years 1456–1457. Another important aspect of the cult of St. Sebastian also points to the year 1457 for the inception of the painting: the reform of the calendar in Milan to honor the Milanese saint. The theme of the plague connected the three figures of Janus, Saturn, and St. Sebastian, because it was the murder of Janus that, by inciting the anger of Saturn, had occasioned the plague; and it was the intercession of St. Sebastian that could avert it. Discussion of the reform of the calendar will further strengthen this link among Saturn, Janus, and St. Sebastian.

A very prominent feature in the Vienna painting has not yet been commented upon: the architecture to which the saint is bound (Fig. 1). It is a double arch—its left part ruined—with an engaged Corinthian column of the Roman type, with unfluted shaft. The design of the capital is peculiar, and I have discussed elsewhere the symbolism of the vase it contains. It refers both to the origin of all measurement of time by means of a vase full of water, and at the same time it is the symbol of eternity and of faith.[29] The presence of a Victory holding a trophy, plus the combination of arches and trabeation with a column, identifies the architecture as a triumphal arch. There are, however, some difficulties in its identification, because the building has two arches of equal height, whereas Late Imperial triumphal arches, such as the Arch of Constantine, which did have more than one arch and also included Victories in the spandrels, had only one tall central arch flanked by two lower ones. Furthermore, triumphal arches are usually placed in the open, while the presence of the marble tiled floor and the low wall behind the building suggest that the archways in Mantegna's painting are placed in an enclosure.

I think that Mantegna did not intend to depict a specific type of building, but rather a combination of a triumphal arch, archways, and a door, in order to convey a chain of symbols associated by a common thought. According to my interpretation, that building represents the triumph of St. Sebastian over his martyrdom by arrows; the two arches of Janus, which measure time; and the door of Apollo, which leads to heaven. The idea of triumph and victory is obviously present and was used by Mantegna as an important clue pointing to one of the main sources for his symbolism in this picture, the *Triumphs* of Petrarch. On the other hand, in the light of two other texts, the building was also meant to be interpreted as a gateway with two arches. According to Cicero, "Janus is the leader in a sacrifice, the name being derived from *ire* ('to go'), hence the names *jani* for archways and *januae* for front doors of secular buildings."[30] The etymology of the name "Janus" given by Cicero as "to go" parallels the

[29]Filarete explains how the subdivision of a vase full of water was used originally to measure first the months of the year, then the days of the week, and finally the hours of the day (see *Filarete's Treatise on Architecture*, trans. by J.R. Spencer, New Haven, Conn., 1965, Bk. XIX, fols. 154–154v, and M. Levi D'Ancona, "Il San Sebastiano di Vienna: Mantegna e il Filarete," *Arte Lombarda*, XVIII, 1973, 72 n. 1). Mantegna here used the vase as an allusion to the measuring of time, and, in

addition, by way of Dante's *Paradiso*, Canto IV and Canto XXVII, 118–19, he associated this vase with the ideas of the immortality of the soul and eternity. By other associations (e.g., vintage relief, signature, and cherub's head), he connected these ideas with faith.

[30]*De natura deorum*, II. XXVII. 67, in Cicero, *De natura deorum. Accademia*, with an English translation by J. Rackham (London, 1933), 189.

I

fourth etymology given in the *Golden Legend* for the name of St. Sebastian: "One who goes about." Cicero mentions that Janus was connected with arches but does not specify their number. This detail is explained by Macrobius, who in *Saturnalia* 1.9.(5) and (9) states that there were two arches, representing the past and the future, and that each of Janus's two faces presided over one of the two heavenly gates. Furthermore, Macrobius states that Janus was said to have been invoked as an intercessor at sacrifices. This seems to be analogous with the role given to St. Sebastian as intercessor against the plague. It also parallels, as we shall see, the greater role played by Christ as intercessor for all mankind in the sacrifice of His Passion.

Janus was closely associated with Saturn, having ruled with him in Italy when the father of the gods was expelled by Jupiter from heaven. There was also a tradition that credited Janus with having been Saturn's own son.[31] In addition, Janus and Saturn were closely associated by their feasts. The Saturnalia were instituted in honor of Saturn to expiate the murder of Janus and were celebrated in December. Janus's own feast followed, in January, and that month received its name from Janus.[32] Saturn was credited with having introduced all measurements, including the measurement of time by the calendar, and he was even identified with time, by way of the Greek god Chronos. Janus was also identified with time, his two arches representing the past and the future. It was the special function of Janus to measure the year (*Saturnalia* 1.9.[10]); in their earliest reckoning of time, the Romans had celebrated the beginning of the year on January 1.

The calendar, like the plague, linked St. Sebastian, Janus, and Saturn. As Janus in Roman times had been the link between the past and the future, so St. Sebastian was the link between the Roman Empire and the Christian Era. The saint had been the leader of the First Cohort under Diocletian, and the Era of Diocletian was the Roman reckoning of time until the sixth century A.D., when the calendar was changed to the Christian Era. Thereafter the beginning of the year was set at various times in the different states of Italy. Some started the year with December 25, the former Saturnalia ("Style of the Nativity"); some with January 1, the month of Janus and the earliest way of starting the year among the Romans ("Style of the Circumcision"); and some with March 25, the Roman reckoning of the god Mars ("Style of the Incarnation"). In the year 1457, the Milanese calendar was changed from the Style of the Nativity to that of the Circumcision,[33] that is, from the feast of Saturn to the month of Janus. January, the first month of the year, was also the month in which the feast of St. Sebastian was celebrated (January 20), and the change may have been motivated by a wish to honor the Milanese saint, whose relics were venerated in nearby Pavia. Thus St. Sebastian, who had been linked with the change of two Eras, was also linked with the change of the calendar in Milan. The Christian Era began with the birth of Christ; whatever the style used (Nativity, Circumcision, or Incarnation), the year started with one of the feasts of Christ. The idea of measuring time by reference to Christ led Mantegna to the idea of the eternity of the Divinity.

[31]See p. 105 and n. 24, above.

[32]The discussion of Janus's feast in January and that god's connection with Saturn is given by Macrobius, *Saturnalia* 1.7.(23).

[33]A. Cappelli, *Cronologia, cronografia e calendario perpetuo*, 2nd ed. (Milan, 1930), 10 and n. 3.

The close connection between Janus and St. Sebastian is expressed in the painting in Vienna by the compact union of the body of St. Sebastian with the two arches behind him—the *jani* of Janus. The high column to which the saint is tied separates the two archways, the left one in ruins representing the past, while the right one, cut by the end of the picture, shows the future. The one at the left, ruined by time, especially where it nears the figure of Saturn-Time-Chronos, also represents the ruin of the Roman Empire,[34] with vestiges of the pagan religion (the fragments of sculpture connected with the Saturnalia) in the left foreground and types of Roman buildings in the background, the only remnants of the past glory of Rome.[35] The right archway represents the Byzantine Empire and bears in its entablature the gaping wound of the mark of the barbarian.[36]

The passage by Cicero quoted above linked Janus with the idea of sacrifice. We saw that the objects scattered on the tiled floor in the Vienna painting represented the "oscilla" connected with the Saturnalia, as well as an indication of the culture of the vine, whence came the wine that led to the murder of Janus and eventually to the expiatory sacrifices to end the plague. The Oracle of Apollo had required the sacrifice of two heads and one man: "Offer heads to Hades and a man to the Father."[37] St. Sebastian, who offered his own life to defend the Christian faith, is the Christian counterpart of this pagan sacrifice.

Christ

The idea of sacrificing a man to the Father suggests the paradigm of all sacrifices, the sacrifice of Christ to His Father in order to redeem mankind. This gave Mantegna the opportunity for linking St. Sebastian with Christ. Patronage against the plague and the reform of the calendar had emphasized only two aspects of the cult of St. Sebastian. But the most important of that saint's actions was his mission as a Christian martyr; indeed, that was his only real action, unlike the story of the plague and the reform of the calendar, which were later interpolations. Furthermore, the role of St. Sebastian as the soldier of Christ, the defender of the faith, was especially appreciated at a moment when a crusade was being planned against the Turks to free the Christian Empire of Constantinople.[38] St. Sebastian had held a high position in

[34]I thank Benjamin Rifkin for having pointed out this important detail to me.

[35]For the identification of the Roman buildings in the left background of the painting as Hadrian's Arch and the Theater of Marcellus, see the article by Tamassia, "Visioni di antichità," 229.

[36]The detail of a gaping wound in the entablature is explained by Filarete, Bk. i, fol. 7 (*Filarete's Treatise on Architecture*, ii.) When he conquered the Eternal City, Totila wanted to erase Rome from the face of the earth. It was pointed out to him, however, that if he did so, no evidence would remain of his conquest, whereupon the barbarian king left a mark of his conquest by using a pickax on the most prominent Roman buildings. The Fall of Constantinople to the Turks in 1453 could be compared to the Fall of Rome, but Mantegna expressed the wish that the Byzantine (Christian) Empire would not disappear, as the Mantua Congress was planned for 1459 to raise a crusade against the Turks. A thorough account of the events can be found in L. von Pastor, *The History of the*

Popes from the Close of the Middle Ages (London, 1910), iii.

[37]According to Macrobius, *Saturnalia* 1.7.(31), the custom of offering two heads in the sacrifices of the Saturnalia was based upon the Oracle of Apollo, which prescribed both to "Offer heads to Hades and a man to the Father," and also "For heads with heads," *Saturnalia* 1.7.(34). Macrobius explained that the heads should be made of clay (*ibid*.1.11.[48]) and also in the image of man (1.7. [11]): "Ut faustis sacrificiis in fausta mutarent inferentes Diti non hominum capita sed oscilla ad humanam effigiem arte simulata." The cult of the Saturnalia underwent many changes through the centuries, and there is considerable disagreement among the ancient Latin authors about the nature and shape of the "oscilla." For a long discussion of this point, see Pauly-Wissowa, *Real-Encyclopädie der klassischen Altertumswissenschaft*, Neue Bearbeitung (Stuttgart, 1942) XVIII₂, cols. 1567–78, "Oscilla"; *ibid.*, zweite Reihe (R–Z) Dritter Halbband, "Saturnalia," cols. 202, 207.

[38]See von Pastor, *The History of the Popes*, iii.

Diocletian's army, being the leader of the First Cohort. His role as soldier of Christ led him first to his martyrdom with arrows, then to flagellation with rods, which caused his death, and finally to his ultimate triumph and eternal reward—his union with Christ.[39]

The motif of death by flagellation suggested Mantegna's identification of St. Sebastian with Christ. This identification was based upon a passage from St. Paul (1 Cor. 12:27): "Now ye are the body of Christ, and members in particular," especially since St. Paul went on to say that nothing equaled the charity of Christ, not even the sacrifice of one's own life (1 Cor. 13:3). The identification of St. Sebastian with Christ was also based on the rules of rhetoric and dialectics. One of the rules of good rhetoric discussed by Macrobius (*Saturnalia* 4.5.[7]) was the use of comparison (*comparatio*) to induce emotion. Another important rule was the comparison from lesser to greater circumstances (*comparatio ad majora*). As an example of this method, Macrobius (*Saturnalia* 4.6.[1–8]) quoted a passage from Vergil's *Aeneid* (4.449), in which the lament over Dido's death was compared to the major disaster of the fall of two cities. Mantegna made use of this type of comparison in two ways. He compared the death of St. Sebastian to the fall of both the Roman and the Byzantine Empires, as shown by the Roman ruins at the left and Totila's mark on the entablature and the wall to the right.[40] He also compared the death of St. Sebastian as a Christian martyr to the death of Christ as Redeemer of all mankind. St. Sebastian was martyred with arrows but survived and died after being flagellated with rods. In this detail, his fate was comparable to that of Christ, but whereas St. Sebastian's flagellation ended his life, Christ's flagellation merely prepared Him for His crucifixion.[41] The identification of the flagellation of St. Sebastian with that of Christ explains the uncommon setting of the Vienna painting.

The *Golden Legend* describes St. Sebastian as having been tied to a tree trunk (or a stake) in the middle of the Campus Martius in Rome, the scene of his martydom by arrows. In the Vienna painting, Mantegna showed instead that the saint survived his martyrdom by arrows, while his executioners vanished to their own death on the curved road (Fig. 4),[42] and that St. Sebastian waited on an inlaid marble pavement, in the attitude of Christ at the column, for his flagellation by rods. This similarity of pathos, formula, and setting indicates the close association of St. Sebastian with Christ.

[39]The term of "Miles Christi" was given to St. Sebastian in the *Acta* (Migne, *Patrologia Latina*, XVII, col. 1056): "Cum miles esset dignissimus Christi" and "O fortissimi milites Christi, o instructissimi divini praelii bellatores, per nimiam virtutem animi fortiter pervenistis ad palman" (*ibid.*, col. 1025, speech by St. Sebastian to Marcellinus and Mark). In the same text the term of "Athlete of God" was also used (*ibid.*, col. 1025): "At ubi vidit Athletas Dei immenso certaminis pondere fatigari." For the mention in the *Acta* of the last reward received by St. Sebastian, the palm of victory and his union with Christ, see n. 15, above.

[40]See n. 36, above. The suggestion of the fall of the Roman Empire is also found in the passage on the fall of a heathen kingdom (Isaiah 14:4), discussed on p. 104f.: "How hath the oppressor ceased! the golden city ceased!" Mantegna also made use of Petrarch's "Triumph of Time" and Ecclesiastes 3:1.

[41]A suggestion of a cross appears in Mantegna's painting (Fig. 1), formed by the column to which St. Sebastian is tied

and the molding at the springing of the arches. St. Sebastian's head, framed by its halo, is well centered at the crossing. This latter detail is an illustration of Alberti's theories of proportions (Alberti, *Della Pittura e della Statua*, Milan, 1804, Book II, p. 56). This detail was pointed out to me by Benjamin Rifkin.

[42]The death symbolism of the curved road is explained by several texts: Vergil's *Aeneid* 6.602 and *Georgics* 3.482; Job 16:23 and 22:15. The death symbolism of the road is reenforced by the presence on it of the archers, instruments of death, who disappear in the water at the end of the road (Fig. 4), and by the pebbles scattered on the surface of the road. The latter detail is explained by way of St. Gregory the Great, *Moralia* in Migne, *Patrologia Latina*, LXXVI, col. 158. That road is very rich in associated symbols, as it is also connected with the idea of the Trinity, as well as with the Liberal Arts: "It was in the reign of Saturn that we made our way, as though to the light, from a gloomy existence to a knowledge of the Liberal Arts" (*Saturnalia* 1.7.[32]).

The theme of Christ's flagellation called for His binding to a column.[43] The setting Mantegna gave to the scene of the flagellation of St. Sebastian had a scriptural basis. According to John 19:1–3, the flagellation of Christ took place in the Judgment Hall, and especially in a place called "The Pavement." The Latin word used in the Vulgate is "Lithostratus," meaning "pavement made of inlaid stones." We saw at the beginning of this essay how Mantegna used the tiles in the floor as a convenient device to measure the spatial recession by perspective and to illustrate Albertian theories of the measurement of space by geometric proportions. We now begin to understand the iconographic significance of the tiles, as well: they are a scriptural reference to the flagellation of Christ and thus are used as one of the arguments in the *comparatio ad majora* to identify St. Sebastian with Christ.[44]

The theme of the flagellation of Christ had an established tradition. What is new in the Vienna painting is the yellow color of the column to which St. Sebastian is tied. This detail, like the rest of the painting, also has its symbolic significance. The Oracle of Apollo had mentioned that the Manes should be appeased by sacrifices in the Saturnalia.[45] Both the yellow color and the cylindrical shape of the column were mentioned among the prescribed sacrifices to the Manes contained in the fifteen canonical books of the Etruscans.[46] The fifteen arrows that Mantegna depicted as imbedded in St. Sebastian's body may be a numerical reference to these canonical books, as well as a symbol of Christian perfection as expressed by the numbers—the number of the Trinity multiplied by the number of the wounds that Christ received on the cross.[47]

The symbolism unraveled so far is but a small part of the surface meaning of this painting, while its deeper meaning still remains to be disclosed. In this essay, I have neither the time nor the space to complete the discussion of this work but will give here only a sketchy outline of what remains to be done, hoping that a knowledge of the beginning may give the reader some indication of the rest of the argument.

The identification of the flagellation of St. Sebastian with the flagellation of Christ is crucial for an understanding of the rest of the symbolism in the Vienna painting and is a preparation for the ontological argument based on the Aristotelian method taught at the

[43]For a penetrating study of the flagellation of Christ, see M. Meiss, "The Case of the Frick Flagellation," *Journal of the Walters Art Gallery* (XIX–XX, 1956–1957), 43–63. Substantial further literature on the subject will be found in C. Schweicher, "Geisselung Christi," in Kirschbaum *et al.*, *Lexikon der Christlichen Ikonographie*, II (Freiburg, 1970), cols. 127–30. In the Vienna painting, St. Sebastian is depicted as tied to the column by his feet, because this detail explained the association of events in time (Cartari, *Le imagini de i dei*, 19).

[44]I can give here only an extremely sketchy indication of Mantegna's method of giving the measure of God's eternity through the tiles in the floor. They are part of a set of associated symbols dealing with eternity. By way of the last four Triumphs of Petrarch (Death, Fame, Time, Eternity), Mantegna arranged his associated symbols to express the concept of eternity. By way of Dante's *Paradise*, he illustrated the idea of God by several symbols. By way of Daniel 2:34–35 and St. Gregory's *Moralia* (Migne, *Patrologia Latina*, LXXVI, cols. 457, 458), Mantegna conveyed the idea of the Lord as a cornerstone. By way of Job 38:4–6 and 18–20, he showed God

as the creator and measurer of the universe, and thereby also as the inventor of perspective: "Where wast thou when I laid the foundations of the earth . . . Who hath laid the measures thereof . . . or who hath stretched the line upon it?" (Job 38:4–5). The tiled floor, shaped like the cornerstone placed in the low wall and proportioned to it, is part of a vast program of proofs of the eternity of God and demonstrations of the ways whereby one can arrive at a knowledge of His essence.

[45]Reference to the sacrifices to the Manes is given by Macrobius in the *Saturnalia* 1.7.(34–35).

[46]The sacrifice to the Manes included a cylindrical stone, and its color was yellow, the color of the liver; see Fabius Planciades Fulgentius, *Mythologiarum libri III* (Milan, 1498): "Vocem antiquam cum testimonio ad Calcidium," 4: "Manales Lapides" (the book is unpaginated).

[47]The associations with wounds appear not only by references to the wounded St. Sebastian and the wounds of Christ, but also by the depiction of the gaping wounds in the buildings and by other associated ideas.

University of Padua. This method of philosophy held that the knowledge of God could be attained by proceeding from the particular to the universal by four main methods and by the principle of twos and threes in nature, which lead from man and his surroundings to God, their creator.[48] Both the measurement of time and the measurement of space by perspective lead to God, the Creator of all measurement and the measure of all things. As we have seen, the ontological method also allowed Mantegna to show how the Christian cult of St. Sebastian superseded the pagan cult of Saturn in patronage against the plague;[49] further it enabled him to contrast the pagan calendar with the Christian one, and to proceed from the measuring of time to reach God, Who is immutable and eternal because He contains all time.[50]

In philosophy, it was held that Saturn, the father of the gods, had created the world, because the word Saturnus contained the Greek word "Nous," the universal mind. The Horseman in the Clouds in the Vienna *St. Sebastian*, far from being a chance image, connects Mantegna's painting with the theory of the unity of the intellect, one of the most distinctive theories of Paduan philosophy in the early fifteenth century.[51] Thus Mantegna included the concept of the operation of man's mind and linked it with God's own creation of the world,[52] the Father's creation of man,[53] as well as with God's incarnation by the infusion of His divinity into His Son. The presence of the figure of Saturn in the clouds and the identification of St. Sebastian with Janus were part of this program. They introduced the concept of the dual nature of God through the figures of Saturn, the father of the gods, and Janus, his son.[54] Furthermore, in the *Saturnalia*, Janus was identified both with Apollo, the "God of the Door," and with Diana Trivia, to whom was assigned the "rule over all roads."[55] The association of the pagan gods Janus, Apollo, and Diana, formed a triad comparable to the Christian Trinity.[56] In addition, the identification of Janus with Apollo afforded an opportunity to strengthen the link between St. Sebastian and the pagan god who, as mentioned in the *Iliad*, had caused the plague by arrows. It also provided a link between the sun god, Apollo; the giver of light, Saturn; the first miracle in the life of St. Sebastian, when the saint was enveloped by light;

[48]See n. 6, above. For Paduan Averroism and Aristotelianism, see E. Troilo, *Averroismo e Aristotelismo padovano* (Padua, 1938); B. Nardi, *Saggi sull' Aristotelismo padovano dal sec. XIV al XVI* (Florence, 1958), especially 75–93; and P. Silvestro da Valsanzibio, *Vita e dottrina di Gaetano di Thiene* (Padua, 1949).

[49]Mantegna did this by identifying his own name with that of the Apostle St. Andrew in his signature, and thereby pointing to the Apostles' Creed, which had been written in Greek in its original form and carved in stone for greater durability. The latter detail is found in the *Commentarius in symbolum Apostolorum auctore Tyranno Rufino* (Migne, *Patrologia Latina*, XXI, col. 337; see also *De singulis libris canonicis Scarapsus*, among the works of St. Firmin the Abbot, Migne, *ibid.*, LXXXIX, col. 1034). Mantegna's signature in Greek is extremely important for the understanding of the Vienna painting. Among the innumerable associated ideas it brings, it also points to the artist's own identification with Vergil by way of Macrobius: "For how could a Venetian, born of peasant parents, and reared amidst forests and scrub, have acquired even a smattering of Greek letters?" (*Saturnalia* 5.2.[1]).

[50]Mantegna did this through Petrarch's *Triumph of Eternity* and Dante's glorification of God in Paradise; see also n. 29 and n. 44, above, and n. 57, below.

[51]For the theory of the Universal Mind, see Fulgentius (*op. cit.* in n. 46). Fulgentius quoted as his source an epic poem on Saturn by Apollophanes (the name means "manifestation of Apollo"), and Mantegna used the pun on the author's name in his identification of St. Sebastian with Apollo, among many other associated ideas. For the Unity of the Intellect, see "Introduction to Pomponazzi," in *Renaissance Philosophy of Man*, ed. E. Cassirer—P.O. Kristeller—J.H. Randall (Chicago, 1956), 258–63; and Nardi, *Saggi sull' Aristotelismo padovano*, 89–93. The teaching and writings of Paul of Venice (d. 1429) and of Cajetan of Thiene (d. 1465) had special influence on Mantegna's painting. Discussion of the Unity of the Intellect was to be forbidden by the Bishop of Padua in 1489.

[52]See n. 44, above.

[53]Mantegna depicted both the creation of man and the incarnation of Christ by various symbols, among which are those associated with Mantegna's signature, the cornerstone, and the mountain.

[54]For a beginning of the discussion of this problem, see my sections on Saturn and Janus (pp. 104–06, 107–09); however, the argument can only be grasped in the context of a full discussion of the symbolism in the Vienna painting.

[55]*Saturnalia* 1.8.(5) and 1.9.(6).

[56]Mantegna made this comparison by way of Macrobius and by the Aristotelian method of the principles of two and three (Aristotle, *Metaphysics*; see n. 6, above).

and finally the Lord, who shines eternal and immutable, never diminished in His brightness, however much light He emanates.[57] This difficult concept is depicted in the Vienna painting both by the uncommonly bright light that pervades the painting and by the symbols connected with numbers. Even more important is the beautiful figure of the saint, nude and beardless, like Apollo, and at the same time a reference to Petrarch's "Triumph of Eternity," 133: "Ne l'età più fiorita e verde avranno/Con l'immortal bellezza eterna fama."

The identification of Janus with Diana Trivia, who ruled over all roads, gave the artist the opportunity of linking St. Sebastian with roads, to justify the etymology of his name given in the *Golden Legend* as "One who goes about."[58] It also provided an allusion to the Trinity through the word "Trivia" ("Three Ways"), as well as pointing to a connection with the Trivium,[59] the highest discipline taught in a Liberal Arts program. It showed as well that, through a knowledge of the Liberal Arts, and by way of Aristotle's philosophy, one could attain to full knowledge of God. The combination of Aristotelian philosophy and Christianity is the essence of Thomist thought, and Mantegna's picture sums up the main points of the *Summa Theologica* by way of Dante's *Paradise*, thus combining the excellence of Vergil, the greatest Latin poet, with that of Dante, the greatest "modern" poet. The artist could rightfully claim "Ut pictura poesis."[60]

The discussion of the iconography of the Vienna St. Sebastian dates the painting beyond the shadow of a doubt at the end of Mantegna's Paduan period. The arguments used in the iconography of the painting are based on the Aristotelianism taught at the University of Padua; furthermore, the deeper meaning of the picture could be clearly understood only by a person trained at the University of Padua. Because of these reasons, I suggest that the painting was commissioned by Jacopo Antonio Marcello, the Mayor of Padua and a graduate of its University, at the end of the plague epidemic that ravaged Padua in 1456–1457. Mantegna himself caught that plague but miraculously survived it. In the same year, 1457, the calendar in Milan was changed from the Style of the Nativity (starting the year at Christmas) to the Style of the Circumcision (starting the year on January 1). As shown above, St. Sebastian was connected both with the plague and with the calendar.

It is my contention that the "operetta" mentioned in the three letters dated 1459 is indeed the Vienna *St. Sebastian*. Among the internal arguments for this identification, I should mention the presence of the boats in the background of the picture (Fig. 5). They allude to the calling of Peter and Andrew, to Saturn's arrival in Italy, and to Mantegna's own calling to Mantua. In one of his letters to Mantegna, dated April 15, 1458, as well as in another letter dated May 14, 1459, the Marquis of Mantua offered to move Mantegna and his family from Padua to Mantua by boat. The boats are depicted on the right, the side of the

[57]See n. 44, as well as Dante, *Paradiso*, Canto 33, 124–26:
"O luce eterna che sola in te sidi
sola t'intendi, e da te l'intelletta
e intendente te, ami e arridi!";
and also Canto 13, 52–60:
"Ciò che non more e ciò che può morire
non è se non splendor di quella idea
che partorisce, amando, il nostro Sire;
chè quella viva luce che sì mea
dal suo lucente, che non si disuna

da lui nè da l'amor ch'a lor s'intrea,
per sua bontate il suo raggiare aduna,
quasi specchiato, in nove sussistenze,
eternalmente rimanendosi una."
[58]*Golden Legend*, ed. Ryan–Ripperger, 105.
[59]This can be understood only by full discussion of the grammatical associations with Mantegna's signature in Greek (for a brief sketch of Mantegna's line of reasoning, see n. 62, below).
[60]I thank Benjamin Rifkin for this quotation.

future, and thus date the picture before 1459–1460, when Mantegna settled in Mantua to become a sort of parallel to the Mantuan-born Vergil. The curved wake of the boat is linked with the image of the sailor steering a ship in the operation of navigation, which was used by the Paduan philosopher Francesco Zabarella (d. 1417) as an illustration of the rational soul.[61]

As we have seen, Mantegna used the Liberal Arts to prove the existence of God. As his unit of measurement for the height of the Vienna painting (26 3/4 inches), he used the cubit of Christ, which is proportionate to the human cubit but larger. He derived this from the Quadrivium, one of the rules of geometry being that the knowledge of one part can give the measure of the whole.

Mantegna's signature in the painting is the key to many associated ideas. The artist's study of epigraphy was necessary to show a connection between his signature and the Apostles' Creed, which was carved in stone. He also studied the rules of grammar (one of the disciplines in the Trivium, the superior section of the Liberal Arts) as one of the many ways by which man can reach the knowledge of God. His deep interest in lettering, and especially in the initial letter, stemmed from this study,[62] his thesis being that through the letter one reaches the Primal Cause, the Word, for "In the beginning was the Word" (John 1:1).[63] This seems an appropriate thought on which to end an essay dedicated to Millard Meiss, whose brilliant study *Andrea Mantegna as Illuminator* opened new vistas for our understanding of Mantegna's art. A complete explanation of the symbolism in the Vienna *St. Sebastian* would strengthen his argument that Mantegna was really the inventor of the "Littera Mantiniana" in 1459.

HUNTER COLLEGE

[61]I am indebted to Benjamin Rifkin for connecting the boats with St. Andrew. For the letters, see Kristeller, *Andrea Mantegna* (London, 1901), 467, doc. 4, and 469, doc. 7. For Zabarella, see *Renaissance Philosophy of Man*, 261.

[62]Briefly to summarize Mantegna's argument, it should be noted that in grammar, the article is a necessary premise for the word. Mantegna's signature starts with the Greek article "το" ("the"), which contains two letters, thereby expressing that faith in the two natures of Christ is a necessary premise for an understanding of his operation ("ergon" means work, operation). The word "ergon," the first noun in the sentence, is composed of five letters, which symbolize the five senses through which the world is perceived, as well as the five wounds which Christ received on the Cross. The second letter in this word, the Greek *rho*, is identical in form to the Latin *P*, which is the initial letter of "Pater" ("Father," in Latin). That letter is connected by an arrow to the body of St. Sebastian-Christ, thereby pointing to the duality of operation of God the Father because of His two natures: He created man (St. Sebastian) and was incarnated in Christ. In Mantegna's signature, the third and fourth letters taken from the body of his name *ΑΝΔΡΕΟΥ* as written in Greek, become in Latin the initials *D* and *P*, respectively, of the words "Deus" and "Pater". Mantegna's line of thought becomes intelligible only through a full discussion of his entire argument.

[63]The word was especially important in the nominalist philosophy ("terminismo") of Paul of Venice, who held that verbs were turned into nouns, and operations into substances. See F. Momigliano, *Paolo Veneto e le correnti del pensiero religioso e filosofico nel suo tempo* (Udine, 1907), and Nardi, *Saggi sul l'Aristotelismo padovano*, 75–93.

Mensurare temporalia facit Geometria spiritualis:
Some Fifteenth-Century Italian Notions about When and Where the Annunciation Happened

SAMUEL Y. EDGERTON, JR.

Ave, Maria; 'tis the hour of prayer;
Ave, Maria; 'tis the hour of love;
Ave, Maria; may our spirits dare
Look up to thine and to thy son's above;

Ave, Maria; oh that face so fair;
Those downcast eyes beneath the Almighty Dove—
What though 'tis but a pictured image strike,
That painting is no idol—'tis too like.

(Lord Byron)

St. Antonine did not care much about art. Even as prior of San Marco when Fra Angelico was painting there, and as archbishop of Florence during the 1440s and '50s when the city was a world-renowned art center, he reveals in his writings only a begrudging acquaintance with the new miracles of Renaissance painting and sculpture. In fact, his few remarks on the subject are rather nasty. He distrusted artists somewhat as modern scholars distrust auto mechanics. He worried about the quality of their work and about their prices. He was particularly bothered that they were not interested in representing reality, that is, in his words, according "to the nature of things," but rather sought to embellish their paintings with worldly delights that deflected from the true didactic purpose of holy images.

St. Antonine's one specific passage about art has already been analyzed by Creighton Gilbert.[1] In Book III of his *Summa theologica*, ca. 1450, the archbishop made a clear attack on painters of the Gothic International Style, such as Gentile de Fabriano, who painted "oddities, which do not serve to excite devotion but laughter and vanity, such as monkeys and dogs chasing hares, or vain adornments of clothing." He was especially incensed when artists included heretical or apocryphal details in pictures about the Life of the Virgin, such as "midwives at the Virgin's delivery," or "the little boy, that is Jesus ... sent fully formed into the womb of the Virgin, as if His body were not produced from the substance of the Virgin."[2]

If the archbishop's harrumphing comments give us some impression of what he did not like, what kind of art might then have pleased him? As Professor Gilbert goes on to imply, the more moralizing qualities of Masaccio's new realism would have been acceptable. This is

[1] C.E. Gilbert, "The Archbishop and the Painters of Florence," *Art Bulletin* (XLI, 1959), 75–89. The definitive biography of St. Antonine is by Abbé Raoul Morçay, *Saint Antonin, Archevêque de Florence* (Paris, 1914). St. Antonine's own writings of special interest to the subject of the Annunciation are the *Summa theologica*, republished in a 4-volume facsimile, after a 1740 printed edition (Graz, 1959), hereafter cited as *Summa*. Cf. also the *Chronicon*, published by the Antonius Koburger press (Nuremberg, 1484), I, Tit. 4, cap. 6, fol. lxxi r and Tit. 5, cap. 1, fol. lxxi v for comments on the Annunciation. Also the manuscript entitled *Convertimini*, Florence, Biblioteca Nazionale, Magl. Conv. sopp. A.8.1750, fol. 28r ff., sermon for March 25, the Feast of the Annunciation.

[2] This translation is after Gilbert, *ibid*. The original Latin is in the *Summa*, III Tit. 11, cap. 10, cols. 547–48.

interesting, especially in the light of recently published evidence by Michael Baxandall, which shows that the contemporaneous humanists were in fact quite fond of International Style painting and were not at first in tune with linear perspective and the new manner of depicting solid forms in three-dimensional space.[3] It would be ironic indeed if St. Antonine, the conservative Dominican priest still preaching fundamentalist medieval theology, were to turn out to be sympathetic to the Renaissance classical style even as the humanists were unappreciative.

Although expressing little further opinion on art, St. Antonine in his writings shows a strong parallel in intent with Leon Battista Alberti, whose treatise on painting of 1435–1436 is regarded as the Magna Carta of the new Renaissance style.[4] For instance, both St. Antonine and Alberti believed in a state of man governed by mathematical order. Understanding this order, which St. Antonine called "scientia," must lead to keener appreciation of man's moral responsibility. Both St. Antonine and Alberti believed that the prime purpose of the arts was to instruct, to communicate moral lessons derived from representations that showed how man lives in harmony with natural law. Each also believed in the Aristotelian virtues of moderation and decorum. Visual images, whether in pictures or only in the imagination ("in figuram," as St. Antonine said), must lead to such a message. Like Alberti, St. Antonine believed that the science of geometry related to God's master plan for the universe: "Spiritual geometry works to measure temporal things . . . it measures dimensions not as quantities but as virtues within God . . . as the length of eternity, the width of His extensive charity, the height of His immense power, and the depth of His clarity of wisdom."[5]

While the above may sound like so much boring scholasticism, St. Antonine's subsequent text relates closely to the peculiar thoughts and attitudes of mid-fifteenth-century Florentines. His *Summa theologica* is particularly filled with analogies to the sciences as practiced in his own time, to the mathematically based arts of the Quadrivium, and to medicine and optics. St. Antonine's Florence was obsessed as never before with measurement—in bookkeeping, land surveying, money exchange, architecture, painting, cartography, and a myriad other activities. The archbishop was very concerned that these mundane interests of his countrymen be made available to theological and moral interpretation.

Book IV of the *Summa theologica* is especially interesting in this regard. Here St. Antonine conducted a long discussion on the Virgin Mary. Generally speaking, this account has to do with her divine attributes according to the traditional, early medieval patristic writings, but the archbishop also went further. He attempted, by application of the above sciences, to cast in the mind of the reader a vivid, rational image of the Virgin and all her events. While it is likely that St. Antonine's mental view was conditioned to some extent by pictures he had already seen about the Life of the Virgin, he clearly was not talking about artifice.[6] Indeed,

[3]*Giotto and the Orators: Humanist Observers of Painting in Italy and the Discovery of Pictoral Composition,* 1350–1450 (Oxford, 1971).

[4]See C. Grayson's recent and authoritative translation from the Latin of Alberti's *De pictura* in *Leon Battista Alberti On Painting and On Sculpture* (London, 1972).

[5]*Summa,* IV, Tit. 16, cap. 1, col. 1265: "Mensurare temporalia facit Geometria spiritualis. . . . Dimensiones non quantitativas,

sed virtuales mensurat in Deo . . . per . . . longitudinem aeternitatis, latitudinem extensae caritatis, altitudinem immensae potestatis, profundum sapientia claritatis."

[6]On the influence of contemporary paintings on the visions of saints, particularly in regard to St. Catherine of Siena, see M. Meiss, *Painting in Florence and Siena after the Black Death* (Princeton, N.J., 1951), 105–07.

his intent was to discuss the events of the Virgin's life as they really happened. In the context of St. Antonine's time, however, reality must not be understood from the modern viewpoint of purely physical description, but rather from the casuistic medieval definition that reality consists in equal measure of literal truth, tropological or moral message, and allegorical or symbolic meaning.[7] In this sense St. Antonine's writings are a good indicator, if not of art *per se*, at least of what an articulate and influential personality at the heart and center of Early Renaissance Italy thought a "realistic" picture of the Annunciation might show.

Before examining what St. Antonine said, one should also understand just how he structured his mental image. This is fairly clear from the pages of the *Summa theologica*, because the archbishop was a man with a very tidy mind. His methodology began with an initial acceptance of the miracles of Mary exactly as described in Scripture. Then he examined the details carefully in the light of the commentaries by the patristic writers. He would cite, for instance, such authorities as Augustine, Thomas Aquinas, Albertus Magnus, and Gregory the Great with the same homage and attention to exact quotation as the modern art historian pays to Panofsky, Wittkower, Friedlaender, and Meiss.[8] Finally, he would rationalize these details, rejecting or accepting those in dispute according to their feasibility in "scientia." For example, to answer the question of the Virgin's physical appearance, he resorted to the most remarkable application of medieval Galenic medicine. The Virgin's skin, he averred, must be the color of white and red in ideal mixture. This is because the four humors—the agents of metabolism in medieval medicine—were in perfect accord in her most perfect body. Her body in turn was in perfect accord with her soul. Hence, red, the color of the sanguine humor, at its peak in youth, represented the essence of her physical being, while white manifested itself as the color of her purest soul. In the same fashion he analyzed the color of her hair. This, he argued, could not be red, because that would mean that the brain, which the hair covered, was mercurial and unstable. The Virgin, however, was a most stable person. Such a stable personality can be caused only by an equilibrium of warmth and dryness in the brain. Dryness generates the color black. Black is the color of the most stable of the four elements, earth (as red fire is the least stable). Hence the Virgin's hair must have been black. St. Antonine also considered arguments that the Virgin's hair was blond, as it is frequently depicted in quattrocento painting. I think he would have liked to prove this, but the inexorable logic of his Galenic endocrinology would not allow him to draw such a conclusion. The archbishop also thought the Virgin was between eleven and fourteen when she was betrothed—which was the customary age in medieval Europe—but was unsure of just when she received the Annunciation. He did, however, acknowledge that even at such an early age her sacred womb was ideally developed for her divine mission.[9]

For the purposes of this essay, the most interesting of St. Antonine's descriptions has to do with the events of the Annunciation.[10] Here the archbishop began, as he usually did in all

[7]St. Antonine comments on these three aspects specifically in regard to the Purification of the Virgin Mary; see *Summa*, IV, Tit. 15, cap. 24, col. 1172.

[8]Concerning the large number of commentaries by the patristic authors in Renaissance libraries, which indeed constituted the majority of inventoried items, see P. Kibre, "Intellectual Interests as Reflected in 14th and 15th Century Libraries," *Journal of the History of Ideas* (VII, 1946), 257ff.

[9]Concerning St. Antonine's Galenic arguments about the color of the Virgin's skin and hair, see *Summa*, IV, Tit. 15, cap. 11, cols. 981–85; concerning her age, see *ibid.*, cap. 7, col. 952.

[10]*Ibid.*, cap. 9, col. 964ff.

his chapters, with an enumerated list of items to be argued. First, he discussed from what hierarchical order the angel of the Annunciation came. Second, he argued concerning the "species" or specially energized substance of which the angel was composed. This became important later, when he considered how the angel was able to pass into Mary's chamber through a closed door. Third and fourth, and most importantly, the archbishop carefully analyzed the exact time of the Annunciation, that is, the year, month, day, and hour, and the place, that is, the country, city, and type of building in which it occurred.

Let us now follow St. Antonine's arguments about the time of the Annunciation. According to those of the Fathers with whom he agreed, the year of the event was 5,199 years after Adam's Fall. This was because, at the Creation, God made man on the fifth day and part of the sixth. But man then sinned, and God decided to punish him with a sentence without grace of a thousand years and an appropriate fraction for every day of the Creation. Hence, the Savior was sent into the world at this date. The month and day was March 25. This was the traditional New Year's Day in Florence as well as in many other centers of Renaissance Europe. Even unofficially, however, the traditional Feast of the Annunciation on this day symbolized the moment when the good Christian should put behind the winter of his discontent and face the oncoming summer with renewed faith and hope. As St. Antonine noted, this date marked the time when warmth and moisture (in the Galenic humoral sense) return, and cold and dryness depart.[11]

Of special interest to our subject is St. Antonine's discussion of the hour of the Annunciation. According to his argument, this could not have been at night, that is, before the "natural day" begins at midnight. His argument is complex here, but the fact that he raised it at all was because many people made this assumption, apparently because the Angelus, with the three chimes of the local church bell in every parish and the hearer reciting "ave, ave, ave" in honor of the angelic visit to Mary, was sounded in the evening. Indeed, the evening Angelus was almost universally accepted throughout Europe after 1269 when St. Bonaventure proclaimed it from the Porziuncola, the little shrine of St. Francis at Assisi.[12] At some subsequent date, however, for reasons perhaps related to those presented by St. Antonine in the *Summa theologica*, a second, morning Angelus was instituted, and St. Antonine himself acknowledged that this was currently being rung daily in Florence.[13] In any case, he argued in favor of the morning as the time when the Annunciation had taken place. The precise time was dawn, the beginning of the "artificial day" in our Northern Hemisphere, because, said the archbishop, this is tropologically and allegorically when the light of the "true sun" illuminates "every man coming into this world."[14]

[11]*Ibid.*, col. 968.

[12]A. Gemelli, *Il Francescanismo*, 7th ed. (Milan, 1956), 93–94.

[13]Concerning the history of the Angelus, see T. Esser, "Das Ave-Maria Läuten und der 'Engel des Herrn' in ihrer geschichtlichen Entwicklung," *Historisches Jahrbuch* (XXIII, 1902), 22–51, 247–69, and 775–825. St. Antonine mentioned the morning and evening Angelus sounding daily in Florence in his *Summa*, IV, Tit. 15, cap. 23, col. 1101: "Statuit insuper Ecclesia singulis diebus pulsari ter campanas Ecclesiarum de sero et iterum de mane; ad quid nisi ut honoretur B. Maria, et laudaretur ex salutatione Angelica?"

[14]*Ibid.*, cap. 9, col. 969: "Demum hora, in qua missus est, etsi nobis non fit certa, tamen secundum Albertum ubi supra convenientior videtur fuisse in ortu solis. Dicit enim, quod circumstantiae nuntiantis debent exprimere proprietatem nuntiati, secundum Dionysium; unde quum annuntiet angelus iste ipsam incarnationem cum proprietatibus suis, illa autem sit ortus veri solis super terram illuminantis omnem hominem venientem in hunc mundum, quod tempus scilicet mane est initium diei; sine praejudicio praesumtionis credimus, quod haec annuntiatio sit facta in ortu diei."

St. Antonine then went on to raise further points against those who would have the Annunciation take place at noon. According to the archbishop, such a time was impossible, because at that hour the sun stands at the zenith, with its rays making right angles with the earth. In the medieval science of optics, light rays at right angles with the surface on which they fall pass on their force most intensely.[15] Hence the sun's rays at noon are hottest. Heat signifies Charity and the Passion. According to Scripture, Christ's Crucifixion occurred at noon. While the archbishop recognized the close tie between the Annunciation and Christ's destiny on the Cross, he noted also that they must be separate events and therefore related to different times of day. Therefore the Annunciation, with Jesus Incarnate, must happen at dawn. The Savior then matures as a man as the sun ("Sol Justitiae") progresses through the morning sky. At high noon, the Savior suffers His inevitable Crucifixion, when He sheds His divine Charity most intensely on mankind.

We now move to St. Antonine's discussion as to just where the Annunciation occurred. According to Luke 1:26, at the time of the angelic visit Mary was living with her parents in the city of Nazareth in Galilee. St. Antonine, the urbanized Florentine, pointed out: "Therefore, not in the sea, because that is the place for fishes, ought the Annunciation be given, nor in the air which is the place of birds, nor in the fields which is the place of wild animals, but in the city . . . because that is the proper place of men."[16] The archbishop also took note that Christ's Incarnation in a city was symbolic of his *ex utero* mission on earth. He then pondered the significance of the Savior's *in utero* gestation.[17] This must indicate, thought the archbishop, a private as well as a public meaning for the Incarnation. The Annunciation, therefore, while occurring in a city, took place specifically within the privacy of a sanctuary that, just like the Virgin's most sacred womb, was protected and suitably dignified and removed from the bustle of the city itself. Hence, it must have happened in a temple. Furthermore, the Virgin was within a private room in this temple, which was closed by a *porta clausa* or "shut door." When the angel appeared to Mary, it came through this closed door, showing that she remained ever virgin both before and after the Incarnation. This entrance offered no problem to the angel, St. Antonine averred; he had already explained the special, metaphysical "species" of which the angel consisted.[18]

None of the symbolic allusions above were original with St. Antonine. Similar references to the Virgin's chastity, such as the imagery of a temple, tower, enclosed garden, etc., are found in countless commentaries, sermons, and hymns from the Middle Ages and

[15]*Ibid.*, cap. 9, col. 970. St. Antonine reveals his optical knowledge in this regard however in *ibid.*, Tit. 9, cap. 1, col. 467 in the chapter entitled "Concerning the Twelve Properties of Divine Grace in their Similarity to Material Light:" "Undecimo lux est augmentativa in radiis, quia augetur a mane in meridiem . . . major enim lux apparet, seu magis illuminatur aer hora tertia quam prima, et in meridie magis hora tertia, quia radius solaris magis directe reverberat terram. Sic lux gratiae continue augetur vel habitualiter vel dispositive. . . . Exponit Gregorius super Ezechielem de conversatione electorum Dei, qui crescunt per bona opera in gratia usque ad diem claram gloriae." See also *ibid.*, I, Tit. 3, cap. 3, cols. 118–24, St. Antonine's chapter entitled "Concerning Those

Things Required for Good Seeing both Corporeally and Spiritually."

[16]*Ibid.*, cap. 9, col. 971f.: "Non ergo in mare, quod est locus piscium, debuit nuntiari; non in aere, qui est locus avium; non in campo, qui est locus animalium silvestrium; sed in civitate concipi debuit, qui est locus hominum proprius . . ." See also St. Antonine's further comments on the Virgin as a city, in *ibid.*, cap. 2, col. 916ff.

[17]*Ibid.*, cap. 9, cols. 971–72.

[18]*Ibid.*, cap. 9, col. 972: "Clauserat, inquam, super se illa hora habitaculum suum prudentissima Virgo, sed hominibus, non Angelis; et sic potuit ad eam intrare Angelus, sed nulli hominum facilis patebat accessus."

Renaissance.[19] But St. Antonine does make several direct references to one specific analogy, which, as we shall see, also began to attract artists illustrating the Annunciation during the fifteenth century. This was to the mystical temple of Ezekiel, as described in the Old Testament, which had been the subject of several long commentaries by the patristic writers, particularly St. Jerome, St. Gregory the Great, Rabanus Maurus, and Nicolaus de Lyra. Ezekiel's prophecy is the source for St. Antonine's image of the "closed door" to the Virgin's chamber. In the Old Testament vision, this *porta clausa* is very definitely on the *east*, and through it came "the Glory of the Lord which filled the house"—that is, in St. Antonine's interpretation, the Light of the Holy Spirit conveyed by the angel Gabriel to Mary.[20]

Beginning with chapter 40 in the Book of Ezekiel, the prophet describes how the Lord lifted him on high so he could behold a "frame of a city" or *aedificium civitatis* on the south. Within the south gate of this mystical edifice, he beheld a "man . . . like the appearance of brass" holding measuring tools, a ball of string, and a rod. The "man" then conducted the prophet all about the city recording careful measurements in cubits of every part. According to all the commentators, Ezekiel's vision represented "in figuram" the Holy Church itself, and the "man" in the south door was no other than Christ. St. Jerome and St. Antonine, too, understood this mystical city as raised on a mountain or founded on a rock, with obvious allusion to Christ's charge to Peter.[21] Rabanus Maurus considered that before the Incarnation, the city stood to the north, that is, in the cold or state of non-grace, and was the Synagogue.[22] With the coming of Christ, it turned to the south, the direction of warmth and Charity, and became the Church. All the commentators were fascinated by the possible meaning of the measurements given for Ezekiel's edifice in Scripture. In a late-fifteenth-century printed edition of Nicolaus de Lyra's commentaries on Ezekiel, someone even tried to convert these measurements into a pictorial reconstruction, with plans and elevations, which charmingly reproduces a medieval turreted and battlemented castle.[23] Indeed, I think fifteenth-century artists as well as medieval churchmen were more than casually interested in Ezekiel's temple because it was so methodically described, appealing to the Italian obsession for measurement in the quattrocento.

As Ezekiel goes on to describe, the visionary temple sat within an enclosing sanctuary, and the whole was entered by three principal gates on the east, north, and south. The east door was of special importance. Beginning with chapter 44, the Book of Ezekiel states: "Then he [the 'man'] brought me back the way of the gate of the outward sanctuary which

[19]Concerning the widespread usage of such imagery in patristic literature, see A. Salzer, *Die Sinnbilder und Beiwörter Mariens in der deutschen Literatur und lateinischen Hymnenpoesie des Mittelalters* (Linz, 1893); also E. Auerbach, "Dante's Prayer to the Virgin (*Paradiso*, xxxiii) and Earlier Eulogies," *Romance Philology* (iii, 1949), 1–27.

[20]*Summa*, iv, Tit. 15, cap. 10. col. 976: "Et hoc signatur Ezech. 43, ubi dicitur: 'Ecce gloria Dei ingrediebatur per portam orientalem' idest per B. Virginem . . ." Also *ibid.* cap. 3, col. 924; St. Antonine, referring to Mary as a city, the city of David or Syan *in figuram* where she lived during the nine months Jesus resided in her womb, writes: "Haec est civitas illa mirabilis figurata, quam vidit Ezechiel in ultima visione, in qua Dominus solus introibat et egrediebatur et porta ejus clausa remanebat."

[21]Jerome, *Commentariorum in Ezechielem prophetam*, Lib. xiii, cap. 43, as published in J.-P. Migne, *Patrologia Latina*, xxv (Paris, 1865), Part v–vi, cols. 437–38; hereafter cited as "Jerome."

[22]*Commentaria in Ezechielem*, Lib. xiv, as published in Migne, *ibid.*, cx, Part iv, col. 884.

[23]See Nicolaus de Lyra, *Postilla super Ezechielem* (Nuremberg, 1493), in the Harvard University Theological (Andover–Newton) Library, Cambridge, Mass. For a detailed modern construction, see G. Richter, *Der ezechielische Tempel* (Gütersloh, 1912). Concerning the influence of Ezekiel's vision on the Christian Fathers, see W. Neuss, *Die Entwicklung des Buches Ezechiel bis zur Zeit der Frühscholastik*, Dissertation, Münster i. W., 1911.

looketh toward the east and it was shut. Then sayeth the Lord unto me; this gate shall be shut, it shall not be opened, and no man shall enter in by it; because the Lord the God of Israel hath entered in by it, therefore it shall be shut." For St. Antonine, it was especially appropriate that this closed door be on the east, because that was the direction not only from whence the Holy Spirit came to Mary but also of the rising sun at dawn, when the Annunciation first occurred.

Of the several patristic commentaries on Ezekiel, perhaps the most important was that of St. Gregory the Great.[24] Rabanus Maurus followed it closely, and St. Antonine referred to it himself in several instances. St. Gregory observed, as had all the commentators, that the north and south portals to Ezekiel's edifice signified cold and warmth respectively, that is, the state of sin and the state of grace. Accordingly, he considered that the three doors together, the east, north, and south, represented Faith, Hope, and Charity. The meaning of Ezekiel's temple is therefore clear. The sinner who contemplates it from the north has Hope that through Faith in the Holy Spirit illuminating the Church from the east, he will receive Christ's ultimate Charity in the south.[25] Rabanus Maurus repeated this same analogy. St. Jerome and Nicolaus de Lyra both made much of the direction south and the virtue of Charity. St. Antonine related the direction east to Faith. While he did not directly allude to the rest of St. Gregory's analogy, he did have much more to say about the Virgin's special relationship to doors. Indeed, he observed further on : "Whence, figuratively speaking, there were two doors in the temple, which were both closed and opened, and these two doors of the temple of the Church are Christ and the Blessed Mary."[26] By his word order, St. Antonine seems to be implying here that the door of Mary is open, in contrast to the *porta clausa* of Christ. He also observed in this connection the well-known passage in John 10:9, in which Jesus says, "I am the door: by me if any man enter in, he shall be saved . . ." As we shall now see, St. Antonine's special concern for doors was also eagerly indulged in by painters of the Annunciation during the fifteenth century.

In early medieval times, the Annunciation was often shown in churches on the triumphal arch before the altar, with the angel on the left side and the Virgin Mary in the more honored position on the right. We see this even as late as the fourteenth century when Giotto painted the scene in the Arena Chapel, ca. 1306 (Fig. 1). The worshipper then must look *between* the two figures as he contemplates the Word made Flesh on the altar itself.[27] By the early fifteenth century, this "sacerdotal" disposition of the two principals had become obsolete. Along with increasing naturalism, artists favored a more humane treatment of the subject: the angel and Mary were brought closer together, and emphasis placed less on the mystery and more

[24]*Homiliarum in Ezechielem prophetam libri duo* as published in Migne, *Patrologia Latina*, LXXVII, Part II, col. 785ff., hereafter cited as "Gregory the Great."

[25]Gregory the Great, Lib. II, Homil. VII, col. 1021 : "Porta quippe ad Orientem est fides, quia per ipsam lux vera nascitur in mente. . . . Porta ad Aquilonem spes, quia unusquisque in peccatis positus, si de venia desperaverit, misericordiam funditus perdit. Unde necesse est ut qui per suam iniquitatem extinctus est, per spem misericordiae reviviscat. . . . Porta ad Meridiem charitas, quia ignes amoris ardet. . . ."

[26]*Summa*, IV, Tit. 15, cap. 20, col. 1061 : "Unde in figuram in templo erant duo ostia, quae simul claudebantur et aperie-

bantur; et istae duae portae in templo Ecclesiae sunt Christus et B. Maria."

[27]Concerning the iconography of the Annunciation, see D.M. Robb, "The Iconography of the Annunciation in the 14th and 15th Centuries," *Art Bulletin* (XVIII, 1936), 480–526; G. Prampolini, *L'Annunciazione nei pittori primitivi italiani* (Milan, 1939), and the article s.v. "Verkündigung" in W. Braunfels *et al.*, *Lexikon der christlichen Ikonographie* (Freiburg i. B., 1972), IV, 435–38. On the theme of the Annunciation in the Arena Chapel, see J. Stubblebine, ed., *Giotto: the Arena Chapel Frescoes* (New York, 1969).

on the intimacy of their conversation. We see this in an *Annunciation* painted by Fra Angelico about 1435, now in the Diocesan Museum in Cortona (Fig. 2). A column in the foreground between the two figures remains as the only vestige of the old hierarchical separation of Gabriel and Mary, but now the angel almost presses the Virgin out of the picture. Indeed, the message of this picture is not divine mystery but the compassion we feel for the sweet young girl overwhelmed by an angel's visit.

A few years later, Fra Angelico painted another version of the above *Annunciation* for the new convent of San Marco (Fig. 3), the prior of which was none other than St. Antonine himself. The angel and Mary in this fresco still retain their intimate relationship, but otherwise the composition has become more austere. The figures of Adam and Eve in the Cortona picture have been eliminated from the San Marco fresco, and the whole composition has been moved more to the center. Furthermore, the light in the fresco comes uniformly from the upper left. The San Marco painting is on the south wall of an upstairs corridor (just outside St. Antonine's own cell), which means that the left side of the picture is in the real easterly direction. In the Cortona painting, the light seems to be coming from several directions at once, although there can be little doubt that Fra Angelico, even at this time, related the left side of his picture, at least figuratively, with the direction east. This is apparent because he shows Paradise in this corner. Throughout the fifteenth century it was commonly held, by no less an authority than Christopher Columbus, that the Terrestrial Paradise was in the east, and it is frequently so shown in the popular "T-O" maps of the period.[28] In the Cortona work, the ceiling of the loggia over the head of the angel and Virgin is colored bright blue and flecked with little gold stars. Thus, we might suspect that at that time Fra Angelico thought the Annunciation occurred at night.[29] It would be interesting to speculate, therefore, that when he came to paint his fresco in San Marco, St. Antonine convinced him of the preferability that the event had happened in the morning. It should also be noticed that in both these paintings by Fra Angelico, there is an open door in the back wall beyond the Virgin. If Fra Angelico really intended the left side of his pictures to represent the east, then these doors must open to the south.

Let us now examine another *Annunciation*, done by Domenico Veneziano just a few years later, ca. 1445, for the center of his predella below the great St. Lucy Altarpiece. This little painting is now in the Fitzwilliam Museum in Cambridge, but once it and the rest of Domenico's masterpiece adorned the high altar of the church of Santa Lucia dei Magnoli in Florence. John Spencer cites this *Annunciation* as the earliest extant example of a revolutionary new "spatial imagery" for the subject, brought about by the advent of Albertian linear perspective;[30] it is illustrated here with an overlay showing the new perspective scheme (Fig. 4).

[28]On Columbus's belief that the Terrestrial Paradise was in the east, see S.E. Morison, *Admiral of the Ocean Sea* (Boston, 1942), II, 275–93. For further comments on the fifteenth century's fascination with, and mystical belief in, the east, see L. Olschki, "Ponce de León's Fountain of Youth: History of a Geographic Myth," *Hispanic American Historical Review* (XXI, 1941), 361–68, and F.M. Rogers, *The Quest for Eastern Christians: Travels and Rumor in the Age of Discovery* (Minneapolis, 1962).

[29]Similarly, Masolino painted such a blue ceiling with gold stars above and behind his *Annunciation* now in the National Gallery, Washington, D.C. This painting shows the Holy Spirit entering from almost overhead but slightly to the left, while the physical light itself illuminates from the right. Perhaps Masolino here was also thinking of an evening Annunciation and painted his light as if it entered from the west.

[30]J. Spencer, "Spatial Imagery of the Annunciation in Fifteenth-Century Florence," *Art Bulletin* (XXXVII 1955), 273–80.

In Fra Angelico's paintings, the two figures are grouped together in more or less intimate relationship. He also employed the new perspective rules to enhance the enclosing space of the Annunciation room. In Domenico's painting, however, the opposite is the case. Instead of using perspective to bring the two figures together into a more intimate unity, Domenico placed them far apart. He even deliberately focused the viewer's attention between the angel and Mary, by making our eye plunge deep through the fictive picture space to a closed door. This door stands at the end of a garden that lies altogether outside and beyond the Annunciation room. It would seem indeed that Domenico here had decided to abandon the humane intimacy of the type of Annunciation scene favored by his contemporaries and turned instead to the ancient and out-of-style format, with the hieratical angel and Mary posed on either side of a church altar. Not only did he focus the viewer's attention on the mystical *porta clausa* of Ezekiel's temple, but the orthogonal lines of his careful Albertian perspective also embrace the symbolic *hortus conclusus* or "enclosed garden" from the Old Testament Song of Songs 4:12, "A garden enclosed is my sister, my spouse . . . ," which was frequently cited by the patristic authors in reference to the Virgin's chastity. There is also a *hortus conclusus* in each of Fra Angelico's paintings, but not on axis with the vanishing point as in Domenico's picture; rather, the gardens are placed at the side and apparently extend beyond the pictures to the left. According to the Book of Ezekiel, the *porta clausa* should be on the east. I do not know if there is any written source or other reason for linking this "closed door" with the further end of the *hortus conclusus*.[31] Fra Angelico, however, remained consistently faithful to this concept. Indeed, he just might have imagined a mystical *porta clausa*, through which the Holy Spirit approached the Virgin from the east, located outside the picture at the end of the garden on the left.

Now it is an interesting fact that the general perspective arrangement of Domenico's *Annunciation*, with the angel and Mary spaced on either side of the converging orthogonals, had the widest influence in Italy during the rest of the fifteenth century, whereas Fra Angelico's more humane and sentimental arrangement did not. Indeed, Fra Angelico himself switched, toward the end of his life, to the Domenico formula in his *Annunciation* panel for the Santissima Annunziata silver-chest doors, now in the Museo San Marco.

Here we must digress briefly to consider the theory of linear perspective as understood in the mid-fifteenth century after the experiments and writings of Brunelleschi and Alberti.[32] This new science for painters was derived largely from the classical, Arab, and thirteenth-century-Christian science of optics, sometimes also called *perspectiva*. Traditional optics, however, was never concerned with perspective in pictures, only with explaining how the eye actually sees according to the laws of Euclidean geometry. What Brunelleschi and Alberti did, therefore, was to extend the old science and define for the first time the theory of what is

[31]See R.F. Littledale, *A Commentary on the Song of Songs from Ancient and Medieval Sources* (London, 1869), 179–83. See also E. Panofsky, *Early Netherlandish Painting* (Cambridge, Mass., 1958), 132 and *passim*. St. Antonine mentions that Mary is a *hortus conclusus* in his *Summa*, IV, Tit. 15, cap. 5, col. 939, and then follows with a passage in which he comments on the meaning of the *porta clausa* from the Vision of Ezekiel. The relation between these two images should have been obvious

enough to anyone in the fifteenth century, but I suspect that among the popular religious writings of the time there may exist some other text specifically relating the *porta clausa* to the eastern end of the *hortus conclusus*.

[32]Concerning Alberti's perspective theories, see S.Y. Edgerton, Jr., "Alberti's Perspective; a New Discovery and a New Evaluation," *Art Bulletin* (XLVIII, 1966), 367–78.

now called the vanishing point. This point, termed by Alberti the *punctus centricus* because he would always have it at or near the center of his picture surface, was the locus to which the artist should draw all his orthogonal lines, as in Domenico's *Annunciation*. The artist was to locate this centric vanishing point by staring straight ahead at the scene to be painted, so that a "visual ray" ran directly from the center of his eye, making a right angle with the exact center of the cornea's surface, and going in a straight line to become perpendicular with the frontal plane of the object seen. This *axis visualis*, as the Latin commentators called the centric ray, was then adapted by Brunelleschi and Alberti to determine the precise place where the phenomenon of apparent convergence of receding parallel lines occurs on the infinite horizon—that is, exactly level with the artist's own eyes as he views or imagines the scene to be painted before him. The *axis visualis*, which Alberti termed the "prince of rays," fixed the vanishing point on the horizon line of the imaginary space behind the picture surface, as long as all the objects depicted were in strictly frontal alignment with it. Alberti implied that the viewer, too, should position himself before the picture so that his eyes are at the same level as the vanishing point, in order to recapitulate the original perspective correctly and therefore benefit most clearly from the message of the artist's *istoria*.[33]

According to the old science, the *axis visualis* was also the single visual ray of the whole visual cone, which penetrated unrefracted to the optic nerve within the eye.[34] All the other rays came obliquely from the object seen and hence were refracted when entering the denser medium of the vitreous humor, which lay within the eye between the lens (then believed to be the image-forming membrane, somewhat as we understand the retina today) and the optic nerve. Such oblique and therefore refracted rays "cause dispersion and irregularity in form and resist unity," as Roger Bacon wrote in the optics section of his *Opus majus* in the thirteenth century : "But the straight line which falls at equal angles and perpendicularly either on planes or on spherical bodies is the one with which nature chooses to work both on account of its equality and greater uniformity, and on account of its shortness."[35] And Bacon added further : "But with greatest clarity will that be seen at which the axis of the visual cone [cone and pyramid were interchangeable words in medieval optics] terminates."[36] In Italy, Dante Alighieri applied the same principle in his *Convivio* in arguing what amounted to the reason that you can tell an honest man by looking him straight in the eye : "It should be known that, although more things than one can enter the eye at one time, that which comes in a straight line into the point of the pupil is truly seen by it, and alone is stamped on the imagination."[37] As we have seen, St. Antonine also applied this axiom in his own rationale of why the noon hour was a suitable time for the Passion.

[33]See Alberti's description of how to draw a perspective picture in Grayson, *On Painting and On Sculpture*, 55–57. A study of Alberti's optics by J.S. Ackerman will be found on pp. 1–27 of this volume.

[34]For a good example of the kind of optical theory with which medieval and Renaissance scholars—and many artists—were familiar, see D.C. Lindberg, *John Pecham and the Science of Optics ; Perspectiva communis* (Madison, Wisc., 1970).

[35]See the translation by R.B. Burke, *The Opus Majus of Roger Bacon* (Philadelphia, 1928), I, 139–40. The original Latin text is to be found in J.H. Bridges, ed., *The Opus Majus of*

Roger Bacon (London, 1897), I, 120.

[36]Burke, *ibid.*, II, 456–58 ; Bridges, *ibid.*, II, 37–38 : "Maxime vero et in fine certitudinis videbitur illud, ad quod terminatur axis pyramidis visualis."

[37]*Il Convivio*, II, 10. See E. Moore–P. Toynbee, eds., *Le opere di Dante Alighieri* (Oxford, 1924), 261–62 : "E qui si vuole sapere, che avvegnaché più cose nell' occhio a un'ora possano venire, veramente quella che viene per retta linea nella punta della pupilla, quella veramente si vede, e nella imaginativa si suggella solamente."

It should now be clear that Domenico Veneziano, by centering his *axis visualis* on the "closed door," meant that detail to be seen more distinctly and with more significance than any other. Indeed, he intended the true message of his *istoria* to reside at this one point. This picture had not to do, therefore, with a gentle Gothic lady's decorum in the face of a miraculous announcement, but rather with the much more theological and quite unsentimental Word itself; literally, "I am the door," the Coming of Christ. The linear perspective scheme of Domenico's painting seems then to have been a very self-conscious act of "spiritual geometry" in the best Antoninian sense. The "temporal" dimensions of length, breadth, height, and depth have been recapitulated in this *Annunciation* according to the geometric rules of linear perspective, not only to give an illusion of physical reality but also to provide symbolic measurement of God's infinity. Just as in the early Middle Ages it had been customary to show the two Annunciation figures on either side of an altar, with the altar—the Word made Flesh—between them, so Domenico wished to update this old interpretation by employing the new device of linear perspective.

While the logic of Domenico's geometrically organized picture did provide a perfect optical path between the intellect and the true message of the Annunciation miracle, the purely physical indications of time and place nevertheless remained confusing and inconsistent. As already noted, the St. Lucy Altarpiece originally occupied the high altar of the church of Santa Lucia dei Magnoli in Florence. This church still stands on its original site on the north side of the Via de'Bardi, and thus its altar is on the north side of the building, symbolically wrong but unavoidable because of the crowded lot-plans on this east-west artery in the medieval city. We may surmise that Domenico thought of his predella *Annunciation* as being at least in the symbolic east of the church, since it sat directly over the altar, even though its true physical direction was north. This circumstance might indeed have inspired him to make his "closed door" the optical center of his picture, especially since it corresponded with the tabernacle on the altar, which like Ezekiel's mystical door, encloses Christ. To confuse the situation further, even though the Holy Spirit seems to be approaching the Virgin from the left, while the closed door behind should lead to the east, the light in this picture comes in uniformly from the upper right. The fact is, however, that from the standpoint of where the St. Lucy Altarpiece once stood in the church, this upper right direction is true east! It would seem that Domenico schemed his whole painting to be "lit" by the eastern clerestory windows on the right of the church as one faces the altar.[38]

From earliest times through the Renaissance, as we have seen, the most common arrangement for representations of the Annunciation was to have the angel at the left and the Virgin right, with the Holy Spirit entering from upper left.[39] It was also commonplace even before St. Antonine to show the light coming in from the left as if synonymous with the Holy Spirit. Whether in direct response or merely by coincidence, this synonymity also paralleled the developing scientific attitude, reflected originally in the thirteenth-century

[38]Concerning the original disposition of Santa Lucia dei Magnoli in fifteenth-century Florence, see W. and E. Paatz, *Die Kirchen von Florenz* (Frankfurt a. M., 1955), II, 606–13.

[39]Concerning the interesting ways in which artists of the North, like Jan van Eyck, handled this problem, see Panofsky,

Early Netherlandish Painting, 145–48. See also D. Denny, "The Annunciation from the Right from Early Christian Times to the Sixteenth Century," Dissertation, New York University, 1964 (extract in *Marysas*, XII, 1964–1965, 71).

writings of Robert Grosseteste and Roger Bacon, which regarded the optical laws that
govern the radiation of natural light and the process by which God spread His grace through-
out the universe as also being synonymous.[40] This notion in fact was incorporated into the
so-called "species" theory of cause and effect that underlay much of the study of optics as
carried on in Italy during the fourteenth and fifteenth centuries. St. Antonine himself applied
the "species" theory throughout his *Summa theologica* and from this basis concluded that the
occurrence of the Annunciation at dawn and the scriptural reference in Ezekiel relating the
light of the Holy Spirit to the direction east was no mere coincidence.[41]

There can be no doubt that this kind of rationalist thinking with respect to the old
iconographic traditions began to attract artists in the fifteenth century in direct proportion
to the spread of knowledge of the old Quadrivium subjects through the expanded availability
of books. At the same time that St. Antonine was formulating these ideas on the Annunciation,
not only had Alberti devised a special science of linear perspective for painters, derived from
optics and geometry, but Lorenzo Ghiberti was avidly reading the texts of Alhazen, Witelo,
Bacon, and John Pecham on optics and inscribing long passages from these, including several
on the "species" theory, in his own memoirs or *Commentari*, written in the 1440s.[42] I would
suggest, therefore, that during these amazingly fecund years in Central Italy, someone
invented an ingenious compromise way of representing the Annunciation, embracing
equally the literal, tropological, and allegorical aspects, almost as St. Antonine described.
This compromise began with the austere perspectival composition of Domenico Veneziano's
example but was modified according to more physically consistent factors, to show a
convincing time and place, as exemplified in Fra Angelico's San Marco fresco. There is
evidence that the prototype of this compromise may have been engendered in Siena, because
the earliest extant example showing at least some of its more salient features is Vecchietta's
Spedaletto *Annunciation* of ca. 1460, now in the Pienza Cathedral, and there is another slightly
later Sienese example by Neroccio de' Landi in the Yale University Art Gallery in New
Haven. We may note also that Piero della Francesca used this compromise type of the
Annunciation for his altarpiece in Perugia.

There exists, however, a painting that I would consider the perfect paradigm of all the
attitudes expressed so far about the Annunciation. This is the *Annunciation* (Fig. 5), now in
the Isabella Stewart Gardner Museum in Boston and usually attributed to the late-fifteenth-
century minor Roman master Antoniazzo Romano. The picture is dated about 1485 and may
therefore have itself derived from any of the earlier examples just mentioned, particularly
from that by Piero, for it can actually be traced at some point in its early provenance to Assisi,
only a few kilometers from Perugia.[43] No matter ; the Gardner painting is a great masterpiece

[40]See Lindberg, *John Pecham and the Science of Optics*, 19, and also my review of this book in *Art Bulletin* (LIV, 1972), 349–50.

[41]Unquestionably, the "species" theories of Grosseteste and Bacon were very influential in Italy during the fourteenth and fifteenth centuries, propagated, I think, through the great popularity of their fellow Englishman John Pecham's handy little treatise on *Perspectiva communis*. This theory is easily traced in such Italian texts on optics as Blasius of Parma's *Quaestiones perspectivae*, written ca. 1395, and the anonymous *Della prospettiva* of the early fifteenth century.

[42]Concerning the texts on optics that Ghiberti used in his third *Commentary*, see G. Ten Doesschate, *De derde Commentaar van Lorenzo Ghiberti in Verband met de middeleeuwsche Optiek* (Utrecht, 1940), 7.

[43]For the provenance of the Gardner *Annunciation*, see Sir Philip Hendy, *The Isabella Stewart Gardner Museum Catalogue of the Exhibited Paintings and Drawings* (Boston, 1931), 14–19. This catalogue is now under revision by Sir Philip but with no extensive change contemplated in the comments on this picture. He still ascribes it to Antoniazzo and notes its early location in the *Porziuncula*, the chapel of St. Francis inside the church of Santa Maria degli Angeli in Assisi.

in its own right. Whoever the artist (I agree with Zeri that he shows more leanings to the Ghirlandaii and the Verrocchio workshop in Florence than does the provincial Antoniazzo), this *Annunciation* contains more specific knowledge about the Annunciation proper, that is, in the way St. Antonine had conceived it as having actually happened, than any other in this compositional format that I know. It also combines these details in one of the most pleasing Alberti-type perspective arrangements in the whole of the fifteenth century. Indeed, if Antoniazzo Romano is the author of this picture, then he should be recognized not only as a much greater artist but also as a ranking intellectual, a man capable of embracing simultaneously the theories of painting as proposed by Leon Battista Alberti and the theological knowledge of the Annunciation as possessed by St. Antonine, with all its scientific rationalizations.

In the Gardner painting, the angel and Mary are canonically arranged in the foreground, left and right respectively, with the light coming in from the upper left, uniformly illuminating all parts of the scene. This light is identified with the path of the Holy Spirit descending toward Mary in the form of a dove. The perspective of the conspicuous squared floor proceeds in good Albertian fashion to a centric vanishing point in the middle of an *open* doorway at the back, which, as we shall see, contains the arcane message of this picture. The idea of an open doorway, substituting for the *porta clausa*, in the background of Annunciation paintings based on the Domenico Veneziano perspectival formula became very common in Italian painting both before and after the Gardner painting. The reason for this substitution, I believe, was simply to retain directional consistency. Just before the background wall and to the left of the open doorway, there is to be seen what looks like a small cloister garden, enclosed by a low retaining wall but with a narrow walkway leading all around. This garden leads off to the left, which might indicate that the painter here was still interested in the *hortus conclusus* symbol, only he subtly turned it sideways, in the manner of Fra Angelico, so that its further end—the "closed door" end, as in Domenico's picture— would correspond to the east. Hence, in the Gardner *Annunciation*, as in others of this type, the open door at the back of the picture was intended to look out upon the south.[44]

There are other superficial references in the Gardner *Annunciation*, and one distinct but hidden clue, that show the artist intended this event to be taking place in the mystical temple of Ezekiel. In the prophet's original vision as described in scripture, there are several mentions of the word *pavimentum*, the same term Alberti used in his treatise on painting to describe his squared floor in perspective. Also, the visionary edifice is explained by the prophet as having both an outer wall and an inner sanctuary, just as the handsome palacelike structure in the Gardner picture shows. The open doorway at the back (Fig. 6) is framed within this outer wall, and (although it may not be clear in the black-and-white reproduction), blue sky continues above and behind this wall and door, marking a clear separation from the inner building.

[44]While the relationship of the Virgin to an open door had wide currency in the hymns, sermons, and commentaries of the Middle Ages and Renaissance, it is worth noting that St. Antonine specifically made such a reference, as well; his *Summa theologica*, in fact, includes a long paragraph on the implications of the Virgin as *porta coeli*, as one of her nine privileges (IV, Tit. 15, cap. 20, cols. 1061–62). The everpopular Jacopo da Voragine in his *Golden Legend* also referred to the Virgin as the "gatekeeper of the Lord" (*portenaria Dei*).

The most convincing clue that this building was intended by the artist to be the mystical temple can be found only by careful scrutiny, since the picture is much abraded. In the open doorway, at the very bottom, just above the threshold, is seen what at first looks to be a path turning slightly to the left and then winding down the hill to join a network of roads and rivers curling back into the infinite distance. This "path" was originally painted light blue, flecks of which are still visible over the exposed brownish gesso ground. I think there can be no doubt that originally it was not a path at all, but a little stream of water issuing out from under the threshold of the door, flowing down the hill, and eventually joining the expanding torrential rivers in the distance. If such is the case here, as it is in other Annunciation scenes,[45] then the reference to Ezekiel's vision could not be more precise. A passage from Ezekiel 4:71–9 reads : "Afterward he brought me again unto the door of the house ; and behold, waters issued out from under the threshold of the house eastward : for the forefront of the house stood toward the east, and the waters came down from under from the right side of the house, at the south side of the altar." The prophet goes on to relate how the "man" took him around through the north gate to the eastern side once again to behold these waters running off from the right as they themselves faced east. Going off to the east, the "man" measured a thousand cubits, during which time the waters were only up to their ankles. After another thousand cubits, it was up to their knees, and so on until "they could not pass over" : "And he [the 'man'] said unto me, Son of Man, hast thou seen this? Then he brought me, and caused me to return to the brink of the river. Now, when I had returned, behold, at the bank of the river were very many trees on the one side and the other. Then he said unto me, these waters issue out toward the east country, and go down into the desert, and go into the sea : which being brought forth into the sea, the waters shall be healed."

While the little stream of water issuing from under the threshold in the Gardner painting clearly relates the depicted edifice behind the Angel and Mary to Ezekiel's visionary temple, the meaning becomes even more complex. In the convoluted symbolism of the Church, propagated by centuries of typological research, such vivid images as Ezekiel's temple had accumulated many layers of meaning dear to the imaginative minds of the patristic authors and to those artists as knowledgeable as the painter of the Gardner *Annunciation*. First of all, there is a clear reference here to the Virgin's name. In the Middle Ages and the Renaissance, there was a well-known word play between *Maria* and the Latin and Italian word for "sea," *mare*. Furthermore, this pun extended also to the word *amara*, which in both languages means "bitter." Hence, the name *Maria* was described by the Fathers as meaning "bitter sea," an obvious reference to the destined Passion of her only Son. St. Jerome originally made the connection between the meaning of Mary's name and the waters flowing from under the threshold of Ezekiel's temple, and St. Antonine described the same derivation of "Maria" in his *Summa*.[46] The Italian sermons of St. Bernardino of Siena also attest to the fact that this

[45]In Fra Lippo Lippi's frescoed *Annunciation* in the Duomo at Spoleto, ca. 1468, for instance, there is an unmistakable stream of water painted as running from under a doorway at the back of the picture. Similarly, water seems to be issuing from under the battlemented portal outside the open door in the back of Il Borgognone's late-fifteenth-century *Annunciation* fresco in the Church of the Incoronata in Lodi. There may

well be many more such examples still unnoticed, because this detail has been taken for granted as a path, an oversight encouraged by our dependence on black-and-white photographs.

[46]Jerome, Lib. xiv, cap. 47, cols. 489–90 ; *Summa*, iv, Tit. 15, cap. 13, cols. 1001–02.

pun on Mary's name was widely understood in the Early Renaissance.[47] In the Gardner painting and many others like it in the late fifteenth century, such an open door at the back of the picture space represents the Virgin's door, similarly opening onto a river leading to the sea, in a warm and balmy summer landscape.

St. Antonine also pointed out a strong tie between the events of the Annunciation and the Passion, which he demonstrated in his application of certain laws of optics and astronomy. This same association was made by the painter of the Gardner *Annunciation*. In the open doorway (Fig. 6) stand two trees—one just to the left, which is shattered and dying, the other to the right, exactly in the center, and by contrast very much alive and blooming. In fact, the single vanishing point for the architectural structure of the whole picture falls precisely on the trunk of this tree.[48] The allusion here is obviously to the popular medieval image of the *Lignum vitae* or Tree of Life. Below follows a description of the Tree of Life by St. Bonaventure, one of the most widely quoted of all the Church Fathers in the fourteenth and fifteenth centuries (St. Bonaventure had been the general of the Franciscan order in Assisi during the late thirteenth century and may actually have been the source of this motif): "Imagination assists understanding . . . picture in your mind a tree. Suppose its roots be watered by an eternally gushing fountain that becomes a great and living river which spreads out in four channels to irrigate the whole garden of the Church. . . This is the fruit born of the virginal womb, and ripened on the tree of the cross to delectable maturity by the midday heat of the Eternal Sun, that is by Christ's love. . ."[49] St. Bonaventure here refers to the "midday heat of the Eternal Sun" (*per aeternis Solis calorem meridianum*). One should note that in both Latin and Italian, the words for "midday" and "south" are the same: *meridies* and *meridiano*. We remember also that the patristic authors continually drew parallels between the direction south and the meaning of Charity through Christ's Passion which began at the hour of noon. The artist's inclusion here of St. Bonaventura's Tree of Life was particularly apt because, as best evidence suggests, the Gardner *Annunciation* once hung in the Porziuncola, the revered little shrine of the Franciscan order now enclosed in the Baroque church of Santa Maria degli Angeli at Assisi.[50] From this very place St. Bonaventure, just two hundred years before, had proclaimed the Angelus as a regular Christian devotion; from here, also, he had instituted the version of the "Ave, Maria" prayer still recited today.[51]

Infinite riches in a little room! The small, innocuous-looking landscape enframed within the austere doorway at the perspective locus of the Gardner painting thus contains the kernel of truth for the entire picture. Certainly the artist understood the medieval optical theory of

[47]See L. Banchi, ed., *Le prediche volgari di San Bernardino da Siena* (Siena, 1884), II, particularly Predica 29, "Della Annunziazione della Virgine gloriosa Maria," 388ff.

[48]It would be interesting to speculate that the artist here was making allusion to another popular pun much beloved by the patristic writers. This was to the similarity between *Virgo* and the word *virga*, which means "stem" or "trunk," with its obvious reference to the Tree of Jesse, Aaron's staff, Moses's rod, and numerous other Marian symbols. As usual, St. Antonine mentioned this word similarity also and discussed the various significances (see *Summa*, IV, Tit. 15, cap. 24, col. 1103). In this respect, one might note also that the angel in the Gardner *Annunciation* holds a lily on a long stalk. The lily is a

reference, which many fifteenth-century painters included, to the fact that the name of the city of Nazareth, translated from Hebrew into Latin, means *flos*, or "flower." St. Antonine observed this symbol (*Summa*, IV, Tit. 15, cap. 9, col. 971) and explained its appropriateness with regard to Christ's birth.

[49]This passage has been translated by J. de Vinck, *The Works of Bonaventura* (Paterson, N.J., 1960), I, 97–100. The passage is excerpted from St. Bonaventure's *Lignum vitae*. The original Latin is given in *Sancti Bonaventurae Opera omnia* (Quaracchi, 1882–1902), VIII, 86.

[50]Hendy, *The Isabella Stewart Gardner Museum*.

[51]J. Hofer, *Johannes Kapistran*, rev. ed. (Heidelberg, 1963), II, 18, n. 54.

the *axis visualis*, which linked the viewer's eyepoint most directly and clearly to the center of significance in the visual field. Was he also aware of the mystical significance of the three doors in Ezekiel's temple as interpreted by St. Gregory the Great?

Unfortunately, our modern attempts at aesthetic appreciation of Renaissance pictures tend to regard linear perspective as merely academic and antithetical to true artistic expression. We overlook the fact that Alberti's theories were not applied, particularly in this case, merely to produce a secular landscape. On the contrary, the artist here applied perspective rules for the most profound of religious reasons—to reveal the tropological, allegorical, and mystical, as well as the literal message of the Annunciation. Would he not have heard continually, in sermon after sermon, Sunday after Sunday, exhortations to just this effect from any number of pulpits throughout Italy? St. Antonine's own views on the Annunciation are but summations of his sermons. To understand the Gardner painting, therefore, we must put ourselves back into a medieval age that could still "see" reality in terms of spiritual geometry. We must also appreciate the significance, in those times, of the Christian Feast of the Annunciation on March 25, falling as it usually does in Lent, a few days or weeks before Easter. Particularly in Central Italy at this time, the date was regarded as the psychological if not the actual beginning of the new year (somewhat, I suppose, as Labor Day is for most present-day Americans). Thus in the old scholastic, casuistic sense of what "reality" meant in the fifteenth century, the observer might imagine himself standing before this painted representation of the Annunciation in his own sinful "north." With his "winter" behind, he should concentrate his "prince of rays" on the open door at the rear of the picture, with Hope that through Faith in the Light of the Holy Spirit and the mystery of the Incarnation he might face a new "summer" with confidence and gain at last the ultimate gift of Christ on the Cross, the greatest of all Christian virtues—Love.

BOSTON UNIVERSITY

Bemerkungen zu Raffaels *Madonna di Foligno*

HERBERT VON EINEM

I

Die Konzeption der *Madonna di Foligno* (Abb. 1)[1] ist nicht unabhängig von dem Ort ihrer Bestimmung zu denken: Santa Maria in Aracoeli, einer der ehrwürdigsten Kirchen Roms, "ecclesia Sanctae Mariae in Capitolio, ubi est ara filii Dei."[2] Auch in der klassischen Kunst der Hochrenaissance spielen Auftrag und Bestimmung noch eine entscheidende Rolle. Was also ist—so müssen wir fragen—das eigentliche Thema des Bildes? Wie sind Maria mit dem Christuskind als Himmelserscheinung, "circondata da un cerchio di sole,"[3] wie die Auswahl der Heiligen, der Stifter, gleichrangig mit den Heiligen, der Engelknabe mit der leeren Inschrifttafel, die Landschaft mit Regenbogen und Kugelblitz zu deuten? Wer ist der Stifter, und was ist der Anlass der Stiftung? Ohne den Versuch einer Klärung dieser Fragen ist die Leistung des Künstlers in der Bewältigung der ihm gestellten Aufgabe nur unvollkommen zu würdigen.

II

Leider geben die historischen Quellen über die Bestimmung des Bildes keine genügende Auskunft. Ist das Bild wirklich—wie es die Raffaelliteratur fast einhellig versichert[4]—das Hochaltarbild der Kirche, oder gehört es etwa zum Grabmal des im Chor von Aracoeli begrabenen Stifters?

Die älteste heute noch nachweisbare Nachricht über das Bild steht im Codice Magliabecchiano, einer Handschrift der Mitte des 16. Jahrhunderts in der florentiner Nationalbibliothek und zwar in dem "Ricordo di alcuni più famosi monumenti d'arte in Roma, scritto negli anni 1544–1546."[5] Dort heisst es: "In Santa Maria Araceli v'è la tavola dell'altare maggiore di Raffaello d'Urbino, cosa bella et molto ben fatta." Zwar wird das Thema des Bildes nicht genannt, aber da Vasari bei der Erwähnung der gleichen Tafel eine genaue Beschreibung gibt, kann es kaum zweifelhaft sein, dass die *Madonna di Foligno* gemeint ist.[6] Wichtig ist die Bezeichnung "tavola dell'altare maggiore." Ein Stifter wird nicht genannt.

[1] L. Dussler, *Raffael. Kritisches Verzeichnis der Gemälde, Wandbilder und Teppiche* (München, 1966), Nr. 117; *idem, Raphael, A Critical Catalogue of His Pictures, Wall-Paintings and Tapestries* (London–New York, 1971), 31, Pl. 82.

[2] W. Buchowiecki, *Handbuch der Kirchen Roms*, II (Wien, 1970), 481.

[3] G. Vasari, "Pietro Cavallini," in *Le vite de' più eccellenti pittori, scultori ed architettori*, Ausg. G. Milanesi (Florenz, 1878), 539.

[4] Dussler, *Raffael*, 65; dazu von Einem, Rezension, *Kunstchronik* (XXI, 1968), 24f. Schon A. Schmarsow, *Melozzo da Forlì* (Berlin, 1886), 161 spricht von der Grabkapelle des Sigismondo de'Conti in Aracoeli. Dusslers Ablehnung der Epitaphhypothese von H. Grimme, "Das Rätsel der Sixtinischen Madonna," *Zeitschrift für Bildende Kunst* (LVII, 1922), 48, mit der Begründung, die Person Contis könne dann nicht als Stifterporträt zu verstehen sein, ist unverständlich, da auf Grabbildern häufig Stifter dargestellt werden.

[5] *Il Codice Magliabecchiano*, hrsg. von C. Frey (Berlin, 1892), 128. Diese Schriftquelle ist von V. Golzio, *Raffaello nei documenti, nelle testimonianze e nella letteratura del suo secolo* (Vatikan, 1936), nicht genannt worden.

[6] Allenfalls könnte an die Kopie der *Madonna della Gatta* gedacht werden, die für ein Werk Raffaels gehalten wurde. Vgl. dazu Anm. 16, *infra*.

Es folgen die Äusserungen Vasaris von 1550 und 1568,[7] sicherlich, wie die ausführliche Beschreibung lehrt, aus eigener Anschauung des Bildes, das Vasari bei seinen Romaufenthalten, zuletzt 1546 und 1547,[8] oft gesehen haben wird. Nur wenigen Tafelbildern Raffaels hat Vasari eine so eingehende Würdigung gewidmet.[9] Er spricht ebenfalls von "tavola dell'altar maggiore" und erwähnt nunmehr auch den Stifter, ohne aber seinen Namen zu kennen: "stimolato da' prieghi d'un cameriere di papa Giulio," wobei er, wie wir gleich sehen werden, fälschlich "cameriere" statt "segretario" sagt.[10] Von einem Grab des Stifters in der Kirche weiss er nichts.

1565 ist die *Madonna di Foligno* aus Santa Maria in Aracoeli entfernt und in die Kirche der Sant'Anna des Nonnenklosters "delle Contesse" nach Foligno überführt worden. Bei dieser Gelegenheit wurde auf dem Rahmen eine Inschrift in goldenen Buchstaben angebracht, aus der der Name des Stifters und das Datum der Überführung hervorgeht: "Questa tavola la fece dipingere Missere Gismondo Conti Secretario primo di Giulio secondo e dipinta per mano di Raphaele de Urbino e Sora Anna Conti Nepote del ditto Missere Gismondo le facta postare da Roma et facta mettere a questo altare nel 1565 à di 23 de Maggio."[11] Von der ursprünglichen Bestimmung des Bildes dagegen verlautet hier nichts.

Sigismondo de' Conti, aus Foligno gebürtig, Verfasser einer neunbändigen Geschichte seiner Zeit,[12] päpstlicher "Segretario" und "Abbreviatore del sacro palazzo apostolico" war mit Papst Julius II. eng befreundet. Er starb am 23.Februar 1512 in Rom und wurde im Chor von Santa Maria in Aracoeli beigesetzt.[13]

Die Überführung des Bildes von Rom nach Foligno wäre kaum möglich gewesen, wenn es nicht noch im Besitz der Familie gewesen wäre. Allein diese Überlegung legt uns nahe, trotz der übereinstimmenden Bezeichnung als "tavola dell'altar maggiore" bei dem Anonymus Magliabecchianus und bei Vasari der Frage der ursprünglichen Bestimmung weiter nachzugehen. Gibt es noch andere Nachrichten, die uns in dieser Frage helfen können?

In seiner *Istoria della famiglia Trinci* (Foligno, 1648) sagt Dorio, dass Sigismondo de'Conti die "devota tavola" seiner Nichte Anna geschenkt habe.[14] Durch diese Angabe erklärt sich der Verfasser der Familiengeschichte der Conti das Verfügungsrecht der Nichte über das Bild. Von der Aufstellung in Aracoeli sagt er nichts. Auch Pater Casimiro Romano, dem wir eine ausführliche Geschichte von Santa Maria in Aracoeli (1736; vgl. Anm. 10) verdanken, weiss über die Aufstellung von Raffaels Tafel keine genauen Angaben zu machen. In Kap. 12 seines Buches, das über den Chor handelt, spricht er von einem "altare di noce" (Altar aus Nussholz) hinter dem Hochaltar, der ein Jahrhundert vor der Erneuerung des Chores

[7]Vasari-Milanesi, IV, 341. Der Text der Ausgabe von 1550 bei H. Grimm, *Das Leben Raphaels* (Berlin, 1886), 137f.

[8]Über Vasaris Romaufenthalte vgl. W. Kallab, *Vasaristudien* (Wien–Leipzig, 1908), 65ff.

[9]Vgl. A. Springer, *Raffael und Michelangelo*, I (Leipzig, 1883), 284.

[10]Vgl. C. Romano, *Memorie istoriche della Chiesa e Convento di S. Maria in Araceli* (Rom, 1736), 142.

[11]Mitgeteilt von C. Romano, *ibid.*, 142. Vgl. auch I.D. Passavant, *Rafael von Urbino*, II. Teil (Leipzig, 1839), 135, und D. Redig de Campos, "La Madonna di Foligno di

Raffaello," *Miscellanea Bibliothecae Hertzianae* (München, 1961), 186. Die Inschrift fehlt bei Golzio, *Raffaello nei documenti*.

[12]*Le storie de' suoi tempi dal 1475 al 1510*, II (Rom, 1883). Zu Sigismondo vgl. Passavant, *Rafael von Urbino*, I, 177 und die bei Redig de Campos, "La Madonna di Foligno," angegebene Literatur.

[13]Zum Todesdatum vgl. Redig de Campos, *ibid.*, 186, gegen Romano, *Memorie istoriche*, der S. 144 das Datum des 18 Februar annimmt. Dussler, *Raffael*, sagt wieder: 18 Februar.

[14]Vgl. Redig de Campos, *ibid.*, 186, Anm. 6.

errichtet worden sei.[15] Auf diesem Altar sehe man eine Tafel, "in cui il gran Raffaello dipinse il divino Bambino, la santissima Vergine, S. Giovanni Battista e S. Elisabetta." Er sagt dann aber ausdrücklich, diese Tafel sei nicht mit der von Raffael für Sigismondo de'Conti gemalten identisch. Wann diese "per alcun tempo" in Aracoeli aufgestellt, und wann sie mit jener anderen ausgetauscht worden sei, habe er nicht in Erfahrung bringen können. Bei der von Casimiro Romano genannten Tafel handelt es sich freilich gar nicht um ein Werk Raffaels, sondern um eine Kopie der *Madonna della Gatta* des Giulio Romano,[16] die sich heute in der Sakristei von Aracoeli befindet.[17] Passavant hat sie noch "auf der Hinterseite des Hauptaltares von Aracoeli," d.h. wohl auf dem "altare di noce" gesehen.[18] Dass gerade Casimiro Romano aus den ihm verfügbaren Quellen nichts Sicheres über die Aufstellung der *Madonna di Foligno* hat feststellen können, ist auffällig. Offensichtlich fehlen genauere Unterlagen.

Lassen sich nun vielleicht aus der Grabstätte des Stifters oder der Geschichte des Hochaltares Schlüsse ziehen?

Über den Grabstein von 1512 wissen wir nichts.[19] Er muss, wie aus der von Casimiro Romano mitgeteilten,[20] heute kaum mehr lesbaren Inschrift hervorgeht, 1547 von den "piissime sorores," d.h. von den Nonnen von Sant'Anna in Foligno erneuert worden sein, als in dem gleichen Grab Sigismondos Neffe Lodovico beigesetzt worden ist. Der Grabstein von 1547 ist erhalten, aber, wie ebenfalls aus der Inschrift hervorgeht, 1565 von den Nonnen restauriert worden. Noch ein anderes Datum erfahren wir aus der Inschrift.[21] Am 13.April 1565 haben die Nonnen das Paviment des alten Chores von Aracoeli erneuert. Spätestens damals muss Raffaels Tafel nach Foligno überführt worden sein, denn am 23. Mai des gleichen Jahres hat sie ihre neue Aufstellung in Sant'Anna gefunden. Erneuerung des Grabsteines und des Pavimentes und Überführung der Tafel nach Foligno scheinen also in Zusammenhang zu stehen. Sollte die Familie Conti an dem alten Chor von Aracoeli die Rechte einer Grabkapelle gehabt und Raffaels Tafel als Eigentum der Familie zur Grablege Sigismondos gehört haben? Sollte sie—wie Casimiro Romano behauptet—später durch die Kopie der *Madonna della Gatta* ersetzt worden, also ihr ursprünglicher Platz auf der "Hinterseite des Hauptaltares" (wie es bei Passavant heisst) gewesen sein?

Für den Hochaltar hat Papst Julius III. kurz nach der Mitte des 16.Jhdts.—jedenfalls vor 1554—ein "tabernacolo ricco, bello e artificioso" zur Aufbewahrung der Eucharistie gestiftet.[22] Unter Papst Pius IV. wurde der alte halbrund geschlossene Chor abgetragen und der heutige rechteckige Mönchschor errichtet.[23] Auch der Hochaltar ist damals erneuert worden.[24] Auf ihm fand 1564 (zwei Jahr vor der Überführung der *Madonna di Foligno* nach Sant'Anna) die hochverehrte sog. *Lukasmadonna*, vermutlich ein italienisches Werk des

[15]Romano, *Memorie istoriche*, 141. Zu diesem Altar vgl. Passavant, *Rafael von Urbino*, II, 308, und Buchowiecki, *Handbuch*, 508.

[16]Vgl. Redig de Campos, "La Madonna di Foligno," 186, und F. Hartt, *Giulio Romano* (New Haven, 1958), I, Kap. 6; II, fig. 91.

[17]Vgl. Buchowiecki, *Handbuch*, 517.

[18]Vgl. *Rafael von Urbino*, II, 308.

[19]Vgl. Redig de Campos, "La Madonna di Foligno," 188, Anm. 6.

[20]*Memorie istoriche*, 143.

[21]Vgl. Redig de Campos, "La Madonna di Foligno," 188, Anm. 6.

[22]Vgl. Romano, *Memorie istoriche*, 28.

[23]Der halbkreisförmige Abschluss des alten Chores ist im Paviment noch erkennbar. Vgl. P. Cellini, "Di Fra' Guglielmo e di Arnolfo," *Bollettino d'Arte* (XL, 1955), fig. 25. Zur Baugeschichte von Santa Maria in Aracoeli vgl. die noch ungedruckte (mir nicht zugängliche) Dissertation, New York University, 1973, von R. E. Malstrom, "S. Maria in Aracoeli."

[24]Romano, *Memorie istoriche*, 32.

Mittelalters, die vorher auf dem "altare della gran Madre di Dio" im Langhaus gestanden hatte, ihren Platz, "ubi decentius videretur," wie es in einem Motu proprio Gregors XIII. heisst.[25] Es ist also nicht unwahrscheinlich, dass die Überführung der noch im Besitz der Familie Conti befindlichen *Madonna di Foligno* nach Sant'Anna durch die Erneuerungsarbeiten im Chor von Aracoeli veranlasst worden ist. Jedenfalls hat man nicht daran gedacht, sie auf dem neuen Hochaltar von 1563 aufzustellen. Vasaris Nachricht von 1568 entspricht also nicht (oder nicht mehr) den Tatsachen.

Auch das Bild selbst gibt uns Hinweise, die eher auf eine "devota tavola," wie es bei Dorio heisst, oder ein Epitaphbild als auf ein Hochaltarbild schliessen lassen. Der Stifter Sigismondo de' Conti ist nicht, wie es bei Stifterbildnissen üblich ist, in gebührender Distanz zu der sakralen Darstellung, sondern—für ein Hochaltarbild ganz ungewöhnlich[26]—durch das Gegenüber des ebenfalls knienden Hl. Franz mit den Heiligen auf gleicher Rangstufe gegeben worden. Bei einer Bestimmung des Bildes als Hochaltartafel würde man erwarten, dass Johannes der Täufer und Franziscus, die Hauptheiligen der Kirche, einander gleich-gewichtig gegenübergestellt, der Stifter dagegen und Hieronymus, der mit Aracoeli nicht eigentlich etwas zu tun hat, von ihnen distanziert worden wären.

Dazu kommt noch etwas anderes. Im Hintergrund des Bildes ist eine kleine Stadt zu sehen, über deren Häusern ein Regenbogen aufleuchtet und ein Kugelblitz auf das erste Haus zur Rechten zufliegt, ohne es aber zu treffen. Wie diese Darstellung zu deuten sein mag, es muss als sicher angenommen werden, dass hier ein persönlicher Bezug zum Stifter vorliegt. Ein *Ex voto* eines noch so angesehenen päpstlichen Würdenträgers kann aber kaum von vorn-herein als Hochaltarbild einer der vornehmsten römischen Kirchen gedacht werden. Warum die Inschrifttafel des Engelknaben leer geblieben ist (wie die letzte Restaurierung eindeutig hat nachweisen können),[27] scheint freilich nach wie vor ein Rätsel zu sein. Heinrich Wölfflins monumentale Erklärung: "Das ist der Idealismus der grossen Kunst"[28] ist jeden-falls nicht genügend.

Will man also an den Aussagen des Codice Magliabecchiano und Vasaris von 1550 festhalten (die Aussage von 1568 hat sich als falsch erwiesen), so könnte nur erwogen werden, dass die Tafel, obwohl ursprünglich für das Grabmal bestimmt, eine Zeit lang (aus welchen Gründen auch immer) auf dem Hochaltar aufgestellt worden war, oder (wofür vielleicht die leer gebliebene Inschrifttafel sprechen könnte), dass ein Bestimmungswechsel stattgefunden hat, der dann aber durch die Erneuerungsarbeiten im Chor von Aracoeli wieder aufgehoben worden ist.

[25]*Ibid.*, 30. Das Marienbild abgebildet bei F.Z. Zimmermann, *Die Kirchen Roms* (München, 1935), Abb. 83.

[26]Das Altarfresko der Sixtinischen Kapelle von Perugino zeigt Papst Sixtus IV. als Stifter; vgl. Handzeichnung in der Albertina, Wien (W. Bombe, *Pietro Perugino*. Klassiker der Kunst, xxv, Leipzig–Berlin, 1914, Taf. 18). Selbst hier aber ist der Abstand zwischen dem knienden Stifter und dem stehenden Heiligen deutlich. Sixtus IV. hat ferner als Papst und Stifter der Kapelle einen höheren Rang als Sigismondo de' Conti.

[27]Redig de Campos, "La Madonna di Foligno," 188. Grimme, "Das Rätsel der Sixtinischen Madonna," 48, sieht Sigismondo de' Conti in Raffaels Bild als Verstorbenen und glaubt, dass die Inschrift sich ursprünglich auf seinen Tod bezogen habe, dann aber, nachdem das Bild Altartafel geworden sei, ausgelöscht wurde. Diese These ist von Dussler, *Raffael*, mit Recht zurückgewiesen worden.

[28]*Die klassische Kunst* (München, 1924), 140.

III

Kann die Frage der ursprünglichen Bestimmung (Hochaltarbild nach dem Zeugnis des Anonymus Magliabecchianus und Vasaris oder *Ex voto* in Verbindung mit dem Grab des Stifters) nur hypothetisch erörtert werden, so ist an der engen Beziehung der Bildkonzeption zur Kirche und insbesondere zum alten Chor von Aracoeli ein Zweifel nicht möglich.

Die Auswahl der Heiligen weist eindeutig auf Aracoeli hin. In einem Dokument Papst Anaklets II. aus dem 12. Jahrhundert ist von dem "monasterio Sanctae Dei genitricis et Virginis Mariae Sanctique Johannis Baptistae in Capitolio" die Rede[29]—hier wird also der Name des Täufers neben dem der Madonna genannt. 1250 sind Kirche und Kloster, die zunächst den Benediktinern gehört hatten, durch Papst Innocenz IV. den Franziskanern übergeben worden—seitdem war der Hl. Franz Patron.[30] Der Hl. Hieronymus galt, wie wir von Sigismondo de' Conti selbst erfahren, als erster Segretario apostolico—Sigismondo hat sich hier also unter dem Schutz gleichsam seines grossen Amtsvorgängers darstellen lassen.

Vor allem weist die Himmelserscheinung der Mutter Gottes mit dem Christuskind vor der goldenen Sonnenscheibe auf das "Signum ex caelo" von Santa Maria in Aracoeli hin.[31] In der Legende, nach der die Gottes Mutter dem Kaiser Augustus am Tage der Geburt des Herrn am Himmel erschien (der Gründungslegende der Kirche) heisst es nach dem Wortlaut der *Legenda aurea*: "Da erschien um Mittentag ein gülden Kreis um die Sonne und mitten in dem Kreis die allerschönste Jungfrau, die stand über einem Altar und hielt ein Kind auf ihrem Schoss."[32] Hier ist also ausdrücklich von dem goldenen Kreis die Rede. Noch 1452 schreibt Nikolaus Muffel, den seine Vaterstadt Nürnberg als Begleiter der Reichskleinodien zur Krönung Kaiser Friedrichs III. nach Rom sandte, in seinem Tagebuch über die Kirche Aracoeli: "da ist Octavianus erschienen in dem Zirckel an dem hymel di junckfrav Maria mit irem kind."[33]

Die Erscheinung der Gottes Mutter vor Augustus ist von der bildenden Kunst oftmals dargestellt worden.[34] Hierbei spielt die kreisrunde Glorie, die die Himmelserscheinung umfasst (gelegentlich auch ein Oval) eine grosse Rolle, ja, sie kann als das eigentliche Kennzeichen dieser Himmelserscheinung angesehen werden. Die älteste Darstellung der Legende (vermutlich aus der ersten Hälfte des 12. Jhdts.) begegnet auf dem ursprünglichen Altar der Cappella di Sant'Elena im nördlichen Querschiff von Aracoeli[35]—an der Stelle, an der nach der Überlieferung die Erscheinung Mariens vor dem Kaiser stattgefunden hat. In den Zwickeln zu seiten des mittleren Bogens ist in Relief links der kniende Herrscher, rechts die Mutter Gottes mit Kind in der Glorie (hier ein Oval) dargestellt.

Handelt es sich bei dem Altar der Cappella di Sant'Elena um ein wenig bedeutendes

[29]Vgl. Buchowiecki, *Handbuch*, 479.

[30]Vgl. Cellini, "Di Fra' Guglielmo," 221, und Buchowiecki, *Handbuch*, 481f. Ein Grabmosaik der thronenden Madonna aus der Schule Pietro Cavallinis in der Cappella della Rosa in Aracoeli zeigt ebenfalls Johannes der Täufer und den Hl. Franz, dazu den knienden Stifter. Vgl. R. van Marle, *The Development of the Italian Schools of Painting*, I (Den Haag, 1923), fig. 288; F. Hermanin, *L'Arte in Roma del secolo VII-XIV* (Bologna, 1945), 279f.; Buchowiecki, *Handbuch*, 5.

[31]So auch W. Schöne, *Raphael* (Berlin–Darmstadt, 1958), 36.

[32]*Legenda aurea des Jacobus de Voragine*, deutsch von R. Benz, 2. Aufl. (Heidelberg, 1963), 52: "Von der Geburt des Herrn." Vgl. auch I. Lutz–P. Perdrizet, *Speculum Humanae Salvationis* (Mühlhausen, 1907–1909), 193ff.

[33]Vgl. Buchowiecki, *Handbuch*, 483.

[34]Vgl. hierzu M. Meiss, *French Painting in the Time of Jean de Berry. The Late Fourteenth Century and the Patronage of the Duke* (London–New York, 1967), 233ff.

[35]*Ibid.*, II, Abb. 814.

Kunstwerk, so schmückte die Apside des alten Chores von Aracoeli ein monumentales
Fresko der Gründungslegende von Pietro Cavallini.[36] Es gehört zu der von Papst Bonifaz
VIII. veranlassten Erneuerung der Ostpartie der Kirche (Querhaus und Chor) durch Arnolfo
di Cambio und stammt aus der Zeit von dessen römischer Tätigkeit im Anfang des 14.
Jahrhunderts. Leider ist gerade dieses repräsentative Fresko bei der Umgestaltung des
Chores im 16. Jahrhundert zerstört worden. Wir sind auf Vasaris Beschreibung angewiesen:
"la Nostra Donna col Figliuolo in braccio, circondata da un cerchio di sole"[37]—also auch hier
der goldene Sonnenkreis. Ein Nachklang dieses verlorenen Freskos ist vielleicht das Mosaik
der Lünette über dem Südportal von Aracoeli (Abb. 2).[38] Wieder der "cerchio di sole." Wenn
hier auch nicht die Augustuslegende dargestellt worden ist, so soll doch deutlich genug der
Kreis an sie erinnern.

Nicht anders ist es bei der *Madonna di Foligno*. Auch hier spielt die goldene Sonnenscheibe
auf den Ort der Erscheinungen. Hatte Raffaels Bild doch (gleich, ob es auf dem Hochaltar
stand oder Grabesbild war) seinen Platz in unmittelbarer Nähe zu Cavallinis Fresko.

Aus späterer Zeit noch zwei Beispiele. Zunächst mag—Raffael aus seinen florentiner
Jahren bekannt—an des Domenico und David Ghirlandaio Fresko auf der Eingangswand der
Cappella Sassetti in Santa Trinita in Florenz von 1485 erinnert werden.[39] Hier umschliesst
der Kreis nicht Maria mit ihrem Kind, sondern allein das Monogramm Christi. Aber gerade
dadurch wird deutlich, dass der Kreis das Kennzeichen dieser Erscheinung ist. In Peruzzis
Fresko der *Augustuslegende* in Santa Maria di Fontegiusta in Siena ist der goldene Sonnenkreis
mit dem Heiligenschein der Maria verbunden, aber als solcher klar erkennbar.[40] Die Marien-
gruppe setzt bereits die Kenntnis von Raffaels Bild voraus—ein Hinweis, dass Raffaels
Madonna von der Augustusvision her verstanden werden muss.

Mehrfach ist die Meinung ausgesprochen worden, dass in der *Madonna di Foligno* auf
das "signum magnum in coelo" der Apokalypse (XII:1) angespielt werden soll: "mulier
amicta sole, et luna sub pedibus ejus et in capite ejus corona stellarum duodecim."[41] In der
Tat ist die Augustusvision gelegentlich mit der apokalyptischen Vision des Johannes
verbunden worden,[42] aber doch immer so, dass das "signum magnum in coelo" erkennbar
bleibt. Der Sinn beider Visionen ist nicht der gleiche. Sonne und Mond sind Zeichen der in
den Himmel aufgenommenen Maria:

[36]Vgl. Cellini, "Di Fra' Guglielmo," und *idem*, "L'opera di
Arnolfo all' Aracoeli," *Bollettino d'Arte* (XLVII, 1962), 180ff.

[37]Vasari-Milanesi, I, 569. Versuch einer Rekonstruktion des
Freskos durch L. Vayer, "L'affresco apsidiale di Pietro
Cavallini nella Chiesa di S. Maria in Aracoeli a Roma," *Acta
Historiae Artium Academiae Scientiarum Hungaricae* (IX, 1963),
39–73, nach dem Vorbild der venezianischen Tafel der
Augustusvision vom anfang des 15. Jahrhunderts in der
Stuttgarter Galerie (Vayer, fig. 2). Gegen diese Rekonstruktion
hat Meiss, *French Painting in the Time of Jean de Berry*, 234, mit
Recht eingewandt, dass das Stuttgarter Bild dem Typus der
"Madonna dell'Umiltà" folgt, der für Cavallini noch nicht in
Frage kommt. Freilich zeigt der "cerchio del sole" den
Zusammenhang des Stuttgarter Bildes mit der römischen
Tradition. A. Cutler, "The Mulier amicta sole," *Journal of the
Warburg and Courtauld Institutes* (XXIX, 1966), 127, hat die

Meinung vertreten, dass Cavallini Maria als "mulier amicta
sole" dargestellt habe. Das wird aber durch Vasaris Beschrei-
bung ausgeschlossen.

[38]Meiss, *ibid.*, 234, fig. 119; van Marle, *Development of the
Italian Schools*, I, 528.

[39]Vgl. C. de Tolnay, "Two Frescoes by Domenico and
David Ghirlandajo in S. Trinita in Florence," *Wallraf-
Richartz Jahrbuch* (XXIII, 1961), fig. 152.

[40]C. L. Frommel, "Baldassare Peruzzi als Maler und
Zeichner," Beiheft zum *Römischen Jahrbuch für Kunstgeschichte*
(XI, 1967–1968), Kat. Nr. 106, Taf. LXXXII.

[41]So Redig de Campos, "La Madonna di Foligno," 184.

[42]Vgl. hierzu J. Bolten, "Augustus," in *Reallexikon zur
deutschen Kunstgeschichte*, ed. O. Schmitt, I (Stuttgart, 1937), Sp.
1270ff. Vgl. ferner Cutler, "The Mulier amicta sole."

Mulier illa sole circumamicta erat,
Quia Maria, circumdata divinitate, in coelum ascendebat.[43]

In der Augustusvision dagegen handelt es sich allein um die Vorstellung der "Maria aeterna,"[44] auf die die alttestamentlichen Verse bezogen wurden: "Ab initio et ante saecula creata sum."[45] "Dominus possedit me in initio viarum suarum, antequam quidquam faceret a principio. Ab aeterno ordinata sum, et ex antiquis antequam terra fieret . . . Quando praeparabat coelos aderam."[46] In den *Mirabilia urbis Romae* wird als Antwort auf die Frage des Augustus der Spruch der Erythraeischen Sibylle gegeben: "Ex caelo Rex adveniet per saecla futurus."[47]

In der *Madonna di Foligno* fehlen sowohl Mondsichel wie die Krone mit den zwölf Sternen auf ihrem Haupt. So soll hier allein auf die Erscheinung der Gottes Mutter als Maria aeterna hingewiesen werden.

Die Madonna im Sonnenkreis erscheint auch auf Grabmälern und zwar gerade von Persönlichkeiten, die mit der Kirche Santa Maria in Aracoeli eng verbunden waren. Von dem Grabmal des Papstes Bonifaz VIII., des Erneuerers der Ostpartie der Kirche, in San Pietro von 1303 ist nur noch die Liegefigur des Entschlafenen von Arnolfo di Cambio erhalten.[48] Aber aus einer Zeichnung Jacopo Grimaldis wissen wir, dass in dem Oberteil des Grabmales in einem Mosaik (vermutlich von Jacopo Torriti) Maria im Sonnenkreis zwischen Petrus und Paulus und dem knienden Papst, von Petrus der Madonna empfohlen, dargestellt war. Ein anderes Grabmonument ist noch erhalten, das Stiftermosaik des Bertoldo Stefaneschi in der Apsis von Santa Maria in Trastevere von Pietro Cavallini:[49] auch hier die Madonna mit dem Christuskind im Sonnenkreis, zu seiten Petrus und Paulus und der kniende Stifter, der von Petrus der Gottes Mutter empfohlen wird. Bertoldo, ein Bruder des mit Bonifaz VIII. eng verbundenen Kardinals Jacopo Stefaneschi, liegt im linken Querschiff von Santa Maria in Trastevere begraben—das Mosaik muss also im Zusammenhang des Grabes aufgefasst werden. In beiden Mosaiken sind wir dem Ausgangspunkt von Raffaels Bild sehr nah. Dass es sich um Grabmonumente handelt, verdient im Hinblick auf die mögliche Funktion von Raffaels Bild unsere besondere Aufmerksamkeit.

IV

Raffael als Künstler konnte sich freilich nicht an solche weit zurückliegenden Vorbilder halten. Um seiner bildnerischen Leistung gerecht zu werden, müssen wir Werke anderer, wenngleich verwandter, Thematik, insbesondere Werke der unmittelbaren Vorgänger und

[43]Lutz–Perdrizet, *Speculum Humanae Salvationis*, 75. Vgl. ferner E.M. Vetter, "Virgo in Sole," *Festschrift für Johannes Vincke* (Madrid, 1962–1963), 381. Vgl. dazu di Predigt des Richard de St. Laurent "De laudibus Mariae virginis," in der das "amicta sole" als leibliche Aufnahme in den Himmel erklärt wird: "Ecce qualiter assumpta scilicet non nuda, id est tantum in anima, sed amicta sole, id est glorificate corpore" (zitiert nach Vetter, *ibid.*, 381f.).

[44]Zum Vorstellungskreis der "Maria aeterna," von Eirem, "Die Menschwerdung Christi des Isenheimer Altares," *Kunstgeschichtliche Studien für Hans Kauffmann* (Berlin, 1956), 164.

[45]Jesus Sirach XXIV : 14.

[46]Sprüche Salomonis VIII : 22ff.

[47]Cod. Vat. lat. 3873, Ende 12. Jahrhunderts. Vgl. F.M. Nichols, *Mirabilia Urbis Romae* (London–Rome, 1889) und Cutler, "The Mulier amicta sole," 125.

[48]E. Panofsky, *Grabplastik* (Köln, 1964), Abb. 335. Zum folgenden vgl. Tiberii Alpharani, *De Basilicae Vaticanae antiquissima et nova structura*, Ausg. M. Cerrati (Rom, 1914), 66; F. Gregorovius, *Die Grabdenkmäler der Päpste* (Leipzig, 1911), 36ff. Die Grabfigur des Arnolfo di Cambio abgebildet bei J. Pope-Hennessy, *Italian Gothic Sculpture* (London, 1955), fig. 55.

[49]G. Matthiae, *Mosaici medioevali delle chiese di Roma* (Rom, 1967), 370, Taf. LXVII; C. Cecchelli, *Santa Maria in Trastevere*. Le Chiese di Roma, XXXI–XXXII (Rom, o.J.), 39, 137f., 149.

Zeitgenossen zum Vergleich heranziehen. So selbstverständlich es für den Künstler war, aus dem Schatz vorgegebener Bildformen zu schöpfen, immer ist für ihn die Freiheit und Souveränität der Umprägung charakteristisch.

Von Werken verwandter Thematik mag es genügen, auf den Bildtypus der "Madonna in der Glorie" hinzuweisen, der mit der Augustusvision unmittelbar nichts zu tun hat, ihr doch aber als Epiphanievorstellung sehr nahekommt. Raffael war er aus der umbrischen und florentinischen Kunst des Quattrocento geläufig. Von seinem Lehrer Perugino gibt es mehrere Bilder des Typus: so die Tafel für die Bruderschaft der Disciplinati von Santa Maria Novella in Perugia von 1498[50] mit den knienden Heiligen Franziskus und Bernhardin von Siena. Hier handelt es sich (wie bei der *Madonna di Foligno*) um ein Fürbittbild. Auch sind die Gebärden der Knienden, das Gegeneinander von Händefalten und Hingabegestus vergleichbar. Ferner die Tafel aus San Giovanni in Monte in Bologna,[51] der gleichen Kirche, die Raffaels *Hl. Cäcilie* barg.

Aus der florentiner Kunst ist vor allem an das Hochaltarbild von Santa Maria Novella in Florenz von Ghirlandaio zu denken (Abb. 3),[52] auf dem die Madonna inmitten eines doppelten Himmelskreises erscheint—vielleicht soll hier sogar das Motiv der Augustusvision anklingen. Schon Wölfflin hat das Bild zum Vergleich mit der *Madonna di Foligno* herangezogen.[53] In der Tat wirkt Raffaels Bild wie eine Korrektur der ihm vertrauten früheren Schöpfung. Bei Ghirlandaio bleiben trotz des Raummotivs die Flächenbezüge vorherrschend. Erst Raffael vermag seine Madonna in die Himmelszone wirklich zu entrücken. Während bei Ghirlandaio die stehenden Figuren in die Glorie hineinreichen, und die Glorie oben von der Madonna, seitlich von den Engeln überschnitten wird, lässt Raffael den Sonnenkreis um Maria herum unberührt und betont die Distanz von unten und oben. Was bedeutet ferner die Umstellung der Stehenden! Statt der pyramidalen Aufgipfelung bei Ghirlandaio geht bei Raffael die Bildbewegung zunächst von den Seiten nach unten. Dann erst wird unser Blick aufwärts gelenkt. Das Gegeneinander der Gebärden bei Johannes dem Täufer und Franziskus, bei Johannes und Hieronymus ist von einer Differenziertheit, von der der ältere Künstler nichts weiss. Der Engelknabe mit der bildparallel gehaltenen Inschrifttafel betont das Schwergewicht unten. Von ihm her erkennen wir, dass das Bild von unten nach oben gelesen werden muss. Zu der bis ins letzte durchdachten und ausgewogenen figürlichen Komposition kommt die Differenzierung des Ausdrucks und des Gebärdenspiels: der rituellen Gebetshaltung des Stifters gegenüber die leidenschaftliche Hingabe des Hl. Franz, dessen Gebärde zugleich als Fürbittgestus gedeutet werden darf. Ihre Bewegung nach aussen ist abgestimmt auf die Aufwärtsbewegung im Zeigegestus des Täufers und auf den bildeinwärts geführten Arm des Hieronymus. Endlich die Wolken: anstelle der Wolkenformeln bei Ghirlandaio gibt Raffael leichte, schwebende Gebilde, die über der Landschaft aufsteigen, und in die auch der Sonnenkreis unten eintaucht. Die Überschneidung des Kreises durch die Wolken betont in besonderer Weise die Räumlichkeit des Bildes. Dass dennoch der Kreis als Kreis erhalten bleibt, gibt der Madonnengruppe ihre sakrale Feierlichkeit.

[50]W. Bombe, *Perugino* (Stuttgart–Berlin, 1914), Taf. 76.
[51]*Ibid.*, Taf. 91.
[52]München, Ältere Pinakothek. Vgl. J. Lauts, *Domenico*

Ghirlandajo (Wien, 1943), Taf. 93.
[53]*Die klassische Kunst*, 138f.

Der Typus der "Madonna in der Glorie" begegnet auch im Norden und zwar hier in der Regel mit der Vorstellung der apokalyptischen Maria verbunden. Im Norden steht uns der Schritt von der Formelsprache des Mittelalters zu der neuen Naturanschauung der späteren Kunst deutlicher als im Süden vor Augen. So ist in dem Dedikationsbild des Stundenbuches des Boucicautmeisters (um die Wende des 14. zum 15. Jahrhunderts)[54] die himmlische Erscheinung vor dem Marschall von Frankreich noch ganz ohne räumliche Überzeugungskraft. Dagegen ist in dem Bild Robert Campins in Aix-en-Provence (Abb. 5)[55] die apokalyptische Maria wohl zum ersten Mal über einer Landschaft, die sich bis tief in die Ferne hinzieht, gegeben worden. Der Strahlenkranz um die thronende Himmelskönigin mit Kind scheint die Wolken aufzubrechen. Der kniende Stifter, in deutlicher Distanz zu den Heiligen, wendet sich bittend an den Hl. Petrus. Dieses Bild führt nahe an den Ausgangspunkt von Raffaels Schöpfung heran.

Ähnlich ein Bild aus dem Umkreis Rogers in Chantilly,[56] das vielleicht von Memling stammt und Jeanne de France (die Tochter Karls VII. von Frankreich), von Johannes dem Täufer empfohlen, kniend vor der Himmelserscheinung der apokalyptischen Maria über einer Landschaft zeigt. Mit diesem Bild sind wir Raffaels Werk motivisch noch näher. Die asymmetrische Anlage der Komposition ist hier durch die Tatsache, dass es sich um die Hälfte eines Diptychons handelt, bedingt.

Ob Raffael vergleichbare Bilder des Nordens gekannt hat, muss freilich offen bleiben.

Der unmittelbaren Bildquelle für Raffaels Schöpfung kommen wir mit dem Apsidenfresko der Grabkapelle Papst Sixtus' IV. bei Alt-Sankt Peter[57] am nächsten, das Raffaels Lehrer Perugino vermutlich 1479 geschaffen hat, von dem wir aber nur noch aus einer Zeichnung Jacopo Grimaldis eine schwache Vorstellung gewinnen können (Abb. 4). Links kniet Papst Sixtus IV. und wird vom Hl. Petrus der Himmelskönigin empfohlen. Maria mit dem Christuskind im Engelkranz wendet sich dem Knienden zu. Hinter Petrus der Hl. Franz. Auf der rechten Seite Antonius von Padua und Paulus. Vor dem Altar (auf dem eine Zeit lang Michelangelos *Pietà* ihren Platz hatte) befand sich das Grab des Papstes. Das Fresko muss also unmittelbar auf das Grab bezogen werden. Es ist eine Intercessionsdarstellung[58]— im Hinblick auf die *Madonna di Foligno* und das Grab des Sigismondo de' Conti von besonderer Wichtigkeit.

Es ist klar, dass Peruginos Formensprache dem jüngeren Künstler, der durch die Schule Leonardos und Michelangelos gegangen war, nicht mehr genügen konnte. So ist es nur natürlich, dass wir auch bei der *Madonna di Foligno* der Einwirkung dieser beiden führenden Meister der Hochrenaissance begegnen.

Die Madonna schliesst sich (was längst aufgefallen ist)[59] eng an Leonardos unvollendetes Gemälde der *Anbetung der Könige* in den Uffizien an (Abb. 6).[60] Haltung der Sitzenden, das

[54]Paris, Musée Jacquemart-André. Vgl. E. Panofsky, *Early Netherlandish Painting* (Cambridge, Mass., 1958), II, Abb. 64.
[55]*Ibid.*, Abb. 209.
[56]Chantilly, Musée Condé, Cat. 1899, fol. 126.
[57]So auch Dussler, *Raffael*, 65. Zu dem verlorenen Fresko und seiner Zugehörigkeit zur Grabkapelle Sixtus IV. vgl. schon A. Schmarsow, *Joost van Ghent und Melozzo da Forlì in Rom und Urbino* (Leipzig, 1912), 180ff. Hier auch (wie schon

1886 in seinem Buch *Melozzo da Forlì*, 161) der Hinweis au die Beziehung zur *Madonna di Foligno*.
[58]Vgl. hierzu L. Ettlinger, "Pollajuolo's Tomb of Pope Sixtus IV," *Journal of the Warburg and Courtauld Institutes* (XVI, 1953), 279.
[59]Vgl. Wölfflin, *Die klassische Kunst*, 32, und Dussler, *Raffael*, 65.
[60]C. Baroni, *Tutta la pittura di Leonardo* (Mailand, 1958), Taf. 19.

Gegeneinander von Wendung des Körpers nach links, des Hauptes nach rechts, die Erhöhung des linken Beines sind von dort aus entwickelt worden. Freilich wird sofort auch der Gegensatz deutlich: die Madonnengruppe ist im ganzen plastischer durchgebildet, die Gegenbewegungen sind betonter, insbesondere macht der einwärts gewandte rechte Arm Mariens Raffaels Bemühung plastischer Formgebung deutlich, während bei Leonardo die körperliche Bewegung dem Wohllaut des Gesamtumrisses untergeordnet wird.

In der betonten Plastizität der Gruppe wird der Einfluss Michelangelos spürbar. Das Motiv des hochgestellten linken Beines ruft die Erinnerung an Michelangelos *Brügger Madonna* wach.[61] Insbesondere kann das Motiv, wie der Jesusknabe den Schoss der Mutter zu verlassen scheint, nicht ohne die *Madonna Doni* (Abb. 7)[62] gedacht werden, die Raffael, seit er sie in Florenz im Hause Doni gesehen, vertraut war und die er später in seiner *Madonna Alba*[63] weit überflügeln sollte. Das übernommene Motiv wird schon hier mit Freiheit und Selbständigkeit dem Formganzen der Gruppe eingeschmolzen.

<center>V</center>

Das Thema der Epiphanie der Himmelskönigin scheint Raffael—auch unabhängig von bestimmten Aufträgen—seit Beginn seiner Römischen Zeit beschäftigt zu haben. Wir tun gut, es nicht allein von Aufträgen, sondern vom Künstler her als inneres Problem seiner Kunst zu sehen. Freilich war es ein Glück, dass ihm durch Aufträge zweimal die Möglichkeit der Konkretisierung gegeben wurde: durch Sigismondo de' Conti in der *Madonna di Foligno* und durch Papst Julius II. in der *Sixtinischen Madonna*. Beide Werke stehen (wie aus den Studien deutlich wird) in gestalterischem Zusammenhang. Die *Sixtinische Madonna* als das spätere Werk ist aus dem Vorstellungskreis der *Madonna di Foligno* entwickelt worden.[64]

Leider haben wir in den Werdegang der *Madonna di Foligno* nur ungenügenden Einblick. Ein Gesamtentwurf fehlt.[65] Vorstudien gibt es nur für die Madonnengruppe. An den Anfang scheint ein Entwurf zu gehören, von dem ein Kupferstich des Marc Anton (B. 47; Abb. 8)[66] und eine nur in zwei Exemplaren in Düsseldorf und Madrid erhaltene Kopie (B. 46) Kunde gibt. Er zeigt, wie stark noch in Raffaels römischer Zeit die florentiner Erinnerungen nachwirken. Ausgangspunkt der Gruppe ist bereits hier Michelangelos *Brügger Madonna*, die Raffael noch vor ihrem Verkauf nach Flandern in Florenz kennen gelernt haben muss:[67]

[61]C. de Tolnay, *The Youth of Michelangelo* (Princeton, N.J., 1947), Taf. 44.

[62]*Ibid.*, Taf. 59. Vgl. hierzu schon Crowe und Cavalcaselle, *Raffael, Sein Leben und seine Werke*, deutsche Ausg. (Leipzig, 1885), II, 130, und J. Pope-Hennessy, *Raphael*. The Wrightsman Lectures (New York, 1970), 207. Raffael, der die Bildnisse von Angelo und Maddalena Doni (Florenz, Palazzo Pitti) gemalt hat, war die zur Hochzeit des Paares geschaffene *Madonna Doni* Michelangelos gut bekannt. Ihr Einfluss begegnet schon in der Silberstiftzeichnung Lille, Musée Vicar, Nr. 454 (730); vgl. O. Fischel, *Raphael-Zeichnungen* (Strassburg, 1898), VIII, Nr. 246 (Studie des Jesusknaben oben links, Beinmotiv). Diese Zeichnung gehört schon der frühen römischen Zeit an.

[63]E. Camesasca, *Tutta la pittura di Raffaello* (Mailand, 1962) Taf. 97.

[64]Vgl. H. von Einem, "Raffaels Sixtinische Madonna,"

Konsthistorisk Tidskrift (XXXVII–XXXVIII, 1968), 68–69, Abb. 6.

[65]A. Schmarsow (vgl. *supra*, Anm. 57) sieht in einer Zeichnung in Würzburg den frühesten Zustand von Raffaels Kompositionen. Vgl. vorher schon L. von Urlichs, *Beiträge zur Kunstgeschichte* (Leipzig, 1884), 107, Taf. 19. Diese These ist aber bereits von Fischel, *Raphael-Zeichnungen*, 132, mit Recht abgelehnt worden. Die Zeichnung, ohne Zweifel später als Raffaels Tafel, "zeigt keine Spur von Raphael und seiner Umgebung, ist wohl überhaupt von keinem Italiener." Seltsamerweise zeigt sie Maria mit übereinander geschlagenen Beinen.

[66]von Einem, "Raffaels Sixtinische Madonna," Abb. 6.

[67]Vgl. schon die *Madonna Jardinière* (Paris, Louvre), Dussler, *Raffael*, Nr. 96 und die vorbereitenden Zeichnungen in Chantilly und Paris (Fischel, *Raphael-Zeichnungen*, III, Nr. 119 und 120).

überdeutlich in dem vom Schoss der Mutter entlassenen Jesusknaben mit dem den Körper übergreifenden Arm, aber auch in der Haltung der Maria, die, in die Wolken entrückt, ins Bewegte umgebildet wird, das Vorbild dennoch erkennen lässt. Die Berührung mit der Madonna der *Anbetung der Könige* Leonardos gehört erst in ein späteres Stadium des Schöpfungsprozesses. Es steht uns in der schönen Londoner Zeichnung (Abb. 9)[68] vor Augen. Schon aus ihr wird aber deutlich, wie sehr Raffael bemüht ist, das Vorbild stärker ins Plastische umzusetzen. Rechter Arm und linkes Bein der Madonna entsprechen fast schon der Ausführung. In der Formgebung des Jesusknaben dagegen hat Raffael hier noch keine endgültige Lösung finden können. Das Standmotiv der *Brügger Madonna* ist aufgegeben, das Sitzen auf dem Schoss nunmehr nach dem Vorbild Leonardos gestaltet worden. Nur das Motiv der Übergreifung des Armes ist aus dem früheren Entwurf beibehalten. Im Gemälde hat Raffael dann aber die Haltung des Jesusknaben noch einmal verändert und—im Zusammenhang der Gesamtkomposition—neu durchdacht. Das Schossmotiv wird verworfen. Raffael kehrt aber nicht wieder zu dem Standmotiv der *Brügger Madonna* zurück, sonderngibt nunmehr in Anlehnung an die *Madonna Doni* das neue Motiv des Herabsteigens vom Schoss. Erst durch dieses neue Motiv erhält der Bezug der Mariengruppe oben zu der Figurengruppe unten (insbesondere zu dem Stifter) sein volles Gewicht.

Weitere Zeichnungen in Frankfurt und Chatsworth[69] zeigen Raffael bereits auf dem Wege zur *Sixtinischen Madonna*. Aus einer flüchtigen Skizze am Rande der Frankfurter Zeichnung ist aber ersichtlich, dass die Vorstadien der *Madonna di Foligno* noch unvergessen sind.

VI

Der Auftrag für die *Madonna di Foligno* muss vor dem 23.Februar 1512—dem Todesdatum des Sigismondo de' Conti—ergangen sein. Der genaue Zeitpunkt ist leider nicht überliefert. Die mehrfach geäusserte Meinung, dass Landschaft und Gloriole die Beteiligung einer anderen Hand (etwa des Dosso Dossi) verrieten, hat die letzte Reinigung und Wiederherstellung des Bildes von 1957–1958 widerlegen können.[70] Das Bild muss ohne fremde Mitarbeit als völlig eigenhändig gelten. Farbgebung[71] und Vortragsweise rücken die Ausführung in die Zeit der Arbeit an der Heliodorstanze, in der sich "der generelle Wandel Raffaels von seiner florentinisch plastischen Formauffassung (noch in der Stanza della Segnatura vorherrschend) zu dem malerischen Stil, der ab 1512 mit der Stanza d'Eliodoro zusehends Boden gewinnt,"[72] vollzogen hat.

Vollendung in der Zeit um 1512 heisst freilich nicht, dass der Auftrag nicht schon früher ergangen sein könnte. Das Verso der Frankfurter Zeichnung[73] mit Kopien nach Figuren der *Schule von Athen* weist auf eine solche Möglichkeit hin.

[68]Fischel, *ibid.*, VIII, Nr. 370. Vgl. *Italian Drawings in the Department of Prints and Drawings in the British Museum* (London, 1962), Kat. Nr. 25.
[69]Fischel, *ibid.*, VIII, Nr. 368 und 369.
[70]Vgl. dazu Redig de Campos, "La Madonna di Foligno di Raffaello e il suo restauro," *Fede e Arte* (V, 1960), 442ff., und *idem*, "La Madonna di Foligno," 190. Vgl. auch Dussler,

Raffael, 66.
[71]Zur Farbgebung, die in diesem Aufsatz unberücksichtigt bleibt, vgl. die ausführliche Analyse von Redig de Campos "La Madonna di Foligno," 190ff.
[72]Dussler, *Raffael*, 66.
[73]Fischel, *Raphael-Zeichnungen*, VIII, Nr. 368.

Wie dem aber auch sei, der Wandel zum Malerischen in der zweiten römischen Arbeits-periode hat keineswegs zu einer Schwächung der Errungenschaften seiner florentiner Zeit geführt. Zeigt doch gerade der in den Studien verfolgbare Schöpfungsprozess der Madonnen-gruppe, wie sehr Raffael um plastische Belebung besorgt blieb, und wie es ihm—in drei-fachem Ansatz—erst in der Ausführung gelang, für die Gruppe in sich und im Zusammen-hang der Gesamtkomposition eine vollendete Lösung zu finden. Insbesondere muss das Zusammenspiel der Gebärden zwischen oben und unten als Ausdruck plastischen Form-denkens verstanden werden.

Für den römischen Raffael ist charakteristisch, dass jede Einzelform durch die Gesamt-form bestimmt wird. So ist der Sonnenkreis auf das Halbrund des oberen Bildabschlusses abgestimmt und wirkt als Flächenfigur mit der bildparallelen Inschrifttafel des vorn stehenden Engelknaben (der einzigen Figur in reiner Vorderansicht) der Tiefenräumlichkeit der Landschaft entgegen.[74] Die Madonnengruppe fügt sich oben ohne Überschneidung dem Sonnenkreis ein. Unten dagegen führt sie über ihn hinaus. Obere und untere Gruppe sind unlösbar mit einander verbunden. Raum und Fläche, Bewegung und Ruhe verschmelzen zu klassischer Einheit. Nur durch den Blick Johannes des Täufers wird die Komposition nach aussen geöffnet und auch der Betrachter in das Bildgeschehen einbezogen.

KUNSTHISTORISCHES INSTITUT DER UNIVERSITÄT BONN

[74]Hier mag als Vorstufe an den knienden jugendlichen Johannes des *Himmelsfahrts* freskos seines Lehrers Perugino in der Sixtinischen Kapelle gedacht werden. Vgl. Handzeich-nungen Wien, Albertina (Bombe, *Perugino*, Taf. 18).

A Late Trecento *Custodia* with the Life of St. Eustace

MARVIN EISENBERG

Of the various forms of late-medieval Italian tabernacle that gave shelter to a sacred relic or venerated effigy, the *custodia* survives only in rare examples. In the superbly preserved *custodia* by Pacino di Bonaguida in the Kress Collection of the University of Arizona at Tucson (Fig. 1) the four shutters when closed provided the sides and doors of an elongated box, which must originally have served to protect a relic of the Cross, judging by the reverential Crucifix in the central panel and the contrast of this symbolic depiction with the narrative *Crucifixion* enacted in the right wing.[1] In the *custodia* at Fossa in the Abruzzi (Fig. 2), the two shutters are hinged to a shallow niche housing the enthroned Virgin and Child and close along the perimeters of the triangular dais and tilted gable.[2] Until early in this century, the church of Sant'Eustachio in the provincial Abruzzese village of Campodigiove displayed a wooden effigy of its patron in a tabernacle decorated with sixteen scenes from the life of the saint (Fig. 3). The two wider shutters were hinged to a niche to form the sides of the *custodia*, while the narrower panels served as the doors, so that the entire cycle was visible only when the tabernacle was closed. In Pacino's *custodia*, the scenes are read in pairs down through each wing, as in Andrea Pisano's contemporary south doors for the Baptistery in Florence. But at Campodigiove the story flowed across the two wings and down through the four registers, recalling Ghiberti's means of unifying the two valves of the north doors, although there the narrative reads from bottom to top. In 1902 the four elongated panels were stolen from Sant'Eustachio[3] and remained without a trace until the 1920s, when two of the scenes from

[1] F. R. Shapley, *Paintings from the Samuel H. Kress Collection, Italian Schools, XIII–XV Century* (London, 1966), 23 (no. K 1717). The sparse evidence of the *custodia* as a type is most fully examined by Richard Offner in the *Corpus of Florentine Painting*, III, VI (New York, 1956), 149. There is a distinction between the *custodia* and the tabernacle or reliquary cupboard in which panels are attached to a structural framework, as, for example, is the case with the extensive set of panels of the Life of Christ and the Life of St. Francis by Taddeo Gaddi in the Accademia in Florence (see L. Marcucci, *Gallerie nazionali di Firenze, I dipinti toscani del secolo XIV*, Rome, 1965, 56–62). I would suggest, incidentally, that the panels of the St. John the Baptist cycle by Giovanni di Paolo may once have formed the two sides and two doors of a *custodia* rather than either the fixed or folding wings of an altarpiece; for a review of the various reconstructions of these panels, see M. Meiss, "A New Panel by Giovanni di Paolo from His Altarpiece of the Baptist," *Burlington Magazine* (CXVI, 1974), 73–74. If the panels did, indeed, form a *custodia,* the scenes would have been visible in the proper sequence when the shutters were open. When closed, the doors would have presented the *Gabriel,* on the back of the *Annunciation to Zacharias* in the Lehman Collection, New York, confronting a *Virgin Annunciate* which must once have been on the back of *The Baptist Accusing Herod* in Munich. The width of the *custodia* would thus have been at least 0.8 m., that is, double the maximum width of the surviving panels and sufficient to contain a sculptured or painted effigy, most likely of the Baptist. Framing elements, of course, would have provided some additional width.

[2] E. Carli, *La scultura lignea italiana* (Milan, 1960), 46, where

the shutters are called early fifteenth-century Abruzzese and the *Madonna* a work of the same school from the late trecento. In lectures given in 1953–1954, Roberto Longhi attributed the *Madonna* to a French sculptor and the wings to a painter active in an area of Umbria close to the Abruzzi: "La pittura umbra della prima metà del Trecento," ed. M. Gregori, *Paragone* (281–83, 1973), 39–41.

[3] A. de Nino, "Notizie degli Abruzzi, Una pittura rubata a Campodigiove (Aquila)," *L'Arte* (V, 1902), 425–26; P. Piccirilli, "Notizie degli Abruzzi, Opere d'arte in Campodigiove," *L'Arte* (V, 1903), 213–16, where the dimensions of the wings are given as 1.94 m. in height (identical with the height of the niche) and 1.18 m. in width, with the broader panels 33 cm. wide and the narrower ones 26 cm. Piccirilli, who described the *custodia* after the theft from the church, indicated that the painted surfaces were visible only when the shutters were open, that is, the scenes were painted on the inner faces of the wings. If this were the case, however, the narrative would have been out of order when the shutters were open. The demands of a chronological reading of the cycle from left to right across the wings, as well as the extensive damage to the painted surface, indicate that the scenes were fully exposed only when the *custodia* was closed around the effigy. There is no record of the original appearance of the backs of the shutters. Piccirilli described the wooden effigy of St. Eustace as a local work of the late fifteenth century, of mediocre quality and much repainted. R. Van Marle, *Development of the Italian Schools of Painting*, V (The Hague, 1925), 378, reports that after the theft the shutters were in a Florentine private collection.

the series (Figs. 7 and 8) appeared on the Parisian art market. Here was the first proof that the *custodia* had been sawed into separate panels. This same pair showed up once again at the Hôtel Drouot in 1930, but their subsequent fate is unknown.[4] In 1950, Erwin Panofsky cited the scene of the miraculous stag (Fig. 4) as an iconographical comparison in a study of Dürer's *St. Eustace* engraving, without knowing the whereabouts of the panel.[5] Shortly after the appearance of his article, that panel, showing the *Conversion of St. Eustace*, as well as another from the cycle, the *Flight from the Plague-Ridden City* (Fig. 6), came to light in the Art Gallery at Grand Rapids, Michigan.[6] And then some years ago I learned of a St. Eustace scene (Fig. 5) belonging to a private collector in Washington, D.C., which proved to be still another element from the Campodigiove shutters.[7] At present, I cannot go beyond these five panels in tracing the surviving fragments of the Sant'Eustachio *custodia*.

In the sixteen scenes of this dismembered tabernacle, nearly every episode of the anguished history of St. Eustace as narrated in the *Golden Legend* is illustrated with a faithful literalness. Certainly it was that popular text and not the more recondite early *vitae* that provided the immediate literary source for this dense pictorial cycle.[8] The mercurial biography of St. Eustace unfolds in four clusters of episodes, which convey the themes of conversion, tribulation, reunion, and martyrdom. Omitting the opening scene of the hunt described in the *Golden Legend*, the Sant'Eustachio cycle begins with the moment of the conversion of the Roman Placidus as Christ appears to him between the antlers of a stag (Fig. 4). Moving horizontally to the right across the four shutters, the next two scenes continue the theme of Placidus's new dedication to Christianity. First, he and his family hasten to be baptized by the Bishop of Rome, whereupon his name is changed to Eustace, and his wife and sons take on their Christian names of Theopista, Agapitus, and Theopistus. In the third scene of this first "act," Christ reappears to Eustace to warn him that since he has overcome evil through his

[4]*Catalogue des tableaux anciens, Primitifs flamands et italiens*, Paris, Hôtel Drouot, Salle No. 6, 4 février 1924, p. 15, nos. 55–56 (illustrated), attributed to the Florentine school, fifteenth century; *Catalogue des tableaux anciens, Collection de M. Pelletier*, Paris, Hôtel Drouot, Salles nos. 5 et 6, 3 décembre 1930, p. 12, nos. 24–25 (illustrated), attributed to the Florentine school, early fifteenth century. Dimensions of each panel: 38 cm. × 29 cm. In both sales, the panel reproduced as our Fig. 7 was called the *Flight into Egypt*, with the two children identified as Christ and St. John the Baptist, and Fig. 8 was simply entitled *A Saint and Two Horsemen*. The catalogue illustrations from which our photographs were made reveal that the damaged areas visible in these scenes in Fig. 3 had been fully repainted.

[5]"Dürer's *St. Eustace*," *Record of the Art Museum, Princeton University* (IX, 1, 1950), 9 and fig. 6. The panel is considered here to be part of a trecento polyptych.

[6]*Conversion of St. Eustace* (47.1.1): painted surface, 18 3/4 × 11 inches; *Flight from the Plague-Ridden City* (47.1.2): painted surface, 18 3/4 × 11 1/4 inches. The modern frames cover only the spandrel and border surfaces of the original panels. Of the known parts of the series, the *Flight* underwent the most extensive revisions during repainting. The original vegetation springing up from the horizon has been replaced by a clump of trees and a rocky mass that changes the original contour between landscape and gold ground (cf. Figs. 3 and 6). According to the file of the Grand Rapids Art Gallery, the panels were acquired from E. and A. Silberman in New York in 1947 and had previously belonged to an Austrian private collection, but nothing further is known of their history. As the two panels were exhibited in the Grand Rapids Art Gallery in 1939 and at the High Museum in Atlanta in 1940, they apparently had been in this country some time before their purchase by Grand Rapids in 1947.

[7]*Second Appearance of Christ to St. Eustace*: painted surface, 17 1/2 × 8 3/4 inches. In spite of the extensive damage, the figures are largely intact, excepting portions of the face and the entire right arm of Christ, which have been repainted (cf. Figs. 3 and 5). The owner has informed me that the panel was purchased from the European art market in the early 1960s. The fact that the modern frame is identical in design to those on the Grand Rapids panels suggests that the three fragments of the *custodia* were at one time in the same hands. I am grateful to Elisabeth Packard for showing me the panel while it was in the Conservation Department at the Walters Art Gallery in Baltimore.

[8]For the standard Latin text of the Eustace story in the *Golden Legend*, see Jacobi a Voragine, *Legenda Aurea*, ed. T. Graesse (Leipzig, 1850). The English edition by G. Ryan and H. Ripperger is based on the Graesse edition (*The Golden Legend*, Part Two, New York, 1941, 555–61). An Italian version of the trecento has been edited by A. Levasti (Iacopo da Varagine, *Leggenda aurea, Volgarizzamento toscano del Trecento*, Pistoia, 1926, III, 1344–55). See also *Acta Sanctorum*, September, VI (September 20), Paris, 1867, pp. 106–22 (Commentary), 123–37 (Life of St. Eustace in Greek and Latin texts).

conversion, "the Devil will fight against thee fiercely" so that "tribulation must make of thee another Job" (Fig. 5). The next four scenes are the fulfillment of Christ's warning, as Eustace suffers the loss first of his possessions and then of his family. In the last panel of the top register, the family flee their country after a plague has destroyed servants and flocks and robbers have stripped their house of all worldly goods (Fig. 6). Moving to the first panel in the second row, the family are shown escaping by sea to Egypt (Fig. 7), a journey culminating in the disasters narrated in the two following scenes. When Eustace is unable to pay the passage money demanded by the covetous captain of the ship, he and his two sons are put ashore, while his wife is carried off as hostage. Hard on the heels of this loss, while fording a river the sons are snatched from Eustace by a lion and a wolf. He can do nothing but stand in midstream and beat his breast in anguish. Such events from the "Slough of Despond" are followed by a sequence of recognitions and miraculous reunions, only brief respite from the tragic course of this biography. The second register ends and the third begins with the discovery and accompaniment of Eustace by two emissaries sent from Trajan to seek out his long-lost general Placidus at a time when the Roman people were "sore beset by their enemies" (Fig. 8). In the third of these episodes of Eustace's restoration, Trajan appoints him commander of the Roman legions, and in the adjoining panel Eustace marches off to do battle at the head of the armies. In two subsequent scenes of Roman encampment, Eustace and his wife, who kept an inn near the camp, are reunited; then the two sons, having recognized one another while staying at their mother's inn but without knowing her identity, embrace their parents, as the family again becomes one. No nineteenth-century opera is more replete with rapid successions of loss and rediscovery. But joy is brief. The three final scenes lead us along the inexorable path to martyrdom. Returning victorious to the court of the new emperor, Hadrian, Eustace is commanded to offer sacrifices of thanksgiving to the pagan gods. Upon his refusal to comply and his pronouncement of the name of Christ as his only deity, Eustace and his family are thrown to a ferocious lion in the arena. In a Christian replaying of the Androcles legend, the lion "ran to them and bowed his head, as if to adore them as saints, and then meekly went away." Finally, the relentless Hadrian ordered that the four be roasted in a brazen bull where they "gave up their souls to the Lord. On the third day they were removed from the bull in sight of the emperor, and were found intact, nor had the heat of the fire touched their hair, nor any part of their bodies."

A Life of St. Eustace as uniquely complete as the cycle of the Campodigiove *custodia* was surely prompted by more than local homage to a patron saint. In fact, the celebration of St. Eustace in the Abruzzi and the adjoining areas of Lazio has a venerable history.[9] According to tradition, the appearance of the miraculous stag during the hunt and the conversion of the Roman Placidus occurred in the mountains near Subiaco. In the early thirteenth century, Claro, bishop of Tivoli, exhorted his parishioners to provide alms for the restoration of the war-damaged sanctuary of Santa Maria in Vulturella at Guadagnolo near Subiaco, which

[9]For the history of the cult of St. Eustace in Italy and texts of his life, see A. Monteverdi, "La Leggenda di S. Eustachio," *Studi medievali* (III, 1909–1910), 169–229 and 392–498. The history of the Greek and Latin as well as later texts is also explored in H. Delehaye, "La Légende de Saint Eustache," *Bulletins de la classe des lettres, Académie Royale de Belgique* (1919), 175–210. The problems of the origins of the Eustace legend are explored by A. H. Krappe in *La Leggenda di S. Eustachio* (Aquila, 1928).

local legend claimed had been erected in the fourth century under the patronage of Sylvester I to commemorate the conversion of Placidus to his new identity as the Christian Eustace.[10] In a Bull of Clement III of April 7, 1188, the church at Campodigiove was dedicated to St. Eustace. How fitting that a church with foundations that were claimed to be the site of a Temple of Jupiter should come under the patronage of a converted Roman general![11] But in spite of various evidences of the later medieval celebration of Eustace in Italy,[12] his romantic history never gained there the popularity it reached in the thirteenth century in the north of Europe and above all in France, where as a patron of furriers and drapers he was commemorated in numerous cathedrals.[13] Given the relative infrequency of Italian depictions of the Life of St. Eustace, the question arises as to where the painter of the Campodigiove shutters found the models for so extensive a cycle.[14] The tracing of the sources of all sixteen of the scenes must await some future study of the iconography of St. Eustace. A sampling here of a few of the most commonly depicted episodes, whether in separate devotional images or in cycles, may nevertheless help to indicate that the imagery of the *custodia* painter has its principal cognates in that corpus of French stained-glass windows wherein the life of Eustace is given its most complete and widespread representation.

Although Panofsky did not intend completeness in his investigation of the iconography of the Conversion of Eustace, he did arrive at the definition of two essentially contrasting treatments of the subject, one formulated in the tradition of Byzantine manuscripts and the other apparently in the High Gothic art of Northern Europe.[15] In the former, the mood is active, with Eustace (Placidus) chasing the running stag, who in turn looks back at his pursuer to reveal the miraculous image of Christ. In the Northern depiction, "the accent is shifted from pursuit and surprise to pious contemplation." Hunter, horse, and stag now come to a halt, and the vision of Christ in the antlers of the animal is revealed to a kneeling, rapt devotee. The Southern tradition of representing Christ as a bust-length figure with a cruciform halo is generally replaced in the North by a full figure on a cross. Each of the elements of the

[10]Monteverdi, "La leggenda," 217–26; A. Rossi, *Santa Maria in Vulturella* (Rome, 1905), 5–32. Rossi convincingly demolished the legendary antiquity of the shrine and proposed a founding date in the twelfth century. A wooden relief signed by a "Master Guilelmus," the fragment of an altar in Santa Maria in Vulturella, depicts both the dedication of the church by Pope Sylvester and the miraculous stag with the half-length figure of Christ in the antlers, an abbreviated reference to the conversion of Eustace. The relief was first mentioned and considered to be a work of the fourth century by the Jesuit scholar Athanasius Kircher in an early study of the Eustace cult, *Historia Eustachio-Mariana* (Rome, 1665), 120–31. Rossi (*ibid.*, 49–68, Pl. VII) described the relief as an Abruzzese work of the twelfth century. P. Toesca, *Storia dell'arte italiana, I. Il Medioevo* (Turin, 1927), 904 n. 59, confirmed this dating but did not specify the regional style.

[11]Piccirilli, "Notizie degli Abruzzi," 210.

[12]The earliest record of the church of Sant'Eustachio in Platana in Rome is from the late eighth century, although only the campanile of 1190 survives from the medieval structure. According to legend, the church was built on the site of Eustace's house; see M. Armellini, *Le Chiese di Roma*, 2nd ed. (Rome, 1942) I, 525. In Bologna the *Matricola* of a Società di Sant'Eustachio is preserved from the year 1258; see D. Fava, *Tesori delle biblioteche d'Italia–Emilia e Romagna* (Milan, 1932), 292.

[13]For thirteenth-century French texts of Eustace's life, see *La Vie de saint Eustache, poème francais du XIII^e siècle*, ed. H. Petersen (Paris, 1928) and *La Vie de saint Eustache*, ed. J. Murray (Paris, 1968). Before the Gothic period, the Northern representations of Eustace are restricted to a few isolated images, mainly on capitals in Romanesque churches; see L. Réau, *L'iconographie de l'art chrétien*, III, 1 (Paris, 1958), 469–71. St. Hubert of Liège, a figure of seventh-century legend, did not appear in the visual arts until the fifteenth century; not until the sixteenth century is the image of the miraculous stag to be considered an illustration of an episode in Hubert's life parallel to that of the Conversion of Eustace (Réau, *ibid.*, III, II, 661).

[14]See G. Kaftal, *The Iconography of the Saints in Tuscan Painting* (Florence, 1952), cols. 356–60 (the Campodigiove shutters are illustrated in figs. 406–09) and *The Iconography of the Saints in Central and South Italian Painting* (Florence, 1965), cols. 416–21. In the important trecento fresco cycle of the Life of St. Eustace by Vitale da Bologna at the Abbey of Pomposa, the iconography is mainly the painter's personal invention and bears virtually no connection with other known images of the same themes; see C. Gnudi, *Vitale da Bologna* (Milan, 1962), 55–56 and Pl. LXXXIX–XCVII.

[15]Panofsky, "Dürer's *St. Eustace*," 5–9.

Northern type is found in the Conversion scene from the thirteenth-century Eustace window in the north aisle of Chartres (Fig. 9).[16] While the panel now in Grand Rapids (Fig. 4), which initiated the Campodigiove cycle, partakes of the Southern tradition to the extent that Christ is shown in bust length, essentially the iconography is of the Northern "contemplative" type. An innovative feature, however, is the shifting of the stag to the same side of the scene as the horse, so that Eustace kneels before both animals—exactly the format Dürer would use some century later. In depicting the *Second Appearance of Christ to Eustace* (Fig. 5), a scene to my knowledge unique to the Campodigiove series, the painter simply adapted the iconography of the Conversion by omitting the stag and rendering Christ as a half-length figure hovering over the landscape.

Inevitably, the fantastic vision of Christ led to the popularity of the Conversion of Eustace over all other representations of this early Christian saint, so that only this episode exists in enough examples from both Mediterranean and Northern sources to allow even the broadest generalizations on the iconography. Nonetheless, the variations within the French tradition itself in the treatment of other scenes of the saint's life, and the clear connection of the Campodigiove *custodia* panels with one or the other of such depictions, suggest that more than one lineage of Northern models had been established and disseminated by the thirteenth and fourteenth centuries. For example, the treatment of the scene of Eustace's Baptism is fundamentally different in contemporary cathedral windows. In an ambulatory window at Sens, the ritualistic aspect is underscored, with the participants restricted to the saint, the officiating bishop, and a kneeling server (Fig. 10).[17] At Chartres, the scene is given a more narrative accent by the expansion of the number of clergy and the inclusion of the saint's wife (Fig. 9). The painter of the *custodia* adopted this latter type, but in keeping with the more familiar narrative mode of the trecento, the formality has been relaxed by moving the font to the side to provide space for both the wife and sons (Fig. 3). With the *Flight from the Plague-Ridden City*, an unmistakable connection again exists between the renderings of the scene at Chartres and Campodigiove (Figs. 6 and 9). Only a common model could explain the choice of an identical nucleus of action for this episode—the mother grasping the child's hand, and the solicitous father turning to them as they flee.[18] At Sens, this scene is nothing more than a reversed variation on this format, while in a window in the Chapel of St.-Savinien in the same cathedral, the iconography is totally distinct (Figs. 10 and 11). In the episode of the Abduction of the Sons, it is now the ambulatory window at Sens that presents the closest parallel to the *custodia*, in the central placement of Eustace and the balancing of the lion and

[16]Y. Delaporte–E. Houvet, *Les Vitraux de la cathédrale de Chartres* (Chartres, 1926), I, 398–404 and II, Pl. CLXVII–CLXIX. Panofsky referred to a different Eustace window at Chartres, one in the north transept in which the iconography is more transitional, in that the pursued stag looks back at Eustace, and the Christ figure is shown in bust length rather than on the Cross ("Dürer's *St. Eustace*," fig. 4 and Delaporte–Houvet, *Les Vitraux*, III, Pl. CCXLVII). The Index of Christian Art at Princeton has been an invaluable source for Northern materials in this brief iconographical investigation.

[17]For an analysis of the two windows at Sens dedicated to St. Eustace (ambulatory and chapel of St.-Savinien), see L. Bégule, *La Cathédrale de Sens* (Lyon, 1929), 48–49 and 55–56.

[18]Other media than panel painting and stained glass reveal the use of such common models. For example, in the early-fourteenth-century Hewer casket, the *Flight* is depicted with only slight modification (R. Koechlin, *Les Ivoires gothiques français*, Paris, 1924, Pl. LXV). In a late fourteenth-century sculptured retable in the Musée de Cluny, the *Baptism* is identical with another distinctive stained-glass version of the scene, that in the north transept window at Chartres, in which the participants include Eustace, the bishop, and the saint's wife and children (cf. J. Braun, *Der christliche Altar*, II, Munich, 1924, Pl. 208, and Delaporte–Houvet, *Les Vitraux*, III, Pl. CCXLVI).

wolf at either side (Figs. 3 and 10). At Sens, the heraldic arrangement of the animals comple-
ments the frontality of the saint's orant pose. Again, in the Italian version, while the format
is essentially the same, the sequential and emotional aspects of the story are heightened by
turning the animals in the same direction within the strictly divided landscape, and by
transforming the gesture of prayer into an anguished beating of the breast.[19] In a unique
change from this symmetrical type, the window at Chartres presents the story in two roundels
(Fig. 12), one devoted to Eustace and a rampant lion in a partial version of the heraldic form,
and the other to the wolf in what seems more a moment from the hunt than of fierce abduction.
Within the lower registers of the same window (Fig. 9), the designer has given a rare attention
to the introductory scene of the chase from the Eustace legend, and now that theme is echoed
in a different context. Such emphasis on animals was appropriate to a window dedicated by
furriers.

The parallels between the Chartres glass and the *custodia* cycle are again evident in the
episode of the Appearance of Eustace before Trajan, in spite of the reversal of the major
figures (Figs. 3 and 12). But the contrast of the kneeling French Eustace with his Italian
counterpart is informative. In the panel, Eustace takes the last step in his urgent journey, and
thus links the three scenes of the *Return*, the *Appearance before Trajan*, and the *Departure for the
Wars* into a close narrative sequence. Some common model must again have provided the
two imperial court settings with arcaded backdrops crowned by architectural elements
suggestive of a palace. Ironically, it is in the *custodia* panel that these fragments of architecture
are most Gallic in flavor, with florid crockets and a slender pinnacle. In the final episode, the
Brazen Bull, we turn away from these apparent correspondences with Northern iconography
to the clear dependence on a Byzantine model, such as the image in that *summa* of martyrdoms,
the tenth-century *Menologion of Basil II* (Fig. 13).[20] Here the cast is reduced to Eustace and his
family in the massive animal-cauldron, unlike the Northern versions at Sens and Chartres,
in which the executioners and the stokers of the fire are included (Figs. 10 and 12). The
ritualistic nature of the martyrdom is heightened in the *Menologion* by placing Eustace and his
wife side by side in frontal, orant poses with the sons applied like small icons against each
parent, a device recalling the hierarchic *Kyriotissa*. While the *custodia* painter's treatment is
less rigid, the four figures are clustered into a strict progression from the frontal Eustace to
the three-quarter Theopista and the sons in profile behind them (Fig. 3). After a series of
intimate moments in the narrative, the iconic formality of this end to the Eustace story
strengthens the parallel between the episode and the Resurrection of Christ.

[19]Two unusual trecento versions of the abduction episode
are noteworthy. In a miniature from the shop of Pacino di
Bonaguida, the lion and wolf are shown back to back in strict
symmetry, while Eustace runs through the river in panic. The
immediately adjoining *Conversion* is linked to this scene by the
bizarre heraldic grouping of the rampant stag and lion (see R.
Offner, *Corpus*, III, VI, 232 and Pl. LXVIIIb). The *Abduction* is
the principal subject of a small altarpiece attributed to Martino
di Bartolommeo in the Società di Esecutori di Pie Disposizioni
in Siena (cited by Kaftal, *The Iconography of the Saints in Tuscan
Painting*, col. 357). Here the figure of Eustace is enlarged to
serve as a central effigy, while the lion and wolf at either side

and a Madonna and Child above are introduced as accessory
elements. In the only published reproduction of this work, a
heavy nineteenth-century frame, now removed, subdivides
these parts so as to give the semblance of a polyptych; see
P. Rossi, "I pittori senesi della fondazione Biringucci,"
Rassegna d'arte senese (XI, 1915), 51, illus. opp. 50; attributed to
the school of Taddeo di Bartolo.

[20]Vatican Cod. Gr. 1613, c. 53; the identical format is used
for the *Martyrdom of S. Pelagia*, c. 96 (*Codices e Vaticanis Selecti*,
VIII, *Il Menologio di Basilio II*, Turin, 1907; also, K. Weitzmann,
Die byzantinische Buchmalerei des 9 und 10 Jahrhunderts, Berlin,
1935, 30).

Since the first mention of the Campodigiove *custodia* early in this century, stylistic labels have been attached in abundance either to the ensemble or to the scattered fragments, but they have never been subjected to an analysis that might help to localize the work with some degree of assurance. The variety of schools proposed ranges from Venice to Tuscany and underscores the difficulty in attempting to tie works of an essentially provincial flavor to a specific tradition.[21] The provincial artist generally creates a hybrid by choosing from the random experience of more sophisticated styles and then submitting these elements to a process of simplification whereby draftsmanship is schematized, modeled forms are reduced to patterns of color, and the elements of a design are assembled into a rudely additive order. In the *Flight from the Plague-Ridden City* (Fig. 6), an inflexible line describes the figures and at the same time flattens them into overlapping silhouettes. Planarity is reinforced by unmodulated areas of local color chosen from a limited palette. The forest green of Eustace's tunic is topped by the scarlet mantle, a sharp note repeated in the lining of the mother's robe and the tunic of the child accompanying her. In a naïve game of color chiasmus, the son with Eustace is clothed in the same yellow-green used for the mother's dress and mantle. These stark shapes seem like the pieces of a collage applied against the barren, greenish-gray rocks. A painter so adept at "cutting and pasting" as a method of design and so untroubled by the demands of spatial logic could understandably devise the new placement of the stag above the horse in the Conversion scene, an example of the ease with which the unsophisticated artist may break from canons of an iconography in the additive assemblage of a composition.

If inherent elements of the style lead to the conclusion that the Eustace cycle is the work of a provincial painter, likely therefore to remain nameless, there is still the need to establish the place and time both of the stylistic traditions on which he depended as well as of his own activity. The original location of the *custodia* in a remote village in the Abruzzi might have influenced the view that the artist was a native of that region, but no element of the style marks these panels as from that provincial school. And the same disclaimer holds for tracing roots in the more advanced traditions of the nearby regions of Umbria and The Marches onto which indigenous Abruzzese styles were so often grafted.[22] If instead, as I believe, the Campodigiove *custodia* is the product of an exclusively Tuscan "culture," the work incorporates so wide a range of Tuscan influences that to limit the source to one shop or school is too restrictive, although Offner's proposal of a painter close to Lorenzo di Niccolò Gerini did isolate an important factor in the style.[23] Our unknown artist's mixed vocabulary typifies

[21]Published attributions referring to the entire cycle are as follows: Piccirilli, "Notizie degli Abruzzi," 216, Tuscan school; Van Marle, *Development of the Italian Schools*, v, 378, close to the panels of the life of St. Catherine in the Gallery at Aquila, the work of an Abruzzese master under Florentine influence; P. Toesca, *Il Trecento* (Turin, 1951), 692 n. 219, Venetian school; Kaftal, *The Iconography of the Saints in Tuscan Painting*, col. 357, Tuscan school?, early fifteenth century. Unpublished attributions of the cycle recorded on a photograph in the Frick Art Reference Library are as follows: Perkins (1923), school of the Abruzzi, ca. 1400; Offner (n.d.), close to Lorenzo di Niccolò Gerini. Attributions of individual panels: Art Gallery, Grand Rapids, Suida (unpublished), Marchigian school, perhaps by Pietro di Domenico da Montepulciano, and close to the St. Lucy panels in the Gallery at Fermo; B.B. Fredericksen–F. Zeri, *Census of Pre-Nineteenth-Century Italian Paintings in North American Public Collections* (Cambridge, Mass., 1972), 393 and 582, Abruzzese, fourteenth century (uncertain).—Private collection, Washington, D.C., E. Sandberg Vavalà (unpublished), Agnolo Gaddi.—Art Market, Paris (present whereabouts unknown), see n. 4, above.

[22]The limits of this brief essay do not permit a contrast of the *custodia* with works of the Abruzzese school. The reader is referred to Van Marle, *Development of the Italian Schools*, v, chaps. I, II, v. The connection of the Eustace series with either the work of the Marchigian Pietro di Domenico da Montepulciano or the Venetian School is without foundation (see n. 21).

[23]See n. 21.

the eclecticism of much of Tuscan painting at the turn from the trecento to the quattrocento, when styles were compounded from the interactions of shops within a single city or through the complex exchanges among the schools of Florence, Siena, and Pisa in particular. But in the Campodigiove cycle the various derivations have not coalesced, so that a descriptive label for the style must be as hyphenated as the method of composition itself.[24] The severe contours of figures, the strict parallelism in the alignment of forms, and the compositional gravitation toward an implied vertical axis tie the panels into the lineage of Orcagnesque painting, which provided a central Florentine idiom that survived until the turn of the century with such masters as Niccolò di Pietro Gerini, Mariotto di Nardo, and Lorenzo di Niccolò. Among these retardataire Florentines it was Lorenzo who tended most to schematize the forms he had inherited from the Gerini shop and from Spinello Aretino, so that his style, which already tended toward primitivism, could have served a provincial painter as a point of contact with the Florentine mainstream (Figs. 14 and 15).[25] The palette of the Eustace panels strikes the astringent color chords of the Orcagna-Gerini tradition, a spectrum devoid of the buoyant Gaddesque notes of pink, lemon yellow, and light blue. Jacopo di Cione, the long-surviving bridge from Orcagna to the Gerini shop, had favored a scenic device in which a narrative is played against landscape cresting to the double slopes of a knife-sharp horizon and a broad reach of gold ground. The *Three Maries at the Tomb* (Fig. 16) from the San Piero Maggiore Altarpiece by Jacopo and his shop could have given the impulse for so distant a reverberation as the *Conversion of Eustace* (Fig. 4).[26] Contemporaneously in Siena, Luca di Tommè was shaping the meeting of land and gold into a similar double scythe, an instance of the continuing dialogue between the shops of Florence and Siena.[27] The broad, uncomplicated stylizations of Jacopo di Cione's rock forms, which persisted in the abstract Florentine backdrops of the later trecento, are replaced in the Eustace scenes by the enfolding shapes of deeply channeled mountains and grottoes and swirling ascents to the horizon, all from the repertoire of the Sienese school. Close analogies may be drawn between the *Second Appearance of Christ to Eustace* (Fig. 5) and Bartolo di Fredi's fanciful stage flat for his *Adoration of the Magi* (Fig. 17), or between the trenched, concave ground plane of Taddeo di Bartolo's *St. Dominic* scene (Fig. 18) and the *Flight from the Plague-Ridden City* (Fig. 6), or between the corrugated grotto in Taddeo's *Adoration*,[28] and, again, the *Flight*, or the *Conversion of Eustace*

[24]Whether the painter, working in a style formed in Tuscany, actually executed the work in that region or in the Abruzzi is a moot point. Numerous Italian painters carried their styles from one region to another, beginning with the conglomerate activities at Assisi or with such major Tuscan masters as Giotto and Simone Martini at Naples. The Sienese Taddeo di Bartolo ranged as wide afield as Genoa and Perugia. The Emilian Andrea da Bologna worked principally in The Marches, where in a reversed influence he absorbed provincial characteristics into his style; see Van Marle, *Development of the Italian Schools*, IV, 427-36, and L. Serra, *L'arte nelle Marche*, I (Pesaro, 1929), 297-304.

[25]While it has been traditional since the nineteenth century to consider Lorenzo di Niccolò to be the son of Niccolò di Pietro Gerini, there is evidence that this was not the case and that the painters were simply collaborators (B. Cole, "A New Work by The Master of The Arte della Lana Coronation," *Burlington Magazine*, CX, 1968, 215 n. 7; unfortunately, the

source of this revision, Colnaghi's *Dictionary of Florentine Painters*, does not give the documentary basis for attaching the cognomen Martino to the name of Lorenzo di Niccolò). For further examples of the work of Lorenzo di Niccolò, see B. Berenson, *Italian Pictures of the Renaissance, Florentine School*, I (London, 1963), figs. 386-96.

[26]For other comparable parts of the San Piero Maggiore Altarpiece, see R. Offner-K. Steinweg, *Corpus of Florentine Painting*, IV, III (1965), Pls. III 16-18. The *Flight by Sea* (Fig. 7) from the Eustace cycle suggests that another Florentine source may have been the type of boat scene repeated with variations by every generation of the trecento (Berenson, *Italian Pictures ... Florentine School*, figs. 47, 51, 176, 247, 353, and Kaftal, *Iconography of the Saints in Tuscan Painting*, fig. 428).

[27]For example, the *Crucifixion* by Luca in the M.H. De Young Memorial Museum, San Francisco (Shapley, *Kress Collection*, fig. 157).

[28]S. Symeonides, *Taddeo di Bartolo* (Siena, 1965), Pl. LXXXIII.

(Fig. 4). The rocky forms in Andrea Vanni's *Descent into Limbo* (Fig. 19) could have been the matrix for the long slope and towering boulders in the scene of *Eustace Returning to the Emperor's Court* (Fig. 8). If the principal roots of figure style and composition in the Campodigiove *custodia* lie in the Orcagnesque modes of mid-century Florence, the landscape forms share an inheritance from the seminal art of Pietro Lorenzetti, most notably in the predella of his Carmelite altarpiece.[29]

Since the stylistic currents of Florentine and Sienese trecento painting on which the painter of the Eustace cycle depended were carried without interruption into the quattrocento, it would not be inappropriate to place the work in the first years of the new century. As our quest, however, has been for a generic definition of place and time rather than for a specific attribution or even an approximate year, I believe that a dating in the late trecento better characterizes the vintage of the forms that were adopted. By the beginning of the fifteenth century, even the adherents to those shopworn Florentine and Sienese models which had given the painter of the Eustace cycle his primary vocabulary were absorbing the fresh and activating force of the International Style.[30] The humble painter of the Campodigiove *custodia* had not yet attempted to pronounce the secure language of the trecento with a new accent.

THE UNIVERSITY OF MICHIGAN

[29]G. Rowley, *Ambrogio Lorenzetti* (Princeton, 1958), II, figs. 96 and 97. Together with the Sienese aspect of the landscape, the group of riding figures in *Eustace Returning to the Emperor's Court* (Fig. 8) is reminiscent of Ambrogio Lorenzetti's equestrian passages in the Palazzo Pubblico frescoes (Rowley, *ibid.*, figs. 212 and 222).

[30]Such changes are vividly demonstrated in the contrast between Lorenzo di Niccolò's *Coronation of the Virgin* in San Domenico, Cortona, 1402, and that by him in Santa Croce, Florence, 1410 (Berenson, *Italian Pictures . . . Florentine School* figs. 394 and 396.)

Michelangelo and Domenico Ghirlandaio

EVERETT FAHY

Theories about Michelangelo's early development are usually linked with untenable attributions. In the present paper some of those relating to panel paintings, frescoes, and drawings will be discussed. Although Michelangelo's apprenticeship to Ghirlandaio is a documented and well-known fact, surprisingly little information has been discovered about the precise relationship between the two artists. In 1488 the thirteen-year-old Michelangelo was placed for three years with the then highly regarded, forty-year-old master. What did he learn? How long did he actually remain with Ghirlandaio, and when did he leave to study in the Medici garden? What share of responsibility, if any, did he have in the execution of Ghirlandaio's murals in Santa Maria Novella? As with everything associated with Michelangelo, the bibliography on these questions is enormous.[1] Yet the few known facts are merely repeated by one writer after another, sometimes given different emphasis, at worst disguised with literary embellishments. One is left with old uncertainties or new hypotheses. But there can be little doubt that Michelangelo learned the fundamentals of art from Ghirlandaio. Like so many members of the atelier, he must have assisted with some of the panel paintings that were produced during the late 1480s. More importantly, he climbed the scaffold in the lofty choir of Santa Maria Novella and became acquainted there with the craft of fresco painting that would soon occupy him for years in Rome.

Among the panel paintings associated with Michelangelo, only the Doni tondo is universally accepted as his work. There is little sense of Ghirlandaio's style in its complex and monumental design, but technical features, such as its carefully applied tempera and bright palette, have often been cited as evidence of Michelangelo's debt to Ghirlandaio. The astonishing quality of the tondo unfortunately reappears in no other panels ascribed to Michelangelo, with the possible exception of the unfinished *Entombment of Christ* in the National Gallery, London.[2] But considerations of quality have not inhibited a host of misattributions. A feeble lunette over Ghirlandaio's *Madonna* in Lucca Cathedral, for example, has been assigned to Michelangelo. Ghirlandaio, however, must have painted the altarpiece before Michelangelo was born, so the suggestion does not carry much conviction.[3] A similar lunette over Ghirlandaio's late altarpiece at Rimini has also been assigned to Michelangelo,[4]

[1] The most useful studies are: H. Wölfflin, *Die Jugendwerke des Michelangelo* (Munich, 1891); K. Frey, *Michelagniolos Jugendjahre* (Berlin, n.d., but probably 1907); A. Bertini, *Michelangelo fino alla Sistina* (Turin, 1945); C. de Tolnay, *The Youth of Michelangelo* (Princeton, N.J., 1947); and P. Barocchi, ed., *Giorgio Vasari: La vita di Michelangelo nelle redazioni del 1550 e del 1568* (Milan–Naples, 1962), 5 vols. For the most recent speculation about Michelangelo's beginnings, see C. von Holst, "Michelangelo in der Werkstatt Botticellis?," *Pantheon* (xxv, 1967), 229–335.

[2] I accept the *Entombment* as a wholly autograph work, as do the authors of the booklet recently published by the National Gallery, *Michelangelo's Entombment of Christ: Some New Hypotheses and Some New Facts* (London, n.d.). S.J. Freedberg, *Painting of the High Renaissance in Rome and Florence* (Cambridge, Mass., 1961), 1, 257 terms it "of Michelangelo's conception, and in part of his execution."

[3] P.E. Küppers, *Die Tafelbilder des Domenico Ghirlandajo* (Strassburg, 1916), 15, rejects the suggestion, made in an early guidebook, that Michelangelo painted the lunette.

[4] C.F. Marcheselli, *Pitture delle chiese di Rimino (con nuove aggiunte di altre cose notabili, antiche, e moderne)* (Rimini, 1754), 48. Both the lunette and the predella of this altarpiece were painted by the Master of the Spiridon Story of Joseph.

but the attribution has quite rightly been ignored by all students of Ghirlandaio and Michelangelo.

The youthful Michelangelo has been credited with paintings that were done by artists only remotely connected with Ghirlandaio. The *Manchester Madonna* in London is a case in point.[5] In the past it was mistakenly regarded as a Ghirlandaio. But because it is unfinished— as are some authentic works of Michelangelo—it gradually came to be accepted as an early Michelangelo. This was a plausible hypothesis as long as the *Manchester Madonna* remained the unique example of this putative early phase in Michelangelo's development. But at least six other paintings are now associated with the *Manchester Madonna*. As Zeri pointed out, they share so many minute details of drawing, handling, and overall design that they must be be viewed as a group made by an independent painter who is not in any way to be confused with either Ghirlandaio or Michelangelo.[6] By subtracting the pictures by the Master of the Manchester Madonna from Michelangelo's oeuvre-list, the aggregate of the latter's total output adds up to a more restricted and historically accurate sum.

A half-length *St. John the Evangelist* (Fig. 1), which has crept into the Michelangelo literature, should also be rejected. It is a curious painting executed in tempera on panel, 51.5×53 cm., representing the saint with his hands clutched before him and his chin abruptly turned up, as he gazes vacantly into the sky. Published in 1953 by Goldscheider, it has turned up in several books on Michelangelo. Longhi, one of the writers who has accepted it as authentic, unknowingly provided a clue that helps to eliminate the possibility that the young artist had anything to do with it.[7] He published a copy of a lost altarpiece from which the panel was cut down. The copy (Fig. 2), now in the church of San Cristoforo a Canonica near Certaldo, is an ungainly *Lamentation over the Dead Christ* flanked by Sts. Christopher and John the Evangelist. The latter corresponds exactly with the fragmentary panel of *St. John*, not only in the design of the figure but in the details of the landscape background as well. While Longhi was prepared to accept the lost altarpiece as a puerile enterprise by the great Buonarroti, its bloated figures and clumsy design are characteristic of the mature style of Raffaello Botticini, an obscure son of Francesco Botticini, who was active during the first decades of the sixteenth century—largely in provincial centers to the east of Florence, such as Empoli, Luccardo, and Certaldo.[8] In 1508 he painted another *Lamentation* (Fig. 3) which, though more compactly organized, shows the same heavy-handed rendering of draperies, vapid facial types, and awkward postures as those in Fig. 2; compare, for example, the two

[5]The early attributions to Ghirlandaio are recorded by C. Gould, *National Gallery Catalogues: The Sixteenth-Century Italian Schools (excluding the Venetian)* (London, 1962), 95–97. It appears to have been published for the first time as a Michelangelo by G.F. Waagen, *Treasures of Art in Great Britain: Being an Account of the Chief Collections of Paintings, Drawings, Sculptures, Illuminated Mss., Etc.* (London, 1854,) II, 417. Waagen's attribution was adopted at the exhibition "Art Treasures of the United Kingdom," held in 1857 at Manchester, from which the picture takes its name. This attribution is still maintained by Gould and is accepted by E. Carli, *Tutta la pittura di Michelangelo* (Milan, 1960), 23, who cites other authorities in agreement with him.

[6]"Il Maestro della Madonna di Manchester," *Paragone* (no.

43, July 1953), pp. 15–27.

[7]L. Goldscheider, *Michelangelo: Paintings, Sculpture, Architecture* (London, 1953), 207, no. 11–8, pl. XVI: R. Longhi, "Due proposte per Michelangelo giovine," *Paragone* (no. 101, May 1958), 62–64.

[8]See F. Zeri, "Raffaello Botticini," *Gazette des Beaux-Arts*, (LXXII, 1968), 159–70. In addition to the works mentioned by Zeri, the following pictures can be ascribed to Raffaello: *Pietà*, Oxford, Christ Church, No. 56; *Holy Family*, Rudolf Ergas, Florence (sold, Hugo Helbing, Munich, November 24, 1931, lot 97); *Madonna of Mercy*, Bologna, Pinacoteca, erroneously published as a late Lorenzo di Credi by G. dalli Regoli, "Un Presunto Innocenzo da Imola," *Critica d'arte* (XIV, 1967), 32–41.

figures of the bearded St. Joseph of Arimathea, the mourning Virgins, and the repetition of the motif of clasped hands. Raffaello Botticini was unquestionably the author of the *St. John the Evangelist*. This firm attribution eliminates another apocryphal work from Michelangelo's early career.

Several frescoes have been identified as Michelangelo's juvenilia. Beginning with the first edition of Vasari's *Lives* (1550), there has been a tradition that he worked with Ghirlandaio in the Tornabuoni Chapel of Santa Maria Novella. The proposal that he executed some of the frescoes there seems to go back to the 1836 edition of Vincenzo Fineschi's guide to Santa Maria Novella.[9] The idea was taken up by Charles Holroyd, who went so far as to assume that Michelangelo "transferred cartoons for Domenico and painted draperies and ornaments." He even suggested that Michelangelo painted the nude with a "sinister expression" in his eyes, seated on the steps in the scene of the *Presentation of the Virgin in the Temple*.[10] But Vasari does not state that he painted anything; he only mentions a drawing Michelangelo made in the chapel one day while Ghirlandaio was away. The drawing supposedly was a realistic portrayal of the scaffold, some painting equipment, and a few of the apprentices.[11] It was so impressive, Vasari reports, that upon seeing it Ghirlandaio exclaimed that his student had far surpassed him.

Similar stories of Michelangelo's precocious talent have led critics to assume that he made the most stylistically advanced parts of the Tornabuoni frescoes. Such an assumption, however, is based on a misconception of the way the frescoes were planned. Marchini, who recently attempted to identify Michelangelo's incunabula with some exceedingly beautiful passages in the scenes of the *Death and Assumption of the Virgin* and the *Baptism of Christ*, follows this mistaken notion.[12] He assigns to the thirteen- or fourteen-year-old Michelangelo some of the most daring and grandiose figures in the entire fresco cycle. But the monumental scale of these figures, which are located near the top of the chapel, must have been determined by Ghirlandaio himself when he designed the cartoons for the frescoes. He consistently made allowances for the change in scale that results from the viewer's low vantage point on the floor of the choir and nave of the church; hence, all the figures in the uppermost frescoes are enlarged, so that some are almost twice as tall as those in the lower tiers. The execution of the uppermost frescoes, likewise, is handled with greater freedom, and in general the forms are broadly painted, as opposed to the tight, realistic portrayal of the Tornabuoni family and its entourage in the frescoes closer to the spectator's eye level.

If Michelangelo had a hand in painting these frescoes, it is unlikely that his contribution was more than that of the other young assistants in the workshop. Like them, he must have been occupied with menial tasks, and if he ever had opportunity actually to work with a

[9] *Il forestiere istruito in Santa Maria Novella di Firenze*, ed. G. Giuliani (Florence, 1836), 25. So far, I have been unable to see this book, but according to R. Salvini, "Michelangelo as Painter" in *The Complete Work of Michelangelo* (London, 1965), I, 161, Fineschi suggests that Michelangelo did some of the frescoes in Santa Maria Novella.

[10] *Michael Angelo Buonarroti: with Translations of the Life of the Master by his Scholar, Ascanio Condivi, and Three Dialogues* from the Portuguese by Francisco d'Olanda (London, 1903), 99.

[11] The passage (reprinted by Barocchi in her edition of Giorgio Vasari: *La Vita di Michelangelo*, I, 8) reads as follows: "si misse Michelagnolo a ritrarre di naturale il ponte con alcuni deschi, con tutte le masserizie dell'arte e alcuni de que' giovani che lavoravano."

[12] "The Frescoes in the Choir of Santa Maria Novella," *Burlington Magazine* (XCV, 1953), 327–28.

paint brush, it probably was to color some inconspicuous area.[13] From Ghirlandaio's preparatory drawings for the frescoes, it can be established that the compositions were carefully designed long before the painting began. The possibility that the young painter made bold innovations in the design of the frescoes seems all the more unlikely when one considers the delicate character of the wooden Crucifix that he carved around 1491 for the prior of Santo Spirito. It has none of the grandeur or *terribilità* of the mature Michelangelo; on the contrary, it is characterized by the care, elegance, and preciosity of a young artist still involved with the technical means rather than the expressive content of a work of art.[14]

Turning to Michelangelo's early drawings, one finds a striking similarity to Ghirlandaio's draftsmanship. This is particularly evident in the pen-and-ink sketches, which both artists modeled with cross-hatching to indicate lighting and three-dimensional effects. Michelangelo seems to have developed this manner of drawing by copying preparatory studies for Ghirlandaio's frescoes. As Gilbert recently demonstrated, the famous group of early Michelangelo drawings believed to have been copied from Masaccio's *Sagra* are undoubtedly connected with a preparatory sketch by Ghirlandaio for his fresco in the Sassetti Chapel of Santa Trinita showing *St. Francis Resuscitating the Spini Child*.[15] The early Michelangelo drawings are thus indebted to Ghirlandaio for more than their technical characteristics.

In the Musée de Lille there is a pen-and-ink drawing of a draped standing figure (Fig. 4), which Berenson and, more recently, Berti have identified as an early work made by Michelangelo in connection with Ghirlandaio's frescoes in Santa Maria Novella.[16] Both writers assume that it is one of the earliest of Michelangelo's drawings to come down to us. Initially, Berenson catalogued it as a work of Francesco Granacci, noting that its style was "remarkably close to that of the very young Michelangelo." Later, in October 1911, he decided that Michelangelo must have drawn it himself, a conclusion he reconfirmed in 1929, 1934, and 1938—and which is reiterated in the posthumous edition of the *Florentine Drawings*, 1961. Berenson even went so far as to associate the sheet with a passage in Vasari's "Life of Michelangelo": "Avvenga che uno de'giovani che imparava con Domenico, avendo ritratto

[13]Since the role of assistants in fifteenth-century Florentine workshops is not well understood, special importance attaches to Andrea di Giusto's memoirs, published by G. Gaye, *Carteggio inedito d'artisti dei secoli XIV.XV.XVI. pubblicato ed illustrato con documenti pure inediti* (Florence, 1839), I, 212. Andrea assisted Benozzo Gozzoli at San Gimignano. Although he specifies the frescoes he painted ("di mia mano sono tutte le sante che sono nello squanco della finestra magore, e i 4 appostoli, 2 per lato bassi dell'archo della chapella, e la magore parte de fregi allato a bottacci"), it is almost impossible to distinguish them from the parts which one assumes Benozzo did on his own. Some interesting remarks about workshop procedures are made by E. Camesasca, *Artisti in bottega* (Milan, 1966); see especially the chapter entitled "L'artista-impresario."

[14]For the wooden *Crucifix*, see M. Lisner, "Michelangelos Krucifixus aus S. Spirito in Florenz," *Münchner Jahrbuch der Bildenden Kunst* (XV, 1964), 7–36. For the reaction of some scholars to Lisner's discovery, see "A Missing Michelangelo," *Life*, February 21, 1964, 45–52. The attribution to Michelangelo appears to be accepted by most well-known authorities. Only Longhi (in conversation, 1965) and Middeldorf (in the *Life* article, p. 52) doubt the attribution, but they have not published their reasons for doing so.

[15]Creighton Gilbert, "The Drawings Now Associated with Masaccio's Sagra," *Storia dell'arte* (no. 3, 1969), 260–78.

[16]B. Berenson, *The Drawings of the Florentine Painters*, amplified ed. (Chicago, 1938), II, nos. 984 and 1475A; idem, *I disegni dei pittori fiorentini* (Milan, 1961), II, nos. 984 and 1475A; L. Berti, "Drawings," in *The Complete Work of Michelangelo*, II, 382 401 n. 2.

The drawing is done in ink with white highlighting on rose-tinted paper, 25 × 12.4 cm. It was tentatively ascribed to Maso Finiguera by H. Pluchart, *Musée Wicar: Notice des dessins, cartons, pastels, miniatures et grisailles* (Lille, 1889), 49–50; and it was catalogued as a possible early work of Michelangelo in 1956 at the exhibition, "De Giotto à Bellini: Les primitifs italiens dans les musées de France," Paris, Orangerie des Tuileries, 1956, no. 148. L. Dussler, *Die Zeichnungen des Michelangelo: Kritischer Katalog* (Berlin, 1959), 252, no. 547, rejected Berenson's attribution and described it as an anonymous Florentine drawing done about 1480–1490. When the drawing was most recently exhibited ("Dessins Italiens du Musée du Lille," Amsterdam–Brussels–Lille, 1968, catalogue no. 64, illustrated pl. 12), it was described as a copy by Michelangelo after a figure in Ghirlandaio's fresco of the *Assumption of the Virgin* in Santa Maria Novella.

alcune femine di penna, vestite, dalle cose del Grillandaio, Michelagnolo prese quella carta e con penna più grossa ridintornò una di quelle femmine di nuovi lineamenti."[17]

Unfortunately, the supposed connection with the Santa Maria Novella frescoes is illusory. What Berti and Berenson failed to recognize is that the drawing is connected with the figure of Emperor Augustus in Ghirlandaio's fresco over the entrance to the Sassetti Chapel (Fig. 5). The posture of the figure and the fall of its drapery are indeed so nearly identical that it must be regarded either as a preliminary study or as a copy from the fresco. The view that the study was made by the young Michelangelo after the figure in the fresco or after a lost preliminary drawing for the figure by Ghirlandaio is inherently improbable, and it is more likely that the drawing is an autograph preparatory study by Ghirlandaio. Its handling is not difficult to reconcile with that of other studies he made for the Sassetti Chapel frescoes, and the fact that it could be attributed to Michelangelo is an interesting illustration of the intimate connection that undoubtedly exists between the graphology of Michelangelo's earliest authenticated drawings and that of his master.[18]

THE FRICK COLLECTION

[17]See Barocchi ed., Giorgio Vasari: *La vita di Michelangelo*, I, 7; II, 77 n. 64.

[18]Several months after this article went to the printer, Irving Lavin kindly informed me that Peter Meller also realized that the drawing at Lille is connected with Ghirlandaio's figure of Augustus. His observation was reported by Charles de Tolnay in a lecture, "I Disegni della gioventù di Michelangelo e un suo disegno inedito nella Farnesina," delivered in Rome on November 28, 1973, and published in *Accademia Nazionale dei Lincei: Quaderno No.* 193 (Rome, 1974), 6–7, fig. 6. Prof. de Tolnay regards the drawing as a literal copy by Michelangelo after Ghirlandaio's fresco or after a lost drawing by Ghirlandaio.

L'Ancien Trône d'émaux de Notre-Dame à Guadalupe et la naissance du Style international en Castille

MARIE-MADELEINE GAUTHIER

A Notre-Dame de Guadalupe, en Estramadure, prieuré fondé en 1340 par le roi de Castille Alphonse XI pour rendre grâce de sa victoire sur les Maures à l'emplacement d'un antique sanctuaire de la Vierge,[1] puis monastère chef d'ordre des Hiéronymites, sont conservés six admirables émaux historiés. Le visiteur ne les trouve ni dans le trésor, ni dans le musée, car ils décorent le flanc majeur d'un grand coffret, l'*Arca del Sacramento* ou *de los esmaltes* (Fig. 1) ; affecté à la réserve du Saint Sacrement pendant la Semaine Sainte, il est appelé donc aussi le *Coffre du Jeudi Saint ;* on le garde au prieuré, dans la chapelle à reliques de la basilique.[2]

Les six plaques presque carrées d'émaux translucides sur argent de basse-taille (Figs. 5 à 10) sont arrangées en échiquier avec des plaques d'argent repoussé, figurant des histoires de la Passion. Les archives du monastère permettent d'attribuer cette façon à un artiste castillan célèbre, Frère Jean de Ségovie, dit "el platero" (l'argentier), actif pendant la seconde moitié du quinzième siècle, et qui fut le chef d'un atelier d'orfèvrerie à Guadalupe même.[3]

[1]Cette statue miraculeuse avait guéri une peste à Rome du temps de St. Grégoire ; ce pape l'envoya par mer à St. Léandre, archevêque de Séville. Plus tard, pour la sauver de l'invasion arabe, les chanoines l'emportèrent dans la montagne et l'enterrèrent, placée en un sépulcre avec une inscription l'authentifiant ; elle resta ignorée pendant plusieurs siècles, jusqu'à son apparition à un vacher suivie d'une résurrection, et jusqu'à son "invention." La légende de l'Image, son culte et l'histoire du monastère sont si étroitement liés que, du quinzième au vingtième siècle, l'historiographie ne les a jamais dissociés, cela d'autant mieux que les mêmes sources narratives, juridiques et artistiques, abondantes et bien conservées restèrent sur place à la disposition des religieux jusqu'au début du dix-neuvième siècle : E. Sarrabio Aguareles–A. Correa–A. Alvarez, *Inventario del Archivo del Monasterio Nuestra Señora de Guadalupe* (Cáceres). Junta tecnica de archivos, bibliotecas y museos, 21. (Madrid, 1958.)

Dès le quinzième siècle, la tradition érudite instaurée par les Hiéronymites a donné à Guadalupe ses propres historiens : le P. Diego d'Ecija (m. 1534), *Libro de la invención de esta Santa imagen de Guadalupe y de la erección y fundación de este monasterio, y de algunas cosas particulares y vidas de algunos religiosos de él, por el padre fray Diego de Ecija*, introd. por Fr. A. Barrado Manzano. Biblioteca extremeña, 9 (Cáceres, 1953) ; Fr. G. de Talavera, *Historia de Nuestra Señora de Guadalupe, consagrada a la Soberana Magestad de la Reyna de los Angeles, milagrosa patrona de este Santuario* (Toledo, 1597) ; Fr. J. de Sigüenza, *Historia de la Orden de San Gerónimo* (Madrid, 1600–1605), publiée de nouveau en 1907-1909 par Garcia dans la série Nueva Biblioteca de Autores Españoles, 8 et 12 ; Le P.F. de San José, *Historia universal de la primitiva y milagrosa imagen de Nra Señora de Guadalupe* (Madrid, 1743) ; J.V. Yañez, *Compendio histórico de la antigüedad, excelencias y prodigios de Nuestra Señora de Guadalupe*, 2e éd. (Madrid, 1820) ; Le P.G. Rubió, *Historia de Ntra. Sra. de Guadalupe o sea Apuntes históricos sobre el origen desarrollo y vicisitudes del Santuario* (Barcelona, 1926), pourvu d'une riche bibliographie, 531–34 ; Le P.A. Alvarez O.S.B., *Guadalupe: arte, historia y devoción mariana*, prologo de D. Pedro de Lorenzo

(Madrid, 1964), mise à jour la plus récente des connaissances.

[2]Son utilisation à cet effet est attestée avant la fin du seizième siècle par Talavera, *Historia de Nuestra Señora de Guadalupe :* 196 : "Tenemos un arca para el Jueves Santo, en qual estè el santissimo Sacramento, que tiene mas de sesenta marcos de plata, y lo demas delle de bronce dorado, hermoseada de muchas piedras preciosas, y adornada de grandes relieves, y historias de mucho artificio y primor" ; ces derniers mots nous paraissent qualifier les émaux. Le coffre mesure 132 cm. de long sur 100 cm. de haut et 55 cm. de large ; l'âme de bois de pin est menuisée de caissons (Alvarez, *Guadalupe*, 196). Il ne subsiste plus une seule pierre précieuse. Les divers guides du pèlerin ou du touriste ont transmis fidèlement, avec plus ou moins de précision, ces indications en reproduisant l'*Arca :* E. Tormo y Monzo, *Monasterio de Guadalupe*, trad. de E. Bertaux. El Arte en España (Barcelona, s.d.), 8, 40–41, fig. Fr. I. Acemel–Fr. G. Rubió, *Guía ilustrada del monasterio de Ntra. Sra. de Guadalupe* (Sevilla, 1912 ; 2e éd. Barcelona, 1927); C.G. Villacampa, *Grandezas de Guadalupe* (Madrid, 1924); C. Callejo Serrano, *El monasterio de Guadalupe*. Los Monumentos cardinales de España, 21 (Madrid, 1958), 82–83 et fig. p. 90.

[3]Fray Juan de Segovie pourrait avoir été le fils d'un autre argentier appelé aussi Juan de Ségovie, laïc cité dans un document financier du monastère en 1464. Fray Juan est mentionné dès 1458 avec grand éloge par le père Fr. Gonzalo de Illescas pour avoir dessiné le projet de son sépulcre. On peut donc supposer que, natif de Guadalupe, il fut élevé dans le monastère et y fit son apprentissage d'argentier à l'atelier sous la direction de son père, comme le suppose Rubió, *Historia de Ntra. Sra. de Guadalupe*, 431, art. 695. L'auteur de sa nécrologie, écrivant au début du seizième siècle, lui attribue "mille" pièces d'orfèvrerie, toutes disparues, hormis le coffret des émaux ; le grand ostensoir du Saint-Sacrement ; la custode eucharistique qui se trouvait dans le Sanctuaire jusqu'à l'arrivée des troupes françaises sous Napoléon ; et un volet de fermail représentant la Cène. Sur le remploi des émaux, cf. *infra*, n. 8.

Ce coffret a été à son tour dépouillé de toutes ses pierreries et d'une grande partie de son parement repoussé, sur le flanc postérieur et les côtés étroits. Son délabrement et son désordre iconographique interdisent même d'assurer que la disposition échiquetée actuelle des émaux et des reliefs soit due à Jean de Ségovie, bien que ce soit l'état déjà consigné vers 1777. Néanmoins, les dimensions, la composition géométrique à caissons et les témoignages anciens engagent à estimer à vingt environ le nombre initial d'émaux remployés dans cet ensemble composite.[4] Car les six sujets historiés en émail—I. *Annonciation* ; II. *Les Mages prenant congé d'Hérode* ; III. *Adoration des Mages* ; IV. *Jésus parmi les Docteurs au Temple* ; V. *Le Sermon sur la Montagne* ; VI. l'*Entrée à Jérusalem*—forment une suite si discontinue qu'elle atteste la richesse du programme originel, lequel embrassait donc au moins un cycle de l'Enfance et un cycle de la Vie publique du Christ. Chaque thème pouvait en outre avoir été traité en une séquence de scènes voisines, comme le prouvent encore aujourd'hui les deux épisodes concernant les Rois Mages (Figs. 6 et 7). Six émaux étant encore conservés sur le flanc majeur, il eût pu s'en trouver six sur l'autre flanc, deux sur chaque côté et peut-être quatre sur le toit ; sa structure similaire à caissons les eût pu loger. Le diagramme ci-dessous rend compte de l'état présent.

Face	Ornement	13 Relief (VII bis) *Mise au Tombeau*	14 Relief (V) *Crucifixion*	15 Relief (V bis) *Crucifixion*	Ornement
7 EMAIL IV *Jésus au temple parmi les Docteurs* (Fig. 8)	8 Relief (III) *Flagellation*	9 EMAIL II *Les Mages prenant congé d'Hérode* (Fig. 6)	10 Relief (I) *Jardin des Oliviers*	11 EMAIL VI *Entrée à Jérusalem* (Fig. 10)	12 Relief (VII) *Mise au Tombeau*
1 Relief (IV) *Portement de Croix*	2 EMAIL I *Annonciation* (Fig. 5)	3 Relief (IV bis) *Portement de Croix*	4 EMAIL III *Adoration des Mages* (Fig. 7)	5 Relief (VI) *Descente de Croix*	6 EMAIL V *Sermon sur la montagne* (Fig. 9)

Or, les documents assurent que ces émaux firent partie du trône-tabernacle le plus ancien dont fut dotée l'antique Image de Notre-Dame. Cette statue, véritable germe du monastère, est toujours et depuis le quatorzième siècle dissimulée sous de multiples vêtements précieux qui ne laissent paraître que son visage : "Sa stature sacrée a un peu moins d'une aune ; à la vue de qui la contemple, le socle et le couronne la font paraître plus haute. Sa couleur est

[4] La face principale était au dix-huitième siècle dans l'état présent, comme l'assure le dessin rehaussé, illustrant l'inventaire du trésor et reproduit par P. Müller, *Jewels in Spain 1500–1800* (New York, 1972) pl. coul. VII face p. 78. Je n'ai pu consulter le manuscrit en question, dont le texte renseignerait peut-être sur l'état des trois autres faces vers 1777, et qui est catalogué par Sarrabio Aguareles *et al.*, *Inventario*, sous le no. 82:

"Inventario de las joyas y efectos de la sacristia que comprende los años 1679 a 1770," 588 p., ou no. 83 : "Descripción de las alhadas de la Virgen de Guadalupe con noticias históricas con grabados y dibujos a la acuarela." Ceci m'est une occasion de remercier Monserrat Alcolea des Archives Mas, Barcelone, pour l'aide extrêmement efficace et rapide qu'elle a amicalement apportée à la documentation présente.

brune, à cause de sa grande antiquité, le visage est très beau, si grave et si parfait qu'il montre bien la majesté de la Dame."[5] Si elle ne date pas, comme le veut la légende, du sixième siècle, elle remonte au moins à l'époque romane.

Les débuts de cette effigie avaient été modestement bucoliques : lors de son invention miraculeuse, elle ressuscita une vache, puis le fils du vacher. Alphonse XI, selon la tradition guadalupéenne, visita son sanctuaire avant la bataille de Salado, le 29 octobre 1340, lorsqu'il mit en déroute le roi du Maroc et deux cent mille Maures. En tout cas, le butin qu'il offrit à Guadalupe y était encore visible au dix-septième siècle et, par la charte de Cadalso du 25 décembre 1340, il fondait une petite communauté placée sous le patronage de l'archevêque de Tolède ; celui-ci en nommait le prieur, d'abord séculier. Le troisième d'entre eux, Diego Fernandez (1368-1384), doyen de Tolède, obtint des rois de Castille, Alphonse XI puis ses fils, les dotations et privilèges assurant la construction de la basilique, du cloître, des fontaines.[6] Henri II le Magnifique, comte de Transtamare, prétendant porté au trône dès 1366 et seul roi en 1369 après le meurtre de son frère Pierre le Cruel, accorda en 1374 des droits souverains au monastère. Il les assortit de tels dons que Diego fit exécuter un très beau et très riche retable, offrant un trône-tabernacle d'argent repoussé et d'émaux pour enchâsser la très sainte Image de Notre-Dame,[7] aidé en cela par les offrandes des pèlerins.

Son successeur, le quatrième prieur Juan Serrano (m. 1403), dut bientôt démanteler cet ornement pour en fournir l'argent à Don Juan de Castille, après la défaite d'Aljubarrota, pendant la guerre de Portugal en 1385.[8] La grandeur de Guadalupe était cependant assurée pour l'avenir. Car les Hiéronymites, à l'origine tertiaires réguliers groupés par Grégoire XI en 1373 sous le gouvernement de Pedro Fernandez Pecha, établirent en 1389 à Guadalupe la maison-mère de leur Ordre, appelée à un glorieux destin.[9]

La nécrologie de Guadalupe atteste la présence d'orfèvres, religieux ou laïcs, au monastère depuis sa fondation. A "Fray Juan de Villareal, prêtre, argentier," décédé en 1398, on est donc tenté avec Rubió d'attribuer l'ancien trône de Notre-Dame. Pourtant un nom et une

[5]Nous traduisons Talavera, *Historia de Nuestra Señora de Guadalupe*, fol. 159v, qui se fait l'écho tardif des convictions byzantines en matière de portraiture sacrée, résumées par T. Velmans récemment, "Copies, répliques, faux," *Revue de l'Art* (no. 21, 1973), 5-29. En effet, de la Vierge Marie, reprend Talavera : "On dit qu'elle était de taille moyenne, qu'elle avait le teint brun, les cheveux peu blonds, les yeux verts très beaux, les sourcils arqués et noirs, le nez un rien grand, les lèvres de corail et le tracé du visage un peu aquilin ; le tout exprimait une grande beauté et une majesté affable." Barrado Manzano, éditeur en 1953 d'Ecija, *Libro de la invención*, complète le cap. 1 : "Origen et invenció de la imagen de N.S. de G.," dont les données se retrouvent aussi chez tous les auteurs cités n. 1 *supra*, par des textes poétiques populaires récents ; ils perpétuent la légende et les miracles, qu'on trouve recensés par Yañez en 1820, *Compendio histórico*.

[6]Cf. Ecija, *ibid.*, cap. 11 : "Erección y fundación de la iglesia y monasterio N.S. de G." ; et Talavera, *Historia de Nuestra Señora de Guadalupe*, fol. 24v ; Rubió, *Historia de Ntra. Sra. de Guadalupe*, 20-21.

[7]Comme l'écrit avant 1534 Ecija, *ibid.*, 86 : "Y como las limosnas que en este tiempo venian a esta iglesia de Guadalupe fuesen muchas, este venerable varón [Diego Fernandez] hizo hacer un retablo de plata como en casamento, muy rico y suntuoso, de muy ricos esmaltes, en que estuviese la santa

imagen. . . ." Talavera, *ibid.*, fol. 24 : "Fu tanta la limosna que de todas partes, y toda suerte de gente en su tiempo se ofrecie a nuestra Señora (conser los gastos excesivos) a que se fabricasse un precioso retablo de plata purissima, con todo el primor arte y grandeza possible." Cf. Acemel-Rubió, *Guía ilustrada*, 20-21, 111-12. Callejo Serrano, *El monasterio de Guadalupe*, 90.

[8]Ecija, *ibid.*, 86 : "retablo . . . el qual despues se deshizó en tiempo del rey don Juan I y del prior don Juan Serrano ; y el rey se llevó la plata y, en pago de ella, dió las escribanias y portazgos de Trujillo y su tierra, las cuales prove hoy día el prior y convento de Guadalupe, come cose suya ; y de los esmaltes que quedaron de este retablo se hizó despues una rica arca de plata dorada en que se encierra el Santo Sacramento el Jueves de la Cena." Talavera, *ibid.* : "Aunque [el retablo] no duró en esta forma mucho, por ser la necessidad en que al Rey don Juan pusieron las continuas guerras, tantas que la tuvó don Juan Serrano, sucessor del priorato, de que se fundiesse, para ayuda a pagar la gente del exercito." Données reprises et simplifiées par Rubió, *Historia de Ntra. Sra. de Guadalupe*, 430 ; Alvarez, *Guadalupe*, 195.

[9]Le Fr. J. de Sigüenza, *Historia de la Orden de San Gerónimo* (Madrid, 1600), cap. IV-XVI et cap. XVII-XIX ; 2e éd., Garcia, Madrid, 1907), 14-94.

date suffisent si peu à déterminer un style que les auteurs ont cherché à attribuer les émaux subsistant à des ateliers connus : on les a crus limousins, toscans ; ils nous ont paru plutôt catalans[10] car ils appartiennent à la tendance italo-gothique dont la capitale incontestée fut, dans la seconde moitié du Trecento, Barcelone, et l'aire de prédilection, le royaume d'Aragon.[11]

C'est pourquoi nous procédons ici à leur examen réaliste, seule démarche susceptible de fonder sur des caractères intrinsèques leur définition en termes de géographie artistique. Mieux même, datables avec certitude d'une brève période de dix ans, celle du règne d'Henri de Transtamare, 1369–1379, ils deviennent, aux yeux des historiens, les témoins objectifs du goût catalan qui prévalut alors, fait surprenant, à la cour royale de Castille : ils élucident la manière dont les raffinements en furent propagés par le milieu ecclésiastique tolédan, dans la province reculée d'Estramadure. Leurs traits formels, la sélection de leurs partis de composition et d'exécution, sont les indices visibles et tangibles d'une réalité moins évidente, sur laquelle ils renseignent cependant en profondeur: destination cultuelle de l'image décorée ; intention narrative, didactique et spirituelle de l'émailleur et de son patron ; environnement natif, naturel et culturel de l'artiste et de ses aides ; mentalité des destinataires. Tout cela est incorporé aux composantes du style.

Les termes des inventaires les plus anciens laissent peu de doute sur la structure qu'affecta l'objet, sur sa fonction cultuelle et sur sa destination. Car le quatorzième siècle connut le développement du retable, intégrant en une seule construction l'image vénérée, placée dans l'axe de l'autel, avec la contretable, cet écran qui s'étend, depuis la fin du douzième siècle au moins, à l'arrière de l'autel sur toute sa longueur.[12] Peinture (Fig. 2), sculpture (Fig. 3), ou orfèvrerie (Fig. 4), l'image médiane est une représentation glorifiée du Sauveur, de la Vierge ou d'un saint, occupant en hauteur la part majeure du champ médian, tandis que des images complémentaires, figures ou histoires d'une échelle moindre, sont distribuées sur les ailes en deux ou plusieurs registres. Il en résulte une construction qui va se développant en triptyque ou en polyptyque, plan ou articulé, bientôt assis sur une prédelle (Fig. 2). Si les

[10]A la suite de ma tentative pour classer stylistiquement ces émaux dans le milieu d'artistes oeuvrant pour la cour d'Aragon (M.-M. Gauthier, *Émaux du moyen âge occidental*, Fribourg–Paris, 1972, 242–43 ; cat. 194, fig. p. 242), j'ai été conduite à l'étude présente. Tentant d'intégrer la teneur des informations les plus anciennes (cf. *supra* n. 4 à 8), on est amené à adopter la conviction critique de Rubió, *Historia de Ntra. Sra. de Guadalupe*, 43, n. 1, article 694, fondée sur le nécrologe, document qui atteste l'existence d'argentiers à Guadalupe dans la seconde moitié du quatorzième siècle, et l'installation d'un atelier : "Los religiosos plateros abundaron desde la fundación del Monasterio. Todavia no era terminado el siglo XIV y ya el Necrologio Guadalupense nos refiere la muerte de Fray Juan de Villareal (Ciudad Real) sacerdote, platero, fallecido el año de 1398." Bien plus tard, Callejo Serrano (*El monasterio de Guadalupe*, 82, 83, 90, 98) ne se prononce pourtant pas sur cette attribution, mais fait une allusion dubitative à l'opinion de ses prédécesseurs qui auraient tenu ces émaux pour "limousins," parmi eux Tormo y Monzo, *Monasterio de Guadalupe*, 18. Les érudits du dix-neuvième siècle n'avaient pas distingué origine, provenance, destination initiale et lieu de conservation : Ch. Davillier, *Recherches sur l'orfèvrerie en Espagne au moyen âge et à la Renaissance* (Paris, 1879), 172–73 ; N. Sentenach y Cabañas, "Bosquejo histórico sobre la orfebreria española," *Revista de Archivos, Bibliotecas y Museos* (XIX, 1908), 177. V. Juaristi, *Esmaltes con especial mención de los españoles* (Barcelona, 1933), 223, fig. 63, pl. XXXI, les crut toscans.

[11]C. R. Post, *A History of Spanish Painting*, II (Cambridge, Mass., 1930), 121, figs. 123, 124, et *passim*, et, essentiellement J. Gudiol Ricart, *Pintura gótica*. Ars Hispaniae (Madrid, 1955) ; *idem La pintura medieval en Aragón* (Zaragoza, 1970).

[12]Ces "images" plastiques du Sauveur, en général crucifié, de la Vierge ou d'un saint, ont subsisté depuis le haut Moyen Age. Leur fonction peut être soit rituelle ou même sacrée, si elles comportent une logette à reliques ou une réserve eucharistique (M.-M. Gauthier, "Les Majestés de la Vierge 'limousines' et méridionales . . .," *Bulletin de la Société nationale des Antiquaires de France* (1968 [1970], 69 n. 1) soit simplement dévotionnelle, si elles ne comportent aucun réceptacle. Leur destination initiale a souvent changé au cours des siècles, ainsi que leur vertu miraculeuse. Le nombre immense des exemplaires, conservés ou mentionnés par les inventaires, a jusqu'ici découragé une discussion d'ensemble de ces images sculptées ou peintes, dans leur relation cultuelle avec l'autel et le retable.

L'intégration qui nous occupe se fonderait sur l'étude générale de J. Braun, *Der christliche Altar in seiner geschichtlichen Entwicklung*, II (Munich, 1924), 5e partie : "Das Retabel," 277–540 ; 6e partie : "Der Altar, der Reliquienaltar und Sakramentsaltar," 546–645 ; en particulier les sections traitant des représentations majeure et secondaires, 427–44, et de l'iconographie, 446–88.

histoires encadrant la grande image et si la forme plane avec la peinture ont triomphé dans les deux péninsules méditerranéennes,[13] on a volontiers allié une statue médiane à des ailes peintes ou sculptées, dès le treizième siècle, en Espagne du Nord.[14] La statue n'est pas nécessairement contemporaine de l'aménagement. Dès le treizième siècle, le trône des majestés de la Vierge s'abrite sous un baldaquin.[15] Pour clore les flancs de ce *tabernaculum*, doté de fonctions liturgiques et offert à des dévotions spirituelles que dicte le texte même des litanies, on articule les ailes du retable en volets mobiles. Le chef-d'oeuvre du genre est le retable majeur de la cathédrale de Tortosa (Fig. 3).[16]

De petits triptyques de dévotion privée, en or, en ivoire ou en émail, ainsi articulés en tabernacles autour d'une statuette de la Vierge reine[17] offrent le modèle réduit du premier retable à trône-tabernacle de Notre-Dame de Guadalupe (Fig. 4). Les collections princières du milieu du quatorzième siècle, en particulier celle de Louis d'Anjou, comportaient ces objets "cloants," qui passèrent de mode vers 1400, puisqu'ils sont absents des inventaires de Jean de Berry, où ne figurent presque plus que des statuettes ou saynètes émaillées, ces "joyaux" sans retable.[18]

Les particularités iconographiques du trône de Guadalupe, en comparaison avec les programmes d'histoires répandues sur les retables de la Vierge (Figs. 2 à 4), sont frappantes. Puisque aucune raison ne justifie le désordre actuel des émaux, la lecture en est faite ci-dessous selon l'arrangement du récit évangélique.

L'*Annonciation*, au caisson 2 (Fig. 5), dispose la Vierge à notre droite, assise de trois quarts dans sa chambre, sur un banc que supporte une estrade basse et au-devant de la courtine qui sans doute dissimule le lit. Les cheveux dénoués, elle est vêtue d'une robe décolletée, d'un manteau couvrant les épaules et dont le pan oblique est ramené sur les genoux. Le visage incliné, elle croise les deux mains devant sa poitrine dans le geste rituel de l'humilité. A l'extérieur de la chambre, au devant d'un mur de clôture, s'est posé de profil, un genou en terre, l'archange qui porte droite sa baguette d'ambassadeur; il profère son message, comme l'indique son geste d'orateur. Un bouquet de lis dans un canthare occupe

[13]J. Braun, *ibid.*, en particulier 463, 468–69; E.B. Garrison, *Italian Romanesque Panel Painting* (Florence, 1949), *passim*; H. Hager, *Die Anfänge des italienischen Altarbildes, Untersuchungen zur Entstehungsgeschichte des toskanischen Hochaltarretabels* (Munich, 1962); Post, *A History of Spanish Painting*, II, v. *supra* n. 11; Gudiol Ricart, *Pintura Gótica, passim*; J. Ainaud de Lasarte, *Museo de Arte de Cataluña, Arte románico, Guìa* (Barcelone, 1973), no. 15784, p. 28 coul.; no. 3939, 3938, 3933, pp. 166–69; no. 15825, 15820, 4377, pp. 250–52.

[14]J. Braun, *ibid.*, 463; Gudiol Ricart, *Pintura e imaginería románica*. Ars Hispaniae IV (Madrid, 1950), *passim*; Retable à trône-tabernacle de la Vierge en Majesté, provenant de Santo Domingo de la Calzada en Castille, au Musée Marés de Barcelone (no. 45 de l'exposition "L'Europe gothique, XIIe–XIVe siècles," Paris, 1968). Ainsi les deux volets du retable articulé provenant de San Martí Sarrocor, et le retable provenant de Gerbs en pierre polychrome, au Musée des Beaux-Arts de Catalogne, Barcelone, inv. 25071.

[15]*Majesté de la Vierge* de Notre-Dame de Lorette; cfr. Gauthier, "Les Majestés de la Vierge," 92–93.

[16]On voit déjà ce genre de retable représenté dans les vitraux de Chartres au second quart du treizième siècle; cfr. Y. Delaporte, *Les trois Notre-Dame de Chartres*, 2e éd. (Chartres,

1965), figs. 16 et 18. Sur le retable de Tortosa, vers 1350; cfr. Braun, *Der christliche Altar*, 431; sur les parties peintes, J. Gudiol Ricart, *Pintura gótica*, 85, fig. 56, attribuées à Francesco d'Oberto.

[17]M. Frinta, "The Closing Tabernacle, a Fanciful Innovation of Medieval Design," *Art Quarterly* (XXX, 1961), 103–18. Retable de dévotion articulé en tabernacle, ouvrage parisien vers 1325–1340 à Milan, Musée Poldi-Pezzoli: cfr. Gauthier, *Emaux du moyen âge occidental*, pl. coul., p. 257–59, cat. 207; R. Koechlin, "L'Atelier des Tabernacles de la Vierge," *Gazette des Beaux-Arts* (XCVII, 1905), 453 sq.

[18]Inventaire de Louis d'Anjou, vers 1379, éd. A. de Laborde, *Notice des émaux, bijoux et objets divers exposés au Musée du Louvre*. II. *Documents et glossaire* (Paris, 1853), 7 no. 37: "Un tabernacle d'argent, doré et esmaillé, séant sur six lyons couchiés, et dedans le tabernacle a un ymage de Nostre Dame en estant tenant son enfant, et en la main destre tient une branche de rosiers à roses vermeilles, e a le tabernacle portes cloans, esmaillées par dedans de la vie de Nostre Dame, et par dehors cizellées de lozanges, et dessus la tête de l'ymage a une voute . . ."; cfr. *ibid.*, no. 42, 62, 67; J. Guiffrey, *Inventaires de Jean duc de Berry (1401–1416)*, I (Paris, 1894), II (1896), A 15, 28, 194, 335; A 35, 61, 63, 65; B 971.

l'arcade qui le sépare de la Vierge. Derrière le mur, s'élèvent les arbres d'un jardin et, au-dessus de la terrasse qui couvre la chambrette virginale, s'allonge l'édifice rectangulaire du Temple.

Les *Rois mages prenant congé d'Hérode*, au caisson 9 (Fig. 6), vont, une pyxide à la main, l'un d'eux désignant l'étoile ; ils s'éloignent à cheval, vers la gauche, au travers de collines plantées d'arbres et parsemées de touffes de grosses fleurs. A droite Hérode couronné, l'épée au côté, suivi d'un groupe de serviteurs, a franchi une porte de Jérusalem pour escorter les voyageurs. Deux puissantes tours carrées, à l'étage supérieur desquelles saillent des échauguettes, flanquent le porche dominé aussi par une échauguette. La muraille crénelée enferme plusieurs édifices ; les larges fenêtres et les baies qui les percent indiquent le luxe du palais d'Hérode.

Dans l'*Adoration des Mages*, au caisson 4 (Fig. 7), de manière peu courante, la Vierge est placée à la gauche de la composition, sur une estrade basse, et assise sur une banquette au devant d'une courtine. Dans son giron, trône l'Enfant qu'elle maintient de la main droite. D'un geste tout à fait insolite, elle pose la main gauche sur la tête du nouveau-né, à demi-nu, qui bénit et tient à la main gauche un oiseau. Une petite salle cubique et plafonnée, sur le côté de laquelle se greffe la volée montante d'un escalier, abrite cette *Majesté de la Vierge*. Le premier Roi, agenouillé au bas de l'estrade, a ôté sa couronne et tend la pyxide ouverte pleine de pièces d'or ; le second, debout, désigne l'Enfant, en se retournant vers le troisième qui lève la main dans un geste de reconnaissance et d'adoration. Derrière eux, un écuyer, armé d'une lance, retient les rênes de trois chevaux. Sous leurs pas, la nature agreste du lieu est marquée par les touffes de grosses fleurs. L'étoile brille au zénith. La scène est abritée par un site tout urbain, car, au-dessus du toit, s'ouvrent les baies d'une terrasse à galerie où se profile un autre bâtiment et au flanc de laquelle s'appuie une tour, pourvue d'un auvent, entre un étage percé d'ogives et l'étage supérieur, ouvert de baies plein cintre. L'enclos où ont pénétré les chevaux est limité par un mur plan, percé d'une porte cochère derrière laquelle se profile un arbre. La paroi visible est décorée d'une peinture où deux oiseaux, perchés antithétiquement sur des arbustes, alternent avec deux lacs d'amour, au-dessus d'une frise de rinceaux.

Jésus au Temple, au caisson 7 (Fig. 8), "âgé de douze ans," a accédé par un escalier à une petite chaire murale, haut placée sous une exèdre. Par un arc brisé auquel pend une lampe, cette loge s'ouvre sur une chambre où se massent, d'abord, Marie et Joseph au pied du degré, puis les docteurs disputant, pourvus de livres par un bibliothécaire. Au-dessus du toit en terrasse, s'allonge un édifice basilical et pousse un arbre.

Le *Sermon sur la Montagne*, au caisson 6 (Fig. 9), est situé dans un paysage tout entier champêtre. Le Christ debout s'adresse à la foule des fidèles assis à gauche ; ses apôtres, nimbés, se groupent derrière lui. Le pré fleuri s'élève doucement à gauche jusqu'à une haie d'arbres et, à droite, s'escarpe en une crête rocheuse.

Dans l'*Entrée à Jérusalem*, au caisson 11 (Fig. 10), de manière inhabituelle, le cortège procède de la droite vers la gauche. Le Christ sur son ânesse bénit, suivi du groupe des apôtres, devant deux arbres d'où Zachée est absent. Les jeunes fidèles, l'un déjà dévêtu, l'autre dépouillant son vêtement, se prosternent à la hauteur de l'ânon. Quatre fidèles agitent leurs palmes, joignent les mains ou les élèvent dans le geste de la reconnaissance et de l'adora-

tion. Ils sortent de la ville par une porte surmontée d'une échauguette et flanquée de deux tours carrées que somment mâchicoulis et créneaux. Le crénelage des murs, plus bas à l'extérieur, ne laisserait pas la place à des lices bien larges; mais il indique la référence à un modèle précis de fortification à double enceinte. Les étroites meurtrières accentuent le caractère militaire de cette architecture, par contraste avec celle du palais d'Hérode.

On examinera successivement le traitement de l'espace pictural, puis les moyens d'expression dramatique, enfin les données témoignant d'une observation de la nature ou des monuments, pour situer l'art de l'émailleur castillan par rapport au goût de son pays et de son temps. Ces éléments décèlent en outre les modèles déjà anciens ou contemporains auxquels il se réfère, qu'il s'agisse de peinture, de sculpture ou d'émaillerie, en Espagne, en France et en Toscane.

L'*Annonciation* (Fig. 5) révèle avec clarté le genre de perspective que pratique notre émailleur: deux secteurs orthogonaux du même espace bâti sont articulés par un mur diaphragme évidé, qui axe la scène et que l'on voit, raccourci en oblique, au-dessus du vase de lis. Ce mur en outre sépare les deux acteurs en affectant à chacun l'atmosphère, extérieure à gauche, intérieure à droite, appropriée à son rôle. Les parois pleines du fond, élevant leur crête aux deux tiers de la composition, sont parallèles au plan pictural avec lequel coïncide, en avant, la façade rectangulaire et l'arcade de l'édicule à droite, projetées frontalement. L'édifice basilical qui se profile au-dessus de la terrasse est visé dans la même perspective, comme si l'observateur était au coin inférieur gauche du tableau. Par contre, le solivage du plafond et le bord de l'estrade instaurent des lignes sécantes aux premières lignes de fuite, comme si ces surfaces horizontales étaient observées depuis la droite, et de plus haut. Enfin la colonnette arrière de l'arc diaphragme est plantée trop bas, au pied de l'ange, en contredisant l'oblique de la terrasse qu'elle supporte.

Ainsi, en dépit de son apparence toscane, cette construction défaut aux principes des compositions siennoises comparables, ainsi celle de l'ombilic d'une des patènes de San Domenico à Pérouse (Fig. 11.) Sur cet émail, datable des environs de 1330, qui s'assortissait à un calice signé par Ugolino di Vieri et Viva di Lando, l'archange s'agenouille selon le même profil; portant cette fois les palmes de l'Annonce de la mort de Marie,[19] il est entré dans le cubiculum; l'arcade du mur de façade s'ouvre aussi vers nous, mais les deux murs latéraux sont rendus visibles en oblique, comme si trois observateurs alignaient parallèlement leurs regards.[20] On choisirait aussi à Sienne des variantes exemplaires, pour le thème de composition plus tard adopté à Guadalupe: l'une en 1316 sur le panneau de la *Maestà* de Duccio, l'autre dès 1320, sur un des gables du retable polyptyque de la Vierge à la Pieve d'Arezzo; le troisième, en émail translucide, sur le socle du Reliquaire du Corporale à Orvieto.[21] Un mur diaphragme divise l'espace et, à Orvieto, abrite le vase de lis. Le chemine-

[19] Patène trouvée en 1955 dans le choeur de San Domenico: Francesco Santi, *La Galleria nazionale dell'Umbria* (Rome, 1969), inv. no. 1016, illustrée par B. Bini, *Antichità Viva* (III₂, 1964), fig. 6, p. 59. Pour le sujet, cf. M. Meiss, *The Great Age of Fresco: Discoveries, Recoveries and Survival* (New York, 1970), 80–83 et pl.: Sinopia d'Ambrogio Lorenzetti et fresque altérée par un de ses aides, à Montesiepi, Oratoire de San Galgano.

[20] Cf. les diagrammes établis par J. White, *The Birth and*

Rebirth of Pictorial Space, 2nd ed. (London, 1967), 29, fig. 2, A au centre.

[21] Panneau du retable de la *Maestà*, avec cette composition appliquée à l'*Annonce de la mort de Marie*, cfr. récemment: J. Stubblebine, "Duccio and His Collaborators," *Art Bulletin* (LV, 1973), 185–204, fig. 4.—Gable du retable polyptyque de la Vierge à la Pieve d'Arezzo, *ibid.*, 195 et fig. 17.—Reliquaire du Corporale miraculeux de Bolsena au Dôme d'Orvieto, cfr. P. Dal Poggetto, *Ugolino di Vieri* (Florence, 1965), pl. 6.

ment de la composition et de ces divers motifs iconographiques vers Barcelone est d'abord
attesté par Ferrer Bassa dans ses fresques de Pedralbés en 1346, puis par l'enlumineur qui
exécuta, dans l'atelier du Maître de Saint Marc, vers 1350, les compléments de la décoration
du *Psautier de Cantorbéry*.[22] Là cependant, le livre sur le lutrin reprend le motif de Duccio, et la
Vierge s'agenouille (Fig. 12), innovation que ne reprendra pas l'émailleur castillan. Toutefois,
la tension horizontale suscitée par la distance qui sépare les protagonistes dans les peintures
précédentes est, réduite comme à Guadalupe, sur la "Croix des émaux" du trésor de Gérone
(Fig. 13),[23] où des édifices dont le plan de masse est insaisissable compriment l'espace dans
un quadrilobe.

Ces différences font d'autant mieux ressortir la parenté de notre émail avec le panneau
peint sans doute par Jaime Serra dans l'atelier de Ramón Destorrents (Fig. 14) sur le retable
de la Vierge provenant de Sigena au musée de Barcelone, en dépit de motifs iconographiques
différents :[24] la Vierge tient son livre ouvert, son lit n'est pas dissimulé par une courtine ;
l'archange, plus proche d'elle, a laissé sa baguette pour une rose ; de la droite du Père, planant
au ciel, émane la colombe du Saint Esprit ; la place a manqué aux arbres derrière le mur du
jardin. Néanmoins, les rinceaux légers qui ornent les panneaux de boiserie et les écoinçons
des arcades, rappelant d'ailleurs ceux de Ferrer Bassa à Pedralbés, sont à peine transposés par
l'émailleur. Le geste d'humilité de la Vierge est d'ailleurs identique, dans l'*Adoration des
Bergers* du même retable (Fig. 2) et dans l'*Annonciation* sur l'émail (Fig. 5).

La mélancolie des visages ovales sous la masse sphérique des chevelures blondes, la
joliesse de la bouche petite, charnue et un peu triste, la texture précieuse des surfaces expriment
la même délicatesse dans le raffinement d'un art de cour. On verrait des preuves de cette
manière dans les panneaux figurant l'*Annonciation* sur presque tous les retables qu'exécutèrent
entre 1360 et 1400 les peintres de la cour d'Aragon, les frères Serra ou leurs émules comme le
Maître de Rubió.[25] Intégrant d'autres menues variantes dans les motifs iconographiques, ils
composent l'espace de ce sujet selon un parti identique, développé avec plus ou moins
d'ampleur, de virtuosité et de science. Mais leurs panneaux ne connaissent jamais l'intersection
de multiples lignes de visée comme le pratique, délibérément plutôt que par maladresse,
l'émailleur de Guadalupe.

Une relation entre le volume intérieur et la masse édifiée extérieure, similaire à celle de
l'*Annonciation*, caractérise aussi l'*Adoration des Mages* (Fig. 7) et *Jésus au Temple* (Fig. 8). On y
retrouve l'organisation bipartite de l'espace disponible, partagé entre protagoniste et inter-

[22]M. Meiss, "Italian Style in Catalonia and a Fourteenth-Century Catalan Workshop," *Journal of the Walters Art Gallery* (IV, 1941), 45–87. La notable particularité de l'ange en vol remontant à un modèle perdu d'Ambrogio Lorenzetti, mais transmise précisément par Ferrer Bassa est discutée par M. Meiss, *French Painting in the Time of Jean de Berry. The Late Fourteenth Century and the Patronage of the Duke* (London, 1967), 212, fig. 709 et 710. Sur l'identification du chef d'atelier désigné comme le Maître de Saint Marc avec Ramon Destorrents, cf. J. Gudiol-Ricart, *Pintura gótica*, 61–66 et *infra* n. 24. L'implantation de colonnes supportant l'arc diaphragme de Ferrer Bassa (Meiss, "Italian Style in Catalonia," fig. 12) et la perspective plausible de son estrade expliquent les maladresses de notre émailleur qui a pu connaître ce modèle par l'inter-

médiaire d'un dessin.
[23]Gauthier, *Emaux du moyen âge occidental*, cat. 191, fig. p. 238 et 298.
[24]Gudiol Ricart, *Pintura gótica*, 79 ; à Barcelone et dans le royaume d'Aragon pour la seconde moitié du quatorzième siècle, la coopération de divers peintres, la succession de maîtres à la tête du même atelier, l'association de plusieurs artistes pour l'exécution de la même oeuvre, les relations des enlumineurs et des peintres, soulèvent des questions multiples dont Gudiol a exposé les données, ainsi que J. Domínguez Bordona, *Miniatura*. Ars Hispaniae XVIII (Madrid, 1962) pl. 144–53.
[25]Gudiol-Ricart, *ibid.*, 67, 68, fig. 44.

locuteurs. Dans l'*Adoration*, la courtine tendue derrière la Vierge escamote les difficultés de perspective comme dans l'*Annonciation* (Fig. 5) qui semble avoir emprunté ce motif plus directement de Ferrer Bassa à Pedralbés.[26] Le solivage oriente la profondeur de la chambre vers notre gauche dans les deux scènes ; mais cette donnée est annulée, dans l'*Adoration*, par l'orientation contraire des consoles soutenant l'auvent; dans *Jésus au Temple* (Fig. 8), elle est contrariée par l'articulation de la salle cubique et de l'exèdre surélevée qui communiquent, par l'ouverture d'un arc brisé, dans la paroi oblique de raccord; car au même aplomb, s'emboîte en outre le percement peu intelligible du plein cintre, dans le mur du fond, escamoté par la couleur uniforme des rinceaux en tenture derrière la chaire.

Les indices spatiaux externes adoptent des solutions qui préfigurent celles du cubisme : le mur pignon à gauche de *Jésus au Temple* fuit en une perspective étroite, prolongée par le long toit basilical ; mais celui-ci redevient parallèle au linteau de la salle, écrasant celle-ci contre le flanc de l'édifice. Sur la terrasse de l'étable, dans l'*Adoration* (Fig. 7), les étages supérieurs offrent leurs flancs à des points de vue qui divergent correctement à la manière toscane, mais la tour carrée derrière le mur développe ses facettes en paravent,[27] comme si le regard d'un autre observateur venait converger avec la première visée. Les échauguettes du palais d'Hérode (Fig. 6) hésitent aussi entre les deux orientations possibles de leurs encorbellements. En somme, l'extérieur des édifices s'ajuste tant bien que mal aux espaces intérieurs en revenant à un parti désormais archaïque, et qui consiste à les utiliser comme des encadrements architectoniques pour la composition, sans intention d'échelle relative aux personnages et avec une valeur narrative. En comparant cette vue de Jérusalem du côté du palais d'Hérode avec la vue d'Orvieto d'Ugolino di Vieri (Fig. 22), pour ne pas citer les vastes paysages urbains des Lorenzetti, on est saisi par l'accumulation des volumes compacts que l'émailleur de Guadalupe projette de bas en haut sur le champ pictural, jusqu'à annuler tout effet de distance.[28]

Pourtant, le rapport de la masse des architectures à la surface décorée n'est pas sans rappeler celui qu'instaura Giotto et celui auquel son disciple Taddeo Gaddi fut particulièrement fidèle. Un des panneaux quadrilobés de la Sacristie de Santa Croce, aujourd'hui à la Galerie de l'Académie (Fig. 15) à Florence, atteste le genre de modèles auxquels remonte, en dernière analyse, l'émail de Guadalupe.[29] Il représente l'Enfant Jésus âgé de douze ans parmi les Docteurs du Temple (Luc II : 40-51). Jésus apparaît, trônant un peu plus haut que les docteurs à l'extrémité gauche de la composition, si bien que le groupe de ses interlocuteurs, assis et debout, intègre la Vierge et St. Joseph et se répartit sur deux plans parallèles au champ pictural. Or le schéma axial auparavant de rigueur pour ce sujet, le *Synthronon*, cette réunion

[26]Cf. Meiss, "Italian Style in Catalonia," fig. 12.

[27]M. Schapiro, *The Parma Ildefonsus*. College Art Association of America, Monographs on Archaeology and the Fine Arts, XI (New York, 1964), 11-13, fig. 1 à 6.

[28]White, *The Birth and Rebirth of Pictorial Space*, 93-101, fig. 24, la *Cité du Mauvais gouvernement* dont la complexité, à gauche, a peut-être instruit le Palais d'Hérode, et fig. 25, celle du *Bon gouvernement* qu'Ambrogio Lorenzetti avait achevé en 1338-1339; R. Oertel, *Early Italian Painting to 1400* (New York, 1968), 234-35.

[29]U. Procacci, *La Galleria dell'Accademia di Firenze*, 2e éd. (Rome, 1961), p. 27, fig. p. 79, no. 8586; R. Oertel, *ibid.*, 191. Le Prof. G. Marchini voudra bien trouver ici mes remerciements pour l'opinion que lui ont inspirée les émaux de Guadalupe; ils lui semblent très italianisants; on est frappé par leur caractère florentin, malgré la saveur locale (lettre du 24 novembre 1973).

en demi-cercle des disciples autour du maître,[30] avait continué de servir de moule à la scène qui nous occupe chez les peintres byzantins, puis à Florence et à Sienne au Trecento. Elle est située dans l'abside par Giotto. Après Duccio et Barna, Ugolino di Vieri la place sous un portique du Temple, dilatant horizontalement l'espace qui sépare Marie et Joseph de l'Enfant (Fig. 16).[31] Puis on exaltera celui-ci sous un baldaquin et sur une estrade toujours plus haute, comme une autre enlumineur de l'atelier du Maître de Saint Marc en a illustré le Psaume 81 (82):1 "Deus stetit in synagoga deorum in medio autem Deus dejudicat."[32] Donc Taddeo Gaddi a eu la hardiesse de faire virer son spectateur de 90° et d'ouvrir le côté du choeur, si bien que son assemblée se présente de flanc, à main droite de l'Enfant. Fait remarquable, il retrouve en cela le parti d'un bas-relief d'Amiens qui inscrivit ce sujet, rarissime dans la sculpture gothique en France, en un médaillon quadrilobé également.[33]

Or de leur côté les peintres des rois d'Aragon restent fidèles à la symétrie du *Synthronon*, comme le prouve le retable de Destorrents-Serra provenant de Sigena (Figs. 2 et 17). Cependant, un sculpteur catalan, dès 1350, a composé le scène de profil, comme l'émailleur de Guadalupe, vers la droite : Jésus, désormais debout sur une sorte de stylobate, prêche les docteurs, assis au premier plan ou debout au second,[34] sur le retable de Tortosa (Figs. 3 et 18).

Dans ce renversement des données toscanes se décèle le caractère hispanique de l'émail (Fig. 8). La recherche d'une expression dramatique intense fait éclater le motif, qu'il s'agisse du contenu de l'image ou de sa forme. En effet, le groupe compact, qui emplit aux trois quarts le champ du tableau, est massé en bas vers la gauche. Les personnages, distribués sur deux plans parallèles et face au spectateur, sont tous orientés par une commune tension vers le point d'attraction de la scène, la toute petite figure en chaire, en haut à droite ; celle-ci est en outre soulignée en bas par une sorte de silence actif—la paroi rectangulaire, lisse mais perforée, de la cage d'escalier.

La première rangée des personnages coïncide avec le premier plan du tableau, bien que chacun profile son côté gauche au devant de la silhouette de celui qui lui fait suite. Trois alignements parallèles de jambes, de torses et de têtes contraignent les positions respectives à

[30]A. Grabar *et al.*, *Synthronon, Art et archéologie de la fin de l'Antiquité et du Moyen Age.* Bibliothèque des Cahiers Archéologiques II (Paris, 1968) ; R. Krautheimer, *Early Christian and Byzantine Architecture* (Baltimore, 1965), 76, 363 ; A. Grabar, "La 'sedia di San Marco' à Venise," *Cahiers Archéologiques* (VII, 1954), 19–34, en part. 23–27. Dans les mosaïques de Monreale, la scène apparaît parmi le cycle de l'Enfance : O. Demus, *Mosaics of Norman Sicily* (London, 1949), pl. 65 B ; E. Kitzinger, *The Mosaics of Monreale* (Palermo, 1967), 29, fig. 4, sujet absent ailleurs. Les deux groupes de docteurs, assis au premier plan, debout au second, et Jésus à droite au fond, mais trônant frontalement, apparaissent dans l'enluminure toscane, vers 1293–1300, illustrant un recueil de prières, à Florence, Laurenziana Plut. 25, 3, fol. 369v., cfr. B. Degenhart–A. Schmitt, *Corpus der Italienischen Zeichnungen 1300–1400* (Berlin, 1968), pl. 9, c.

[31]White, *The Birth and Rebirth of Pictorial Space*, fig. 15b et p. 63–64 ; C. Gnudi, *Giotto* (Milan, 1959), fig. 93 ; le panneau de Duccio, cfr. J. Stubblebine, "Duccio and His Collaborators," 189 fig. 8. La fresque de Barna à San Gimignano est illustrée par M. Meiss, *Painting in Florence and Siena after the Black Death* (Princeton, N.J., 1951), 56, 61, fig. 81, accompagnée d'un commentaire sur la présence des parents de Jésus.

[32]Meiss, "Italian Style in Catalonia," 73, fig. 28. L'enlumineur catalan réussit d'ailleurs à loger à l'avant du même compartiment le deuxième épisode de l'histoire, les remontrances de la Vierge à Jésus.

[33]W. Sauerländer, *Gotische Skulptur in Frankreich* (Munich, 1969), 146, fig. 173. Ainsi se trouve évoquée la mystérieuse filiation qui unit Giotto et ses disciples à la sculpture française classique du milieu du treizième siècle : cfr. C. Gnudi, "Le Jubé de Bourges et l'apogée du 'Classicisme' dans la sculpture de l'Ile de France au milieu du XIIIe siècle," *Revue de l'Art* (no. 168, 1969), 18–36, fig. 18 à 23 surtout. Taddeo Gaddi a d'ailleurs inventé une autre composition du même sujet, en oblique cette fois : P.P. Donati, *Taddeo Gaddi* (Florence, 1962), pl. coul. 8 et p. 18–19, cat. 33, fresque à la Chapelle Baroncelli de Santa Croce ; un parapet dissimule le bas de l'assemblée, comme sur la fresque d'Orvieto à peu près contemporaine où, avec Jésus trônant à droite sur une cathèdre très surélevée, on trouve une composition très voisine de celle de Guadalupe.

[34]Gudiol Ricart, *Pintura gótica*, 85, fig. 56, attribue les peintures des joues, sur le retable sculpté de Tortosa, à Francesco d'Oberto.

un rythme commun ; mais gestes, draperies, couleurs, diversifient ce qu' auraient de trop autoritaire ces répétitions. Surtout la convention ancienne exprimant la *disputatio*, qui fait se tourner l'un vers l'autre les visages de deux voisins, est dotée, dans sa version gothique, d'une valeur dramatique qu'intensifie la gesticulation. Dans toutes ses oeuvres et dans le quadrilobe de l'Académie (Fig. 15) en particulier, Taddeo Gaddi a certes tiré un parti expressif de ce contrepoint formel qui, chez lui, ne nuit jamais à la majesté des sentiments.[35] Or l'émailleur espagnol utilisa aussi ce motif, mais dans un esprit tout différent. Car il y incorpora la contestation. L'antithèse même lui sert à expliciter, avec beaucoup de verve, le double comique de la scène : le bibliothécaire s'élance avec son fardeau de livres à la rencontre du divin prêcheur, tandis que les docteurs se détournent de la parole vivante pour se précipiter vers les textes. La Vierge récrimine avec passion.

Cette profonde ironie des "docteurs enseignés" a animé le panneau correspondant du retable de Sigena (Figs. 2 et 17). Les livres ouverts, fermés, jetés à terre, déchirés même de fureur, interviennent avec une autorité tapageuse comme les véritables antagonistes de l'Enfant âgé de douze ans.

La véracité hispanique se révèle dans l'observation des réalités sensibles. La chaire murale où a grimpé l'Enfant (Fig. 8) est une nouveauté de l'architecture. La prédication qu'exerçaient les Ordres mendiants depuis le treizième siècle en avait déterminé la fonction et entraîné l'implantation à l'intérieur des églises. On en édifia une aux Jacobins de Toulouse, comparable à celle qui subsiste encore au réfectoire de Saint-Martin des Champs à Paris.[36] Les artistes catalans introduisent cette construction nouvelle et significative dans des histoires où le prêcheur figure ainsi de profil : il peut s'agir de St. Étienne que Ramón Destorrents a installé dans un ambon au parapet rectangulaire (Fig. 19) ;[37] ou du Christ que l'émailleur valencien de la Croix de Játiva (Fig. 20) y place, lorsqu'il s'adresse à ses apôtres après sa résurrection.[38]

Autre indice archéologique remarquable, les échauguettes ont intéressé vivement l'émailleur (Figs. 6, 10). Saillant sur deux fortes consoles, elles sont maçonnées en encorbellement et couvertes de toits de tuiles ;[39] les étroites meurtrières qui les percent empêchent qu'on les confonde avec des miradors, tels ceux que Giotto représente à Assise, dans les fresques de l'église supérieure figurant les démons d'Arezzo, ou bien à Padoue, avec les loggias qui dominent l'*Annonciation* à la chapelle des Scrovegni.[40] L'enceinte fortifiée, aujourd'hui détruite, dont fut dotée Villareal en Castille, après sa fondation en 1225 par Alfonse X, existait déjà lorsque notre émailleur supposé, Frère Jean, y vit le jour :[41] échauguettes de châteaux chrétiens ou miradors de palais andalous, il est vraisemblable que des constructions de ce genre aient été observées directement par l'artiste de Guadalupe. Mais la Jérusalem de l'Espagne n'était-elle pas Tolède ceinte de ses murailles fortifiées ?

Post a noté la "délicieuse littéralité de la vie contemporaine" qui distingue la peinture italo-gothique du quatorzième siècle. Cette fraîcheur d'inspiration a favorisé la nature

[35]Donati, *Taddeo Gaddi, passim* ; Meiss, *Painting in Florence and Siena*, fig. 40.
[36]F. de Lasteyrie, *Architecture gothique*, II (Paris, 1927), 497–502.
[37]Gudiol Ricart, *Pintura gótica*, 65.
[38]Gauthier, *Émaux du moyen âge occidental*, cat. 239, fig. p. 295.

[39]C. Enlart, *Manuel d'archéologie française*, II (Paris, 1932), 111–15 ; avec archères, p. 518.
[40]Gnudi, *Giotto*, fig. 39: Arezzo ; pl. XXVIII et fig. 84b et 85b: loges miradors à Padoue, chapelle des Scrovegni ; fig. 24a: loge et terrasse du Palais garni d'armes à Assise, église supérieure.
[41]Province de Linarès, *Catálogo monumental de España, passim*.

végétale; comme les peintres catalans, l'émailleur castillan est un paysagiste de coeur, même si, là encore, la manière lui est venue de Toscane. De beaux volumes précis, ovoïdes ou sphériques, issus de branches maîtresses bien détachées, enveloppent la feuillée que Giotto avait massée parfois en touffes rondes, mais en l'aérant par des touches et taches claires. La variété décorative des essences méditerranéennes que représenta Duccio est apparentée à celle que connaît l'émailleur. C'est toutefois Taddeo Gaddi encore qui semble être à l'origine des stylisations que l'on admire à Guadalupe, avec les palmiers en ombelles superposées qui ombragent la *Nativité*, l'*Annonce aux Bergers*, la *Résurrection*, l'*Apparition du Christ Ressuscité*, sur les quadrilobes de la sacristie de Santa Croce.[42]

Les peintres de la cour d'Aragon, émules des Toscans, qui pouvaient rafraîchir leur expérience à la vue des *huertas*, avaient repris eux aussi avec prédilection les jardins et paysages plantés d'arbres,[43] Jaime Serra en particulier (Fig. 2, *Baptême* et *Résurrection*). L'émailleur a, peut-être par observation technique directe ou à travers des recueils de modèles, transposé exactement les oliviers qui ombragent tel paysage d'Ugolino di Vieri (Fig. 21) dans l'arbre le plus proche, en avant du premier Mage (Fig. 6), avec ses trois touffes de feuilles lancéolées. Partout ailleurs, le modelé graphique inventif dont il décore sa feuillée laisserait croire qu'il rêvait des jardins andalous et connaissait leur luxuriance: bourrelets striés (Figs. 5, 6, 8), imbrications ondulées (Fig. 5), écailles laurées (Figs. 9, 10), palmes touffues (Fig. 9) suggèrent le pin, le cyprès, le palmier, le grenadier, l'oranger. Les zones concentriques gravées de stries hélicoïdales autour d'une grande fleur sont douées d'un exotisme tropical (Figs. 7, 8).

Les grosses fleurs rosacées qui, par deux ou trois, parsèment la prairie et les pentes du coteau dans le *Sermon sur la Montagne* (Fig. 9) sont insolites par leur échelle et par la manière dont leur grande taille annule la profondeur du paysage. Par leur forme, elles transposent en argent émaillé les rosaces poinçonnées sur les nimbes dorés, dans la prédelle due à Jaime Serra à Barcelone (Fig. 2); les corolles crucifères à étamines appartiennent au répertoire traditionnel de l'ornemaniste plutôt qu'à celui du naturaliste. En effet, les broderies de soie, à fond de rinceaux d'argent et d'or en relief, l'*opus florentinum*, l'utilisèrent; or un des chefs-d'oeuvre en est conservé à Manresa. La fleur crucifère parsèmera pour une grande part la décoration marginale des Heures peintes par Giovannino dei Grassi.[44]

Au prix d'une extrapolation, on retiendra ce détail comme un simple indice, renseignant sur le mode de diffusion hypothétique des ornements, migrant de l'atelier de l'enlumineur à celui du peintre, du brodeur, de l'orfèvre, voire à celui du verrier, d'une rive à l'autre de la

[42]*Joachim se retire chez les Bergers*, Chapelle des Scrovegni; cfr. Gnudi, *Giotto*, pl. XIX et p. 113; *Noli me Tangere* et l'*Ensevelissement de la Vierge* dans la *Maestà* de Duccio, cfr. White, *The Birth and Rebirth of Pictorial Space*, 345, fig. 16; *idem*, "Measurement, Design and Carpentry in Duccio's *Maestà*," *Art Bulletin* (LV, 1973), 340, fig. 9: *Entrée à Jérusalem*. Panneaux de Santa Croce par Taddeo Gaddi à la Galerie de l'Académie, cfr. R.Offner, *A Critical and Historical Corpus of Florentine Painting*, III–III (New York, 1930), pl. XIV/29.

[43]Post, *A History of Spanish Painting*, 1; A. de Bosque, *Artistes italiens en Espagne* (Paris, 1965), 36, 37; 41–43; Post, *ibid.*, II, 246, fig. 158.

[44]Broderie florentine: M. Salmi, "Il Paliotto de Manresa, e l'*opus florentinum*," *Bollettino d'Arte* (x, 1930-1931), 385 sq.; *idem*, "Stoffe e ricami," *Civiltà delle Arte minore in Toscana*

(Rome, 1973), 85–95, p. 91: pl. LXXIX et fig. 10, pl. LIII coul.; fleurs portées par les anges, sur le Paliotto brodé et signé par Gero Lapi, brodeur à Florence, conservé à la cathédrale de Manresa, donné en 1357 par Raimondo de Arca, conseiller de Pierre IV le Cérémonieux, armateur négociant avec l'Italie. Jésus au milieu du demi-cercle des docteurs est figuré de face, parmi les scènes au bandeau supérieur du Paliotto brodé par Jacobo Cambi en 1366 pour Santa Maria Novella: cfr. A. Santangelo, *I tessuti d'arte italiani* (Milan, 1959), pl. coul. 36, p. 19. L'exportation fit des broderies un des véhicules les plus importants du style florentin, comme l'a souligné Meiss, *French Painting in the Time of Jean de Berry*, 60, fig. 447, 449, 452. Facsimilé des *Heures Visconti*: M. Meiss–E. Kirsch, *The Visconti Hours* (New York, 1972), LF 18v, LF 26, LF 41, LF 51, LF 57v, LF 74v.

Méditerranée. Les églantines doubles qui, à la française, sont sculptées dans les gorges des moulures encadrant les statues, sur les piédroits de la *Puerta del Reloj*, la Porte de l'Horloge à la cathédrale de Tolède, appartiennent à la même famille.[45]

Sur les émaux du trône de Notre-Dame, cette floraison inédite décore une scène insolite (Fig. 9). Car le *Sermon sur la Montagne*, pour autant qu'il m'a été possible de m'en assurer, n'apparaît pas dans les retables espagnols de la Vierge ou même ceux de la Passion. Le texte de St. Matthieu v : 8, avait été jadis illustré de manière symbolique, avec les allégories des Béatitudes. La représentation littérale est peu fréquente dans les manuscrits du Nouveau Testament.[46] Il est notable, dans notre perspective, de constater que le sujet en a été choisi pour des reliefs du campanile de Florence ; mais la sculpture gothique espagnole semble l'ignorer.[47]

Qu'à Guadalupe le Christ apparaisse deux fois enseignant, à douze ans au Temple et pendant sa vie publique, indique un parti délibéré de l'auteur du programme. L'accent mis ainsi sur l'aspect didactique et oratoire de la mission de Jésus doit être porté au compte du prieur Diego Fernandez, doyen du chapitre de Tolède.[48] Sur le tympan sculpté de la Porte de l'Horloge, contemporain de ses fonctions, *Jésus parmi les Docteurs* est introduit au troisième registre, sujet partout ailleurs inconnu aux tympans gothiques.[49] On voit donc se préciser le milieu aristocratique de prélats tolédans qui contribua d'une part à fixer un orfèvre émailleur castillan à Guadalupe, véritable enclave tolédane en Estramadure, et d'autre part, à y préparer l'installation des Hiéronymites, qui obéissant à la règle de St. Augustin, unissaient la prédication aux exercices de la vie contemplative.[50]

En contrepartie, le style et l'exécution des émaux restituent la biographie artistique de l'émailleur. Ses compositions ont indiqué que ses maîtres ont été les peintres florentins, entre 1320 et 1340. L'examen de sa palette d'autre part nous assure à la fois qu'il est le plus grand des émailleurs espagnols du Trecento et qu'il a probablement appris l'émaillerie à Sienne même. Mais tout en usant avec virtuosité du coloris siennois, il le combine avec le dessin simplement rehaussé (Fig. 8) de souche florentine. Il s'éloigne radicalement des tonalités blondes et argentées des émailleurs de Gérone et de leurs fonds unis d'azur pâle. Il n'opacifie jamais non plus les verts et bleus par des ombres froides, comme l'auteur barcelonais du calice des Comtes de Majorque.[51] La gamme de ses bleus, azur profond et limpide, rivalise avec celle d'Ugolino di Vieri, la dépasse peut-être même par certains saphirs (l'*Annonciation*: Vierge ; l'*Entrée à Jérusalem*: Christ). Comme ce maître, il use largement du lilas, du violet, du

[45]A. Duran Sanpere–J. Ainaud de Lasarte, *Escultura gótica*. Ars Hispaniae VIII (Madrid, 1956), fig. 92.

[46]L. Réau, *Iconographie chrétienne, Nouveau Testament* (Paris, 1957), 320, cite la *Somme le Roi* (1295) de la Bibliothèque Mazarine, MS 870 ; le Sermon est inséré dans un contexte allégorique, au fol. 64v.

[47]D'après l'ouvrage général de Duran Sanpere–Ainaud de Lasarte, *Escultura gótica*, et son index iconographique.

[48]Cfr. Diego d'Ecija, éd. 1953, 85.

[49]L. Vazquez de Parga, "La Puerta del Reloj en la Catedral de Toledo," *Boletín de la Sociedad Española de Excursiones* (XXXVII, 1929), 241–65. On a souligné le caractère graphique de cette sculpture ; le programme pouvait donc avoir été suggéré par des oeuvres dessinées ou peintes, comportant ces mêmes sujets, ainsi les petits retables à scènes multiples de

l'Italie centrale ; cfr. Garrison, *Romanesque Panel Paintings*, no. 877 à Pérouse ; no. 354 et 357 à Oxford et Milan. Le sujet est d'autre part courant dans les retables peints par les artistes de la cour aragonaise (cfr. Fig. 2).

[50]Fr. J. de Sigüenza, *Historia de la Orden de San Geronimo* (Madrid, réédition 1907–1909). Je n'ai pu consulter les *Soliloques* du Frère Pedro Fernandez Pecha, fondateur de l'ordre des Hiéronymites d'Espagne, courtisan de Pierre le Cruel, compagnon d' Alfonso évêque de Jaen, qui fut en relation avec Ste. Brigitte, et qui écrivit cette oeuvre ascétique et mystique, éditée par le P.A.C. Vega, O.S.B., "Los Soliloquios de fray Pedro Fernandez Pecha, fundador de los jerónimos de España," *La Ciudad de Dios* (CLXXV, 1962), 710–63.

[51]Gauthier, *Émaux du moyen âge occidental*, cat. 193, pl. coul. p. 241.

rose, qu'il sépare par des zones d'ambre, en des harmonies très chaleureuses (l'*Annonciation*: architecture). Il surpasse en délicatesse les Siennois par la légèreté des turquoise, des gris acier, des verts jaune, posés en impalpables lavis vitrifiés (*Rois Mages prenant congé, Entrée à Jérusalem* : édifices) ; dans ces tons pâles, il égale l'émailleur parisien (Fig. 4) dont il ignore cependant les noirs anthracite et le rouge cire opaque ; de même le saumon et l'orangé anglais lui échappent. Le vert émeraude profond dont il baigne, par larges plages, les arbres et les prés, lui est très personnel (*Le Sermon sur la Montagne*). Il n'hésite pas à le faire voisiner avec un bleu d'intensité et de transparence équivalentes (*Entrée à Jérusalem*). Il recherche par la feuillée (Fig. 9), par les diaprures perlées sur les tentures (Fig. 7), par les assises horizontales sur les murs (Figs. 5, 6), par les rinceaux en tapis sur les cloisons (Figs. 5, 8), à nuancer et enrichir au maximum la texture des surfaces. Les figures font alors exception, car il préserve l'uni du modelé, leur pureté sculpturale (Figs. 8, 9). Peut-être enfin surpasse-t-il tous ses confrères par la maturité expressive des visages (Fig. 9) ou leur tendresse (Fig. 5).

La science de la composition colorée le fait jouer des alternances de tons clairs (docteurs, Fig. 8 ; fidèles, Fig. 9 ; murs et toits, Figs. 6 et 10) en opposition avec des valeurs saturées (la Vierge et Joseph, bleu profond et vert émeraude, en partie dépouillés de leur couche d'émail, Fig. 8 ; paysage, Fig. 9). L'impossibilité pour l'émailleur sur argent de réaliser le "rouge clair" et l'absence de fonds d'or empêchent de mettre en équivalence ce chromatisme avec celui d'un Duccio, autrement comparable.

Car l'analyse comparative met aussi en évidence maints traits formels inhérents, sinon à l'origine ethnique, du moins à la culture hispanique dominante chez l'artiste. L'accumulation rythmique de lignes horizontales (Figs. 5 à 8), des volumes et des figures (Figs. 8, 9), celle des ornements (Fig. 9), peut être tenue pour un caractère national. Hispanique aussi est la saveur mauresque émanant de tel détail, ainsi la frise peinte d'oiseaux sur un mur (Fig. 7) ; les longues robes ou les bliauds ajustés des Mages reflètent la mode des courtisans hantant les alcazars et les almudaynas (Figs. 6, 7). Les bonnets phrygiens des serviteurs d'Hérode (Fig. 6) sont des coiffures de pêcheurs méditerranéens. La joliesse des physionomies féminines et la gravité des faces barbues caractérisent alors l'oeuvre de Destorrents et des Serra.

La série des six plaques se trouve pourtant affectée par quelques disparates, outre l'absence de principe unificateur de l'espace déjà commenté. Les différences d'échelle entre les personnages dans leur rapport au champ décoré est la plus frappante : certaines plaques portent des figures grandes (Figs. 5, 8 et 9), les autres menues pour un décor identique d'arbres et de murailles (Figs. 6, 10), l'une même mêle grandes et petites figures, situées au même plan (Fig. 7). On verrait là la preuve de la combinaison de modèles de sources variées et de leur emploi simultané par des mains différentes, entraînées rigoureusement à la pratique d'un style commun et oeuvrant sous la tutelle d'un chef d'atelier libéral. Si cette induction est exacte, elle viendrait ajouter une donnée au faisceau grandissant de faits qui expliquent l'organisation des ateliers médiévaux et de la production artistique.[52]

[52]E. Carli, "Su alcuni smalti senesi," *Antichità Viva* (1, 1968), 1–16 ; Gauthier, *ibid.*, 217–36 ; Stubblebine, "Duccio and His Collaborators," 185 sq. ; Meiss, *French Painting in the Time of Jean de Berry. The Boucicaut Master* (London, 1968), 23–33 ; F. Avril, "Un chef-d'oeuvre de l'enluminure sous le règne de Jean le Bon : La Bible Moralisée manuscrit français 167 de la Bibliothèque nationale," *Monuments et Mémoires, Fondation Eugène Piot* (LVIII, 1973), 91–125.

Je proposerais même d'apparier par la mise en page et d'attribuer ici, à titre hypothétique, les plaques subsistantes à trois mains ou à trois moments de conception et d'exécution : à la main "florentinisante," l'*Annonciation* et *Jésus parmi les Docteurs* (Figs. 5 et 8) ; à la main castillane, les *Mages prenant congé d'Hérode* et l'*Adoration des Mages* (Figs. 6 et 7), à la main barcelonaise, le *Sermon sur la Montagne* et l'*Entrée à Jérusalem* (Figs. 9 et 10) ; cette dernière est celle d'un artiste formé à l'atelier de Ramón Destorrents et de Jaime Serra, comme les physionomies et la végétation permettent de l'avancer (Figs. 2, 14, 23).

Or une source narrative directe apprend que ces émaux du trône de Notre-Dame ne furent pas les seuls à être produits au monastère pendant le dernier tiers du quatorzième siècle. Dès sa fondation, les lampes votives avaient été parmi des objets précieux les plus généreusement offerts au sanctuaire ; elles y constituaient une véritable collection, perpétuant la prière des donateurs et illuminant la nuit du choeur.[53] Or, au "temps de Diego Fernandez, se fit et se donna, offrande des pasteurs et des seigneurs de la *Mesta*, la lampe majeure, laquelle fut exécutée par mandement de cet honorable prieur. C'est une pièce très riche, avec des émaux très riches et un grand poids d'argent qui compte 120 marcs, et on mit autour d'elle une inscription qui dit : Cette lampe fut donnée à cette église par le Conseil de la *Mesta* des royaumes de Castille, ayant mandé de la faire le prieur Don Diego Fernandez, dans l'ère de 1414" (=1382).[54]

On peut croire que le prieur Diego Fernandez qui, ancien doyen du plus riche chapitre d'Espagne, avait d'abord géré les biens de la cathédrale primatiale, sise dans la capitale majeure des royaumes de Castille, Tolède, ait fait appel aux meilleurs artistes du temps, ceux de la cour du roi. Or c'est à Jaime Serra, successeur de Ramón Destorrents et déjà peintre du roi d'Aragon Pierre IV le Cérémonieux[55] qu'Henri de Transtamare, patron royal et généreux du monastère de Guadalupe, avait commandé un retable de la Vierge où il figure en donateur et dont le panneau central est conservé (Fig. 25).[56] On s'accorde à dater cette peinture de la phase antérieure à l'accession au trône, pendant les années 1360. La prise du pouvoir par ce prince, à l'aide de Bertrand du Guesclin, dut déclencher une modification du goût à la cour de Tolède et de Séville et contribuer à introduire, dans la Castille "franco-gothique," l'"italo-gothique" du royaume d'Aragon, d'autant mieux que la nouvelle reine, Jeanne Manuel, était une princesse byzantine. On connaît d'autre part l'attachement indéfectible d'Henri II le Magnifique à la France, à son roi Charles V et à son allié Louis d'Anjou.[57]

Cette situation politique et diplomatique nouvelle en Castille explique la part de l'inspiration française dans le chef-d'oeuvre que fut le retable à trône-tabernacle de Notre-Dame. Cette inspiration se marque dans le choix du matériau, l'émaillerie translucide sur

[53]Talavera, *Historia de Nuestra Señora de Guadalupe*, fol. 186–187 "En que se trata del habito y majestad de la imagen."

[54]Ecija, *Libro de la invención*, 85.

[55]J. Gudiol Ricart, *Pintura Gótica*, 61–80 ; Domínguez Bordona, *Miniatura*, 144–53 ; Post, *A History of Spanish Painting*, II, 193 sq.

[56]*Vierge en Majesté avec le donateur et sa famille*, sur un panneau provenant de Tobéd, naguère à Saragosse, dans la collection Román Vicente, aujourd'hui à Barcelone, dans la collection Fernando Birk ; cfr. Gudiol Ricart, *ibid.*, 74 ; Post, *ibid.*, 9 et 268, rend compte de la discussion chronologique pour adopter la date haute, avant 1369.

[57]P. Lopez de Ayalá, *Crónicas de los Reyes de Castilla*, II (Madrid, 1780), texte du Testament, 115 art. 21 : "Otrosi mandamos al dicho Infante que guarda é tenga firmamente la paz é el buen amor que es puesto entre nos, é el Rey de Francia, é el Duque Dangeos su hermano : é estre mismo que la guarda á su fijo heredero de la Casa de Francia bien é verdaderamente. . . ." A. Coville, *L'Europe occidentale de 1328 à 1380*. Histoire générale dir. par Glotz, *Moyen âge*, VI (Paris, 1941), 610–14. Ballesteros y Beretta, *Historia de España*, III (Barcelone, 1920) ; E. Delachenal, *Histoire de Charles V*, III (Paris, 1916), chap. XI ; J. Valdeon Baruque, *Enrique II de Castilla : la guerra civil y la consolidación del regimen 1366–1371* (Valladolid, 1966).

N

argent de basse-taille (cf. Fig. 4), préférée, parce que plus "riche," à la peinture ou à la sculpture, habituelles et mieux appropriées, aux grandes dimensions. La magnificence du roi, du prieur et de la *Mesta* porta donc sur la taille des émaux : les plaques sont, avec celles d'Orvieto, les plus grandes que nous connaissions à cette époque. C'est donc au niveau des moyens financiers et de l'inspiration politique que la critique—décidément "aristocratique" en ce cas—situera le rôle du mécène royal.

Le texte du testament dicté par Henri de Transtamare sur son lit de mort le 29 mai 1379 est éloquent en ce qui concerne les moyens : les "joyaux" ne sont qu'un article dans la trésorerie du royaume et dans sa cassette personnelle.[58] Ils sont de l'or qui fut magnifié par l'art. Leur existence précaire, tout éphémère qu'elle fût, incorpora les images qui reflètent la grandeur et aussi l'humilité royales : la preuve de cette inspiration se lit dans le nombre exceptionnel des scènes, dont l'une nouvelle donnée, aux Rois bons et méchants, les Mages (Fig. 7) et Hérode les reconduisant courtoisement à la porte de son palais (Fig. 6). Elle éclate dans la stature étrangement imposante de la Vierge et de l'Enfant qu'ils viennent adorer (Fig. 7). Ici l'attitude étonnante de la Vierge trouverait enfin son explication : selon un geste rituel de l'investiture, de l'adoubement ou de la présentation,[59] elle a posé la main gauche sur la tête de l'Enfant, comme pour la couvrir d'une invisible couronne, celle de la royauté vivante, conférée par l'amour de la mère à son fils, Dieu incarné.[60]

La leçon du prophète Isaïe, lue pour la fête de l'Epiphanie, pouvait, en 1374, résonner dans l'oreille du roi en évoquant des évènements bien précis : 60 : 2, "Super te autem orietur Dominus et gloria ejus in te videbitur . . .;" 60 : 4, . . . "omnes isti congregati sunt ; venerunt tibi filii tui de longe venient et filiae tuae in latere surgent" (tous les archevêques et évêques d'Espagne étaient présents et furent les signataires de la grande charte de 1374 en faveur de Guadalupe. Au nombre de ceux-ci on trouvait "Mosén Beltran Claquin," Messire Bertrand du Guesclin, devenu duc de Escámara comte de Luengrià et de Borga) ; 60 : 5, "Tunc videbis et afflues et mirabitur et dilatabitur cor tuum quando conversa fuerit ad te multitudo maris" (comme après les victoires navales, de l'embouchure du Tage à celle de la Garonne contre les galères du Prince Noir) : "fortitudo gentium venerit tibi . . ." (les mercenaires de Pierre le Cruel et son trésor abandonné passèrent aux mains de son frère). Il était logique que les dotations princières aux sanctuaires mariaux contribuassent à l'imagerie d'essence

[58]Lopez de Ayalá, *ibid.*, 106–21, art. 6: "Otrosi mandamos para las obras de Sancta Maria de Guadalupe, é de Sancta Ana de Sevilla, porque ruegen á Dios por nuestra ánima, á cada una dellas diez mil maravedis"; 115, art. 22, lequel règle la part de joyaux qui reviendront à l'Infante pour sa dot: "qu*;* la dicha Infanta aya las dichas joyas que le nos dimos . . ."e 118, art. 30 : prend des dispositions financières pour accomplir le legs: "E si por aventura en los nuestros tesoros no fueren fallados tantos maravedis de nuestras rentas, que sean vendidas las nuestras joyas, é paños é vaxilla fasta la quantia que montare éste nuestro testamento. E si de los dichos maravedis, é paños, é joyas, é vaxilla non oviere cumplimiento, mandamos que puedan vender é empeñar algunas villas é logares . . ."

[59]*Cfr. infra*, n. 60. Les donateurs sont "présentés" par leur saint patron qui pose ainsi la main sur leur tête sur le retable florentin du Thrène provenant de Santi Romeo e Remigio attribué à Maso : Van Marle, *The Development of the Italian School of Painting*, III (La Haye, 1924), pl. face à p. 418.

[60]Je n'ai pu consulter les ouvrages relatifs aux *Ordines* du sacre royal en Navarre, Castille et Aragon, recensés par la bibliographie de P.E. Schramm, *Der König von Frankreich*, II, 2e éd. (Weimar, 1960), 33–34. Le texte du concile cité par E.H. Kantorowicz, *The King's Two Bodies* (Princeton, N.J., 1957), 336 n. 76, éclairerait ce geste de la Vierge. "Et dicebatur antiquitus, dum Romanum Imperium erat in flore, quod corona Imperialis invisibilis imponebatur a Deo . . .," cette invisible couronne est ici imposée au Fils nouveau né du Tout Puissant.

Malgré une large enquête, je n'ai pas trouvé d'autre exemple de la Vierge de l'Epiphanie posant sa main sur la tête de l'Enfant, en Italie et en Espagne à tout le moins. J. Gudiol Ricart, *Pintura e imagineria románica*. Ars Hispaniae IV (Madrid, 1954), illustre près de cent majestés de la Vierge du douzième au quatorzième siècle, auxquelles ce geste est également étranger.

monarchique. L'Epiphanie étant une des douze fêtes majeures du calendrier ecclésiastique, l'*Adoration des Rois Mages* est toujours présente sur les retables des peintres barcelonais,[61] ainsi Jaime Serra à Sigena (Figs. 2, 23), ou sur les orfèvreries (Fig. 24). Mais l'intention monarchique devint même, au cours du quatorzième siècle, d'autant plus évidente que les prétentions aux trônes de France, d'Angleterre, de Naples, de Portugal, d'Aragon et de Castille se firent plus acerbes et plus embrouillées par le jeu des lignages légitimes ou bâtards.[62]

Par cette raison l'Image de Notre-Dame de Guadalupe, à l'origine protectrice des pasteurs, devint, à partir d'Alfonse XI, une de ces "Vierges des batailles," une icône *nicopeia* des armées, garantissant la victoire à ses fidèles à la manière byzantine.[63] Pourtant ce furent les pasteurs et les guerriers de l'assemblée du peuple castillan, "pastores et senores de la *Mesta*," qui lui offrirent son premier trône d'argent et d'émaux,[64] produit de leurs troupeaux et de leurs victoires, par l'entremise et par "la décision du roi Henri qui avait fait merci et aumône à cette église du village de Guadalupe." Un roi le donna et le fit; un autre roi son fils le défit, car il le reprit bientôt pour le fondre et en payer l'armée[65] en 1384 contre le Portugal. Mais les religieux propriétaires du village, des terres et gardiens du trésor, ne le cédèrent que contre de solides possessions en Estramadure : greffe de tribunal et péage de Trujillo et sa terre. C'est pourquoi le retable eut peu d'avenir artistique. Seuls restes de l'atelier monastique d'émaillerie de Guadalupe, les six émaux peuvent être tenus pour les reliques d'une oeuvre déjà "internationale" par sa date probable vers 1374, par le patronage d'un roi en lutte contre ses frères, porté sur le trône par l'ingérence des mercenaires français, par la fusion du style gothique italien dans une oeuvre inspirée par le gothique français et par le culte sans frontière rendu à Notre-Dame.

CENTRE NATIONAL DE LA RECHERCHE SCIENTIFIQUE

[61]Retable de Sigena, cf. notre Figs. 2 et 23 ; la même composition fut reprise en 1396, quoique dans le cadre de la grotte, par Pere Serra à Manresa (nég. Mas. 32074) ; Retable de l'église de Rubió, près Barcelone, par le Maître de Rubió (nég. Mas C. 93383) ; Retable de l'église de Parets Delgado (prov. de Tarragone) par Juan de Tarragone (nég. Mas A 6730). Cfr. Gudiol Ricart, *Pintura gótica*, 70 à 86 et pl.

Les retables sculptés de la Vierge, avec statue médiane, particulièrement nombreux en Espagne, comportent l'*Adoration des Mages*. Cfr. J. Braun, *Der christliche Altar*, II, 469 : Tarragone (pl. 255 et pl. 219) ; notre fig. 3 ; Gandia (pl. 254) ;

Saragosse (pl. 362) ; Lequeito (pl. 195), etc. ; Tortosa ; en outre notre pl. 57, 3.

[62]Cfr. *supra* n. 57.

[63]L'icone de la Vierge portée en procession sauva Constantinople lors du siège conduit par les Perses : A. Grabar, *L'Iconoclasme byzantin, dossier archéologique* (Paris, 1957), 35, 212–14, 226–27, fig. 151.

[64]Ecija, *Libro de l'Invención*, 85 ; cf. *supra*, n. 7 et n. 8.

[65]Talavera, *Historia de Nuestra Señora de Guadalupe*, fol. 24v ; cfr. notre n. 8, *supra*.

Giovanni Bellini's Topographical Landscapes

FELTON GIBBONS

While there are a number of general histories of Italian Renaissance landscape painting, no one has yet written the full story of Western painting's gradual but growing interest in the topographically exact landscape.[1] The coming of the Renaissance to Italian painting brought a progressive realism in every field of the painter's concern, in landscape no less than in the presentation of space and the human figure. Several of the great painters of the trecento and most of those of the quattrocento contributed to the growth of realism by studying the topography around them and putting it into their landscapes. Giovanni Bellini, as the most inventive painter of the Venetian quattrocento, showed a developing concern for topographical landscape. My purpose in this essay is to assess his use of the landscape and architecture that he saw about him in northeastern Italy and so to contribute one chapter to the unwritten history of Renaissance topographical landscape painting.

The writer who up till now has most extensively discussed what he aptly calls the "landscape of fact" is Kenneth Clark in his brilliant series of essays, *Landscape into Art*. Clark attributes to Flemish painters the first use of topographical landscape, citing the seaside scene in the van Eycks' Milan-Turin Hours, wherein a prince and his entourage are shown on a windswept northern shore. He goes on to mention Jan van Eyck's cityscapes, the Master of Flémalle's Dijon *Nativity*, Conrad Witz's remarkable view of the shores of Lac Léman in his *Miraculous Draught of Fishes*, the wintry landscape of Hugo van der Goes's Portinari Altarpiece, and Albrecht Dürer's topographical watercolors.[2] But as Panofsky and others have stressed, the beginnings of Northern Renaissance painting drew heavily on progressive Sienese art of the trecento,[3] and it is in Siena at that time—not unexpectedly—that there appear in Western painting the first landscapes fully faithful to the artist's experience of the world around him. Two major examples come first to mind: Simone Martini's fresco of the condottiere Guidoriccio da Fogliano riding on his caparisoned horse before the fortified hills between Florence and Siena, and Ambrogio Lorenzetti's view of his native city and its countryside in his allegories of *Good and Bad Government*. It would probably be going too far to link Simone's landscape with an actual site, but there is little doubt that he has imbued his fresco with an exact feeling for the barren hills around Siena, made all the more austere by the ravages of war. Ambrogio, on the other hand, records Siena and its countryside with accuracy, although this first truly topographical landscape of the Renaissance is a rather special case, dictated by its allegorical iconography, its location in the Sala della Pace of the Palazzo Pubblico, and the exigencies of Siena's political position at the time.[4] But the historical

This article was begun in 1968 while I was fortunate to be a fellow at the Harvard University Center for Italian Renaissance Studies, Villa I Tatti, Florence, to whose always kind staff goes my gratitude for much help, not only during this year but in the past.

[1] A useful brief bibliography of Renaissance landscape painting is in A.R. Turner, *The Vision of Landscape in Renaissance Italy* (Princeton, 1966), 213.

[2] *Landscape into Art* (London, 1949), 16ff.

[3] *Early Netherlandish Painting, Its Origins and Character* (Cambridge, Mass., 1953), 26f., 30f.

[4] J. Guthmann, *Die Landschaftsmalerei der toskanischen und umbrischen Kunst von Giotto bis Raphael* (Leipzig, 1902), 65–86, stresses the importance of Simone's and Ambrogio's contributions to topographical landscape.

point remains : Ambrogio was Giotto's most progressive heir, and, just as he carried perspective accomplishment to a point not to be reached again for eighty years, so also his topographical landscapes held lessons for fifteenth-century realists, both Flemish and Italian.

With the definitive coming of the Renaissance to quattrocento Florence, an interest in topographical landscape blooms along with the general concern for a naturalistic art. The landscape of Masaccio's *Tribute Money* could be the view from a Florentine rooftop looking northwest toward the hills behind Prato, and the landscape of his *St. Peter Giving Alms* is enriched by a glimpse of a typical trecento Florentine fortified villa, which looks down over the city from the slopes above. Late medieval Florence itself is the setting of much of the Brancacci cycle by Masaccio and Masolino : its narrow streets overhung by protruding upper storeys supported by brackets, its plain brown buildings with their arched windows in austere functional façades, the square of the *Tabitha* fresco with its simple loggias and strolling pedestrians. Masaccio's feeling for Florentine topography is generalized, but, as L. Gori-Montanelli pointed out, even at the time of the Brancacci frescoes there was an instance in early Renaissance Florence of a specifically identifiable view in Bicci di Lorenzo's fresco of the dedication of San Egidio.[5] An early and often noted Florentine landscape of an identifiable site in the countryside—perhaps the earliest—is Fra Angelico's charming glimpse of the wide view from the western edge of Cortona south toward the Lago di Trasimeno in his panel of the *Visitation* in the predella of the Cortona *Annunciation*. Masaccio's other successors among the Florentine realists prolifically expanded the interest in specific landscape that begins in the third decade of the century. As Vasari noted,[6] Baldovinetti recorded the Arno valley in his paintings, most notably in his Santissima Annunziata *Nativity*, and Pollaiuolo also painted the glimmering plain of the river valley several times, for example, in his Hercules panels and his *Rape of Deianira*. The Florentine landscape of fact was perfected by Piero della Francesca in the shimmering river valley at the center of his *Battle of Maxentius and Constantine*, in the dry hills of his *Resurrection*, and in the extensive landscapes behind his Urbino portraits, in which hills, harbors, and towns lie sizzling under a pale but insistent sunlight.[7] Like Masaccio's views of Florence and its surroundings, most of these Central Italian landscapes are generalized to some degree. They do not, for the most part, record specific sites, but their relation to the landscapes that their painters observed in their travels is that of fact distilled through memory rather than of literal recording in the sense of later topographical views. But the beginnings of topographical painting, like the beginnings of all the other aspects of later European art, lay in quattrocento Florence, as the few examples here cited indicate. There was thus ample precedent for Bellini's topographical concern for the landscape about him. He continued a tradition already practiced by many others, but he also reinterpreted it in a way characteristic of Venice and of his own brilliantly inventive mind.

[5]*Architettura e paesaggio nella pittura toscana dagli inizi alla metà del Quattrocento* (Florence, 1959), 120f. It is doubtful if, as Gori-Montanelli says, Bicci's fresco predates the Brancacci chapel.

[6]G. Vasari, *Le vite dei più eccellenti pittori, scultori e architettori*, ed. Milanesi (Florence, 1878), II, 595.

[7]For detailed reproductions of landscapes I have cited, see especially D. Neri–H. Kiel, *Paesaggi inattesi nella pittura del Rinascimento* (Milan–Florence, 1952).

Giovanni Bellini, from the first moments of his career, began to develop his own vision of landscape. His *St. Jerome* in the Barber Institute, Birmingham—now accepted by critics as one of his earliest works—already contains a clearly organized landscape of sweeping distances suggested by atmospheric perspective, which is of fundamental importance to the design of the panel.[8] Indeed, Jerome is firmly placed within this landscape, which to a significant extent becomes the protagonist of the painting. Even at this early date, Giovanni has developed the soft rocks arranged in graceful curvilinear patterns and the broad sunlit middle distance that characterize his landscapes throughout his long career, and he has already begun to use a device of his own invention, characteristic of many of his landscapes : roads that sweep in gentle diagonals from one spatial zone to the next and so create an orderly overlay on the landscape that contributes to the clarity of its organization. Despite its accomplishment, however, the landscape of the Barber *St. Jerome*, like its figure, still owes much to Jacopo Bellini, particularly in the rocky escarpment to the left, which, with its still somewhat Gothic patterns of curves, echoes the setting of certain scenes in Jacopo's drawings in Paris and London. Nor can it be said that the *St. Jerome* landscape is in any sense topographical ; it gives no impression whatever of recording a specific site but rather seems to be wholly the invention of its author, aided by his training under his father's eye. Surely this landscape is no more than an exercise of the artist's already impressive ability to visualize space in nature, laid out in orderly recession under a warm bath of revealing light. Surely it contains no more than the distant memory of landscapes seen. The same point must be made, as we shall see, concerning Giambellino's landscapes during the entire first two decades of his career.

Soon after his earliest works, which still show a certain loyalty to his father's teaching, and certainly by 1460 if not before, Bellini came under the influence of his precocious brother-in-law, Andrea Mantegna. In his Mantegnesque period, which extends throughout the 1460s, architecture began to enter Giovanni's landscapes and to play an increasingly important and sometimes a dominating role in them. For example, in the Mantegnesque *Transfiguration* in the Museo Correr, Bellini introduced a glimpse of distant landscape on the left, his usual sweeping view of ideal nature, well watered and strung together by a network of roads and paths. But this typical early landscape is dominated by a single and curious piece of architecture : a round crenelated tower with a steep conical roof.[9] Though such a structure might appear in medieval North Italy, always subject to Northern influences, it is strikingly transalpine in appearance, and one is tempted to wonder if, as early as this in his career, Bellini had already experienced Flemish paintings or manuscripts with their many records of native architecture.

The architecture in the other paintings of Giambellino's Mantegnesque period is predominantly Italian and sometimes quite Roman. The landscapes of his two Mantegnesque paintings in the National Gallery in London contain typical late-medieval Italian villages, in the plain or on hilltops. In the miniaturelike *Blood of the Redeemer*, the village is tucked in the left corner, and its two most notable monuments are another round fortified tower with a

[8]For detailed illustrations of Bellini's landscapes, see R. Pallucchini, *Giovanni Bellini* (Milan, 1959) ; figs. 5, 7 for the Barber *St. Jerome*.
[9]*Ibid.*, figs. 17, 18.

low conical roof that seems far more Italian in appearance than that in the Correr *Trans-figuration*, and a campanile so typical in style that it could appear anywhere in Italy.[10] Curiously, this archetypal village is balanced on the right by some ruins past which a monk and a similarly dressed boy walk—the low base of another round tower and a crumbling arch. It would perhaps be bold to suggest that these ruins have iconographical significance, but it would not be inconsistent with the symbolism of the rest of this painting. As Saxl noted, the central theme here of Christ's sacrifice is echoed in two painted reliefs of pagan sacrifice on the balustrades.[11] Behind, on the left, above Christ's right arm, is a recent and thriving Christian village, dominated by its modest church under a prominent campanile, the main monument of this little *paese*. On the right the arch and crumbling tower base could be taken as Roman, like the pagan reliefs—the now deserted and ruined monuments of a prior civilization replaced by the new dispensation, whose primary eucharistic symbolism is enacted in the foreground. The architecture of this small panel of deeply felt religious sentiment is hardly topographical but possibly allegorical. Its varied architecture is completed by a larger walled village in the far background, also on Christ's right.

Bellini's other Mantegnesque painting in London is the *Christ in the Garden of Gethsemane*, one of his two masterpieces of this period (along with the Brera *Pietà*).[12] The rocky escarpments of its landscape, miraculously lit by the creamy light of dawn, contain three villages, two hill towns, and a low-lying settlement just visible over Christ's left shoulder. The most prominent of these is the town at the upper left, painted almost as a cubistic exercise in the grouping of blocky forms, and anomalously lit from the front, though the sun seems about to rise behind it. So compact is the arrangement of these buildings that they seem almost a single structure, like a large monastic complex. Neither these three towns nor those in the *Blood of the Redeemer* are identifiable today, and one can doubt if they were in Bellini's time. Like the landscape of the Birmingham *St. Jerome* and those of other early works, they seem generic, not topographical sites, invented by Bellini *ad hoc* to support the formal (and, in the case of the *Redeemer*, perhaps the iconographical) aims of his picture.

Another important record of Giovanni Bellini's early debt to Mantegna, as well as to Donatello, is the *Man of Sorrows* in the Correr Museum (Fig. 1). The architecture of its landscape is of an entirely different character from that encountered so far in Bellini's works. It is dominated by Roman monuments in good condition, for the most part located in a town on the slope of a hill, surrounded by a medieval wall punctuated by frequent watch towers of varying heights and tops. Within these walls a Roman outpost of cisalpine Gaul seems reborn. Its elements include a three-tiered stadium, a dome that must top a round temple, double columns under an architrave that breaks sharply forward over them in the Imperial style, a half-domed aedicula with columns attached to the end of a basilicalike building, a façade with four columns *in antis*. To the right, outside the town, is a Roman arch of two bays articulated by single engaged columns over which the architrave breaks, with the figure of a man, a freestanding arch, and other ornamental bits of architecture on top, silhouetted against the distant background. (A similar Roman arch appears on the left of Bellini's *Madonna and*

[10]*Ibid.*, fig. 20.
[11]F. Saxl, "Pagan Sacrifice in the Renaissance," *Journal of*

the Warburg Institute (II, 1939), 350–52.
[12]Pallucchini, *Giovanni Bellini*, figs. 21, 22.

Child from the Theodore M. Davis Collection in The Metropolitan Museum, New York, another early work from his Mantegnesque period.)

The homage to Rome that Giovanni pays in his Correr *Man of Sorrows* is also a homage to his brother-in-law. Mantegna's landscapes throughout his career are passionately and consistently archeological. It is hardly necessary to cite the many familiar examples of Andrea's recreations of the Roman cityscape and countryside, which are surely the most archeologically correct and profoundly antique of the quattrocento—his *Martyrdom of St. James* formerly in the Eremitani, his versions of the *Agony in the Garden* in London and Tours, his Louvre and Vienna *St. Sebastians*, the frescoed landscape above the scene of the Marchese of Mantua meeting his son, to name some major examples.[13] As in Bellini's Correr painting, the hill towns of Mantegna's landscapes mix medieval and Roman architecture, standing outside time, astride two eras of history. In both his paintings of *Christ in the Garden*, for example, medieval walls with massive watch towers surround towns that are architectural pot-pourris, in which a Roman stadium or triumphal column may stand next to a medieval campanile. And in these two paintings Mantegna's architecture is massively monumental, overwhelming in scope, but drily painted with all the linear accuracy of an academically trained architectural draftsman. The austere grandiosity of his architecture and the determined precision of its presentation are entirely in contrast to his brother-in-law's more modest echoes of Rome, painted lightly and softly like evocations of a far age dimly seen through a veil of long-intervening time. The few early instances of the Paduan *romanità* in Bellini's landscape echo Mantegna's passion for archeology, but the manner of their statement is quite Venetian and in Bellini's own terms. And whereas Mantegna retained his love of the Roman landscape throughout his career with little change, Bellini, always restless of mind, always ready to pass on to a new phase, modified his landscapes after he went beyond his early interest in his brother-in-law's art, in the direction of a topographical concern for the countryside around him that was much less a product of romantic love for the glories of a prior age and much more the result of direct observation and literal recording of his own experience.

I have not cited all the city- and landscapes of Bellini's Mantegnesque period. There are others, such as the backgrounds of the panels of his polyptych in Santi Giovanni e Paolo, Venice, but these can add little to the observations already made concerning his attitude toward landscape, architecture, and topography in his early years. This attitude can be summarized in a word by saying that Giambellino's first landscapes were imagined. They were less the product of observation of the world around him than of inner urges to stretch his pictorial imagination to the horizons of a world bathed in light and rich in spatial adventure. Giovanni felt the stimulus of Mantegna's art, more advanced than his own in these early years, and he showed a somewhat diluted interest in the antiquities of Rome, which his contemporaries were beginning to see afresh. But he seemed at first to care more for the workings of his own artistic imagination as it distilled nature than for direct visual stimulus from the landscapes that he saw. Thus his early stance toward landscape was more

[13]For illustrations, see E. Tietze-Conrat, *Mantegna, Paintings, Drawings, Engravings* (London, 1955), figs. 19, 25f., 35, 42, 57, 59, 64, and frontispiece. On Mantegna's archeological land-scapes, see R. Eisler, "Mantegnas frühe Werke und die römische Antike," *Monatberichte über Kunst und Kunstwissenschaft* (III, 1903), 1–11.

akin to that of Masaccio or Fra Angelico, who recreated through their mind's eye the Tuscan landscapes that they knew, than to that of Baldovinetti or Pollaiuolo—his own contemporaries —who more accurately recorded the topography of the Arno valley. Bellini's early landscapes show how, paradoxically, he was both conservative and progressive. Slow to begin, in part through his own gradualist mental processes, in part because Venetian art at mid-century had little strikingly new to teach him, he nevertheless moved ahead step by step toward an interpretation of the topographical landscape that ranks as one of the many original and significant inventions of quattrocento painting.

At about the end of his second decade of work, when he was roughly forty years old, Giovanni Bellini apparently took an extended trip on the mainland south along the Adriatic coast at least as far as Ancona. This trip and the architecture and landscape that he saw during it had echoes in his art throughout the rest of his career. The masterpiece of this new period in Giovanni's life, and perhaps the reason for his trip, is his altarpiece of the *Coronation of the Virgin*, made for the church of San Francesco in Pesaro and today in the museum of that city (Fig. 2). In the Pesaro altarpiece there appears prominently Giovanni's first identifiable topographical landscape, a view of the fortifications climbing up the Rocca di Gradara eight miles north of Pesaro and just west of the road by which Bellini must have traveled south (Fig. 3). It is true that the fortification behind Gradara looks different today from the landscape inserted into Bellini's painting, in a manner that has rightly been called disrupting.[14] But it is in the nature of fortifications to be constantly renewed, and there can be little doubt, I think, about the identification of Bellini's landscape with this site, suggested thirty-five years ago by G. Pacchioni.[15] The Pesaro altarpiece marks a large step forward into new areas of style in Giovanni's development. The figures, up to this point more narrowly Venetian, here take on a breadth and grandeur that owe much to the main current of Central Italian Renaissance art in the quattrocento. Bellini's trip to Pesaro stimulated him in many ways, only one of which was the inclusion of the purely topographical view of the Gradara fortifications. As the Pesaro altarpiece is the most monumental and accomplished in Venetian art so far in the presentation of the human figure, so too its landscape is topographically the most exacting yet to appear in Venice. This painting introduces Bellini's monumental style of the 1470s; an aspect of this style throughout the new decade in Giovanni's career is his consistent concern with actual architecture that he doubtless saw during his trip south along the Adriatic coast to Pesaro.[16]

Other major paintings by Bellini of this decade are the *St. Francis* in the Frick Collection, the *Resurrection* in Berlin, the *St. Jerome* formerly in the Contini-Bonacossi Collection in Florence and now in the Pitti, and the Naples *Transfiguration*. Of these paintings by far the

[14]M. Meiss, *Giovanni Bellini's St. Francis in the Frick Collection* (Princeton, N.J., 1964), 18.

[15]"Galleria e museo della ceramica di Pesaro," *Bolletino d'Arte* (XXXI, 1937), 132, dating the painting after Alessandro Sforza's reconquest of the Rocca in 1463. G. Robertson, *Giovanni Bellini* (Oxford, 1968), 70, suggests a Trinitarian symbolism in the Pesaro altar's landscape with its three towers.

[16]E.P. Fahy, "New Evidence for Dating Giovanni Bellini's *Coronation of the Virgin*," *Art Bulletin* (XLVI, 1964), 216–18,

used topographical evidence for dating the altar, based on the model of a fortress held by St. Terenzio in the right-hand panel of the predella. While his date is certainly generally correct, I am doubtful of the specific identification of St. Terenzio's model with the Rocca Costanza of Pesaro, since many fortifications in the Marches assumed this form. Other elements of architecture in the predella have defied identification, even the Gothic apse in the *Stigmatization of St. Francis*, which bears only a generic relation to such a Venetian church as San Gregorio.

richest in identifiable monuments is the *St. Jerome*, its background cityscape a curious pot-pourri of identifiable architectural monuments of Northern Italy (Fig. 4). At the left is a polygonal Early Christian church buttressed at the corners, with six arched windows in each flank and an echoing cupola above, which bears a striking resemblance to San Vitale in Ravenna. The identification is bolstered by the unusual campanile next to the church. Round, capped by a low conical roof, and with tripartite windows running around each of its upper three storeys, the tower is certainly like those which Bellini could have seen in Ravenna as he traveled south from Venice to Pesaro. It is impossible to say, however, that this campanile is that of San Vitale; somewhat generalized, it bears as close a resemblance to the campanili of Santa Maria Nuova and Sant'Apollinare in Classe as it does to that of San Vitale. The bridge at the center of this painting that links these monuments to the town has been identified with the so-called Ponte di Augusto at Rimini, and indeed its resemblance to this rare Roman bridge as it stands today is striking. Though the Augustan bridge at Rimini now has five arches and Bellini's only three, the design is the same, even to the niches between each arch and the evenly spaced supports that hold up the cornice below the protecting solid rail at the road level (Fig. 5).[17]

The town to the right contains a number of houses that are no doubt simply invented or recorded from memory but also several more conspicuous monuments whose identification is in some cases possible. The round structure with a low domed roof buttressed at the edge, next to the campanile, seems certainly inspired by the Tomb of Theodoric in Ravenna. Its adjacent campanile is Venetian in type. It has two long vertical channels on each side below three windows under the cornice, which is decorated with small pyramids at the corners; its roof is high, conical and pointed. Such a campanile is common in Venice, and it would be hazardous in this case to advance a specific identification. Nor can the other higher tower of this town view be named, for it is a simple fortified square form with a crude wooden hut as superstructure. Bellini's cityscape in the Contini-Bonacossi *St. Jerome* is thus a mixture of invented or generalized architectural motifs and at least four well-known monuments. His method in painting this landscape mingles topographical accuracy, remembered sensation, and, we may surmise, pure invention. He does not present a unified view of one site but rather single monuments rearranged according to his own ideas of composition and the needs of this particular background. Running a gamut from direct transcription through form inspired by memory to form created, this landscape is a painted scale of the varied methods of Bellini's creative process—or in fact of any artist.

Giovanni's other major landscapes of the 1470s present less material for topographical analysis than the *St. Jerome*, yet they supplement the revelations of the artist's creative methods gained from that picture. The fortified village of the Frick *St. Francis* cannot be identified today, nor can one say with certainty that this exact village existed in the artist's own time. But Millard Meiss has pointed out the similarity between the rocky escarpment before which St. Francis stands and the topography of La Verna, where the saint received the

[17]Pallucchini, *Giovanni Bellini*, 140, identifies the monuments of Ravenna and Rimini in the *St. Jerome*. See also R. Pallucchini, "Catalogo illustrato della mostra Giovanni Bellini," Venice, 1949, 140.

stigmata.[18] The relation between Bellini's rocks in the painting and the topography of La Verna is not precise, and I cannot say in this case whether Bellini knew La Verna from personal experience and adapted its rocky ridge to the needs of his composition, or whether he depended upon some graphic or verbal description. In the Naples *Transfiguration*, the monuments of Ravenna appear again, as Roger Fry recognized at the beginning of this century: the Tomb of Theodoric and near it a round campanile, echoed by others on the right.[19]

The Berlin *Resurrection* has in its background a village on a river bank with a bridge and fortified towers that are certainly not identifiable. But the painting is of interest to this study because there is a drawing in the Ambrosiana in Milan that corresponds to this portion of the picture, including also the three Maries approaching the site of the Resurrection (Fig. 6).[20] Neither the drawing nor, in all likelihood, this portion of the painting can be said to be by Bellini's own hand, but this is one of the rare instances in which a Bellinesque drawing matches one of his paintings and so tells us something of how his drawings were used and how they relate to his use of topography. Whether Bellini was inspired by an actual site in the Venetian landscape in painting the background of the Berlin *Resurrection* cannot be said; but the motif was recorded carefully and accurately by a member of his workshop for future reference. Giovanni's use of this method of repeating motifs that were recorded in drawings is confirmed by the reappearance of the fortifications at Gradara in a major painting of a later date. The Rocca of Gradara, much as it appeared in the Pesaro altarpiece, recurs as the major architectural element in the landscape to the right of Bellini's Doge Barbarigo votive altar at Murano.[21] It is possible to assume that Giovanni had these fortifications recorded in a drawing similar to the one in Milan and thus was able to make use of them some fifteen years later. Unfortunately the drawing that must have been the means for this repetition no longer exists, and one cannot say whether it was Bellini's own, done at the site near Pesaro, or a workshop *simile* like that in the Ambrosiana—more probably the latter. These instances of the use of topographical drawings are among the few but significant hints that have survived of Bellini's creative methods and of the organization of his workshop. They exemplify the pragmatic and limited view of creativity that prevailed in Giovanni's shop, a prototype for the great productive workshops of Venice in the sixteenth century and thence of the international Baroque.

The Barbarigo votive altar of 1488 is the only major instance of an identifiable topographical site in Bellini's painting of the 1480s. Some of the Madonnas of this period contain landscapes with architecture, for example the Harewood *Madonna* or the *Madonna* in the Accademia Carrara at Bergamo,[22] but these landscapes are too distant and too generalized to permit identification of the sites in them. It may be, in such cases and others like them, that

[18]*Giovanni Bellini's St. Francis*, 22.

[19]*Giovanni Bellini* (London, 1900), 27.

[20]H. Tietze–E. Tietze-Conrat, *The Drawings of the Venetian Painters in the 15th and 16th Centuries* (New York, 1944), 92–93, no. 347, as a workshop *simile*; cf. F. Gibbons, "Practices in Giovanni Bellini's Workshop," *Pantheon* (XXIII, 1965), 151–52. The Tietzes list the several paintings in which this drawing is reused, indicating its presence in Bellini's workshop for at least two decades.

[21]Pallucchini, *Giovanni Bellini*, fig. 125. It reappears for a third and probably last time in Catena's *Adoration of the Shepherds*, now in The Metropolitan Museum of Art, New York; see G. Robertson, *Vincenzo Catena* (Edinburgh, 1954), 60–61, pl. 32.

[22]Pallucchini, *ibid.*, figs. 132, 136, 138.

Bellini either remembered or had at hand in the form of drawings actual sites that he had observed in the Veneto, but the point remains moot. It is not until the later 1490s and around 1500 that Giovanni turned his attention again to the use of specific motifs in his background.

The *Crucifixion* in the Niccolini di Camugliano collection in Florence, datable, I believe, in the second half of the 1490s, is a major instance of Giovanni's topographical interests (Fig. 7). The city in the background contains a number of monuments whose identity is clear, some of them drawn from the artist's former experience of Ravenna and the Adriatic coast, but two others Vicentine in origin. The domed church on the left of the city in the *Crucifixion*'s background is certainly San Ciriaco, the Duomo of Ancona, which might have been the terminus of Giovanni's trip south in the 1470s. The campanile in front of it is the Torre di Piazza in Vicenza. In the background at the right of Christ is a round temple with a colonnade whose main body is based on the Tomb of Theodoric. A round tower in this part of the painting appears Ravennate also, but in front of it, nestled in a low lying area of the city, is the upper part of a cusped Gothic church façade with a single round window. This certainly represents the façade of the Duomo of Vicenza, as it was intended to be finished in the time when Bellini painted this picture.[23] The other towers of this conglomerate city view, generally northeastern Italian in type, are not identifiable nor, of course, are the rustic farm buildings in the middle ground. But it is clear that Bellini in the Niccolini *Crucifixion* has returned to the method of topographical presentation that he used in the Contini-Bonacossi *St. Jerome*. Certain monuments, either remembered or recorded in drawings that no longer exist, have been selected by the artist and put together in a topographical mixture that does not present a full view of a single city, yet contains several individual monuments that can be identified. The result is realistic and convincing as a city, but it remains a city imagined, a recreated conglomerate of some actual monuments and others that fuse buildings Bellini had seen and remembered.

Probably just later than the *Crucifixion* in Florence is the *Pietà* in the Accademia in Venice, which may be dated around 1500 (Fig. 8).[24] The cityscape in this painting represents the climax of Giovanni Bellini's concern with topographical landscape, for it approaches an entire view of the city of Vicenza as it existed in the fifteenth century. The city is surrounded by a wall with gates, as it no doubt then was. On a hill overlooking it to the right is a church with two towers, which seems to relate to the city as Monte Berico with its shrine does today, though the form of this monument is now entirely Baroque. The highest tower of Bellini's city, as of Vicenza, is the Torre di Piazza. Behind it is a large, plain, rectangular building with a low arched roof, which (as Lorenzetti recognized) is very likely the basilica of Vicenza before Palladio encased it in its present arcades.[25] Next to these monuments to the right is a conspicuous Gothic church façade, with three cusps on either side each decorated by a Gothic aedicula, and three round windows. This is the façade of the cathedral of Vicenza, in a form, to be sure, which it never had and does not have today. With the artist's license that he so often took, Giovanni has completed the Duomo façade in a manner to his own liking,

[23]P. Zampetti, "Una veduta cinquecentesca del Duomo di Ancona," *Le Arti* (IV, 1942), 211–12, first identified San Ciriaco in this painting. On the archeology of the façade of the Duomo in Vicenza, see E. Arslan, *Vicenza, le chiese* . . . (Rome, 1956), 23–24.

[24]Pallucchini, *Giovanni Bellini*, figs. 185, 188, 189.

[25]G. Lorenzetti–L. Planiscig, *La collezione dei Conti Donà dalle Rose* (Venice, 1934), 3.

or perhaps even following the wishes of its architect, probably Domenico da Venezia.[26] To these various identifications of Vicentine monuments in Bellini's paintings, which were already made by Lorenzetti, Arslan has recently added the Torre dei Busiri, the fortified tower to the left of the city gate at the far left of Giovanni's cityscape.[27]

Despite these several identifiable monuments put together by the artist in a way that seems almost a complete picture of the city from a single point of view, Bellini's Vicenza in the *Pietà* cannot be said to be an entire topographical view in the sense that these occur in later art. As in earlier paintings, he has admixed monuments from other sites. The round bell tower in front of the pre-Palladian basilica is Ravennate, and in front of the Duomo of Vicenza appears a more complete and more accurate view of San Vitale in Ravenna than the one that Giovanni used in the Contini-Bonacossi *St. Jerome*.[28] The low campanile of this church—perhaps so general in type that it could appear anywhere—most resembles that of San Zaccaria in Venice, with its two vertical channels and three windows.[29] Thus the process of reordering actuality, of interpretation with license, that Bellini has used so far is still illustrated by the city in the *Pietà*. Nevertheless its cityscape, of all those in Bellini's paintings, most nearly approaches a complete and topographically accurate view of a single site. This small painting of a subject often chosen by Giovanni is a major monument in the history of topographical art.

After the turn of the century, in Bellini's High Renaissance period, he seems to have been little concerned with his former topographical interests. Perhaps in this period of generalization and synthesis, stimulated by the work of Giorgione in Venice, Bellini found less reason to be as specifically realistic in his backgrounds as he had been in the 1470s and the 1490s. His own contribution to the history of topographical landscape had been made and, in a manner characteristic of his constant restless development, he turned to other matters, leaving to his many pupils the depiction of actual sites, which once had been his concern.[30]

As has been implied several times above, there is an inexorable, determined quality to Giambellino's development throughout his long career. This is true of most aspects of his style, including the use of topographical sites in his landscapes. At first his backgrounds

[26]As suggested by Arslan, *Vicenza, le chiese*, where it is noted that Bellini's painting was used as a guide to rebuild the church façade after its destruction in the Second World War. The Duomo façade with the basilica and the Torre di Piazza appear in a Bellinesque *Madonna* bearing the master's signature in Stuttgart; cf. F. Heinemann, *Giovanni Bellini e i Belliniani* (Venice, 1962), I, 8f., no. 35a; II, 225, dating the design in the late 1480s on good evidence. Thus this limited view of Vicenza was preparatory to the broader one in the Venice *Pietà*, which tends to undermine any argument on the dating of the latter that links it to Bellini's Vicenza *Baptism* of 1500–1502.

[27]Arslan, *ibid*. The tower is illustrated in G. Pettinà, *Vicenza* (Bergamo, 1905), 22.

[28]As noted in S. Moschini-Marconi, *Gallerie dell'Accademia di Venezia, opere d'arte dei secoli XIV e XV* (Rome, 1955), 75–76.

[29]See C.A. Levi, *I campanili di Venezia* (Venice, 1890), fig. IV F. A glance through the plates of this book in comparison to the campanili in Bellini's paintings demonstrates how hazardous exact identifications are. The campanile in the

Pietà, for example, also looks like that of Santa Maria della Misericordia (Levi, fig. III N). That in the Contini-Bonacossi *St. Jerome* resembles, and perhaps fuses, those of the Carità (W.G. Constable, *Canaletto . . .*, Oxford, 1962, I, figs. 196, 198), of Santa Margharita (*ibid.*, fig. 277), and of San Barnaba, Venice (Levi, fig. VI E). It also looks like the bell tower of Sant'Anastasia, Verona.

[30]The hill village in Bellini's *Madonna of the Meadow* in London (Pallucchini, *Giovanni Bellini*, fig. 184), for example, whose actuality cannot be checked, reappears twice in paintings by his workshop: in the *Christ Blessing* in Ottawa (*ibid.*, fig. 184) and in the *Madonna and Child* in the Metropolitan Museum (*ibid.*, fig. 210). The latter work, in my opinion, is by Previtali. The last identifiable monument in a Bellinesque painting is the view of San Ciriaco in the *Martyrdom of St. Mark* in the Scuola Grande di San Marco, Venice, finished in 1526 by Vittore Belliniano (*ibid.*, fig. 232), an elaboration of Bellini's similar depiction of the cathedral of Ancona in the Niccolini di Camugliano *Crucifixion*. Cf. C. Gamba, *Giovanni Bellini* (Milan, 1937), 180.

contain imagined architecture, stimulated by Mantegna's austere Roman views but filtered through a haze of time distilled as Venetian light. Then, struck by the Byzantine monuments of Ravenna, by Marchigian fortifications, and by the vigorous, compact Romanesque style of San Ciriaco in Ancona, Bellini began in the 1470s to include actual architecture in his landscapes, but at first only in bits and pieces. From the Contini-Bonacossi *St. Jerome* to the Niccolini *Crucifixion* to the *Pietà* in the Venetian Academy he moved slowly toward—without ever arriving at—the total rendering of a single actual topographical site. His method remained that of a mosaicist; topographical tesserae from here and there are laid next to each other with at first little, and ultimately only partial, regard for the realities of the unified city view. Nevertheless his contribution to the history of the topographical landscape is an original one. Unlike his Florentine contemporaries, Pollaiuolo and Baldovinetti, he did not literally record the landscape around him; he was rather fascinated with monuments more distant in time and place from fifteenth-century Venice, which he fitted into his own vision of ideal landscape as if to moor this vision to historical reality. But by 1500, in the Accademia *Pietà*, he approached closely a complete view of contemporary Vicenza, a major contribution to the history of realistic view painting which assures his place in this chapter of the general history of art.

It is significant that this contribution was made in Venice. Giovanni's Venetian colleagues in the quattrocento, Gentile Bellini and Carpaccio, were also noteworthy topographical artists. Gentile, the literal-minded state painter, on occasion recorded the fifteenth-century Venetian scene with the dry, pedestrian accuracy of a journalistic photographer. In the history of *veduta* painting, his city views must occupy a prime place, yet they are far less interesting than his younger brother's conglomerate landscapes, partly imagined, partly observed, so richly combining the actual and the ideal. Carpaccio specialized rather repetitively in an exotic and surreal architecture, stimulated by the woodcuts in contemporary travel books, such as Breydenbach's. Despite the fairy-tale charm of his topography, it, like other aspects of his style, is an historical cul-de-sac, an eccentric and rarefied personal expression that must be admired today in a vacuum, for it is without significant sequel. Giambellino's style, unlike his brother Gentile's, unlike Carpaccio's, is the germ of a fruitful future in Venetian painting. When Titian recalls his boyhood in the Dolomites in, for example, the landscape of his *Presentation of the Virgin* for the Scuola della Carità, Bellini's topographical landscapes provide a precedent; Veronese's Palladian settings are foreshadowed by Bellini's interest in earlier architectural styles. Giovanni Bellini's use of topographical architecture is but one clue among many to the significance of his place in the history of Venetian, and of European, art. Canaletto, Pannini, Piranesi are all, in a sense, his debtors.

PRINCETON UNIVERSITY

The Patron of Starnina's Frescoes

CREIGHTON GILBERT

Meiss's definitive review[1] of Frederick Antal's *Florentine Painting and Its Social Background* (London, 1947) was justifiably both severe and detailed. In being detailed, it paid tribute to the real interest of the topic and the fact that it had not been explored to any extent, while in being severe it found that Antal had failed to convince by his findings. Antal proposed correlations between certain styles of painting and certain classes of patrons; but it emerged that his arguments were circular, since the evidence for the class to which the frequently unknown patron was alleged to have belonged was often only the style of the resulting work. (Antal was able nevertheless to offer his findings without inhibition, for the not uncommon reason that he was himself so convinced of his theory.)

The result is discouraging, for it seems that external evidence on Florentine patrons, not only their social status but even the more limited determination of their wealth, may be difficult, if not impossible, to obtain. The computer study of the 1427 census now under way will undoubtedly give us tremendous amounts of data, though only when it becomes accessible will we be able to begin to devise useful ways of correlating these with the paintings. An obvious difficulty will be that the wealth shown is not the true amount but what was reported to the tax collector; perhaps, however, the quantity of materials will permit some reconstruction of the normal difference between the two.

Under the present circumstances, then, there is special interest in being able to call attention to a document that informs us of the true capital resources of a patron of frescoes, because it comes not from his tax declaration but from confidential notes made when his estate was being inventoried by his family, a kind of source rarely available. It is thus only a single instance rather than an assemblage, but it does have broader interest, for in running counter to a generally accepted view of the norms, it suggests that the patron of the chapel in question was somewhat below the level of wealth that we have more or less distinctly tended to expect, and so may modify our general ideas.

Drawing attention to this document also has a virtue of a different kind, attractive to scholars who would never concern themselves with broad sociological approaches but would keep to the most literal philology of individual cases. For the patron family of the chapel of St. Jerome in the Carmine has been wrongly identified in Procacci's important study of the artist, Starnina.[2] The two elements of interest are related, for the wrong identification of the patrons attached them to an important family, whereas in fact they were of a more modest social position.

Finally, the document may be of interest from still a third viewpoint, as evidence on the career of the painter Starnina. This is agreeable, since he may be defined as the most obscure

[1] *Art Bulletin* (XXXI, 1949), 143–50.
[2] "Gherardo Starnina," *Rivista d'Arte* (XV, 1933, 151–90; XVII, 1935, 333–84; XVIII, 1936, 77–109), referring also to his previous article, "L'incendio della chiesa del Carmine del 1771," *Rivista d'Arte* (XIV, 1932), 171, on the Carmine chapels.

among all the Florentine painters who were leading figures in their time. In the generation between Agnolo Gaddi and Lorenzo Monaco, often rightly regarded as a trough in the long chain of Florentine achievements in painting, he is probably the most attractive figure, as Procacci's persuasive confirmation of the attribution of the Uffizi *Thebaid* especially indicates.[3] But just as the frescoes of St. Jerome, his most ambitious work, are almost entirely destroyed, so also information is lacking on his life and circumstances; thus, the present document may have value even if it illuminates them to only a slight extent.

The records heretofore known on the early patronage of the chapel may first be presented in chronological order. This is perhaps clearer than the inverse order, that of the finding of the documents by Procacci, in which the latest document led back in a chain to preceding ones.

(1) *1393, September 30 :* Tommaso, son of the late Guidone di Pagni, *lanaiuolo*, made his will, requiring his heirs to construct and have painted a chapel in the Carmine in honor of St. Jerome, and to spend 600 florins on it. This will does not exist, as far as is known, but is quoted extensively in the three succeeding documents, as is natural since it is the basis for all the ensuing actions. These later citations, the first in Latin and the latter two in Italian, agree on all points except the name of the notary who drew up the will (in the sixteenth century he is called Antonio di Chello, and in 1689 Filippo di Christofano di Leonardo); luckily, whichever of several explanations of this discrepancy is the right one, it does not appear to affect the matter that concerns us.

(2) *1404, October 4 :* The prior of the convent, Fra Matteo di Giovanni, declares the testator's son Matteo free of all obligations, since the chapel has now been completed, including its altar and paintings. This original document, which still exists, refers to the earlier will of "Tomasus olim Guidonis Pagni lanifex," which had required that a chapel in honor of the blessed Jerome "erigatur et fiat in ecclesia S. M. del Carmine," and furthermore "pingenda," for 600 florins. It then certifies that on this day, Matteo "Tommasi Guidonis," wool manufacturer, receives acknowledgment that "perfecisse unam cappellam cum altari et picturis et ornamentis et in omnibus et per omnia secundam formam dicti testamenti." This document was located by Procacci on the basis of the allusion to its exact date made in the one that follows.

(3) *Sixteenth century :* The book of records of the convent from 1334 to 1567 deals with the chapel of St. Jerome on a page that is an early-sixteenth-century transcript summarizing the two previous documents.

(4) *1689 :* A similar volume, the church's book of the patronages of chapels and tombs, compiled by a Padre Castaldi, treats the chapel in a similar way, but with additional points.

[3] Justification for this view of Starnina's significance is offered briefly in two general studies of mine, in *Spätmittelalter und beginnenden Neuzeit. Propyläean Kunstgeschichte*, VII, ed. Białostocki (Berlin, 1972), 215, a summary critique of his personal achievement, and *History of Renaissance Art* (New York, 1973), 57, a summary of his status in relation to the period.

The author begins with a different heading; the chapel is no longer called that of St. Jerome, but of the "Signori del Pugliese" and "detta della Comunione." After then citing the dedication to St. Jerome and the frescoes of the saint's life by Starnina, painter of the altar as well. Castaldi turns to the patrons: "E Padronato della nobil famiglia del Pugliese, fatta fare da Tomaso di Guidone per un suo lascito di fiorini secento, obligando per ciò i suoi eredi, come per suo Testamento rogato da ser Filippo di Christofano di Leonardo nel 1393, e del 1404 restò del tutto compita. Piero di Francesco di Jacopo del Pugliese dotò questa Cappella di fiorini centoventi . . ." This endowment took place shortly before 1470, when the convent used the 120 donated florins to buy part of a farm. The text then continues with further Pugliese donations after 1500.

In his article on Starnina, Procacci concludes his comments on the chapel with a reference to this record of 1689, which he had already quoted in his previous article on the chapels of the church: "Ecco le parole precise del padre Castaldi a proposito della cappella: 'Fatta fare da Tomaso di Guidone (*del Pugliese*) per un suo lascito...'" With hindsight, we can now see that there was an unfortunate ambiguity in this phrasing of Procacci's, which refers to the "precise words" of the text and then introduces an interpolation. Indeed, when it suggested itself to me that the parenthesis "del Pugliese" had been added by Procacci, it seemed necessary to recheck the source. This was generously done for me by Mr. Rab Hatfield, whose results are embodied in the quotation from the 1689 text given above. They show that the words "del Pugliese" do not follow the name "Tomaso di Guidone" in the original, but also show how plausible it was for Procacci to assume that they should be supplied in the absence of any surname, since the Pugliese appeared immediately above in the introductory words about the chapel, and also immediately following, in the reference to Piero di Francesco di Jacopo del Pugliese.

The now alert reader will have taken note that the earlier texts—the quite formal contract of 1404 and the church summary of the early sixteenth century—do not mention this name. Evidently, Procacci supposed them simply to be incomplete in this respect, so that the 1689 record was a valuable adjunct, but in fact these patrons were not of the Pugliese family at all. What is of interest is that no surname was given because they had none, as we shall see, (In presenting all this as thoroughly as possible, I should like it to be understood that I imply a necessary tribute to Procacci, whose small mistakes among many large services have to be treated in detail precisely because he makes so few. It is an example of the fact that poor work becomes forgotten, whereas good work is honored by corrections.)

Evidence of the non-Pugliese identity of the chapel's original patrons occurs in a document of 1407, printed in the nineteenth century in a different context and never used by art historians. In it we are informed that Matteo di Tommaso di Guido, who fulfilled his father's instructions by building the chapel, died on July 24, 1407, leaving a widow Maddalena but no children. As his heirs, after a life interest to his wife, he named his wife's brother and the latter's children—I think an unusual choice, and a certain indication that his own family was extinct. This brother-in-law was Gregorio Dati, known as Goro di Stagio, the merchant who

Q

was also the author of a chronicle of Florence, and who has also left us his confidential book of accounts, a text of very great art-historical interest.[4]

On a fresh page of his notebook Goro recorded the following :

MCCCCVII

Matteo di Tomaso di Guido, marito della Madalena nostra sirocchia, passò di questa vita a di XXIIII di luglio anno sopradetto 1407; e acconciò tutt'i suo' fatti dell'anima e del corpo, e fece suo testamento per le mani di ser Filippo di Cristofano Lionardi, e lasciò molti legati; e in tra gli altri a santa Maria Nuova ogni anno, mentre che viverà la Madalena, uno moggio di grano, uno cogno di vino, libre C. di carne di porco; e dopo la vita della Madalena, vuole che in perpetuo abiano ogni anno fiorini LX. E suo erede lascia la Madalena, mentre che durerà il tempo della sua vita; e dopo la vita sua lascia suoi eredi me Goro di Stagio e miei figliuoli e discendenti, con l'incarichi detti di sopra e con più altri, e con f. 6 s. 12 a oro che avea di prestanza. Piaccia alla divina bontà avere misericordia dell'anima sua e riposarla in vita eterna, e a noi dia grazia di fare la sua volontà perfettamente.

 Beni rimasi in detta eredità sono questi: cioè, una casa in Borgo Tegolaio, dove abitava, e tre casette in altri luoghi che si appigionano, com'appare al memoriale a c. 2; terreni in Mugello in due contrade affittati, appare al detto memoriale a c. 2; uno podere con case alla Lastra, e terre in piano in 5 pezi, e terre presso a Signa in 3 pezi e una vigna sopra Rimaggio, e uno pezo di terra su ad alti: di tutto è scritto distesamente al detto memoriale a c. 4. Danari in su la bottega e danari in sul monte: arassene a pagare l'incarichi. Fu fatta la stima d'ogni cosa per la gabella de' contratti: appare al detto memoriale a c. 12. Masserizie in Firenze e in villa rimangonsi a uso della Madalena, e logoransi: una cappella dipinta nel Carmino a onore di Dio e di san Girolamo.

We might, to be sure, ask for still more data than this, of the kind that was on the twelve-page inventory cited. But we are surely extremely lucky to have so much. Besides the dwelling house, we can feel confident that the three others mentioned in this private record as rented out really were small, *casette*. The emphasis on the "one farm with houses" at Lastra with its five pieces of valley land, and three other pieces of valley land at Signa, though we cannot tell their dimensions, presumably indicates that the latter had no houses on them, so that the "villa" where the widow had the use of household goods may be presumed to be the largest of the houses on the one farm.

The image is quite precise. What it means must await, naturally, comparison with a large quantity of other records. We may begin, however, by observing that Matteo di Tomaso was notably less rich than the patron of frescoes in a nearby chapel in the Carmine, Felice Brancacci, one of the rare patrons whose property holdings have indeed been explored, and who was also related by marriage to Goro Dati. (When Goro married Ginevra Brancacci as his third wife, her cousin Felice represented her interests.) We can also get from the tax records some idea of Matteo's status relative to others, with due regard for the dubious factors involved.

[4]*Il libro segreto di Gregorio Dati*. Scelta di Curiosità Letterarie inedite o rare, Dispensa CII (Bologna, 1869), 84-86. The edition, of 200 copies, has now been reprinted photographically (Bologna, 1968), but unfortunately seems to have become hardly less rare. In a previous study on Dati's remarks on Florentine buildings in his chronicle, I drew attention to the value of his *libro segreto*, which shows his contacts with Brunelleschi and Donatello ("The Earliest Guide to Florentine Architecture, 1423," *Mitteilungen des Kunsthistorischen Instituts in Florenz*, XIV, 1969, 33-46). Since in that study also I took Meiss's review of Antal as a point of departure, I should probably explain that I omitted there to point out the citation of Starnina's frescoes, not in order to present it separately but because I did not then realize that it involved unknown materials.

From the *prestanze* of 1403, the names of the 150 highest-paying householders in each of the four quarters of Florence have conveniently been published by L. Martines.[5] In the quarter of Santo Spirito, Matteo di Tommaso di Guido *lanaiuolo* appears at the very end (no. 147) paying five florins, the lowest sum included in Martines's tables. The list of 600 principal heads of households seems to be intended by Martines, and I would think correctly, to be linked to another consideration. It is his observation that the government of Florence was conducted by the top ten percent of family heads, and this, with a major qualification, might be equated with the 600 he has listed.[6] Be that as it may, it would appear that, since the family head ranking as the six hundredth constructed a chapel, there were at least 600 families who were in a position to become patrons of chapels. That is, I think, a considerably larger number (and proportion) than we have generally supposed.[7]

We should be wrong in drawing this inference if certain special factors were at work in this instance, which is possible but implausible. It is certainly the case that a childless couple might establish a chapel at a lower income level than one with children; but that does not apply here, since the decision was made not by the childless Matteo but by his father. It could be argued that in 1393 Tommaso made this provision in his will on the supposition that his only son Matteo would remain childless. This view would be supported by the fact that, in all probability, in 1393 Matteo had been married to Maddalena for thirteen years,[8] so that if in fact he then had no children, his father might have given up hope. But such an argument would depend, I think, on modern conditions, and would be anachronistic. Goro Dati, for instance, had four wives, and children by all of them, a not unusual result of the then-current patterns of life expectancy, so that calculations in such an area by the father would certainly have taken into account a possible future second wife for Matteo. Again, deduction that the six-hundredth man could build a chapel might be improper, if Matteo (approximately the six hundredth) in 1403 was relatively lower in the ranking of property holders than his father (the allocator of the chapel) had been in 1393. But this seems rather unlikely, in view of some admittedly intangible considerations—the suggestions of prosperity and of a sense of well-being (charity bequests, forgiveness of debts) in Goro's list of Matteo's holdings, and the added interesting reason that even as the six hundredth, Matteo seems to be at the top of a category that it may be permissible to isolate, a category to which his father had also belonged (so that we would not incline to suppose his father had been higher up), that of those without a surname.

[5] *The Social World of the Florentine Humanists* (Princeton, 1963), 365.

[6] In 1427, according to the new computer studies of the *catasto*, there were 9,836 households in Florence. This number should be decreased if we think of households in our sense, since some people were counted as a separate household unit whom we generally would not so treat, e.g., widowed mothers living with their sons. Of these households 3,081 were exempt as having no taxable income, the official poor. Hence 600 family heads would be 10 per cent of all those from whom, at the most, governing bodies might perhaps have been expected to be drawn. (For the figures see D. Herlihy, "Vieillir au Quattrocento," *Annales; Économies, sociétés, civilisations* (XXIV, 1969), 1340, 1341.

[7] A different approach to this question would be to count the family chapels in use in Florentine churches about this date. With allowance for destroyed churches, it seems to me quite likely that it would come to over 600. Medium-size churches, such as Santa Trinità, the Annunziata, San Lorenzo, would each have provided a dozen. In 1339, Florence had 57 parish churches and 53 convent churches, and presumably not fewer in 1400.

[8] Goro Dati records in his notebook the marriage of his sister Maddalena in June, 1380 (*Libro segreto*, 14). He does not name her husband, so that it is possible this was another earlier marriage of hers, but since no other marriage by her is noted by her brother, it was probably her marriage to Matteo.

In the published lists of 600 payers of *prestanze*, where surnames are almost invariable, "Matteo di Tommaso di Guido lanaiuolo" appears with none, thus finally demonstrating, if it is still necessary, that he had none, Pugliese or any other.[9] The fact that he is unusual in this respect among these tax payers is suggestive of the reason for our having gone astray. Procacci looked for a surname, which he thought must simply be missing from the document, because he was acting on the probably unconscious assumption that anyone who commissioned a chapel would be someone with a surname, even though most Florentines at the time did not have one. When we observe that Matteo is rare among the 600 *prestanza* payers in lacking a surname, and when we automatically attach a surname to a family building a chapel, we are offering two variations of the same assumption : that in this transitional period, richer people had surnames and poorer people did not. We would probably all concur in this general view,[10] though as far as I know no specific studies of nomenclature have been made from such a viewpoint. Our correction of Procacci's assumption that the surname Pugliese should be supplied is thus another way of correcting a wider assumption of assigning chapel patronage to a too narrow group : the line below the "rich" must be drawn lower for chapel donors than for surnames.

A final note concerns the evidence from Goro Dati's confidential book that bears on the way Matteo di Tommaso came in contact with his painter Starnina. Though the *Libro segreto* tells us no more about Matteo directly, it of course gives us all kinds of reports on various members of his wife's family. In the present connection their strong associations with Valencia are particularly interesting. From 1390 on, Goro traveled there repeatedly to trade in silk ; on the first trip he stayed two years.[11] When he returned in 1394 from his second trip,[12] he left his brother Simone behind to take care of business.[13] Simone made brief visits to Florence in 1396–1397 and 1402,[14] but went back to Spain and was still there in 1404.[15]

Our interest in this is that Starnina was in Valencia from 1398 to 1401, working for local

[9]As a different type of negative proof, Mr. Hatfield has kindly inspected the useful key to names of Florentine citizens, the MS *Poligrafo Gargani*, and found that the names Tommaso and Guido do not occur in the Pugliese family in the fourteenth and fifteenth centuries. The basic proof that these original owners were not the del Pugliese is implied, of course, in the fact that Matteo willed the chapel out of his family (certainly because he was the last of his line) so that its subsequent owners—the Del Pugliese—must be of another. His immediate male heir, Goro Dati, would not want the chapel, since his family parish and tombs were established at Santo Spirito, where later he was one of those who projected the new building. Without doubt the chapel of St. Jerome was then sold to the Del Pugliese. This is evidently to be correlated with the obscurity of the Del Pugliese until the later fifteenth century ; as a new family, they needed a chapel. It is often observed that Florentine prosperity and population did not grow in the fifteenth century, and in general there was no increase in number of churches. Thus the demand for the chapels from "new" families, however few they were, must have exceeded the supply, so that there would have been a ready market for any offered for sale, an event that apparently would only follow the extinction or complete financial ruin of an old family. These observations are based merely on empirical impressions, and a documented study of the patterns would be most welcome.

[10]Thus, while patrons are assumed always to have had surnames, and in fact nearly always did, artists almost never had surnames in the fourteenth and early fifteenth centuries. This is truer than we generally show by our usage, for some artists have been wrongly supplied with surnames by later anachronistic usage, from Vasari to the twentieth century. The normal pattern of baptismal name and patronymic, as in Giotto di Bondone and Duccio di Buoninsegna, or Nardo di Cione and Bartolo di Fredi, could be extended. Thus it seems likely that names like Simone Martini and Allegretto Nuzi are mistranslations from the Latin "Symon Martini" and "Allegrettus Nuzi" seen on signatures. If we were to call them "Simone di Martino" and "Allegretto di Nuccio," I think we would not only be more correct but would gain a more vivid sense of how they fitted comfortably into their times. I would, however, not try to recommend such a shift of deeply established usage. Taddeo Gaddi is surely an analogous case, but it is possible that Agnolo Gaddi really had a surname, in accordance with the common Florentine pattern of getting a surname by "freezing" the patronymic. This might well occur early in instances in which a family shop and profession were retained with exceptional acclaim through several generations.

[11]*Libro segreto*, 18, 24, 31.

[12]*Ibid.*, 28, 33.

[13]*Ibid.*, 29, 33, 34, 45, 53.

[14]*Ibid.*, 34, 38, 53–54.

[15]*Ibid.*, 58–59, 88.

churches and other patrons.[16] This has seemed, from our usual viewpoint, simply to represent a hiatus in our knowledge of him. But we can now take it that the two resident Florentines were acquainted there, and that Simone Dati answered an inquiry about Starnina's suitability before his brother-in-law put him to work on the Carmine frescoes. Thus Starnina's most remote and most ambitious activities are linked, and our sense of his identity is a little less fragmentary.

QUEENS COLLEGE

[16]Procacci, "Gherardo Starnina. Appendix I. La critica moderna e il soggiorno dello Starnina in Spagna," *Rivista* *d'Arte* (XVIII, 1936), 77-94.

Il Ciclo cavalleresco del Pisanello alla corte dei Gonzaga:
I. Il Pisanello e la grande scoperta di Mantova

CESARE GNUDI

I due massimi contributi recati negli ultimi anni alla conoscenza della pittura tardogotica e agli studi dei rapporti fra pittura italiana, francese e fiamminga dalla fine del Trecento alla metà del Quattrocento sono venuti, da un lato, dalla completa ricognizione critica compiuta da Millard Meiss di un immenso materiale pittorico in gran parte ancora ignoto, nella mirabile serie di volumi sulla pittura francese nel tempo di Jean de Berry (quasi tutta pittura su libri, salita nei primi due decenni, come giustamente afferma il Meiss, col Maestro di Boucicaut e coi fratelli Limbourg al più alto livello della pittura europea); e d'altro lato dalla scoperta del ciclo cavalleresco del Pisanello nel Palazzo Ducale di Mantova.

È questo senza dubbio il più grande rinvenimento artistico degli ultimi decenni, almeno nel campo dell'arte italiana, effettuato da Giovanni Paccagnini con un acume di filologo e di studioso che ha guidato il cammino, non certo casuale, ma calcolatissimo, delle ricerche. Condotte fino a quel momento assai distrattamente—ed anzi da tempo abbandonate, nella convinzione ormai consolidata che la sala del Pisanello (di cui restava notizia soltanto in alcune lettere del 1480 riferentisi al crollo del soffitto) fosse stata distrutta quando Giulio Romano rimodernò il palazzo—le ricerche furono orientate dal Paccagnini, "nel groviglio di strutture intricate e sovrapposte del Palazzo Ducale," verso i palazzi della Corte Vecchia, dove i Gonzaga avevano abitato fino al 1459, e dove qua e là erano affiorati frammenti di decorazioni tardogotiche del Trecento e del Quattrocento. È una lettura emozionante quella delle pagine ove il Paccagnini, nel fondamentale volume che ha fatto seguire al rinvenimento, narra le fasi della ricerca e della scoperta, e del restauro—estremamente difficile e complesso per la particolare natura della pittura murale pisanelliana—eseguito con eccezionale perizia dai restauratori Nonfarmale e Corfani.

Nello studio che segue in questa raccolta dedicata a Millard Meiss lo stesso Paccagnini approfondirà, della sua indagine critica, la parte che riguarda le tecniche grafiche e pittoriche usate dal Pisanello: studio reso particolarmente interessante dalla incompiutezza dell'opera. La grande decorazione pittorica, infatti, interrotta, quasi certamente dalla morte dell'artista, nel corso della creazione—e interrotta nei vari luoghi in momenti diversi del lungo percorso—dà, come poche, la possibilità di un contatto diretto con l'opera nel suo farsi: dà la possibilità di ricostruire passo passo il complesso procedimento usato dal Pisanello nella realizzazione della pittura murale.

Sulle immense pareti mantovane tutto è visto da un occhio accostato alla parete, nella fase delle sinopie, come sul foglio del taccuino di appunti; così come poi nella fase pittorica le grandi pareti dovevano venir punteggiate dal pennello in ogni loro particolare infinitesimo, come le pagine di un libro miniato.

Certo occorre uno sforzo mentale per raffigurarci il termine ultimo di questo percorso che qui vediamo interrotto: per raffigurarci disteso su quelle grandi superfici quel tessuto

pittorico prezioso che ora vediamo soltanto in qualche parte della *Battaglia*; ma il percorso che possiamo seguire sulle pareti mantovane ci consente di ricostruire e di afferrare con chiarezza quel risultato finale attraverso il procedere del cammino teso a raggiungerlo, e ci fa penetrare più a fondo nel segreto della grande, enigmatica personalità del Pisanello, svelandocene intera la grandezza.

Non si è ancor spenta l'eco della grande scoperta che già si va approfondendo nel campo degli studi storico-artistici e nel più vasto mondo della cultura la consapevolezza dell'eccezionale rilievo che il nuovo documento pittorico viene ad assumere nel quadro dell'arte tardogotica europea del Quattrocento da un lato, e in quello della civiltà italiana del Rinascimento dall'altro. Ed è proprio in questo duplice volto, in questa duplice prospettiva che s'apre nell'una e nell'altra direzione, verso l'uno e l'altro polo della cultura del tempo, che sempre più si rivela la singolarità e l'importanza della personalità poetica del Pisanello, che mai come in quest'opera, grazie anche alla sua meravigliosa incompiutezza, mai come in questo estremo e supremo messaggio aveva messo a nudo il crescere e il lievitare della propria creazione, la qualità più intima della propria ispirazione.

La contemporaneità, la simultaneità dell'aggancio con le due diverse culture mai come in quest'opera sembra contenere le oscillazioni entro l'unità di una visione che allaccia motivi spirituali e formali di tradizioni diverse: cosicché sia il panorama della cultura tardogotica sia quello del Quattrocento italiano si trovano ad essere allargati da questo capitale documento pittorico, anche se con nessuna delle due esso si identifica e combacia, differenziandosi d'all'una e dall'altra nell'atto stesso in cui penetra nel profondo di entrambe. Con esso la personalità del Pisanello si colloca ad un punto altissimo del crinale che divide i due mondi, con essi in egual modo comunicante.

Nulla di più lontano dal Rinascimento nella sua accezione più tipica (quella che si configura, poniamo, nella visione di Masaccio, di Donatello o di Piero della Francesca) e nulla di più congeniale con le forme spirituali instabili e inquiete proprie dell' "autunno del Medioevo" del mondo poetico del Pisanello, dell'errare senza posa della sua fantasia nei meandri sinuosi e misteriosi di una terra di incanti e di sogno; nulla di più lontano dalle astratte, irreali cadenze tardogotiche, nulla di più radicato nella cultura italiana di quel disegno che accanitamente ricerca e indaga la verità oltre la superficie delle cose. Nulla di più vicino ai fiamminghi di questa visione molecolare, di questa intensità del dettaglio nella rappresentazione della natura, nel filo d'erba come in un volto umano; nulla di più vicino a certi aspetti della pittura toscana della costruzione volumetrica delle forme nella allucinante composizione "metafisica" della *Battaglia*. L'alterno atteggiamento spirituale, che la poesia unifica, di questo spirito ricercatore e sognante, che solleva ogni aspetto del reale nella sfera dell'immaginazione e del sogno, che dà alla materia dell'immaginazione non solo l'apparenza ma anche la sostanza profonda della vita, si risolve e si compone, nel ciclo di Mantova come mai altrove, nella complessità e nella continuità di una rappresentazione circolante che contiene in sé tutte quelle oscillazioni e vibrazioni facendone il contenuto stesso della sconfinata e, nel suo infinito variare, unitaria visione poetica.

Della civiltà fiamminga il Pisanello accoglie quella vibrazione cromatica per cui "l'oggetto è visto nella sua attualità fenomenica dove anche una goccia di rugiada intensifica la frequenza

dell'immagine" (Brandi). Dal Rinascimento attinge nuova cultura umanistica, nuovo spirito di ricerca e quasi un abito scientifico nell'esplorazione del vero; e una nuova misura classica, nella definizione delle forme naturali, che ormai esclude ogni svago decorativo della linea per mirare alla solidità, alla realtà corporea e alla diretta verisimiglianza dell'immagine.

La raffinatezza della cultura tardogotica si affranca per tal via dalle dispersioni decorative e astratte per ancorarsi più stabilmente ad una realtà rappresentata nella sua organicità strutturale; nel tempo stesso che l'ideale cavalleresco di grazia, di eleganza, di raffinatezza, incarnandosi nelle nuove forme naturali, prendendo nuova e diversa sostanza vitale, passa da quelle divaganti astrazioni ad una più sofferta verità.

Operando ancora all'interno di una tradizione antica, il Pisanello sta sull'ultima soglia si affaccia alla nuova età e—senza perdere il contatto col mondo da cui proviene—si addentra in essa : divenendo la sua arte un elemento interno della dialettica spirituale in essa presente e operante. Si spiegano così i suoi contatti col Ghiberti e con Paolo Uccello, gli innegabili aspetti umanistici e rinascimentali della sua visione, specie nelle medaglie, e il loro convivere con gli aspetti medioevali e gotici, l'oscillazione fra questi diversi orientamenti di cultura e di civiltà della sua altissima poesia che non si può comprendere in una sola chiave e in una sola dimensione.

Oltre che per l'altezza della forma espressiva, il ciclo di Mantova acquista una straordinaria importanza nel quadro della civiltà non solo figurativa del Quattrocento per il suo contenuto tratto dai poemi e romanzi cavallereschi bretoni della Tavola Rotonda. Come in nessun'altra opera del Pisanello il tema iconografico, il contenuto letterario vengono così perfettamente a combaciare con l'ispirazione più profonda, con la realtà poetica dell'artista immaginoso e inquieto che di questo mondo favoloso, di questo trascolorante autunno del Medioevo è stato il più alto e lucido interprete. Dall'accostamento e dallo scontro fra bellezza e morte (i grandi temi del tardo Medioevo), fra gentilezza e violenza, fra il vagare libero e avventuroso dei cavalieri nella natura incantata e l'epilogo mortale nella battaglia cruenta, nascono gli accenti più patetici e struggenti della poesia del Pisanello, e quel sentimento che per tutto si diffonde di alta e profonda malinconia.

Lo studio del contenuto narrativo—che, come ha perfettamente dimostrato il Paccagnini, si compone di vari episodi riferiti ad eroi della vecchia e della nuova Tavola Rotonda "in una sorta di retrospettiva e panoramica visione del ciclo arturiano"—è necessario dunque alla comprensione non solo del grande ciclo ritrovato ma anche alla comprensione, fattasi ora tanto più vasta, dell'arte del Pisanello e di tutta una vicenda poetica di cui il poema mantovano segna, anche idealmente, la conclusione.

Sembra che per l'ultima volta l'artista voglia vivere ed offrirci nella sua realtà ancor viva e vicina quel mondo che getta ancora i suoi vivi riflessi nella vita delle corti. In particolare nelle corti settentrionali dei Gonzaga, degli Estensi e dei Visconti i testi della poesia cavalleresca venivano raccolti con speciale interesse, e certo dovevano costituire un elemento importante della loro cultura e dei loro costumi. Il poema figurato del Pisanello che ci dà l'immagine più completa della giuntura fra la letteratura cavalleresca e la vita delle corti proprio mentre quel mondo entra in crisi—nel tempo stesso in cui raggiunge il suo massimo fulgore, l'estremo limite della raffinatezza—aveva dunque dietro di sé il corso secolare di una tradizione letteraria

ricchissima, attraverso il quale la poesia cavalleresca vive le tappe della sua lunga storia.

Era nato in età "romanica" il mondo ferreo, compatto, della *Chanson de Roland*, chiuso dentro la sua forza, dentro le sue leggi dure e violente, di una maestà sacrale che è tutta combaciante con quella realtà: non oltre e al di sopra di essa così da sovrastarla, da circondarla e contenerla, come sarà del "gotico," ma tutta interna ad essa, tutta interna a quel mondo dove l'irreale, il trascendente ha la stessa presenza fisica del reale. La famosa Battaglia di Roncisvalle—progenitrice di tutte le battaglie dei poemi cavallereschi, piene di scontri frontali, di ferocia, di violenza e di morte—è narrata con un ritmo grandioso, incombente, incalzante, con larghe aperture e solenni riprese, con accenti altamente drammatici:

> La bataille est étrange et générale
> Cependant la bataille est devenue plus dure. . . .
> La bataille est prodigieuse et pésante. . . .
> La bataille est prodigieuse et grande.
> Les Français frappent des épieux brunis.
> Vous eussiez vu si grande douleur de gens
> Tant d'hommes morts, et blessés, et sanglants.
> L'un gît sur l'autre, face au ciel, face à terre. . . .
>
> (Traduzione di Albert Pauphilet,
> Bibliothèque de la Pléiade, Paris, 1952.)

La materia poetica cavalleresca si incarna poi e si diffonde nella inesauribile fioritura delle leggende bretoni, la cui espansione accompagna il formarsi e il crescere dell'arte gotica, nel cui ambito e nel cui spirito prendono vita e forma la poesia raffinata e patetica dei poemi e romanzi arturiani di Tristano, di Lancillotto, della Tavola Rotonda, e la costruzione mistica, simbolica e teologale della Queste du Graal.

Di fronte allo svelato mistero del Graal si disperdono e svaniscono le magie e gli incantesimi; e vengono respinti verso la corte di Artù i cavalieri erranti. La conclusione mistica della leggenda del Graal coincide così con la catastrofe della grande battaglia che conduce alla morte di re Artù. Degli accenti drammatici e pieni di pietà della *Mort Artu*, di quel sentimento e presentimento di morte sembra riflettersi l'eco e l'immagine—in un ambiente "tardogotico" fattosi più raffinato e prezioso—nella poesia del Pisanello, quand'egli rappresenta nella parete di fondo della sala mantovana il *Torneo-Battaglia di Louverzep* (Figg. 1 e 5) che è il punto di partenza e insieme di arrivo dell'avventuroso errare dei cavalieri rappresentato nelle altre pareti. Così, nel poema del Pisanello, nella rappresentazione più vasta che nelle arti figurative sia mai stata data della civiltà cavalleresca, sembra essere riecheggiata e figurata, in sintesi, tutta la sua lunga storia. Quel mondo giunge fino a lui dal lontano passato senza soluzione di continuità, come cosa ancor viva, che trova in quella raffinata cultura di corte il luogo della sua ultima evoluzione e trasformazione. Il Pisanello, nella "visione retrospettiva e unitaria di quel mondo" (Paccagnini), lo attualizza, lo porta, ancor vivo e presente, con tutta la sua ricchezza, nel cuore della civiltà del suo tempo; e in essa, in questa civiltà estremamente colta, complessa e spesso contradditoria, egli traspone e riflette, di quel mondo nel tempo stesso antico e vicino, gli aspetti più presenti al suo spirito e alla sua fantasia: il fasto delle

corti, la bellezza delle donne, la malinconica passione dei cavalieri, gli ombrosi misteri della natura, l'assurdo giuoco della morte.

E là, nella grande scena del torneo, che nella sua stesura finale doveva rifulgere di un allucinante splendore—nella parete di fondo (Figg. 5-10) e nell' angolo della parete maggiore ove sono figurati i cavalieri che si apprestano a buttarsi in quel giuoco mortale sotto lo sguardo malinconico delle dame (Figg. 2-3)—si trovano gli accenti più lirici, più patetici e dolenti di tutta l'opera a noi nota del Pisanello, le sue immagini più sconvolgenti. Non ci lasciano più, se per una volta li abbiamo incontrati, gli sguardi malinconici e intensi dei cavalieri che ci fissano di sotto le celate, non si dimentica la malinconia assorta e presaga dei guerrieri cristiani e mori che si accingono a scendere in campo, e quel loro precipitarsi nella mischia, quel cozzo, quel groviglio terribile ; e la pietà con cui l'artista ha rappresentato i corpi dei feriti e dei morti "face au ciel, face à terre." L'eredità della tradizione poetica delle battaglie che vedono la morte di Orlando, o quella di Artù, sbocca in Pisanello con una tonalità dolce e triste, che sarà poi solo del Tasso. Nel mezzo, splendono la gioia spensierata del Boiardo, il luminoso, dominante sorriso dell'Ariosto.

Come ha ben visto il Paccagnini, gli intenti celebrativi del Marchese Ludovico Gonzaga, che l'eroismo dei cavalieri del ciclo arturiano intendeva proporre come paragone e specchio delle proprie imprese, non trovano nel Pisanello una rispondenza spirituale. Le immagini del Pisanello non si prestano a divenire facciata posticcia, pretesto celebrativo. Esse vivono nel sentimento profondo dell'artista una vita che proprio per essere posta dentro la realtà del tempo non può non essere segnata da quel sentimento di accorata nostalgia, da quel presentimento di fine e di morte che il mondo cavalleresco recava in sé in un'epoca in cui nuove forze spirituali gli si opponevano. Il Pisanello lo vive proprio in questo suo finire, in questo suo estremo risplendere, in questo suo contrastare—nelle immagini più alte che mai avesse espresso della sua raffinata bellezza—il mondo nuovo che ormai lo fronteggia. Vent'anni dopo nelle stesse corti di Ferrara e di Mantova ove il Pisanello aveva a lungo operato e lasciato il suo capolavoro, la sua visione poetica sembra venire respinta indietro verso un passato favoloso e lontano. Nel Salone dei Mesi, nella Camera degli Sposi una diversa società, una realtà più vicina e terrena nella rappresentazione della vita delle città, dei campi, delle corti, nello stile una ferrea astrazione che rinchiude in sé l'individuazione possente di ogni particolare, di ogni momento del vero : un'astrazione che non ha più nulla a che fare con la trasfigurazione della realtà nel mito cavalleresco, con la assimilazione di quel mondo alla realtà che in esso tutta si trasfonde. Bastano venticinque anni perché Matteo Maria Boiardo, riprendendo i temi cavallereschi, vi ritorni come a un mondo ormai lontano nel tempo, non più recuperabile se non come puro giuoco dell'immaginazione, senza più quel legame col presente ancora esistente nel Pisanello, che quel mondo aveva fatto penetrare nel suo intatto splendore dentro le fibre della realtà da lui vissuta, dentro le fibre stesse della natura che si adorna di quella bellezza sognante, che in quella luce declinante si trasfigura. Nel Boiardo la "visione retrospettiva" del mondo cavalleresco, il recupero di esso operato dall'immaginazione, avvengono da una posizione spirituale già radicalmente diversa, da un momento dello spirito e della civiltà che, con uno stacco improvviso, è già altro da quello che il Pisanello aveva vissuto. È già un ricorso della fantasia a un tempo remoto che riemerge con la sua

inesauribile ricchezza nella nuova costruzione che il poeta umanista felicemente elabora nella sua "officina" per il nutrimento del suo spirito, per il deletto dei suoi ascoltatori:

> Signori e cavallier che ve adunati
> Per udir cose dilettose e nove,
> Stati attenti e quïeti, et ascoltati
> La bella istoria che'l mio canto muove;
> E vedereti i gesti smisurati,
> L'alta fatica e le mirabil prove
> Che fece il franco Orlando per amore
> Nel tempo del re Carlo imperatore.
> Non vi par già, signor, meraviglioso
> Odir cantar de Orlando innamorato, . . .
> (Lib. 1, Can. 1, 1–2)

È un passato che rinasce gioioso nell'immaginazione con quei toni di ironia, e perfino di grottesco, ed anche di nostalgico trasporto verso il bene perduto di quel libero giuoco dell'amore e del valore.

"L'operazione boiardesca," afferma Domenico De Robertis, "consiste nel ricongiungimento a quella lontana stagione, nel ritorno a quell'accordo venuto a mancare 'un gran tempo.' "

> Così nel tempo che virtù fioria
> Ne li antiqui signori e cavallieri,
> Con noi stava allegrezza e cortesia,
> E poi fuggirno per strani sentieri,
> Sì che un gran tempo smarirno la via,
> Né del più ritornar ferno pensieri;
> Ora è il mal vento e quel verno compito
> E torna il mondo di virtù fiorito.
> Et io cantando torno alla memoria
> Delle prodezze de' tempi passati,
> E contarovi la più bella istoria
> (Se con quiete attenti me ascoltati)
> Che fusse mai nel mondo. . . .
> (Lib. 1, Can. 1, 21)

In quei pochi anni che erano succeduti alla scomparsa del Pisanello, nel colto ambiente letterario e artistico delle corti rinascimentali un salto di civiltà era avvenuto. Quel breve tempo era divenuto "un gran tempo." Sarebbero impossibili nel Pisanello quelle coloriture di ironia e di grottesco, ed anche, e forse soprattutto, quella gioia. Quel mondo veniva ora resuscitato dall'immaginazione con toni e accenti impensabili nel Pisanello che pochi decenni prima aveva vissuto, sofferto ed espresso il suo irreparabile tramonto.

Fissiamo lo sguardo sui volti del S. Giorgio e della Principessa in Sant'Anastasia, o su

quello malinconico dell'*Isotta* di Mantova (Fig. 4) o sull'allucinante visione d'insieme e sui singoli drammatici episodi, sui singoli personaggi del *Torneo-Battaglia* (Figg. 1–2 e 5–10), o sulle figure di cavalieri che errano solitari e silenziosi (Figg. 13 e 15) mentre ascoltiamo, a contrasto, il Boiardo quando presenta i suoi personaggi:

> Re Carlo Magno con faccia ioconda
> Sopra una sedia d'or tra' paladini
> Se fu posato alla mensa ritonda.
> > (Lib. 1, Can. 1, 13)

> Però che in capo de la sala bella
> Quattro giganti grandissimi e fieri
> Intrarno, e lor nel mezo una donzella,
> Che era seguita da un sol cavallieri.
> Essa sembrava matutina stella
> E giglio d'oro e rosa de' verzieri.
> > (Lib. 1, Can. 1, 21)

> Va Feraguto con molto ardimento
> Per quella selva menando fracasso,
> Ché ciascuna ora li parea ben cento
> di ritrovarse a fronte con Gradasso.
> > (Lib. 1, Can. IV, 13)

Nulla di più lontano dal Pisanello di questi accenti o spregiudicati e dissacranti, o lievi e gioiosi. Un solco invalicabile si è verificato fra l'uno e l'altro momento dello spirito. Da quella estrema maturazione di bellezza ormai decadente si passa al vagheggiamento del "primitivo." Se in Boiardo riaffiora il ricordo dello spirito primitivo e violento della *Chanson de Roland*, esso si deforma nel grottesco, si dilata nell'iperbole, si anima degli accenti di una gioia, di una felicità che a noi si trasmette.

> Giunse al gigante in lo destro gallone,
> Che tutto lo tagliò, come una pasta,
> E rene e ventre, insino al petignone;
> Né de aver fatto il gran colpo li basta,
> Ma mena intorno il brando per ragione,
> Perché ciascun de' tre forte il contrasta. . . .
> Fiè Feraguto un salto smisurato:
> Ben vinti piedi è verso il ciel salito;
> Sopra de Urgano un tal colpo ha donato,
> Che 'l capo insino ai denti gli ha partito.
> Ma mentre che era con questo impacciato,
> Argesto nella coppa l'ha ferito
> D'una mazza ferrata, e tanto il tocca,
> Che il sangue gli fa uscir per naso e bocca.
> > (Lib. 1, Can. 1, 77–78)

Le vicende cavalleresche, eroiche e cortesi, non sono più che una favola meravigliosa che sorride alla fantasia del poeta sia nella sua bellezza che nei suoi orrori. È bastato quel quarto di secolo perché il mondo spirituale del Pisanello venisse buttato indietro dalla realtà presente in quel passato lontano.

La pienezza della civiltà rinascimentale e il genio solare di Ludovico Ariosto—che crea il suo capolavoro fra l'inizio del primo e la metà del secondo decennio, negli anni culminanti della classicità del Rinascimento, negli anni delle Stanze, della volta della Sistina, della *Gioconda*—varranno a spianare i confini fra l'immaginazione e il vero, a comporre gli squilibri in un'armonia suprema che tutto unifica, dove le passioni e i contrasti perdono la loro crudezza, dove il reale e l'irreale, il vero i il meraviglioso hanno la stessa simultanea presenza, dove il dolore e il piacere, il valore a l'amore, la bellezza e l'orrore hanno la stessa levità, gli stessi sfumati confini, in una visione globale dove l'uomo e i suoi sentimenti sono tutt'uno con l'universo.

Lo sguardo dell'artista è al centro di quell'orizzonte infinito. Tutto è veduto da lontano, così che i contorni della realtà si fanno più tenui, e tutto si amalgama e digrada, proprio al contrario che in Pisanello dove tutto è veduto da vicino, dove ogni particolare è esaltato ed evidenziato, dove tutto si ispessisce e si accosta a noi, al nostro occhio, ci prende e ci avvolge.

In questa visione, dove l'eroico e il meraviglioso delle *Chansons de geste* e dei romanzi bretoni viene riassunto dalla fantasia per creare intorno alla realtà un alone di sogno verso cui la realtà si allarga e sfuma, in questa visione dominata dalla pienezza di un'armonia dove tutto, anche la morte, è contenuto nell'esaltante e gioioso spettacolo della vita, non c'è più posto per l'alta, struggente malinconia dell' "autunno del Medioevo," di cui il Pisanello fu il sommo poeta. Delle sue descrizioni di battaglia potè dire il Momigliano: "Nessun sorriso di poeta brillò mai così luminoso e fugace come il suo su le povere membra mutilate dei vinti."

> Tutto in un corso, senza tor di resta
> La lancia, passò un altro in mezzo 'l petto;
> Quivi lasciolla, e la mano ebbe presta
> A Durindana; e nel drappel più stretto
> A chi fece due parti della testa,
> A chi levò dal busto il capo netto;
> Forò la gola a molti; e in un momento
> N'uccise e messe in rotta più di cento.
> Più del terzo n'ha morto, e 'l resto caccia
> E taglia e fende e fiere e fora e tronca. . . .
> (Lib. I, Can. XXIII, 60–61)

Bisogna scavalcare l'armonia piena del Rinascimento, di cui l'Ariosto è creatore sovrano, e ripiegare nel dramma che si consuma nel contrastato spirito di Torquato Tasso per ritrovare nella descrizione di una battaglia accenti lugubri e patetici di accorata pietà che possano riallacciarsi a quelli del Pisanello, e far riecheggiare persino l'eco lontana della battaglia di Roncisvalle. La lettura di questi versi ci fa rivolgere nuovamente lo sguardo alle pareti di Mantova:

Così si combatteva: e in dubbia lance
Col timor le speranze eran sospese.
Pien tutto il campo è di spezzate lance,
Di rotti scudi e di troncato arnese;
Di spade, ai petti, alle squarciate pance
Altre confitte, altre per terra stese;
Di corpi, altri supini, altri co' volti,
Quasi mordendo il suolo, al suol rivolti.
Giace il cavallo al suo signore appresso;
Giace il compagno appo il compagno estinto;
Giace il nemico appo il nemico; e spesso
Sul morto il vivo, il vincitor sul vinto.
Non v'è silenzio, e non v'è grido espresso;
Ma odi un non so che roco e indistinto;
Fremiti di furor, mormori d'ira,
Gemiti di chi langue e di chi spira.

(Lib. I, Can. xx, 50-51)

E osservando lo sguardo triste e pensoso di "Isotta" (Fig. 4), ci viene alla mente Erminia
che osserva la battaglia dall'alto della torre:

Mirò, quasi in teatro od in agone,
L'aspra tragedia dello stato umano:
I vari assalti e il fero orror di morte,
E i gran giochi del caso e della sorte.

(Lib. I, Can. xx, 73)

Non è dunque da sottovalutare l'importanza della scoperta di Mantova anche nei reflessi
della futura poesia cavalleresca, dal Boiardo al Tasso, fiorita proprio in quella corte estense
ove Pisanello aveva a lungo operato e che a quella dei Gonzaga era strettamente legata. È con
certezza che si può affermare che nulla di così alto poeticamente nei testi letterari esisteva
in questo momento terminale della storia del Medioevo, al punto da cui si stacca la nuova
vicenda poetica dei letterati del Rinascimento. In quel punto di congiunzione e di trapasso
il ciclo del Pisanello si pone ora come il fatto di maggior rilievo. Di questa grande presenza
dovranno ormai tener conto, perciò, anche gli storici della letteratura.

Il ciclo di Mantova è il solo esempio, nelle arti figurative, di un poema che della grande
letteratura cavalleresca medioevale ripete e riflette l'illimitato e l'ininterrotto procedere
dell'immaginazione e del ritmo poetico. Questo indefinito e infinito trascorrere della vita,
senza un termine, senza un centro, entro gli avventurosi meandri di una natura incantata ci è
restituito dal fluire continuo delle immagini nelle grandi pareti mantovane, dalla narrazione
che si svolge senza soste, non già nell'accostamento o sovrapposizione delle singole scene
della rappresentazione, ma nell'ininterrotto procedere di una sola rappresentazione, che
contiene e sviluppa dentro di sé il succedersi degli episodi in una spazialità diffusa, in un
circolo che non si chiude.

Non vi è qui distanza prospettica, che unifichi la visione secondo un solo punto di vista, secondo una misura data dalla mente, ma anzi un occhio vicino: un occhio che vaga e si porta vicino a tutti gli oggetti, ad uno ad uno, che si collocano in quello spazio indeterminato e illimitato. Lo spettatore, vagando anch'egli per la sala, si addentra con l'occhio in ogni meandro di quel paesaggio che lo circonda, come nel vero. Ed è straordinaria a Mantova la consonanza fra la soluzione formale e visiva e il contenuto poetico e letterario. "Il mondo cavalleresco," disse Giulio Carlo Argan presentando a Mantova il libro di Paccagnini, "è un mondo senza centro. Il mondo di Brunelleschi e di Alberti è un orbe che è urbe, con perimetro, limite, centro. Il mondo cavalleresco è al contrario un mondo non urbano che si espande indefinitamente nello spazio." Ed infatti l'inesauribile materia poetica dei cicli cavallereschi arturiani viene qui evocata e svolta in una rappresentazione continua, che mai si conchiude.

La rappresentazione non ha centro e non si conchiude nemmeno nella grande *Battaglia di Louverezep*, rappresentata nella parete di fondo, e che è anch'essa scentrata (Figg. 1 e 5). E c'è una ragione. La visione che scorre intorno alla sala in un ritmo senza fine e indefinito non vuole nella battaglia fermarsi e conchiudersi. Anche se la narrazione porta alla battaglia come al suo punto culminante, in essa non si ferma, ad essa arriva e da essa riparte. La battaglia non è infatti centrata nella grande parete: irrompe da sinistra e si smorza a destra, si dilegua e si nasconde negli anfratti del paesaggio montuoso e boschivo. Sospinti dall'urto della battaglia sembra che i guerrieri vadano a disperdersi, nella parte destra della parete, fra quei boschi e quei valloni e di lì inizi il loro girovagare che li riporta e li respinge, attraverso le altre pareti, di avventura in avventura, verso il castello e la città donde il torneo si diparte, precipitando con furia; e così sembra all'infinito ripetersi questo ritmo che mai si conchiude, che non trova il suo centro, il suo termine; a cui non si vuole, anzi non si può, se non a costo di negarne il significato espressivo, dare un centro.

Questo movimento continuo della visione si manifesta non solo nello sviluppo della rappresentazione, ma anche dall'interno, nello svolgersi del lungo percorso creativo.

Anche se in parte riferibile ai precetti del Cennini, resta pur sempre eccezionale e sorprendente la lunghezza del processo mediante il quale il Pisanello giunge all'immagine finale della *Battaglia*: processo che passa attraverso versioni e realizzazioni formali che si differenziano l'una dall'altra quando addirittura non sembrano contraddirsi. Così nell'incredibilmente complesso procedimento per giungere all'immagine finale sembrano scontrarsi e dialogare le sue varie anime, sembrano scomporsi le varie facce del suo volto enigmatico.

Anche senza considerare i disegni su carta e fermandoci a ciò che palesano le grandi pareti mantovane, sembrerebbe impossibile—se il distacco e il restauro non avessero messo in luce le varie fasi esecutive, così acutamente indagate e interpretate dal Paccagnini nello studio che segue—la coesistenza, nell'ambito di una stessa opera, non solo di tecniche, ma anche di visioni formali così diverse come quelle che si sovrappongono e si distruggono l'un l'altra nella grande *Battaglia*: tanto diversi fra loro non solo tecnicamente, ma proprio sul piano espressivo, sono questi momenti che si susseguono; dalla prima alla seconda sinopia, dal disegno a verdaccio sullo smalto disteso per la realizzazione pittorica fino alla superficie colorata a mezzo fresco e a secco, solo a tratti eseguita nell'opera rimasta incompiuta.

Forse il disegno irruento, volante, impetuoso della grande sinopia della *Battaglia* (Figg. 11–12) è il punto più alto di tutta l'opera del Pisanello per ciò che si riferisce alla libertà e alla forza della sua più immediata forma espressiva, anteriore al filtro mentale e poetico che lo guidava verso un risultato finale diverso e quasi contraddittorio. La commozione intensa con cui egli affronta l'ideazione della parte più importante di tutto il grande ciclo fa sì che tralasciando l'abbozzo iniziato col pennello nero sostituisca e sovrapponga, quasi sotto l'incalzare dell'ispirazione, un disegno più rapido, come se dovesse fermare sul muro, prima che gli sfuggisse, la visione che era apparsa alla sua fantasia. Nella grande sinopia un vortice di immagini si spinge da sinistra verso il centro della parete, dove si evidenziano i alcuni protagonisti del torneo (assai più che nella visione finale, nella quale essi maggiormente si confondono nel groviglio, nel tumulto generale): una violenza, un vortice di luci e ombre che sembrano preludere alla *Battaglia di Anghiari* di Leonardo. Non ci sono, nella sinopia, i singoli oggetti, i dettagli scrutati e definiti uno per uno; c'è la visione d'insieme del fatto nel suo manifestarsi. Ma per Pisanello questa non è la realtà vera delle cose e degli esseri. La realtà vera è per lui quella che si nasconde e si rivela in ogni molecola della natura. Entro quella visione che gli era apparsa improvvisa, il suo pennello doveva poi, perché quella visione acquistasse ai suoi occhi parvenza e sostanza di vero, ricostruire quella verità ricercando la vita di ogni atomo, scomponendo quella sintesi nell'infinita analisi e connessione dei particolari in cui, per lui, la realtà consiste.

Il disegno a verdaccio sullo smalto preparato per la pittura è il passaggio alla realtà da quella prima visione, che per il Pisanello precedeva la realtà. L'accostarsi progressivo a questa sua verità, l'avvicinarsi—che egli ha in comune coi fiamminghi—dell'occhio alle cose, sempre più vicino, gli fa perdere la visione sintetica della rappresentazione, che si infittisce nella somma infinita e nell'infinito succedersi dei particolari, e si converte in una visione analitica e continua, che non può interrompersi in nessun punto, e dove l'occhio, più che afferrarla nel suo complesso, penetra e scorre. Per questo la realtà non ha un centro per il Pisanello, la realtà essendo soltanto per lui un succedersi ininterrotto di immagini, un congiungersi infinito, sia nell'apparenza esteriore, sia nella sostanza interna, delle infinite molecole che la compongono.

Così la grande scena della *Battaglia* nel passaggio dalla sinopia sull'arriccio al disegno a verdaccio sulla parete destinata alla pittura sembra rassodarsi, consolidarsi, ispessirsi; per poi assumere, nella definitiva stesura pittorica, una variata evidenza di forme cristalline nello splendore dei colori, in contrasto col misterioso senso di morte, di rovina, di distruzione che dentro quello splendore si cela.

Nel cercare la verità fiamminga dell'atomo luminoso Pisanello traspone in quella irreale visione quasi di sinistra magia l'immagine balenata nella prima visione. Cercando una realtà più vera arriva ad una realtà metafisica, al sogno più irreale. Nega se stesso o trova se stesso? Qui è la meravigliosa ambiguità della sua espressione poetica. La sintesi delle due forme e delle due esperienze non avviene. Restano una sull'altra. Sotto il mirabile caleidoscopio variopinto di luci e colori della *Battaglia di Louverzep*, sotto il disegno a verdaccio che dava la struttura plastica a quelle forme colorate e smaglianti c'era, invisibile e imprevedibile, la grande sinopia "leonardesca" (Figg. 11–12). Questa prima sintesi viene negata dall'analisi

che egli costantemente vuole e conduce, giacché la sua convinzione è che la realtà vada cercata in ogni fibra, in ogni atomo in cui palpita la segreta sorgente della vita. Sono, queste, oscillazioni e contraddizioni non superficiali ma interne alla più profonda essenza del suo spirito, e perciò esse stesse fonte di poesia.

Le grandi sinopie delle altre pareti realizzano la forma in un modo ancora diverso (Figg. 13–14). Superata la fase dei primi rapidi e sintetici abbozzi si attua qui, subito, sul muro, nelle sinopie rosse, con un percorso più diretto di quello che era stato necessario alla ideazione ed alla elaborazione della *Battaglia*, un risultato più vicino a quello che avrebbe dovuto tradursi in pittura, nella descrizione progrediente e continua del paesaggio, dei castelli, delle colline, delle figure e delle foglie. Si prevede assai più vicino il finale conclusivo nella visione atmosferica e lucente, nel brillare di atomi infinitesimi di luce e di colore. Da questa sinopia alla pittura il percorso era dunque più diretto e non così contrastante come nella grande sinopia della *Battaglia*.

E vi è anche nella concezione spaziale una differenza tra la descrizione dei grandi paesaggi nelle altre pareti e la rappresentazione della *Battaglia*. Nei paesaggi lo spazio digrada dai primi piani, ove si inseriscono le figure di maggiori dimensioni, verso l'alto, ove le figure dei cavalieri erranti si rimpiccioliscono, e dove dietro e sopra le colline appaiono le città e i castelli. È questa, come ha ben visto il Paccagnini, una concezione spaziale assai simile a quella del Ghiberti nella seconda porta, specie nella scene degli *Israeliti dinnanzi alle mura di Gerico*, o in quella dell'*Uccisione dei Filistei*. Nella *Battaglia*, invece, dove tutte le figure sono di eguali dimensioni, il Pisanello, con estrema libertà fantastica, ribalta la prospettiva, quasi raffigurando dilagante su di un grande piano visto dall'alto—dall'alto del palco donde si affacciano le dame—l'irrompere improvviso e il violento scontro dei guerrieri. Solo il Pisanello poteva far vivere con tanta libertà nell'unità complessiva della visione un'articolazione spaziale così mobile, indefinibile e sfuggente.

È in questa coerente indeterminatezza la genialità di questa visione poetica, d'un mondo che contrasta con la razionalità e la misura mentale del Rinascimento toscano, dandoci la più alta misura che finora ci fosse nota di questa grande alternativa—come ebbe a chiamarla Argan—all'interno della cultura quattrocentesca italiana. Di qui la straordinaria, ineguagliabile importanza della scoperta mantovana.

Per costituire una alternativa all'altra visione del mondo, all'altra via che si era affacciata nella storia, il rapporto fra le due visioni non poteva essere fra un prima e un dopo—giacché in quel caso alternativa non ci sarebbe stata—ma un rapporto di contemporaneità tra due fatti che salgono alla ribalta della storia, non come sopravvivenza ma come presenza. Nella prima metà del Quattrocento la presenza di Pisanello da Venezia a Mantova a Ferrara, da Roma a Napoli fu—forse solo ora lo si comprende pienamente—una presenza vivissima, se non dominante. E dai più la sua era considerata, come avverte il Paccagnini, nell'estremo raffinamento delle tecniche pittoriche, la via "moderna" dell'arte. Perciò veramente, sulla metà del secolo, quando essa giunse al suo traguardo più alto, essa costituiva un'alternativa al mondo del Rinascimento toscano. La grande tradizione artistica e letteraria tardogotica sbocca, col Pisanello, ad un suo esito altissimo, attualizzata da un linguaggio moderno che la fa rivivere, nella sua compiutezza e continuità, nel nuovo tempo: nell'estrema maturazione di

P

un linguaggio che è nello stesso tempo e nella stessa misura nutrito di quella tradizione antica e di tutte le più moderne, stimolanti e inquietanti esperienze.

Cresce intanto la nuova cultura giungendo, nel momento stesso del ciclo di Mantova, al supremo traguardo di Piero della Francesca ad Arezzo: e mi sembra che queste, subito intorno alla metà del secolo, siano le opere che al più alto livello si contrastano e si fronteggiano; mentre il Paolo Uccello delle *Battaglie* sembra mostrare aderenze e contatti con entrambe. In Piero, proprio mentre il Pisanello scioglie nei mobili e patetici accenti di Mantova la più distaccata bellezza del S. Giorgio e della Principessa, quella bellezza si eterna nell'assolutezza della visione di un mondo misurato e fermamente dominato dallo spirito e dalla mente dell'uomo. L'unità che nel Medioevo le forme del visibile avevano trovato nella trascendenza divina—che il mondo tardogotico aveva infranto—si ricompone in Piero della Francesca in una nuova sintesi ove l'unità doveva riconquistarsi nell'equilibrio e nell'accordo, universale e immanente, fra la natura e l'uomo. Ma era moderna anche l'altra via che spezzava quella struttura universalistica spingendo a fondo l'esplorazione e l'analisi su ogni particolare del vero, quella forza centrifuga che liberava tanta ricchezza umana e fantastica negli infiniti frammenti del reale. Per questi motivi l'arte del Pisanello si poneva, a mezzo il Quattrocento, come alternativa. Di questa alternativa il ciclo di Mantova ci restituicse il punto più alto, e in quel supremo confronto e scontro può dirsi che venga restituita più completa e intera anche l'altra e opposta grandezza.

BOLOGNA

Il Ciclo cavalleresco del Pisanello alla corte dei Gonzaga: II. Tecnica e stile nel ciclo murale

GIOVANNI PACCAGNINI

In questo articolo sulla tecnica murale del Pisanello a Mantova torna opportuno ricordare che, fra le tante ricerche diramate in ogni direzione con le quali Millard Meiss ha esplorato vaste aree della pittura del tardo Medioevo e del Rinascimento, non ultime sono da porre quelle svolte dall'illustre studioso per una migliore conoscenza degli elementi costitutivi di alcuni dei più famosi cicli della pittura murale italiana. Uno studio illuminante su questo argomento è ad esempio quello, condotto in *équipe* col restauratore L. Tintori, sui vari procedimenti della tecnica murale, con particolare riferimento a quelli usati da Giotto negli affreschi di Assisi e di Padova.[1] Eppure, mentre incrementava a breve distanza di tempo i rilevanti risultati raggiunti in un campo d'indagine così pieno d'incognite, gli stessi autori giustamente notavano, con acuto senso dei limiti attuali e delle possibilità di un rapido sviluppo delle conoscenze in proposito: "Inasmuch as the study of mural technique is still in its early stages, it is not surprising that observations recorded only three years ago can be significantly extended."[2]

Al significato di tali considerazioni come ricerca in atto sono da ricollegare queste note che riprendono, chiarendone con qualche aggiunta alcuni punti e ricapitolandone altri, le osservazioni fatte nel corso del recente ricupero del ciclo murale cavalleresco, che il Pisanello eseguì negli ultimi anni della sua attività in una sala della Corte dei Gonzaga a Mantova.[3] Questo poema figurativo—di un'importanza eccezionale non soltanto per la storia della pittura del primo Quattrocento, ma anche per le interne connessioni che il contenuto del grande racconto arturiano della "sala del Pisanello"[4] ha con la tradizione letteraria dei poemi e romanzi cavallereschi francesi e con i più tardi esiti italiani di quella materia—pone una serie di complessi problemi riguardanti più discipline. Su di essi si è cercato di dare quelle risposte che, allo stato attuale della questione si presentavano possibili; e naturalmente la molteplicità degli interessi suscitati da un argomento tanto importante ha già incontrato, nel breve giro di un anno, ampi consensi e sollevato ripercussioni, destinate ad estendersi in diverse direzioni man mano che il ciclo pittorico verrà esaminato sotto le più varie angolazioni di ricerche settoriali.[5]

[1] *The Painting of the Life of St. Francis in Assisi, with Notes on the Arena Chapel* (New York, 1962).

[2] "Additional Observations on Italian Mural Technique," *Art Bulletin* (XLVI, 1964), 377-80. Con quanta costanza e acume il Meiss abbia poi sviluppato questi suoi studi sulla tecnica murale lo documenta la sua più recente pubblicazione: *The Great Age of Fresco. Discoveries, Recoveries and Survivals* (Londra, 1970).

[3] G. Paccagnini, *Pisanello e il ciclo cavalleresco di Mantova*, (Milano, 1972); catalogo della Mostra "Pisanello alla Corte dei Gonzaga," a cura di G. Paccagnini con la collaborazione di M. Figlioli (Milano, 1972); G. Paccagnini, *Pisanello* (Londra, 1973).

[4] Quella denominazione si trova in tre lettere del 15 dicembre 1480—due delle quali scritte dall'architetto Luca Fancelli e da Ippolito Andreasi al marchese Federico Gonazaga e la terza, in risposta, dello stesso marchese—dal cui contenuto si apprende che nella notte precedente era crollato il soffitto di un ambiente detto "sala del Pisanello." Quei documenti, che non fanno alcun riferimento alla decorazione della sala, nè indicano la sua ubicazione, fecero ritenere che la sala fosse andata distrutta durante le trasformazioni cinquecentesche dei palazzi di corte dei Gonzaga.

[5] Non è qui possibile elencare i moltissimi articoli, scritti da valenti critici e giornalisti sulla stampa quotidiana e sulle riviste d'informazione, dal momento della scoperta della decorazione (1969) all'apertura della Mostra delle opere restaurate (1972) e successivamente. Si limita pertanto la seguente rapidissima indicazione bibliografica agli scritti apparsi su libri o riviste: G. Amadei, "Il Pisanello di Mantova,"

Un'idea della complessità dei problemi tecnici che il Pisanello affrontò per la realizzazione di questa grandiosa decorazione murale—e, per altro verso, delle difficoltà che dovettero superare i restauratori nelle operazioni di ricupero di quella delicata e instabile materia pittorica[6]—si può subito avere rammentando che la sua eccezionalità, oltre che all'intensa e altissima espressione formale raggiunta dall'artista con l'applicazione quasi integrale di tecniche pittoriche a secco e a mezzo fresco in questo suo estremo capolavoro (e si dovrà lasciare da parte, per non uscire dai limiti di questo articolo, la rarità e l'interesse di un tema cavalleresco del genere fra le pitture parietali giunte fino ai nostri giorni)[7] è dovuta anche alla quantità e grandezza davvero inconsueta dei reperti. Le parti ricuperate dalle quattro pareti della sala superano infatti complessivamente i duecento metri quadrati per quanto riguarda le superfici più antiche sulle quali, dopo averle liberate dai vari strati d'intonaco che le tenevano da tanto tempo occultate e sepolte, sono riemerse le pitture murali e le sinopie del Pisanello.[8]

Ma, in conseguenza delle vicissitudini subite nel corso di cinque secoli, e soprattutto perché l'artista lasciò incompiuto il lavoro dopo averlo condotto avanti per anni con una tormentata insoddisfazione che gli suggeriva continue modifiche, il ciclo presenta grandi lacune nelle superfici rinvenute nella zona superiore della sala, ed è mancante in basso degli episodi di primo piano, perduti o in parte non eseguiti (Fig. 1). E tuttavia esso ha l'aspetto singolarmente stimolante di una grande opera in divenire, che rivela tutte le fasi del suo procedimento tecnico e offre l'occasione di seguirne l'appassionante sviluppo, dalle prime idee tracciate in piccoli schizzi su carta o pergamena all'elaborazione dell'insieme compositivo disegnato sull'arriccio con le splendide sinopie (Figg. 11–14), alla stesura pittorica delle immagini del *Torneo* (Fig. 5).

È probabile che il progetto della decorazione prevedesse in un primo tempo una sistemazione dei vari episodi cavallereschi arturiani come storie singole inquadrate entro cornici rettangolari, disposte sulle pareti in due ordini secondo una logica successione

Civiltà mantovana (17 giugno 1969) 287–319; G. Passavant, "Wiederendeckte Pisanello-Fresken in Mantua, *Kunstchronik* (XXII, giugno 1969), 158–59; G. Paccagnini, "Il ritrovamento del Pisanello nel Palazzo Ducale di Mantova," *Bollettino d'Arte del Ministero della Pubblica Istruzione* (ser. v, an. LII, 1967; articolo pubblicato nel marzo 1969), 17–19; *idem*, "Il Pisanello ritrovato a Mantova," *Commentari* (IV, 1968; articolo pubblicato nel marzo 1969), 253–58; *idem*, *Il Palazzo Ducale di Mantova* (Torino, 1969), 22–42; M. Fossi-Todorow, *I disegni dei Maestri: L'Italia dalle origini al Pisanello* (Milano, 1970), 20–21; G.A. Dell'Acqua–R. Chiarelli, *Pisanello* (Milano, 1972), 9,100; C. Tellini Perina, "Considerazioni sul Pisanello. La monografia di G. Paccagnini," *Civiltà mantovana* (XXXV, novembre, 1972), 305–17; M. Fossi-Todorow, "Pisanello at the Court of the Gonzaga at Mantua," *Burlington Magazine* (CXIV, 1972), 888–91; *idem*, "Pisanello alla Corte dei Gonzaga," *Antichità viva* (v, 1972), 73–75; T. Pignatti, "La Mostra 'Pisanello alla Corte dei Gonzaga,'" *Arte Veneta* (XXVI, 1972), 294–97; M. Fagiolo dell'Arco, "Le donne, i cavalieri, l'arme, gli amori," *Bolaffi Arte* (dicembre 1972), 14–16; G.L. Mellini, "Pisanello esce dal muro," *Comunità* (no. 168, dicembre 1972), 327–44; V. Bertolucci Pizzorusso, "I cavalieri del Pisanello," *Studi mediolatini e volgari* (XX, 1972) 31–48; H. Kiel, "Mantua. Palazzo Ducale, Esposizione: Pisanello alla Corte dei Gonzaga," *Pantheon* (XXXI, 1973), 95–96; B. Degenhart, "Pisanellos Mantuaner Wandbilder," *Kunstchronik* (III, 1973), 69–74;

A. Zanoli, "Sugli affreschi del Pisanello nel Palazzo Ducale di Mantova." (*Paragone*, no. 277, 1973), 23–44; B. Degenhart, "Pisanello im Mantua," *Pantheon* (XXXI, 1973), 364–411; M. Boskovits, in *Pittura Umbra e Marchigiana fra Medioevo e Rinascimento* (Firenze, 1973), 25, 26, 44.

[6]Le operazioni per lo scoprimento, il ricupero e il restauro dei murali della sala del Pisanello, dirette dallo scrivente, furono realizzate in modo encomiabile dai restauratori mantovani Assirto Coffani e Ottorino Nonfarmale, coadiuvati dalle loro squadre di eccellenti operatori tecnici.

[7]Per alcune sommarie indicazioni sul tema cfr. Paccagnini, *Pisanello e il ciclo cavalleresco di Mantova*, cap. III, 45–75 e *passim*. Un importante e molto articolato esame, in relazione alla cultura della tradizione cavalleresca e al suo sviluppo nelle arti figurative, ne ha fatto di recente il Degenhart nell'eccellente studio citato (Degenhart, "Pisanello im Mantua"; in particolare cfr. le pp. 379–92). C. Gnudi ne ha esaminato acutamente in un saggio di questa raccolta (pp. 192–204) i motivi compositivi e il rapporto del ciclo pittorico con i poemi cavallereschi del Boiardo, dell'Ariosto e del Tasso; a quel saggio rimando il lettore anche per le illustrazioni dell'insieme e dei particolari, più volte qui ricordati.

[8]Le dimensioni dei singoli frammenti ricuperati sono indicate nel catalogo della Mostra "Pisanello alla Corte dei Gonzaga," 62, 74, 86.

narrativa ; e che da questo schema illustrativo, simile alla partizione della materia di un libro in capitoli, il Pisanello sia poi pervenuto alla composizione unitaria che infine realizzò nelle sinopie della sala. I fogli nn. 2594v e 2595 del Louvre, con gli schizzi di due *Scene cavalleresche* sovrapposte e la notissima *Cavalcata*[9] sembrano riflettere questo passaggio dall'una all'altra concezione. Comunque sia, la composizione aperta e fluente nella quale il Pisanello rievocò nella sala di Mantova il favoloso mondo arturiano, rappresentando i personaggi e le gesta emblematicamente più significanti di quel mondo nel grandioso scenario paesistico che gira tutt'intorno sulle pareti in una visione panoramica, aveva in quegli anni un carattere di assoluta novità, perché poneva per la prima volta il problema dell'identificazione della spazialità di un intero ambiente con quella stessa creata dalla decorazione pittorica, continua e unitaria, sviluppata sulla sua superficie parietale. E sebbene risulti evidente che quella decorazione fu condotta avanti pittoricamente soltanto nel dipinto del *Torneo*, che copre la superficie di una delle pareti laterali, mentre gli episodi cavallereschi figurati sulle altre rimasero al primo stadio di elaborazione grafica testimoniata dalle sinopie, ciò non sminuisce affatto l'intensità espressiva che assume in ogni parte il linguaggio del Pisanello. Cosicché, dopo la scoperta del ciclo cavalleresco di Mantova, scompare ogni sospetto di retorica dalle lodi ammirate che grandi umanisti tributarono a quell'artista singolare, per le sue incredibili capacità di visualizzazione naturalistica e per gli straordinari risultati raggiunti nelle numerose decorazioni murali, oggi quasi tutte perdute, che egli eseguì nel corso della sua lunga attività.

Ma quei risultati non erano soltanto il frutto di una eccezionale facoltà d'improvvisazione, che pure il Pisanello possedeva, e che sembra aver guidato la sua mano spiritata, come in un *raptus* della fantasia, nella impressionante velocità di esecuzione con cui tracciò a pennello le innumerevoli immagini delle sinopie sull'arriccio e i rapidi disegni chiaroscurati, dipinti a verdaccio sul successivo strato d'intonaco fino. In realtà il processo di formazione dei cicli pittorici del Pisanello, come documenta la sala di Mantova, era assai complesso e laborioso, e nelle varie fasi operative niente era abbandonato all'estro del momento che, se pure improntava i rapidi schizzi del maestro, era del tutto estraneo alla condotta delle operazioni. Con quei procedimenti egli realizzava, con costante progressione, le opere murali progettate fino alla definitiva stesura delle smisurate superfici pittoriche, il cui prezioso e fitto tessuto cromatico, trattato a punta di pennello, articolato da una inesauribile quantità di particolari lavorati a pastiglia coperta a foglia d'oro o d'argento, non differiva nella sua minuta accuratezza da quello elegantissimo dei piccoli quadri di cavalletto. Era una enorme quantità di lavoro dunque quella che il Pisanello, con la sua squadra di abilissimi aiuti, doveva affrontare per portare a termine tali decorazioni con difficoltose tecniche di coloritura a secco applicate sulle superfici murali con pratiche metodiche e controllatissime, indispensabili per poter ottenere la necessaria omogeneità di risultato formale in un'opera di così ampie proporzioni. Meglio si comprende allora come l'elemento conduttore per lo sviluppo delle grandi imprese murali del Pisanello fosse costituito dal disegno, che restava sempre la struttura portante dell'immagine anche nell'ultima fase pittorica dove il colore, inteso nel suo valore cromatico e luministico, assumeva nell'orchestrazione generale quell'importanza niente

[9]Cfr. il catalogo della Mostra "Pisanello alla Corte dei Gonzaga," no. 43 e no. 44.

affatto secondaria testimoniata, nel ciclo di Mantova, dalle vibranti alternanze timbriche dei manti dei cavalli, dei cimieri piumati, delle preziose stoffe, e più ancora dalla delicatezza della materia pittorica degli incarnati di alcuni luminosi volti femminili, che sono fra le più sottili espressioni della pittura italiana del Quattrocento. Quel procedimento costitutivo della pittura murale era inoltre preceduto e accompagnato, fino al termine dell'opera, da un'integrante analisi dei suoi contenuti e delle forme di espressione, attuata mediante l'elaborazione di numerosi disegni su carta o pergamena, con i quali il maestro fermava le prime idee compositive—che poi sviluppava in disegni più elaborati da usare come riferimento per la stesura delle sinopie sull'arriccio delle pareti—studiava i modelli per i vari personaggi e i moltissimi motivi ornamentali da realizzare sull'intonaco fino sovrapposto all'arriccio per l'esecuzione della superficie pittorica, attingeva dal suo ricco repertorio di disegni eseguiti dal vero e di appunti ricavati dalla cultura figurativa del tempo, quelle immagini che apparivano idonee ad essere inserite nell'iconografia del ciclo in corso di lavorazione.

Un metodo di lavoro così articolato e sostenuto in tutto il suo sviluppo da una incessante elaborazione grafica della materia—metodo che per molte sue particolarità, ma non per tutte, si ricollega alle tecniche rispecchiate dalla precettistica del *Libro dell'arte* di Cennino Cennini—presentava una complessa problematica già nella sua prima fase esecutiva, la stesura delle sinopie sull'arriccio. Per quanto molte di quelle bellissime rappresentazioni grafiche siano andate perdute,[10] da ciò che resta si può arguire che il Pisanello aveva trattato interamente il tema cavalleresco della decorazione sviluppandone gli episodi sulle quattro pareti della sala, in una unitaria visione scenica.

Per la necessaria chiarezza dei riferimenti al contenuto narrativo della decorazione, si ricorda che, secondo l'interpretazione che se ne è data altrove, le parti ricuperate raffigurano il grande *Torneo-battaglia di Louverzep* su una delle due pareti laterali (Figg. 1, 5–10), *Un gruppo di cavalieri armati e il palco delle dame che assistono al torneo* sulla parte terminale destra della lunga parete interna (Figg. 2–4), *Episodi dei cavalieri erranti di re Artù alla ricerca del Graal* sulla rimanente superficie della parete interna e sull'altra parete laterale (Figg. 13–15) uno sfondo paesistico ininterrotto di monti, boschi, castelli, borghi, città turrite, costituisce il fantastico luogo di quelle gesta.[11] Quelle figurazioni cominciarono a delinearsi sulla superficie muraria quando il Pisanello—con la scorta dei suoi disegni di repertorio e l'ausilio di schizzi appositamente preparati, come quelli già citati del Louvre—prese a disegnare sopra l'arriccio preesistente della sala[12] un rapido abbozzo a carboncino, col quale egli stese sui piani delle pareti un primo, schematico testo grafico della composizione, labile quanto la polvere di carbone che lo realizzava, ma necessario nella sua provvisorietà, per stabilire in questa fase iniziale del lavoro la struttura sommaria, il reciproco rapporto, la sequenza delle immagini.

[10]Circa le perdite causate dalle ripetute trasformazioni della sala dal Seicento in poi, cfr. Paccagnini, *Pisanello e il ciclo cavalleresco di Mantova*, 12–16 e 18–19 n. 15.

[11]Paccagnini, *ibid.*, cap. III, 71–72. Si è voluto indicare, col termine composto di *Torneo-battaglia di Louverzep*, il carattere cruento e crudele, perfettamente reso nella rappresentazione del Pisanello, di grande e strenua lotta collettiva, niente affatto diversa da una grande battaglia, che ebbe quel torneo secondo i romanzi cavallereschi che su di esso si soffermano in lunghe descrizioni.

[12]L'ambiente trecentesco che fu, con alcune modifiche archittoniche realizzate verso la metà del Quattrocento, trasformato nella "sala del Pisanello," aveva una decorazione ad affresco con un motivo decorativo geometrico mistilineo, di cui si conservano i resti nella soffitta. Sulle pareti della sala l'intonaco di quell'affresco tardo gotico fu distrutto, ma rimase il sottostante arriccio che il Pisanello utilizzò, aggiungendone o sovrapponendone altro nuovo in varie zone, per sviluppare la sua decorazione (cfr. Paccagnini, *ibid.*, 10–13; 18 n. 15).

Sebbene il segno del carboncino fosse destinato ad essere cancellato, dopo che il pittore ne aveva fissato a pennello con l'ocra liquida i contorni e ombrato le figure, molte tracce delle linee a carbone dell'abbozzo sono rimaste in varie parti nella prima e nella seconda stesura delle sinopie (Fig. 11). È così possibile seguire fin dall'inizio il trasformarsi continuo della struttura delle immagini durante il lungo percorso creativo che conduceva gradualmente alla superficie pittorica finale. E il confronto diretto del segno nei vari stadi di elaborazione grafica, documentati dai reperti, sembra indicare che alla mutevolezza del tratto corrispondeva naturalmente un diverso stato d'animo e d'impegno formale, ma soprattutto una diversa funzione che il segno assumeva nei confronti dei problemi tecnici ed espressivi che volta per volta dovevano essere risolti nel corso dell'opera. Osservazione che può riferirsi in parte anche alle frequenti variazioni di stile, senza dubbio sconcertanti per la discontinuità e la diversità delle tecniche usate, che tendono a formare gruppi distinti e spesso controversi fra i numerosi disegni del repertorio del Pisanello rispondenti alle più diverse finalità. Ciò non significa che quei disegni non debbano essere singolarmente giudicati per la loro qualità intrinseca, ma che può essere utile, anche per la loro valutazione estetica e storica, precisare gli interessi e le tendenze di base che li portano a gruppi nel raggio di diverse motivazioni e funzioni.

Pensando alle capacità eccezionali di grandissimo disegnatore che caratterizzarono il Pisanello—la cui personalità e cultura ebbero un medesimo peso sia nella formazione della sua poetica, sia nelle scelte delle tecniche usate nelle varie branche della sua attività—si avverte subito, qualunque sia l'opera che di lui si esamina, che egli realizzò interamente nel disegno ciò che aveva nella mente, forse ancor più di quanto non abbia fatto Leonardo che, pur pensando graficamente si esprimeva anche in quella lingua italiana che conosceva in modo mirabile, e non da "omo sanza lettere" come dichiarava di essere. Così la grafica era per il Pisanello un linguaggio col quale egli esprimeva pensieri, pratici o poetici, lirici o prosastici ; e naturalmente il *ductus* corrispondeva al corso di quei pensieri, il segno equivaleva ad una sorta di azione diretta, ad una capacità rappresentativa che doveva sembrare quasi magica, mediante la quale il "discorso mentale," dove confluivano tutte le presenze dell'esperienza, si identificava con le immagini grafiche corrispondenti ("ciò che è nell'universo per essenza, presenza o immaginazione, esso [il pittore] lo ha prima nella mente, e poi nelle mani," diceva Leonardo). Idee nate da impulsi diversi e ordinate a molteplici fini, si accumulavano anche in uno stesso foglio, e nello stesso taccuino ; e, al contrario, un solo modello grafico, utilizzato—come spesso accade nel Pisanello—per opere diverse, assumeva in ciascuna di esse un *ductus* assai differenziato. Ciò si verifica ad esempio in una testa femminile conservata a Roma nel Museo di Palazzo Venezia (Fig. 16)—probabile frammento dei perduti affreschi di San Giovanni in Laterano—e nell'immagine della bionda testa femminile che, nel ciclo di Mantova, è stata indicata come ritratto di Isotta (Fig. 4). La testa femminile di Palazzo Venezia, anche se iconograficamente simile a quella di Mantova—ciò che fa ragionevolmente ritenere al Degenhart che entrambe derivino da uno stesso modello[13]—ha un segno più

[13]Il Degenhart attribuisce la testa femminile di Palazzo Venezia al Pisanello, giudicandola come un frammento che testimonia l'attività di questo artista nella basilica di San Giovanni in Laterano. Per il Degenhart l'uso di un unico disegno per la testa di Palazzo Venezia e per quella di Mantova conferma—come questo studioso aveva più volte sostenuto

duro e fermo che l'avvicina al carattere stilistico della *Principessa salvata da S. Giorgio*, nella Cappella Pellegrini in Sant'Anastasia a Verona, mentre i passaggi dolcissimi e morbidi che si riscontrano nella testa femminile del ciclo mantovano hanno la sottigliezza e l'intensità pittorica delle opere dipinte dal Pisanello nell'ultimo decennio della sua attività.

Il ritrovamento del ciclo cavalleresco di Mantova offre straordinarie possibilità per un riesame della produzione grafica nota del Pisanello; e ciò non perchè siano moltissimi (ma certamente numerosi) i disegni oggi esistenti preparati per quel ciclo, ma per il fatto che il procedimento di lavoro che esso ci ha rivelato con le sue diverse tecniche grafiche e pittoriche applicate nelle varie fasi esecutive, getta nuova luce anche sui problemi analoghi riscontrabili nello studio dei disegni su carta e pergamena del repertorio pisanelliano: disegni che dovranno essere posti più di quanto non sia stato fatto finora, in rapporto con la ricchissima serie delle grandi immagini tracciate nella sala di Mantova, dalle quali quei problemi tanto discussi potranno avere l'avvio verso la loro soluzione.[14]

Nello sviluppo della decorazione mantovana l'esecuzione particolareggiata delle sinopie —dopo che gli aurorali filamenti d'immagini dell'abbozzo a carbone, sospesi sul muro come ragnatele appena filate, erano stati ripresi in una tenue trama fissata a pennello—segnò il momento culminante della fondamentale e assai dibattuta fase grafica del processo creativo, durante la quale il pittore fu a lungo e totalmente impegnato a risolvere i problemi relativi alla stesura di tutti gli episodi del grande tema cavalleresco sull'arriccio delle pareti. Questa fase riflette da vicino i noti procedimenti suggeriti dal Cennini nella parte del capitolo dedicato al "modo e ordine a lavorare in muro," affinché le figure delle storie fossero disposte armonicamente e disegnate con la massima cura.[15] Ma i precetti dettati dal Cennini servivano a determinare le immagini in uno schema grafico sommario, che potesse essere facilmente riportato sulla piccola superficie di smalto umido sovrapposto alla corrispondente porzione della sinopia, in maniera da poter eseguire nella stessa giornata il relativo pezzo di affresco. Per il Pisanello questo problema non sussisteva poiché le tecniche di coloritura a mezzo fresco e a secco, da lui applicate nell'ultima fase del processo operativo per realizzare la superficie pittorica, si allontanavano sostanzialmente da quel "lavorare in fresco, cioè di quel dì," che il Cennini giudicava come "la più forte tempera, e migliore e più dilettevole lavorare che si faccia." E per quanto il Cennini, allievo del fiorentino Agnolo Gaddi, con-

nei suoi precedenti studi—che il Pisanello sistematicamente usava uno stesso modello come lavoro preparatorio di parecchie opere (Degenhart, "Pisanello im Mantua," 401, 410). L'attribuzione al Pisanello aveva invece, per il Santangelo, soltanto un carattere indicativo (A. Santangelo, *Museo di Palazzo Venezia. Catalogo, I.Dipinti* (Roma, 1948), 41). Anche C.L. Ragghianti, in una lettera del 1973, esprime l'opinione che la testa femminile di Palazzo Venezia sia un frammento degli affreschi di San Giovanni in Laterano, e dichiara di aver riconosciuto quest'opera, mostratagli da E. Lavagnino, come un autografo del Pisanello "circa quarant'anni fa." Boskovits (*Pittura Umbra e Marchigiana*, 25, 26) sostiene l'indubbia paternità pisanelliana della testa di Palazzo Venezia, che ritiene proveniente da San Giovanni in Laterano, pur osservando che mancano indizi sicuri sull'origine romana dell'opera.

[14]Qualche indicazione per nuove classificazioni di alcuni disegni del Pisanello sono in Paccagnini, *Pisanello e il ciclo cavalleresco di Mantova*, 24–26, 135–38; 223–24; 240–44;

catalogo della Mostra "Pisanello alla Corte dei Gonzaga," 94–106. Un particolare importante contributo a questo problema lo ha dato il Degenhart nel "Pisanello im Mantua," 394–407.

[15]Cennini, *Libro dell'arte*, cap. LXVII: "Poi componi col carbone, come detto ho, storie e figure; e guida i tuo' spazii sempre gualivi e uguali. Poi piglia un pennello piccolo e pontìo di setole, con un poco d'ocria senza tempera, liquida come acqua; e va' ritraendo e disegnando le tue figure, aombrando come arai fatto con acquerelle quando imparavi a disegnare. Poi tolli un mazzo di penne e spazza bene il disegno del carbone. Poi togli un poco di senopia senza tempera, e con pennello pontìo sottile va' tratteggiando nasi, occhi, cavellaure e tutte stremità e intorni di figure; e fa' che queste figure sieno ben compartite con ogni misura, perché queste ti fanno cognoscere e provedere delle figure che hai a colorire."

siderasse il disegno come un fondamento essenziale della pittura, altra concezione aveva il Pisanello della grafica, assai più vicina semmai, come si è notato, a quella di Leonardo. D'altronde ben diversi erano la personalità e il temperamento che portavano l'artista ad esprimere la sua visione naturalistica in valori pienamente articolati di luce e di spazio, in una forma grafica aperta, che rappresentava senza residui l'aspetto che assumeva nel suo discorso mentale il tema cavalleresco in quel momento. Così il suo estro impetuoso dette ai grandi disegni delle sinopie, tratteggiati a pennello in nero o in rosso, una forza e una vibrazione pittorica incredibile, come nei fantasmi che si agitavano nella sua mente suscitando nel favoloso spazio irradiato in circolo sulle superfici parietali, le irruenti immagini dei guerrieri catafratti che si scontrano a gruppi nel *Torneo*, l'incantevole schiera delle dame che assistono ai combattimenti dal palco addobbato a fianco del castello, le figure solitarie dei cavalieri erranti nel selvaggio paese delle loro avventure, le città, i borghi, i castelli che si ergono vividi, come proiezioni surreali e incantate della fantasia, sul crinale di monti dirupati e boscosi. I rapidi tratti rossi e neri del pennello che evocano quel mondo danno il senso del continuo moto vitale delle immagini, su cui guizzano luci e ombre condotte da linee, piani, volumi che, sulla materia scabra dell'arriccio sapientemente sfruttata per rendere più vivo e reale il ritmo degli intensi valori luministici, si articolano in una composizione di ampio respiro, nelle modulazioni delle duttili linee rosse e nere delle figure, cui danno corpo sottili passaggi chiaroscurali e liquide velature grigie, ocra, rosa.

Si resta sbalorditi pensando che questa espressione così libera e lirica della grafica pisanelliana non era infine nient'altro che un'opera effimera, destinata a scomparire subito dopo la sua creazione—come realmente accadde nelle parti dove il processo esecutivo giunse pressoché al termine—sotto l'intonaco di supporto della superficie pittorica finale. Ma il Pisanello sapeva che quelle straordinarie sinopie, anche scomparendo dalla superficie, continuavano ad agire nell'opera, attraverso la grande quantità di disegni che egli vi aveva ricavato, studiandone su carta episodi e figure singole, che doveva poco dopo sviluppare nella superficie pittorica. La rapidità di realizzazione della rappresentazione figurata nelle sinopie non era d'altra parte frutto di una facile improvvisazione, ma il risultato di un lungo studio che ne precede e ne accompagna con infiniti ripensamenti l'esecuzione. Se infatti si osserva attentamente la fitta trama grafica delle sinopie rinvenute sulle tre pareti della sala— quella del *Torneo* fu ricuperata dopo la rimozione della soprastante superficie pittorica—ci si accorge che, nelle zone dove i dipinti murali furono portati avanti, il testo della sinopia presenta due successive stesure, una sull'antico arriccio scuro dipinta col pennello grosso e quasi dovunque in nero con un tratto fortemente marcato (Figg. 17 e 19); l'altra eseguita con linee volanti e vari colori, rosso, nero e grigio su una leggera scialbatura chiara, sovrapposta alle precedenti figure per cancellarle (Figg. 11 e 18). Su questa superficie chiara il Pisanello disegnò nuovamente a carboncino i gruppi dei guerrieri secondo una composizione assai diversa, anche per l'iconografia, da quella sottostante, dando alla nuova stesura un carattere più drammatico e concitato che nella parte più conservata, al centro della parete, sembra anticipare nel violento movimento vorticoso dei cavalieri combattenti (Figg. 11–12) il leonardesco turbinare dei guerrieri nella *Battaglia di Anghiari*. Sulla superficie di sinistra della sinopia del *Torneo* è stato possibile separare un particolare da quello che, nella sinopia sotto-

stante, rappresentava un guerriero che colpiva alla schiena con la spada il suo avversario (Fig. 17). L'episodio che lo sostituisce nella seconda sinopia raffigura un viluppo di cavalieri, cavalli e cimieri nel quale cominciano a delinearsi le umanissime immagini, passate infine nella superficie pittorica, del cavaliere vittorioso in piedi che, toltosi l'elmo, guarda con malinconica pietà l'avversario abbattuto. Il disegno che configura questo episodio nella seconda sinopia (Fig. 18) è di un'intensità pittorica e di una modernità sconcertanti: non ne sono protagonisti i cavalieri combattenti e i cavalli, ma le linee leggere e volanti che si espandono nello spazio come vibrazioni del moto fluttuante di quelle immagini nel turbinare della battaglia. Continuando l'osservazione delle sinopie, durante il ricupero dei resti della decorazione nella parte superiore della sala e nella soffitta, creata nella trasformazione ottocentesca dell'ambiente, si notò che la figurazione del *Torneo* nella prima stesura della sinopia proseguiva per un breve spazio anche sull'adiacente parete interna, dove il Pisanello, con la stessa tecnica a tratti forti e neri, aveva rappresentato un gruppo di cavalieri armati (Fig. 19), che poi si trasformò nel bellissimo episodio pittorico, affatto diverso per iconografia e stile, dei cavalieri che circondano il vincitore del torneo, indicato come Tristano (Fig. 2).

Ma ciò che appare più importante, guardando le sinopie nel loro insieme, è la diversità che si riscontra fra la prima sinopia in nero del *Torneo* e quelle in rosso che raffigurano le già ricordate scene cavalleresche sulle altre pareti. Tale diversità non è determinata dal colore rosso o nero delle sinopie, ma dal tratto vigoroso che segna plasticamente le immagini dei guerrieri nella prima stesura grafica del *Torneo* differenziandosi dal segno leggero e sottile della seconda stesura, e più ancora dalle finissime modulazioni formali e dalle notazioni psicologiche che il Pisanello seppe cogliere nei personaggi, tracciando con la punta di un pennello sottile le loro immagini nelle sinopie rosse delle altre pareti e articolandone con passaggi chiaroscurali i delicati valori pittorici. Il contrasto fra il carattere grafico più marcato e plastico delle prime sinopie, con la finezza e ricchezza d'inflessioni pittoriche della successiva redazione, è reso più evidente dall'immediato contatto in cui si trovano sulla parete interna, il già citato gruppo dei cavalieri tracciato in nero nella prima sinopia del *Torneo* (Fig. 19) e i vicini ritratti delle dame (Fig. 20) elegantemente modulati nei toni caldi del rosso, del rosa, dell'ocra. Anche qui torna utile un'osservazione tecnica: quei cavalieri furono disegnati col penello grosso sull'arriccio scuro preesistente,[16] senza che il Pisanello neppure badasse al frammento orizzontale di colore scuro, appartenente alla precedente decorazione tardo gotica della sala, su cui passò sopra col pennello, tracciando a tratti neri le figure degli armati. Evidentemente in quel momento egli non ricercava particolari finezze formali, e doveva soprattutto essere interessato a dare una vigorosa definizione del contenuto narrativo del ciclo. Ma a sinistra di questo gruppo l'arriccio scuro fu coperto da un nuovo strato d'intonaco rustico più chiaro; ed è su questo nuovo intonaco che fu eseguita la grande sinopia rossa della parete interna e dell'altra parete laterale, come si può notare nel punto dove inizia la rappresentazione delle dame nel palco (Fig. 21). Ciò indica una esecuzione della sinopia rossa successiva alla prima sinopia del *Torneo*. Poco dopo anche la prima stesura del *Torneo* fu radicalmente modificata dalla seconda, eseguita su un sottile strato d'intonaco chiaro soprammesso a quello scuro della prima sinopia.

[16]Cfr. *supra*, n. 12.

Come si vede, anche nella preparazione della struttura grafica della composizione, l'interminabile processo esecutivo della decorazione murale rivela l'inquieto impegno che doveva avere pressoché totalmente assorbito il pensiero del Pisanello nel grande tema arturiano, costringendolo a introdurvi continue trasformazioni iconografiche e formali, senza potere infine portarlo a termine, essendo il ciclo rimasto incompiuto. Ciò che si può affermare con certezza è che—come un grande poeta per cui l'opera principale che lo rappresenta non è mai finita, ed egli la modifica senza posa con continue varianti che vanno sempre più a fondo nel tema, accrescendone la portata umana di messaggio e testimonianza conclusiva di tutte le sue esperienze—il Pisanello non cessò mai, finché gli fu possibile, di sviluppare con nuove immagini, il grande racconto che, negli ultimi anni della sua attività, figurò nella sala della corte dei Gonzaga. Terminata infatti l'elaborazione grafica del tema cavalleresco con le prime sinopie e le successive varianti, quando ormai tutta la composizione sembrava definitivamente stabilita per il passaggio alla fase finale della pittura, egli ricominciò daccapo a studiare singolarmente le immagini figurate nelle sinopie, ricavando da quelle analisi i disegni e i modelli per le figure da riportare sullo smalto destinato all'esecuzione della superficie pittorica. Non si può spiegare diversamente l'elegante sicurezza del segno e la precisione dei rapporti reciproci fra le grandi figure dei combattenti del *Torneo* nei disegni definitivi che il Pisanello eseguì a verdaccio su quello smalto chiaro e levigatissimo, correggendo quasi dovunque le precedenti immagini disegnate nelle sinopie, e introducendo nella composizione molti altri episodi inediti. Per il bellissimo fregio con le volute eleganti e le insegne dei Gonzaga intrecciate con il motivo serpeggiante di foglie e fiori (Fig. 22)—fregio che doveva essere ultimato a pastiglia dorata o argentata, e che invece rimase bianco e incompiuto—l'artista aveva preparato modelli su carta perforata, di cui sono evidenti sull'intonaco bianco le tracce lasciate dal carbone durante lo spolvero.[17] Immagini stupende che non apparivano neppure nella seconda stesura della sinopia furono create in questa fase : ad esempio il grande cavaliere, sinistro "signore della guerra," che cavalca in primo piano stringendo in pugno il simbolo del suo potere (fig. 5) ; le due figure, che costituiscono un unico episodio, dell'anziano guerriero morto riverso sul terreno e del giovane cavaliere, ferito da una lancia, che gli si avvicina carponi toccandogli un piede (Figg. 7–8) ; il guerriero caduto bocconi, rappresentato di scorcio con crudele realismo in tutta la sua misera sofferenza umana (Fig. 9) ; le figure e i volti splendenti di giovinezza di Tristano e dei cavalieri che lo circondano (Fig. 2).

Il confronto fra la sinopia del *Torneo* e la sua rappresentazione pittorica rende evidente, più di ogni descrizione, la quantità incredibile di varianti e di nuovi particolari che appaiono imprevisti sulla superficie cromatica, realizzata con procedimenti di pittura a mezzo fresco e a secco. Ma è soprattutto da rilevare il continuo crescendo di questa grandiosa impresa nel passaggio dall'una all'altra fase operativa, ognuna delle quali assume forme linguistiche che non hanno niente di provvisorio, seppure siano differenziate da diversi valori espressivi, che danno loro una vita e una validità autonoma, nella linea di sviluppo unitaria che tutte le

[17] Alla tecnica dello spolvero si riferisce anche il Cennini, *Libro dell'arte*, cap. cxli. Per uso dello spolvero nel Trecento e nel Quattrocento cfr. E. Borsook, *The Mural Painters of Tuscany* (Londra, 1960), 21 ; U. Procacci, *Sinopie e affreschi* (Firenze, 1960), 64, 67 ; Meiss–Tintori, *The Painting of the Life of St. Francis in Assisi*, 17–19 ; Meiss, *The Great Age of Fresco*, 16, 17, 136, 151, 153, 235.

comprende nel suo arco. Quasi indescrivibili e difficili da seguire singolarmente sono le interminabili operazioni tecniche che il Pisanello eseguì nell'ultima fase del suo lavoro per dare alla superficie pittorica l'aspetto di un raffinatissimo tessuto cromatico, che quasi si direbbe materico, tendente a rendere tangibile la qualità e le caratteristiche degli oggetti mediante graduati rapporti di superfici metalliche luminose, trattate a foglia d'oro o d'argento, e spesso lavorate a pastiglia—le armature bianche dei guerrieri, le lance, le spade, le cotte, le bardature di cuoio, le borchie metalliche, le trombe, le insegne, ecc.—oppure con le vibranti stesure di colori a tempera—le preziose stoffe, gli addobbi del palco, le vesti dei personaggi, le gualdrappe dei cavalieri, ecc.—o con le piccole pennellate quasi divisioniste dei cimieri piumati, dei manti degli adorati cavalli, delle pellicce degli animali selvatici che popolano quel paesaggio montagnoso. E inoltre la varietà delle espressioni psicologiche e della materia pittorica che distingue gli affascinanti personaggi umani, già rilevata dagli amici umanisti del Pisanello, il Guarino, il Basinio, il Facio.[18] Il Pisanello alternava sul filo di mobilissime linee, i *ductos colores* dei suoi personaggi per esprimerne i sentimenti, come si nota nel pallore delle giovani dame bionde, nei volti affaticati dei combattenti che la visiera alzata dell'elmo lascia scoperti, nel delicato trascolorare di alcuni giovani feriti, nel verde terreo della morte che si stende sul viso dell'anziano guerriero abbattuto, nel bruno violento del moro messo a contrasto col tenue incarnato del biondo adolescente; e le notazioni potrebbero continuare a lungo, senza allontanarsi dal gruppo dei cavalieri e dame cui si riferisce una così sfumata varietà di espressioni umane. Questo è un altro aspetto dell'affinarsi e interiorizzarsi della pittura del Pisanello negli ultimi anni della sua attività che rivela, ci sembra, il forte influsso che esercitava su di lui in quel periodo la pittura fiamminga di Jan van Eyck e soprattutto di Rogier van der Weyden, di cui il Pisanello aveva avuto qualche nozione anche in anni precedenti, ma che sperimentò con pienezza alla corte di Alfonso d'Aragona a Napoli.

Una struttura cromatica dunque tanto ricca e differenziata, una ricerca di verità naturalistica attentissima e talvolta crudele nel ritrarre persone, animali e cose, richiedeva una fondamentale condotta grafica del pennello anche in questa finale stesura, che cresceva con una lenta stratificazione della materia pittorica. Il colore veniva volta per volta applicato su piccole superfici delimitate dal solco, segnato sullo smalto con un punteruolo,[19] lungo le linee dei disegni a verdaccio delle figure che il Pisanello aveva riportato precedentemente sullo smalto tratteggiandone anche il chiaroscuro. Si deve qui correggere l'opinione, inizialmente espressa altrove,[20] che quei disegni eseguiti a verdaccio sullo smalto chiaro siano ad affresco. L'impressione che dava il segno forte e perfettamente conservato, come se fosse stato allora appena dipinto, fece ritenere che si trattasse di una tecnica particolarmente resistente all'usura del tempo qual'è l'affresco. Inoltre i metodi usati dal Pisanello nelle sue precedenti decorazioni murali che ancora sussistono a Verona e che partivano (ma non dovunque) da una preparazione ad affresco, poi ultimata a tempera, facevano supporre che anche a Mantova il procedi-

[18]Accenni su questi aspetti della pittura del Pisanello sono in Paccagnini, *Pisanello e il ciclo cavalleresco di Mantova*, 31, 49, 51, 128, 243 e *passim*. Per un più ampio sviluppo delle idee relative alla differenziazione pisanelliana nella raffigurazione dell'uomo si rimanda alle finissime considerazioni del Degenhart nel citato "Pisanello im Mantua," 394.

[19]Nei capitoli LXXXVIII e CXXIII del suo *Libro dell'Arte* il

Cennini si riferisce a questa tecnica dell'incisione dei contorni per campiture con colori a secco su tavola. Ma tale tecnica era usata anche nella pittura murale già nel Trecento: ad esempio da Simone Martini e Ambrogio Lorenzetti a Siena, da Altichiero a Padova (Cfr. Paccagnini, *Pisanello e il ciclo cavalleresco di Mantova*, 35 n. 24.

[20]Paccagnini, *ibid.*, 31.

mento pittorico dovesse essere simile a quelli applicati dall'artista nella decorazione del monumento Brenzoni nella chiesa di San Fermo e in quella della cappella Pellegrini in Sant'Anastasia.[21] In realtà a Mantova il metodo usato dal Pisanello nella preparazione grafica di base non poteva essere quello dell'affresco, poiché egli smaltò a grandi superfici, e totalmente, tutta la parete dov'era la sinopia del *Torneo*; poi, sullo smalto asciutto, eseguì i grandi disegni a verdaccio dei cavalieri, servendosi dei modelli già preparati, e realizzando gradualmente la grande composizione monocroma del *Torneo*, dove le immagini dei cavalieri erano già pienamente definite, per quanto riguarda la loro configurazione grafica. Infine il Pisanello dipinse in nero, con una materia diluita in olio, la superficie di fondo dello smalto, facendo risaltare su di esso i luminosi volumi dei guerrieri catafratti come in un grandioso rilievo, fortemente scandito da un drammatico alternarsi di luci e ombre profonde. Il *Torneo* prese allora quell'aspetto singolarissimo e quasi ossessivo, di uno spettacolo che si rivela improvviso e violento sulla parete, con la suggestiva forza di un'apparizione illusiva, dove i corpi dei combattenti emergono dal fondo di un'ombra notturna che sembra da un momento all'altro assorbirne le immagini. Una battaglia, si direbbe, che si svolge nei meandri di una cupa boscaglia vista dall'alto, al chiaro di luna, con tutti gli inganni ottici e l'ansia sospesa che esercita quel lume sul riguardante.

Questa impressionante stesura monocroma del *Torneo* potrebbe anche far ritenere, per la sua suggestiva bellezza, che lo stesso Pisanello, affascinato dalla forza visuale che avevano già assunto le immagini, pur nelle condizioni d'incompiutezza in cui si trovava ancora la superficie pittorica, potesse considerare la figurazione del *Torneo* come già conclusa per lui. Certo i superbi disegni dei guerrieri campeggianti sullo sfondo scuro, definiti nei più minuti particolari delle armature, dei cavalli, degli strumenti bellici, articolati da un preciso, rapido tratteggio nei loro sottili passaggi chiaroscurali, possono ben considerarsi come monumentali capolavori grafici del Pisanello, e niente avrebbe potuto renderne più compiuta l'espressione. Tuttavia i residui frammenti delle varie materie pittoriche che sussistono sulle figure della zona superiore o di quella mediana del *Torneo*, non soltanto dimostrano che su tutta quella grande rappresentazione grafica doveva svilupparsi l'ultima fase pittorica, ma che essa non sarebbe stata inferiore—come documentano i meravigliosi particolari meglio conservati—alla precedente figurazione monocroma che ne costituiva l'indispensabile fondamento. La perfezione della composizione disegnata a verdaccio, che la pittura finale doveva coprire, rispondeva certo anche agli impulsi espressivi e al temperamento di un artista privatissimo e segreto qual'era il Pisanello, che lavorava soprattutto per se stesso, poco curandosi che i suoi più interiori pensieri figurativi potessero essere chiaramente percepiti e compresi da altri: lo dimostrano l'aspetto enigmatico delle sue opere e i tanti dettagli finissimi che, nelle decorazioni murali, ha posto (o nascosto?) così in alto sulle pareti nei punti meno avvicinabili e fuori della vista. Ma a quei grandi e stupendi disegni, che realizzavano la superficie monocroma del *Torneo*, era ancora affidata, nei confronti della successiva esecuzione della superficie pittorica, una funzione essenziale che si può avvicinare a quella della matrice di una scultura da gettare in

[21]Per la tecnica dei citati dipinti murali veronesi cfr. la scheda di M. Muraro sul *S. Giorgio e la Principessa* a p. 66 del catalogo "Pitture murali nel Veneto e tecnica dell'affresco," Mostra a cura della Fondazione Giorgio Cini (Venezia, 1960); e le schede di J. Raspi Serra per *Monumento Brenzoni* e per il *S. Giorgio e la Principessa* a pp. 84–87 di "Pitture murali restaurate," Mostra a cura della Soprintendenza ai Monumenti di Verona, 1970.

bronzo. I colori dovevano fondersi, per riprendere il paragone con la scultura, sciogliersi e fluire lungo le linee portanti e i graduati passaggi chiaroscurali di quei disegni, incorporandosi su quelle forme; le foglie d'argento e d'oro dovevano saldarsi ai piani sagomati e ricurvi delle armature per rivelarne la perfezione strutturale nei volumi luminosi e lampeggianti sull'oscurità del fondo. I procedimenti che il Pisanello applicò per l'esecuzione della superficie pittorica del *Torneo* e dei frammenti sulle pareti laterali furono quelli in uso per le coloriture a mezzo fresco e a secco.[22] A mezzo fresco furono eseguiti i fondali paesistici (ripresi però con campiture nere ad olio nella preparazione di fondo della boscaglia), i vari animali selvatici, i cavalli, i cimieri, le teste dei cavalieri e delle dame nel frammento in alto della parete interna, parti dei volti di alcuni guerrieri con la visiera dell'elmo alzata, la testa del guerriero morto, quella del giovane ferito, e qualche altro particolare. Tutte le parti rimanenti—armature, giornèe, lance, spade, finimenti dei cavalli, ecc.—furono dipinte a secco, con stesure di colori a tempera, o con l'applicazione di foglie d'oro e d'argento, purtroppo quasi dovunque cadute sulle armature, o annerite per ossidazione dei frammenti residui, salvo nelle superfici di molte lance decorate, dove l'oro e l'argento si sono ben conservati.

La coloritura a secco esigeva, come si è accennato, che le materie da applicare fossero gradualmente lavorate su piccole superfici delimitate da incisioni lungo i bordi, affinché le varie tempere, o l'oro e l'argento, non sbavassero espandendosi sulle zone adiacenti, già fatte o da fare. Queste incisioni venivano fatte con una punta metallica seguendo le indicazioni dei disegni a verdaccio sottostanti, che pertanto erano indispensabili come cartoni per stabilire l'esatta delimitazione della zona da colorire a secco. E a questo proposito ha un particolare interesse osservare che tali incisioni—insieme a residui d'oro e d'argento ossidato, e di vari pigmenti—si trovano soltanto sulle figure della zona superiore e mediana del *Torneo* e su quelle dell'adiacente frammento pittorico della parete interna. Sulle altre disegnate a verdaccio nella zona inferiore—ma anche in alcune più in alto, come ad esempio sulle armature del citato gruppo dei due guerrieri caduti—non vi è alcuna traccia di materie pittoriche, nè vi sono, lungo le linee di sviluppo di quei disegni, le incisioni occorrenti per l'attuazione del procedimento di coloritura a secco adottato dal Pisanello. Ciò significa evidentemente che le operazioni relative alla stesura della superficie pittorica del *Torneo* erano rimaste incompiute a quel punto. Non sembra necessario indicare una per una le figure, facilmente individuabili, dei guerrieri e dei cavalli sulle quali il processo pittorico si arresta; ma l'interruzione che si nota a sinistra del frammento pittorico con i cavalieri e le dame sulla parete interna (Fig. 3), sviluppante la rappresentazione del *Torneo* che è sull'altra parete, si presenta in maniera tanto improvvisa che vale la pena rilevarla. In questo frammento il Pisanello dipinse a mezzo fresco i cavalli e i volti dei cavalieri, colorì con tempera su pastiglia il berrettone di Tristano, rivestì di foglia d'argento le armature dei guerrieri, incise i contorni dello stendardo per delimitare la superficie della coloritura a secco, che poi non eseguì, dipinse a mezzo fresco i ritratti delle due dame bionde sotto il baldacchino, cui sono stati dati i nomi di Isotta e della fida compagna Branguina.

[22]Per le definizioni e per alcune documentazioni di opere a *mezzo fresco* e *a secco* cfr., oltre ai relativi capitoli del citato *Libro dell'Arte* di Cennino Cennini: Procacci, *Sinopie e affreschi*; Borsook, *The Mural Painters of Tuscany*; Meiss–Tintori, *The Painting of the Life of St. Francis at Assisi*; idem, "Additional Observations"; "The Great Age of Fresco: Giotto to Pontormo," catalogo della Mostra di dipinti e disegni murali, The Metropolitan Museum of Art, New York, 1968; Meiss, *The Great Age of Fresco*.

Infine tracciò a verdaccio, sulla preparazione dello smalto, altre due immagini femminili che, come quelle già dipinte, modificavano le figure precedentemente delineate nella sottostante sinopia rossa. Ma quei due ritratti femminili, disegnati sotto il baldacchino a sinistra delle due dame bionde, non furono mai dipinti; e l'interruzione del lavoro è qui così brusca e netta— come fosse avvenuta mentre il Pisanello era pienamente intento nella sua opera—che ha il senso drammatico di un lavoro improvvisamente abbandonato, e in modo definitivo. Sulle grandi superfici dove erano stati raffigurati con le sinopie rosse i già ricordati episodi caval- lereschi, l'artista non ebbe neppure la possibilità di sovrapporre lo smalto necessario per poter iniziare l'esecuzione della superficie pittorica.

Da questi accenni sul processo tecnico e stilistico della decorazione murale della "sala del Pisanello" sembra possibile ricavare alcune conclusioni relative al periodo in cui essa fu eseguita. Si può innanzi tutto ritenere pressoché certo che la situazione rappresentata dal- l'insieme delle sinopie e dai dipinti murali rinvenuti—se si escludono i danni del tempo alla superficie pittorica (modificazioni chimiche irreversibili di alcune materie, disgregazione delle tempere, ecc.) e le gravi lacune provocate dalle varie trasformazioni subite dalla sala— corrisponde allo sviluppo che aveva la decorazione quando i lavori furono definitivamente interrotti. E con ciò s'intende anche dire che la sua realizzazione non appare essere stata condotta in modo continuo, e che qualche indugio sembra avere sospeso, in alcuni momenti, il corso dei lavori. Le due successive stesure delle sinopie del *Torneo* sono, come si è notato, molto diverse, e la prima di esse, più statica e plastica, può confermare l'inizio della decora- zione intorno al 1447, quando il Pisanello eseguì anche la medaglia per il marchese Ludovico Gonzaga, eletto in quell'anno capitano generale delle forze fiorentine. Quella sinopia nera, dal segno vigoroso, si differenzia anche dalle sottili modulazioni pittoriche della sinopia rossa, il cui aspetto è più quello di un dipinto che di un disegno, raffigurante vari episodi cavalle- reschi sulla lunga parete interna e su quella laterale contigua. È da ricordare che la sinopia rossa fu tracciata su un nuovo strato d'intonaco sovrapposto a quello più antico della prima sinopia del *Torneo* che si conclude con la rappresentazione sommaria del già ricordato gruppo di armati (Fig. 19); e ciò non può che indicare un momento successivo nell'esecuzione della sinopia rossa. Infine si rileva che nella seconda stesura della sinopia del *Torneo* il pittoricismo ancora più avanzato, il movimento irruente e vorticoso delle sue linee (Figg. 11 e 18), sembra seguire piuttosto che precedere la libertà ariosa, l'intenso e alterno moto della luce e del- l'ombra che si verifica nei disegni eseguiti dal Pisanello fra il 1449 e il 1450, quando egli era alla corte napoletana di Alfonso d'Aragona. Stilisticamente si direbbe—e la consecutiva sovrapposizione degli strati d'intonaco e dei disegni sembra confermare l'ipotesi—che almeno tre momenti dell'espressione pisanelliana si susseguano in un rapidissimo sviluppo, dalla prima sinopia del *Torneo*, alle successive sinopie rosse, culminando nella libertà e modernità grafica della seconda stesura della sinopia del *Torneo* e nella monumentale perfezione dei grandi disegni a verdaccio sullo smalto della superficie pittorica.

È possibile dunque che la decorazione sia stata interrotta una prima volta quando il Pisanello verso la fine del 1448 partì per Napoli, e che egli l'abbia ripresa quando si allontanò

nel 1450 dalla corte di Alfonso d'Aragona. Niente sappiamo sull'attività che svolse il Pisanello negli ultimi anni della sua vita, dopo che egli aveva lasciato Napoli. Ma la scoperta del ciclo mantovano riempie questo vuoto, poiché sembra dimostrare con la sua presenza che l'artista era in quel periodo a Mantova, prevalentemente impegnato nell'attuazione dei lunghissimi procedimenti tecnici necessari per condurre avanti il suo grande capolavoro murale. I disegni che sono stati indicati dagli studiosi come opere preparatorie per la decorazione della sala nella corte dei Gonzaga, e quelli che il Pisanello fece per Alfonso d'Aragona (Parigi, Louvre 2486 e 2306), scarsamente si distinguono fra loro per i caratteri formali e tendono a costituire stilisticamente un solo gruppo, connesso nel modo più diretto col ciclo cavalleresco di Mantova.[23] Sembra, dunque, che la "sala del Pisanello" sia da considerare come la più importante e conclusiva impresa pittorica di questo grande artista, nella quale egli raggiunse una delle punte più avanzate e moderne del suo tempo. E l'ipotesi che appare più logica per spiegare lo stato d'incompiutezza in cui fu lasciata un'opera così capitale è che la sua definitiva interruzione sia dovuta alla morte del Pisanello.

LEGHORN

[23]L'ipotesi della stretta connessione stilistica e cronologica dei disegni del periodo napoletano con quelli dell'ultima attività del Pisanello a Mantova, di cui l'incompiuto ciclo cavalleresco appare l'opera più importante, è stata ampiamente accolta dalla maggior parte di coloro che ne hanno scritto nei saggi citati. Se ne discostano in particolare il Boskovits, che tende a porre il ciclo di Mantova negli anni trenta, il Mellini e la Zanoli che lo ritengono più tardo e successivo alla cappella Pellegrini di Sant'Anastasia a Verona, ma anteriore al 1442. Gli articoli di questi due ultimi studiosi (si veda l'indicazione bibliografica alla n. 5) contengono numerose argomentazioni che li differenzia notevolmente l'uno dall'altro. Non potendo in una breve nota discutere in modo adeguato dei vari problemi del Pisanello che vi si agitano e che in questo articolo non sono neppure accennati, ma sui quali mi ero soffermato nei capitoli IV e V della mia monografia citata sul ciclo di Mantova (117-221), debbo rinviare ad altra sede la discussione che l'interesse di quegli articoli merita.

Qui aggiungo soltanto che l'ipotesi che la sala di Mantova fosse stata eseguita qualche anno dopo Sant'Anastasia e interrotta prima della morte di Gianfrancesco Gonzaga (1444) era stata da me considerata, durante la stesura del mio libro, poiché, sebbene sollevasse un insieme di problemi, non creava forti discordanze con le ultime opere del Pisanello. Tuttavia mi decisi a scartarla per varie ragioni che qui sarebbe troppo lungo esporre; e tuttora il mio parere, condiviso da molti storici dell'arte, è sempre quello che la struttura formale e il *ductus* dei disegni napoletani per Alfonso d'Aragona, degli ultimi disegni mantovani per i Gonzaga e delle sinopie della "sala," sono talmente vicini fra loro da far ritenere che l'ipotesi più probabile, anche per motivi storici da non trascurare, sia quella che tutto l'insieme possa appartenere all'estrema attività del Pisanello: e cioè che quelle opere si collochino in quel tempo e in quel clima di "umanesimo cavalleresco" del marchese Ludovico Gonzaga, che si conclude in modo definitivo nel corso del sesto decennio del secolo con l'affermarsi dell'umanesimo classico alla corte dei Gonzaga, con la chiamata, o con l'intervento a Mantova, di artisti quali il Fancelli, Donatello, il Mantegna, Leon Battista Alberti.

Eine verspätete Apocalypsen-Handschrift und ihre Vorlage

REINER HAUSSHERR

I

Für die Geschichte der Bildüberlieferung des Mittelalters wie für die stilistische und inhaltliche Umformung und Neubildung von Bilderzyklen bieten die illustrierten Apocalypsen reichen Stoff, der trotz der ausgebreiteten Literatur bei weitem nicht ausgeschöpft ist. Dabei ist zwischen den Quellen eines bestimmten Zyklus und seiner Überlieferungsgeschichte zu unterscheiden—beides ist für den sogenannten anglo-französischen Zyklus des 13. Jahrhunderts, der richtiger der englische genannt werden muss, bisher nur teilweise untersucht.[1] Nach der Entstehung dieses in vielen Handschriften überlieferten Zyklus bildet das Erscheinen von Dürers Holzschnittfolge 1498 einen entscheidenden Einschnitt in der Geschichte der Apocalypsen-Illustration. Aber schon vorher war das Interesse an dem englischen Zyklus erlahmt; in den Blockbüchern des 15. Jahrhunderts[2] und mehreren Handschriften, von denen die letzte eine französische *Apocalypse* des ausgehenden 15. Jahrhunderts ist,[3] wird er noch überliefert, um später nur in stark veränderter und verwandelter Form weiterzuleben. Eine Ausnahme von dieser Regel soll im Folgenden behandelt werden.

II

Nach Ende des Zweiten Weltkrieges wurden der Bibliothek der Staatlichen Kunstakademie in Düsseldorf elf illustrierte Handschriften des 13.–16. Jahrhunderts übergeben.[4] Die nahezu durchweg weder sehr qualitätvollen noch wirklich bedeutenden Codices stammen, wie die Stempel zeigen, aus einer 1945 aufgelösten Bibliothek, nämlich der der "Hermann-Göring-

Für Hilfe bei der Vorbereitung dieser Studie möchte ich Dr. John Plummer und der Pierpont Morgan Library, New York, sowie Dr. Adelaide Bennett und dem Princeton Index of Christian Art, Princeton University, meinen Dank aussprechen. Sie wurde im Herbst 1973 während meines durch eine Fellowship der Kress Foundation möglich gemachten Aufenthaltes am Institute for Advanced Study in Princeton geschrieben. Beiden Institutionen sei auch hier für ihre grosszügige Unterstützung gedankt.

[1]Zusammenfassung und Bibliographie bis ca. 1960: H. Aurenhammer, *Lexikon der christlichen Ikonographie*, I (Wien 1959–1967), 176–207. Unbrauchbar dagegen der Artikel "Apokalypse des Johannes" von R. Chadraba (E. Kirschbaum, ed., *Lexikon der Christlichen Ikonographie*, I, Rom, 1968), Sp.124–42.—Grundlegend zur Geschichte des englischen Zyklus mit Verzeichnis der Handschriften: L. Delisle–P. Meyer, *L'Apocalypse en français au XIIIe siècle (Bibl. Nat. franç.* 403). Société des anciens textes français, 44 (Paris, 1901), u. M. R. James, *The Apocalypse in Art*. The Schweich Lectures of the British Academy 1927 (London, 1931) (bei der Nennung von Handschriften werden die Nummern ihrer Verzeichnisse zitiert). Seitdem vor allem: R. Freyhan, "Joachism and the English Apocalypse," *Journal of the Warburg and Courtauld Institutes* (XVIII, 1955), 211–44. Zu den ikonographischen Quellen der englischen Apocalypsen: P.H. Brieger, Einführung zur Faksimileausgabe *The Trinity Apocalypse* (London, 1967), I. Dazu unentbehrlich die Besprechung von J. Poesch,

Art Bulletin (L, 1968), 199–203.—T. Mroczko, "Geneza ikonografii Apokalipsy wrocławskiej," *Rocznik historii sztuki* (VII, 1969), 47–106. Vgl. auch W. Neuss, "Die ikonographischen Wurzeln von Dürers Apokalypse," *Volkstum und Kulturpolitik, Georg Schreiber zum 50. Geburtstag* (Köln, 1932), 185–97. Zur Filiation der englischen Apocalypsen-Handschriften Freyhan, *ibid.*; Poesch, *ibid.*, 201f., und G. Henderson, "Studies in English Manuscript Illumination," *Journal of the Warburg and Courtauld Institutes* (XXX, 1967), 104–37 (XXXI, 1968), 103–45.

[2]G. Bing, "The Apocalypse Block-Books and Their Manuscript Models," *Journal of the Warburg and Courtauld Institutes* (v, 1942), 143–58.

[3]Glasgow, Hunterian Museum 398 (v. 2. 18). Vgl. Delisle-Meyer, James Nr. 45; J. Young–P.H. Aitken, *A Catalogue of the Manuscripts in the Library of the Hunterian Museum in the University of Glasgow* (Glasgow, 1908), 317f.; Katalog "Trésors des Bibliothèques d'Écosse," Brüssel, 1963, Nr. 38. Die Handschrift enthält 48 Illustrationen zu Apoc. 1–14, Verzeichnis bei Young-Aitken, 318.

[4]Prof. Dr. Eduard Trier, Bonn, war so liebenswürdig mich auf diese Handschriften hinzuweisen. Prof. Dr. Heinrich Theissing, Düsseldorf, machte die Untersuchung der Handschriften möglich und erlaubte die Veröffentlichung. Einen kurzen Katalog hoffen Eberhard König und ich in absehbarer Zeit vorzulegen.

Q

Meisterschule für Malerei" in Kronenburg in der Eifel. Diese war 1938 für den Maler Werner Peiner eingerichtet worden, eben jenen unter dem Malern des Dritten Reiches, der in den folgenden Jahren die Entwürfe für riesige Bildteppiche mit der Darstellung von Schlachten für Hitlers Neue Reichskanzlei in Berlin anfertigen sollte.[5] Über die Erwerbung von Bilderhandschriften für die Kronenburger Bibliothek haben sich keine Akten erhalten,[6] nach der Erinnerung Peiners wurden sie im September 1940 im Pariser Kunsthandel gekauft.[7] Unter den sechs Stundenbüchern und den fünf anderen Handschriften fällt eine reich illustrierte *Apocalypse* besonders auf, die offensichtlich in der einschlägigen Literatur nicht vorkommt und die hier vorgestellt werden soll.

Unter der Signatur A.B.143 wird in der Düsseldorfer Kunstakademie eine 33 Blätter umfassende, 338 zu 243 mm. messende Pergament-Handschrift aufbewahrt, die einen französischen Einband der zweiten Hälfte des 18. Jahrhunderts oder der Zeit um 1800 besitzt. Auf das Vorsatzpapier ist eine Kunsthandelsnotiz in französischer Sprache geklebt, die die Handschrift ins späte 15. Jahrhundert datiert—sicher zu früh—und in ihr zwei Maler unterscheidet. Die Seiten der Handschrift sind neuzeitlich paginiert, insgesamt 66 Seiten, jeweils mit einer die halbe Seite füllenden Miniatur und Texten auf der unteren Hälfte aller Seiten. Unter den Miniaturen findet sich der zugehörige Text der Apocalypse in lateinischer Sprache und Auszüge aus dem Apocalypsen-Kommentar des Berengaudus,[8] auch sie in lateinischer Sprache. Leider ist über die Geschichte der Handschrift vor ihrer Erwerbung für Kronenburg nichts bekannt.[9] Nur die Familie des Auftraggebers lässt sich bestimmen. In der Bordüre der ersten Seite findet sich gleich zweimal ein Wappen, das in den Initialen der Handschrift häufig wiederkehrt: auf blauem Feld ein goldener Schrägbalken von rechts oben nach links unten, neben ihm je eine goldene Kugel (Abb. 1). Es handelt sich um das Wappen der Familie Monnier de Savignat, die in der Franche-Comté beheimatet ist.[10]

Eine Zuschreibung der Düsseldorfer *Apocalypse* an bestimmte Maler oder an ein

[5]H. Vollmer, *Allgemeines Lexikon der Bildenden Künstler des xx. Jahrhunderts*, III (Leipzig, 1956), 563; J. Sommer, "Marksteine deutscher Geschichte—Zu Werner Peiners Entwürfen der Bildteppiche für die Marmorgalerie der Neuen Reichskanzlei," *Die Kunst im Deutschen Reich* (IV, 1940), 114–23. Ein Zeitungsbericht über die Eröffnung der Kronenburger "Meisterschule" mit Wiedergabe einer Rede Görings abgedruckt bei: J. Wulf, *Die bildenden Künste im Dritten Reich—Eine Dokumentation* (Gütersloh, 1963), 203–05.

[6]Mitteilung des Hauptstaatsarchivs Düsseldorf, Brief vom 23. Juli 1973.

[7]Brief vom 16. August 1973.

[8]Vgl. die Übersicht über den Inhalt der Handschrift im Anhang.—Der in den Apocalypsen-Handschriften mit dem englischen Zyklus sehr verbreitete Kommentar des Berengaudus (vgl. Delisle–Meyer, CLXVIII–CLXXV; James, *The Apocalypse in Art*, 45) ist veröffentlicht Migne, *Patrologia Latina*, XVII, 843–1058, F. Stegmüller, *Repertorium Biblicum Medii Aevi*, Nr. 1711. Der Autor wird seit dem 18. Jahrhundert mit einem 859 erwähnten Mönch von Ferrières identifiziert. Begründungen für eine gelegentlich geäusserte Datierung seines Kommentares ins 12. Jahrhundert sind mir nicht bekannt geworden. Vgl. *Dictionnaire d'histoire et de géographie ecclésiastiques*, VIII (Paris, 1938), 358f.; M. Buchberger, ed., *Lexikon für Theologie und Kirche*, II (Freiburg, 1958), 215; W. Kamlah, *Apokalypse und Geschichtstheologie—Die mittelalterliche Auslegung der Apokalypse vor Joachim von Fiore*. Historische

Studien 285 (Berlin, 1935), 15 Anm. 17; R. Laurentin, *Court traité sur la vierge Marie* (Paris, 1967), 76 Anm. 27 (datiert den Kommentar ohne Begründung um 1125); P. Prigent, *Apocalypse 12—Histoire de l'exégèse*. Beiträge zur Geschichte der biblischen Exegese 2 (Tübingen, 1959), 38f. Nicht unter den Apokalypsen-Kommentaren des 9. Jahrhunderts erwähnt bei L. Scheffczyk, *Das Mariengeheimnis in Frömmigkeit und Lehre der Karolingerzeit*. Erfurter Theologische Studien 5 (Leipzig, 1959), 404f. H.D. Rauh, *Das Bild des Antichrist im Mittelalter—Von Tyconius zum Deutschen Symbolismus*. Beiträge zur Geschichte der Philosophie und Theologie des Mittelalters, NF 9 (Münster, 1973), 227 Anm. 175, 447 Anm. 26, scheint den Kommentar für karolingisch zu halten.

[9]Eine Identizierung mit James Nr. 91, ehem. Sammlung van de Cruisse, Waziers, ist nicht möglich, obgleich man die Nennung von 65 statt 66 Miniaturen für einen Irrtum halten könnte. Die ausserordentlich knappe Beschreibung bei E. van Drival, *L'Exposition de Lille—Études sur les objets d'art religieux réunis à Lille en 1874* (Arras, 1876), 154, erwähnt "65 grandes peintures en grisailles, avec des nimbes d'or et ciels d'azur." Die Düsseldorfer *Apocalypse* enthält aber weder Grisaillen noch goldene Nimben. Die Handschrift der Sammlung van der Cruisse sonst nur noch erwähnt bei L. de Farcy, *Histoire et description des tapisseries de la Cathédrale d'Angers* (Lille-Angers, o. J.), 13 Anm. 6.

[10]J.B. Rietstap, *Armorial général*. 2e éd. (Gouda, 1887), II, 245, Pl. hg. von H.V. Rolland, III, Pl. 229.

bestimmtes Atelier bereitet Schwierigkeiten, die teilweise in der Qualität der Handschrift begründet sind. Bereits eine erste Durchsicht verrät, dass hier nicht sonderlich begabte Maler am Werke waren, manche Miniaturen haben gar etwas Dilettantisches. Wie sich später zeigen wird, ist Dürers *Apocalypse* von 1498 eine der Voraussetzungen der Handschrift, und der Figurenstil im Allgemeinen, viele italianisierende Figuren wie beispielsweise die beiden Engel auf p. 64 (Abb. 16) oder die Bordürenornamentik von p. 1 (Abb. 1) verweisen die Handschrift in die erste Hälfte des 16. Jahrhunderts. Manche Köpfe und auch Architekturen erinnern von ferne an jene Miniaturen, mit denen ein Mitarbeiter Jean Perréals im beginnenden 16. Jahrhundert eine Handschrift der *Énigmes* des Pierre Sala schmückte, doch bewahren diese im Faltenstil viele gotische Züge.[11] Ein ähnliches Festhalten an älteren Stilelementen zeigt noch die Figur eines liegenden Kranken in der Titelminiatur einer um 1525 entstandenen Handschrift,[12] wenn man sie mit dem liegenden Johannes auf p. 1 der Düsseldorfer *Apocalypse* vergleicht. Das modernste Element ist augenscheinlich die Rollwerkkartusche für das Wappen in der rechten Bordüre von p. 1, ein Detail, das die *Apocalypse* in die Jahre nach 1530 verweist.[13] Wo sie in Frankreich entstanden sein mag, liess sich bislang nicht feststellen.

Die Düsseldorfer *Apocalypse* ist zusammengesetzt aus zwei Quinionen (p. 1–20, 21–40), einem Quaternio (p. 41–56) und einem Ternio (p. 57–66), dessen letztes Blatt abgeschnitten ist. Es fehlen aber am Ende keine Miniaturen und keine Stücke des Textes, der Zyklus schliesst auf p. 66 mit den letzten Versen der Offenbarung des Johannes. Das erste Blatt (p. 1–2) ist ein Einzelblatt, das an den Falz des zehnten Blattes (p. 19–20) geklebt ist. Auf p. 20 findet sich rechts unten ein Reklamant ("et septimus") mit dem Beginn des Textes von p. 21 (Apoc. 16: 17). Die Lagenordnung ist also an dieser Stelle korrekt. Am Ende des zweiten Quinio, auf p. 40 rechts unten ist eine weiterer Reklamant zu sehen ("et iratus," Apoc. 12 : 17), der nicht dem Anfang des Textes auf p. 41 (Apoc. 13 : 3b) entspricht. Die nächste Lage ist ein Quaternio, die Nichtübereinstimmung von Reklamant der vorhergehenden Lage und Textbeginn führt zu dem Schluss, dass ein Blatt zwischen p. 40 und p. 41 fehlt. Ursprünglich war sicher ein Quinio vorhanden, also muss auch ein Blatt zwischen p. 56 und p. 57 ergänzt werden. Die Düsseldorfer *Apocalypse* enthielt mithin anfänglich vier Seiten mehr.

Wie bereits eine erste Durchsicht der Handschrift zeigt, sind Texte und Illustrationen falsch geordnet. So sind am Anfang die *Anbetung des Herrn und des Lammes durch die grosse Menge* (Apoc. 7 : 9–17 ; p. 5) und die *Verteilung der sieben Posaunen* (Apoc. 8 : 2–4 ; p. 6) zwischen die *Tröstung des Johannes durch einen Ältesten* (Apoc. 5 : 1–5 ; p. 4) und die *Anbetung des Herrn durch die 24 Ältesten* (Apoc. 4 : 10–11 ; p. 7) geraten. Noch auffälliger ist, dass nicht weniger als zwölf Szenen aus den Kapiteln 15–19 der Apocalypse vom *Offenen Tempel im Himmel* und der *Verteilung der Zornesschalen* (Apoc. 15 : 5–8 ; p. 15) bis hin zu der Szene, in der *Johannes vor dem Engel niederfällt* (Apoc: 19: 9–10 ; p. 26), im Anschluss an die *Bekleidung der Seelen unter dem Altar* (Apoc. 6 : 9–11 ; p. 15) und vor dem *Rauchfassengel und der ersten Posaune* (Apoc. 8 :

[11]London, British Museum, Stowe 955. C. Sterling, "Une peinture certaine de Perréal enfin retrouvée," *L'Oeil* (nos. 103–104, 1963), 2–15, 64f., Abb. 30–33.

[12]Paris, Bibliothèque Nationale, franç. 5715 fol. AV, *Les Gestes de Blanche de Castille*, Handschrift für Louise de Savoie. Vgl. A. Blum–P. Lauer, *La miniature française aux XVe et*

XVIe siècles (Paris–Bruxelles, 1930), Pl. 88 ; Katalog *Manuscrits à peintures du XIIIe au XVIe siècle* (Paris, Bibliothèque Nationale, 1955), Nr. 360, Pl. XL.

[13]P. Jessen, *Der Ornamentstich—Geschichte der Vorlagen des Kunsthandwerks seit dem Mittelalter* (Berlin, 1920), 61.

5–7; p. 27) erscheinen—die *Vision vom Reiter Treu und Wahrhaftig* (Apoc. 19: 11–16; p. 55)
folgt unmittelbar auf die *Aufforderung zur Weinlese* (Apoc. 14: 17–18; p. 54). Zunächst möchte
man vermuten, die Handschrift sei später falsch gebunden worden. Vergegenwärtigt man
sich aber dann die Anordnung der Lagen, die durch die Reklamanten gesichert ist, wird man
feststellen, dass eine Berichtigung der Abfolge des Zyklus nicht möglich ist, ohne die Lagen
aufzulösen und zusammenhängende Doppelblätter zu zerschneiden. Um nur die längere
Szenengruppe als Beispiel zu nehmen: sie erstreckt sich über die letzten drei Blätter des
ersten Quinio und die drei ersten Blätter des zweiten Quinio. Sie müssten von ihren Gegen-
blättern getrennt werden, um zwischen dem vorletzten und dem letzten Blatt der dritten
Lage eingefügt zu werden. Der Befund ist unbestreitbar, und nur eine mögliche Erklärung
bietet sich an: es wurde eine falsch gebundene, ältere illustrierte *Apocalypse* Seite für Seite
kopiert, ohne dass man sich die Mühe machte, die richtige Abfolge wiederherzustellen, was
schliesslich mit Hilfe des Apocalypsen-Textes ohne grössere Mühe möglich gewesen wäre.
Der Auftraggeber hatte offensichtlich bei der Werkstatt die Kopie einer Vorlage bestellt,
und man wird sich fragen, wie die Vorlage ausgesehen hat.

<div align="center">III</div>

Die Vorlage der Düsseldorfer *Apocalypse* lässt sich auf Grund dieses Befundes eindeutig
identifizieren. Erstaunlicherweise ist nicht eine Handschrift des 15. Jahrhunderts, also ein
relativ modernes Buch, ausgesucht worden, sondern ein sehr viel älterer Codex, nämlich
eine englische illustrierte *Apocalypse* des mittleren 13. Jahrhunderts. Unter allen von Léopold
Delisle und Montague Rhodes James verzeichneten illustrierten Apocalypsen-Handschriften
mit dem englischen Zyklus gibt es nur eine einzige, die die gleiche falsche Anordnung des
Zyklus enthält, oder besser enthielt, denn die Handschrift, Metz, Bibliothèque Municipale,
MS Salis 38,[14] wurde im Zweiten Weltkrieg vernichtet. Über ihre Geschichte ist nur bekannt,
dass sie im ausgehenden 18. Jahrhundert in Amsterdam versteigert und 1847 im Londoner
Handel durch den Baron von Salis erworben wurde, der sie zusammen mit seiner Hand-
schriftensammlung der Metzer Bibliothek hinterliess.[15] In einem Einband des 18. Jahrhun-
derts befanden sich 34 Pergamentblätter, von denen eines leer war, die Masse betrugen 290 zu
210 mm.,[16] eine Bestandsaufnahme der Lagenordnung ist leider nicht überliefert. Die Metzer
Apocalypse enthielt, genau wie die Düsseldorfer Handschrift, 66 Miniaturen mit Szenen aus
der Offenbarung, sie füllten jeweils eine halbe Seite, während der Text der Apocalypse und
Auszüge aus dem Kommentar des Berengaudus, beides in lateinischer Sprache, die andere
Hälfte einnahmen. Delisle, der die Metzer *Apocalypse* mit einer ganzen Reihe weiterer illus-
trierter Apocalypsen-Handschriften verglich, werden Angaben über Lücken und Umstel-
lungen verdankt, er stellte Lücken nach fol. 6, 11 und 17 fest und bemerkte, dass fol. 2 nach
fol. 6 und fol. 7–12 zwischen fol. 26 und fol. 27 eingeordnet werden müssen.[17] Bereits seinen
Bemerkungen über die falsche Einbindung mehrerer Blätter der Metzer *Apocalypse* kann

[14]Delisle–Meyer, James Nr. 6. F.X. Kraus, "Hora,
Metenses," *Bonner Jahrbücher* (LXIX, 1880), 75; Abbé E. Pauluse
"Supplément au catalogue des manuscrits de la bibliothèque
de la ville de Metz," *Le Bibliographe Moderne* (VII, 1903), 406.
[15]Paulus, *ibid*: Nr. 184 auf der Versteigerung Crevenna

(Lugt, *Répertoire des catalogues de ventes publiques*, The Hague,
6138, I, 5110: 1793, Oct. 2ff., Amsterdam).
[16]Angaben nach Paulus, *loc. cit.*
[17]Delisle–Meyer, LXXXI.

entnommen werden, dass die Düsseldorfer *Apocalypse* genau dieselben Szenen und Texte an einer falschen Stelle enthält.[18] Da es sich allem Anschein nach um die einzige ältere Apocalypse mit eben diesen Umstellungen handelt, liegt der Verdacht nahe, die Metzer *Apocalypse* habe als Vorlage für die Düsseldorfer *Apocalypse* zur Verfügung gestanden. Glücklicherweise ist die Metzer Handschrift vor ihrer Vernichtung vollständig durchfotografiert worden, und die Fotoserie von Miniaturen und Texten, die sich in der Pierpont Morgan Library in New York befindet, bestätigt den eben geäusserten Verdacht. Nicht nur die Abfolge von Texten und Bildern stimmt überein, sondern auch die Texte selber. Ein Vergleich der Düsseldorfer Miniaturen mit den Metzer lavierten Federzeichnungen demonstriert die Abhängigkeit von der fast drei Jahrhunderte älteren Vorlage.

Beide Handschriften enthalten je 66 Miniaturen, von denen vier der Metzer *Apocalypse* keine Entsprechung in der Düsseldorfer Handschrift haben und vier der Düsseldorfer *Apocalypse* keine in der Metzer Handschrift. In der Düsseldorfer Handschrift fehlen zwischen p. 40 und 41 der *Kampf des Drachen mit den Angehörigen des Weibes* (Apoc. 12: 17–18; Metz fol. 19) und die *Übergabe der Macht an das Tier aus dem Meer durch den Drachen* (Apoc. 13: 1–3a; Metz fol. 19v), ausserdem zwischen p. 56 und 57 der *Sieg über das Tier und die Könige durch den Reiter* (Apoc. 19: 19–20b; Metz fol. 27 bis) und die Szene, in der das *Tier und der falsche Prophet in den Feuerpfuhl gestossen werden* (Apoc. 19: 20–21; Metz fol. 27bis v). Es fehlen also jene Szenen, die in der Düsseldorfer Handschrift auf dem zu ergänzenden äusseren Doppelblatt der dritten Lage enthalten gewesen sein müssen—und der Beginn des Textes zur ersten Szene Apoc. 12: 17 ist durch den Reklamanten der zweiten Lage gesichert. Hier hilft mithin die Vorlage, die spätere Kopie zu rekonstruieren. Andererseits ist der Zyklus der Metzer Handschrift vollständiger gewesen, als er im 16. Jahrhundert kopiert wurde, jene vier Szenen, die die Düsseldorfer über die Metzer Handschrift hinaus enthält, bezeugen, dass damals zwischen fol. 1v und 2 der Metzer *Apocalypse* ein Blatt mit der *Grossen Himmelsvision* (Apoc. 4: 1–9; Düsseldorf p. 3) und dem *Gespräch zwischen Johannes und dem Ältesten über das versiegelte Buch* (Apoc. 5: 1–5; Düsseldorf p. 4) und zwischen fol. 17v und 18 ein weiteres Blatt mit der *Wiederbelebung und Himmelfahrt der beiden Zeugen* (Apoc. 11: 9–14; Düsseldorf p. 37) und der *Siebenten Posaune und der Anbetung des Herrn* (Apoc. 11: 15–18; Düsseldorf p. 38) vorhanden waren. Damals umfasste der Zyklus also 70 Miniaturen.

IV

In seiner Analyse der *Apocalypse* London, Lambeth Palace Library, MS 209 stellte Eric G. Millar 1924 eine Gruppe von Apocalypsen-Handschriften zusammen, deren Bildzyklus sehr weitgehend übereinstimmt.[19] Zu ihr gehören folgende Handschriften:

[18]Vgl. die Inhaltsübersicht im Anhang (Ss. 235–40), die sich auf die im Folgenden erwähnte Serie von Fotografien stützt.

[19]"Les Principaux manuscrits à peintures du Lambeth Palace de Londres," *Bulletin de la Société Française pour la Reproduction des Manuscrits à Peintures* (VIII, 1924), 38–66; James, *The Apocalypse in Art*, 56. L.F. Sandler, *The Peterborough Psalter in Brussels and Other Fenland Manuscripts* (London, 1974), 62–87, 100–07, 151–54, zeigte soeben, dass die von James, *The Apocalypse in Art*, 57, zusammengestellte Untergruppe wie die Cambrai-, Lambeth-, Gulbenkian-, Abingdon- und einst auch

Metz-Apocalypsen den Zyklus in 78 Miniaturen enthält. Es handelt sich um folgende Handschriften: Oxford, Bodleian Library, Tanner 184 (James Nr. 86); ebenda, Canonici Bibl. 62 (Delisle-Meyer, James Nr. 46); Cambridge, Magdalene College, MS 5 (James Nr. 63). Die beiden zuletzt genannten Zyklen sind jetzt durch Sandler, *Peterborough Psalter*, 66–85, vollständig veröffentlicht worden. Zur Erweiterung des Zyklus in den Handschriften des 14. Jahrhunderts aus Millars Gruppe, Freyhan, "Joachism and the English Apocalypse," 227.

Metz, Bibliothèque Municipale, MS Salis 38 (Delisle–Meyer, James Nr. 6)
Cambrai, Bibliothèque Municipale, MS 482 (Delisle–Meyer, James Nr. 5)
London, Lambeth Palace Library, MS 209 (Delisle–Meyer, James Nr. 44)
Lissabon, Gulbenkian Museum, MS LA. 139 (ehem. Slg.
 Henry Yates Thompson Nr. 55) (Delisle–Meyer, James Nr. 16)
London, British Museum, Add. 42555[20]
Namur, Grand Séminaire, MS 77 (Delisle–Meyer, James Nr. 8)[21]
New York, Metropolitan Museum of Art, The Cloisters (Delisle–Meyer, James Nr. 15)[22]
London, Brit. Mus., Add. 17333 (Delisle–Meyer, James Nr. 13)
Paris, Bibliothèque Nationale, lat. 14410 (Delisle–Meyer, James Nr. 12)

Für eine Rekonstruktion des Metzer Zyklus können nicht die zuletzt genannten Handschriften herangezogen werden, die alle den Zyklus erweitern, indem sie bestimmte Ereignisse, die in den Handschriften des 13. Jahrhunderts in einer Miniatur dargestellt wurden, auf mehrere verteilen. Eine Sonderstellung nehmen die Gulbenkian- und die Abingdon-*Apocalypsen* ein, weil sie die Reihe der Illustrationen zum Text der Offenbarung durch eine Serie von Illustrationen zum Kommentar des Berengaudus ergänzen. Der Zyklus zur Apocalypse selbst stimmt aber fast völlig mit dem der Handschriften Metz, Cambrai und Lambeth überein. Cambrai- und Lambeth-*Apocalypsen* verteilen den Inhalt des letzten Buches der Bibel auf insgesamt je 78 Miniaturen. Danach wird die Metzer *Apocalypse* auch 78 Miniaturen enthalten haben, in ihr fehlen ausser den vier bereits erwähnten Szenen noch acht weitere, und zwar:

nach fol. 6v	Apoc. 6: 12–17	*Erdbeben, Verfinsterung von Sonne und Mond, Sternenfall.*
	Apoc. 7: 1–8	*Die vier Windengel.*
nach fol. 17v (und den Düsseldorf p. 37–38 entsprechenden Seiten)	Apoc. 11: 19–12: 6	*Der offene Tempel im Himmel, die Erscheinung des Drachen, das Weib in der Sonne reicht einem Engel ihr Kind.*
	Apoc. 12: 7–12	*Das Weib sitzt an einem Baume, Michael bekämpft den Drachen.*
nach fol. 26v	Apoc. 14: 19–20	*Die Weinlese, die Zorneskelter, die Pferde im Blut aus der Kelter.*
	Apoc. 15: 1–4	*Die Harfenspieler auf dem gläsernen Meer.*
nach fol. 11v	Apoc. 18: 21–24	*Der Mühlsteinengel.*
	Apoc. 19: 1–5	*Der Jubel im Himmel über den Fall der grossen Buhlerin.*

Wichtig für die Rekonstruktion der Metzer *Apocalypse* ist, dass jeweils zwei Miniaturen, also ein Blatt fehlt. Nach den parallellaufenden Zyklen in den Handschriften Cambrai und Lambeth dürfte sie ursprünglich folgendermassen angeordnet gewesen sein: fol. 1, fehlendes Blatt, fol. 3–6, fehlendes Blatt, fol. 2, fol. 13–17, zwei fehlende Blätter, fol. 18–26, fehlendes Blatt, fol. 7–11, fehlendes Blatt, fol. 12, fol. 27–32, insgesamt also 39 Blätter. Überlegt man,

[20]Es handelt sich um die Abingdon-*Apocalypse*, die zuerst von R.E.W. Flower, *British Museum Quarterly* (VI, 1931–1932), 71–73, 109f. bekannt gemacht wurde. Ihre Verwandtschaft mit der Gulbenkian-*Apocalypse* erkannte James, *The Apocalypse in Art*, v.

[21]P. Faider, *Catalogue des manuscrits conservés à Namur*, Catalogue général des manuscrits des bibliothèques de Belgique, I (Gembloux, 1934), 509f.
[22]F. Deuchler–J.M. Hoffeld–H. Nickel, *The Cloisters Apocalypse*, 1–2 (New York, 1971).

wie die Lagen zusammengesetzt gewesen sein mögen, wird man wohl mit Quaternionen rechnen dürfen, denn am Schluss gehören sieben Blätter als vollständig zusammen, also doch wohl ein Quaternio, dem das letzte Blatt fehlte.[23] Auch die an einer falschen Stelle eingefügte Lage fol. 7–12 ergibt mit den beiden fehlenden Blättern einen Quaternio. Für die Rekonstruktion von Quaternionen spricht auch, dass in mehreren englischen Apocalypsen die Doppelblätter durchweg oder mit Ausnahme der letzten Lage zu Quaternionen geordnet sind.[24] Setzt man Quaternionen voraus, ergibt sich folgende Anordnung der Lagen:

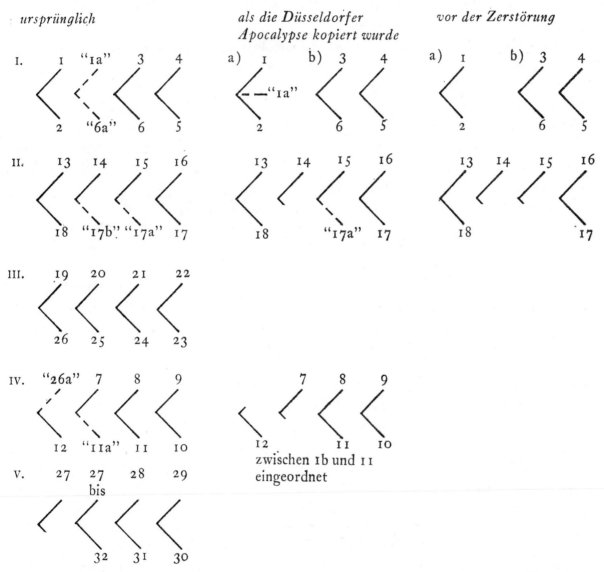

ursprünglich

als die Düsseldorfer Apocalypse kopiert wurde

vor der Zerstörung

zwischen 1b und 11 eingeordnet

[23]Oder war jenes leere Blatt zugehörig, das Paulus (wie Anm. 14) in seiner Beschreibung erwähnt? Dann hätte es sich um einen vollständigen Quaternio gehandelt.

[24]Leider gibt es nur von wenigen Apocalypsen-Handschriften ausreichende Beschreibungen. Die von James vollständig veröffentlichten Exemplare sind beinahe durchweg aus Quaternionen zusammengesetzt: *The Trinity College Apocalypse*, The Roxburghe Club (London, 1909), 29 (3 Quaternionen, 1 Ternio, Einzelblätter); *The Apocalypse in French and Latin* (*Bodleian MS. Douce* 180), The Roxburghe Club (London, 1922) (3 Quaternionen); *The Apocalypse in Latin MS.* 10 *in the Collection of Dyson Perrins* (Oxford, 1927), 56 (5 Quaternionen, 1 Einzelblatt); *The Dublin Apocalypse*, The Roxburghe Club (London, 1932), 1 (3 Quaternionen, 1 Quinio?, eine Lage unbestimmbar).—Die Lambeth-Apocalypse ist so gebunden, dass keine Bestimmung der Lagen möglich war, vgl. Millar, "Les Principaux manuscrits . . . du Lambeth Palace," 38, u. M.R. James–C. Jenkins, *A Descriptive Catalogue of the Manuscripts in the Library of Lambeth Palace*, Part 2 (Cambridge, 1932), 331.

Da eine Nachprüfung der Lagenordnung an der Handschrift selber nicht mehr möglich ist, muss die hier vorgeschlagene Rekonstruktion hypothetisch bleiben. Jedoch entspricht sie einer Lagenordnung und einer Form des Zyklus, die nach allem, was wir über die verwandten Handschriften wissen, auch für die Metzer *Apocalypse* vorausgesetzt werden dürfen. Ausserdem erklärt sie alle Lücken und Umstellungen in der Düsseldorfer Handschrift.

Eine Einordnung der Metzer *Apocalypse* in die Geschichte der englischen Buchmalerei und in die Geschichte des englischen Apocalypsen-Zyklus ist bislang nur sehr eingeschränkt möglich, wobei hervorzuheben ist, dass stilistische Datierungen von Vorstellungen über die Abhängigkeit verschiedener Varianten des Zyklus voneinander beeinflusst sind und umgekehrt.[25] Gesicherte Ergebnisse werden erst möglich sein, wenn mit Hilfe von Veröffentlichungen von sehr viel mehr englischen Apocalypsen-Zyklen (so fehlen beispielsweise vollständige Wiedergaben so wichtiger Handschriften wie New York, Pierpont Morgan Library, M. 524, der Lambeth-, Gulbenkian- und Abingdon-*Apocalypsen*, auch von der Metzer *Apocalypse* sind bisher nur wenige Miniaturen veröffentlicht worden) die Filiation der Zyklusvarianten geklärt und zudem die Stilentwicklung in den einzelnen englischen Scriptorien des mittleren 13. Jahrhunderts auch in den Einzelheiten bekannt sein wird. Hier müssen wenige Hinweise auf den Stand der Forschung genügen.

Nach den grundlegenden Untersuchungen von Delisle, James und Millar[26] griff erst Robert Freyhan 1955 das komplexe Problem einer Gruppierung der frühen englischen Apocalypsen wieder auf und fasste seine Ergebnisse, die offensichtlich auf einem sehr gründlichen Vergleich beruhen, sehr knapp zusammen, da sein Hauptinteresse bestimmten inhaltlich-historischen Punkten galt. Als Archetyp, von dem die weitere Entwicklung des Zyklus ausging, bezeichnete er jene Handschriften von Delisles erster Familie, die als eine Art von reinem Bilderbuch Text- und Kommentarstücke in den grossen Spruchbändern und in den freien Flächen der Kompositionen enthalten. Nach Freyhan ist der Archetyp in der Handschrift New York, Pierpont Morgan Library, M. 524 (Delisle–Meyer, James Nr. 3) erhalten, von ihm ist die *Apocalypse* Oxford, Bodleian Library, Bodl. Auct. D. 4. 17 (ebenda Nr. 2) abhängig. Als Antriebskraft für die weitere Entwicklung des Zyklus konnte er die Ausgestaltung zu einem Buch mit dem vollständigen Text der Apocalypse und oft auch mit Teilen aus dem Kommentar des Berengaudus nachweisen, wodurch die Spruchbänder zum grössten Teil ihren Sinn verloren und die Kompositionen umgearbeitet werden mussten, ein Vorgang, der sich an der *Apocalypse* Paris, Bibliothèque Nationale, franç. 403 (ebenda Nr. 1, mit dem altfranzösischen Apocalypsen-Kommentar) nachweisen liess, welche den Zyklus beinahe überall genau kopiert. Eine Umformung dieses Zyklus ist dann nach Freyhan jene Serie von Apocalypsen-Illustrationen, die sich in der von Millar zusammengestellten Gruppe findet. Von ihr, zu der die Metzer Handschrift gehört, unterschied Freyhan zwei weitere Gruppen, einmal eine, zu der er trotz ihrer Sonderstellung die Trinity-*Apocalypse* (ebenda Nr. 39) rechnete und die auf der eben erwähnten Gruppe beruht, und eine weitere, die Szenen der beiden anderen Gruppen benutzt und erweitert. Freyhan datierte seinen Archetyp, also M.524 der Pierpont Morgan Library, und die Prototypen der Metzer und der

[25]Die Notwendigkeit, die Stilentwicklung der englischen Buchmalerei zu berücksichtigen, hat vor allem Henderson,

"Studies in English Manuscript Illumination," herausgearbeitet. [26]Vgl. Anm. 19, 24.

letzten Gruppe in die Jahre zwischen 1255 und 1260.[27] Nachdem Derek H. Turner 1964 auf Grund stilisticher Kriterien für die Trinity-*Apocalypse* eine Ansetzung um 1245–1250 und für Bibliothèque Nationale franç. 403 um 1250–1260 vorschlug,[28] konzentrierte sich die weitere Forschung vor allem auf die Frage, welche Stellung die Trinity-*Apocalypse* in der Entwicklung des englischen Apocalypsen-Zyklus einnimmt. Peter H. Brieger sah in ihr den Ausgangspunkt für alle anderen Ausformungen des Apocalypsen-Zyklus, während George H. Henderson sie für einen Zyklus hielt, der gleichberechtigt neben M. 524 die späteren Apocalypsen beeinflusste. Für Jessie Poesch waren die Zyklen M. 524–Oxford einerseits, Lambeth–Metz andererseits die einflussreichsten Varianten der englischen Apocalypsen-Ikonographie vor 1260, ihr zufolge ist Trinity als Parallele oder als Derivat der zweiten Variante zu verstehen.[29] Ein Vergleich der drei Zyklen könnte wohl zeigen, dass Trinity tatsächlich viele Figuren und Figurengruppen aus dem Zyklus Lambeth–Metz übernimmt, wahrscheinlich aber auch den von M. 524 kennt. Die vielen Eigenheiten der Apocalypsen-Illustration von Trinity lassen sich als Umformungen der anderen Zyklen verstehen. Für die Datierung der erhaltenen Handschriften dürfen aus einer solchen Abfolge der Redaktionen der Apocalypsen-Illustration keine Folgerungen gezogen werden, will man nicht bestimmte Codices für die Archetypen selber erklären.

In einer Anmerkung seiner Arbeit zur englischen Buchmalerei des 13. Jahrhunderts sagte Henderson, Cambrai und Metz seien im Verhältnis zu Lambeth das, was Oxford für M. 524 sei.[30] Hier muss an Beobachtungen Millars erinnert werden,[31] der Metz und Lambeth auf einen gemeinsamen Prototyp zurückführte, weil Metz unter anderem auf fol. 26v das *Gestell für den Weinstock* vollständig darstellt, während Lambeth auf fol. 24v und 25[32] es nur unvollständig und missverstanden zeigt. Ausserdem ist die Metzer *Apocalypse* offenbar stilistisch älter als die Lambeth-*Apocalypse*. Die lavierten Federzeichnungen der Metzer *Apocalypse* sind in einer Variante jenes Muldenfaltenstiles ausgeführt, der etwa auch für Morgan M. 524 und Bibliothèque Nationale franç. 403 massgeblich war, während die Miniaturen der Lambeth-*Apocalypse* bereits eine Reihe hochgotischer Schüsselfalten und Faltenbrüche enthalten. Schliesst man sich der Ansetzung dieser Handschrift durch Henderson "nicht später als um 1260" an,[33] muss man die Metzer *Apocalypse* wohl um die Mitte des 13. Jahrhunderts datieren.

V

Die Werkstatt, die die Düsseldorfer *Apocalypse* nach 1530 auszuführen hatte, müssen die Darstellungen der Vorlage sehr altertümlich vorgekommen sein. Der Auftrag, den sie erhalten hatte, war ausgesprochen retrospektiv, und im Vergleich von Vorlage und Kopie lässt sich zeigen, mit welchen Mitteln man eine Modernisierung des Zyklus zu erreichen versuchte.

[27]"Joachism and the English Apocalypse," 218f., 234–42.
[28]"The Evesham Psalter," *Journal of the Warburg and Courtauld Institutes* (XXVII, 1964), 23–41.
[29]Brieger, Henderson, Poesch (vgl. Anm. 1). Freyhan, "Joachism and the English Apocalypse," 234, leitet den Zyklus der Trinity-*Apocalypse* von seinem Archetypus, also M. 524, vom Prototyp der Gruppe Metz etc. und von den Beatus-Apocalypsen ab.

[30]Henderson, "Studies in English Manuscript Illumination" (1967), 135 Anm. 72.
[31]"Les Principaux manuscrits . . . du Lambeth Palace," 43. Vgl. ders., *English Illuminated Manuscripts from the Xth to the XIIIth Century* (Paris–Brüssel, 1926), 62.
[32]Henderson, "Studies in English Manuscript Illumination" (1968), Pl. 46c.
[33]*Ibid.*, 143f.

Bereits die erste Seite beider Handschriften ist charakteristisch für das Verhältnis von Vorlage und Kopie (Abb. 1–2). Die Seitenaufteilung im Allgemeinen wurde übernommen, die Illustration füllt die obere Hälfte der Seite, darunter der Text in zwei Columnen. Weggelassen wurde die Darstellung des sitzenden Autors mit dem Engel in der Initiale zum Text. Beide Initialen, die zum Prolog und die zum Text, wurden im Gegensatz zur Vorlage auf beinahe die gleiche Grösse gebracht. An die Stelle der Ausläufer der Initiale, von denen einer sich zu einer Art unterer Rahmenleiste der ganzen Seite entwickelt hatte, trat oben, rechts und unten eine Bordüre, zu der ein schmaler Rahmenstreifen links gehört und die mit Grotesken-ornamentik gefüllt ist, das Wappen des Auftraggebers ist unten in einem Kranz und rechts in einer Rollwerkkartusche dargestellt. Das Bildschema der Miniatur wurde treu übernommen, Johannes liegt schlafend, das Haupt mit der Rechten aufgestützt, rechts oben ein Engel mit einem Spruchband, das Text aus Apoc. 1 : 11 enthält. Aber an die Stelle einer an drei Seiten von Wasser umgebenen Insel ist eine Landschaft mit Felsen getreten, die rechts einen Ausblick auf die See gewährt. Das Schiff links unten und die durch Namen bezeichneten kleinen Inseln um Patmos wurden weggelassen, aus dem Vogel auf der Insel Sardis rechts wurde das Adlersymbol des Johannes gemacht. Auch die Figur des Engels wurde geändert. Aus dem horizontal schwebenden Engel, unter dem sich das Spruchband erstreckt, wurde die Figur eines Engels im Knielaufschema, der das Spruchband hält. Die Darstellung des 13. Jahrhunderts ist in die Bildsprache des 16. Jahrhunderts übersetzt, aus dem flächigen Neben- und Übereinander des Darzustellenden wurde eine räumliche Zuordnung. Nicht nur die Einzelheiten wurden modernisiert, sondern auch die gesamte Strukturierung der Szene.

Das wird selbst in einer Szene deutlich, die ein für die Düsseldorfer *Apocalypse* ganz anachronistisches Detail treu übernimmt, nämlich in der Darstellung des *Rauchfassengels und der ersten Posaune* (Apoc. 8 : 5–7; Abb. 3–4). Hier wurde sogar das Spruchband mitten in der Szene mit dem Text der Verse 6–7 kopiert,[34] während sonst beträchtliche Änderungen vorgenommen wurden. Zunächst wurde als Schauplatz wieder eine in die Tiefe führende Landschaft gewählt. Die beiden Engel, die in Metz auf dem Boden stehen, wurden in die Luft erhoben—eine sehr charakteristische Abweichung, die sich auch in vielen anderen Miniaturen der Düsseldorfer Handschrift beobachten lässt. Dadurch war unten Platz geworden, der durch die Figur des sitzenden Sehers, der nicht in der Vorlage vorkam, gefüllt wurde. Zusätzlich wurde der Altar mit dem Feuer aus der vorigen Szene (Abb. 5–6) in den Wolkenkranz mit den blasenden Häuptern eingeführt. Überall wird das Bemühen um eine "realistische" Darstellung der apokalyptischen Visionen spürbar, die allerdings—und das liegt nicht nur an der mässigen Qualität der Düsseldorfer *Apocalypse*—die Durchschlags-

[34]Ausser Metz fol. 13 der Text auch in der Miniatur Lambeth fol. 9, während das entsprechende Spruchband in Cambrai fol. 31 leer geblieben ist. Das Spruchband mit Text weist auf die Abhängigkeit des Zyklus Metz-Lambeth-Cambrai von der Ikonographie von Freyhans "Archetypus" hin. Vgl. Oxford fol. 6v oben (H.O. Coxe, *The Apocalypse of St. John . . .*, The Roxburghe Club, London, 1876) und Paris, Bibliothèque Nationale franç. 403 fol. 13v (Delisle-Meyer, Pl. fol. 13v). Auch eine andere Eigenheit spricht für die Abhängigkeit des Zyklus in Metz etc. von M. 524-Oxford- franç. 403. Apoc. 5:

1–5, das *Gespräch des Johannes mit einem der Ältesten*, ist vor Apoc. 4:10–11, die *Anbetung des Herrn durch die 24 Ältesten* gestellt, eine Abweichung vom Bibeltext, die sich durch eine Verteilung des in der unteren Hälfte von M. 524 fol. 1v, Oxford fol. 3v (= franç. 403 fol. 7, Delisle-Meyer, Pl. fol. 7) Dargestellten auf vier Miniaturen erklärt. In dieser, also der älteren Fassung des Zyklus wird in einem Kompartiment ganz links, also zu "Beginn" der Szene, das *Gespräch zwischen Johannes und dem Ältesten* gezeigt.

kraft und die Mächtigkeit der einzelnen Figuren und Szenen erheblich mindert, was bei einem Vergleich des die erste Posaune blasenden Engels in beiden Handschriften vielleicht besonders deutlich wird.

Wie grossen Wert die Werkstatt der Düsseldorfer *Apocalypse* auf die Verdeutlichung von Himmelsvisionen legte, zeigt die vorhergehende Szene mit der *Verteilung der sieben Posaunen und dem Rauchfassengel* (Apoc. 8 : 2–4 ; Abb. 5–6). Die Darstellung von Engeln, die auf einer welligen Bodenlinie schreiten, war für diesen Zweck nicht zu brauchen—nach Meinung des 16. Jahrhunderts konnte sich die Vision nur in Wolken abspielen. Dafür wurde der Altar in die Mitte gerückt und vom unteren Rahmen durch Wolkenschichten getrennt, die Erscheinung des Herrn wurde in eine räumliche Relation zum Altar gebracht. Ausserdem verteilte man die Engel hinter- und nebeneinander gestaffelt symmetrisch um den Altar. Die feierliche Prozession der von links nach rechts zu lesenden Streifenkomposition wurde von einer sich in die Tiefe erstreckenden Zentralkomposition abgelöst. Ein Motiv, das für die englischen Apocalypsen des 13. Jahrhunderts sehr charakteristisch war, musste für die Bildersprache der Düsseldorfer *Apocalypse* als gänzlich unpassend erscheinen: die Darstellung des Sehers ausserhalb der gerahmten Miniatur, der durch ein Fenster in das Bildfeld hineinsieht, jenes Motiv, das Freyhan *ostium-apertum*-Motiv nannte.[35] Stattdessen wurde die Figur des sitzenden Johannes in die Wolken versetzt. Überall, wo in Metz der Seher ausserhalb des Bildfeldes dargestellt war, wurde diese Eigenheit von der Kopistenwerkstatt beseitigt, meist indem Johannes innerhalb des Rahmens gezeigt wurde.

Dieser Einordnung des Sehers in die Darstellung von Visionen entspricht die Auflösung der Einteilung von Miniaturen in einzelne Felder. Als Beispiel dafür sei die *Anbetung des Herrn und des Lammes durch die grosse Menge* (Apoc. 7 : 9–17 ; Abb. 7–8) genannt. In der Metzer *Apocalypse* ist zunächst links in einem schmalen, hochrechteckigen Feld Johannes mit einem der Ältesten dargestellt. Der Miniator der Düsseldorfer *Apocalypse* hob die Abtrennung dieser Szene von der Vision auf und unterliess es, die Engel, die Ältesten und die Menge mit den Palmen in einzelne Streifen einzuteilen. Statt in einem von einem Vierpass gefüllten Kreis thront der Herr nun in Wolken. Verändert ist auch das Spruchband mit Apoc. 7 : 14b, das von der Hand des mit Johannes redenden Ältesten ausgeht, es spannt sich jetzt über die ganze Szene. Neu ist weiterhin die Darstellung der Menge mit Palmwedeln; in der Metzer *Apocalypse* tragen sie keine Stolen, aber durchweg Kopfbedeckungen. Die geänderten Einzelheiten wurden offenbar einer anderen Quelle entnommen, nämlich Dürers Holzschnitt mit der *Anbetung des Lammes* (Abb. 9), wo die Menge ohne Kopfbedeckungen und mit Stolen gezeigt wird und wo vor ihr auch eine Rückenfigur erscheint. Die Figur des Johannes links im Gespräch mit dem Ältesten variiert Dürers Johannes, was an seiner linken Hand vielleicht besonders deutlich wird. Selbst die ganze Komposition der Miniatur, vor allem die Staffelung der anbetenden Ältesten an den Seiten stammt aus Dürers Holzschnitt. Zugleich zeigt die Gegenüberstellung, wie schwer es dem Miniator fiel, Dürers Konzeption seinem Querformat anzupassen.

Die Benutzung von Dürers *Apocalypse* in der Werkstatt der Düsseldorfer Handschrift ist auch in anderen Miniaturen nachzuweisen, in denen die Abweichungen von der Metzer

[35]Freyhan, "Joachism and the English Apocalypse," 232–34.

Apocalypse auffällig sind. Als eine Kombination der Metzer Vorlage mit einem Holzschnitt Dürers erweist sich die Darstellung, in der ein *Engel Johannes die Himmelsstadt zeigt* (Apoc. 21: 9–19a; Abb. 10–11, vgl. Abb. 12). In der Metzer *Apocalypse* erhebt sich rechts ein Hügel, auf dem sich die Himmelsstadt befindet, vor dem Hügel eine Eule. Links ein weiterer Hügel, auf den Johannes steigt, von einem Engel geführt, der ihn stützt und ihm die Stadt zeigt.[36] In der Düsseldorfer *Apocalypse* ist von dieser Komposition nur der Hügel rechts mit der Eule übernommen, auf den der Miniator den Engel und Johannes stellte. Das himmlische Jerusalem erscheint links unten im Hintergrund. Johannes und der Engel rechts auf einem Hügel und die Stadt links im Hintergrund sind nun aber die bestimmenden Elemente der Darstellung ebenderselben Szene im letzten Holzschnitt von Dürers *Apocalypse*.[37] Obgleich sich der Miniator für die Szene insgesamt fast ganz an Dürer hielt, übernahm er die Eule aus seiner Hauptvorlage, ein Detail also, das für die Illustration des Textes ganz unwesentlich war.

Eine andere Miniatur der Düsseldorfer *Apocalypse* ist noch stärker von Dürer bestimmt: die Darstellung des *Starken Engels* (Apoc. 10: 1–10; Abb. 13–15). Aus Dürers Holzschnitt stammen die Diagonalkomposition, die beiden Säulenfüsse des Engels, sein kreisförmiger Regenbogennimbus, die Szene, in der Johannes das Buch tatsächlich isst, der Engel als Darstellung der himmlischen Stimme aus Apoc. 10: 8 und vor allem der Altar links oben. In Dürers stark komprimiertem Zyklus weist der Altar voraus auf den Tempel im Himmel mit seinem Altar, den Johannes messen soll (Apoc. 11: 1),[38] eine Szene, die sowohl in der Metzer wie in der Düsseldorfer *Apocalypse* in einer eigenen Miniatur dargestellt ist, die sich direkt an die hier behandelte anschliesst. Aus seiner Hauptvorlage kopierte der Düsseldorfer Miniator die Köpfe in dem Wolkenkranz links oben, die die Donnerstimmen Apoc. 10: 3f. repräsentieren. Bei der Wiedergabe des *Starken Engels* wagte er es nicht, Dürers kühne Vision zu kopieren, er gab dem Engel ein Gewand und hüllte ihn in einen Wolkenkranz. Über die Hauptvorlage und Dürer hinaus wurden Spruchbänder mit Inschriften zugefügt.

Auch in weiteren Miniaturen wurden Einzelheiten aus Dürers Zyklus benutzt, aber eben Details und nicht wie in den beiden eben genannten Darstellungen vollständige Kompositionen. Weshalb gerade für diese Szenen Dürer als Vorlage gewählt wurde, ist schwer zu sagen. Vielleicht ist ein Grund darin zu sehen, dass hier die Umsetzung einer hochformatigen Bildkomposition ins Querformat möglich war oder dass einem Holzschnitt eine querformatige Szene entnommen werden konnte. In beiden Fällen wird der Miniator Dürers Bildkonzeption als die schlagkräftigere Verbildlichung der Szene erschienen sein, obgleich er in der Darstellung des *Starken Engels* Dürers grössere Nähe zum Text nicht beibehielt.

Bei einem Vergleich Szene für Szene zwischen der Vorlage aus dem 13. und der Kopie aus dem 16. Jahrhundert lassen sich immer wieder dieselben Bestrebungen feststellen, die Visionen als räumlich möglich in einer Landschaft oder in den Wolken des Himmels spielen

[36]Zur Entstehung dieser Komposition Freyhan, *ibid.*, 231.
[37]A. Heimann, "Moses Shown the Promised Land," *Journal of the Warburg and Courtauld Institutes* (XXXIV, 1971), 323f.
[38]Die Wiedergabe des Altars macht auch deutlich, dass es Dürers *Apocalypse* gewesen sein muss, die in der Werkstatt der Düsseldorfer Handschrift zur Verfügung stand; denn die von Dürer abhängigen Apocalypsen-Zyklen führen die Darstellung des *Himmlischen Tempels und des Sehers mit dem Messstab* wieder ein und lassen infolgedessen den Altar in der Darstellung des

Starken Engels aus. Vgl. L.H. Heydenreich, "Der Apokalypsen-Zyklus im Athosgebiet und seine Beziehungen zur deutschen Bibel illustration der Reformation," *Zeitschrift für Kunstgeschichte* (VIII, 1939), Abb. 16–17, 33–34 und das von K. Arndt, "Dürer als Erzähler—Beobachtungen an einem Blatt der Apocalypse," *Anzeiger des Germanischen Nationalmuseums Nürnberg* (1971–72), 48–60, zusammengestellte Vergleichsmaterial, von dem nur die Kopie des Zoan Andrea (*ibid.*, Abb. 19) den Altar übernimmt.

zu lassen. Das Bemühen um eine naturnahe Darstellung wird überall deutlich. Dass dabei alle Figuren und Versatzstücke in den modernen Stil des 16. Jahrhunderts umgesetzt wurden, braucht beinahe nicht eigens gesagt zu werden. Gelegentlich werden neue Figuren hinzugefügt. Eine Darstellung der Metzer *Apocalypse* musste in ihrer abstrakten Zuordnung dem Kopisten besonders widerstreben: der *Strom des Lebenswassers vom Throne Gottes und des Lammes* (Apoc. 22 : 1–7 ; Abb. 16–17). In der Metzer *Apocalypse* strömt das Wasser aus der Mandorla mit Christus und dem Lamm auf dem Regenbogen rechts oben in die abgekürzte Darstellung der Himmelsstadt in der Mitte unten. Dahinter ein Hügel, an den hingestreckt oder ihn besteigend halb liegend Johannes zu sehen ist, zwischen zwei Bergzügen ausserdem drei Zuschauer. Der Kopist liess Johannes, den Hügel, die Zuschauer und die Himmelstadt ganz weg. Stattdessen stellte er eine Landschaft mit Obstbäumen dar, in deren Mitte ein Strom fliesst, der von Wasser aus dem Wolkenkranz in der Mitte oben gespeist wird. Dort sind der Herr und das Lamm auf dem Regenbogen zu sehen. Aus dem zeichenhaften Nebeneinander der vom Bibeltext genannten Erscheinungen ist also die Darstellung eines "Naturereignisses" gemacht worden. Ausserdem wurden rechts zwei spätquattrocenteske Engel hinzugefügt.

Die Modernisierung der Vorlage betrifft natürlich auch die Kostüme. Wo die Vorlage Gewänder des 13. Jahrhunderts dargestellt hatte, werden sie jetzt selbstverständlich durch solche des 16. Jahrhunderts ersetzt. Man könnte hierfür viele Miniaturen zitieren, so unter anderem die drei ersten Reiter. Als Beispiel für eine durchgehende Änderung einer ganzen Szene lässt sich die *Hochzeit des Lammes* (Apoc. 19 : 6–8 ; Abb. 18–19) heranziehen, wo vor einer Renaissancearchitektur eine fürstliche Tafel des 16. Jahrunderts gezeigt wird, an einer Stelle, an der in der Vorlage keine Hintergrundarchitektur und sehr viel weniger Figuren vorhanden waren. Zum anderen zeigt gerade diese Miniatur, zu wie grotesken Ergebnissen das Bemühen führen konnte, die Vorlage des 13. Jahrhunderts in einen naturnahen Stil zu übersetzen. Das Lamm wurde von einem Hügel links neben der Tafel auf eine Wolke versetzt, die in den Hochzeitssaal schwebt. Merkwürdigerweise umarmt die Braut in der Kopie nicht das Lamm, sondern neigt sich ihm nur mit zusammengelegten Händen anbetend entgegen. Damit ist übrigens eine Eigenheit genannt, die sich oft findet. Wo die Vorlage eine körperliche Berührung gezeigt hatte, wird dies in der Kopie vielfach vermieden—man möchte von einem fast komischen Bestreben nach möglichster Dezenz der Darstellung sprechen. In der Erscheinung der *Vögel, die an Leichen von Königen fressen* (Apoc. 19 : 17–18 ; Abb. 20–21), wurde die Figur in der rechten unteren Ecke an eine weniger auffällige Stelle und der Vogel an einen weniger anstössigen Körperteil versetzt.

Der Auftrag, eine sehr viel ältere Handschrift genau zu kopieren, führte also zu einer bemerkenswerten Umformung jeder einzelnen Szene, die soweit gehen kann, dass der Zusammenhang von Vorlage und Kopie nur noch mit Schwierigkeiten auszumachen ist. Neben der Metzer *Apocalypse* ist auch Dürers Holzschnittfolge als Vorlage benutzt worden.

VI

In den Apocalypsen des 14. Jahrhunderts wurde der englische Zyklus in einem moderneren Figurenstil relativ genau übernommen, die grundsätzliche Konzeption der einzelnen Szenen

wurde nicht geändert. Dagegen finden sich ähnliche Vorgänge der Umsetzung in eine verwandelte Vorstellung von Bildzusammenhang und Aktionsraum, wie sie bei der Benutzung der Metzer *Apocalypse* durch die Werkstatt der Düsseldorfer *Apocalypse* zu beobachten waren, bereits in verschiedenen illuminierten Apocalypsen des 15. Jahrhunderts. Wenn hier einige Bemerkungen über ihre Art der Umformung älterer Zyklen gemacht werden, so geschieht das nur anhand einiger Zyklen und ohne den Versuch unternehmen zu wollen, ihre Bilderserien auf bestimmte Vorlagen zurückzuführen.

Im frühen 15. Jahrhundert wurde in Paris für den Duc de Berry eine *Apocalypse* angefertigt, New York, Pierpont Morgan Library, M. 133; den Miniator nannte Millard Meiss nach eben dieser Handschrift den Meister der Berry Apocalypse.[39] Der Text ist eine französische Übersetzung der Apocalypse und von Teilen des Berengaudus-Kommentares. An die Stelle von querformatigen, die halbe Seite füllenden Miniaturen sind hochformatige, ein wenig über das Quadrat hinausgehende, zu einem grossen Teil auch hochformatige, die ganze Seite einnehmende Darstellungen geworden. Die Figur des Johannes ausserhalb des Rahmens wurde grundsätzlich ausgelassen, falls sie in der benutzten Vorlage überhaupt vorhanden war. Gegenüber dem englischen Zyklus wurde die Zahl der Figuren in einer Szene stark reduziert, es gibt sogar Miniaturen, die gar keine Figuren enthalten. Der ganze Zyklus der Berry-*Apocalypse* zeichnet sich durch die Vereinfachung der Kompositionen aus, was gelegentlich auch auf Kosten der Genauigkeit der Darstellung einer Szene geht. Überall werden die Szenen in eine Landschaft oder wenigstens in angedeutete Räume gestellt, Gebäude werden perspektivisch gezeigt. Die himmlischen Erscheinungen des Herrn werden oft im oberen Teil der Miniaturen über Wolken als sich tatsächlich im Himmel ereignend dargestellt, die Grenzen verfliessen aber auch, oder das himmlische Geschehen findet auf einer Wiese statt. Es gibt offenbar keine bestimmte Methode, Visionen wiederzugeben—wenn auch in einem Falle das Ergebnis, eine himmlische Erscheinung in Wolken über einer menschenleeren Landschaft (Apoc. 5 : 7–14; fol. 9v), auf Dürer vorauszudeuten scheint. Die visionäre Kraft dieses Zyklus beruht zum einen auf der entschlossenen Umformung einer älteren Vorlage, zum anderen auf den Stileigenheiten des Meisters, insbesondere der von ihm benutzten Farbskala mit vielen fahlen Tönen. Meiss hat herausgearbeitet, wie sehr sein Stil eine der Voraussetzungen des Meisters der *Grandes Heures de Rohan* ist.[40]

Für die Herzöge von Savoien wurde 1428–1434 von Jean Bapteur und Péronet Lamy eine prachtvoll ausgestattete und vollständig illustrierte *Apocalypse* begonnen, die aber erst 1490 von Jean Colombe vollendet wurde (Escorial, Cod. E. Vitr. v).[41] Im Gegensatz zu der Beschränkung auf wenige Personen und Versatzstücke, durch die die Berry-*Apocalypse* die

[39]Delisle–Meyer, James Nr. 7. C. Nordenfalk, *Kung Praktiks och Drottning Teoris Jaktbok* (Stockholm, 1955), 61, 94; M. Meiss, "The Exhibition of French Manuscripts of the XIII–XVI Centuries at the Bibliothèque Nationale," *Art Bulletin* (XXXVIII, 1956), 196; ders., *French Painting in the Time of Jean de Berry. The Late Fourteenth Century and the Patronage of the Duke* (London, 1967), 277, 300, 311, 354; ders., *French Painting in the Time of Jean de Berry—The Limbourgs and Their Comtemporaries* (New York, 1974), 296–303, mit der Begründung einer Datierung kurz vor 1416. Ausserdem wird die eng verwandte, um 1415 entstandene *Apocalypse* Chantilly, Musée Condé, MS 28 (1378) (Delisle–Meyer, James Nr. 14) behandelt.

[40]*The Rohan Master—A Book of Hours* (New York, 1973), 9, 16; jetzt *The Limbourgs*, 256–77, mit einer sehr differenzierenden analyse von Voraussetzungen und Werk des Rohan-Meisters.

[41]Delisle–Meyer, James Nr. 43. Vollständig veröffentlicht durch C. Gardet, *De la peinture du moyen âge en Savoie*, 3 : *L'Apocalypse figurée des ducs de Savoie* (Annecy, 1969), mit Literaturangaben. S. Edmunds, "The Missals of Felix V and Early Savoyard Illumination," *Art Bulletin* (XLVI, 1964), 132ff.; dies., "The Medieval Library of Savoy (III)," *Scriptorium* (XXVI, 1972), 281. Ich möchte der Autorin für den freundlichen Hinweis auf ihre Untersuchungen über die savoyische Bibliothek sehr danken.

Visionen anschaulich zu machen versuchte, werden in der Escorial-*Apocalypse* fast immer weite Landschaften, von oben gesehen, dargestellt. Ging es nur um himmlische Anbetungs- szenen, wurde um die frontal wiedergegebene Gestalt des Herrn eine in die Tiefe verkürzte kreisförmige, hinten offene Bank mit den 24 Ältesten geordnet. Beschränkte sich die Darstellung auf wenige Figuren, sind diese auf einem perspektivisch verkürzten Fussboden mit Fliesenmuster dargestellt oder erscheinen riesenhaft in einer Landschaft. Johannes, in der Vorlage sicher ausserhalb des Rahmens, mit dem Geschehen aber durch das *ostium- apertum*-Motiv verbunden, ist hier stets ausserhalb des Rahmens zu sehen, seine Reaktionen werden vorgeführt. Durch die Häufung von Figuren, den Bildtyp der "Überschaulandschaft" und die überaus prächtigen Kostüme, auch durch die vielfältige Farbigkeit machen die Miniaturen den Eindruck des Märchenhaften und Kostbaren. Trotz einer realistischeren Ausgestaltung der Einzelheiten wird dies in dem später ausgeführten Teil beibehalten. Doch treten an Stelle der von oben gesehenen Landschaften solche, die stärker als von vorne gesehen wirken.[42]

Jene Schwierigkeiten bei der Übertragung des englischen Apocalypsen-Zyklus in den realistischen Stil der altniederländischen Malerei, die in den jüngeren Teilen der Escorial- *Apocalypse* durch das Festhalten an der Kompositionsweise der älteren Teile umgangen worden waren, führten die Miniatoren von zwei um 1470 entstandenen Apocalypsen- Handschriften zu sehr verschiedenen Lösungen. Die Unterschiede sind umso auffälliger, da beide Handschriften fast gleichzeitig für Karl den Kühnen und seine Gemahlin Margarete von York angefertigt wurden. In Gent entstand um 1475, geschrieben von der Werkstatt David Auberts, die *Apocalypse* für Margarete von York, New York, Pierpont Morgan Library, M. 484.[43] Die Handschrift enthält die Apocalypse in französischer Sprache und den von Delisle und Meyer edierten altfranzösischen Apocalypsen-Kommentar, den James die "non-Berengaudus-gloss" nannte. In den Miniaturen wurde der Versuch unternommen, die Visionen möglichst "naturgetreu" darzustellen. Was sich auf der Erde abspielt, wird in sich in die Tiefe dehnende Landschaften versetzt, deren am Horizont liegende Teile durch blaue Farbe als weit entfernt bezeichnet sind. Müssen eine himmlische Erscheinung und Erden- bewohner aufeinander bezogen werden, thront beispielsweise der Herr ganz klein in einer grossen Lichtgloriole, so dass irdischer und himmlischer Bereich deutlich voneinander geschieden werden. Die Figur des Sehers wurde oft ausgelassen. Ist der irdische Bereich ohne Bedeutung für die Szene, wird sie in grosse, farbig abgestufte Wolkenkreise versetzt. Eine Annäherung an das "Natürliche" ist auch für die Schreckensvisionen angestrebt, die allerdings gelegentlich geradezu ruhig wirken.

[42]Von besonderem Interesse ist das Bildschema der Dar- stellung des *Stromes des Lebenswassers in der Himmelsstadt* als eines Stromes in einer von der Mitte gesehenen, sich geradeaus in die Tiefe erstreckenden Baumallee (fol. 46; Gardet, *De la peinture du moyen âge en Savoie*, Pl. 46). Gegenüber älteren Darstellungen einer himmlischen Baumallee (vgl. die neapolitanische Tafel aus der Sammlung des Grafen Erbach- Fürstenau, Stuttgart, Staatsgalerie; A. Schmitt, "Die Apoka- lypse des Robert von Anjou," *Pantheon*, XXVIII, 1970, 475–503, Farbtafel, Nr. 44) ist die Bildformel als eine Art von per- spektivischem Lehrstück neu. Die spätere Uberlieferung wäre einmal zusammenzustellen, sie reicht von Serlios *Scena satirica* (E.H. Gombrich, "The Renaissance Theory of Art and the

Rise of Landscape," in *Norm and Form* [London, 1966], 119 u. Abb. 154) bis zu Hobbemas *Allee von Middelharnis* (M. Imdahl, "Ein Beitrag zu Meindert Hobbemas Allee von Middelharnis," *Festschrift Kurt Badt zum 70. Geburtstage*, Berlin, 1961, 173–83; W. Stechow, *Dutch Landscape Painting of the 17th Century*, London, 1966, 32). Auch bei Poussin kommt das Schema vor, wenn auch in veränderter Form (A. Blunt, *Nicolas Poussin*, London, 1967, Pl. 184).

[43]Delisle–Meyer, James Nr. 49.—O. Pächt, *The Master of Mary of Burgundy* (London, 1948), 62–63. L.M.J. Delaissé im Ausstellungskatalog "La Miniature flamande—Le mécénat de Philippe le Bon," Brüssel, 1959, Nr. 199.

Um 1470 wurde in Brügge für Karl den Kühnen ein *Lektionar* mit einer *Apocalypse* angefertigt, New York, Pierpont Morgan Library, M. 68; der Stil der Miniaturen ist mit dem Loyset Liédets verwandt.[44] Wie die Brügger *Apocalypse* für die Gemahlin Karls enthält die Handschrift den Text der Offenbarung und die "non-Berengaudus-gloss" in französischer Sprache. Gerade wenn man die Übereinstimmung des Textes bedenkt, ist der Unterschied zwischen beiden Serien von Illustrationen umso auffälliger, zumal er nicht nur das stilistische Detail, sondern auch die Auffassung der Szenen überhaupt betrifft. Zunächst bemerkt man gegenüber der *Apocalypse* für Margarete von York, deren Miniaturen teilweise zur Grisaille tendieren, die viel grössere Farbigkeit, ja Buntheit der Genter *Apocalypse*. Der Autor, der in den Szenen der Brügger Handschrift beinahe durchweg fehlte, ist hier in jeder Miniatur dargestellt. Die Vergegenwärtigung der Visionen hat etwas fast Naives, wie die himmlischen Erscheinungen in eine irdische Landschaft gesetzt sind oder sich ohne rechte Beziehung zum irdischen Geschehen im Himmel befinden. Jene Trennung von irdischen und himmlischen Szenen durch eine ganz unterschiedliche Darstellung beider ist in der *Apocalypse* für Karl den Kühnen offenbar nicht angestrebt worden.

Vergleicht man die verschiedenen Umformungen des englischen Apocalypsen-Zyklus in der Kunst des 15. Jahrhunderts mit der Düsseldorfer *Apocalypse*, dann zeigt sich, dass die Übersetzung in einen modernen Stil bereits im späten 15. Jahrhundert zu sehr ähnlichen Ergebnissen geführt hatte. Zwischen der *Apocalypse* für Karl den Kühnen und der Düsseldorfer Kopie der Metzer *Apocalypse* besteht eigentlich nur der Unterschied des Zeitstiles, aber keine grundsätzliche Differenz in der Auffassung der Szenen. Auch die Berry-*Apocalypse*, die Escorial-*Apocalypse* und die *Apocalypse* für Margarete von York hatten verschiedene Möglichkeiten erprobt, die überlieferte Ikonographie in einer veränderten Darstellungsweise lebendig zu machen. Aber erst die *Apocalypse* für Karl den Kühnen und die Düsseldorfer Handschrift machen den Gegensatz zwischen der ikonographischen Konzeption des englischen Apocalypsen-Zyklus und der neuen Auffassung von Bild und Raum ganz klar. Sie zeigen, dass in verschiedenen Formen dieses modernen Stiles eine Weiterbenutzung des hochmittelalterlichen Zyklus kaum mehr möglich war—es bedurfte einer gewissen Naivität, um seine Übersetzung in den Stil der Zeit zu versuchen. Eine Bewältigung des Stoffes, die die neuen Stilmöglichkeiten zur Ausdruckssteigerung ausnutzte, gelang Dürer in seinem Zyklus von 1498.[45] Über ihn sagte Émile Mâle: "Il semblait que les dessins de Dürer fussent revêtus du même caractère d'éternité que la parole de saint Jean; il n'y avait plus, pensait-on, qu'à les imiter."[46] Es sollte nur knapp zehn Jahre dauern, bis Dürers *Apocalypse* in Frankreich einen Nachfolgezyklus fand. Und Mâle konnte zeigen, dass alle ihm bekannten französischen Apocalypsen Dürers Holzschnittfolge zum Vorbild wählten.[47] Von dieser im Banne Dürers

[44]Nicht bei Delisle–Meyer und James. Katalog "Flanders in the 15th Century—Art and Civilization," Detroit, 1960, Nr. 207.

[45]Zur ikonographischen Ableitung immer noch Neuss, "Die ikonographischen Wurzeln von Dürers Apokalypse." Zur Würdigung vor allem E. Panofsky, *Albrecht Dürer*, 3. Aufl. (Princeton, N.J., 1948) I, 51–59. Eine ausreichende ikonographische Untersuchung fehlt, da die Bücher von F. Juraschek, *Das Rätsel in Dürers Gottesschau—Die Holzschnittfolge der Apokalypse und Nikolaus von Cues* (Salzburg, 1955), und R.

Chadraba, *Dürers Apokalypse—Eine ikonologische Deutung* (Prag, 1964), anderen Problemen galten. Vgl. K. Arndt, *Dürers Apokalypse* (Diss. phil. Göttingen, 1956), und Ausstellungskatalog "Albrecht Dürer 1471–1971," Nürnberg 1971, Nr. 596.

[46]*L'art religieux de la fin du moyen âge en France*. 2. Aufl. (Paris, 1922), 443.

[47]*Ibid.*, 449–56. Vgl. auch L. Réau, "L'influence de Albert Dürer sur l'art français," *Bulletin de la Société Nationale des Antiquaires de France* (1924), 219–22.

stehenden Ikonographie hebt sich die Düsseldorfer Apocalypse ab, die nur in einigen Szenen und in einer Reihe von Einzelheiten die Kenntnis Dürers verrät, sonst aber völlig von einer englischen Handschrift des mittleren 13. Jahrhunderts abhängig ist. Nur durch einen bestimmten Auftrag ist ein solcher Kopiervorgang zu erklären, und, nach dem Erscheinen von Dürers *Apocalypse* entstanden, muss dieser Ausläufer des hochmittelalterlichen englischen Zyklus verspätet genannt werden.

UNIVERSITÄT BONN

ANHANG

ÜBERSICHT ÜBER DEN INHALT DER APOCALYPSEN-HANDSCHRIFTEN EHEM. METZ, BIBLIOTHÈQUE MUNICIPALE, SALIS 38 UND DÜSSELDORF, KUNSTAKADEMIE, A. B. 143

APOCALYPSE	BERENGAUDUS*		METZ fol.	DÜSSELDORF pag.
Prolog** 1: 1–12a	——	*Johannes auf Patmos*	I	I
1: 12b–20; 2: 1a. 8a. 12a. 18; 3: 1a. 7a. 14a. 22.	843, ad v. 1 Z. 2; 845, ad v. 4, Z. 3–5; 847, ad v. 5, Z. 1–4, ad v. 6, Z. 1–10	*Erscheinung des Menschensohnes inmitten der sieben Leuchter, die sieben Kirchen.*	IV	2
4: 1–9	874, ad v. 1, Z. 1–13	*Grosse Himmelsvision: Der Herr und die 24 Ältesten.*	——	3
5: 1–5	888, ad v. 1–889, ad v. 2	*Der Engel: Wer ist würdig, das Buch aufzutun? Einer der Ältesten tröstet Johannes.*	——	4
7: 9–17	929, ad v. 15, Z. 10–14	*Anbetung des Herrn und des Lammes durch die grosse Menge, einer der Ältesten spricht mit Johannes.*	2	5
8: 2–4	930, ad v. 1, Z. 17— 931, ad v. 3, Z. 8	*Verteilung der sieben Posaunen an die Engel, der Engel mit dem Rauchfass am Altar.*	2v	6

*(Migne, *Patrologia Latina*, XVII)
**(Stegmüller, *Repertorium Biblicum Medii Aevi* Nr. 829)

R

APOCALYPSE	BERENGAUDUS		METZ fol.	DÜSSELDORF pag.
4: 10–11	887, ad v. 10, Z. 18—888, ad v. 11, Z. 2	*Anbetung des Herrn durch die 24 Ältesten.*	3	7
5: 6	890, ad v. 6	*Das Lamm auf dem Altar inmitten der vier Wesen und der 24 Ältesten.*	3v	8
5: 7–14	890, ad v. 7	*Öffnung des versiegelten Buches durch das Lamm, Anbetung.*	4	9
6: 1–2	893, ad v. 1—894, Z. 23	*Der erste Reiter mit dem Bogen auf dem weissen Pferd, der Engel spricht zu Johannes.*	4v	10
6: 3–4	904, ad v. 3–4, Z. 21–52	*Der zweite Reiter mit dem Schwert auf dem roten Pferd, der Löwe spricht zu Johannes.*	5	11
6: 5–6	913, ad v. 5–ad v. 6, Z. 13	*Der dritte Reiter mit der Waage auf dem schwarzen Pferd, der Stier spricht zu Johannes.*	5v	12
6: 7–8	915, ad v. 7, Z. 1–13 ; 920, ad v. 8, Z. 43—921, Z. 14	*Der vierte Reiter, der Tod, auf dem fahlen Pferd, hinter ihm die Hölle, der Adler spricht zu Johannes.*	6	13
6: 9–11	921, ad v. 9, Z. 17 —922, ad v. 10–11, Z. 6	*Bekleidung der Seelen unter dem Altar.*	6v	14
15: 5–8	985, ad v. 5, Z. 1–18	*Der offene Tempel im Himmel, der Löwe verteilt die Zornesschalen an die sieben Engel.*	7	15
16: 1–2	988, ad v. 1–v. 2, Z. 17	*Der Engel aus dem Tempel befiehlt Aus-giessen der Zornesschalen, die erste Zornes-schale wird ausgegossen.*	7v	16
16: 3–7	989, ad v. 3–Z. 19	*Die zweite und dritte Zornesschale werden ausgegossen, der Wasserengel (als vierter Engel) mit einer Zornesschale, der Altar im Himmel.*	8	17
16: 8–9	990, ad v. 8–9—991, Z. 7	*Die vierte Zornesschale wird in die Sonne ausgegossen.*	8v	18

APOCALYPSE	BERENGAUDUS		METZ fol.	DÜSSELDORF pag.
16 : 10–12	991, ad v. 10–11, –Z. 23	*Die fünfte und sechste Zornesschale werden ausgegossen.*	9	19
16 : 13–16	992, ad v. 13–14— 993, Z. 13	*Die unreinen Geister (Frösche) aus den Mündern des Drachen, des Tieres und des falschen Propheten.*	9v	20
16 : 17–21	994, ad v.17– Z. 16	*Die siebente Zornesschale wird ausgegossen, die Stimme aus dem Tempel.*	10	21
17 : 1–2. 15–18	995, ad v. 1—996, Z. 3	*Der Engel zeigt Johannes die grosse Buhlerin an den Wassern sitzen.*	10v	22
17 : 3–11	——	*Der Engel trägt Johannes und zeigt ihm die grosse Buhlerin auf dem siebenköpfigen Tier.*	11	23
18 : 1–10	——	*Der Engel verkündet den Untergang Babylons.*	11v	24
19 : 6–8	1008, ad v. 1–8, Z. 34–1009, Z. 15	*Ein Posaunenengel, die Hochzeit des Lammes.*	12	25
19 : 9–10	1010, ad v. 9—ad v. 10	*Johannes schreibt, ein Engel redet zu ihm, Johannes fällt vor dem Engel nieder.*	12v	26
8 : 5 (6–7 auf Spruchband)	932, ad v. 5—933, Z. 1	*Der Räucherengel giesst das Rauchfass aus, der erste Engel bläst die Posaune.*	13	27
8 : 8–12	934–935, ad v. 8	*Der zweite, dritte und vierte Engel blasen ihre Posaunen.*	13v	28
8 : 13 ; 9, 1	937, ad v. 13–Z. 15 ; 938, ad v. 1, Z. 1–4; 935, Z. 2–10	*Der Weheadler, der fünfte Engel bläst die Posaune.*	14	29
9 : 1b–12	——	*Die Heuschreckendämonen aus dem Brunnen des Abgrundes.*	14v	30
9 : 13–16	943, ad v. 12–13— ad v. 14, Z. 8	*Der sechste Engel bläst die Posaune, Altar im Himmel, die vier Euphratengel.*	15	31
9 : 16b–21	944, ad v. 17–945, Z. 7	*Die Reiter auf den Pferden mit den Löwenköpfen.*	15v	32

APOCALYPSE	BERENGAUDUS		METZ fol.	DÜSSELDORF pag.
10: 1–10	——	Der starke Engel mit den Füssen auf Erde und Meer gibt Johannes das Buch, die Stimme vom Himmel als Engel.	16	33
10: 11—11, 3	950, ad v. 11—ad v. 1, Z. 8	Ein Engel gibt Johannes den Messstab, der Tempel des Herrn.	16v	34
11: 3–6	951, ad v. 3–4—952, Z. 3	Die beiden Zeugen töten ihre Feinde durch Feuer aus ihrem Mund, die beiden Zeugen an einem Fluss, Zuschauer.	17	35
11: 7–8	953, ad v. 7–8, 954, Z. 7	Ungeheuer töten die beiden Zeugen.	17v	36
11: 9–14	954, ad v. 9–12—Z. 20	Wiederbelebung der beiden Zeugen durch den Lebensgeist, zwei Tauben, Himmelfahrt der beiden Zeugen, Erdbeben zerstört zehnten Teil der Stadt.	——	37
11: 15–18	956, ad v. 15, Z. 1–10. 22–23	Der siebente Engel bläst die Posaune, Anbetung des Herrn durch die 24 Ältesten.	——	38
12: 13–14	964, ad v. 13—ad v. 14, Z. 16	Der auf die Erde gestürzte Drache verfolgt das Weib, das Flügel erhält.	18	39
12: 15–16	964, ad v. 15–16, —965, Z. 9	Der Strom aus dem Munde des Drachen wird von der Erde verschlungen, das Weib fliegt.	18v	40
12: 17–18	965, ad v. 17. 18	Der Drache kämpft mit den Angehörigen des Weibes.	19	——
13: 1–3a	965, ad v. 1—Z. 21	Das Tier aus dem Meer, der Drache übergibt ihm seine Macht, ein Kopf des Tieres wie tot.	19v	——
13: 3b–7a	967, ad v. 3, Z. 28 —968, ad v. 5, Z. 9	Anbetung des Drachens und des Tieres.	20	41
13: 4b–6	968, ad v. 6	Anbetung des Tieres aus dem Meer, Drache im Hintergrund.	20v	42
13: 7–10	968, ad v. 7—ad v. 8, Z. 14	Das Tier aus dem Meer tötet einen Menschen und wird angebetet.	21	43

APOCALYPSE	BERENGAUDUS		METZ fol.	DÜSSELDORF pag.
13 : 11–14a	969, ad v. 11—970, Z. 16	*Das Tier mit den Lammshörnern aus der Erde lässt die Menge das Tier aus dem Meer anbeten und Feuer vom Himmel fallen.*	21v	44
13 : 14b–15	970, ad v. 14—971, ad v. 15, Z. 12	*Das Tier mit den Lammshörnern lässt ein Bild des Tieres aus dem Meere machen; alle, die es nicht anbeten, werden getötet.*	22	45
13 : 16–18	971, ad v. 16— Z. 20	*Das Tier mit den Lammshörnern, Reiche und Arme.*	22v	46
14 : 1–4	972, ad v. 1— Z. 12	*Das Lamm auf dem Berge wird von der grossen Menge angebetet.*	23	47
14 : 2–5	972, ad v. 2—973, Z. 6	*Neues Lied: Der von den vier Wesen umgebene Thron, die 24 Ältesten.*	23v	48
14 : 6–8a	977, ad v. 6—978, Z. 10, u. Anfang von v. 7	*Der Engel mit dem Evangelium aeternum, die auf der Erde Sitzenden.*	24	49
14 : 8	978, ad v. 8, Z. 7-23	*Ein Engel verkündet den Untergang Babylons.*	24v	50
14 : 9–12	978, ad v. 9–10— 979, Z. 13	*Der dritte Engel und der Zorneskelch Gottes.*	25	51
14 : 13	979, ad v. 12–13, Z. 4—980, Z. 11	*Selig sind die Toten, die in dem Herren sterben.*	25v	52
14 : 14–16	980, ad v. 14–19, Z. 18—981, Z. 2	*Der Menschensohn mit der Sichel, der Engel aus dem Tempel, die Kornernte.*	26	53
14 : 17–18	981, ad v. 14–19, Z. 2–21	*Ein zweiter Engel aus dem Tempel, der Feuerengel am Altar, Aufforderung zur Weinernte.*	26v	54
19 : 11–16	1010, ad v. 11— Z. 13	*Der Reiter Treu und Wahrhaftig mit seinem Reiterheer, der Keltertreter.*	27	55
19 : 17–18	1013, ad v. 17—ad v. 18, Z. 9	*Der Sonnenengel, Vögel fressen die Leichen von Königen.*	27v	56

APOCALYPSE	BERENGAUDUS		METZ fol.	DÜSSELDORF pag.
19: 19–20b	1013, ad v. 19— 1014, Z. 12	Der Reiter besiegt das Tier und die Könige.	27 bis	——
19: 20–21	1014, ad v. 20–21— Z. 30	Der Reiter; das Tier und der falsche Prophet werden in den Feuerpfuhl gestossen.	27 bis v	——
20: 1–3	1014, ad v. 1— 1015, Z. 18	Der Engel fesselt den Drachen und wirft ihn in den Abgrund, den er verschliesst.	28	57
20: 4–6	1015, ad v. 4 —1016, Z. 16	Die Auferstehung der Gerechten, die auf Thronen herrschen.	28v	58
20: 7–9a	1018, ad v. 7–Z. 23	Satan führt ein Heer (Gog und Magog) gegen die heilige Stadt, Feuer vom Himmel verzehrt sie.	29	59
20: 9b–10	1020, ad v. 9–Z. 6 —ad v. 10	Satan, Tier und falscher Prophet im Höllenrachen.	29v	60
20: 11–21, 1	1020, ad v. 11— Z. 14	Der Weltenrichter, Öffnung der Bücher, Auferstehung der Toten.	30	61
21: 2–8	1023, ad v. 2— Z. 11	Herabsteigen des neuen Jerusalem, der Herr bzw. ein Engel spricht zu Johannes.	30v	62
1: 9–19a	——	Der Engel zeigt Johannes die Himmelsstadt.	31	63
22: 1–7	1050, Z. 14–25	Der Strom des Lebenswassers vom Throne Gottes und des Lammes.	31v	64
22: 8–9	1052, ad v. 8–9— Z. 29	Johannes kniet vor dem Engel.	32	65
22: 10–21	——	Johannes kniet anbetend vor dem Herrn, der in Wolken erscheint.	32v	66

Qui è la veduta:
Über einige Landschaftszeichnungen Leonardo da Vincis im Madrider Skizzenbuch (Cod. 8936)

LUDWIG H. HEYDENREICH

Es ist seit jeher ein zentrales Thema der Leonardoforschung gewesen, zu ergründen, wie dieser universale Geist der Natur gegenübertrat und welche Gedanken und Empfindungen ihn angesichts der Landschaft bewegten, die er wieder und wieder in mannigfachen Variationen dargestellt hat. Dabei ist oft auch die Frage aufgeworfen worden, wie weit seine Landschaftsmotive in freier Erfindung gestaltet oder aber als wirklichkeitsgetreue Abbilder nach der Natur aufzufassen sind.[1]

Die berühmte Zeichnung von 1473—Leonardos früheste Landschaftsskizze und zugleich wohl die erste reine Landschaftszeichnung der italienischen Kunst—ist meist und mit Recht als *invenzione libera* gedeutet worden (Abb. 1); wohl mag Leonardo ein Stück geschauter Natur in seinem Heimatgebiet um Vinci in der Erinnerung vorgeschwebt haben, doch wurde es zu einer freien Bildszene umgestaltet.[2]

Auch die Darstellung einer Felsengrotte (Windsor 12395)—wohl um 1483 entstanden[3]—ist ein Produkt künstlerischer Phantasie, wenngleich sicher ebenfalls angeregt durch eine gesehene Höhlenformation der Alpen (Abb. 2). Und selbst die allbekannte herrliche "Regenlandschaft" (Windsor 12409, u.E. doch eher um 1499 zu datieren), muss wohl als eine Kombination von Erlebtem und Freigestaltetem verstanden werden (Abb. 3).[4]

Erst recht gilt dies für die Landschaftsdarstellungen in Leonardos Gemälden: angefangen mit dem berühmten Landschaftsausschnitt in Verrocchios *Taufe Christi* über die Bildhintergründe der—im Grad ihrer Eigenhändigkeit noch immer umstrittenen—*Verkündigungen* in den Uffizien und im Louvre bis zu den wunderbaren Naturstücken der *Mona Lisa* und der *Heiligen Anna Selbdritt*.

In allen Landschaftsdarstellungen Leonardos von der Frühzeit an begegnen wir einer ungemein eindringlichen Beobachtung der Natur, sowohl im Hinblick auf ihre vegetative und geologische Struktur wie auch im Hinblick auf ihre atmosphärischen Phänomene. Im Feuchtigkeitsgehalt der Luft entdeckt Leonardo die verschleiernde Substanz (das "trübe

[1]Am eindringlichsten hat u.E. G. Castelfranco das Thema—gleichsam subsumierend—in zwei hervorragenden Arbeiten behandelt: "Il paesaggio di Leonardo" (Vortrag, Brescia, 1953) und "Sul pensiero geologico e il paesaggio di Leonardo," in *Leonardo, saggi e ricerche* (Rom, 1954); beide Aufsätze wiedergedruckt in idem, *Studi Vinciani* (Roma, 1966), 125ss und 143ss). An älteren Äusserungen zum Thema sind hervorzuheben: A.E. Popp, *Leonardo da Vinci. Zeichnungen* (München, 1928), *passim*; A.E. Popham, *The Drawings of Leonardo da Vinci* (London, 1946), 66 und *passim*; K. Clark, *The Drawings of Leonardo da Vinci at Windsor Castle*, 2. Aufl. (with the assistance of Carlo Pedretti), I–III (London, 1936–1969),

passim; L. Goldscheider, *Leonardo da Vinci, Landscapes and Planes* (London, 1952).

[2]Popham, *Drawings*, 160; Castelfranco, *Studi Vinciani*, 133.

[3]Clark, *The Drawings . . . at Windsor Castle*, Katalog Nr. 12395.

[4]Castelfranco geht hier ziemlich weit: "sul disegno 12409 vedo una trasformazione della Conca di Lecco vista dalle alture di Sud-Est; è chiara la città di media grandezza sul fondo che tra monti cosi alpestre Leonardo può avere visto solo lì; somiglianze nella forma e nella disposizione dei monti sono remarchevoli, seppur naturalmente non fotografiche" (*Studi Vinciani*, 152 mit Abbildung der Conca di Lecco fig. 64).

Mittel" der Farbenlehre Goethes), die zwischen dem Auge des Beschauers und dem gesehenen Naturobjekt liegt, so dass wir niemals dessen wirkliche Form, sondern nur deren Scheinbild (*simulacro*) wahrnehmen. So baut er die Lehre seiner Farb- und Luftperspektive auf und erläutert sie an zahlreichen Beispielen in seinem *Malereitraktat*, der damit in einigen seiner Abschnitte mit Recht von Popham als der erste Traktat über Landschaftsmalerei bezeichnet worden ist.[5] Schon im *Paragone*, der in wesentlichen Abschnitten noch in den Mailänder Jahren vor 1500 abgefasst wurde, findet sich im Rangstreit zwischen Malerei und Poesie der wundervolle Passus, der uns—wenngleich von literarischen Topoi durchsetzt—Leonardos künstlerisches Erleben der Natur lebendig vor Augen rückt: "was bewegt Dich, o Mensch, deine eigene Stadtwohnung zu meiden, Verwandte und Freunde zurückzulassen und durch Berg und Tal ländlichen Plätzen zuzuwandern, wenn nicht die Naturschönheit der Welt, die Du, wenn Du es recht überlegst, nur mit dem Gesichtssinn [*senso del vedere*] geniessest."[6]

Wie weit Leonardos phantasiereiche Vorstellungskraft rein imaginäre Naturphänomene erfindet und zu kühnen Bildvisionen gestaltet, bezeugt seine romantisch gestimmte Beschreibung des Taurusgebirges (Codex Atlanticus 145v und 214v [d]), die im allgemeinen in die letzten Jahre seines ersten Mailänder Aufenthalts datiert wird.[7] Gegen Ende seines Lebens entstehen schliesslich, aus der Altersweisheit des allerfahrenen Naturforschers heraus Leonardos "Visionen" vom Untergang der Welt, die den Charakter einer prophetischen Kosmogonie besitzen (Abb. 4)[8]

Zwischen diesen zwei Phasen liegt die *Selbstausbildung* des Künstlerforschers, der die ihm verliehene hohe Gabe des *Saper vedere* nutzt, um die Phänomene der Natur, wie sie sich seinem Auge darbieten unter den verschiedensten Aspekten zu ergründen. Hier nun gewinnt die Landschaft als Umwelt des Menschen für Leonardo ein zweifaches Interesse: als geologische Formation (bewachsen oder unbewachsen) und als geographische Situation.

Über Leonardos Geologie und Kosmologie besitzen wir umfassende, eingehende und bedeutende Untersuchungen, die wohl am weisesten von Giorgio Castelfranco zusammengefasst sind.[9] Uns sollen hier allein Leonardos geographische Studien beschäftigen, weil sich gerade diese durch das neue, in den wiedergefundenen Madrider Codices bekannt gewordene Material uns in ungleich weiterem Umfang erschliessen.[10]

Zu den verschiedenen Beweggründen, die Leonardo veranlassten, sich mit dem geographischen Bilde der Landschaft zu befassen, trat bald nach 1500 ein gänzlich neuer hinzu: die Aufgabe, sich für mehrere spezifische Zwecke als Kartograph zu betätigen und zu bewähren. Wenn wir auch annehmen dürfen, dass Leonardo schon für Ludovico Sforza

[5]Popham, *Drawings*, 159. Wichtig und aufschlussreich ist in diesem Zusammenhang, auf die Chronologie der verschiedenen Textteile des *Traktats* zu achten: Leonardos Naturbild entfaltet und formt sich sein ganzes Leben hindurch.

[6]*Das Buch von der Malerei*, ed. H. Ludwig. Quellenschriften zur Kunstgeschichte, XVIII (Wien, 1882), I, 44–45 (Nr. 23).

[7]G. Castelfranco, *Studi Vinciani*, 137. C. Pedretti hat sie neuerdings später—1505—angesetzt: *Leonardo da Vinci* (Berkeley–Los Angeles, 1973) 103.

[8]Vgl. Clark, *The Drawings . . . at Windsor Castle*, Katalog Nr. 12377–12387 und 12665 mit ausführlicher Bibliographie.

[9]S.o.Anm.1. Ältere Literatur: M. Baratta *Leonardo da Vinci*

e i problemi della terra (Turin, 1903); L. Di Lorenzo, *Leonardo da Vinci e la geologia* (Bologna, 1920); A. Gianotti, *Geografia e geologia negli scritti di Leonardo da Vinci* (Mailand, 1953).

[10]Zu den geographischen Studien vgl. ausser den in der vorigen Anmerkung zitierten Werken besonders: M. Baratta, *I disegni geografici conservati nel Castello di Windsor*. I Manoscritti e i Disegni di Leonardo da Vinci pubblicati dalla Reale Commissione Vinciana. Fascicolo unico (Rom, 1941). Siehe auch die erschöpfenden Kommentare zu den einzelnen Blättern im Windsorkatalog (Clark, *The Drawings . . . at Windsor Castle*) unter der jeweiligen Nummer.

kartographische Arbeiten ausgeführt hat, so ist jedoch—abgesehen von einem flüchtigen Stadtplan von Mailand (Codex Atlanticus 73v [b])[11]—der Grad seiner Fertigkeit im Vermessen und Zeichnen geographischer Pläne und Karten in dieser Mailänder Zeit noch nicht genauer fixierbar. Auch seine Karte des Isonzogebietes, die er fraglos—im Frühjahr 1500—im Auftrag der Republik Venedig angefertigt hat und in welcher sein Projekt entwickelt war, das Land im Falle eines Einfalls der Türken von der Landseite her unter Wasser zu setzen, ist nicht erhalten.[12]

Greifbar wird uns Leonardo als Kartograph erst aus den Plänen und Landkarten, die er im Operationsgebiet des Cesare Borgia zeichnete, als er 1502–1503 für etwa ein Dreivierteljahr in dessen Diensten als oberster Architekt und Generalingenieur stand. Aus dieser Zeit stammen die meisterhaften Karten des toskanisch-mittelitalienischen Raums (Windsor 12277, 12278, 12682 und 12683), sowie der Stadtplan von Imola (Windsor 12284), über dessen Entstehungsetappen—die Vermessung des zu erfassenden Geländes und dessen zeichnerische Darstellung—jüngst Carlo Pedretti noch aufschlussreiches Dokumentationsmaterial beigebracht hat.[13]

Über den Herstellungsprozess der Leonardo'schen Landkarten waren wir bisher weniger genau unterrichtet, obwohl einzelne Zeichnungstypen die Sorgfalt und Umsicht der Leonardo'schen Geländeaufnahmen vermuten liessen.[14] Hier nun bildet das mit den Madrider Codices bekannt gewordene Material eine wertvolle Ergänzung und Bereicherung.

Die Blätter des Codex Madrid 8936 enthalten eine ganze Reihe von kartographischen Skizzen und Aufzeichnungen, die sich auf zwei grosse Themen beziehen, mit denen Leonardo in den Jahren 1503 und 1504 befasst war: einmal das kühne—vornehmlich von Machiavelli geförderte—militärtechnische Projekt, die von den Florentinern belagerte Stadt Pisa durch Ableitung des Arno ihrer Verbindung zum Meere zu berauben und damit alle, bisher unbehinderte Zufuhr auf dem Wasserwege abzuschneiden.[15] Wir wissen nicht, wie weit Leonardo an diesem utopischen Vorhaben, das wegen seiner praktischen Undurchführbarkeit sehr bald zum Scheitern verurteilt war, beteiligt war: sein Rat als erfahrener Wasserbauingenieur wurde zwar erbeten, indem er als Gutachter ins Feldlager der Florentiner entsandt wurde, und seine Aufzeichnungen im Madrider Codex bezeugen, dass er sich mit den topographischen Gegebenheiten wohl vertraut gemacht hat. Doch über seinen eigenen Vorschlag—wenn es überhaupt zu einem solchen gekommen ist, sagen seine Aufzeichnungen nichts aus; nur eine grosse Baggermaschine seiner Konstruktion kann ausser der einen noch zu erörtenden

[11]Abbildung in L.H. Heydenreich, *Leonardo da Vinci* (Basel–London–New York, 1953), fig. 145.

[12]Cf. E. Solmi, "Leonardo da Vinci e la repubblica di Venezia," *Archivio Storico Lombardo* (An. xxv, Ser. 4x, 1908), 327. Die Notizen Leonardos im Codex Atlanticus fol. 231v und Codex British Museum 270v, abgedruckt in J.P. Richter, *The Notebooks of Leonardo da Vinci*, paperback ed. (New York, 1970), II, Nr. 1062 und 1077.

[13]*A Chronology of Leonardo da Vinci's Architectural Studies after 1500* (Genf, 1962), 31; idem, *Studi Vinciani* (Genf, 1957), 217ff.

[14]Vgl. Baratta, *I disegni geografici, passim.*

[15]Das Projekt zusammenfassend dargestellt von E. Solmi, "Leonardo e Machiavelli," *Archivio Storico Italiano* (xlix, 1912), 123ff., doch mit irrigen Schlüssen über Leonardos Anteil am Projekt.

Zur rascheren Information des Lesers zitieren wir nachstehend die wichtigsten und gut illustrierten Erst-Berichte über die Madrider Codices: L. Reti, "The Two Unpublished Manuscripts of Leonardo da Vinci in the Biblioteca Nacional of Madrid," *Burlington Magazine* (cx, 1968), 10–21 u. 81–89; M. Rosci, "The Madrid Manuscripts of Leonardo," in *Leonardo da Vinci* (Den Haag, 1967), 594ff.; L.H. Heydenreich, "Bemerkungen zu den zwei wiedergefundenen Manuskripten Leonardo da Vincis in Madrid," *Kunstchronik* (xxi, 1968), 85–100.

Landkarte auf das Projekt bezogen werden.[16] Eine Notiz auf der Karte Windsor 12279, welche die Umleitbarkeit des Arno wegen der ständigen Veränderung seiner Ufer durch den Schwemmsand der im Mündungsgebiet einmündenden Nebenflüsse in Zweifel zieht, lässt viel eher vermuten, dass er dem ganzen Vorhaben sehr skeptisch gegenüberstand.[17]

Jedoch hatte Leonardos intensive Beschäftigung mit dem Arnolauf eine Folgerung von grösster Tragweite: sie führte ihn erneut auf ein weitaus bedeutenderes Thema, die Schiffbarmachung des Arno zwischen Florenz und dem Meere durch die Anlage eines Kanals, der—unter Umgehung der Stromschnellen in der Gola della Golfolina zwischen Signa und Montelupo—in grossem Bogen von Florenz über Prato und Pistoja zum Pass von Serravalle geleitet und von dort—nach Überwindung der starken Höhenunterschiede durch Schleusen- oder Tunnelbauten—in der Ebene nach Vico Pisano (oder Fucecchio) geführt werden sollte, um dort in den Arno einzumünden.[18]

Diesem grossartigen, dem allgemeinen Nutzen dienenden Projekt, das zugleich die Bonifizierung weiter Landstrecken vorsah, widmete sich Leonardo mit weit grösserem Interesse als dem verfehlten, dabei nur Schaden bringenden Kriegsplan von Pisa. Sein Plan sieht eine Regulierung des Arnolaufs oberhalb von Florenz im Chianatal vor; unmittelbar hinter Florenz (westlich) sollte dann der Kanal beginnen.[19]

Im Rahmen dieser Studien im Arnogebiet entstand nun jene Reihe von Landschafts-Aufnahmen, die das eigentliche Thema unserer Betrachtung bilden. Wir glauben, sie als die ersten sicher datierbaren "Veduten" Leonardos bezeichnen zu dürfen.

Auf fol. 7v des Madrider Codex 8936 ist in Rötel die Hügelgruppe der Pisaner Berge (Monte Pisano) gezeichnet, wie sie sich als Panorama vom gegenüberliegenden Ufer des Arno bei Cascina darbietet (Abb. 5). Die Ortsangabe "Cascina" auf dem Blatt und der zusätzliche Vermerk "qui è la veduta" besagen, dass Leonardo mit diesen Worten den genauen Standort präzisierte, von dem aus er die "Vedute" aufgenommen hatte. Tatsächlich ist es auch dem Verfasser gelungen, diesen Standort in Cascina genau auszumachen: Es ist die Dachterrasse des Festungsturmes am nördlichen Ausgang der Stadt. Heute ist zwar der Ausblick von dort durch die zwischen der Hauptstrasse und dem Arnodamm errichteten

[16]Codex Atlanticus fol. 1r. L. Reti (†) hat nachgewiesen, dass dieser Baggerkran ein Konkurrenzmodell zu demjenigen auf fol. 2r ist, das von einem anderen Ingenieur entworfen wurde (mündliche Mitteilung).

Die Karte der weiteren Umgebung von Pisa mit dem von Strassen und Wassergräben durchsetzten Mündungsgebiet des Arno auf fol. 52v, 53r des Codex Madrid 8936 lässt die Vermutung zu, dass hier zwei projektierte Ableitungskanäle eingetragen sind: einmal die mit "rotta d'Arno" bezeichnete Doppellinie, die vom letzten Arnoknie vor Pisa südwärts zum "fosso dello spedaletto" führt, und zweitens die lange schwach gekrümmte Linie, die vom Arno vor Cascina direkt zu der grossen Lagune von Livorno ("stagno di Livorno"—heute bonifiziert) verläuft. Doch sind die Eintragungen auf der Karte so flüchtig gezeichnet dass sie u.E. kaum mehr bedeuten können als skizzenhafte "Notierungen" im Laufe einer Besprechung im Feldlager. Eine detaillierte Beschreibung und Auswertung dieser Karte der Pisa-Ebene findet sich—leider sehr entlegen—in dem Aufsatz von E. Tolaini, "La mappa del pian di Pisa di Leonardo," *Rassegna Periodica di Informazioni del Comune di Pisa* (III, 1967), 37ff.

[17]Der Passus abgedruckt in Richter, *The Notebooks of Leonardo da Vinci,* II, No. 1006. Vgl. auch Leonardos Beobachtungen über Stromschnellen des Arno im Codex Leicester fol. 13a (Richter 1008).

[18]Vgl. G. Castelfranco, "Il canale Firenze–Mare nei Progetti di Leonardo," in *Studi Vinciani,* 153ff. mit guter Rekonstruktion des Projekts in moderner Karte; Rosci, "The Madrid Manuscripts of Leonardo," 512.

[19]Die Idee des Arno-Kanals ist alt; sie wurde schon im 13. Jahrhundert erwogen und von den Medici wieder aufgegriffen. 1489 erinnert der Architekt Luca Fancelli Lorenzo Medici an einen solchen Plan, den er (Fancelli) schon mit seinem Vater Piero de'Medici eingehend besprochen habe. Auch Leonardo war dies grosse Thema, wie Aufzeichnungen der neunziger Jahre in Mailand (Codex Atlanticus 46v a) bezeugen, wohl vertraut. Er mag es mit seinem Landsmann Fancelli in Mailand diskutiert haben. 1503-1504 wird er als Militäringenieur der Florentiner im Heerlager von Pisa erneut auf das Thema geführt. (Vgl. hierzu Clark, *The Drawings . . . at Windsor Castle,* s.Nr. 12278, 12279 und 12682.)

Neubauten des 20. Jahrhunderts versperrt, aber vom Arnodamm selbst aus (in der Achse des Turms) liess sich eine photographische Aufnahme der Berggruppe gewinnen, die die Exaktheit der Leonardo'schen Vedute bis in die Einzelheiten bestätigt (Abb. 6). Im Vordergrund sind die Ortschaften Caprona, Noce, Lugnano und Cucigliana erkennbar, am rechten äussersten Rande noch Häuser von San Giovanni alla Vena und darüber Vico Pisano angedeutet. Hinter dem kleinen Steinbruch links, der noch heute in Betrieb ist, wird die Strasse Caprona-Calci sichtbar; rechts schliesst dann die Hügelkette an, die sich vom Monte Verruca (mit seiner berühmten Festung) über zwei niedrigere Gipfel zum Monte Dolorosa und weiter nach Buti hinzieht; das davorliegende Castel di Nocio ist deutlich kenntlich gemacht.

Leonardo hat also die ganze Berggruppe in allen ihren Schichtungen getreu skizziert. Die einzige Abweichung zwischen dem photographierten und dem gezeichneten Bildpanorama besteht darin, dass Leonardo die Landschaft mit "physiologischem Sehen" als geschlossenere, gedrungenere Formgruppe wahrgenommen und entsprechend gezeichnet hat, und zwar genau so, wie wir sie auch heute mit blossem Auge wahrnehmen, während das starre Objektiv der Kamera das gesamte Bergmassiv nicht mit einem "Sehbild" erfassen konnte, sodass der Fotograf genötigt war, zwei Aufnahmen zu machen und aneinander zu fügen. Der Vergleich der fotografischen Wiedergabe des Landschaftsbildes mit dem Panorama Leonardos ist also ungemein lehrreich: Leonardos Zeichnung entspricht unserem natürlichen Sehbild viel mehr—man ist versucht zu sagen "genauer"—als die mechanische Reproduktion der Kamera; sie ist eine wirkliche "Vedute."[20]

Durch die Verifizierung der Cascina-Vedute ermutigt, hat der Verfasser sich bemüht, noch ein anderes Landschaftsmotiv ausfindig zu machen, das im gleichen Codex mehrfach erscheint und in der Zeichnung auf fol. 17r seine beste Ausführung findet (Abb. 7). Die Angaben "Paradiso," "Incontro," "Arno" verwiesen auf das Hügelgebiet im Arno-Knie zwischen Florenz, Pontassieve und Rignano, innerhalb dessen der Monte Incontro (575 m) die höchste Erhebung bildet.[21] Das Aufspüren des Punktes, von welchem aus Leonardo diese Zeichnung machte, war schwieriger, weil Leonardos Blatt keinen Hinweis auf den genauen Standort trägt. Doch gelang es, die Stelle auf dem gegenüberliegenden Ufer—im Hügelgebiet zwischen dem Monte Ceceri und Molino del Paino oberhalb Sieci—mit ziemlicher Genauigkeit zu ermitteln. Wieder ist das Panorama in seinen markanten Einzelformen genau wiedergegeben (Abb. 8). Der besonders starke Feuchtigkeitsgehalt der Luft gerade dieser Gegend bewirkt, dass sich die Landschaft fast nie in völlig klaren Konturen darbietet, sondern ständig mehr oder weniger in Dunst gehüllt ist. Aus diesem Grunde war es nicht möglich, eine Aufnahme mit schärferen Umrissen herzustellen, doch sind auf der Originalfotografie die verschiedenen sich überschneidenden Hügelkonturen in ihrer Tiefenstaffelung gut genug zu erkennen, um ihre Übereinstimmung mit der Leonardo'schen Vedute zu dokumentieren: Vom Gipfel des Monte Incontro aus breiten sich nach beiden Seiten die Berghänge aus; rechts erscheint das Arnotal wie auf Leonardos Blatt.

[20]Auf fol. 8r und 9v des Codex befinden sich zwei weitere Rötelskizzen desselben Motivs von einem leicht veränderten, weiter rechts gelegenen Standpunkt aus gezeichnet. Sie tragen die Orstangaben "Veruca" un "do/loro/sa" (8r) bzw. "Caprona," "Monte Dolorosa," "Vico," "Montichi" (9v). Fol. 7v, das wir abbilden, ist die ausgearbeitetste Zeichnung der Gruppe.

[21]Zwei weitere Skizzen—fol. 18v mit den Ortsangaben "L'Incontro," "Paradiso," "Ruciano" und fol. 19r mit den Angaben "Paradiso," "Ruciano"—zeigen die Hügelgruppe von ihrer rückwärtigen Seite, d.h. vom Süden her.

Auch in dieser Zeichnung Leonardos beobachten wir das gleiche Phänomen wie in der Skizze der Pisaner Berge: gegenüber der fotografischen Aufnahme ist auch hier die Berggruppe geschlossener, gleichsam "kompakter"—unserem natürlichen Sehbild adäquat— dargestellt. Einem scharfen Beobachter wird nicht entgehen, dass Leonardos Incontro-Vedute mit ihren bewachsenen Hängen—Leonardo verwendet einmal den schönen Ausdruck "monte pelata"—viel stärker in Sfumatotönen gezeichnet ist, als das Blatt der Pisaner Berge, d.h. also, dass auch er die "Diesigkeit" der Atmosphäre empfunden hat.

Einige weitere Skizzen auf den benachbarten Seiten des Codex geben andere Bergformationen des Arnogebiets im näheren Bereich von Florenz wieder: auf fol. 17v erkennen wir in flüchtigen Umrissen, die die Stadt im Süden rahmende Hügelkette mit den Ortsangaben "Monte Oliveto," "Bellosguardo," "Montici"; fol. 20v hält den nördlich der Stadt gelegenen Berghang mit den Bezeichnungen "Fiesole," "Arno," [monte] "Ceceri," "Mugnone" fest; fol. 19v, 20r und 21r enthalten—heute nur noch in sehr schwachen Umrissen erkennbar— einige Hügel oberhalb des Arnotals im gleichen Gebiet mit den Bezeichnungen "Montici," "Arno," "Ema."

Alle diese Skizzen müssen als Vorstudien für eine Landkarte gewertet werden, die Leonardo zu zeichnen beabsichtigte. Eine andere Gruppe von Skizzen verzeichnet rein numerisch die Distanzen zwischen verschiedenen Fixpunkten der jeweiligen Gesamtstrecke; sie sind demnach Vorstudien für die massgerechte Vermessung der darzustellenden Gebiete.[22]

Aus der Kombination solcher Vermessungsskizzen mit den "Veduten," die die Höhen-(und auch in gewissem Sinne Tiefen-) dimensionen schätzungsweise festhalten,[23] entwickelt Leonardo sein kartographisches Bild eines Gebiets, das in verschiedenen Ausführungstypen vorliegt: als rein planimetrische Landkarte, wie sie, noch skizzenhaft, in Windsor 12279 (Abb. 9), dann sorgfältiger ausgeführt im Madrider Codex fol. 22v–23r (Abb. 10) und auch, schematischer angelegt, im Pisa-Plan fol. 52v–53r[24] schliesslich dann in ausgereifter Form in dem prachtvollen Windsor-Aquarellblatt 12277 vorliegen (Abb. 11); oder aber als "Reliefkarte," die in einer imaginativen Hyper-Vogelperspektive das jeweilige Gebiet in plastischer Bildhaftigkeit darstellt, z.B. Windsor 12278 und 12683 (Abb. 12–13).

Subsumierend lässt sich die Behauptung aufstellen, dass der primäre Beweggrund, der Leonardo zur Zeichnung einer wirklichkeitsgetreuen Vedute veranlasste, ein ausserkünstlerischer war und von der kartographischen Praxis her bedingt war.[25] Aber wie überall in Leonardos Schaffen spürbar wird, ist sein künstlerisches und wissenschaftliches Denken

[22]Codex Madrid 8936, fol. 1v, 2r, 3r, 15r, 16r. Diese Skizzen sind jedoch nur als zufällig erhaltene—weil im Codex notierte— Materialien zu werten, denen eine grosse Menge nicht mehr erhaltener Aufnahmen hinzugerechnet werden muss. Vgl. über diese Vermessungen Pedretti, *Studi Vinciani* (1957), 217ff.

[23]Unseres Wissens gibt es keine Aufzeichnung Leonardos, die geographische Höhenmasse numerisch angibt; ein Faktum, das ein noch ungeklärtes Problem darstellt und weiterer Untersuchungen bedarf. Denn in seinen farbig angelegten Karten—am stärksten in Windsor 12277—gibt Leonardo durch unterschiedliche Tönung von Grün über Ocker zu Braun eine deutliche Differenzierung der Höhenschichten.

Die Zahlen der Hügelkuppe in Piombino, die Leonardo abzukappen plante (Codex Madrid 8936, fol. 32v, 33r), um eine freie Schussbahn zu gewinnen, dienen lediglich der

pauschalen Errechnung des kubischen Volumens der abzutragenden Erdmassen.

[24]Gute Abbildungen in Reti, "The Two Unpublished Manuscripts," fig. 22 und 23.

[25]Die Entwicklungsgeschichte der modernen Kartographie ist trotz sehr verdienstlicher Untersuchungen von Baratta und Castelfranco sowie der eingehenden Erläuterungen zu den Windsor-Blättern von Clark und Pedretti noch nicht genügend erforscht. Vor allem fehlen Karten aus der Leonardos Wirken unmittelbar vorausgehenden Periode. Einen richtungsweisenden Beitrag zur Frühgeschichte der geographischen Karte haben soeben B. Degenhart–A. Schmidt veröffentlicht: "Marino Sanudo und Paolo Veneto," *Römisches Jahrbuch für Kunstgeschichte* (xiv, 1972).

niemals zu trennen: die Veduten der Pisaner Berge und des *Incontro*-Hügels sind zugleich Schöpfungen eines im Grunde rein künstlerischen Sehens. Die Landschaften im Madrider Codex gehören zu den schönsten Zeugnissen der Leonardo'schen Zeichenkunst. Sie leiten, jene Reihe von exakten Landschaftsaufnahmen ein, die in den folgenden Jahren—vor allem in der Periode des zweiten Mailänder Aufenthalts—relativ häufig sind und zuweilen gleichfalls aus einem ursprünglich technisch-wissenschaftlichen Beweggrund entstehen: so die Gruppe der sogenannten Adda-Flusslandschaften, die Leonardo im Zusammenhang mit dem projektierten Wasserweg Como-Mailand zeichnete; Windsor 12399 (Abb. 14) ist die exakte Bestandaufnahme der Stromschnellen der Adda bei der Rocchetta di Santa Maria zwischen Brivio und Trezzo, der "Tre corni," deren wasserbautechnische Regulierung in einem Grundriss auf fol. 335r (und 141v [b]) des Codex Atlanticus dargestellt ist.[26] Aber über seinen technischen Zweck hinaus, die Situation des Flusslaufes und seiner Uferformation zu veranschaulichen, ist das Blatt ein wunderbares Beispiel der reifen Zeichenkunst des Meisters. Auch Windsor 12400 (Abb. 15)—"die Fähre"—und Windsor 12398—eine weitere Skizze der Adda und seiner Ufer—sind vermutlich aus dem gleichen Anlass entstanden, als Leonardo im Dienste des französischen Statthalters die Schiffbarmachung der Adda erwog.[27]

Schliesslich sind aus dieser Zeit (zwischen 1508 und 1511) noch die Zeichnungen der Bergkette der Bergamasker Alpen zu nennen, für deren Entstehung kein technisch-praktischer Beweggrund vorlag; sie gehören vielmehr in den Bereich der geologischen Studien Leonardos, die zugleich mit seinen späten Textentwürfen zum *Malereitraktat* in Verbindung stehen mögen. Windsor 12414 (Abb. 16) erweist sich als eine genaue "Vedute," etwa von den Colline di Montevecchia in der Brianza aufgenommen mit den Gipfeln der Grigna, den Corni di Canzo, Albenza mit Monte Tesaro; der Hügelzug davor stellt die Colline di San Genesio dar. Zwischen diesen beiden Bergzügen liegt das obere Adda-Tal.[28]

Auch für die ähnlichen in die gleiche Zeit gehörigen Alpenmotive der Zeichnungen Windsor 12410–13, darunter die herrliche Landschaft eines Flussdeltas (Windsor 12412), liessen sich sicher die Standorte Leonardos finden; sie haben sämtlich den Charakter von Veduten.[29]

Wir dürfen mit Sichherheit annehmen, dass Leonardos Karte der Küste bei Terracina mit den Pontinischen Sümpfen, die er 1515 im Auftrag seines Patrons Kardinal Giuliano de'Medici anfertigte, aus ähnlichen Vorstudien erwuchs, wie wir sie von den toskanischen Karten her kennen (Windsor 12684). Die eigentümliche Verbindung der rein kartographischen Darstellungsprinzipien mit naturalistischen Landschaftsformen, wie sie in der Wiedergabe der *macchia* des Sumpfgeländes erscheinen, macht auch diese Landkarte zu einem Kunstwerk sui generis.

[26]Vgl. Heydenreich, *Leonardo da Vinci*, I, 160 und II, Abb. 219 und 228; G. Calvi, *I manoscritti di Leonardo da Vinci* (Bologna, 1925), 195 f. Vgl. auch das interessante, von Pedretti beigebrachte Bildmaterial zum gleichen Motiv, in *Leonardo da Vinci*, fig. 16–19.

[27]Vgl. die Erläuterungen im Windsorkatalog (Clark, *The Drawings . . . at Windsor Castle* zu den betreffenden Nummern. Zu Windsor 12400, *die Fähre*, schreibt Clark: "This is the most exquisite of all Leonardo's landscapes, drawn with an oriental freedom of composition. Just as the Tosa School used conventional cloud to obliterate those parts of the picture which were inessential, so Leonardo's vision begins and ends as balance, not logic, demands."

[28]Cf. L.H. Heydenreich, Besprechung von A.E. Popham, *The Drawings of Leonardo da Vinci, Phoebus* (I, 1946), 183.

[29]Vgl. zu Windsor 12411 und 12413 C. Pedretti, "Note sulla cronologia del Trattato della pittura di Leonardo" (continua) *L'Arte* (LVIII, 1959), 155 (fig. 10 u. 11, La Grigna nello Sfodo di Lecco); F. Malaguzzi-Valeri, *La Corte di Ludovico il Moro*, II (Mailand, 1915), 581, bringt vier schöne fotografische Aufnahmen von Adda-Landschaften, denen Leonardos Motive sehr nahe kommen.

Wir ersehen aus dem Vorgebrachten, dass es wohl zunächst ein ausserkünstlerischer Anlass war, der Leonardo zur vedutenmässigen Wiedergabe von Landschaftsstücken führte: um 1500 setzen seine kartographischen Studien ein, zu deren Thematik die "Veduten" gehören. Zugleich aber erkennen wir, dass Leonardos künstlerisches Auge diese Landschaften visuell gleichsam als "Bildmotive" erfasste und zu jener vollkommenen Gestaltung brachte, die sie zu den Inkunabeln der Landschaftsvedute machen. Hierin liegt ihr besonderer Wert und ihr unvergleichlicher Reiz.

Wie untrennbar in Leonardos Wahrnehmungsvorgang künstlerische und wissenschaftliche Überlegungen verbunden sind, wird in der Skizze des "Monte Verruca" auf fol. 4r des Madrider Codex 8936 evident (Abb. 17): inmitten seiner gleichsam "sachlichen" Bestandaufnahme der Monti Pisani fesselt ihn das "Motiv" des Monte Verruca. Mit extremer Ökonomie der zeichnerischen Mittel stellt er das Emporwachsen der nackten Felskuppe aus dem bewachsenen Berghügel—"monte pelata" in Leonardos anschaulicher Terminologie—dar, deren steinerne Krone die Festung bildet (Abb. 18): ein rein künstlerisches Sujet, dessen spezifischen Reiz Leonardo wohl in der Verschmelzung von Naturform (Felsmassiv) und Kunstform (Kastell) fand, dergestalt dass das Letztere auf weitere Sicht kaum wahrnehmbar ist; eine "Rocca" im ursprünglichen Sinne des Worts![30] In der Exaktheit der Wiedergabe darf man auch in dieser Skizze eine Vedute sehen, nicht weniger als in der Zeichnung der Meereswogen, die am Felsgestade der Küste von Piombino branden (Codex Madrid 8936, fol. 41r) (Abb. 19). Hier wird das "kosmologische Auge" Leonardos gebannt; und es sind die "onde del mare di Piombino, tutte d'acqua schiumosa," deren sich der Künstler erinnert als er zehn Jahre später, gegen Ende seiner Tage, den Textentwurf für eine Darstellung der Sintflut in seinem *Malereitraktat* niederschreibt.[31] Die "Vedute" wandelt sich zur "Vision."

ZENTRALINSTITUT FÜR KUNSTGESCHICHTE, MUNICH

[30]Vgl. zur Festung Monte Verruca, die Leonardo auch als Kriegsingenieur besuchte, C. Pedretti, "Monte Verruca," *Renaissance Quarterly* (XXV, 1972), 417ff.

[31]Vgl. die Erläuterungen zu diesem Blatt im Windsorkatalog (Clark, *The Drawings ... at Windsor Castle*) unter der Nr. 12665.

Meister Bertrams Engelsturz

GEORG KAUFFMANN

Aus der Masse der durchweg anonymen und—was die Qualität betrifft—recht mittelmässigen norddeutschen Tafelmalerei des späteren Mittelalters ragt als ein Hauptwerk der um 1380 entstandene Altar des Meisters Bertram aus der Petri-Kirche in Hamburg hervor. Nicht nur seiner sehr beträchtlichen Abmessungen wegen beansprucht das heute in der hamburger Kunsthalle befindliche Stück die Aufmerksamkeit. Seine klare Formanschauung, die Genauigkeit in sachlicher Hinsicht, handwerklich gediegene Ausführung machen den Altar zu einem Exemplar besonderer Güte[1]. Ob die heute leeren Aussenseiten jemals Bilder getragen haben, bleibt eine Frage.[2] Beim Öffnen des ersten Flügelpaares zeigt sich eine durchgehende Bilderwand von vierundzwanzig gemalten Tafeln vor Goldgrund, die in zwei Friesen übereinandergeordnet ist. Die obere Reihe enthält die Schöpfungsgeschichte bis zur *Vertreibung aus dem Paradies*, in der unteren sieht man zunächst auf sechs Tafeln Szenen des Alten Testamentes, dann auf den letzten sechs die Jugend Christi von der *Verkündigung* bis zur *Flucht nach Ägypten*. Beim Aufklappen des zweiten Flügelpaares wird der Blick auf mehr als achtzig Skulpturen freigegeben—Apostel, Heilige und Propheten, welche die zentrale Kreuzigungsgruppe flankieren.

Als Ganzes gibt das Programm keine Rätsel auf, auch bei den Einzelthemen ergaben sich kaum gewichtige Fragen,[3] darum sind bisher auch in der Forschung die ikonographischen Probleme hinter den stilistischen zurückgetreten, welche sich aus den Versuchen enwickelten, die im Rahmen der lückenhaften Überlieferung des späten 14. Jahrhunderts schwer durchschaubaren Stilgrundlagen der für ihre Zeit neuartigen Monumentalmalerei Bertrams namhaft zu machen. Dass aber auch ikonographische Untersuchungen noch einen gewissen Aufschluss geben können sei an einer der gemalten Tafeln gezeigt, und zwar gleich an der ersten des ganzen Altares (Abb. 1).

Am Anfang des Zyklus steht die Schöpfungsgeschichte. Gottvater beginnt das Werk mit der *Trennung von Licht und Finsternis* nach Genesis 1 : 3–5 : "Und Gott sprach : Es werde Licht ! Und es ward Licht. Und Gott sah, dass das Licht gut war. Da schied Gott das Licht von der Finsternis und nannte das Licht Tag und die Finsternis Nacht." Meister Bertram bedenkt

[1]Der Altar kam 1731 nach Grabow (weshalb er auch Grabower-Altar genannt wird), allerdings nicht komplett, weil die Aussenflügel, 1595 von Ägidius Coignet übermalt, in Hamburg verblieben waren. 1903 kehrte das Werk nach Hamburg zurück, wobei Coignets Übermalungen bereitigt wurden. Vgl. A. Lichtwark, *Meister Bertram* (Hamburg, 1905); A. Stange, *Deutsche Malerei der Gotik*, II, (Berlin, 1936) 132ff; Ders., *Kritisches Verzeichnis der deutschen Tafelbilder vor Dürer*, I (München, 1967), 173f. Die Höhe beträgt 180 cm, die Breite bei geöffneten Flügeln 720 cm.

[2]Lichtwark, *Meister Bertram*, 182, vermutete auf den Aussenflügeln vier lebensgrosse Heiligengestalten, darunter die Patrone der Petri-Kirche Petrus und Paulus. P. Portmann, *Meister Bertram* (Zürich, 1963) 6, dachte sich aussen gemalte Szenen.

[3]Im Genesiszyklus folgen aufeinander die *Trennung von Licht und Finsternis*, die *Erschaffung des Himmels*, der *Gestirne*, der *Pflanzen*, der *Tiere, Adams, und Evas*. Die Bibel setzt dagegen die Pflanzenerschaffung vor die Gestirnerschaffung. Man kann aber nicht sagen, dass Bertram von sich aus die Szenen "vertauscht" habe, denn einerseits verfährt das Mittelalter in Auswahl und Reihenfolge der Genesismomente ohnehin uneinheitlich, andererseits neigt es gelegentlich dazu, die himmlische Schöpfung vor die irdische zu setzen, weshalb die von Bertram gewählte Reihenfolge auch andernorts anzutreffen ist, z.B. in Cod.1. von Michelbeuren aus dem 2. Viertel des 12. Jahrhunderts; vgl. G. Swarzenski, *Die Salzburger Malerei* (Leipzig, 1912), I, 68, II, pl. XXIV, fig. 82; A. Heimann, "Trinitas Creator Mundi," *Journal of the Warburg Institute* (II, 1938–1939), 45, pl. 4 c.; A. Weis, "Das Freiburger Schöpfungsportal und das Musterbuch von Strassburg," *Das Münster* (V, 1952), 190, Abb. 9; E. Kirschbaum u.a. in *Lexikon der christlichen Ikonographie*, IV (Rom–Freiburg i. Br., 1972), sp. 108ff.

jeden dieser drei Verse : links steht Gott im langen Gewand, die Rechte wie befehlend erhoben,
um gemäss Vers 3 das Licht zu schaffen. Er hat rechts oben eine Aureole hervorgebracht.
Vers 4 besagt, dass das Licht "gut" war, was den Maler veranlasste, im rötlichen Kern des
Lichtkreises das Antlitz Christi mit dem Strahlennimbus erscheinen zu lassen, entsprechend
der Gleichsetzung Christi mit dem Lichte. Schliesslich wird, wie in Vers 5 berichtet, die
Finsternis vom Licht geschieden, und zwar so, dass unter die Lichtsphäre ein dunkler Kreis
gesetzt wird. Der Vorgang der "Scheidung" wird verdeutlicht, indem gezeigt wird, wie aus
dem Lichte dumpffarbige Dämonen herausdrängen und in den Kreis des Dunkels eingehen.
Entsprechend dem Licht als dem Sitz des Guten wird damit zugleich die Finsternis zum Sitz
des Bösen.

Über die sorgfältige Darstellung des Textes hinaus bietet dieses Bild aber auch Einzel-
heiten, die *nicht* durch die Schöpfungsgeschichte der Bibel angeregt worden sind. So lässt sich
z.B. der untere Kreis der Finsternis näher bestimmen als ein olivgrüner Globus mit welliger
Oberfläche, auf der man Gebirge und Talzüge ausmachen kann, als habe die Absicht bestan-
den, ein geologisch charakterisiertes Abbild der Erde zu geben. Demzufolge wäre für Bertram
der "Ort der Finsternis" die irdische Welt (vgl. dazu Honorius von Regensburg, *De imagine
mundi libri tres*, 133 A: "Sicut enim terra est in medio aere; ita est infernus in media terrae").
Zweitens sieht man zwischen den Dämonen, die aus der Aureole herabstürzen und teils auf
die Erde zufallen, teils in ihr eintauchen einen besonders durch auffallende Grösse und eine
goldene Krone hervorgehoben. In der rechten Tatze trägt er ein Schriftband mit den Worten
"ascendo super altitudinem nubium similis ero altissimo," einer Stelle aus Jesaias 14: 14.
Luzifer hatte sich über Gott erhoben und war zur Strafe aus dem Himmel verstossen und zum
Höllenfürsten Satanas erklärt worden. Dieses Ereignis ist geeignet, auch Bertrams Charak-
terisierung der "Finsternis" als "Erdkugel" zu verdeutlichen, heisst es doch anlässlich des
Michaelskampfes in der Offenbarung Johannis 12:9: "Und es ward ausgeworfen der grosse
Drache, die alte Schlange, die heisst der Teufel und Satanas, der die ganze Welt verführt, und
war geworfen auf die *Erde*, und seine Engel wurden auch dahin geworfen."

Die *Trennung von Licht und Finsternis* ist in der Bildkunst durch die Jahrhunderte hin
unterschiedlich dargestellt worden. In der Frühzeit scheidet Gott vornehmlich ungestaltete
Massen, wie im *Ashburnham Pentateuch* der Pariser Nationalbibliothek (Nouv.acq.lat.2334,
fol. 1v) aus dem 7. Jahrhundert. Ebenso früh kommt es vor, dass Gott Hell und Dunkel in
Gestalt zweier menschlicher Figuren trennt, so in den nur in Kopien des 17. Jahrhunderts
erhaltenen Fresken von San Paolo fuori le mura in Rom, oder bei Herrade von Landsberg.
Eine Sonderform stellt das Bild im *Welislas-Codex* (Prag, Universitätsbibliothek, XXIII, C. 24,
lob. 412, fol. 1r), der teils ins 13., teils ins 14. Jahrhundert datiert wird, dar: zwei sitzende
Figuren, den Kopf melancholisch in die Hand gestützt und "Tenebir" bezeichnet, repräsentie-
ren die Finsternis. Die Taube des hlg. Geistes schwebt über dem "Abissus," während rechts
davon "Lux" als lichter Knabe von Gott mit dem Zirkel erschaffen wird. Hier zeigt sich ein
Zusammenhang mit Schöpfungsideen neuplatonischer Art, insbesondere der Dürers
Melancholie zugrunde liegenden Vorstellungswelt. Häufig wird die Trennung von Licht uns
Dunkel durch eine Scheibe veranschaulicht, die in eine weisse und eine schwarze Hälfte
geteilt ist. Auch kommt es vor, dass Gott in der einen Hand das Licht als helle Scheibe, in der

anderen die Finsternis als dunkle Masse hält. Es stellt sich die Frage, aus welchen Gründen Meister Bertram keine dieser Überlieferung benutzt sondern zur Illustration der *Trennung von Licht und Finsternis* das Bild des *Engelsturzes* herangezogen und dieses alsdann mit Zügen versehen hat, die sich nicht aus Genesis 1 :3–5, überhaupt nicht aus der Schöpfungserzählung, sondern aus ganz anderen biblischen Textstellen ableiten.

Dass im Zusammenhang der Schöpfungsgeschichte ein *Engelsturz* erscheint, hat nichts Aussergewöhnliches an sich. Die mittelalterliche Bildkunst beitet hierfür einige Beispiele.[4] Im Gegensatz jedoch zur *Trennung von Licht und Finsternis*, die an einer exakt benennbaren Bibelstelle berichtet wird, enthält die Heilige Schrift keine entsprechend präzise nachweisbare Schilderung auch des Engelsturzes. Vielmehr wird das, was man über diesen weiss, aus einer Reihe unterschiedlicher Textstellen zusammengetragen. Die Geschichte vom Engelsturz stammt also nicht aus dem Primärbereich der biblischen Quelle, sondern fand erzählerische Gestalt erst innerhalb der theologischen Exegese, weshalb er als Ereignis genommen auch vielfältiger Auslegung zugänglich sein kann. Konstant bleibt dabei jeweils die Vorstellung einer Strafe für diejenigen Engel, die ihre Willensfreiheit zur Empörung gegen Gott missbraucht und deshalb ihren Platz im Himmel und zugleich auch die Engelsgestalt verloren haben.[5] Was nun die Gründe der Strafe im Einzelnen anlangt, so können aus der Bibel selbst sehr verschiedene Ursachen namhaft gemacht werden. Es kann sich handeln um eine Bestrafung der Engel nach Adams Verführung, oder weil sie sich sündhaft Menschenfrauen genähert hatten (Genesis 6 :2–4), was dann den Anlass zur Sintflut abgab. Es kann um den Hochmut Luzifers gehen, worauf ja auch Meister Bertrams Bild verweist. Voraussetzung einer Annäherung des Sinnbereichs des Engelsturzes an denjenigen der Schöpfung kann die Idee sein, dass Engel und Welt gleichzeitig geschaffen wurden. Der Name "Luzifer" verweist auf einen Zusammenhang zwischen der Erschaffung der Engel und der Erschaffung des Lichtes. "Creatio lucis angelorum creationem significat" und "Divisio lucis a tenebris divisionem bonorum angelorum a malis significat" heisst es in der *Bible moralisée*.[6] Eine Initiale aus der *Bibel von Lobbes* von 1084 in der Bibliothek des Priesterseminars von Tournai (MS I, fol. 6r) zeigt im untersten von sieben Medaillons mit der Schöpfungsgeschichte die Kombination des ersten Schöpfungstages mit der *Trennung von Licht und Finsternis* zusammen mit dem stürzenden Luzifer (Abb. 2).[7] Gott kann dann auch schon *vor* der Weltschöpfung die

[4]Vgl. K. A. Wirth im *Reallexikon zur Deutschen Kunstgeschichte*, ed. O. Schmitt (Stuttgart, 1967), s.v. "Engelsturz."

[5]Vgl. 2. Petrus 2 : 4; Judasbrief 6; Johannes 8 : 44; Lucas 10 : 18; Apokalypse 12 : 7–9; B.J. Bamberger, *Fallen Angels* (Philadelphia, 1952).

[6]A. de Laborde, *Étude sur la Bible moralisée* (Paris, 1911–1922), I, Taf. 2.

[7]Im Gegensatz zur *Bible moralisée*, die *Trennung von Licht* und *Finsternis* und *Engelsturz* in zwei separaten Darstellungen nebeneinander bringt, zieht die *Bibel von Lobbes* (die auf dem Tridentinum für die Revision des Vulgata-Textes benutzt wurde) beide Szenen in einem Bilde zusammen. Die Photographie verdanke ich Chanoine A. Milet. Vgl. auch P. Bloch, "Der Siebenarmige Leuchter in Klosterneuburg," *Jahrbuch des Stiftes Klosterneuburg* (II, 1962), 166, fig. 9. Die Kombination beider Ereignisse in einem Bilde ist übrigens ausserordentlich selten, ich vermag nur vier weitere Beispiele nachzuweisen: New York Pierpont Morgan Library, MS. M. 638, fol. 1r,

Nordfrankreich um 1250. Es handelt sich um eine Serie von Miniaturen, die wahrscheinlich einem Psalter voranstanden, vom 1608 verstorbenen Kardinal Bernard Maciejowski dem König von Persien geschenkt; vgl. S.C. Cockerell–M.R. James–C.J. Ffoulkes, *A Book of Old Testament Illustrations of the Middle of the Thirteenth Century*. Roxburghe Club (Cambridge, 1927), 77; S.C. Cockerell–J. Plummer, *Old Testament Miniatures* (New York K, 1969); . Weitzmann, "The Jephtha Panel in the Bema of the Church of St. Catherine of Mount Sinai," Dumbarton Oaks Papers (XVIII, 1964), 349, fig. 13; H. Buchthal, *Miniature Painting in the Latin Kingdom of Jerusalem* (Oxford, 1957), 56ff., 68ff., 72ff., pl. 148. Das zweite Beispiel ist die gleichfalls aus dem 13. Jahrhundert stammende Bibel der Bodleian Library in Oxford, Auct. D.3.2, fol. 1r (im obersten ovalen Schild der Initiale I Darstellung der *Trennung der guten von den bösen Engeln* als Illustration des ersten Schöpfungstages). Und drittens wäre zu verweisen auf Lucca, Biblioteca Governativa, MS 1942, *Liber Divinorum der Hildegard von*

Engel erschaffen wie auch ihren Sturz bewirkt haben.[8] Entsprechend stösst man in der bildenden Kunst auf den *Engelsturz* vor der *Schöpfung* resp. im Zusammenhang mit deren Vorbereitung.[9]

Je nachdem, wie man sich den Zeitpunkt des Engelsturzes denkt, ergeben sich für dessen Vollzug unterschiedliche Ortsangaben. Findet er vor der Weltschöpfung statt, dann fallen die Rebellen in das Chaos oder in die Hölle herab. Glaubte man, der Engelsturz sei nach der Himmelsschöpfung, aber vor derjenigen der Erde erfolgt, dann wurde meist nur gezeigt, wie die sündigen Engel aus dem Himmel vertrieben wurden. Bestand dagegen zum angenommenen Zeitpunkt die Erde schon, dann war auch die Ansicht möglich, Luzifer und die Seinen stürzten auf den Erdglobus, so, wie man es bei Meister Bertram sieht, der—wie gesagt—die "Finsternis" als Erdkugel charakterisiert. Dies aber bedeutet nun einen ausgessprochenen Widerspruch zur Placierung im Bildzusammenhang einer *Trennung von Licht und Finsternis*, denn da diese den allererersten Akt der Weltschöpfung ausmacht, vollzieht sie sich auch in einem Moment, der zweifellos demjenigen der Erschaffung der Erde vorangeht.

Die Integration eines *Engelsturzes* in die Darstellung des ersten Schöpfungstages ergibt also einen theologischen Sinn. Die von Meister Bertram gewählte Bildform dagegen will zum Zeitpunkt des Ereignisses nicht passen. Die Erklärung kann nur darin liegen, dass der Maler die erste Genesisszene durch Aufnahme des *Engelsturzes* zu vertiefen beabsichtigte, seine Idee dann aber nur anhand eines Musters realisieren konnte, das ursprünglich für einen anderen, und zwar späteren Zeitpunkt der biblischen Erzählung konzipiert worden war, dass Bertram—mit anderen Worten—die *Erschaffung von Licht und Finsternis* durch den Hinweis auf die Scheidung der guten von den bösen Engeln im Sinn der *Bible moralisée* kommentierte, in die Inszenierung dann aber durch Rückgriff auf eine aus anderen Zusammenhäng stammende Erfindung eines anderen Meisters eine Zweideutigkeit brachte. Man wäre in diesem Falle alsdann genötigt, Bertrams Aufnahme des *Engelsturzes* in die erste Genesisszene nicht nur von der Bibelexegese her zu begründen, sondern auch aus dem Vorhandensein eines bereits existierenden Vorbildes zu erklären, wobei sich dann wieder einmal zeigen liesse, wie dauerhaft eine Bildformel ihre Lebenskraft selbst dort noch behaupten kann, wo sie ihrem ursprünglichen Sinnzusammenhang entfremdet und in einen anderen Kontext verpflanzt ist.[10]

Bingen, Miniatur zur Vision VI, fol. 118r, die—allerdings in visionärer Verfremdung—*Engelsturz*-Gedanken mit solchen der *Trennung von Licht und Finsternis* in Form einer weissen und schwarzen Wolke vereint (vgl. dazu B. Maurmann, "Die Himmelsrichtungen im Weltbild des Mittelalters," Diss. Münster, 1974, maschinengeschrieben, 150ff). Die Kenntnis des vierten Beispiels verdanke ich Helen M. Franc, New York: auch das Frontispiz der sogenannten *Lothian Bible* der Pierpont Morgan Library, M. 791 (englisch, 13. Jhdt.) kombiniert Schöpfung und Engelsturz, wobei das "Licht" des ersten Schöpfungstages durch die guten Engel dargestellt wird; vgl. *The Pierpont Morgan Library, Review of the Activities and Acquisitions of the Library from 1930 through 1935* (New York, 1937), Pl. IV, S. 21. Diese vier Beispiele stammen alle aus dem 13. Jahrhundert, wodurch die singuläre Stellung der *Lobbes-Bibel* aus dem 11. Jhdt. unterstrichen wird. Reiner Haussherr macht mich darüber hinaus auch auf die Eingangschöre in Haydns *Schöpfung* aufmerksam, welche Trennung von Licht und Finsternis und Engelsturz besingen. Für weitere Hinweise und Hilfe habe ich dem Index of Christian Art der Universität Princeton, insbesondere Rosalie B. Green und Adelaide Bennett zu danken.

[8]Rupert von Deutz, *De victoria verbi Dei*, I, 25 (Migne, *Patrologia Latina*, CLXIX, sp. 1238 und 1241f.).

[9]Vor der *Schöpfung* z.B. im *Hortus Deliciarum* oder im *Psalter Ludwigs des Heiligen und der Blanche von Castilien* (Arsenal, MS 1186), bei der Vorbereitung der *Schöpfung* in der *Bilderbibel des Guards des Moulins* (Paris um 1410), Brüssel, Bibliothèque Royale, MS. 9001, fol. 19. Hier wird im linken Bildteil der *Ratschlag der Dreifaltigkeit* und die *Erschaffung der Engel* gezeigt, im rechten der *Engelsturz* und Satan nebst Spruchband mit "ascendam in celum"; vgl. L.M.J. Delaissé–H. Liebaers–F. Masai, *Mittelalterliche Miniaturen* (Köln, 1959), Nr. 21, 96–99. Über den Engelsturz bei Dante (*Paradiso*, XXIX, 37ff.) siehe P. Brieger–M. Meiss–C.S. Singleton, *Illuminated Manuscripts of the Divine Comedy* (New York, 1969), II, Taf. 507.

[10]Vgl. E. Panofsky, "Zum Problem der Beschreibung und Inhaltsdeutung von Werken der bildenden Kunst," in *Aufsätze zu Grundfragen der Kunstwissenschaft* (Berlin, 1964), 85–97.

Diese Formel ist durch senkrechte Gegeneinanderstellung zweier Sphären gekenn-
zeichnet, der leuchtenden Aureole mit dem göttlichen Bilde oben und der Erdkugel unten.
Durch die Leere zwischen beiden stürzen die gefallenen Engel. Eine solche Variante des
Engelsturzes ist ausgesprochen selten, denn nur in den wenigsten Fällen wird der Ort, auf den
die rebellischen Engel niederfallen, als Globus gegeben. Bedeutendster Repräsentant ist der
Engelsturz der Brüder Limburg in den *Très Riches Heures de Jean Duc de Berry* (Abb. 3).[11]

Da diese prachtvolle Miniatur um 1415, also später als der Petri-Altar gemalt wurde,
kann sie nicht in den Kreis der möglichen Vorbilder Meister Bertrams einbezogen werden.
Erheblich älter dagegen ist ein *Engelsturz*, der seit 1967 in der Grande Galerie des Louvre
ausgestellt ist und auf dem die Erde gleichfalls als runde Kugel gezeigt wird (Abb. 4). Auf
dem qualitätvollen, wenn auch durch Übertragung auf Leinwand etwas beschädigten Gemälde
sieht man oben den lichtdurchfluteten Himmel mit Engelchören. Leer geblieben sind die
Trone der Abtrünnigen, die nach unten auf die Erde niederstürzen. An der Himmelsgrenze
hält ein geschlossener Trupp von Geharnischten Wacht. In diesen Einzelheiten deckt sich der
Motivbestand des Pariser Bildes mit dem *Engelsturz* der *Très Riches Heures*. Laclotte, der das
Werkchen zusammen mit seiner (heute abgetrennten ehemaligen) Rückseite, die eine Gruppe
des *Hlg. Martin mit dem Bettler* zeigt, veröffentlichte, datierte es in die Zeit zwischen 1335 und
1348, aller Wahrscheinlichkeit nach in die Jahre 1340–1345.[12] Es handelt sich um das frühest
bekannte Beispiel eines *Engelsturzes* "mit Erdglobus" und somit auch um den ältesten Beleg
für den Typus, zu dem die Versionen sowohl Meister Bertrams wie auch der *Très Riches
Heures* gehören.

Vergleicht man alle drei Fassungen untereinander, so zeigt sich, dass Bertrams *Engelsturz*
dem Bilde des Louvre näher steht als der Miniatur der Brüder Limburg :

Sowohl in Paris wie bei Bertram erscheint in der himmlischen Aureole Christus, während
in Chantilly Gottvater mit der Tiara tront.

Sowohl in Paris wie bei Bertram sind die Rebellen ihrer ersten Gestalt entkleidet und
zu Dämonen verwandelt, während in Chantilly Engel niederstürzen.

Sowohl in Paris wie bei Bertram wechselt die Abmessung der Dämonen, es gibt grosse
und kleine, während in Chantilly das einheitliche Mass gewahrt ist.

Sowohl in Paris wie bei Bertram stürzen alle Rebellen auf die Erdkugel zu, während in
Chantilly einige seitlich an ihr vorbeifliegen.

Sowohl in Paris wie bei Bertram scheint der Maler den Vorgang von einem distanzier-
teren Standpunkt her aufzufassen, während die Brüder Limburg eine Optik wählen, welche
dem Betrachter den Eindruck vermittelt, er sehe einen doppelten Strom von Fallenden in
prächtiger Kurve aus der Tiefe des Raumes her auf sich und seinen erdnahen Standpunkt
zukommen.

Viel geringer ist die Zahl der Paralellen zwischen Meister Bertrams Fassung und
derjenigen der *Très Riches Heures* :

[11]Chantilly, Musée Condé, MS 65 (1284), fol. 64v ; P. Durrieu, *Les Très Riches Heures de Jean de France, Duc de Berry* (Paris, 1904), Taf. 41.

[12]Das Bild kam auf dem Tauschwege aus dem Museum zu Bourges in den Louvre ; Höhe 58 cm, Breite 26 cm ; Inventar Nr. D.L. 1967-1 und 1 bis (Rückseite). Vgl. M. Laclotte, "Le 'Mâitre des Anges Rebelles,'" *Paragone* (237, 1969), 3–14.

In Chantilly wie bei Bertram stürzen die Rebellen in einer Doppelreihe vom Himmel, während das Pariser Bild eher einen kreisenden Wirbel fallender Körper zeigt.

In Chantilly wie bei Bertram wechselt die Farbe der Abtrünnigen zwischen Hell und Dunkel, und zwar regelmässig; in den *Très Riches Heures* folgt auf je ein dunkel gekleidetes ein hell gekleidetes Paar, sodass die Symmetrie des kompositionellen Aufbaus der Sturzes auch auf das Farbliche übergreift. Bei Meister Bertram stürzen drei Paare zur Erde nieder, jeweils ein dunkler und ein heller Dämon.

Schliesslich muss erwähnt werden, dass in jedem der drei Bilder die Kombination der beiden wichtigsten Protagonisten eine andere ist: Bertram setzt Christus gegen Luzifer; Chantilly setzt Gottvater gegen Luzifer; Paris setzt Christus (und Michael, den in der Bildmitte herausgehobenen strafenden Vollzieher des göttlichen Willens) gegen eine personell nicht weiter differenzierte Masse von Dämonen.

Jedes einzelne der drei Beispiele sieht den *Engelsturz* also vor einem etwas anderen exegetischen Hintergrund: Meister Bertram konzentriert sich auf die Antithese "Licht-Finsternis";[13] die *Très Riches Heures* ordnen ihn in den Bereich von Gottesstaat- und Gerichtsvorstellungen ein;[14] das Bild im Louvre tendiert zum apokalyptischen Sinn der Michaels-Ikonographie.[15]

In einem Punkte bleibt Meister Bertrams Fassung für sich: nur bei ihm fehlen Engel. Nun gehört der Verzicht auf die Wiedergabe von Engeln in der Engelsturz-Ikonographie zwar zu den Neuerfindungen des späteren Mittelalters,[16] in unserem Falle wird man jedoch weniger eine selbständige Bildkonzeption als die Verkürzung eines ursprünglich reicheren Motivbestandes anzunehmen haben, und zwar aus Gründen des thematischen Zusammenhangs. Da es im Mittelalter kein vereinzeltes Vorkommen eines Engelsturzes gibt, kann auch Bertrams Vorlage nur aus einem zyklischen Kontext hergenommen sein. Wie dieser beschaffen war, dürfte sich kaum mehr feststellen lassen, doch kann man aus den drei infrage kommenden Versionen einige Anhaltspunkte gewinnen. Der *Engelsturz* der *Très Riches Heures* gehört zu den grossen textunabhängigen Miniaturen. Er steht am Beginn der Busspsalmen und kann durchaus mit der Überlieferung der Psalterillustration in Beziehung stehen. Der Zusammenhang, aus dem das Pariser Bild herkommt, ist nicht mehr zu rekonstruieren,[17] nicht zuletzt deshalb, weil die Komposition offenbar im Repertoire der franco-

[13]In der Gegenüberstellung Christus-Luzifer meint der Sturz Luzifers die Erhöhung Christi, hier insbesondere mit der Pointierung auf das "Ich bin das Licht der Welt" (Johannes 8:12).

[14]Vgl. die französische Übersetzung des *Gottesstaates* von Raoul de Presles für Karl V in dem reich illustrierten Exemplar des frühen 15. Jahrhunderts, die vielleicht vom "Orosius-Meister" stammt (M. Meiss, in Katalog "The International Style. The Arts in Europe around 1400," Walters Art Gallery, Baltimore, 1962, Nr. 49, Taf. XLIX). Die Frontispizminiatur setzt im Bilde des *Engelsturzes* antithetisch das *Reich des Himmels* mit dem in der Engelsglorie tronenden, tiragekrönten Gottvater dem Reich der Erde als dem Reich der Hölle und des Teufels gegeneinander. Zur Kombination von *Engelsturz* und *Weltgericht*: H. Swarzenski, "Unknown Bible Pictures by W. de Brailes, and Some Notes on Early English Bible Illustration," *Journal of the Walters Art Gallery* (1, 1938), 66, Abb. 27. Dass Gottvater unmittelbar die zu Teufeln verkehrten Engel in den Höllenschlund befiehlt, zeigt u.a. das Genesis-

Fenster des Erfurter Doms (um 1370); *Inventar Provinz Sachsen, Die Stadt Erfurt* (Burg, 1929), 187, Abb. 150.

[15]Vgl. *Reallexikon zur deutschen Kunstgeschichte*, v, sp. 654ff.

[16]*Ibid.*, sp. 645.

[17]Laclotte, "Le 'Maître des Anges Rebelles,'" 14, Anm. 7. Laclotte hält (p. 3) die Tafel für den Teil eines kleinen beweglichen Polyptichons, wobei er offen lässt, ob Mittelbild oder Flügel. Benutzungsspuren an der ehemals rückseitigen *Martinsgruppe* deuten darauf hin, dass der weniger beschädigte *Engelsturz* innen sass. Laclotte ventiliert aber auch die etwas gesucht wirkende These, dass es sich um den Teil eines mit beweglichen Doppelflügeln ausgestatteten Diptychons gehandelt haben könnte. Die Möglichkeit eines Polyptichons mit feststehenden Flügeln lässt er ausser Acht. Dabei hätte die Tafel doch auch (vielleicht in die obere Zone) eines derartigen Ensembles gepasst. Die Heiligengruppe auf der Rückseite brauchte dem nicht widersprechen. Ein Schluss von der Rückseite der Pariser Tafel auf die verlorene Aussenbemalung des Petri-Altares scheint zur Stunde nicht möglich.

flämischen Buchmalerei ohne Vorbild ist. Bertrams Komposition steht am Beginn des Schöpfungsberichtes. Alle drei Fassungen enthalten den jedem *Engelsturz* innewohnenden Gerichtsgedanken, dessen Übertragung auf die Genesis-Erzählung jedoch nur unter der Voraussetzung möglich ist, dass sich der Engelsturz als Allegorie der Entstehung des Bösen in den Dienst der Moralisierung stellt. Am leichtesten wäre dies zu bewerkstelligen, wenn bei der Vertreibung der Rebellen Michael hervorgehoben wäre. Das älteste der drei Exemplare, nämlich das Pariser Stück, arbeitet nun in der Tat den Michaelskampf heraus, woraus geschlossen werden könnte, die ikonographische Reihe, aus der Bertrams Vorlage genommen wurde, sei in einer Tradition verankert, die den apokalyptischen Streit betont und somit von vornherein die Integration des Engelsturzes in die Schöpfungsgeschichte erleichtert habe. In diese Richtung würde auch der Erdglobus deuten, denn im Bibeltext wird die Erde wie gesagt nur in der apokalyptischen Erzählung des Michaelskampfes erwähnt.

Dem stünde entgegen, dass Satans Spruchband bei Bertram die Jesaias-Stelle mit dem Hinweis auf bestraften Hochmut enthält, also noch auf einen anderen Hintergrund als den apokalyptischen verweist. Wir kämen damit mehr in die Nähe der Miniatur der Brüder Limburg, die Satan zwar ohne Spruchband, aber auch ohne den ihn bekämpfenden Erzengel darstellt. Es bliebe die unaufgelöste Frage, wie denn einerseits im Motivischen die stärkere Bildung Meister Bertrams an die Version des Louvre, andererseits im Thematischen seine grössere Nähe zur Miniatur der *Très Riches Heures* zu verstehen sei. Die einzige sich anbietende Lösung wäre, dass nicht etwa das Pariser Bild den Brüdern Limburg als Anregung für ihre Miniatur vorgelegen hätte—wie Laclotte anzunehmen geneigt ist[18]—sondern ein anderes, jetzt verlorenes, das auf der Pariser Fassung fussend, eine Wendung von der Michaels- zur Satan-"superbia"-Thematik vollzogen hätte. Man könnte sich denken, dass diese Spielart auch Bertram zu Gesicht gekommen wäre. Er hätte dann seine Komposition um die Engel reduziert, die Brüder Limburg dagegen hätten die ihre zu einer sehr personenreichen Szene ausgebaut. In einem solchen Falle müsste eine gemeinsame Vorlage für Bertram wie für die Miniatur der *Très Riches Heures* angenommen werden, es wäre—mit anderen Worten—Meister Bertrams *Engelsturz* in seiner bescheidenen Weise geeignet, einen gewissen Begriff von dem verlorenen Prototyp des *Engelsturzes* der Brüder Limburg zu vermitteln.

Damit kommen wir nunmehr zu einem Ergebnis unserer Untersuchung. Der hypothetische Prototyp war ein ikonographisches Mischprodukt mit doppelter Wurzel sowohl in Apokalypse 12:7–9 wie in Jesaias 14:14 fundiert, unter Vorwiegen der apokalyptischen Tradition. Er hat überall dort Daseinsberechtigung haben können, wo es um die Bestrafung des Bösen in mehr gleichnishafter Weise geht, wie im Psalter oder im *Speculum humanae*

[18]*Ibid.*, 11. Angesichts des *Engelsturzes* der *Très Riches Heures* hatte noch der Duc d'Aumale bemerkt "nous ne connaissons rien d'analogue" (Durrieu, *Les Très Riches Heures*, 213, vgl. auch 125). Man vermutet, dass die Brüder Limburg in Bourges lebten; vgl. M. Meiss, *French Painting in the Time of Jean de Berry. The Late Fourteenth Century and the Patronage of the Duke* (London, 1967; 2. Aufl. 1969), I, 293. Aber aus dem Umstand, dass das Pariser Bild gleichfalls aus Bourges kommt, kann keine Bekräftigung der Vermutung abgeleitet werden, das Stück habe für die Miniatur in Chantilly als Vorbild gedient. Es war in einer Privatsammlung, der weitere Stammbaum ist offenbar nicht bekannt.

salvationis.[19] Deshalb ist es plausibler, Bertrams Vorbild—wie dies ja auch für den seiner Schule zuzuweisenden Londoner Apokalypsenaltar gilt—eher in der Buchmalerei als in der Tafelmalerei zu suchen, wie denn überhaupt die Einmaligkeit seiner Darstellung des Sechstagewerkes auf einem Flügelaltar nicht gerade auf zugrunde liegende Tafel- oder Freskomalerei verweist.[20] Die Integration der Szene in den ersten Schöpfungstag scheint Bertrams persönliche Leistung gewesen zu sein, denn bis auf ein einziges Beispiel aus der Mitte des 12. Jahrhunderts, in dem ein Michaelskampf als Illustration für eine Genesis-Paraphrase gedient hat (Wien, Nationalbibliothek, Cod. 2721, fol. 11r), ist die vorwiegend apokalyptische Version des *Engelsturzes* im Zusammenhang des Schöpfungsberichtes in der *vor* Bertram liegenden Bildtradition nicht nachzuweisen (im übrigen zeigt diese Wiener Miniatur nicht den

[19]E. Breitenbach, *Speculum humanae salvationis* (Strassburg, 1930), 83–85. Der moralische Effekt der Bestrafung Satans ist später oft hervorgehoben worden, z.B. im *Buch der guten Sitten* des Jacques Le Grand (nach 1455), Delaissé, u.A., *Mittelalterliche Miniaturen*, 136, Nr. 31. Der Bezug auf Jesaias 14 : 14 auf Satans Spruchband in Bertrams Darstellung darf nicht zu dem Schluss verleiten, das Vorbild habe aus einer reinen Jesaias-Illustration stammen können, denn die betreffende Textstelle ist kaum jemals illustriert worden. Mir sind nur zwei Beispiele (beide des 13. Jahrhunderts) bekannt : Gregorius' *Moralia in Hiob* der Klosterbibliothek Herzogenburg, fol. 151r und *Bible moralisée*, Paris, Bibliothèque Nationale, MS. lat. 11560, fol. 110r. Angesichts dieses überaus spärlichen Denkmälerbestandes scheint es ausgeschlossen, dass Meister Bertram von einer genuinen Jesaias-Illustration ausgegangen ist.

Anders liegen die Dinge in Bezug auf einen apokalyptischen Ursprung von Bertrams *Engelsturz*. Wesentliches Indiz für die Herkunft der Vorlage aus diesem Themenbereich ist— neben der Erdkugel—das charakteristische "Eintauchen" der Dämonen in die Erde, und zwar kopfüber und bereits halb in der Erde steckend. Dieses Moment ist ausschliesslich nur in der apokalyptischen Illustration nachweisbar : *Apokalypse*, Oxford, Bodleian Library, Auct. D. 4. 16, p. 66 (Satan verschwindet kopfüber in der Erde, Michael steht mit anderen Engeln auf Wolken dabei, rechts in ganzer Figur Johannes mit Buch, das Ganze ähnlich komponiert wie Bertrams Darstellungen); *Apokalypse*, Cambridge, Trinity College, B. 10. 6, fol. 13v (Satan verschwindet kopfüber in der Erde; vgl. M.R. James, *The Western Manuscripts in the Library of Trinity College*, I (Cambridge, 1900), 297ff.; L. Delisle, *L'Apocalypse en français au treizième siècle* (Paris, 1901), LVIII f.; M.R. James, *The Apocalypse in Art* (London, 1931) 2, 6, n. 18; *Apocalypse*, Oxford, Bodleian Library, Auct. D.4.17, fol. 11r (Satan verschwindet kopfüber in der Erde, Michael und andere Engel stehen auf der Erde daneben; vgl. H. Coxe, *The Apocalypse of St. John the Divine represented by figures reproduced in facsimile from a manuscript in the Bodleian Library* (London, 1876), XVI, pl. 11a). Die erwähnten Beispiele stammen alle aus dem 13-Jahrhundert, indessen muss Bertrams Vorbild doch wohl in das 14. Jahrhundert gesetzt werden, und zwar wegen der besonderen Form des Erdglobus und den auf ihm eingetragenen Tälern und Bergen. Die Bildtradition beginnt mit dem Kosmos als Scheibe, in die man während des ganzen frühen Mittelalters schematisch die Kontinente Asien, Afrika und Europa einzeichnet. Die Kosmosscheibe kann zum Sammelplatz mehrerer Darstellungen werden, sei es der "Sphären" in konzentrischen Ringen, sei es, dass Himmel und Erde zusammen auf der Scheibe erscheinen. Noch um 1400 ist in Brüssel, Bibliothèque Royale, MS. 9094, fol. 12r (Barthélemy l'Anglais, *Propriétés*) Christ-Logos an einer Scheibe tätig, auf der Tagewerke der Schöpfung eingezeichnet sind. Auf einem Ala-

basterrelief des 14. Jahrhunderts in Baltimore, Walters Art Gallery, Nr. 27.307 kann man im Zweifel sein, ob mit der runden Kugel, die Gottvater in Händen hält, und auf der Land, Wasser und ein Fisch erkennbar werden, die Erde oder der Kosmos gemeint ist. Sie steht für die Tendenz, den ursprünglichen Schematismus mit fortschreitender Zeit zugunsten der konkreteren Anschauung zu überwinden. Eindeutig als "Kugel" zu lesen ist die Scheibe überall da, wo Einflüsse des *Cosmas Indicopleustes* anzunehmen oder nachzuweisen sind, d.h. *geographische* Einzelheiten der Erde erkennbar werden. Dies gilt beispielsweise für das *Weltschöpfungs*-fresko im Paduaner Baptisterium aus dem späten 14. Jahrhundert. Erst ganz zuletzt erscheinen auf dem Abbild der Erde auch die *geologischen* Merkmale, wie Berge und Täler, die nicht vor dem 14. Jahrhundert vorzukommen scheinen (Weltkugel in der Hand Christi auf dem Fresko im Giebel über dem Portaltympanon der Kirche Notre Dame in Avignon, 1339–1344, und fol. 5r der 1391 datierten Bibel, New York, Pierpont Morgan Library, M. 833, Initiale *I* mit Medaillons, im obersten die Schöpfungstage 1–4 zusammengezogen, dabei die Erde als Kugel mit Gebirgszügen geschildert). Selbstverständlich können geographische und geologische Einzelheiten dann auch gemischt werden, wie auf der Weltkugel im um 1380 entstandenen italienischen Stundenbuch, Paris, Bibliothèque Nationale, MS. lat. 757, fol. 30r (3. Schöpfungstag).

[20]Ganz abwegig ist A. Rohdes Ableitung von Meister Bertrams *Engelsturz* aus dem geistlichen Schauspiel, "Das geistliche Schauspiel des Mittelalters und das gemalte Bild bei Meister Bertram von Minden," *Monatshefte für Kunstwissenschaft* (XV, 1922), 173–80. Rohde hat nicht nur die Bildtradition ausser Acht gelassen, sondern auch übersehen, dass eine entsprechende Vermutung schon vorher von J.K. Bonnell ausgesprochen worden war : "The Serpent with the Human Head in Art and in Mystery Play," *American Journal of Archaeology* (XXI, 1917), 267. Die Vermutung eines literarischen Vorbildes für Bertram wird ferner ausgesprochen in dem bis auf eine Erwähnung bei L. v. Wilckens, "Beobachtungen am Buxtehuder Altar und zu Meister Bertram," *Museum und Kunst Beiträge für Alfred Hentzen* (Hamburg, s.d.), 290ff., Anm. 7, von der Forschung übersehenen Artikel von C.R. af Ugglas: "Ett birgittinskt inslag i en Bertram-Komposition?" in *Vornvännen. Meddelanden från K. Vitterhets Historie och Antikvitets Akademien* (I, 1930), 49–53, der den "Engelsbesuch" aus dem Buxtehuder Altar mit Birgittas von Schweden Visionen in Beziehung setzt. H. Stierling, "Theologische Erklärungen zu einigen Bildern Meister Bertrams in der Hamburger Kunsthalle," *Repertorium für Kunstwissenschaft* (XXXIV, 1924), 273–82 setzt Bertrams Schöpfungsgeschichte in Bezug zum "Fliessenden Licht der Gottheit" der Mechthild von Magdeburg. Dabei wird das erste Bild des Grabower Altars nur als Engelsturz beschrieben, nicht in erster Linie als Trennung von Licht und Finsternis.

Erdglobus, der kein einziges Mal im Zusammenhang "Schöpfung–Engelsturz" vorkommt).
Wir dürfen also annehmen, dass Bertram eine genuin apokalyptische Darstellung mit bereits
eingearbeitetem Textbezug auf Jeremias 14:14 aus einem Zusammenhang, der vermutlich
nicht die Genesis, und mit noch grösserer Sicherheit nicht der erste Schöpfungstag gewesen
ist, genommen hat und unter einem etwas mühsamen Versuch der Anpassung in seinen
Kontext durch Einfügung Christi in die Lichtaura verändert und durch Fortlassen der Engel
verknappt hat. So gelang ihm eine Kombination der *Trennung von Licht und Finsternis* und
Engelsturz im Sinn der *Bible moralisée* und so, wie es sich nach Johannes 3:19 darstellt, wobei
das "fiat lux" auch Wortlaut ist der Strafverkündigung an die Engel. Gott ist Schöpfer und
Richter zugleich. Damit wird schon im ersten Bilde des Petri-Altares jener heilsgeschichtliche
Gesichtspunkt hervorgekehrt, der in der geschnitzten *Kreuzigung* des Innenschreins zur
Vollendung gebracht ist.

Es bleibt zu erörtern, welchem Stilbereich Bertrams Vorlage angehört haben mag.

Der Maler des Engelsturzes im Louvre (Abb. 4) lässt sich nicht namhaft machen. Seine
künstlerische Grundlage ist sienesisch, allerdings nicht in ganz reiner Form. Die Krieger-
gruppe an der Himmelsgrenze schliesst sich fest zusammen wie ein pisaner Statuenpfeiler,
die Einlegearbeiten (Rhomben) an den leeren Tronen der rechten Sitzreihe verweisen auf die
Inkrustationstechniken nordtoskanischer Protorenaissance. Man hat es wohl mit einem
Künstler der Schule Simone Martinis zu tun, der vielleicht Barna kannte und ausserdem—
wie die straffe Perspektivführung des Himmelssaales andeutet—mit den optischen Praktiken
Ambrogio Lorenzettis vertraut war, aber zugleich auch weiter blickte in Richtung auf
Giovanni da Milano. Dieser Meister vertritt die unmittelbar vor der internationalen Gotik
liegende Stilstufe. Laclotte entwickelte die Hypothese eines anonymen Begleiters von Simone
Martini in Avignon. In diesem Sammelbecken vielseitiger Strömungen mischten sich ornamen-
tales Raffinement mit gewissen profan-naturalistischen Tendenzen. In Avignon herrschte das
Sienesische vor, aber es äusserte sich flexibler als am Ursprungsort.[21]

Indem wir uns Laclottes Ergebnisse zu eigen machen, stellen wir aufs Neue die vielfach
ventilierte Frage nach Meister Bertrams Bildungsgrundlagen. Bertram war Westfale, er kam
aus der Umgebung von Minden.[22] Seine Herkunft hat sich allerdings an westfälischen Kunst-
werken nie recht deutlich machen lassen. Zuerst hatte Goldschmidt auf das Un-Westfä-
lische seiner Kunst hingewiesen.[23] Lichtwark tappte auf der Sache nach vergleichbaren
Stilmerkmalen in Westfalen ganz im Dunkeln und da auch in Hamburg so gut wie nichts aus
der Generation vor Bertram erhalten geblieben ist, vermutete er, Bertram sei eine autochthone
Erscheinung, ein Trugschluss, der in erster Linie auf den Lücken des Materials basierte.
Heute beschränkt man sich bei Vergleichen mit Westfälischem auf den Netzer- oder den

[21]Laclotte, "Le 'Maître des Anges Rebelles,'" 8; L. H. Labande, "Les Manuscrits de la Bibliothèque d'Avignon," *Bulletin Historique,* (1894), und "Les miniaturistes avignonnais et leurs oeuvres," *Gazette des Beaux-Arts* (xxxvii, 1907), 304.

[22]Das von Nordhoff in Mindener Archiv entdeckte Dokument, in dem 1415 der Rat der Stadt Minden der Rat von Hamburg bittet, sich für die Erben des "verstorbenen Malers Bertram" einzusetzen, befindet sich nicht mehr (wie Lichtwark, *Meister Bertram*, 54, meldet) im Archiv zu Münster sondern ist nach Minden zurückverbracht worden (Urkunde Nr. 251; freundliche Auskunft von Staatsarchivdirektor Prof. Dr. W. Kohl).

[23]*Lübecker Malerei und Plastik bis 1530* (Lübeck, 1889), 4ff.

Schottener Altar,[24] beide sind in erster Linie für Bertrams Frühstil interessant. Dass Meister Bertram zumindest indirekten Kontakt mit weiter auswärts gelegenen Kulturkreisen hatte, ist belegbar. 1375 unternahm er eine Dienstreise zu dem als Markgraf von Brandenburg in Lübeck weilenden Karl IV; in seinem Testament von 1390 gelobte er eine Pilgerfahrt nach Rom. Der reichere, farbige Kulturschmelz des Ostens scheint in seinen Bildern einen Wider- schein hinterlassen zu haben, weshalb man—anfangs stark übertreibend—den westfälischen Wahlhamburger zu einem halben Böhmen machte.[25] Aber weder Bertrams Figurenstil mit der zarten Naivität des Erzählens noch seine Ikonographie können als typisch böhmisch gelten. Es bleibt also auch für den Petri-Altar bei der Feststellung, dass zwar die Komposition der Schöpfungsszenen ähnlich in böhmischen Werken vorkommt,[26] vorher und gleichzeitig aber auch ganz woanders, z.B. in der französischen Buchmalerei, etwa bei Jean Pucelle in der *Bibel des Robert de Billyng* von 1327 (Paris, Bibliothèque Nationale, ms. lat. 11935, fol. 5).[27] Überhaupt muss beachtet werden, dass die merkwürdige Multiplikation Gottvaters in Bertrams einzelnen Darstellungen des Schöpfungstages eher einer französischen Eigenart entspricht. Eines der frühesten Beispiele der in Frankreich aufgekommenen Tradition, an jedem einzelnen Schöp- fungstag einen Gottvater zu beteiligen, der sich "rhetorisch" (meist nach rechts hin) seinem jeweiligen Werke zuwendet, bietet die Nordvorhalle der Kathedrale von Chartres resp. die Miniatur fol. 10v der zwischen 1225 und 1250 geschaffenen *Bibel des Robert de Bello*.[28]

Meister Bertrams Verbindungen nach Frankreich sind noch wenig untersucht,[29] interes- santerweise hat sich aber von der historischen Seite innerhalb der französischen Beziehungen gerade die Komponente "Avignon" herausarbeiten lassen. 1958 veröffentlichte John Plummer

[24]Auf den Netzer Altar verwiesen Stange, *Deutsche Malerei der Gotik*, II, 139f. und neuerdings mit subtileren Beobach- tungen P. Pieper, "Miniaturen von Meister Bertram," *Jahrbuch der Hamburger Kunstsammlungen* (XII, 1967), 47. Beide Autoren haben für ihre Vergleiche auch den Schottener Altar herange- zogen. Dieser wird "nach allgemeiner Überzeugung" (P. Pieper, "Der Schottener Altar," in *600 Jahre Schotten* (Schotten, o.J. [1954], 45–62) um 1380 angesetzt und als Werk eines Meisters bezeichnet, der vielleicht vom Norden an den Mittelrhein kam. Dagegen deutet C.M. Kauffmann, *An Altarpiece of the Apocalypse from Master Bertram's Workshop in Hamburg* (London, 1968), 8, eine Umkehrung der Verhältnisse an, wenn er von der Möglichkeit spricht, dass der Schottener Altar, den er auf ca. 1390 hinaufrückt, durch Bertram inspiriert sei. Allerdings hatte schon Stange (*ibid.*, II, 140) den Schottener Altar "um einen Grad entwickelter als den Petri-Altar" genannt. Ähnlich liegen die Dinge beim Netzer Altar, für den Meyer-Barkhausen ("Das Netzer Altarbild," *Jahrbuch der Preussischen Kunstsammlungen*, L, 1929, 233ff.) und Stange die 70-er Jahre vorschlugen ("eher früher als später"), während Käte Klein ("Der Passionsaltar aus Osnabrück," *Wallraf- Richartz Jahrbuch*, N.F.II/III, 1933–1934, 155ff.) näher an die Bertramzeit herangeht und Martens seine Entstehung in den 80-er oder 90-er Jahren dachte, jedenfalls in der Generation *nach* Bertram (vgl. H. Rensing, "Meister Bertram," Diss. München, 1952, Maschinen-Exemplar). Neue Überlegungen zu Bertrams Verwurzelung im Westfälischen sind von Pieper im Bezug auf die silbernen Apostel im münsteraner Domschatz angestellt worden (*Festschrift Wackernagel*, 1958, 67f.), ausgebaut wurde dieser Ansatz durch K.B. Heppe, *Gotische Goldschmiede- kunst in Westfalen vom 2. Drittel des 13. bis zur Mitte des 16. Jahrhunderts* (Diss. Münster, 1973), 364, Anm. 29 und insbe- sondere im Exkurs zur Problematik einer Rekonstruktion des gotischen Reliquienaltares des Doms zu Münster, ebenda 84–88.

[25]Am weitesten ging A. Rohde, "Der Hamburger Petri- (Grabower)-Altar und Meister Bertram von Minden," Diss. Marburg, 1914 (1916, Teildruck), der 49–51 den Londoner Apokalypsen-Altar in die Kapelle von Karlstein lokalisieren wollte. Heubach ("Die Hamburger Malerei unter Meister Bertram und ihre Beziehungen zu Böhmen," *Jahrbuch des Kunsthistorischen Instituts Wien*, X, 1916, 101ff.), den Bertrams weiches Hell-Dunkel an Meister Theoderich erinnerte, sah das Problem insofern differenzierter, als er den Meister der Hohenfurter Heilslegende als Quelle sowohl für Bertram wie für Theoderich ansah. Nach Pieper, "Miniaturen von Meister Bertram," 58, lässt sich Bertram am ehesten schon in Westfalen mit der böhmischen Malerei verknüpfen, wobei natürlich nicht an persönliche Verbindungen zu Böhmen gedacht wird.

[26]Wie in der spätestens um 1389 begonnenen *Wenzelbibel* (Wien, Oesterreichische National Bibliothek, Cod. 2759–2764) oder der Bibel von 1402 im Museum Plantin-Moretus, Antwerpen.

[27]Gemäss einer Mitteilung am Ende der Apocalypse illu- striert von Jean Pucelle, Anciau de Sens und Jacquet Maci. Ebenso im *Livre des Propriétés des choses* mit den Bildern des Jehan de Nizières (Paris, Bibliothèque Ste. Geneviève, ms. 1028, fol. 14) oder in einer *Bible moralisée* (vor 1404; Paris, Bibliothèque Nationale, ms franç. 166, fol. 1), vgl. H. Martin, *La Miniature française du 13. au 15. siècle* (Paris–Brüssel, 1923), Taff. 34, 74, 95.

[28]Chartres : E. Houvet, *Cathédrale de Chartres (Portail Nord)*, II (Chelles S.-et-M., 1919), Taf. 21ff.—London, British Museum ms. Burney 3, vgl. E. A. Bond–E. M. Thompson, *Facsimiles of Manuscripts and Inscriptions–The Palaeographical Society*, Sec. I, III (London, 1873–1883), Taf. 73.

[29]Nach Hinweisen in Burgers *Handbuch* (1913, 410ff.) und bei Rohde, "Der Hamburger Petri-Altar," 13; neuerdings H. Rensing, *Meister Bertram* (Diss. München, 1952).

Fragmente eines Missale der Pierpont Morgan Library (M. 892), drei Blätter eines ursprüng-
lich sehr umfangreichen Manuskriptes mit Miniaturen Meister Bertrams. Glücklicherweise
hat sich im Text neben dem Bild mit der *Auferstehung* (IX) der Name des Stifters dieser *Missale*,
Johann von Wunstorp erhalten.[30] Ausführlich nahm sich dann 1967 Paul Pieper dieses
angesehenen Hamburgers an, der schon in jungen Jahren mit Avignon verbunden war,
nämlich durch jenen merkwürdigen Prozess, den das Domkapitel wegen angeblicher Ver-
höhnung des Priesterstandes in einem Rathausbild gegen den Hamburger Rat führte.
Wunstorp ist zuerst 1338, dann noch 1344 und 1345 in Avignon nachweisbar.[31] Er stammte—
wie Bertram—aus der Diözese Minden. Denkbar ist, dass er auf die Übersiedlung des Malers
nach Hamburg nicht ohne Einfluss geblieben war. Die nun naheliegende Konsequenz,
Bertram über Wunstorp mit der avignonesischen Kunst zu verknüpfen, wird dann allerdings
von Pieper als "Fehlschluss" bezeichnet, schien ihm doch schwer vorstellbar, dass die
zurückliegenden Zeiten in Avignon noch nachwirkten, als Bertram, der erst 1367 in Hamburg
erwähnt wird, mit Wunstorp in Beziehung trat.[32] Wunstorps letzter Bericht aus Avignon von
1345 liegt zweiundzwanzig Jahre vor Bertrams Auftauchen in der Hansestadt. Nun gibt aber
die erste Szene des Petri-Altares zu bedenken, ob wirklich ein solcher Vorbehalt am Platze ist,
kann hier doch der Kontakt mit einer seltenen Variante des Engelsturzes belegt werden,
deren frühestes Auftauchen auf der von Laclotte als avignonesisch angesprochenen und kurz
vor Mitte des 14. Jahrhunderts zu datierenden Tafel des Louvre nachzuweisen ist. Als 1379
der Petri-Altar begonnen wurde, lebte Wunstorp noch. Er starb erst 1381 und Bertram, der
für ihn schon das New Yorker Missale illustriert hatte, könnte durch ihn doch auch Kenntnis
einer französischen Engelsturz-Komposition erlangt haben. Warum sollte darüber hinaus
nicht auch einmal ein avignonesisches Bild oder ein dort illustriertes Manuskript den Weg
nach Hamburg gefunden haben?[33]

Wer wollte die Unterschiede des Geschmacks und des artistischen "Überbaus" verleug-
nen, die zwischen "Avignon" und "Hamburg" bestehen. Bertrams derbe und scheinbar
bäurische Form schien schon von selbst den Gedanken an Kontakte zu einem verfeinerten
Hof zu verbieten, ja man hat an unserem Meister geradezu die ausgesprochene Polarität
zwischen einer "grossen europäischen Stilentwicklung" und der Kategorie des "Provinziel-
len" demonstrieren wollen.[34] Aber es kommen bei Bertram ja nicht eigentlich Formen vor,

[30]*Report to the Fellows of the Pierpont Morgan Library* (IX, 1958–1959), 22–24.

[31]Pieper, "Miniaturen von Meister Bertram," 5 ff.

[32]*Ibid.*, Anm. 34. Schon Heubach, *Die Hamburger Malerei*, 165 hatte bemerkt: "Der Abstand der hamburger Malerei von der Kunst in Avignon scheint mir zu gross, um ein solches unmittelbares Verhältnis möglich erscheinen zu lassen."

[33]K.B. Heppe, *Gotische Goldschmiedekunst in Westfalen*, 79, konstatierte, dass die rheinisch-westfälische Goldschmiedekunst des späten 14. Jahrhunderts "in einem bislang noch nicht recht erkannten Umfang von den Formerfindungen franco-flämischer Buchmaler und Goldschmiede abhängt." Damit wäre für Norddeutschland noch nachzuholen, was ansatzweise schon für den englischen und spanischen Bereich geleistet wurde. Zum Englischen, vgl. C. Hansen, *Die Wandmalerien des Kapitelhauses der Westminsterabtei in London* (Diss. Kiel, 1936 [1938]), 14, vgl. auch 54, mit dem Hinweis auf Stilparallelen in der Apokalypse an der Nord-Seite des Kapitelsaales mit Meister Bertram; E. Panofsky, *Early Netherlandish Painting* (Cambridge, Mass., 1953), I, 115, fig. 166 (gleichfalls mit Hinweis auf Bertram). Zum Spanischen: M. Meiss, "Italian Style in Catalonia and a Fourteenth-Century Catalan Workshop," *Journal of the Walters Art Gallery* (IV, 1941), 45–87. Statt übrigens Meister Bertrams ausgesprochene Perspektiven in den Baldachinen über einzelnen Szenen des Petri-Altares mit dem Erfurter Regler-Altar zusammen zu bringen, sollte man sie eher mit der ausdrucksstarken Fluchtpunktkonstruktion im oberen Teil des Pariser *Engelsturzes* vergleichen. Dass dessen Stilbereich auch in seinem Vorkommen an der europäischen Peripherie Parallelen zu Bertram bietet, zeigen die Baldachine beim katalanischen sogen. "Master of St. Mark," z.B. die dreiseitigen von unten her einsehbaren Zentralbaldachine wie im Triptychon der Kathedrale zu Manresa, im Psalter, MS. 8846 der Pariser Bibliothèque Nationale (fol. 146) oder im *Llibre Verd* des Archivo Histórico in Barcelona (fol. 205), vgl. dazu Bertrams *Isaak und Esau* und *Isaak und Jacob* im Petri-Altar, Abb. bei Meiss, a.a.O.

[34]So Heubach, *Die Hamburger Malerei*, 109.

die Unkenntnis von Neuem und Besserem verraten, sondern solche, die derartige Kenntnisse in die heimische Sprache rückübersetzen. Das schön punzierte Goldgewand vor Goldgrund des Engels in der *Vertreibung aus dem Paradies* des Petri-Altars ist eher eine *re*-provinzialisierte Form, es entspricht dem, was wir aus Siena kennen (vgl. auch das Goldgewand des Verkündigungsengels). In der ihm eigenen Art methodischer Überdehnung hatte Erwin Panofsky eine Brücke zwischen Meister Bertram und Asien geschlagen, als er den berühmten *Widder* von Ur aus dem Universitätsmusseum von Philadelphia mit dem Widder des Petri-Altars in Bertrams *Isaakopfer* verglich.[35] Richtig daran ist insbesondere, dass es "Iconographica" und nicht eigentlich Stilelemente waren, die Bertram seinem wenn auch begrenztem, so doch gewiss sorgfältig verwalteten Musterschatz entnahm.

Als Maler, Buchmaler und Bildschnitzer war Bertram ein Meister von beachtlicher Statur, dessen Arbeit von tüchtigen Schülern weitergeführt wurde und dessen Leben und Wirken klar zu umreissen ist. Zum ersten Mal in der deutschen Kunstgeschichte sind in seinem Falle Nachrichten über einen bildenden Künstler nicht nur exakt mit erhaltenen Werken zu verbinden, sondern auch die Lebensumstände näher bekannt. Heute ist er in Hamburg beinahe wieder populär.[36] Norddeutschland galt lange als kulturelles Randgebiet, wissenschaftlich stand es unter dem Handicap der ungünstigen Meinung, dass, je weiter man sich von der mittelmeerischen Zivilisation entferne, das künstlerische Vermögen umso spröder werde.[37] Um dem Eindruck eines Kolonialzustands im deutschen Norden entgegenzuwirken, hatten mehrere deshalb Forscher von "Hansa-Kunst" gesprochen,[38] hatte man versucht, Hamburg als Kulturzentrum neben Köln und Westfalen aufzuwerten.[39] Dem kunstgeschichtlichen Regionaldenken haftet aber aus vielerlei Gründen etwas Dubioses an, im übrigen hat sich der Norden auch nicht Hinterwäldlerischer verhalten als andere cisalpine Landschaften.[40] Das erste Bild des Petri-Altares ist allerdings in einer allgemeineren Weise kennzeichnend für die Situation im europäischen Norden überhaupt. Theologische Gelehrsamkeit bildete die Basis für die Abschätzung inhaltlicher Möglichkeiten. Dem literarisch geformten Wissen fehlte dann aber die schöpferische Kraft, die malerische Phantasie musste sich an vorhandenen Beispielen entzünden, ohne dass es doch gelungen wäre, eine Komposition ganz ohne inneren Bruch hervorzubringen. Als grösster Altar des deutschen 14. Jahrhunderts dokumentiert das mächtige Bildwerk freilich nicht nur das kräftige handwerkliche Vermögen seines Autors auf dem Boden einer wenig üppigen bodenständigen Kunst. Es ist auch in der Lage, Meister Bertram als einen geistigen Menschen zu charakterisieren, der etwas Überpersönliches zu einem persönlichen Anliegen zu machen verstand, womit er jene Kluft überbrückte, die sich stets zwischen einer künstlerischen Hochkultur und dem Strom des alltäglichen Volkslebens auftut.

UNIVERSITÄT MÜNSTER

[35]*Grabplastik* (Köln, 1964), 13.

[36]Seit 19 2 hat Hamburg (in Barmbek-Nord) eine Meister-Bertram-Strasse.

[37]"Kränkelnd und verschlossen" wurde 1804 die norddeutsch Kunst genannt, vgl. Rohde "Der Hamburger Petri-Altar," 9, und man begann sie erst zu schätzen, als sie sich mit Massstäben des Südens messen liess, vgl. O. Beyer, *Norddeutsche gotische Malerei* (Braunschweig–Hamburg, 1924), 10f.

[38]Lichtwark, *Meister Bertram*, 58ff.; Stange, *Deutsche Malerei der Gotik*, II, 132ff; C. Habicht, *Hanseatische Malerei und Plastik in Skandinavien* (Berlin, 1926); G. F. Hartlaub, "Zur hanseatischen Kunst des Mittelalters," *Zeitschrift für Bildende Kunst*

(1913), 127–41. Wegen der grossen Verschiedenheit der an die Ostsee grenzenden Kulturen bleibt der Ausdruck "Hansa-Kunst" aber von zweifelhaftem Wert. Dazu M. Tauch, "Hanse und Kunst," im Katalog "Hanse in Europa," Köln, 1973, 297–300 und K. Bund in *Kunst in Köln* (VI, 1973).

[39]C.G. Heise, *Norddeutsche Malerei. Studien zu ihrer Entwicklungsgeschichte im 15. Jahrhundert von Köln bis Hamburg* (Leipzig, 1918), 87.

[40]Vgl. Katalog "Meister Francke und die Kunst um 1400," Hamburg, 1969. Zur Methodenkritik der Kunstgeographie, R. Haussherr, "Kunstgeographie—Aufgaben, Grenzen, Möglichkeiten," *Rheinische Vierteljahrsblätter* (XXXIV, 1970), 158–71.

Albrecht Dürer um 1500

HANS KAUFFMANN

Mit "Dürer um 1500" möge des Meisters Wandlung von der *Apokalypse* 1498 bis zu *Adam und Eva* 1504, seiner auffälligsten und radikalsten Leistung im Jahr vor seiner zweiten Italienreise, bezeichnet sein. Eine Spanne zwischen weit auseinander liegenden Gipfeln: dort Eschatologie, hier Weltschöpfung, dort ein Zyklus gross angelegter Buchholzschnitte, Lesebilder mit himmlischen und irdischen Figurenscharen in hoheitsvoller Ferne wie im Aufruhr des Kosmos, hier ein Einblatt des ersten Menschenpaars, eine Darstellung der Kreatur, die sich selbst zu erklären scheint, während die "Fabel" neutralisiert ist, ein Kupferstich erstmals gemäldeartig bis an den Rand mit Form bedeckt, dazu—dem Schritt von griechischer schwarz- zu rotfiguriger Vasenmalerei vergleichbar—helle Figuren in dunklem Ringsum.[1] Für den Stecher war *Adam und Eva*, nach Vorgängern beim Meister E S und bei Israel von Meckenem, kein allzu naheliegendes Thema, für Dürer verband sich mit ihm ein Weltbezug durch das Exemplarische seiner Gestalten für Menschenbildung überhaupt, das vorerst abschliessende Ergebnis längerer Versuchsreihen. Doch soll hier nicht das Proportionsproblem um seiner selbst willen bedacht werden. Vielmehr soll uns die Proportionierung, so leidenschaftlich und beharrlich auch Dürer sich ihrer bemächtigt und lebenslang sie überdacht hat, nur als ein Bezirk in dem weiteren Feld seiner um 1500 einsetzenden neuen Ökonomie beschäftigen. Im *Adam und Eva*-Stich sehen wir die Bestrebungen verwirklicht, mit denen Dürers Stilformen neuerdings auf gültigere Objektivierungen hinzielten. Mit ihnen kam es zu der folgenreichsten Wendung im Verlauf seines Schaffens.[2]

Im *Marienleben*[3] und in der *Grünen Passion* reift die neue Bildvorstellung heran. Dürer löst sich von dem Gedränge der späteren neunziger Jahre und erhebt sich zu der Gelassenheit des Ausdrucks und zur Fasslichkeit einer geläuterten Anordnung.[4]

Es gibt zu denken, dass nun erst Vorzeichnungen, und zwar wirklich verwertete, auf den Holzstock—nicht ohne Änderungen—übertragene einsetzen, Vorzeichnungen ganzer Kompositionen. Natürlich ist es undenkbar, dass den Holzschnitten von *Apokalypse* und *Grosser Passion* keine Vorstudien vorangegangen sein sollten, aber für das parataktische Bildgefüge jener Zyklen—jede Bildfläche ausgelegt mit mehreren gesonderten, in sich selbständigen Personen- oder Geschehenskreisen und Landschaftsabschnitten—hätte der Zeichner

[1]E. Panofsky, *Albrecht Dürer*, 3. Aufl. (Princeton, 1948), 87, hat an Antonio Pollaiuolo erinnert. Man wird auch an Andrea Mantegna zu denken haben, gerade auch an dessen von Dürer nachgezeichnete Stiche, wenn auch ohne Baumwuchs.

[2]Dies muss im Gegensatz zu Th. Hetzers, *Dürers Bildhoheit* (Frankfurt, 1939) aus allzu persönlichen Prämissen (Nachwirkungen von Giottos Arenafresken) abgeleiteter und durch unzulässige Verallgemeinerungen unterstützter These der ausschlaggebenden Wendung um 1510 gesagt werden. Ganz zutreffend hat Panofsky, *ibid.*, 95 geäussert: "the period between 1500 and 1505, now, is a transitional one," doch schreibe ich Dürers damaligen Schritten grundsätzlichere Bedeutung zu.

[3]Man kann es erstaunlich finden, dass das *Marienleben* selbst

noch von H. Wölfflin (*Die Kunst Albrecht Dürers*, 3. Aufl. München 1919) nach der erbaulichen, gemütvoll-erzählerischen Seite gewürdigt worden ist, auch später noch, nachdem gerade Wölfflin für einige der Formwerte ein Auge gehabt hatte. Diese sind neuerdings von E. Flechsig, *Albrecht Dürer* (Berlin, 1928 und 1931), von F. Winkler, *Albrecht Dürer, Leben und Werk* (Berlin, 1957) erst recht von Panofsky, *ibid.*, ins Bewusstsein gehoben. Immerhin glaube ich einige weiterreichende Gesichtspunkte, bei voller Beschränkung auf Formprobleme (unter Verzicht auch auf Fragen der Ikonographie) zur Diskussion stellen zu dürfen.

[4]Die Leitgedanken des ersten Teils dieser Darlegungen habe ich bereits im Dezember 1954 in Berlin vorgetragen.

mit partienweisen mehr oder weniger ausgearbeiteten Skizzen auskommen können.[5] An die
Ereignisse des *Marienlebens* ging Dürer dagegen nach dem Zeugnis der vier bekannten
Kompositionsentwürfe (W.291–94; ausserdem die Studie für den Marienkopf der *Anbetung
der Könige*, W.275, 1503) von vornherein mit Gesamtvorstellungen heran, die er bald freizügi-
ger, bald berechnender vorbereitete, und für alle Szenen der *Grünen Passion* (W.298–314)[6]
dürfte er mit der Feder fertig durchgearbeitete Werkzeichnungen für ausführende Schüler-
hände hergestellt haben. Das grosse Ganze ist ihm wichtig geworden, und mit einem rah-
menden Rundbogen umschliesst er gern den Schauplatz: die Szene tut sich vor uns auf, sodass
der Beschauer merkt, es geht um nachdrückliche Sichtbarmachung.

Tritt man nach *Apokalypse* und *Grosser Passion* Blättern des *Marienlebens* gegenüber,
so springt als das Unterscheidende, Neue die Frontalität ins Auge. Zwar ist auch früher
Frontales nicht selten,[7] doch erst nach 1500 setzt sich mit dem Tiefenmass von Bauten die
Frontalität in der Konzeption des Bildganzen durch, und so schon 1502 in der Coburger
Geisselung Christi (W.259). Hierher gehört auch die Symmetrie des Gekreuzigten in der
Grünen Passion gegenüber der verschobenen Ansicht in Dürers vorangehenden Kreuzigungs-
darstellungen; ähnliches lässt sich von dem Christus der *Geisselung* in den drei Passion-
zyklen (einschliesslich der *Albertina-Passion*) sagen. Die orthogonale Ansicht und der klare
Aufriss—auch im Durchblick durch mehrere Zonen—kommen zur Herrschaft, und an den
Senkrechten und Wagerechten orientiert man sich über die Tiefenrichtung der zurück-
fluchtenden Schrägen. Perspektive erschliesst sich von den Bildparallelen aus und durchdringt
sie. Mit der Frontalität gewinnt auch die reine Profilansicht höheren Rang: in *Eustachius* und
in der *Nemesis*, durch heraldische Strenge in Unnahbarkeit entrückt, entstehen eindrucksvolle
Zeugen,[8] doch sind auch *Marienleben* und *Grüne Passion* an markanten Profilfiguren reich.
Aus der Verbindung von Facegestalt und Profilkopf—in zeitlicher Nachbarschaft mit dem
Adam von 1504—leitet sich Christi hoheitsvolles Auftreten in seinem *Abschied von Maria* (B.92)
her, dann auch die Feierlichkeit und angehaltene Stille der *Anbetung der Könige* (1504)
in Florenz.

Auf einmal verlegt der Künstler das Bildgeschehen in oder neben stattliche, sehr vielge-
staltige Bauwerke, nicht wie Kulissen hereingeschoben (*Geisselung, Ecce Homo, Kreuztragung*),
sondern tektonisch gefügte, raumverdrängende und raumhaltige Architekturen, Aussen- und
Innenansichten, gleichsam umschreitbar oder betretbar, jede so vollständig, dass sie auch ohne
die Figuren zu bestehen und die Lokalität zu bezeichnen vermöchten. Stücke einer Palastwand
oder eines Stadttors (*Grosse Passion*) ergänzten sich in der *Grünen Passion* zu monumentalen
Quaderbauten und Bogenhallen, auch hoch gestimmte Räume, ruhig und klar, mit Pfeilern
und Säulen unter Tonnen, Gewölben oder Kassettendecken haben früher nicht ihresgleichen.

[5]Ein gelegentlicher Rückgriff auf einzelne Figurenskizzen,
die noch unabhängig von dem Vorhaben der *Apokalypse*
entstanden waren (E. Marx, "Die Herkunft von einigen
Bildmotiven in Dürers Apokalypse," *Redslob-Festschrift*
(Berlin, 1954), 301ff., ersetzt sie nicht. Für die *Grosse Passion* ist
noch kein vorbereitendes Blatt ermittelt worden.

[6]Ausser diesen Winkler-Nummern verdient die Nachzeich-
nung von Hans von Kulmbach in der Ambrosiana bedacht zu
werden; Katalog der Ausstellung "Dürer und seine Zeit" in
der Graphischen Sammlung, München, 1967–1968, Nr. 74.

[7]*Der Ewige auf dem Regenbogen inmitten der sieben Leuchter*
(B. 62; auch 63 und 74), *Der starke Engel auf den Säulenbeinen*
(B. 70), der Engel in B. 75, die Altäre in B. 65, 68–70; in der
Grossen Passion Maria unter dem Kreuz.

[8]Als erste durchproportionierte Figur im Stich macht
Nemesis evident, dass Proportion und reine Ansicht (Face oder
Profil) einander bedingen, dass nur bei gerader Ansicht pro-
portionierte Strecken auffassbar und optisch wirksam werden
können.

Mit der Strenge elementarer Geometrie (Horizontale, Vertikale, Kreisbogen) zieht ein gemässigtes Figurenspiel ein, ein neues Verhältnis zwischen Belebtem und Unbelebtem bildet sich aus, vor den geraden Linien und Flächen gewinnen schon verhaltenere Regungen Aussagekraft.

Neue optische Relationen ziehen ein. Die Figur tritt in ein neues Verhältnis zum Grund. Als vorherrschender Zug wirkt sich Entflechtung aus. Nachbarn lösen sich voneinander, ein geklärter Figuralstil wächst heran: die Gestalten nehmen geschlossene, zusammenhängend verfolgbare Umrisse an, leichte Fassbarkeit prägt sich aus. Dies gilt für das Personal wie für die Szenerie von Landschaft und Architektur. Führende Motive dominieren offener. In der *Heimsuchung* (B.84) stehen sich von rechts her beleuchtet Hauswand und Waldrand gegenüber und geben dunkel vor hell und hell vor dunkel den Fernblick auf Berge und bewölkten Himmel frei. Die glatte Hauswand hat nur eine Quaderbank und ein Rundbogenportal, der Mischwald ist so straff zusammengehalten (straffer als in der Vorzeichnung, W.293), dass dunkles Gezweig nicht hinausragt und in die helle Mittelpartie eingreift—anders als im *Herkules*-Stich (B. 73) oder -Holzschnitt (B.127), im *Ritter und Landsknecht* (B. 131) oder in Blättern der *Grossen Passion*—, deren höchste Bergzacken nicht in Wolkenballen übergehen, wovon das parallele Gefälle von Gebirg und Gewölk im *Meerwunder* (B. 71) absticht. Auch die Personen halten sich aufrecht in geradlinigen Umrissen, stehen vor kontrastierender Folie, und die Statisten wahren geziemenden Abstand von den heiligen Frauen in der Mitte. Die Landschaft, in der der Engel zu Joachim herabschwebt (B. 78),[9] offnet sich mit aller erdenklichen Übersicht: kontinuierliche Tiefenerstreckung über Geländewellen bis zum Meereshorizont, seitlich hochstämmige Laub- und Nadelbäume zu einer Wand tonig zusammengestrichen, nebenan sehr gegenteilig freistehend, ein grosser zumeist kahler Baum, sein Stamm und einseitiger Ast sind reich an Windungen. Engel, Menschen, Tiere gross, zur Ferne hin kleiner, je für sich und hell beschienen vor getönter Folie dem Auge verständlich gemacht. Dagegen hat man, wie sich im Schlussblatt der *Apokalypse* (B. 75) der *Engel mit dem Schlüssel am Abgrund* von seiner Umgebung nicht recht lösen lässt, und der andere, auf Jerusalem deutende in den schräg wachsenden Baum hineinlangt, in der *Grossen Passion* oft Schwierigkeiten, eine Figur zu umgreifen, ihre Begrenzungen zu erfassen. In der *Grabtragung* (B. 12) lassen sich wucherndes Buschwerk und Bäume in Gestalt eines vielsträngigen Geästs weder von ihrem Felsboden noch von den fernen Berglinien zweifelsfrei auseinanderhalten. Wie nahe rücken auch in der *Kreuzigung* (B. 11) die schwebenden Engel an die Bäume und Berghöhen heran, und die Formverwandtschaft macht fraglich, wieweit das eine und das andere reicht. In dem grandiosen Formendickicht der *Kreuztragung* (B. 10)—ähnlich dem Distelwerk neben dem Stein, auf den sich der unter dem Kreuz Niedergebrochene stützt—sieht man Grösseres und Kleineres vielfältig zerlegt und mit Angrenzendem verflochten, sodass sich ein engmaschiges Liniennetz ausbreitet, in dem manches Einzelne nicht deutlich hervortritt; in Durchblicken entdeckt man Pferdehufe und muss nach den Pferden suchen. Werden bei *Eröffnung des sechsten Siegels* der *Apokalypse* (B. 65) acht oder neun Leute von Erdspalten verschluckt? Im Löwen-

[9]Bei Erörterung der Beispiele halte ich keinerlei zeitliche Entstehungsfolge ein, wie sie nach E. Flechsig von Panofsky, *Albrecht Dürer*, 99f. und F. Winkler, *Albrecht Dürer*, 150ff.—im grossen und ganzen ziemlich übereinstimmend—festgelegt worden ist; dabei rechnet Winkler offenbar mit einer etwas kürzeren Gesamtdauer (um 1503–1504).

bezwinger *Simson* (B. 2) wie in der *Katharinenmarter* (B. 120) zeigen sich in der Umgrenzung und Zugehörigkeit eines Gliedes oder eines Gewandstücks enge Verwickelungen. Eine assimilierende Textur legt sich in diesen Jahren über verschiedene Wirklichkeitsbereiche, kann selbst Felsen und Bäume, belaubte und unbelaubte Zweige—jene nach unten, diese nach oben krallenartig gekrümmt—einander angleichen: "Gestaltlose Grossheit der Natur" (Goethe, *Tagebücher* 30. September 1797).

Der *Eustachius*-Stich (B. 57) offenbart nach der Jahrhundertwende den neuen Aufbruch zu typenmässiger Gestalthaftigkeit. Mensch und Tier, Baum und Berg stehen vereinzelt, profilieren sich mit klaren Umrissen und stellen sich in kennzeichnender Eigenart und in abgestufter Grösse zur Schau. Der Hirsch hält sich anders als das Pferd oder die Hunde, er legt seine Lauscher zurück und erkennbar unterscheidet sich sein Geweih von den Bäumen und dem Gezweig, das ihn baldachinartig übergreift. Concinnitas zwischen den Figuren, ihren Nachbarn und ihrer Umgebung. Konzentrieren wir uns auf das *Marienleben* und sogleich auf die *Begegnung unter der Goldenen Pforte* (B. 79), 1504. Die Leute, der Platz, die Mauer und ihre Tore, die Landschaft und der Himmel: jeder Bereich hat entschiedener als in der *Heimsuchung*, die zwar schon darauf hinzielte, sein eigenes Formgepräge, keiner verschlingt sich mit dem anderen. Ausladungen und Verzweigungen sind zurückgenommen worden. Die Figurengruppe silhouettiert sich, grossformig umrissen, klar vor der geradlinig konturierten und durchziselierten Stadtmauer, wieder anders erheben sich jenseits feine tonig zusammengehaltene Bäume vor hell beschienenem Hügel unter gestreiftem Himmel. Jeder Gegenstandsbereich bekommt und besitzt seine eigene, unverwechselbare Struktur. Sie grenzen sich kontrastierend voneinander ab und verdeutlichen sich gegenseitig durch ihre augenfälligen Unterschiede. Selbst unter den Figuren stösst man auf keine Verwechselbarkeiten mehr: zwei Männer stehen in emsigem Gespräch eingehakt da, aber wortlos umarmen sich nebenan Joachim und Anna liebevoll, und an ihm—mit dem einzigen würdevollen Faceantlitz—findet die Gerührte—nur sie in reinem Profil—sichernden Halt. An Binnenzeichnung wird gespart, sodass sich in breitflächigem Aufbau ein elementares Bewegungsbild abzeichnet, und die Personen hell beschienen hervortreten und von schattigeren Gründen abrücken.[10] Als durchgehender Zug des graphischen Vortrags will beachtet sein, dass das *Marienleben*, gemessen an der Brillanz und Vehemenz der Schwarz-Weiss-Gegensätze vorangehender Jahre, auf eine Mittellage der Tonwerte eingestimmt ist, und lichte Felder erhöhen die milde schimmernde Helligkeit. Am Altar der *Darbringung im Tempel* (B. 88) wird die Kniende nur von wenigen Schatten in durchsichtigen Schraffuren gestreift, sie zeigt sich sogut wie ganz in ununterbrochener Lichtheit: ungeteilt wird diese Figur, sehr anders als Johannes in der *Weisung gen Himmel* (B. 63) oder im *Lobgesang der Auserwählten* (B. 67), im Gesamtzusammenhang ihres schlanken Wuchses und ihrer aufrechten Haltung lebendig. Geht man die zahlreiche Versammlung der lebhaften Frauen in der *Mariengeburt* (B. 80) durch, so wird man nicht ohne Erstaunen feststellen können, wie weitgehend der Künstler mit blossen Konturierungen ausgekommen ist, wie geringe Binnenzeichnungen er aufgewendet, auch den Engel grösstenteils hell gelassen hat: Umrisse umfassen und artikulieren, machen Posen leicht lesbar,

[10]Auf die Lichtheit hat Panofsky, *ibid.*, 96 mit der summarischen Wendung "a passion for the luminary" hingewiesen.

jede eindeutig, und ihre Verschiedenheiten leuchten unmittelbar ein; ein wechselreiches
Neben- und Gegeneinander, und durch die Nähe der Geraden und der rechten Winkel
(Mobiliar und Boden) belebt sich das Organische am Geometrischen, für unser Augenmass
hilfreiche Gradmesser der Körperhaltungen und Beleuchtungsweisen[11]—ähnliche Begegnung-
en umrahmen und bereichern das Ensemble des *Zwölfjährigen Jesus im Tempel* (B. 91). Man
gebe sich vor dem *Sposalizio* (B. 82) darüber Rechenschaft, mit wievielen Sachbeständen
unser Auge beschäftigt wird: vielerlei Kostüme, verschiedene Arten des Tragens von
Kleidern und Mänteln, hier wird ein Stoffende aufgenommen, dort eines hängen gelassen.
Jede Figur für sich greifbar, und die ausgebreitete Ordnung legt auch kleine Dinge offen:
in Mariens Pelz die Hermelinschwänzchen, ihr Gürtelschleifchen und ihren durchsichtigen
Schleier, Josephs linke Hand unter einem Mantelende, des Priesters Finger, die das Armepaar
der Heiligen lenken, nicht zuletzt der schlanke, profilierte Kerzenleuchter zwischen den
Hintergrundssäulen. Und wie überlegt setzt Dürer Kontraste ein! Kaum noch eine Hand
oder ein Arm ausser den beiden so beredten und für das Thema so wesentlichen in der
Mitte.[12] Hinter Maria—entgegenkommend vorgeneigt und in aufgeschlossener Ansicht—
hält sich die Nürnbergerin im Kirchenkleid (nach den Zeichnungen in London und Wien,
W. 232 und 224) zurück, ganz in sich gekehrt, hinter Joseph wendet der resolut auftretende,
durch seine Rückenansicht neutralisierte Mann den Kopf unter hohem Hut nach auswärts.
Überall genügt jetzt eine geklärte Sachbeschreibung, um ohne aufwendiges Arrangement
festlichen Reichtum einziehen zu lassen. Jedes Motiv kommt nur einmal vor, und der
Vergleich verleiht dem Spezifischen erhöhte Signifikanz; Artverschiedenes sieht man benach-
bart, sodass sich die Besonderheiten steigern und verschärfen. Die ganze Gruppe agiert vor
einem schattigen Kirchenraum jenseits des umrahmenden (mit Marias und Josephs Zuneigung
zusammengehenden) Rundbogens. Näheres steht vor Entfernterem, Belebtes vor Unbelebtem,
Beleuchtetes vor dämmerigem Helldunkel. Wie Akzente ragen Säulen hinter den drei Han-
delnden auf, Marksteine, die das Auge anziehen, am höchsten ein mächtiges Säulenbündel über
Maria, von links her beleuchtet, d.h. umgekehrt wie der nahe Torbogen und die Akteure selbst.

Was Dürer an Kontrasten einzusetzen vermochte, belegt wieder die *Zurückweisung von
Joachims Opfer* (B. 77). Solch einen Rundbogen, elementar frontal (der vorderste vor noch
zwei zurückliegenden), gibt es in der *Grossen Passion* nicht (vgl. die *Geisselung Christi*, B.8).[13]
Im *Marienleben* überragt er die kräftige, die ganze Bildbreite durchmessende Wagerechte der
Vorhangstange. Der Bogen aus keilsteinförmigen Quadern öffnet sich in einer Ziegelwand
mit teilweise abgeblätterter Verputzung, und vor ihr hängen—schöne Beispiele Dürerscher
Verkehrungen—die Vorhanghälften links breiter, rechts schmäler und von Eintretenden
aufgerafft; ihre entsprechend unterschiedenen Licht- und Schattenwellen erglänzen vor der
in sich stetigen, gleichmässig ausgebreiteten Beleuchtung und Beschattung der Architektur.
Wieder anders fängt die faltenlos weisse Altardecke nur ein paar Schlagschatten auf (über
dem Gehänge in abgetöntem Halbschatten)—in der anderen Umgebung der *Darbringung im*

[11]Das Bett und sein Baldachin beziehen den Eindruck von
Weichheit und Veränderlichkeit nicht zuletzt aus der Starrheit
der gegenüber liegenden Wand; vgl. dagegen das Himmelbett
in der *Marienverehrung* (B. 95).

[12]Man blicke demgegenüber auf die die *Apokalypse* ein-

leitende *Johannesmarter* (B. 61) zurück.

[13]Dazu die kotierte Hamburger Studie W. 259, bei der mir
eine Erinnerung an Mantegnas Stich *Christus in der Vorbölle*
(B. 5) nicht bloss wegen des frontalen Durchblicks durch den
Doppelbogen angebracht erscheint.

Tempel (B. 88) wandelte Dürer sie nochmals ab zu einem schmiegsamen Behang über den kantigen Stufen. In beiden Szenen steht der Altarkubus als Raumzentrum inmitten des Geschehenskreises der bewegten Gewandfiguren, und über *Joachims Opfer* hält die Vorhangöffnung, mitsamt dem Kronleuchter das Betrachterauge fest, lässt uns verweilen und trifft gerade mit der Reichweite der beiden Hauptpartner zusammen. Derart einfache, sinnfällig wirksame Erfahrungseindrücke hat Dürer erst in diesen Jahren seinen Kompositionen einverleibt, "nach Gerechtigkeit der Sach" zeichnerisch erfasst und differenziert, sodass sich das Einzelne in seiner Sonderart gegenüber Andersartigem ausprägt, mannigfaltige Wirklichkeitsbereiche charaktervoll gegeneinander treten. An ähnlichen Beständen der *Beschneidung Christi* (B. 86) (Vorhänge vor Rückwand) sind solche Qualitäten noch nicht in gleichem Grad entwickelt.

Immer aufs neue bewundernswert die *Flucht nach Ägypten* (B. 89): eine erschöpfende Bilderzählung, die nichts auslässt. Im Vordergrund die Familie (der Austausch der Blicke) unterwegs, der voranschreitende, geleitende Joseph, rittlings Maria mit ihrem Kind, die Tiere, gewachsene Natur und Gebilde von Menschenhand (links der einwärts weisende Stangenzaun, rechts der hinausleitende gemauerte Brückenbogen), ein feiner dunstiger Wolkenschleier mit einer Cherubimschar, und alles dies bis zu den beiden wendigen Salamandern und dem kauernden Hirsch artgerecht. Ein Wald,[14] zwar nur ein Ausschnitt, jedoch bilderfüllend und unabsehbar tief, dicht und trotzdem durchdringende Sonne (über Maria). Gibt man sich genauere Rechenschaft, so bemerkt man, mit wie wenigen Formtatsachen das Ganze "Wald" zustande gebracht worden ist. Nichts Krauses, kein vielteiliges Geäst, nur in der Mitte ziemlich nahes Buschwerk (hochrankend ein Weinstock zwischen Dattelpalme und Feigenbaum), dazu ein, zwei niedrige Baumkronen. Rundum fast nur Stämme statt vollständiger Bäume, die über die Bildhöhe hinausragen würden, und als verbindendes Medium raumeinwärts zunehmendes Halblicht unter nur zu ahnendem Blätterdach. Stamm bei Stamm, jeder eigen in Wuchs und Beleuchtung, kaum sich verzweigend: lauter lebendig profilierte und schwellende, mehr tektonisch und bildnerisch als malerisch durchgeformte Einheiten. Vorstufen für diesen Baumwuchs nimmt man zuerst in dem Holzschnitt der *Hll. Antonius und Paulus* (B. 107) wie in dessen Vorzeichnungen (W.183 mehr als W.182) wahr, und einen weiteren Schritt wohl auch über den Holzschnitt des *Marienlebens* hinaus hat unser Meister im *Adam und Eva*-Stich von 1504 gewagt mit seinem nicht genug zu betonenden, für den Garten Eden etwas verwunderlichen Waldesdunkel zwischen Baumstämmen fast ohne eine Krone; nochmals in der *Satyrfamilie*, 1505 (B. 69). Nur *eine* Formengattung, doch jedes Exemplar eigen, lauter Varianten, mit Dürer zu sprechen "Verkehrungen," aber "vergleichlich" wie unter Menschen Mann und Frau. Umgesetzt in eine architektonische Szenerie bietet die Säulenhalle der *Darbringung Jesu im Tempel* (B. 88) ein Analogon zu den Wäldern von Baumstämmen.[15] Dabei ist zu bedenken, dass sich ein so begrenztes Blickfeld im Wald wie in einer Säulenhalle nur bei sehr entschiedener Nahsicht einstellt. Die optische Aufnahme ist dadurch charakterisiert, dass der Gegenstand dem Beschauer auge so dicht wie möglich

[14]Gerade dies hat Schongauer nicht gebracht, sodass sein seit M. Thausing, *Dürer; Geschichte seines Lebens und seiner Kunst*, I (Leipzig, 1884), 339 noch jüngst besprochener

"Einfluss" zurückhaltender beurteilt werden sollte.

[15]Unbegreiflich ein so verständnisloses Urteil wie das jenige von Thausing, *ibid.*, I, 339.

genähert worden ist. Daran geben sich die reifen Blätter des *Marienlebens* zu erkennen.

Von hier aus öffnet sich ein weiteres Beobachtungsfeld. Mit Architekturen schafft sich Dürer im *Marienleben* innerbildliche Rahmungen, wie sie in seinen früheren Kompositionen und in Einzelblättern der ausgehenden neunziger Jahre nicht vorkommen, ausser wo etwa Bäumen oder Baumgruppen, nachdrücklicher alsdann bei *Antonius und Paulus* (B. 107) eine solche Rolle zufällt. An dem Vertikalismus flankierender Architekturen, auch der Baumstämme der Waldlandschaft in der *Flucht nach Ägypten* (B. 89) richtet sich die ganze Komposition auf. Bei dieser Randbefestigung und Einengung geht es um Konzentration. Indem Dürer Räume erschliesst und Dimensionen ausdehnt, die das Menschenmass übersteigen, nimmt er zugleich darauf Bedacht, den Aktionsraum des Personals dichter zu umhegen. Dabei bildet sich ein rationales Verhältnis zwischen den Figuren und ihrem Milieu heraus. Wie Joachim im Rundbogenportal der *Heimsuchung* (B. 84) begrüssend auf der Schwelle verharrt, mit parallel gesenkten Armen das Gewände überschneidend und von ihm überschnitten— markanter als in der Vorzeichnung (W. 293)—, kann nicht einprägsamer gedacht werden; die schlagende Kontrastierung zwischen schlicht agierender, jedoch faltenreicher Gewandfigur[16] und schmuckloser Bauform möge mit dem gehäuften und schwierigen Beieinander rings um Pilatus im *Ecce Homo* der *Grossen Passion* (B. 9) verglichen werden. Sehr Ähnliches in der *Geburt Christi* (B. 85): Joseph von grossem Mantel umhüllt, herabhängendes Kopftuch über schräger Aufraffung (durch den Stock), behutsam die Lampe voran, das scharfe Profil gleich neben dem Türpfosten, er macht einen letzten Schritt, ist im Begriff, in den Stall einzutreten; mit der schattigen Wand als Folie wird er schon von der das Gebäude und die Personen erhellenden Beleuchtung getroffen. Beidemal gehören Mensch und Bau zusammen, ist gerade dieser Bau gerade diesem Menschen angemessen; die *Heimsuchung* zeigt ganz ausdrücklich Joachims Haus.

Dehnen wir unsere Betrachtung über die Verhältnismässigkeit zwischen Person und Umwelt aus, so rühren wir zunächst an abweichende Phänomene der späten neunziger Jahre. Wieweit ist das *Weiherhäuschen* von der *Maria mit der Meerkatze* (B. 42) entfernt? Zwischen ihrer Rasenbank und dem jenseitigen Ufer liegt ein spiegelglattes Gewässer, das zur Abschätzung von Distanzen keinerlei Anhalt bietet. Dem Londoner Aquarell *Weiherhäuschen* (W. 115) nachgestochen, also unter einem eigenen Blickwinkel aufgenommen, wie geschickt auch immer kombiniert und wie reizvoll dem Vordergrund beigegeben (das hohe Strandgras vorn stammt gleichfalls aus dem Aquarell), ist beides doch nicht in nachprüfbarem, abgreifbarem Übergang verbunden; es gibt da eine Leerzone, einen Hiatus.[17] Keine Ungewissheit solcher Art treffen wir dagegen 1503 in der *Madonna an dem Zaun* (B. 34) an. Fernsicht entfällt, nur Vordergrund, aber dieser leichte Zaun (Andeutung des *Hortus conclusus*) besteht aus einem Gestänge wie von Maria ausgesucht, von ihren Händen zusammengefügt und verschnürt neben dem biegsamen Stämmchen, dem Gras und Gesträuch. In der *Apokalypse* ist das Schwanken der Grössenmasse, das Springen von einem zu einem beliebigen anderen, wieder und wieder anzutreffen, sei es dass Engel in Menschenstatur auftreten, sei es dass sie sie weit

[16]Zwölf Quadersteine hoch = sechs Kopflängen; vgl. die vitruvianischen Masseintragungen in der Londoner Vorzeichnung zur *Nemesis*; H. Kauffmann, *Tymbos für Wilhelm Ahlmann* (Berlin, 1951), 135ff.

[17]Ebenso unbestimmbar ist im *Büssenden Hieronymus* (B. 61) die Entfernung des Felsenberges—wie das *Weiherhäuschen* nach der wuchtigen Pinselzeichnung ehemals Bremen (W. 108) der Heiligenfigur beigegeben.

T

überragen, und ähnliche Varianten geht Gottvater ein. Der *Siebenköpfige Drache* (B. 71) ist
gemessen an der Grasstaude vorn nicht überwältigend gross und reicht dennoch mit seinem
Schweif hoch in die Sterne, das Sonnenweib ist weder grösser noch kleiner als Gottvater.
Überaus kennzeichnend für Dürers damaligen Phantasiespielraum spricht uns das grandiose
Blatt, überwältigend wie weniges, *Johannes der das Buch verschlingt* (B. 70) an: wie gross ist der
"starke Engel," dieses Wunder einer Himmelserscheinung (Offenbarung 10)? Seine Säulen-
beine fussen auf Erde und Meer, Leib und Arme fügen sich aus Gewölk zusammen, "ein
Regenbogen auf seinem Haupt und sein Antlitz wie die Sonne" und "hub seine Hand auf gen
Himmel." Allein, rechts wachsen weit höhere Bäume auf, alles Menschliche des "starken
Engels" überbietet des Johannes Körpermasse nicht, noch übertrifft das Buch, das er hinhält,
damit Johannes es verschlinge, den eigenen Folianten, von dem sich der Apokalyptiker
soeben abgewendet hat (da der starke Engel "schrie mit grosser Stimme, wie ein Löwe brüllet:
und da er schrie, redeten sieben Donner ihre Stimme," Vers 3). Zwar scheint sein Standort
dem Vordergrund nahe, jedoch Körper und Haupt entweichen in unbestimmbare Fernen.
Als ein unermesslicher tritt der "starke Engel" auf, der visionären Welt der "Offenbarung"
entsprungen und dem Ungeheuerlichen zugehörig, nach Dürers späterer Terminologie ein
"Traumwerk." Inkommensurables rückt in der Bildkomposition nebeneinander, umgekehrt
ausgedrückt: kein rationales Grössenverhältnis bestimmt Auswahl und Ordnung.[18] Wie
anders prägt sich wenig später des *Christophorus* (B. 104) Riesenhaftigkeit aus. Wohl ist die
Grosse Passion von den hochgradigen Ungereimtheiten der *Apokalypse* frei, doch gibt es genug
Bruchstellen, sodass die Kontinuität und die Orientierung aussetzen: im *Ecce Homo* (B. 9) der
windschiefe Pilatusbau und die jenseitige Ferne, links vorn der Knabe zu klein für die Männer
nebenan; wo steht, wozu gehört in der *Geisselung* (B. 8) die Säule, wo und wie ist der Vorhang
(ohne Ringe) befestigt, wie ist in der *Kreuztragung* (B. 10) der Torbau zusammengesetzt und
was liegt zwischen ihm und den Rundtürmen? Warum sehen in *Grabtragung* (B. 12) und
Beweinung Christi (B. 13) Grabeshöhle und umgebende Landschaft so verschieden aus? Ist das
Pferd der *Reiterin neben dem Landsknecht* (B. 82) nicht zu klein? Die *Vier Hexen* von 1497
(B. 75) halten Isokephalie ein, obwohl zwei von ihnen eine, wenn nicht zwei Stufen tiefer
stehen; im *Traum des Doktors* (B. 76) wird uns ein Einblick in die Raumverhältnisse verwehrt.
Nimmt man danach die *Hll. Antonius und Paulus* (B. 107) vor, so treffen wir eine nirgends
aussetzende Stimmigkeit an: Einklang zwischen allen Bildbeständen und dem Menschenmass
und kontinuierliche Abstufungen der Zonen. Die hohen Bäume sind so stark, dass sie von
den Männern noch umspannt werden könnten—anders als die schlanken im *Herkules*-Stich
(B.73)—, der Rabe ist nahe und das halbierte Brot, das er bringt (mitten im Bild), passt
ebenso wie die Geräte auf dem Tisch in die Hände der Heiligen, Felsentisch und Felsensitze
sind ihnen angemessen; der schmale Bach wird von einer halbrund gefassten Quelle gespeist.
Die Männer sind grossflächig erhellt.

 Ähnlich dem *Sposalizio* des *Marienlebens* (B. 82) überrascht die schon erwähnte *Darbrin-
gung im Tempel* (B. 88) mit der erstaunlichsten Neuerung. Die denkbaren Voraussetzungen
dieser allerseits, auch auf uns zu weitergehenden Säulenhalle mit offener Kassettendecke

[18]In *Sieben Posaunenengel* (B. 68) fehlt jeder Vergleichsmass-
stab; das Händepaar an dem Felsklotz, der ins Meer geworfen
wird, ist viel grösser als alle anderen Hände.

(Piero della Francesca), desgleichen die asymmetrische, "stathmische" Perspektive lasse ich jetzt beiseite zugunsten der noch nicht hinreichend gewürdigten Dimensionen dieser Säulen und ihrer Gebälke: Säulen, die wie an der vordersten handgreiflich demonstriert wird mit einer Armeslänge halb zu umspannen sind, aber zierliche Weinrankenkapitelle (eucharistischer Hinweis) tragen, ein ihrer Höhe korrespondierendes Volumen, vitruvianisch 6, 4 untere Säulendurchmesser hoch,[19] somit dem Mass entsprechend, um das sie die Personen überragen—analog den Stämmen im Wald der *Flucht nach Ägypten* wie auch des *Sündenfalls* von 1504. Je weniger zufällig die Grössenverhältnisse und die Gegensätze zwischen Menschen und Säulen wirken, umso achtloser scheint man über das Ausserordentliche dieser regelstrengen Organisation hinweggesehen zu haben.[20] Perspektive erscheint nur mehr als ein Zweig allgemeiner Massgerechtigkeit und Verhältnismässigkeit.[21] Und so ist denn auch für die *Mariengeburt* (B. 80) und für ihr ganzes Ensemble nicht die Perspektive in erster Linie bestimmend, grundlegend ist vielmehr, dass die Architektur und alle Dinge an ihr und in ihr auf die Personen zugeschnitten sind, die mit ihnen umzugehen haben und mit ihnen hantieren, ein Einklang, der uns unmittelbar berührt und aus dem nirgends Ungereimtes herausfällt. Hier setzt ein, was, anders als im Paumgärtner Altar, die Florentiner *Anbetung der Könige* von 1504 durchdringt und—darf man ein Jahrzehnt vorausschauen—für die "Meisterstiche" massgebend bleibt: die *Melancholie* könnte alle Werkzeuge, die sie umgeben, wie ihren Zirkel handhaben, sodass sich alles "vergleichlich reimt."[22]

Indem Dürer geräumige Architekturen errichtet und grössere Dimensionen einführt die das Menschenmass übersteigen und ihm gerade dadurch gemäss sind, nimmt er als Erzähler zugleich darauf Bedacht, die Komposition auf das Geschehen gravitieren zu lassen. Den Kern der Geschichte, den Bezirk des Geschehens grenzt er enger und enger ein, umhegt die Hauptgruppe knapper. Im weiteren und höheren Ringsum wird eine Zelle für das namengebende Ereignis mit den Trägern der Handlung ausgespart. Die *Verkündigung* (B. 83) macht gerade auch nach der Berliner Vorzeichnung (W. 291, 1503) Dürers Bestrebung offenbar, die Begegnung von Maria und Gabriel nicht dem ungeteilten Höhenmass der Bogenhalle auszusetzen, sondern einige interne Begrenzungen einzuarbeiten, kleinere Felder entstehen zu lassen und das vergrösserte Figurenpaar mit einem niedrigeren Baldachin zu umgeben.[23] Das Bildfeld ist weniger steil aber breiter und es ist mehrfach unterteilt, grösseren Rechtecken sind kleinere einbeschrieben.[24] In dem kleinsten Gehäuse hat Maria an Stattlichkeit und Personenwert zugenommen. Eine innerste Umrahmung umgreift und überhöht eigens die

[19]Vitruv Lib. III : 3, 2.

[20]"Die Beschauer mussten sich sagen : ja, das haben wir unbewusst sehr lange empfunden, hier zum erstenmal ist das Siegel gelöst" : G. Dehio, *Geschichte der deutschen Kunst* (Berlin, 1926), III, 47.

[21]Über die kandelaberartigen Säulen, Vitruvs (Lib. III ; 3, 5) "species barycephala" in *Mariens Tempelgang* (B. 81)—in Fra Giocondos Vitruvausgabe (Venedig, 1511), 51v, mit Abbildung ; über die Datierung vgl. A. Gottschewki-G. Gronau, [G. Vasari], *Die Lebenschreibungen der berühmtesten Architekten, Bildhauer und Maler*, VII², ed. F. Schottmüller (Strassburg, 1927), 3, 5f. u. 15—lässt sich Derartiges nicht sagen, während im *Zwölfjährigen Jesus im Tempel* (B. 91) die Säule bei Maria der Vollwertigkeit nahekommt.

[22]Wie vielsagend, dass die Wage in der Berliner Vorzeich-

nung (W. 620) erheblich grösser und umgekehrt belastet (anders der nebenan gesondert gezeichnete Wagebalken), demnach im Stich ganz neu gezeichnet worden ist. Übereinstimmendes schon bei Verwendung des Hundes (Vorzeichnung in Windsor W. 241) im *Eustachius*-Stich (B. 57).

[23]Die beträchtlichen Neuerungen des Holzschnitts fordern dazu auf, sie bei dessen Datierung einzurechnen, das Blatt also nicht zu früh, näher der Wende 1503-1504 als früher anzusetzen.

[24]Hier seien aus späteren Jahren die *Anbetung der Könige* von 1511 (B. 3), ausserdem *Der Büssende (Reuiger David ?)* von 1510 (B. 119) und *Herodias überbringt das Haupt des Johannes* von 1511 (B. 126) herangezogen, nicht zuletzt der Entwurf zum *Hl. Hieronymus* (Ambrosiana) 1511 (W. 590) mit dem Holzschnitt (B. 119).

heiligen Hauptpersonen des *Sposalizio* (B. 82), während ihren Begleitern die Plätze von "Gewändefiguren" überlassen sind. In der *Anbetung der Könige* (B. 87) ist die Hl. Familie bereits in der Londoner Vorzeichnung (W. 294) von einem Rundbogen und Tonnengewölbe baldachinartig übergriffen. Vollends ragt die *Darbringung im Tempel* (B. 88) mit ihrer in schattige Höhe und Ferne ausladenden Halle hervor durch zwei-dreimalige Umstellung des Geschehenskreises zwischen Joseph und Simeon mit Säulen und Gebälken: ein innerer Bezirk, nicht mehr als ein Drittel des gesamten Bildgevierts ist für die Zeremonie ausgespart, sodass sich diese nicht in der Weite verliert, und die Figuren, obwohl nicht gross, sich in einer güngstigeren Relation zu dem hochgebauten Raum einordnen. Ebenso wenig kann man übersehen, wie in der *Flucht nach Ägypten* (B. 89) Joseph und Maria von zwei kräftigen Bäumen eingefasst und zusammengehalten werden, und wer empfände nicht in *Christ, Abschied von Maria* (B. 92) die behutsamen Unterteilungen durch die überklammernde Zinnenmauer und die zugleich isolierende wie erhebende Wirkung von Tor und Baum (mit dem sprechenden Kontrast zwischen einem prallen Baumstamm in seiner Rinde und einem vierkantigen, gemaserten Holzpfosten).[25] Ein Äusserstes hat Dürer 1504 in seinem *Weihnachten*-Stich (B. 2) (18, 5 × 12 cm) gewagt: eine geräumige Architekturszenerie, mehr als haushoch, die Fassade zum Greifen nahe, auf kurze Distanz sehen wir uns ihr gerade gegenüber, darin unten winzig die Hl. Familie und ein anbetend kniender Hirte. Das Ganze ein jüngerer Nachfolger der *Anbetung des Kindes* vom Paumgärtner Altar. Perspektive gab es dort schon, freilich bei höher liegendem Augenpunkt in jäher Konvergenz wie bei Nahsicht.[26] Der klare Aufriss des Fachwerkbaus und des Brunnenpfostens ist das Neue, unverzerrt überschaubar und abgreifbar, geschossweis unterteilt, sodass die Grössenverhältnisse optisch wirksam werden. Die *Anbetung des Kindes* geschieht im Erdgeschoss in nahezu quadratischem, schattigem Balkengeviert (reichlich 1/9 der Bildfläche insgesamt), ein Intimbereich, Herzstück der Bilderzählung, und diese Sphäre auf das Figurenmass eingespielt und vice versa. Und nun unterlasse man nicht, sich des *Verlorenen Sohns* im Stich (B. 28; um 1496) zu entsinnen: seine meisterlich schöne, vorher noch nie gesehene Häusergruppe wirkt, krass gesagt, substanzlos, wie Kartenhäuser, Mauern und Dächer kaum unterschieden, und ihr Abstand von den Vordergrundsfiguren, auch schon in der Londoner Skizze (W. 145) lässt sich nicht schätzen. Wie eingänglich sind dagegen im *Weihnachten*-Stich Monolithe, Quader- und Ziegelbau gegenüber dem Fachwerkhaus und seinem Strohdach individualisiert, kontrastiert; ja, das Fachwerkhaus ist so erschöpfend bis ins Letzte durchgearbeitet, dass es Stück für Stück nachbaubar wäre, überall Menschenwerk und Menschenhände spürbar werden, nicht grösser

[25]Weitere Beispiele brauchen wohl nicht namhaft gemacht zu werden. Immerhin, wieviel hilft in der *Begegnung unter der Goldenen Pforte* (B. 79) die perspektivische Konvergenz mit der Begrenzung der Mauer für das Zueinander der Ehegatten; *Mariens Tempelgang* (B. 81) spielt sich vor einer mehrfach fächerweis unterteilten, doch nicht recht kommunizierenden Szenerie ab; die *Geburt Christi* (B. 85) rückt mit der *Anbetung der Könige* (B. 87) an die Seite der *Verkündigung*; die *Beschneidung Christi* (B. 86) dürfte der *Zurückweisung von Joachims Opfer* (B. 77) vorangegangen sein. Auch unter diesen Gesichtspunkten hält sich die *Ruhe auf der Flucht* (B. 90) abseits, nicht dagegen das Schlussblatt *Mariens Verehrung* (B. 95), sodass Panofskys (*Albrecht Dürer*, 97) Zeitbestimmung "of slightly earlier date than the rest of the series" nicht zwingend wirkt, vielmehr ganz benachbart der Coburger *Geisselung Christi* von 1502 (W. 259).

[26]An eine so frühe Datierung, wie sie neuerdings befürwortet wurde (F. Anzelewsky: *Albrecht Dürer—Das malerische Werk*, Berlin, 1971, Nr. 50) denke ich nicht, schon wegen der lichthaltigen, weich abgetönten Farbigkeit; ich stimme der Zeitbestimmung im Katalog der Alten Pinakothek München, II, *Altdeutsche Malerei* (1963), 72ff. zu: "nach 1498 ... zwischen 1502 und 1504" = E. Panofsky; D. Kuhrmann: Rezension von Anzelewsky, *Albrecht Dürer—Das malerische Werk*," *Kunstchronik* (XXVI, 1973), 304.

als sie Joseph und Maria eigen oder zuzutrauen sind. Das Haus ist alt, vom Verfall bedroht, von zwei Fensterläden ist einer weit aufgeschlagen, der Fensterflügel nach innen geöffnet, sodass man merkt, ein Zimmer liegt hinter dieser Front, und die Treppe führt hinauf. Hoch oben sind die Bäume durchsichtiger auseinander gehalten als im Paumgärtner Altar.

Es geht nicht an, bei *Weihnachten* die musterhafte Perspektive, bei *Adam und Eva* die exemplarische Proportionierung (mit der jahrelange Vorarbeiten ans Ziel kamen) zu unterschätzen. Muss man aber soweit gehen, um der Konstruktion willen beide Stiche von 1504 gleichsam in einem Atem zu nennen?[27] Der Bildgestaltung im Ganzen suche ich inne zu werden mit der Kennzeichnung der Formwerte, die seit 1500 aufgekommen sind und im *Marienleben* Raum gewonnen haben. Schon im Vorangehenden ist der eine oder andere Zug des *Adam und Eva*-Stichs berührt worden : die Nahsicht bei offener Frontalität, zugleich mit dem regulären Profil der Köpfe (beides auch zur Sichtbarmachung der Massverhältnisse) ; die Reinheit der Umrisse und die möglichst absatzlose Lichtheit (so verschieden von der partienweisen Umrandung der Muskulatur im *Herkules*-Stich, B. 73 und im *Traum des Doktors*, B.76) ;[28] der Wald als eine Ansammlung von Stämmen ; der Vertikalismus. Adam und Eva zeigen sich *sub specie* des Universums, "paradiesisch" als Kreaturen unter Kreaturen[29] und ihre Eigenarten manifestieren sich wieder durch Kontraste, die durch die Mitwirkung der unübertroffenen Meisterschaft in der Differenzierung der Oberflächenqualitäten intensiviert werden : wo gibt es dermassen subtilen Feinstich wie die Zartheit von Evas Haut? Entgegen den Vierbeinern—dem Elch liegt die Londoner Zeichnung (W. 242) zugrunde—halten sich die Menschen aufrecht, aber von den Bäumen unterscheiden sie sich durch ihren gegliederten Bau, durch ihr bewegliches Auftreten und durch gegenseitige Verständigung, neben den Baumrinden und deren Narben durch ihre glatte Haut über Muskulatur und bei Eva noch zartere Übergänge ; nirgends vermengen sich Blattwerk und Haare. An Menschen Proportionierung, an Bäumen nicht einmal ein Ansatz dazu. Ohne den meist betonten normativen Rang dieser Proportionsfiguren, dass Menschen, auch Tiere—wenngleich verschieden—proportioniert sind, herabsetzen zu wollen, sollte angesichts des Bildganzen der Individualisierung der Primat zuerkannt werden : Species neben Species und jede eigen, so denn auch der Mensch ein Geschöpf sui generis, und Mann und Frau nochmals differenziert, Varianten, graduell verschieden, will sagen "vergleichlich."[30] Allein, auf ihre Grössenunterschiede hin angesehen auch alle anderen Geschöpfe untereinander "vergleichlich," d.h. masstabgerecht.

Seit ca. 1500 begann Dürers künstlerisches Denken den Proportionen von Menschen und Tieren (hauptsächlich Pferden) nachzugehen. Mit dem Eindringen in sie dehnte er sich auf die Morphologie der Naturwesen aus. Von der gleichbleibenden Stetigkeit jedes Gattungstypus, seiner Variationsbreite und deren Grenzen sah er sich gefesselt und suchte sie zu definieren. Sein damals aufkommender Eifer, dieser Bildungsgesetze von Gewächsen,

[27]Panofsky, *Albrecht Dürer*, 85, und Winkler, *Albrecht Dürer*, 164. Zum Thema insgesamt zuletzt W. Schadendorf im Katalog der Nürnberger Dürer-Ausstellung, 1971, 240ff.

[28]Wer könnte den Männern des *Männerbads* (B. 128), auch im Vergleich mit ihrer Umgebung ansehen, dass sie nackt sind? Oder in der *Grossen Passion* Christus von der *Kreuzigung* an (B. 11–13)?

[29]Der Panofsky, *Albrecht Dürer*, 84f. aufgedeckte allegorische Hintersinn der Tiere behält natürlich seine volle Geltung ;

Vorzeichnungen zu Elch, Papagei und Kaninchen (W. 242, 244, 359). Parallel die *Maria mit den vielen Tieren* (W. 295–97).

[30]"Verkehrung" und "Vergleichung," die fundamentalen Kategorien der Dürerschen Proportionslehre (H. Kauffmann, *Albrecht Dürers rhythmische Kunst*, Leipzig, 1924, 99ff. ; dann auch E. Panofsky, *ibid.*, 273–80) verhalten sich reziprok. "Verkehrung" bei gleichartiger Stammform sichert "Vergleichung," und "Vergleichung" heisst "es gibt eine grosse Vergleichung in ungleichen Dingen."

Menschen und Tieren inne zu werden, ihre Regeln zu ergründen, drängte ihn zu den erschöpfenden, mit Wesensmerkmalen gesättigten Feder- und Pinselstudien, Reihen von Blättern, die in dem *Hasen* (1502), in dem *Grossen Rasenstück* (1503) und in dem *Pferd* (1503) gipfelten, vollends 1504 in den auf den *Adam und Eva*-Stich hinzielenden Vorarbeiten. Das kostbare, aus linker und rechter Hälfte zusammengeklebte Blatt der Pierpont Morgan Library (W. 333) sieht so fertig aus, als wäre es auf die Kupferplatte abgedrückt. In Wahrheit sind Zeichnung und Stich keineswegs deckungsgleich. Über Winklers Erläuterung der veränderten Attribute und Momentwahl hinaus sehen wir nicht nur Standniveau und Scheitelhöhe des Paars und den Abstand zwischen Mann und Frau gewandelt, sondern auch Eva verschmälert, gegen ihre Schwere in W. 333 im Stich ungleich feiner gewachsen und über ihrem Standbein einseitiger ponderierend (mehr noch gegenüber W. 334, seitenverkehrt reproduziert, und W. 335). Schaut man noch genauer hin, so findet man beider Umrisse (und nicht nur Aussenkonturen) ganz neu gezogen[31] und zwar dergestalt, dass die Massfiguren (Zeichnung) mit mehr Lebensimpulsen (Stich) angefüllt worden sind. Kurvenreicher wechseln Wölbungen und Buchten.[32] Die kühle Rechnung der in der Zeichnung niedergelegten Proportion besteht als konstitutiver Faktor fort, bleibt für das Gerüst massgebend und bedeutet sozusagen die eine, heimliche Seite des Körperbaus. Sie ist in der stecherischen Ausführung mit muskulöserer, schwellender und atmender Leiblichkeit überkleidet, sodass von innen her belebte Organismen erstanden und das Aussehn beherrschen. Dieselben Schritte beobachten wir von der Londoner Vorzeichnung (mit Masseintragungen) W. 266 zu dem Stich der *Nemesis*. Es ist deshalb in meinen Augen ein Missverständnis, dass Dürers Kunst in *Adam und Eva* "reiner Formalismus zu werden drohte" (Winkler). Vielmehr verdienen *Adam und Eva* wegen ihrer Proportionierung nicht mehr als wegen ihrer Leibhaftigkeit und Belebung gewürdigt zu werden,[33] und so, als vollgültige Menschenbilder vereinigen sie sich mit den sie umgebenden Naturwesen und erheben sich über sie. Schliesslich soll nicht übergangen sein, dass erst im Stich die Spiegelbildlichkeit der Binnenkonturen des Paars zur Wirkung gekommen ist, eine Korresponsion, die zu der schönen Harmonie Bestimmendes beiträgt.

Fragt man nach der Fortdauer der Errungenschaften, die sich in diesen Anfangsjahren des neuen Jahrhunderts eingestellt hatten, so darf man sagen, dass Dürer sie nicht mehr preisgegeben, sondern sich weiterhin von ihnen hat leiten lassen. Mochten auch Aufgabenbereiche und Themenkreise von Jahr zu Jahr sich ausdehnen, so blieb doch die im *Marienleben* aufsteigende Bildkunst der "Vergleichlichkeit" fruchtbar und hat sich zu immer neuen und freieren Spielarten "verkehrt." Das *Rosenkranz fest* und der Helleraltar haben sich—ungeachtet aller Traditionsfragen—diesen Ordnungen gefügt (Gestaltenklarheit, Frontalität, innerbildliche Rahmung, Nahsicht, Individualisierung; Kontrast zwischen Rücken- und Facefiguren). Die nachträgliche Vervollständigung des *Marienlebens* 1510 durch *Tod* und, dem Helleraltar

[31]Dies hat auch Panofsky, *ibid.*, II, 58, Nr. 458 angedeutet; ob freilich zwischen dieser Zeichnung und dem Stich noch eine "endgültigere" Vorarbeit einzuschieben ist, erscheint mir fraglich.

[32]Man vergleiche hier und dort Adams Halslinie, seinen hochgreifenden Arm, unterhalb von ihm den Kontur des Rumpfs, bei Eva Hals und Schultern, die Beuge ihres vorgreifenden Arms, ihren hängenden Arm und neben ihm ihre Hüftlinie.

[33]Auf dem Wege zum Ziel, also erst nach W. 333 hat Dürer 1504 das Londoner Studienblatt W. 336 ausgearbeitet. In den Zusammenhang des Stichs und nicht in den des Madrider Bilderpaars von 1507 reihe ich, abweichend von Winkler und Panofsky, *ibid.*, II, 58, Nr. 460 und 461, ausser der Londoner *Eva* (W. 335) das doppelseitig bezeichnete *Adam*-blatt (W. 421–422) ein; im Madrider Bilderpaar kommt eine ganz andersartige emotionale Bewegtheit auf, und die Beleuchtung fällt von links her ein.

nahe, *Himmelfahrt* (B. 93 und 94) bestätigt, wie bewusst Dürer die Organisation der früheren Blätter festgehalten hat. Von der Vorzeichnung des *Marientodes* (W. 471) zum Holzschnitt wurden die Figuren wuchtiger, das Ensemble dichter, der Abstand zum Beschauer geringer (Einarbeitung der Stufen vorn) und die Aufsicht verstärkt; zwingender setzt sich die achsiale Öffnung des Bildraums durch, zugleich sieht man Maria erhöht, die Haltungen der grosszügig vereinfachten Apostel markanter abgestuft, und die Kontraste vermehrt und verschärft (am Betthimmel die Lambrequins und die Asymmetrie der seitlichen Vorhänge). Alle Belebtheit leitet sich aus dem Gegensatz zu den tektonischen Geraden, Kuben und Kreisen der Raumform und des sparsameren Mobiliars her, aus den breiten Helligkeiten vor dunklerer Folie, und das Blickfeld zieht sich von der Gesamtweite zu dem innersten Rechteck zuzammen, das am Kopfende des Bettes die feierliche Zeremonie, die schöne Begegnung der Hände von Maria und Johannes (mit der Kerze) und Petri Hand mit dem Weihwasserwedel umrahmt.

BERLIN—BONN

The Chantilly *Miroir de l'humaine salvation* and Its Models

HERBERT L. KESSLER

It is not surprising that Millard Meiss's investigation of French painting at the time of John of Berry is above all else a study of manuscript illumination. Throughout the Middle Ages the illustration of texts had occupied the greatest artists, and the decades around the year 1400 were not exceptions. The most creative talents of the period—Jacquemart d'Hesdin, the Boucicaut Master, and the Limbourg brothers—were all illuminators and, as Professor Meiss states in his introduction, "illumination was then not a minor but a major art."

Less than a century after the death of Duke John—some would claim within a few years of his passing in 1416—manuscript illumination had degenerated into a secondary, largely derivative art form. However impressive the accomplishments of the Master of Catherine of Cleves, Jean Fouquet, and the illuminators employed by Philip the Good, they were entirely overshadowed by contemporary achievements in panel painting and printmaking.

Fifteenth- and sixteenth-century manuscripts are not, however, devoid of artistic merit or without historical interest. This is especially true of the Ghent-Bruges manuscripts, which display a level of technical excellence rarely equaled in earlier books and which, precisely because they were so derivative, preserve valuable records of contemporary and antecedent art in the whole range of media.

One manuscript, hitherto entirely ignored in the study of Ghent-Bruges illumination, is a unique document of the illustrator's art at the turn of the sixteenth century. This manuscript is the *Miroir de l'humaine salvation* at Chantilly (Musée Condé, MS franç. 1363)[1]—a handsome volume containing an abbreviated French translation of the popular fourteenth-century typological treatise, *Speculum humanae salvationis*, illustrated with 168 miniatures.[2] Students of sixteenth-century illumination have neglected the Chantilly *Miroir* because, ever since it first became known in Paris early in the nineteenth century, the manuscript has been mistakenly identified as a volume from the library of Philip the Good.[3] It does, in fact, fit the description of an illustrated volume in the inventory prepared at the time of Philip's death in 1467: "Ung autre livre en parchemin couvert d'ais rouges, intitulé au dehors : *Le miroir de humaine Salvacion*; comançant au second feuillet, *Preceptum datur* et au dernier, *Commūn regis Assueri*."[4] The first lines of fol. 2r (Fig. 1), and of fol. 43r in the Chantilly *Miroir* match perfectly those cited in the entry. This correspondence is especially noteworthy because the volume lacks the prologue and last three chapters of the *Speculum* text, which are included in

The author wishes to thank Professors Robert A. Koch and Jethro Hurt for commenting on an earlier draft of this article.

[1]F. Guyer, *Chantilly, Musée Condé, Le cabinet des livres: Manuscrits* (Paris, 1900), 128ff.; J. Meurgey, *Les Principaux manuscrits à peintures du Musée Condé* (Paris, 1930), 138ff.; J. Lutz–P. Perdrizet, *Speculum Humanae Salvationis* (Mulhouse, 1907), 105, 256, 276, 297, and 331.

[2]For the full Latin version of the *Speculum* text, see Lutz and Perdizet, *ibid*. The translation in the Chantilly volume is one of seven into French.

[3]The manuscript was sold at least three times during the nineteenth century. It was item no. 77 in the 1827 sale of L.M.J. Duriez (de Lille); it was sold again in 1833 at the Bruyère-Chalabre sale, from which it was purchased by Armand Cigongne; and finally, it was acquired by the Duc d'Aumale in 1861. Cf. *Catalogue des livres de M. Armand Cigongne* (Paris, 1861), no. 24, p. 5; Guyer, *Chantilly, Musée Condé . . . Manuscrits*, 128–30; and Meurgey, *Les Principaux manuscrits*, 138–44. It was identified as the *Miroir* of Philip the Good in *Supplement. Catalogue des Livres . . . de M. Crozet* (Paris, 1841), no. 8; see n. 14, below.

[4]J.B.J. Barrois, *Bibliothèque protypographique* (Paris, 1830), item 760.

most of the French translations. It is understandable, therefore, that once this manuscript had been associated with the item in the Burgundian inventory, it was generally accepted as a product of the mid-fifteenth century.

Philip's *Miroir* was listed a second time. It appears in an inventory prepared at Ghent in 1485. In that listing, however, the librarian recorded not the picture captions but lines of the actual French text: "Item, ung livre en parchemin de lettre bastarde, couvert de cuyr rouge et de clous et de cloans de léton, intitulé: *Le Miroir de l'umaine salvacion*, où il y a en chacun feuillet trois hystoires au viel Testament et une du nouvel; quemenchant au second feuillet, *Lieu n'estoit pas quy [sic] d'un arbre ne de deux*, et finissant, *le Père et le Filz et le Saint-Esperit. Amen*."[5] The Chantilly *Miroir* terminates "le Père et le Filz et le Saint Esperit. Amen," but fol. 2 does not begin "lieu n'estoit pas garni d'un arbre ne de deux." That partial sentence occurs on fol. IV. The second leaf commences, "haulz et esleues quilz sembloient touchier aux . . ." The *Miroir de l'humaine salvation* now in the Musée Condé at Chantilly certainly cannot be the volume once in the library of Philip the Good.

Internal historical evidence and an analysis of its style further confirm the conclusion that the Chantilly manuscript is not the volume inventoried in 1467 and again in 1485. The Chantilly *Miroir* contains two inserted leaves occupied entirely by the coats-of-arms of its early owners. The first displays the arms of the Flemish family Le Fèvre. The second depicts an angel carrying in its right hand the Le Fèvre arms and in its left those of the Dutch family Van Heemstede.[6] It is likely, therefore, that this manuscript once belonged to Roelant Le Fèvre, who had married Hadewij van Heemstede some time in the second half of the fifteenth century, and whose children took the name Le Fèvre-Van Heemstede.[7] Although it is not certain that Roelant Le Fèvre actually commissioned the manuscript, it is evident from the Le Fèvre-Van Heemstede arms that it could not have been in the Burgundian collection during the sixteenth century. The volume described in the inventories of 1467 and 1485, on the other hand, remained in the Burgundian library until after 1577, when it was recorded in the Viglius catalogue.[8] It was subsequently removed and is not cited in the Sanderus inventory of 1643.[9]

The style of its miniatures, however, is the most compelling proof that the Chantilly *Miroir* is not Duke Philip's manuscript. The robust, carefully individualized figures, the richly differentiated textures, and the spacious settings of its miniatures are not typical of mid-fifteenth-century illumination but are characteristic of Ghent-Bruges art around the year 1500. Specific similarities can be noted in such famous Ghent-Bruges products as the *Grimani Breviary* (Venice, Biblioteca Marciana),[10] the Breviary in the Musée Mayer van den Bergh in Antwerp,[11] and the *Breviary of Eleanor of Portugal* (New York, Pierpont Morgan Library, M. 52).[12]

[5]*Ibid.*, item 1620.

[6]Le Fèvre: ecu d'or à aigles de sable armés et becqués de gueules, séparés par une épée de sable posée en bande avec la devise "secours à Dieu." Van Heemstede: ecu d'or à sept merlettes de gueules rangées en orle. In the seventeenth century, the manuscript belonged to L. d'Haudion, Sr. de Grebrechies.

[7]S.V. Leeuwen, *Batavia Illustrata* ('s-Gravenhage, 1685), I, 980.

[8]F. Frocheur, "Inventoire de Viglius," in *Catalogue des manuscrits de la Bibliothèque Royale des Ducs de Bourgogne* (Brussels–

Leipzig, 1842), cclx.

[9]*Ibid.*

[10]G. Coggiola, *Le Bréviaire Grimani* (Leyden, 1908); M. Salmi *et al.*, *Breviario Grimani* (Venice, 1971).

[11]C. Gasper, *Le Bréviaire du Musée Mayer van den Bergh à Anvers* (Brussels, 1932).

[12]P. Wescher, "Sanders and Simon Bening and Gerard Horenbout," *Art Quarterly* (IX, 1946), 191ff.; catalogue of the exhibition "Illuminated Books of the Middle Ages and the Renaissance," Walters Art Gallery, Baltimore, 1949, 76.

Particularly close in style to the Chantilly illustrations are several of the small miniatures in the Morgan Library manuscript. The depiction of the *Amalekite Bringing Saul's Crown to David* (fol. 297v; Fig. 2) is a good example and can be compared to the representations of *Christ Derided by the Jews* and *Michol Deriding David* in the Chantilly *Miroir* (fol. 25v; Fig. 3). In both manuscripts, the narratives are enacted by heavy, meticulously detailed figures; and in each, the nervous, irregular strokes that delineate the features give a rather sleepy, unfocused expression to the craggy faces. David in the Chantilly miniatures resembles his New York counterpart in the style of rendering, in facial type, and even in costume. He can also be compared to the kneeling Amalekite. The difficulty the illuminator had in foreshortening the arm of the figure between the Amalekite and David in the Morgan picture is also evident throughout the Chantilly *Miroir*. In both manuscripts, garments are rendered in tinted washes and are modeled in deeper shades; rocky hills frame the clustered figures in both; and although the feathery trees of the Chantilly illustration have no counterpart in the Morgan Library David miniature, similar foliage types appear in other scenes in the *Breviary*.

The portrait of Eleanor of Portugal and the *cordelière* of the widow on fol. 1v provide a date between 1495 and 1525 for the Morgan Library manuscript. On the basis of its similarity to the *Breviary* and to other Ghent-Bruges manuscripts, the Chantilly *Miroir* can be dated to the same period—probably toward the beginning of the thirty-year span. This attribution corresponds perfectly with the origin indicated by the Le Fèvre-Van Heemstede arms.

Although the Chantilly *Miroir* cannot be the manuscript from the library of Philip the Good, it nevertheless must be related to it. It contains the same abbreviated prose translation of the *Speculum* text and Latin captions identical with those in the ducal volume. Fortunately, the *Miroir de l'humaine salvation* cited in the inventories of 1467 and 1485 can now be identified and its relationship to the Chantilly version investigated in detail.

Philip the Good's *Miroir* belongs today to The Newberry Library in Chicago (MS. 40).[13] In format, contents, and illustrations, it is almost identical to the Chantilly volume. Like the latter, it is written in two columns of 28 lines on 43 folios and is illustrated with 168 miniatures. The Newberry *Miroir* measures 38.2 × 28.3 cm.; the Chantilly manuscript, 39.5 × 30 cm. The Chicago volume contains the same Latin captions and the identical text as that in the Chantilly *Miroir*. It is no wonder, then, that ever since they appeared on the Paris market in the 1840s, the two manuscripts have been compared and confused with one another.[14] Whereas the Chantilly volume conforms to only one of the fifteenth-century inventories of

[13]Formerly in the Chicago collection of Louis Silver. C.U. Faye–W.H. Bond, *Supplement to the Census of Medieval and Renaissance Manuscripts in the United States and Canada* (New York, 1962), 176; catalogue of the exhibition "Manuscripts Selected from the Louis Silver Collection," The Newberry Library, Chicago, 1965, no. 43; catalogue of the exhibition "French and Flemish Illuminated Manuscripts from Chicago Collections," The Newberry Library, Chicago, 1969, no. 6. The author, in collaboration with Professor Robert A. Koch, is currently preparing a monographic study of the Newberry *Miroir*.

[14]Newberry MS 40 appeared in a sale of the library of Joseph Crozet at Techner's on Christmas Day, 1841. In the catalogue entry of that sale (*Catalogue des Livres . . . de M. Crozet* [Paris, 1841], 2), the Chantilly manuscript is disparagingly cited as

"un pareil manuscrit, mais moins beau de conservation et de reliure, a été payé 2,860 fr. Duriez, et 1,981 fr. Bruyère-Chalabre." This judgment was changed in the supplement to the Crozet catalogue:

J'ai annoncé que l'exemplaire du Speculum humanae salvationis, vendu en dernier lieu chez Bruyère-Chalabre, etait *moins beau de conservation et de reliure* que le notre. Aijant eu depuis occasion d'examiner cet exempl., qui a passé dans l'un des plus riches cabinets de la capitale, je suis obligé de reconnaître que j'ai été induit en erreur. L'exemplaire de M. C[igongne] est d'un velin moin blanc que celui de la vente Crozet, mais ses miniatures coloriées sont supériures, et de plus il est doté d'une belle reliure anciennes, avec tetes de clous et fermoirs, bien plus précieuse aux yeux de l'amateur de livres que l'élégant habit de maroquin fabriqué

the Burgundian library, the Newberry manuscript agrees with both. The captions in the Newberry *Miroir*, like those of the Musée Condé manuscript, correspond to references in the 1467 catalogue, but only the Chicago manuscript also fits the 1485 description. The first line of fol. 2r (Fig. 4) in Newberry MS 40 reads, "lieu nestoit pas garni d'un arbre ne de deux"— precisely the phrase recorded in the inventory.

Three illuminators decorated the Newberry *Miroir*. Fols. 1 through 36 (cf. Figs. 4, 9, and 12) recall the work of a Dutch illuminator who seems to have been active in England during the 1450s, and who probably practiced his art in Flanders before going abroad.[15] The last gathering, fols. 37 through 43, was illustrated by two Flemish masters. One of these also collaborated in the *Llangattock Hours* (New York, H. P. Kraus),[16] and the other participated in the decoration of the great *Roman d'Alexandre* (Paris, Bibliothèque Nationale, MS franç. 9342), prepared for Philip the Good in 1448 (cf. Fig. 5).[17] There can be no doubt that the Newberry *Miroir* was produced in Flanders during the 1450s; and there is every reason to believe that it is the ducal manuscript.

What, then, is the relationship between the Chantilly *Miroir* and that in Chicago? The text, format, the sequence of miniatures, even the decorative borders and initials indicate that the former manuscript was copied from the latter. This is apparent in the miniatures on fol. 2r, which show the *Creator Admonishing Adam* and the *Temptation of Eve* (Figs. 1 and 4). The Ghent-Bruges illuminator retained the grouping of figures and numerous details from the earlier compositions, but he transformed the squat, rather crudely rendered figures of the Dutch model into larger, more elegant forms and placed them in a broad landscape setting.

The close connection of the two manuscripts is even clearer in the complex representations of the *Punishment of the Damned in Hell* (fol. 41v, Figs. 5 and 6). Almost every detail of the Newberry miniature is repeated in the Musée Condé copy. This vivid depiction of the tortured souls was not an invention of the Newberry artist. A number of fifteenth-century replicas of the same composition proves that the miniature was copied from a famous model, now lost.[18] Of these copies, the Newberry miniature is the earliest, but a drawing in the Louvre (Fig. 7) is certainly the most accurate.[19] The Louvre drawing has been attributed to Pieter Bruegel and surely dates from the sixteenth century. Because it seems to be a faithful witness of the fifteenth-century prototype, however, it can serve as a control in evaluating the relationship between the Newberry and Musée Condé miniatures.

pour le notre par Bauzonnet. Ajoutons de plus que l'exemplaire de M. C. . . . provient de la Bibliothèque des ducs de Bourgogne.
The Newberry *Miroir* was sold again in 1844. Meurgey (*Les Principaux manuscrits*, 144) asserted that it subsequently entered the Ashburnham Collection; but this cannot be substantiated. It did, however, get to England. By 1853, it had found its way into the library of Robert Holford, where it was seen by G.F. Waagen, *Treasures of Art in Britain* (London, 1854), II, 221. In 1925, A.S.W. Rosenbach of Philadelphia purchased it in a bloc of books from the Holford collection and brought it to America. Louis Silver acquired the manuscript in 1952, and in 1964 it entered the holdings of The Newberry Library.

[15]His style is related to that of *Queen Mary's Hours* of ca. 1455 (Oxford, Bodleian Library, MS Auct D. inf. 2. 13). Cf. L.M.J. Delaissé, *A Century of Dutch Manuscript Illumination* (Berkeley-Los Angeles, 1968), 78.

[16]R. Schilling, "Das Llangattock Stundenbuch," *Wallraf-Richartz Jahrbuch* (XXIII, 1961), 211ff.; H.P. Kraus, *Thirty-five Manuscripts: Catalogue 100* (New York, 1962), no. 25; Delaissé, *ibid.*, 64ff.

[17]Catalogue of the exhibition "Le Siècle d'or de la miniature flamande," Palais des Beaux-Arts, Brussels, 1959, no. 40; L.M.J. Delaissé, "Les Chroniques de Hainaut et l'atelier de Jean Wauquelin à Mons dans l'histoire de la miniature flamande," *Miscellanea Erwin Panofsky* (Brussels, 1955), 21ff.

[18]Cf. A. Chatelet, "Sur un Jugement Dernier de Dieric Bouts," *Nederlands Kunsthistorisch Jaarboek* (XVI, 1965), 17ff.

[19]Chatelet, *ibid.*; catalogue of the exhibition "Dieric Bouts," Brussels, 1957, 114; F. Winkler, "Die Wiener Kreuztragung," *Nederlands Kunsthistorisch Jaarboek* (IX, 1958), 105ff.; F. Grossman, "New Light on Bruegel," *Burlington Magazine* (CI, 1959), 345.

The illuminator of the Newberry *Miroir* reduced and abbreviated the original composition; but except for the Hell Mouth, every element of his miniature has a counterpart in the Louvre drawing. The winged serpent at the top of the rectangular drawing, for example, has been brought down to fill the upper left corner of the square miniature; and the demon at the right who attacks with a fork is a simple modification of the model. Other changes can be noted, but these are minor. The Newberry miniaturist certainly worked either from the very composition that was copied a century later in the Louvre drawing or a faithful replica of it, and this accounts for the exceptional complexity and verve of the Hell scene in the Chicago manuscript.

Every element of the original design that is repeated in the Chantilly miniature is also found in the Chicago illustration. The modifications introduced in the latter were also copied—the demon with a pitchfork is a good example. Certain details of the model that were retained in the Newberry miniature, however, have been deleted in the Chantilly copy. The winged serpent is gone, and so is the tail of the demon at the upper left. It is evident, therefore, that the Chantilly illuminator copied the Newberry miniature and not the original composition. He made a few changes and even added several figures; but basically, he remained faithful to this manuscript model.

Of the 168 miniatures in the Musée Condé *Miroir*, 123 were copied from the Newberry manuscript. Even the initials and borders of the Chantilly *Miroir* were based on those in the mid-fifteenth-century model. The Musée Condé manuscript is not, however, merely a slavish replica of the Newberry volume. In addition to numerous minor changes, such as those in the Hell scene, significant modifications were made in more than 40 of the Chantilly depictions. Fol. 13r (Fig. 8) contains an instructive example. Of the two Old Testament types for the Baptism of Christ represented on this page, the second—the *Passage of the Ark of the Covenant through the Jordan*—was simply copied from the Newberry *Miroir* (Fig. 9). The open ark, the group of Israelites, and even details of the landscape and architecture were taken from the earlier miniature. The Chantilly depiction of *Naaman Washing Himself in the Jordan*, however, is quite different from the Chicago composition. Elisha, who supervises the bath, is similar in the two miniatures; but the crouching Naaman, his horse and mounted attendants, and the setting have no parallels in the earlier representation. These elements were taken from the second major source used by the Chantilly illuminator, the blockbook *Speculum humanae salvationis*.[20] Printed in Latin and Dutch editions in Utrecht about 1471, the blockbook *Speculum* was readily available to the Ghent-Bruges illuminators, who used it to correct and supplement their manuscript model. From the printed *Speculum* (Fig. 10), they adopted the pose of Naaman, his horse, clothes, and men, and even the receding banks of the Jordan. The companion scene of the *Crossing of the Jordan* in the blockbook *Speculum*, on the other hand, which is less interesting than the Newberry miniature, did not influence them at all.

In other cases, the Chantilly illuminators copied complete compositions from the block-

[20]E. Kloss, ed., *Speculum humanae salvationis : ein niederländisches Blockbuch* (Munich, 1925); A. Stevenson, "The Quincentennial of Netherlandish Blockbooks," *British Museum Quarterly* (XXXI, 1966), 83ff.: catalogue of the exhibition "Le Cinquième Centenaire de l'imprimerie dans anciens Pays-Bas," Brussels, 1973, 66ff. Prof. Robert Koch, who first noted the relationship between the Chantilly manuscript and the printed edition, believed that the blockbook was based on the manuscript. Because of the dates and the connection with the Chicago *Miroir,* that is impossible.

book and substituted them for the Newberry depictions. The miniatures of fol. 27v (Fig. 11), for instance, have nothing in common with those in the Newberry Library *Miroir* (Fig. 12). The *Lamentation and Entombment of Christ* in the Chantilly manuscript is an elaborate ceremony in which Nicodemus, Joseph of Arimathea, and St. John, as well as the Three Maries, participate. The companion scene of *David Mourning the Death of Abner* is also entirely unlike the earlier depiction. The mournful David follows Abner's bier, which is carried through the palace by two monks and two noblemen. For these two scenes, and also for the types of the *Entombment* on the facing leaf (fol. 28r), the illuminator of the Chantilly *Miroir* followed the blockbook *Speculum* (Fig. 13). He used the woodcuts as his models not only for the figural compositions but also for numerous details of his painted miniatures. He copied Joseph's cloak in the *Entombment*, the monks' cowled robes and David's garment in the Abner scene, for example; and he repeated the niched tomb of Christ and the windows and tiled floors of the palace interior.

In all, the illuminators of the Chantilly *Miroir* copied 25 complete compositions from the blockbook *Speculum* and incorporated details from 24 others.[21] The dependence on a book printed about 1471 is further proof that the manuscript in the Musée Condé never belonged to Philip the Good, who had died in 1467. In general, the Ghent-Bruges artists used the printed model only to correct or embellish the iconography of their manuscript source. For example, they preferred the more traditional *Entombment* composition of the blockbook to the unusual conception in the Chicago manuscript; and they seem to have favored the pictorial richness of the printed Abner scene to the rudimentary composition in the Newberry *Miroir*. In cases where the painted model was more complete or more interesting than the blockbook, however, as the scene of the *Passage of the Ark through the Jordan*, the artists of the Chantilly *Miroir* generally remained true to the Chicago manuscript. The Naaman miniature, on the other hand, demonstrates a willingness also to combine elements from both models to form scenes that are richer than either source alone.

In their attempts to enhance the lifelike details and interest of their miniatures, the Ghent-Bruges artists also consulted other manuscript sources and even panel paintings. Details of five miniatures[22] and at least one complete composition were drawn from manuscript material available in the workshop. The fullest example is the *Deposition from the Cross* (fol. 26v, Fig. 14). The depiction of this scene in the Chantilly *Miroir* is entirely unlike the representations in the Newberry manuscript and the blockbook *Speculum*. It is virtually identical, however, with the tiny miniature in the *Hours of Engelbert of Nassau* (Oxford, Bodleian Douce 219, fol. 84v, Fig. 15).[23] The Oxford manuscript, produced between 1477 and 1490 in the workshop of the so-called Master of Mary of Burgundy, certainly was not the direct model of the Chantilly miniature. The source was probably a drawing used first in the

[21]Compositions in the Chantilly *Miroir* copied entirely from the blockbook *Speculum* are: fols. 7v(b), 8r(b), 13v(a), 14v(b), 15r(a), 16v(a), 17v(a), 19r(b), 21r(a), 21v(a), 22v(b), 23v(b), 24r(a), 27r(a and b), 27v(a and b), 28r (a and b), 31v(a and b), 32r(a and b), 32v(b), 41r(a). Compositions with a mixture of elements are: fols. 3r(a), 3v(a), 4v(b), 5r(b), 6v(b), 7r(a), 8r(a), 8v(b), 10r(a and b), 11v(a), 13r(a), 13v(b), 14v(a), 18r(b),

18v(a), 19v(a and b), 20v(b), 22v(a), 25v(b), 40v(a).

[22]These are fols. 5v(a), 9r(b), 16r(a), 22v(a), and 24v(a).

[23]*The Master of Mary of Burgundy: A Book of Hours for Engelbert of Nassau* (New York, 1970); G. Lieftinck, *Boekverluchters uit de Omgeving van Maria van Bourgondie* (Brussels, 1969), 39ff. and *passim*.

atelier of the Master of Mary of Burgundy and inherited with other modelbook material by the Ghent-Bruges workshop.[24]

The Chantilly *Miroir*, in turn, may have exerted an influence on other manuscripts from the Ghent-Bruges atelier. Because of the imprecise dates, it is generally impossible to decide which of two similar compositions preceded the other and, of course, a common source for both is always a possibility. In the case of the Annunciation miniature in a Book of Hours in Vienna, Oesterreichische Nationalbibliothek, Cod. 1858, fol. 39v (Fig. 16),[25] however, it may be possible to point to the *Miroir* in the Musée Condé as the specific source. The composition of the Vienna *Annunciation* is not the one most commonly used by Ghent-Bruges illuminators. Instead of showing Mary kneeling before a lectern in a Gothic chapel,[26] it represents her at prayer in her bedchamber. Interrupted by Gabriel, who enters at the left, she reacts demurely by crossing her hands and lowering her eyes. The *Annunciation* in the Chantilly *Miroir* (fol. 7v, Fig. 17) is similar to the Vienna composition ; but what makes the close relationship of these two manuscripts especially evident are the scenes of *Moses and the Burning Bush* in both. As the first Old Testament type for the Annunciation, Moses is represented in the *Miroir* in the adjacent miniature. He removes his sandals in response to God, who is depicted emerging from a fiery copse. This scene is, of course, specified by the typological text of the *Miroir*. Its inclusion in the border of the Vienna miniature, therefore, makes it highly likely that the illustrator of the *Book of Hours* was inspired by an illustrated *Miroir*—perhaps by the manuscript now in the Musée Condé.

Neither the *Annunciation* nor *Moses and the Burning Bush* in the Chantilly *Miroir* is based on the Newberry Library manuscript, the blockbook *Speculum*, or on any known workshop drawings. For these scenes and for a number of other miniatures, the Ghent-Bruges illuminators consulted the fourth major source of their art—panel paintings. The *Annunciation* is based on a composition popular in Flemish art, which seems to have been derived ultimately from Roger van der Weyden's early panel in the Louvre.[27] Its immediate source, however, may have been the nearly contemporary painting by Gerard David, the handsome diptych in Frankfurt (Städelsches Kunstinstitut).[28] *Moses and the Burning Bush*, in turn, apparently was adapted from the panel by Dirk Bouts in the Johnson Collection, Philadelphia, or a similar work.[29] Although only a few of the 168 themes of the *Miroir* were ever subjects of panel paintings,[30] several other panels also influenced the Chantilly illuminators.

Perhaps the most interesting examples of such an influence are the scenes of the *Creator Admonishing Adam* and the *Temptation of Eve* on fol. 2r (Fig. 1). In overall design and in the disposition of figures, the Chantilly compositions follow the Newberry manuscript model (Fig. 4). The sixteenth-century copyist increased the scale of the figures, however, and refined the portrayal of anatomical and botanical detail. He also transformed the serpent into a four-legged reptile whose webbed feet and long tail identify it as a salamander. According to

[24]Wescher, "Sanders and Simon Bening," and O. Pächt, *The Master of Mary of Burgundy* (London, 1948).

[25]F. Unterkircher, *Inventar der illuminierten Handschriften . . . der Oesterreichischen Nationalbibliothek*, 1 (Vienna, 1957), 53.

[26]E.g., in the *Grimani Breviary*, fol. 530v and the *Breviary of Eleanor of Portugal*, fol. 388v.

[27]M. J. Friedländer, *Early Netherlandish Painting* (Leyden, 1967ff.), 11, pl. 17.

[28]*Ibid.*, VI, pl. 176.

[29]*Ibid.*, III, pl. 21.

[30]These include Campin's lost panel of the *Vengeance of Tomyris* (Vienna), Bouts's *Abraham and Melchizedek* (Louvain), and Hugo's lost night *Nativity* (copy in London).

medieval bestiaries, salamanders were capable of poisoning fruit trees; and apparently it was Hugo van der Goes who, in his Vienna panel of ca. 1467 (Fig. 18), first conceived of the devil in the Fall of Man as a human-headed salamander.[31] Evidently, the Chantilly illustrator consulted Hugo's painting. Not only did he borrow the motif of the salamander, he also used the painting to refashion the figures of Adam and Eve. Adam in the *Admonition* is little more than a mirror reversal of Hugo's figure, and Eve in the *Temptation* is a simple adaptation from the Vienna painting. The influence of Hugo van der Goes on Ghent-Bruges illumination is well documented.[32] These illustrations in the Chantilly *Miroir*, however, are especially clear examples of how the illuminators used his compositions to monumentalize their art.

Because many of its models can be precisely identified, the Chantilly *Miroir de l'humaine salvation* affords rare insights into the atelier procedures of the Ghent-Bruges school. To provide their manuscript with an extensive set of pictures, its illuminators used as their basic pictorial model the same mid-fifteenth-century volume that had served the scribes as the source of the text. This model, which the illuminators faithfully followed in the majority of compositional designs and border and initial patterns, was the *Miroir* of Philip the Good, now in Chicago. Presumably the manuscript was issued to the atelier from the library of the dukes of Burgundy in Ghent. The Ghent-Bruges artists transcribed Philip's *Miroir* in their own style; and the elegance and fuller naturalism of their artistic idiom transformed the diagrammatic, often crude illustrations of the earlier manuscript into lifelike representations of the sacred parables.[33] The illuminators of the Chantilly *Miroir* also consulted the block-book *Speculum humanae salvationis*, but in general they used the printed source only to revise the eccentric and somewhat schematic iconography of the manuscript model. In addition, they used source material from their own workshop and from a number of panel paintings to modify the basic prototype. The result is an intelligent revision rather than a thoughtless duplication of the Chicago manuscript. In the Chantilly *Miroir*, the human and emotional aspects of the images have been enhanced through the introduction of elements carefully culled from a rich variety of sources.

The methods used by the Ghent-Bruges illuminators to illustrate the *Miroir de l'humaine salvation* did not differ appreciably from those employed throughout the Middle Ages. A similar amalgam of motifs copied from manuscript and monumental sources is indicated in such early manuscripts as the *Rabbula Gospels*[34] and has been deduced by Millard Meiss from the books produced more than eight hundred years later for John of Berry.[35] Why, then, are Ghent-Bruges manuscripts such as the impressive volume at Chantilly relegated to the footnotes in histories of fifteenth- and sixteenth-century art? The answer to this question lies not in the quality of Ghent-Bruges manuscripts or in the procedures used to produce them. It is found in the changed circumstances of artistic creation during the period in which they were made. When, during the years around 1400, artists employed by John of Berry trans-

[31]Friedländer, *Early Netherlandish Painting*, IV; R. Koch, "The Salamander in Van der Goes' *Garden of Eden*," *Journal of the Warburg and Courtauld Institutes* (XXVIII, 1965), 323ff.

[32]Hugo's *Temptation and Fall* exerted an influence on folio 286v of the *Grimani Breviary*. Cf. Salmi *et al.*, *Breviario Grimani*; F. Winkler, *Das Werk des Hugo van der Goes* (Berlin, 1964), *passim*; and S. Ringbom, *Icon to Narrative* (Åbo, 1965), 194ff.

[33]An admiration for the style led to the belief that the finer Chantilly manuscript was the model of the Newberry volume, cf. n. 14, above.

[34]C. Cecchelli, "The Iconography of the Laurentiana Syriac Gospels," in *The Rabbula Gospels* (Olten, 1959).

[35]*French Painting in the Time of Jean de Berry* (New York-London, 1967–1974), 3 vols.

formed French art by incorporating attitudes and techniques developed in Italy, Bohemia, and France by Pucelle and Bondol, they introduced a new conception of artistic expression that soon relegated book illustration to a secondary position. To be sure, this new conception first emerged in manuscript art. Jacquemart d'Hesdin, the Boucicaut Master, and the Limbourg brothers were all illuminators. But the new devotional style, which was characterized by unqualified veracity and demanded strong viewer empathy, was not well suited to the decoration of the manuscript page. Oil painting on panel was more appropriate, and the leading talents of the succeeding generations all favored that medium.[36] Even for the illustration of texts, hand-written and hand-painted manuscripts became obsolete after the invention of various printing processes around the middle of the fifteenth century. Printed volumes such as the blockbook *Speculum* could fill the growing demand for books more efficiently and more economically than could hand-produced codices such as the Chicago and Chantilly *Miroir* manuscripts.

Illuminators continued to work long after 1500, but the most innovative and enterprising artists did not join their ranks. Manuscripts had become antiquarian items. Like the Chantilly *Miroir*, they were often very elaborate and well-fashioned, but nonetheless derivative products, generally devoid of imagination and genuine artistic spirit.

THE UNIVERSITY OF CHICAGO

[36]In considering fifteenth-century devotional images, Sixten Ringbom, *Icon to Miniature*, also discussed attempts by Ghent-Bruges illuminators to accommodate their medium to the new artistic requirements.

New Criteria for Dating the Netherlandish
Biblia Pauperum Blockbook

ROBERT A. KOCH

Concurrently with the rich illumination of manuscripts from the time of the Duke of Berry, so comprehensively and skillfully presented by Millard Meiss in his multivolume magnum opus, there began to be formulated the elements of another type of illustrated book, one with printed text and pictures. Shortly after 1400, monasteries in the heartland of Northern Europe first issued devotional religious images cut on blocks of wood that were inked and printed on paper to serve as comparatively inexpensive visual aids to prayer. Some of the prints were provided with brief texts cut into the block below the image, such as the well-known *St. Christopher* in the Rylands Library, Manchester, dated 1423. The next step, probably undertaken in the 1430s, was the blockbook, a laborious and uneven product combining text with illustrations on page-sized woodblocks. Possibly the earliest and one of the best blockbooks is the Netherlandish *Apocalypse*, a prophetic adumbration in the realm of folk art of the demise of the costly illuminated manuscript book. By 1445 Johann Gutenberg had perfected movable type cast in metal; and shortly thereafter in Germany and Holland the tedious, hand-printed xylographic book with uneven letterpress gave way to the press-printed, easily multipliable, typographic book uniformly printed on paper pages. By the early 1460s the printer Albert Pfister, in Bamberg, issued the first books that were illustrated in the new manner with woodblock prints.

In this article, which honors Millard Meiss's interest in the art of the book, I propose to deal with the question of dating and localizing the most controversial of the blockbooks, the forty-page Netherlandish *Biblia pauperum*. We may come close to the answer, I believe, by focusing on the practical role it played as a model for book illumination, and in particular for a specific book illuminator who worked in Utrecht in the early 1460s.

Later in date than the *Apocalypse* blockbook but stylistically related to it are four others, also of Dutch origin: the forty-page *Biblia pauperum* just mentioned, the *Ars moriendi*, the *Canticum canticorum*, and the *Speculum humanae salvationis*. All were very popular in their day, as the several editions of each attest; and all—even individual leaves—are now of the utmost rarity, since unlike parchment manuscripts these were preeminently utilitarian products and hence expendable, like paperback textbooks in our own time.[1] Two centuries and more have passed since scholars, until the 1920s almost exclusively historians of printing, addressed themselves to the problems of place and date of origin of the blockbooks and the invention of printing; and a superabundant literature has been brought to bear upon the subject.[2]

[1]The editions of these blockbooks were defined and described by W.L. Schreiber in his monumental *Manuel de l'amateur de la gravure sur bois et sur métal au XVᵉ siècle*, IV (Berlin–Leipzig, 1902); sample pages illustrated in facsimile in vols. VII, 1895, and VIII, 1900. A convenient table of editions of the *Biblia pauperum* appears in A.M. Hind, *An Introduction to a History of the Woodcut* (London, 1935), I, 236–40 (reprinted in Dover paperback, 1963).

[2]According to J. Poortenaar (*Coster-Niet Gutenberg*, Naarden, 1947, 109) already in 1765 a writer in Haarlem complained about the amount of literature on the invention of printing! Unfortunately a strongly chauvinistic bias plagues much of the literature.

U

Finally the question of priority in the discovery of metallic typographic printing—i.e., Gutenberg at Mainz versus Coster at Haarlem—has been solved, or at least mercifully laid to rest, in favor of Gutenberg; and the perfection of practical printing is now known to have occurred quite independently of the xylographic blockbook, which both preceded and post-dated it by a quarter of a century. H. Theodor Musper, however, whose specialty is the blockbook, along with those who accept his thesis, continues to connect what he feels to be the *Urausgaben* of the *Apocalypse* and the forty-page *Biblia pauperum* with Laurens Coster and hence to place them, with the other and later blockbooks in this group, in Haarlem.[3] In my opinion the much more likely place of origin is not Haarlem but Utrecht, which was the most important center in the North Netherlands of the production of manuscript books throughout the better part of the fifteenth century.

Dr. Musper, who is an historian of Late-Gothic German and Netherlandish painting as well as of woodcuts, has been a staunch advocate of much earlier dates for three of the block-books than those proposed by most scholars.[4] He places the *Apocalypse* around 1420, the forty-page *Biblia pauperum* just after 1430, and the *Ars moriendi* between 1430 and 1440. For stylistic reasons he has agreed with consensus opinion that the most elegantly drawn block-book, the *Canticum canticorum*, was done in the 1460s, for it is close to the woodcut *Figure Alphabet* in Basel, which is dated 1464.[5] The *Speculum humanae salvationis* represents a still further development of pictorial realism and has been dated by all modern scholars between 1470 and 1479.[6] This edition of the *Speculum*, which is really more a typographic than a xylographic production, marks in any event the effective termination of the making of blockbooks.[7]

In his effort to date the *Biblia pauperum*, Musper has raised the fundamental question of original design versus copy. Did the draftsman create essentially new designs for these block prints, as Musper believes, or did he copy closely a now lost illuminated or pen-drawn manuscript model, as Schreiber assumes? (Alas, no actual model for any of the blockbooks has been discovered.) Of the ten editions of the forty-page *Biblia pauperum* described by Schreiber, the best in quality, his edition I, already has breaks and "misunderstandings" and hence is not the *editio princeps*, which Schreiber assumes to be lost.[8] Among three editions that Schreiber felt to be "crude," Musper thinks he has found the original, or *Urausgabe*: Schreiber's VIII.[9] In this edition Musper finds not crudeness at all, but rather the mentality of a designer of woodcuts, speaking his own language and not following an illuminated or pen-drawn manuscript. Thus, where Schreiber sees ineptness—and suggests that edition VIII might be a German copy—Musper sees woodcut quality, which he interprets as originality. I

[3]*Der Holzschnitt in fünf Jahrhunderten* (Stuttgart, 1964), 70ff. Max Schretlen in 1925 also believed Haarlem to be the place of origin (*Dutch and Flemish Woodcuts of the XV Century*, 20).

[4]Musper first made his case in 1937 in "Die Urausgaben der niederländischen *Biblia pauperum* und *Apokalypse*," *Die Graphische Künste*, 81ff., 128ff.

[5]Illustrated, e.g., in A.J.J. Delen, *L'Illustration du livre en Belgique* (Brussels, 1930), 74–75; a page from the *Canticum Canticorum* is illustrated on p. 72.

[6]Facsimile edition published by E. Kloss, *Speculum humanae salvationis* (Munich, 1925).

[7]On the relationship of this blockbook to an illuminated manuscript in Chantilly, see the article by Herbert Kessler in this volume, pp. 274–82.

[8]Schreiber cites textual as well as visual misunderstandings made by copyists. For example, although edition VI reproduces the most details of the original, it cannot be the oldest, since it follows IV. Editions I, IV, and VI are all supposed by Schreiber to be copies of a lost xylographic first edition.

[9]See n. 4, above. His arguments are repeated in the text volume of his facsimile publication, *Die Urausgaben der holländischen Apokalypse und Biblia pauperum* (Munich, 1961).

agree in part with both writers. There *is* woodcut quality, but it is German, not Dutch as Musper believes, and moreover the quality is rather poor. Musper's "proof" of the originality of the designs is not at all convincing, and edition VIII is surely a copy, not an original.[10]

In the most recent book-length study of this blockbook, a facsimile edition of a copy of Schreiber 1, today in the Library of the Archdiocese Esztergom in Hungary, Elisabeth Soltesz treads cautiously; but basically she rejects both Musper's thesis and date, preferring for a lost first edition a date in the later 1440s to one in the early 1430s.[11]

Whereas Schreiber was incorrect in his assumption that no blockbook was to be dated before 1460, since the *Apocalypse* of the Netherlandish group is clearly the product of a pictorial style of the second quarter of the fifteenth century, his proposed date of ca. 1463 for the lost first edition of the forty-page *Biblia pauperum* is more nearly correct, I believe, than the somewhat compromising "ca. 1450" date given it by most subsequent writers.[12] I should like to suggest a date of 1458–1460, and perhaps specifically the year 1460, based on the evidence provided by a Utrecht *Book of Hours* dated in that year.

Hitherto unnoticed as having been copied more or less closely from the blockbook are the eight Old Testament miniatures in the Dutch *Hours of Mary of Vronensteyn* (Brussels, Bibliothèque Royale, MS. II 7619), produced in Utrecht in 1460.[13] This is the earliest appearance known to me of the use of the xylographic *Biblia pauperum* as a model for a miniaturist. With its convenient corpus of Old Testament scenes, this blockbook continued in use in the 1460s, and frequently in tandem with the xylographic *Speculum humanae salvationis* after 1480

[10]Musper interprets what I believe are misunderstandings as subtle intentions. For example, in the scene of the *Baptism*, page i, Musper thinks that the baptizing hand and arm of John "cleverly" shows through the nimbus, whereas in Schreiber 1 it would have been "misunderstood" as a lock of hair. If true, this would be the only transparent nimbus in the whole repertory of nimbi in the book, and for no patent reason; and also the lock of hair is a commonplace in these designs. As a second example, in the figure of Christ on the rainbow in the *Last Judgment*, page .R., the right leg and foot are very inorganically drawn and executed, and the face of Christ is without expression; also the beautifully controlled modeling lines of Schreiber 1 and other editions are quite wanting in VIII. In the scene of the *Doubting Thomas*, page .N., the perspective shading is all wrong on the left wall in the building in VIII, whereas it is correct in 1. In the scene of *David Greeted by Songs*, page O, edition 1 has details that the copyist in edition VIII omitted: two trees, and the top of the spire; also omitted are the distant trees in the scene opposite on page O, *The Children of the Prophets Honor Elisha*. Omissions of this type are usually the hallmark of a copy, and this is surely the situation here. Hind, *An Introduction*, 238, also believed that edition VIII is German and dated it as late as ca. 1470.

[11]*Biblia pauperum* (Hanau-Main, 1967).

[12]E.g. P. Kristeller, *Kupferstich und Holzschnitt in Vier Jahrhunderten* (Berlin, 1921); Schretlen, *Dutch and Flemish Woodcuts of the XV Century*, 1925; and J. Poortenaar, *Coster-Niet Gutenberg*, 1947. An exception is A.J.J. Delen, *L'Illustration du livre en Belgique*, 1930, in a book fraught with errors and misconceptions. He would be pleased if the *Biblia pauperum* were to prove to be Flemish, not Dutch, and to date 1430 or even earlier.

Equally erroneous is the recent attempt of Allan Stevenson to date what he calls the "first edition" of a British Museum copy of the forty-page *Biblia pauperum* in the year 1465 on the specious evidence of watermarks ("The Quincentennial of Netherlandish Blockbooks," *British Museum Quarterly*, XXXI, 1966–1967, 83–87). M. Koning as early as 1818 tried to analyze the blockbooks from the evidence offered by watermarks (*Bijdragen tot de Geschiedenis der Boekdrukkunst*, Haarlem); but neither he, the eminent Sotheby in 1858 in vol. III of his monumental *Principia Typographica*, nor any subsequent scholar has been able to draw conclusive evidence as to either the origin or date of any of the blockbooks on the basis of paper watermarks; too many variables are involved.

Hind did adopt Schreiber's dating of ca. 1463 for the forty-page *Biblia pauperum* blockbook, adding "certainly not before 1460." He based this on the relation of the woodcuts in Schreiber 1 to later printed Dutch book illustration, notably books published by Bellaert in Haarlem in 1484–1485 (*An Introduction to a History of the Woodcut*, 242).

[13]First published by L.M. J. Delaissé, "Le Livre d'Heures de Mary van Vronensteyn, chef-d'oeuvre inconnu d'un atelier d'Utrecht, achevé en 1460," *Scriptorium* (III, 1949), 230–45; more briefly discussed in the same author's *A Century of Dutch Manuscript Illumination* (Berkeley, 1968), 45ff.

The eight comparatively large miniatures occur in capital letters illustrating the Hours of the Holy Ghost and Hours of the Cross. Beneath each are one or two smaller initial miniatures containing busts of what can only be interpreted as prophets, as found in the *Biblia pauperum*. The Old Testament episodes are: *Elijah's Sacrifice*, fol. 74 (wrongly identified as the *Adoration of the Golden Calf* by Delaissé, *ibid.*, 234, illus. pl. 31); *Joab Killing Abner*, fol. 124 (wrongly called *Joab Killing Amasa*, *ibid.*, pl. 30); *Jezebel Threatens Elijah*, fol. 126v (not identified by Delaissé; not illus.); *Ham Mocking Noah*, fol. 128 (illus. *ibid.*, pl. 30); *Sacrifice of Isaac*, fol. 130 (illus. *ibid.*, pl. 30); *Brazen Serpent*, fol. 131v (not illus.); *Joseph in the Cistern*, fol. 133 (illus. *ibid.* pl. 30); and *Jonah Thrown into the Sea*, fol. 135 (not illus.).

and into the sixteenth century, as a pattern book for artists working in other media.[14] Had the Dutch *Biblia pauperum* blockbook been available earlier than 1460, we would surely find its impact on other media earlier, and notably upon manuscript illumination in Utrecht, which was a fountainhead of Old Testament illustration in the fifteenth century.

Of the Old Testament miniatures in the *Hours of Mary of Vronensteyn*, I have selected three to compare with their woodcut models, along with a single figure in the margin of the manuscript, which has been taken from another page of the blockbook, confirming the fact that this was the source used by the miniaturist. It is unnecessary, and I believe unrealistic, to hypothesize that both miniatures and woodcuts depend on a lost model.

In the first comparison, *Ham Mocking Noah* (Fig. 1), which is used in the *Biblia pauperum* as one of two Old Testament types for the *Crowning with Thorns and Mocking of Christ* (Fig. 2), the miniaturist has followed the design of the woodcut almost to the letter, with the changes in drawing accountable in large measure by the compression of the compositional field from a vertical oblong to a field that is almost circular, forming a capital letter *G*. The woodcut has been carefully followed, even in such a detail as the spitcurl that appears on the foreheads of Noah and his three sons.

The illuminator chose both the Old Testament scenes, *Joseph in the Cistern* (Fig. 3) and *Jonah Thrown into the Sea* (Fig. 4), as he found them on page .G. of the Netherlandish blockbook (Fig. 5), as types of the *Entombment of Christ*. Again, most of the changes represent the painter's response to a squatter composition. It is interesting to note, particularly in the miniature with the young Joseph, that the painter has evidently been influenced by the woodcutter's technique of hatched lines for internal modeling. He prefers to draw them on a bias, and other manuscripts attributed to him attest this graphic modeling technique as a hallmark of his style, though the hatched lines here and in the later blockbooks are more controlled and generally parallel to the picture plane. As an illuminator in Utrecht his relationship to the designer of the blockbook *Biblia pauperum*, which I believe was also produced in this city at this time, may well have been more than a casual one.

In the marginal decoration of the Vronensteyn page with *Jonah Thrown into the Sea* (Fig. 4) there appears the half-length figure of a mourning woman emerging from a flower, speaking in Dutch the words uttered by the Bride seeking the Bridegroom in the Song of Songs 3:2: "I sought him but I found him not." For this image the miniaturist turned to page .K. of the blockbook, where the figure of Ecclesia seeking her husband is used as a type for the *Three Maries at the Tomb* (Fig. 6).

The three Old Testament miniatures cited, as well as the other five in this Utrecht manuscript of 1460, were painted by an unidentified master of second-rate talent whom Delaissé designated as Master C, overshadowed in the *Vronensteyn Hours* by the "Grand Master," known as the Master of Evert van Soudenbalch, who painted the exciting full-page miniatures

[14]For a discussion of the influence of these two blockbooks on a program of portal sculptures in France, dating ca. 1480, see R. Koch, "The Sculptures of the Church of Saint-Maurice at Vienne, the *Biblia Pauperum* and the *Speculum Humanae Salvationis*," *Art Bulletin* (XXXII, 1950), 151–55; and for their influence on panel painting, see W. Gibson, "A New Identification for a Panel by the St. Barbara Master," *Art Bulletin* (XLVII, 1965), 504–06.

depicting the Passion of Christ.[15] Delaissé's Master C had also been named the Master of the Feather Clouds by G.J. Hoogewerff in an analysis of the style of this painter as the major participant in the acknowledged masterpiece of Utrecht illumination in the later fifteenth century, the Dutch Bible in the Oesterreichische Nationalbibliothek, Vienna (MS 2771–2).[16] It was commissioned around 1465 by Evert van Soudenbalch, who had been appointed canon of the Cathedral of Utrecht in 1445. One (and probably others) of the miniatures by our master in this Bible, *Christ Dining in the House of Simon*, fol. 52v (Fig. 7), reveals a continued dependence, this time for a scene from the New Testament, on the *Biblia pauperum* blockbook. The woodcut, on page N (Fig. 8), shows that the four central figures and the interior setting were adapted by the miniaturist with very few changes.

Master C had been given yet another name by Byvanck in 1937: the Master of the London Passional.[17] According to Byvanck, the leading scholar of Dutch manuscript illumination before the advent of the late L.M.J. Delaissé, the Passional dates about 1465 and was probably made in a Carthusian atelier in Utrecht, which for decades was the main center in that city for the writing, illustrating, and binding of manuscripts.[18] Henrik Cornell had earlier called attention to the fact that in this manuscript the prophet busts below the miniatures are sometimes given banderoles containing Leonine verses taken from the *Biblia pauperum* blockbook.[19] The page illustrating the *Presentation of the Christ Child in the Temple* (Fig. 9) has such a prophet, though there is no banderole; and again the scene above it has been closely adapted in a composition which the illuminator expands from the corresponding scene in the blockbook to accommodate a rectangular field.[20]

I know of two other illustrated manuscripts that depend in whole or in part on the forty-page blockbook, one dated and the other datable in the 1460s; almost certainly, others exist.[21] The first is another Dutch Book of Hours with a calendar for the Diocese of Utrecht, dated 1468: Cracow, Muzeum Narodowe (formerly Czartoryskich), MS 3091.[22] Its seven New Testament miniatures are adaptations of the woodcuts by yet another minor and unidentified master, whose skill as illuminator matched his lack of creative imagination.

The second manuscript, on the other hand, is perhaps the most interesting and by far the best of all of the known manuscripts of the *Biblia pauperum*. This is the sumptuously illuminated parchment codex in grisaille, with figures set against a blue ground and framed by colonettes painted in red: The Hague, Museum Meermanno-Westreenianum, Gr. fol. 13

[15]"Le Livre d'Heures de Mary von Vronensteyn." The Soudenbalch Master was probably a pupil, in Utrecht, of the Master of Catherine of Cleves.

[16]*De Noord-Nederlandsche Schilderkunst*, I (The Hague, 1936), 538.

[17]*La Miniature dans les Pays-Bas Septentrionaux* (Paris, 1937), 88ff. This Passional, which is a Middle Dutch adaptation of Voragine's *Legenda aurea*, has been studied by P.J.H. Vermeeren, "Het Passyonael van den Heyligen in het Brits Museum te Londen Add. MS 18162," *Het Boek* (XXXIII, 1959), pp. 193–210.

[18]Miniatures by our master are to be found in another Dutch Bible, now in The Hague (78 D 39), dated 1468 and known to have issued from this Carthusian atelier. See Byvanck, *ibid.*, 88, pls. LXXXVII–VIII, figs. 218–21.

[19]*Biblia pauperum* (Stockholm, 1925), 200–01. See the illustration of the Nativity page, fol. 19, in Byvanck, *ibid.*, pl. LXXVIII, fig. 217.

[20]For the blockbook illustration, see Soltesz, *Biblia pauperum*, pl. 4.

[21]Three unillustrated manuscripts should also be mentioned, as they are germane to our argument for dating the blockbook just before or in the year 1460: St. Gallen, Stiftsbibliothek, Cod. 604, I–III (Cornell, *Biblia pauperum*, 115–16, 168ff., and especially p. 180). Written and compiled by the monk Gallus Kemly, probably when he was in residence in St. Gallen, these three copies of the text of the forty-page *Biblia pauperum* blockbook are dated 1465, thus confirming, as Cornell notes, Schreiber's dating of ca. 1463.

[22]Byvanck, *La Miniature dans les Pays-Bas Septentrionaux*, 132; two folios illustrated on pl. XCII, figs. 245–46.

(A c). Heitz and Schreiber believed it to be of French origin, dating somewhat later than the blockbook,[23] whereas Cornell called it an exquisite example of Netherlandish miniature painting from the end of the fifteenth century.[24] Delaissé, to whom I showed photographs of the manuscript, believed the miniatures to be Dutch, with the text and rubrication in the French manner. Thus, while its localization remains problematic, it is surely not the model, but rather a somewhat free adaptation, of the blockbook, and therefore dates after 1460.

Both the style of the woodcuts in the forty-page *Biblia pauperum* blockbook and the costumes of many of the actors in the Old Testament scenes confirm, I believe, a date in the decade beginning 1460, quite consistent with Netherlandish miniature and panel painting at this time. Though establishing a precise date by means of fashionable garb is hazardous, one very specific costume in the blockbook does provide a clue that seems to confirm both my date for the blockbook and my suggestion of Utrecht as its place of origin. It is worn by a brother of Joseph in the scene of the *Betrayal of Jacob* on page Q (Fig. 10), used as an Old Testament type for the *Betrayal by Judas*. Schreiber wrongly guessed that this was young Joseph himself, "vêtu en élégant," being recognized by Jacob as his favorite son; but this interpretation does not conform to the traditional scene for this page in the *Biblia pauperum*.[25] The figure is instead the fraternal betrayer, but dressed in the fancy garb of no less eminent a personage than Duke Philip the Good of Burgundy. The woodcut figure is almost a paraphrase of the Duke's appearance as we know it in the well-known frontispiece miniature by Roger van der Weyden in the *Chroniques de Hainaut* (Fig. 11).[26] In casting the powerful Duke of Burgundy, or one might better say his "emissary," in the role of "villain," the designer of the blockbook took a bold step indeed, for Philip controlled the Netherlands. An explanation may reside in the fact that the Duke had caused the Pope to name one of his natural sons, David of Burgundy, who had been Bishop of Thérouanne, to the bishopric of the See of Utrecht in October 1455. Philip then had to resort to the threat of military might to enforce the appointment, and Bishop David entered the city and took privileges on August 6, 1456. Notwithstanding the fact that the political and religious climate remained troubled thereafter, the beginning of the episcopate of David, who like his father was interested in illuminated manuscripts, probably accounts for the increased production, or at least better quality, of manuscript illumination in Utrecht in the late 1450s and '60s.[27] Bishop David may or may not have seen the forty-page *Biblia pauperum* blockbook when it appeared as a monkish product in Utrecht shortly after he took up residence there; but if he did, one might assume that he did

[23]*Biblia Pauperum (noch dem einzigen Exemplare in 50 Darstellungen)* (Strassburg, 1903), no. 29, illus. opposite p. 8.

[24]*Biblia pauperum,* no. 56, p. 115, Taf. 69.

[25]*Manuel de l'amateur,* IV, 3. In fifteenth-century manuscripts, the fraternal messenger is often depicted presenting to Jacob the bloodied coat of Joseph, e.g., in a South German manuscript from the third quarter of the fourteenth century (G. Schmidt, *Die Armenbibeln des XIV. Jahrhunderts,* Graz, 1959, Taf. 36). The composition is continued in the type manuscript followed by the forty-page blockbook, a series of pen-drawn pages, without text, in rotulus format: probably a Venetian work dating from the mid-fifteenth century, and now in Istanbul (A. Deissmann–H. Wegener, *Die Armenbibel des Serai,* Berlin–Leipzig, 1934, Taf. 16).

[26]The fifty-page *Biblia pauperum* blockbook, which adapts and expands the forty-page edition, retains the Burgundian courier. A banderole with a quotation from Gen. 37:33 ("An evil beast hath devoured him") makes the scene explicit. See P. Heitz–W.L. Schreiber, *Biblia Pauperum,* facsimile page x of the blockbook.

The miniature has been most recently discussed and reproduced in M. Davies, *Rogier van der Weyden* (London, 1972), 208, fig. 74, with succinct bibliography. Davies dates the miniatures in 1446, the year in which the writing of the manuscript was completed, "or very few years later." We need not assume a connection between this miniature and the woodcut, for this court costume of the Duke was well known throughout his domain.

[27]Delaissé, *A Century of Dutch Manuscript Illumination,* 7.

not perceive (even as the modern scholar Schreiber did not perceive) the thinly veiled anti-Burgundian propaganda in a scene in which we find a conspiratorial brother of Joseph bedecked in Burgundian ducal finery as he speaks deceitfully to their grief-stricken father.[28]

To summarize: the forty-page *Biblia pauperum* blockbook must have appeared in or perhaps just before the year 1460, the date of the earliest reflection, to my knowledge, of its Old Testament compositions in the sister art of book illumination, namely in the *Hours of Mary of Vronensteyn*, which is dated 1460. As this *Book of Hours* was produced in Utrecht, and since a number of other Utrecht manuscripts dating in the 1460s (though not earlier) also adopt the convenient models of comparatively rare Old Testament subjects to be found in the blockbook, I think it quite likely that the blockbook itself first appeared in Utrecht at this time as the product of a monastic, perhaps Carthusian, atelier.[29] That one of its woodcut scenes appears to allude in a disparaging manner to the troubled presence of David of Burgundy as Bishop of Utrecht may add support to this hypothesis.

<div align="right">PRINCETON UNIVERSITY</div>

[28]I have pointed out elsewhere, also on the basis of garb, another type of propaganda in this interesting blockbook, namely that of the claim of the Carmelites that their order was founded by the prophet Elijah, since both he and his follower Elisha appear as tonsured monks in these woodcuts ("Elijah the Prophet, Founder of the Carmelite Order," *Speculum*, XXXIV, 1959, 547–60.)

In that article, I suggested that the forty-page *Biblia pauperum* blockbook might have been produced in some Carmelite monastery in the Netherlands. Although further investigation is necessary, I now wonder whether it might not have been produced in Utrecht under the auspices of the Carthusian atelier, famous for its production of manuscripts throughout the fifteenth century. On the Carthusians' interest in books and bookmaking, both manuscript and early printed volumes, see the brief discussion by "A Carthusian Monk," *The History of the Great Chartreuse* (London, 1934), 190–93.

As for the propaganda on behalf of the Carmelite claim of Elijah and Elisha as the archtypes of their eremitical succession, the recluse and also white-robed Carthusians very likely were in tune with the Carmelite claim.

[29]On the much earlier fifteenth-century Dutch manuscript tradition for the milieu of the blockbook *Apocalypse*, probably Utrecht, see J. Marrow, "Dutch Manuscript Illumination before the Master of Catherine of Cleves," *Nederlands Kunsthistorisch Jaarboek* (XIX, 1968), 104–07, "Postscript: The British Museum Hours (Add. MS 50005) pen and wash illustrations and the origin of the blockbook."

Fra Angelico and — perhaps — Alberti

RICHARD KRAUTHEIMER

The history of architecture is a sweet poison. It is apt to dull the victim to anything outside his own field. But occasionally even an architectural historian looks at a painting—though primarily, I admit, when it confronts him with an architectural problem.

Such is the case with Fra Angelico's murals in the Chapel of Nicholas V in the Vatican, the *Capella secreta Domini Nostri Papae* or *Chapeletta piccola* of the documents.[1] The date of these paintings has been established, though with some margin. Work was under way by May 11, 1447—we do not know since when ; it was proceeding in February 1448 ; and it was completed before January 5, 1451—precisely how long before again remains open. Three of the murals, the *Ordination of St. Lawrence* (Fig. 1), *St. Lawrence Distributing Alms* (Fig. 2), both in the lower register, and the *Ordination of St. Stephen* (Fig. 3) in the upper, are set inside a church interior. In all three, the nave is bounded by colonnades carrying either a simple trabeation or a full-fledged entablature ; in all three, the nave terminates in a transept ; and in at least two, if not in all three, the transept opens into a semicircular apse. These features are rarely found combined in Rome. Constantine's basilica of Saint Peter's, as it stood in the fifteenth century, was the outstanding example. The presence of St. Peter in one of the murals and of the Pope enthroned in another further identifies the setting as Saint Peter's basilica, considered at the time the See of the Papacy ; and this in spite of the absence of one of that church's most characteristic features—its double aisles. But, after all, the church interiors shown in the

[1] To my knowledge, the architectural settings in Fra Angelico's murals in th Chapel of Nicholas V have not been discussed in detail with reference to their relation to fifteenth-century projects for the remodeling of Saint Peter's. T. Magnuson, *Studies in Roman Quattroce to Architecture. Figura,* Studies edited by the Institute of Art History, University of Uppsala, IX (Rome, 1958), 201, after discussing Nicholas V's project for rebuilding Saint Peter's, speaks brie'ly of these settings. He views them as illustrating "the current architectural taste at the papal court, which appears to have favoured a fusion of paleo-Christian and fifteenth-century st les that bears a striking resemblance to the Pope's project for the reconstruction of St. Peter's . . ." He cautiously shies away, however, from seeing them as variants on that project, because of their early date and the architectural differences between them and the projects, as described by Gianozzo Manetti and shown in the Uffizi drawing UA 20 (Fig. 4) respectively. Neither of these arguments seems to me to be decisive. In this context, see also Elisabeth MacDougall's review of Magnuson in *Art Bulletin* (XLIV, 1 62), 67–75.

Manetti's description of the building project of Nicholas V has been interpreted and used as a basis for envisaging that project in recent years by G. Urban, "Zum Neubau-Projekt von St. Peter unter Papst Nikolaus V," in *Festschrift für Harald Keller* (Darmstadt, 1963), 131–73. The impact of that project on Roman architecture in the late quattrocento has also been dealt with by Urban, "Die Kirchenbaukunst des Quattrocento in Rom," *Römisches Jahrbuch für Kunstgeschichte der Bibliotheca Hertziana* (IX–X, 1961–62), 73ff. *passim*, and by myself in "S. Pietro in Vincoli and the Tripartite Transept in the Early Christian Basilica," *Proceedings of the American Philosophical*

Society (LXXXIV, no. 3, 1941), 364, n. 40. Alberti's involvement in the designs for the Borgo and the remodeling of Saint Peter's was proposed many years ago by G. Dehio, "Die Bauprojecte Nikolaus des Fünften und L. B. Alberti," *Repertorium für Kunstwissenschaft* (III, 1880), 241ff. His argumentation was lacking in documentary proof (Magnuson, *Studies*, 86ff.), necessarily so, but to me his thesis has always been convincing.

For the dating of the Fra Angelico murals, see D. Redig de Campos, *I Palazzi Vaticani.* Roma Christiana, XIII (Bologna, 1967), 50f., with reference to documents published by E. Müntz, *Les Arts à la cour des papes pendant le XIV° et le XV° siècle,* I. Bibliothèque des Écoles Françaises d'Athènes et de Rome, 4 (Paris, 1878), 116, and *ibid.,* II. Bibliothèque des Écoles Françaises d'Athènes et de Rome, 5 (Paris, 1 879), 316, and by F. Ehrle and H. Egger, *Der Vatikanische Palast in seiner Entwicklung bis zur Mitte des XV Jahrhunderts* (Vatican City, 1935), 133. Redig de Campos's dating revises previous suggestions made by J. Pope-Hennessy, *Fra Angelico* (London, 1952), 187f., on the basis of a different group of documents (Müntz, *op. cit.,* I, 126f.), all of which date from 1447. (The date summer 1449, given by Pope-Hennessy as a possible terminal, has admittedly no documentary foundation.) These documents, however, refer to work in the "chapella di Santo Pietro," or in "maiori capella ecclesiae Sancti Petri," that is, the apse of Old Saint Peter's, which was apparently given new fresco decoration in 1447.

For the sequence of the murals in the Chapel, as proposed on the basis of stylistic criteria, see Pope-Hennessy, *Fra Angelico,* 24ff., and Redig de Campos, *Itinerario pittorico dei Musei Vaticani* (Rome, 1964), 13.

murals abbreviate, they do not copy, reality—a reality not yet existent, but envisaged, I suspect, in this case.

Clearly, the paintings do not represent the church of Saint Peter's as it looked in 1447 or 1450. In all three the structure is vaulted : either with a barrel vault over the nave, as in the *Distribution of Alms* (Fig. 2); or with groin vaults, as in the *Ordination of St. Lawrence* (Fig. 1) and presumably in the *Ordination of St. Stephen* (Fig. 3) as well. In all three the transept, rather than being shallow, as it was in Old Saint Peter's, has been deepened so as to be as wide as the nave; the square shape of the vault over the crossing is marked off by four delimiting arches of equal height. At the same time, in the *Ordination of St. Lawrence* (Fig. 1), the transept vaults are represented as oblong—the short lunettes abutting the transept wall leave no doubt of this. Corinthian half-columns flank the apse and carry a continuous entablature across the length of the transept wall; an oculus is set into the wall above the apse opening, as it is also in the *Distribution of Alms* (Fig. 2); and, in the nave colonnades, a strengthening pier has been inserted on either side. The apse, which is low in the *Ordination of St. Lawrence*, carries in its vault a mosaic with indistinguishable figures. In the *St. Lawrence Distributing Alms*, it is tall and steep, its wall opened by four windows, its half-dome carrying a shell design. In the *Ordination of St. Stephen* (Fig. 3), the nave interior is shown *pars pro toto* only, by the colonnade and its entablature; behind it, the aisle is represented, with pointed tracery windows and, near its end, a pilaster answering the end pier of the nave colonnade. On the other hand, the clerestory is seen from the outside, opened in *bifore* windows and articulated by a terminating cornice and pilaster-buttresses, the latter possibly hinting at vaults over the nave; they may have been planned as oblong groin vaults. The transept, on the other hand, is shown in greater detail: a forechoir, rather than an apse, opens from the crossing on the left side, that is, westward; the transept arm, obviously the northern one, is divided into two rectangular bays, is groin vaulted, and ends in the hemicycle of an apse; pilasters carry the bands separating the vaults; between them, two chapels project westward from the transept arm, their openings flanked by fluted Corinthian pilasters, the soffits with bands of foliage; above, an oculus opens in each of the lunettes formed by the vaults.

All three settings, then, reflect variants on a common theme : the Constantinian basilica of Saint Peter's, remodeled, vaulted, clad in "classical" garb, and brought up to date. Indeed, the majority of the elements incorporated in and distributed among the three variants of the remodeling proposed in the murals call to mind fourth and fifth versions : the projects for rebuilding Saint Peter's, as discussed and begun to be carried out from 1452 to 1454 under Nicholas V. These latter two variants are known, the one from an *ekphrasis* included by Gianozzo Manetti in his life of Nicholas V, the other from the large sanguine drawing in the Uffizi, UA 20 (Fig. 4). Written after 1455, but based on earlier material, Manetti's text is clear enough. It describes the project: nave and aisles, divided by six colonnades, two of them apparently of half-columns or pilasters, placed against the aisle walls, presumably to carry groin vaults; the transept, covered by seven groin vaults—that over the crossing square, and three over each of the transept arms rectangular and springing from eight columns set against the walls; the forechoir as wide as the crossing, but nearly twice as deep; oculi in nave and transept, rows of chapels along the aisles; outside, a crossing tower surmounted by a

lantern. UA 20 confirms Manetti's *ekphrasis*, if with some differences. Overlaid by two variants of the project for New Saint Peter's, as of 1506, replacing the plan of the old basilica, the transept, forechoir and apse are outlined as planned by Nicholas V. Buttresses, reinforcing the strong walls, mark off two bays in the forechoir and three in each transept arm. No hint is given as to a remodeling of nave and aisles, in which construction had never been started.

There is no need in the present context to discuss the possible reconstruction of the project as outlined by Manetti; Urban's recent proposal (see n. 1) seems convincing enough. Nor need one go into the history of that rebuilding in detail. One need only recall that work from 1447 to 1449 was limited to repairing and redecorating the old building—painting in the apse, stained-glass windows, paving the narthex, repairing and painting the roof of the nave; in short, no major rebuilding was seriously envisaged. Construction on the new chancel and apse and possibly the new transept got under way apparently in June 1452 and continued on a large scale into 1454; it appears to have stopped in October of that year, with what seems to have been a terminal payment to the contractor. By that time, the walls had risen three *braccie* high. Then, in 1470–1471, work started again and was brought to a provisional conclusion; it was finally completed by Bramante, whether in 1506 or later, with a coffered barrel vault over the chancel and a half-dome over the apse, scalloped as in Fra Angelico's *Distribution of Alms*. Under Nicholas, at any rate, the foundations of the western transept walls may have been built, while the remodeling of nave and aisles was but vaguely envisaged—a bridge to be crossed, once one got there—witness UA 20 on the one hand, Manetti on the other. Likewise, one should remember that, in the first phase of construction under Nicholas V, all payments went to a contractor, Beltrame da Varese. Bernardo Rossellino, while *ingegnere di palazzo* from at least December 1451 and, according to Manetti, in charge of all papal construction, is never specifically mentioned in connection with the Saint Peter's project—the term "Rossellino choir," long customary to designate the chancel started in 1452, thus being apparently a misnomer. It should be noted that Mattia Palmieri, at Nicholas's court at the time in question, reported twenty years later in his chronicle that work was interrupted on Alberti's advice and ceased altogether with the Pope's death in 1455.

Fra Angelico's murals, then, antedate the start of construction in 1452, and they may antedate or be contemporary with the project as described by Manetti. Plans must have been under consideration as the Frate was working in the Chapel in May 1447, or indeed earlier, as he already began working, presumably, in the last year of Eugene IV's pontificate, 1446–1447. The discussions in which the project for remodeling the Constantinian basilica was born created the climate in which the architectural settings of the murals were designed. All share, one recalls, essential features of the rebuilding project. At the same time, however, this project is represented and interpreted in the murals with fundamental differences. The two St. Lawrence scenes reflect in only the vaguest way disjointed elements of the remodeling envisaged; notions, one is inclined to think, of a project not fully understood. A barrel vault floats over the nave in the scene of *St. Lawrence Distributing Alms* (Fig. 2), groin vaults over nave and transept in the *Ordination of St. Lawrence* (Fig. 1), none supported even minimally on brackets, just pasted against the walls. No pilasters articulate the nave, and windows are haphazardly placed. In the *Ordination of St. Lawrence*, a classical order is thrown arbitrarily

across the transept wall, unrelated to the covering groin vaults; a pier is inserted into either nave colonnade without rhyme or reason. The walls in both scenes rise straight from a simple trabeation, without the intermediary of an entablature. The walls are cardboardlike, the spaces boxlike, neatly defined, but ill related to one another. In short, the settings lack structural credibility. Like settings designed by Fra Angelico in earlier years, in the *Annunciation* at San Marco in Florence (Fig. 5) or the *Presentation* at Cortona (Fig. 6), they are in the tradition of architectural settings customary in painters' workshops ever since the early trecento. By contrast, a clear and convincing relation of part to part, of solid to solid, of space to space prevails in the *Ordination of St. Stephen* (Fig. 3). The detail is precise, the new architectural concept consistent and fully understood, the structure credible. Rather than being a painter's setting, the architecture looks as if it could be built any day, though in surviving medieval fashion the outside clerestory wall rises from the interior nave colonnade. Transept, chancel, chapels, and the apse terminating the transept arm are all clearly set off against, and structurally related to, one another. The vaults over the transept rise from half-piers, soundly projecting from the wall; their webs are held in place by strong transverse bands. The walls—witness the chapel openings—are solid, their proportions convincing. The mentality of architecture and design replaces that of painting. The perspective, too, rather than being simply head-on, as in the Lawrence scenes, with the vanishing point dead center, is handled with new sophistication; it is viewed diagonally, with volumes and masses consistently foreshortened and overlapping.

The general consensus among experts of quattrocento painting seems to be that the St. Lawrence scenes are stylistically more advanced than those of the Life of St. Stephen. Indeed, the *Ordination of St. Stephen* (Fig. 3) appears in the upper register of the Chapel, and therefore, following usual mural procedure, it should have been painted before the *Ordination of St. Lawrence*, just below (Fig. 1). But in that case there is a strange contradiction between style and architectural settings. In fact, the settings in the lower scenes are much more in keeping with those in Fra Angelico's earlier work. It is true that he was fascinated by the new architecture that evolved in the 'twenties and 'thirties in Florence. But he was attracted by its ornament rather than its structural concepts. Nothing could be more elegantly and more "correctly" designed than the ornament on the pilasters framing the *St. Lawrence Distributing Alms* (Fig. 2). Fra Angelico's settings, on the other hand, always smack of the painter's workshop. The Cortona *Presentation* (Fig. 6), as early as 1430, is set inside a church much like Brunelleschi's San Lorenzo, which incidentally was far from being completed at the time. But *ante litteram* though it is, the setting is transposed into the painter's language, cardboardlike and structurally unconvincing, much like the settings in the St. Lawrence scenes. I must leave to experts in quattrocento painting the decision whether any and which of the murals were designed or executed by assistants. I can only ask whether in designing the *St. Stephen* setting (Fig. 3), Fra Angelico was guided or possibly assisted by someone more involved than he in the principles and concepts of the new architecture.

I propose to postpone the question for a short while. I would rather stress the points so far clarified through the settings of Fra Angelico's murals and their early date. The rebuilding of Saint Peter's as begun in 1452 was under discussion from at least the start of

Nicholas's pontificate early in 1447. The project, fully developed in the *Ordination of St. Stephen* (Fig. 3)—not specifically dated, but prior to 1451 and possibly as early as 1447—was limited to the western portions of the rebuilding, those actually started in 1452; the nave and aisles and the question of their vaulting being unresolved at that time were, as has been said, regarded as a bridge to be crossed once one got there. Within such limits, the project, as reflected in the mural's setting, anticipates the essential elements of the plans both as described by Manetti and rendered in UA 20 (Fig. 4): the oblong groin vaults of the transept, the oculi, possibly the chancel. Some features present in the mural, to be sure, had changed by the time the building was begun and discussed by Manetti; pilasters, too weak to carry the transept vaults, gave way, as pointed out by Urban, to free-standing columns in superimposed orders. Lastly, and most important in this context, the project as reflected in the *Ordination of St. Stephen* is replete with elements that were eliminated as the Nicholas building faced reality: apses terminating the arms of the transept and joining the apsed chancel in the elongated trefoil plan; chapels projecting from the transept and flanking the chancel; *bifore* windows. The Nicholas remodeling of Saint Peter's, both as described by Manetti and as begun in 1452, was then a reduction, deprived of essential elements, of a fuller original project that is reflected in Fra Angelico's mural. These very elements, however, reappear in and dominate Roman church planning of the 'seventies and 'eighties: the elongated trefoil plan at Santa Maria del Popolo, 1472–1478, at Sant'Agostino, 1479–1483, at Santissimi Apostoli, 1473–1478 (here possibly on early foundations), and in a project for Santa Maria in Aracoeli, ca. 1480 (Vat. lat. 11257, fol. 185); chapels flanking a long forechoir again at Sant'Agostino and in the project for Santa Maria in Aracoeli.

The impact of the Saint Peter's project on church planning in Rome during the later quattrocento has been discussed before. This impact, however, it now appears, was not exerted primarily, and certainly not solely, by the building under construction from 1452 to 1454 or by Manetti's *ekphrasis*. Rather, it sprang from two different roots: on the one hand, from a further reduction of that plan, replacing the nave vaults by a flat ceiling or open timber roof—what might be called the neo-Early-Christian church type of the quattrocento; on the other, the fuller variant as reflected prior to 1451 and perhaps as early as 1447 in the *Ordination of St. Stephen*. It remains an open question how this fuller original project was transmitted to later Roman church planners. Not through Fra Angelico's mural, I submit, nor by word of mouth; drawings, sketches, or a model are likely to have existed, worked out in some detail prior to 1451. Of greater import, though, is the question of how it was possible that in an ambience heretofore as barren in building activities and architectural concepts as Rome was in the first half of the quattrocento such a design could have originated; a design anticipating not only the remodeling of Saint Peter's as begun a few years afterward, though shorn of some of the best features of the original plan, but also church building as it came to fruition in Rome a full generation later.

This is where conjecture must take over. Obviously, there was one man in Rome just before the middle of the century prepared to open up far-reaching architectural prospects: Leone Battista Alberti. Having returned to Rome in the suite of Eugene IV, presumably in 1443, he was working on *De re aedificatoria*, completed in 1452 and presented that year to

Nicholas V. His concern with and intimate knowledge of the precarious conditions of Old Saint Peter's comes to the fore in a number of passages from that work, and apparently he could advise the Pope to interrupt the remodeling after a two-year start. Hence, and based on the correspondence of numerous features in the building projects of Nicholas, as described by Manetti, with some passages in *De re aedificatoria*, Alberti has long been linked to both the remapping of the Borgo and the planned rebuilding of Saint Peter's. Indeed, it is hard to imagine that he was not involved in the years just before and after 1450 in the project of solidifying the old church and giving it a form more appropriate to modern architectural concepts and liturgical needs, as they are reflected in Manetti's *ekphrasis* as well as in the *Ordination of St. Stephen*. But definite proof is hard to establish. No reference to Alberti is found in surviving building accounts, nor is he mentioned in Manetti's account of Pope Nicholas's building activities. Parallels between individual features of the structure as planned and started, on the one hand, and scattered remarks torn from *De re aedificatoria* can never be pinned down with precision; and nowhere in his writings does Alberti refer approvingly to basilical church plans, vaulted or with flat ceilings; on the contrary, he deplores their use. Finally, there is Palmieri's note to the effect that construction on Saint Peter's was interrupted on Alberti's advice. It is but understandable that scholarly consensus has been cautious and indeed reluctant in linking him to Nicholas's project for remodeling Old Saint Peter's.

Caution, though, can go too far. I believe a good case can be made for Alberti's being involved in, or indeed responsible for, the design of that project as reflected first in the *Ordination of St. Stephen*. At least I shall try to do so. That Messer Battista's name is missing from the account books is but self-evident. A gentleman at court was provided for, but he was not paid in specie. Alberti neither wrote nor thought of himself as a builder. He saw himself as an adviser on architecture, one to give counsel without soiling his hands; just as he would advise on other subjects, such as painting, city planning, statecraft, economics, archaeology—as a Counselor-at-humanism, to coin a term. For just that reason a fellow humanist, Manetti, would avoid bringing up his name in the context of a building actually started—a building, moreover, which by the time of Manetti's writing Alberti would have brought to a halt in evident disapproval.

Nor should the absence from the Saint Peter's project, as reflected in the mural, of major elements *all'antica* weigh too heavily against the hypothesis of Alberti's participation; this notwithstanding their predominance in known Albertian work in the same years and slightly later. The task at Saint Peter's was not to envelop an older structure in a classical shell, as at Rimini; or to set up a smallish free-standing monument, as at Ferrara; or to build *ex novo* a *viso fantastico* such as San Sebastiano at Mantua. On the contrary, the assignment was anything but fanciful: to preserve the old fabric of Saint Peter's as far as possible—just as two hundred years later this was Borromini's task at the Lateran; to patch up and remodel it as far as needful and possible; to enlarge the transept; to set off shrine and main altar more distinctly; to add chapels for additional altars and masses; and to build chancel and apse deep enough to accommodate a numerous clergy for choir services. Within such limits no question arose of a grand display *all'antica*. Parts of a vocabulary in the new fashion would suffice: a scalloped apse dome, fluted pilasters, composite or Corinthian capitals.

Parallels, too, between *De re aedificatoria* and actual buildings, whether Saint Peter's or others, need to be handled with caution. On the written page theoretical considerations prevail, whereas in practice concessions would have been made to the requirements and limitations of hard reality. Moreover, in *De re* many layers are superimposed, written as it was over nine years or more. Early notions as to the patching up of Old Saint Peter's—perhaps preparing the campaign of repairs in Nicholas's early years—stand alongside late half-utopian conceits, such as the basic unsuitability of basilicas, always with flat ceilings, for church planning, and the demand that they be replaced by central plan *templa*, always vaulted. A vaulted basilica, such as Saint Peter's as projected, was a hybrid in this context. It might be forced on the designer by the practical need of saving as best as possible, yet bringing up to date, a venerated old structure. But it would be dropped from discussion, dissonant as it was with the basic theory being developed during the writing of *De re aedificatoria*. Alberti's having advised Pope Nicholas to interrupt (I repeat, it does not say, to stop) construction should be understood, perhaps, within that same context: either caused by the realization that the old nave would not sustain vaults, thus requiring reconstruction from scratch; or by Alberti's growing conviction that church plans ought not to be basilical anyhow; or by his being dissatisfied with the original project's being pared to the bone, as it was when construction got under way in 1452.

None of this proves that Alberti was responsible for the planned remodeling of Saint Peter's. It only copes with some of the objections raised against the hypothesis of his being the man responsible. The decisive factor favoring the hypothesis seems to me to be the original full project, as reflected prior to 1451 and perhaps as early as 1447, in the *Ordination of St. Stephen*, but not followed up in actual building until the last quarter of the century. The likelihood of the presence in Rome in the late 'forties of a genius other than Alberti, prepared to envisage a church plan and architectural concepts forecasting those of thirty and forty years later, seems to me slim. Is it then really too bold to see Messer Battista as the planner of the original project for remodeling Saint Peter's? Or, indeed, the adviser—if not more—of Fra Angelico in designing the architectural setting of the *Ordination of St. Stephen*?*

ROME

*While this article, submitted in October 1973, was in press, Creighton Gilbert's "Fra Angelico's Fresco Cycles in Rome: Their Number and Dates" appeared in *Zeitschrift für Kunstgeschichte* (XXXVIII, 1975), 245 ff. This is not the place to air my agreement or disagreement with his proposals; I have both. But I gratefully welcome his calling attention to Fra Angelico's documented presence in Rome as early as May 10, 1446, unnoticed heretofore by myself and others.

The Mystic Winepress in the Mérode Altarpiece

MARILYN ARONBERG LAVIN

In a 1945 issue of the *Art Bulletin*, Millard Meiss made observations concerning the Mérode Altarpiece that changed all subsequent thinking about that work of art. He showed that, along with other aspects of the painting, the golden rays bringing light through the window at the upper left of the central panel could be normal elements of the interior scene while at the same time they bear "subtle and pervasive symbolism . . ."[1] Upon these rays glides a tiny figure of Christ carrying on His shoulder the cross of His future sacrifice. The number of rays, as Meiss pointed out, is precisely seven and thus recalls the seven gifts of the Holy Ghost listed by Isaiah and associated with the sacrificial Lamb in the Revelation of St. John. Besides putting an end to the notion that the scene is a simple domestic interior, these remarks already made clear that the ostensible subject of the central *Annunciation* holds within it a christological cycle of much broader scope.

Stimulated, as he said, by prepublication discussions with Meiss, Meyer Schapiro in the same issue of the *Art Bulletin* made further observations of the same kind of combination of representational truth and theological symbolism in the Mérode Altarpiece. Schapiro discovered the antidiabolic significance of St. Joseph's activities in the right wing (Fig. 1). In the two completed mousetraps, among many accouterments of the carpenter's trade in the workshop, Schapiro recognized St. Augustine's metaphor for the vanquishing of the devil through Christ's death on the cross. The workshop, too, was thus revealed as holding allusions to Christ's mission beyond the Incarnation. Schapiro's insight, moreover, helped to define the increased veneration for St. Joseph in the later Middle Ages, during which his function in the scheme of salvation was expanded to being "guardian of the mystery of the incarnation and one of the main figures in the divine plot to deceive the devil."[2]

Although he was to return to it later, in his earlier article Schapiro left unmentioned the object in St. Joseph's hands, upon which he is actually at work. By virtue of Schapiro's own analysis, the lacuna became obvious, and soon a quest for the object's identification began and has continued up to the present day. It is to this point that my paper is addressed.

St. Joseph holds a small rectangular board, on which he has marked spots where he intends to bore holes: a definite pattern of seven (again the symbolic number) staggered

[1]"Light as Form and Symbol in Some Fifteenth-Century Paintings," *Art Bulletin* (XXVII, 1945), 175–81.

It is by now generally agreed that Robert Campin is the triptych's author. It was painted about 1426 for a young couple named Inghelbrechts who lived in the town of Malines; cf. E. Panofsky, *Early Netherlandish Painting* (Cambridge, 1953), I, 129, 133, 136, 142f.; C. de Tolnay, "L'Autel Mérode du Maître de Flémalle," *Gazette des Beaux-Arts* (LIII, 1959), 65–78. See also M. Frinta, "The Authorship of the Mérode Altarpiece," *Art Quarterly* (XXXI, 1968), 247–65. A bibliographical checklist compiled by M. Laszlo and R. Nachtigall, with the assistance of A.F. Gutman, was printed to accompany an exhibition, "Literature on the Mérode Altarpiece," New York, The Metropolitan Museum of Art Library, Oct. 1974–Feb. 1975. But see now L. Campbell, "Robert Campin, The Master of Flémalle and the Master of Mérode," *Burlington Magazine* (CXVI, 1974), 634–46, where the attribution is challenged.

[2]"'Muscipula Diaboli,' The Symbolism of the Mérode Altarpiece," *Art Bulletin* (XXVII, 1945), 182–87. C. Gottlieb, "Respiciens per Fenestras: The Symbolism of the Mérode Altarpiece," *Oud Holland* (LXXXV, 1970), 65–84, proposes Canticles II : 15, as an alternative source.

parallel rows. He has already made three holes and, with an auger in his right hand, steadying the board with his left, he prepares to start on the fourth. As the configuration is similar to a variety of objects in daily life, the many interpretations proposed have all had the requisite basis in reality. In addition, most of the interpretations fit cogently into the general symbolism of the altarpiece. Panofsky, the first to comment, believed the board to be "the perforated cover of a footstool intended to hold a warming pan"; he did not speculate on its meaning.[3] Margaret Freeman, and then Charles de Tolnay, saw it as the base of a spike block, later to be hung from the cord around Christ's waist to torment him as he carried the cross.[4] For them, it was a symbol of the Passion. When Schapiro himself took up the problem in 1959, he found the object similar to roughly contemporary representations of the lid of a fisherman's bait box.[5] Later, Irving Zupnick proposed the floor of a doweled mousetrap, and William Heckscher recognized it as part of a fire screen, similar to that in the central panel.[6] All these latter objects would harmonize with Schapiro's original observation, the theme of Joseph's intervention against the devil. The most recent contribution was made by Charles Minott, whose article brings the meaning of most of the objects in the wing and elsewhere in the altarpiece into very sharp focus.[7] His identification of the board, however, is tentative: the holder for the rods of Mary's suitor's, in which case it would refer simply to Joseph's role as husband and protector of Mary. All these suggestions, however, share several deficiencies: each makes the board redundant, essentially a repetition of points made by other details in the painting; none explains the fact that, psychologically, the board is the focal point of the wing; and, more importantly, none carries the overall symbolism of the altarpiece to a higher level of meaning.

Not long ago in early fall while in Italy, I was invited by a friend to visit his resuscitated *casa colonica* on the slopes of Monte Argentario, to participate in his annual *vendemmia* or grape harvest. The property includes a handsome winepress of antique manufacture, which consists of a rectangular wooden trough with perforated bottom and raking sides supported on

[3] Panofsky, *Early Netherlandish Painting*, I, 164.

[4] M. Freeman, "The Iconography of the Mérode Altarpiece," *Bulletin of the Metropolitan Museum of Art* (XVI, 1957), 130–39; de Tolnay, "L'Autel Mérode," 75. Cf. A. E. Rientjes, "Het Spijkerblok in de Kruisdraging van Christus," *Het Gildeboek* (V, 1922), 41–47. This comparison carries much weight visually: spike blocks are always rectangular, and the spikes are arranged in regular rows. In the case of Joseph's board, however, one doubts if it would be necessary to bore holes in so thin a plank preparatory to driving in the spikes. Moreover, in some cases, such blocks have been cited as made of metal (J. Plummer, *The Book of Hours of Catherine of Cleves*, New York, 1964, 31, pl. 10), thus removing them altogether from the realm of carpentry.

[5] "A Note on the Mérode Altarpiece," *Art Bulletin* (XLI, 1959), 327f.

[6] "The Mystery of the Mérode Mousetrap," *Burlington Magazine* (CVIII, 1966), 126–33 (rebuttal by J. Jacob, "The Mérode Mousetrap," *ibid.*, 373–74; but see F. Zeri, "Un Trittico del 'Maestro della Leggenda di Santa Barbara,'" *Paragone*, XI, 1960, 41–45, who calls attention to the fact that St. Joseph is at work on a mousetrap in the left wing of the Adoration Altarpiece in the Colonna Gallery, Rome. The trap is of the doweled type.).—W. S. Heckscher, "The Annunciation of the Mérode Altarpiece: an Iconographical Study," *Miscellanea Joseph Duverger* (Ghent, 1968), 37–65, esp. 49.

[7] "The Theme of the Mérode Altarpiece," *Art Bulletin* (LI, 1969), 267–71; in particular the tiny white stone on the work-bench and the three levels of meaning for the ax, saw, and rod on the floor at Joseph's feet. There are details on the ax and the saw that, as far as I know, have not been commented on, namely metal marks on the blades. These marks bear out Minott's interpretations of the implements. On the saw is a small Maltese-style cross, which I propose identifies the instrument of Isaiah's death directly with that of Christ. On the ax, Isaiah's metaphor for retribution, referring to the mission of St. John the Baptist, there is a mark made up of three small circles forming a triangle. This mark refers, I believe, to the Trinity revealed for the first time at the moment John baptized Christ. I warmly thank Professor Minott for his enthusiastic response to, and illuminating comments on, this paper.

quartered logs (Figs. 2–4).[8] When in use, it is suspended over a wooden tub. The trough is big enough to hold two adults or one adult and a couple of children. Having performed the traditional rite of tramping, stamping, squashing, and squeezing—a task harder than it sounds and somewhat painful—at a certain moment the procedure had to come to a halt. The juice of the grapes was no longer able to pass from the trough to the tub because of the accumulation of vines, stems, and skins. The strainer, called a *pestalardo* in local dialect, then had to be lifted out and cleaned. It was a rectangular board perforated with circular holes bored in a regular pattern (Fig. 5). When I saw it, I immediately recalled the board in Joseph's hand in the wing of the Mérode Altarpiece.[9]

The theme of the Mystic Winepress has a long and well-studied history in Christian iconography. A passage in Isaiah 63 : 3 is the fundamental text: "Torcular calcavi solus, et de gentibus non est vir mecum; calcavi eos in ira mea, et adspersus est sanguis eorum super vestimenta mea, et omnia indumenta mea inquinavi" ("I have trodden the winepress alone; and of the people there was none with me: for I will tread them in mine anger, and trample them in my fury; and their blood shall be sprinkled upon my garments, and I will stain all my raiment"). St. Augustine brought this passage together with the Marvelous Grape of the Book of Numbers (13 : 23–24) and explained that Christ was the grape of the Promised Land who was put into the press. The symbolism thus established spread throughout Europe in sermons, hymns, and prayers, and by the twelfth century there was a visual tradition as well. Early illustrations addressed themselves to the ministry of the Church toward the believer by showing Christ trampling grapes with his feet in a press from which pours wine that is distributed to the populace. In a second phase, the illustrations emphasize the redemptive qualities of the blood. At the end of the fourteenth century, and with ever-increasing frequency in fifteenth- and sixteenth-century panel painting, Christ Himself is shown under the vise of the press with blood exuding from His wounds and collected in a chalice.[10] In the later versions, the press came to stand not only for the Crucifixion and the whole Passion, but also by implication for the miracle of transubstantiation, in which the blood of the Savior is turned to the wine of communion while remaining intact.

Winepress illustrations throughout the Middle Ages and early Renaissance, both in the christological context and in seasonal and calendar scenes, reflect contemporary local tech-

[8]I am grateful to Roberto and Karin Einaudi, Rome, for their gracious invitation, and to Mr. Einaudi for supplying me with the excellent photographs reproduced in Figs. 2–6.

[9]This association was corroborated by an observation made independently by William Voelkle, Associate Curator of Manuscripts, The Pierpont Morgan Library. In the summer of 1974, Mr. Voelkle saw two large presses on public display in the city of Liège, one in the courtyard of the Curtius Museum and the other in the Musée de la Vie Wallonne. They are both identified as vinegar presses and dated to the twentieth century. Their straining devices are made up of four wooden sides formed into a boxlike shape. Each of the four sides is a rectangular board perforated with drilled holes in staggered parallel rows. These box-shaped strainers rest directly under a metal vise upon a channeled spout. Mr. Voelkle reports that he too was immediately struck by the relationship of these strainers to Joseph's board. Upon learning of my forthcoming

study, he very generously turned over to me his photographs and other information; see below, n. 13.

[10]A. Thomas, *Die Darstellung Christi in der Kelter* (Düsseldorf, 1936); see also, E. Mâle, *L'art religieux de la fin du moyen âge en France* (Paris, 1931), 115–22; M. Vloberg, *L'Eucharistie dans l'art* (Gr no le–Paris, 1946), II, 175–83; *Reallexikon zur deutschen Kunstgeschichte* (Stuttgart, 1954), III, 673–87; L. Réau, *Iconographie de l'art chrétien* (Paris, 1957), II, pt. II, 421–24; *Lexikon der christlichen Ikonographie*, ed. E. Kirschbaum *et al.* (Freiburg, 1970), II, 497–504. Two passages in the Book of Revelation in which the winepress is used as a metaphor for the wrath of God are relevant in this context: 14: 19–20 and 19: 11–16. The pertinent text of St. Augustine is in *Enarratio in Psalmum LV*, J.P. Migne, *Patrologia Latina*, XXXVI, 649, esp. "Primus botrus in torculari pressus est Christus. Cum ille botrus passione expressus est. . . ."

w

niques of winemaking.[11] Rarely do they show the straining apparatus : whether the press is a simple basket or tub, or has a more or less elaborate vise mechanism with one or two screws, the trough is most frequently seen from the front with the tramplers' feet disappearing into the depth. If the tub is tilted toward the picture plane, the bottom is usually covered by bunches of grapes. In one of the few cases I have found in which a strainer is overtly represented, the fresco of *October* in the Castello del Buon Consiglio, Trento, a kind of sagging colander hangs over the barrel.[12] In scenes with Christ in the press, a strainer is or is not there by implication. If the juices spill over a flooring and directly out through a channeled spout, as in the *Book of Hours of Catherine of Cleves* (Fig. 7), it is not. If, on the other hand, the spout is at a low level on the side of or below the trough, as in a rondel from a late thirteenth-early fourteenth-century *Bible Moralisée* (Fig. 8), a strainer is implied.

At this writing, I have found no prior representations of the strainer as an isolated object. Notwithstanding this lack of visual precedents,[13] I propose that St. Joseph in the Mérode Altarpiece is at work on the centerboard of the strainer of a small winepress. This object, in contrast to those suggested by previous scholars, has precisely the form of Joseph's board without requiring visual adjustments in shape and size. In fact, the slightly small r dimensions of the painted sieve, in comparison to the actual one I reproduce (Figs. 5–6), may be justified by its being intended for a "one-man" press, thus fulfilling literally the words of Isaiah : "Torcular calcavi *solus.*"

Since wine manufacture is not characteristic of the Netherlands generally,[14] the artist probably used some source of information other than familiar custom in shaping his "pressfat."[15] The iconography of the Mystic Winepress, however, does have local Flemish resonance. The earliest and one of the most famous of the Confraternities of the Precious Blood was founded in the city of Bruges in the later fourteenth century. This organization centered around veneration of the drops of Christ's blood rediscovered in the Romanesque

[11]A basic source for later medieval viticulture is the text by Pietro de' Crescenzi, *Ruralium Commodorum libri duodecem,* of about 1303, in which Book IV (*De vitibus et vineis et cultu earum . . .*) is entirely consecrated to vines and wine making. The text was translated into many languages and used throughout Europe for many centuries. The author, who concentrates on hygiene in agriculture, confirms his respect for local custom in the passage (as given in an Italian translation published in 1478) in which he says : "Approximandosi lavendemmia cio e il tempo davendemmiare dapparechiare et aconciare sono itini inque luoghi dove usanza e. Il vino cosuo raspi et acini bollire. inaltri i canali ellherbe : et cofani : et ceste : et tucti istrumenti et vasiche aciaschuni necessarii sono secondo che varia consuetudine deluoghi, et ogni vasi necessarii optimamente damollificare et dalavare sono . . . (*Il libro della agricultura di Pietro Crescentio,* Florence, Nicolaus Laurentii, Alemanus, 1478, Libro Quarto, cap. c. xxi, "Dapparechiare lavendemmia").

[12]A. Marescaletti–G. Dalmasso, *Storia della vite e del vino in Italia* (Milan, 1933), II, pl. VI; see also fig. 105 (p. 163), a Florentine engraved calendar of about 1465, which shows a large rectangular press seen slightly from above, displaying a striated surface, presumably the strainer, upon which the stamper stands. For early calendar illustrations, see J.C. Webster, *The Labors of the Months in Antique and Mediaeval Art to the End of the Twelfth Century* (Princeton, N.J., 1938).

[13]Another object in the triptych is used symbolically for the

first time, i.e., the smoking candle on the table of the Annunciation scene; cf. Minott, "The Theme of the Mérode Altarpiece," 270, who calls the candle an autogenous symbol.

W. Voelkle (see above, n. 9) and L. Campbell, "Robert Campin, The Master of Flémalle and the Master of Mérode," n. 80, point out a repetition of the motif of St. Joseph drilling holes with an auger on a similar wooden board in the background of Colijn de Coter's *Virgin with St. Luke,* Church of Vieure (Allier), near Moulins (reproduced in M.J. Friedländer, *Early Netherlandish Painting,* ed. Leiden, 1969, IV, pl. 92). Coster's painting is proposed as a direct copy of a lost *St. Luke* by Robert Campin; see G. Ring, *Beiträge zur Geschichte Niederländischer Bildnismalerei im 15. und 16. Jahrhundert* (Leipzig, 1913), 105. The significance of Joseph's presence in a scene of the Virgin with St. Luke would be to refer to the Incarnation, described more fully in the Gospel of St. Luke than in any other biblical source. His making of the board-strainer apparently has the same proleptic implication as in the Mérode wing.

[14]Cf. J. Craeybeckx, *Un Grand commerce d'importation: les vins de France aux anciens Pays-Bas, XIIIe-XVIe siècle* (Paris, 1958). I am indebted to Professor Paul Rosenfeld for this reference.

[15]The Tuscan dialect term *pestalardo,* mentioned above, is a derivative of the word for press, *pestatoio* (similarly in Venetian dialect, *pigiatoio*); information from Karin Einaudi.

tomb of the crusader Thierry d'Alsace in Bruges.[16] It was the efficacy of this relic, and other similar ones found or refound throughout Europe in this period, that stimulated the development and ultimate dissemination of eucharistic winepress images.

As an allusion to Isaiah's winepress, Joseph's board is linked closely to other symbolic elements in the painting. Minott's work leaves no doubt that passages from the Book of Isaiah underlie most of the detailed imagery in all three panels of the altarpiece, and that Isaiah, the prophet-messenger himself, is represented beside the gate in the left wing.[17] So crucial is Isaianic content for the iconography as a whole that it would be surprising indeed if there were no reference to the Mystic Winepress, one of the most important of his prophecies.

The broad theological implications of the Mérode Altarpiece and Joseph's role as deceiver of the devil in the scheme of salvation are thus consummated in the board. Having served to dissimulate Mary's virginity at the time of the Incarnation, and having prepared the cross with which to trap the devil at the time of the Passion, the craftsman in this heavenly workshop now fashions the most secret part of the winepress, instrument of transubstantiation and symbol of man's redemption through the sacrifice at the altar.

PRINCETON, NEW JERSEY

[16]Mâle, *L'Art religieux de la fin du moyen-âge*, 109, reviews this material with references.

[17]Minott, "The Theme of the Mérode Altarpiece," *passim*, esp. 271.

Ariosto's *Roger and Angelica* in Sixteenth-Century Art:
Some Facts and Hypotheses

RENSSELAER W. LEE

The *Orlando furioso*, first published in 1516, received the polished and amplified form in which we read it today in 1532, the year before Ludovico Ariosto's death. It is the literary masterpiece of the High Renaissance, the greatest of the Italian poems based on Carolingian epic and the romances of the Arthurian cycle, bequeathed to Italy by France.[1] At the end of the fifteenth century, Matteo Maria Boiardo had far excelled all previous Italian writers of romances in the brilliant and vigorous, but chaotic poem *Orlando innamorato*, which, however, he left incomplete. Ariosto, writing in the same tradition, first set out to finish Boiardo's poem but ended by joining his own poem to his predecessor's only in an informal and allusive way; and to his knowledge of Boiardo and the romances he brought an immense store of classical learning that vastly enriches the substance and texture of the poem and is an essential element in its Renaissance character.[2] The *Orlando furioso* continues the form of a romance proceeding picaresquely from episode to episode. But its "sprawling seemingly haphazard"[3] structure of adventures and wanderings, sudden encounters and disappearances, rapid changes of scene and sound, is in reality controlled at all points by a masterly and self-conscious narrator, who interweaves the many strands of his elaborate design with unostentatious skill. To a remarkable overview of human nature Ariosto joins a mastery of irony, serious and comic, which pervades the poem and gives it an elegant and sophisticated unity of tone. The rich world of the *Orlando furioso* offers a vast variety of human motives and passions, which are viewed along a scale ranging from ideal to earthy, from heroic to cowardly, from magnanimous to mean; but it is love viewed in every typical aspect that is the central propulsive force in this large image of life on earth. The protagonist in Ariosto's treatment of this passion is Orlando himself, whose madness, erupting at the exact mid-point of the poem, is caused by his single-hearted, ideal devotion to Angelica, the haughty and beautiful queen of Cathay. Angelica, beloved of many brave and celebrated knights, scorns them all, most notably Orlando, only to fall in love, suddenly and ironically, with a poor, common soldier. Meanwhile, fleeing from her lovers, as we see her on the inhospitable beaches of the northern ocean or, at the poem's beginning, in the midst of the forest, disappearing and reappearing among its lights and shadows, she is a symbol of promise and frustration, of seductive enchantment, arousing no pity but only fascination,[4] and always, despite her fears and dangerous escapes, a proud figure, who holds the whole world in disdain and thinks no man

In preparing this paper I have been particularly indebted to Miroslava Beneš. Besides acknowledgments in the footnotes, I wish also to thank Felton Gibbons, Diana Graves, Evelyn Harrison, Brooks Otis, Kyle M. Phillips, and Birute Vileisis for useful suggestions.

[1] See P. Rajna, *Le fonti dell' Orlando furioso* (Florence, 1900), 3–36, for Ariosto's background and sources in the romances.

[2] *Ibid., passim*, and cf. A.B. Giammati, *The Earthly Paradise and the Renaissance Epic* (Princeton, 1969), 137ff., for a sensitive analysis of the form and spirit of the *Orlando furioso*.

[3] Giammati, *ibid.*, 137.

[4] See A. Momigliano, *Saggio su L'Orlando Furioso* (Bari, 1932), 60 ff., for very perceptive comment on the character of Angelica and her poetic significance.

worthy of herself.[5] She is also a symbol of something more profound, the *varium et mutabile* of human experience and the instability of things possessed.[6] In fact, Ariosto views life in the world in a deeper sense as illusion, of which wandering in a forest, where much of the poem's action takes place, is another symbol. And the poem itself in the restless form of a romance of adventure, with endlessly changing scenes and characters and without formal structure in the classical sense, is an image of the eternal flux of things that is at the heart of the poet's view of life.

Since Angelica and her early adventures are a symbol of the transitory and unattainable, it may come as a surprise that throughout the history of artistic illustration of the *Orlando furioso* this wandering and elusive figure occupies a predominant role assumed by no other character. But the reasons, pictorial and other, are not far to seek, and they rest on Ariosto's treatment of two famous episodes. The idyl of Angelica's honeymoon with Medoro in the country[7] is one of the most attractive pastoral interludes in great poetry; with a long classical and some Renaissance tradition behind it, and with enthusiasm for the pastoral continuing in later Italian and European Renaissance literature, it was a foregone conclusion that for three centuries it would provide for painters the Ariostan subject par excellence. The other episode that concerns us here was a poor second in their esteem, though it is highly pictorial and very dramatic. Like the first, it draws, though far more directly, on classical literature, being mainly inspired by Ovid's account of Perseus delivering Andromeda from the sea monster.[8] In Canto X of the *Orlando furioso*, Roger the paladin, as he rides his famous hippogriff through the air (the hippogriff is a Renaissance counterpart of the classical Pegasus), glances down and sees Angelica, whom evil people have chained naked to a cliff by the sea to be devoured by the Orca, a sea monster; moved to pity by her helplessness and beauty, he flies down, maneuvers brilliantly in the air on his winged steed, and saves her from an appalling death.

This famous scene, recorded in sixteenth- and seventeenth-century book illustration, is infrequent, as we shall see, in drawing and painting of the sixteenth century but recurs in the eighteenth, and in the romantic climate of the nineteenth achieves considerable popularity, enlisting the major talent of Ingres and later perhaps of Delacroix, not to mention many lesser painters whose names are now largely forgotten.[9] To portray it the painters had their special invitation from Ariosto himself, who with Ovid's help, in a crystalline and luminous image that seizes the visual imagination, compares Angelica to "a statue made of alabaster or other finest marble and fastened on the rock by the skill of ingenious sculptors."[10] In the

[5]Canto I, stanza 49:
 Come colei c'ha tutto il mondo a sdegno
 e non le par ch'alcun sia di lei degno.
[6]See the interesting comment of R.M. Durling, *The Figure of the Poet in Renaissance Epic* (Cambridge, 1965), 175ff.
[7]Canto XIX, stanzas 17–40. I am preparing an article on this subject.
[8]*Metamorphoses*, IV, 665–752.
[9]See G. Rouchès, "L'Interprétation du Roland Furieux dans les arts plastiques," *Études Italiennes* (II, 1920), 137–39. For the Liberation of Angelica in Delacroix's *oeuvre*, cf. the remarks of P. Jamot in *Mémorial de l'Exposition Eugène Delacroix* (Paris, 1963), 284.

[10]Canto X, stanzas 95–96:
 La fiera gente inospitale e cruda
 Alla bestia crudel nel lito espose
 La bellissima donna così ignuda
 Come Natura prima la compose.
 Un velo non ha pure in che richiuda
 I bianchi gigli e le vermiglie rose,
 Da non cader per Luglio o per Dicembre,
 Di che son sparse le polite membre.

 Creduto avria che fosse statua finta
 O d'alabastro o d'altri marmi illustri

succeeding canto, Ariosto again invokes the art of sculpture in the description of another beauty, Olimpia, who is exposed to the same fate as Angelica, until her rescue by Orlando. (Olimpia, however, unlike Angelica as we know her up to this point in the story, is a type of constant and devoted love.) Olimpia's well-modeled charms, says Ariosto, seem to have been turned on the lathe by Phidias or some more skillful hand, a potent compliment indeed.[11] Her deliverance, however—less spectacularly dramatic, but dramatic nonetheless—was, in contrast to Angelica's, rarely depicted; and a not unlikely reason is that accompanying the sculptural comparison is an incremental description of her beauties, part added to part ("linked sweetness long drawn out," to recall Milton's phrase), in fact too extended to yield a satisfactory visual impression.[12] This catalogue, so to speak, of Olimpia's fair parts is surpassed in additive completeness only by Ariosto's account in an earlier canto of the beautiful witch Alcina.[13] This description, praised by Ludvico Dolce in the sixteenth century as a model for painters to follow,[14] was to be condemned by Lessing in the eighteenth, because its interminable accretion of detail in temporal sequence leaves no clear impression of corporeal beauty on the mind,[15] something that literary art in its very nature, Lessing believed, is incapable of achieving. But where Ariosto had failed with Alcina by a direct comparison to a statue (here one may readily share Lessing's view), he succeeded with Angelica. In her case the image of light on shining marble (Ariosto's marvelous Mediterranean inheritance!) is visually compelling and the accompanying description restrained. Furthermore, it emphasizes color, the rose and white of her body and the gold of her hair. Thus, through the poet's own plastic emphasis on form and color, the figure of Angelica, in her wanderings and disappearances a fascinating symbol of illusion, becomes in this dramatic episode a capital subject for the visual arts, appreciated even in our own century by such painters as Odilon Redon, and perhaps Giorgio de Chirico.[16] But it was Fragonard who in his famous series of some 150 splendid drawings for the *Orlando furioso* particularly got the point. To the story of Orlando's *Deliverance of Olimpia* he devoted three, only one of them, and that superb, representing Olimpia chained naked to the rock.[17] To the story of Roger's *Deliverance of Angelica* he devoted no less than five, which, with greater or less emphasis but always with awareness of Angelica's beauty, show her in full nudity.[18] As for Ariosto himself, in this passage and in another wherein he describes Angelica crossing an arm of the northern ocean on the back of a horse (here he remembers Ovid's story of Europa)[19] while "the sea and all the greater winds were quiet perhaps intent on such great beauty,"[20] he pays his own profound

Ruggiero, e su lo scoglio così avvinta
Per artificio di scultori industri;
Se non vedea la lacrima distinta
Tra fresche rose e candidi ligustri
Far rugiadose le crudette pome
E l'aura sventolar l'aurate chiome.
[11]Canto XI, stanza 69:
 I rilevati fianchi e le belle anche
 E netto più che specchio il ventre piano,
 Pareano fatti, e quelle cosce bianche,
 Da Fidia a torno, o da più dotta mano.
[12]Canto XI, stanzas 67–69.
[13]Canto VII, stanzas 11–15.
[14]*Dialogo della pittura* (Florence, 1735; first ed. Venice, 1557), 178.

[15]*Laokoön*, XX.
[16]See K. Berger, *Odilon Redon* (New York, n.d.), 191–93 and 208–09; I. Far, *Giorgio de Chirico* (Milan, 1968), 19 and pls. 100–01.
[17]See E. Mongan–P. Hofer–J. Seznec, *Fragonard Drawings for Ariosto* (New York, 1945), pl. 76. Altogether 137 drawings are reproduced in this publication. To an earlier pathetic phase of Olimpia's story, her abandonment by Bireno, Fragonard devotes seven splendid and very expressive drawings, but they are not concerned with corporeal beauty.
[18]*Ibid.*, pls. 66–70.
[19]*Metamorphoses*, II, 843ff.
[20]Canto VIII, stanza 36:
 Stavano cheti tutti i maggior venti,
 Forse a tanta beltà col mare attenti.

tribute—and perhaps that of an age nourished on Platonism and aware of the ideal element in antique sculpture—to the power of female loveliness to stir and exalt the imagination. Raphael, painter par excellence of the High Renaissance, writing to Baldassare Castiglione in 1514, two years before the *Orlando furioso*'s appearance, had invoked in his own mind the idea of beauty as the untarnished model for his portrayal of beautiful women.[21]

Angelica's appeal to the painters and graphic artists, therefore, may owe something to Ariosto's pictorial treatment of her in this brilliant and active episode of her rescue by Roger, who in accomplishing his act of chivalry performs dazzling aerial acrobatics on the famous hippogriff. But the episode also had clear iconographic forebears in time-honored subjects of similar content, in which, as in Ariosto, a beautiful woman is saved from a ravenous monster by a gallant warrior—notably St. George and the Dragon, long familiar in Christian iconography, and with particular relevance Perseus and Andromeda; representations of these themes could have been known to painters and stimulated them to illustrate a like fable found in a popular modern poem. We have already noted that Ariosto in his narration of Angelica's deliverance remembers Ovid's account of Perseus rescuing Andromeda. Both poets describe a beautiful woman, naked, chained to a cliff by the sea, and resembling a statue in her beauty, while a warrior attacks a monster from the air, the only difference being that Roger rides the hippogriff whereas Perseus flies on winged feet under his own power. And just as the modern poet found a compelling model in an antique fable told by a craftsman of his own art, so the Italian painters and engravers who were to portray Angelica's deliverance could have had before them, in earlier or contemporary Renaissance examples, visual representations of Perseus saving Andromeda. These, based on Ovid's text, have behind them a solid pictorial tradition in antiquity, which shows Perseus descending through the air on winged feet to save Andromeda chained to a cliff.[22]

But a century before the publication of *Orlando furioso* in 1516, a novel mode of depicting Perseus saving Andromeda had appeared in miniatures executed in the north of Europe. The written tradition that prompted this iconography had longevity of its own, and at this point in our consideration of the kindred theme, Roger and Angelica, it merits consideration.

[21] V. Golzoi, *Raffaello nei documenti* (Vatican City, 1936), 30ff.

[22] See K.M. Phillips, Jr., "Perseus and Andromeda," *American Journal of Archaeology* (LXXII, 1968), 1–23, pls. 1–20, for an excellent discussion of ancient and medieval treatment of the subject in painting and sculpture, for its origins and the variant accounts in ancient literature, and for bibliography. The iconography of Andromeda chained to a cliff by the sea evolved in the artistic environment of Tarentum during the fourth century B.C. and became the basis for the tradition of Campanian wall painting, in which Perseus flies down on winged feet or boots, the head of Medusa in his left hand, the *harpe* or hooked sword in his right, to save Andromeda, whose bound arms are outspread against the cliff, e.g., the fresco from Boscotrecase, The Metropolitan Museum of Art, New York, *ibid*, pl. 1, fig. 2 and variants of this type illustrated by Phillips, figs. 3, 4, 6. In a second well-known type, also of Tarentine origin, Perseus, who has slain the monster and freed Andromeda, courteously assists her to step down from the rock, as in the fresco from the Casa dei Dioscuri, Pompeii, National Museum, Naples (*ibid*. pl. 4), and the famous relief in the Capitoline Museum (fig. 9); cf. also the interesting painting of the fourth century A.D., now in the Antiquario Comunale, Rome, found on the wall of a niche in a Roman house on the slopes of the Capitoline. Here Perseus, wearing a Phrygian cap and carrying a hooked bill, assists Andromeda, nude above the waist and wearing a pearl necklace and plain armlets, to descend from the rock (see J.M.C. Toynbee, *The Art of the Romans*, New York–Washington, 1965, 125, 258, and fig. 72). Athenian and South Italian pottery (generally Apulian) of the fourth century B.C. represents Andromeda bound between two posts, columns, or flowering trees, with Perseus near at hand; she is generally clad in peplos, chiton, or oriental dress but on a Campanian hydria in the Naples Museum she is shown nude, tied between two posts (Phillips, *ibid*., pl. 8, fig. 20, and cf. figs. 41 and 42). It seems not improbable that when Ovid described Andromeda chained to the cliff ("marmoreum ratus esset opus"), he thought of her as nude, even though the tradition in art had generally represented her clad; he could have had in mind the statue of a Hellenistic Venus. In Ariosto, whose description is close to Ovid's, Angelica is nude *pur sang*

For it is the steed that Roger rides through the air, the fabulous hippogriff, a winged griffin with eagle's head and forequarters of a lion but the hindquarters of a horse,[23] which raises an interesting question concerning Ariosto's relation to Ovid and to his later interpreters; and it may also have some bearing on the illustrators of the story of Perseus and Andromeda in Italy and northern Europe after the mid-sixteenth century. The hippogriff, Ariosto informs us with tongue in cheek, is not a creature of fiction but a natural animal, sired by a griffin, mothered by an ass. It is like its father in front, its mother behind, and is found, though rarely, in the Ripaean mountains beyond the frozen seas.[24] A hint from Vergil's eighth *Eclogue* may have suggested to Ariosto the hippogriff's miscegenetic parenthood;[25] on the griffin side, Ariosto was certainly familiar with representations of this creature, a mixture of lion and eagle, in ancient art and particularly on the entablatures of temples.[26] But the important antique forebear of the hippogriff, as Pio Rajna recognized long ago,[27] is the winged horse Pegasus, sprung, as Ovid and others report, from the blood of Medusa after her decapitation by Perseus.[28] Like Pegasus, the hippogriff, carrying a hero on his back, flies vast distances over fabled countries and performs glorious aerial feats. This similarity in function and accomplishment is what matters; physical dissimilarities are unimportant. "La differenza," Rajna correctly observes, "sta tutta negli accidenti." But the antique rider of Pegasus par excellence was not Perseus, the savior of Andromeda, but Bellerophon who, riding the winged horse, slew the chimera.[29] Thus, in Ariosto's mind, when he described the liberation of Angelica, there may have been not only Ovid's account of Perseus flying on winged feet to attack the monster, but also the ancient story of Bellerophon attacking the chimera from the back of the flying Pegasus, which too the poet could have seen portrayed on Roman coins and gems.[30] Ariosto's account, therefore, could represent a conflation of Ovid's story, which

[23]*Orlando furioso*, IV, 18:

> Non è finto il destrier, ma naturale,
> Ch' una giumenta generò d'un grifo;
> Simile al padre avea la piuma e l'ale,
> Li piedi anteriori, il capo è il grifo;
> In tutte l'altre membra parea quale
> Era la madre, e chiamasi Ippogrifo;
> Che nei monti Ripei vengon, ma rari,
> Molto di là dagli agghiacciati mari.

[24]Herodotus (IV, 13) reports that the griffins guard gold in the country next to the Hyperboreans (who dwell near the northern limits of the world); cf. Aeschylus, *Prometheus Bound*, 812ff. For the inhospitable Ripaean mountains see Sophocles, *Oedipus at Colonnus*, 1248ff; Aristotle, *Meteorologica*, II, 13. Ariosto could also have found them in Pliny, *Historia Naturalis*, VI, 14 and 39. For speculation as to the hippogriff's remote and nearer origins see Rajna, *Le fonti dell'Orlando Furioso*, pp. 115ff., and S. Reinach, "Pégase, l'hippogriffe et les poètes," *Revue Archéologique* (5th ser., XI, 1920), 227ff.

[25]In Eclogue VIII, 26–28, Damon asks what lovers may not expect now that Nysa is given to Mopsus. "Griffins will now mate with mares (*iungentur iam grypes equis*) and in the age to come the timid deer will come to drink with the hounds."

[26]Rajna, *Le fonti dell'Orlando Furioso*, 119.

[27]*Ibid.*, 114.

[28]Ovid, *Metamorphoses*, IV, 765–86. For Greek sources, see J.M. Woodward, *Perseus, A Study in Greek Art and Legend* (Cambridge, 1937), 4–23.

[29]For ancient literary sources of the myth, see Homer, *Iliad*, VI, 155ff., Hesiod, *Theogony*, 319–25, and Pindar in two odes, Olympian XIII and Isthmian VII. Bellerophon's combat with the chimera is also related by the mythographers: Hyginus, *Poeticon astronomicon*, XVIII, as early as the second century A.D.; Fulgentius (fifth to sixth century), *Mythologiae*, III, 1 (for these writing, see the edition of A. van Staveren, *Auctores mythographi latini*, Leiden, 1742); and in the three Vatican Mythographers (see G.H. Bode, *Scriptores rerum mythicarum latini tres Romae nuper reperti*, Celle, 1834, I, 71–72; II, 131; III, 14; a new facsimile edition, Hildesheim, 1968, contains a convenient index).

[30]For instance, a late antique gem in Munich (*Antike Gemmen in deutschen Sammlungen, I, Part 2. Staatliche Münzsammlung, München*, ed. E. Schmidt (Munich, 1970), 131 and Taf. 138, no. 1390, and the reverse of the famous medal, struck at Corinth, of the Emperor Lucius Aurelius Verus, born 130 A.D. and coemperor at one time with Marcus Aurelius (see S. Erizzo, *Discorso sopra le medaglie degli antichi*, Venice, 1568, 511, fig. 1). In both of these and in similar examples, Bellerophon on the winged horse thrusts his lance diagonally downward at the chimera turning its lion's head, lower right. Erizzo, *ibid.*, 513, refers to the borrowed illustration and moral interpretation of the Verus image in Alciati's *Emblemata*, in which it appears first in the Paris edition of 1535 under "Consilio et virtute Chimaeram superari, hoc est, fortiores et deceptores." The same essential image appears in Ripa's *Iconologia* under "Virtù" (1603 ed., 509) wherein Alciati is quoted and reference made to the medal of Lucius Verus. An interesting reference to contemporary history is found on the medal of Philip II of Spain showing Bellerophon and the chimera after ancient models, in which Bellerophon is under-

he follows in sequence of action and in detail, with the myth of Bellerophon—the latter suggesting the image of a rider on a winged steed in victorious combat with a monster.

Shortly before the *Orlando furioso* was published in 1516, however, another tradition, originating not in ancient literature but with the ancient and medieval mythographers, was given fresh currency. This tradition, as it grew, was to place Perseus uncanonically on the back of Pegasus, where he usurps the saddle that antiquity seems universally to have given Bellerophon.[31] As a result of mythographical summary and commentary, confusion developed between Perseus and Bellerophon.[32] Thus, in a twelfth-century manuscript, Bellerophon is declared identical with Perseus: "Bellerophontis qui et Perseus,"[33] and while Boccaccio, writing in the third quarter of the fourteenth century, does not identify them, he states clearly in his article on Pegasus in the *Genealogia deorum* that the winged horse had carried each rider on an exploit—Bellerophon against the chimera, Perseus when he traveled to the land of the Gorgons.[34] Now a Latin *Moralized Ovid* written at Avignon about 1340 by Petrarch's friend, the Dominican Pierre Bersuire (Petrus Berchorius),[35] which somewhat antedates the *Genealogia*,[36] was printed in Paris four times between 1509 and 1521.[37] Perseus, says Bersuire

stood to be Philip and the chimera the Anglican Church; see A. Heiss, *Les Médailleurs de la Renaissance* (Paris, 1891), II, 36, pl. II, 7 and 8. Representations of Bellerophon and the chimera had a rare survival in the seventeenth century. Thus, Rubens in 1635 included the theme in the designs he prepared for the street decorations for the triumphal entry of Ferdinand of Austria into Antwerp. His brilliant sketch in the Musée Bonnat at Bayonne also has its ancestry in Corinthian medals like that of Lucius Verus, and its immediate forebear is Ripa's *Virtù*, which Rubens obviously knew and transformed into a vital work of art; see J.R. Martin, *The Decorations for the Pompa Introitus Ferdinandi* (Brussels, 1972), 212–15 and pls. 110–11. And a ceiling fresco of 1678 by Giuseppe Passeri in the Barberini Palace in Rome shows Bellerophon conquering the chimera and is also based on the illustration in Ripa. For the origin and significance of Passeri's fresco as *exemplum virtutis*, see J. Montagu, "*Exhortatio ad Virtutem*, a Series of Paintings in the Barberini Palace," *Journal of the Warburg and Courtauld Institutes* (XXXIV, 1971), 366–72, pl. 64.

[31]Another view would favor the origin of the tradition in classical antiquity. Thus, it has been noted that on an antique terracotta relief from Melos, Perseus appears with the slain Medusa; and he is mounted on a horse. But is the horse Pegasus? He sprang, it is true, from Medusa's blood. Yet here the horse has no wings and therefore cannot be surely identified as Pegasus, certainly not as Pegasus in the context of Perseus's late medieval adventures on his back. See P. Jacobsthal, *Die melischen Reliefs* (Berlin, 1931), 46, pls. 28–29, and Reinach, "Pégase," 210. And Ovid's line in the *Amores* (III, 12), "Victor Abantiades alite fertur equo," is translated "the victorious grandson of Abas (i.e., Perseus) is borne by a winged horse." But it has been argued that "victor Abantiades" is a copyist's error—Ovid had intended Bellerophon (Reinach, *ibid.*, 211-12). So neither ancient art nor ancient literature provide any sure sign that Perseus rode Pegasus through the air. When Catullus writes (LV), "Non si Pegaseo ferar volatu," "Pegasean flight" is an image of speed and in no way connotes Perseus on the horse's back (see Reinach, *ibid.*, 234). See also the articles of Baldwin and Steadman cited in n. 32 and 38, below.

[32]For discussion of the complicated evolution of the change of ownership, see T.W. Baldwin, "Perseus Purloins Pegasus," *Philological Quarterly* (XX, 1941), 363–65. The tradition that

Pegasus was a swift ship as well as a horse (both originally belonging to Bellerophon) goes back to the Early Christian centuries. In the Middle Ages, it appears in Vatican Mythographers II and III (Bode, *Scriptores rerum mythicarum*, II, 112, p. 113; III, 14, p. 251) and Boccaccio thus sums it up in the mid-fourteenth century: "Alii tamen [as opposed to those who hold by Pegasus as a horse] volunt eum ad transfretandum habuisse navim, cuiusque insigne vel nomen fuerit Pegasus" (*Genealogia deorum*, XII, 25).

[33]Vatican Mythographer I (Bode, *ibid.*, 71, p. 24). See K.O. Elliott and J.P. Elder, "A Critical Edition of the Vatican Mythographers," *Transactions of the American Philological Association* (LXXVII, 1947), 199.

[34]X, 28: "Hunc insuper dicunt Bellerophontem adversa chimeram monstrum euntem tulisse. Sic et Perseum dum ad Gorgones ivit."

[35]This *Ovidius moralizatus* (I shall hereafter refer to the mimeographed text, Utrecht, 1962, made after a microfilm of the copy of the 1509 edition in the Bibliothèque Nationale) is Book XV, separately published, of Bersuire's large work, the *Reductiorum morale*, and contains his moralized version of the *Metamorphoses*. The four early-sixteenth-century editions, mentioned in n. 37, below, were mistakenly printed under the name of the Englishman, Thomas Walleys, author of another moralizing work, *De archana deorum* (ed. R.A. van Kluyve, Durham, 1968).

[36]The *Genealogia* was begun toward the middle of the century, and Boccaccio worked on it during the last twenty-five years of his life. See J. Seznec, *The Survival of the Pagan Gods* (New York, 1953), 220 (original French edition *La survivance des dieux antiques*, London, 1940).

[37]For Bersuire's life and writings, and their sources, see C. S[amaran], "Pierre Bersuire," *Histoire littéraire de la France*, XXXIX (Paris, 1962), 259–450; for the printed editions of 1509, 1511, 1515, 1521, see pp. 429–50; see also the introduction by J. Engels to Bersuire's *De formis figuresque deorum*. Werk materiaal 3 (Utrecht, 1966), II-XXIII. The *De formis* is the introductory chapter to the *Ovidius moralizatus* (see n. 35 above). Cf. also E.H. Wilkins, "Descriptions of Pagan Divinities from Petrarch to Chaucer," *Speculum* (XXXII, 1957), 511–22, and E. Panofsky, *Renaissance and Renascences in Western Art* (Stockholm, 1960), 78 n. 2.

(following Ovid, as Boccaccio does), cut off the head of Medusa, and immediately the winged horse Pegasus sprang from her blood. Then, diverging from Ovid,[38] he relates that the hero climbed on the horse's back and was carried far and wide through the air.[39] In Bersuire, as in the sources, Perseus is equipped against danger with the shield of Pallas, and with the *harpe*, or hooked sword, and the winged sandals (*talaria*) of Mercury.[40] Before continuing the story, Bersuire, following, as he says, the fifth-century Latin grammarian and mythographer Fulgentius, explains the allegorical meaning of this: the flight aloft of Perseus on Pegasus signifies fame, which carries a man's name and virtue to the ends of the earth.[41] It also typifies Christ's ascension into Paradise, just as later we are told that the saving of Andromeda from the monster signifies Christ's saving the human soul, bound by sin to this earthly shore, from possession by the devil.[42] The author then resumes his narrative to tell how Perseus flew on Pegasus to the abode of the giant Atlas, whom he turned to stone by displaying the terrifying head of Medusa when Atlas refused him the hospitality of a lodging; hence the huge stony ridges of the Atlas Mountains. There follows the telling passage for our discussion: "Athlante in montem mutato Perseus cum equo suo ascendit aera et cum ab Hispania usque ad oppidum quoddam in aethiopia venisset volando vidit in littore maris andromedam virginem pulcherrimam unicam cephei regis filiam et haeredem vinculis ferreis ad cautes

[38]See J.M. Steadman, "Perseus upon Pegasus and *Ovid Moralized*," *Review of English Studies* (n.s. IX, 1958), 407–10. I was directed to this article by the discussion of illustrations of Perseus and Andromeda in Carla Lord's unpublished doctoral dissertation (Columbia University Library) on the illustration of the *Ovide moralisé* in verse; David Duvivier, among other kindnesses, had called my attention to Mrs. Lord's thesis. Steadman, whose article has been little known to historians of art, was I believe the first to note the important contribution of Bersuire to the tradition that mounted Perseus on Pegasus. He and Boccaccio seem, in fact, to have brought together here two traditions, one of Bellerophon on Pegasus, conquering the chimera, the other of Pegasus springing from Medusa's blood after Perseus has decapitated her. The final stage in the long, confused association of Bellerophon and Perseus would seem, then, to be Perseus simply mounting the horse at whose birth he was present, but which antiquity gave to Bellerophon, riding off on him to perform an act similar to Bellerophon's, and then, backed by allegory, appropriating him.

Elizabeth Beatson has made the interesting and plausible suggestion that the close proximity or actual juxtaposition of the figures of Andromeda, Perseus, and Pegasus in medieval astrological manuscripts might have given a hint for the combination of Perseus and Pegasus as horse and rider in representations of the Liberation of Andromeda. Thus, in a Carolingian manuscript of the *Aratea* in Leiden (University Library, Voss. lat. 79), Andromeda appears on fol. 30v, half nude and chained between two rocky posts; one turns to fol. 32v and finds a winged Pegasus, while Perseus with wings bound to his ankles and carrying Medusa's head is not far away on fol. 40v; see G. Thiele, *Antike Himmelsbilder* (Berlin, 1898), 27ff. and figs. 31, 32, 36; Seznec, *The Survival of the Pagan Gods*, 149ff. The prototypes for such illustrations reach back to the last centuries of the Roman Empire. Among later examples in which Andromeda, Pegasus, and Perseus appear on the recto and verso of the same folio or on adjacent folios we may cite a twelfth-century manuscript in Durham (Cathedral Library, Hunter MS 100): fol. 62r shows Andromeda entirely nude, a winged Pegasus below, while the verso shows Perseus; see F. Saxl, *Verzeichnis astrologischer und mythologischer Hand-*

schriften des Lateinischen Mittelalters, III (with H. Meier), *Manuscripts in English Libraries* (London, 1953), 445 and Taf. LXX, Abb. 176. As Gothic examples we may cite Tübingen, University Library, Cod. M.d.2, fols. 314v and 315v, and London, British Museum, Add. MS 41,600, fols. 46r and v, both illustrated in Phillips, "Perseus and Andromeda." In a fifteenth-century manuscript in Vienna, Cod. 5442, fol. 127v, all three appear, Andromeda bound between flowering posts, and a winged Pegasus at whose right stands Perseus with foot wings holding Medusa's head; see Saxl, *ibid.*, II. *Die Handschriften der National-Bibliothek in Wien* (Heidelberg, 1927), 155–56, Taf. VI, Abb. 77.

[39]*Ovidius moralizatus*, 85, fol. XLIIa: "Perseus amputavit caput medusae quod erat serpentinum monstrum et homines in lapides convertebat et statim de sanguine eius natus est pegasus equus scilicet alatus sive pennatus et alis in pedibus praemunitus. *Super quem cum perseus ascendisset portavit eum per aera circumquaque.*"

[40]Cf. *Metamorphoses*, IV, 655–56, 782. See also Hyginus, *Fabulae*, LXIV; all three Vatican Mythographers (Bode, *Scriptores rerum mythicarum*) mention the shield of Pallas, I and III the *harpe*, but none the winged sandals; Bersuire (*ibid.*, 83, fol. XLI, a) mentions the *pennas* as well as the *scutum* and *harpe*, but then proceeds inconsistently to mount Perseus on Pegasus. Boccaccio, *Genealogia deorum*, XII, 25, says that in his expedition against the Gorgon Perseus had "Pegasum alatum equum, et Palladis egydem et talaria ensemque Mercurii," but he does not say in the ensuing account of the saving of Andromeda whether Perseus flew on the winged *talaria* or on Pegasus. If he is unclear here, he is also inconsistent when he reports elsewhere (x, 28) that Pegasus was born of Medusa's blood.

[41]*Ovidius moralizatus*, 85, fol. XLII, a: "Istud exponit fulgentius: dicit enim quod perseus occidit medusam de cuius sanguine natus est equus et ita statim quod aliquis facit aliquod notabile factum inde nascitur equus volucris portans eum id est fama quae ipsius et nomen et strenuitatem virtutis eius ad regiones remotas portat et more volucris cito volat. De virtute autem fama nascitur qua volante homo cognoscitur et portatur." Cf. Fulgentius, *Mythologiae*, I, 26.

[42]*Ibid.*, 88, fol. XLIII, b.

religatam a quodam monstro protinus devorandam."[43] Thus Perseus, inheriting the rider's privilege of Bellerophon, is flying high in the air on his winged horse, when looking down he descries Andromeda chained to the rock. He descends, pities the girl, falls in love with her, and then, after making an agreement with her parents that she will become his bride if he saves her from the monster, "eam (bestiam) occidit et puellam duxit" (in marriage).[44] In this account Bersuire follows Ovid and for the most part in Ovid's order, the major difference (the allegory, of course, aside) being that Perseus riding the air on his winged horse has supplanted the classical and Ovidian figure of Perseus flying on footwings. A prose *Ovide moralisé*, probably composed between April 1466 and September 1467,[45] contains a similar version (the writer almost certainly knew and borrowed from Bersuire), which is at the same time more vivid in its account of Perseus's aerial peregrinations, and describes, as Bersuire does not, Perseus flying above the monster on the back of Pegasus and wounding it with his hooked sword: "Et atant se monta Perseüs dessus son cheval Pegasus, si s'en alla volant en l'air par dessus la dite beste, qui desja estoit bien près de la rive marine où estoit la dite pucelle lyée, et de son fachon trenchant luy donna plusiers et diverses plaies."[46]

Such, then, in summary is the tradition, originating in the mythographers, mentioned briefly in Boccaccio, amplified and consolidated in Bersuire and the prose *Ovide moralisé*, that made Perseus the rider of Bellerophon's horse Pegasus.[47] Once securely established, the new image of Perseus on Pegasus was to captivate the imagination of the sixteenth century. One excellent and natural reason for this was that Perseus riding Pegasus to rescue the beautiful and helpless Andromeda had obvious appeal for those who were nurtured in the traditions of courtly love and the romances of adventure, whereas Bellerophon's exploit lacked chivalric

[43]*Ibid.*, 87, fol. XLIII, a. Steadman ("Perseus upon Pegasus," 408) states that Bersuire did not introduce "the winged horse specifically into Perseus' adventures with Atlas and Andromeda." But Berchorius says clearly that Perseus flew to the domain of Atlas on the back of Pegasus and later took off again on Pegasus, who carried him through the air until he looked down, saw Andromeda, and descended.

[44]*Ibid.*

[45]C. de Boer (in collaboration with J.T.M. van't Sant), "Ovide moralisé (texte du quinzième siècle)," *Verhandelingen der koniklijke Akademie van Wetenschappen te Amsterdam, Afdeeling Letterkunde* (n.s., LXI, 1954), 3.

[46]*Ibid.*, 166.

[47]Bersuire would seem to be the first known writer on present record to place Perseus squarely on the back of Pegasus both for his journey to Atlas and thence to the homeland of Andromeda. In the verse *Ovide Moralisé* of the beginning of the fourteenth century, Perseus flies on winged feet, as in Ovid and the Greek sources; see C. de Boer, ed., "Ovide moralisé," *Verhandelingen der koniklijke Akademie van Wetenschappen te Amsterdam* (n.s. XXI, 1920), 128ff., 5637, and n. 38, above. As to Perseus on Pegasus, the following comment is also in order: the illustrated edition of the *Metamorphoses*, published at Frankfort in 1563, contains the famous *Argumenta* or *Narrationes* (prose summaries or digests of Ovid's narratives) of the so-called Lactantius Placidus, which also appear in greater or less part in a number of previous and subsequent editions; they had occurred centuries earlier in manuscripts of the *Metamorphoses*. In the 1563 edition, the summary account of that part of the Perseus story dealing with the transformation of Medusa's hair into serpents is, with some textual

variants, Lactantius's *Argumentum* and is then immediately followed by this passage: "Perseus igitur ei dormienti tectus scuto Palladis, caput abscidit, post insidens Pegaseo quem ex Neptuno Medusa peperit, in varias hinc inde regiones avectus est." This same passage, recounting the slaying of Medusa and Perseus borne aloft on Pegasus immediately thereafter, occurs also in other illustrated editions containing the *Argumenta* of Lactantius and published in Northern Europe, e.g. those of Leipzig, 1582 and 1596, and of Amsterdam, 1591. T.W. Baldwin, "Perseus Purloins Pegasus," 367, mentions still other editions, including a Paris series beginning in 1583, in which the passage occurs. But it is found in none of the seven extant manuscripts of the *Metamorphoses* containing the *Argumenta* (ninth to twelfth centuries), nor does it occur in the two full recensions of the text of the *Argumenta* that have been published; see B. Otis, "The Argumenta of the So-Called Lactantius," *Harvard Studies in Classical Philology* (XLVII, 1936), 131ff. and D.A. Slater, *Towards a Text of the Metamorphosis of Ovid* (Oxford, 1927), the Lactantius text, XVII–XX. The passage is probably, therefore, a late accretion, perhaps dependent on Bersuire, but not related to the original Lactantius material, which is probably descended from a copy of a fifth- or sixth-century codex of the *Metamorphoses* with the *Argumenta* written in the margin (Otis, *ibid.*, 160). The name Lactantius appears first in its Ovidian connection in the fifteenth century in the early editions of the *Metamorphoses*, and in one fifteenth-century manuscript.

In all the illustrated editions mentioned above, Perseus is represented riding Pegasus (thus being in accord with the passage discussed above), except the Amsterdam edition of 1591, in which inconsistently he flies on footwings as in Ovid.

and amatory overtones. Also, according to the ancient myth as told by Homer and Pindar, which appears in its latest development in the famous mythographical manual of Natalis Comes of 1551,[48] Bellerophon after his valiant exploit against the chimera attempted to scale the heights of heaven on his winged steed; but Zeus, offended by his arrogance, caused him to fall to earth,[49] a tragic victim of his own hubris, while Pegasus flew on without his rider to be handsomely stabled in the stalls of Olympus. Bellerophon's catastrophe, then, while it might provide Comes with an exemplum of human *superbia*, did not recommend him, in comparison to Perseus, as an example either of chivalrous behavior or sound horsemanship.

Returning now to Ariosto, after what may appear an overlong digression, one should note again that although he drew mainly on the action and imagery, and even on the language, of Ovid's account of Andromeda's rescue in his parallel episode of Angelica's deliverance, and although he presumably knew the legend of Bellerophon riding the winged horse when he slew the chimera and might have seen antique portrayals of this exploit, he was likewise inheritor of another tradition, which had received fresh emphasis in print in the three editions of Bersuire published within the five years immediately preceding the appearance of his *Orlando furioso* in 1516.[50] It was this tradition of mounting Perseus on the horse that had belonged to Bellerophon that could have furnished Ariosto with a most likely source for Roger riding a winged steed to deliver a woman from death. Whether Ariosto actually availed himself of this tradition one cannot definitely say. Certainly it presented itself to him in no very attractive literary form, and it may be that with the ancient fable and image of Bellerophon's exploit as well as Ovid's Perseus and Andromeda in mind, and remembering a curious line from Vergil, he had invented his own winged steed, the hippogriff, without recourse to the brief word on Perseus riding Pegasus in Boccaccio, or the full account of the saving of Andromeda in Bersuire. But the tradition had been strongly reaffirmed and was alive in the early sixteenth century, and there is strong likelihood that Ariosto knew it.[51] In any case, it is interesting that in the edition of the *Orlando furioso* published by Valgrisi in Venice in 1556, the commentator, Geronimo Ruscelli, states clearly that Ariosto's account of Roger's rescue of Angelica on his hippogriff is based on the story of Perseus's saving Andromeda on Pegasus: "Non solo s'è accomodato de i nomi, ma di molte cose ancora, come Angelica esposta al monstro liberata da Ruggiero sù l'Ippogrifo appresenta Andromeda esposta al

[48]*Mythologiae* (Venice, 1551). For the Bellerophon myth, see especially M. Lascelles's illuminating article, "The 'Rider on the Winged Horse,'" *Elizabethan and Jacobean Studies Presented to Frank Percy Wilson* (Oxford, 1959), 173–76 and 185–88.

[49]The fall of Bellerophon occurs very rarely in visual illustration and not to my knowledge before the seventeenth century. One example occurs in *Pauli Maccii Emblemata* (Bologna, 1628); cf. A. Bartsch, *Le Peintre-graveur*, XIX, 27, no. 89. Another is a Dutch seventeenth-century seascape in a London private collection, which shows Bellerophon thrown by Pegasus high in the sky (photo: Warburg Institute).

[50]See p. 307 and n. 37, above.

[51]According to the inventories, Ovid's works were well represented in the libraries of the Dukes of Ferrara, who were also inclined to be generous in lending their books. See

G. Bertoni, *La Biblioteca Estense e la coltura francese ai tempi del Duca Ercole I (1471–1505)* (Turin, 1903), 49, 62, 89, 110, 215; A. Cappelli, "La Biblioteca Estense nella prima metà del secolo XV," *Giornale Storico della letteratura italiana* (XIV, 1886), 1–30; D. Fava, *La Biblioteca Estense nel suo sviluppo storico* (Modena, 1925), 29 and 291. There is, however, no record of Pierre Bersuire or of any *Ovide moralisé* or *Ovidius moralizatus* in any inventory of the ducal libraries. But between 1509 and 1516 Ariosto might have borrowed an *Ovidius moralizatus*, a new book, or possessed a copy of his own, for that matter. For a valuable discussion of books, libraries, and learning at Ferrara, see W. Gundersheimer, *The Style of a Renaissance Despotism* (Princeton, 1973), 85–88, 90–140, 168–69. I am indebted to Professor Gundersheimer for directing me to the Ferrarese inventories.

monstro liberata da Perseo su'l cavallo Pegaseo. . . ."[52] Thus by mid-century in Italy, although the fine arts in the peninsula had not yet caught up, the possession of Pegasus by Perseus was already a *fait accompli* in the world of letters and cultivated life. At the end of the century Perseus on Pegasus is common coin among the Elizabethans in England. A particularly interesting example in the context of this paper occurs in Edmund Spenser's *Ruins of Time*, written about 1590. In the "tragic pageant" or vision of Sir Philip Sidney's death and apotheosis Spenser places the poet-knight:

> . . . all armed upon a winged steed;
> The same that was bred of Medusae's blood
> On which Dan Perseus borne of heavenly seed
> The fair Andromeda from perill freed:[53]

Pegasus then bore Sidney straight to heaven, as Spenser says he must bear all men whose deeds have gained them immortal fame. Perseus on Pegasus, then, has come entirely into his own. An ancient cloudy identification with Bellerophon has yielded by now to a full acceptance of Perseus as the pre-eminent rider of the winged horse, on which he saves Andromeda. For this variant of the story from Ovid and its dissemination in Renaissance and later literature, and, as we shall see, in art, fair credit must be given the versions of the *Ovide moralisé* (notably the *Ovidius moralizatus* of Bersuire), which we have considered here. These, with Boccaccio, were also a likely source for keeping current as inspiration for sixteenth-century and later poetry the congenial idea of the lofty flight of Perseus on Pegasus as signifying fame, notably the fame of poets inspired by the Muses who dwelt on Mount Helicon, where Pegasus had caused the famous spring to gush forth by a blow of his hoof.[54]

We have seen above that the tradition of Perseus riding Pegasus to save Andromeda had received fresh currency in three editions of Bersuire's *Ovidius moralizatus* published in the years preceding the appearance of the *Orlando furioso* in 1516; and that Ruscelli's statement, forty years later, that Ariosto had appropriated Perseus on Pegasus saving Andromeda as a model for Roger's deliverance of Angelica on the hippogriff bespeaks familiarity at mid-century with the tradition of Perseus riding Pegasus. Ruscelli's remark also tends to confirm Ariosto's own earlier familiarity with the role of Pegasus in the liberation of Andromeda as told by Bersuire, and the probability that the poet himself read the story in one of the editions of the *Ovidius moralizatus* that began coming off the press in 1509. Granted, then, that he probably knew a recent textual source (we should remember that except for the transformation of

[52]The Valgrisi editions with Ruscelli's annotations were numerous during the second half of the sixteenth century; see G. Agnelli–G. Ravegnani, *Annali delle edizioni ariostee* (Bologna, 1933) I, 98ff. I quote from the edition printed at Venice in 1562, p. 555. Ruscelli's comment was first noted by Steadman, "Perseus upon Pegasus," 409.

[53]*Ruins of Time*, 647–50; cf. 422–28. See also the references to Pegasus and Perseus in Shakespeare, *Henry V*, Act III, scene 7, and J.D. Reeves, "Perseus and the Flying Horse in Peele and Heywood," *Review of English Studies* (N.S. VI, 1955), 397–99. Perseus as owner of Pegasus had, however, appeared in English literature as early as the second quarter of the

fifteenth century in John Lydgate's *The Debate of the Horse Goose and Sheep*, written not long after 1436:

> The stede of Perseus was callid the Pegase,
> With swifte wengis, poetis seyn the same;
> Was, for swiftnesse callid the hors of Fame.

See *The Minor Poems of John Lydgate*. Early English Text Society (Old Series, CXCII, 1934, 541, stanza 8).

[54]For Ovid's version, see *Metamorphoses*, V, 250ff. A mid-sixteenth century medal of Bembo shows on the reverse Pegasus rearing, with the fountain Hippocrene gushing from the ground under his hoofs; see G.F. Hill, *Renaissance Medals* . . . (Oxford, 1931), 196, pl. XCIV.

Pegasus into the hippogriff Ariosto follows Ovid's own fable closely), had he also seen in art any portrayal of Perseus riding Pegasus to save Andromeda? We have noted above that the theme had appeared in novel form in Northern art in the early fifteenth century[55]; and the novelty lay precisely in the fact that for the first time in art Perseus rode Pegasus to liberate Andromeda. The subject occurs in this form in miniatures illustrating the *Épître d'Othéa* written about 1400 by the famous author and poet of the Parisian court, Christine de Pisan, and highly popular in its day. The fourteenth-century *Ovide moralisé* in verse is among the major sources for Christine's brief summaries of ancient myth or history; each of these she then elaborates and explains in a gloss, followed by a moral allegory.[56] As a transmitter of Ovidian fable she was important, and although for her account of Perseus and Andromeda her allegory owes something to the moralized version in verse, she was certainly indebted for Perseus's riding Pegasus to Bersuire's *Ovidius moralizatus*, for in the verse version Perseus flies on winged feet. Christine's short text was variously illustrated during the fifteenth century: first, as Millard Meiss has pointed out, by the Master of the Épître d'Othéa between 1406 and 1408, and very shortly thereafter by an artist in the workshop of the Master of the Cité des Dames, whose miniature of Perseus and Andromeda in a manuscript of Christine's works in the British Museum (Fig. 1) is a copy of the finer miniature by the Épître Master.[57] The splendidly dramatic invention shows Perseus in medieval armor; riding a Pegasus with flaming red wings and wielding a scythe intended to represent the *harpe* or hooked sword, he attacks a terrifying monster that thrusts its massive head from a sea of powerfully stylized waves, while Andromeda, fully clad, kneels on a rock with her hands together in the attitude of prayer. In Andromeda kneeling in prayer and Perseus, the medieval knight in armor, attacking the monster, there is iconographic similarity to representations of St. George and the Dragon, a sister theme of similar content. Indeed, another miniature of Perseus and Andromeda, this time of mid-century, in an Othéa manuscript in Brussels, might easily be taken for a St. George and the Dragon, were it not for a telltale Perseus riding the winged

[55]See above, p. 305.

[56]For Christine, her fame, and her version of Perseus and Andromeda, see the excellent account in C. F. Bühler, *The Epistle of Othea translated from the French text of Christine de Pisan by Stephen Scrope.* Early English Text Society, 264 (Oxford, 1970), XI–XIII, 14–16, 133; and for further comment on Christine's sources for the story, see R. C. G. Campbell, *L'Épître d'Othéa, Étude sur les sources de Christine de Pisan* (Paris, 1924), 123–24. Campbell finds it difficult to decide whether, in Christine's original French version, Perseus mounts Pegasus or not. But Scrope, Christine's mid-fifteenth-century translator (see Bühler, *ibid.*, XVIII), had no doubt, and he was right, that Christine intended Perseus to ride Pegasus when he saved Andromeda, nor certainly had the artists who illustrated the *Épître d'Othéa.* Campbell also remarks that Boccaccio, *De Genealogia deorum*, XII, 25, mounts Perseus on Pegasus when he saves Andromeda. In this he seems to me mistaken, for Boccaccio is entirely unclear as to whether Perseus rode Pegasus on this occasion (*ibid.*, X, 27, and see n. 40, above).

[57]The miniature of *Perseus and Andromeda* by the Épître Master occurs in the *Épître d'Othéa*, MS franç. 606, fol. 4v, in the Bibliothèque Nationale, Paris, and the copy by the Cité des Dames Workshop in the British Museum, MS Harley 4431, fol. 98v; see M. Meiss, *French Painting in the Time of Jean de Berry.*

The Limbourgs and Their Contemporaries (New York, 1974), 27, Fig. 91; cf. Fig. 154. Similar portrayals of the scene, though of inferior dramatic quality, occur in other manuscripts of the first half of the fifteenth century, e.g., in the French MS Laud Misc. 570, fol. 33v of the Bodleian Library (see R. Tuve, *Allegorical Imagery*, Princeton, 1966, fig. 11) and in Stephen Scrope's English translation of the *Épître d'Othéa* in MS 208 fol. 9r, St. John's College, Cambridge, by an English artist of the period (see O.E. Saunders, *English Illumination*, Florence, 1928, pl. 128; Saxl–Meier, *Verzeichnis astrologischer und mythologischer Handschriften*, III, pl. XLVIII; and Bühler, *ibid.*, XIV–XV).

I am greatly indebted to my friend, Millard Meiss, for generously allowing me to read in manuscript the chapter entitled "Antiquity in Early Fifteenth-Century Paris" in his recently published book, *The Limbourgs and Their Contemporaries.* In this chapter (p. 27), he writes eloquently concerning the miniature of *Perseus and Andromeda* by the Épître Master, commenting on its novelty in both expression of dramatic emotion and iconography. He also remarks that Bersuire was in all probability the source for Christine's placing Perseus on Pegasus's back when he saves Andromeda. The chapter runs parallel to my own interests in writing this essay in his honor. I have had both pleasure and profit in reading it, as I have from an enduring friendship of over half a century.

horse and again bearing a scythe (Fig. 2).[58] For here is the familiar setting with a park and castle in the background, and Andromeda, a princess in contemporary costume, with the palms of her hands held outward in a gesture of fright, as an unconvincing monster thrusts up its head from a pond. And Pegasus, although equipped with wings, is not flying through the air; like the horses ridden by St. George, he is rearing, with his hind feet firmly anchored to earth (cf. Fig. 6).

It is certainly not impossible that Ariosto had seen a fifteenth-century portrayal of Perseus riding Pegasus to save Andromeda in a manuscript illuminated beyond the Alps, or perhaps in an illustrated Bersuire like the curious (hitherto unpublished) manuscript in Bergamo, in which Perseus rides Pegasus through the air to deliver a clothed Andromeda, seated and bound, from a colossal caricature of a monster (Fig. 3);[59] or he might have seen Perseus riding Pegasus in illustrated books other than Ovid's *Metamorphoses*.[60] It is more likely, however, that as a man of letters he followed Bersuire's account of Perseus's adventure, which is a variant on the story in Ovid that he knew well. Although the pictorial examples we have just considered provided a rider on a winged steed, they were unlikely to appeal to the taste of a cinquecento Italian nourished on classical literature and aware of classical art. But Ariosto's knowledge may, of course, have embraced both written and visual sources. In any case, we have seen that within the first decade of the fifteenth century in Northern Europe, Perseus on Pegasus in art first became a visual *fait accompli*. For our later argument, this fact is worth remembering.

In Italy, by contrast, the theme of Perseus and Andromeda became current in art at the beginning of the cinquecento, after the publication of the well-known illustrated edition of the *Metamorphoses* at Venice in 1497, wherein the woodcuts naturally follow Ovid's text. The cut illustrating the Perseus fable shows the hero at the left holding the head of the slain Medusa, with winged Pegasus standing behind, Andromeda bound in the center, and at the right Perseus, borne on footwings, attacking the monster (Fig. 4). Appearing in identical or modified form in later editions, this cut influenced portrayals of Perseus and Andromeda during the first half and more of the century. Indeed, once the correct Ovidian iconography became current in book illustration, there was no change in the manner of Perseus's flight through a series of well-known works of art extending beyond 1550. An interesting exception at the very beginning of the cinquecento, however, is Signorelli's medallion of Perseus and Andromeda in Orvieto Cathedral (Fig. 5). Here Andromeda is bound to a cliff at the sea's edge, twin peaks of rock thrusting up behind her, with the sorrowful members of her family standing nearby. So far Ovid. But the rest of the scene, and here it recalls the Northern miniatures, is a virtual borrowing from St. George and the Dragon, painted frequently in

[58]Fol. 8v of MS 9392 of the Bibliothèque Royale, Brussels. The 100 miniatures of the manuscript have been published by J. van den Gheyn, S.J., *Christine de Pisan . . . , miniatures du manuscrit 9392* (Brussels, 1913). The manuscript contains the "remaniement" of Jean Miélot made for Philip the Good, Duke of Burgundy, toward 1460.

[59]Biblioteca Comunale, φ5 retro 8, fol. 52r (fifteenth century). I am greatly indebted to Carla Lord for this illustration. For a list of the manuscripts of the *Ovidius moralizatus* of the four-

teenth and fifteenth centuries, 13 of them in Italian libraries, see C. Samaran, "Pierre Bersuire," 437–39.

[60]As in Boccaccio, *De claris mulieribus* (Ulm, 1473), XXII, in which a woodcut shows Neptune embracing Medea and begetting Pegasus, who crouches at the left; at the right Perseus, mounted on Pegasus, flies through the air; or in an edition of the same work (Louvain, 1487), in which there is a similar cut on signature B7.

trecento and quattrocento Italy. Perseus on a rearing Pegasus without wings attacks the monster with a huge broadsword—not a sea monster, but a winged dragon in the earlier Italian tradition with long neck, thicker body, and long tail—as St. George attacks the dragon in Carlo Crivelli's painting of some two decades earlier in the Isabella Stewart Gardner Museum in Boston (Fig. 6). Signorelli's version is thus a quaint mélange of pagan and Christian iconography; the model for a warrior attacking a monster being close at hand in popular Christian imagery, the painter used it with artistic license, even though it differs both from Ovid's own story and from the versions of *Ovidius moralizatus*, in which the attack, one way or another, is made on wings and from the air. But, as we have said, Signorelli is an exception, painting just before the orthodox Ovidian imagery in the 1497 edition had begun to make itself felt. For the next half century Italian artists, in an age deeply nourished by Ovid, show Perseus on footwings. Thus Piero di Cosimo in the Uffizi (the painting may date before 1510),[61] a number of majolica dishes dating from the first decade to the middle of the century, Benvenuto Cellini's famous relief in the Loggia de'Lanzi,[62] and Perino del Vaga's *Perseus* frieze of about 1545 in the Castel Sant' Angelo in Rome (Fig. 7). In this fresco and in a much earlier majolica dish, dating ca. 1520 and painted by Nicola Pellipario of Urbino (Fig. 8), occur the twin peaks of rock before which Andromeda is chained, like those we have just noted in Signorelli (Fig. 5). These recall a tradition of the ancient world, apparently originating in the third century B.C., that the sea monster leaping for the food (Andromeda), which had been exposed between twin rocks, swallowed Perseus instead.[63] Later writers of antiquity successively located the rocks at Joppa on the coast of Palestine, and the latest, Josephus, in the first century A.D., remarks that "here are still shown the impressions of Andromeda's chains to attest the antiquity of the legend," a legend to which Boccaccio in the fourteenth century still bears witness.[64] It is also worth noting that in Pellipario's dish, Andromeda's left arm is raised and chained to the rock above her head.[65] This motif also has its origin in antiquity, being found in such a rendering of the final moment in the story of Perseus and Andromeda as the famous fresco from the House of the Dioscuri in Pompeii, in which, as Perseus, who has freed Andromeda from her bonds, courteously hands her down from the

[61]S.J. Freedberg dates it "probably around 1508": *Painting of the High Renaissance in Rome and Florence* (Cambridge, Mass., 1961), I, 74; II, fig. 66. But see the interesting comment by M. Bacci, *Piero di Cosimo* (Milan, 1966), 106–07 who expresses doubt concerning the general attribution to Piero and would, in any case, place the painting later, about 1515.

[62]Illustrated in J. Pope-Hennessy, *Italian High Renaissance and Baroque Sculpture* (London, 1963), fig. 84. Cellini's bronze was unveiled in April 1554, though the model was completed nearly ten years earlier; see C. Gould, "The *Perseus and Andromeda* and Titian's *Poesie*," *Burlington Magazine* (CV, 1963), 114.

[63]Lycophron, *Alexandra*, 836–39; see Phillips, "Perseus and Andromeda," 3.

[64]See Strabo, *Geography*, XVI, 2, 28; Pliny, *Natural History*, V, 14; Josephus, *Jewish War*, III, 9, 3. Boccaccio, *Genealogia*, XII, 25 (he quotes St. Jerome): "Preterea et Ieronimus presbiter in libro quem de distantiis locorum composuit, dicit: Ioppe Oppidum Palestine maritimum in tribu Dan, ubi hodieque saxa monstrantur in litore in quibus Andromeda religata Persei quondam viri sui fertur liberata fuisse subsidio."

[65]See B. Rackham, *Catalogue of Italian Majolica, Victoria and Albert Museum* (London, 1940), I, 184–85, no. 549. Another dish by Pellipario again shows Angelica (here seen from behind) with her left arm bound above her head; it also shows more completely than the first the influence of the 1497 edition of the *Metamorphoses*: at the left Andromeda bound, while above her Perseus flies down on footwings; at the right, he stands holding the *harpe* and the head of Medusa, with Pegasus standing behind him. The date is about 1515 (see Rackham, "Some Unpublished Majolica by Pellipario," *Burlington Magazine*, LII, 1928, 230 and 235, pl. IC). For other examples of the first half of the cinquecento, see again Rackham, *Italian Majolica* (New York, n.d.), 21, fig. 28, ca. 1500–1510 (Faenza); J.P. von Erdberg–M.C. Ross, *Catalogue of the Italian Majolica in the Walters Art Gallery* (Baltimore, 1952), 23, no. 47, pl. 30, ca. 1528, by Francesco Xanto (Urbino); Rackham, *Catalogue of Italian Majolica*, I, 243, no. 734, II, pl. 116, ca. 1535–1540; T. Borenius, *Catalogue of Italian Majolica Belonging to Henry Harris* (London, 1930), 57, no. 71, pl. XVII, D, 1548 (Urbino).

rock, her left arm remains raised, as it had been when chained to the cliff (Fig. 9).[66] The motif recurs in Benvenuto Cellini's Loggia de'Lanzi relief unveiled in 1554.[67] Here Andromeda's right arm is raised, her left lowered, as Perseus swoops down on footwings to attack the beast. The same disposition of Andromeda's arms is found five years or so later in Titian's superb picture in the Wallace Collection, the finest cinquecento interpretation of the subject in its combination of rhythmic beauty and grace, in the figure of Andromeda, and of spectacular drama in Perseus's aerial attack on a furious monster (Fig. 10).[68]

Our discussion of Italian portrayals of Perseus liberating Andromeda has now reached about the year 1560, and it is time to return to the other voice in this contrapuntal essay, the derivative theme, now become the parallel theme, of Roger and Angelica. The first illustrated edition of the *Orlando furioso* to depict this subject was published by Gabriel Giolito de Ferrari at Venice in 1542. The woodcut for Canto x features the combat between Roger riding his winged steed, the hippogriff, and a gargantuan Orca, into whose jaws Roger thrusts his lance, as described by Ariosto, while Angelica, a minuscule figure, appears in the background (Fig. 11). She stands, we may note, as Andromeda had sometimes done, before twin rocks, her arms chained behind her; thus the ancient tradition that localizes the site of the deliverance of Andromeda has a further echo in this depiction of a theme of related content. The twin rocks are more clearly represented in the woodcut in the Valvassori edition, Venice, 1553, for which the 1542 illustration probably served as a suggestive model (Fig. 12).[69]

The Giolito woodcut may be the first representation of the subject. The first painting to portray it may be a furniture panel probably by an unknown retardataire painter of North Italy who had come under the enduring spell of Giorgione. The composition is that of the woodcut of 1542 reversed, with the ship and the figure of Angelica changing places (Fig. 13), the figure of Olimpia on the rock at the left being omitted as irrelevant to both content and composition. Roger on an accurately depicted hippogriff attacks the rather paltry Orca with a huge tournament lance, while Angelica is bound as before with hands behind her back, but the twin rocks are lacking. It is unlikely that there is any reference here to earlier portrayals of Perseus and Andromeda.[70]

The case is different with a fascinating picture of the mid-century in the El Paso Museum of Art (Fig. 14), attributed by Longhi to an anonymous painter of Ferrara, where the Ariostan tradition was strong—perhaps Girolamo da Carpi, who died in 1556.[71] This is the most

[66]Cf. a similar example from Pompeii in the National Museum, Naples, reproduced in A. Maiuri, *Roman Painting* (Geneva, 1953) fig. on p. 79.

[67]See n. 62, above.

[68]The original composition of four or five years earlier had shown Andromeda "standing firmly on the ground both arms chained above her head." The painting was remodeled after 1559 in its present form, in which the antique motif is present. See E. Panofsky, *Problems in Titian, Mostly Iconographic* (New York, 1969), 166ff.

[69]The female figure standing on the rock at the left is Olimpia in anguish; she has been deserted by her lover Bireno, who sails away in the ship.

[70]In the catalogue of the 1955 exhibition at Venice, "Giorgione e i Giorgioneschi" (ed. P. Zampetti), 212, fig. 101 on p. 213, this painting, once belonging to Lionello Venturi, bears the unlikely attribution to Girolamo Romanino and is labeled *Perseus and Andromeda*. It had earlier carried the attribution to Romanino in an exhibition entitled "Giorgione and His Circle," held in 1942 at The Johns Hopkins University, Baltimore (see the catalogue, 41).

[71]*Officina Ferrarese* (Ampliamenti, 1940) (Florence 1956), 167. Longhi comments perceptively on the artistic influences on the picture, Italian and Northern.

x

interesting painting of the subject in the cinquecento and is thoroughly Ariostan in its mood and imagination. Like the North Italian picture just discussed, in its general disposition of the figures it recalls (though at longer range and less literally) the woodcut of 1542. As in the woodcut, the enormous and terrifying Orca dwarfs not only a pitiful but lovely Angelica, chained to a rock at the right, but only to a less extent the wonderful group in the air of Roger on the hippogriff. Roger brandishes his sword (not the lance of Ariosto), ready to smite, and the hippogriff, swooping down on the quarry, has the convincing action of a vast bird of prey. And here, in contrast to the Giorgionesque panel, one is tempted to find clear echoes of antique tradition, no doubt transmitted by such portrayals of Perseus and Androm- eda as we have considered. Angelica in this picture (which should precede Titian's *Perseus and Andromeda* by five to ten years) has her left arm raised as in the ancient painting from Pompeii (Fig. 9) and Pellipario's majolica dish (Fig. 8); at the right two huge cliffs, recalling the tradition of Joppa, rise from a turbulent sea. Angelica, however, is not chained canonically between them, as we have seen Andromeda to be in earlier paintings, but is moved to the rocky height at the extreme right. But such details aside, in its fantastic landscape bathed in magical light, its nebulous, shimmering, far horizon, its sense of chivalric adventure in a visionary world peopled by "shapes of things unknown," its recollection of the poet's sense of feminine beauty in the figure of Angelica, and of the antique as stimulant of that sense, this painting is a remarkable mirror of the complex Ariostan spirit and imagination, second only to Dosso Dossi's famous *Melissa* of about thirty years earlier in the Borghese Gallery. Only Ferrara could have been the *fons et origo* of these two paintings.

Two other sixteenth-century examples call for brief comment. One, a majolica dish in the Victoria and Albert Museum, painted by Orazio Fontana at Urbino in 1549 (Fig. 15),[72] again maintains the ancient tradition in placing Angelica between two rocks, here of unequal height as in the illustrations of 1542 and 1553, the taller one crowned with trees. She stands in the pose of an antique Venus. On the left we see her brought in a ship to the Isle of Tears to be exposed on the seashore; on the right Roger in the air, riding a pseudo-hippogriff (the beast should not have the forehoofs of a horse), brandishes his sword as he prepares to attack the Orca.

But Titian's drawing of Roger and Angelica at Bayonne is unique in the pictorial annals of the subject (Fig. 16). The painter employs no Perseus and Andromeda as a model; instead, with curious effect, he places Ariosto's drama in the unprecedented setting of a wide country landscape. For no good iconographic reason, the drawing has been called "Jason and Medea,"[73] but the foreclaws and head of the beast carrying the armed rider through the air proclaim the hippogriff. Chained to no rock, the opulent Angelica, whose pose is reminiscent of Titian's sumptuous, recumbent Venuses of 1545-1550, with her right arm bent over her head in the classical attitude of sleep, gazes with deliberate equanimity at an unimpressive

[72]See Rackham, *Catalogue of Italian Majolica*, 242, no. 732.

[73]There is nothing in the story of Jason and Medea to which this drawing corresponds. There is no reason for associating it with the mention of a *Jason and Medea* (now lost) in a letter that Titian wrote to Philip II in 1554, although R. Pallucchini, *Tiziano* (Florence, 1969), 143 and 1333, quotes Hans Tietze

to the effect that the drawing is a study for the lost picture. See Panofsky, *Problems in Titian*, 122 and 154, who dates the drawing after 1545. For early copies, one attributed to Domenico Campagnola, see J. Bean, *Les Dessins italiens de la collection Bonnat* (Paris, 1960), no. 173. The drawing was engraved by Cornelis Cort in 1565.

land dragon of the St. George type; the sea on whose inhospitable shore she was exposed has dwindled to a small upland pond. This wonderful drawing is less the illustration of a fable than an airy and spacious landscape, rich in details of vegetation and carefully observed architecture, including a reminiscence of the Castel Sant' Angelo in the background. In the air above, Roger on the hippogriff, again brandishing a sword, erupts from a cloud—with no effect on Angelica, who appears unconcerned at being saved from an Orca incapable of serious harm. Titian was evidently to put his dramatic talent into the later *Perseus and Andromeda*. In this peaceful expanse of the Venetian hinterland, Ariosto's poem plays only an accessory and inaccurate part. His chivalric fable is little more than an adumbration, the roll of a distant drum, heard not even by Angelica, who in her pastoral repose seems hardly more disturbed by the "ugly worm" than are her sister Venuses by the observant organ players. Millard Meiss may wish to take note that in no portrayal of any scene from Ariosto is sleep in—or at least near—Venice, so closely approximated.

Our previous discussion has shown that Ariosto, though relying mainly on Ovid in his episode of Perseus and Andromeda, could have found in the *Ovidius moralizatus* of Bersuire a likely source for his rider on a winged steed; less probably, he might have seen Perseus riding Pegasus in Northern manuscripts or other illustrations of the fifteenth century. As we have seen, however, the Italian artists who portrayed the Liberation of Andromeda during the first half and more of the cinquecento were faithful to Ovid's text, illustrated in many editions of the *Metamorphoses* beginning in 1497. In the Italian examples we have observed two features: the twin peaks or tall rocks to which or before which Andromeda is bound, and her upraised left arm (sometimes her right), which reflect at long range ancient traditions, written and visual. Finally, we have noted that those traditions are also continued in mid-sixteenth-century illustrations of Ariosto's *Roger and Angelica*, transmitted no doubt through portrayals of the parent fable of Perseus and Andromeda. To these the Italian artists were as naturally attracted as Northern illustrators of Christine de Pisan had been to portrayals of the related theme of St. George and the Dragon.

In 1557, one year after Ruscelli had seen in Ariosto's account of Roger liberating Angelica an imitation of Perseus and Andromeda, an influential event occurred in the history of art—the appearance at Lyons of an abbreviated version of the *Metamorphoses, La Métamorphose d'Ovide figurée*, with illustrations by Bernard Salomon. In his woodcut entitled "Perseüs combatant pour Andromeda" (Fig. 17), the rider of Pegasus, with a lance or spear ready to strike, plunges downward on the monster, which turns its head towards the descending hero, while the nude Andromeda is chained to a huge rock, her right arm raised, as in Titian's picture, instead of her left. By the year 1557, thanks to the published editions of Bersuire—and, one should add, of Boccaccio's *Genealogia*[74]—and to its appearance in European literature, Perseus on Pegasus saving Andromeda had become a part of the long European accumulation of myth and allegory; and Salomon could have come by this version of the fable

[74]The *editio princeps* was Venice, 1472, followed by seven editions within the next sixty years, five Italian, then Paris, 1511, and Basel, 1532; see E.H. Wilkins, "The Genealogy of the Editions of the Genealogia Deorum," *Modern Philology*, XVII, (1919), 425–38.

quite naturally. But a more interesting question here concerns his use of visual models. He could, with more probability than Ariosto, have seen the rider on the winged horse in fifteenth-century illustrations of Christine de Pisan's *Othéa* or elsewhere.[75] But he was illustrating Ovid, not Ovid moralized. Andromeda with upraised arm, whom "one would have thought a marble statue," and whose body betrays the rhythm of ancient sculpture, is no praying and frightened princess of the Northern miniatures but a type we have seen earlier in the sixteenth century, both as Andromeda (Fig. 8) and as Angelica (Fig. 14); while at the left, as in earlier Italian versions, is the group of Andromeda's family.[76] Indeed, the illustration follows Ovid closely, save for Perseus, who is borne aloft by Pegasus instead of flying on winged feet. In the single stanza of eight lines under the woodcut, summarizing Ovid's story, there is no mention of the rider on the winged horse. What, then, is Salomon's most likely visual source?

Here Ruscelli's suggestion of a resemblance between Perseus and Roger on their winged steeds becomes doubly interesting. Is it not possible, in fact very likely, that Salomon was entirely familiar with book illustrations of Roger on the hippogriff liberating Angelica, and that in his woodcut of *Perseus and Andromeda* we have not only a reflection of the now well-established tradition based on versions of the moralized Ovid but visually an influence on the older theme of portrayals of Roger and Angelica? As we have seen, the reverse had been the case before 1557, the pictorial imagery of Perseus and Andromeda having influenced that of Roger and Angelica in particular ways. But with Salomon there is every reason to believe in counterinfluence. The image of Roger attacking the Orca on the hippogriff, appearing first in 1542, fifteen years before Salomon's book, had been repeated in some sixteen Giolito editions before 1557.[77] Some of these must have crossed the Alps. It had likewise appeared in the edition of Rampazetto in Venice in 1549 and in the Valvassori editions of 1554 and later.[78] The plunging hippogriff of the edition of 1549 (Fig. 18), and Roger thrusting the lance diagonally downward, or the active images in the other editions we have mentioned (Figs. 11 and 12), are far closer to Salomon's portrayal of Perseus on Pegasus than those in the fifteenth-century manuscripts discussed earlier (Figs. 1 and 2). We may further note that three editions of the *Orlando furioso*, two containing the Giolito illustrations of 1542, were published in Lyons itself in 1556,[79] the year before the appearance of Salomon's woodcuts in the *Metamorphose figurée*. An artist and connoisseur of books, he must have turned the pages of many illustrated volumes of the *Orlando furioso*.

If we are correct in our hypothesis that book illustrations of Ariosto's poem provided Salomon with a visual model for Perseus on Pegasus in his *Liberation of Andromeda*, then Ariostan iconography through his influential woodcut may be said to have had a wide, though covert, effect on later portrayals of the Liberation of Andromeda in which Perseus rides the winged horse.[80]

[75]See above, pp. 312–13, and Figs. 1 and 2.

[76]As in Signorelli, Piero di Cosimo, Cellini, etc. See above, pp. 313–15.

[77]See Agnelli–Ravegnani, *Annali delle edizioni ariostee*, I, 60–105.

[78]*Ibid.*, 95–96.

[79]Those containing the Giolito cuts were published by Honorati; the third, published by Rovillio, contains illustrations that are similar but not identical. For this information I am greatly indebted to Enid Falaschi, who is completing a study of the book illustration of the *Orlando furioso*. Cf. Agnelli–Ravegnani, *ibid.*, 102–04, 106.

[80]For Salomon's influence on later book illustration of the *Metamorphoses*, see the basic study of M.D. Henkel, "Illustrierte Ausgaben von Ovid's Metamorphosen im XV, XVI, und XVII. Jahrhundert," *Vorträge der Bibliothek Warburg* (1926–1927), 72–81, 87–95, 104–44. In seventeenth-century painting, Perseus riding Pegasus to save Andromeda was the mode, displacing the version of Ovid. It appeared in the works of many notable seicento painters, including the Cavaliere d'Arpino (many examples), Annibale Carracci, Domenico Feti, Guido Reni, and in four versions by Rubens. I am preparing an article on the fortunes of Perseus and Andromeda and of Roger and Angelica beyond the sixteenth century.

Salomon's illustration of Perseus on Pegasus looks back to a post-antique tradition, laden as we have seen, with allegory, which, culminating late in the Middle Ages in fourteenth-century versions of *Ovid Moralized*, had already in the fifteenth century found pictorial interpretation in Northern miniatures. As an instance of medieval revival in the second half of the sixteenth century, a period characterized by many remanifestations of medievalism, his image of Perseus on the winged horse is not without interest.[81] Not that Salomon himself, though he employs imagery recalling the texts of Bersuire and, perhaps, Boccaccio, necessarily shared their concern with allegorical meaning. Probably he did not. In any case, we have noted that visually his portrayal of Perseus riding Pegasus to save Andromeda may well owe its inspiration to illustrations of the parallel story of Roger and Angelica. And this had been told by a poet of luminous intelligence, entirely representative of the classical High Renaissance, whose mind, though he may owe his own rider on a winged steed to Bersuire's account of Andromeda's liberation, was unclouded by adventitious medieval allegory and exegesis.

This essay began with a brief glance at the character and fortunes of Angelica in Ariosto's great poem. We may end with a word about the immediate outcome of her rescue by Roger. Having released her from her chains, he flies her on the hippogriff to another lonely place, so moved by her beauty that he has in transit fallen violently in love with her, entirely forgetting his own true love Bradamante. Safely on land again and beset by desire, he proceeds to remove his armor and underwear in order to possess the lady—in such a hurry, as Ariosto with high humor remarks, that for every lace he unties, he knots up two.[82] This comical episode is portrayed in a number of illustrated editions of the cinquecento and after,[83] and occasionally in seicento painting. Thus, in Cecco Bravo's beautiful picture in Chicago (Fig. 19), we see Roger struggling to undress,[84] while Angelica, in the pose of one of Michelangelo's *ignudi*, prepares to swallow a magic ring—useful in this kind of predicament because it will render her invisible, and the hippogriff seizes the opportunity to take off through the air. Though it lies well beyond the chronological limit of this paper, we may appropriately end with Fragonard's fine drawing of the ensuing moment (Fig. 20), when Roger, suddenly finding no Angelica, rushes about in wild frustration embracing the empty air.[85] She, meanwhile, always resourceful, discovers a safe cave to rest in, finds some rude clothes, and wanders away alone—symbol of the elusiveness of things desired but, in a world subject to change and instability, as Ariosto believed, seldom long possessed.

PRINCETON, NEW JERSEY

[81]Of the three mythographical manuals published between 1548 and 1556—those of Giraldi, Conti, and Cartari—Seznec remarks that "not one contains anything essentially new. On the contrary what we find—in varying proportions but in all three—are the materials, methods and even the images of the past . . . in their choice and classification of sources they abide by mediaeval habits" (*The Survival of the Pagan Gods*, 233–34).

[82]Canto X, stanzas 112–15; XI, 1–13.

[83]In the illustration for Canto XI in several Venetian editions, e.g., Valgrisi, 1556, and his later editions; Guerra, 1570; Farri, 1580; Sessa, 1609.

[84]The scene also occurs in Giovanni Biliverti's painting at Petraia and in the copy thereof in the Kunsthistorisches Museum, Vienna.

[85]Cf. the Venetian edition of Franceschini, 1584.

Vicende di una pala

GIUSEPPE MARCHINI

La predella con storie della Sacra Cintola della Galleria Comunale di Prato (Fig. 1a), un' opera tra le più preziose di Bernardo Daddi, deve aver fatto parte—in base ad un'ovvia considerazione—del polittico dell'altar maggiore dell'attuale Duomo pratese, di quell'altare che conteneva allora la reliquia venerata per conservar la quale in maniera più degna si era addirittura ingrandita la chiesa con l'aggiungerle il transetto a cappelle.

Si sa infatti che gli operai dell'allora pieve provvedevano nel 1337 e 1338 "ad facendum fieri et pingi quamdam gloriosam et pulcerimam tabulam ad honorem Dei et beate Virginis Marie et gloriosissimi eius Cinguli, que poni debet ad eius altare in maiori Plebe."[1]

Gli scomparti maggiori del polittico, se la predella debitamente integrata della sezione che le manca raggiungeva l'estensione di circa 240 cm, saranno stati in numero di cinque, tenendo conto delle preferenze correnti in questi anni in fatto di misure, e dovevano recare—con altrettale preziosità del raffinato maestro—allato della Vergine col Bambino, le figure di S. Stefano, in quanto titolare della chiesa; di S. Lorenzo, che gli era associato nei testi agiografici e nel culto—sicchè vediamo che anche nella lunetta (robbiana) del portale maggiore della stessa chiesa spetta a questi due santi di tener compagnia alla Vergine; del Battista, contitolare della chiesa che era sede di fonte battesimale—tanto che troviamo allo stesso santo dedicata una metà delle storie della cappella maggiore (di Filippo Lippi); e un altro santo su cui non è possibile fare induzioni.

Comunque, nessuno fra i grandi scomparti di polittico noti di Bernardo Daddi presenta caratteristiche tali per proporsi come proveniente da quest'insieme.

Deve però aver fatto parte di tale notevole complesso la serie delle otto tavolette della Pinacoteca Vaticana con le storie di S. Stefano e di S. Lorenzo (Fig. 1b), ormai unanimemente associate alla predella pratese per lo stile, ma ad essa legate anche per le dimensioni, in quanto alte gli stessi 27 cm e capaci di formare, messe in fila, un fronte della stessa misura di 240 cm all'incirca.[2]

La presenza inconsueta di una doppia predella sotto il polittico, già sospettata, trova conferma poi nel ricorso sul luogo dello stesso motivo in altri due polittici: di Giovanni da Milano e di Pietro di Miniato entrambi oggi presenti nella Galleria Comunale.

Il secondo ci offre pure l'esempio di una diversa partitura delle scene nelle due predelle sovrapposte, quale doveva figurare pure nel polittico del Daddi (una predella aveva infatti cinque riquadri e l'altra otto), che avrà trovato magari compenso, come nel polittico di Pietro di Miniato, nella disposizione più avanzata, a guisa di gradino, di quella inferiore.

[1] Per le vicende qui accennate e le altre concernenti il Duomo di Prato si vedano G. Marchini, *Il Duomo di Prato* (Milano, 1957) e *Il Tesoro del Duomo di Prato* (Milano, 1963); volumi dotati di indici analitici. Per la bibliografia della predella: G. Marchini, *La Galleria Comunale di Prato* (Firenze, 1957), e G. Datini, *Musei di Prato* (Bologna, 1972). La dimensione originaria della predella la si ricava attribuendo all'ultimo scomparto di destra (che doveva contemplare due storie, cioè anche il trasporto della reliquia alla chiesa, un soggetto ripreso

da Agnolo Gaddi) la stessa dimensione degli altri. La sua pittura doveva estendersi esattamente per 237 cm.

[2] Le tavolette, private della cornice o scontornate, misurano in media cm. 26.5 d'altezza per 30.5 di larghezza. Per le attribuzioni, vedi G. Sinibaldi–G. Brunetti, catalogo della "Mostra giottesca . . . 1937" (Firenze, 1943), 513; e per la prima ipotesi dell'appartenenza, G. Marchini, *La Galleria Comunale di Prato*.

Il grande scomparto centrale del polittico daddesco del Duomo pratese doveva raffigurare come si è detto la Vergine col Bambino e non un soggetto più specificamente calzante per quel luogo, quale ci aspetteremmo, cioè l'Assunta che concede la cintola a S. Tommaso, in quanto —lo vedremo dopo—esso le fu aggiunto più tardi e forse a quest'epoca, non era stato ancora adottato.[3] Non aveva avuto infatti nessun accenno relativo alla sacra cintura nemmeno la *Madonnina* di Giovanni Pisano, autore dell'ingrandimento della chiesa, che avrà creato certamente l'immagine per l'altare della Madonna, sia pure per un altare provvisorio durante i lavori di ristrutturazione dell'edificio, mentre la stessa raffigurazione di tale iconografia considerata come la più antica del Trecento, offertaci dalla tavoletta di Berlino che si attribuisce a Maso di Banco, tanto per il formato quanto per la composizione, ha l'aspetto di un sommesso tentativo. Questa tavoletta fu già collegata con la *Dormitio* di Chantilly e l'*Incoronazione* di Budapest (Fig. 2), ma il Longhi giustamente suppose che tutte e tre facessero parte di uno stesso insieme proveniente dal Duomo pratese, assegnando loro tuttavia un ruolo non chiaro in un problematico tabernacolo di cui la tavoletta con l'Assunta sarebbe stata lo sportello.[4] A parte il fatto che nella stessa tavoletta non è traccia del buco per la chiave, non avrebbe senso una decorazione del genere nascosta all'interno di un ricetto e un tabernacolo che la mostrasse all'esterno per tre lati difficilmente sapremmo immaginarlo in una forma e con una destinazione plausibili.

L'altezza delle tre tavolette, pari alla somma delle altezze delle due predelle della pala di Bernardo Daddi,[5] ci fa sospettare invece che esse abbiano formato una nuova grande predella, a guisa di basamento della stessa pala in sostituzione delle due predelle originarie, per aggiornarne i soggetti.

Il culto della reliquia deve aver ricevuto un rapido impulso a quel tempo o per un qualche autorevole riconoscimento da parte ecclesiastica o per una creazione letteraria di particolare fortuna o anche per uno spontaneo movimento popolare di cui testimonianza certa è nel gran numero di manoscritti della leggenda del Sacro Cingolo in redazioni diverse che si incontrano specialmente nelle biblioteche e negli archivi di Prato e di Firenze, databili o risalenti giusto ad archetipi dei primi decenni del Trecento.[6]

Si sarà voluto allora, sul luogo stesso della conservazione e del culto della reliquia, accreditarla con un titolo più forte che non quello di una storia agiografica involgente in fondo oscure persone mortali quale veniva offerto dalla predella ora nella Galleria Comunale;[7] e metterne invece in evidenza, seppur timidamente, l'origine dal contesto ben più universalmente autorevole e noto della *Vita della Vergine*.

[3] Le considerazioni espresse ne *Il Duomo di Prato* sono in parte diverse perchè non era noto ancora il documento del 1367 (v.dopo). Una sporadica figurazione della *Vergine che concede la cintola a S. Tommaso*, con la Vergine in piedi e la consegna diretta (come nella tavoletta di Berlino, che forse potrebbe dipenderne per diretto contatto?) si trova in un affresco della fine del Dugento della chiesa dei SS. Giovanni e Paolo di Spoleto. Vedi R. Van Marle, *The Development of the Italian Schools of Painting*, I (L'Aia, 1923), fig. 320.

In relazione alle vicende della pala del Daddi più avanti adombrate si può ritenere magari che i due polittici sopra nominati abbiano derivato il motivo della doppia predella da altri esemplari oggi non più esistenti; e così la pala del Daddi con le predelle originarie potrebb'esser tornata per qualche tempo sull'altar maggiore del Duomo ad ispirare il polittico di Pietro di Miniato.

[4] R. Longhi, "Giudizio sul duecento," in *Proporzioni* (II, 1948), 52, e "Qualità e industria in Taddeo Gaddi ed altri, II," *Paragone* (no. 111, 1959), 6.

[5] I tre pezzi sono alti cm. 51.2; i maggiori larghi 51.7, e il piccolo 22.5. Sono stati tutti privati dalle scorniciature di contorno.

[6] È sufficiente consultare in proposito la *Bibliografia pratese* di C. Guasti (Prato, 1844).

[7] Ne è protagonista il cittadino pratese Michele Dagomari, artigiano pellettiere. Ciò non diminuisce il senso poetico della storia, ma è indice di un momento spirituale diverso.

Se i riquadri maggiori di questa sequenza fossero stati quattro invece dei due che cono-
sciamo, il complesso delle cinque scene verrebbe, giusto, a coprire l'estensione delle due
predelle daddesche (Fig. 3).[8]

Non ci è dato di conoscere, come si è detto, l'occasione possibile di un simile cambiamen-
to giacchè la data del 1346, dell'anno cioè in cui un colpo della mano secolare, appuntato lo
sguardo sull'enorme quantità di donativi che affluivano al clero, si impossessò della reliquia e
la trasferì in un altro altare in fondo di chiesa a destra affidandola in amministrazione a un'o-
pera laica (l'Opera del Sacro Cingolo che così ebbe origine), appare troppo tardiva rispetto
allo stile.

Comunque, l'iconografia prescelta in questo caso per l'origine della Cintola sottolinea la
provenienza diretta della reliquia dalle mani della Vergine, perpetuandosi nell'ambiente
fiorentino, mentre in ambito senese, dove essa pur compare circa alla stessa epoca[9] (facendo
così sospettare l'impulso esterno della terza fonte cui accennavamo), sembra derivare dalla
narrazione della *Legenda aurea* in quanto raffigura, come poi sempre, la Vergine a mani giunte
nell'atto dell'assunzione e la Cintola che cade per suo conto.

La successiva affermazione importante di quella nuova iconografia sul luogo del culto
della reliquia è costituita poi dall'altorilievo attribuito a Niccolò di Cecco del Mercia, cui si
suole assegnare una data intorno al 1359, e che deve aver formato con altri della serie il nuovo
altare in fondo di chiesa, isolato tutto intorno e adorno pertanto, è probabile, della statuetta
di Giovanni Pisano.

Poi, un'ulteriore più evidente affermazione della provenienza e quindi della santità della
Sacra Cintura la si ebbe certamente nel 1367, allorquando si completava la costruzione del
transetto coprendolo con le volte. Sotto l'11 maggio di quell'anno si trova infatti registrato
nelle carte d'archivio questo pagamento: "a Dego cognato del Proposto per arra della tavola
che si fa fare per l'accrescimento della tavola dell'altare maggiore, fiorini x d'oro."[10]

Un resto di tale accrescimento è probabilmente sopravvissuto e deve forse riconoscersi
nel frammento di cuspide di notevoli dimensioni, con l'Assunta in atto di porgere la Cintola a
un S. Tommaso (del quale si intravendono appena ormai le mani), conservato nella collezione
Lehman di New York (Fig. 4).[11]

Il pezzo ci sembra che si attagli bene alle circostanze prospettate mostrando una com-
binazione strana di elementi culturali che ne ha forse limitato la bibliografia alla prudente
scheda del catalogo della collezione cui appartiene. Vi si colgono infatti finezze, anche di
colore, di marca daddesca che possono essere state suggerite dal desiderio o imposte dalla
prescrizione di uniformarsi alla pala di base, unite a una ieratica fermezza di segno e di volume
per evidente influsso orcagnesco.

[8]Le altre due storie che potrebbero essere andate perdute
potevano raffigurare: anteriormente all'Assunzione, uno dei
tanti episodi abituali del ciclo mariano (ad esempio l'Annuncio
della morte); e dopo quella, insieme coll'Incoronazione, forse
la scena degli apostoli intorno al sepolcro vuoto, che apriva
pure la serie della prima predella daddesca.

Potrebbe anche darsi che gli spazi lasciati liberi dalle tre
tavolette che conosciamo—se siano state le sole presenti—
fossero riempiti da ornati.

[9]Il riferimento è al *Caleffo dell'Assunta* dell'Archivio di Stato
di Siena, miniato con questa scena da Niccolò Tegliacci, si dice,

intorno al 1334.

[10]G. Marchini, *Il Tesoro del Duomo di Prato*, doc. no. 19.

[11]Cfr. il catalogo dell' "Exposition de la Collection Lehman
de New York" (Paris, 1957), 11, n. 13. Il dipinto vi è così
classificato: "la partie supérieure de ce retable [della Cattedrale
di Prato], sorti de l'atelier de Daddi, ou une composition qui
reflète celle de Daddi et executée par un artiste de son
entourage." La tavola misura cm 107 d'altezza per 136 di
larghezza ed è stata ritagliata nei contorni, come piallata sul
tergo.

Un certo residuo della sintetica vitalità di Maso di Banco potrebbe magari far pensare a un'estrema evoluzione (con deterioramento di qualità) di quell'Alesso d'Andrea che fu già operoso a Prato e nello stesso Duomo. Qualche inflessione particolare infatti coincide con suoi modi.[12]

L'abnorme aggiunta che dovette incombere sulla zona centrale del polittico, puntando decisamente sul motivo dell'origine della reliquia, veniva ora a proclamarne imperiosamente la santità, come un grande cartellone pubblicitario, dall'altare maggiore, riempiendo della sua voce tutta la chiesa, tanto da domandarsi se non vi sia stato all'origine un fatto di rivalità fra il clero e l'Opera laica del sacro Cingolo che faceva capo al sacello in fondo di chiesa.

Quanto abbia durato però tale sistemazione non è dato sapere, ma è probabile che la costruzione di una nuova ulteriore e degna sede per la reliquia, quella attuale, nella apposita cappella sulla sinistra entrando in chiesa dalla porta maggiore, abbia determinato l'accentramento in quel luogo di tutta l'attenzione, accentramento favorito anche dalla fusione dell'Opera della Pieve con quella del Sacro Cingolo,[13] sicchè può ben darsi che il polittico dell'altar maggiore, trasferito sul luogo del culto della reliquia e troppo ingombrante per questa nuova ubicazione, sia designato proprio dalla indicazione di quella "tabulam picta(m) de ymagine Virginis Marie et aliorum existentem applicatam in muro iuxta et propre ... altare" annotata negli inventari del 1390 e 1391,[14] avviata ormai così per la imminente decorazione della nuova cappella da parte d'Agnolo Gaddi, verso la decadenza e l'alienazione, avulso dalle predelle, che per nostra fortuna, seguendo vie diverse, ci sono pervenute.

SOPRINTENDENZA ALLE GALLERIE, FLORENCE

[12]Vedi la più recente trattazione in M. Meiss, "Alesso d'Andrea," in *Giotto e il suo tempo. Atti del Congresso Internazionale per la celebrazione del VII centenario della nascita di Giotto,* *1967* (Roma, 1971), 401–18.

[13]G. Marchini, *Il Tesoro del Duomo di Prato,* doc. no. 25.

[14]*Ibid.*

Hatred, Hunting, and Love:
Three Themes Relative to Some Manuscripts of Jean sans Peur

CARL NORDENFALK

I

Throughout the Middle Ages manuscript illumination achieved its greatest distinction through royal patronage, and at no time is this so obvious as in the quarter centuries that precede and follow the year 1400. In France two brothers of the Valois dynasty, Charles V and Jean de Berry, stand out as the most zealous of all patrons of this art—the one distinguished by a conspicuously long nose and the other by a nose remarkably short, but both endowed with an equally keen scent for artistic values.[1]

The de luxe manuscripts they ordered or received as presents are today the pride of any collection fortunate enough to possess one. That they can still be identified is owing largely to two circumstances : the frequency of portraits of either the King or Duke in the manuscripts they respectively commissioned, and the care with which the surviving inventories of their libraries were kept. Both types of documentation have been thoroughly commented upon by outstanding European scholars, to whom Millard Meiss has added an American name of equal distinction.[2]

Compared to Charles V and Jean de Berry, other members of the Valois family can aspire to only a subordinate place in the history of French miniature painting. Not that they were insusceptible to the charms of illuminated books. Within the same generation the youngest son of Jean le Bon, Philippe le Hardi, Duke of Burgundy, had before he died in 1404 founded a collection, *la librairie de Bourgogne*, which half a century later was to rival that of the French kings.[3] It is also well known that some of the leading French artists came from the northern provinces of his duchy, or from regions adjacent to it ; indeed, it was Philippe le Hardi who first availed himself of the extraordinary talents of the Limbourg brothers.[4]

The author wishes to offer his respectful thanks to the Chancellor of the Order of the Golden Fleece for authorizing him to publish three miniatures from the Statutes of the *Court amoureuse* of Charles VI in the Archives of the Order in Vienna, and to other institutions for corresponding courtesies. To his friends François Avril and Elizabeth Beatson he is greatly indebted for valuable help in preparing this paper—to the former for a great deal of information about the manuscripts in the Bibliothèque Nationale and other French libraries, to the latter for reading the paper with expert knowledge, both as a linguist and as an art historian in her own right.

[1] For the portraits of the King, see C.R. Sherman, *The Portraits of Charles V of France*. Monographs on Archaeology and the Fine Arts, xx (New York, 1969) ; for those of the Duke, see M. Meiss, *French Painting in the Time of Jean de Berry : The Late Fourteenth Century and the Patronage of the Duke* (London–New York, 1967), 68ff.

[2] The standard work on Charles V's library is still L. Delisle, *Recherches sur la librairie de Charles V* (Paris, 1907), now supplemented by the catalogue of the exhibition "La Librairie de Charles V," Paris, 1968. On the books owned by the Duke of Berry, see Meiss, *ibid.*, Appendix, 309–18.

[3] L.M.J. Delaissé, *Medieval Illuminations from the Library of Burgundy in the Department of Manuscripts of the Royal Library of Belgium* (Brussels, 1958 ; French ed., Geneva, 1959).

[4] The manuscript referred to is the *Bible Moralisée* in Paris, Bibliothèque Nationale, franç. 166, left unfinished at the death of the Duke. Cf. G. Hulin de Loo, "La Bible de Philippe le Hardi historiée par les frères de Limbourc," *Bulletin de la Société d'Histoire et d'Archéologie de Gand* (xvi, 1908), 183ff., and with particular regard to its model, franç. 167, see F. Avril, "Un chef-d'oeuvre de l'enluminure sous le règne de Jean le Bon : La Bible moralisée manuscrit français 167 de la Bibliothèque Nationale," *Fondation Eugène Piot, Monuments et Mémoires* (Académie des Inscriptions et Belles-Lettres), (LVII, 1972), 91-125.

Since this was written, the third volume of Meiss's *French Painting in the Time of Jean de Berry* has appeared ; in this, *The Limbourgs and Their Contemporaries* (1974), the *Bible moralisée* is extensively treated.

Philippe, however, as Millard Meiss has pointed out, acquired most of his manuscripts through agents.[5] His lack of intimate contact with the artists is reflected by the fact that few of the manuscripts written and illuminated for him bear either his portrait or even his coat-of-arms or emblems.[6] His eldest son and successor, Jean sans Peur, who was also a client of the Paris book dealers, seems to have taken a more personal interest in the decoration of the manuscripts he ordered. Among them are some of the finest products of book illumination, as for instance his Breviary in London (British Museum, Add. 35311 and Harley 2897)[7] and that splendid collection of travelers' accounts of the Orient, known as *Le Livre des merveilles*, which he commissioned from the Boucicaut Master's atelier and gave in 1413 to his uncle the Duke of Berry.[8]

The frontispiece to the Hayton "Fleurs des histoires" section of the latter manuscript shows Jean sans Peur being presented with the book in his chamber.[9] He is easily recognizable, not only from his *houppelande* embroidered with his devices—golden branches of hops alternating with golden planes—but also by his aristocratic nose and thin lips, which give him an air of haughtiness combined with petulance.[10] His arms and devices also appear in the margin and initial of the opening page of each separate treatise, though today they are partly overpainted by the arms of subsequent owners. Similarly in the *Livre de l'information des rois et des princes*, now MS 9475 in the Bibliothèque Royale, Brussels, the Duke's emblems take the place of the usual vines in the margins of the historiated pages.[11]

[5]Meiss, *French Painting in the Time of Jean de Berry: The Late Fourteenth Century*, 8.

[6]In his Book of Hours in Brussels, Bibliothèque Royale, MS 10392, he is represented as a young man kneeling at his prie-dieu in front of the Madonna (C. Gaspar-F. Lyna, *Les principaux manuscrits à peintures de la Bibliothèque Royale de Belgique*, I (Paris, 1937), pl. LXXVI a). Among the instructions for the illustrations of a copy of Bouvet's *Somnium super materia scimatis*, published by G. Ouy, "Une maquette de manuscrit à peinture," *Mélanges d'histoire du livre et des bibliothèques offerts à Monsieur Frantz Calot* (Paris, 1960), 43ff., there is one item referring to a portrait of the "dux Burgundiae in quandam pulchra aula" together with the Dukes of Orléans and of Bourbon. But since the Duke of Berry and Charles VI were also to be represented in separate miniatures, there is not enough evidence for assuming that the instructions were written for a manuscript ordered by Philippe le Hardi. We know best what he looked like through the Versailles copy of what was probably an *ad vivum* portrait, and from the kneeling statue on the portal of the Chartreuse de Champmol at Dijon (A. Liebreich, *Claus Sluter*, Brussels, 1936, pl. VII). The ring with a profile bust in enamel owned by Comte Blaise de Montesquiou (E. Steingräber, *Antique Jewelry*, London, 1957, Fig. 91), generally said to represent Jean sans Peur, seems to me because of its fleshy nose more probably a likeness of his father.

[7]E. Panofsky, *Early Netherlandish Painting*, paperback edition (New York, 1971), I, 76 n. 4 with bibliography, and M. Meiss, "The Master of the Breviary of Jean sans Peur and the Limbourgs." Lecture on Aspects of Art. *Proceedings of the British Academy* (LVI, 1970), 111–29; more recently, *idem*, *The Limbourgs and Their Contemporaries*, 232–37.

[8]Paris, Bibliothèque Nationale, MS franç. 2810; facsimile edition of all the miniatures in the series published by the Bibliothèque Nationale under the direction of H. Omont (Paris, 1907), 2 vols. See also Meiss, *French Painting in the Time of Jean de Berry. The Boucicaut Master* (New York–London, 1968), 116ff. and *passim*. The idea thrown into the debate by

L. Delisle, *Recherches sur la librairie de Charles V* (Paris, 1907), II, 254, that this manuscript could already have been begun at the order of Philippe le Hardi, repeated by G. Doutrepont, *La Littérature française à la cour des ducs de Bourgogne*, Bibliothèque du XVe siècle, VIII (Paris, 1909), 476 and 479, has not been taken seriously by later scholars. For Jean sans Peur was also written and illuminated the original manuscript of Laurent de Premierfait's translation of Boccaccio's *Decamerone* (c. 1415), now in the Vatican Library, Pal. lat. 1989 (M. Meiss, "The First Fully Illustrated Decameron," *Essays in the History of Art Presented to Rudolf Wittkower*, London, 1967, 56–61).

[9]Reproduced in color in Meiss, *The Boucicaut Master*, Fig. 98. The setting reminds us of the instruction quoted in n. 6 above concerning a portrait of Philippe le Hardi "in quandam pulchra aula."

[10]The best likeness of Jean sans Peur would seem to be the colored alabaster relief in the museum at Dijon, reproduced in R. Vaughan, *John the Fearless* (London 1966), fig. 7. We have only later copies of the portrait which shows the Duke holding the ring with a precious stone that he inherited with his duchy, and which was therefore probably painted in 1404. Cf. H. Adhémar, "La date d'un portrait de Jean sans Peur, duc de Bourgogne," *Revue du Louvre* (XI, 1961), 265–68. The type is, as pointed out by Mme Adhémar, repeated in the miniature by the Boucicaut Master in the *Livre des Merveilles*. It also occurs in the wry profile of the fool on the Hohenlohe chain (Meiss, *The Boucicaut Master*, fig. 47a), which makes it very probable that this important example of Parisian goldsmith's work of the early fifteenth century was at the time a high political document, ordered by someone who intended to ridicule Jean sans Peur, and thus a weapon in the struggle between the Orléans and the Burgundian parties. Yet, as long as its cryptic inscription "m.h.b.n.m." cannot be interpreted, it will go on masking its tantalizing secret; cf. n. 58, below.

[11]Gaspar-Lyna, *Les principaux manuscrits*, I, no. 186, Pl. CIV, and C. Nordenfalk, *Kung Praktiks och drottning teoris jaktbok*. Nationalmuseiskriftserie, III (Stockholm, 1955), 93 and fig. 77.

None of the librarians of the early dukes of Burgundy performed their duties with the same conscientiousness as did Jean Flamel and Robinet d'Estampes for Jean de Berry. The only librarian of Philippe le Hardi known to us by name, Richard Le Comte, served at the same time as his "first barber."[12] Jean sans Peur for a time employed Guillebert de Metz, who signed his name in a manuscript now in the Royal Library of The Hague, adding the title "libraire de mons[eigneur] le duc Jehan de Bourgoingne."[13] There are, however, no further indications as to the degree of competence with which he may have discharged his duties. According to the inventories, some of the most precious books owned by the ducal family had clasps with their coats-of-arms, but unfortunately none of them seems to have been preserved. The same is true of the leather caskets with armorial decorations, such as those ordered by Richart Le Comte for Philippe le Hardi from the comb-dealer in Paris, Henry Des Gres.[14]

In order to get a more complete picture of the interest taken by the first dukes of Burgundy in the art of illumination we are not, however, dependent solely on the manuscripts documented in the inventories or on other similar marks of ownership. We may also take into consideration certain books of which the text was of particular interest to them; and to some of these I shall now call attention.

II

First and foremost among such texts is the so-called "Justification" of the assassination of the Duke of Orléans, drawn up by one of Jean sans Peur's tools, Maître Jean Petit, doctor of theology at the University of Paris.[15] The events that gave rise to it are well known. On the evening of November 23, 1407, the Duke of Orléans received a false summons to visit the King, and after leaving his residence he was assaulted and miserably put to death by assassins. At a meeting in the King's Cabinet the following day, the Duke of Burgundy confessed privately to the Duke of Berry that he had ordered the crime at the instigation of the devil. Later on, however, he changed his mind; by accusing his cousin of having contemplated a coup d'état, he claimed the murder to have been a patriotic act for which he deserved praise rather than blame. This interpretation, combined with other insinuating charges of fornication and sorcery made against his victim, he engaged Jean Petit to expound in a truly scholastic fashion on his behalf, in an oration held publicly in the Hôtel Saint-Pol in Paris on March 8, 1408, in the presence of the Dauphin and a great number of *grand seigneurs*, as well as representatives of the city.

The oration was the final version of a text that Jean sans Peur had originally drafted in the Netherlands before turning it over to the venomous pen of Jean Petit to whip into shape.[16]

[12]B. Prost, "Quelques acquisitions de manuscrits par les ducs de Bourgogne Philippe le Hardi et Jean sans Peur, 1396–1415," *Archives historiques, artistiques et littéraires* (II, 1891), 341–42.

[13]G. Doutrepont, *Inventaire de la "librairie" de Philippe le Bon (1420)* (Brussels, 1906), III, no. 169. The manuscript is signed "Escript de la main de Guillebert de Metz, libraire de mons. le duc Jehan de Bourgoigne."

[14]G. Doutrepont, *La Littérature française à la cour des ducs de Bourgogne*, 122.

[15]On this text and its author, see Doutrepont, *ibid.*, 283, and

particularly A. Coville, "Le véritable texte de la justification du duc de Bourgogne par Jean Petit," *Bibliothèque de l'École des Chartres* (LXXII, 1911), 57–91; *idem, Jean Petit. La question du tyrannicide au commencement du XVe siècle* (Paris, 1932), and "Maître Jean Petit," *Deuxième Congrès des Sciences Historiques, 1930* (Algiers, 1932), 125–39. On the event itself, see L. Mirot, "Raoul d'Anquetonville et le prix de l'assassinat du Duc d'Orléans," *Bibliothèque de l'École des Chartres* (LXXII, 1911), 445–58.

[16]Coville, "Le véritable texte," gives a full account of how the text was developed.

Immediately after its presentation, the Duke decided to have it reproduced in four de luxe copies for himself, his wife, his brother, the Duke of Brabant, and his young son, the future Philippe le Bon. This we know from a payment to Jean Petit of July 26, 1408, for four copies that he had made "in the form of books, each containing six quires, written in formal book script, historiated and illuminated in gold and blue and bound in tooled leather," for a price of 26 *livres tournois*.[17]

Besides these de luxe manuscripts, other copies were made and sold to different clients, so that the document attained a fairly wide distribution, until at a synod held in Paris in 1414 it was solemnly condemned, and owners of copies were ordered to burn them under pain of excommunication. The Duke of Burgundy, however, was in no way shaken by the order, nor did he change his conviction, as we see from the fact that, whereas the cheaper copies have practically all perished, those ordered by the Duke for himself and his family have, with one exception, survived. They are now in the following libraries : (1) Vienna, Nationalbibliothek, cod. 2657;[18] (2) Paris, Bibliothèque Nationale, franç. 5733 ;[19] (3) Chantilly, Musée Condé, 878 (1197).[20] All three agree with the description quoted above in being "ystoriez et enluminez d'or et azur." The "illumination" refers to the initials in the text and the borders of the first two pages, which are painted in the typical Paris style of the first decade of the fifteenth century. The "ystoire" consists of an allegorical frontispiece, a miniature that interprets, in the same way as the text, the assassination of the Duke of Orléans by Jean sans Peur as a rescuing measure taken to prevent Orléans from overthrowing the government of Charles VI and usurping the crown. The composition is the same in all three manuscripts, though handled somewhat differently in each instance.

The finest and apparently the earliest is the Vienna manuscript (Fig. 1). Set in a landscape, a wilderness outside a city, the royal tent occupies the foreground, its flaps being held aside by two big knots. The tent is of royal blue studded with gold fleurs-de-lis, and it is connected specifically with the reigning king by having his colors (black, green, white, and red) in the bands holding together the roof and in the double-tongued pennant flying above. The latter, moreover, displays one of his emblems—fine sprays of broom with golden pods—which are also embroidered on the interior of the tent. In the opening, royal power is symbolized by a large golden fleur-de-lis, as a surrogate for the king himself. Approaching the tent from the left, a wolf (*loup*, one of the Duke of Orléans's armorial bearings) with open jaws is about to snatch the crown, which is already askew. But the lion (the armorial symbol of Burgundy), entering from the right, aims a deadly blow with his right forepaw at the neck of the wolf, which is bleeding. In the lower half of the page an explanatory caption has been added :

Par force le leu rompt et tir/A ces dens et gris la couronne.
Et le lyon par tres grant ire/De sa pate grant coup luy donne.

[17]Coville, *Jean Petit*, 134: ". . . faites par maniere de livres, chacune contenant six quaiers de petit volume de parchemin, escrips de forme, ystoriez et enluminez d'or et d'azur et couvert de cuir empains, c'est assavoir l'un pour mon dit seigneur, l'autre pour madame la Duchesse, le tiers pour monseigneur de Brabant et le quart pour monseigneur de Charrolois."
[18]Fully described in H.J. Hermann, *Die westeuropäischen*

Handschriften der Gotik und der Renaissance. Englische und französische Handschriften der ersten Hälfte des 15. Jahrhunderts. Beschreibendes Verzeichnis der illuminierten Handschriften in Österreich, N.F.VII,7, pt. 3 (Leipzig, 1938), 27ff., no. 7.
[19]Coville, *Jean Petit*, 146–49.
[20]*Ibid.*, 149–50.

The Paris copy contains the same representation and the same verse; however, the miniature is badly rubbed and stained, particularly at the upper right (Fig. 2). In some respects, it is a simplified and weaker version of the Vienna composition. The royal tent is now partly hidden behind trees in the left corner, and since it lacks the devices and pennant, it has lost a great deal of its heraldic splendor. It is placed further back to make space for a road descending from the cliffs in the upper right corner, alluding to mountainous Burgundy; down this path the lion approaches, as it were at great speed, to foil the wolf's traitorous intentions. The lion is more heraldically conceived, with its legs spread and its tail (still visible in spite of rubbing) in an S-curve over its back. Not only the crown but also the fleur-de-lis topple toward the left, with the secondary but by no means unintentional effect that both seem to be applied to the head of the lion—thus endowing Jean sans Peur with those very claims to royal power that he had imputed to his cousin, and for which he had demanded his condemnation!

In the third version at Chantilly, the miniature does not occupy a complete page, but only the upper part of the first page of the text (Fig. 3). The quatrain has been left out, as well as the introductory remarks about the place and date of the oration. The composition has been reversed; the wolf now emerges from a grove in the lower right corner, and the lion comes down a slope from the left, leading out of a cave formed by the cliffs. His body is an almost exact repetition, in mirror reverse, of the Paris version. The head, however, is turned unheraldically in three-quarter profile and is surrounded by the mane like a halo. The tent has disappeared, leaving the royal symbols under the open sky in a meadow studded by plants and trees *en bouquetaux*. The horizon has been raised and is almost covered by a forest, leaving only a glimpse of the sky in the upper left corner.

Although there was little need to influence the members of the ducal family for whom these copies of the *Justification* were made, their miniatures are characteristic examples of the art of book decoration serving as a means of political propaganda. From the fact that a paper manuscript of the text in the Bibliothèque Nationale, MS franç. 5732, has space reserved for a frontispiece miniature, it can be assumed that some of the cheaper copies were also provided with the same illustration.[21] Had the poster been invented in those days, Jean sans Peur would no doubt have made provision for displaying the composition in the streets of Paris. This is not by any means the first instance in which the art of illumination was used for propaganda purposes. Throughout its history, not only do we find miniatures designed to express a specific political viewpoint of the commissioner, but we also have examples of such manuscripts produced in series in a number of de luxe copies for presentation to high-ranking persons. The oldest example of this kind is probably Marino Sanudo's *Liber secretorum*

[21]See Coville, *Jean Petit*, 125. Coville first assumed a manuscript once in the possession of Lord Stuart de Rothesay and sold in London in 1857 to be such a case, since it was referred to by V. de Viriville in *Magasin pittoresque* (1860, 135) as having a line drawing of our scene, as shown by a reproduction on p. 136 of this periodical. He later realized, however, that this manuscript in reality was the one now at Chantilly, which in fact had been bought by the Duc d'Aumale at the Lord Stuart sale. This is fully confirmed by the reproduction in *Magasin pittoresque*, which could only be a line-for-line copy of the Chantilly miniature. The matter is, however, further embroiled by the fact that a copy of the *Justification* said to have come from the Stuart de Rothesay sales is recorded in the library of Lucius Wilmerding of New York (S. de Ricci—W. J. Wilson, *Census of Medieval and Renaissance Manuscripts in the United States and Canada*, New York, 1937, II, 1853). It is described as written on paper of ca. 1450, having the arms of Philippe le Bon in an initial, but apparently no miniature. This manuscript appeared in the third sale of the Wilmerding library (Parke-Bernet, October 29–31, 1954, no. III, 588) but with no mention of the Stuart de Rothesay provenance. Its present whereabouts is unknown. I owe this piece of information to the kind research of Dr. John Plummer.

fidelium crucis, an illustrated guide to the Holy Land, produced in Venice in or about 1332 and given by the author to a number of crowned heads and other influential people with the objective of arousing their interest in a new crusade.[22] In another instance, the normative edition of the *Revelations* of St. Bridget of Sweden was produced about 1375 in multiple copies by a Neapolitan workshop to promote the author's canonization.[23] A copy was in fact brought to Burgundy in the time of Philippe le Hardi by a certain Franciscan theologian, Petrus de Burgundia; it evidently entered the ducal library, since ultimately it was presented by the second daughter of Jean sans Peur, Mary of Cleves, to the Brigittine monastery that she founded at Marienboem, where a copy of it (still preserved) was subsequently executed.[24]

Apart from the copies of the *Justification* made for Jean sans Peur and his family, the allegorical composition of their frontispiece miniatures makes its appearance once more in a little Prayer Book of the Duke, written and illuminated in Ghent, which was acquired by the Bibliothèque Nationale in Paris about the time of World War II (nouv. acq. lat. 3055).[25] This time it is repeated in an abridged version as a vignette in the lower margin, under the miniature showing All Saints in a heavenly tribune praising the Trinity, supplemented by the Virgin— the three seated figures being curiously united by a chain around their knees (Fig. 4). Not only the royal tent but also the fleur-de-lis and its crown have been omitted, so that what is left shows only a menacing confrontation between the two beasts, more consistent with the political situation after the assassination of Louis d'Orléans. The descending posture of the lion shows that the Paris miniature, or a replica of it, served the Flemish miniaturist as his model. The inclusion of the scene in a prayer book gives it an even more pretentious significance, as if its owner considered the assassination of the Duke of Orléans to be not only a patriotic deed, but little short of a pious one, entitling him to share post mortem the heavenly abode of the blessed—a further enhancement of his hypocritical self-esteem, and a continuation, as it were, of the propagandistic intent of the image, now directed even toward the Almighty.

Unfortunately, the document quoted above recording the payment to Jean Petit for the four copies of his oration made for the Duke and his family does not mention the workshop that executed the commission. In view of the circumstances referred to above, however, and the short time of slightly more than four months available for the completion, there can be little doubt that it was one of the leading Paris ateliers. This is also evident from the high quality of both the miniatures and the decoration. Whereas the marginal vine is practically the same in the Vienna and the Paris manuscripts and only slightly different in style in the Chantilly copy, the pictures are obviously the work of three different artists. Since the Vienna

[22]O. Pächt–J. Alexander, *Illuminated Manuscripts in the Bodleian Library* (Oxford, 1970) II, 12, no. 118, with full bibliography. There are two copies of Sanudo's work in Brussels, Bibliothèque Royale, MSS 9347–48 and 1904–05, according to Gaspar-Lyna, *Les principaux manuscrits*, I, nos. 121–22, both added to the Burgundian library by Jacqueline of Bavaria in 1434.

[23]C. Nordenfalk, "Saint Bridget of Sweden as Represented in Illuminated Manuscripts," *De artibus opuscula XL. Essays in Honor of Erwin Panofsky*, ed. M. Meiss (New York, 1961), 379ff. F. Bologna, *I pittori alla corte angioina di Napoli, 1266–*

1414 (Rome, 1969), 329, quotes me as dating these manuscripts "ai primi del secolo xv"—quite contrary to my argumentation for a date ca. 1375, which is also his.

[24]Nordenfalk, *ibid.*, 384–85.

[25]V. Leroquais, *Un Livre d'Heures de Jean sans Peur, Duc de Bourgogne* (Paris, 1939); *idem, Supplement aux Livres d'Heures manuscrits de la Bibliothèque Nationale* (Mâcon, 1943), 5ff. E. Panofsky, *Early Netherlandish Painting: Its Origin and Character*. The Charles Eliot Norton Lectures, 1947–48 (Cambridge, Mass. 1953), 119ff. I owe the reference to this manuscript to Mrs. Beatson.

version is the finest, it was no doubt executed by the *chef d'atelier*, who designed the composition under the direction, one would imagine, of Jean Petit, if not of Jean sans Peur himself. The Paris copy is by an assistant who, although less skillful in rendering the finer details, hit on the impressive idea of showing the lion descending a sloping road. Finally, as A. Coville pointed out, the Chantilly miniature is by an artist of a different trend, which manifests itself particularly in his treatment of the landscape setting. The loose pattern of flowering shrubs on the open ground, as well as the curious stalactitelike cliffs on the left, have parallels in the work of the master whom Meiss has called Pseudo-Jacquemart.[26] Since this artist must already have been at work in the 1380s, he would have been an elderly man at the time when the Chantilly copy was made. The *chef-d'atelier*, on the other hand, belongs to a younger generation. The sinewy treatment of the tree trunks, the whitish-green leaves forming star patterns against a darker background, the craggy cliffs, the dizzy silhouettes of high towers behind spherical hills along the horizon, the atmospheric toning down of the blue sky—all find obvious parallels in the miniatures of the finest copy of *Le Livre de chasse* by Gaston Phébus, Paris, Bibliothèque Nationale, franç. 616 (Figs. 8 and 10), another manuscript connected, as we shall now see, with the bibliophile inclinations of Jean sans Peur.

III

After the ravages of the Black Death, three French experts in hunting sat down to codify the time-honored rules of their art. In 1359, when after the battle of Poitiers Philippe le Hardi, together with his father, was still held prisoner in England, the royal chaplain, Gace de la Buigne, at the King's request started to write for the instruction of the young prince a versified treatise on the different ways of hunting, entitled *Le Roman des deduits et des oyseaulx*.[27] Although it was completed only in 1370, he dedicated it, in accordance with the original intention, to his ex-pupil. Whereas this poem remained without illustrations, two other manuals on hunting in prose received a rich cycle of miniatures. One was an almost contemporary hunting book by a Norman nobleman by the name of Henri de Ferrières, published together with another moralizing work by the same author, *Le Songe de pestilence*, under the common title *Les Livres du Roy Modus et de la Royne Ratio*.[28] Largely on account of its illustrations, this manual became a great success, as can be inferred by the survival of more than a dozen copies. One of these, of the early fifteenth century (Vienna, Österreichische Nationalbibliothek, cod. 2575), judging from the badges embroidered on the arms of the hunters, was probably made for Jean sans Peur and possibly within his own duchy.[29] Later it served as a model for an even more distinguished copy made for Philippe le Bon by his own court painters (now Brussels, Bibliothèque Royale, 10218–19).[30]

Yet the most distinguished of all French hunting books is without doubt the *Livre de*

[26]*French Painting in the Time of Jean de Berry. I. The Late Fourteenth Century and the Patronage of the Duke*, 151–54.

[27]Edited by Åke Blomqvist in *Studia Romanica Holmiensia*, III (Karlshamn, 1951).

[28]Edited in modern French by G. Tilander in *Les Maîtres de la vénerie*, I (Paris, 1931) and in old French in the Société des Anciens Textes Français, LXXV–LXXVI (Paris, 1932), both with illustrations.

[29]Hermann, *Die westeuropäischen Handschriften*, no. 14, and C. Nordenfalk, *Kung Praktiks*, English résumé, 93–94.

[30]Nordenfalk, *ibid.*, 94, with bibliography.

chasse written by Gaston Phébus, count of Foix, in 1387–89.[31] It is of particular importance to us because the author dedicated it to his admired ally and fellow-hunter Philippe le Hardi, "master of us all who are in the craft of hunting," as he calls him in his concluding paragraph.[32] And like the *Livre du Roy Modus* which inspired it, it is accompanied by a rich cycle of illustrations.

Among the forty-six surviving manuscripts of this hunting manual which have been preserved, the last editor of its text, Gunnar Tilander, has singled out four copies as being the oldest and most reliable. They are the following: (*A*) Paris, Bibliothèque Nationale, MS franç. 616; (*P*) New York, Clara Peck Collection, s.n.; (*L*) Leningrad, Hermitage (formerly Museum Stieglitz), cod. 14.044; (*D*) Paris, Bibliothèque Nationale, MS franç. 619.

Whereas *D* has only drawings shaded in grisaille, the other three are illustrated in full color. Otherwise the cycle is identical in all four manuscripts. According to Tilander's stemma, their relationship as regards the text is as follows:

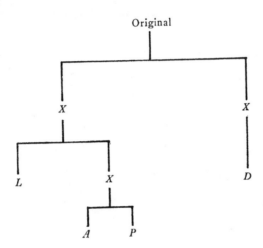

Consequently, *L*, *A* and *P* would form one branch of transmission, with *A* and *P* particularly closely interrelated, and *D* standing alone. The art historian concerned with the illustrations can confirm only the close affinity of *A* and *P*; without doubt, their miniatures come from the same workshop. He is less willing to admit that *L* belongs to a branch different from *D*, for from the standpoint of style and iconography these two manuscripts also form a close group clearly deviating from that of *A* and *P*. An example, chosen more or less at random may suffice to demonstrate this.[33]

Chapter XXXVIII of *Le Livre de chasse* deals with "comment l'asemblee se doit fere en este et en yver."[34] In all four manuscripts, it is preceded by a representation of the hunters at an

[31]*Le Livre de chasse*, edited by R. and A. Bossuat in modern French in *Les Maîtres de la vénerie*, II (Paris, 1931), and by G. Tilander in old French in his *Cynegetica*, XVIII (Karlshamn, 1971). The illustrations have been published in Paris, Bibliothèque Nationale, *Livre de la chasse par Gaston Phébus; reproduction réduite des 87 miniatures du manuscrit fr. 616* (C. Couderc), (Paris, [1909]), and by W. A and F. Baillie-Grohman, *The Master of Game by Edward, Second Duke of York* (London, 1904). Twelve miniatures were reproduced in color by H. Malo in a booklet with the somewhat inadequate title *Les Chasses à Chantilly* (Paris, n.d.). Since this note was written, a full-color facsimile, with introduction by M. Thomas, has been published: *Gaston Phébus—Le Livre de la Chasse* (Graz, 1975).

[32]*Le Livre de chasse*, ed. Tilander, chap. 86,8 (p. 291).

[33]The miniature I have chosen as an example is one of the only two in *P* of which photos are available. The manuscript itself has for some time been inaccessible. It should also be mentioned that the miniature in the Leningrad manuscript has been extensively repainted at a later date.

[34]Tilander, *Le Livre de chasse*, 172ff.

early open-air breakfast before remounting their horses to pursue the stag (Figs. 5–8). This breakfast should take place, the author says, "in a fair mead, well green, where fair trees grow all about, the one at some distance from the other, and a clear well or a running brook close by." The hunting staff should bring provisions from home "well and plenteously, and should lay the towels and beard-clothes all about upon the green grass, and set divers meats upon great platters after the lord's power."[35]

These indications clearly underlie the way in which this *déjeuner sur l'herbe* has been represented in all four manuscripts; for, however they may differ from one another, they obviously go back to the same archetype. The position of the figures and the animals, as well as their respective actions, are repeated more or less identically. The Master of the Game is seated behind a table, flanked by two fellow-hunters. Evidently, the inventor of the illustration did not find it proper for the lord to sit on the ground, and so a table had to be brought out for this purpose.[36] He is attended by two servants who from across the table proffer a golden cup and a plate.[37] At the same time, a hunter approaches from the left, presenting, as the text describes, the droppings from a stag he has just been following.[38] Another scout has already laid down his findings at the opposite corner of the table, and now a discussion begins as to which of the two quarries would promise the best hunt.

The lower personnel are seated on the ground around two tablecloths, one spread parallel, the other diagonal to the lower frame. All four miniatures agree in showing a man cutting his food at the obliquely placed cloth and, in the opposite half of the scene, another man holding a barrel to his mouth with both hands. In other motifs *L* and *D* agree, as against *A* and *P*. Only the two former have at the left tablecloth a hunter reaching for a platter with both hands, and in the lower right corner a dog, apparently the limer, picking a bone.[39] Since these details are not mentioned in the text, they must be additions made by the artist, with or without the agreement of the author. The same holds true of the horses at the upper left waiting in an enclosure for their riders to finish the meal, a motif that recurs in all four copies.

It is in the rendering of this enclosure that the manuscripts fall most clearly into two groups. *L* and *D* show the horses looking over a hedge, *A* and *P* over a fence. In the former the hedge begins at the left side of the frame and moves in a curve to the upper border, cutting out, as it were, a space with no convincing bond uniting it spatially to the rest of the picture. In the second group this lack of coherence has been eliminated. The fence is firmly fixed on the ground, and it recedes in a curve instead of moving upward across the sky. In *L* and *D*, the horses are shown nibbling at the hedge, obviously the original idea; it makes less sense that they go on doing the same with the fence in *A* and *P*. The two former copies are thus closer to the archetype.

Evidently *L* and *D* belong to a more primitive stage in the development of perspective,

[35]The English translations are from W. Baillie-Grohman, *Sport in Art*, 2nd ed. (London, 1919), 16ff.

[36]The artist of *P* provides similar tables for everyone eating, thereby deviating even more from the text.

[37]In *A*, the table is shorter, and therefore one of the servants has been left out. The remaining one, carrying a pie, turns his back toward the spectator. Undoubtedly the other three manuscripts are here more in accordance with the archetype.

[38]In *A*, *L*, and *D* this hunter still has his riding boots on. The artist of *P* has overlooked this realistic detail.

[39]In *L*, the poor condition of the miniature makes it difficult to see this dog in the reproduction.

as can also be seen in the relation of the lord's high table to the ground. In the earlier miniatures it cuts the horizon, whereas in the later examples it is placed further down, in a middle zone that hardly exists in the former versions. In *L* and *D*, the background is only an abstract space, covered in *L* with a golden rinceaux ornament. This remains true of *P*, as distinct from *A*, which already has a piece of blue sky visible under the trees—an indication that, of the two miniatures, the one in *A* is the later.

Of the four manuscripts, *L*, according to Tilander, preserves the best text, but unfortunately we cannot follow its history back into the Middle Ages. We are better off with *D*, its closest relative as regards the illustrations, for it belonged to the second successor of Gaston Phébus as lord of Foix and Béarn, Count Jean I (1412–1436), whose device "J'ai belle dame" has been added on the last page. Both manuscripts show the style characteristic of the Avignon school in the late fourteenth century.[40] In the Bibliothèque Municipale of Chartres there was, before its lamentable destruction at the beginning of the Second World War, a Pontifical (cod. 508, CCXXV), written and illuminated, no doubt at Avignon, for François, Archbishop of Arles, in 1389, the very year in which Gaston Phébus finished his hunting book.[41] An historiated initial on fol. 1, illustrating a visit paid by the Holy Father to a parish, contains figures that bear a strong resemblance to the servants in front of the table in both *L* and in *D*; note particularly the clumsy profiles and the creases in the blouses of the laymen presenting children to the Pope for confirmation (Fig. 9).

The close affinity of the two earliest manuscripts of *Le livre de chasse* to the works of the Avignon school in the last decades of the fourteenth century allows us to assume that it was to an artist of this city that Gaston Phébus turned for the illustration of his hunting manual.[42] We know that he employed a scriptorium in his castle at Orthez; Froissart, who visited him there at the time the hunting book was being finished, tells us that there were four scribes in his service, whom their master called not "Jehan, or Gautier, or Guillame," but by nicknames such as *Mau me sert* ("Serve-me-ill").[43] It seems quite natural that Gaston Phébus could not have entrusted the task of illustrating his text to them but had to call in a specialist for the purpose, who would have worked under his supervision. We know that the book was intended from the outset to have miniatures, since the author himself on two occasions refers to illustrations.[44] The many telling details that appear in the miniatures, providing specific

[40]Tilander definitely dates this manuscript too late, "ca. 1440," whereas P. Tucoo-Chala, *Gaston Fébus et la vicomté de Béarn* (Bordeaux, 1959), 19, rightly insists upon the costumes being of the late fourteenth century. The idea that *D* could be the original that Gaston Phébus had made for himself is, however, definitely ruled out by Tilander's analysis of its text.

[41]Y. Delaporte, *Les Manuscrits enluminés de la Bibliothèque de Chartres* (Chartres, 1929), 120ff. The negatives of the photos taken from the Chartres manuscripts before their destruction are now in the Bibliothèque Nationale. The Chartres Pontifical belongs to a group of illuminated liturgical books, on which see the catalogue of the exhibition "Les Manuscrits à peintures en France du XIIIᵉ au XVIᵉ siècle" (Paris, 1955), nos. 137–41, to which should be added a Book of Hours in the New York Public Library, Spencer Collection, cod. 51.

[42]In fact, Gaston Phébus's relations with the Avignon school of illumination started earlier, since the copy of Barthélemy l'Anglais's *Livre des Propriétés des Choses* in the Bibliothèque Ste. Geneviève in Paris, MS 1029, which has the same verse at

the end as Bib. nat. franç. 619 with the device of Jean I de Foix-Béarn, was originally written and illuminated for Gaston Phébus as early as ca. 1355. This has been convincingly demonstrated by A. Boinet, "Les Manuscrits à Peintures de la Bibliothèque Sainte-Geneviève de Paris," *Bulletin de la Société Française de Reproductions de Manuscrits à Peintures*, V (Paris, 1921), 112–22. Another manuscript of the Avignon school is the *Missal of Cardinal Nicolò Rosselli* in Turin, Biblioteca Nazionale, MS D. I. 21, written between 1356 and 1362; see *Il Messale miniato del Card. Nicolò Roselli detto il Cardinale d'Aragona* (Turin, 1906) and I. Ragusa, "The Missal of Cardinal Roselli," *Scriptorium* (XXIX, 1975), 47–58.

[43]Froissart, *Chroniques*, Book III, chap. 8 in *Voyage en Béarn*, ed. A.H. Diverres. French Classics (Manchester, 1953), 68.

[44]Speaking of the head of the fallow deer, he says that it is difficult to describe it properly without painting it, and about the steen-buck that it carries its head "come yci est figuree" (Tilander edition, 67 and 69).

information that supplements the text, can be due only to the direction of an expert hunter like Gaston himself. Once the cycle of illustrations had been established, further copies could, of course, be made outside Orthez, but since the author in sending a dedication copy of his work to the Duke of Burgundy set about distributing the treatise himself it does not seem unlikely that before he died in 1391 he had seen the completion of more than one copy.

The manuscript presented to Philippe le Hardi must have been closely related to L and D, and at least of the same artistic standard. In all probability it had, like L, illustrations in color and not drawings only, like D. It cannot be identical with either of these for the following reason. We have seen that the cycle repeated in A and P, although more progressive in style, follows the same compositions as L and D —that is, of the archetype. When the miniatures in A are compared to those in the older manuscripts, it can be seen that they contain a great many details that have parallels sometimes in L, but not in D, and sometimes vice versa.[45] Consequently, the presentation copy, on which A and P depend, must have been a third manuscript, now lost. To Tilander's stemma, quoted above (p. 331), I would prefer the following one:

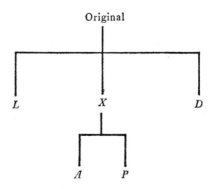

Even though L and D are inferior to A and P in their interpretation of three-dimensional space, they are remarkably advanced for the time in their representation of nature. This stands out particularly clearly if they are compared with the illustrations of the *Roy Modus* manuscripts, even those made as late as about 1400.[46] Just as the text of *Le livre de chasse* in its description of the various species of game and of hunting methods surpasses the older treatise in a number of realistically observed facts, so the illustrations of the former are far more advanced in their naturalism than those of the latter. This is due not only to their more accomplished text but also to the fact that they were conceived by an artist familiar with the advances in the study of nature made by the Lombard painters of the last quarter of the fourteenth century.[47] In that respect the *Tacuinum sanitatis* manuscripts in particular had set a new

[45]A agrees mostly with L against D, and often so closely that it would seem as if it were a direct copy of it. Yet there are also a few instances in which A agrees with D against L. One such case is in the miniatures with a representation of the treatment of sick dogs, fol. 25v of franç. 616, where the order and placement of the animals is almost the same in A and D, but differs in L.

[46]For a study of the development of landscape painting in the Roy Modus manuscripts, see Nordenfalk, *Kung Praktiks*, 39ff, figs. 11ff.

[47]O. Pächt, "Early Italian Nature Studies and the Early Calendar Landscape," *Journal of the Warburg and Courtauld Institutes* (XIII, 1950), 13–47.

standard.[48] By following in the footsteps of the Italian masters, the illuminator of Gaston Phébus's hunting book becomes more than just a representative of a provincial French school. He certainly deserves to be counted among those artists who, at the turn of the century, contributed to the rapid development of French illumination toward a more direct approach to nature.

Philippe le Hardi might still have been satisfied with the illustrations of his dedication copy. But to Jean Sans Peur they must have already looked old-fashioned and obsolete. He knew that the artists of his time could do better, and that must have been the main reason why he had new copies made of the book he inherited from his father. We have already seen that there exists a strong stylistic relationship between the miniatures in *A* and the frontispiece in the best version of Jean Petit's *Justification*. They must come from the same workshop and be about contemporary. If one of the two should be regarded as earlier, it is most likely the hunting book, in which a diapered or rinceaux-patterned background has been retained in most of the miniatures, except in two or three cases—of which the one representing *le connil* seems to be by a different artist from the rest (Fig. 10). He may actually be identical with the master of the Vienna allegory (Fig. 1); the treatment of the corkscrew mountains and the distant city are remarkably similar. Of the two hunting manuscripts, *P* is, as we have seen, likely to precede *A*, but probably by a year or two only.

IV

At this point of the discussion, it seems appropriate to introduce one more manuscript connected with the early dukes of Burgundy, namely the oldest copy of the charter and rolls of the *Court amoureuse* or *Court damours de Charles VI*, preserved in the Archives of the Order of the Golden Fleece in the Staatsarchiv, Vienna. Only historians of literature have so far shown the manuscript the attention it undoubtedly deserves. Its splendid series of coats-of-arms has up to now remained unpublished.[49]

An Order by the name of *Court amoureuse* could easily evoke in the uninitiated a suspicion of immorality, and indeed this was the interpretation placed upon it when in the eighteenth century it first came to the notice of the *curieux*.[50] The reality was different. In the first place the *Court amoureuse* was an academy to which ladies were not admitted, although it was instituted "a lonneur, loenge, recommendacion, et service de toutes dames et damoiselles." Its main purpose was to promote love poetry. Just as Boccaccio made the plague an excuse for presenting *la jeunesse dorée* of Florence as they spent a pleasant time together, telling one another love stories, so according to the opening sentences of the charter "ceste desplaisant

[48] Of greatest importance as a source of inspiration for the Gaston Phébus cycle is the oldest version of the *Tacuinum* in Paris, Bibliothèque Nationale, nouv. acq. lat. 1673, published by E.B. Toesca, *Il Tacuinum Sanitatis della Biblioteca Nationale di Parigi* (Bergamo, 1936).

[49] A. Piaget, "La Cour amoureuse dite de Charles VI," *Romania* (xx, 1891), 417–54, and "Un manuscrit de la Cour amoureuse," *ibid.* (xxxi, 1902), 597–603; Doutrepont, *La*

Littérature, 366–69. I have not been able to consult F. Diez, *Essai sur les Cours d'Amour* (Paris, 1842), or O. Le Maire, "La Cour amoureuse de Paris, fondée en 1401 et ses armoriaux," *Le Blason* (x, 1956).

[50] Piaget, "La Cour amoureuse," quotes the 1770 quarto edition of Velly's *Histoire de France,* in which the Order was said to be a typical exponent "d'un siècle grossier où l'on ignorait l'art si facile d'être vicieux du moins avec décence."

et contraire pestilence de epidimee presentement accourant en ce tres chretien royaume" of France made it seem advisable to found an Order "pour passer partie du temps plus gracieusement et affin de trouver esveil de nouvelle joie." Another and more specific reason apparently was the controversy, which had started not long before the new Order was founded, between Christine de Pisan and the humanist Jehan de Montreuil concerning the allegedly antifeminist bias of the *Roman de la Rose*.[51] In this debate, the statutes were on the side of the poetess in ordering that whosoever dared to so much as advance an idea in any way offensive to the weaker sex should immediately be dismissed and pay a fine.

The "courtiers" of the God Amor, numbering several hundred from the very beginning, were recruited from the intellectuals of all classes of society, from princes of the blood and high ecclesiastics down to *petits bourgeois* of the city of Paris. Although the King headed the list, its acting president was a *Prince damours*, elected among the *beaux esprits*. For this honor a young nobleman from Tournai was chosen—Pierre de Hauteville, called Le Mannier, *échanson du Roi*, and later on *conseiller et maître d'hôtel* of Philippe le Bon of Burgundy.[52] The other members were divided into various categories. Apart from the King there were two *Grands conservateurs*, his uncle Philippe le Hardi and his maternal uncle Louis de Bourbon. There followed 24 *Conservateurs*, one of whom was Pierre d'Hauteville, an equal number of *Ministres*, then 121 *Grand-seigneurs* without special function, and finally a number of special dignitaries ranked as *Grands veneurs*, *Veneurs*, *Auditeurs*, *Chevaliers d'honneur conseillers*, *Tresoriers des Chartes et registres*, *Ecuyers d'amours*, *Maîtres des requestes*, *Secretaires* and *Concierges des jardins et vergers*. No royal household was ever more carefully organized.[53]

Whereas the *Conservateurs* were in practice only honorary members, the functioning of the assemblies depended chiefly on the *Ministres*, who were expected to have "experts cognoissance en la science de rhetorique." They were bound by oath to hold "joyeuse feste de puy damours" on the first Sunday of every month.[54] At each meeting they were to propose a *refrain* to serve as theme and to be inscribed on two enameled golden *vergettes*, which were awarded as prizes to the best performers.[55] Furthermore, they were to pay for "pervenche, pain, vin, et poires pour boire en recreation."

The Order was instituted in Mantes on January 6, 1401 (or 1400, Old Style) in the presence of the King, and a month later, appropriately on St. Valentine's day, February 14, the first regular meeting was held in the Paris residence of the Duke of Burgundy, the Hôtel d'Artois. There is little doubt that the initiative originated from a humanist at the court of

[51]M. Roy, *Oeuvres poétiques de Christine de Pisan*, II (Paris, 1891), I–IX; C.F. Ward, *The Epistle on the "Romance of the Rose" and other Documents in the Debate* (Chicago, 1911); M.-J. Pinet, *Christine de Pisan. Etude biographique et littéraire* (Paris, 1927), 7off.; G. Pare, *Le Roman de la Rose et la Scolastique courtoise* (Paris–Ottawa, 1941); Alan Gunn, *The Mirror of Love, A Reinterpretation of "The Romance of the Rose"* (Lubbock, Texas, 1952); M. Favier, *Christine de Pisan. Muse des Cours souveraines* (Lausanne, 1967), 117–49.

[52]Guillebert de Metz mentions him in his *Description de Paris* of ca. 1407 as a person "qui tenoit avec lui musiciens et galans qui toutes maieres de chancons, ballades, rondeaux, virelais, et autres dicties amoureux savoient faire et chanter" (ed. A. Le Roux de Lincy, Paris, 1855, 85).

[53]Cf. the organization of the Burgundian court as described by W. Tyler, *Dijon and the Valois Dukes of Burgundy. The*

Centers of Civilization, XXIX (Norman, Oklahoma, 1971), 48–59.

[54]"Puys" was the *terminus technicus* for days of poetry competition, which were held from the thirteenth century on in different places. It is thought to be derived from a chapel in Valenciennes, Notre-Dame-du-Puy, in which such competitions first took place. Cf. G. Gröber, *Grundriss der romanischen Philologie* (Stuttgart, 1902), III, 948. The word, being derived from the Latin *podium*, could also refer to the platform from which the poems were recited.

[55]What sort of ornament is meant by *vergettes* is not quite clear. They were given the winner *pour couronne* and to the runner-up *pour chapel*. Note that according to E. Littré, *Dictionnaire de la langue française*, IV (Paris, 1877), 1633, *vergette* can also be a "terme de blason. Pal étroit qui n'a que la troisième partie de la largeur ordinaire."

Philippe le Hardi. Both the Duke of Orléans and the Duke of Berry figure among the *Conservateurs*, but the majority of members were, in one way or another, partisans or dependents of the Burgundian Duke. Evidently, meetings were still held in the time of Jean sans Peur, but otherwise little is known of what part the *Court amoureuse* may have played in the literary life of France during the first two decades of the fifteenth century.[56] Shortly after its foundation, however, it inspired Christine de Pisan to a flight of imagination in her poem "Dit de la Rose." She describes a supper in the house of Louis d'Orléans, after which a goddess appears to her in a dream, giving her the statutes for an *Ordre de la Rose* (the white rose being one of the badges of Louis d'Orléans).[57] In reality, no such rival Court of Love seems to have been founded.[58]

As to the Vienna copy of the rules and rolls of the Royal *Court amoureuse*, it has every appearance of having been executed at the request of a leading personality of the Order. It can hardly be the main register kept by the *Prince damours*, since that was to contain those poetical effusions of the members which met with the court's approval, and nothing of the sort exists in the Vienna manuscript.[59] It does not appear in any of the inventories of the dukes of Burgundy, but its presence in the archives of the Golden Fleece makes a Burgundian provenance more than likely.[60]

Artistically, the important part is the coats-of-arms of the members drawn in ink and painted in watercolor. Armorials are seldom of primary interest to art history, since they are usually the work of less-qualified artists strictly circumscribed by the rules of heraldry. The manuscript with which we are concerned, however, is at least in part an exception because of the settings containing the arms of the highest-ranking members. Those of the *Prince damours* and of the twenty-four *Ministres* are surrounded by laurel wreaths with multi-colored flowers (Fig. 11), whereas the arms of the *Conservateurs* are exhibited two by two on a green, strewn with flowers and surrounded by turfed benches opening towards the spectator (Fig. 12). The idea of placing a coat-of-arms in a garden is known from a seal of the sixth Duke of Bavaria of 1406 and another of John, Duke of Brabant, of 1418, and in both cases the shield is supported by a lion, seated in a small flower garden enclosed by a wattle fence.[61] In the case of the

[56]Piaget, "Un Manuscrit de la Cour amoureuse," 603, quotes a document according to which a magistrate of Amiens paid a herald for having brought letters from the *Prince damours* regarding "certaine feste et assemble qui se devoit faire au dit lieu de Paris" in 1410. Between 1408 and 1413 a little-known poet, Amé Malingre, dedicated a versified *épître* to the Prince, asking him to present his case to the *Ministres* of the Order. Even after Agincourt, meetings were apparently held, since in the Paris copy of the rolls (franç. 5233) certain new members are mentioned as substitutes for original members who had died in 1416.

[57]*Oeuvres poétiques*, ed. M. Roy (Paris, 1886–1896), II, 29–48. She describes the statutes, left at her bed by the goddess, as being (like the Vienna manuscript) beautifully written :

> Le parchemin de fin or yere
> Et les lettres furent escriptes
> De fin azur, non trop petites
> Ne trop grans, mais si bien formees
> Que mieulz ne peust . . . (vv. 573–77).

She also describes the cover as being "de soye azure" and having as a clasp a precious stone on which was engraved "le dieu d'Amours," standing on a leopard, and the goddess Loyauté (replacing Venus). Since the Order was not yet founded, there is no mention of any coats-of-arms of its members.

[58]Gröber, *Grundriss*, II, 1038; H. Göbel, *Wandteppiche*, I. *Die Niederlande* (Leipzig, 1923), 79, and, quoting Göbel, R. Van Marle, *Iconographie de l'art profane au Moyen-âge et à la Renaissance* (The Hague, 1931–1932), 417, take the existence of the Orléans *Ordre de la Rose* for granted. Note, however, that the Hohenlohe chain, referred to in n. 10 above, has white roses, alternating with knotted sticks.

[59]Could the empty pages in it have been left blank for this purpose?

[60]The present binding in tooled leather has a stamp with the name "Ja Gontier," who has so far not been identified. The manuscript then belonged to Gilles Rebecques, *roi d'armes de Hainaut*, etc., who signed his name in it with the date 1498.

[61]Turfed benches were a common feature in medieval gardens, for which see the treatise by Petrus de Crescentius, *Opus ruralium commodorum*, quoted by Frank Crisp, *Medieval Gardens* (New York, 1966), 15 and 81–83, illustrating the arms mentioned.

Court damours manuscript such a setting was no doubt chosen as being particularly appropriate to members whose chief pursuit was listening to love poetry. As already mentioned, among its dignitaries there were special *Concierges des jardins et vergers*.[62]

The most elaborate setting has quite properly been bestowed upon the King's own coat-of-arms, which stands alone on the first illuminated page (Fig. 13). The blue shield with three gold fleurs-de-lis (*France moderne*) is surmounted by a royal crown. It is held by an angel descending from the sky, with a scroll loosely attached to his right hand bearing the inscription "Charles roy de France VIᵉ de ce nom."[63] The background is *parsémé* on either side by his emblems, to the left leaves and pea pods, to the right peacock feathers. From the bottom of the shield rays emanate over a rock, in the crevices of which grow three shrubs of broom, another of the King's personal emblems. To the right, separated from the rock by a fine spray of broom, a peacock spreading its tail is shown frontally. To the left a small lion, rendered in profile, wears a royal crown around his neck like a collar, from which hangs a minute pair of pea pods like a pendant. Both the lion and the peacock are royal emblems, the latter of old also a symbol of immortality.[64]

The lion approaches a fountain in the form of a stone trough, and we see his head mirrored in the smooth surface of the water. The motif was easily understood by contemporaries as an allusion to the lover in the *Roman de la Rose* who, having entered the Garden of Diversion, discovers in its midst the well of Narcissus.[65] Approaching it he sees his own image, like the royal lion in our miniature (Fig. 14). Nothing could be more appropriate for the frontispiece of the armorial of the *Court amoureuse* founded for the cultivation of love poetry than this reference to the most famous and widely read of all medieval romances.[66] A close parallel existed in the emblem embroidered upon one of the two "longues houppelandes de drap de Damas noir," which Louis d'Orléans ordered for his embassy to Germany in 1396, showing "sur le coste un tygre sur une roche se mirant dans une fountaine."[67]

The copy belonging to the Order of the Golden Fleece has been variously dated. It was thought by Piaget to be not earlier than 1426, because Philippe, Comte de Ligny and de Saint Pol, is entitled Duke of Brabant, which he became only after the death of his father Antoine in that year.[68] Not only the words "et depuis duc de Brabant," however, but apparently the whole title has been written over an erasure by a scribe who also in other instances added "et depuis" notes.[69] None of these additions can therefore be used in dating the manu-

[62]See above, p. 336.

[63]A similar shield-bearing angel, although not descending from heaven, appears in the seal of Charles VI attached to his will of 1392, Paris, Archives Nationals, J. 404 (A. de Bastard d'Estang, *Peintures et ornements des manuscrits*, XII), and in an initial painted by Pseudo-Jacquemart in the Lactantius manuscript of the British Museum, Harl. 4947, fol. 2 (Meiss, *French Painting in the Time of Jean de Berry. The Late Fourteenth Century* (fig. 248). I owe this reference to Otto Pächt.

[64]A. Whittick, *Symbols, Signs and Their Meaning* (Newton, Mass., 1960), 234–36. One would like to know why the third zoömorphic device of the King, the stag or hart, does not appear.

[65]This motif has been thoroughly discussed with reference to the illuminated manuscripts by J.V. Fleming, *The Roman de la Rose. A Study in Allegory and Iconography* (Princeton, N.J., 1969), 95ff. and figs. 3, 5, 23–26. Also J. Frappier, "Variations sur le

thème du miroir, de Bernard de Ventadour à Maurice Sceve," *Cahiers de l'Association Internationale des Études Françaises* (XI, 1949), 134ff.; E. Köhler, "Narcisse, la fontaine d'amour et Guillaume de Lorris," *Journal des Savants* (1963), 86–103, and F. Goldin, *The Mirror of Narcissus in the Courtly Love Lyric* (Ithaca, N.Y., 1967), 52–59.

[66]The Narcissus fountain appears in the oldest part of the *Roman de la Rose* written by Guillaume de Lorris, and therefore it was not among the objections raised by Christine de Pisan and Gerson against the later part, added by Jean de Meun.

[67]A. Champollion-Figeac, *Louis et Charles, Ducs d'Orléans* (Paris, 1844), 113. The use of the tiger, instead of the wolf, might indicate that Louis d'Orléans regarded himself in rank next to the King (the Lion).

[68]"Un manuscrit de la Cour amoureuse," 598.

[69]I am much indebted to Professor Otto Pächt for having checked the manuscripts for me with regard to these additions.

script. That it is in reality at least ten years earlier than 1426 can be deduced from the fact that among the ministers appears Guillaume Maigret, "maistre des eawes et des foretz de Valloys," who died in 1416 and was replaced in that year by Thiébaut de Maisseray, whose name does not appear in the Vienna copy.[70] Furthermore, the name and titles of the Dauphin Louis, Duke of Guyenne, who died in 1415, are by the hand who wrote the "et depuis" additions, and if this entry antedates the death of the Dauphin, as seems likely, the manuscript itself must be even older.[71]

On the other hand, the Vienna manuscript cannot, as has recently been suggested, be the original charter of 1401.[72] For in that case Jean sans Peur, entered in the original hand, would not have appeared with his father's title, namely Duke of Burgundy. And whereas in the Paris copy of the statutes, published by Piaget in his first article, Jean Rasoir, seigneur d'Audomez, is described as "thresorier de Jehan, dauphin de Viennois"—a title he could have borne only between 1415 and 1417—in the Vienna manuscript he is still only "Clerk de Jehan, duc de Bourgoigne." This and other entries appertaining to members in the service of Jean sans Peur clearly show that the copy was made in the time of the second Duke of Burgundy, and most probably at the request of the Duke himself.

This dating accords well with the fact that the watermark of the paper consists of a balance with triangular scales very similar to, though not identical with, Briquet nos. 2412 and 2413.[73] No. 2412 provides the best parallel, and it is attested between 1390 (Gex) and 1414 (Damme). No. 2413 is documented for 1417 both in Dijon and Gramont. Both watermarks indicate that the paper was fabricated within the Duchy of Burgundy.[74] This does not, however, prove that the book was also written there. Since the original charter was kept in Paris, where the meetings of the *Court damours* were held, it seems most likely that the Vienna copy was made in the capital.

Nevertheless, the drawing style of the illuminations has a non-Parisian character. It points to the northern provinces, or even further east. The emphasis on the black contours makes the angel holding the coat-of-arms (Fig. 13) look as if it had been taken from a primitive woodcut, a technique in which German art excelled.[75] It also reminds us of the drawing style of the German *Volkshandschriften;*[76] there are also, however, close parallels in Flemish art

[70]See Piaget, "La Cour amoureuse," 492, quoting the Paris copy, franç. 5233, in which we find as no. 40 Thiébault de Maisseray "ou lieu de feu Guillaume Maigret que Dieu absoille." This was one of Piaget's grounds for dating the Paris list to 1416. In comparison with its coats-of-arms, those in the Vienna copy look considerably older.

[71]Louis's brothers Jean and Charles do not appear at all, perhaps because they were either too young or, in the case of Charles, not yet born when the Order was founded. Pierre de Luxembourg, seigneur d'Enghien, and his brother Jehan, seigneur de Beaurevoir, have also been given "et depuis" titles by the corrector, which confirms the manuscript as being earlier than 1426.

[72]J.–B. de Vaivre, "Les Armoiries de Pierre de Mortain," *Bulletin monumental* (CXXXI, 1973), 36 n. 3. It is worthwhile noting that the "et depuis" formula has also been applied to Jean sans Peur himself by the original hand. It proves that the Vienna copy goes directly back to the list of 1401, in which the son of Philippe le Hardi can have had only the title Comte de Nevers.

[73]*Les Filigranes*, Jubilee edition (Amsterdam, 1968), I, 182. I owe my information about the watermark of the Vienna *Court d'amours* manuscript to the kindness of Dr. U. Jenni and Dr. Pächt.

[74]The balance, Briquet no. 2413, is attested for the *Comptes d'hôtel* of the Burgundian dukes in the Côte-d'Or Archives, B. 333.

[75]H.T. Musper, *Der Holzschnitt in fünf Jahrhunderten* (Stuttgart, 1964), 45, with bibliography.

[76]R. Kautzsch, *Einleitende Erörterungen zu einer Geschichte der deutschen Handschriftenillustration im spätern Mittelalter*. Studien zur deutschen Kunstgeschichte, III (Strassburg, 1894); H. Wegner, "Die deutschen Volkshandschriften des späten Mittelalters," *Mittelalterliche Handschriften. Festgabe für Hermann Degering* (Leipzig, 1926), 316ff. Cf., among other manuscripts, the *Weltchronik* of Rudolph von Ems in the New York Public Library, Spencer MS 49, of 1402 (Catalogue of the exhibition "Illuminated Books of the Middle Ages and Renaissance," Baltimore, 1949, no. 143, Pl. LV).

of the period. The corkscrew curls of the angel occur very similarly in the stained-glass windows from the Town Hall in Bruges, now in the Gruuthuse Museum.[77]

There were several book illuminators of foreign origin working in Paris for the great bibliophiles of the time, and among them must have been the artist of the *Court damours* manuscript. Many were natives of the northern provinces of Burgundy, but the name of at least one indicates a birthplace further east. This painter was Haincelin from Haguenau, a city in Alsace. He was the third of the *équipe* that worked on an important Bible in French and Latin (thus a *Bible moralisée*) originally ordered by Philippe le Hardi as a present for Jean de Berry, but paid for only after his death through Jacques Raponde in 1407.[78] Haincelin is here described as "enlumineur," which usually, but not always, indicates an artist specializing in the decorative parts of a manuscript, as distinct from the *historieur* who was responsible for the miniatures.[79] He was also paid less than his two colleagues. In 1403, according to another document, he was employed by Queen Isabeau of France to paint arms and devices on two of her book caskets.[80] From 1409 on, he served the Dauphin as *enlumineur en titre et valet de chambre*.[81] In 1415, he offered a steel mirror for sale to some English envoys, again possibly a sign that he specialized in decorative designs.[82] It seems less certain that he can be identified with the Jean Haincelin, "enlumineur demourant à Paris," who first in 1409, and then as late as 1448, appears in the accounts of the dukes of Orléans.[83]

"Little Hans" from Hagenau was credited by Comte Durrieu with a pioneer role in French painting at the beginning of the fifteenth century.[84] Together with the Boucicaut Master, alias Jacques Coene, he was, Durrieu believed, responsible for abandoning the patterned backgrounds, earlier in use, in favor of a landscape stretching into infinite depth. This would have occurred first in the Gaston Phébus manuscript (Paris, Bibl. Nat. franç. 616), which Durrieu attributed to the Alsatian master, and subsequently in the manuscripts made for the Duke of Bedford, from which the artist takes his name, the Bedford Master.[85]

Durrieu's hypothesis has not met with the same approval as his identification of the Boucicaut Master with Jacques Coene.[86] Panofsky rightly objected that it would have been more plausible had there been any traces of German influence in the works ascribed by

[77]Kindly brought to my attention by O. Pächt; see J. Helbig, *Les vitraux médiévaux conservés en Belgique 1200–1500.* Corpus vitrearum Medii Aevi, Belgique, 1 (Brussels, 1961), 73–78, figs. A–E. As pointed out to me by O. Pächt, the initial on the first text page of the *Court damours* is similar to those found in manuscripts of Burgundian, Dutch, and German origin. *Initiales filigranées* are rare in books written in Paris, which prefer rinceaux fillings. It seems, however, that we have to do rather with a distinction between manuscripts on paper and manuscripts on parchment: the former use filigran (or *fleuronné*) fillings, whether they are done in Burgundy or in Paris.

[78]The document is fully published by M. Meiss, *French Painting in the Time of Jean de Berry. The Boucicaut Master* (London, 1968), 141.

[79]P. Durrieu, *La miniature flamande au temps de la cour de Bourgogne (1415–1530)* (Brussels–Paris, 1921), 8ff.

[80]A. de Champeaux–P. Gauchery, *Les Travaux d'art executés pour Jean de France* (Paris, 1894), 127 n.1.

[81]B. Prost, "Liste des artistes mentionnés dans les états de la maison du roi et des maisons des princes du xiiie à l'an 1500," *Archives historiques* (1, 1889–1890), 426.

[82]Meiss, *French Painting in the Time of Jean de Berry. The Boucicaut Master*, 62.

[83]*Ibid.*, 62 with literature. E. Panofsky, *Early Netherlandish Painting*, 51–52 and 61 n. 3, rejected the identification of Haincelain of Hagenau with Jean Haincelin and suggested that the latter might have been a son of the former.

[84]"L'Exposition des Primitifs français, iii," *Revue de l'Art Ancien et Moderne* (xv, 1904), 258ff. Cf. also Durrieu's contribution to A. Michel, *Histoire de l'art*, iii, 1 (Paris, 1907), 165ff.

[85]It is true that in the Phébus manuscript franç. 616 the miniature showing the rabbits (Fig. 10), has an open-sky landscape, but as a rule the miniatures in this book still make use of the diapered or otherwise patterned background (see above, pp. 335).

[86]By agreeing with Durrieu, K. Perls in his article "Le tableau de la famille des Juvenal des Ursins, le 'Maître du duc de Bedford' et Haincelin de Haguenau," *Revue de l'art Ancien et Moderne* (lxviii, 1935), 173ff., carries Durrieu's idea *ad absurdum*.

Comte Durrieu to Haincelin of Hagenau.[87] Since the documentary evidence suggests that this artist was an illuminator mainly distinguished for decorative work, the Vienna copy of the *Court damours* presents itself as suggesting a no less tempting alternative. An artist who adorned the book caskets of the Queen of France with armorial bearings and devices might well have been employed by Jean sans Peur for similar work on a copy of the statutes and rolls of the royal *Court damours*.

The master of the atelier that produced the *Justification* and the Gaston Phébus copies for Jean sans Peur, whether or not he was identical with the future Bedford Master, was without question a painter of great renown in Paris. If he is to be identified with one of the three artists employed by Philippe le Hardi to decorate his Bible, would it not be more reasonable to think of Imbert Stanier, who is mentioned first and who received the highest payment of all? Unfortunately, Stanier eludes us by not being mentioned in any other document.[88] Only the unexpected reappearance of Philippe le Hardi's *Bible moralisée*, or some other lucky discovery in the archives, would help us out of our present state of ignorance.

ENVOI (freely after Gaston Phébus)

Et, pour ce qu'il ne peut être que je n'aie failli ou laissé trop de choses qui appartiennent au bon historien de l'art, et cela par moult de raisons : l'une, que je ne suis pas si sage comme il me serait besoin, l'autre, qu'on ne puisse trouver en ma contribution beaucoup à emender et à reprendre ; et aussi ma langue n'est pas si bien duite de parler l'anglais comme mon propre langage, et trop d'autres raisons qui seraient longue pour écrire.

Pour ce je prie et supplie très-haut, très-honoré et très-puissant seigneur, messire MILLARD MEISS, par la grace de Dieu professeur à l'Institut des Hautes Etudes de Princeton, docteur d'honneur de l'Université de cette même ville, membre de maintes academies, grand officier de l'Étoile de la Solidarité d'Italie, et caetera, et caetera, d'accueillir cet article avec sa bienveillance accoutumée, et cela pour le grand et noble lignage de notre ami, le regretté messire Erwin Panofsky dont il vient ; pour les nobles et bonnes coutumes et vaillances qui sont en lui ; et pour ce qu'il est maître de nous tous qui sommes du métier de l'histoire de l'art.

Et bien que je sache qu'à lui ne convient aucunement ma pauvre science—car il en a plus oublié que je n'en sus jamais—et, comme je souffre a présent de ne plus le voir à mon aise, ce qui moult me pèse, je lui envoi mon article pour remembrance, qu'il se souvienne de moi qui suis de son métier, et son serviteur, et le supplie par sa bonne courtoisie qu'il lui plaise d'en combler les lacunes et d'en emender les défauts.

UNIVERSITY OF PITTSBURGH

[87] *Early Netherlandish Painting*, 51–52. He therefore suggested that works like the two Canon miniatures in the Missal from the Ste.-Chapelle (Brussels, Bibliothèque Royale, MS 9125) deserved attention in this respect. In believing Haincelin de Haguenau to be behind the "Bedford trend," Comte Durrieu was apparently led—or misled—by some words written in German on the scroll of a miniature in the *Bible historiale*, Paris, Bibliothèque Nationale MS franç. 159. For this inscription see Meiss, *The Boucicaut Master*, 152 n. 17.

[88] The present state of the Bedford Master problem has been well summarized by Meiss, *The Boucicaut Master*, 35ff. and *The*

"*De Lévis" Hours and the Bedford Workshop*. Yale Lectures on Medieval Illumination (New Haven, Conn., 1972), 24–25. Meiss emphasizes particularly the close stylistic relationship between the miniatures in the Phébus manuscript, franç. 616, and those painted by the Adelphoe Master in the Arsenal *Térence des Ducs*, both belonging to what he calls "the Bedford trend." He leaves open the possibility of the Bedford Master himself, first clearly identifiable in the Châteauroux Breviary of ca. 1415, having been at work as early as the first decade of the fifteenth century. See now also his *French Painting in the Time of Jean de Berry : The Limbourgs and Their Contemporaries*, pp. 363f.

"Petri de Burgo opus"

ROBERT OERTEL

Ein unbekanntes Gemälde von Piero della Francesca? Die Frage ist zu bejahen, obwohl das Bild, das hier vorgestellt werden soll, die Piero-Forschung schon seit Jahrzehnten beschäftigt hat. Aber man diskutierte über ein Palimpsest, dessen ursprünglicher Text fast unleserlich geworden war. Erst die Abnahme der sehr alten, nahezu totalen Übermalung hat uns ein vollgültiges, originales Werk des Meisters wiedergeschenkt (Abb. 1).[1]

Die *Landschaft mit dem Hl. Hieronymus als Büsser*, 1922 von Wilhelm von Bode für die Berliner Galerie erworben, war bisher für die Fachwelt vor allem eine Quelle der Beunruhigung. Der Cartellino mit der zweifellos echten Signatur und dem Datum 1450 (Abb. 2) versprach einen Fixpunkt für die so spärlich dokumentierte Chronologie des Malers. Aber die Handschrift Pieros war nur an wenigen Stellen des Bildes zu entdecken.[2] Das Bücherstilleben in der Felsnische und die auf der Bank liegenden Bücher schienen die Aussage der Signatur zu bestätigen, obwohl auch sie, wie sich zeigen sollte, nicht frei von entstellenden Übermalungen waren. Die Felspartie rechts hinter dem Heiligen liess stellenweise noch die zarte, aquarellartig dünne Farbmaterie Pieros erkennen. Fast alles übrige war in geschlossenen Flächen übermalt, mit derbem Strich und dickem Impasto, den Formen des Originals nur in groben Umrissen folgend.[3] Der provinzielle Maler, der wohl etwa im dritten Jahrzehnt des 16. Jahrhunderts mit der "Renovierung" des Bildes beauftragt wurde, hat Pieros Absichten vielfach missverstanden. Vorhandenes wurde unterdrückt, anderes eigenmächtig hinzugefügt, wie der Zweig vor der Hauswand in der Bildmitte und der blaugrüne, bewaldete Bergrücken am Horizont. Die Hügelkette hinter dem Gebäude war in dunklem, grünlichem Blau übermalt. Der Wasserlauf wurde mit hellblauen Wellenlinien überdeckt, zwischen denen die Reflexe der Baumstämme nur noch schwach erkennbar waren; das Spiegelbild der Baumkrone im Mittelgrund war gänzlich verschwunden. Die Bäume, der Rasen, das Gebüsch auf den Hügeln—nichts blieb verschont. Die Himmelsfläche war mit breitem Pinsel überstrichen, am oberen Bildrand mit trübem Dunkelblau beginnend, nach unten zunehmend aufgehellt bis zu Weiss über dem willkürlich hinaufgerückten Horizont.[4]

Was war der Anlass für diese barbarische Übermalung? Pieros Gemälde war keineswegs

[1]Berlin, Staatliche Museen Preussischer Kulturbesitz, Gemäldegalerie. Kat. Nr. 1904. Erworben 1922 aus Privatbesitz. Kastanienholz, 51.5 × 38 cm; mit dem Originalrahmen 59 × 45.7 cm. Nach der Erwerbung gereinigt, wobei Schäden am Inkarnat der Figur festgestellt wurden. Eine Restaurierung im Jahre 1935 beschränkte sich auf die Sicherung des Bestandes und Verbesserung älterer Retuschen. Die Abnahme der Übermalung wurde durch den Chefrestaurator der Gemäldegalerie, Hans Böhm, seit 1968 in mehrjähriger Arbeit durchgeführt (ohne Lösemittel mit dem Skalpell unter Stereomikroskop bei zehnfacher Vergrösserung).

[2]E. Battisti, *Piero della Francesca* (Mailand, 1971), II, 5, 6, gibt einen Überblick über die Versuche der bisherigen Forschung, den Umfang der Übermalung bezw. des noch erkenn-

baren Originalbestands zu klären; dazu die eigene Interpretation Battistis: I, 53f.

[3]Vgl. die (leider sehr unzulängliche) Farbtafel des übermalten Bildes bei O. Del Buono–P. L. De'Vecchi, *L'opera completa di Piero della Francesca* (Mailand, 1967), Taf. XI.

[4]Die von Dr. Hermann Kühn, München, vorgenommene Farbanalyse ergab mit hoher Wahrscheinlichkeit, dass die Übermalung im 16. oder 17. Jahrhundert ausgeführt wurde ("in den Proben der Übermalung sind keinerlei Pigmente— auch nicht in Spuren—enthalten, die erst seit dem 18., 19. oder 20. Jahrhundert bekannt sind"). Eine noch engere Eingrenzung des Enstehungszeitraums ist mit Hilfe der chemischen Farbanalyse nicht möglich.

unvollendet und wies keine gravierenden Beschädigungen auf. Es mag sein, dass man es wegen der sehr flüchtigen Behandlung mancher Partien für "unvollendet" gehalten hat.[5] Der locker hingetuschte Bewuchs der Hügel links in der Tiefe konnte zu solcher Fehleinschätzung verleiten—aber er ist höchst charakteristisch für Pieros Handschrift und sowohl auf dem Tafelbild der *Taufe Christi* wie auf dem Fresko der *Auferstehung* wiederzufinden. Für die Generation, die an die körperhafte, gesättigte Farbmaterie der Hochrenaissance gewöhnt war, musste die kühle und sparsame, helltonige Malerei des quattrocentistischen Meisters befremdlich und vielleicht wirklich unfertig erscheinen. Vor allem wurde wohl auch der experimentelle Charakter des Bildes—auf den noch zurückzukommen ist—nicht mehr verstanden. Am wenigsten war dies freilich von einem Besitzer zu erwarten, der eine so radikale "Erneuerung" eines Bildes zuliess oder sogar ausdrücklich veranlasst hat.[6]

Die Leuchtkraft des Originals, die bei der Abnahme der Übermalung wieder hervortrat, übertraf alle Erwartungen. Das lichte, doch intensive Blau der Himmelsfläche—zunächst nur in winzigen Abschnitten, Millimeter für Millimeter freigelegt—hat die gleiche kühle Ausstrahlungskraft wie auf der *Taufe Christi* in London. Die schneeweissen Wolken, an den Unterseiten zart grau getönt, ziehen in grosser Höhe aus der Tiefe des Horizontes heran. Alle auf einer Ebene liegend, haben sie eine unverkennbare perspektivische Funktion, ganz ähnlich wie schon auf dem *Schneewunderbild* aus Santa Maria Maggiore in Rom. Ein Bild dieser Art von Masaccio oder Masolino mag Piero zu Ende der dreissiger Jahre in Florenz gesehen haben. Seine Naturbeobachtung geht dabei schon um einen Schritt weiter: die ursprünglich kompakten Wolken beginnen sich in federförmige Zipfel und Fetzen aufzulösen.[7] Von dem leuchtenden Himmel hebt sich das Grün der Baumkronen ab, reich abgestuft in Licht und Schatten, zugleich raumfüllend und durchsichtig locker (Abb. 3). Die Röntgenaufnahme lässt erkennen, dass Piero zunächst das Skelett seiner Bäume aufgebaut hat (Abb. 4).[8] Der grosse Baum in der Mitte weist die gleichen, lanzettförmigen "Negativformen" zwischen den Ästen auf, wie der Baum in der Landschaft des Konstantinsfreskos in Arezzo. Während dort das—*a secco* gemalte—Laub heute weitgehend fehlt, ist es auf der Berliner Tafel vollständig erhalten. Bei der Baumgruppe links hat Piero zunächst die Stämme mitsamt dem Geäst angelegt; sie treten im Röntgenbild klar hervor. Die leicht sichelförmigen, spitz zulaufenden Zweige sind dieselben wie die der entlaubten Bäume in dem Fresko der

[5]Ein "begonnenes"—d.h. unvollendetes—Bild des Hl. Hieronymus befand sich noch 1515 im Nachlass Pieros (vgl. Battisti, II, 6, 87, 246). Battisti hält es für möglich, dass es sich um das heute in Berlin befindliche Bild handelte, das nicht an den Auftraggeber ausgehändigt worden sei. Diese Möglichkeit lässt sich zwar nicht völlig ausschliessen; ich halte es jedoch für sehr unwahrscheinlich, dass Piero ein schon 1450 gemaltes Bild, das in seinen Augen zweifellos vollendet war, bis zu seinem Tode bei sich behalten hätte. Die Signatur mit dem Hinweis auf die Herkunft des Malers könnte im übrigen dafür sprechen, dass das Bild nicht in Borgo San Sepolcro gemalt wurde oder wenigstens für einen auswärtigen Besteller bestimmt war.

[6]Vor der Übermalung wurde der Rahmen der Tafel neu vergoldet. Von der dafür erforderlichen, weissen Grundierung fielen einige Spritzer auf die originale Farbfläche bzw. den Originalfirnis, wo sie bei der Abnahme der Übermalung wiedergefunden wurden.

[7]Ähnlich geformte Wolken gibt es schon bei Gentile da Fabriano, Sassetta und Fra Angelico sowie auf Reliefs von Donatello, im übrigen auch bei Giovanni Boccati, u.a. auf den Predellenbildern seines Altarwerks von 1447 in Perugia. Aber nirgends sind die Wolken so konsequent als Mittel der Raumgestaltung verwendet wie bei Piero.

[8]Die Abbildung zeigt die obere Hälfte des Gemäldes. Links die Baumgruppe mit ihrem Astwerk; an der grossen Baumkrone ist links unten ein Rest der Übermalung stehen gelassen, ebenso rechteckige Stücke des Himmels am oberen und rechten Bildrand; bei dem Streifen rechts seitlich ist die horizontal verlaufende Wolke bereits freigelegt. Am Baumstamm nahe der Bildmitte ist in der Holztafel eine Galle erkennbar, die ausgeleimt wurde, um eine einwandfreie Malfläche zu erzielen. Unten halbrechts der Kopf des Heiligen, rechts in der Ecke das perspektivisch verkürzte Kreuz, das auf der Oberfläche des Bildes nur noch teilweise sichtbar ist.

Auferstehung. Auch der mächtige Baum, der die Lünettenfläche über dem *Tod Adams* in Arezzo füllt, zeigt die gleiche Art des Wachstums, wenn auch reicher differenziert.

Das mit Weiss gemischte Blau des Himmels ist, wie das Röntgenbild erkennen lässt, bis dicht an die Spitzen der Äste herangemalt, während die Baumkronen—deren Grün sich nicht abzeichnet—viel weiter ausladen. Der Maler erreicht damit, dass die Bäume luftig und durchsichtig vor der Himmmelsfläche stehen, die überall zwischen den Blättern durchschimmert. Die *Taufe Christi* bietet auch dafür schlagende Parallelen, ebenso das Hieronymusbild in Venedig.[9] Vergleichbar ist auch, dass der Betrachter von unten in die Baumkronen hineinblickt, während die Fusspunkte der Stämme nach der Tiefe hin immer höher hinaufrücken. Der perspektivische Horizont liegt etwa in Kopfhöhe des Heiligen; doch ist sogleich zu betonen, dass es sich um eine rein empirische, noch vortheoretische Perspektive handelt, ohne Verwendung konstruktiver Hilfsmittel.

Das lebendigste Interesse des Malers galt zweifellos der Landschaft und ihrer räumlichen Entfaltung. Die Bäume dienen als Markierungspunkte für die Tiefenerstreckung, aber mehr noch als Raster für das reizvolle Spiel der Durchblicke und Überschneidungen. Der gewundene Wasserlauf blinkt zwischen den Stämmen hervor und verschwindet schliesslich hinter dem Hügel an der linken Bildseite, begleitet von dem Weg, der ihn im Vordergrund mit einer Furt durchquert. Die Wasserfläche ist elfenbeinfarbig—der Maler mag dabei an die Flüsse und Bäche seiner Heimat gedacht haben, die so oft von mitgeführtem Sand oder Lehm gefärbt sind. Auf ihr erscheinen die Spiegelbilder der Stämme, des links stehenden Baumstumpfs und des vordersten der drei Bäume im Mittelgrund. Die zylindrische Form des Baumstumpfs wird durch die Wiederholung im Spiegelbild demonstrativ betont; hier meldet sich der künftige Theoretiker der Perspektive zu Wort. Auch die Uferränder, von der Strömung wie mit dem Messer abgeschnitten, spiegeln sich im Wasser; eine feine weisse Linie bezeichnet die Grenze der Wasserfläche, die sich "wie eine Glasscheibe"[10] zwischen den Ufern ausspannt. Der Elfenbeinton des Wassers wird nochmals aufgenommen von dem fensterlosen Gebäude, das den Mittelgrund des Bildes abschliesst; sein hellrotes Dach fügt sich harmonisch in die grauen und grünen Töne ein, die es umgeben. Alles ist kühler, sparsamer, nüchterner als in den Landschaften des Jan van Eyck und seiner Nachfolger, und doch nimmt uns die poetische Stimmung gefangen, die Piero mit rationalen Mitteln und seiner oft flüchtigen, spröden Malerei heraufruft. Sein Sinn für das Konstruktive ist überall präsent, doch nur bei den Spiegel-Effekten im Wasser tritt Pieros Interesse für das optische Experiment offen hervor. Das Motiv hat offenbar keine ikonographische Bedeutung—eher liesse sich sagen, dass es die Aufmerksamkeit von dem eigentlichen Inhalt des Bildes ablenkt.

Piero hat seine Bildbühne entworfen und fast vollständig ausgeführt, bevor er die Figur des Heiligen und den Löwen einfügte. Die braune Silhouette des Löwen ist so dünn gemalt, dass heute darunter wieder die Biegung des Weges erkennbar ist, der zu dem Wasserlauf hinführt.[11] Der Heilige kniet, zum Kreuz emporblickend, vor einer einfach gezimmerten

[9]Auch sonst war es üblich, Bäume über das darunter liegende Himmelsblau zu malen; Piero benutzt dieses Verfahren in spezifisch malerisch-koloristischer Absicht.

[10]C. Gilbert, *Change in Piero della Francesca* (Locust Valley, N.Y., 1968), 24.

[11]Der Löwe ist nicht verputzt, sondern die braune Farbe ist so dünn aufgetragen, dass die darunter liegende Schicht wieder durchgewachsen ist. Auch die zarte Weisshöhung der gelockten Mähne und der Körperformen ist deshalb nur noch schwach erkennbar. Dass diese Details ursprünglich deutlich sichtbar waren, beweist die alte Kopie in Turin (s. unten); diese zeigt auch das geschlossene Auge des Löwen.

Bank. Sein Umriss verbindet ihn mit der hinter ihm aufsteigenden Felsformation; auch farbig hebt er sich nur wenig von dieser ab. Man könnte meinen, der Maler habe ihn aus der Mittelachse des Bildes nach rechts gerückt, um den Blick in die Landschaft freizugeben. Sicherlich wohlüberlegt ist die geringfügige Überschneidung des Horizonts durch den Kopf des Heiligen. Die Wolken an dieser Stelle machen deutlich, dass hier die grösste Tiefenerstreckung des Bildes liegt. Von einem Nimbus haben sich keine Spuren gefunden.[12] Das Kreuz, das aus zwei schmalen Holzleisten besteht, ist heute nur noch schattenhaft erkennbar.[13] Wie bei anderen Hieronymus-Bildern ist es in einen gekappten Baumstamm eingefügt, der als Sockel dient. An den Stamm ist unten der Zettel mit der Signatur geheftet: PETRI DE/ BVRGO/OPVS·M/CCCCL (Abb. 2). Die Buchstaben T und R in der ersten Zeile sind zusammengezogen; die nach vorn gekrümmte Ecke des Zettels stellt sicher, dass die Jahreszahl vollständig ist. Vorn am Boden liegt der Kardinalshut des Heiligen. Die wichtigsten Attribute des grossen Gelehrten und Schöpfers der Vulgata sind jedoch seine Bücher, die sich wie kostbare Edelsteine von den Grautönen der Felspartie abheben. Das Blau, Rot und Grün ihrer Einbände, das feurige Gelb der Schnittflächen und Beschläge hat eine Leuchtkraft, die an keiner anderen Stelle des Bildes zu finden ist. Auch die Akribie des Details—in der Wiedergabe der Schliessen, der als Lesezeichen dienenden Schnüre—ist nur hier so weit getrieben. Kein Zweifel, dass Piero dabei ein niederländisches Vorbild im Sinne hatte, vielleicht ein Werk von Rogier van der Weyden, das er am Hof von Ferrara sehen konnte. Der besondere Glanz der Farben spricht sogar dafür, dass er um diese Zeit auch schon ein Werk von Jan van Eyck kennengelernt hatte.[14]

Endlich die Figur des Heiligen selbst: sie ist der einzige Teil des Gemäldes, der in neuerer Zeit Schaden gelitten hat. Als Bode das Bild 1924 veröffentlichte, bezeichnete er es als "im wesentlichen gut erhalten." Er hat also die fast vollständige, frühzeitige Übermalung nicht als solche erkannt. Doch er fügte hinzu: "nur die dünn aufgetragene Fleischfarbe des Heiligen ist etwas verrieben oder verputzt."[15] Schon vor dem Ankauf des Bildes für die Berliner Galerie ist offenbar an der Figur eine Putzversuch gemacht worden, der die nackten Teile, vor allem Brust und Arme, schwer beschädigt hat; die Hände wurden fast bis zur Unkenntlichkeit verputzt.[16] Von den Fleischteilen sind—ausser der blassgrünen Untermalung—nur noch Reste der einstigen Weisshöhung und geringe Spuren von Rosa erkennbar. Relativ gut sind die Füsse und Unterschenkel erhalten, am besten glücklicherweise der Kopf

[12]Der Verzicht auf den Nimbus ergab sich aus dem neuen Realitätsverständnis des beginnenden 15. Jahrhunderts. Jan van Eyck und Robert Campin haben in ihren späteren Werken die heiligen Gestalten konsequent ohne Nimben dargestellt. Rogier van der Weyden, dessen Kunst auch sonst archaisierende Züge aufweist, nahm den traditionellen Brauch in zurückhaltender Form wieder auf. Für die Entwicklung in Italien ist es bezeichnend, dass Filippo Lippi seine 1437 datierte *Madonna aus Tarquinia*—zweifellos unter niederländischem Einfluss—ohne Nimben dargestellt hat, dann aber wieder auf Nimben in verschiedenen, zum Teil betont traditionellen Formen zurückgriff.

[13]In der Röntgenaufnahme deutlich sichtbar (vgl. Anm. 8).

[14]Im Medici-Inventar von 1492 wird ein kleines Bild des Hl. Hieronymus von Jan van Eyck beschrieben, das möglicherweise mit dem *Hieronymus im Gehäus* in Detroit identisch ist. Panofsky hat mit guten Gründen vermutet, dass dieses Werk im Auftrag des Kardinals Albergati von Jan van Eyck begonnen und von Petrus Christus vollendet wurde. Albergati starb 1443 in Siena und wurde in der Certosa di Val d'Ema bei Florenz beigesetzt. Es ist also nicht auszuschliessen, dass dieses Bild schon in den vierziger Jahren nach Florenz gelangt ist. Vgl. E. Panofsky, "A Letter to St. Jerome," *Studies in Art and Literature for Belle da Costa Greene* (Princeton, 1954), 102ff. Weitere Informationen in dem Ausstellungskatalog "Flanders in the Fifteenth Century: Art and Civilization" (Detroit, 1960), 69ff. Dazu auch E. Hall, *Art Quarterly* (XXXIV, 1971), 181–201.

[15]W. v. Bode, "Der Hl. Hieronymus in hügliger Landschaft von Piero della Francesca, Neuerwerbung des Kaiser-Friedrich-Museums," *Jahrbuch der Preussischen Kunstsammlungen* (XLV, 1924), 201–05.

[16]Anschliessend wurden die Hände oberflächlich wieder ergänzt. Nach der Abnahme dieser Retuschen wurde auf eine erneute Rekonstruktion verzichtet.

des Heiligen. Nur das linke, im Schatten liegende Auge erwies sich als etwa zur Hälfte
zerstört; hier wurde die alte Retusche, die die Fehlstelle ausfüllt, bei der Abnahme der
Übermalung belassen. Dagegen konnte der grau und weiss melierte Bart in seiner ursprüng-
lichen, keilförmig vorstossenden Form wieder freigelegt werden: er zeigt in exemplarischer
Art die Handschrift Pieros. Bei dem Rock des Heiligen hatte die alte Übermalung den
Putzversuchen widerstanden; sie war blau, mit kräftigen Schatten an der vom Licht ab-
gewandten Seite. Stattdessen kam nunmehr ein zartes Lilagrau mit feiner Weisshöhung
zutage; um die Hüften liegt eine schmale, hellgrüne Ranke, die dem Heiligen als Gürtel
dient. Zum Originalbestand gehört auch der Stein, den der Heilige in der rechten Hand
hält, und der einfache Rosenkranz mit weissen Perlen in seiner Linken.

Es kann also nicht die Rede davon sein, dass das Gemälde an irgendeiner Stelle noch
unvollendet war, als es übermalt wurde. Wir besitzen dafür noch eine weitere, wertvolle
Bestätigung: das lünettenförmige Bild aus der Sammlung Gualino in der Galleria Sabauda
in Turin, dessen Zusammenhang mit der Berliner Tafel schon vor der Abnahme der Über-
malung erkannt worden ist (Abb. 5).[17] Das Bild in Turin vermittelt uns wichtige Informa-
tionen, gibt aber auch manches Rätsel auf. Der Maler, der diese eigenwillige "Replik"
geschaffen hat, muss die Berliner Komposition im Original vor Augen gehabt haben, nicht
etwa nur eine heute verlorene Variante. Er hat fast alle wesentlichen Elemente übernommen,
allerdings auch manches missverstanden oder willkürlich verändert, so die Felspartie, bei der
er zu der längst veralteten, vom Trecento ererbten "kristallinischen" Struktur zurück-
gekehrt ist. Neu hinzugefügt hat er die Höhle, die ihm von anderen Hieronymusbildern
bekannt war.[18] Konventionell wie die Felsen sind auch die Baumkronen gemalt, und der bei
Piero flüchtig hingetuschte Bewuchs der Hügel ist durch winzige, penibel auspunktierte
Bäumchen und Büsche ersetzt. Der im Vordergrund beginnende Weg verliert sich schon
nach der ersten Bodenwelle. Die Wasserfläche, durch die man den im Bachgrund liegenden
Kies erkennt, ist durch graue, wellenförmige Pinselzüge angedeutet.[19] Die Spiegelbilder der
Stämme und des Uferbanketts sind weggelassen—vielleicht nicht nur aus Unverständnis,
sondern weil der Kopist sie als nicht zur Sache gehörig betrachtete. Die Figur des Heiligen
ist in der Armhaltung verändert, sonst aber sehr genau dem Original nachgebildet. Kopf-
haltung und Blick, Form und Farbe des Bartes bestätigen den Befund, der nach der Abnahme

[17]Turin, Galleria Sabauda, Nr. 659. Holz in Lünettenform,
90×202 cm. Vgl. N. Gabrielli, *Galleria Sabauda, Maestri
italiani* (Turin, 1971), 168f., als "Matteo da Gualdo" (Zuschrei-
bung von C. Brandi). B. Berenson reihte das Bild anfänglich
(1932, 1936) unter die "unbekannten Florentiner" ein, erkannte
aber bereits seine Abhängigkeit von Pieros Berliner Kompo-
sition; 1957 (*Venetian Painters*, 121) schrieb er das Lünettenbild
dem in den Marken tätigen Nicola di Maestro Antonio
d'Ancona zu. F. Zeri (*Paragone*, IX, 1958, Nr. 107, 34–41)
akzeptierte diese Zuschreibung mit Vorbehalt, schloss aber
die Möglichkeit nicht aus, dass es sich um ein Spätwerk des
"Meisters der Barberini-Tafeln" handeln könnte.—E. Battisti,
I, 53, 56; II, 114, Abb. 25.

[18]Gemeint ist die Höhle der Geburt Christi in Bethlehem.
Damit werden zwei verschiedene Lebensabschnitte des
Heiligen in legendärer Weise in Zusammenhang gebracht.
Hieronymus (geb. um 347) begab sich 374 oder kurz danach
von Antiochia aus für zwei Jahre zu Bussübungen in die
Wüste, anschliessend nach Konstantinopel und schliesslich
nach Rom. Von dort ging er 385 wieder in den Orient und liess
sich 386 in Bethlehem nieder, wo er 419 oder 420 starb. Die
kantige, schollenförmige Struktur der Felsen auf dem Turiner
Bild steht in seltsamem Gegensatz zu den einfachen Formen der
Hügel im Hintergrund, bei denen der Maler dem Vorbild
Pieros zu folgen versucht.

[19]Vermutlich handelt es sich um eine ursprünglich hellblaue,
durch Alterung ausgeblichene Farbe. Ein ähnlicher Grauton
liegt über dem Grün des Rasens im Mittelgrund, das ebenfalls
etwas leuchtender gewesen sein dürfte. Auffallend ist das
braune Inkarnat des Heiligen; auch sonst dominieren
Brauntöne in dem ganzen Bild, mit Ausnahme des Himmels,
dessen Blau—im Gegensatz zur Wasserfläche—seine Leucht-
kraft bewahrt hat. Farbige Abbildungen bei N. Gabrielli,
Collezione Gualino Catalogo (Genua, 1961), 16–17, und M.
Bernardi, *La Galleria Sabauda di Torino* (Turin, 1968), 158–59,
Taf. 17.

der Übermalung wieder zutage gekommen ist. Auffallend genau hat der Kopist den zerschlissenen Saum des Rockes mit den herabhängenden Fetzen wiedergegeben; die als Gürtel dienende Ranke hat er unmissverständlich als Weinranke charakterisiert. Abweichend von seinem Vorbild versah er den Heiligen wieder mit einem Nimbus, in Gestalt einer perspektivisch verkürzten, mit Blattgold belegten Scheibe, in der sich die Schädelkalotte spiegelt. Dies ist die Nimbenform, die Piero selbst bei seinen Altarwerken verwendete, wenn die Rücksicht auf die Wünsche der Auftraggeber es erforderte. Der Nimbus als räumlich gesehene, spiegelnde Scheibe war freilich eine Perversion seiner ursprünglichen, mittelalterlichen Erscheinungsform. Piero übernahm ihn vermutlich von Domenico Veneziano (*Carnesecchi Madonna*, um 1440).[20] Er trieb das Spiel mit den überraschenden Reflexen fast bis zum Skurrilen, so schon bei dem 1445 in Auftrag gegebenen Misericordia-Altar in seiner Heimatstadt, aber auch noch bei dem viel später entstandenen Peruginer Altarwerk.

Der Maler des Turiner Lünettenbildes scheint also noch andere Werke Pieros gekannt zu haben als die *Hieronymus-Tafel* von 1450. Dennoch war er wohl nicht sein Schüler im herkömmlichen Sinne. Von der koloristischen Meisterschaft und der Formengrösse Pieros hat er keinen Hauch verspürt. Der verknöcherte, provinzielle Stil seines Bildes ist kaum früher als etwa um 1470 denkbar; Vorbild und Nachahmung liegen also um zwanzig Jahre, wenn nicht noch weiter auseinander.

Pieros Gemälde war vermutlich nicht für eine Kirche oder Kapelle bestimmt, in der es öffentlich zugänglich war. Es ist ein typisches Andachtsbild, das sich aller Wahrscheinlichkeit nach in Privathand befand. Hieronymus war der Patron der Gelehrten und Humanisten—in ihrem Kreise wäre der Besitzer des Bildes in erster Linie zu suchen. Wie kam der spätere Kopist an das Original heran? Es ist kaum angängig, eine "Musterzeichnung" als Zwischenglied anzunehmen, denn die Übereinstimmung mit dem Vorbild geht bis in einzelne Farben hinein, etwa das Rot und Blau der Bucheinbände und das Weiss des Rockes. Ungewöhnlich ist auch, dass der Nachahmer das kleinformatige Vorbild für einen völlig anderen Bildtypus verwendet hat: als Bekrönungsstück für eine Altarbild von über zwei Meter Breite. Fragen über Fragen, deren Lösung wir nur näherkommen könnten, wenn es gelänge, das Altarbild selbst und damit vielleicht auch seinen Entstehungsort zu identifizieren.

Was ergibt sich für Pieros eigenes Schaffen aus dem wiedergewonnenen, 1450 datierten Bild? Es wäre verlockend, in ihm die früheste Fassung der so eng verwandten Landschaftsmotive der *Taufe Christi* und der *Konstantins-Schlacht* zu erkennen. Wahrscheinlich gab es aber—wie bereits E. Battisti vermutet hat—ein Landschaftsbild ähnlicher Art unter den Arbeiten Pieros in Ferrara, die gegen Ende der vierziger Jahre anzusetzen sind.[21] Seine Wandmalereien für Leonello d'Este und in einer der Augustinerkirchen der Stadt—vermutlich Sant'Andrea[22]—sind zwar längst verlorengegangen, aber ihre Auswirkungen auf die

[20]Reflektierende Nimben verwendet auch Castagno bereits in seinen 1442 datierten Fresken in San Zaccaria in Venedig und nach seiner Rückkehr aus Venedig im *Abendmahl* in Sant'Apollonia in Florenz. Der "Erfinder" dieses Motivs war möglicherweise Uccello, dessen noch erhaltene Werke jedoch keine sicheren Hinweise mehr enthalten. Vgl. auch Battisti, I, 478, Anm. 164.

[21]Battisti (I, 45) nimmt an, dass Piero schon um 1446–1447

nach Ferrara berufen wurde; er vermutet (I, 47) dass die von Piero dort gemalten Fresken u.a. auch eine Flusslandschaft enthielten, die Bono da Ferrara als Vorbild gedient hat.

[22]Nach Battisti (I, 465, Anm. 53) könnte es sich auch um eine andere Kirche gehandelt haben. Vasari spricht von Fresken in einer Kapelle "in Sant'Agostino"; in späterer Zeit—um 1770—gab es in Ferrara drei Niederlassungen der Augustiner.

z

ferraresischen Maler und Miniaturisten lassen gewisse Rückschlüsse auf sie zu. Eins der frühesten Zeugnisse für die Nachwirkung Pieros in Ferrara ist das 1451 vollendete—heute ebenfalls zerstörte—*Christophorus-Fresko* des Bono da Ferrara in Padua.[23] Nicht nur die Figuren in diesem Bild sind möglicherweise von dem Frühstil Pieros beeinflusst—frappierend ist vor allem die virtuose Darstellung des Flusses, in dessen Wasserfläche sich die Beine der Figuren und die Uferkanten spiegeln. Spiegelbilder von Figuren—für damalige Betrachter zweifellos ein überraschender optischer Effekt—finden sich auch auf Pieros Bild der *Taufe Christi*. Es ist kaum denkbar, dass der ferraresische Maler unabhängig von Piero zu so auffallend ähnlichen Ergebnissen gekommen sein könnte. Nur bleibt bei ihm das Motiv der Flussbiegung im Bildaufbau isoliert; die nach hinten aufsteigenden, übereinandergeschichteten Hügelkuppen verbinden sich nicht überzeugend mit dem Vordergrund. Bei Piero dagegen steht die spiegelnde Wasserfläche in konsequentem Zusammenhang mit der perspektivischen Sicht des gesamten Landschaftsraumes. Das Motiv der verfallenen Brücke im Vordergrund von Bonos Fresko ist zwar vom Thema her gerechtfertigt: weil die Brücke nicht mehr begehbar ist, trägt der Riese Christophorus die Reisenden durch den Strom. Doch die im Wasser stehenden Pfeiler bieten erneut Gelegenheit, das Phänomen der Spiegelbilder zu demonstrieren. Auch hier macht sich der experimentelle Geist bemerkbar, der wohl nur von Piero ausgegangen sein kann. Sollte das von Piero stammende Vorbild, das wir voraussetzen möchten, ebenfalls eine Christophorus-Darstellung gewesen sein? Dann fände auch das Motiv des Flusses seine natürliche Erklärung: es ist zur Verdeutlichung der Christophorus-legende unentbehrlich, bei einem Hieronymusbild dagegen ganz unmotiviert.

Der Fluss mit seinen Windungen könnte zwar auch einer Darstellung der Taufe Christi entnommen sein, wo er den Jordan verkörpert. Es lässt sich jedoch zeigen, dass der Zusammenhang mit dem Motivbestand der Christophorus-Ikonographie besonders eng und konkret ist. Wir folgen hier nochmals einem Hinweis von E. Battisti, dessen Gedankengang sich noch ein Stück weiterführen lässt.[24] Die sogenannten "Skizzenbücher" des Jacopo Bellini—aus denen Battisti eine Christophorus-Darstellung heranzieht—enthalten mehrere, sehr verschiedenartige Formulierungen dieses Themas. Das bei Battisti abgebildete Blatt in Paris (Golubew II, Nr. XVIII) gehört zu den bildmässig durchgeführten Kompositionen, die wohl mit Sicherheit erst nach 1450 zu datieren sind.[25] Eine der Londoner Zeichnungen (Golubew I, Nr. XXXIII) zeigt das Christophorus-Thema noch in einfacherer Form. Der Heilige steht in dem schwungvoll gewundenen Fluss, dessen Ufer scharfkantig in das ebene Gelände eingeschnitten sind. Die Figur ist stilistisch eine der altertümlichsten des

[23]Gute Abbildung bei G. Fiocco. *L'Arte di Andrea Mantegna* (Venedig, 1959), Taf. 135. E. Rigoni in *Arte Veneta* (II, 1948), 141ff. hat nachgewiesen, dass Bono im Juli 1451 für das Fresko bezahlt wurde und im August dieses Jahres seine Tätigkeit beenden musste, da er nicht der dortigen Maler-zunft angehörte.

[24]Battisti, I, 115f., 466, Anm. 62, dazu II, Abb. 60.

[25]H. Tietze-E. Tietze-Conrat, *The Drawings of the Venetian Painters* (New York, 1970), 94ff., datieren das Blatt in das 3. Viertel des 15. Jahrhunderts. Wie vor ihnen schon L. Fröhlich-Bum, H. Simon und andere hielten sie die Bände in London und Paris für Sammelbände, in denen Studienmaterial aus mehreren Jahrzehnten, also Einzelblätter vereinigt wurden. Demgegenüber konnte M. Röthlisberger nachweisen, dass die

Zeichnungen erst ausgeführt wurden, als die Bände bereits gebunden waren ("Notes on the Drawing Books of Jacopo Bellini," *Burlington Magazine*, XCVIII, 1956, 358–64, und "Studi su Jacopo Bellini," *Saggi e Memorie di Storia dell'Arte*, II, 1958–59, 43–89); alle Zeichnungen seien innerhalb eines relativ kurzen Zeitraums gegen 1455 angefertigt worden, wobei Jacopo auf verschiedenartige, zum Teil wesentlich ältere Vorlagen zurückbegriff.—B. Degenhart-A. Schmitt ("Ein Musterblatt des Jacopo Bellini," *Festschrift Luitpold Dussler*, München–Berlin, 1972, 139–68) sehen in den Zeich-nungsbänden selbständige Werke Jacopos, die als "Aus-wertung" seines Vorbilderschatzes zu betrachten sind (S. 150).

ganzen Zeichnungskomplexes.[26] Nicht nur der Fluss lässt an Pieros Berliner Tafel denken, sondern auch das ländliche Gebäude im Mittelgrund und die Berge in der Tiefe. Die dritte Fassung des Themas, ebenfalls in London (Golubew I, Nr. XLV; Van Marle XVII, fig. 56)[27] zeigt den Heiligen bis zum oberen Bildrand aufragend, den Fluss mit seinen Windungen und—als neu hinzugekommenes Motiv—locker im Gelände verteilte Bäume mit frei entfalteten Kronen. Der Motivbestand der Berliner Tafel ist also weitgehend in den Christophorus-Darstellungen des Jacopo Bellini wiederzufinden. Nur fehlt bei diesen die Spiegelung auf der Wasserfläche, der wir bei Piero und Bono da Ferrara begegnen.

Ist also die Flusslandschaft des Berliner *Hieronymusbildes* aus einer Christophorus-Darstellung übernommen? Und vor allem: dürfen wir eine Berührung Pieros mit der Kunst des Jacopo Bellini voraussetzen? Bekanntlich war Jacopo schon 1441 in Ferrara tätig und stand seitdem mit dem estensischen Hof in guten Beziehungen. Und es wäre nicht überraschend, wenn Piero von Ferrara aus auch Venedig besucht hätte. Es ist also keineswegs auszuschliessen, dass er nicht nur Gemälde, sondern auch Zeichnungen Jacopos gesehen hat. Viele Kompositionen des Londoner Bandes würden eine Datierung in die vierziger Jahre durchaus erlauben. Auch wenn es zutrifft, dass die Zeichnungen rasch nacheinander nach schon vorhandenen Vorlagen ausgeführt wurden, wird man annehmen dürfen, dass Jacopo nicht nur auf Musterblätter von fremder Hand, sondern weitgehend auch auf eigene, ältere Zeichnungen zurückgegriffen hat. Jacopos Auffassung der Landschaft als einer von Hügeln und Bergen begrenzten Ebene musste Piero vertraut erscheinen. Sie war eine Teilaspekt des Interesses für die Probleme der Perspektive, das beiden Malern gemeinsam war. Und nicht zuletzt: das venezianische Farbempfinden lag Piero näher als das der Florentiner. Wohl schon seit seiner Zusammenarbeit mit Domenico Veneziano war die Farbe für ihn das wichtigste Ausdrucksmittel.

Diese von uns vermutete venezianische Komponente war jedoch nicht die einzige Grundlage für Pieros Stil in der Zeit um 1450. Weit stärker war er von dem Klima der toskanischen Kunst geprägt, das ihn—von Siena herüberwirkend—schon in Borgo San Sepolcro umgab, vor allem aber in Florenz, wo er seine entscheidenden künstlerischen Eindrücke empfing. Auch dafür lassen sich Hinweise gewinnen, wenn wir nochmals den ikonographischen Typus des Berliner Bildes ins Auge fassen. Hieronymus als Büsser, in einer Landschaft kniend, ist ein Thema, das schon vor 1450 in der toskanischen Malerei bekannt war. Kein geringerer als Masaccio hat es als einer der ersten dargestellt, auf seiner wenig bekannten Tafel in Altenburg (Abb. 6).[28] In einer düsteren Felsenszenerie kniet der

[26]Nach Tietze, *ibid.*, 103, ist die Figur des Heiligen eine der altertümlichsten des ganzen Skizzenbuchs. Röthlisberger, "Studi su Jacopo Bellini," 68, sagt dazu: "Il Bellini può al tempo stesso realizzare un S. Cristoforo secondo l'antica maniera del suo maestro Gentile (I, 33) e secondo quella nuova dei padovani (I, 45, II, 52, II, 78)."

[27]Nach Tietze, *ibid.*, 103, 110, aus der Spätzeit Jacopos oder von Gentile Bellini.—Meines Erachtenshat Jacopo auch in diesem Fall auf älteres Studienmaterial zurückgegriffen.

[28]R. Oertel, *Frühe italienische Malerei in Altenburg* (Berlin, 1961), 140ff., Taf. 54–57. Einheitliche, original gerahmte Tafel mit Dreiecksgiebel, 62×43.5 cm. Oben das *Gebet Christi am*

Ölberg, unten der *Hl. Hieronymus als Büsser* (Bildfläche 20× 34.5 cm). "Nimmt man die Beteiligung eines Gehilfen an, dann wäre am ehesten wohl an Andrea di Giusto zu denken." L. Berti, der irrtümlich von zwei Tafeln spricht, akzeptiert die Zuschreibung an Masaccio unter Mitarbeit von Andrea di Giusto (*Masaccio*, Mailand, 1964, 156, Taf. 35–37).—Zur Entstehung der Hieronymus-Darstellungen in der toskanischen Malerei vgl. die nach Abschluss meines Manuskripts erschienene, inhaltreiche Studie von M. Meiss, "Scholarship and Penitence in the Early Renaissance: The Image of St. Jerome," *Pantheon* (XXXII, 1974), 134–40.

Heilige vor einem Altar, auf dem ein Kreuz steht; wie auf Pieros Bild trägt er ein weisses Gewand und hält in der Rechten einen Stein, in der Linken einen Rosenkranz.[29] Ein Engel schwebt in stürmischer Bewegung herab und reicht ihm einen Palmzweig.[30] Am Boden kriechen Skorpione und anderes Gewürm. Hieronymus ist hier buchstäblich der "Genosse der Skorpione," wie er sich selbst in einem Brief beschrieben hat, den die *Legenda aurea* zitiert. Vor ihm am Boden—in unserer Abbildung nicht erkennbar—liegt sein Kardinalshut.[31] Dagegen fehlt der Löwe, der sich bei späteren Darstellungen fast stets dem Heiligen zugesellt. Man hat den Eindruck, dass der Bildtypus des büssenden Hieronymus sich noch nicht konsolidiert hatte, als Masaccios Gemälde entstand.

Die weitere Entwicklung lässt sich in der sienesischen Malerei der dreissiger und vierziger Jahre verfolgen. Sano di Pietro hat das Thema wiederholt in Predellenbildern aufgegriffen.[32] Zwei von ihnen gehören zu datierten Altarwerken aus den Jahren 1436 und 1444. Wieder finden wir die schon erwähnten Requisiten: den Kardinalshut, die Skorpione, nun auch den Löwen, einmal auch den Altar mit einem Kruzifix. Als neues Element kommt die Höhle von Bethlehem hinzu, in deren Nähe Hieronymus die drei letzten Jahrzehnte seines Lebens verbracht hat.[33] Sano di Pietro beschränkt sich jedoch nicht auf diese ikonographisch bedingten Motive. Die Berggipfel sind von Burgen und Städten bekrönt, die felsige Landschaft erhält durch locker verteilte Bäume einen eher idyllischen Charakter. Die Predellentafel von 1444 (Paris, Louvre) zeigt den büssenden Heiligen umgeben von Skorpionen und Schlangen, daneben einen Orangenhain mit zwei äsenden Hirschen. In vereinfachter Form ist in diesen Landschaften noch das Vorbild des Gentile da Fabriano spürbar, wenn auch ohne dessen farbige Glut und raffinierte Lichtbehandlung; die Bäume mit ihren knorrigen Stämmen und ornamental stilisierten Blättern verraten noch ihre Abkunft aus der Miniaturmalerei. Doch die Baumgruppe steht nun als raumbildendes Element in der Landschaft, so wenig diese vorerst perspektivisch artikuliert ist. Die Durchblicke zwischen den Stämmen verstärken die räumliche Wirkung, ähnlich wie auf der Berliner Tafel; der durch das Wäldchen führende Weg ist ebenfalls schon vorhanden. Ein Bild dieser Art mag Piero in Erinnerung gehabt haben, als er die Szenerie für seine Hieronymus-Darstellung entwarf. Zugleich war ihm die Lehre Masaccios gegenwärtig, die besagt, dass der perspektivisch organisierte Raum die Voraussetzung für jeden Figurenaufbau ist.

Pieros Landschaftsentwurf greift also auf sehr verschiedenartige Anregungen zurück. Er enthält kaum ein Motiv, das nicht in der älteren oder gleichzeitigen Malerei schon vorgeprägt war. Das gilt sogar für ein so auffallendes Detail wie die Baumstümpfe, die zunächst wie ein Stück spontaner, vielleicht etwas eigenwilliger Naturbeobachtung wirken. Sie begegnen uns aber—in Verbindung mit Baumgruppen und Waldstücken—schon auf Pisanellos Londoner Bild der *Zwei Heiligen mit der Madonna* und auf der Hieronymus-Tafel mit der

[29]Der Gebrauch des Rosenkranzes beim Gebet kam seit dem Mittelalter in Aufnahme und wurde vor allem durch den Dominikanerorden propagiert. Der Hl. Hieronymus erhielt möglicherweise den Rosenkranz als Attribut, weil er von den Dominikanern besonders verehrt wurde. Vgl. auch Battisti, I, 528f., Anm. 548.

[30]Der Palmzweig ist ikonographisch unmotiviert, da Hieronymus kein Märtyrer war. Der herabschwebende Engel ist offenbar in Analogie zu der oberen Szene eingeführt, wo

ein Engel Christus den Kelch überreicht. Der verbindende Gedanke für beide Darstellungen ist die Kraft des Gebets.

[31]Der "Mythus," dass Hieronymus Kardinal war, wurde von den Dominikanern geschaffen; vgl. Panofsky, "A Letter to St. Jerome," 106.

[32]C. Brandi, *Quattrocentisti senesi* (Mailand, 1949), Taf. 87, 91–93.

[33]Siehe oben ,Anm. 18.

umstrittenen Signatur des Bono da Ferrara, ebenfalls in London. Pisanello entnahm das Motiv der französischen Buchmalerei, in der es zu Anfang des 15. Jahrhunderts als Requisit einer "realistisch" gemeinten Landschaftsschilderung auftritt. In einer Handschrift wie dem *Boccace de Jean sans Peur* (zwischen 1409 und 1411)[34] sind die auf felsigem Boden wachsenden Wäldchen fast stets von den Stümpfen abgehackter Bäume umgeben. Im *Stundenbuch des Maréchal de Boucicaut* (um 1405–1408) sind die Baumstümpfe bereits zu formelhaften Versatzstücken geworden, die auch ohne den zugehörigen Wald in der Landschaft erscheinen.[35] Im übrigen hat auch dieses, ikonographisch scheinbar ganz neutrale Motiv seine Wurzeln vermutlich in einer wohlbekannten Bildtradition: in den Monatsdarstellungen. Auf dem Dezemberbild im Adlerturm in Trient sind Bauern damit beschäftigt, Bäume zu schlagen; die am Waldrand stehenden Stümpfe gehören hier unmittelbar zu der dargestellten Szene.[36] Auch in diesem Fall greift Piero also auf eine vorgegebene Formel zurück, die bei ihm freilich in völlig neuer Funktion erscheint: als Material für eine optische Demonstration.

Was bleibt also, wenn wir zuletzt nach Pieros eigener Leistung fragen? Die faszinierende Landschaft, deren einzelne Elemente fast durchweg auf ältere Traditionslinien zurückzuführen sind, ist als Ganzes etwas völlig Neues. Eine neue Stufe der Naturdarstellung ist erreicht, die über alles Frühere hinausgeht. Pieros Landschaft ist nach wie vor "komponiert," sie ist kein "Landschaftsporträt" im Sinne des 19. Jahrhunderts, aber sie ist frei von jeder herkömmlichen Stilisierung. Die aus der Tradition übernommenen Motive wirken nun wie "gesehene" Wirklichkeit. Das Sperrige und zugleich Durchsichtige der Baumkronen, das Flimmern der Blätter im Licht, die graubraunen, nur noch als Farbwert empfundenen Stämme des Wäldchens, das ist alles völlig unbefangen beobachtet, unbelastet von traditionsbedingten Vorstellungsbildern. Die Objektivierung des Sehens entspringt dem gleichen rationalen Geist wie der perspektivische Aufbau der Landschaft im Ganzen. Piero sieht die Landschaft *senza ornato*—wie Masaccio, dem er näher steht als jedem anderen Meister der vorangehenden Generation.[37] Was die zwei grössten Maler der Frührenaissance verbindet, sind nicht so sehr bestimmte stilistische Eigenheiten, obwohl auch da unbestreitbare Zusammenhänge bestehen. Es ist ihre vorbehaltlose Offenheit für die sichtbare Wirklichkeit, auf der Grundlage eines alles umfassenden konstruktiven Denkens. Auch das kleine Berliner Bild, das unsere Kenntnis von Pieros Schaffen so unerwartet bereichert, ist eine vollgültiges Zeugnis für diese neue künstlerische Haltung.

KIRCHZARTEN

[34]H. Martin, *Le Boccace de Jean sans Peur*, Paris, *Bibliothèque de l'Arsenal* (Brüssel–Paris, 1911).

[35]M. Meiss. *French Painting in the Time of Jean de Berry: The Boucicaut Master* (London, 1968).

[36]N. Rasmo, *Gli affreschi di Torre Aquila a Trento* (Rovereto,

1962), Taf. 12 u. 44.

[37]"Masaccio fu optimo immitatore della natura, di gran' rilieuo, uniuersale et buono componitore et puro, senza ornato . . ." (*Il libro di Antonio Billi*, hrg. von Carl Frey, Berlin, 1892), 16.

Disegni per esercitazione degli allievi e disegni preparatori per le opera d'arte nella testimonianza del Cennini

UGO PROCACCI

Nel 1960, pubblicando il mio libro sulle sinopie e sugli affreschi, scrivevo: "Le sinopie vengono a costituire quasi gli unici disegni—pervenuti a noi—dei nostri artisti più antichi, dalla fine del Duecento alla metà circa del Quattrocento, essendo, come è noto, pochissimi i disegni su carta o su cartapecora che si conservano fino a tutto il Trecento, e scarsi quelli del primo Quattrocento. Questa rarità di disegni nel tempo in cui si usava fare le sinopie, non può non essere considerata attentamente e non portare ad alcune riflessioni. È difficile infatti accontentarci, per chiarire un tal fatto, di una spiegazione che si basi sull'osservare semplicemente che si tratta di tempi lontani da noi; tanto più se si tien conto che i disegni diventano all'improvviso numerosissimi nella seconda metà del Quattrocento, proprio quando vengono a mancare le sinopie. E neanche può soddisfare del tutto la considerazione, certo di ben altro peso, della mancanza o quasi, nei tempi più antichi, della carta; la cartapecora non era poi un genere di gran lusso, e del resto dalla metà del Trecento in poi la carta divenne sempre più d'uso comune, mentre i disegni, anche per questo periodo, continuano a mancare. Dobbiamo quindi giungere ad altra conclusione: i disegni, in questi tempi lontani, erano quelli che si tracciavano direttamente sul muro; erano cioè le sinopie. La preparazione di un'opera d'arte murale non avveniva, come poi sarà in seguito, nelle botteghe; ma sui ponti, davanti alle stesse muraglie da affrescare. Qui si studiavano le composizioni e le figure, delineandole da prima con il carboncino e tradòcendole poi in definitivo disegno con il iosso sinopia, a mano libera, senza l'ausilio di quegli accorgimenti tecnici che saranno usati più tardi. . . . La sicurezza che le sinopie costituivano la vera preparazione e lo studio per gli affreschi, non esclude naturalmente che potessero esistere in qualche caso anche parziali schizzi e appunti, o che vi siano state eccezioni alla regola. La quale però trova una conferma nel fatto . . . che spesso sui muri, dove sono tracciate in sinopia le composizioni, si trovano delineate anche teste, studi parziali di figure o cose, che con le composizioni stesse non hanno nulla a che vedere, e che risultano quasi sempre eseguiti—e spesso debolmente o in maniera inabile—da scolari. La scuola dunque si trasferiva dalla bottega sui ponti, e continuava di fronte alle grandi muraglie da affrescare."[1]

Questa mia ipotesi, e cioè che le sinopie siano state di regola i soli disegni che si facevano come preparazione agli affreschi, prima che con la quadrettatura sorgesse l'uso costante della trasposizione quasi meccanica di disegni in piccolo, su carta, a disegni della grandezza a cui dovevano essere eseguiti gli affreschi, per essere adoperati in un primo tempo per lo spolvero e in seguito per il cartone,[2] è stata, subito dopo la pubblicazione del libro, da alcuni senz'altro

[1] *Sinopie e affreschi* (Firenze, 1960), 13–14; e cfr. anche quanto si dice alle pagg. 14–19 e alla pag. 45.

[2] Cfr. per questo il mio citato volume alle pagg. 19–20 e quanto ho scritto nell'introduzione al catalogo della Mostra di affreschi staccati, tenuta in diverse città d'America e di Europa tra il 1968 e il 1971 (pubblicato in varie lingue; edizione inglese *The Great Age of Fresco: Giotto to Pontormo.* New York, 1968, 18–44; edizione italiana Lugano 1970 oppure Milano 1971).

accettata,[3] da altri accolta, ma con dubbi per alcuni casi, eccettuando però da tali dubbi tutte quelle sinopie, tracciate con assoluta spontaneità o in maniera sommaria e compendiaria, per le quali sarebbe arduo pensare a disegni preparatori;[4] di conseguenza, date queste perplessità, Michelangelo Muraro, per una sua recensione al mio libro, ritenne opportuno rivolgermi alcune domande in proposito, riportando poi, nel suo scritto, le mie risposte; con le quali, mentre ripetevo che la mia ipotesi non voleva, né poteva assolutamente, escludere che anche nel Trecento vi siano stati disegni su carta per servire poi all'esecuzione degli affreschi, riaffermavo però come si potesse ritenere che questa non fosse la procedura abituale allora seguita; e facevo in proposito varie considerazioni, alle quali rimando per non ripetere cose già dette.[5]

È poi venuta la pubblicazione di Millard Meiss e Leonetto Tintori, sul ciclo francescano della chiesa superiore di Assisi, di eccezionale importanza per le osservazioni sulla tecnica di quelle celebri pitture; nella quale, inoltre, con alcune considerazioni sul nostro argomento, che meritano la più attenta riflessione, si vengono a determinare quali potessero essere le eccezioni alla regola, dando in tal modo consistenza ai dubbi in proposito.[6] Così, mentre si accetta in via di massima che le sinopie siano state eseguite come disegni preparatori senza preventivi studi, si nota però che non si sarebbero potute impostare le composizioni di alcuni grandi affreschi, specialmente se in essi vi siano architetture, senza disegni studiati prima su carta in piccolo; e ancor meno questo sarebbe stato possibile quando si avessero, sempre in affreschi di grandi dimensioni, linee ortogonali per le architetture, convergenti addirittura fuori del campo visivo della superficie murale. Casi, tutti, particolari—se pur non infrequenti—per i quali non è certo illogico pensare a preliminari studi prima che sull'arriccio

[3]Si veda per esempio L. Puppi in *Arte Lombarda* (VII, 1962), 174–75. Naturalmente R. Oertel, "Perspective and Imagination," in *Studies in Western Art: The Renaissance and Mannerism.* Acts of the Twentieth International Congress of the History of Art (Princeton, N.J., 1963), II, 146–59, riprendendo la tesi già da lui sostenuta nel suo importantissimo articolo "Wandmalerei und Zeichnung in Italien: Die Anfänge der Entwurfszeichnung und ihre monumental Vorstufen," *Mitteilungen des Kunsthistorischen Institutes in Florenz* (V, 1940), 217–314, sostiene ancora che gli affreschi venivano ideati direttamente sui ponti con i grandiosi disegni murali. Analogo sembra essere il giudizio di R.W. Scheller, *A Survey of Medieval Model Books* (Arlemo, 1963), per il quale il genere di disegni di questi libri di modelli sembra dare appoggio alla ipotesi dell'Oertel, dato che essi appaiono esser più strumenti di lavoro che produzioni artistiche indipendenti. I disegni preparatori venivano fatti nello stesso posto del dipinto; gli artisti potevano sapere a memoria le forme e non avevano quindi bisogno di studi preliminari su carta; donde la loro rarità, conclude lo Scheller.

[4]Si confronti, per esempio, A. Martindale, "The Literature of Art; Sinopia Painting," *Burlington Magazine* (CIV, 1962), 436–37; alcune osservazioni di questo autore, come quelle che si riferisce al passaggio dalla sinopia allo spolvero, hanno avuto una risposta in quanto ho scritto nella citata introduzione al catalogo della Mostra di affreschi staccati.

[5]*Art Bulletin* (XLV, 1963), 154–57.

[6]*The Painting of the Life of St. Francis in Assisi*, con prefazione di U. Procacci (New York, 1962). Questo libro è stato scritto contemporaneamente (v. pag. 187) al mio sulle *Sinopie e affreschi*, il cui testo non fu però conosciuto dagli autori; giudizi coincidenti sono stati quindi espressi indipendentemente. Cfr. anche, degli stessi Tintori e Meiss, "Additional

Observations on Italian Mural Technique," *Art Bulletin* (XLVI, 1964), 377–80, specialmente per quanto si dice su diagrammi in incisione e in linee rosse osservati nella decorazione della volta della cappella degli Scrovegni, che sono in numero sufficiente per poter ricostruire l'intero disegno geometrico. Cfr. inoltre di M. Meiss, "Nuovi dipinti e vecchi problemi," *Rivista d'Arte* (XXX, Annuario 1955, Firenze, 1956), 137–42 e *The Great Age of Fresco* (New York, 1970), specialmente a pag. 106. Posso ora aggiungere, a quanto ho scritto in passato, riprendendo argomenti trattati dal Meiss e dal Tintori, che diverse altre volte mi è occorso di trovare, in superfici affrescate nel Trecento, punteggiature dovute all'uso dello spolvero (cfr. *Sinopie e affreschi*, 20–21) ma sempre, e solo, in fasce decorative ornamentali. In quanto all'uso del cartone nella pittura prima del rinascimento, l'affresco duecentesco di San Bartolommeo in Pantano a Pistoia rimane l'unico esempio da me conosciuto, essendo altre incisioni sull' intonaco fatte solo per determinare nettamente i contorni entro cui dovevano essere eseguite aureole, o dipinte teste o panneggi; nei panneggi alcune volte è indicata, sempre in incisione, qualche piega che doveva esser messa, nella pittura, in evidenza (*Sinopie e affreschi*, 21). Necessario era poi questo accorgimento, secondo il Cennini, quando si trattava di un manto da dipingere in azzurro, a secco: "Se vuoi fare un mantello di Nostro Donna d'azzurro della Magna, o altro vestire che voglia fare solo d'azzurro . . . prima gratta la perfezion delle pieghe con qualche punteruolo di ferro, o agugiella" (cap. LXXXIII); lo stesso per le pitture su tavola (cap. CXXIII). Recentemente (ultimi mesi del 1974) l'uso del cartone è stato rilevato, sempre a Pistoia, in alcuni affreschi, databili presumibilmente ai primi anni del Trecento, tornati alla luce nell'antico palazzo vescovile della città toscana.

fossero affrontate simili complicate composizioni. Nel caso poi di repliche da opere particolarmente ammirate—ne son ben conosciute diverse da pitture di Giotto o di artisti di grande fama—non può trovare che assoluto consenso l'ipotesi che venissero fatte, dai pittori che ne avessero interesse, copie su carta,[7] da ripetersi poi, pedissequamente o con varianti; e questo forse anche per volere dei committenti, non esistendo evidentemente alcun divieto a tal fatto, che anzi doveva essere di prassi comune. Del resto lo stesso Cennini consiglia, nell'esecuzione del disegno preparatorio per una pittura su tavola, fatto sulla ingessatura, forse di copiare da opere di grandi artisti, e, in ogni modo, di ispirarsi ad esse: "che puoi ritrarre e vedere delle cose per altri maestri fatte, che a te non è vergogna" (cap. CXXII).

Alcuni dei concetti espressi nel libro del Tintori e del Meiss, si ritrovano nel volume che Eve Borsook e lo stesso Leonetto Tintori hanno dedicato alla cappella Peruzzi in Santa Croce.[8] Di parere contrario totalmente sono invece Bernard Degenhart e Annegrit Schmitt che, nella loro monumentale opera sui disegni italiani dal 1300 al 1450, sostengono in modo assoluto la tesi che disegni preparatori su carta siano sempre stati fatti, nel Trecento, prima che venissero tracciate le sinopie sull'arriccio; questi disegni avrebbero costituito una premessa necessaria, e quindi non può nè deve far meraviglia il silenzio su di essi del Cennini, essendo la loro citazione del tutto superflua; la loro esistenza era infatti sottintesa. Sarebbero poi andati perduti, subito, durante il lavoro, mentre si conserveranno in tempi posteriori, nell'alto rinascimento, quando verranno a rappresentare espressioni personali del genio. Rimane inoltre—dicono ancora i due autori—in alcuni contratti di allogagione, il ricordo di disegni fatti per il committente, disegni che potevano essere elaborati, alle volte coloriti (e in questi casi sono da presupporre per essi studi preparatori) o anche semplici schizzi quando il committente fosse stato un intenditore.[9] Naturalmente queste considerazioni, e altre che sono nel testo, non possono davvero non essere valutate con la maggiore attenzione, dato il valore e la serietà degli studiosi, e inoltre le loro ampie conoscenze e la loro competenza nel campo dei disegni.

I pareri sono dunque ancora tutt'altro che concordi;[10] e per questo, siccome anche so

[7]Vedi esempi di alcune di queste copie in B. Degenhart–A. Schmitt, *Corpus der italienischen Zeichnungen 1300–1450* (Berlino, 1968).

[8]*Giotto: La Cappella Peruzzi*, con prefazione di U. Procacci (Torino, 1965), 22 e n. 74–76 bis. Cfr. anche E. Borsook, *The Mural Painters of Tuscany from Cimabue to Andrea del Sarto* (London, 1960), 21–22.

[9]*Corpus der italienischen Zeichnungen*, XVI–XXIII. Per alcuni casi particolari di disegni ricordati in documenti v. *Sinopie e affreschi*, 46 n. 6 e alcune mie osservazioni in *Art Bulletin* (XLV, 1963), 156–57. Analogo a quello dei due autori sopra citati sembra essere il parere di L. Grassi, *I disegni italiani dal Trecento al Seicento* (Milano, 1961), per il quale la sinopia rappresenta la fase intermedia tra il disegno su carta e l'opera completa; vedi anche, dello stesso autore, l'articolo "Considerazioni a proposito del Corpus dei disegni italiani dal 1300 al 1450," in *Scritti in onore di Roberto Pane* (Napoli, 1972), 224. Così pure è per L. Magagnato che, nella sua premessa alla nuova edizione del Cennini di Franco Brunello (Vicenza, 1971), parla di "abozzo preparatorio a carboncino e sanguigna da usare come studio in iscala prima di tracciare le sinopie, sull'intonaco."

[10]Per la tecnica seguita dal Pisanello nelle sue pitture murali a Mantova vedi le acute e precise osservazioni di G. Paccagnini, *Pisanello e il ciclo cavalleresco di Mantova* (Milano, 1972), 21–35.

Siamo però ormai già fuori del tempo che ci interessa. Il Pisanello, "artista incontentabile che cambiava di continuo particolari autografi anche bellissimi," variò sinopie già eseguite, dopo averle coperte con un sottile velo di calce, e dipinse poi ad affresco, a mezzo fresco e a secco, in maniera complessa e molteplice, per poter ottenere, dalla sua pittura, gli effetti che egli voleva; ma la sua tecnica non avrebbe certo avuta l'approvazione del Cennini. Le sinopie a lui, come sarà a Firenze per Andrea del Castagno a Sant'Apollonia, servirono specialmente per avere un effetto complessivo della composizione nel luogo dove sarebbe stata eseguita la pittura (il padre Ignazio Pozzo, nella sua "Breve instruttione per dipingere a fresco," che è dell'anno 1700, consiglierà che il "disegno in carta quanto è grande l'opera," cioè il disegno che doveva servire come spolvero o cartone, "si possa attaccare al luoga per veder da lontano gli errori, se ve ne fossero, per correggerli"); e "quando si hanno a dipingere luoghi grandi come chiese, sale, o volte storte e irregolari, nelle quali o non si posson far carte così grandi, o non si posson distendendere, è necessario servirsi della graticolatione, la quale è molto utile per trasferir dal piccolo—cioe dal piccolo disegno—in grande . . . nella parete arricciate"); da queste sinopie venivano poi tratti disegni di ugual grandezza per gli spolveri, oppure poteva avvenire viceversa, come si dice il padre Pozzo.

che l'argomento interessa particolarmente Millard Meiss, amico carissimo, con il quale tante e tante volte si è insieme discusso di tecnica e di restauro, ho pensato che sia opportuno riprendere in esame la questione dei disegni preparatori nel Trecento, non solo per gli affreschi ma anche per i dipinti su tavola.[11]

Va subito fatto presente, a sostegno della possibilità di eccezioni a una prassi generalmente seguita, che mai tutti i pittori di uno stesso periodo di tempo hanno seguito, nell'operare, una medesima identica tecnica; anzi si possono spesso riscontrare, in questo campo, tra l'uno e l'altro artista, differenze anche molto notevoli. Così, nella stessa Firenze del Trecento, accanto alla perfetta tecnica in affresco della scuola di Taddeo, e poi di Agnolo Gaddi (e per nostra fortuna il Cennini fece parte di questa scuola così che il suo scritto ci fa conoscere la più esemplare tecnica del tempo) troviamo, nella scuola orcagnesca, un uso spesso preponderante di pittura a secco o nel cosiddetto mezzo fresco, se si fa eccezione per i volti sempre dipinti ad affresco; di conseguenza si ha qui la logica mancanza di sinopie, mentre diviene possibile che in tal caso, come pensa il Meiss, venissero usati disegni su carta da tradurre poi rapidamente, e nei soli tratti essenziali, sull'intonaco, prima di dare inizio alla pittura; quei tratti che alle volte tornano alla luce quando sia caduto il colore messo a secco.

Assurdo poi sarebbe supporre che i pittori del Trecento avessero una specie di idiosincrasia per disegnare; non solo infatti, come vedremo, del disegno parla, e a lungo, il Cennini, ma documenti ci fanno addirittura sapere che alle volte i pittori fornivano propri disegni agli scultori perché li usassero per le loro sculture. È ben noto poi che alcuni artisti hanno avuto taccuini in cui disegnavano tutto ciò che per essi aveva interesse. Disegni dovevano inoltre esser dati, sciolti o riuniti in libretti, dai maestri agli allievi perché si esercitassero nella copia o nell'imitazione; e in grandissimo numero, come vedremo, venivano dagli allievi eseguiti schizzi, abbozzi, copie e infine propri disegni, tutti certo andati presto dispersi perché tenuti in nessun conto, come esercizi scolastici senza importanza. Del resto lo stesso Cennini ci dice che per certi panneggi, in cui un colore doveva campeggiare su un fondo aureo, si doveva usare lo spolvero; esisteva dunque un disegno del panneggio, che, riportato, appunto con lo spolvero, sul colore dato sopra l'oro, serviva come guida sicura per vedere quale parte del colore stesso fosse da lasciare e quale invece da togliere.[12]

Questo passo del *Libro dell'arte* mentre da un lato ci fa conoscere l'uso di un disegno preparatorio su carta per una pittura su tavola, d'altro lato non può non portarci alla considerazione che sembra strano che il Cennini abbia passato invece sotto silenzio un ben più

[11]È da notare che il disegno tracciato dall'artista, sull'ingessatura della tavola, era alle volte in parte assorbito dal colore che gli veniva soprapposto; di conseguenza in tali casi, se si esegue il trasporto della sola pellicola del colore, in questa, nella faccia di tergo, torna alla luce quella parte appunto del disegno originale saldatasi con il colore. Negli affreschi la sinopia veniva sempre in parte assorbita dall'intonaco soprammesso; la carbonatazione di questo intonaco serviva però, nello stesso tempo, a fissare il colore rimasto sull'arriccio, che perciò ha una certa saldezza, se pur temporanea, quando torna allo scoperto, sebbene, come ci fa sapere il Cennini, sia colore senza tempera. Quindi la sinopia, che torna alla luce con il distacco di un affresco, ha un minor grossezza di colore di quella che aveva in origine. In qualche raro caso, se avvenga che l'intonaco nell'operazione di strappo rimanga tutto aderente alla tela, si può vedere la sinopia sdoppiata, per metà del suo spessore sull'arriccio e per metà sulla parte a tergo dell'intonaco stesso (affresco della chiesa di S. Donato in Polverosa a Firenze per il quale è stato possibile il distacco anche di questa seconda parte e si hanno quindi ora due sinopie, ottenute con lo sdoppiamento del colore; in queste, come è ovvio, i tratti del disegno sono contrapposti specularmente).

[12]Capitoli CXLI–CXLII. Nel cap. IV si elenca; tra le cose che il pittore deve saper fare, lo "spolverare," che non è previsto invece, nello stesso passo, per il "lavorare in muro."

importante uso di tali disegni; anche se questo non fosse avvenuto nella bottega da lui frequentata, ma si facesse abitualmente in altre botteghe; egli infatti non manca alle volte di descrivere, sia pur per biasimarle, tecniche non seguite da lui e dalla corrente gaddesca.

Ma non vorrei che questa mia considerazione potesse sembrare detta a sostegno della mia ipotesi. Io ritengo, è vero, e riassumo così il mio pensiero, che nel Trecento non vi fosse l'uso, come prassi comune, di disegni preparatori su carta sia per gli affreschi, sia per le pitture su tavola, ma ammetto, naturalmente, eccezioni alla regola, o per metodo personale seguito da un artista, o per composizioni di particolare difficoltà. Non essendo però il tracciare questi disegni su carta la regola comune, il numero di essi dovè essere molto più limitato di quanto non sarà in seguito, quando invece quest'uso verrà universalmente seguito; di conseguenza la scarsezza di disegni di questo tempo rispetto a quelli dei secoli successivi. Questo mio scritto in ogni modo non vuole essere—ripeto—una difesa di questa mia tesi, ma solo una minuziosa analisi del testo del *Libro dell'arte*, utile, spero, anche se forse può apparire fastidiosa, per chiarire, con le parole stesse del Cennini, come veniva praticato il disegno durante tutta la vita di un artista: da quando, fanciullo, mostrava appunto al disegno attitudine, al tempo in cui, come apprendista, rimarrà per molti anni nella bottega di un maestro, fino al momento nel quale, ormai esperto nel dipingere, concepirà e creerà l'opera d'arte. Per parte mia mi limiterò a chiosare, senza però forzarne il significato e l'interpretazione, le parole del testo cenniniano, che alle volte, a una lettura non approfondita, può sembrare non chiaro, o con strane ripetizioni e confusione di tempi, ma che invece apparirà di una precisione assoluta e di comprensione esplicita quando sia esaminato con particolare attenzione. Solo un'osservazione di carattere generale mi sia consentita; per me è molto difficile potermi convincere che il Cennini, il quale ci dà, anche per cose di secondario interesse, descrizioni minuziose, alle volte addirittura prolisse, passi poi sotto assoluto silenzio un atto così importante nella creazione di un'opera d'arte, quale è quello dei disegni preparatori su carta; tanto più se si pensa che il Vasari, che dedica alla tecnica della pittura poche pagine in confronto al Cennini, si diffonde molto, sia pure in tempi differenti e profondamente cambiati, a parlare proprio di questi disegni.

Dall'esame del testo del *Libro dell'arte* potrà dunque forse risultare quale fosse l'abituale e comune procedura seguita dai pittori per quel che si riferisce ai disegni di preparazione alle pitture su tavola o su intonaco; le eccezioni e i casi particolari sfuggono naturalmente a questa analisi e non possono quindi esser presi in considerazione.

Il Cennini dunque non trascura davvero di parlare del disegno, che anzi, come è naturale, considera, insieme con il colore, base assoluta della pittura: "el fondamento dell'arte . . . è il disegno e 'l colorire" (cap. IV);[13] l'importanza che egli attribuisce appunto al disegno, da

[13]Tutti i passi del *Libro dell'arte*, che qui si riportano, sono stati collazionati sul quattrocentesco manoscritto Laurenziano Plut. 78 cod. 23, e sul cinquecentesco manoscritto Riccardiano cod. 2190. In entrambi questi codici resultano evidenti errori di trascrizione dovuti a mancata comprensione del testo copiato (questa cosa da sola fa escludere che il codice Laurenziano possa essere l'originale del Cennini). Ho preso a base il più antico codice Laurenziano—del 1437 come è noto—ma ne ho sostituita la lezione in quei casi in cui ci si trovi davanti a errori evidenti, mentre il testo appare giusto nel codice Riccardiano. Una maniera così poco ortodossa di trascrizione può esser giustificata dal fatto che questo mio scritto ha il solo intento di rendere facilmente comprensibile il testo cenniniano. Per parole che possono apparire di astruso significato, sia perché di carattere tecnico, sia per essere di dialetto veneto, cfr. la "Tavola delle voci attenenti all'arte" nell'edizione dei due Milanesi (Firenze, 1859), 145-95, e il "Glossario dei termini ricorrenti nel Libro dell'arte" della recente citata edizione di F. Brunello, 220-26. Per la conoscenza della bibliografia cenniniana v. l'attento e particolareggiato studio di G.L. Mellini, "Studi su Cennino Cennini, II," in *Critica d'Arte* (1965, fasc. 75), 48-64.

apprendersi prima di ogni altra cosa, risulta del resto ben chiara dal fatto che, al principio del libro, ben trenta capitoli—dal v al xxxiv—sono dedicati al suo insegnamento ;[14] né il giovane discepolo dovrà tralasciare di esercitarsi neppure per un solo giorno durante i dodici anni necessari per l'apprendistato : "sempre disegnando, non abbandonando mai né in dì di festa, nè in dì di lavorare" (cap. CIV).

A due cose ancora, prima di iniziare la lettura del testo, occorre fare attenzione ; la prima è che il Cennini, mentre ci descrive, a mano a mano, quel che deve essere appreso progressivamente da chi vuol dedicarsi alla pittura, interserisce però, in questa sua narrazione, alcune digressioni per anticipare concetti o regole che egli evidentemente ritiene indispensabile siano subito conosciuti; così è per l'importanza della sorgente di luce (principio fondamentale di cui dovrà sempre esser tenuto conto), per il consiglio di prendere a esempio l'opera del miglior maestro del luogo e, infine, per l'ammonimento circa una vita sobria e accostumata che un artista dovrà sempre tenere. La seconda osservazione riguarda proprio i già citati capitoli in cui si parla dell'insegnamento del disegno, nei quali—già si è accennato— può sembrare che il Cennini si ripeta, e che vi sia, nel suo scritto, una certa confusione circa un logico progredire nel lungo tirocinio dell'allievo. Ma non è così; il *Libro dell'arte* fu scritto per i lettori del tempo, i quali ben sapevano—mentre questo non è per noi di lampante evidenza—quale fosse la successione degli insegnamenti secondo la consuetudine allora seguita. Incertezze su questo punto non potevano per loro sorgere ; quel che occorreva, erano consigli pratici e utili per un buon insegnamento, da cui il giovane potesse trarre il miglior frutto.

Non è difficile però, con un attento esame del testo, determinare i vari tempi dell'apprendistato, appunto circa il disegno. Da prima saranno semplici esercitazioni : su una tavoletta inossata all'inizio (capp. v–xiii), poi su cartapecora, o su carta bambagina, in lapis, da ripassare in penna o con colori (capp. x–xii) ; quindi direttamente in penna (cap. xiii) e infine su carta tinta (cap. xv). A questo punto ci si eserciterà a calcare, con carta lucida, disegni o pitture di grandi maestri (cap. xxiii) ; poi, per la pratica ormai acquistata, si copieranno ancora le pitture dei maestri maggiori, non più però quasi meccanicamente con la carta lucida, ma a mano libera, da lontano, nelle chiese, valutando per il proprio disegno, rispetto all'originale, spazio, proporzioni, luci, ombre, chiariscuri, e usando da principio—e per la prima volta—il carboncino facilmente cancellabile per correzioni ; inizialmente disegnando su carta bianca, poi su carta tinta (capp. xxix–xxxii).

Vediamo ora le pagine del *Libro dell'arte*. Dopo un primo capitolo in cui, secondo una consuetudine molto diffusa in quel tempo, il racconto comincia dalla creazione del mondo, e dopo che vien vantata la nobiltà dell'arte del dipingere, la quale, come la poesia, deriva direttamente dalla scienza e dal sapere "con operazione di mano," il Cennini ci dice chi egli sia, il suo discepolato per dodici anni presso Agnolo Gaddi e la discendenza dal grande Giotto, per mezzo appunto del suo maestro Agnolo e del padre di lui Taddeo. Dai tre capitoli che seguono risulta poi che egli concepiva la sua arte quasi come una missione : "Alcuni sono che per povertà e necessità del vivere seguitano, sì per guadagno e anche per l'amor

[14]Circa l'importanza dei capitoli sul disegno, v. Lionello Venturi, *Storia della critica d'arte* (Firenze, 1945), e L. Magnato nella premessa all'edizione di F. Brunello.

dell'arte; ma soprattutto da commendare è quelli che per amore e per gentilezza all'arte predetta vengono"; e ancora: "Adunque voi che con animo gentile sete amadori di questa virtù, principalmente all'arte venite, adornatevi prima di questo vestimento: cioè amore, timore, ubidienza e perseveranza. E quanto più tosto puoi, incomincia a metterti sotto la guida del maestro a imparare; e quanto più tardi puoi, dal maestro ti parti."

Ed eccoci al capitolo quinto: "si come detto è, dal disegno t'incominci. Ti conviene avere l'ordine di potere incominciare a disegnare il più veritevile"; ma come? Il fanciullo, che principiava a esercitarsi nel disegno, non doveva inutilmente sciupare carta bambagina (la carta comune) o cartapecora. Quindi "prima abbi una tavoletta di bosso, di grandezza, per ogni faccia, un sommesso [ossia un pugno con il pollice alzato] ben pulita e netta, cioè lavata con acqua chiara, fregata e pulita di seppia, di quelle che gli orefici adoperano per improntare. E quando la detta tavoletta è asciutta bene, togli tanto osso ben tritato per due ore, che stia bene; e quanto più sottile, tanto meglio. Poi raccoglilo, tiello, e conservalo involto in una carta, asciutto; e quando tu n'hai bisogno per ingessare la detta tavoletta, togli meno di mezza fava di questo osso, o meno; e colla scìliva rimena questo osso e va distendendo con le dita per tutta questa tavoletta; e innanzi che asciughi, tieni la detta tavoletta dalla man manca, e col polpastrello della man ritta batti sopra la detta tavoletta tanto quanto vedi ch'ella sia bene asciutta; e viene inossata igualmente così in un luogo come in un altro." Per questo uso "è buona la tavoletta del figàro ben vecchio; ancora certe tavolette le quali s'usano per mercatanti, che sono di carta pecorina ingessata e messe di biacca ad olio; seguitando lo inossare con quell'ordine che detto ho" (cap. VI). Ora "bisogna sapere che osso è buono"; il Cennini ci dice anche questo: "Togli osso delle cosce e delle alie delle galline o di cappone; e quanto più vecchi sono, tanto sono migliori. Come gli truovi sotto la mensa, così gli metti nel fuoco; e quando vedi son tornati bene bianchi più che cenere, tranegli fuora, e macinagli bene in su proferito; e adoperalo secondo che dico di sopra. Ancora l'osso della coscia del castrone è buono, e della spalla, cotto per quella forma è detto" (capp. VII e VIII).

La tavoletta inossata è pronta; ed ecco quindi il fanciullo ora all'opera: "e poi abbi uno stile d'argento o d'ottone, o di ciò si sia, purché dalle punte sia d'argento, sottili a ragione, pulite e belle. Poi con essempio comincia a ritrarre cose agevoli quanto più si può per usare la mano [oggi si direbbe per esercitare la mano] e collo stile su per la tavoletta leggermente, che appena possi vedere quello che prima incominci a fare, crescendo i tuo' tratti a poco a poco, più volte ritornando per fare l'ombre; e quanto l'ombre nelle stremità vuoi fare più scure, tanto vi torna più volte; e così, per lo contrario, in su e rilievi tornavi poche volte." A questo punto è la digressione sulla luce e la sorgente luminosa. Il fanciullo, che deve, naturalmente, avere per il disegno inclinazione e talento—"la luce dell'occhio tuo"—nonché attitudine e facilità—"la man tua"—deve però anche subito sapere e conoscere qual sia, appunto, l'importanza che ha, per il disegno e la pittura, la luce del sole e, nelle chiese o al chiuso, la sorgente luminosa secondo la provenienza dalle finestre: "E 'l timonella guida di questo potere vedere, si è la luce del sole, la luce dell'occhio tuo e la man tua; ché senza queste tre cose nulla non si può fare con ragione. Ma fa' che quando disegni abbi la luce temperata e il sol ti batta in sul lato manco. E con quella ragione t'incomincia a usare in sul

disegnare, disegnando poco per dì, perchè non ti venga a 'nfastidire né a rincrescere" (cap. VIII);[15] nel capitolo nono quindi si danno i consigli da seguire quando si debba disegnare in luoghi chiusi "in cappelle" nelle quali tu "non potessi avere la luce dalla man tua o a tuo modo."[16]

Il ragazzo ha ormai buona pratica nel disegnare su tavolette inossate, che potevano esser rinnovate di continuo senza alcuna spesa. Ora egli passa a disegnare su cartapecora e su carta bambagina; sulla prima—e si dirà subito dopo anche sulla seconda—poteva esser disteso, così come sulle tavolette, un velo di osso in polvere che era poi possibile raschiare: "ancor si può disegnare in carta pecorina e bambagina. Nella pecorina tu puoi disegnare, o vero dibusciare [ossia abbozzare] collo stile detto, mettendo prima del detto osso, seminato isparso e nettato con zampa di levre, per su per la carta, asciutto e spolverato in forma di polvere o di vernice da scrivere. Se vuoi [si passa ora a usare l'inchiostro o addirittura i colori] poi che hai collo stile disegnato, chiarire meglio il disegno, ferma con inchiostro ne' luoghi stremi e necessarii. E pòi aombrare le pieghe d'acquerella da' nchiostro, cioè acqua quanto un guscio di noce tenessi dentro due goccie d'inchiostro; ed aombrare con pennello fatto di code di vaio, mozzetto e squasi sempre asciutto; e così, secondo gli scuri, così annerisce l'acquerella di più gocciole d'inchiostro. E per lo simile puoi fare ed aombrare di colori e di pezzuole [ritagli di lino imbevuti di colore da sciogliere][17] secondo che i miniatori adoperano; temperati e colori con gomma o veramente con chiaro—albume d'uovo, ben rotta e liquefatta. Ancora puoi senza osso disegnare nella detta carta [ossia nella cartapecora] con istile di piombo; cioè fatto lo stile due parti piombo e una parte stagno ben battuto a martellino. Nella carta bambagina puoi disegnare col predetto piombo senza osso ed eziandio con osso. E se alcuna volta t'avvenisse trascorso che volessi tor via alcuno segno fatto per lo detto piombino, togli un poca di midolla di pane e fregavela su per la carta e torrai via quello che vorrai. E similmente su per la detta carta puoi aombrare d'inchiostro, di colori e di pezzuole con le predette tempere" (capp. X–XII).

Il giovinetto, dopo circa un anno di questi esercizi, può ora eseguire i disegni direttamente con l'inchiostro, senza averli prima delineati con il facilmente cancellabile lapis: "Praticato che hai in su questo essercizio un anno, e più e meno secondo che appetito o diletto tu arai preso, alcuna volta puoi disegnare in carta bambagina pur con penna che sia temperata sottile; e poi gentilmente disegna e vieni conducendo le tue chiare, mezze chiare e scure a poco a poco colla penna più volte ritornandovi. E se vuoi rimangano i tuoi disegni un poco più lecchetti, davvi un poco d'acquerelle, secondo t'ho detto di sopra, con pennello di vaio

[15]Cfr. Leonardo, *Trattato della pittura*, II, 67: "Quando tu, disegnatore, vorrai far buono ed utile studio, usa nel tuo disegnare di fare adagio . . . ," con quel che segue.

[16]Questo capitolo è per noi di grande interesse perché mostra quale importanza veniva data, sia per il disegno, sia per la pittura, alla provenienza della luce nelle chiese o in qualsiasi luogo chiuso; cosa di cui oggi invece non si tiene nessun conto quando si espongono i quadri nelle gallerie. Così alcun conto vien tenuto dell'altezza da terra che la pittura aveva originariamente; ed è questa cosa ancor più grave dato che ogni composizione veniva studiata dall'artista in relazione appunto all'altezza in cui si sarebbe venuta a trovare; fuori della quale, specie se vi sia prospettiva, non si potrà avere

una visuale giusta e perfetta; cfr. per questo, Vasari, ediz. Milanesi, VII, 687, in un passo della sua vita che si riferisce alla grande tavola con le nozze di Ester e Assuero dipinta per il convento di S. Fiora e Lucilla ad Arezzo: ". . . ma prima metterla in sul luogo, e quivi poi lavorarla. Il qual modo (e lo posso io affermare che l'ho provato) è quello che si vorrebbe veramente tenere, a volere che avessono le pitture i suoi propri e veri lumi; perciocché, in fatti, il lavorare a basso, o in altro luogo che in sul proprio, dove hanno a stare, fa mutare alle pitture i lumi, l'ombre e molte altre proprietà." Cfr. anche Leonardo, *Trattato*, II, 82 e 107.

[17]V. la edizione di F. Brunello, 12 n. 5.

mozzetto. Sai che t'avverà praticando il disegnare di penna? Che ti farà sperto, pratico e capace di molto disegno entro la testa tua" (cap. XIII).

Nel capitolo XIV si insegna come si deve appuntire la penna d'oca per disegnare con inchiostro. Ed eccoci a una nuova fase dell'apprendistato, di eccezionale importanza per noi, perché si viene a sapere che per incominciare ad aver pratica nel colorire—cosa che il disegno semplice non poteva dare—si faceva uso di carte tinte che davano la possibilità, pur sempre disegnando, di avere tre gradazioni di colore : il colore della carta tinta, lo scuro con inchiostro o colori scuri, il chiaro con il bianco o colori chiari : "Per venire a luce di grado in grado, e incominciare a volere trovare il principio e la porta del colorire, vuolsi pigliare altro modo di disegnare che quello di che abbiamo detto perfino a mo'. E questo si chiama disegnare in carta tinta, cioè o in carta pecorina o in carta bambagina" (cap. XV). Le carte possono essere di vario colore, "o in rosetta, o in biffo, o in verde, o azzurrine, o berrettine, cioè colore bigie, o incarnate, o come ti piace"; e il Cennini insegna, in ben sette capitoli dal XVI al XXII, come si possono fare tali carte. Fino a questo momento il ragazzo ha fatto solo prove sue di disegno, esercitazioni di principiante ; ora, per seguitare la via di apprendere il disegno, passa alla copia, con carta trasparente di opere dei maggiori pittori : "Bisognati essere avvisato ancora è una carta che si chiama carta lucida, la quale ti può essere molto utile per ritrarre una testa o una figura o una mezza figura secondo che l'uomo truova di man di gran maestri ; e per avere bene i contorni o di carta [quindi disegni per l'insegnamento] o di tavola o di muro, che proprio la vogli tor su, metti questa carta lucida in sulla figura, o ver disegno, attaccata gentilmente in quattro canti con un poco di cera rossa o verde" (è cosa questa che ci fa sussultare se, come sembra dalle parole del Cennini, si faceva non solo con i disegni ma anche con gli affreschi e con le tavole). "Di subito per lo lustro della carta lucida traspare la figura, over disegno, di sotto, in forma e in modo che 'l vedi chiaro. Allora togli o penna temperata ben sottile o pennel sottile di vaio sottile e con inchiostro puoi andare ricercando i contorni e le stremità del disegno di sotto ; e così generalmente toccando alcuna ombra siccome a te è possibile potere vedere e fare. E levando poi la carta pòi toccare d'alcuni bianchetti e rilievi, siccome tu hai i piaceri su" (cap. XXIII). Seguono le istruzioni e gli insegnamenti per rendere trasparente sia la cartapecora sia la carta bambagina (capp. XXIV–XXVI).

Con il capitolo XXVII, chiuso un primo periodo di esercitazioni, di insegnamenti pratici, di disegni di principiante e calchi in carta lucida, il Cennini, con una seconda digressione, porta il discorso sopra un punto che a suo parere—e secondo la concezione e le consuetudini del tempo—era della massima importanza : il giovane allievo prenda a modello e si ispiri all'opera di un grande maestro, ritraendo, ora a mano libera, le figure di quello. "Pure a te è di bisogno si seguiti innanzi, acciò che possi seguitare il viaggio della detta scienza. Tu hai fatto le tue carte tinte ; è mestieri di seguire di tenere questo modo. Avendo prima usato un tempo il disegnare, come ti dissi di sopra, cioè in tavoletta, affaticati e dilettati di ritrar sempre le miglior cose che trovar puoi per mano fatte di gran maestri ; e se se' in luogo dove molti buon maestri sieno stati [il pensiero del Cennini è certo a Firenze] tanto meglio a te. Ma per consiglio io ti do : guarda di pigliar sempre il miglior e quello che ha maggior fama ; e, seguitando di dì in dì, contra natura sarà che a te non venga preso di suo' maniera e di suo' aria ; perochè se ti muovi a ritrarre oggi di questo maestro doman di quello, né maniera

dell'uno né maniera dell'altro non n'arai e verrai per forza fantastichetto [cioè imperfetto, discorde] per amor che ciascuna maniera ti straccerà la mente. Ora vuo' fare a modo di questo, doman di quello altro, e così nessuno n'arai perfetto. Se seguiti l'andar d'uno per continovo uso, ben sarà lo intelletto grosso che non ne pigli qualche cibo. Poi a te interverrà che, se punto di fantasia la natura t'arà conceduto, verrai a pigliare una maniera propia per te, e non potrà essere altro che buona ; perchè la mano, lo intelletto tuo, essendo sempre uso di pigliare fiori, mal saprebbe torre spina."

Nel capitolo XXVIII si dice ora "che la più perfetta guida che possa avere e migliore timone, si è la trionfal porta del ritrarre de' naturale" ; affermazione che non poteva mancare sull'esempio degli antichi testi ; ma a parte questo convenzionale dire, risulta che il Cennini consiglia i giovani di ritrarre anche dal vero : ". . . ogni dì non manchi disegnar qualche cosa, chè non sarà si poco che non sia assai ; e faratti eccellente prò."

L'allievo ha ormai fatto una buona pratica, ma dovrà perseverare con sempre maggior amore e volontà nella via da lui intrapresa ; a questo punto cade perciò opportuna per il Cennini una nuova digressione con il consiglio a una vita morigerata, quasi si potrebbe dire ascetica—ma non è certo da pensare che tutti gli artisti si siano attenuti a queste ammonizioni —che il pittore avrebbe dovuto sempre seguire : "La tua vita vuole essere sempre ordinata siccome avessi a studiare in teologia, o filosofia, o altre scienze ; cioè del mangiare e del bere temperatamente, almen duo volte il dì, usando pasti leggieri e di valore, usando vini piccoli ; conservando e ritenendo la tua mano, riguardandola dalle fatiche, come in gittare pietre, palo di ferro e molt'altre cose che sono contrarie alla mano da darle cagione di gravarla. Ancor ci è una cagione che, usandola, può alleggerire tanto la mano, che andrà più ariegando, e volando assai più che non fa la foglia al vento ; e questa si è usando troppo la compagnia della femmina" (cap. XXIX).

"Ritorniamo al fatto nostro," dice ora il Cennini che ci fa sapere, con parole per noi di grande interesse, in che modo i giovani dovessero sempre più perfezionarsi nello studio del disegno copiando e imitando, ora a mano libera, come già è stato detto, le opere dei grandi maestri del passato. "Abbi d'una tasca fatta di fogli incollati, o pur di legname, leggiera, fatta per ogni quadro, tanto vi metta un foglio reale, cioè mezzo ; e questo t'è buono per tenervi i tuo' disegni ed eziandio per potervi tenere su il foglio da disegnare. Poi te ne va' sempre soletto o con compagnia sia atta a fare quel che tu, e non sia atta a darti impaccio ; e quanto questa compagnia fusse più intendente, tanto sarebbe meglio per te.[18] Quando se' per le chiese o per cappelle e incominci a disegnare, ragguarda prima di che spazio ti pare o storia o figura che vuogli ritrarre ; e guarda dove ha gli scuri, e mezzi, e bianchetti : e questo vuol dire che hai a dare la tua ombra d'acquerelle d'inchiostro, in mezzi lasciare del campo proprio, e 'l bianchetto dare di biacca" cioè ben distinguere, nel disegno, i chiari dagli scuri e dal chiaroscuro.

[18]Leonardo, *Trattato*, II, 68 : "Dico e confermo che il disegnatore in compagnia è molto meglio che solo, per molte ragioni. La prima è che tu ti vergognerai di esser visto nel numero dei disegnatori essendo insufficiente, e questa vergogna sarà cagione di buono studio ; secondariamente, la invidia buona ti stimolerà ad essere nel numero de' più laudati di te, ché l'altrui laude ti spronerà ; l'altra è che tu piglierai degli atti di chi farà meglio di te ; e se sarai meglio degli altri, farai profitto di schivare i mancamenti, e l'altrui laude accrescerà la tua virtù." Però quando poi il pittore sarà intento "alle speculazioni e considerazioni," dovrà esser solo (II, 48).

Ormai il giovane allievo, per gli insegnamenti avuti dal proprio maestro e lo studio fatto sull'opere dei maggiori artisti del passato (come si seguitò del resto a fare per tutto il rinascimento; si ricordino le parole del Vasari per la cappella Brancacci: "tutti coloro che hanno cercato imparare . . . sono andati a imparare sempre a questa cappella ed apprendere i precetti e le regole del far bene dalle figure di Masaccio")[19] è giunto al punto di poter eseguire, in disegno, copie di pitture a mano libera; da prima in carboncino, che può esser facilmente cancellato se qualche tratto del disegno non sia riuscito bene; poi a punta d'argento, in sostituzione del carboncino; e infine su quelle carte tinte con le quali si aveva già preso fin da fanciullo pratica. "Togli prima il carbone sottile e temperato, come è una penna o lo stile; e la prima misura che pigli a disegnare, piglia l'una delle tre che ha il viso, che ne ha in tutto tre, cioè la testa [ossia la fronte], il naso, e 'l mento colla bocca. E pigliando una di queste, t'è guida di tutta la figura, de' casamenti, dall'una figura all'altra; ed è perfetta tuo' guida, aoperando il tuo intelletto di sapere guidar le predette misure. E questo si fa perché la storia, o figura, sarà alta che co' mano non potrai aggiugnere per misuralla; conviene che con intelletto ti guidi; e troverrai la verità, guidanoti per questo modo. E se di primo tratto non ti vien bene in misura la tua storia o figura, abbi una penna e co' peli della detta penna, di gallina o d'oca che sia, frega e spazza, sopra quello che hai disegnato, il carbone; andrà via quel disegno. E ricomincialo da capo tanto e quanto tu vedi che con misura si concordi la tua figura coll'essempro; e poi, quando t'avvedi che stia appresso di bene, togli lo stile d'argento e va' ricercando su per li contorni e stremità de' tuo' disegni, e su per le pieghe maestre. Quando hai fatto così, togli da capo la penna pelosa e spazza bene il detto carbone; e rimarrà il tuo disegno fermato collo stile" (cap. xxx).

Ed eccoci alle carte tinte, come si dice nella stessa intestazione del'capitolo xxxi: "quando hai la pratica nella mano d'aombrare [cioè di ombreggiare in un disegno a carboncino e poi a punta d'argento] togli un pennello mozzetto e con acquerella d'inchiostro in un vasellino va' col detto pennello tratteggiando l'andare delle pieghe maestre; e poi va' sfumando, secondo l'andare, lo scuro della piega. E questa tale acquerella vuole essere squasi com'acqua poco tinta e 'l pennello vuole essere squasi sempre siccome asciutto; non affrettandoti, a poco a poco venire aombrando, sempre ritornando col detto pennello ne' luoghi più scuri. Sai che te ne interviene? Che se questa tale acqua è poco tinta, e tu con diletto aombri e senza fretta, el ti viene le tue ombre a modo d'un fummo bene sfumate. Abbia a mente di menare il pennello sempre di piatto. Quando se' venuto a perfezione di questo aombrare, togli una gocciola o due d'inchiostro e metti sopra la detta acquerella [cioè aggiungila all'acquerella già usata] e col detto pennello rimescola bene. E poi al detto modo va' cercando col detto pennello pur nella profondità delle dette pieghe, cercando bene i lor fondamenti; avendo sempre la ricordanza in te del tuo aombrare, e cioè in tre parti dividere: l'una parte ombra, l'atra tinta del campo che hai [cioè il colore della carta tinta] l'altra biancheggiata. Quando hai fatto così togli un poco di biacca ben triata con gomma arabica . . .; ogni poca biacca basta. Abbi in uno vasellino acqua chiara e intignivi dentro il pennello tuo detto di sopra, e fregalo su per questa biacca macinata del vasellino, massimamente s'ella fusse risecca. Poi

[19]Leonardo, *Trattato*, ii, 60: "Il pittore deve prima suefare v. anche ii, 45 e ii, 79.
la mano col ritrarre disegni di mano de' buoni maestri," e

te l'acconcia in sul sodo della mano o del dito grosso, racconciando e premendo il detto pennello e discarcandolo quasi asciugandolo. E incomincia di piatto il detto pennello a fregare sopra e in quelli luoghi dove de' essere il bianchetto e rilievo; e seguita più volte andando col tuo pennello, e guidalo con sentimento. Poi in sulle stremità de' rilievi, nella maggiore altezza, togli un pennello con punta e va' colla biacca toccando colla punta del detto pennello, e va' raffermando la sommità de' detti bianchetti. Poi va' raffermando, con un pennello piccolo, con inchiostro puro, tratteggiando le pieghe, i dintorni, nasi, occhi e spelaure di capelli e di barbe" (cap. XXXI).

Quando il giovane allievo avrà preso maggior pratica allora potrà usare la biacca che abbia come glutine il rosso d'uovo: "Ancora io t'avviso, quando tu sarai più pratico, a voler perfettamente biancheggiare con acquerelle, si come fai l'acquerella d'inchiostro. Togli la biacca macinata con acqua e temperala con rossume d'uovo, e sfumma si a modo d'acquerella d'inchiostro. Ma è a te più malagevole e vuolsi più pratica. Tutto questo si chiama disegnare in carta tinta ed è via a menarti all'arte del colorire. Seguitalo sempre quanto puoi, ch'è il tutto del tuo imparare. Attendivi bene e sollecitamente e con gran diletto e piacere" (cap. XXXII). Queste ultime parole vengono a togliere ogni dubbio—se vi potesse esser stato—che qui si tratta di consigli a giovani allievi così come in tutti i capitoli precedenti. Copie— e forse ormai anche disegni propri—portati a perfezione in ogni particolare—"spelaure di capelli e di barbe"—ma sempre eseguiti per esercitazione; e non per altro.

Gli ultimi due capitoli di questa parte del libro non hanno per il nostro tema interesse, dato che il primo insegna in che modo "si fanno i carboni da disegnare" e il secondo fa sapere che esiste una pietra tenera per disegnare, cioè la grafita per lapis. Seguono ben ventotto capitoli (dal XXXV al LXII), sui colori e quattro sui pennelli (capp. LXIII–LXVI); e si giunge così all'importantissimo capitolo LXVII con il quale ha inizio la parte del libro che si riferisce all'insegnamento delle pitture: "Col nome della Santissima Trinitae ti voglio mettere al colorire." Si ha ora nel testo del Cennini una curiosa incongruenza che può però trovare una spiegazione plausibile nell'amore grande dell'artista—come presumibilmente fu per tutti i pittori del tempo suo—verso il dipingere in affresco, "ch'è 'l più dolce e 'l più vago lavorare che sia." Egli infatti parla prima della pittura murale (capp. LXVII–CII) che di quella su tavola (capp. CIII–CLVI) nonostante che subito al principio di questa seconda maniera di dipingere —anch'essa del resto detta "la più dolce arte e la più netta che àbbimo nell'arte nostra"—dica in modo ben chiaro "e tieni bene a mente che chi imparasse a lavorare prima in muro e poi in tavola non viene così maestro nell'arte[20] come perviene a imparare prima in tavola e poi in muro" (cap. CIII). Logicamente quindi, dopo queste parole, si ha quell'importantissimo capitolo, il CIV, in cui si dà notizia del tempo che, almeno secondo il parere del Cennini, ci voleva, a un giovane apprendista, per rendersi padrone prima del disegno e della tecnica e quindi della pittura: "Sappi che non vorrebbe essere men tempo imparare come prima studiare da piccino un anno a usare i' disegno della tavoletta; poi stare co' maestro, a bottega, che sapesse lavorare di tutti i membri che appartiene di nostra arte; e stare e incominciare a triare de' colori e imparare a cuocere delle colle e triar de' gessi; e pigliar la pratica del-

[20]"nell'arte"; così i Milanesi e tutti gli editori del testo cenniniano per cercar di chiarire la errata trascrizione del Laurenziano ("nellachato") e del Riccardiano ("perfetta neleco maestro").

l'ingessare l'ancone, e rilevare, e raderle; mettere d'oro, granare ben; per tempo di sei anni. Poi, in praticare a colorire, ad ornare di mordenti, far drappi d'oro, usare di lavorare di muro, per altri sei anni, sempre disegnando, non abbandonando mai né in dì di festa né in dì di lavorare. E così la natura per grande uso si convertisce in buona pratica; altrimenti, pigliando altri ordini, non ne sperare mai che vegnino a buona perfezione; che molti son che dicono che senza esser stati con maestri hanno imparato l'arte; nol credere, che io ti do l'essempro di questo libro: studiandolo di dì e di notte, e tu non ne veggia qualche pratica con qualche maestro, non ne verrai mai da niente, né che mai possi con buon volto stare tra i maestri." Un anno quindi di esercitazioni sulla tavoletta inossata, forse prima—sembra—di entrare nella bottega di un maestro;[21] poi dodici anni con questo maestro,[22] presso il quale, come sappiamo, il fanciullo cominciava il suo tirocinio in genere in età fra gli otto e i dodici anni. Di conseguenza fino a circa venti anni i giovani non potevano essere considerati esperti pittori; si può così capire come dopo tanto addestramento si venisse a possedere un'assoluta pratica e perfezione tecnica; e ad avere inoltre—si pensi specialmente agli affreschi—una facilità e una rapidità di lavoro che, se non si tenesse conto appunto di una padronaza tecnica eccezionale, ci apparirebbero quasi inconcepibili.

Il Cennini dunque ci dice che il giovane artista doveva imparare a dipingere le tavole prima che gli affreschi; quindi anche noi, invertendo l'ordine del testo cenniniano, vedremo come si procedeva in queste per quel che si riferisce alla parte che ci interessa, e cioè al disegno preparatorio.

Una volta preparata dal maestro d'ascia e legname, la tavola veniva impannata, facendo aderire ad essa una fine tela di lino, e quindi ingessata (capp. cv–cxxi). Ed eccoci al disegno, all'atto di invenzione di quello che si voleva rappresentare. "Sendo ben raso il gesso e tornato a modo d'avorio, la prima cosa che dei fare si vuole disegnare la tua ancona, o ver tavola, con quelli carboni di salice che per addietro t'insegnai a farli; ma vuolsi legare il carbone a una cannuccia o ver bacchetta, acciò che stia di lungi dalla figura, ché molto ti giova in nel comporre. E abbi una penna appresso, ché quando alcun tratto non ti venissi ben fatto, che co' i peli della detta penna possi torlo via e ridisegnarlo; e disegna con leggier mano, e quivi aombra le pieghe e i visi, come facessi col pennello o come facessi con la penna che si disegna, a modo si penneggiasse. Quando hai compiuto di disegnare la tua figura, spezialmente che sia d'ancona di gran pregio che n'aspetti guadagno e onore, lasciala stare per alcuno dì, ritornandovi alcuna volta a rivederla, e medicare dove fusse più bisogno."[23] Dunque il

[21] Si potrebbe supporre che la strana consuetudine di far esercitare un fanciullo nel disegno per un anno su una tavoletta inossata prima di entrare nella bottega di un maestro—ma forse si tratta solo di non chiara dizione del testo cenniniano—fosse dovuta al fatto che in tal modo un pittore poteva venire ad avere un'idea precisa della disposizione all'arte del ragazzo, prima di accettarlo come apprendista. Ma a questa ipotesi sembrano contradire le disposizioni dello Statuto dei pittori del 1315, secondo le quali un maestro aveva quindici giorni di tempo, prima di stendere l'atto pubblico di accettazione di un fanciullo come discepolo, appunto per poterne giudicare la disposizione e l'ingegno: "Possit tamen quilibet de dicto membro tenere discipulum, ante conductionem factam per publicum instrumentum, quindecim diebus, ut possit videre et cognoscere, si discipulus est capax ingenii ad discendum artem predictam, et consulere si discipulus est capax ingenii, necne. Completo autem termino conductionis ipsum talem

discipulum denuntiare debeat notario dicte artis, ut possit de arte lucrari predicta" (*Statuti dell'arte dei Medici e Speziali* editi a cura di R. Ciasca (Firenze, 1922), 81–82.)

[22] Statuti, 81: "... Et quod quilibet artifex quando discipulum conduxerit, ipsum conducere debeat in termino trium annorum ad minus expensis discipuli, et in termino sex annorum ad minus expensis magistri." Dunque anche le disposizioni vigenti prevedevano una durata minima di nove anni per il discepolato.

[23] Leonardo, *Trattato*, II, 62: "Ricordo a te, pittore, che quando col tuo giudizio o per altrui avviso scopri alcuni errori nelle opere tue, che tu li ricorregga, acciocché nel pubblicare tale opera tu non pubblichi insieme con quella la materia tua; e non ti scusare con te medesimo, persuadendoti di restaurare la tua infamia nella succedente tua opera, perché la pittura non muore immediate dopo la sua creazione come fa la musica, ma lungo tempo darà testimonianza dell'ignoranza tua."

disegno viene eseguito nella maniera identica di come era stato insegnato a fare all'apprendista secondo quanto abbiamo già visto nel capitolo XXX; ora però non è più l'allievo a operare, ma il giovane divenuto pittore. Può osservarsi il fatto che l'artista "compone" (non parebbe quindi che copiasse) prima il suo disegno con il carboncino, in modo da poter correggere e rifare le parti che non andassero bene; inoltre lo esegue da lontano per valutarne meglio l'effetto; tutto veramente sembrerebbe far pensare che qui si tratti del momento di invenzione del disegno preparatorio e non di trasferire a riportare in grande una composizione già studiata e risolta in piccolo, su carta. Strano sarebbe specialmente, in questo secondo caso, il consiglio di attendere qualche giorno prima di procedere nel lavoro, in modo de poter tornare ogni tanto a osservare l'eseguito disegno e correggerlo se ve ne fosso bisogno. Ma riprendiamo a leggere il testo cenniniano: "Quando a te pare stia presso di bene (che puoi ritrarre e vedere delle cose per altri buoni maestri fatte, che a te non è vergogna) staendo la figura bene, abbi la detta penna e va' a poco a poco fregandola su per lo disegno, tanto che squasi dimetta giù il disegno; non tanto però che tu non intenda bene i tuoi tratti fatti; e togli in uno vasellino, mezzo d'acqua chiara, e alcune gocciole d'inchiostro, e con uno pennelletto di vaio puntio va' raffermando tutto il tuo disegno. Poi abbi un mazzetto delle dette penne e spazza per tutto 'l disegno del carbone. Poi abbi un'acquerella del detto inchiostro e con pennello mozzetto di vaio va' aombrando alcuna piega e alcuna ombra nel viso; e così ti rimarrà un disegno vago, che farai innamorare ogni uomo de' fatti tuoi" (cap. CXXII).

E passiamo alla pittura murale; qui l'artista incominciava la sua opera con il suddividere la superficie dell'arriccio, su cui doveva eseguire la sinopia, mediante una o più linee verticali e orizzontali: i mezzi degli spazi, come li chiama il Cennini, ottenuti con il filo a piombo i verticali, e gli orizzontali in maniera ben nota geometricamente, come ci fa sapere la particolareggiata descrizione del testo. Lo scrupolo con cui questa operazione veniva eseguita, per avere un'assoluta esattezza, sembrerebbe eccessivo qualora vi fosse stato un disegno preparatorio, essendo forse più opportuna, in tal caso, una spartizione che si riferisse alla composizione già disegnata.

Ed ecco il pittore incominciare il suo disegno: "Poi componi col carbone . . . storie o figure e guida i tuo' spazi sempre gualivi e uguali; poi piglia un pennello piccolo e pontìo di setole, con un poco d'ocria senza tempera, liquida come acqua, e va' ritraendo e disegnando le tue figure, aombrando come arai fatto con acquerelle quando imparavi a disegnare; poi tolli un mazzo di penne e spazza bene il disegno del carbone." Tutto come per le tavole; ed eccoci alla fase finale del disegno con il rosso sinopia con cui non solo si ripassa, ma si completa e arricchisce—anche ora analogamente alle tavole—il leggero color giallo ocra: "Poi togli un poco di senopia senza tempera e con pennello puntìo sottile va' tratteggiando nasi, occhi e cavellaure, e tutte stremità e intorni di figure; e fa' che queste figure sieno ben compartite co'ogni misura, perché queste ti fanno cognoscere e provedere delle figure che hai a colorire." Il disegno preparatorio è finito, e comincia l'opera pittorica. Da segnarlare solo che non di rado, come è ben noto, vi sono, tra la sinopia e il corrispondente affresco, cambiamenti senza alcun dubbio dovuti alla volontà del comittente. Tali cambiamenti, qualora vi fossero stati disegno preparatori su carta, si sarebbero ben potuti concordare prima del trasferimento della già studiata composizione nei grandi disegni murali.

Un lasso di tempo, ora, di centocinquanta anni e siamo al Vasari, la seconda fonte di eccezionale importanza per la conoscenza delle antiche tecniche pittoriche. È il capitolo XVI che a noi interessa e cioè il secondo "Della pittura," nell'introduzione alle *Vite*; nel primo infatti si parla del disegno e della pittura solo in maniera generale. Leggiamo il testo vasariano: "Gli schizzi . . . chiamiamo noi una prima sorte di disegni che si fanno per trovare il modo delle attitudini, et il primo componimento dell'opra e sono fatti in forma di una macchia, e accennati solamente da noi in una sola bozza del tutto. Et perchè dal furor dello artefice sono in poco tempo con penna o con altro disegnatoio o carbone espressi, solo per tentar l'animo di quel che gli sovviene, perciò si chiamano schizzi. Da questi dunque vengono poi rilevati in buona forma i disegni;[24] nel far de' quali, con tutta quella diligenza che si può, si cerca vedere dal vivo se già l'artefice non si sentisse gagliardo in modo che da sé li potesse condurre. Appresso, misuratili con le seste o a occhio, si ringrandiscono da le misure piccole nelle maggiori, secondo l'opera che si ha da fare. Questi si fanno con varie cose; cioè o con lapis rosso . . . o con la pietra nera . . .; altri, di chiaro e scuro, si conducono su fogli tinti, che fanno un mezzo, e la penna fa il lineamento, cioè il dintorno o profilo, e l'inchiostro poi con un poco d'acqua fa una tinta dolce che lo vela et ombra; di poi, con un pennello sottile intinto nella biacca stemperata con la gomma, si lumeggia il disegno; e questo modo è molto alla pittoresca e mostra più ordine del colorito [descrizione analoga a quella del capitolo XXXI del libro del Cennini]. Molti altri fanno con la penna sola, lasciando i lumi della carta [ossia i chiari vengono ottenuti con lo stesso bianco della carta], che è difficile, ma molto maestrevole; ed infiniti altri modi ancora si costumano nel disegnare, de' quali non accade fare menzione perché tutti rappresentano una cosa medesima, cioè il disegnare." Il Vasari, dunque, prevede tre stadi nei disegni di figura su carta per la preparazione dell'opera d'arte, prima di passare, come vedremo, al cartone: gli schizzi, creati "dal furor dell'artefice"; i disegni in piccolo, "rilevati in buona forma" dagli schizzi, magari servendosi di persone, come modelli da mettersi nella posa voluta, oppure, con ogni probabilità, di quel "modello di legno grande quanto il vivo, che si snodava nelle congenture, e . . . vestiva con panni naturali," cioè il manichino, inventato da Fra Bartolommeo, come il Vasari stesso ci dice nella vita di questo artista; infine gli ingrandimenti di questi disegni, "misuratili con le seste o a occhio . . . da le misure piccole nelle maggiori."

Ed eccoci ora al cartone, che nel Cinquecento aveva ormai preso definitivamente il posto dello spolvero, dal Vasari non ricordato neppure; alla sua esecuzione si giungeva quasi meccanicamente ingrandendo i disegni, ormai considerati definitivi, con la quadrettatura, che il Vasari dice però di usare solo per le prospettive e non per le figure, tracciate invece a mano libera; cosa questa che però non doveva davvero esser di regola e da tutti seguita dato che si conservano moltissimi disegni di sola figura quadrettati:[25] "Fatti così i disegni, chi vuole lavorar in fresco, cioè in muro, è necessario che faccia i cartoni, ancora ch'è si costumi per molti di fargli per lavorar anco in tavola." Segue la descrizione di come si facevano i cartoni, impastando tra loro vari fogli di carta; quindi venivano attaccati sulla superficie di

[24]Leonardo, *Trattato*, II, 61: "Il bozzar delle storie sia pronto, e il membrificare non sia troppo finito; sta' contento solamente a' siti di esse membra, le quali poi a bell'agio, piacendoti, potrai finire."

[25]Cfr. per esempio la quadrettatura che si ha sui due disegni del Pontormo dell'*Angiolo annunziante* e della *Madonna annunziata*, serviti per il capolavoro dell'artista nella chiesa di Santa Felicita a Firenze.

un muro per i lati, bagnandoli perché non facessero grinze; "da poi, quando sono secchi, si vanno con una canna lunga, che abbia in cima un carbone, riportando [i disegni] sul cartone, per giudicar da discosto tutto quello che nel disegno piccolo è disegnato con pari grandezza; e così a poco a poco quando a una figura e quando a l'altra danno fine." L'uso della canna, a cui fosse legato in cima il carbone da disegnare—uso ricordato quasi con le stesse parole anche dal Cennini—era utile, o addirittura necessario, se, nell'ingrandimento, si disegnavano sul cartone le figure a mano libera secondo il consiglio del Vasari: se invece si adoprava anche per esse la quadrettatura, non v'era naturalmente alcun bisogno di ricorrere a questo accorgimento. "Qui fanno i pittori" riprende il testo del Vasari "tutte le fatiche dell'arte del ritrarre dal vivo ignudi e panni di naturale, e tirano le prospettive, con tutti quelli ordini che piccoli si sono fatti in su' fogli, ringrandendoli a proporzione. E se in quegli fussero prospettive, o casamenti, si ringrandiscono con la rete; la qual'è una graticola di quadri piccoli ringrandita nel cartone che riporta giustamente ogni cosa. Per che, chi ha tirate le prospettive ne' disegni piccoli, cavate di su la pianta, alzate col profilo, e con la intersecazione e col punto fatte diminuire e sfuggire, bisogna ch'e' le riporti proporzionate in sul cartone." Seguono altre considerazioni e consigli che per il nostro argomento non hanno interesse, tra cui la precisa descrizione su come i cartoni venivano usati per gli affreschi e per le tavole; e si conclude con una lode per l'invenzione dei cartoni stessi: "Ma certo chi trovò tal invenzione ebbe buona fantasia, attesoché ne' cartoni si vede il giudizio di tutta l'opra insieme e si acconcia e guasta finché stiano bene; il che nell'opra poi non può farsi."[26] Quasi le stesse parole del Cennini che si riferivano però ai disegni preparatori fatti sull'arriccio o sul bianco gesso delle tavole.

FLORENCE

[26]G. Vasari, *Le vite dei più eccellenti pittori, scultori e architettori nelle redazioni del 1550 e 1568*, testo a cura di R. Bettarini, commento secolare a cura di P. Barocchi, 1 (Firenze, 1966), 117-21. Il testo, salvo qualche variante di parole senza importanza, è uguale nelle due redazioni.

The Architectural Setting of Antonello da Messina's San Cassiano Altarpiece

GILES ROBERTSON

When, in 1929, Johannes Wilde made his brilliant reconstruction of the altarpiece that Antonello da Messina painted for the church of San Cassiano in Venice in 1475/6 (Fig. 1),[1] he recognized that, while the evidence of the surviving fragments and of copies and engravings of fragments now lost, supplemented by that of works evidently derived from Antonello's picture, made his reconstruction of the main figure group of the Madonna and her flanking saints virtually certain,[2] the reconstruction of the rest of the picture remained a matter of conjectural inference. In his visual reconstruction, he wisely left the area in front of the Madonna's throne blank, though he inclined to believe that it had originally contained music-making angels of some sort; but for the architectural setting he offered a tentative solution based on the evidence of the backgrounds in the surviving fragments of the original or in copies, supplemented by the evidence of presumedly derivative works. It is perhaps unfortunate that he did not differentiate the more conjectural nature of this part of his reconstruction by the use of some such device as a broken line, since it has come to be accepted as being almost as authoritative as that of the figure group.

Behind this reconstruction lay the hypothesis that the *Sacra conversazione* as we know it in the last quarter of the fifteenth century in Venetian painting, showing the Madonna enthroned on a high pedestal amid saints gathered in an architectural structure, with a centralized perspective and a relatively low viewing point, was in fact introduced into Venice by Antonello in the San Cassiano picture, and that not only was Bellini's *San Giobbe Madonna* painted later than Antonello's and influenced by it but that also his lost altarpiece for Santi Giovanni e Paolo was not painted before about 1480 and was dependent on Antonello's. More recently, doubts have been expressed as to whether Giovanni's lost altarpiece did not in fact precede Antonello's; and although in the present state of our knowledge this problem cannot be decisively resolved, there is sufficient uncertainty about Antonello's priority to warrant an inquiry as to how far the setting of his picture may have conformed to the type commonly found later in Venice. We can do no more than raise questions, and for this reason it is not proposed to submit a visual reconstruction of a scheme alternative to Wilde's but only to suggest possible ways in which his might be modified.[3]

A common feature of the great majority of Venetian altarpieces of this type is the union of the three-dimensional architecture of the carved frame with the painted architecture of the panel, whereby the frame becomes not a sort of proscenium arch through which a separate picture space is viewed but a sort of architectural façade to the painted structure containing the figures; this in turn is conceived of as a chapel opening out of the body of the church

[1] "Die 'Pala di San Cassiano' von Antonella da Messina," *Jahrbuch der Kunsthistorischen Sammlungen in Wien* (N.F. III, 1929), 57–72. This article illustrates most of the relevant material.

[2] A slight modification is suggested below.

[3] For a discussion of the relative dating of the San Cassiano Altarpiece and Bellini's lost altarpiece see G. Robertson, *Giovanni Bellini* (Oxford, 1968), 58–62, also L. Coletti, *Pittura veneta del Quattrocento* (Novara, 1953), lxii. We need not follow Coletti in dating the San Giobbe Altarpiece also before Antonello's visit.

in which the spectator is standing and spatially continuous with it. At the end of his article Wilde discussed rather briefly, by way of contrast, the spatial arrangements of Piero della Francesca's Brera Altarpiece from San Bernardino at Urbino, in which, as he pointed out, elements of the foreground architecture are represented in paint on the panel itself. This important distinction has been further elaborated by Millard Meiss.[4] In such a scheme the spectator, instead of viewing the picture space as something seen through the opening of the frame and continuous with the space in which he is standing, transfers himself in imagination from the space of the church *into* the picture space, which in his imagination is projected to include him.

The majority of Venetian examples follow the type with linked frame and architecture, which we may most conveniently illustrate by a montage showing Giovanni Bellini's *San Giobbe Madonna* in the Accademia in Venice restored to its original frame, still *in situ* over the third altar to the right in the church (Fig. 2). There is, however, one painting, whose close relationship to Antonello has been recognized by a number of scholars, which follows, by contrast, the pattern of Piero's Brera altarpiece. This is the *Sacra conversazione* by Marcello Fogolino from the Mauritshuis at The Hague, now deposited on permanent loan in the Rijksmuseum, Amsterdam (Fig. 3).[5] It is signed but not dated. We first hear of Fogolino in 1519, and he was still alive in 1548, but this would seem to be among his earliest works, and we should not be far wrong in dating it to the opening years of the cinquecento. We cannot suppose that this is a pioneering picture, in which Fogolino deliberately introduced a novel system of architecture, but are entitled to assume that he is here following some notable prototype. The close relationship of the figures, and especially of the Madonna,[6] to the fragments of Antonello's altarpiece in Vienna make the hypothesis that the latter was in fact Fogolino's prototype very tempting, especially in view of the general acceptance of Roberto Longhi's intuition of the role of Piero in Antonello's formation.[7] It would seem worthwhile to reexamine the evidence for the architectural setting of Antonello's picture with this hypothesis in mind.

Although Antonello's picture is more widely noticed and praised by early writers than any other in Venice, none of them describe it in any detail.[8] The materials for a reconstruction,

[4]M. Meiss–T.G. Jones, "Once Again Piero della Francesca's Montefeltro Altarpiece," *Art Bulletin* (XLVIII, 1966), 203–06. My article, begun after discussions with Professor Meiss, should be read as a footnote to his and is dedicated to him in gratitude for all sorts of help and encouragement.

[5]Fogolino's altarpiece was cited by B. Berenson, "A Madonna in Vienna and Antonello's San Cassiano Altarpiece," *Study and Criticism of Italian Art*, 3rd Series (London, 1916), 113; G. Glück, "A Drawing by Antonello da Messina," *Burlington Magazine* (XLI, 1922), 375, and J. Wilde, "Die 'Pala di San Cassiano,'" 68, but the significance of the presence of the architectural elements in the foreground of this rectangular panel was not remarked. This was briefly noted by Meiss, "Once Again," 204 n. 16. A somewhat similar arrangement is found in Buonconsiglio's altarpiece in the Municipio at Montagnano, and in Carpaccio's in San Francesco at Pirano, of 1519.

[6]Berenson, "A Madonna in Vienna," 113, speaks of Fogolino as having "all but copied" the *San Cassiano Madonna* in his *Sacra conversazione*.

[7]"Piero dei Franceschi e lo sviluppo della pittura veneziana," *Arte* (XVII, 1914), 241–63.

[8]Matteo Colazio in a letter printed in his *De verbo civiltate* (Venice, 1486), sig. c iv verso, particularly praises Antonello for his skill in perspective, which indicates the impression that the setting of the picture made on the spectator; see also Marcantonio Sabellico in his *De Venetae urbis situ* (Venice, n.d., but early 1490s); Marin Sanudo in his *Cronica* of 1493 (Venice, Museo Correr, MS Cicogna 1920, c. 25), cited by P. Paoletti, *L'architettura e la scultura in Venezia* (Venice, 1893), 185 n. 1. Berenson ("A Madonna in Vienna," 114–17) is certainly wrong in interpreting Sabellico's sentence ". . . tabula Messenii pictoris cui ad exprimenda que voluit nihil videtur praeter animam quam dare non potuit defuisse" and Sanudo's related phrase "non li manca se non l'anima" as stylistic criticism of Antonello, indicating that his figures were lacking in emotional expression. They are hyperbolic, rhetorical tropes signifying that the figures were so lively that they lacked only the breath of actual life, which the painter could not give them, since this is the prerogative of God. One may suspect that behind

within whatever hypothesis of its influence on later altarpieces one may accept, are the indications of the background in the fragments in Vienna and in the missing fragments, known to us from reduced copies by Teniers and the engravings in the *Theatrum Pictorium*.[9] Of these, the indications in the existing Vienna fragments are mandatory; no reconstruction that fails to account for any feature of them is acceptable. Evidence from the fragments known only from copies and engravings is less authoritative, since it is apparent that these panels were made up and enlarged to make them viable as separate pictures at the time the altarpiece was dismembered and that considerable repainting in the backgrounds then took place. If we had the original panels, it would no doubt be possible to define the original forms with certainty, but this is not possible working only from copies and engravings.

We learn from the Vienna fragments (Fig. 4) that a violet cloth of honor was suspended so as to fall between the Madonna and the back of the throne. A similar arrangement was found in Bellini's lost altarpiece for Santi Giovanni e Paolo, in which the cloth, since it is suspended from a tie-rod at the base of the arch at the rear, determines the exact position of the throne in relation to the architecture. Probably in Antonello's picture the cloth was similarly suspended and performed the same function. (It is interesting to note that Bellini abandoned this feature in his later enthroned Madonnas in San Giobbe and San Zaccaria.) Behind the throne was a much wider green hanging, which extended nearly as far as the backs of the heads of St. Nicholas and St. Dominic. As Wilde pointed out,[10] this hanging must lie a considerable distance behind the throne and the cloth of honor, since the whole of its left side lies in their shadow. Still further beyond this, we see at the outer sides of the Vienna fragments areas of ivory-colored paint—the only areas of the church's architecture that appear there. Wilde was certainly right in assuming that these represented pieces of a wall closing the composition at the back and parallel to the picture plane; but whether this was a flat wall, as Wilde assumed, or the curved wall of a shallow apse such as we see in Bellini's San Giobbe and San Zaccaria Madonnas and in Fogolino's *Sacra conversazione* remains uncertain. From the point of view of a reconstruction of the setting the most important feature of these areas is their bright illumination. Plainly, neither of them lies in shadow. It is very difficult to reconcile this with Wilde's reconstruction of a closed rectangular choir behind the Madonna, with no openings in its side walls to admit light. With regard to the area at the left, Wilde writes, "Auf den Mauerstreifen links fällt von dem grünen Vorhang kein Schatten, was nur so erklärt werden kann, dass der Mauer sich weit hinter diesem befindet."[11] I take this to mean that the shadow of the green curtain falls entirely on the receding left wall of the choir, and that the left part of the back wall is illuminated by light coming from the same source, high to the right, as that which illuminates the figure group, passing behind the curtain to the right. But if this were the case, then the right portion of the back wall should lie in the shadow of the receding right wall of the choir, which it does not. If we look at the corresponding passages in the Fogolino painting (which is lit from the other

this, and the phrase of the Sicilian historian Maurylocus, writing in 1562, "Vivas rerum vivasque pene animalium rededebat effigies," lies a lost humanist verse epigram. All the relevant texts are printed in full by G. Gronau, "Die Quellen der Biographie des Antonello da Messina," *Repertorium für Kunstwissenschaft* (xx, 1897), 347–61.

[9] The Teniers copies were made for the use of the engravers, and it does not seem that the engravings, in the minor points in which they differ from these copies, can be taken as independent evidence of the appearance of the original pictures.
[10] "Die 'Pala di San Cassiano,' " 66.
[11] *Ibid.*

side), we see that the illumination of these areas gives very good grounds for supposing that light was admitted into the background architecture through side openings.

This hypothesis brings us up sharply against the question of the reliability of the evidence of the lost fragments, since it is from one of these that Wilde was led to assume deep unbroken side walls for his choir. The copy of the *St. Sebastian* from the right edge of the composition, now also in Vienna, and its engraving in the *Theatrum Pictorium* need not concern us, beyond noting that the column to which the saint is bound does not seem to have formed part of the architecture, since at the time of the dismemberment the background beyond this column was obviously wholly repainted with a dark pigment. The fragment from the left side with the warrior and female saint (St. George and St. Rosalie?), on the other hand, contains the indications on which Wilde based much of his reconstruction. At the time he wrote, this fragment was known only through the engraving in the *Theatrum Pictorium* and a small copy hanging on the wall in a view by Teniers (then in the collection of Baron Alphonse de Rothschild, now in the Kunsthistorisches Museum, Vienna), showing Archduke Leopold Wilhelm's picture gallery. The Teniers copy from which the engraving for the *Theatrum* was made has since come to light and is now in the collection of Count Seilern in London, by whose kind permission I am able to reproduce it here (Fig. 5). We cannot be positive exactly how much of what we see in it represents parts of the original panel of the altarpiece. The left edge of the Vienna fragment with St. Nicholas comes very close indeed to the face of St. Rosalie in the upper right, and in this part of the picture everything to the right of her head must have been made up. Further down, beneath the level of the bottom of the Vienna fragment, which falls a little below St. George's waist, the original panel probably extended further to the right, showing the lower part of the spear and behind it the brocade cope of St. Nicholas, which appears in Teniers's copy as a piece of drapery unconvincingly clasped by St. Rosalie, with a new hand. It also seems probable that a considerable addition was made down the left side of the panel; by analogy with other altarpieces, St. George should have been right up against the frame. To bring the side of the panel in to touch, or almost touch, his elbow would be to cut St. Sebastian's hand in Wilde's reconstruction, if a corresponding adjustment were to be made on the other side; but the figure of St. Sebastian is the only one whose position is not exactly determined by its relation to other fragments, and I believe that Wilde has placed him a little too far to the right. I suggest that he should be moved in until his right shoulder almost touches St. Dominic's back. If, as I also suggest, there has been an addition to the left side of the St. George panel, there would have been repainting in the background on that side too, which may have affected the architectural forms.

The architecture shown behind these figures, which Wilde took as a basis for his reconstruction, dictated two features that do not seem entirely satisfactory. I have already referred to one of these, the depth of the unbroken, receding side walls, arrived at by projecting the diagonal cornice above the head of St. Rosalie and the vertical angle behind the head of St. George so that they meet. Wilde himself was not happy about the right profile of this wall, which he thought had been modified by overpainting at the time that the additions to this side were made. It seems very possible that this repainting has made the wall appear wider

than it should be or that an opening in it has been painted out. The other unsatisfactory feature is the extreme narrowness of the pilaster rising behind St. George. This in turn dictates the width of the side arches in Wilde's reconstruction, which are uncomfortably narrow. I suggest that the repainting of the background consequent on the enlargement of the panel to the left greatly reduced the width of this pilaster.

The evidence of the Seilern painting as it stands certainly does not do much to confirm a reconstruction on the lines of the Fogolino altarpiece, but its indications are not decisive, and the backgrounds of the Vienna fragments seem to demand an opening to admit light in the background of the picture. If the side wall is to be retained unbroken and at the depth that Wilde deduced for it, we must suppose an opening beyond it. If the vault were a cross and not a barrel vault, we might assume an open lunette above the level of the cornice, but this would not seem to accord with fifteenth-century practice and would scarcely admit sufficient light to account for the illumination in the Vienna fragments.

As to the nature of the vault, we have no evidence. Wilde opted for a barrel vault for the choir, with a dome over the forward space. The hypothesis of a barrel vault is tempting for two reasons. If we assume that Antonello's inspiration came at least in part from Piero's Brera Altarpiece, it would be natural for his picture to reflect one of that work's most striking features, and the presence of such a vault in the San Cassiano picture would also have provided the inspiration for the splendid one in Bellini's *San Giobbe Madonna*. Against this, on the other hand, we may set the evidence of the Fogolino. But even if we accept the hypothesis of Fogolino's dependence on Antonello's picture, this is still not decisive as to Antonello's having used a cross vault, since there has evidently been much simplification of Antonello's forms in the *Sacra conversazione*, and the substitution of a cross vault for a foreshortened barrel vault might fall within this category. On the other hand, in the great arches in the background of his *St. Sebastian* in Dresden, Antonello uses cross rather than barrel vaults, which might suggest his preference for this form.

A similar uncertainty surrounds the evidence that Fogolino's altarpiece provides as to what took place before the Madonna's throne. The absence of music-making angels may be no more than a part of the general simplification of Antonello's design, exemplified in the omission of the cloth of honor and the reduction of the number of flanking saints from eight to six. The placing at the foot of the throne of a glass, which seems to be inspired by the one carried by the female saint to the left in the Vienna fragments, looks rather like an effort to mask a baldness left by the deliberate omission of something in the original model. Meiss has remarked on the confused positioning of the figures in Fogolino's picture, and a similar confusion attends the positioning of the dark curtain, which though shown as suspended behind the side openings nevertheless casts no shadow in the apse.

To conclude: while we can have no certainty as to the background of Antonello's picture, we should bear in mind the possible alternatives and accept at least the possibility that Fogolino's painting, precisely because of its pedestrian character, may be our most faithful witness—even if a confused one—to Antonello's actual rendering.

UNIVERSITY OF EDINBURGH

Per Paolo Uccello

MARIO SALMI

I grandi artisti presentano sempre nuovi problemi e sul maestro fiorentino in specie, la storiografia e la critica dell'arte dimostrano un crescente impegno nel definire e approfondire le origini geometrico-prospettiche e la essenza poetica dell'artista, in rapporto anche con odierne tendenze di gusto e con correnti figurative recenti.

Limitandomi a fatti concreti, ricordo che Paolo Uccello nel 1425, a ventotto anni, si recava a Venezia dove restava almeno fino al 1430, per operare di mosaico nella Basilica di San Marco nella quale urgevano restauri considerevoli in seguito all'incendio del 1419. È documentato che egli eseguì appunto in mosaico una figura di S. Pietro nella facciata della chiesa; la sua opera bensì ebbe in quel monumento una assai maggiore estensione.

Di mosaico egli condusse parti decorative nell'atrio fra le quali un disco a girandola (motivo questo, ben noto anche agli antichi) che altrove già posi a raffronto con quello identico ad intarsio marmoreo in una finestra della tribuna di Santa Maria del Fiore a Firenze, ritenendolo dello stesso Paolo.[1] A Venezia il maestro riparava poi il grande litostrato di San Marco con marmi policromi intarsiati, composti di elementi geometrici in prospettiva come rosoni in movimento rotatorio, pannelli a punte di diamante, transenne e, in aspetti più complicati, solidi costruiti impeccabilmente nella loro struttura geometrica come certe sfere sfaccettate a "punte di diamanti" (Vasari). Di queste soluzioni presento un saggio inserito entro cerchi concentrici, essi pure geometrici, che ci ricorda un analogo perfettissimo solido in un disegno del Louvre ascritto appunto a Paolo (inv. 1969). L'intarsio è fiancheggiato da due dischi di proporzioni minori, che insieme riproduco (Fig. 1), fra l'altro, con raggiere in prospettiva simili ai nimbi visibili in vari dipinti dell'artista.

Queste precisazioni dimostrano come prima del suo soggiorno veneziano, Paolo Uccello si fosse esercitato a Firenze in analoghi ideali geometrici e probabilmente in altri ancora attestati dai disegni superstiti degli Uffizi: un vaso assai complicato (no. 1758 A) e due famosi mazzocchi (no. 1756 A e 1757 A), assai più tardi questi trasferiti nella pittura del maestro. *Ad abundantiam*, per ribadire la presenza di Paolo quale mosaicista nella decorazione di San Marco, si veda un complicato rosone che consta di cerchi, di una ruota simile a quelle dei timoni, e di nastri disposti a girandola (Fig. 2), che, proprio per quei nastri, s'intorna al grande cappello con striscie diagonali di uno dei combattenti della *Battaglia* degli Uffizi (Fig. 3). Gli interessi per la prospettiva e la geometria che avevano condotto l'artista a certe soluzioni dovevano avere avuto tuttavia la loro spinta dal Brunelleschi al quale sono stati giustamente avvicinati gl' intarsi marmorei nella nicchia del tabernacolo di Orsanmichele a Firenze per la discussa

[1] Rimando, per il raffronto, alle figg. 27–28 del mio articolo "Commento al coro di San Francesco a San Sepolcro," *Commentari* (IV, 1962), 351–65. A tale proposito vedremo come anche il Brunelleschi usò tondi con ornati a girandola ma diversi da quelli sottili di Paolo nel mosaico veneziano. A Firenze la tarsia marmorea aveva avuto una sua alta tradizione romanica e gotica ma con uno svolgimento quasi sempre geometrico, in superfice. Cfr. M. Salmi, *Atti del I Convegno delle Arti minori in Toscana, Arezzo*, 11–15 *maggio* 1971 (Firenze, 1973), 113–20. Però nella Porta della Mandorla in Santa Maria del Fiore la cornice della cuspide del grande rilievo con l'*Assunta* di Nanni di Banco (1414–1421) è intarsiata con lumiere in una prospettiva di profondità spaziale, che costituiscono un diretto precedente di Paolo, corrispondendo in pieno alle di lui invenzioni, se non furono addirittura realizzate da lui.

statua del *S. Pietro* di Donatello (Fig. 4), vicina nel tempo a quelle tanto superiori del *S. Marco* e del *S. Giorgio*, posta in opera nel 1414 circa. Le specchiature a marmi policromi (verde, rosa e bianco) del tabernacolo schematizzano bifore viste in prospettiva da un interno in rapporto con l'andamento curvilineo della nicchia e certi dadetti esagoni forati e congiunti da una funicella. Tali motivi richiamano il Brunelleschi; ed il secondo si scorge nell'intradosso degli archi della fiorentina Sacrestia di San Lorenzo e sono diffusi dallo stesso Paolo nel pavimento della basilica Marciana. Con altri elementi geometrici i dadetti compariranno nella tarsia in legno; innanzi tutto, insieme con dischi a girandola, nel bancone della Sacrestia Laurenziana riferito dal Venturi ad un disegno dello stesso Brunelleschi.[2] Ci chiediamo però se Paolo Uccello, insistendo soprattutto in quelle che il Vasari chiama "bizzarrie" e che Donatello avrebbe giudicato utili solo a quelli "che fanno le tarsie," avesse esercitato un influsso, e quale, sui maestri ligniarî, e se fosse passato dall' *opus sectile* marmoreo a praticare la tarsia in legno. Su questo punto non ci aiutano le fonti. Sebbene il Vasari ponga la vita del nostro prima di quella del Brunelleschi, il biografo si dilunga nel ricordare l'impegno di lui nel ritrarre prospetticamente gli edifici con effetti di profondità e secondo un organico rapporto spaziale con le figure: Paolo doveva sempre attingere alle dimostrazioni dell'iniziatore della Rinascita. Illuminanti furono per il nostro e per altri pittori le famose tavolette con le piazze del Battistero e di Palazzo Vecchio per le quali si è avanzata una datazione: 1416, mentre per la veduta del San Giovanni già supposi e ritengo che sia solo possibile un terminus ante quem: il 1423.[3] Ma se ciò è dimostrato chiaramente per la pittura di Paolo (nella quale peraltro spazio e prospettiva presentano una originale interpretazione) non sembra, almeno da quanto ci è rimasto, che l'artista cercasse di ambientare le sue "bizzarrie" in uno spazio definito, e che queste fossero solo isolate soluzioni geometrico-prospettiche come gli intarsi marmorei di Venezia, cioè che non s'inserissero in composizioni tali da potere essere tradotte nella tarsia lignea. Ed è da pensare che a tale tecnica Paolo non si fosse dedicato mai; e che anche dopo il soggiorno veneziano avesse abbandonato o quasi quella dell'*opus sectile*, preso come era, specialmente dalla attività pittorica, senza tuttavia abbandonare i suoi studi sulla "dolce prospettiva."

I "ghiribizzi" ebbero una loro risonanza, innanzi tutto, a seguito di un diretto contatto fra Paolo e Piero della Francesca, alto spirito matematico che con rigore di stile attese ad analoghe esperienze e disegno pure mazzocchi nel *De prospectiva pingendi*, aprendo la via al nobilissimo artigianato dei Canozzi da Lendinara e alle ricerche di Luca Pacioli.[4] Questo frate matematico infatti solo tramite Piero potè pubblicare nel suo libro sulla *Divina proportione* i solidi che Paolo Uccello aveva realizzato nel marmo.[5] Circa i Canozzi, essi incontrarono

[2] Le osservazioni sul tabernacolo di Orsanmichele si devono a G. Castelfranco, "Sui rapporti tra Brunelleschi e Donatello," *Arte Antica e Moderna* (nos. 34-36, 1966), 109-22. Il bancone della Sacrestia Laurenziana con tondi a girandola baccellati è pubblicato col nome del Brunelleschi da A. Venturi, *Storia dell'arte italiana*, VIII (Milano, 1923), figg. 65-67. Tondi simili baccellati e a girandola si scorgono anche in altri mobili, per esempio in una porta nella raccolta E. Simon a Berlino pubblicata da F. Schottmüller, *Wohnungskultur und Möbel der italienisches Renaissance* (Stuttgart, 1921), tav. 218.

[3] La *Presentazione al Tempio* di Gentile da Fabriano al Louvre, parte dell'*Adorazione dei Magi* degli Uffizi (1423), mostra infatti una piazza in prospettiva con un tempio centrale largamente ispirata, a quella col Battistero, di Filippo Brunelleschi; cfr. le mie dispense su *I primi eventi e i primi maestri del Rinascimento* (Roma, 1955-1956), 100-01. Il rilievo del tabernacolo del *S. Giorgio* di Donatello (1415c.) che è stato più volte menzionato come un esempio di prospettiva rinascimentale, non è affatto coerente nei riguardi prospettici e costituisce solo un tentativo.

[4] *De prospectiva pingendi*, edizione critica a cura di G. Nicco Fasola (Firenze, 1942), 42-44 e fig. 41.

[5] Cfr. L. Pacioli, *Diuina proportione*, 1502, *passim*. Il Pacioli può avere anche studiato nella stessa Venezia l'opera di Paolo nel pavimento di San Marco.

probabilmente a Ferrara Piero della Francesca, poco prima del 1449 o in quello stesso anno in cui quei mastri ligniari avevano eseguito le tarsie per lo studio degli Estensi a Belfiore. Sempre a Ferrara, i Canozzi interpretavano Piero nelle tarsie del coro della Cattedrale (1456) in soggetti diversi come edifici presi dal vero (lo stesso Piero dipinse più volte quelli del nativo Borgo Sansepolcro e negli affreschi di Arezzo pose una ideale veduta di quella città) o inserendo oggetti diversi, specie suppelletali sacre, in finto scansie coi loro sportelli aperti in prospettiva, la cui fonte prima è sempre brunelleschiana, sviluppando nella varietà delle cose presentate la natura morta che aveva avuto altri precedenti in tempo gotico. Per dimostrare quanto i Canozzi sentissero sempre gli insegnamenti di Piero, vediamo a quali più complesse composizioni geometriche essi giunsero nel coro del duomo di Modena terminato nel 1465 (Fig. 5).[6]

A Firenze, ad esempio, negli armadi della Sacrestia Vecchia del Duomo di Giuliano da Maiano (1463 e segg.), accanto a girandole baccellate entro tondi e ad altri motivi di eco brunelleschiana, appariscono scansie più sviluppate a due ordini (Fig. 7)—come già in tempo gotico aveva fatto ad esempio Taddeo Gaddi in un gustoso particolare della cappella Baroncelli in Santa Croce, ovviamente al di fuori della visione prospettica rinascimentale—talora con oggetti di impeccabile rigore geometrico, mentre gli sportelli a trafori in prospettiva possono trovare, col ricordo di Paolo, qualche affinità del tutto independent con cose del mondo antico, come dimostra una transenna mosaicata e in prospettiva, parte di un litostrato nel Museo-Pinacoteca di Faenza (Fig. 6). Sta di fatto che a Firenze la tarsia lignea si ispira soprattutto al Brunelleschi: sopratutto nella struttura prospettica delle scansie che hanno un loro schematico precedente nelle specchiature con le bifore del tabernacolo di Orsanmichele (Fig. 4). Di Paolo Uccello gli intarsiatori ripetono solo qualche solido come i famosi mazzocchi che nel tardo Quattrocento diverranno virtuosi particolari nella tarsie degli studioli dei palazzi ducali di Urbino e di Gubbio e persino in quelle di fra Giovanni da Verona, ad esempio nel coro di Monte Oliveto Maggiore.[7]

Paolo Uccello aveva compiuto il suo tirocinio presso il Ghiberti ed è da iugurarci che uno studio sistematico sulla oreficeria a Firenze nei primi decenni del Quattrocento, possa condurre a qualche persuasiva attribuzione a lui. Ma prima di finire desidero segnalare un altro punto di contatto fra lui e le arti minori. Una casula del Duomo di Pistoia alla quale fu applicato un ricco stolone ricamato a figure del Trecento, è sicuramente quattrocentesca e di una rara bellezza. Ne riproduco un particolare che mostra sul fondo di seta bianca a vivacissimi fiorami rilevati di velluto, policromi con bocciuoli quasi di tulipano o fiori

[6]Per Piero della Francesca a Ferrara, cfr. M. Salmi, *Pittura e miniatura a Ferrara nel primo Rinascimento* (Milano, 1961), 11 ss.; per i Lendinara oltre lo studio di G. Fiocco, "Lorenzo e Cristoforo da Lendinara e la loro scuola," *Arte* (XVI, 1913) 278–88 e 321–40; si veda su Cristoforo in particolare A.C. Quintavalle, *Cristoforo da Lendinara* (Parma, 1959) e dello stesso, sul coro di Ferrara, "Tarsie e urbanistica," *Critica d'Arte* (XI, 1964), 35–46. Per il coro di Modena, v. A. Mezzetti–O. Caprara, *Il coro del Duomo di Modena restaurato* (Modena, 1962); per l'opera del Lendinara a Padova, G. Fiocco–F. A. Sartori, "I cori antichi della chiesa del Santo," *Il Santo* (I, 1961), 13–65.

[7]Per i precedenti gotici accennati, v. C. de Tolnay, "Postilla

sulle origini della natura morta moderna," *Rivista d'Arte* (XXXVI, 1961–1962), 3–10, e per le derivazioni da Paolo, v. M. Salmi, "Commento al coro di San Francesco." Per la natura morta segnalo quella del 1440 c., dipinta (secondo un andamento rettangolare per largo, come più tardi quelle nel coro dei Lendinara per il Duomo di Modena, finite, come si disse, nel 1465, e altrove specie nell'Italia settentrionale) da un fiorentino, forse Paolo Schiavo, nella loggia del Palazzo Branda a Castiglione Olona; v. M. Salmi, "Lombardia, Veneto e Toscana a Castiglione Olona," *Arte Lombarda* (VIII, 1963), fig. 20.

aperti con petali distaccati l'uno dall'altro (Fig. 8), di un gusto che ci ricorda i finali piumati degli elmi dei cavalieri nella *Battaglia* degli Uffizi (Fig. 9). Ciò fa ritenere che lo stesso maestro abbia disegnato questo raro pezzo con quella originalità fantastica che gli ha assegnato un posto eccezionale nell'arte fiorentina del primo Rinascimento.

ISTITUTO NAZIONALE DI STUDI SUL RINASCIMENTO, FLORENCE

Paralipomena su Leonardo e Dürer

ROBERTO SALVINI

Paralipomena : omissioni da parte mia, quanto cioè ho dovuto lasciar da parte toccando dei rapporti fra Leonardo e Dürer nel commento ad una raccolta antologica di disegni.[1] Ma omissioni anche da parte della Dürer-Forschung in generale. Perché l'aspetto del problema che più è stato indagato e sul quale sono state scritte pagine fondamentali specialmente da Erwin Panofsky[2] è quello che attiene alla teoria dell'arte—quanto cioè il maestro di Norimberga potè apprendere dal fiorentino sulle proporzioni dell'uomo e del cavallo, sulla prospettiva, sull'anatomia e sulla classificazione delle fisionomie umane, nonché quanto del pensiero estetico di Leonardo potè offrire materia di riflessione e di confronto all'autore dei *Vier Bücher der menschlichen Proportion*. Assai meno approfondito è stato invece l'altro aspetto del problema : quanto e come i ripetuti incontri con l'arte di Leonardo abbiano contribuito alla formazione artistica di Albrecht Dürer. Su questo argomento la critica è andata poco più in là di un inventario—esuberante da un lato, incompleto dall'altro—dei *motivi* che Leonardo avrebbe trasmesso a Dürer e di qualche cenno—assai centrato ma rapido—dovuto ancora al Panofsky,[3] sull'influenza stilistica esercitata dal fiorentino su alcune opere del maestro di Norimberga. Talvolta poi i rapporti con Leonardo sono stati messi in un fascio con l'ascendente esercitato dall'arte italiana sull'artista tedesco e trattati come un aspetto particolare, scarsamente differenziato, dell' "italianismo" o addirittura del "classicismo" di Dürer. E se la difficoltà, anzi l'impossibilità di ripercorrere intera la sterminata letteratura sul maestro non mi inganna, ho l'impressione che nessuno si sia mai impegnato nel definire *qualità* e *sostanza* del "leonardismo" di Albrecht Dürer e che nessuno si sia chiesto ancora che cosa mai abbia spinto l'artista tedesco a ricercare un contatto assai più difficile a concretarsi e certamente meno *ovvio*—proprio nel significato etimologico della parola—di quelli col Mantegna, coi Bellini e con altri veneti, nelle cui opere, e spesso nelle cui persone, doveva inevitabilmente imbattersi durante i suoi due soggiorni sulle rive della laguna.

Tutto ciò mi incoraggia a dedicare a Millard Meiss, indagatore acutissimo della storia di particolari motivi iconografici e stilistici, ma sempre profondamente impegnato a penetrare, di là da questi, i più ampî legami storici e la più riposta sostanza dell'opera d'arte, il presente tentativo di precisare il significato di quell'incontro, non solo rivedendo l'inventario dei "motivi" passati dall'uno all'altro artista e tentando di definire il contenuto stilistico di tali trapassi, ma cercando anche di penetrare le ragioni più intime che spinsero Dürer a guardare a Leonardo : forte del plotiniano detto di Goethe, "wär nicht das Auge sonnenhaft, wie

Questo saggio è stato elaborato e scritto a Princeton, New Jersey durante il periodo della mia aggregazione ("membership") alla School of Historical Studies dello Institute for Advanced Study per l'anno accademico 1973-1974, in parte finanzaita dal National Endowment for the Humanities. Desidero pertanto esprimere la mia più profonda riconoscenza al Direttore dell'Istituto e alla Facoltà della Scuola nonché al predetto Fondo Nazionale per gli Studî d'Umanità.

[1] Il volume, un in-folio, contenente la riproduzione in facsimile di sessanta disegni di Dürer, un'introduzione sullo svolgimento dell'arte del maestro quale si rileva dai suoi disegni, un commento critico alle singole tavole e una ampia—anche se non completa—bibliografia, è stato pubblicato (Firenze, 1973) col titolo : *Dürer. Disegni*.

[2] *Dürers Kunsttheorie vornehmlich in ihrem Verhältnis zu der der Italiener* (Berlino, 1915). Cfr. anche, dello stesso autore, *Idea. Ein Beitrag zur Begriffsgeschichte der älteren Kunsttheorie* (Lipsia–Berlino, 1924), nonché l'ultimo capitolo della monografia sull'artista citata alla nota seguente.

[3] *The Life and Work of Albrecht Dürer* (Princeton, N.J., 1943) e successive edizioni (1945, 1948, 1955), *passim* e specialmente pp. 90 sg.

könnten wir das Licht erblicken?" ("se l'occhio non fosse solare, come potremmo vedere la luce del sole?"), mi chiedo dunque che cosa per naturale disposizione fosse in Dürer affine a Leonardo. La risposta non mi par dubbia, ancorché forse generica, se non ambigua: ciò che, anche a prescindere da ogni eventuale rapporto fra i due artisti, pone Dürer e Leonardo—per dirla con un termine coniato dal Focillon—nella stessa "famiglia spirituale" è l'atteggiamento *scientifico* di fronte alla natura, la comune convinzione che fosse compito dell'arte l'*apprensione* della realtà. Quanto a Leonardo, è notissimo che egli asseriva essere la pittura "filosofia naturale," ossia scienza naturale, ed è osservazione dello Heydenreich[4] che egli usava il disegno come strumento di una *scienza visiva*, nella quale "la percezione ottica del problema viene identificata con la sua conoscenza assoluta." Che anche Dürer considerasse compito dell'artista pervenire ad una conoscenza in qualche modo scientifica della natura, è se non altro attestato dal ben noto passo posto alla fine del terzo dei *Vier Bücher der menschlichen Proportion*: "dann wahrhaftig steckt die Kunst in der Natur, wer sie heraus kann reissen, der hat sie . . . ," che nella traduzione latina del Camerarius suona: "prorsus enim in natura demersa est ars, quam si extrahere potueris. . . ." Dove ovviamente *Kunst* e *Ars* sono da intendersi come "scienza." Il punto focale è opposto nelle asserzioni di Leonardo e di Dürer: ché nel primo l'arte della pittura è al servizio della conoscenza scientifica, mentre nel secondo la scienza racchiusa nella natura è al servizio dell'artista: "überkummst du sie, so wirdet sie dir viel Fehls nehmen in deinem Werk" ("[quam] jam adeptus errores multos vitaveris in opere tuo"). Ma il risultato alla fine è lo stesso, poiché ambedue chiedono all'arte di carpire alla natura le sue norme ed ambedue ritengono che sia precipuo compito della pittura definire la realtà visiva delle cose della natura.

Anche un altro, e in certo senso opposto, aspetto della pittura—quello immaginoso e fantastico—è in modo non troppo dissimile presente ai due artisti. A Leonardo la considerazione delle facoltà fantastiche dell'arte strappa uno dei passi insieme più eloquenti e più liricamente ispirati del *Trattato*: "Se'l pittore vol vedere bellezze che lo innamorino, egli è signore di generarle, et se vol vedere cose mostruose che spaventino o che sieno bufonesche e risibili o veramente compassionevoli, ei ne è signore et dio . . . ," con tutto quel che segue e che, per essere meritamente famoso, risparmierò di citare, limitandomi a ricordarne la conclusione: "et in effetto ciò ch'è nell'universo per essenzia, presenzia o immaginazione esso l'ha prima nella mente e poi nelle mani" E Dürer in modo, secondo il suo costume, assai più pacato ma non meno perentorio dichiara—sempre alla chiusa del terzo libro della *Proporzione*—che la mente dell'artista è piena di immagini ("inwendig voller Figur") e che, vivesse centinaja d'anni, saprebbe ogni giorno versar fuori ("ausgiessen") forme sempre nuove e mai da alcuno vedute di uomini e di altri esseri. Che il pensiero di Dürer non dipenda qui da quello di Leonardo, ma che i due artisti siano giunti ciascuno per proprio conto a conclusioni analoghe, è accertato dal fatto che il passo del terzo libro della *Proporzione* è preceduto da un primo abbozzo, di una diecina d'anni prima, nel quale la fonte dell'immaginazione del pittore è individuata nelle "idee di cui scrive Platone," mentre nessun sapore neoplatonico mi pare si possa cogliere nell'esclamazione di Leonardo.

[4] *I disegni di Leonardo da Vinci e della sua scuola nella Galleria dell'Accademia di Venezia* (Milano, 1954), nota a nr. 238r.

Leonardo e Dürer concordano dunque sull'alfa e l'omega dell'arte della pittura : scienza nei suoi primi principî, libera immaginazione nei suoi ultimi risultati. Ma più significativo ancora è che comune ai due artisti è il mezzo precipuo che serve a mettere in pratica la vocazione conoscitiva della pittura. Questo mezzo è il disegno. Né negli scritti di Leonardo né in quelli di Dürer si trova alcunché che possa assomigliare ad una definizione teorica del disegno. Nell'uno e nell'altro siamo egualmente lontani dalla neoplatonica definizione che del disegno darà il Vasari come dell' "apparente espressione e dichiarazione del concetto che si ha nell'animo, e di quello che altri si è nella mente imaginato e fabricato nell'idea." E sì che del neoplatonismo Leonardo a Firenze e Albrecht nella casa dell'amico Willibald dovevano avere orecchiato non poco. Il fatto è che tanto per Leonardo quanto per Dürer il disegno è un mezzo del tutto naturale per dominare la realtà—un mezzo spontaneo, come la parola, sul quale non viene fatto di riflettere o di indagare. Leonardo anzi esplicitamente afferma che "la pittura [e vi si può comprendere il disegno, che per Leonardo è parte non *ex professo* distinta della pittura] rappresenta al senso con più verità e certezza l'opere de natura che non fanno le parole o le lettere . . ."; e in un altro passo—assai più raramente citato, forse a causa della popolaresca ingenuità dell'argomento—dichiara con tutta fermezza il valore semantico del disegno. Discutendo se sia maggior sventura rimaner privo della vista o dell'udito, così argomenta : ". . . per il vedere si comprende il bello delle cose create, massime delle cose che inducono all'amore, nel quale il cieco nato non pò pigliare per lo audito perché mai non ebbe notizia che cosa fusse bellezza d'alcuna cosa. Restali l'audito, per il quale solo intende le voci e'l parlare humano nel quale i nomi de tutte le cose a chi è dato il suo nome. Senza la saputa d'essi nomi ben si pò vivere lieto, come si vede nelli sordi nati, cioè li muti, ch'è mediante il disegno, del quale i più de' muti si dilettano." Il disegno dunque sostituisce la parola, il linguaggio figurativo quello verbale. D'altronde i codici leonardeschi sono vivo esempio d'una scrittura figurativa che accompagna, traduce e integra la scrittura verbale. Osserva lo Heydenreich : "The unusual, and in fact unique feature of Leonardo's system of teaching, is his completely new correlation of word and image . . . the full use of this collaboration of word and image, of linguistic explanation and pictorial representation."[5] Ciò che è verissimo ed ha la sua radice nel principio, più o meno esplicitamente enunciato da Leonardo, dell'equivalenza, anche dal punto di vista *semantico*, del linguaggio verbale e del linguaggio grafico. Quanto a Dürer, se nei suoi scritti nulla si legge in proposito, il più rapido sguardo ai suoi disegni basta a convincere che prima ancora che un mezzo di espressione artistica il disegno era per lui un mezzo *linguistico*. Se l'uomo in genere si impossessa della realtà, ossia definisce e ordina le proprie esperienze dando un nome alle cose e ai rapporti tra le cose, Dürer dà la viva impressione di impadronirsi della realtà *disegnandola*, ossia trovandone di volta in volta un equivalente grafico. Prima di essere "prime idee" e progetti di opere d'arte da realizzarsi in altra tecnica o prima di essere, come in molti casi si verifica, opere d'arte compiute e conchiuse in se stesse, i suoi disegni sono la registrazione di determinati aspetti della realtà, sono un modo di dare un

[5]Introduction, in *Leonardo da Vinci: Treatise on Painting*, translated and annotated by A.P. McMahon (Princeton, N.J., 1956), xxxix. Ma cfr. anche quanto molto bene osserva G. Castelfranco, *Studi Vinciani* (Roma, 1966), 45 : "Il disegno è il suo [scil. di Leonardo] vero linguaggio, in esso egli sembra fissare ed esprimere tutto quello che pensa, cé egli sembra sempre pensare visivamente. Il corpus dei suoi disegni non è insomma solo l'assieme dei disegni di un grande pittore, ma un grande diario figurativo, come un grande archivio, sempre ad altissima tensione espressiva, di tutti i fatti figurativi della sua vita, una vita dedita con energia impareggiabile all'intelligenza delle forme delle cose."

nome alle cose e alle relazioni tra le cose. La stessa enorme varietà dei soggetti della sua
attività grafica—che spazia dal nudo al costume, dal paesaggio al ritratto, dalla pianta al-
l'animale, dalla favola mitologica alla storia sacra, dallo studio fisionomico alla figura "co-
struita," e l'enumerazione non è ancora completa—indurrebbe quasi a ordinar le sue carte in
una sorta di schedario adatto a costituire la base di un vocabolario grafico della lingua
figurativa. Pochi casi particolari, la riproduzione di alcuni "fenomeni" o "scherzi di natura"
verificatisi ai suoi tempi—come la mostruosa scrofa di Landser, le sorelle siamesi, il fanciullo
barbuto—fatta da lontano, fuori dalla presenza dell'oggetto, in base alle notizie o alle illu-
strazioni grafiche pervenutegli, confermano il valore conoscitivo che egli annetteva al disegno :
per comprendere lo strano fenomeno non v'era mezzo migliore che impegnarsi a tradurre in
esatto linguaggio grafico l'ingenua figurazione del volantino o la vaga descrizione verbale
raccolta sulla piazza del mercato. Ciò non significa che i disegni di Dürer non fossero *anche*
opere d'arte o non fossero pronti a trasformarsi in espressioni d'alta fantasia. Significa solo
che *primariamente* essi possedevano per il loro autore un contenuto informativo. Lo dimo-
strano, a prescindere da ogni valore espressivo, la precisione talvolta puntigliosa, il vigore e
la fermezza icastica del segno. Non meno di Leonardo Dürer pensa graficamente e per lui,
come per Leonardo, il disegno è uno strumento d'indagine e la pittura è—almeno entro certi
limiti—una scienza. Anche se poi l'oggetto di questa scienza non coincideva nei due artisti
e se le loro indagini erano diversamente orientate. Ricercava infatti, com'è ben noto, Leonardo
attraverso l'esperienza e la descrizione grafica dell'esperienza, "la ragione che infusamente
vive" nella natura, quei suoi interni principî che avrebbero dovuto spiegare tutti i fenomeni
fino a render superflua l'esperienza stessa. Dürer teneva per contro il suo occhio fermo sul-
l'apperanza delle cose e voleva cogliere, con la chiara esattezza della forma, la fisica vitalità
dell'oggetto. L'energia di un tratto estremamente analitico e sovranamente sintetico e
all'occorrenza, come negli acquerelli, la corposità del colore sono i non appariscenti strumenti
con i quali egli rende in modo perentorio la sostanza fisica e la vitalità naturale delle cose. Per
questo il disegno di Leonardo è dinamico e il suo segno è fluido, talvolta sfuggente, impre-
gnato di luce e d'ombra, vibrante nello "sfumato," mentre il disegno di Dürer è statico e il
suo segno è vigoroso e s'incide sulla carta come il contorno di un corpo in uno spazio privo
d'aria e illuminato da ferma luce zenitale. Resta però che era comune ai due artisti la con-
sapevolezza del valore *semantico* del disegno, della vocazione conoscitiva della pittura, ed era
loro comune la sete dell'apprendere, e la convinzione di poterla soddisfare con mezzi analoghi :
un'operazione di mano guidata dall'intelletto (e solo in seconda istanza, quasi dono non
richiesto, ispirata dalla fantasia). Ecco, nella profonda diversità dell'educazione e dei tem-
peramenti, ciò che avvicina i due artisti, ecco ciò che indusse Dürer a ricercare Leonardo, ciò
che gli permise di intenderne, a modo suo, la lezione.

Lo studio dei rapporti fra Leonardo e Dürer si è in gran parte limitato finora, come accennavo
in principio, alla redazione di un inventario dei motivi che il maestro di Norimberga desunse
da opere del fiorentino. Uno dei primi fra questi inventarî è quello contenuto nel saggio di
Gustav Pauli su Dürer, l'Italia e l'antico.[6] Nota per primo il Pauli che il più precoce accostarsi

[6]"Dürer, Italien und die Antike," *Vorträge der Bibliothek
Warburg herausgegeben von Fritz Saxl* (1921–1922), reprinted with the permission of the Warburg Institute, University of London
(Liechtenstein, 1967), 51.

di Dürer a Leonardo si riscontra nel foglio di studî degli Uffizî, eseguito durante il primo soggiorno veneziano, nel 1494-1495, dove accanto a motivi di origine veneta il cavallo-unicorno immaginosamente corazzato e il suo cavaliere richiamano ad esemplari leonardeschi, sì da far supporre che il maestro abbia avuto davanti agli occhi "uno di quei giocosi fogli di studî con i quali Leonardo soleva accompagnare i suoi grandi lavori." La fonte tipologica del minuscolo schizzo di bambino nello stesso foglio—che successivi studiosi faranno risalire a Lorenzo di Credi—è invece indicata, poco più lontano, dal Pauli nel Perugino al tempo in cui stava nella bottega del Verrocchio. Nell'incisione della *Madonna col giacco* (B. 42) al richiamo a Lorenzo di Credi già affacciato dal Weisbach il Pauli aggiunge quello diretto al cartone della *S. Anna* per il Bambino, ed emette l'ipotesi che sia stato Jacopo del Barbari a mostrare ad Albrecht qualche foglio di schizzi di Leonardo. Queste prime riprese dal fiorentino sarebbero, secondo lo studioso, casi particolari della ricerca della "bella posa" che il nostro va inseguendo nelle opere del Barbari, del Perugino, del Credi e, appunto, de' Vinci. Il successivo incontro con Leonardo avrebbe per oggetto gli studî di proporzione dell'uomo e comincerebbe col nudo proporzionato in una serie di cerchi concentrici di Berlino,[7] per riprendere nel 1503 con gli studî sulla proporzione del cavallo. Molto più ricco—ma per verità più arido—l'inventario dei motivi leonardeschi in Dürer redatto dal Suida nel capitolo sulla fortuna dell'artista della sua fondamentale monografia su Leonardo e la sua cerchia.[8] Accettate le indicazioni del Pauli sul disegno di Firenze e sulla *Madonna del giacco*, vi aggiunge, sul 1497, le incisioni B. 63 (*Penitenza di S. Giovanni Crisostomo*), B. 45 (*Maria alla Porta*, ormai riconosciuta per un falso)[9] e le xilografie B. 97 e 99 (*Sacra Famiglia con due angeli musicanti* e *Sacra Famiglia con cinque angeli*) che dipenderebbero tutte dalla leonardesca *Madonna di Fernando de Llanos* a Zurigo, la quale (o naturalmente il suo prototipo leonardiano) avrebbe inoltre esercitato la sua influenza sulla Madonna nella *Pala del Rosario* eseguita nel 1506 a Venezia ed oggi a Praga, e sulla *Madonna col gladiolo* oggi a Londra, rimasta incompiuta alla partenza per l'Italia nel 1505 e terminata dalla bottega nel 1508 (ma il Suida la ritiene copia di un originale scomparso del 1508). La *Madonna* di Montréal avrebbe invece suggerito il motivo del Bambino nei disegni e nella stampa della *Madonna con molti animali* del 1503. La *Madonna* di Dürer al Metropolitan Museum presupporrebbe la *Madonna col giglio* di Leonardo, mentre la visione di alcune caricature vinciane avrebbe influenzato il quadro della *Disputa coi dottori* oggi a Lugano, eseguito a Venezia nel 1506, nonché—come già aveva avvertito il Lippmann— i disegni L. 34 e 378 (studî fisionomici databili al 1515 c.).[10] Di impronta leonardesca sarebbero poi, oltre ai nodi copiati da quelli dell' "Accademia" vinciana ed oltre ai disegni e stampe di cavalli a partire dal 1503, nonché agli studî, distribuiti in varî momenti, sulle proporzioni del corpo umano, il disegno di Monaco con *Lotte di animali*, del 1505, ispirato ad uno schizzo con

[7] Questo disegno è stato ormai espunto dal corpus degli autografi del maestro. Cfr. E. Flechsig, *Albrecht Dürer*, II (Berlino, 1931), 199, e Panofsky, *The Life and Work of Albrecht Dürer*, Handlist nr. 1626: "The drawing is not only inferior in quality, but also shows a system of construction (apparently developed from the more popular Italian canons such as those transmitted by Pomponius Gauricus and Lorenzo Ghiberti), which has no parallel in Dürer's work."

[8] *Leonardo und sein Kreis* (Monaco, 1929), 253 sg.

[9] Questa incisione è ormai ritenuta un *pasticcio* di motivi düreriani ad opera di un imitatore. Cfr. Panofsky, *The Life and Work of Albrecht Dürer*, Handlist nr. 152.

[10] Si tratta di studî di fisionomie "caricate" e corrispondono a W. 656 e 657 (F. Winkler, *Die Zeichnungen Albrecht Dürers*, Berlino, 1936-1939).

un cavallo e un leone della serie per la *Battaglia di Anghiari*. Da schizzi per la *Battaglia* con-
servati a Venezia deriverebbe la grande xilografia di *Caino e Abele* (B. 1), sul 1510. Dalla
Leda, quale si vede riflessa nel disegno del 1506 di Raffaello a Windsor, deriverebbero il
disegno del 1508 per la *Lucrezia* e il quadro di dieci anni dopo. Ancora da Leonardo, e
precisamente da documenti grafici relativi al *Battista-Bacco* del Louvre, discenderebbe il Cristo
seduto del frontespizio della *Grande Passione*, mentre dal disegno del *S. Sebastiano* a Bayonne
discenderebbe uno dei ladroni della grande *Crocifissione* xilografica. E tornando al periodo
giovanile, appena successivo al primo viaggio in Italia, si riscontrerebbero motivi leonar-
deschi, se pur limitati a particolari ornamentali, nella *Circoncisione* della serie di Dresda. Più
breve, ma in compenso più ragionato ed arricchito di un importante gruppo di disegni
permeati di uno spirito leonardesco che era fino allora sfuggito alla critica, è l'elenco dei
motivi desunti dal Vinci nell'ancora insuperata monografia del Panofsky. Questi, accogliendo
le indicazioni relative al disegno degli Uffizî e all'incisione della *Madonna col giacco*, inclina
tuttavia a ritenere indiretti in queste opere giovanili i suggerimenti vinciani—trasmessi, pensa,
da Lorenzo di Credi. Il primo contatto diretto di Dürer con originali o copie fedeli dell'arte
di Leonardo si sarebbe verificato nel 1503, e non solo nei disegni e nella stampa del *Piccolo
cavallo*. Infatti—continua il Panofsky—"in two portraits in silverpoint (1060 & 1105, i.e.
W. 278, 277) Dürer attempted to render a fleeting smile, and one of the studies in charcoal,
presently used for a Virgin Mary, shows, in addition, a mildness of posture and expression and
a *sfumato* treatment of lighting which strike us as Leonardesque (717, i.e. W. 275). The
Vienna *Madonna in Half-Length*, also dated 1503, and the *Portrait of Endres Dürer* in Budapest,
datable 1504, shine with the same sweet smile, and in the *Adoration of the Magi* in the Uffizi, of
1504, the head of the standing king, pictured in full profile in spite of the frontal pose of the
figure, gently inclined, with no perceptible break between the long, straight nose and the
forehead, and almost femininely soft in temperament and modelling, would readily fit into
Leonardo's *Last Supper*" Questo, nonché lo studio degli articolati e complessi rapporti
con Leonardo nella teoria delle proporzioni e nei relativi disegni, è il maggior contributo del
Panofsky sull'argomento. Quanto al resto, egli ammette l'influenza delle caricature leonar-
desche sul *Cristo fra i dottori* di Lugano, richiama ai progetti per il monumento Trivulzio a
proposito della famosa incisione del *Cavaliere, la morte e il diavolo*, scorge un indiretto rapporto
con Leonardo, attraverso Quentin Metsys, nel *S. Gerolamo* di Lisbona, ed osserva che Dürer
"approaches, for once, the Leonardesque ideal of *sfumato*" nella nonfinita, ed anzi ripudiata,
puntasecca della *Sacra Famiglia* databile sul 1512, che richiama alla mente la *S. Anna* del
Louvre. Non molto di nuovo sui rapporti fra i due maestri nel recente catalogo dei dipinti di
Dürer dell'Anzelewsky,[11] benché questo studioso, accogliendo l'ipotesi dell'Arnolds che il
Cristo fra i dottori sia stato dipinto a Roma,[12] proponga una visita di Albrecht, al suo pas-

[11]*Albrecht Dürer. Das malerische Werk* (Berlino, 1971).
[12]L'ipotesi di G. Arnolds, "Opus quinque dierum," *Fest-
schrift Friedrich Winkler* (Berlino, 1959), 187 si basa su di una
copia a disegno, passata sul mercato a Parigi nel 1944, nella
quale si legge sul cartellino, al posto della riga mancante
nell'originale, cioè sotto la data e a fianco della sigla, "F.
Romae," ed è stata accolta e ribadita da F. Winzinger, "Albrecht
Dürer in Rom," *Pantheon* (XXIV, 1966), 283 in seguito alla
scoperta di sia pur deboli tracce di lettere nel cartellino

dell'originale in occasione della pulitura del dipinto. Secondo
questa ipotesi nell'autunno del 1506 Dürer avrebbe prolungato
fino a Roma, passando presumibilmente per Firenze, il docu-
mentato viaggio a Bologna. L'ipotesi è suggestiva e non
appare improbabile. Non sono tuttavia ancora emerse prove
atte a dissipare le riserve di molti studiosi: cfr. la recente
recensione al volume dell'Anzelewsky da parte di D. Kuhrmann,
Kunstchronik (XXVI, 1973), 289 (a p. 307 sg.). L'Anzelewsky
discute del *Cristo fra i dottori* a p. 58 e specialmente a p. 203.

saggio per Firenze nell'autunno del 1506, alla bottega di Leonardo. Inoltre la cosiddetta *Avarizia* (per l'Anzelewsky *Lussuria*) dipinta a tergo del ritratto di *Burcardo di Spira* si dovrebbe collegare con la *Vecchia* "col tempo" di Giorgione, ma essa sarebbe vicina, anche nella tecnica—sottile e fluido lo strato del colore—al *Cristo fra i dottori*, e ambedue i dipinti richiamerebbero alle caricature di Leonardo: e per la *Avarizia-Lussuria* si dovrebbero anche ricordare il disegno di Leonardo a Vienna della *Coppia male assortita* e il foglio del Christ Church College di Oxford con allegoriche vecchie dai penduli seni.

Se adesso vogliamo, sulla traccia delle riprese di motivi indicate dalla critica, cercare di renderci conto di che cosa di volta in volta Dürer abbia cercato in Leonardo, non ci converrà sostar molto sui primi, e certo indiretti, contatti verificatisi durante il soggiorno veneziano (e magari il possibile passaggio per Milano) del 1494-1495. Lo schizzo del cavaliere sul corazzato destriero mascherato da unicorno nel foglio degli Uffizî è sì dotato di una rapidità e vibrazione inconsuete a Dürer, tanto da giustificare pienamente le calorose espressioni del Pauli, "wo sonst als bei dem grossen Seltsamen finden wir diese phantastischen Formen beisammen? Die Umdeutung des Rosses in das Einhorn, die in eine Spitze ausgezogene Bildung des Kopfpanzers des Tieres, das aufgesperrte Tiermaul, aus dem der Pferdeschweif hervorschaut?"[13] ma rimane un episodio senza conseguenze per la maturazione del pittore tedesco e si può attribuire ad un momentaneo entusiasmo del nostro di fronte alla levità del segno ed alla chiaroscurale vibrazione di qualche capriccio leonardesco capitatogli sotto gli occhi. E così ha poco senso discutere, come pure si fa, se i motivi leonardeschi del Bambino e del lieve reclinar della testa della Vergine nell'incisione, di poco anteriore al 1497, della *Madonna del giacco* siano derivati da esemplari del maestro o da Lorenzo di Credi; quei motivi non furono sentiti da Dürer come specificamente leonardeschi, ma come genericamente italiani. Rispondevano al desiderio di trovare motivi di una "grazia" e di una "intimità" più naturali e più rivestite di carne di quelle che fino allora gli avevano offerto Schongauer e il Maestro del Libro di Casa. Il vero incontro con l'arte di Leonardo—ed è grande merito del Panofsky l'averlo segnalato—avvenne qualche anno più tardi, nel 1502, ed impresse il suo segno in alcune opere di quell'anno e di quello seguente. Il Winzinger ha di recente affacciato una suggestiva ipotesi per spiegare come nella lontana Norimberga Dürer abbia potuto mettere gli occhi su qualche documento dell'arte del fiorentino: la visita di Giovanni Galeazzo da Sanseverino all'amico e compagno di studî Willibald Pirckheimer. Risulta infatti da una minuta di lettera del Pirckheimer a Konrad Celtes del marzo 1503 che Galeazzo si trovava a Norimberga nel giugno 1502, dove rimase coinvolto nella sfortunata vicenda della "scaramuccia di Affalterbach" il 19 di quel mese (una delle non infrequenti incursioni del margravio di Brandenburgo).[14] Il conte Galeazzo, sposo di una figlia naturale

[13]"Dürer, Italien und die Antike," 59.

[14]F. Winzinger, "Dürer und Leonardo," *Pantheon* (xxix, 1971), 3. Brillante saggio, e di importanza notevole, ma limitato al tema del cavallo. La testimonianza della presenza del conte milanese Giovanni Galeazzo di Sanseverino a Norimberga, ospite di Willibald Pirckheimer, nel giugno del 1502 e della sua sfortunata apparizione alla "scaramuccia di Affalterbach" è contenuta nella minuta in latino di una lettera indirizzata dal Pirckheimer a Konrad Celtis nel marzo del 1503, pubblicata da E. Reicke–A. Reimann, *Willibald Pirckheimers Briefwechsel*, 1 (Monaco, 1940), nr. 58, e riportata in traduzione tedesca in W.P. Eckert–C. v. Imhoff, *Willibald Pirckheimer, Dürers Freund* (Colonia, 1971), 330.

di Lodovico il Moro, era a sua volta amico di Leonardo, al quale risulta (da un appunto di Leonardo stesso) che prestava cavalli come modelli per i progettati monumenti equestri milanesi, e non è pertanto incredibile che, conoscendo la grande amicizia del Pirckheimer per Dürer e il vivo interesse di questo per l'arte italiana, abbia portato con sé una cartella di disegni di Leonardo, non limitati—possiamo credere—all'argomento del cavallo.

Ora, del 1502–1503 sono di Dürer alcuni disegni acquerellati di piante, il più famoso dei quali è la *Grande zolla*, ed alcuni disegni di animali, fra i quali emerge per bellezza e per fama il *Leprotto*. Nessuno, se non erro, ha mai pensato a collegare queste opere, che sono al tempo stesso straordinarî pezzi di bravura ed altrettanto straordinarie espressioni artistiche, ad impressioni leonardesche. Eppure è questo uno dei momenti nei quali, a prescindere da puntuali riprese di motivo, meglio si manifesta l'affinità spirituale fra i due artisti, la convergenza dei loro interessi, il loro comune uso del linguaggio figurativo come incisiva prosa scientifica che al di là delle loro intenzioni si traduce in alta poesia. Certo, nel dipingere il *Leprotto* (Fig. 1), Dürer dovette fare appello a tutta l'esperienza della pittura fiamminga acquisita durante il quadriennale vagabondaggio per la Germania, che—è ormai dimostrato—lo portò fino ai limiti occidentali della "Germania inferior" ossia nei Paesi Bassi e nelle Fiandre: lo dimostra la capillarità dell'analisi, ne fornisce la riprova la sbarra della finestra riflessa nell'occhio dell'animale, che cosí funziona come lo specchio convesso in ben noti dipinti di Van Eyck, del Maestro di Flémalle e di Petrus Christus.[15] Ma in virtù della fermezza del disegno generale e della sensibilissima gradazione delle tinte in accordo col variare dell'incidenza della luce, i particolari infinitesimi non si sommano, ma si fondono in un'alta sintesi tutta tesa a cogliere il palpito vitale della bestiola. A prima vista nulla può apparir più diverso della vibrante immobilità del leprotto dalle agilissime e guizzanti immagini di gatti schizzate da Leonardo o dallo slancio che appena si blocca nella tensione dell'artigliata zampina nell'ermellino (o donnola) in braccio a Cecilia Gallerani (Fig. 2). Ma è comune l'intento di fissare in una vigorosa e conchiusa immagine—immobile in Dürer, nel compatto articolarsi della forma, come una natura morta, mobilissima invece nel Vinci perché incentrata sulla meccanica del movimento—il calore vitale dell'animale.

Un analogo senso della vitalità della natura anima gli studî di piante di Leonardo e quelli di Dürer. Certo, il pittore di Norimberga non si preoccupa di scoprire le leggi della fillotassi ed è più interessato all'anatomia che alla fisiologia della pianta. Ma nella *Grande zolla*, del 1503, per la quale la critica non ha accolto il precoce suggerimento dell'Ephrussi,[16] che richiamava oltre che al Pisanello a Leonardo, le sfumature del verde sono colte con un impegno che ricorda le scientifiche osservazioni del *Trattato* vinciano sul variar dei colori nella luce, e l'ammirazione per l'umile capolavoro della natura si esprime, oltre che nel vigore del segno e nella strenua analisi, nella scelta di un punto di vista raso terra: sicché quel cespo di erbe e di fiori campestri acquista la solennità e la forza di un gruppo di alberi nella foresta. L'intento e il risultato sono in questi studî botanici gli stessi che in Leonardo: nessuna attenzione alle possibilità ornamentali o comunque "estetiche" del motivo, ma impegno di verità, invece, ed un'esaltazione commossa della potenza vitale della natura. E a questo punto si può

[15]Sul motivo della finestra riflessa nell'occhio, cfr. l'articolo di J. Białostocki in questo volume (pagg. 61–72) e la biblio-

grafia ivi citata.

[16]*Albert Dürer et ses dessins* (Parigi, 1882), 79.

affacciare l'ipotesi che Dürer non fosse ora—nel 1503, a Norimberga—al suo *primo* incontro con la botanica vinciana, ma avesse già avuto occasione di vedere qualche studio di piante di Leonardo sette od otto anni avanti a Venezia o a Milano. Nella *Madonna delle Prealpi*, rinvenuta ridipinta e vagante sul mercato dal Longhi ed oggi pulita e in collezione privata a Schweinfurth, si vede sulla sinistra un gruppo di alberi (Fig. 3), che per conformazione ed anche, a giudicar dalla foto, per certi aspetti dell'illuminazione richiama al ciuffo di pioppi di Windsor nr. 12,431 (Fig 4), che insieme con lo schizzo di un albero sul verso della stesso foglio illustra il seguente enunciato: "Quella parte dell'albero che campeggia di verso l'ombra è tutta d'un colore e dove li alberi overo rami son più spessi ivi è più scuro, perchè lì manco si stampisce l'aria. Ma dove li rami campeggiano sopra altri rami, quivi le parti luminose si dimostrano più chiare e le foglie lustre per lo sole che le allumina."[17] La *Madonna* di Schweinfurth fu probabilmente dipinta a Venezia nel 1495 o in patria poco dopo il ritorno, il citato foglio di Windsor è datato dal Popham c.1498 e dallo Heydenreich, più latamente, fra il 1495 e il 1500,[18] sicché il rapporto potrebbe davvero sussistere. Eppoi non è detto che fra i tanti disegni di Leonardo scomparsi non ce ne fosse uno analogo. L'idea di rappresentar la Madonna sullo sfondo di un paesaggio nonché il taglio della composizione sono attribuiti dall'Anzelewsky[19] all'influenza di un gruppo di Madonne belliniane degli anni novanta. Ma io mi chiedo se quel paesaggio senza abitacoli umani, con arboree siepi e corsi d'acqua o palustri stagni e quell'accenno alle Prealpi nel fondo non possa invece risalire a idee leonardiane del tipo di quelle registrate in alcune giovanili Madonne sue o della sua scuola.

Per la *Madonna con molti animali* (Fig. 5) è del Suida l'osservazione dell'origine leonardesca del motivo del Bambino, che la critica successiva si è per lo più dimenticata di raccogliere. Ma c'è ben altro. A parte che il volto della Vergine, inclinato e malinconico, con le palpebre abbassate, ricorda vivamente la Madonna dell'*Adorazione dei Magi* (Fig. 6) di Leonardo agli Uffizî, se abbandoniamo il terreno sicuro ma limitato degli imprestiti di motivi non tarderemo ad osservare in questo delicato acquerello una trepida leggerezza di segno, una sfumata vibrazione di chiaroscuro e di luce che accomuna figure e paese, piante ed animali in una dolce amistà universale. Gli stessi pastori esultanti all'apparir della stella, le pecore del gregge, le casette, il borgo lontano, gli alberi sfumanti in nubilosi pennacchi, le rocce scoscese, le alpestri montagne dello sfondo, le nubi d'ovatta che fan da coltre alla calata dell'angelo, tutto è schizzato con fluidità e leggerezza inconsuete al maestro; e l'occhio percorre il quadro (come in genere quelli di Leonardo) recedendo dai primi piani ai lontani, attratto dal continuo allargarsi del respiro compositivo. Il tratto lieve e tremulo del disegno diventa quasi un equivalente dello sfumato leonardesco e come quello concorre ad esprimere l'atmosfera di un cosmico idillio. Molto acutamente il Panofsky fa cadere la breve ma affettuosa citazione di questo disegno nel mezzo del discorso sulla serie xilografica della *Vita di Maria*.[20] E io mi

[17] J.P. Richter, *Literary Works of Leonardo da Vinci* (Londra, 1883; 2° ediz. Londra, 1939), §456.

[18] A.E. Popham, *Catalogue of the Drawings of Leonardo da Vinci in the Collection of His Majesty the King at Windsor Castle* (New York-Cambridge, 1935), 60, e *The Drawings of Leonardo da Vinci* (New York, 1945). L.H. Heydenreich, *Leonardo da Vinci*, English edition (New York–Basilca, 1954), pl. 16c.

[19] *Albrecht Dürer. Das malerische Werk*, catalogo nr. 17.

[20] *The Life and Work of Albrecht Dürer*, 97: "Like the delightful water colour drawing known as *The Virgin with a Multitude of Animals*—with the wicked fox tied to a tree stump, a little griffon dog attacked by a stag beetle, and St. Joseph engaged in wistful conversation with the stork—the Life of the Virgin is pervaded by an atmosphere of intimate warmth, tenderness and even humor."

chiedo se quello spirito di calda intimità che pervade—come unanime ha avvertito la critica—quelle stampe non sia stato reso possibile dall'esperienza leonardesca che più direttamente si riflette nel foglio della *Madonna con molti animali*. Ciò che ora Dürer cercava in Leonardo era il modo per addolcire la sua forte presa sulla realtà.

Ed è questa richiesta di addolcimento, questa ricerca di un'ombra di dubbio capace di mitigare la perentorietà del suo segno, l'aspra certezza della sua parola grafica che muove l'artista a guardare a Leonardo quando fissa sulla carta volti di uomini e di donne. L'indicazione è dovuta, come si è visto, al Panofsky, il quale cita a questo proposito i ritratti della *Donna sorridente* di Brema e del *Giovane dal sorriso* già in collezione privata a Londra, ambedue a punta d'argento (W. 277, 278), la testa di Madonna di Berlino, a carboncino (W. 275) e, fra i dipinti, la *Madonna a mezza figura* di Vienna, anch'essa, come i disegni, del 1503, e il *Ritratto di Endres* a Budapest, del 1504. Ma tre disegni almeno, non ricordati dal Panofsky, sono da aggiungere al gruppo. Il ritratto del *Giovane diciottenne* dell'Accademia di Vienna, a carboncino, del 1503 (Fig. 7), presenta una tenerezza di chiaroscuro che è difficile interpretare diversamente che come una traduzione dello sfumato di Leonardo. Certo, Dürer è sempre incisivo e fermo nel cogliere la forma, e qui l'ampio arco descritto dal berretto basta ad ancorare con sicurezza l'immagine al piano e allo spazio, ma il chiaroscuro vibrante, l'allungarsi in orizzontale della bocca e della sopracciglia, la lieve asimmetria degli occhi introducono un accento di transitorietà e d'incertezza nell'espressione psicologica del giovinetto. Il *Ritratto del Pirckheimer* a punta d'argento (W. 268) presenta già una sottile vibrazione dei tratti sensibili e lievi che in qualche modo lo accosta alla *Madonna con molti animali*, ma quello di Berlino (W. 270), eseguito col duttile mezzo della matita a carboncino (Fig. 8), ha una densità e delicatezza pittorica ed una sospensione espressiva prima del tutto inconsuete al maestro. Il Panofsky, che non scorge il rapporto con Leonardo, sottolinea tuttavia giustamente la ricchezza pittorica del modellato e legge volontà di potenza e intelligenza sottile nella fronte taurina, mentre "la bocca esprime non solo sensualità ma anche erasmiana ironia," e giustamente nota nel profilo qualcosa della dignità di un imperatore romano, supponendo questo aspetto suggerito da una medaglia.[21] Ma proprio questa idea di ritrarre medaglisticamente i volti delle persone è leonardiana, e si possono ricordare i profili del Salai Windsor 12,557, del 1496–1497 c., e 12,554, datato dal Popham c. 1504, ma la più forte affinità stilistica si riscontra forse con lo studio di una testa per il *Cenacolo*, Windsor 12,548 (Fig. 9). E un'aura leonardesca, anche se meno precisabile, è nel ritratto berlinese, a carboncino, di *Crescentia Pirckheimer* (W. 269), anche per la costruzione ampia della testa e del busto. Infatti tutti questi ritratti, a differenza dei rari disegni di teste e mezzibusti del Dürer anteriori al 1500, si accampano in modo nuovo ed ampio nello spazio, con quella loro rotondità della testa e delle spalle che rimanda a un modulo formale sferoidale che Leonardo era stato il primo a raggiungere e che soltanto in questi anni stava trapassando in Raffaello. Sul leonardismo della testa di *Madonna* di Berlino (W. 275) che—quasi a conferma di quanto si accennava di sopra—fu utilizzata per una delle stampe della *Vita di Maria*, non occorre insistere perchè fu già riconosciuto dal Panofsky. Ma è proprio questa testa, con quella sua sospensione espressiva, quasi di un sigillo che sta per disserrarsi, che ha permesso a chi scrive di riportare a questo momento

[21]*ibid.*, 90.

l'acquerello su tela della Biblioteca Nazionale di Parigi, che il Panofsky datava sul 1520 ed altri poneva invece nel 1496.[22] Credo si debba aggiungere alla serie dei ritratti del 1503 in qualche modo ispirati a Leonardo anche quella testa di *Uomo sofferente* (W. 271 ; Fig. 10), che il Panofsky mette in rapporto con l'epidemia manifestatasi a Norimberga a partire dall'estate di quell'anno.[23] La densità chiaroscurale e l'escavazione delle implicazioni psicologiche del dolore fisico le conferiscono una forte aria leonardesca e richiamano alla mente lo schizzo vinciano della testa di un *Cristo portacroce* a Venezia, databile c. 1499-1500 (Fig. 11), che daltronde sembra sia stato ripreso anche in uno scomparso dipinto del Dürer (Anzelewsky 126 K). E la testa di *Cristo morto* disegnata dall'artista durante la sua malattia (W. 272) potrà sì esser debitrice per lo scorcio audace ad opere simili alla *Testa del Battista* di Giovanni Bellini, già attribuita a Marco Zoppo, ma pare anch'essa nell'intenso sfumato e nella profondità psicologica riflettere pensieri di Leonardo. Il Panofsky giudica poi leonardesca la testa del re in piedi nell'*Adorazione* del 1504 agli Uffizî. Ma io mi chiedo se il leonardismo di questo dipinto non vada al di là di questo particolare. Anzitutto anche il vecchio re in ginocchio (Fig. 12) ha una testa assai leonardesca, che può trovar rispondenza in alcune teste dell'*Adorazione* incompiuta del Vinci agli Uffizî e specialmente in quella del vecchio che porta la mano alla fronte (Fig. 13) a destra (per l'osservatore) della Madonna. Maggiore importanza ha a parer mio il fatto che gli edifici in rovina, sulla sinistra, simboleggianti secondo una ormai antica tradizione il crollo del mondo pagano, non si dispongono come di solito nella pittura transalpina in modo casuale e pittoresco, ma organizzano le loro forme, decisamente romaneggianti, in una esatta costruzione prospettica che assume per la composizione un effetto determinante. Ed a parte l'assenza del motivo, troppo "stravagante" per potere essere facilmente ripreso, della scalinata, le forme stesse di quell'architettura, con le grandi arcate archirotonde e i loro conci a raggera, non sono troppo lontane da quelle immaginate da Leonardo in alcuni disegni, fra cui quello famoso degli Uffizî, e solo parzialmente utilizzate nel dipinto : anche se Dürer da buon oltramontano non esiti ad appoggiare a quei ruderi solenni pittoreschi trabiccoli di legname indubbiamente ispirati all'architettura rustica della sua terra. Che Dürer si sia ispirato a qualche schizzo di Leonardo per lo sfondo della sua *Adorazione* mi sembra tutt'altro che fuori dalle possibilità, tanto più che nella appena precedente *Adorazione del Bambino* della Pala Paumgartner, databile dal 1502 al 1504, si riscontra già un tentativo, meno rigoroso, di coordinare prospetticamente simili romaneggianti edifici, e qui anzi è ripreso, se pur trasferito sul lato destro, anche il motivo del portico, che compare, di là dalla prima scalinata, sul lato sinistro del disegno prospettico degli Uffizî. In questa tavola poi i lievi, fruscianti angioletti che si affollano intorno al Bambino e par lo sollevino da terra (Fig. 14) trovano riscontro in una serie di schizzi di Leonardo che registrano prime, rapidissime idee per il Bambino nell'*Adorazione dei Magi* di Firenze, come nei fogli di Venezia (Fig. 15) e di Amburgo (Popham 40B, 41) o per quello della *Madonna del gatto*, come in un

[22]R. Salvini, "Dürer. Mezzo Millennio," *Commentari* (XXII, 1971), 289 (a 290).
[23]*The Life and Work of Albrecht Dürer*, 90. La stessa datazione al 1503 era nel frattempo raggiunta, attraverso un esame tecnico che portava alla scoperta di una data leggibile con ogni probabilità 1503, da W.L. Strauss, "Portrait of a Lady,"

Gazette des Beaux-Arts (LXXVII, 1971), 93. Cfr. anche il no. 84 del catalogo della Mostra "Albrecht Dürer. Ausstellung des Germanischen Nationalmuseums Nürnberg 1971" (Monaco, 1971) che da notizia della scoperta prima dell'uscita dell'articolo dello Strauss.

disegno del British Museum (Popham 11). E si potrebbe ancora procedere e riscontrare nel Giobbe della cosiddetta Pala Jabach una testa piena di dignità leonardesca, o suggerire che a spiegare l'equilibrata elasticità di posa del suonatore di piffero nell'altra tavola "Jabach" (Fig. 16) non basti il *Mercurio* dei tarocchi ma occorra anche richiamarsi a qualche esemplare vinciano del tipo del nudo di spalle (Fig. 17) in un foglio del Louvre (Popham 44).[24] Ma è più importante osservare come nei *Magi* di Dürer agli Uffizî compaia una sorta di composizione piramidale col suo vertice nella testa del re stante, che potrebbe essere una libera ripresa della composizione piramidale dell'*Adorazione* di Leonardo, anche se lì il vertice è nella testa della Vergine. Per verità, Dürer già conosceva ed aveva applicato la composizione piramidale nella xilografia e nella tavola del *Compianto sul Cristo morto* (Monaco), desumendola da precedenti di Geertgen tot Sint Jans. Ma era una piramide erta, dalla base relativamente stretta e dal vertice altissimo, profondamente diversa nelle sue conseguenze espressive da quella più ampia e riposata della composizione vinciana.

Se è così, credo che si dovrà risolvere a favore di un'origine leonardesca la questione della fonte della composizione piramidale nella pala veneziana della *Madonna del Rosario*, questione dibattuta fra lo Strzygowski che l'affermò, i Tietze che la negarono e l'Anzelewsky che propone adesso una soluzione salomonica.[25] Del resto, durante il soggiorno veneziano del 1505–1506 Dürer continuò a sfruttare vecchie impressioni leonardesche o ne ricevette di nuove. Certo è—benché la critica, se ho ben visto, assolutamente ne taccia—che il ritratto a penna di una contadina slovena, la *Vilana windisch* del British Museum (Fig. 18), incontrata nell'autunno del 1505 fra gli "schiavoni" di Venezia non è meno leonardesco di quello della *Donna ridente* di Brema, di due anni prima.[26] Le due immagini si accampano con eguale sicurezza nello spazio attraverso la costruzione sferoidale della testa e del busto, ambedue sono colte in un momentaneo sorriso. Nessuno all'infuori di Leonardo avrebbe potuto suggerire a Dürer quel modo incisivo e rapido di fermare un'espressione momentanea e transitoria, diffondendo il passeggero sorriso su tutto il volto, su tutta intera, si direbbe, la personalità del modello. E non c'è bisogno di scomodare il sorriso della *Gioconda*, poichè i sorrisi abbondano, lievi—or più segreti or più aperti—in tanti schizzi di angeli e di Madonne del Vinci. Che poi nell'uno e nell'altro caso la dipendenza da esemplari leonardiani sia prontamente riscattata dallo spirito di franca, esuberante vitalità nel quale è immersa l'immagine, va ascritto alla forte personalità del maestro di Norimberga. Nessuno ha mai sospettato un'ispirazione leonardesca nel bellissimo *Ritratto di un moro* che reca la sospetta data 1508 e fu invece

[24]Nel *Mercurio* della ben nota serie dei tarocchi (vedilo adesso nello splendido catalogo di J.A. Levenson–K. Oberhuber–J.L. Sheehan, *Early Italian Engravings from the National Gallery of Art*, Washington, 1973, nr. 55) infatti la figura ha un'accentuata ondulazione che nel suonatore di piffero Jabach si traduce in una curva armoniosa ed equilibrata, come appunto, fra l'altro, nel citato schizzo di Leonardo.

[25]Cfr. J. Strzygowski, "Dürers Madonna vom Jahre 1519, sein und Holbeins Verhältnis zu Leonardo," *Zeitschrift für bildende Kunst* (XII, 1901), 236; H. Tietze-E. Tietze-Conrat, *Der junge Dürer* (Augsburg, 1928); Anzelewsky, *Albrecht Dürer. Das malerische Werk*, 192: "Man wird Dürer also zuerkennen müssen, diese neue Bildkomposition mitgeschaffen zu haben."

[26]Non ha importanza in questo contesto il problema del-

l'autografia del disegno su carta del British Museum di recente negata da H. Musper, "Das Original der 'Windischen Bäuerin' von Albrecht Dürer," *Pantheon* (XXIX, 1971), 474, che lo ritiene copia—antica e di un notevole ma difficilmente identificabile artista—di un disegno su pergamena in collezione privata, cui spetterebbe il vanto di essere l'originale di mano del maestro. Sena pretendere di dare un giudizio sul difficile problema, non riesco tuttavia—nonostante l'indubbio peso degli argomenti "microstilistici" e grafologici proposti dal Musper—a sottrarmi all'impressione di una maggiore spontaneità e freschezza del foglio londinese rispetto alla pergamena, la quale—stante la sua alta qualità—potrebbe anche essere un'autocopia, con meditate correzioni di particolari e perdita di qualche grammo di freschezza espressiva.

probabilmente eseguito nel 1506–1507 a Venezia (Fig. 19).[27] Un'aria leonardesca spira indubbiamente anche da questo ritratto, che sarebbe ingiusto ritenere—come pure quasi tutti credono—promosso dal pratico intento di arricchire il campionario di un modello utile per il re moro di una futura *Adorazione dei Magi*. Dürer fu piuttosto mosso dall'impulso ad impossessarsi di un aspetto inconsueto della realtà—un impulso appunto di natura scientifica e leonardiana. Ma non ci si deve fermare al valore documentario dell'immagine. Delineata con mano sicura, essa reca tuttavia con sé, nelle superfici teneramente accarezzate dallo sfumato, non so qual senso di sospensione, e dalla dialettica dei due momenti nasce quel senso di ammirato stupore di fronte ad una dignità e ad una bellezza che si manifestano in tanto insolito aspetto.

A parte questi ritratti, assonanze vinciane si rilevano in altre opere di questo momento. Il foglio di Monaco con animali in lotta richiama, come già da lungo tempo è stato riconosciuto, ad esemplari leonardeschi del tipo dei noti fogli di Windsor con studî di felini, cavalli ed altri animali. Anche qui, se il turbine di moto universale che nei fogli di Leonardo nasce dal, pur non intenzionale, concatenarsi dei singoli schizzi si arresta sotto il segno vigoroso e possessivo della penna di Dürer in una serie di impulsi continuamente bloccati di indubbia suggestione drammatica, dipende dall'alta capacità del grande artista di far proprio ogni stimolo esterno.[28] Il leonardismo del quadretto del *Cristo fra i dottori*, "opus quinque dierum," è stato opportunamente ridimensionato da un brillante saggio del Białostocki.[29] Ma che una almeno delle facce dei dottori derivi da una ben nota "caricatura" di Leonardo sembra indubitabile, e che, pur rifacendosi a una tradizione nordica, Dürer si avvicini nello spirito al Vinci è con giusta enfasi affermato dal Białostocki. Dürer avrebbe seguito il principio leonardesco dell'opposizione diretta del bene e del male incarnati da immagini di giovanile bellezza e di ripugnante vecchiaia, nonché il precetto vinciano della varietà dei tipi. Ma qui cade a proposito l'inedita osservazione che in alcune almeno delle facce dei dottori è già il seme che darà vita, vent'anni più tardi, alle imperative, ammonitrici sembianze dei *Quattro Apostoli*: la fermezza infatti con la quale la linea sigilla il rilievo dei volumi ed arresta sul filo di un'aspra tensione il processo della deformazione caricaturale mi pare che preluda, stilisticamente, alla prorompente eppure bloccata terribilità degli *Apostoli*. Così, a mio parere, i dottori del quadretto di Lugano furono intesi da Dürer più che come incarnazioni del male in assoluto, come simboli di un'ostinazione intellettuale impermeabile alla luce

[27]Cfr., per un accenno al "leonardismo" di questo ritratto, R. Salvini, "Dürer, Mezzo Millennio," 301 e, per la datazione al secondo periodo veneziano, anche P. Strieder nel catalogo della Mostra "Albrecht Dürer. Austellung des Germanischen Nationalmuseums Nürnberg," nr. 534, il quale osserva, attribuendola ad influsso veneto, "la fattura straordinariamente pittorica nel giuoco della luce sulla pelle scura."

[28]Ogni rapporto di questo disegno con esemplari leonardiani è stato negato da B. Degenhart–A. Schmitt, "Uccello: Wiederherstellung einer Zeichnung," *Albertina-Studien* (I–II, 1963–1964), 101 e in *Corpus der Italienischen Zeichnungen*, nr. 310, 311, i quali hanno dimostrato che le origini del motivo risalgono ad una scomparsa tavola di Paolo Uccello con "battaglie de draghi et leoni" nella camera grande terrena di Lorenzo de' Medici, di cui è un'eco in due disegni da campionario dello stesso Paolo. Non s'intende diminuire affatto l'importanza della scoperta di Degenhart-Schmitt se si osserva che tuttavia la disposizione dei gruppi degli animali nel disegno di Monaco presenta chiare analogie con i fogli di Leonardo a Windsor con cavalli e con gatti. Inoltre Winzinger, "Dürer und Leonardo," p. 7, ha segnalato un'impressionante corrispondenza fra le teste dei due cavalli assaliti nel presente foglio e le teste di due cavalli in un disegno di Leonardo a Cambridge. È da ritenere pertanto che Dürer, derivando il motivo da ricordi grafici della perduta composizione di Paolo Uccello, lo abbia ricomposto sotto l'influenza di disegni leonardeschi, e forse questo lavoro combinatorio è da tener responsabile di quell'ombra di fatica che in questo foglio si avverte e che ha fatto dubitare talvolta dell'autografia (cfr. Kuhrmann in B. Degenhart–D. Kuhrmann, catalogo della Mostra, "Dürer und seine Zeit. Zeichnungen und Aquarelle. München 14 Nov. 1967–14 Jan. 1968," Monaco, 1967.

[29]"Opus quinque dierum," *Journal of the Warburg and Courtauld Institutes* (XXII, 1959), 17.

della verità : le caricate fisionomie manifestano gli effetti di un assoluto, ottuso impegno dello spirito nella custodia gelosa di una fede immutabile. Si è ancora parlato di non ben definibili rapporti da un lato con Leonardo, dall'altro con Giorgione a proposito dell'*Avarizia* (o *Lussuria*) dipinta a tergo del ritratto del *Burckhard von Speyer*.[30] Ma gioverà anche qui, svincolandosi dalla servitù degli imprestiti di motivo, osservare che se da un lato la *Laura* terminata di dipingere da Giorgione il 1 giugno 1506 nella bottega di Vincenzo Catena non è immune da una certa aria leonardesca—dal momento che la nuova morbidezza pittorica che vi si riscontra appare generata da un discreto innesto dello "sfumato" leonardesco su quel "tonalismo locale" che il maestro di Castelfranco aveva prima dedotto da premesse poste da Giovanni Bellini ed anche da Hieronymus Bosch—dall'altro alcuni dei ritratti dipinti da Dürer a Venezia, come la *Fanciulla* del 1505 a Vienna, il *Fanciullo* dall'aspetto androgino del 1507 a Berlino e specialmente la *Dama* erroneamente identificata talvolta con la moglie Agnese, pure a Berlino, recano un'impronta leonardesca e al tempo stesso, per doti di profonda fusione pittorica e di luminosità, richiamano alla *Laura* e a Giorgione. Siamo purtroppo di fronte ad imponderabili, e non sarebbe possibile documentare queste mie asserzioni ponendo foto contro foto. Ma sono convinto che una costellazione Leonardo-Giorgione-Dürer dovette per una breve stagione apparire nel cielo pittorico di Venezia, e, lavorando di fantasia, si potrebbe immaginare una discussione di Giorgione ed Albrecht davanti a qualche esemplare di Leonardo approdato sulle rive della laguna.

Più tardi gli incontri col mondo artistico di Leonardo saranno per Dürer sporadici e occasionali.[31] Ma nel periodo della formazione essi non ebbero, a mio parere, un'efficacia minore di quella che si è soliti attribuire ai contatti col Mantegna e con Giovanni Bellini. Dopo aver chiesto a Leonardo, al tempo del suo primo incontro con l'Italia, non più di quanto chiedeva agli altri artisti italiani incontrati sul suo cammino, Dürer, attratto dal severo impegno scientifico del Vinci, lo andò via via consultando nello sforzo di cogliere al di là della struttura formale delle cose il palpito vitale della natura, lo elesse a maestro di propor-

[30]Cfr. specialmente Anzelewsky, *Albrecht Dürer. Das malerische Werk*, 40 sg., il quale riconosce un taglio giorgionesco nel ritratto del *Burckhardt von Speyer*, ma v. anche V. Oberhammer, "Résumé : Albrecht Dürer, Portrait of Vanitas in the Vienna Gallery," *Pantheon* (xxv, 1966), 155.

[31]Appare incerto—come giustamente osserva l'Anzelewsky, *ibid.*, 82—che il disegno della *Lucrezia* del 1508 (e il quadro del 1518) rifletta studî di Leonardo per la *Leda*, poiché totalmente manca nel disegno di Dürer la torsione del corpo ; è quindi improbabile l'ipotesi avanzata più oltre (p. 247) dallo stesso Anzelewsky che Dürer abbia potuto vedere la *Leda* incompiuta nello studio di Leonardo, passando per Firenze nell'autunno del 1506. Non sembra sostenibile l'asserzione di E. Tietze-Conrat, "Albrecht Dürers Grosser Kreuzigungsholzschnitt," *Belvedere* (ix-x, 1926), accolta dal Suida, *Leonardo und sein Kreis*, che uno dei ladroni della *Grande Crocifissione* xilografica derivi dal leonardesco disegno di un *S. Sebastiano* a Bayonne (che fra l'altro non è di Leonardo), ed anche mi pare assai dubbio che il Cristo seduto del frontespizio della *Grande Passione* xilografica, del 1511, derivi—come propone il Suida—dal *Battista-Bacco*, di scuola leonardesca, al Louvre, l'unico motivo comune alle due figurazioni essendo quello delle gambe accavalciate e per di più in due diverse varianti. Riecheggiano ancora Leonardo, naturalmente, il cavallo dell'incisione del *Cavaliere*,

del 1513, e gli studî fisionomici di W.656, 657, databili c. 1515, ciò che va pienamente daccordo col fatto che Dürer andava in quegli anni elaborando il trattato sulle proporzioni del corpo umano. Ed è giusta l'osservazione del Panofsky, *The Life and Work of Albrecht Dürer*, 149, sullo sfumato leonardesco nella puntasecca della *Sacra Famiglia*, del 1512 c., anche se forse più per quanto riguarda la tecnica che lo stile. La critica non ha, se ben vedo, raccolto l'osservazione del Suida circa la derivazione del foglio xilografico dell'*Uccisione di Abele* (B.1), del 1511, da idee leonardiane per la *Battaglia d'Anghiari* come quelle registrate in tre rapidissimi schizzi in un foglio di Venezia. Eppure Dürer raggiunge in quella stampa l'espressione di un'azione continua e furiosa in una unità di gesto che par veramente suggerita da quegli schizzi (o più probabilmente da successivi più elaborati studî del motivo). Ma poiché una figura molto simile a quella dell'Abele già compare nella *Cattura di Cristo* della *Passione Verde*, bisogna ammettere che Dürer si sia servito due volte di quel modello di Leonardo, una prima volta soltanto per la figura abbattuta, una seconda volta per l'intero gruppo. Ricordi di Leonardo riaffiorano insomma più volte nel Dürer maturo (così come un preciso modulo compositivo di Giovanni Bellini riaffiora nei *Quattro Apostoli*), ma l'azione formativa delle impressioni leonardesche su Dürer si attua in sostanza dal 1502 al 1506.

zioni e di prospettiva, ne assorbí un più vasto respiro compositivo. Ma specialmente riuscì a carpire qualcosa di quella crepuscolare vibrazione che Leonardo coglieva "per le strade sul fare della sera [ne] i visi di homini e di donne quando è cattivo tempo."[32] Il grande tedesco poteva cosí addolcire in una vaga atmosfera di universale fraternità la perentoria *presenza* delle sue immagini.

UNIVERSITÀ DI FIRENZE

[32]Vedi il passo famoso in *Treatise on Painting* citato a n. 5, a carta 51 r, §134 del facsimile (II vol.) e la sua traduzione in inglese nel vol. I, 70.

A Note on Early Titian: The *Circumcision* Panel at Yale

CHARLES SEYMOUR, JR.

I

The first Venetian painting to have come to the New World might be hard to identify. But what may well be the first Renaissance Venetian painting of prime art-historical significance to have been exhibited in the United States is recorded. It is the rather modestly scaled early-cinquecento panel representing *The Circumcision of Christ* in the Yale University Art Gallery (Fig. 1).[1]

The picture was introduced to these shores in 1859 by James Jackson Jarves, the Bostonian expatriate-collector. It was first shown in the exhibition of his Italian pictures in 1860 in New York at what was then known as the "Institute of Fine Arts," situated at the time at 625 Broadway. Three years later, at the height of the Civil War crisis, the picture was again publicly shown by Jarves, on that occasion at The New-York Historical Society, to which later came the small but distinguished group of early Italian paintings brought together by Thomas Jefferson Bryan, Jarves's only American rival as a pioneer in the collecting of Italian "primitives."[2] Within the succeeding decade Jarves's pictures were acquired in 1871 by Yale College, and the *Circumcision* was among those purchased. The details of the acquisition, at times the subject of dispute (usually generated, it must be said, beyond the confines of New Haven), do not touch the topic of this paper. What is of concern here is the justification of the phrase "art-historical significance" as it may apply to Venetian painting rather than to the lore of American collecting or the still broader parameters of the history of taste.[3]

It is of importance to realize, first, that between roughly 1870 and 1915, or for nearly two whole generations, while the picture was first at Yale, the panel remained outside the mainstream of study of Italian art; it simply was not seen by more than one or two of the handful of specialists who were only beginning to attack systematically the problems of Venetian painting that have since become so familiar on both sides of the Atlantic. Although by 1900 he had already begun to compile the "Lists," Bernard Berenson, according to all available records, never saw the Jarves Collection (including the *Circumcision*) in the original; but his

[1] Accession number 1871.95. Oil (it would seem) on panel, 36.6 × 7.94 cm. Restored 1915 and 1928. Cleaned 1967–1969. The most recent work on the panel at Yale was under the direction of Mr. Andrew Petryn, in charge of conservation in the Yale University Art Gallery. Catalogued (as Cariani) by O. Sirén, *A Descriptive Catalogue of the Pictures in the Jarves Collection belonging to Yale University* (New Haven, 1916), 231–32; C. Seymour, Jr., *Early Italian Paintings in the Yale University Art Gallery* (New Haven–London, 1970), 243–46 (as Titian).

[2] See [J.J. Jarves], *Descriptive Catalogue of "Old Masters," Collected by James J. Jarves to Illustrate the History of Painting from A.D. 1200 to the Best Periods of Italian Art* (Cambridge, Mass., 1860), 58. The essentials were reprinted under the authorship of Russell Sturgis, Jr., *Manual of the Jarves Collection* (New Haven, 1868). As a footnote to a footnote, it may be of interest that the model for Edith Wharton's protagonist-collector of Italian painting in the novel entitled *False Dawn* was not Jarves, as is often stated, but Thomas Jefferson Bryan. I am most grateful to Professor Philipp Fehl for information on the early importation to America of works of art from Italy; see in particular his recent article, "The Account Book of Thomas Appleton of Livorno," *Winterthur Portfolio* (IX, 1974), 123–51.

[3] The problems relating to the sale and acceptance of the Jarves Collection are outlined in F. Steegmuller, *Two Lives of James Jackson Jarves* (New Haven, 1951), and by T. Sizer, s. v. "Jarves" in *Dictionary of American Biography*—later expanded in a longer article, "A Forgotten New Englander," *New England Quarterly* (VI, 1933).

wife, Mary Logan Berenson, seems to have made the long journey, before World War I, to New Haven.[4]

It should also be emphasized that up to 1928, the picture was in a heavily repainted state, and the best available photographic reproductions could convey only the dull suggestion of turgid forms. The best of these reproductions was that made in 1915, after a "restoration" by Hammond Smith of New York (Fig. 2). Nonetheless, in reviewing his photographic data in anticipation of the revised edition of the "Lists" of 1932, Berenson does appear to have paused for an important moment as the older photograph of the Jarves *Circumcision* panel passed through his fingers. In 1928, in a letter to Theodore Sizer, then Curator at Yale, he wrote of his "feeling" that the panel was by Titian. He urged cleaning as a first step toward establishing the possibility of his attribution.[5]

Earlier, two different attributions had been made. The first, that of Jarves himself, when he compiled the catalogue for the exhibition of 1860, was to Giorgione. Then in 1915, Osvald Sirén, who had been retained by Yale University to write a new catalogue of the Jarves pictures, gave the *Circumcision*, as a partly finished "sketch," to Cariani. In 1928, at Berenson's suggestion, Sizer took the step of sending the panel to the Fogg for X-ray analysis (hitherto unutilized for any of the Jarves Collection pictures) and cleaning.

The Fogg Museum's X-ray report, written by Alan Burroughs, could hardly have been reassuring. It reveals a cautious, quite skeptical approach. On balance, the conclusion, if such it can be called, was in favor of a loosely phrased "Giorgionesque" style, neither surely Cariani's nor conceivably Titian's: "Even making an allowance for the difference between a sketch like the *Circumcision* and a finished work by Titian there seems to be no possibility of finding Titian's style here."[6] In the aftermath the panel was cleaned, and some inpainting supplied to lessen the effects of losses. A photograph (similar to Fig. 3) was made of the new state. In the 1932 edition of the "Lists," oblivious of the X-ray analysis by Burroughs, or at least overriding that analysis, if he had read it, Berenson included the Jarves *Circumcision* under the rubric of "Titian. Early" (that is, before 1511).

II

A discussion of the relationship between knowledge of the state of a painting and knowledge of its style as interlocking elements of a basis for attribution will, I hope, seem appropriate to a publication honoring Millard Meiss. No one has fought more valiantly than he in the cause of conservation—and study through conservation—of medieval and Renaissance paintings, including several of those in the Jarves collection. No one in our time has made finer contributions to knowledge along this line. And few probably know better than he the multi-headed hydra of controversy that may still remain in the area of attribution after what is loosely called "cleaning."

[4]That it was Mrs. Berenson, and not Berenson himself, who took notes on the paintings in the Jarves Collection before World War I seems to be the case, according to an indication made by Frank Jewett Mather in 1926; this was confirmed for me in conversation by the late Nicky Mariano. Mather not only visited the Jarves collection but published an interesting critique of its value in the *Yale Alumni Weekly* (May 20, 1914).

[5]A copy of Berenson's letter and the originals of Theodore Sizer's subsequent correspondence on this matter are preserved in the curatorial files of the Yale University Art Gallery.

[6]Typescript copies are in the conservator's and curatorial files of the Yale University Art Gallery.

The history of opinion on the Jarves *Circumcision* since the overpaints were removed in 1928 and Berenson's 1932 ascription to Titian has turned out to be something of a patchwork of conflicting ideas, and, as will be seen, in at least one case somewhat unpredictably so. What appears to have been abundantly evident to those who actually saw the painting after it was treated in the Fogg Museum was that though much was missing from the surface, particularly in the area of the heads of the group at the left, a great deal was left. Berenson's "act of faith," as published in 1932, was in many quarters considered justified. Even with only the mono-chrome photograph as a basis of study, there seemed to be sufficient evidence for a number of scholars to ratify Berenson's opinion rather than to stick by the older attribution of Giorgione. But in 1957 came an unexpected twist: Berenson reversed himself and, in the revised "Lists" of that year, denied the panel to Titian in favor of Giorgione.[7] Recent writers have in general tended to favor the Titian attribution; in a case or two, the condition of the picture offered ground for doubts, though as far as I know those doubts were not prompted by direct study either of the original or of the visual X-ray evidence which, until now, has remained un-published.[8]

The chief purpose of this paper is to make available at least some idea of that evidence and to cite additional evidence favoring Titian's hand. It will also offer a report on the current state of the panel's surface following a second cleaning that was decided upon in 1965, largely because of distortions of visual effect caused by darkening varnish, grime, and dis-coloration of the inpainting in oil that had occurred after 1928. These latter are in part visible in Fig. 3.

As a result of the most recent cleaning, the armature of human imagery and stage proper-ties for the scene was indeed found to be intact, as expected (Fig. 4). To speak of "over-cleaning" here would be to disregard unjustifiably the operation of 1928. What was removed between 1967 and 1969 was *essentially* what had been added in 1928 after a thorough removal of nineteenth-century overpaint. I italicize the word "essentially," because in all candor one cannot compare the two operations precisely. That of 1928 was only partially recorded photo-graphically; the second was photographed step by step and accomplished much more slowly, in stages over a period of nearly three years. Without doubt, more modern techniques and materials made possible the removal of discolorations that had resisted complete cleaning in 1928. But on the whole, the losses were found to be those already known. The most recent inpainting was kept to a minimum and done mainly to compensate for the glaring contrasts in value of the random peppered tones occasioned by past blistering. In the blue robe of the

[7]B. Berenson, *Venetian Painters of the Renaissance* (London–New York, 1957). On rereading Berenson's own published memoirs and above all the important diary entries edited by Miss Mariano under the title *Sunset and Twilight* (New York, 1963), particularly pp. 357, 373, I would think that the shift occurred in 1954–1955 when Berenson and his assistants at I Tatti were busied with a thorough-going review of Renais-sance Venetian painting, which was characterized by a dramatic change in emphasis on Giorgione. This was perhaps reenforced by Berenson's experience of the great Giorgione retrospective in Venice in the fall of 1955. The Jarves *Circumcision* was requested for the Venice exhibition, but for reasons of con-dition it was not sent.

[8]Longhi in 1946, Morassi in 1954 and 1966, Valcanover in 1960, and Pallucchini in lectures before his comprehensive monograph of 1969 all accepted the panel as Titian (Pallucchini with a note on its apparently poor condition, p. 232). Earlier, in 1937, Duncan Phillips (*pace* Pallucchini) gave the panel to Titian but under the strong influence of Giorgione, in fact in Giorgione's shop. In 1942, G.M. Richter thought the panel had been begun by Giorgione but finished by Titian. Latterly Wethey (*Titian*, 1, London, 1969, 500), at least partly on the basis of condition, it would seem, gave the panel to a "Giorgionesque Master." Freedberg (*Painting in Italy 1500–1600*, Harmondsworth–Baltimore, 1971, 477), on the contrary, gave the panel without hedging to Titian, ca. 1507–1508.

Virgin, inequalities of surface were smoothed by minute patches of gesso (Fig. 5). The in-painting was done where possible in neutral tones, and in all cases in tempera; instead of varnish, a coating of synthetic resin was sprayed on the surface.

Comparative study of the X-rays (see Figs. 6 and 7) will reveal fairly clearly that the design remains substantially intact, with no severe losses but with several interesting *pentimenti*; this, and the character of the brushwork, which includes some striking contrasts of touch, suggest that the painting was left incomplete by the artist. The overall design would appear to have been brushed in at first boldly, without careful underdrawing. Then in certain portions, concentrated mainly in the massing and edges of drapery folds, a much finer and more heavily loaded pointed brush was used to build up the body of the paint structure. The feathery effect, for example of the modeling of the Virgin's veil, has the look of form approaching finality. Of glazes, however, which Vasari mentions in connection with the late Titian, there is no trace. Whether they were planned here as a final surface layer is a matter virtually of pure speculation—though in some areas, such as the flat ivory tints of the clouds, this might have been the case. One could argue, however, that the cloud forms as we see them represent a simpler base on which more delicate tones were to be applied in body color rather than by glazing. On the whole, the pattern of flesh tones of relatively light atomic density and a far richer modeling of the drapery forms agrees with what can be seen from published X-ray photographs of paintings quite generally attributed today to the early period of Titian.[9]

So also do the changes evident in the *Circumcision* that seem to have been made during the course of painting. In the 1928 report Burroughs had mentioned that the sky near the Virgin's head had originally been intended to continue for an appreciable distance toward the right edge of the panel; the element of architecture with its simple molding, and very possibly too the bulk of the curtain, were painted over the sky as modifications, probably with the aim of framing more definitely the important profile of the Virgin's head. Originally, too, that head had been painted as at a slightly oblique angle instead of in the full classical profile, reminiscent of a medallion or a stone relief such as that painted by Titian on the parapet in the so-called *Schiavona* of the National Gallery. In the group of men in the left portion of the *Circumcision* panel there are to be seen changes in drapery pattern; more important, perhaps, the head of the youth nearest the frame edge was moved inwards at one point, to achieve a closer unity within the group and lead the eye toward the center of the composition.

To summarize in part, it would appear that the panel was left unfinished, though in some areas it had been brought along a fair distance toward completion. The intimate scale indicates the function of a domestic devotional object. The idea of a "sketch" seems unwarrantedly to predicate an anachronism, and the possibility of a "predella element" so remote as to abandon entirely. Equally untenable seems the notion previously advanced that the picture was begun by "one artist"—Giorgione—and finished by "another in the shop"—Titian. The painting is stylistically of a piece. One has the feeling that it grew more or less organically as it was

[9] I have in mind two well-known and well-examined paintings: the *Noli Me Tangere* and the so-called *Schiavona* in the National Gallery, London. The X-rays are published with commentary in W.H. Bragg–Ian Rawlins, *From the National Gallery Laboratory* (London, 1940), Figs. 14 and 15, and in C. Gould, "New Light on Titian's *Schiavona*," *Burlington Magazine* (CIII, 1961), 45–50, Fig. 2.

worked on, not that the changes reflect the hands of two artists. The X-ray evidence and the newly revealed color, in its full intensity of deep reds, brick browns, sulphurous and saffron yellows, and vivid greens tending toward bronze in the half-shadows, all point to Titian and away from Giorgione. There are additional analogies in style to Titian's frescoes of 1508 and 1511.[10] These considerations, which involve a new concept of monumentality, rather beyond Giorgione, certainly as we think we know him, deserve to be raised now.

III

The study of Titian's early period as a whole has benefited most in recent years from a more sympathetic approach to his fresco style of 1508–1511. Unfortunately the damage to the Fondaco dei Tedeschi series of 1508 places serious impediments, but, as work of conservation on them continues, apparently not by any means unsuperable ones. At Padua, in the Scuola del Santo, where Titian worked in 1511, it is far easier to sense his usual fusion of a personal warmth of feeling and a largeness of vision appropriate to monumental art. What I should like to emphasize here is that despite real differences in size, and to some extent in format, there are some remarkable connections between the Jarves *Circumcision* and the firmly dated monumental work of 1508 and 1511. Perhaps the most persuasive clues to the panel's authorship and date lie in this direction.

Let me cite first the loose, broad brushstrokes of the laying-in phase of the *Circumcision*. These strokes are remarkably close to the broad brushstrokes in fresco in certain scenes at Padua (Fig. 8). Similarly, the tilted pose first given the Virgin's head in the *Circumcision* is almost precisely the same as that given the relatively well-preserved head of the so-called *Judith* in the monumental frescoes of the Fondaco dei Tedeschi.[11] More noteworthy still is the clear influence on the *Circumcision* of what was then the greatest mural painting in the entire North Italian area: Leonardo's *Last Supper* in Milan (Fig. 9). It is believed that late in 1499, shortly after the "completion" of the *Last Supper*, Leonardo came to Venice and stayed there at least until the spring of 1500 was well along. He brought drawings and undoubtedly ideas that, as one can reasonably assume from his behavior elsewhere and on other occasions, he was glad to share with his temporary hosts. Influence from the *Last Supper* is found even in early-cinquecento Venetian sculpture, for example, in the fragment of an unfinished marble relief from the shop of the Lombardi of about 1500 or slightly later, preserved in Santa Maria dei Miracoli (Fig. 10).[12]

We find in the *Circumcision* panel changes in the background that echo in some ways the architectural framing of the figures in Leonardo's mural in Milan. The traditional "altar" in Venetian representations of the Circumcision has also been extended laterally; it suggests a

[10]See in particular the reproductions in A. Morassi, *Tiziano: gli affreschi della scuola del Santo a Padova* (Milan, 1956), Pls. I–XI, XVIII, XX, XXV. As regards color, I am also following the recent trend to give the Glasgow *Christ and the Woman Taken in Adultery* to Titian rather than to Giorgione.

[11]R. Pallucchini, *Tiziano*, II (Florence, 1969), figs. 12 and 14.

[12]I am indebted to David Alan Brown, who is preparing for publication a large-scale study of Leonardo's influence in Northern Italy outside Milan, for valuable comments on Leonardo's influence in Venice; and to Wendy Stedman Sheard, who is similarly preparing a new study of Tullio Lombardi, for equally valuable comments on the Lombardi *bottega*.

table, and the stripes of the cloth (Fig. 11) recall the embroidered stripe motifs of the table-cloth of the *Last Supper* (Fig. 12). The grouping of the three male figures at the left, also, recalls the grouping by triads of the Apostles. The strong pyramid of the central Christ at Milan, featured against the sky, finds counterparts in the *mohel*, or officiating priest (representing the Old Dispensation), and the Virgin (symbolizing the Church to come). Leonardesque also is the sense of dramatic *istoria* that pervades the Jarves *Circumcision* and modifies the earlier iconic character of the theme.[13] The Child moves energetically away from the knife, seeking comfort in the arms of the figure that must certainly originally have been intended to be the officiating priest. The original identity and role of this figure are suggested by his sacerdotal costume. At one point, however, a shift occurred in the imagery; what was once to have been the figure of Joseph, near the Virgin, was made to enact instead the role of the priest from whom the Child now shrinks. This iconographic change was perhaps required by the visual prominence of this figure, whose light carmine robe plays so effectively against the azure of the sky. By such changes in the stage position of the actors, the drama gains in intensity, and the symbolic counterpoint of Old and New Dispensations, their relationship and contrast, acquires a more self-defined accent.[14]

At Padua, there are other echoes of what may be found in the *Circumcision*. The group of male figures around the infant in the *Miracle of the Speaking Babe* (Fig. 8), which are somewhat in the shadow and are given the accent of a still darker vertical curtain of flat tone as background, bears a relationship to the group of male figures around the Child of the *Circumcision*. The profiles of the women to the right, in the same fresco in Padua, though noticeably fleshier, have something of the quality of the more idealized Virgin of the *Circumcision* (see Figs. 13 and 14). One of the most admirable passages in the *Circumcision*, however, points to a very slightly more distant future. The hand holding the unguent jar at the extreme left, encased in richly painted drapery (Fig. 15), has a good deal of the elegance and power of gesture of the hand of the nude Venus holding aloft a lamp in the Borghese Gallery *Sacred and Profane Love*.

IV

To conclude: Berenson's intuition of 1928 with regard to the *Circumcision* would seem to have been in the end sounder than his later change of mind, as published in 1957, which seemingly was motivated by his more consciously meditated reconstruction of Giorgione's oeuvre. The Jarves panel, I submit, does indeed today appear to be by Titian, and by Titian at a critical

[13]For a general discussion of the transformation of the theme of the Circumcision in Venetian painting I refer to the study by Sixten Ringbom, *Icon to Narrative. The Rise of the Dramatic Close-up in Fifteenth-Century Devotional Painting* (Åbo, 1965), in particular pp. 77–78. No less than thirty-five copies of the first Bellinesque formula of the Circumcision in painting in or near Venice, and six derivations of it, are cited.

[14]The Circumcision was considered in the Renaissance an Old Testament antetype of the New Testament sacrament of Baptism (the most prominent pictorial expression of this typology being in the late fifteenth-century frescoes of the Sistine Chapel in the Vatican). In the Judaic tradition, circum-

cision on the eighth day (Luke 2:21) was the occasion (as in Christian baptism) of giving the child his name; in Luke the passage on the Circumcision is followed immediately by the incident of the Presentation in the Temple and Simeon's recognition of Jesus as the Christ. In the tradition deriving from Paul (particularly Colossians 2:10–15), the Circumcision of Christ becomes a most important cryptosymbolic event for the establishment of the Universal Church. This may be in part a reason for the similar importance of the theme in painting in Venice, though nowhere else, it must be emphasized, is the specifically Judaic aspect of the theme so sympathetically presented (see Fig. 16).

juncture in his career: rich in possibilities for that monumental style upon which the second decade of cinquecento in Venice was about to draw.

The date of the panel is most difficult to pinpoint. It would appear to be somewhat before 1511—perhaps by more than two or three years, perhaps by even a little more, for the analogies with the frescoes in Padua seem to presuppose the priority of the *Circumcision* rather than, as might be casually thought, the reverse. At that approximate moment, drawing upon the most striking "modern" developments in monumental painting, specifically Leonardo's *Last Supper*, the young Titian may be seen less as a follower, or even junior partner, of Giorgione than as an individualistic experimenter setting forth on his own adverturesome quest. Even the way in which the *Circumcision* panel appears to have been painted has a suggestion of a voyage of pictorial discovery.

We have been dealing here with an admittedly problematic painting that does not yield easy answers to most of the questions that could be asked of it. But despite outstanding questions still unanswered: what is the precise date of the panel? why was it left incomplete? it would seem that there is still enough here to help define a turning point in history, the opening of an epoch. That the young Titian owed much to Bellinesque example in the pictorial handling of the theme is undisputable (Fig. 16). But it should be clear also how much new light, new atmosphere, new breadth he brought into an older subject. He made use also of a new, much freer, and more direct concept of technique.[15] Deriving from the *Circumcision* panel and likewise incorporating several Leonardesque elements (such as the long "table" and grouping by triads) is a drawing in Bayonne attributed to Cariani (Fig. 17). If anything could convince us of the unsuitability of Sirén's attribution of the Jarves *Circumcision* to Cariani, surely this drawing, still so gently infused with Giorgione's pastoral mood as opposed to Titian's decisive monumentality, would take a place in the foreground of the argument.[16] Linking as it does much more directly, and clearly, Leonardo with the Veneto, the Jarves panel modestly makes an art-historical point to ponder. It is not often that one can enjoy a work of art, even from Venice, that promises so much and struts so little.

YALE UNIVERSITY

[15]Recent results of research by Miss Elizabeth Packard of the Walters Art Gallery, Baltimore, have disclosed that the technical procedures of the Bellini *bottega*, even into the sixteenth century, were based on extremely complex, painstaking, and necessarily slow methods of building up a paint structure. Such methods are in striking contrast with the technique to be found in the Jarves *Circumcision*.

[16]The drawing has been published by J. Bean, *Les Dessins italiens de la Collection Bonnat. Bayonne, Musée Bonnat. Inventaire*

générale des dessins des musées de province (Paris, 1960), no. 18. The old attribution to Giorgione was first changed to Cariani by the Tietzes, and later backed by Wilde. Bean emphasizes the closeness to Giorgione in the spirit of the Bayonne drawing. As a provocative sidelight, it would appear that the onlookers to the right include at least one saint (an armed warrior). Apparently we have here an interesting enlargement of the fifteenth-century handling of the theme into something approaching a *Sacra conversazione*.

A Manuscript Illustrated by Bacchiacca

JOHN SHEARMAN

Almost everybody likes Bacchiacca. He is an engaging parasite among the artists of the Florentine High Renaissance, engaging partly because he appears not to take his betters too seriously. He is a minor poet—but, at least, a poet—who makes a living and an art form out of diminutive paraphrases, very desirable ornaments that are a kind of spin-off from more serious events. He was the only Florentine who had the wit to do this successfully. And because his art attracts so compellingly, as a piquant distillation of major styles, it is perfectly familiar. There are, it is true, many problems of attribution, but it is not difficult to establish a sensible and noncontroversial notion of his work; what is remarkable is that this consensus rests upon very slight information, particularly about dates. The object of this appropriately diminutive study is to present a work that has lain hidden and to apply the information it can provide.

It may at first sight seem logical that an artist who specialized in small-scale work should have illustrated a manuscript. It is indeed logical that he should have been commissioned to do so, but the result is in fact—rather typically—gently provoking. The illustration is a full-page miniature, representing the Medicean *Sts. Cosmas and Damian in a Landscape* (Fig. 1), and it decorates a manuscript in the Biblioteca Laurenziana, the *Genealogia Medicea*, which a goldsmith Piero Cattaci dedicated to Leo X.[1] This little book has the merit, from our point of view (and the loss, from any other point of view, is slight), of being unfinished, which seems to imply that its illustrations were made as it was compiled and were not added subsequently to a completed text. Consequently, the internal genealogical evidence, which dates the text within the year starting May 2, 1518, can be taken as evidence for the date of the painting as well.[2]

The demonstration of an attribution can be embarrassing to its sponsor if to him it seems self-evident, as it does in this case. I prefer not to labor the point. This little picture seems to me consistent with, on the one hand, Bacchiacca's six Borgherini panels, the *Story of Joseph*, in the National Gallery in London and the Borghese Gallery in Rome, and, on the other hand, his *St. Achatius* predella in the Uffizi. This consistency is particularly marked in color. But the justice of any attribution is, in the last resort, dependent upon the insertion of the candidate-

[1]Med. Palat. Cod. ccxxv: Petrus Cattacius Aurifex, *Genealogia Medicea*. For a description, see A.M. Bandini, *Biblioteca Leopoldina Laurentiana*, III (Florence, 1793), col. 465, and P. d'Ancona, *La miniatura fiorentina* (Florence, 1914) II, 456, no. 897, who, however, makes no mention of the sheet discussed here, which is on fol. 1r. Fols. 1 and 2 are one folded sheet of parchment, 3 and 4 another, and the dedicatory text runs from 1v to 3r. Fols. 3v–4r make a single spread, on which the family tree from Averardo de' Medici is represented. Fols. 4v and 5r are blank, and 5v is occupied by a full-page illumination showing Leo X enthroned and surrounded by the seven Virtues, partially reproduced in J. Shearman, *Raphael's Cartoons . . .* (London, 1972), fig. 83; the papal arms below are flanked by those of Lorenzo, Duke of Urbino (with the Order of St. Michael) and his wife Madeleine de la Tour d'Auvergne. Fols. 6r and 6v contain verses in praise of Leo, and fols. 7r to 10v the arms of cardinals created by him, beginning with Lorenzo Pucci, six to a page; this series is incomplete, but is referred to in the dedication. The folio painted by Bacchiacca, which has been trimmed, now measures 31.4×21.5 cm.

[2]See the previous note. Lorenzo married Madeleine on May 2, 1518 and died on May 4, 1519; cf. G. Pieraccini, *La stirpe de' Medici di Cafaggiolo*, I (Florence, 1924), 254, 269. A similar date for the manuscript is given by K. Langedijk, *De Portretten van de Medici* (Amsterdam, 1968), 36.

work at a convincing place in a sequence, and so in this case the demonstration is implicitly continued in the discussion of chronology that follows.

First, however, there is comment to be made upon the object itself. The *Sts. Cosmas and Damian* is painted in oil on parchment—in fact, on the recto of a folio that has on its verso the beginning of Cattaci's dedicatory text. The recto has, in addition, been rather heavily varnished, and the paint has, not surprisingly, flaked. This damage, which providentially affects expressively less-significant areas, is the only exception to an immaculate state of preservation, for the painting has been well protected from abrasion and light, and it has not been restored. The usefulness of the work for the study of Bacchiacca is in part due to its freshness, and in part to the very fact that its technique is the same as that of his panel paintings and is not specifically a miniaturist's. Therein lies the artist's perversity, for his master Perugino did adopt a technique, and to some extent a style, specific to illumination when he collaborated on the *Ghislieri Book of Hours* now in the British Museum, in which his *Martyrdom of St. Sebastian* is by no means simply a reduction of his panel-painting manner;[3] and moreover Bacchiacca, to judge from his *Resurrection* in Dijon, was familiar with this aspect of Perugino's work. Perhaps Bacchiacca made other manuscript illuminations; the question has not been asked, as far as I know, and I do not find any evidence in the sources. But in this instance, at least, he saw no reason to modify his habitual manner.

The reconstruction of the chronology of Bacchiacca's work has been guided, of necessity, by inspiration rather than facts, and for the most part the situation will remain unaltered; it is only to the first stage of his career that we may now apply some control. Hitherto there have been three approximate points of reference: the six panels that Bacchiacca contributed to the furnishings of the bedroom of Pierfrancesco Borgherini and Margherita Acciaiuoli are usually thought to belong, like others in the set by Andrea del Sarto, Granacci, and Pontormo, to the years immediately following the couple's marriage in 1515;[4] The Uffizi *St. Achatius* predella may be of the same date (1521) as the main panel of the altarpiece by Sogliani, now in San Lorenzo (but the chances of its being otherwise should be rated high); and the *Baptism* in Berlin belongs to a set of panels painted for Giovanni Maria Benintendi, of which one, by Franciabigio, is dated 1523.[5] These few and imprecise indications have left much room for difference of opinion, not simply about absolute dates but also—because they relate to his beginnings—about what kind of an artist Bacchiacca was. He was born in 1494. There is general agreement that such Peruginesque works as the Dijon *Resurrection* and (even more faithfully) the Bassano *Deposition* ought to belong to his earliest active years, but in absolute terms they have been placed between ca. 1511 and ca. 1515.[6] The *Sts. Cosmas and Damian*,

[3]Yates Thompson MS 29; the most recent discussion, with reproduction, is in H. Brigstocke, "James Dennistoun's Second European Tour," *Connoisseur* (CLXXXIV, 1973), 244ff. Perugino's miniature, like Aspertini's *Nativity*, is signed.

[4]A list of these panels, with evidence for their disposition and date, is in J. Shearman, *Andrea del Sarto* (Oxford, 1965), II, 230ff.

[5]*Ibid.*, II, 259. A landscape sketchbook in the Uffizi, in which one sheet is dated 1527, is sometimes, but I think wrongly, attributed to Bacchiacca, for example by L. Marcucci,

"Contributi al Bacchiacca," *Bollettino d'Arte* (XLIII, 1958), 26ff.

[6]The earlier date, for example, in F. Abbate, "L'Attività giovanile del Bacchiacca," *Paragone* (N.S. 9; XVI [189], 1965), 32, the later date in S.J. Freedberg, *Painting of the High Renaissance in Rome and Florence* (Cambridge, Mass., 1961), 501. But whereas Abbate and Freedberg nearly concur on the Borgherini panels (1515-1518 and 1516-1518, respectively), Marcucci places them 1517-1520.

painted in the second half of 1518 or the first half of 1519, suggests that the later date is more probable, and that he was not a precocious artist; it also pinpoints a significant moment of change.

The most Peruginesque paintings seem immediately to precede the Borgherini panels, in which the influence of Bacchiacca's master is combined, in a manner neither conspicuous nor eccentric, with wider experience of Florentine art and especially that of his collaborators on the same enterprise; it was probably under the guidance of Andrea del Sarto, especially, that he began to be interested in Northern prints. But at this point Bacchiacca's forms, like his colors, are simple in a naïve sense and rather heavy, their hardness mitigated more by suave modeling than by an appearance of atmosphere. The transition from this style to the mature one of the *St. Achatius* predella occurs in a group of works that may now be assembled around the *Sts. Cosmas and Damian* and dated ca. 1518–1519, the earliest of which is the small upright *Baptism* formerly in the Mond Collection.[7] In this *Baptism*, the residual influences of apprenticeship retain that identity and to a great extent that character which they had in the Borgherini panels; yet the references first to Perugino, then to Andrea or Lucas van Leyden, are perceptibly more deliberate and more self-conscious. The color is lighter, and so are the forms. And that increase in subtlety is taken a stage further in the *Sts. Cosmas and Damian*, where it begins to have the significance of sophistication. Morphological simplicity has given way to complication, both spiky and, as it were, knotted in a manner that recalls Pontormo's late addition to the Borgherini room, the panel of ca. 1518 in the National Gallery. At a similar stage, and not earlier, Bacchiacca probably painted two small works (now badly damaged), the *Madonna with St. Elizabeth and the Baptist*, formerly in the Canonica at Asolo, and the *Christ Preaching before the Temple* in the gallery of Christ Church, Oxford; and perhaps also (but the issue is confused by the change of scale) the *Lady with a Nosegay* in the Isabella Stewart Gardner Museum, Boston. In these works and others like them, Bacchiacca explores effects of atmosphere as a softening and unifying agent that can replace Peruginesque, that is to say surface-bound, *sfumato*, and his color acquires delicacy and variety. But in this sequence, too, he retreats from the contact with reality, minimal as it was, that he felt necessary in the Borgherini panels; from this point it is as if all his visual experiences, or at least all those that nourished his painting, were of works of art. It is characteristic of this situation that the landscape backgrounds of the ex-Mond *Baptism* and the *Sts. Cosmas and Damian* are transcriptions—the one more accurately, the other less—from the *Baptism* print by Lucas van Leyden from which Bacchiacca was to draw continuing inspiration.[8] There remained, however, a step to be taken before he would achieve the highly-wrought and wholly artificial style, with cooler, clearer, and still less real color, of such works as the *Moses* panels in Washington and Edinburgh; and that step was taken in the *St. Achatius* predella.

To go much further would be to embrace, almost certainly, both the Biological and the Rosary Fallacies. There are other early works that may be placed with reference to the Laurenziana miniature, and there are others, such as the *Baptism* in Budapest, with which it

[7] Sold at Sotheby's, March 24, 1965, no. 96.
[8] B.40, Hollstein x, 92; further examples in A. Scharf, "Bacchiacca: A New Contribution," *Burlington Magazine* (LXX, 1937), 60–65.

JOHN SHEARMAN

does not help at all. It may be enough to conclude that the assessment of the chronology of Bacchiacca's works needs in general to be retarded (which may mean, incidentally, that he was trained by Perugino in Umbria rather than in Florence), but that his work on the Borgherini room is properly placed nearer 1515 than 1520.

UNIVERSITY OF LONDON, COURTAULD INSTITUTE OF ART

Taddeo Gaddi, Orcagna, and the Eclipses of 1333 and 1339

ALASTAIR SMART

In his account of Taddeo Gaddi in the *Vite*, Vasari had little to say about the stylistic innovations of Giotto's great pupil, observing only that, while he always adhered to Giotto's manner, he "did not greatly improve it, except in the coloring, which he made fresher and more vivid."[1] The distinctiveness of Taddeo Gaddi's style and the nature of his contribution to trecento painting are much clearer to us today. The reflections in his art of the new spiritual climate that was to become dominant in Tuscany after the universal plague of 1348 have been illuminated by Millard Meiss in his classic *Painting in Florence and Siena after the Black Death*.[2] Scarcely less interesting are Taddeo Gaddi's explorations of effects of light, which while owing much, no doubt, to Giotto's example, go far beyond what is to be found in any surviving work from Giotto's own hand.

Attention has often been drawn to the night scene in the fresco of the *Annunciation to the Shepherds* (Fig. 1) in the Baroncelli Chapel, in which the hillside is illumined by a dazzling light from the heavens; and although the light here is supernatural, Taddeo's imagination must have been stimulated by his evident curiosity about natural phenomena. Indeed his curiosity was so great that in middle life he suffered serious damage to his eyes by gazing at an eclipse of the sun. The circumstances have been noted by a number of writers;[3] but no attempt has been made to identify the eclipse or to relate the artist's tragic experience, which induced in him a profound melancholy, to the thought-patterns of an age that saw in such portents as eclipses and comets the signs of God's judgment upon the sins and follies of mankind. The matter seems to be worthy of closer attention, especially since it bears not only upon a remarkable representation of an eclipse by Orcagna but also upon the wider issue of the historical circumstances that gave rise to the grim frescoes of the *Triumph of Death* executed by Orcagna in Santa Croce in Florence and the similar compositions by Traini in the Camposanto at Pisa.[4]

Our information about this chapter in Taddeo Gaddi's life comes from a source virtually unique in itself—a letter written by the painter to his friend Fra Simone Fidati, whom he had met in Florence in the 1330s. A member of the Augustinian Order, which he had entered in 1313, Fra Simone had left his native Umbria in 1333 in order to reside in Florence, where he was to remain until his departure for Rome in or about 1338. He is remembered by two treatises, the *Ordine della vita cristiana* of 1333 and the more comprehensive *De gestis* (begun in 1338), both of which set forth the ideas that he expounded from the pulpit as one of the most

[1] *Le Vite de' più eccellenti pittori, scultori ed architettori* (1568), ed. G. Milanesi (Florence, 1878-1885), I, 585. The English translation given here is that of A.B. Hinds, *Vasari's Lives of the Painters . . .*, translated by A.B. Hinds (London, 1927), 141.

[2] *Painting in Florence and Siena after the Black Death: The Arts, Religion, and Society in the Mid-Fourteenth Century* (Princeton, N.J., 1951; rev. ed., New York–Evanston–London, 1964), 16ff., 26, 30, 38f., 147ff., 172ff.

[3] Cf. Padre N. Mattioli, *Il Beato Simone Fidate da Cascia . . . e suoi scritti editi ed inediti*. Antologia Agostiniano, II (Rome,

1898), 436ff.; I. Maione, "Fra Simone Fidati e Taddeo Gaddi," *L'Arte* (XVII, 1914), 107ff.; R. Oertel, *Early Italian Painting to 1400* (London, 1966), 190f.

[4] For the attribution to Traini, see especially M. Meiss, "The Problem of Francesco Traini," *Art Bulletin* (XV, 1933), 97ff. For recent discussions, cf. P. Sampaolesi—M. Bucci—L. Bertolini, *Camposanto Monumentale di Pisa* (Pisa, 1960), especially 46ff., and J. White, *Art and Architecture in Italy, 1250 to 1400* (Harmondsworth, 1966), 367f.

celebrated preachers of his time. It has been argued that his teaching may have influenced Taddeo Gaddi's interpretation of the stories of the Life of the Virgin and the Infancy of Christ in the Baroncelli Chapel.[5]

Taddeo Gaddi's letter to Fra Simone is to be found in a collection of Fidati's correspondence, the *Epistolarium Fratris Symonis de Cascia*,[6] and its preservation must be due to the value that was attached to Fra Simone's lengthy reply, with all its spiritual consolations. Although it is not unlikely that the painter wrote to his friend in the vernacular, this pathetic document has come down to us in Latin. An English rendering of some of the central passages of the correspondence, which has not previously been translated, may be of interest. Taddeo Gaddi thus addresses his spiritual mentor:

A bodily infirmity, which has come upon me suddenly in these days, compels me to weary your ears. For from days not long past I have suffered, and still suffer, from an unendurable infirmity of the eyes, which has been occasioned by my own folly. For while, this year, the sun was in eclipse I looked at the sun itself for a long period of time, and hence the infirmity to which I have just referred. For I constantly have clouds before my eyes which impede the vigor of my sight. Hence I can truly say with him who sang: "Mine eyes fail with looking upward. O Lord, I am oppressed, be thou my surety. What shall I say, and what shall be my surety, since he himself has brought it to pass?"[7] But why is it so? I grieve much because of this, but O that I should! For I grieve because this infirmity hinders certain undertakings of mine, but I do not weep over what is most to be deplored—that this indisposition, which through the mediating power of Christ ought to restore and strengthen the sharpness of my inward eye, has rather, by virtue of its own frailty, darkened it completely, and has thus bent the backbone of my own inward man. For I am plunged into the deepest abyss of melancholy;[8] and what is worse, I do not call out, but sleep; but already the hour appointed for my awakening is at hand.... I am compelled to write for two reasons. First of all, it is to seek the support of your prayers. I therefore pray you to intercede with God immediately, that He may act mercifully toward me. Secondly, it is to obtain the solace of some exhortation from you. I therefore beseech you to be so good, if you can spare the time, as to send me a little note. I bring to an end these words of mine, which I scatter prodigally like one out of his mind; but I am confident in my knowledge that you will not look for sublimity of speech, but rather for words of honest truthfulness. Farewell.[9]

It is tempting to identify the "undertakings" (*propositis*) mentioned in the letter with commissions that the damage to the painter's eyes prevented him from fulfilling: his despair may well have been due principally to the difficulty he now found in painting. Immersed in melancholy ruminations, he derived no comfort from the thought that he was the recipient of a divine visitation, intended to illuminate the inner eye, while darkening the outer; and he recognized that his affliction had produced the opposite effect.

[5]Maione, "Fra Simone Fidati e Taddeo Gaddi," *loc. cit.*

[6]Mattioli, *Il Beato Simone Fidate*, 259ff.; for Taddeo Gaddi's letter, see 436ff. (reprinted in Maione, *ibid.*, 109).

[7]An allusion to Isaiah 38: 14–15. The passage in question begins: "Attenuati sunt oculi mei, suspicientes in excelsum: Domine vim patior, responde pro me . . ." In the Revised Version of the Bible, the whole text is translated: "Mine eyes ail with looking upward; O Lord, I am oppressed, be thou

my surety. What shall I say? He hath both spoken unto me, and himself hath done it." These verses come from the song of Hezekiah, uttered after his recovery from grave illness.

[8]*accidie.*

[9]I am much indebted to Mr. George Every for help in construing what seemed to me to be obscurities in the Latin text of Taddeo Gaddi's letter and Fra Simone's reply to it.

It may be doubted, therefore, whether he would have been much consoled by Fra Simone's answer to his letter.[10] Fidati, addressing him as his "dearest friend" (*Amico Karissimo*), begins, almost predictably, with the admonition: "Would that you had looked, with the indefectible insight of the mind, upon the Sun of eternal righteousness which cannot be eclipsed!" He goes on to cite passages from the apocryphal Wisdom of Solomon about the vanity of earthly pursuits, pleasures and rewards, and continues:

> Behold the image of a life that passes. Know the images of a sinful soul. For these are not my words, but those of Solomon, the wisest of men. O if you had looked upon that supernatural eclipse, when at Christ's death the sun grew pale and hid the whole world in thick darkness! Would that, having endured these injuries, you would open the eye of memory to that failure of the sun which came about not because of the interposition of the moon but because the creature condoled with the Creator and the sun bore witness to the Sun! You should have looked upon that eclipse which removed the eclipse of the human race, and which would then have cleared your eyes and sharpened the sight of your intellect. But you have suffered a total eclipse because you looked at the failure of the sun's light not only rashly but with curiosity.

Fra Simone now inveighs against the arrogance of all human inquiry into the secrets of Nature—indeed against that very curiosity of mind which, for us, makes Taddeo Gaddi so interesting as a painter of light:

> Examine your conscience and address your heart, for justly has this penalty smitten you. For curiosity never leaves her author unavenged, so that the kind of pain with which you must be punished may make the point for you, since you presume to look so rashly upon what it is not permitted to desire. ... Your eyes are weakened because you looked surmisingly into the heavens; yea, they are affected and darkened because you lifted your face with pride toward the heights, not toward your Creator and not to praise His majesty or the wonders He has made, but so that you might understand those things which there is no usefulness in knowing.

Such a passage gives us an insight into the prejudices that characterized the spiritual climate of the period; and their pervasiveness makes the visual curiosity of a Giotto or a Taddeo Gaddi all the more remarkable. As Fidati expressed it in his letter to Gaddi, "With corporeal eyes men can look only at corporeal things; with intellectual vision we behold virtues and things of the spirit."

Fra Simone goes on to cite the example set by men of God who endured blindness and yet saw truth all the more clearly—St. Paul, struck down on the Damascus Road, and impelled by this experience to seek out God's will for him; Isaac, who although blind perceived the divine mysteries; the eyeless Samson, who became the type of the Passion and Resurrection of Christ; and Tobias, whose spiritual insight was increased by his blindness. Taddeo Gaddi is now roundly rebuked, in the severest terms, for his failure to learn the spiritual lesson that his bodily affliction ought to have taught him, and he is urged to flee the temptations of melancholy. The letter concludes with further exhortations of a like nature, and with the date: *Scripta Rome prima die XL* ("written in Rome on the first day of 1340").

[10]Mattioli, *Il Beato Simone Fidate*, 438–47.

Presumably Taddeo Gaddi would have written to Fra Simone before January 1, 1340 (the date of the reply), since according to Roman usage the year began then rather than on March 25. The eclipse at which he had gazed with such curiosity had taken place, as he explained in his letter, during the year in which he wrote, i.e. 1339. The precise date of his unfortunate experience can in fact be determined, for an annular eclipse is known to have occurred on July 7 of that year.[11] Although on astronomical charts (Fig. 2) the track of this eclipse lies to the north of Italy, crossing central Europe diagonally, the obscuration of the sun was visible from Florence, and we have only to turn to the *Cronica* of Giovanni Villani to find a description of it :

> In the year 1339, on the seventh day of July, between Nones and Vespers, the sun was obscured in the sign of Cancer and had passed through more than two of the sections of that sign; but because at the time of the sun's failure it was after midday, it did not become dark as though it was night, but nevertheless it appeared very gloomy.[12]

Taddeo Gaddi's eye-trouble must therefore have occurred before his visit to Pisa, where he is documented in 1342, and presumably after his work in the Baroncelli Chapel had been completed. The frescoes in the Baroncelli Chapel are often dated between 1332 and 1338, but evidence for so late a dating is wanting.[13] It is, however, tempting to speculate on the possibility that some personal experience of a dramatic nature, similar to that occasioned by his observation of the eclipse of 1339, accounts for an unusual feature of the *Annunciation to the Shepherds* (Fig. 1), which has been pointed out by Meiss : such was the painter's overriding concern with light in this scene that it affected his entire technical procedure from the beginning, leading him to darken the wall by preparing his fresco with a brown ground, which is now clearly visible in large areas of the sky where the overpainting has peeled away. "In this dusky environment," Meiss has written, "the yellow light of the angel becomes incandescent."[14]

It was left to another Florentine painter, Taddeo Gaddi's younger contemporary Orcagna, to give us a representation of an actual eclipse. We find it in a little scene[15] set into the decorative border of Orcagna's all-but-vanished masterpiece at Santa Croce, the vast *Triumph of Death* which once covered the south wall of the nave and which comprised (like

[11]See T. Von Oppolzer, *Canon der Finsternisse* (Vienna, 1887), Bl. 122. I am grateful to Mr. C.A. Murray, of the Royal Greenwich Observatory, Herstmonceaux, for so kindly answering my inquiries, and likewise to my father, W.M. Smart, Regius Professor Emeritus of Astronomy, University of Glasgow.

[12]Libro XI, cap. xcix (*Istorie fiorentine di Giovanni Villani*, Milan, 1808, VII, 216): "Nell'anno 1339 a dì 7 di luglio tra la nona e vespro scurò il sole nel segno del cancro più che le due parti; ma perchè fu dopo il meriggio al dicrinare del sole, non si mostrò la scurità, come se fosse notte, ma pure si vidde assai tenebroso." The translation of this and subsequent passages is that of the present author. For her kindness in clarifying for me the astrological references and related passages in Villani, I am indebted to Dr. Barbara Reynolds, who also drew my attention to M.A. Orr's fundamental study, *Dante and the Early Astronomers*, rev. ed., with an Introduction by Barbara

Reynolds (London, 1956).

[13]Cf. C. A. Isermeyer, *Rahmengliederung und Bildfolge in der Wandmalerei bei Giotto und den Florentiner Malern des 14. Jahrhunderts* (Würzburg, 1937), 48ff.; and, more recently, J. Gardner, "The Decoration of the Baroncelli Chapel in Santa Croce," *Zeitschrift für Kunstgeschichte* (XXXIV, 1971), 89ff. Prof. Gardner favors a date ca. 1333 for the completion of the frescoes, which he supports with persuasive arguments.

[14]*The Great Age of Fresco: Discoveries, Recoveries and Survivals* (New York and London, 1970), 55.

[15]For Orcagna's frescoes at Santa Croce, see especially R. Offner, *A Critical and Historical Corpus of Florentine Painting*, Section IV, Vol. 1 (New York, 1962), 43ff.; Meiss, *Painting in Florence and Siena after the Black Death* (revised ed.), 14, 74, 83f.; idem, "Alesso di Andrea," in *Giotto e il suo tempo: Atti del Congresso Internazionale per la Celebrazione del VII Centenario della Nascita di Giotto* (Rome, 1971), 401ff.

the comparable work by Traini at Pisa) a *Last Judgment* and flanking scenes of the *Triumph of Death* and the *Inferno*. The eclipse represented by Orcagna (Fig. 3) is rendered with extraordinary realism: two men are seen looking up at the sun, which is obscured by the dark disc of the moon; both men shield their eyes with one hand; and, what is still more remarkable, in view of Taddeo Gaddi's sufferings, a third figure (to the right) turns away from the spectacle in evident pain, with his hand raised to his right eye. In Taddeo Gaddi's *Annunciation to the Shepherds* (Fig. 1), one of the shepherds also shields his eyes from the blinding light; and in the *Appearance of the Star to the Three Magi* one of the kings does the same: in each case, the gesture is more than the conventional expression of wonderment, for it is manifestly related to the dazzling light in the heavens. We cannot, of course, connect the two frescoes with the eclipse of 1339, except in so far as they illustrate that curiosity about unusual light effects which apparently was to prompt Taddeo Gaddi, to his cost, to stare for a long time at the eclipse. On the other hand, the realism of the little scene in the border of the *Triumph of Death* (Fig. 3) is hard to account for unless Orcagna had observed such an eclipse himself; and if that was so, he would have been well advised not to stare directly at the sun for any length of time, for in the case of an annular eclipse the danger to his eyesight would have been very great. From the ruins of Orcagna's decoration there have survived two other scenes in the border of the fresco: all three scenes allude to the signs that would precede the Judgment, according to the Book of Revelation, where we read of the darkening of the sun (6: 12), an earthquake (6: 12), and a plague of locusts (9: 3).[16] Orcagna represents the earthquake by showing its effects upon a city, as it cracks the walls of buildings and brings them tumbling down (Fig. 4).

Although such subjects have their place in the iconography of the Last Judgment, they were far from being remote symbols. Each new natural calamity or celestial portent aroused in the medieval mind an awed response, prompting a quickly awakened sense of guilt. Indeed, just as certain conjunctions of the planets were regarded as evil omens, so also an eclipse of the sun, the appearance of a comet, and other "signs in the heavens" were interpreted as warnings of divine retribution for the sins of mankind; and the hand of God was seen likewise in such terrifying natural phenomena as earthquakes, violent thunderstorms, floods, and outbreaks of some dire pestilence. Calamities of this kind were commonly associated with Christ's eschatological discourse in Matthew 24 concerning the imminence of the Last Judgment and the signs presaging it. In the *Decameron*, Boccaccio gave two alternative explanations of that calamitous visitation to which Meiss has related the two versions of the *Triumph of Death* painted by Orcagna and Traini—the Black Death of 1348. "It started in the East," Boccaccio wrote, "either through the influence of the heavenly bodies or because God's just anger with our wicked deeds sent it as a punishment to mortal men." And it was in precisely this way that men of the period sought to account for the eclipse of 1339 and for

[16]Offner, *ibid.*, 45f., 53f. The surviving fragments of Orcagna's fresco were exhibited in 1958, after restoration, at the Forte di Belvedere in Florence: cf. U. Baldini, in *Catalogo della Mostra di Affreschi Staccati* (Florence, 1958), 131ff. They were also included in the great exhibition of Florentine frescoes held in 1968–1969 in New York, London, and Amsterdam: cf. *The Great Age of Fresco*, with a Preface by Millard Meiss and an Introduction by Ugo Procacci (exhibition catalogue, Metropolitan Museum of Art, New York, 1968), 78f., and *Frescoes from Florence*, with a Preface by John Pope-Hennessy and an Introduction by Ugo Procacci (exhibition catalogue, Arts Council of Great Britain, London, 1969), 70f.

an earlier annular eclipse of 1333 (about the time when Taddeo Gaddi was probably completing his great fresco cycle).

In hindsight, the Black Death naturally stands out as the most terrible calamity that Italy—and indeed Western Europe—can ever have known. But before its onset, and even apart from the ravages of the earlier plague of 1340, a series of other disasters that had taken place in Florence had been interpreted as signs of God's wrath on account of the enormity of men's sins. A Florentine living before 1348 could not know that the most terrible visitation of all lay ahead; there were calamities enough to impress upon him the urgent need for repentance, and, further, to account to his satisfaction for the ominous eclipses of 1333 and 1339. In fact, it was in the former year that the first natural catastrophe of an overwhelming nature struck the city of Florence, when on November 1—All Saints' Day—the city was inundated by a flood that caused devastation throughout Tuscany, being comparable in its severity with the tragic inundations of 1966. It became known as *il gran diluvio*, and it was at once associated with the eclipse that had taken place earlier in the year, on May 14. The track of this eclipse passed much closer to Florence than that of its successor of 1339 and crossed central and southern Italy (Fig. 2).[17] The eclipse of 1333 was also described by Villani; but before we come to his account of it, more must be said about the great flood that it was believed to have presaged.

Villani devotes an unusual amount of space to the flood and its causes; the first three chapters of the eleventh book of the *Cronica* are all given over to it, together with a further chapter containing a letter to the Florentines concerning the flood written by the city's protector, King Robert of Sicily. Perhaps the most striking features of Villani's narrative are its millennial content and eschatological character. The year 1300—the year, of course, of the Jubilee—appeared to Villani to possess a special significance for Florence, marking the beginning of the city's troubles and of the evils for which the great flood had been sent by God as a chastisement. Yet by the year 1333 all had seemed well again. Nevertheless, in His discourse on the Last Things, recorded in the Gospel according to Matthew, Christ had given a warning about the dangers of such an assumption; and of that warning Villani reminds his readers:

On the first day of November in the year of Our Lord 1333, the city of Florence being in a position of great power and in a condition of wellbeing and happiness, much more than it had yet been since the year of Our Lord 1300, it pleased God that it should indeed be so, according to what He said by the mouth of Christ in His gospel, "Watch, for you do not know the hour nor the day of the Judgment." God having willed to visit upon our citizens a scourge and a punishment for their sins, on that All Saints' Day it began to rain in Florence and round about, and in the hills and mountains and it went on thus continuously for four days and four nights, the rain increasing all the time; and indeed there was such an extraordinary fall of rain that the floodgates of the heavens seemed to be open (and perhaps they were); and the rain was accompanied by much thunder and lightning, as frequent as it was terrifying; so that everybody lived in great fear, and all the bells of the churches were rung throughout the city, until the waters ceased to rise; and in every house basins or pots were set out to catch the rain; and on all sides one heard those who were in danger

[17]Cf. von Oppolzer, *Canon der Finsternisse, loc. cit.*

crying out to God, "Mercy, mercy"; and there were people fleeing from house to house and from roof to roof, and making bridges from one house to another; wherefore there was so much clamor and tumult that the sound of the thunder could scarcely be heard.[18]

In order to understand the panic that overcame the Florentines as the waters of the Arno continued to rise, it is necessary to appreciate the vast extent of the damage suffered by the city, even apart from the great loss of life. Houses were swept away, their owners and their families fleeing to the hills; the city walls were breached in various places; buildings and towers crumbled as their foundations were inundated; the three great bridges over the Arno—the Ponte Vecchio, the Ponte Santa Trinita, and the Ponte alla Carraia—collapsed under the impact of the rising current; and, by way of evil omen, the antique statue of Mars tumbled down from its pillar at the Ponte Vecchio into the river, bringing to people's minds the ancient prediction that "if it fell or was moved the city would suffer great change of fortune." The flood water swept into the Palazzo del Popolo and the Palagio del Podestà; it rose alarmingly high in the Baptistery and the Cathedral; in the Badia and at Santa Croce, it reached the level of the high altar; at Santa Croce, it swamped the quarters of the Friars Minor, where, according to Antonio Pucci, the friars fled to the roof in fear of their lives.[19] In Florence and the district there were about three hundred deaths, and there was an immediate shortage of food, and especially of bread, owing to the ravages done to the land, the loss of sheep and cattle, and the destruction of mills and bakehouses, although it proved possible to bring in considerable quantities of bread and flour from outlying regions. As Villani observed, there had not been such a calamity since the city was destroyed by Totila, nor had there ever been a flood as severe as this. In Villani's opinion the flooding was greater than on any previous occasion, because it had been caused not only by rain but also by earthquake; and he claimed to have seen, in many places, jets of water spurting up from the depths of the earth. Besides Florence, the neighboring city of Pisa, which also stands on the Arno, itself suffered severely, although to the surprise of the Florentines, who regarded the Pisans as worthier than themselves of chastisement, the damage was not as extensive.

The day on which the rains began, All Saints' Day, had seen the city of Florence at the height of its prosperity and good fortune. No doubt the significance attached by Villani to this feast was due to the fact that it was then that the faithful honored the Elect who were knit together by God "in one communion and fellowship." So, he implies, it was with the Florentines, or seemed to be: but then the terrifying storms and floods had come upon the city as a visitation of God upon the sins of the people, calling to their minds, in their fear, Christ's warning that the Day of Judgment would arrive when it was least expected.

The admonition cited by Villani, "Watch, for you do not know the hour nor the day of the Judgment," paraphrases two almost identical Gospel texts: "Watch therefore: for ye know not on what day your Lord cometh" (Matthew 24: 42), and "Watch therefore, for ye know not the day nor the hour" (Matthew 25: 13). These two texts belong to the long section in Chapters 24 and 25 of the Gospel that is concerned with the advent of the Son of Man as

[18]*Cronica*, XI, i. [19]*Centiloquio*, Canto LXXXIII, 15–16.

judge. After a period of "tribulation," [20] Christ says, there will be signs in the heavens:

> . . . the sun shall be darkened, and the moon shall not give her light, and the stars shall fall from heaven, and the powers of the heavens shall be shaken: and then shall appear the sign of the Son of man in heaven: and then shall all the tribes of the earth mourn, and they shall see the Son of man coming on the clouds of heaven with power and great glory. And he shall send forth his angels with a great sound of a trumpet, and they shall gather together his elect from the four winds, from one end of heaven to the other (Matthew 24:29–31).

But men will be taken unawares, as they were at the time of the Flood:

> And as were the days of Noah,[21] so shall be the coming of the Son of man. For as in those days which were before the flood they were eating and drinking, marrying and giving in marriage, until the day that Noah entered into the ark, and they knew not until the flood came, and took them all away; so shall be the coming of the Son of man. Then shall two men be in the field; one is taken, and one is left: two women shall be grinding at the mill: one is taken, and one is left. Watch therefore: for ye know not on what day your Lord cometh (Matthew 24:37–42).

As is clear from the *Cronica*, the flood of 1333, which had been preceded by an eclipse of the sun, was at once associated in the minds of the Florentines, including Villani himself, with the idea of Judgment; even if the Last Days were not at hand, God had undoubtedly chosen to punish the Florentines severely for their sins, so that in these latter times they were truly experiencing the workings of the Divine Judgment. The whole tone of these chapters of the *Cronica* is apocalyptic, as Villani anxiously considers the different opinions of the theologians, the natural philosophers, and the astrologers as to the cause of the *gran diluvio*, or traces the history of the evils that had preceded it in the interval since the crucial year 1300:

> But it is a great marvel to see how, despite everything, God continues to sustain us (and perhaps it will seem to many people that I say too much, and that it is not for me, as a sinner, to say it at all); but if we Florentines do not wish to deceive ourselves, it is all quite true what I say about the number of chastisements and punishments which God has given us in these present times since the year 1300. . . . First, there was the division among us between the Black and White Parties; then the coming of Charles of France and his banishment of the White Party, with all the consequences and indeed the ruin that; followed from this and then the judgment of the great fire which occurred in 1304, and afterwards many other events in the city of Florence through the years, which had adverse consequences for numerous citizens. There was the coming of the Emperor Henry of Luxembourg in 1312, with his siege of Florence and his ravaging of the country round about, resulting in disease and death in the countryside and the city. Next there was the defeat at Montecatini in 1315; next, the hostility of Castruccio, the war waged by him, the defeat at Altopaccio in 1325, and the sequel of his downfall and the excessive expense incurred by the Commune of Florence on account of these wars; next, the dearth and famine in the year 1329 and

[20]The most profound, and at the same time the most lucid, interpretation of the meaning of the "Tribulation" still seems to me to be that of Albert Schweitzer in *The Quest of the Historical Jesus* (London, 1910).

[21]The significance attached in the Middle Ages to man's wickedness since "the days of Noah" is discussed in E.H. Gombrich, "Bosch's '*Garden of Earthly Delights*': A Progress Report," *Journal of the Warburg and Courtauld Institutes* (xxxii, 1969), 162ff.

the coming of the Bavarian, who styled himself Emperor; next, the coming of King John of Bohemia; and then the present flood; whence arises the question whether all these other adversities rolled into one were, all things considered, greater than this. And therefore, citizens of Florence, I beg you to acknowledge that these numerous chastisements and warnings from God have not come about without having been occasioned by very great sins, and that these judgments upon us are equal to the adversities suffered by our forebears in ancient times. And I, the author, am of the opinion concerning this flood, that because of our outrageous sins God sent this judgment, mediated to us through the heavens as they turned in their course, and that then God gave us His gift of mercy in not letting us all perish—for the devastation lasted a short time—in response to the prayers of the holy and religious people dwelling in our city and round about, and to the extensive acts of almsgiving undertaken by the people of Florence. And therefore, dearest brethren and fellow-citizens, those who are living now and those still unborn, whoever reads and understands must have very great reason to correct his faults and to abandon his vices and sins out of the fear of God and because of His warnings to us. . . .[22]

One is reminded of the inscription on a tablet in Orcagna's *Triumph of Death* at Santa Croce, which ends: "O reader, direct your mind so that you are always prepared and will not be caught in mortal sin."

The view that the great flood was a judgment sent by God was general; and to appease the divine wrath the people flocked to the churches to pray, to make confession, and to take communion. Sermons were preached upon the significant fact that a few months before the flood there had been an eclipse of the sun—which, it was said, portended the onset, after a period of dryness, of a superfluity of water accompanied by thunderstorms and resulting in widespread mortality among human beings and animals.

The constant injunction was the need for penitence. Villani himself heard such sermons, and one of the preachers was probably Fra Simone himself. His views on the flood of 1333 are known from an address to the Florentines upon the catastrophe, which is preserved in the *Epistolarium*.[23] In brief, Fidati accepts the general opinion that the floods must be seen as a divine judgment upon the sins of the Florentines, which he castigates in some detail. Historians of manners may find it of interest that he should have drawn attention to the unnatural behavior of the Florentine women, who are criticized not only for their sexual laxity, but also for the abandonment of decorum, which was to be seen in their fondness for affecting a masculine appearance by cutting their hair short and wearing clothes more suited to boys.[24]

Meanwhile the reasons for the flood were being debated, with great intensity, by natural philosophers, astrologers, and theologians. The natural philosophers blamed the inefficient manner in which the Florentines had built the Arno dams; the astrologers pointed to a malign conjunction of the planets, of which the eclipse was a demonstration; and the theologians saw in the disaster only a judgment upon human sin. Villani gives the following account of the significance attached to the eclipse of May 1333 in these discussions:

On the part of the astrologers it was answered that, apart from considerations concerning the will of God, the cause lay to a great extent in the motions of the heavens and in the conjunction of

[22]*Cronica*, XI, ii.
[23]Mattioli, *Il Beato Simone Fidate*, 261ff.
[24]". . . ut garsiones ex habitu potius quam femine videantur."

planets, many reasons being adduced in support, which we shall recount briefly and in general terms for the sake of clarity; that is to say, that on the fourteenth of May last there was an eclipse, or if you like an obscuration of the sun, which was then towards the end of the sign of Taurus in the house of Venus, the head of Draco being also visible.[25]

What is meant here is that it was toward the end of the period when the sun is in the constellation of Taurus (April 21 to May 21), and that the planet Venus and the stars forming the head of the constellation of Draco were in conjunction with it.

Even the death of Pope John XXII, on December 4, 1334, was associated with the eclipse of the previous year.[26] Nor were the tribulations of the Florentines at an end: there was another flood in 1334, which although relatively minor would have turned a great part of the city into a lake (or so Villani assumed) if the dams destroyed by the *gran diluvio* had still been standing, and if the bed of the Arno had not been much lowered; and in 1335 there was an outbreak of smallpox from which more than two thousand children died. The appearance of a comet in 1337 was regarded as an ill omen, presaging famine, widespread deaths, and other disasters. But Villani attached even greater significance to the eclipse of the sun that took place in 1339 (to the misfortune of Taddeo Gaddi), which was followed by dramatic thunderstorms in August and September. "All these things," Villani wrote, "were signs of future evils for our city, such as followed soon afterwards." And again: "As the ancient experts in astrology have written, every obscuration of the sun in Cancer, which takes place once in about a hundred years, is of great significance with regard to evils to come in this century."[27]

Villani now describes the collapse of the economy in the same year, leading to food prices beyond the reach of most of the populace, who were therefore in danger of starvation. Illegal profits on vital imports of grain were made by officials of the Commune, and various injustices meted out to the poor were typical of the general chaos. All this was matched by the venality of a corrupt Church, which received vast sums in this year from the heirs of Azzo Visconti of Milan—Cardinal Giovanni Visconti and his brother Luchino—as the price of an accord whereby they renounced their allegiance to the antipope. "O venal and avaricious Church," Villani wrote in despair, "how your pastors have led you astray from your good and humble and your poor and holy beginnings with Christ!"[28]

In 1340, at the end of March, another comet appeared, and was interpreted in the usual way as an evil omen, especially for Florence. And indeed it was followed, soon afterward, by an outbreak of bubonic plague, from which more than fifteen thousand people died in the city alone. The nature of this terrible visitation has been somewhat obscured by the emphasis that has understandably been placed upon the second appearance of the plague, on a European scale, eight years later. But of the ghastly consequences of the plague of 1340 there can be no

[25]*Cronica*, XI, ii. In different places Villani uses the terms *astrologi* and *astrologi naturali*; but as he does not distinguish clearly, as we should today, between the science of astronomy and the pseudo-science of astrology, I have preferred in translating Villani to use the word "astrologer," which seems more appropriate than "astronomer" to the context of the debate reported in the *Cronica*.

[26]*Ibid.*, XI, xx: "Dissesi, che lo eclissi del Sole, che fu del mese di maggio l'anno d'innanzi, significò la sua morte dovere essere, quando il Sole verrebbe all'opposizione del suo mezzo corso; e così parve, che fosse."

[27]*Ibid.*, XI, xcix.

[28]*Ibid.*, XI, c: "O Chiesa pecuniosa e vendereccia, come i tuoi pastori t'hanno disviata dal tuo buono e umile e povero e santo cominciamento di Cristo!"

doubt, as we learn from a passage of stark horror in Villani's *Chronicle*:

> And there died more than a sixth of the citizenry, among them the best and most dear, male and female alike, so that there did not remain a single family of which some member did not die; and some families lost two or three or more; and this pestilence endured until the coming winter. And more than fifteen thousand bodies, those of men, women and children, were buried in the city, so that the entire city was filled with lamentation and mourning. And one scarcely attended to anything but the burying of the dead.[29]

Hard upon the heels of the plague came famine and the beginnings of a general collapse of the economy. "Evil followed evil," and the afflictions of the people persisted to such an extent that "in many cases the living envied the dead."

To return at last to the scenes in the borders of Orcagna's frescoes at Santa Croce, it seems very possible that their realism is partly to be explained by the artist's recollection of events that he himself had witnessed. In that case the scene of the eclipse (Fig. 3) may well preserve a memory of the eclipse of July 7, 1339—the very one that Taddeo Gaddi had observed with such deleterious consequences for his eyesight.[30] In this context the figure turning away, with a hand to his eye, is of intriguing interest. The earthquake scene (Fig. 4) does not give quite the same impression of personal experience, although the artist (or one of his assistants) could undoubtedly have seen buildings falling down in Florence no less dramatically during the great flood of 1333, which according to Villani had been accompanied and aggravated by an earthquake. On such grounds, tenuous though they may appear, it might be argued that Orcagna's frescoes should be dated as close as possible to the year 1339, and that the grim theme of the *Triumph of Death* relates to the plague of 1340, especially since the ominous eclipse of 1339 occurred nearly a decade before the Black Death,[31] but less than a year before the onset of the earlier plague.[32]

Yet there are strong stylistic arguments (with which I am not concerned in this paper) in favor of a date for the frescoes considerably later than the 1340s. Only if the difficulties presented by the conflicting evidence of style were to be resolved would it be possible to advance the hypothesis of an early dating. Nevertheless these considerations do not affect

[29]*Ibid.*, XI, cxiii: ". . . E morinne più che il sesto di cittadini pure de' migliori e più cari, maschi e femmine, che non rimase famiglia, ch' alcuno non ne morisse, e dove due o tre e più; e durò questa pestilenzia infino al verno vegnente. E più di quindici mila corpi morti tra maschi e femmine e fanciulli se ne seppellirono pure nella città, onde la città era tutta piena di pianto e di dolore, e non si intendea a pena ad altro, che a seppellire morti."

[30]Between 1339 and Orcagna's death in 1368 there was only one eclipse of the sun—that of May 5, 1361—which could have been at least partly visible from Italy: cf. T. von Oppolzer, *Canon der Finsternisse*, Bl. 123. Some scholars do, of course, date the frescoes at Santa Croce as late as the 1360s.

[31]For the effects of the Black Death, see especially, in addition to Meiss's *Painting in Florence and Siena after the Black Death*, F.A. Gasquet, *The Black Death of 1348 and 1349* (London, 1908), and P. Ziegler, *The Black Death* (London, 1969); the latter work contains a useful bibliography.

[32]It seems to me that the plague of 1340 may have a signifi-

cance for the historian of early Tuscan art that has not generally been appreciated. Here the question of the dating of Traini's *Triumph of Death* at Pisa appears particularly relevant. Recently Professor Joseph Polzer has found evidence for a date well before 1348; and I am most grateful to him for his kindness in showing me some of his photographic material. On this, see M. Meiss, "Notable Disturbances in the Classification of Tuscan Trecento Paintings," *Burlington Magazine* (CXIII, 1971), 178ff., where Polzer's findings are discussed. Meiss observes (186 n. 32): "If exceptional mortality was one of the factors in the choice of subject, we should recall, in view of our new chronological evidence, that there was an earlier though less disastrous pestilence in 1340." A connection between the Pisa frescoes and the plague of 1340 was also suggested by W. Valentiner, "Orcagna and the Black Death of 1348," *Art Quarterly* (XII, 1949), 68. Meiss indicates a possible terminus ante quem of 1345, but questions the very early date proposed by Polzer ("Aristotle, Mohammed and Nicholas V in Hell," *Art Bulletin*, XLVI, 1964, 457ff.).

the proposition that at least the scene of the eclipse (Fig. 3) may refer to the period preceding the advent of the Black Death, when signs in the heavens were interpreted as portents of coming disasters for the city of Florence, one of which was the plague of 1340, so graphically described by Villani.

It is too often assumed that that period was much more a time of prosperity and general wellbeing than it was in fact. As one writer put it, with regard to Orcagna's frescoes at Santa Croce, "It would be hard to account for a representation of such a tremendous and frightening tragedy on the walls of a church in a city as happy as Florence in the first half of the fourteenth century, if it were not for the fresh memories Florentines still had of the terrible plague."[33] We may rather see this period in Florentine history as one in which the conditions for that dark mood after 1348 which Meiss has so brilliantly described were already being created. The apocalyptic pages of Villani, who was himself to be struck down by the Black Death, open up a vision of horrors and calamities that must have seemed, in retrospect, to be divine warnings of a still greater punishment to come—a supreme chastisement for the sinfulness of mankind. Such was the menacing world in which Taddeo Gaddi and Orcagna practised their art.

<div style="text-align: right">UNIVERSITY OF NOTTINGHAM</div>

ADDENDUM: Owing to an oversight, the author regrettably omitted to refer to Miklòs Boskovits's important article, "Orcagna in 1357—and in Other Times," *Burlington Magazine* (CXIII, 1971), 239 ff., in which Orcagna's Santa Croce frescoes are already linked to the plague of 1340 and other historical circumstances in the 1340s. Boskovits also questions the assumptions of Dal Poggetto and others about the supposedly happy state of Florence before the Black Death. He offers new stylistic evidence for a date about 1345 for Orcagna's frescoes.

[33]P. Dal Poggetto, in *The Great Age of Fresco* (see n. 16, above), 80.

Un Nouveau Tableau bourguignon et les Limbourg

CHARLES STERLING

C'est en 1943 ou 1944 que j'ai vu pour la première fois ce beau tableau (Fig. 1). Il appartenait à la maison Duveen, et Armand Lowengard, alors à la tête de celle-ci, me l'a montré à New York. J'y ai aussitôt reconnu, comme l'avait fait d'ailleurs ce connaisseur distingué, un ouvrage français. Mais des éléments familiers s'y juxtaposaient à d'autres, assez imprévus. Davantage que le nombre et l'urgence des travaux, ce fut ma perplexité en face de cette peinture singulière qui m'en a fait retarder pendant trente ans la publication. Avant d'en parler, je désirais trouver des précisions qui m'eussent permis de situer ce *Calvaire* dans un contexte déterminé par l'un des foyers principaux de la peinture en France, au début du quinzième siècle. Je suis loin d'être satisfait de ce que je peux en dire aujourd'hui. J'aurais peut-être mieux fait d'attendre la prochaine parution du livre de Millard Meiss sur les Limbourg où j'aurais trouvé, comme dans toutes ses publications, une foule de documents visuels nouveaux. Mais le temps presse, inexorable, et je me décide de livrer ces lignes à l'imprimeur; de les livrer surtout à l'ami Millard qui, mieux que quiconque, sera en mesure d'ajouter tout ce qui manque à mon exposé.

Le *Calvaire* (aujourd'hui dans une collection particulière américaine) est peint sur panneau de peuplier;[1] son cadre est d'origine mais ne paraît pas sculpté dans le même morceau de bois. La surface peinte mesure 46,4 cm sur 28 cm ($18\frac{1}{4} \times 11$ inches). Le modelé et le coloris (dont je regrette beaucoup de ne pouvoir donner une idée par la reproduction) sont d'une grande finesse et d'une conservation satisfaisante. Seul le manteau de la Vierge est maintenant si foncé qu'il est difficile de préciser son exacte teinte d'origine; c'était peut-être un violet modelé de gris dans les lumières. Il semble que l'intention du peintre était de fournir par ce manteau une tache sombre d'une valeur émotive funèbre et rendre plus intenses, plus lumineuses, toutes les autres couleurs du tableau. La robe de la Vierge est verte, d'un vert olive. Une guimpe blanche, transparente, enserre le visage et le cou de Marie; là où elle recouvre la robe, elle en éclaircit le vert. Un bout du pied, chaussé de noir, apparaît au sol, dans les plis de la robe. La Madeleine, agenouillée au pied de la Croix, est vêtue de rouge vermillon, sa longue chevelure prend un ton d'or orangé, nettement différent de l'or pâle, métallique, du fond du tableau. Ce rouge sonore, ce chaleureux flot de cheveux complètent intimement le mouvement ardent de la tête et le geste passionné du bras. St. Jean l'Evangéliste porte un vaste manteau rose, très clair dans les parties touchées par la lumière. La doublure du manteau est d'un vert identique à celui de la robe de la Vierge. Le saint est vêtu d'une robe qui retombe sur ses pieds nus et dont le rouge lie-de-vin s'accorde de façon raffinée au rose du manteau, peint avec la laque de garance. Ses cheveux sont blonds. Telle est aussi la lourde chevelure du Christ, dont les corps livide—il diffère des chairs des autres personnages légèrement teintées de rose—est entouré d'un énorme pagne blanc aux ombres grisâtres. On distingue

[1] Selon l'examen effectué en 1973 par Hubert von Sonnenberg, alors le chef d'atelier de restauration du Metropolitan Museum of Art.

mal sur la reproduction le *suppedaneum* qui soutient les pieds du Crucifié et l'abondance du sang qui jaillit en grosses gouttes de la plaie au côté, retombe en pluie des paumes et coule des pieds sur le sol rocheux. Ce sol est d'un gris verdâtre au premier plan, où il est éclairé, et brunâtre vers le fond ; il forme une terrasse brusquement taillée à l'avant-plan en un bord ondoyant. L'insistance sur le sang, comme les gestes dramatiques, n'arrivent cependant pas à dominer le ton de tendre et sereine dignité qui marque tous les visages. Le fond d'or ajoute une note de sobriété ; il est nu, seuls l'ornent et l'animent discrètement les nimbes formés de pointillés, légers, transparents. Ceux de la Vierge et de St. Jean sont identiques. Celui du Christ n'est pas cruciforme, mais il diffère des autres par de très courts rayons qui émanent de la tête. Le nimbe de la Madeleine est réduit à une simple ligne circulaire.

La particularité qui frappe immédiatement tout historien familier de la peinture en France, au début du quinzième siècle, c'est l'exceptionnel italianisme du Christ. Bien entendu, depuis le début du quatorzième siècle, les Français et les Flamands travaillant en France ne cessaient de suivre et de refléter les nouveautés florentines et siennoises. Pourtant, je n'arrive pas à retrouver dans les enluminures, les vitraux, les peintures sur mur et sur bois qui nous restent de la production française entre 1300 et 1425 environ, un Christ aussi calmement monumental, de pure filiation giottesque. Sculptural, pesant et vertical, il est, dans notre *Calvaire*, inséré parmi des personnages de race différente, d'un aplomb moins assuré et aux silhouettes plus mouvementées. Une tentative de l'artiste d'accorder le St. Jean au Christ, en lui donnant un visage ample et des plis saillants, ne procure pas au tableau une plasticité uniforme. La Vierge et la Madeleine restent moins volumineuses. Il y a également dans la composition entière une frappante inconsistance dans l'échelle des figures. Elles sont toutes de taille différente. St. Jean est le plus grand et cette autorité semble lui avoir été conférée par la place qu'il occupe dans l'espace de la scène—la plus rapprochée de nous. Attentivement analysé, le groupe entier se révèle situé dans la profondeur légèrement en diagonale. Le poteau vertical (*stipes*) de la Croix est, en effet, vu de côté, et la Vierge nous apparaît plus petite, car elle est la plus éloignée du bord de la terrasse du sol. Un peu plus reculé, le Christ est encore plus petit que la Vierge. Quant à la Madeleine, sa taille minuscule est déterminée—comme l'est son nimbe simplifié—par la hiérarchie iconographique qui échappe aux préoccupations réalistes d'évocation spatiale. De plus, l'endroit où elle est agenouillée paraît trop distant du pied de la Croix pour lui permettre de l'étreindre. Ces écarts dans l'échelle et la structure incertaine de la profondeur suffisent à eux seuls pour nous avertir que nous ne sommes pas très éloignés du début du quinzième siècle. Et le large déploiement de toutes les silhouettes sur le plan de la surface peinte (la traverse de la Croix rejoint les bords du tableau), l'insistance sur la valeur décorative des formes et sur leurs accords rythmiques dominent nettement des tentatives de mise en perspective et d'unification de l'éclairage qui vient d'en haut. Ces traits ne font que confirmer l'attachement de l'artiste aux principes du gothique international.

L'italianisme du *Calvaire* n'est pas limité à la figure du Christ. L'iconographie formelle de la scène entière est toscane du quatorzième siècle. Elle comporte quatre motifs essentiels: la Vierge au visage levé, les bras étendus et abaissés, les mains ouvertes en une attitude de douleur et de témoignage ostentatoire; St. Jean, les bras également abaissés mais les mains convulsivement jointes, geste de dramatique lamentation que souligne le rigide envol des

boucles; la Madeleine agenouillée près de la Vierge, saisissant le bois de la Croix, le visage passionnément levé vers le Christ; la poutre horizontale de la Croix, très longue, touchant les bords latéraux de la peinture. Pour ne prendre que l'exemple de Jacopo del Casentino, son triptyque signé des Offices montre la Vierge et St. Jean dans l'attitude de notre *Calvaire*, et son triptique de l'ancienne collection Bondy, à Vienne, ajoute la Madeleine agenouillée;[2] dans les deux, la poutre horizontale de la Croix touche les bords de la peinture.

Pourtant, on ne saurait prendre le Christ du *Calvaire* pour une copie d'un Christ italien Sa tête et son pagne sont introuvables dans la peinture transalpine. Si le crâne très ample dérive du type byzantin que développèrent Cavallini et Giotto (et que, avant eux, on voit dès 1241, dans le *Crucifix* signé par un certain Pietro, à San Antonio à Campi Basso, Spolète),[3] dans le *Calvaire*, il assume des proportions quasiment démesurées, rares en Italie mais familières à la tradition française. Ce crâne volumineux qui rend le visage du Christ plus petit, plus fin, plus touchant, s'affirme en France vers 1300. Il marquera d'ailleurs également d'autres personnages et deviendra vite une formule d'école. Maître Honoré et Jean Pucelle l'adopteront et les têtes aux chevelures comme enflées à l'arrière de la tête régneront dans le *Parement de Narbonne*. Alors que les artistes français ne cessent de s'y complaire, les Italiens du dernier tiers du Trecento semblent abandonner ce crâne volumineux. Lorsqu'il réapparaîtra en Italie, ce ne sera qu'au Quattrocento, chez Fra Angelico, à la faveur du retour toscan à l'ampleur giottesque, ou bien dans les centres où la filiation du gothique septentrional sera vivace, comme à Sienne, chez Francesco di Vannuccio[4] ou dans les Marches, chez Bartolommeo di Tomaso de Foligno.[5] Mais nulle part au Sud des Alpes, l'exiguïté du visage triangulaire contrastant avec l'ample masse de cheveux ne sera autant soulignée que dans notre *Calvaire*, ni le modelé ne donnera à ce visage cette sorte d'ombreuse meurtrissure, cette tendre morbidesse qui relèvent du sentiment septentrional. Il y a là un italianisme absorbé jusqu'à devenir le point de départ d'une création originale. Italianisme parallèle à celui dont les Limbourg ont donné la preuve dans leur *Homme astrologique* (ou *Zodiacal*) des *Très Riches Heures*.[6] Ce nu vient de Toscane. Il dérive du même prototype que le petit *Christ ressuscité* masolinesque à Strasbourg (Musée des Beaux-Arts) attribué parfois à Francesco d'Antonio,[7] ou l'*Homme de Douleurs avec la Vierge et Ste. Lucie* de San Giovanni Valdarno.[8] Il partage sa silhouette avec le jeune *Saint*, de Masolino, plus tardif car terminé en 1424, à Sant'Agostino, à Empoli.[9] Le prototype de ce nu frontal légèrement déhanché fut peut-être créé par Ghiberti, à l'époque de la Porte Nord du Baptistère de Florence (1404–1407) et ressemblait de près au Christ du *Baptême* qui y apparaît.[10] Les modèles italiens ont fourni à l'*Homme astrologique* son canon et son attitude. Mais ni sa taille bien prise et cambrée, ni ses contours courvilignes ni, surtout, son impalpable *sfumato*, cette cendre légère qui semble vêtir ses chairs d'un épiderme frissonnant. Une qualité analogue de la chair se retrouve dans le Christ du *Calvaire*.

[2]B. Berenson, *Italian Pictures of the Renaissance*. I. *Florentine School* (Florence, 1963), figs. 102 et 110.

[3]*Pittura italiana di duecento e trecento. Catalogo della Mostra Giottesca di Firenze del 1937*, no. 36, Tav. 20.

[4]B. Berenson, *Italian Pictures of the Renaissance*. II. *Central and North Italian Schools* (Londres, 1968), fig. 386.

[5]*Ibid.*, fig. 625.

[6]M. Meiss-J. Longnon-R. Cazelles, *The "Très Riches Heures" of Jean, Duke of Berry* (New York, 1969), pl. 14 (fol. 14v).

[7]R. van Marle, *The Development of the Italian Schools of Painting*, IX (Le Haye, 1927), fig. 196.

[8]F. Antal, *Die Florentinische Malerei und ihr sozialer Hintergrund* (Berlin, 1958), fig. 120a.

[9]Catalogue de l'exposition "The Great Age of Fresco," New York, Metropolitan Museum of Art, 1968, 121.

[10]R. Krautheimer, *Lorenzo Ghiberti* (Princeton, N.J., 1970), pl. 32.

La deuxième particularité de ce Christ, le pagne, lourd, complexe, enrobant les jambes par devant et par derrière, est encore plus étrangère aux traditions italiennes. Le Trecento connut surtout un pagne transparent et, lorsque les giottesques tardifs, tel Taddeo Gaddi, rendirent son étoffe plus opaque et plus rigide, jamais ils ne lui donnèrent l'importance qu'il assume dans notre *Calvaire*. Le cas exceptionnel de Giovanni da Modena (*Calvaire* au Palazzo Venezia, à Rome), ce peintre toujours surprenant par d'étranges échos septentrionaux dont son art résonne, confirme cette règle.[11] Il est clair que nous sommes en présence, dans notre *Calvaire*, d'une expression picturale des trouvailles de la sculpture—de la sculpture bourguignonne des premières années du quinzième siècle. La Vierge de notre tableau, la tête couverte d'un large manteau qui lui donne une silhouette au contour accidenté, appartient à la famille des Vierges sculptées bourguignonnes. On retrouve cette silhouette, ainsi que les plis disposés au sol autour du pied, dans une *Vierge à l'Enfant* (inédite, collection particulière; 69 cm du haut), de tradition directement slutérienne, mais qui ne paraît pas antérieure aux années 1435–1440 (Fig. 2). La double cascade des plis symétriques qui descend du bras droit de la statue s'apparente de près à la chute en volutes du manteau que soulève le bras droit de St. Jean (Fig. 1).

L'analyse des autres détails du *Calvaire* nous conduit également vers les rares peintures certainement nées ou, en tout cas, présentes en Bourgogne, au début du siècle. Le visage de la Madeleine (Fig. 3) est du type des anges de la *Grande Pietà* (ou *Trinité*) du Louvre (Fig. 4). La main ouverte de la Vierge (Fig. 5) suit directement le canon de la main de St. Jean du même tableau (Fig. 6). C'est encore ce tondo ainsi que la petite *Madone* bourguignonne au Louvre (entrée avec la collection Beistegui) et le grand *Retable de St. Denis* terminé à Dijon, par Henri Bellechose, en 1416 (également au Louvre) qui présentent des fonds d'or analo gues à celui du *Calvaire*, unis et enrichis seulement par des nimbes aérés, légèrement gravés. Le retable de Bellechose offre le seul exemple français connu d'un Christ quelque peu comparable car très puissant mais point aussi italianisant. L'inconsistance dans l'échelle des personnages (le Christ crucifié est beaucoup plus grand que le Christ qui donne la communion à St. Denis) n'est pas sans analogie avec le principe compositionnel de notre *Calvaire*.

Par d'autres traits, ce tableau se rapproche de l'art des Limbourg. Le doux profil de la Vierge (Fig. 7) est remarquablement voisin de celui des *Belles Heures* (Fig. 8), où l'on trouve également des têtes masculines carrées et bouclées (Fig. 9) comme la tête de St. Jean (Fig. 10). Celle-ci ne s'apparente pas moins à la tête de l'*Homme astrologique*, miniature trop célèbre pour qu'il soit indispensable de la reproduire;[12] et le geste dramatique de St. Jean est analogue au geste de la Vierge dans la *Descente de Croix*, une autre miniature des *Très Riches Heures*. Il semble donc que notre artiste ait conçu le *Calvaire* après l'interruption de l'illustration de ce livre, en 1416. Mais il est loin de faire figure de disciple direct des Limbourg. Les drapés du *Calvaire* n'ont aucune parenté avec les plis de ces maîtres dessinateurs des pans d'étoffes longs et fluides qui flottent en l'air ou serpentent à terre. En comparaison avec les Limbourg, le contact des drapés avec le sol est, dans notre *Calvaire*, bref et simple. On le retrouve semblable

[11]*I Maestri del colore. Il gotico internazionale in Italia,* Documenti, fig. 12, no. 255. [12]Voir au-dessus, n. 6.

dans la sculpture bourguignonne dont voici un exemple dans notre Fig. 2.[13] Dans la peinture dijonnaise, cette tendance vers la simplification s'affirme nettement dès 1416 dans le *Retable de St. Denis* de Bellechose. Je suis tenté de dater le *Calvaire* des alentours de 1420.

Le lien entre notre *Calvaire* et l'art des Limbourg ne détermine donc pas le style de ce tableau. Mais il est bien distinct et il contribue à faire situer ce panneau dans le milieu bourguignon. Il importe, en effet, de corriger la tendance courante qui rattache trop exclusivement les frères à leur mécène majeur, le duc Jean de Berry. Elle produit l'illusion que leur art ne pouvait marquer que les milieux où se trouvaient les résidences principales de ce seigneur, à Paris et à Bourges. Millard Meiss a ouvert des perspectives sur le rayonnement possible de l'art des Limbourg en Bourgogne. Dans son étude sur le Maître du Bréviaire de Jean sans Peur, il attira l'attention non seulement sur ce collaborateur et satellite des Limbourg qui travailla pour un duc de Bourgogne mais sur la première commande que Pol et Jean ont reçue de Philippe le Hardi, grâce sans doute à leur oncle Jean Malouel, peintre en titre du prince.[14]

La carrière documentée de ces deux frères commence lorsque le duc Philippe les charge le 9 février 1402 (nouveau style) *d'achever et de continuer* les "histoires" (scènes historiées) d'une "très belle et notable Bible que ledit seigneur *avait* nagaires [depuis peu] *fait encommencier*."[15] Comme on voit, ce texte mentionne explicitement l'existence au moment de l'engagement des frères, de certaines "histoires" faites par d'autres artistes. Il parait donc en frappant désaccord avec la *Bible moralisée* (Paris, Bibliothèque Nationale, MS franç. 166) laquelle *débute* par trois cahiers illustrés par les Limbourg.[16] Ni dans les scènes de ces trois

[13]La statue, de pierre, mesure (base exclue) 64 cm. de haut. La base (18 cm. × 23 cm.) reposait à l'origine sur un socle percé sur ses trois côtés de petits arcs trilobés dont on voit les sommets. L'absence du quatrième arc indique que la statue devait être adossée à un mur. Son dos cependant est travaillé avec le même soin que le reste de la statue et montre une série de larges courbes parallèles semblables aux plis sur le devant. L'ampleur du drapé du dos témoigne de la tradition slutérienne directe et ne parait pas designer une période posterieure à 1440 environ.

[14]M. Meiss, *The Master of the Breviary of Jean sans Peur and the Limbourgs* (Lecture on Aspects of Art, British Academy) (Londres, 1971), 5-6.

[15]"Pour parfaire les histoires d'une très belle et notable Bible que avoit nagaires fait encommencier ledit seigneur, que pour l'accomplissement d'icelles et des ystoires qui y devront estre faictes." Les trois documents des Archives de la Côte d'Or, à Dijon, qui concernent la Bible confiée par Philippe le Hardi à Pol et Jean de Limbourg, ont été réimprimés par P. Cockshaw, "Mentions d'auteurs, de copistes, d'enlumineurs et de libraires dans les Comptes Généraux de l'État Bourguignon (1384-1419)," *Scriptorium* (XXIII, 1969), 133-35, no. 46, 51 et 57. Cependant, les textes n'y apparaissent pas tout à fait complets. Les annotations en marge du premier et du dernier document (numérotés respectivement par Cockshaw 46 et 57) manquent. Or, elles ne sont pas sans intérêt. La première constate que le délai de la période maxima de quatre ans, stipulé pour la réalisation de l'illustration, commence à courir à partir du 6 mars 1402 (nouveau style). La seconde, qui accompagne la reconnaissance signée par Jean Durant le 18 janvier (non le 17 comme imprimé chez Cockshaw au no. 57) 1404 (nouveau style), parle de la restitution de la Bible au duc; ce n'est probablement qu'une simple formule

juridique de garantie mais le fait qu'elle soit mentionnée au bout de vingt-deux mois de travail pourrait également indiquer que le travail des enlumineurs n'était alors pas loin d'être achevé. Avant de donner les trois textes, dont la lecture a été, sur ma demande, très obligeamment vérifiée par Pierre Quarré, je tiens à ajouter à la vive gratitude que je lui dois ma reconnaissance à Mme Jean Richard dont les recherches bibliographiques sur Jehan Durant m'ont confirmé que celui-ci ne possédait d'autre logement que l'hôtel de Paris.

Ici cette note écrite, comme l'article, en automne 1973, donnait le texte intégral des trois documents. Mais maintenant, au début de 1975, au moment où je reçois les épreuves, nous possédons déjà le capital ouvrage de Millard Meiss sur les Limbourg (*French Painting in the Time of Jean de Berry. The Limbourgs and Their Contemporaries*, New York, 1974). On peut y trouver, I, 72-73, les trois documents dont le texte est pratiquement identique à celui vérifié par Pierre Quarré. Il convient seulement, à la suite du document de 1402, d'ajouter l'annotation suivante: "Super dictum magistrum Jo. Durant et caveatur de tempore dictorum IIII annorum qui videntur incipere VI[ta] marcii n[0] CCC[0] primo." Et, à la suite du document 1404 daté du 18 non le 17 Janvier (imprimé I, 73-74), d'ajouter l'annotation: "Super dictum magistrum Johannes Durandi prout in compoto precedenti fo. XIIIIxx XIX pro aliis VI[0] fr. et caveatur quod dicta Biblia reddatur domino vel etc."

[16]La difficulté qui nait de cette contradiction empêcha Durrieu d'identifier la "très belle et notable Bible" avec la *Bible historiée* MS franç. 166. Voici sa dernière opinion, celle de 1922 (*Les Très Belles Heures de Notre-Dame du du Jean de Berry*, 73): "Cette Bible (MS franç. 166) peut-elle être identifiée avec celle que faisait faire le duc de Bourgogne Philippe le Hardi? La question me parait plus que douteuse." Cette opinion a sans doute échappée à F. Avril ("Un chef-d'oeuvre de l'enluminure

cahiers ni dans les encadrements qui les entourent on n'aperçoit la moindre trace d'un dessin sous-jacent qui serait d'une autre main et qui eût exigé d'être "parachevé" par les frères. La seule manière de concilier le document et le MS franç. 166 serait de supposer que les cahiers avec les miniatures commencées avant 1402 eussent été enlevées; de sorte que maintenant ce sont les cahiers des Limbourg qui inaugurent l'illustration du MS franç. 166. Cette supposition ne serait peut-être pas tout à fait gratuite : il semble qu'avant l'année 1518, ce manuscrit contenait deux cahiers avec des instructions destinées aux enlumineurs.[17] On comprend qu'après 1518 la présence de ces notes auxiliaires eût parue gênante et inutile ; mais cette élimination autorise le soupçon que d'autres changements aient pu intervenir au début du manuscrit. Si l'on n'accepte pas cette solution plutôt fragile, il faut nous résigner à admettre que la "très notable Bible," qui n'était pas nécessairement du type des Bibles moralisées, ne nous est pas connue. Les Limbourg y ont travaillé à Paris, pendant vingt-deux mois, du 6 mars 1402 jusqu'au 18 janvier 1404, date du dernier paiement connu. Ils étaient surveillés par Jean Durant, médécin de Philippe le Hardi, qui habitait un "hostel" au cloître Notre-Dame et qui les payait de la part du duc. Pol et Jean s'étaient engagés à travailler exclusivement pour le duc et à terminer l'illustration le plus rapidement possible, en quatre ans au plus. Agé, Philippe désirait sans doute voir cette Bible achevée. Le travail avançait à sa satisfaction. Dix mois après son commencement, le 12 janvier 1403, à l'occasion du Nouvel An, le duc gratifia chacun des frères de dix écus d'or "pour avoir de la robe pour qu'ils besoignoient pour mon dit seigneur chascun jour en l'ostel de Maistre Jehan Durant son phisicien." Ce médecin favori de Philippe le Hardi, fréquemment récompensé, était un lettré. Les comptes le qualifient parfois de conseiller ducal.[18] Il fut souvent chargé par le grand bibliophile de surveiller la confection des manuscrits, de régler les frais des matériaux et les gages des artistes. On ne

sous le règne de Jean le Bon : La Bible Moralisée, manuscrit français 167 de la Bibliothèque Nationale," *Monuments et Mémoires*, Fondation E. Piot LVIII, Paris, 1973, 93) qui écrit : "Or Durrieu a demontré de façon convaincante que ce dernier manuscrit (franç. 166) était sûrement identifiable avec une 'belle et notable Bible . . .' " et se refère à l'article de Durrieu publié dans *Le Manuscrit*, en 1895. Elle a été également oubliée dans la bibliographie, par ailleurs si complète, du MS franç. 166, que donne le récent livre de Meiss sur les Limbourg (p. 343), alors que cet auteur l'avait scrupuleusement mentionnée dans son étude sur le Maître du Bréviaire de Jean sans Peur (citée ci-dessus, n. 14), 6, n. 1. Comme Durrieu, Jean Porcher n'a pas admis l'identification et a résumé ses objections dans son remarquable catalogue de l'exposition *Les Manuscrits à peintures en France du XIII⁰ au XVI⁰ siècle* (Paris, Bibliothèque Nationale, 1955), no. 188, pp. 91–92. Mais parmi ces objections, je ne puis accepter, d'accord avec Meiss et Avril, la tardive datation des trois cahiers des Limbourg dans le MS franç. 166 de l'époque des *Belles Heures* (1405–1408) ; le style de ces cahiers est certainement antérieur de plusieurs années. Dans son étude sur le Maître du Bréviaire de Jean sans Peur (1970), Meiss annonçait une "full discussion" du problème. Elle n'a pas été incluse dans le récent livre sur les Limbourg, où l'auteur accepte l'identification.

[17]P. Durrieu, "Manuscrits de luxe executés pour des princes et des grands seigneurs français," *Le Manuscrit* (II, 1895), 121.

En mentionnant ces deux cahiers d'instructions détaillées, Durrieu se basait sur le passage suivant de L. Delisle, "Livres d'images destinés à l'Instruction Religieuse et aux exercices de piété des Laïques," extrait de l'*Histoire Littéraire de la France*, XXI (Paris, 1890), 243 :

La plus ancienne mention que nous ayons recontrée de la Bible moralisée N° 166 nous a été fournie par le Catalogue des Livres du Roi François Ier, dressé à Blois en 1518 et conservé en original à la Bibliothèque Imperiale de Vienne. Nous y lisons :

"Une Bible en parchemin, en latin et français, bien et richement historiée des figures du Vieil Testament avec le Nouveau, et est couverte à bandes de velours cramoisi et de drap d'or, avec camaieulx de pourcellines. Item le résidu de la Bible dessus dict, en parchemin, lequel n'est point historié, avec deux cayés du papié ou sont contenus la forme de faire les dictz histoires."

Ainsi, la Bible moralisée que François Ier possédait au commencement de son règne était coupée en deux volumes : le premier orné de peintures est le volume qui porte aujourd'hui le N° 166 dans le fonds français, le second se composait de cahiers non enluminés, dont il nous est parvenu quelques feuillets recueillis dans de vieilles reliures. A ce second volume étaient joints deux cahiers de papier remplis d'instructions pour les peintres chargés du travail d'enluminure, cahiers dont la perte est infiniment regrettable. . . .

Si l'on accepte cette identification du MS franç. 166 avec la Bible historiée ayant appartenu à François Ier on est porté à croire que les cahiers d'instructions concernaient les enlumineurs du second volume, donc, plus tardifs que les Limbourg.

[18]Cf. le document réimprimé par Cockshaw (voir au-dessus, n. 15).

sait si, après la mort de Philippe le Hardi, en avril 1404, les deux frères ont continué la décoration de la "très notable Bible" pour le nouveau duc, Jean sans Peur, qui cependant a retenu les services de leur oncle Malouel.

Il convient de suivre Meiss en estimant que les illustrations des trois cahiers des Limbourg dans la *Bible moralisée* franç. 166 sont leurs oeuvres des débuts dont le style ne s'oppose pas à une datation vers 1400–1404, les dernières années du principat de Philippe le Hardi. Il est d'autre part quasi certain que ce manuscrit a dû être commandé par ce duc car il est directement basé sur un livre qui lui appartenait, la *Bible moralisée*, Bibliothèque Nationale MS franç. 167, illustrée vers le milieu du quatorzième siècle.[19] Mais cette étroite dépendance d'un modèle si ancien, sans doute imposée, favorise l'idée que les trois cahiers du MS franç. 166 étaient la première commande du duc Philippe aux jeunes neveux de son peintre et, qu'après ce "coup d'essai" satisfaisant, le prince a décidé de confier à Pol et à Jean la tâche d'achever l'illustration d'une Bible somptueuse déjà commencée par d'autres artistes.

Meiss a observé dans les trois cahiers des reminiscences incontestables et directes des tableaux que j'ai pu rendre à Jean de Beaumetz et ses collaborateurs et qui, depuis 1395, ornaient les cellules des Chartreux de Champmol.[20] Il n'est donc pas exclu que Pol et Jean aient exécuté les enluminures du MS franç. 166 non à Paris mais à Dijon, vers 1401. S'ils n'ont pas mené l'illustration au delà des trois premiers cahiers, ce fut peut-être parce que, au début de 1402, ils ont déménagé à Paris, par ordre du duc Philippe qui voulait faire surveiller leur travail sur la "très notable Bible" par son homme de confiance Jean Durant, dans son domicile même, au cloître Notre-Dame. Mais quelle que soit la date exacte du MS franç. 166—et elle ne saurait varier que de deux ans environ—une chose est certaine : ces enluminures prouvent la connaissance de l'art pratiqué à Champmol vers 1395 et nous invitent à conclure, avec Meiss, que la formation des frères a dû s'accomplir non seulement à Paris mais aussi et, peut-être, surtout, à Dijon, aux alentours de 1400, sous l'influence de leur oncle Malouel.

Ce ne sont pas les seules raisons de croire que l'art des Limbourg a pu être connu en Bourgogne même après leur mort, en 1416. Dans le domaine de la peinture sur panneau, c'est notre *Calvaire* qui en témoigne. Dans celui de l'enluminure, leur art détermine les oeuvres du Maître du Bréviaire de Jean sans Peur, dégagé et étudié de près par Meiss qui date ce manuscrit de 1414–1419 environ.[21] Patronné par le duc, cet artiste a pu peindre le *Bréviaire* aussi bien à Dijon qu'à Paris, où Jean sans Peur exerçait une influence politique dominante et où il séjournait fréquemment.[22] Mais c'est le lieu où se trouvait le livre qui

[19]Voir à ce sujet Avril, "Un chef d'oeuvre de l'enluminure," 95–125, où l'illustration de ce livre a été étudiée à fond et avec des résultats fort importants pour notre connaissance de l'évolution de l'enluminure en France sous les règnes de Jean le Bon et de Charles V.

[20]*The Master of the Breviary of Jean sans Peur*, 7, n. 1, pl. II b et pl. III a et b.

[21]Dans son livre récent sur les Limbourg (p. 233), Meiss avance légèrement la date : vers 1413–1419.

[22]C'est également le cas de la jolie petite *Vierge à l'Enfant* de la Frick Collection : il y a, dans l'état actuel des connaissances, autant d'indications pour le domicilier à Paris qu'à Dijon. Il y a trente-cinq ans, j'ai eu tort de la dater trop tard (1415–20) et de l'attribuer (dubitativement, il est vrai) à un atelier avignonnais (Charles Jacques [Sterling], *La Peinture française* :

Les Peintres du Moyen Age, Paris, 1942, légende sous la planche 41 : "Atelier d'Avignon? vers 1415–1420. Influence franco-flamande venant de Bourgogne"; et *Répertoire*, 10, no. 45). Ces deux indications n'étaient pas tout à fait illusoires. D'un côté, on ne connait de composition plus proche de cette *Madone Glycophilousa* que celle d'une miniature du *Bréviaire* de l'antipape Benoît XIII, exécutée entre 1394 et 1409, en Avignon (reproduite dans l'article de Otto Pächt, "The Limbourgs et Pisanello," *Gazette des Beaux Arts*, LXII, 1963, 111, fig. 3). D'autre part, la gravure du fond d'or où serpente l'arabesque de tiges finement pointillées correspond aux habitudes bourguignonnes (depuis sa forme simple, dans le *Calvaire* de Beaumetz, à Cleveland, 1395, jusqu'à l'*Homme de Douleurs* à Troyes, vers 1405–1410). On comprend que Pächt ait situé la *Madone Frick* nettement en Bourgogne, bien que

compte pour le rayonnement de son influence. Et il est vraisemblable qu'ayant été destiné, comme le suggère Meiss, à la duchesse Marguerite de Bavière, on pouvait le voir à Dijon plutôt qu'à Paris.

Les documents actuellement connus ne mentionnent en Bourgogne, pour le premier quart du quinzième siècle, que peu de peintres, en dehors de ceux qui étaient au service des ducs. Nous possédons, en 1421, la mention de Pierre Verjus "peintre demourant à Dijon" qui sert de témoin à un contrat d'apprentissage passé par Henri Bellechose. De toute évidence, il a pu travailler plus tôt, à l'époque probable de notre *Calvaire*, mais rien ne permet de le lier à ce tableau. En 1424, l'atelier de Bellechose accueille à titre de compagnons deux artistes qualifiés de "paintres," donc déjà formés et non nécessairement en Bourgogne. La formation du premier, Jacquet Neveu, très généreusement payé, nous est inconnue, mais son nom est à retenir. Le second, Michellet Estellin, arrive de Cambrai avec son titre de peintre. On a récemment constaté que la *Messe de St. Grégoire* donnée au Louvre par Paul Jamot se trouvait au quinzième siècle à la Chartreuse de Champmol;[23] elle montrait donc en Bourgogne le fragile graphisme et le coloris pâle et froid du Nord de la France, patrie de Michellet Estellin. Mais ce peintre déjà formé en 1424 ne peut pas être l'auteur de ce tableau que le costume du donateur et l'assimilation de l'art de Roger van der Weyden situent raisonnablement vers 1460 au plus tôt. Le nombre d'aides et d'apprentis de Bellechose au début des années 1420, aussitôt après sa confirmation comme peintre en titre de Philippe le Bon, donne l'impression d'une arrivée massive d'artistes attirés par la réputation du milieu dijonnais.[24] Certes, l'activité autour de la Chartreuse et pour le compte des ducs diminua par rapport à ce qu'elle était sous Jean sans Peur. Mais elle ne tarit pas. Les documents attestent que Bellechose et Maisoncelles continuent de recevoir des commandes importantes. D'autre part, les tableaux bourguignons du second quart du siècle qui survivent sont plus nombreux qu'on ne le dit généralement. En dehors de plusieurs dont les mieux connus sont le *Calvaire au Chartreux* (autrefois dans la collection Martin Le Roy, aujourd'hui dans celle de la comtesse Du Luart, à Paris), la *Présentation au Temple*, à Dijon, que Pierre Quarré rendit, de façon plausible, à Jean de Maisoncelles, et le grand *Retable de St. Georges*, au Louvre, dont le rude langage s'avère autochtone, il y a lieu d'en mentionner deux autres que je regrette de ne pas pouvoir reproduire dans cet article.

L'un c'est une *Vierge à l'Enfant*, d'une rustique fraîcheur, qui a été exposée et reproduite

a datant, peut-être, un peu trop tôt, entre 1390 et 1400. Or, une *Madone Glycophilousa* très analogue de composition se trouve précisément dans le *Bréviaire de Jean sans Peur*; elle orne l'initiale du fol. 8 (reproduit par Meiss, *The Master of the Breviary of Jean sans Peur*, et *French Painting in the Time of Jean de Berry. The Limbourgs and Their Contemporaries*, New York, 1974, I, fig. 64). Et comme ce manuscrit n'exclue pas une origine parisienne, la *Madone Frick* s'apparente par son type et son voile transparent à la Madeleine de la *Petite Pietà Ronde* du Louvre, laquelle fait partie d'un groupe des petits tableaux qui peuvent avoir été exécutés aussi bien en Bourgogne qu'à Paris. Il ne faut pas oublier que ce caractère hybride correspond très précisément aux documents: tant Jean de Beaumetz que Jean Malouel furent mandés par Philippe le Hardi de Paris et nous ne savons toujours pas quels sont exactement les éléments de l'art parisien dans les oeuvres identifiées de Beaumetz et dans

celles attribuées à Malouel (dans le grand tondo de la *Trinité*, au Louvre, en particulier).

[23]Observation due à Jacques Thuillier et confirmée par la découverte d'une inscription au dos du tableau, jusqu'alors cachée.

[24]En 1421, Bellechose accepte comme apprenti Jehannin Chrétien qui vient de Troyes. En 1424, lors des préparatifs du mariage de la soeur de Philippe le Bon, Agnès de Bourgogne, avec le duc Charles de Bourbon, Bellechose emploie, sous la conduite de Jacquet Neveu "son varlet et serviteur" (dont le salaire est à peine inférieur au sien) jusqu'à sept aides: Guiot le Borgne, Gilet "le peintre," Philibert Totin, Josse "le peintre," Lambert Chousteau, Perrin Saintier et Richard Seve (Documents publiés par C. Monget, *La Chartreuse de Dijon d'après les documents des archives de Bourgogne*, II, Montreuil-sur-Mer, 1901, 105–06).

à Londres, en 1962, comme une oeuvre de l'école de Malouel, sans doute parce qu'on l'a rapprochée de la *Madone Beistegui*, au Louvre.[25] Plutôt que cette affinité superficielle, ce tableau montre un rapport évident, quant au style et à la facture, avec le *Calvaire au Chartreux* de la collection Du Luart et il pourrait dater de 1430 environ.

Le second tableau, inédit, représente une *Pietà* et se trouvait, en 1963, dans la collection Loewenheim, à Montréal. Sous une Croix, dont les bras touchent les bords latéraux du grand panneau, la Vierge dolente, les mains jointes à la hauteur de la poitrine, est agenouillée et penchée sur le corps du Christ étendu à terre, sur un liceul. Ce groupe placé sur un sol rocheux est d'un noble et tranquille effet monumental. Par malheur, le tableau est ruiné ; il a été vidé, ou presque, de sa substance picturale originelle et il a subi un nettoyage implacable suivi d'une restauration découragée. Cependant, son somptueux fond d'or gravé de larges rinceaux de tiges aux grosses feuilles pointillées, bien bourguignon, et les nimbes, très grands et riches, sont bien conservés. Les silhouettes massives de la Vierge et du Christ, à peu près authentiques, font penser à la sculpture bourguignonne et confirment la localisation. Le type du Christ pourrait même dériver de celui de Sluter, qui nous reste du *Calvaire* de Champmol. La silhouette de la Vierge ressemble à celle de la *Madone Beistegui*. Quant à la date, les alentours de 1425 paraissent convenir.

Ainsi, les tableaux bourguignons conservés, dès qu'ils sont postérieurs au *Retable de St. Denis* achevé en 1416, constituent un groupe stylistiquement hétéroclite. Quoi de foncièrement commun entre la *Présentation au Temple* attribuée à Maisoncelles, le *Calvaire au Chartreux* de la collection Du Luart, le *Retable de St. Georges* et la *Pietà* de la collection Loewenheim? Ils sont bourguignons tantôt par leur provenance tantôt dans la mesure où ils avouent certains souvenirs locaux, partagent certains motifs et s'apparentent à la sculpture régionale. Non parce qu'ils partagent une conception artistique unique dont ils ne seraient que des variantes. Mais cette situation correspond précisément au témoignage des documents qui nous montrent la Bourgogne de la première moitié du quinzième siècle comme un rendez-vous d'artistes d'origine et de formation diverses. Et cette diversité même, qui atteste la vitalité du milieu bourguignon, rend l'aspect original de notre *Calvaire* moins inattendu.

Peut-on, à la suite de tout ce qui vient d'être dit, conclure tranquillement que ce tableau a été exécuté en Bourgogne? Hélas, non. Car il est peint sur peuplier, bois qu'on ne rencontre pas dans les tableaux bourguignons (toujours de chêne). A moins de faire voyager notre peintre, de lui faire descendre la vallée du Rhône jusqu'au Mâconnais, on ne trouverait pas de région bourguignonne appropriée. Mais c'est encore plus loin qu'il a pu descendre. Car le peuplier règne dans la peinture de l'Italie, surtout en Toscane.[26] Compte tenu de l'exceptionnel italianisme du Christ, l'éventualité de l'exécution du *Calvaire* en Italie par un peintre français venu de Bourgogne ne saurait être exclue. Comment ne pas se souvenir ici des Limbourg qui—ou, au moins, l'un d'eux—ont certainement franchi les Alpes? Ils n'étaient

[25]Exposition "Religious Themes in Painting from the 14th Century Onward," London, Wildenstein Gallery, 1962, no. 10 ; reproduit in *Art International* (VI, 1962), 99. L'attribution à l'"école de Malouel" se fondait sur une certaine analogie avec la *Madone Beistegui*, au Louvre, laquelle cependant ne peut être revendiquée par Malouel. La comparaison avec le *Calvaire Martin Le Roy* est beaucoup plus significative. Il est possible

que cette petite *Madone* ait formé le centre d'un triptyque domestique car l'Enfant se tourne et bénit vers la gauche, tandis que la Vierge regarde avec insistance vers la droite : chacun des donateurs sur les volets aurait eu ainsi sa part de la faveur divine.

[26]J. Marette, *Connaissance des primitifs par l'étude du bois* (Paris, 1961), 50 et 51, 54 et 55.

d'ailleurs pas les seuls parmi les peintres français à prendre ce chemin avant Fouquet. Leur exemple a pu encourager l'auteur de notre *Calvaire*.

Les Limbourg ont travaillé, entre 1400 environ et 1416, à Paris et à Bourges et, très probablement, à Dijon, pendant un an ou deux. Dans chacun de ces milieux, ils impression-nèrent des artistes locaux. On leur empruntait cependant des motifs isolés plutôt que le style dont le maniérisme a pu paraître trop personnel et la culture italienne trop subtile pour être facilement assimilable. Un tel emprunt apparaît dans un tableau intrigant, la *Vierge enceinte*, de la National Gallery à Washington (Fig. 11).

Le peintre a choisi le moment où Marie, pensive et émue, portant un livre dans sa gaine, l'image même de l'innocence virginale et de la piété, s'achemine lentement vers le lieu de la Nativité. Un ange l'y conduit par la main. Elle est suivie de deux jeunes femmes, si jeunes qu'on pourrait les prendre pour des fillettes ; on les a trop souvent prises pour des donatrices, mais ce sont les deux sages-femmes des Apocryphes, qu'on représente parfois de taille délibérément diminuée. Plus loin, déjà séparé de l'évènement divin auquel il n'assistera pas, Joseph apparait derrière un rideau suspendu à une tringle.[27] Il est sombre et soucieux, il n'emporte avec lui qu'un livre et un bâton de voyageur. Deux chérubins tiennent une grande couronne au-dessus de la tête de la Vierge ; mais cette partie du tableau est ruinée et restaurée au point de ne plus se prêter aux déductions d'ordre stylistique.

On a cru pouvoir constater une parenté entre les visages de ce tableau et ceux du *Sacerdoce de la Vierge* (au Louvre), peint à Amiens, en 1437. On a donc proposé pour l'exécution de la *Vierge enceinte* la même date et le même lieu d'origine.[28] Cependant, la ressemblance des types est superficielle, celle du style également. Le gracieux tableau de Washington est encore fort imprégné de gothique international. Les robes de la Vierge et d'une des sages-femmes forment des séries de volutes qu'on cherche en vain dans le panneau amiénois. C'est dans le petit tondo du *Couronnement de la Vierge*[29] et dans la *Madone aux Papillons* (les deux à Berlin) qu'on trouve des parallèles à de tels plis ; et ces tableaux sont certainement antérieurs à 1415. On ne saurait cependant assigner la même période au panneau de Washington. Car son St. Joseph n'est qu'une paraphrase du moine qui participe à la procession du pape St. Grégoire, miniature des *Très Riches Heures* (Fig. 12) restée inachevée en 1416. Il est vrai que cette figure de moine (qui parait d'ailleurs alourdie par une retouche de Jean Colombe) fait partie d'une famille de personnages de profil dont les membres sont innombrables dans l'oeuvre des Limbourg, depuis les trois cahiers du MS franç. 166 et les *Belles Heures*. Mais aucun n'offre à la fois le bonnet rond et le bâton recourbé; il semble légitime de croire que le modèle du St. Joseph vient des *Très Riches Heures*. L'auteur de la *Vierge enceinte* a également suivi les Limbourg en utilisant cette silhouette de profil pour clore la composition de la scène, en la plaçant le long

[27]Sur le fol. 34 des *Grandes Heures,* le duc de Berry en oraison reçoit le rayon de la grâce divine devant un rideau suspendu à une tringle, dans une aire qui devient sacrée. Pour la reproduction, voir M. Thomas, *Les Grandes Heures de Jean de France duc de Berry* (New York, 1971), pl. 52.

[28]Opinion de R. Longhi rapportée par le catalogue *Paintings and Sculpture from the Samuel H. Kress Collection, National Gallery of Art* (Washington, D.C., 1951), no. 76. Pour la reproduction en couleur du *Sacerdoce de la Vierge,* voir C. Jacques [Sterling], *Les Peintres du Moyen Age,* pl. CXXX.

[29]La série de volutes au bas de la robe de la Vierge, à Washington, est encore très similaire à celle de la Vierge couronnée, dans le tondo bien connu de Berlin, tableau qui ne saurait être postérieur à la première décennie du quinzième siècle. Dans ce tondo, on retrouvera également quelques autres traits du tableau de Washington—les robes horizontale-ment striées et le sol semé de plantes et de fleurs. Mais là s'arrêtent les analogies entre ces deux tableaux français qui, étant donné la différence de leur style, semblent sortir des deux milieux distincts.

du bord du tableau. La date du panneau de Washington ne saurait être postérieure aux alentours de 1420.

D'autre part, une enluminure des *Heures de l'Infant de Portugal D. Duarte* qui représente la *Vierge enceinte* (fol. 144v) offre une remarquable similarité de composition, bien que Marie n'y soit accompagnée que de deux anges musiciens (Fig. 13). Comme dans le tableau de Washington, elle marche lentement vers la gauche, un livre à la main, et un bandeau orne ses cheveux ; au lieu d'un gazon, elle foule un carrelage, mais, au premier plan, ce sol, comme parfois chez le Maître de Boucicaut, est découpé en terrasse et laisse apercevoir l'herbe verte semée de plantes jaunes ; au lieu du rideau, une basse cloison sépare la Vierge du monde, lui ménage une aire sacrée. Ces variantes ne nous empêchent pas de reconnaître que nous sommes devant la même formule compositionnelle de ce thème alors fort rarement traité. Il serait donc d'un intérêt certain de tâcher de localiser l'enluminure.

Que peut-on savoir des *Heures de Duarte*? L'analyse du calendrier, des suffrages et des litanies a montré que le personnage qui a commandé le livre avait une prédilection pour les saints vénérés surtout dans le comté de Flandre, domaine des ducs de Bourgogne.[30] Aucun saint n'est spécifiquement portugais ; le manuscrit ne paraît donc pas destiné à un Portugais. Au fol. 97, qui commence l'Office de la Vierge, on voit, dans l'initiale, les armes du Portugal, et, au bas de la page, en dehors de la bordure décorée, une inscription dont l'écriture diffère de celle du texte. L'inscription apparaît sur un rouleau tenu par une main qui émerge arbitrairement du décor de la bordure ; rouleau et main sont légèrement dessinés au trait. Cette inscription, visiblement ajoutée, n'est pas une dédicace mais un constat de propriété. Elle affirme que le livre est "au prince Edouard (Duarte) fils du roi Jean de Portugal et d'Algarve, seigneur de Ceuta." Les armes sont-elles d'origine ou furent-elles ajoutées en même temps que l'inscription? Pour y répondre, il faudrait une vérification au laboratoire qui n'a pas encore été faite, du moins à ma connaissance. Mais même si elles sont d'origine, elles ont pu être placées par ordre du personnage du domaine bourguignon lorsqu'il a décidé d'offrir le livre au prince Duarte. On suggère d'habitude, mais sans la moindre preuve à l'appui, que le cadeau a pu venir de la soeur du prince, Isabelle de Portugal, devenue duchesse de Bourgogne en 1430. L'offrande se situerait ainsi entre cette date et 1433, lorsque Duarte cessa d'être prince pour ceindre lui-même la couronne. Cette datation a été acceptée par Panofsky, qui reconnut dans les *Heures de Duarte* un joyau du vaste groupe dit "aux rinceaux d'or" (the Gold Scroll), dont l'atelier principal semble bien se situer à Gand.[31] Panofsky indique, en

[30]Une importante étude des sources littéraires et des saints des *Heures de D. Duarte* a été récemment publiée par M. Martins S.J., *Guia Geral das Horas del . . . Rei D. Duarte*, éd. Brotéria (Lisbonne, 1971). Ce livre reproduit 23 miniatures des *Heures*, dont plusieurs en couleur de bonne qualité. Malgré la mention des deux saints particulièrement vénérés dans la vallée de la Meuse, la prépondérance de ceux dont le culte est décidément localisé dans le Nord de la France et la Flandre fait nettement pencher pour cette région. Il est intéressant d'observer que le *St. Jerome* du fol. 310v (reproduit, chez Martins, face à la p. 192) est l'antécédent le plus direct, actuellement connu, du *St. Jérôme* au North Carolina Museum of Art, Raleigh, N.C. (du milieu des années 1430) dont l'attribution à Lochner, souvent proposée, n'est pas entièrement convaincante. La composition et les détails

offrent une remarquable analogie et, en même temps, une différence stylistique qui justifie la datation des *Heures de Duarte* vers 1415.

Je dois la connaissance du livre du père Martins, des informations sur les *Heures* et d'excellentes photographies à l'amicale obligeance de Maria Manuela S.O. Marques da Mota, Conservateur au Musée de la Fondation Gulbenkian.

[31]En acceptant la date de 1428–1435, Panofsky (*Early Netherlandish Painting*, 122 et 406–07 n. 1) suivit l'indication erronée du *Bulletin de la Société Française de Reproduction des Manuscrits à Peintures* (XIV, 1930), 16–17, où, à propos d'Isabelle on a cité 1428, l'année de l'arrivée au Portugal de son portraitiste, Jan van Eyck, au lieu de citer 1430, l'année de son mariage bourguignon.

même temps, que ce livre est celui du groupe qui est le plus marqué par l'influence du Maître de Boucicaut, et c'est l'évidence même.[32] Les schémas compositionnels des scènes, les motifs tels que les sols, les fonds et les arbres, le type de la bordure, la couleur sont directement empruntés aux *Heures de Boucicaut* décorées à Paris et, selon Meiss, entre 1405 et 1408. Le style des enluminures des *Heures de Duarte* ne s'oppose nullement à une datation aux alentours de 1415. Et il me semble possible de suggérer que le commettant et le donateur de ce manuscrit au prince de Portugal pouvait être Jean sans Peur. Trois raisons militent en faveur de cette hypothèse. D'abord, le duc était en rapport avec le milieu d'enlumineurs gantois : il possédait un beau *Livre d'Heures* écrit et enluminé pour lui à Gand, vers 1407 (Paris, Bibl. Nat., ms lat. nouv. acq. 3055). Ensuite, même si les *Heures de Duarte* furent écrites et illustrées à Gand, l'influence du Maître de Boucicaut—de sa production des années 1405-1415—les a déterminées si nettement que l'enlumineur qui exécuta la *Vierge enceinte* du fol. 144v a dû être son disciple direct, formé dans son atelier parisien. Or, Jean sans Peur appréciait certainement des artistes de cette formation car il commanda à l'atelier du Maître de Boucicaut le superbe *Livre des Merveilles du Monde* illustré avant 1413 (probablement en 1411-1412). Pour lui également, selon toute vraisemblance, et dans le même atelier, furent produites les *Heures dites de Joseph Bonaparte* (Bibl. Nat., lat. 10538). Enfin, Jean sans Peur entretenait, dans les années 1411-1415 précisément, des relations très étroites avec la cour de Portugal à laquelle il offrait des oeuvres d'art. J'ai eu l'occasion de rappeler qu'il fit peindre par Jean Malouel, entre 1411 et 1413, son propre portrait "pour ycellui envoier au Roy de Portugal." Ce tableau a très bien pu être porté au roi Jean par Diego d'Olivieira ("Dyago Doliviere du royaume de Portugal"), nommé, entre 1412 et 1414, écuyer d'honneur de Jean sans Peur et envoyé par celui-ci, en 1415, "pour aller hastivement de sa part en un certain lieu secret."[33] Nous reconnaissons ici la formule des comptes de Bourgogne que Philippe le Bon fera si souvent employer pour les missions confidentielles de Jan van Eyck et d'autres de ses familiers. La conquête de Ceuta, en 1415, pouvait être l'occasion de cette mission soudaine. Cette victoire sur l'Islam était particulièrement appréciée par le duc de Bourgogne dont la croisade n'aboutit qu'à la défaite de Nicopolis et la captivité turque. Est-il invraisemblable qu'en rendant un hommage personnel au père, le duc n'ait pas voulu oublier Duarte, l'héritier présomptif de la couronne de Portugal, âgé de 24 ans, en lui offrant un beau livre?

Il est donc très probable que le prototype compositionnel de la *Vierge enceinte* des *Heures de Duarte* ait été créé dans l'atelier du Maître de Boucicaut et connu à Paris. Cela nous fournit-il un argument pour situer la *Vierge enceinte* de Washington également à Paris? On aimerait pour le suggérer avec plus d'assurance acquérir une certitude ou, du moins, réunir des éléments d'une grande probabilité que les *Très Riches Heures* dont ce tableau contient une modeste "citation," étaient connues à Paris peu de temps après l'interruption de leur décoration, au début de l'année 1416. Or, le duc de Berry mourut dans le courant de la même année et nous

[32]Panofsky, *ibid.*

[33]Pour l'envoi du portrait au roi de Portugal voir C. Sterling, "La Peinture du portrait à la cour de Bourgogne," *Critica d'Arte* (1958), 302-303 et n. 48. Diego d'Olivieira est déjà cité comme se trouvant à la cour de Bourgogne, en 1411 (Lehoux, *Jean de France duc de Barri*, III, Paris, 1968, 212, n. 5). Jean sans Peur avait d'autres Portugais à son service. En 1414, au siège d'Arras, dans la joute qui opposa quatre chevaliers français aux quatre chevaliers bourguignons, trois de ces derniers étaient des Portugais "de l'hôtel du duc de Bourgogne" (M. de Barante, *Histoire des ducs de Bourgogne*, Paris, 1837, III, 118).

ignorons le sort du manuscrit jusqu'à son apparition parmi les livres de la maison de Savoie. On peut cependant affirmer que le manuscrit s'y trouvait avant 1440–1445, période où commença l'illustration des *Heures de Louis de Savoie*, dans lesquelles l'influence des *Très Riches Heures* est patente.

Une fois de plus, nous voici dans l'incertitude lorsqu'il s'agit d'assigner un tableau à un atelier parisien. La difficulté vient non seulement du fait que nous ne connaissons toujours pas un seul tableau dont l'origine parisienne soit assurée mais de la grande diversité de style qui devait régner dans la capitale. Diversité inhérente au courant du gothique international et qui correspond aux documents. Qui oserait parler d'une "école" d'enluminure parisienne, d'une tradition dominante, d'un style commun, maintenant que Millard Meiss déroula le grandiose et grouillant panorama du monde des miniatures des années 1390–1425 ? Ce n'étaient que collaborations et échanges entre ateliers dominés par de fortes personnalités dont les principales furent Jacquemart de Hesdin, le Maître de Boucicaut (très probablement Jacques Coene de Bruges), le Maître des Heures de Rohan (très probablement venu du Nord des Pays-Bas), le Maître de Bedford (peut-être Hans [Haincelin] de Hagenau en Alsace). Il y a tout lieu de supposer une vitalité et une diversité analogues dans la production de tableaux, alors que nous savons que ces grands enlumineurs, et bien d'autres, étaient en même temps peintres sur panneau ; et que nous possédons une liste de vingt-cinq noms (établie en 1391) des principaux maîtres-peintres de la ville de Paris, liste qui débute par les peintres en titre du roi Charles VI, du duc Jean de Berry et du duc Louis d'Orléans. Douter de l'existence d'une production de tableaux parisienne, abondante et de haute qualité, serait une faute élémentaire de méthode historique. On l'a commise, malgré le témoignage des documents, pour la Bourgogne, jusqu'au jour où furent identifiés les tableaux de Jean de Beaumetz. Si la production parisienne reste mystérieuse, elle est loin d'être mythique. Nous avons des panneaux et même de petits groupes de panneaux qui n'attendent que l'apparition d'un seul nouveau tableau certainement parisien pour être aimantés et nous permettre, peut-être, de ressusciter un Jean d'Orléans, un Étienne Langlier, un Colard de Laon. Mais il serait illusoire de s'attendre à voir surgir un aspect homogène soudant entre eux les tableaux qu'on arriverait à rendre aux ateliers parisiens.

Même en Bourgogne où le mécénat des deux premiers ducs (mécénat sans équivalent, semble-t-il, à Paris) assura, pendant trente ans (1390–1420), au chantier de la Chartreuse de Champmol une tradition assez prononcée, la diversité de style ne manqua pas de se manifester. Le style des deux tableaux de Beaumetz n'est pas identique ; les écarts sont sans doute dus à la disparité d'origine et de formation des compagnons collaborateurs, ce qui correspond d'ailleurs aux documents si précis qui concernent ces tableaux. Notre *Calvaire* se rattache parfaitement à la Bourgogne. Il montre des liens avec la *Trinité* qui, sans être nécessairement née à Dijon (elle a pu être peinte à Paris pour Philippe le Hardi), s'intègre nettement dans la tradition de Champmol par l'influence qu'elle y a exercée (tout comme les volets de Broederlam, peints à Ypres, ne restèrent pas sans échos en Bourgogne). Il avoue la connaissance de l'art des Limbourg, cet art qu'il est légitime de compter parmi les éléments constitutifs de la culture picturale bourguignonne. Il est tributaire de la sculpture de cette région. Et pourtant, d'une finesse plus mélodieuse, plus français peut-être que le *Retable de*

St. Denis peint par le Brabançon Bellechose, plus singulièrement italienisant, il reste isolé. Isolement énigmatique et radieux où il rejoint le *Diptyque Wilton*, le petit *Diptyque du Bargello* et quelques autres joyaux du gothique septentrional.

Avant de clore ici ces lignes, je me permets une digression au sujet d'une oeuvre qui n'est pas sans rapport avec les Limbourg, mais qui, au lieu d'illustrer leur influence apporte une contribution à l'analyse de leur culture artistique. Mes principales excuses pour en parler sont, à dire vrai, la beauté de l'oeuvre et l'intérêt qu'elle représente pour les études de la peinture franco-flamande, domaine dont elle a été indûment exclue.

Il s'agit d'un verre peint et doré (à froid), technique qu'on s'obstine à confondre avec celle du verre églomisé. Cette pièce fait partie de l'importante collection des verres peints du Museo Civico de Turin (Fig. 14).[34] On y voit la Vierge allaitant l'Enfant, assise sur un trône derrière lequel est tendu un drap d'honneur. A sa gauche, un ange joue de la harpe. Au-dessus de la tête de la Vierge, deux chérubins soutiennent une couronne. On s'aperçoit aussitôt que le verre, maintenant ovale, a été coupé. Du chérubin de gauche, il ne reste que les bras ; les ailes de l'autre sont mutilées ; à gauche également, le reste d'un nimbe, peut-être plus petit que celui de la Vierge, trahit la présence d'un personnage sacré disparu, placé hors du trône. Toute petite qu'elle soit, cette pièce s'impose par la justesse et la sobriété du dessin, par le raffinement et la fermeté du modelé, la grâce des mouvements et des expressions et la sourde richesse du coloris où de très grandes surfaces de l'or (le manteau de la Vierge, les nimbes, la plupart des motifs ornementaux du drap d'honneur) s'accordent avec des marrons rougeâtres et des verts profonds.

L'attribution initiale à "l'école d'Ulm vers 1430" a été "corrigée" en celle à "l'art rhénan vers 1450." Dernièrement, le verre a été décrit comme marqué "plus précisément par l'ambiance colonaise, dans un climat à la Stephan Lochner" et comme difficile à dater à cause des "souvenirs plus anciens du maniérisme colonais."[35] La pièce n'a cependant pas de rapport avec la peinture allemande et elle est d'un tiers de siècle antérieure aux débuts supposés de Lochner. Il convient de la restituer au domaine franco-néerlandais, aux alentours de 1400, peut-être vers 1395, lorsqu'on la compare d'un côté aux enluminures des *Très Belles Heures de Notre Dame* (*Heures de Turin*) de 1385 environ, et, de l'autre côté, à celles des *Grandes Heures du duc de Berry* qui datent de 1407 à 1409 au plus tard. La composition s'insère parfaitement dans la tradition ininterrompue représentée dans l'enluminure pratiquée en France tant par les artistes français que par les Néerlandais. La Vierge à l'Enfant, en pied, trônant, accompagnée d'anges musiciens et couronnée (parfois par des chérubins) s'y rencontre si régulièrement pendant près d'un siècle qu'on peut être quasiment certain, qu'avant d'être mutilé, le verre turinois représentait la Madone en figure entière et non à mi-corps. En effet, dès avant 1346, on en voit un exemple dans le *Bréviaire de Catherine de Valois*,[36] puis, vers 1405–1408, chez les

[34]Inv.V.O. (vetro a oro) 30–2924. 13 × 10.5 cm. Entré au musée en 1890 avec la collection D'Azeglio. Je remercie vivement Signa Dott. S. Pettenati, du Museo Civico, de m'avoir fourni, avec la plus grande obligeance, les renseignements sur cet objet et sa photographie. Elle prépare un catalogue des verres peints (à froid) qui appartiennent au Museo Civico.

[35]L. Mallé, *Palazzo Madama in Torino*, II, *Le Collezioni d'Arte* (Turin, 1970), 339, qui rapporte également l'opinion de Toesca.

[36]Pour la reproduction voir M. Meiss, *French Painting in the Time of Jean de Berry. The Late Fourteenth Century and the Patronage of the Duke* (London–New York, 1967), II, fig. 657.

Limbourg dans leurs *Belles Heures* (Fig. 15) et chez le Maître de Boucicaut.[37] Dans ces trois images un grand pli curviligne du manteau descend de la nuque de la Vierge sur ses genoux. Et chacune d'elles comporte un ou plusieurs éléments du verre turinois : le *Bréviaire*, le type même de la Vierge, avec sa longue boucle dans le dos, souvenir pucellien ; les *Belles Heures*, le motif de l'allaitement, les anges musiciens, le fond orné et la frappante cassure du pan du manteau qui s'arrête dans sa chute sur le siège du trône ; les *Heures de Boucicaut*, le même pan d'étoffe sur le trône, la position analogue des jambes de l'Enfant, les anges musiciens, les chérubins tenant la couronne au-dessus de la Vierge et un drap d'honneur horizontalement strié, dont les ornements sont à Turin d'un dessin très italianisant. Les Limbourg, le Maître de Boucicaut et l'auteur du verre devaient connaître un prototype célèbre de cette composition, créé vers 1390, et le verre lui-même ne saurait être que de peu postérieur.

L'Enfant Jésus de Turin, tout nu, avec sa grande tête aux cheveux abondants, légèrement bouclés mais courts, ses jambes grêles, sa plasticité et sa vivacité, est marqué par le virulent réalisme néerlandais, celui qui cerne des chairs saillantes et palpables d'un contour incisif et impérieux (Fig. 14). Il suffit pour s'en convaincre de le comparer à l'Enfant Jésus, qu'au cours des années 1420 peindra Robert Campin (Fig. 16). Cet artiste né en 1375 a dû être formé vers 1390–1400, car il est qualifié de maître et vend ses oeuvres déjà en 1406. Ainsi, le modeste fragment de Turin est à compter parmi les ouvrages franco-néerlandais qui nous aident à déterrer certaines racines communes de l'art de ce grand novateur et de l'art des Limbourg. Et des raisons ne cessent de s'accumuler pour croire que la patrie de Campin voisinait avec la Gueldre, patrie de Malouel et de ses neveux.

LAUNAY (YVELINES)

[37]Pour la reproduction voir M. Meiss, *French Painting in the Time of Jean de Berry. The Boucicaut Master* (London–New York, 1968), fig. 28.

The Back Predella of Duccio's *Maestà*

JAMES H. STUBBLEBINE

Duccio's *Maestà* of 1308–1311 for the Siena Cathedral has, among other extraordinary features, the earliest extant predella and, furthermore, it was a predella with paintings on both the front and the back. Although the altarpiece was dismembered in the late eighteenth century, critics have been able to recompose the front face of the predella: seven scenes of Christ's infancy alternating with six prophet figures—all of these parts being preserved to us today. A number of the back predella scenes, however, were eventually dispersed, and several of them were lost, with the consequence that the original composition of the predella has been difficult to perceive in modern times.

The subject of the back predella is the mission or teaching cycle of Christ's life; and the following eight scenes are preserved: (1) the *Temptation on the Temple* (the second temptation); (2) the *Temptation on the Mountain* (the third temptation); (3) the *Wedding at Cana*; (4) the *Calling of Peter and Andrew*; (5) *Christ and the Woman of Samaria*; (6) the *Healing of the Man Born Blind*; (7) the *Transfiguration*; and (8) the *Raising of Lazarus* (Figs. 1–8).[1]

Previous reconstructions of the *Maestà* by E. Dobbert (1885),[2] by C. Weigelt (1909),[3] by V. Lusini (1912),[4] by E. DeWald (1955),[5] and by F. Cooper (1965),[6] have yielded a number of ideas about this side of the predella, but no one has studied thoroughly the problems that are posed. On the other hand, it should not be impossible to reconstruct its appearance as well as its iconographic program. We have a number of later Sienese paintings that in varying degrees copy the *Maestà*. Almost without exception, the predella scenes of Ugolino's polyptych for Santa Croce in Florence copy the corresponding narratives of the *Maestà*. The most complete and accurate reworking of a number of *Maestà* scenes occurs on the back of the altarpiece by Duccio and his shop in the Cathedral of Massa Marittima. Neither of these imitations, however, are as helpful for our study of the back predella as are several other works that are generally neglected in this respect.

One of these is the provincial, mid-fourteenth-century tabernacle in Pienza; in many of its forty-eight scenes, the iconography and compositions of the *Maestà* are extensively aped.[7] *Christ and the Woman of Samaria*, the *Raising of Lazarus*, the *Temptation on the Temple*, and the *Temptation on the Mountain* illustrate how true this is (Fig. 10).

[1] The best illustrations are those in E. Carli, *Duccio* (Milan, 1962), pls. 25–31.

[2] "Duccio's Bild 'Die Geburt Christi' in der Königlichen Gemälde Galerie zu Berlin," *Jahrbuch der Königlich Preussischen Kunstsammlungen* (VI, 1885), 153–63.

[3] "Contribuito alla ricostruzione della Maestà di Duccio di Buoninsegna nel Museo Metropolitana di Siena," *Bullettino Senese di Storia Patria* (XVI, 1909), 191–214 (diagram after p. 194 or in *idem*, *Duccio* (Leipzig, 1911), pl. 66).

[4] "I dipinti di Duccio," *Rassegna d'Arte Senese* (VIII, 1912), 65–98 and diagram following p. 98; reprinted in Società degli Amici dei Monumenti, *In onore di Duccio di Buoninsegna e della sua scuola* (Siena, 1913).

[5] "Observations on Duccio's 'Maestà,' " *Late Classical and Medieval Studies in Honor of Albert Mathias Friend, Jr.* (Princeton, N. J., 1955), 363–86.

[6] "A Reconstruction of Duccio's Maestà," *Art Bulletin* (XLVII, 1965), 155–71.

[7] E. Carli, *Pienza, la città di Pio II* (Rome, 1966), 54 n. 13 and figs. 13–15. The tabernacle is also discussed by M. Meiss, "Italian Primitives at Konopiště," *Art Bulletin* (XXVIII, 1946), 11–12.

An enameled reliquary known as the *Santissimo Corporale* in the Cathedral of Orvieto, dated 1338, contains thirty-two scenes from Christ's life;[8] these also reflect the *Maestà*, even though, as with the Pienza tabernacle, there are a number of other, later influences at work on the artist. Nevertheless, the *Maestà* provided the inspiration for the architectural backgrounds and precise details of a number of scenes, among them the *Adoration*, the *Flight into Egypt*, the *Presentation of the Christ Child in the Temple*, and the *Entry into Jerusalem*.

Finally, the predella of an altarpiece by the Sienese painter Taddeo di Bartolo on the high altar of the Cathedral of Montepulciano, dated 1401, copies a number of the *Maestà* Passion narratives with surprising closeness, considering the lapse of almost a century between the two works (Figs. 9, 17, 18).[9]

Furthermore, as we have demonstrated elsewhere,[10] the program for the life of Christ on the *Maestà* has iconographic and stylistic affinities with several contemporary Byzantine manuscript and fresco cycles. This has led us to believe that Duccio and his assistants had a fairly recent Byzantine manuscript at hand when the *Maestà* was composed. A number of elements on the back predella are to be understood in terms of such an influence.

We might begin our reconstruction by saying that no one has suggested that the back predella had no more than the eight scenes still preserved; and indeed, for a number of iconographic and aesthetic reasons, as well as the practical matter of filling the space at hand, this would not have been feasible. On the other hand, there has not been any unanimity as to the number of scenes the predella originally contained. Dobbert, working with very little information (since at the time he wrote a number of these panels were still in private hands and not generally known), composed a grouping of seven scenes alternating with six prophets, an arrangement identical to that of the front predella. This reconstruction, however, must be dismissed, if only because we now possess more than the seven scenes he proposed.

Weigelt's reconstruction of the predella, concurred in by DeWald and Brandi,[11] is particularly awkward in its arrangement of ten narratives. It should be noted that even numbers, such as eight or ten, would have been considered unaesthetic by artists of that time, preferring as they did an odd number of scenes, one of which would mark the central axis. Lusini, in his reconstruction, made a grouping of eleven scenes from the cycle of Christ's mission, but to do so he had to overextend the predella at either end; as a result, the first and last episodes fit beneath the broad, pilasterlike frames he provided. While this placement is to be rejected, it must be admitted that Lusini's reconstruction has the special merit of considering the aesthetic aspects of the altarpiece.

We would propose that the back predella must, first of all, bear a logical relation to the front predella. Thus, if the front had seven scenes alternating with six prophets, as everyone agrees it did, the back predella must have been of an equivalent size. Even with the imprecise measurements available, it is obvious that the six prophets are approximately equal in width

[8]A. Schmarsow, *Italienische Kunst in Zeitalter Dantes* (Augsburg, 1928), 179ff. and pls. 132–53; P. Dal Poggetto, *Ugolino di Vieri, gli smalti di Orvieto*. I Maestri del Trecento in Toscana (Florence, 1967), with color plates.

[9]S. Symeonides, *Taddeo di Bartolo* (Siena, 1965), 93–97 and pls. xx, xxix–xxxi; F.M. Perkins, "Pitture senesi poco conosciute," *La Diana* (vi, 1931), 187–90.

[10]J. Stubblebine, "Byzantine Sources for the Iconography of Duccio's *Maestà*," *Art Bulletin* (LVII, 1975), 176–85.

[11]For Brandi, see Istituto Centrale di Restauro, *Il restauro della "Maestà" di Duccio* (Rome, 1959), 9.

to two scenes.[12] The total width of the painted surface of the front predella is about 160 inches; that of the surviving eight panels of the back, averaging about 18⅛ inches, comes to approximately 145 inches. This, then, would suggest that the back predella had a total of nine narratives;[13] on the basis of this, we would be lacking one scene.

We must next consider what episode is most likely to have been included in addition to the eight scenes we have. And in doing so, we must ask whether the eight scenes we have today constitute an incomplete program iconographically. Of the three Temptations of Christ recounted in the Gospels, only the last two, the *Temptation on the Temple* and the *Temptation on the Mountain* (Figs. 1 and 2) are among the panels preserved from the back predella of the *Maestà*.[14] A serious gap in the program is the first of the three, the Temptation in the Wilderness. Dobbert, Weigelt, Lusini, and DeWald all restore this episode in their reconstructions. As a matter of fact, if a series does not include all three episodes, usually the first will suffice; on the other hand, the second and third are not represented without the first. Something of the composition of the scene as it may have appeared on the *Maestà* can be gauged from the same episode on the Pienza tabernacle (Fig. 10). There, Satan and Christ stand on a plain with mountains behind; a cluster of stones lies on the ground between the two figures. Inasmuch as the second and third Temptations on the Pienza tabernacle copy the *Maestà* scenes fairly closely, we may suppose that the first is also an imitation. If, then, we add the first Temptation to the sequence of the back predella, we attain the number of nine scenes. The iconographic sequence on the back predella, however, is still without one major ingredient, the Baptism. It is unimaginable that a program as comprehensive as that of the *Maestà* would not have included this pivotal episode from Christ's life, which is represented in even the briefest cycles. The Baptism was, in fact, included in the reconstructions of Dobbert, Weigelt, Lusini, and DeWald.[15] Although we do not happen to have any representations of the theme in Ducciesque painting, it is found in both the Pienza tabernacle and the *Santissimo Corporale* in Orvieto. There is no reason to suppose that Duccio omitted the theme from his altarpiece.

Thus, we must restore to the *Maestà* both the Baptism and the Temptation in the Wilderness, making a total of ten narratives, which, as we have seen, is an undesirable number. This, in turn, leads to a further conclusion: if the number of episodes for the back predella cannot be less than ten in terms of iconography, then for aesthetic reasons the number must have been eleven. Putting to one side for a moment the question of the physical arrangement of these narratives, we may ask which other episode is most likely to have formed part of a group of eleven.

One of the episodes proposed by Lusini was the Multiplication of the Loaves, but there is no compelling reason to choose this narrative as opposed to any other commonly illustrated miracle scene. Lusini's suggestion that there was also something called a "Good Shepherd"

[12]The painted surface of each front scene is about 17¼ inches in width, and that of each prophet about 6¼ inches wide.

[13]This is the number reached by Cooper, "A Reconstruction of Duccio's Maestà," 168–70, but only as a result of a suspect arrangement of scenes.

[14]Weigelt recovered the *Temptation on the Temple* from a storeroom at the Opera del Duomo, Siena ("Contribuito alla ricostruzione della Maestà," 201ff.).

[15]But not by Cooper ("A Reconstruction of Duccio's Maestà," 169), who claims it is not necessary to the narrative, citing as a precedent a thirteenth-century (sic) tabernacle in Pienza, in which he failed to see the *Baptism* in the lower part of the left wing.

must be dismissed outright. It should be noted that Lusini transposed the Baptism onto the front predella, whereas it can only have formed part of the cycle of the back predella. We must, furthermore, reject Cooper's placement of the *Twelve-Year-Old Christ Child Disputing with the Elders* as the first scene of the back predella, as well as his statements that there is not room for the episode on the front, and that it belongs iconographically to the mission cycle.

As it happens, there is one other episode that we suspect not only formed part of the back predella but actually began the mission cycle, preceding the Baptism. It would be one of the various moments during his preaching when St. John the Baptist indicates the presence and the nature of Christ. Only rarely, as in the eleventh-century Byzantine manuscript, Paris, Bibliothèque Nationale, grec 74, do we find a detailed accounting of each event and occasion of the Baptist's preaching;[16] ordinarily, one or another of these moments may be chosen for representation. An example is the episode usually called the First Recognition of Christ by John the Baptist; it comes from the text of the Gospel of St. John the Evangelist: "Look, this is the Lamb of God; look, this is he who takes away the sin of the world" (John 1 : 29).[17] The mosaic in the Baptistery at Florence is an example of this First Recognition (Fig. 11). The Baptist points out to the crowd the figure of Christ, isolated on an eminence at the right.[18] The Baptist's scroll is inscribed "Ecce Angnus [Agnus] Dei."

The second occasion on which the Baptist recognized Christ was on the following day. It is easily distinguished from the first occasion by the presence of two of the Baptist's disciples, Andrew and John the Evangelist, who, hearing their leader pronounce, "Look, this is the Lamb of God," turn to follow Christ (John 1 : 35–37). The thirteenth-century St. John Altarpiece, no. 14 in the Siena Gallery, illustrates this Second Recognition (Fig. 12); the two disciples are present to the right of the Baptist. The same episode is shown at Chartres in the window of the History of the Apostles.[19] The Baptism follows immediately after these scenes.

Several pieces of evidence, nevertheless, point to the likelihood that the scene on the *Maestà* represented not the Recognition of Christ but rather one of the times when the Baptist attested to the nature of Christ, the so-called "John the Baptist Bearing Witness of Christ." First of all, in the preamble to his Gospel, Evangelist John, describing the role of the Baptist, explains how the Baptist will give his testimony: "I told you, cried John, there was one coming after me who takes rank before me; he was when I was not" (John 1 : 15). Then the Evangelist tells us about the first event, when the Baptist is questioned by the Pharisees: "I am baptizing you with water; but there is one standing in your midst of whom you know nothing; he it is, who, though he comes after me, ranks before me. I am not worthy to untie the strap of his shoes" (John 1 : 26–27). And the next day, we are told by the Evangelist, the Baptist gives testimony a second time: "It is of him that I said, One is coming after me who takes rank before me; he was when I was not."

[16]Paris, Bibliothèque Nationale, *Évangiles avec peintures byzantines du XIe siècle*, ed. H. Omont (Paris, n.d. [1908]), pls. 143–46.

[17]This and other scriptural references are quoted from *The New Testament . . . Newly Translated from the Vulgate Latin . . .*, trans. R. Knox (New York, 1944).

[18]A panel in the City Art Museum of St. Louis (no. 46–41), much cut down, is a variant of the mosaic in the Florence Baptistery by a Pisan follower of the San Torpé Master (illustrated in *Art News*, XL, Nov. 1–14, 1941, 8).

[19]Y. Delaporte, *Les Vitraux de la cathédrale de Chartres . . .* (Chartres, 1926), pl. XCII.

A mosaic in the Karieh Djami (1315–1321) includes the episode of the Witnessing of Christ (Fig. 13), but it is a curious conflation, since the inscription above the Baptist's head refers to the preamble in John 1 : 15 and not to one of the two events when the witnessing actually took place.[20] Furthermore, the disciples are present, ready to follow Christ, in reference to still another passage and a later time. The Karieh Djami mosaic is, nevertheless, a rare instance of the theme of the witnessing.

The representation that may have formed part of the back predella of the *Maestà* was probably an illustration of the first time that the Baptist bore witness, that is, referring to John 1 : 26–27, quoted above. Two depictions of this episode appear to us to be relevant to the *Maestà*. One of these is a fresco in the Church of the Protaton, Mt. Athos, decorated at the beginning of the fourteenth century (Fig. 14). As we have demonstrated elsewhere,[21] this cycle has a great many things in common with the *Maestà*, both in the larger aspects of the iconographic scheme and in very particular motifs, as well as in stylistic matters. Unquestionably, these frescoes were inspired by a manuscript similar to one upon which Duccio and his shop relied when they painted the *Maestà*.

At the Protaton, the large fresco of the Baptism is preceded by a small vignette in which the Baptist, standing on one side of the Jordan, points across the river toward a crowd in whose center, prominently elevated, is the figure of Christ. We would be sure this were an illustration of John 1 : 26–27 in which Christ is so explicitly described as "standing in your midst," even if precisely those two verses were not inscribed on the background above the Baptist's head.

There is another representation of this particular episode that is even more significant for our reconstruction of the *Maestà* predella; this is the panel by a follower of Ugolino in the Budapest Museum (Fig. 15).[22] In the center, the Baptist stands with his feet in the Jordan; crowds cluster to either side listening to him preach. On the right, Christ is among the crowd and, once again, His figure is raised up above the others in such a way as to emphasize that He is "in the midst" of the crowd. It is tempting to believe that the Budapest panel copies a composition from the *Maestà*: the similarity of the figure types to those found on the *Maestà*, as well as the groupings and even the layout of the composition, have always seemed to me to be conspicuous factors for the understanding of this picture.

That the Budapest panel and the Protaton fresco illustrate the episode of St. John the Baptist Bearing Witness persuades us that this subject may have been the first scene of the mission cycle on the back predella of the *Maestà*. If it is now asked where we would propose to put eleven scenes, there are two answers, though I believe only one of them is correct. We have already pointed out that Lusini proposed eleven scenes for the back predella, and that he did so by placing the first and the last underneath broad, lateral framing elements of the main panel. But even if the *Maestà* did have such generous framing, the back predella could not have been wider than the front one, which has a width equivalent to only nine scenes.

[20]P. Underwood, *The Karieh Djami* (New York, 1966), I, 112–14 and II, pls. 216–21. For the date of the mosaics, see I, 15–16.

[21]"Byzantine Sources for the Icongraphy of Duccio's *Maestà*," 181–82.

[22]The picture is discussed by R. van Marle in *The Development* of the Italian Schools of Painting, II (The Hague, 1924), 107–08, and by G. Coor-Achenbach, "A Contribution to the Study of Ugolino di Nerio's Art," *Art Bulletin* (XXXVII, 1955), 162 n.46. See also M. Boscovits, *Early Italian Panel Painting* (Budapest, 1966), no. 14. The picture is generally called *The Baptist Preaching*.

The other possible answer is that the first and the last scenes were not, in fact, on the back of the *Maestà* but, rather, on the short ends of the wide, boxlike structure that the predella must have had. As we have pointed out elsewhere,[23] the *Maestà* predella originally projected out from the front and back of the main panel to such an extent as to require a separate curtain to cover the predella. The depth of the predella would, consequently, have been sufficient to allow space for narratives on the ends (see diagram). Few other trecento paint-

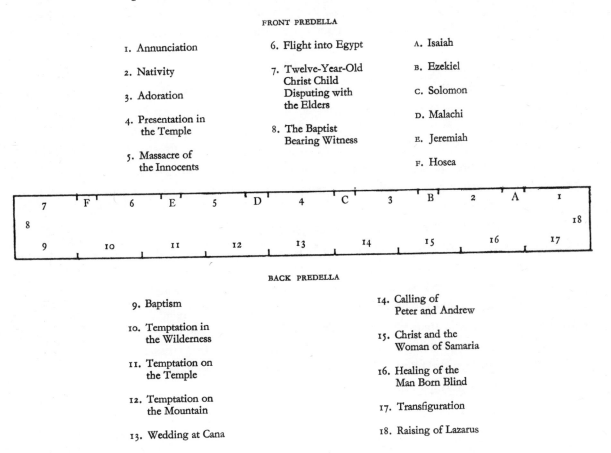

FRONT PREDELLA

1. Annunciation	6. Flight into Egypt	A. Isaiah
2. Nativity	7. Twelve-Year-Old Christ Child Disputing with the Elders	B. Ezekiel
3. Adoration		C. Solomon
4. Presentation in the Temple	8. The Baptist Bearing Witness	D. Malachi
5. Massacre of the Innocents		E. Jeremiah
		F. Hosea

BACK PREDELLA

9. Baptism	14. Calling of Peter and Andrew
10. Temptation in the Wilderness	15. Christ and the Woman of Samaria
11. Temptation on the Temple	16. Healing of the Man Born Blind
12. Temptation on the Mountain	17. Transfiguration
13. Wedding at Cana	18. Raising of Lazarus

ings were as elaborate as the *Maestà*: nevertheless, this arrangement of narratives on the short ends is found in two works inspired by the *Maestà*. One of them, the *Santissimo Corporale* at Orvieto (which Weigelt rightly called an interesting echo of the *Maestà*)[24] has thirty-two narratives from Christ's life placed on its front and back, as well as on both sides of the wide, sloping predella on which the shrine rests. Furthermore, there is a narrative on each of the short ends: the *Presentation of the Christ Child in the Temple* and the *Temptation on the Mountain* (Fig. 16). Another reflection of this usage is to be found in Taddeo di Bartolo's impressive Altarpiece of the Assumption in the Cathedral of Montepulciano (Fig. 9). Its predella has a sequence of nine scenes: the *Entry into Jerusalem*, the *Last Supper*, the *Betrayal*, the *Via Crucis*, the *Crucifixion*, the *Entombment*, the *Resurrection*, the *Descent into Limbo*, and the *Way to Emmaus*.

[23] J. Stubblebine, "Angel Pinnacles in Duccio's *Maestà*," *Art Quarterly* (XXXII, 1969), 149.

[24] *Sienese Painting of the Trecento* (New York, n.d. [1930]), 66 n. 16.

It is typical of such later Sienese painters as Taddeo to use, with slight variations, the inventions of the early trecento Sienese masters, and these predella scenes are no exception. They are largely routine copies of those of almost a hundred years earlier on the *Maestà*. What is interesting to us here, however, is that while the nine narratives on the face of the predella have been mentioned in the literature, two other scenes on the short ends have never been mentioned or photographed. On the left is the *Raising of Lazarus* (Fig. 17) and on the right, out of sequence, is the *Three Maries at the Tomb* (Fig. 18).[25] We suppose that Taddeo borrowed from the Duccio altarpiece this idea of placing narratives on the short ends of the predella; and it is surely more than coincidence that one of the end scenes should be, as on the *Maestà*, the *Raising of Lazarus*.

With scenes on the short ends of the predella, the turning points in the narrative of Christ's life on the *Maestà* are put into sharper focus. Thus, the *Twelve-Year-Old Christ Child Disputing with the Elders* draws the infancy cycle on the front predella to a close. Turning the angle to the short end, we discover the scene of *John the Baptist Bearing Witness*, a narrative that in its import introduces and is transitional to the entire program on the back of the altarpiece. The back of the predella, then, has a sequence of nine episodes beginning with the *Baptism* and ending with the *Transfiguration*. Again turning an angle to the other short end, we find the *Raising of Lazarus*, which not only concludes the teaching cycle but, since it alludes to Christ's own Resurrection, serves to introduce the Passion and Resurrection cycles that follow above on the back of the altarpiece.

Such subtleties were lost on the copyists. In the Orvieto shrine, the end scenes do not constitute turning points in the narrative, while in the Montepulciano altarpiece there is no narrative on the back to justify the end scenes. The placing of the two narratives on the short sides of the *Maestà* predella would have emphasized that this was a freestanding work, to be read not only on the front and back but on the sides as well— a visually rich experience as one circulated around it in the Siena Cathedral.[26]

RUTGERS UNIVERSITY

[25]Both panels have lost between a quarter and a third of their width, in both cases on the side toward the rear of the altarpiece—evidence of a mutilation at some later time.

[26]Since this article was prepared for publication, a new study of the *Maestà* has appeared: J. White, "Measurement, Design and Carpentry in Duccio's *Maestà*," *Art Bulletin* (LV, 1973), 334-66, 547-69. White reconstructs the back face of the predella with nine scenes as we do (p. 349). But since he believes these nine episodes constitute the entire Mission cycle, he concludes that only one scene is missing; he leaves it undecided whether this would be the first Temptation or the Baptism (pp. 560-63). Furthermore, whereas White has the *Calling of Peter and Andrew* precede the *Wedding at Cana* (p. 560), we believe it was the other way around, and that Duccio would have preferred to place the stabilized composition and iconographic weight of the Cana episode at the center of the back predella. Indeed, at another point, White demonstrates the suitability of this scene as the centerpiece of his (shorter) series (p. 560.)

Il Bianco di piombo nelle pitture murali della Basilica di San Francesco ad Assisi

LEONETTO TINTORI

"Questo colore quanto più il macini, tanto è più perfetto ; ed è buono in tavola. Ben s'adopera in muro. Guàrdatene quanto puoi, ché per ispazio di tempo vien nera."[1] Quest'ultimo rilievo di Cennini sulla instabilità della biacca, non ha mai avuto esempio più calzante di quello sofferto dalle pitture murali della Basilica di San Francesco ad Assisi. E sicuramente Cennini ha raccolto qui il materiale più importante su cui basare le sue osservazioni.

Già nelle più antiche decorazioni delle volte della Basilica inferiore, la biacca venne usata. Cimabue adopera questo colore con entusiasmo, giungendo nella *Crocifissione* (Figg. 1–2) a sostituirlo totalmente al bianco di sangiovanni. Sul fresco e sul mezzo fresco delle sue pontate, affida senza riserve alla biacca la luce delle sue pitture, ignaro dell'amara sorpresa riservatagli in futuro.

Da una più prudente applicazione adottata dai continuatori nel proseguimento delle decorazioni, si può arguire che ancora prima di finire il transetto fossero già apparse le prime alterazioni. Quest'ipotesi può essere convalidata dal fatto che nell'ultima pontata in basso non si presentano gli stessi effetti. Nel *Calvario* e nelle gambe dei personaggi che assistono all'agonia del Cristo, le luci delle vesti e dei calzari, per quanto dipinte con biacca, si sono conservate chiare. La stesura di questa zona presenta un legante più solido che sopra, e fu certamente realizzata quando l'intonaco era già secco.

L'allarme suscitato da questo increscioso fenomeno ha probabilmente suggerito l'astensione dall'uso di questo bianco : infatti nelle storie del Vecchio e del Nuovo Testamento degli ordini superiori della navata centrale, non se ne scorge traccia. Col tempo la diffidenza si fa minore e, anche per effetto dell'esempio dato da Cimabue con l'ultima pontata della *Crocifissione*, si ritorna alla biacca, purché usata con tempera sul secco. Questa la regola, purtroppo non seguita da tutti, poichè i tortiglioni che separano gli episodi della vita di San Francesco recano chiari segni di come la biacca fosse usata sull'intonaco umido.

Cennini ha raccolto anche notizie sulla variante, ed in altra parte del suo libro scrive : "Ogni colore di quelli che lavori in fresco, puoi lavorare anche in secco ; ma in fresco con colori che non si può lavorare, come orpimento, cinabro, azzurro della Magna, minio, verderame e biacca."[2] La convinzione di poter usare la biacca sul muro, purché applicata a tempera, ha ad Assisi innumerevoli esempi. Ma, purtroppo, non sempre i risultati sono quelli attesi con tanta fiducia dagli artisti.

L'organizzazione della "Fabbrica" doveva essere vasta, solida ed efficiente. Alla costante ricerca del meglio, tanto per quanto riguarda le maestranze come per i materiali, un ben fornito deposito di colori doveva offrire ai pittori opportunità di disporre in qualsiasi momento del necessario per il loro lavoro e, data la mole dell'impresa, le provviste dovevano essere abbondanti, oltre che selezionate. Anche la biacca, sicuramente, figurava nella racolta, giunta

[1]Cennino Cennini, *Il libro dell'arte*, ed. F. Brunello (Vicenza, 1971), 61. [2]Ibid., 85.

dal miglior centro di produzione, in panetti pronta ad ogni richiesta. Per l'ottima qualità, e forse anche per l'alto prezzo che era costata, doveva esser tenuta in gran conto insieme all'azzurrite ed al cinabro, tanto da suscitare dispiacere il doverla trascurare. E così ritorna pian piano nell'uso, prima per ritocchi finali, poi, con Simone Martini, ad un ruolo assai più importante. Nessun bianco di sangiovanni, macinato a tempera, poteva rivaleggiare con la luminosità della biacca. Anche questo è un altro elemento di spiegazione per la diffusione di questo colore, già riconosciuto come instabile.

Decorazioni della volta vicino all' ingresso della Basilica inferiore

Nei motivi floreali o geometrici delle fasce e delle arcate, si scorgono evidenti le alterazioni da biacca. Sola o mista ad altri colori, quando la quantità della biacca è preponderante, basta un processo di ossidazione per provocarne l'alterazione del colore. Spesso l'alterazione è accompagnata dalla caduta dello strato superficiale della pittura. Questo fenomeno si vede bene sul primo arcone della navata, dove i chiari degli scacchi sono in parte scrostati e la scrostatura risulta scura.

Scene della Vita di San Francesco nella navata della Basilica inferiore

Il maestro che ha dipinto queste scene e quelle sulla parete di fronte, usa la biacca alternata o mista al bianco di sangiovanni, quasi per riservare alla biacca effetti impossibili da ottenere con il bianco di calce. L'alterazione della biacca è discontinua e non troppo evidente, anche perchè stesa su intonaco quasi secco.

Volte del transetto della Basilica superiore

In massima parte le cornici, le fascie ed i costoloni sono dipinti usando il bianco di calce. Solo nelle vele, e parzialmente, viene introdotta la biacca di piombo. Se ne scorgono le alterazioni negli edifici della città nella vela di *S. Luca Evangelista* e nelle luci della veste (Fig. 3), similmente a quelle delle vele con gli altri Evangelisti.

Pareti del transetto della Basilica superiore

È su queste pareti che si osserva, al massimo, il fenomeno dell'ossidazione della biacca. Apprezzata per il suo eccezionale rendimento, la biacca entra nell'uso corrente e viene impiegata senza sospetto fino all'ultima pontata.

Una ricostruzione di come potrebbe essere avvenuto il fenomeno è stata condotta dal Dr. Valerio Malaguzzi-Valeri. Dalle sue indagini ed esperimenti è risultato che la biacca inizia il suo ciclo di trasformazione con una prima reazione a contatto con l'idrato di calcio. Se la biacca viene stesa su un intonaco non perfettamente asciutto, l'effetto della conseguente reazione è più immediato ed evidente.

In un primo tempo il cambiamento di colore si verifica soltanto nello strato ad immediato contatto con la calce : questo è stato osservato esaminando al microscopio numerose sezioni trasversali di frammenti originali. Lo strato in cui è presente biacca insieme a calce idrata assume un colore bruno rosato come il litargirio. In seguito, laddove la biacca risulta priva di strati protettivi superficiali (ovvero dove la parete è molto porosa), la pittura è "attaccata" facilmente anche dall'esterno attraverso l'umidità contenente anidride carbonica.

Una possibile ricostruzione del fenomeno può essere la seguente :

(1) In queste parti si verifica una migrazione delle particelle di ossido di piombo verso la superficie ; la conseguente ossidazione a biossido di piombo, di colore nero violaceo, può essere dovuta alla presenza di forti agenti ossidanti quali i raggi solari o anche all'utilizzazione sulla stessa pittura di soluzioni non idonee (per esempio l'acqua ossigenata).

(2) Quest'ultima (acqua ossigenata) è stata spesso utilizzata anche perchè si riteneva che le parti annerite derivassero dalla trasformazione della biacca in solfuro di piombo nero : se così fosse stato, l'acqua ossigenata avrebbe fatto ricomparire l'originale colorazione bianca dovuta all'ossidazione del solfuro a solfato bianco.

(3) È doveroso comunque ricordare che la presenza sulle pitture murali di solfuro di piombo dovuto all'influenza di acido solfidrico dell'atmosfera, non è mai stata riscontrata sperimentalmente.

In passato, prima di accettare l'alterazione avvenuta come un fatto inalienabile, in varie riprese durante operazioni di restauro di cui non abbiamo precise notizie, è stato fatto il tentativo di alleggerire l'annerimento. I risultati furono talmente pietosi da sconsigliarne il proseguimento. E così, almeno in parte, la suggestiva *Crocifissione* di Cimabue fu salva.

Cimabue dipinse usando la biacca senza alcun sospetto, tanto da rinunciare completamente al bianco di calce anche nella fase di preparazione. L'annerimento delle luci è totale e ne deriva un effetto simile a quello di un negativo fotografico. A parte il pezzo dipinto da terra, dopo aver smontato le impalcature, la trasformazione dei chiari è costante, conservando così unità alla composizione anche se con effetto invertite.

Sul diverso comportamento della zona sopra la porta della sacrestia, sono state fatte varie congetture. La più attendibile è quella che questa zona sia stata completata quando l'intonaco era già asciutto, evitando così la prima reazione molto pericolosa come preparazione a successivi sviluppi.[3]

Volta della navata centrale della Basilica superiore

Per quanto riguarda la biacca, i pittori di queste vele si sono attenuti in tutto allo stesso procedimento adottato nel transetto : molto bianco di sangiovanni nelle stesure di getto, sulle quali venivano stesi tutti gli altri colori, rispettando il fondo di preparazione. Isolati interventi con biacca di piombo, dove fosse necessario correggere la luminosità di un particolare.

[3]Lo studio iniziato dal Dr. Malaguzzi e proseguito dal Dr. Matteini ha confermato la presenza di biacca inalterata nella zona sopra la porta della sacrestia. La fotografia della sezione di un piccolo frammento prelevato dalla gamba di una delle ultime figure a destra in basso mostra l'inizio di ossidamento non ulteriormente sviluppato (Fig. 1) ; cfr. pp 443–44.

Oppure, come nel *S. Gregorio* intento a scrivere, il mantello di azzurrite aggiunto a tempera è lumeggiato con biacca (Fig. 4).

Tutto sommato, da come viene usata in queste vele, si capisce che la biacca venne considerata, insieme ad altri colori ritenuti inadatti sul muro, buona soltanto se messa a tempera.

Pareti della navata centrale della Basilica superiore

Come è stato accennato precedentemente, le scene del Vecchio e del Nuovo Testamento ai lati dei finestroni non mostrano segni di biacca. Non sappiamo se per tradizione, o dopo aver constatato i guasti nel transetto, questi pittori si siano astenuti da introdurre il colore incriminato nelle loro opere.[4]

Si ritrova la biacca presente nelle scene della Vita di S. Francesco. Oltre alle colonne tortili messe a divisione dei diversi episodi, si incontrano particolari trattati con l'ausilio di questa polvere luminosa, che doveva rappresentare un'insistente tentazione. Quale significato potrebbe essere attribuito a questo parziale ritorno ad un colore già condannato? Speranza di aver trovato una soluzione per renderlo inalterabile? Debolezza per la fascinosa facilità con cui potevano essere realizzati risultati sorprendenti?

Spesso si tratta soltanto di qualche lumeggiatura sulle mani, come in quelle della *Visione dei Troni*, ma altre volte in particolari più impegantivi. Il cavallo del *S. Francesco dona il suo mantello al povero* è rielaborato con biacca (Fig. 5). Molte macchie sulle gambe e sulla testa sono di biacca pura, ora di biossido di piombo, mentre il corpo in generale è di biacca mista a bianco di calce e ad altri colori. Non è improbabile che anche il cavallo abbia subito un tentativo di risvegliare i chiari con azione chimica leggermente abrasiva, come nel transetto, e con risultati altrettanto negativi.

Proseguendo un rapido esame nel susseguirsi delle scene della Vita del Santo, si incontrano luci annerite nell'*Estasi* (Fig. 6), nella *Natività di Greccio*, nella *Morte de Celano*. A volte si tratta di piccole correzioni, altre volte di interi elementi architettonici, come i pilastrini nella *Predica davanti ad Onorio III*.[5]

Affreschi di Giotto e dei suoi aiuti nella Basilica inferiore

Nella Basilica inferiore la situazione riguardante la presenza di questa biacca è ancora più sconcertante, specialmente per quanto riguarda le vele sopra l'altare e le scene del braccio destro del transetto. Qui Giotto ed i suoi aiuti sembrano sicuri di aver trovato un valido rimedio contro l'annerimento della biacca e ne usano senza timore. In parte l'ottimismo di Giotto è giustificato dalla considerazione che, della biacca messa a tempera, soltanto una piccola parte risulta annerita.

[4]Non conoscendo le precedenze dei singoli gruppi di artisti operanti anche contemporaneamente nelle due Basiliche, ogni illazione risulta opinabile.

[5]La biacca presente in queste storie e nei tortiglioni a divisione delle singole scene fu già segnalata nel libro di L.

Tintori–M. Meiss, *The Painting of the Life of St. Francis in Assisi, with Notes on the Arena Chapel* (New York, 1962). Ora è stata analizzata dal Dr. Matteini. I risultati delle ricerche confermano la segnalazioni del 1962 (cfr. pp. 443–44).

Nelle vele, il muro del Castello nell'*Allegoria della Castità*, è scrosticchiato ed annerito per effetto di ossidazione (Fig. 7). Uguale effetto si riscontra nell'*Incontro della Vergine con Elisabetta*, dove il portichetto e varie luci delle rocce risultano scrosticchiate ed annerite (Fig. 8), come in altre scene.

Da come si presentano le scrostature, non si può pensare a semplici ritocchi di biacca alterati, bensì ad intere zone dipinte con biacca e solo in parte ossidate. Anche nelle altre scene di questo braccio del transetto la biacca partecipa abbondante, con poche alterazioni nelle massime luci.

Sulla *Natività* e su altre scene gli ossidamenti sono di poco rilievo e limitati al paesaggio, ma queste poche macchie indelebili alimentano un preoccupante pensiero : sarà ancora possibile il propagarsi del fenomeno di ossidazione?

Nella Cappella della Maddalena i segni di ossido di piombo sono ancora più limitati e sembra che la biacca introdotta sia poca e limitata ad interventi isolati. Se ne scorgono tracce sul terreno della *Resurrezione di Lazzaro*, nelle nubi che sorreggono la Maddalena a colloquio con gli Angeli, e nel bimbo nel *Viaggio della Maddalena a Marsiglia*. Queste sono le alterazioni più evidenti. Altre potrebbero essere segnalate con uno studio più particolareggiato. Personalmente non ritengo indispensabile segnalare tutte le tracce di ossidazione della biacca, sarebbe assai più importante conoscere quanta ne resti ancora inalterata.

Cappella del Cardinale Montefiore di Simone Martini

Potrà risultare monotona ed inadeguata questa persecuzione di un solo colore, ma pensando alla minaccia che può rappresentare non è possibile fare a meno di insistere.

Altre alterazioni si associano a quelle del nostro argomento : una è quella dell'azzurrite disposta a diventare verde, l'altra, molto più subdola, è un affioramento giallo che immerge i riquadri toccati dall'umidità infiltratasi dal tetto, in una patina itterica di origine ignota e sulla quale varrebbe la pena di indagare. Ma questo potrà essere argomento di altre ricerche.

Tornando alla nostra biacca ed iniziando dall'alto, troviamo graffi e scrostature annerite sulle nubi e sulle ali degli angeli nella *Glorificazione di S. Martino*. Poi ne incontriamo sul piano sotto il Santo morto ed alla base del pilastro. Scrostature parziali atte a segnalare biacca ancora inalterata. Il *S. Martino fatto cavaliere* è turbato sul piano in basso e sulle luci della veste azzurra indosso all'uomo che allaccia gli speroni al Santo. Nella *Meditazione* l'ossidazione ha distrutto quasi totalmente il piano chiaro ai piedi del Santo, sostituendolo con un bruno pesante (Fig. 9). Fra tanti altri particolari turbati dalla trasformazione della biacca, risultano gravi e sinistri quelli che hanno parzialmente distrutto i chiari della veste di *S. Elisabetta d'Ungheria* ed hanno già intaccato il piano (Fig. 10). La stessa sorte è toccata a *S. Caterina*, così due delle più belle e luminose figure femminili della Cappella sono già segnate dall'alterazione e peggiori conseguenze si possono temere.

Da un'analisi condotta dal chimico Dr. Mauro Matteini su campioni prelevati dal piano di S. Elisabetta, è risultato : (1) il bianco = carbonato basico di piombo ; (2) lo scuro = biossido di piombo (cfr. la relazione a pp. 443-44).

Le macchie irregolari simili a scrostature causate dall'ossidamento diluiscono ancora un

pò di ossido, al disotto dello strato di colore con biacca inalterata. E la biacca non ancora intaccata è molta in questa Capella, tanta da tremare al pensiero di vederla annerire.

Simone Martini, più di tutti gli altri pittori, aveva sperato di aver trovato il modo di rendere quasi incorruttibile la biacca. Però anche per le sue pitture qualcosa è avvenuto a manometterne l'integrità.

Il procedimento tecnico del ciclo della Cappella Montefiore stupisce per la vivacità, ricchezza e perfezione. I tagli delle giornate risultano piuttosto grandi e la elaborazione sul fresco è accurata, sensa perdere niente della spigliata sicurezza del grande artista: dalla levigatezza dell'intonaco alle ricche bulinature impresse sull'intonaco fresco, fino alle morbide, fresche modellature dei volti e delle mani. Questi volti e queste mani restarono, insieme ad altri pochi particolari di vesti e di fondo, gli unici punti visibili del lavoro su fresco. Tutto il resto fu ricoperto di preziosi colori a tempera: oro, cinabro, lacca, azzurrite, malachite e biacca rivestirono di un ricco tessuto cromatico tutta la superficie, in tutto simile ad una pittura su tavola.

Ancora, per quanto logorate dal tempo e dalle vicissitudini, queste tempere illuminano le scene con i loro preziosi residui, attraverso i quali intravediamo l'abbozzo eseguito sull'intonaco fresco. Insieme a poche terre, Simone Martini si serve del bianco di sangiovanni per modulare le tonalità dell'affresco. Mentre per le tempere usa sempre biacca: ed aspetta che l'intonaco sia ben secco prima di sovrapporre questo completamento.

Ciononostante, alcune zone non sono potute sfuggire all'insidia delle ossidazioni. Non troppe, se si pensa alla grande quantità di biacca presente. Così, nella stessa maniera della trasformazione dell'azzurrite, il bianco di piombo è stato tradito dalla prolungata carbonatazione della calce del muro e, non è da escludere, da solventi inadatti adoperati nei vari restauri.

Dal confronto di vecchie fotografie con la condizione attuale di alcune zone dove è sicuramente presente la biacca, non sembra sia avvenuta espansione del fenomeno, almeno negli ultimi cinquanta anni. Però, è sempre da ritenere utile la cognizione precisa di questa presenza, in modo da evitare qualsiasi intervento che possa incoraggiare, anche minimamente, l'aggravamento.

MUSEO DELLE CARROZZE, FLORENCE

ANALISI CHIMICHE

Firenze, 29 marzo 1973

Oggetto : Affreschi di Giotto, Simone Martini, Cimabue situati ad Assisi.

Analisi chimiche qualitative di no. 7 campioni di colore prelevata dalla superficie degli affreschi o dallo strato immediatamente sottostante.

C.1 : Affresco di Giotto—nero—Dal cavallo della scena *S. Francesco dona il suo mantello al povero*

C.1A : Affresco di Simone Martini—nero—Strato sottostante il {prelevati dal piano
C.2A, *scrostato* }alla base di
C.2A : Affresco di Simone Martini—bianco—strato superficiale {*S. Elisabetta d'Ungheria*
C.3A : Affresco di Simone Martini—Stesso strato del C.1A }il 7 marzo 1973

C.1B : Affresco di Cimabue—bianco non annerito—su una gamba di una figura in basso nella *Crocifissione*

C.2B : Affresco di Cimabue—bianco del *Calvario*

C.3B : Affresco di Cimabue—nero del *Calvario*

numero campione	colore	sostanze trovate	quantità approssimative
C. 1	bruno	PbO_2 $CaCO_3$ $CaSO_4 . 2H_2O$	+++ ++ tracce
C. 1A	bruno	PbO_2 $CaCO_3$	+++ +++
C. 2A	bianco-grigio	$2PbCO_3 . Pb(OH)_2$ $CaCO_3$	+++ +++
C. 3A	bianco	$CaCO_3$ $2PbCO_3 . Pb(OH)_2$ SiO_2	++++ ++ +
C. 1B	grigio azzurro	$2PbCO_3 . Pb(OH)_2$ $CaCO_3$ $2CuCO_3 . Cu(OH)_2$ SiO_2	++++ +++ +++ +
C. 2B	ocra gialla	$CaCO_3$ SiO_2	+++ +
C. 3B	rosso bruno	$CaCO_3$ $2PbCO_3 . Pb(OH)_2$ SiO_2	+++ ++ ++

Osservazioni

Nel campione dell'affresco di Giotto, in due dei campioni di Simone Martini (quelli degli strati sotto-stanti) e in due dei campioni di Cimbaue, è presente biacca (Idrocerussite = $2PbCO_3.Pb(OH)_2$.

Nel campione dell'affresco di Giotto e in quello superficiale di Simone Martini è presente il Pb allo stato ossidato di biossido (Plattnerite = PbO_2).

In tutti i campioni si è trovato Calcio Carbonato sotto forma di Calcite e in alcuni anche Silice, entrambi componenti della malta. Nel campione superficiale dell'affresco di Cimabue si è trovato anche un pigmento: Azzurrite = $2CuCO_3.Cu(OH)_2$.

Il colore del campione 3B (rosso bruno) non è in accordo con i composti trovati, nel senso che oltre alla Calcite e alla Biacca, entrambe bianche, è presente qualcos'altro che scurisce il colore. Non si tratta di biossido di Piombo, né di ossidi di Ferro. Parte del colore bruno è dovuto a un legante organico presente ma c'è qualcos'altro che, data l'esiguità del campione, non si riesce ad accertare.

(firmato) DR. MAURO MATTEINI

Vecchietta and the Persona of the Renaissance Artist

HENDRIK W. VAN OS

In the earliest days of art history, Ghiberti and Vasari searched for, and found, the origin of the true artist in Italian art of the fourteenth and fifteenth centuries. He was a man for whom art was more than a straightforward craft; a man who put so much of his own personality into the work of his hands that he could be regarded as a creator who used the medium of his art to transpose reality into beauty.

Nowadays, we have become accustomed to identifying the characteristics of this new art without concerning ourselves with the artist himself. From works of art we learn of the discovery of nature, of perspective, of classical antiquity, but what this new art meant for the person who produced it remains unclear. The works show us a new individualism, but the individual who created them remains in the shadows. To the art historian, this is no great loss—what concerns him is the work of art, not the man behind it. The scientific approach to the work of art as an autonomous entity surrenders the person of the artist as a hostage to the febrile imagination of the novelist. Art historians wince at Hermann Grimm, who blows Michelangelo the man up to *übermenschliche* proportions; at Freud, plumbing the depths of Leonardo's soul; and they get intensely annoyed with all the pretentious gold-diggers who deprive them of the art in favor of a romanticized picture of the artist. But the one thing these art historians forget is that it is they who have opened the gates to these interlopers by failing to provide scientifically based alternatives. They have created a no man's land, a vacuum that novelists, pseudocultural philosophers, and failed clergymen rush all too eagerly to fill.

This state of affairs could possibly be excused if the importance of the new art for the person of the artist had not been recognized as being of paramount importance at the time. But Ghiberti waxes enthusiastic over the artist as scholar, as represented in the works of Ambrogio Lorenzetti, and Vasari gives preferential and detailed treatment to those artists whose work he sees as expressing a new artistic personality. So it is vitally important not to separate the work from its creator, if one wishes to acquire a balanced historical understanding.

Must one then follow Von Martin and steep oneself in the artist's social position, or produce a sort of historical psychoanalysis as Rudolf and Margot Wittkower did in their impressive *Born under Saturn*?[1] Not necessarily. And in any case, both these approaches still separate the work of art from the artist, the difference being that they focus on the artist rather than on his work. To my mind, it is more important to isolate a number of individual instances and study them as case histories, with social position, personal performance, and the claims of the artist's work displaying a clear and logically demonstrable interrelation. Lorenzo di Pietro—Il Vecchietta—is a case in point.

Vecchietta's first documented work is a fresco in the pilgrims' hospice of the Spedale di

This article is the text of a written and annotated address delivered by the author before the Kunstgeschichtliche Gesellschaft zu Berlin on December 15, 1972 and the Nederlands Interuniversitair Kunsthistorisch Instituut te Florence on May 24, 1973. Translation © 1973 Michael Hoyle.

[1]A. von Martin, *Soziologie der Renaissance*, Stuttgart, 1932.— R. and M. Wittkower, *Born under Saturn; The Character and Conduct of Artists* (London–New York, 1963).

Santa Maria della Scala in Siena (Fig. 1). The record of payment for this work is dated 1441.[2] The painting of the hospice walls was in itself an unusual undertaking. The requirement was for a whole series of works on secular themes, illustrating the excellence of the hospital in its roles as a social institution charged with the care of the poor and the education of foundlings, as a medical center, and as a lodging place for pilgrims. The two most important artists commissioned to illustrate these unusual themes were Vecchietta and Domenico di Bartolo, two artists who deliberately sought to align themselves with the modern art of their day. Compared to the great Sienese painters of the 1440s (Sassetta and Giovanni di Paolo), they were out-and-out revolutionaries, but each in his own way. Domenico was an unrivaled realist. The striking details in his frescoes and certain illusionist effects give his realism an almost ostentatious quality, and his concentration on detail often detracts from the unity and arrangement of the composition. In Domenico, realism and fantasy are complementary, not mutually exclusive, and it is this particular quality that gives his frescoes their great charm. He creates the most bizarre structures and then uses them as settings for realistically painted events.

While Domenico is a narrator, Vecchietta is a monumentalist. In this fresco, the architecture serves to delineate the pictorial space, and the wealth of detail is subordinate to that function. Even as "modern" a painter as Vecchietta, however, was fully aware of the importance of the great Sienese tradition of art, as is shown by the fact that he borrowed the entire architectonic arrangement of the composition from Ambrogio Lorenzetti. In Lorenzetti's *Purification of the Virgin* for the altar of St. Crescentius in Siena Cathedral, painted exactly one hundred years before Vecchietta's fresco, the temple has the same compositional function.[3] His architectonic design was commonly used thereafter by Sienese artists as a stylization of the Jewish Temple, although with its abundant decoration radically simplified. Vecchietta ran counter to the trend by adopting the design but modernizing the architecture, and by adding a great deal of new ornamentation borrowed, in the main, from the façade of Siena Cathedral. One of his rather surprising innovations is the frieze of *boucranoi*.[4] The presence of Adam and Eve at the upper left and Abel with the sacrificial lamb and Cain with his club at the upper right (Fig. 2) show that Vecchietta's building was also intended to represent a temple. These "reliefs" proclaim Vecchietta to be preeminently an artist with claims to "modernity." In the first place, of course, there is the illusionistic effect, but these reliefs of nude figures also create another and quite different illusion. They give the impression of being faithful copies of classical art. Abel and Cain bear a closer resemblance to Jason with the Golden Fleece and Hercules with his club than they do to the children of the first man and woman, whose nakedness after being driven out of Paradise was cause for shame. Panofsky has already pointed out that whereas classical heroes were given medieval clothing, biblical

[2]D. Gallavotti, "Gli affreschi quattrocenteschi della Sala del Pellegrinaio nello Spedale di Santa Maria della Scala in Siena," *Storia dell'Arte* (XIII, 1972), 16–22, 35, with many references to earlier publications. In a forthcoming article I shall consider the iconography of Vecchietta's fresco in greater detail. For Domenico di Bartolo's work in the Spedale, see the article in this volume by Enzo Carli, pp. 73–82, and accompanying illustrations.

[3]H.W. Van Os, "Giovanni di Paolo's Pizzicaiolo Altarpiece," *Art Bulletin* (LIII, 1971), 289–303.

[4]The first use of this ornamental device in painting is to be found in Masolino's frescoes in the Baptistry of Castiglione Olona; see Gallavotti, "Gli affreschi . . . della Sala del Pellegrinaio," 17.

figures provided a good excuse for portraying pseudoclassical heroes. Here we have an excellent—albeit highly confusing—example of this.[5]

The modernistic details are not, however, limited to the architecture alone. The secondary figures at the extreme left and right are dressed in the fashion of the day and serve to show the distance between the surface of the wall opened up by the richly ornamented arch and the temple itself. Similar figures—completely oriented toward the observer—are repeated at either side of the vision of Blessed Sorore in the center but are much more sumptuously dressed, in a way reminiscent of the aristocratic minor figures in the works of Domenico Veneziano. In this fresco we are constantly encountering a painter who is emphasizing that his work accords with the most up-to-date requirements. This is probably seen most clearly in the ostentatious way in which he has tried to give a feeling of depth, as defined by the architecture, even when accompanying a horizontal band of figures. The combination of isocephaly and depth in the arrangement of the figures seems to come straight from the theory book.[6] What we are seeing here is an art with claims totally different from those of Vecchietta's great contemporaries, Sassetta and Giovanni di Paolo; but it is difficult to express this contrast in terms of quality, since the "old-fashioned" art of the day was in no sense inferior to the "modern." One can only say that it is different, and that is why I am strongly inclined to search for that difference in the artist's personal and social deviation from the norm.

Clear evidence of the fact that Vecchietta was cultivating an image as an artist different from the one that was customary in the Siena of his day is provided by the signature under the badly damaged fresco decoration in the sacristy of the hospital church, which was dedicated to Santa Maria Annunziata (Fig. 3). In Vecchietta's day, this sacristy played a crucial role in the religious life of the hospital, since it was here that the precious relics bought in Constantinople in 1359 were kept. In 1444, Vecchietta painted the reliquary with the assistance of Sano d'Andrea and Pietro d'Ambrogio. In 1446, he painted the vault with a fresco of the Savior surrounded by Fathers of the Church and Evangelists, and in 1449 his pupils painted twenty large frescoes for the sacristy walls.[7] These latter works—illustrations of the twelve Articles of Faith with Old Testament prefigurations—are particularly illustrative of the contemporary taste for highly complex iconographic schemes. The entire decoration is marked by an abundance of texts deliberately presented as classical inscriptions. The most striking of these is the signature, which has survived almost intact:

. . . EQUITE PRAECELLENTISSIMO HUIUS SANCT[AE]
[MARIAE D]OMUS PRAEFECTO LAURENTIUS PETRI
FILIU[S] [S]ENENSIS HOC SACRA[RI]UM UNDIQUE
VERSUM PICTURIS HONESTAVIT MCCCCXLVIIII.

Since "eques" was the title of the Rector of the hospital, we must assume that the original text began "Urbano Equite," that post being held in 1449 by one Urbano dello Bello. I know

[5]For the confusion, see Gallavotti, *op. cit.*, 21 : "bassorilievi a metà tradizione religiosa e recupero di temi profani"; C. Brandi, *Quattrocentisti senesi* (Milan, 1949), 123 : ". . . due bassorilievi con il Peccato originale e l'Ercole (quale miscuglio presuntuoso!) . . ."

[6]L.B. Alberti, *On Painting and On Sculpture*, ed. C. Grayson

(London, 1972), particularly 55, 111ff., with references to current literature on the topic.

[7]H.W. Van Os, *Vecchietta and the Sacristy of the Siena Hospital Church: A Study in Renaissance Religious Symbolism* (The Hague, 1974).

of no signature in Sienese painting to compare with this inscription, whereby the artist, in scrupulous humanist Latin, has provided himself and his patron with a sort of humanistic monument. In this connection it should be noted that Vecchietta enjoyed a very special relationship with his patron and can, in fact, be regarded as the hospital artist. He and his pupils carried out numerous commissions for the Rector. In the sacristy alone they were responsible for the reliquary, the frescoes on the vault and walls, a Crucifix, a *Madonna della Misericordia*, and a baldachin depicting the Savior and two angels. Among the treasures on the high altar in the church was a beautiful Vecchietta ciborium, dating from 1472, which was transferred to the high altar in the Cathedral by order of Pandolfo Petrucci. That Vecchietta was closely associated with the hospital is borne out by the fact that part of his payment for this magnificent work included the offer of a house next to the hospital for the rest of his life. Other records reveal that Vecchietta's fellow citizens held him in unusually high regard for a painter—someone who at that time was regarded as nothing more than a craftsman pure and simple. Vecchietta's tax returns, despite their almost obligatory pro-testations of financial difficulties, show that he was very well off, and that compared to fellow artists such as Sano di Pietro and Giovanni di Paolo he counted as a man of means.[8] Bearing in mind the Wittkowers' examination of this point, I think it can safely be assumed that it was this close connection with one extremely influential patron that enabled Vecchietta to attain a social position unique among Sienese artists. He could survive without the protection of the Guild and as a result was probably less subject to the restrictions of the system. In this sense the signature on the sacristy frescoes proclaims a new breed of individual artist—one who could place himself alongside an "eques," a distinguished patron, and thus break the economic and social links with the medieval system of collectivity.

On April 3, 1460 the city fathers gave Vecchietta a flattering and profitable commission for two marble statues on the Loggia della Mercanzia "so that he has cause to pursue his calling in Siena and not elsewhere, which is requested of him and which he is endeavoring to do," as the commission puts it. Nevertheless, five days later we find the city authorities writing a letter of recommendation for Vecchietta to the Sienese Pope Pius II. The statues were not to be delivered until 1462.[9] Since money was obviously not the main reason for Vecchietta's leaving Siena, it is possible that he undertook the journey, as did other artists in the second half of the fifteenth century, because "they were driven by a strange combination of a thirst for knowledge and a yearning for freedom far beyond anything that had ever moved their fellow-craftsmen."[10] It seems probable that while in Rome Vecchietta came into contact with friends of Cardinal Branda Castiglione (who had died in 1443), who com-missioned him to complete the painting of the Choir Chapel of the Collegiata in far-off Castiglione Olona. The vault had already been painted by Masolino with scenes from the life of the Virgin (Fig. 4).

An anonymous Florentine—possibly Paolo Schiavo—had worked on the walls below the vault, taking as his themes Sts. Stephen and Lawrence, the two patron saints of the

[8]For Sano di Pietro, see G. Milanesi, *Documenti per la storia dell'arte senese*, II (Siena, 1854), 278–79, 388. For Vecchietta, see *idem*, III (Siena, 1856), 284–85. For Giovanni di Paolo, see S. Borghesi–L. Banchi. *Nuovi documenti per la storia dell'arte*

senese (Siena, 1898), 182–83.
[9]G. Vigni, *Lorenzo di Pietro detto il Vecchietta* (Florence, 1937), 65, 80.
[10]Wittkower, *Born under Saturn*, 44.

church of the art-loving Cardinal who had made his birthplace such a remarkable monument to the early Renaissance. These were the paintings that Vecchietta completed. They definitely do not belong to his earliest work, as is generally supposed, but must be dated around 1460, for a number of reasons that can be gone into only briefly here :[11]

(1) The remains of Vecchietta's fresco of the *Martyrdom of St. Lawrence* (Fig. 5) show that it was painted above an opening made in the side wall at the left to take the tomb of Cardinal Branda. So 1443, the year in which the Cardinal died, is in all likelihood a *terminus post quem* and not the *terminum ante quem* for dating the fresco.

(2) There is clear evidence that the frescoes were not commissioned by the Cardinal. The two donors appear in the fragmentary fresco on the center wall (Fig. 4)—a woman and a man kneeling next to the *Burial of St. Lawrence* and the *Burial of St. Stephen*, respectively (Figs. 6 and 7).

(3) The predominant influence of Domenico Veneziano, the Castiglione fresco's color scheme and composition, can be noted in Vecchietta's work only in his so-called Spedaletto Altarpiece in the Pienza Museum.[12] The remarkable spatial scheme of the *Martyrdom of St. Lawrence* also occurs in this painting, which must be dated 1462.

The lower part of the painting, now largely concealed by benches, consists of an illusionistic painting of architecture that is startlingly advanced for its day. A row of columns is set off against a background consisting of an extremely true-to-life imitation of colored marble. The high altar has been decorated in the same way (Fig. 4). A window has been painted on one of these pseudomarble grounds, and behind it a man dressed in contemporary costume (Fig. 8). Salmi, who in 1928 was the first to publish these frescoes, suggested that this is a self-portrait of the artist. Suggestions of this sort, of course, are frequently based on only the flimsiest of arguments, the attitude of the head and the direction of the gaze often being enough to make the art historian think of a self-portrait. In this case, however, there is an additional argument. The man behind the window is looking toward the *Martyrdom of St. Lawrence* (Fig. 5), who is the name saint of Lorenzo di Pietro, our Vecchietta. The unusual position of this figure in relation to the painting as a whole and its equally unusual relationship to the iconographic scheme make it very likely, to say the least, that we are looking at Vecchietta himself.

Nor is it the first self-portrait in Sienese art. In 1400, Taddeo Bartolo inserted a self-portrait in his large Assumption Altarpiece for Montepulciano Cathedral, and again it is recognizable as such because of a similar iconographic trick. Taddeo also played on the relationship between artist and name saint, but he did so by portraying himself as the apostle Jude Thaddeus. The fact that it was these two painters who immortalized themselves in their art is no coincidence. Taddeo was also an artist who achieved the ideal of the artist-scholar, albeit not with new forms but with extremely complex and highly personal iconographies.

[11]See also Van Os, *Vecchietta and the Sacristy of the Siena Hospital Church*, chap. III, §3. The paintings were published by M. Salmi in his "Gli affreschi nella Collegiata di Castiglione Olona," *Dedalo* (VIII, 1927/8), 227–44; (IX, 1928/9), 3–30. For the attribution, see also R. Longhi, "Ricerche su Giovanni di Francesco," *Opere complete*, IV (Florence, 1968), 24; the article was first published in *Pinacotheca* (I, 1928), 34–8. J. Pope-Hennessy is the only authority who has contested the attribution of the Castiglione frescoes to Vecchietta; see, *inter alia*, *Sassetta* (London, 1939), 158.

[12]E. Carli, *Pienza* (Rome, 1967), 126; G. Coor, *Neroccio de'Landi, 1447–1500* (Princeton, N.J., 1961), 19; Brandi, *Quattrocentisti senesi*, 130.

In the Montepulciano altarpiece he has portrayed himself, as Panofsky remarked, as a scholastic theologian checking off arguments on his fingers.[13] Broadly speaking, it can be said that an artist who introduces himself into his own works by means of a self-portrait has entered into a subjective relationship with his art that no longer squares with the craftsman's objective production norms.

The Castiglione frescoes are a nonstop pyrotechnic display of Vecchietta's talents: scenic continuity despite the discontinuity of the wall, daring tricks of perspective, accentuated plasticity, and formal experimentation with the properties of light. Each individual figure is a study in itself, which is why the composition as a whole sometimes looks like a collection of studio models. The display of erudition produced some very interesting buildings in the background of the *Burial of St. Stephen* (Fig. 7). At left is Vecchietta's personal interpretation of the Santo at Padua (Fig. 9), while the building at the right has come straight from the model book (Fig. 10).[14] Vecchietta's portrayals of old men display none of his usual restlessness, and the splendid figures of Evangelists and Fathers of the Church on the hospital's sacristy vault and the highly detailed self-absorbed figure (Fig. 11) are the very acme of his art.

Back in Siena once again, Vecchietta could bask in the favor of the city fathers. He delivered the statues ordered before he left and executed a number of other commissions.[15] In 1467, he went to the small town of Sarteano and converted it into a fortification, one of several exercises in military architecture that he carried out in this period. When the city authorities embarked on an ambitious plan to provide Siena with a secure stronghold on the sea, it was Vecchietta who made the drawings and models converting the port towns of Orbetello, Talamone, and Monte Acuto into fortresses.[16] In this connection, a curiosity that should be mentioned is a fresco fragment, perhaps by Vecchietta, which was auctioned a few years ago at Lempertz in Cologne (Fig. 12). From a photograph in the Kunsthistorisches Institut, Florence, I have unfortunately been unable to obtain any more information about this piece. It is important to realize that knowledge of military architecture and siege techniques acquired an entirely new status during this period, particularly in Italy. The famous Sienese military engineer il Taccola, who flourished in the first half of the century, was no more than an inventive, dedicated technician, while theoreticians like Alberti and Filarete displayed little interest in fortifications. In 1472, however, a book appeared that had actually been completed in 1455 and whose ideas were to alter the situation radically. The book's author, Roberto Valturio, is important not so much as a technical innovator but as someone who elevated the status of the craft, which he believed to be one of the liberal arts and thus an essential element in the formation of personality.[17] The description of the actual

[13]H. W. Van Os, *Marias Demut und Verherrlichung in der sienesischen Malerei (1330–1450)* (The Hague, 1969), 172–73. Both self-portraits show the artists as young men, despite the fact that they were middle-aged when they painted them. This tendency to idealize is not uncommon in later self-portraits.

[14]For Fig. 10, see B. Degenhart–A. Schmitt, *Corpus der italienischen Zeichnungen 1300–1450*, 1 (Berlin, 1968), 583, no. 596.

[15]Vigni, *Lorenzo di Pietro detto il Vecchietta*, 65–66.

[16]For the documents, see Milanesi, *Documenti senesi*, II, 370.

[17]R. Valturius, *De re militari libris XII* (ed. Paris, 1872). For the valuation of military architecture and siege techniques, see B. Gille, *Les Ingénieurs de la Renaissance* (Paris, 1964). Taccola

and Valturio are discussed on pp. 74–80. See also F. Gilbert, "Macchiavelli: The Renaissance of the Art of War," in *Makers of Modern Strategy*, ed. E.M. Earle (Princeton, N.J., 1943), 3ff. E. Rocchi examines numerous Italian examples of fortifications in his indispensable *Le origini della fortificazione moderna* (Rome, 1894). See also the same author's *Le fonte storiche dell'architettura militare* (Rome, 1908). For an analysis of the political importance of Vecchietta's fortifications, see G. A. Pecci, *Memorie Storico-Critiche della Città di Siena*, IV (Siena, 1760), 43, and L. Banchi, *I porti della Maremma durante la Repubblica* (Florence, 1871).

engines of war occupies only a small part of the book. Valturio considered it far more important to demonstrate how the technical facts fitted into a tradition dating right back to Homer. Fortification as he saw it was an art that resurrected antiquity. Might this not be the reason why an artist such as Vecchietta, eager as he was for that sort of prestige, occupied himself building fortifications, just as Leonardo was to do half a century later? The irony is that it was Vecchietta's pupil, Francesco di Giorgio, who was to win the fame as a military architect that his master so craved.

Thus, as early as the 1460s, the picture of the artist as *uomo universale* emerged in the shape of Vecchietta. This characterization, however, must be approached with a certain amount of caution, since medieval artists frequently undertook the most varied commissions. One and the same man might be a painter, sculptor, architect, and cabinetmaker. On closer examination, the dividing line between the *uomo universale* and the jack-of-all-trades turns out to be extremely blurred, the only clear distinction being that the artist as "universal man" derived status from his versatility, often deliberately selecting a combination of some skills and rejecting others. In this way his versatility became more a question of personal initiative than a response to market mechanisms. We can be reasonably certain that the versatility displayed by Vecchietta—particularly in the 1460s—was part and parcel of the conscious stylization of his persona as artist. For instance, when signing sculptures such as the bronze tabernacle for the high altar of the hospital church, the bronze relief of the Resurrection, and the wooden statue of St. Bernardino in the Bargello, he refers to himself as "Vecchietta Pictor."[18] Now one could, of course, say that he did so because he regarded himself as a painter first and foremost, but the fact is that the major painting of his later period—the altarpiece of the Assumption in Pienza Cathedral, dating from 1462—bears the signature "Vecchietta Sculptor."[19] Obviously, then, he was deliberately drawing attention to his own versatility.

At the end of his life, Vecchietta decided he wanted to erect a monument to himself as artist. On December 20, 1476 he petitioned the hospital administrators to allow him to build a chapel in the church to receive his tomb, a quite remarkable request published *in extenso* by Milanesi.[20] The artist asked if he might build a "capella murata" as shown in an accompanying drawing and model. For the altar he intended to make a bronze statue of the Resurrected Christ, with behind it a painting of the Madonna. The chapel would be dedicated to the Savior, and the Feast of the Ascension was to be celebrated each year. He went on to ask for the insurance "che la decta capella non si possi levare del luogo dove mi sia consegnato et edificata, ne cavare le imagine sopradetta, et che sia in mio nome. Et così sempre in perpetuo in mio nome et de li miei passati et de la mia donna." It is as if he had a presentiment of what the future held in store, because in the sixteenth century the chapel was demolished, and now not a trace of it is to be found. Today the bronze statue of the Resurrected Christ adorns the high altar (Figs. 13–15), while the recently restored painting of the Madonna hangs in the Pinacoteca (Figs. 16–18).

[18]The tabernacle is signed: OPUS LAURENTII PETRI PICTORIS AL VECCHIETTA DE SENIS MCCCCLXXII and has been installed on the high altar of the Cathedral since 1506. The relief is signed: OPUS LAURENTII PETRI PITTORIS AL VECCHIETTA DE SENIS MCCCCLXXII. The statue of St. Bernardino is signed: OPUS LAURENTII PETRI PICTORIS SENENSIS. For discussion of these works see, in addition to Vigni's monograph, C. del Bravo, *Scultura senese del Quattrocento* (Florence, 1970), 87, 89.

[19]The signature reads: OPUS LAURENTII PETRI SCULTORIS DE SENIS. See E. Carli, *Pienza* (Rome, 1967), 107.

[20]Milanesi, *Documenti senesi,* II, 368–69. Vigni, *Lorenzo di Pietro detto il Vecchietta,* 67.

The bronze was already installed on the high altar, replacing Vecchietta's ciborium,[21] when Bossio made an inventory of the hospital church in 1573. A second inventory carried out in 1609 mentions a chapel that had been dedicated to Sts. Peter and Paul in 1558, and this was presumably Vecchietta's grave chapel. Once the bronze statue of the Savior, to whom the chapel had been consecrated, had been removed, there must have been a rededication to the two saints who flanked the Madonna in the altarpiece (Fig. 16). Della Valle described this altarpiece in 1786 as being "accanto lo Spedale maggiore di Siena in un atrio, frequentato da certe monache serventi alle inferme."[22]

The only "capella murata" in the present church is the chapel where the prayers for the sick are said, which is far older than its eighteenth-century decoration and painting might suggest. An inscription tells us that a chapel was founded here in 1626 by one Darius Pompenius F. Casulanus, "civis senensis," and the dedicatory inscription itself gives reason to believe that it was an existing area that had been rebuilt.[23] This must have been a sort of portal from the church to the old sacristy where so many of Vecchietta's works were to be seen. Girolamo Macchi, an archivist of the hospital, stated that this is where Vecchietta and his brother Bartolo were buried.[24] Onto the sacristy, which honored his distinguished patron, Vecchietta must have added a chapel in which he, the artist, occupied the central position.

Vecchietta's is not the only artist's grave chapel known to Sienese history. In 1477, Giovanni di Paolo directed that he was to be buried in the Chapel of St. John Baptist in the small church of San Gilio, which used to stand somewhere in the city center. Bacci, who published the relevant document in 1944, suggested that Giovanni's famous panels depicting scenes from the Life of the Baptist were located in this chapel.[25] This, however, is a very different case: a chapel dedicated to the Baptist for which Giovanni—if Bacci is correct—had produced a painting more than twenty years previously. Giovanni, seizing on the coincidence that it was dedicated to his name saint, asked to be buried there. Vecchietta, on the other hand, deliberately designed a chapel to take his own tomb. The statue of the Resurrected Christ

[21]"Visita apostolica di monsignor Bossio," Siena, Archivio Arcivescovile, MS 21, fol. 116v–117r: "Visitavit postea altare maius ad quod per plures gradus ascenditur, et lapideum non sacratum, nec dotatum cum mensa lignea, ac pietra sacra non infixa, quam infigi mandavit. Predella erat congrua. Altare totum erat [c]opertum tribus tobaleis, et desuper super gradines aderant decem candelabra occonea decentes. *Pro Icona adest Imago Domini Nostri Jesu Christi enea magni valoris, et artificiose elaborata.*"

[22]*Lettere senesi*, III (Rome, 1786), 66. The chapel of Sts. Peter and Paul is mentioned in "Inventaria exhibita in visitatione habita ab Ill.mo et Rev.mo Vicario Generale Illmi et Rev.mi D. Camilli Burghesii Archiepiscopi Senarum," Siena Archivio Archivescovile, MS 33. An extract from this inventory and from several others will be found in G. Macchi, "Memorie . . . ," II, 1708, Siena, Archivio di Stato, MS D–108, 78–81.

[23]MATRI DEI/Quae quos operit fovet. supplices/Quos audit tutatur./ Darius Pomponii F. Casulanus civis senen./Saccellum dote ditavit./ Novum duplici sacrificio cultum exhibendum/ Omni hebdomada. ut liberuit/ Pietate adiecit./Festos dies Resurrectionis. Pentecostes. Nativitatis/ Domini secludendos./ Ear altero solemnitatum die./Ac singulis diebus dominicis./ In D. Hieronymi Xenodochii substructionibus/soldalitatis. Aede supplicationum/Deo sacra facienda decrevit. A.D. MDCXXVI/Locis assignatis instituto sacerdoti/Altaris munus

non servanti./Nec praestandum curanti/Dieb. Paschalibus librarum. VII./Ac reliquis. duarum. pro singulis commissionibus/ Multa esto. Xenodochio tribuenda.// Bernardini Bartholini. A. tabulis, ecclesiasticis notis publicis consignata."

See also Van Os, *Vecchietta and the Sacristy of the Siena Hospital Church*, 15. The problem revolves around the precise meaning of the phrases" in . . . substructionibus" and "locis assignatis." Is it a new chapel or an old one restored? There is an unpainted surface between the two frescoes on the short north wall of the old sacristy—one with the signature (Fig. 3) and one with the Rector of the Hospital—which suggests that this was the original entrance to the sacristy. This hypothesis is reenforced by the way in which the frescoes must be read successively. For further discussion of this point, see Van Os *op. cit.*, chap. III.

[24]G. Macchi, "Origine dello Spedale di Sta. Maria della Scala di Siena," Siena, Archivio di Stato, MS. D–113, fol. 18r: Vecchietta was buried where "hoggi è la Porta di Ferro della Chiesa di detto Spedale." This "Porta di Ferro" (L. Alfieri, R. R. *Spedali Riuniti de S. Maria della Scala, Guida Storica Artistica*, Milan, 1913, 15) apparently closed off the entrance to the chapel then as it does now.

[25]P. Bacci, *Fonti e commenti per la storia dell'arte senese* (Siena, 1944), 88–89.

is signed: "OPUS LAURENTII PETRI PICTORIS AL VECHIETTA DE SENIS. MCCCCLXXVI. PER SUI DEVOTIONE FECIT HOC." "Per sui devotione"—a devotion that found expression in one of the most physical representations of the resurrected Christ. Picture, for a moment, the simple yet progressive architecture of the original fairly small chapel. Beneath a low dome, like so many to be built by Vecchietta's pupil Francesco di Giorgio, stands this dominating bronze figure. Christ is in the most literal sense the embodiment of physical triumph over death, which is sin, symbolized by the snake. That is the inner motivation for this verism, unprecedented in Siena, the fanatical observation of the external anatomy being at the same time an artistic demonstration of a grasp of reality.

The painting behind the bronze formed a golden niche organically related to the available width of the wall. In that niche sits the Madonna and Child, flanked by Sts. Peter and Paul (Fig. 16). Kneeling at the left in front of the Madonna is the deacon Lawrence—Vecchietta's name saint (Fig. 17)—with St. Francis on the opposite side. The signature reads: "OPUS LAURENTII PETRI PICTORIS ALIAS EL VECCHIETTA OB SUAM DEVOTIONEM." Vecchietta used this painting to demonstrate his talents as painter, sculptor, and architect. The niche with its heavy plastic figures was to suggest the real presence of the Madonna and Child in the chapel, a chapel displaying a fusion of the artist's religious experience and artistic genius. "Nil omnis moriar"—Vecchietta has appropriated this phrase from Horace and given it his own very personal interpretation. Naturally it was no new idea that the work of art generally outlived its creator, but up until then the persona of the creator had not been involved in this way. Broadly speaking, the art product of the craftsman, once delivered, led an autonomous existence as a functional object. Vecchietta, however, knew that he would live on in his works, and wished it so. This subjective relationship with his art bespeaks a new self-awareness on the part of the artist. The seventeenth-century historian Ugurgieri actually read Vecchietta's epitaph in the grave chapel, and it is an epitaph worthy of a humanistic artist: "Senensis Laurens Vivos de marmore vultus/Duxit, et excussit mollius Aera manu."[26]

The artist who does not hide behind his work like a craftsman but places himself in the spotlight by means of his art encourages the personal approach. His work and his life are indissolubly intertwined. Vasari, for whom the artist's personality was so important that he used biography as a means of writing about art, concentrated primarily on artists like Vecchietta. It is no coincidence that he devoted a great deal of attention to Vecchietta and his pupil Francesco di Giorgio, although he had little to say about other quattrocento Sienese painters. We are told, *ad nauseam*, that it is difficult to distinguish between *Wahrheit und Dichtung* in Vasari. He is generally used, in fact, to separate the *Wahrheit* from the *Dichtung*. Wittkower, however, has shown that Vasari's *Dichtung* is as interesting—if not more interesting, from the point of view of cultural history, at least—as the factual information contained in his biographies. One thing that Vasari tells us about Vecchietta is that he was a melancholy and solitary man who used to lose himself in contemplation. Della Valle, the eighteenth-century Sienese art historian, goes so far as to say that melancholy prevented Vecchietta from giving his bronzes a "tono più sublime e più grandioso,"[27] thus linking the artist's psychological make-up with his work. It is extremely difficult to decide

[26]Cf. Della Valle, *Lettere senesi*, III, 67. [27]*Ibid.*, 66.

how one is to interpret Vasari's biographies; they are certainly not biographical information in the modern sense of the word. Melancholy and solitariness were significant personality attributes rather than character traits. In Vecchietta's day, the Neoplatonist Ficino had linked melancholy to genius and could point to Aristotle as his authority.[28] It should be noted that this amounts to a definite revaluation of a particular psychological trait. In the Middle Ages melancholy, i.e., *acedia* or sloth, was regarded as one of the most serious vices. Of course, one hears it said that Vasari, whose aim was to publicize the new, emancipated artist, ascribed similar personality attributes to all and sundry, and that consequently they have no shred of biographical value. In my view, this displays a quite ludicrous skepticism. Surely we should assume that Vasari selected, among others, precisely those quattrocento Sienese painters who enabled him to present the new type of artist. He was certainly close enough in time to the historical reality for his purpose. This does not necessarily mean that Vecchietta was a melancholic in the modern sense, but rather that his image-building struck such a chord in Vasari's day that the latter could ascribe to him personality attributes that Vecchietta's contemporaries held to be the stamp of genius.

It is possible that if an artist like Vecchietta had appeared in Florence instead of Siena, he would have attracted far less attention, surrounded as he would have been by so many great artists and their distinguished patrons. As it was, however, Vecchietta could assume a unique position in a city where the outlines of his persona as an artist stood out more sharply against the background of the traditional practice of art. That is precisely why Siena, rather than Florence, offered such an excellent climate for the stylization of the individual of genius without first requiring him to develop the monumental aspect of a man like Michelangelo.

INSTITUUT VOOR KUNSTGESCHIEDENES DER R.U., GRONINGEN

[28]Wittkower, *Born under Saturn*, 102ff.

The Earliest Known Painting by Niccolò da Foligno

LUISA VERTOVA

In my review of the new catalogue of Italian primitives at Yale (*Burlington Magazine*, CXV, 1973, 60, fig. 16), I singled out, among the previously unpublished pictures, a *Madonna Enthroned with Saints and Angels* (Fig. 1), which had been vaguely ascribed to Florentine School of the mid-fifteenth century,[1] yet bore an extraordinary resemblance to the work of Niccolò da Foligno. Any uncertainty lingering in my mind because of the minute scale and poor quality of the catalogue illustration was dispelled when Yale University, via the editor of the *Burlington Magazine*, sent me adequate photographs. The small panel (15 × 12 5/16 inches = 38.1 × 31.2 cm) shows in every aspect of its conception and every detail of its execution the unmistakable style of Niccolò di Liberatore. The marble throne with its concave back appears again and again, enriched with carved ornamentation, in his later pictures, for example, the Madonnas at Deruta, in the Fogg Art Museum at Cambridge, Mass., in the Galleria Nazionale d'Arte Antica at Rome, in the Pinacoteca at Gualdo Tadino (Fig. 2), in the church of San Giovanni Battista at Cannara, and in the Pinacoteca of Bologna; and so do other features, such as the type of the Virgin and of her dress, the reclining Christ Child, the strong faces of the two kneeling saints, the semicircle of angels that fences in the throne and protects the holy figures with straight, narrow wings pointed skyward like lances at rest.

The Yale catalogue assumes that the two kneeling "Dominican Saints may represent Saint Peter Martyr (left) and Saint Antoninus (right)."[2] The latter assumption, however, is contradicted by the open book placed in the hand of the so-called Antoninus, which is inscribed in capital letters "TIME/TE.D/EUM/ET.D/ATE /ILLI./ONO/REM/QUIA/VENI[t hora iudici eius]." This quotation from the Apocalypse (XIV : 7) plainly identifies the bearer of the book as St. Vincent Ferrer. But it is not the only inscription in the open volume. At the bottom of the left page the painter added a now almost erased capital *N* and at the bottom of the right page one still reads, quite clearly, the date 1440 (Fig. 3). There can be no doubt about the authenticity of this date. Even the effort to read the last figure as "nine" rather than "zero" does not leave one convinced, because this digit looks just like a clean, oval zero.

The discovery is bewildering. We have documentary evidence of Niccolò's death in 1502, and so far his earliest known works were the frescoes in Santa Maria in Campis near Foligno, formerly signed and dated 1456(8?), and the *Madonna dei Consoli* (Fig. 4) at Deruta, inscribed 1457. On the basis of this knowledge, his birth has traditionally been placed around 1430; hence the surprise at discovering that Niccolò had already mastered a personal style of painting by 1440.

[1] C. Seymour, Jr: *Early Italian Paintings in the Yale University Art Gallery* (New Haven–London), 1970, 138 n. 97. Unfortunately the panel, which entered the Yale University Art Gallery at New Haven in 1937 as part of the Edwin A. Abbey Memorial Collection (Acc.no. 37.341), is not in pristine condition. Much more vexing than the two clean cracks recorded in the catalogue entry is the insidious retouching that impairs the quality of the heads of the angels, while the 1965 cleaning has given disturbing prominence to the losses of color in the clothes and background.

[2] *Ibid.*, 296.

Nothing prevents us, of course, from moving the date of his birth back a decade and assuming that he died, in 1502, at the age of eighty, rather than in his seventies. We know that his son Lattanzio, also a painter, was elected Priore of the City of Foligno in 1480, and he must have been by then an active and respected adult citizen, in order to be chosen for such a responsible and authoritative post.[3] This means that his father married, most probably, between 1440 and 1450. We also know from internal evidence that paintings ascribed to Niccolò or even signed by him after 1480 were mostly painted by Lattanzio or by other assistants.[4] In fact, the very repetitiveness of Niccolò's later production is typical of a flourishing workshop that exploits the successful cartoons of the master, and is incompatible with the activity of a still-developing single artist. This, then, is an additional reason for placing Niccolò's birth close to 1420.

Before we do so, however, let us make sure that the date 1440 painted below the quotation from the Apocalypse has no significance in connection with the life of the saint who holds the book; instead of dating the execution of the picture, it might simply refer to some important event in the biography or hagiography of Vincent Ferrer.

St. Vincent was a Spaniard, born at Valencia on January 23, 1350; he joined the Order of St. Dominic at a very early age (February 6, 1367) and died at Vannes in France on April 5, 1419. In 1440, therefore, he had been dead for some time; and that year also does not coincide with his canonization, by Pope Callixtus III, which took place later, in June, 1455.

The results of this biographical inquiry seem disappointing, yet they are not entirely negative. The period intervening between the death of a monk and the recognition of his sainthood on the part of Holy Mother Church is—iconographically—most interesting. The seductive power of the visual medium can transform the representation of a prospective saint into a formidable advertising weapon. We know that the Franciscan Observants popularized the image of Bernardino da Siena before his canonization, and we might expect the Dominican Observants to do the same with that of the Spanish preacher. The date on the Yale panel poses the question: how soon after the death of Vincent Ferrer were the faithful confronted with his image, either alone, or presented in the vicinity of the Virgin Mary, or shown in the act of performing one of those miracles that were a necessary step to be proclaimed a saint?

This question can be found to have a rewarding answer: the most important evidence of any worship of Vincent Ferrer in Italy before his canonization is encountered—what a coincidence!—near Foligno. The preacher from Valencia had been dead only a few years when the Dominicans of Gubbio commissioned from Tommaso Nelli an altarpiece with his full-length portrait (now on the third altar left in the church of San Domenico); and in order that the merits of their candidate for canonization should become familiar, nay, should

[3]See R. Ergas, *Niccolò di Liberatore genannt Allunno* (Munich, 1912), 17 and 131 n. 1.

[4]Cf. B. Berenson's list of works by Niccolò da Foligno in *Italian Pictures of the Renaissance* (Oxford, 1932; Milan, 1936; London, 1968), in which the dated paintings at Cannara (1482), Vescia near Foligno (1494), and La Bastia near Assisi (1499) are listed as "partly autograph," "studio work," and "by Lattanzio," respectively. In my opinion the cooperation of an assistant (his son Lattanzio?) can already be detected in the polyptych of Villa Albani at Rome (photo Alinari 27747), which is inscribed with the name of Niccolò and the date 1475.

appear as important as the deeds of established saints, they also commissioned—this time from the leading painter Ottaviano Nelli—the fresco decoration of a whole chapel (second left), in which the salient events of Vincent's career were coupled with episodes from the life of another Dominican preacher, the popular Peter Martyr of Verona, whose sanctity had been ratified two centuries earlier, in 1253.[5]

The canonization of Vincent Ferrer was effected by Callixtus III, the Spanish Pope, as soon as he acceded to the papal throne; and in the second half of the fifteenth century, the image and the miracles of the new saint were represented all over Italy, especially where Spain could exert its authority: first of all, naturally, in Naples—transformed as it had been since 1442 by the new king, Alfonso of Aragon, into a flourishing Hispano-Italian center (cf. the St. Vincent Ferrer altarpiece by Colantonio, about 1460, now in the Galleria di Capodimonte); but soon in Emilia also, thanks to the influential presence of the Collegio di Spagna at Bologna and to the Borgia connections of the Este family at Ferrara (cf. the altarpiece of St. Vincent Ferrer painted by Francesco del Cossa and Ercole Roberti about 1473 for the Grifoni Chapel in San Petronio at Bologna—now divided among the London National Gallery, the Brera, and the Pinacoteca Vaticana—and the polyptych of St. Vincent Ferrer painted around 1476/78 by Bartolomeo degli Erri for the Dominican church of Modena and best known for the twelve scenes from the Estensische Sammlung in the Gemäldegalerie at Vienna, nos. 1901–1912). Before 1455, on the other hand, representations of Vincent Ferrer were confined to the worship of his fellow-Dominicans and are extremely rare.[6] This is why our curiosity is whetted by the visual evidence that a *Spanish* preacher had been honored as a saint in remote *Umbria*, long before the Pope had given his assent to such an honor.

The leadership—in terms of holy propaganda—of an ancient, isolated hilltown like Gubbio ceases to be puzzling, however, if we keep in mind the religious upheavals that affected the church in Italy during the early fifteenth century. The elections of popes and antipopes upset all the clergy and forced every religious community to take sides and to bear the consequences of its declared loyalty. And so it happened that the Reformed Dominicans

[5] *Iconography of the Saints in Central and South-Italian Painting* (Florence, 1965), no. 408, fig. 132a and no. 30c B, fig. 1079).

[6] G. Kaftal, *Iconography of the Saints in Tuscan Painting* (Florence, 1952), 314a, fig. 1147, mentions Vincent's portrait among the sixteen busts of Dominican worthies in the frieze below the *Crucifixion* painted by Angelico in the Chapter Hall of the Convent of San Marco in Florence—a very humble testimony in a very secondary position (on the same wall, St. Peter Martyr is given place of honor beside the Crucified). In the nearby Galleria dell'Accademia, the altarpiece attributed to Giovanni Francesco da Rimini (no. 3461), which represents St. Vincent Ferrer and three scenes from his life, already belongs to the third quarter of the fifteenth century. Professor Kaftal kindly informs me that a panel for private devotion, formerly in the Massari Zavaglia Collection at Ferrara (photo Gabinetto Fotografico Nazionale, Rome, C 7602) also portrays Vincent Ferrer. Here again the picture, which is wrongly attributed to Michele di Matteo, could have been painted *after* 1455. Incomparably more important is the triptych in the Hermitage, also brought to my attention by Kaftal, which represents the Virgin between Sts. Francis and Vincent Ferrer (not St. Donatus, as stated by Lazareff, in "Maestro Paolo e la pittura veneziana del suo tempo," *Arte Veneta*, VIII, 1954, 77–89, and by R. Pallucchini in "La Pittura Veneziana del Trecento," Venice-Rome, 1964, 199, fig. 610). In this case, the iconographical identification is of great consequence for the dating of the triptych, attributed by the above-mentioned scholars to the workshop of Catarino and Donato Veneziano. Donato and Catarino worked together in 1370–75, when Vincent Ferrer, born 1350, was in his early twenties. The need to assign a later date to the Hermitage triptych and to ascribe it to a *follower* of Catarino and Donato, therefore, seems imperative.

For a convincing reconstruction and dating of the polyptych of St. Vincent Ferrer by Bartolomeo degli Erri formerly in the church of San Domenico at Modena, see A. M. Chiodi, "Bartolomeo degli Erri e i polittici domenicani," *Commentari* (II, 1951), 17ff., fig. 33. A still later instance of the promotion of the cult of Vincent Ferrer in Emilia is offered by Lorenzo Costa in the framework of an altarpiece painted in Bologna in the late 1480s (see F. R. Shapley, *Paintings from the Samuel H. Kress Collection, Italian Schools XV–XVI Century*, London, 1968, fig. 160).

of Fiesole, who persevered in their obedience to the deposed Pope Gregory XII after their Prior had been arrested for this reason by the Master General of the Order (1409), fled to Foligno, where they were welcomed by the learned Bishop Federigo Frezzi, who shared their views.[7] The documents concerning their flight and exile have heretofore been studied for the sole purpose of ascertaining the absence from Florence and the prolonged sojourn in Umbria of Fra Giovanni da Fiesole, not yet referred to as "Beato Angelico."[8] But a side-result of these studies is that we have obtained more detailed information about the reformed community to which Angelico belonged; so now we know that one of Angelico's companions was a Spanish monk, called Fra Niccolò da Valenza. The presence at Foligno, among the reformed Dominicans of Fiesole, of a fellow-citizen of Vincent Ferrer, and the progressive attitude of those refugees led by the zealous Antoninus of Florence, are two facts that go a long way to explain the early veneration of a Dominican preacher from Valencia among the Dominicans in and around Foligno. In these circumstances, the presence of an altarpiece and of frescoes dedicated to Vincent Ferrer in nearby Gubbio is not at all surprising.

We can now close our iconographical parenthesis, having established that the date 1440 on a panel that represents Peter Martyr and Vincent Ferrer on either side of the Virgin is not only acceptable but perfectly convincing, since the painting had been commissioned from an artist of Foligno. Given its size and contents, the little panel was obviously destined for the private devotion of a Dominican prior, bishop, or abbot. As a final remark, let us notice that the painter omitted the halos both for the canonized Dominican on the left and the would-be Dominican saint on the right (the coarse punching above part of the head of Vincent Ferrer is plainly due to a later intervention).

If we therefore accept—as we must—the date 1440 as the year of execution of the Yale picture, we must also accept the backdating of the painter's birth to around 1420. Consequently, we must admit that Niccolò di Liberatore da Foligno was a contemporary of Benozzo Gozzoli (1420–1497), not his junior. This reassessment of their respective ages is not pointless, as we shall see; on the contrary, it is essential for a better understanding of Benozzo's influence not only on Niccolò but also on the school of Foligno in general.

The attribution of our panel to the Florentine School, mid-fifteenth century, that Charles Seymour put forward in the Yale catalogue is, in a sense, perfectly correct. The artist who painted it appears steeped in Florentine Late-Gothic/Early-Renaissance culture. We are reminded of Pesellino, Masolino, Angelico, Domenico Veneziano, even—for the strong modeling of some flesh-parts—of Masaccio; but the name of Benozzo Gozzoli does not come remotely into one's mind. No wonder, since he did not become an independent master until ten years later!

Benozzo's activity in Umbria is first recorded in 1447, when he was assisting Angelico in the Cappella di San Brizio at Orvieto; but his first original work, the celebrated frescoes in the churches of San Fortunato and San Francesco at Montefalco, are dated 1450 and 1452. A few years later (1456 or 8?) Niccolò di Liberatore signed and dated the frescoes of Santa

[7]On Federigo Frezzi, see S. Frenfanelli Cibo, *Niccolò Alunno e la Scuola Umbra* (Rome, 1872), 104. [8]*Ibid.*, 94; S. Orlandi, *Beato Angelico* (Florence, 1964), 22.

Maria in Campis at Foligno, which betray a general knowledge of the formal achievements of Florentine painting, no special indebtedness to Benozzo, a passionate temperament, and a purely Umbrian religious fervor. On the other hand, in the year 1457, the same Niccolò signed and dated the restrained, Benozzesque *Madonna Enthroned with Sts. Francis, Bernardinus, Angels, and the Donor Jacobus Rubeus*, now in the Pinacoteca Comunale of Deruta (Fig. 4).

The Deruta *Madonna*, which is the only surviving panel of a large triptych painted for Santa Maria dei Consoli, was supposed to have been Niccolò's starting point: and as Benozzo's influence is here at its strongest, it has been assumed by all scholars that Niccolò began his artistic career as an Umbrian pupil of Gozzoli's. The objection that Niccolò would never have been commissioned to paint an altarpiece for the church of the famous and prosperous maiolica manufacturers of Deruta had he not previously offered good proof of his ability to carry out such an important assignment is reasonable; and it was formulated by Ergas.[9] But it carried little weight as long as no painting attributable to Niccolò da Foligno and datable before 1457 was found. Now at last the Yale *Madonna with Sts. Peter Martyr and Vincent Ferrer* provides ample visual evidence that Ergas's doubts were justified.

The Yale panel reveals, besides, that the mature style of Niccolò da Foligno is closer to the style of his youth than to the Benozzesque manner of the Deruta *Madonna*. The simplicity and liveliness of the early portable picture may be due not only to the youthful exuberance of its author but also to its small size (this is surely the reason why the concave throne is represented with its back arching downward and not upward, as in all the later representations, which belong to altarpieces placed high and seen from below); but the most interesting aspect of this small panel is that one already finds in it the bold modeling and expressiveness that are Niccolò's best qualities in later years. The Christ Child is anatomically studied and wriggles plausibly in the lap of His Mother, casting a quizzical glance at St. Vincent, who goes on preaching with lifted hand and a faraway look in his eyes, perfectly aware that he is arousing the devout admiration of St. Peter Martyr but only the curiosity of the Infant Savior. As for the attention of the Virgin and of the attendant angels, it is piously and whole-heartedly concentrated on the unruly Christ Child. How much more attractive His restlessness is than the placid gaze of the baby on the knees of the *Madonna dei Consoli* (Fig. 4)! The quiet prettiness and more graphic rendering of form that strike us in the latter picture betray a determination, which fortunately did not last long, to imitate Benozzo's facile and fashionable manner. Soon Niccolò's plastic and dramatic feeling, so genuinely expressed in the amusing trio that dominates the foreground of the Yale panel, reasserted itself again with a vigor that sometimes verges on crudity, but never on affectation.

Since Niccolò da Foligno had developed his own style long before Gozzoli ventured into Umbria, let us see what other influences went to form it. Foligno was a prosperous city with a splendid artistic tradition. Ottaviano Nelli's narrative of the Life of the Virgin in the chapel of the Palazzo Trinci, formerly bearing the signature and date 1424, is full of charm. The other cycles of frescoes in the same Palace, which represent the Liberal Arts, Allegories of the Planets, or the legendary Origins of Rome, although fragmentary, reveal a sophisticated

[9] *Niccolò di Liberatore*, 131 n. 1.

culture, a narrative power, a decorative charm, and an elegance of detail that put them on a level with the best murals of the Gothic International Style in Italy. They must have been the pride of the town when Niccolò di Liberatore was a child; and when he was in his teens, the whole of Umbria was seduced by the "angelic" art of Fra Giovanni da Fiesole, the gifted friar patronized by the powerful and progressive Dominican monks. Angelico's polyptych and frescoed lunette in the church of San Domenico at Cortona are dated 1435–1440, and his marvelous altarpiece formerly in San Domenico at Perugia (now divided between the Pinacoteca Vaticana and the Galleria Nazionale dell'Umbria) was painted in 1437. Their influence on local painting has not yet been fully realized. Nor should we forget the presence of Masolino at Todi in 1432.[10]

In fact, if we try to find a prototype for Niccolò's Madonnas, we shall not discover it in the work of Benozzo Gozzoli; the bare head and slim face, the mantle precariously wrapped around the shoulders and folded back around the neck, as in Domenico Veneziano and Pesellino, are elements that seem to derive directly from the Virgins in Angelico's Coronations or Annunciations. And the best of the latter was the *Annunciation* painted by Angelico about 1430 for the Chiesa del Gesù at Cortona (not far from Foligno). This type of Virgin differs noticeably from that of Benozzo's Madonnas, whose chubby cheeks are always framed in by the geometrical folds of the cloak that covers their cubic head.

Benozzo's round faces can be detected even in the Vatican frescoes, executed in collaboration with his master Angelico; but on two occasions Benozzo adopted an elongated oval face for his Virgins: in his first documented work, a fresco painted in 1450 at Montefalco near Foligno (Fig. 5), and, to a lesser degree, in an altarpiece executed soon afterwards (possibly for Fra Jacopo da Montefalco), which is now in Vienna (Fig. 6). These two exceptions, both closely connected with Foligno, induce one to wonder. Niccolò di Liberatore seems to have turned the tables on his supposed teacher, and the itinerant Florentine painter seems to have been forced to accept an ideal of beauty that found favor in Umbria but was alien to him.

In the signed and dated fresco of San Fortunato at Montefalco, Benozzo Gozzoli not only adapted Niccolò's type of Virgin to his personal predilections but also transferred to the wall—in reverse—the group of Mother and Child exactly as it appears in the newly identified panel in the Yale University Art Gallery, which is dated ten years earlier. Moreover, the composition of the Yale panel seems also to have inspired Benozzo's Vienna altarpiece, in which the enthroned Virgin is accompanied by two kneeling saints and a kneeling donor, while two angels lift a cloth behind her.

Until now, art historians have seen Benozzo Gozzoli's Vienna altarpiece from a different point of view, in the light of its similarities with Niccolò's *Madonna dei Consoli* of 1457. They considered the former the prototype of the latter and dated it either in or around the year 1452, or between 1453 and 1458.[11] The identification of the Yale panel sandwiches the Vienna

[10]A voice in favor of relating the early production of Niccolò da Foligno to the whole of Tuscan art and not only to the work of Benozzo Gozzoli has been raised by G. Boccolini, in discussing the frescoes of Santa Maria in Campis, "Affreschi

di Niccolò Alunno," *Le Arti* (LVI, 1942–43), 356.

[11]See A. P. Rizzo, *Benozzo Gozzoli Pittore Fiorentino"* (Florence, 1972), 119 (with previous bibliography).

picture by Benozzo between two compositions by Niccolò and reveals this interplay of influences in a different historical perspective. It now becomes clear that in the Vienna altarpiece Benozzo Gozzoli combined a design well known among the followers of Angelico—that of the seated (rather than enthroned) Madonna, who adores with crossed hands the Infant Jesus lying in her lap,[12] with a new concept that he had picked up in Umbria and first used in the fresco at Montefalco.

This Umbrian concept, however, requires that the Virgin be enthroned, her head turned sideways, her hands joined in prayer, while the naked Christ Child reclines on her knees. It hovers between the representations of the Madonna in a *Maestà* and the Adoration of the Christ Child and is documented in and around Foligno by several paintings, but none as early as 1440. A contemporary of Niccolò's, Pier Antonio Mezzastris, repeats this scheme with slight variations in two frescoes : a *Madonna*, dated 1461, in the church of San Francesco at Montefalco, and a *Madonna with Two Franciscan Saints and Angels*, of a later style, in the church of San Martino at Trevi. We cannot be certain that this peculiar concept originated with Niccolò di Liberatore da Foligno ; but we can safely state that he was the painter who brought it across the Apennines in the 1460s.

In the Marches, Niccolò was only superficially affected by the polyptychs of Carlo Crivelli, whereas he himself exerted a deep influence on local artists. His closest imitator, Lorenzo d'Alessandro da San Severino, must have known either the Yale panel or—more likely—a repetition of it by the master, because he includes the concave throne hemmed in by angels in his early altarpiece at San Severino (Fig. 7) and mechanically repeats the group of Mother and Child—not forgetting the white cloth on the Virgin's knees—up to the end of the century. Yet, in the votive fresco of the *Maestà* at San Severino, in the frescoed chapel of the Collegiata at Sarnana, signed and dated 1483 (Fig. 8), in the polyptych of Serrapetrona (formerly dated 1494), the lively invention of Niccolò da Foligno is formalized, frozen into a perfunctory mannerism ; and Niccolò's dynamic, quizzical Infant Jesus becomes a doll with stiff neck, rigidly bent arms, and straight, unbendable little legs.

FLORENCE

[12]A typical example of the scheme is the *Madonna of Humility,* seated on a cushion before a cloth held by two angels, now in the National Gallery, Washington.

Una Tavola boema del Trecento

FEDERICO ZERI

Nel riordinare delle vecchie carte mi ricapita sotto gli occhi la fotografia di un dipinto che, malgrado il suo grande interesse, non è, a quanto mi consta, noto agli specialisti della rara scuola cui va restituito (Fig. 1).

Non mi piace illustrare o commentare opere che non conosco *de visu*, ma nel caso presente voglio fare un'eccezione, perché l'apporto è davvero insolito e significativo; tra l'altro, c'è da dubitare che il dipinto esista ancora. Non essendo infatti riapparso durante gli ultimi trenta anni, non è escluso che sia andato distrutto nel corso della *Blitzkrieg* nazista su Londra; la sua fotografia comunque è assai preziosa, perché il suo negativo (Cooper 88388) è tra quelli che andarono persi durante una di quelle incursioni. Tutto quello che so della storia esterna di quest'opera è che nel 1935 si trovava a Londra, presso il mercante Asscher and Welker; se tra i lettori di questo mio scritto c'è qualcuno che ha visto recentemente la tavola e sa dove si trova, farà cosa molto utile per gli studi a segnalarne l'attuale dimora.

Ho detto "tavola," perché la bella fotografia mostra il legno e la sua grana, oltre i limiti del campo dipinto e del fondo d'oro; e qui, lungo il bordo, il lieve rialzo che doveva continuare nella originaria cornice, prova che non si tratta di un frammento. Nessuna indicazione delle misure; ma a giudicare dal cretto, dai punzoni nei fregi e da altri particolari, l'originale non doveva essere molto più grande della riproduzione in mio possesso, che misura cm. 28.7× 20.

Che questo dipinto costituisca un'aggiunta, e anche assai notevole, allo scarsissimo catalogo della Scuola boema del Trecento, è un fatto che non mi provo a dimostrare; su questo punto, confido nel grado di conoscenza specifica del lettore. Ma non posso fare a meno di notare che, a parte i confronti ben precisi, la medesima origine è suggerita dall'inconfondibile sapore che, persino dalla lettura di una fotografia, viene evocato da questa immagine; il medesimo (difficile a rendere a parole per chi è abituato alla frequenza con l'arte italiana del Trecento) che resta nel ricordo della visita alla sale dei più antichi pittori boemi, al pian terreno della Galleria Nazionale di Praga. Sono quel clima di favoloso e persino di fiabesco, quella tensione intima, sincera e profonda ma gentile, quell'assoluta immunità dalla tradizione classica (e anche nei suoi derivati *bizantini* o *volgari*), quella fusione di stilismo perfetto e di notazioni naturalistiche, secondo il cui metro tornano tradotti i ricordi del Trecento nostrano; come in questa tavoletta, dove il tema della *Madonna dell'Umiltà*, esemplificato su di un qualche prototipo emiliano (anzi certamente modenese) viene del tutto rinnovato dalla inconsueta preoccupazione che sollecita l'interesse della Vergine. Io non conosco altro esempio *iconografico* che mostri come qui la Madonna dell'Umiltà mentre aiuta il Bambino ad alzarsi, afferrando il suo braccio sinistro e sorreggendolo per la schiena. Non si può che convenire sulla fonte implicita in una notazione di tale, diretta presa dal vero; fonte che va identificata in Tommaso da Modena, e che ci conduce ad una data verso il 1360. E infatti, tutto fa pensare che questa tavola significhi (assieme all'altra *Madonna dell'Umiltà* nella Chiesa dei Santi Pietro

462

e Paolo a Praga, più nota come *Madonna del Vysehrader*) la conversione ai modi di Tommaso di una delle maggiori, anche se finora non ricomposta, persone del Trecento boemo.

Domando scusa ai colleghi cecoslovacchi se invado il loro campo, ma ho la netta impressione che il Trecento boemo attenda ancora di essere arato, e che una buona operazione "morelliana" potrebbe dare risultati assai soddisfacenti. Così, mi pare assai evidente l'appartenza ad una medesima personalità artistica sia di questa nuova tempera che di quella del Vysehrader; dirò di più, queste due tavole, che indicano l'aderenza a Tommaso da Modena, sembrano costituire la fase finale di un pittore riconoscibile in altre tre opere, e tra le più celebri di tutto il catalogo del Trecento boemo: la *Madonna di Glatz* a Berlino, la *Dormitio Virginis* nel Museum of Fine Arts di Boston e infine la *Madonna* a mezza figura nella Chiesa di San Giacomo Maggiore a Zbraslav. È infatti irragionevole imputare ad una coincidenza il ripetersi, in modi del tutto identici, della peculiare, marcata caratterizzazione (introvabile altrove) secondo cui è descritto il volto del Bambino in questo nuovo dipinto, che ritorna in quello della tavola di Zbraslav e nel donatore, l'Arcivescovo Ernst da Pardubitz, della *Maestà* di Berlino; quanto alla tempera di Boston, l'analogia tipologica e strutturale della testa del Cristo rispetto alla nostra *Madonna dell'Umiltà* è più che indicativa. Certo è che, negli studi sul Trecento italiano, questa serie di raffronti sarebbe più che sufficiente a costituire un gruppo, e tra i più solidi; ma lascio l'ultima parola agli specialisti del campo. Se ho visto bene, questo importante pittore deve aver visitato l'Italia, e forse già prima del 1340. È assai difficile ravvisare con precisione gli agganci con la pittura nostrana, perché i ricordi sono tra i più rielaborati, e spesso mescolano fonti tra le più disparate: come nella tavola di Zbraslav, che rammenta la Siena del primo Trecento e l'Emilia di qualche decennio dopo, o come nel capolavoro di Berlino (che da notizie esterne pare databile verso il 1350), e il cui trono ha un singolare sapore italiano. Ma nel pannello stupendo di Boston la trama architettonica e prospettica denuncia la conoscenza di Assisi, e cioè del *Cristo tra i Dottori* del cosidetto Maestro delle Vele nella Basilica inferiore. Questo riferimento non è nuovo, e già la storiografia cecoslovacca lo ha rilevato;[1] non credo però si sia notata l'assonanza tra le esasperate figure e certi passi del Maestro espressionista di Santa Chiara, un punto questo che meriterebbe un'indagine ulteriore.

MENTANA

[1]Cf. A. Matějček e J. Pešina, *Gotische Malerei in Böhmen* (Praga, 1955), 53. Rimando a questo testo fondamentale anche per i confronti con le opere citate e discusse, tutte riprodotte.